W9-CAE-826

PHOTOGRAPHER'S MARKET **2018**

ArtistsMarketOnline.com

How & Where to Sell What You Create

THE ULTIMATE MARKET RESEARCH TOOL FOR PHOTOGRAPHERS

To register your *Photographer's Market 2018* and **start your FREE 1-year online subscription**, scratch off the block below to reveal your activation code*, then go to ArtistsMarketOnline.com. Click on "Sign Up Now" and enter your contact information and activation code. It's that easy!

Carefully scratch off the block with a coin. **Do not use a key.**

REFERENCE

UPDATED MARKET LISTINGS

EASY-TO-USE, SEARCHABLE DATABASE • RECORD-KEEPING TOOLS

INDUSTRY NEWS • PROFESSIONAL TIPS & ADVICE

*Valid through 12/31/18

ArtistsMarketOnline.com

How & Where to Sell What You Create

PHOTO18

PHOTOGRAPHER'S MARKET® 2018

HOW AND WHERE TO SELL YOUR PHOTOGRAPHY

REFERENCE

Noel Rivera, Editor

NORTH LIGHT BOOKS
CINCINNATI, OHIO
artistsmarketonline.com

General Manager, Fine Art Community: David Pyle
Content Strategiest, Fine Art Community: Michael Gormley
Content Director, North Light Books: Pam Wissman
Market Books Assistants, North Light Books: Roshawn Jenkins and Dion Branham

Artist's Market Online website: artistsmarketonline.com
Artist's Network website: artistsnetwork.com
North Light Shop website: northlightshop.com

2018 Photographer's Market. Copyright © 2017 by F+W Media, Inc. Published by F+W Media, Inc., 10151 Carver Rd., Suite 200, Blue Ash, Ohio 45242. Printed and bound in the United States of America. All rights reserved. No part of this book may be reproduced in any form or by any electronic or mechanical means including information storage and retrieval systems without written permission from the publisher. Reviewers may quote brief passages to be printed in a magazine or newspaper.

Other fine North Light Books are available from your local bookstore, art supply store or online supplier. Visit our website at fwmedia.com.

Distributed in Canada by Fraser Direct
100 Armstrong Avenue
Georgetown, ON, Canada L7G 5S4

Distributed in the U.K. and Europe by F&W Media International, LTD
Pynes Hill Court, Pynes Hill, Rydon Lane, Exeter, EX2 5AZ, UK
Tel: (+44) 1392 797680
E-mail: enquiries@fwmedia.com

ISSN: 0147-247X
ISBN-13: 978-1-4403-5253-9
ISBN-10: 1-4403-5253-4

Project managed by Noel Rivera
Cover design by Emma Baehren
Interior design by Geoff Raker
Production coordinated by Debbie Thomas

Attention Booksellers: This is an annual directory of F+W Media, Inc. Return deadline for this edition is December 31, 2018.

fw a content + ecommerce company

CONTENTS

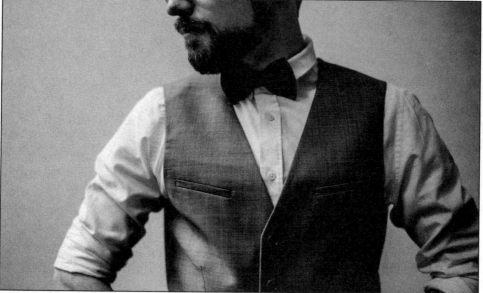

Groom's attire by Natalie Marquis

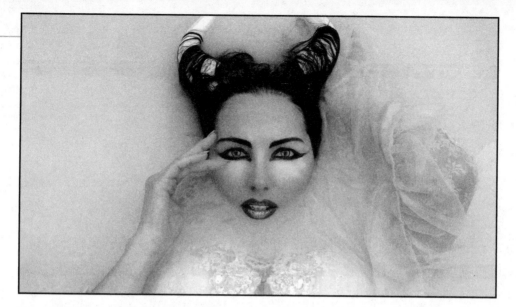

Intense black makeup and brunette locks appear in sharp contrast to the pale horns and lace in this foggy image from Laura Dark's Floating series.

MARKETS

RESOURCES

INDEXES

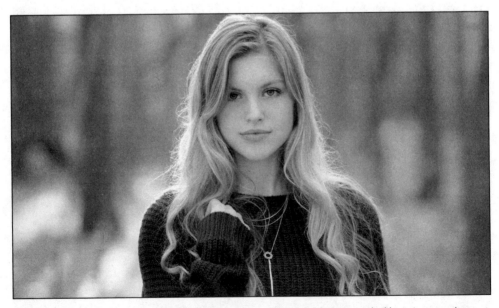

In this 2017 senior school photo, Jaky Janine and her client hiked to a wooded location near her studio in Climax, Michigan.

FROM THE EDITOR

Change takes place in every industry, and photography is no exception. This edition of *Photographer's Market* looks at some of the new challenges and advances in the market with articles that address changes in the technology and the language of photography.

You'll also find features on core topics such as working with galleries, marketing yourself, knowing your rights, and determining what photos will sell and re-sell. Interviews with four successful freelance photographers will inspire you while providing food for thought when it comes to your own photography business.

As always, we've included more than 1,500 individually verified market contacts (complete with payment information). So don't wait! Get started now.

Keep creating and good luck!

C. Noël Rivera

Noel Rivera
photomarket@fwmedia.com
www.artistsmarketonline.com

P.S. Don't forget to register at **Artist's Market Online, which you get FREE for a year with the purchase of this book**. With your free 1-year subscription, you'll be able to search market contacts, track your submissions, read up on the latest market news, and much more. Use the activation code from the front insert to access your free subscription today.

HOW TO USE THIS BOOK

The first thing you'll notice about most of the listings in this book is the group of symbols that appears before the name of each company. Scanning the listings for symbols can help you quickly locate markets that meet certain criteria. (You'll find a quick-reference key to the symbols as well as a sample listing on the back inside cover of the book.) Here's what each symbol stands for:

- **⊕** This photo buyer is new to this edition of the book.
- **◑** This photo buyer is located in Canada.
- **◐** This photo buyer is located outside the U.S. and Canada.
- **◎** This photo buyer uses only images created on assignment.
- **◑** This photo buyer uses only stock images.

COMPLAINT PROCEDURE

If you feel you have not been treated fairly by a company listed in *Photographer's Market*, we advise you to take the following steps:

- First, try to contact the listing. Sometimes one phone call, e-mail, or letter can quickly clear up the matter.
- Document all your correspondence with the listing. If you write to us with a complaint, provide the details of your submission, the date of your first contact with the listing, and the nature of your subsequent correspondence.
- We will enter your letter into our files.
- The number and severity of complaints will be considered in our decision whether to delete the listing from the next edition.

◐ This photo buyer accepts submissions in digital format.

✪ This photo buyer uses film or other audiovisual media.

◐ This art fair is a juried event; a juror or committee of jurors views applicants' work and selects those whose work fits within the guidelines of the event.

Pay Scale

We asked photo buyers to indicate their general pay scale based on what they typically pay for a single image. Their answers are signified by a series of dollar signs before each listing. Scanning for dollar signs can help you quickly identify which markets pay at the top of the scale. However, not every photo buyer answered this question, so don't mistake a missing dollar sign as an indication of low pay rates. Also keep in mind that many photo buyers are willing to negotiate.

$	Pays $1–150
$$	Pays $151–750
$$$	Pays $751–1,500
$$$$	Pays more than $1,500

Openness

We also asked photo buyers to indicate their level of openness to freelance photography. Looking for these symbols can help you identify buyers who are willing to work with newcomers, as well as prestigious buyers who publish only top-notch photography.

○ Encourages beginning or unpublished photographers to submit work for consideration; publishes new photographers. May pay only in copies or have a low pay rate.

◑ Accepts outstanding work from beginning and established photographers; expects a high level of professionalism from all photographers who make contact.

● Hard to break into; publishes mostly previously published photographers.

⊘ May pay at the top of the scale. Closed to unsolicited submissions.

Subheads

Each listing is broken down into sections to make it easier to locate specific information (see sample listing on the back inside cover of this book). In the first section of each listing you'll find mailing addresses, phone numbers, e-mail and website addresses, and the name of the person you should contact. You'll also find general information about photo buyers, including when their business was established and their publishing philosophy. Each listing will include one or more of the following subheads:

Needs. Here you'll find specific subjects each photo buyer is seeking. (Use the subject index at the end of the book to help you narrow your search.) You'll also find the average

FREQUENTLY ASKED QUESTIONS

1 How do companies get listed in the book?

No company pays to be included—all listings are free. Every company has to fill out a detailed questionnaire about their photo needs. All questionnaires are screened to make sure the companies meet our requirements. Each year we contact every company in the book and ask them to update their information.

2 Why aren't other companies I know about listed in this book?

We may have sent those companies a questionnaire, but they never returned it. Or if they did return a questionnaire, we may have decided not to include them based on our requirements.

3 Some publishers say they accept photos with or without a manuscript. What does that mean?

Essentially, the word *manuscript* means a written article that will be published by a magazine. Some magazines will consider publishing your photos only if they accompany a written article. Other publishers will consider publishing your photos alone, without a manuscript.

4 I sent a CD with large digital files to a photo buyer who said she wanted to see my work. I have not heard from her, and I am afraid that my photos will be used without my permission and without payment. What should I do?

Do not send large, printable files (300 dpi or larger) unless you are sure the photo buyer is going to use them, and you know what you will be paid for their usage and what rights the photo buyer is requesting. If a photo buyer shows interest in seeing your work in digital format, send small JPEGs at first so they can "review" them—i.e., determine if the subject matter and technical quality of your photos meet their requirements. Until you know for sure that the photo buyer is going to license your photos and you have some kind of agreement, do not send high-resolution files. The exception to this rule would be if you have dealt with the photo buyer before or perhaps know someone who has. Some companies receive a large volume of submissions, so sometimes you must be patient. It's a good idea to give any company listed in this book a call before you submit anything and be sure nothing has changed since we contacted them to gather or update information. This is true whether you submit slides, prints, or digital images.

5 A company says they want to publish my photographs, but first they will need a fee from me. Is this a standard business practice?

No, it is not a standard business practice. You should never have to pay to have your photos reviewed or to have your photos accepted for publication. If you suspect that a company may not be reputable, do some research before you submit anything or pay their fees. The exception to this rule is contests. It is not unusual for some contests listed in this book to have entry fees (usually minimal—between five and twenty dollars).

number of freelance photos a buyer uses each year, which will help you gauge your chances of publication.

Audiovisual Needs. If you create images for media such as filmstrips or overhead transparencies, or you shoot videotape or motion picture film, look here for photo buyers' specific needs in these areas.

Specs. Look here to see in what format the photo buyer prefers to receive accepted images. Many photo buyers will accept both digital and film (slides, transparencies, prints) formats. However, many photo buyers are reporting that they accept digital images only, so make sure you can provide the format the photo buyer requires before you send samples.

Exhibits. This subhead appears only in the Galleries section of the book. Like the Needs subhead, you'll find information here about the specific subjects and types of photography and gallery shows.

Making Contact & Terms. When you're ready to make contact with a photo buyer, look here to find out exactly what they want to see in your submission. You'll also find what the buyer usually pays and what rights they expect in exchange. In the Stock section, this subhead is divided into two parts, Payment & Terms and Making Contact, because this information is often lengthy and complicated.

Handles. This subhead appears only in the Photo Representatives section. Some reps also represent illustrators, fine artists, stylists, make-up artists, etc., in addition to photographers. The term *handles* refers to the various types of *talent* they represent.

Tips. Look here for advice and information directly from photo buyers in their own words.

HOW TO START SELLING YOUR WORK

If this is your first edition of *Photographer's Market*, you're probably feeling a little overwhelmed by all the information in this book. Before you start flipping through the listings, read the eleven steps below to learn how to get the most out of this book and your selling efforts.

1. Be honest with yourself. Are the photographs you make of the same quality as those you see published in magazines and newspapers? If the answer is yes, you may be able to sell your photos.

2. Get someone else to be honest with you. Do you know a professional photographer who would critique your work for you? Other ways to get opinions about your work: join a local camera club or other photo organization; attend a stock seminar led by a professional photographer; attend a regional or national photo conference or a workshop where they offer daily critiques.

- You'll find workshop and seminar listings in the Markets section.
- You'll find a list of photographic organizations in the Resources section.
- Check your local camera store for information about camera clubs in your area.

3. Get organized. Create a list of subjects you have photographed and organize your images into subject groups. Make sure you can quickly find specific images and keep track of any sample images you send out. You can use database software on your home computer to help you keep track of your images.

Other resources:

- *Photo Portfolio Success* by John Kaplan (Writer's Digest Books)
- *Sell and Re-Sell Your Photos* by Rohn Engh (Writer's Digest Books)

- *The Photographer's Market Guide to Building Your Photography Business* by Vik Orenstein (Writer's Digest Books)

4. Consider the format. Are your pictures color snapshots, black-and-white prints, color slides, or digital captures? The format of your work will determine, in part, which markets you can approach. Below are some general guidelines for where you can market various photo formats. Always check the listings in this book for specific format information.

- **digital**—nearly all newspapers, magazines, stock agencies, ad agencies, book and greeting card publishers
- **black-and-white prints**—some galleries, art fairs, private collectors, literary/art magazines, trade magazines, newspapers, book publishers
- **color prints**—some newsletters, very small trade or club magazines
- **large color prints**—some galleries, art fairs, private collectors
- **color slides (35mm)**—a few magazines, newspapers, some greeting card and calendar publishers, a very few book publishers, textbook publishers, stock agencies
- **color transparencies (2¼×2¼ and 4×5)**—a few magazines, book publishers, calendar publishers, ad agencies, stock agencies. Many of these photo buyers have begun to accept only digital photos, especially stock agencies.

5. Do you want to sell stock images or accept assignments? A stock image is a photograph you create on your own and then sell to a publisher. An assignment is a photograph created at the request of a specific buyer. Many of the listings in *Photographer's Market* are interested in both stock and assignment work.

 Listings that are interested only in stock photography are marked with this symbol.

 Listings that are interested only in assignment photography are marked with this symbol.

6. Start researching. Generate a list of the publishers that might buy your images—check the newsstand, go to the library, search the Web, read the listings in this book. Don't forget to look at greeting cards, stationery, calendars, and CD covers. Anything you see with a photograph on it, from a billboard advertisement to a cereal box, is a potential market.

7. Check the publisher's guidelines. Do you know exactly how the publisher you choose wants to be approached? Check the listings in this book first. If you don't know the format, subject, and number of images a publisher wants in a submission, you should check their website first. Often, guidelines are posted there. Or you can send a short letter with a self-addressed, stamped envelope (SASE) or e-mail asking those questions. A quick call to the receptionist might also yield the answers.

8. Check out the market. Get in the habit of reading industry magazines.

9. Prepare yourself. Before you send your first submission, make sure you know how to respond when a publisher agrees to buy your work.

Pay Rates

Most magazines and newspapers will tell you what they pay, and you can accept or decline. However, you should become familiar with typical pay rates. Ask other photographers what they charge—preferably ones you know well or who are not in direct competition with you. Many will be willing to tell you to prevent you from devaluing the market by undercharging.

Other resources:

- *Pricing Photography: The Complete Guide to Assignment & Stock Prices* by Michal Heron and David MacTavish (Allworth Press)
- *fotoQuote*, a software package that is updated each year to list typical stock photo and assignment prices, (800)679-0202, www.cradocfotosoftware.com
- *Negotiating Stock Photo Prices* by Jim Pickerell (www.jimpickerell.com)

Copyright

You should always include a copyright notice on any slide, print, or digital image you send out. While you automatically own the copyright to your work the instant it is created, the notice affords extra protection. The proper format for a copyright notice includes the word or symbol for copyright, the date and your name: © 2018 Jane Photographer. To fully protect your copyright and recover damages from infringers, you must register your copyright with the Copyright Office in Washington DC.

Rights

In most cases, you will not actually be selling your photographs, but rather, the rights to publish them. If a publisher wants to buy your images outright, you will lose the right to resell those images in any form or even display them in your portfolio. Most publishers will buy one-time rights and/or first rights.

Resource:

- *Legal Guide for the Visual Artist* by Tad Crawford (Allworth Press)

Contracts

Formal contract or not, you should always agree to any terms of sale in writing. This could be as simple as sending a follow-up letter restating the agreement and asking for confirmation, once you agree to terms over the phone. You should always keep copies of any correspondence in case of a future dispute or misunderstanding.

Resource:

- *Business and Legal Forms for Photographers* by Tad Crawford (Allworth Press)

10. Prepare your submission. The number one rule when mailing submissions is: "Follow the directions." Always address letters to specific photo buyers. Always include a SASE of sufficient size and with sufficient postage for your work to be safely returned to you. Never send originals when you are first approaching a potential buyer. Try to include something in your submission that the potential buyer can keep on file, such as a tearsheet and your résumé. In fact, photo buyers prefer that you send something they don't have to return to you. Plus, it saves you the time and expense of preparing a SASE.

Resource:

- *Photo Portfolio Success* by John Kaplan (Writer's Digest Books)

11. Continue to promote yourself and your work. After you've made that first sale (and even before), it is important to promote yourself. Success in selling your work depends in part on how well and how often you let photo buyers know what you have to offer. This is known as self-promotion. There are several ways to promote yourself and your work. You can send postcards or other printed material through the mail, send an e-mail with an image and a link to your website, and upload your images to a website that is dedicated to showcasing your work and your photographic services.

RUNNING YOUR BUSINESS

Photography is an art that requires a host of skills, some that can be learned and some that are innate. To make money from your photography, the one skill you can't do without is business savvy. Thankfully, this skill can be learned. We'll cover:

- Submitting Your Work
- Digital Submission Guidelines
- Using Essential Business Forms
- Stock List
- Charging for Your Work
- Figuring Small Business Taxes
- Self-Promotion
- Organizing & Labeling Your Images
- Protecting Your Copyright

SUBMITTING YOUR WORK

Editors, art directors, and other photo buyers are busy people. Many spend only 10 percent of their work time actually choosing photographs for publication. The rest of their time is spent making and returning phone calls, arranging shoots, coordinating production, and doing a host of other unglamorous tasks that make publication possible. They want to discover new talent, and you may even have the exact image they're looking for, but if you don't follow a market's submission instructions to the letter, you have little chance of acceptance.

To learn the dos and don'ts of photography submissions, read each market's listing carefully and make sure to send only what they ask for. Don't send prints if they want only digital files. Don't send color if they want only black and white. Check their website or send for

guidelines whenever they are available to get the most complete and up-to-date submission advice. When in doubt, follow these ten rules when sending your work to a potential buyer:

1. Don't forget your SASE. Always include a self-addressed, stamped envelope whether you want your submission back or not. Make sure your SASE is big enough, has enough packaging, and has enough postage to ensure the safe return of your work.

2. Don't over-package. Never make a submission difficult to open and file. Don't tape down all the loose corners. Don't send anything too large to fit in a standard file.

3. Don't send originals. Try not to send things you must have back. Never, ever send originals unsolicited.

4. Label everything. Put a label directly on the slide mount or print you are submitting. Include your name, address, and phone number, as well as the name or number of the image. Your slides and prints will almost certainly get separated from your letter.

5. Do your research. Always research the places to which you want to sell your work. Request sample issues of magazines, visit galleries, examine ads, look at websites, etc. Make sure your work is appropriate before you send it out. A blind mailing is a waste of postage and a waste of time for both you and the art buyer.

6. Follow directions. Always request submission guidelines. Include a SASE for reply. Follow *all* the directions exactly, even if you think they're silly.

7. Include a business letter. Always include a cover letter, no more than one page, that lets the potential buyer know you are familiar with their company, what your photography background is (briefly), and where you've sold work before (if it pertains to what you're trying to do now). If you send an e-mail, follow the same protocol as you would for a business cover letter and include the same information.

8. Send to a person, not a title. Send submissions to a specific person at a company. When you address a cover letter to Dear Sir or Madam, it shows you know nothing about the company you want to buy your work.

9. Don't forget to follow through. Follow up major submissions with postcard samples several times a year.

10. Have something to leave behind. If you're lucky enough to score a portfolio review, always have a sample of your work to leave with the art director. Make it small enough to fit in a file but big enough not to get lost. Always include your contact information directly on the leave-behind.

DIGITAL SUBMISSION GUIDELINES

Today, almost every publisher of photographs prefers digital images. Some still accept "analog" images (slides and prints) as well as digital images, but most accept only digital images. There are a few who still do not accept digital images at all, but their number is rapidly decreasing. Follow each buyer's size and format guidelines carefully.

STARTING A BUSINESS ///

To learn more about starting a business:

- Take a course at a local college. Many community colleges offer short-term evening and weekend courses on topics like creating a business plan or finding financial assistance to start a small business.

- Contact the Small Business Administration at (800)827-5722 or check out their website at www.sba.gov. The U.S. Small Business Administration was created by Congress in 1953 to help America's entrepreneurs form successful small enterprises. Today, SBA's program offices in every state offer financing, training, and advocacy for small firms.

- Contact the Small Business Development Center at (202)205-6766. The SBDC offers free or low-cost advice, seminars, and workshops for small business owners.

- Read a book. Try *Commercial Photography Handbook: Business Techniques for Professional Digital Photographers* by Kirk Tuck (Amherst Media) or *The Business of Studio Photography* by Edward R. Lilley (Allworth Press). The business section of your local library will also have many general books about starting a small business.

Previews

Photo buyers need to see a preview of an image before they can decide if it will fit their needs. In the past, photographers mailed slides or prints to prospective photo buyers so they could review them, determine their quality, and decide whether the subject matter was something they could use. Or photographers sent a self-promotion mailer, often a postcard with one or more representative images of their work. Today, preview images can be e-mailed to prospective photo buyers, or they can be viewed on a photographer's website. This eliminates the hassle and expense of sending slides through the mail and wondering if you'll ever get them back.

The important thing about digital preview images is size. They should be no larger than 3×5 inches at 72 dpi. E-mailing larger files to someone who just wants a peek at your work could greatly inconvenience them if they have to wait a long time for the files to open or if their e-mail system cannot handle larger files. If photo buyers are interested in using your photographs, they will definitely want a larger, high-resolution file later, but don't overload their systems and their patience in the beginning with large files. Another option is sending a CD with preview images. This is not as efficient as e-mail or a website since the photo buyer has to put the CD in the computer and view the images one by one. If you send a CD, be sure to include a printout of thumbnail images; if the photo buyer does not have time to put the CD in the computer and view the images, she can at least glance at the printed thumbnails. CDs and DVDs are probably best reserved for high-resolution photos you know the photo buyer wants and has requested from you.

Size & Quality

Size and quality might be the two most important aspects of your digital submission. If the quality is not there, photo buyers will not be interested in buying your image regardless of its subject matter. Find out what the photo buyer needs. If you scan your slides or prints, make sure your scanning quality is excellent: no dirt, dust, or scratches. If the file size is too small, they will not be able to do much with it either. A resolution of 72 dpi is fine for previews, but if a photo buyer wants to publish your images, they will want larger, high-resolution files. While each photo buyer may have different needs, there are some general guidelines to follow. Often digital images that are destined for print media need to be 300 dpi and the same size as the final printed image will be (or preferably a little larger). For example, for a full-page photo in a magazine, the digital file might be 8×10 inches at 300 dpi. However, always check with the photo buyer who will ultimately be publishing the photo. Many magazines, book publishers, and stock photo agencies post digital submission guidelines on their websites or will provide copies to photographers if they ask. Photo buyers are usually happy to inform photographers of their digital guidelines since they don't want to receive images they won't be able to use due to poor quality.

Note: Many of the listings in this book that accept digital images state the dpi they require for final submissions. They may also state the size they need in terms of megabytes (MB). See subhead Specs in each listing.

Formats

When you know that a photo buyer is definitely going to use your photos, you will then need to submit a high-resolution digital file (as opposed to the low-resolution 72 dpi JPEGs used for previews). Photo buyers often ask for digital images to be saved as JPEGs or TIFFs. Again, make sure you know what format they prefer. Some photo buyers will want you to send them a CD or DVD with the high-resolution images saved on it. Most photo buyers appreciate having a printout of thumbnail images to review in addition to the CD. Some may allow you to e-mail images directly to them, but keep in mind that anything larger than 9 megabytes is usually too large to e-mail. Get the permission of the photo buyer before you attempt to send anything that large via e-mail.

Another option is FTP (file transfer protocol). It allows files to be transferred over the Internet from one computer to another. This option is becoming more prevalent.

Note: Most of the listings in this book that accept digital images state the format they require for final digital submissions. See subhead Specs in each listing.

Color Space

Another thing you'll need to find out from the photo buyer is what color space they want photos to be saved in. RGB (red, green, blue) is a very common one. You might also encounter

CMYK (cyan, magenta, yellow, black). Grayscale is for photos that will be printed without any color (black and white). Again, check with the photo buyer to find out what color space they require.

USING ESSENTIAL BUSINESS FORMS

Using carefully crafted business forms will not only make you look more professional in the eyes of your clients, it will make bills easier to collect while protecting your copyright. Forms from delivery memos to invoices can be created on a home computer with minimal design skills and printed in duplicate at most quick-print centers. When producing detailed contracts, remember that proper wording is imperative. You want to protect your copyright and, at the same time, be fair to clients. Therefore, it's a good idea to have a lawyer examine your forms before using them.

The following forms are useful when selling stock photography as well as when shooting on assignment:

Delivery Memo

This document should be mailed to potential clients along with a cover letter when any submission is made. A delivery memo provides an accurate count of the images that are enclosed, and it provides rules for usage. The front of the form should include a description of the images or assignment, the kind of media in which the images can be used, the price for such usage, and the terms and conditions of paying for that usage. Ask clients to sign and return a copy of this form if they agree to the terms you've spelled out.

FORMS FOR PHOTOGRAPHERS

Where to learn more about forms for photographers:
- Editorial Photographers (EP), www.editorialphoto.com
- *Business and Legal Forms for Photographers* by Tad Crawford (Allworth Press)
- *Legal Guide for the Visual Artist* by Tad Crawford (Allworth Press)
- *ASMP Professional Business Practices in Photography* (Allworth Press)
- The American Society of Media Photographers offers traveling business seminars that cover issues from forms to pricing to collecting unpaid bills. Write to them at P. O. Box 31207, Bethesda, MD 20824 for a schedule of upcoming business seminars, or visit www.asmp.org. You can also call (t877)771-2767 or e-mail asmp@vpconnections.com.
- The Volunteer Lawyers for the Arts, 1 E. 53rd St., 6th Floor, New York NY 10022, (212)319-2787 (ext. 1). The VLA is a nonprofit organization, based in New York City, dedicated to providing all artists, including photographers, with sound legal advice.

PROPERTY RELEASE

In consideration of $_____ and/or _____
_____, receipt of which is acknowledged, I being the legal owner of or having the right to permit the taking and use of photographs of certain property designated as _____, do hereby give _____, his/her assigns, licensees, and legal representatives the irrevocable right to use this image in all forms and media and in all manners, including composite or distorted representations, for advertising, trade, or any other lawful purposes, and I waive any rights to inspect or approve the finished product, including written copy that may be created in connection therewith.

Short description of photographs: _____

Additional information: _____

I am of full age. I have read this release and fully understand its contents.

Please Print:

Name _____

Address _____

City _____ State _____ Zip Code _____

Sample property release

Terms & Conditions

This form often appears on the back of the delivery memo, but be aware that conditions on the front of a form have more legal weight than those on the back. Your terms and conditions should outline in detail all aspects of usage for an assignment or stock image. Include copyright information, client liability, and a sales agreement. Also, be sure to include conditions covering the alteration of your images, the transfer of rights, and digital storage. The more specific your terms and conditions are to the individual client, the more legally binding they will be. If you create your forms on your computer, seriously consider altering your standard contract to suit each assignment or other photography sale.

Invoice

This is the form you want to send more than any of the others, because mailing it means you have made a sale. The invoice should provide clients with your mailing address, an explanation of usage, and the amount due. Be sure to include a reasonable due date for payment, usually thirty days. You should also include your Employer Identification Number or Social Security number.

Model/Property Releases

Get into the habit of obtaining releases from anyone you photograph. The releases increase the sales potential for images and can protect you from liability. A model release is a short form, signed by the person(s) in a photo, that allows you to sell the image for commercial purposes. The property release does the same thing for photos of personal property. When photographing children, remember that a parent or guardian must sign before the release is legally binding. In exchange for signed releases, some photographers give their subjects copies of the photos; others pay the models. You may choose the system that works best for you, but keep in mind that a legally binding contract must involve consideration, the exchange of something of value. Once you obtain a release, keep it in a permanent file.

You do not need a release if the image is being sold editorially. However, magazines now require such forms in order to protect themselves, especially when an image is used as a photo illustration instead of as a straight documentary shot. You always need a release for advertising purposes or for purposes of trade and promotion. In works of art, you need a release only if the subject is recognizable. When traveling in a foreign country, it is a good idea to carry releases written in that country's language. To translate releases into a foreign language, check with an embassy or a college language professor.

STOCK LIST

Some market listings in this book ask for a stock list, so it is a good idea to have one on hand. Your stock list should be as detailed and specific as possible. Include all the subjects you have in your photo files, breaking them into logical categories and subcategories.

CHARGING FOR YOUR WORK

No matter how many books you read about what photos are worth and how much you should charge, no one else can set your fees for you. If you let someone try, you'll be setting yourself up for financial ruin. Figuring out what to charge for your work is a complex task that will require a lot of time and effort. But the more time you spend finding out how much you need to charge, the more successful you'll be at targeting your work to the right markets and getting the money you need to keep your business, and your life, going.

MODEL RELEASE

In consideration of $ _____ and/or _____,
receipt of which is acknowledged, I, _____, do
hereby give _____, his/her assigns, licensees, and
legal representatives the irrevocable right to use my image in all forms and
media and in all manners, including composite or distorted representations, for
advertising, trade, or any other lawful purposes, and I waive any rights to in-
spect or approve the finished product, including written copy that may be cre-
ated in connection therewith. The following name may be used in reference to
these photographs:

My real name, or _____

Short description of photographs: _____

Additional information: _____

Please print:

Name _____

Address _____

City _____ State _____ Zip code _____

Country _____

CONSENT

(If model is under the age of 18) I am the parent or guardian of the minor named
above and have the legal authority to execute the above release. I approve the
foregoing and waive any rights in the premises.

Please print:

Name _____

Address _____

City _____ State _____ Zip code _____

Country _____

Signature _____

Witness _____ Date _____

Sample model release

STOCK LIST

INSECTS
Ants
Aphids
Bees
Beetles
Butterflies
Grasshoppers
Moths
Termites
Wasps

PROFESSIONS
Bee Keeper
Biologist
Firefighter
Nurse
Police Officer
Truck Driver
Waitress
Welder

LANDMARKS
Asia
 Angkor Wat
 Great Wall of China

Europe
 Big Ben
 Eiffel Tower
 Louvre
 Stonehenge

United States
 Empire State Building
 Grand Canyon
 Liberty Bell
 Mt. Rushmore
 Statue of Liberty

TRANSPORTATION
Airplanes and helicopters
Roads
 Country roads
 Dirt roads
 Interstate highways
 Two-lane highways

WEATHER
Clouds
 Cumulus
 Cirrus
 Nimbus
 Stratus
Flooding
Lightning
Snow and Blizzards
Storm Chasers
Rainbows
Tornadoes
Tornado Damage

Sample stock list

Keep in mind that what you charge for an image may be completely different from what a photographer down the street charges. There is nothing wrong with this if you've calculated your prices carefully. Perhaps the other photographer works in a basement on old equipment and you have a brand new, state-of-the-art studio. You'd better be charging more. Why the disparity? For one thing, you have a much higher overhead, the continuing costs of running your business. You're also probably delivering a higher-quality product and are more able to meet client requests quickly. So how do you determine just how much you need to charge in order to make ends meet?

Setting Your Break-Even Rate

All photographers, before negotiating assignments, should consider their break-even rate—the amount of money they need to make in order to keep their studios open. To arrive at the actual price you'll quote to a client, you should add on to your base rate things like usage, your experience, how quickly you can deliver the image, and what kind of prices the market will bear.

Start by estimating your business expenses. These expenses may include rent (office, studio), gas and electric, insurance (equipment), phone, fax, Internet service, office supplies, postage, stationery, self-promotions/portfolio, photo equipment, computer, staff salaries and taxes. Expenses like film and processing will be charged to your clients.

Next, figure your personal expenses, which will include food, clothing, medical, car and home insurance, gas, repairs and other car expenses, entertainment, retirement savings and investments, etc.

PRICING INFORMATION

Where to find more information about pricing:

- *Pricing Photography: The Complete Guide to Assignment and Stock Prices* by Michal Heron and David MacTavish (Allworth Press)
- *ASMP Professional Business Practices in Photography* (Allworth Press)
- fotoQuote, a software package produced by the Cradoc Corporation, is a customizable, annually updated database of stock photo prices for markets from ad agencies to calendar companies. The software also includes negotiating advice and scripted telephone conversations. Call (800)679-0202, or visit www.cradocfotosoftware.com for ordering information.
- Stock Photo Price Calculator, a website that suggests fees for advertising, corporate and editorial stock, stockphotopricecalculator.com.
- Editorial Photographers (EP), www.editorialphoto.com.

Before you divide your annual expenses by the 365 days in the year, remember you won't be shooting billable assignments every day. A better way to calculate your base fee is by billable weeks. Assume that at least one day a week is going to be spent conducting office business and marketing your work. This amounts to approximately ten weeks. Add in days for vacation and sick time, perhaps three weeks, and add another week for workshops and seminars. This totals fourteen weeks of non-billable time and thirty-eight billable weeks throughout the year.

Now estimate the number of assignments/sales you expect to complete each week and multiply that number by thirty-eight. This will give you a total for your yearly assignments/sales. Finally, divide the total overhead and administrative expenses by the total number of assignments. This will give you an average price per assignment, your break-even or base rate.

As an example, let's say your expenses come to $65,000 per year (this includes $35,000 of personal expenses). If you complete two assignments each week for thirty-eight weeks, your average price per assignment must be about $855. This is what you should charge to break even on each job. But, don't forget, you want to make money.

Establishing Usage Fees

Too often, photographers shortchange themselves in negotiations because they do not understand how the images in question will be used. Instead, they allow clients to set prices and prefer to accept lower fees rather than lose sales. Unfortunately, those photographers who shortchange themselves are actually bringing down prices throughout the industry. Clients realize if they shop around they can find photographers willing to shoot assignments at very low rates.

There are ways to combat low prices, however. First, educate yourself about a client's line of work. This type of professionalism helps during negotiations because it shows buyers that you are serious about your work. The added knowledge also gives you an advantage when negotiating fees because photographers are not expected to understand a client's profession.

For example, if most of your clients are in the advertising field, acquire advertising rate cards for magazines so you know what a client pays for ad space. You can also find print ad rates in the *Standard Rate and Data Service* directory at the library. Knowing what a client is willing to pay for ad space and considering the importance of your image to the ad will give you a better idea of what the image is really worth to the client.

For editorial assignments, fees may be more difficult to negotiate because most magazines have set page rates. They may make exceptions, however, if you have experience or if the assignment is particularly difficult or time-consuming. If a magazine's page rate is still too low to meet your break-even price, consider asking for extra tearsheets and copies of the

issue in which your work appears. These pieces can be used in your portfolio and as mailers, and the savings they represent in printing costs may make up for the discrepancy between the page rate and your break-even price.

There are still more ways to negotiate sales. Some clients, such as gift and paper product manufacturers, prefer to pay royalties each time a product is sold. Special markets, such as galleries and stock agencies, typically charge photographers a commission of 20 to 50 percent for displaying or representing their images. In these markets, payment on sales comes from the purchase of prints by gallery patrons, or from fees on the rental of photos by clients of stock agencies. Pricing formulas should be developed by looking at your costs and the current price levels in those markets, as well as on the basis of submission fees, commissions, and other administrative costs charged to you.

Bidding for Jobs

As you build your business, you will likely encounter another aspect of pricing and negotiating that can be very difficult. Like it or not, clients often ask photographers to supply bids for jobs. In some cases, the bidding process is merely procedural and the assignment will go to the photographer who can best complete it. In other instances, the photographer who submits the lowest bid will earn the job. When asked to submit a bid, it is imperative that you find out which bidding process is being used. Putting together an accurate estimate takes time, and you do not want to waste your efforts if your bid is being sought merely to meet some budget quota.

If you decide to bid on a job, it's important to consider your costs carefully. You do not want to bid too much on projects and repeatedly get turned down, but you also don't want to bid too low and forfeit income. When a potential client calls to ask for a bid, consider these dos and don'ts:

1. Always keep a list of questions by the telephone so you can refer to it when bids are requested. The answers to the questions should give you a solid understanding of the project and help you reach a price estimate.
2. Never quote a price during the initial conversation, even if the caller pushes for a ballpark figure. An on-the-spot estimate can only hurt you in the negotiating process.
3. Immediately find out what the client intends to do with the photos, and ask who will own copyrights to the images after they are produced. It is important to note that many clients believe if they hire you for a job, they'll own all the rights to the images you create. If they insist on buying all rights, make sure the price they pay is worth the complete loss of the images.
4. If it is an annual project, ask who completed the job last time, then contact that photographer to see what he charged.

5. Find out who you are bidding against and contact those people to make sure you received the same information about the job. While agreeing to charge the same price is illegal, sharing information about reaching a price is not.
6. Talk to photographers not bidding on the project and ask them what they would charge.
7. Finally, consider all aspects of the shoot, including preparation time, fees for assistants and stylists, rental equipment, and other materials costs. Don't leave anything out.

FIGURING SMALL BUSINESS TAXES

Whether you make occasional sales from your work or you derive your entire income from your photography skills, it's a good idea to consult with a tax professional. If you are just starting out, an accountant can give you solid advice about organizing your financial records. If you are an established professional, an accountant can double-check your system and maybe find a few extra deductions. When consulting with a tax professional, it is best to see someone who is familiar with the needs and concerns of small business people, particularly photographers. You can also conduct your own tax research by contacting the Internal Revenue Service.

Self-Employment Tax

As a freelancer it's important to be aware of tax rates on self-employment income. All income you receive over $400 without taxes being taken out by an employer qualifies as self-

TAX INFORMATION

To learn more about taxes, contact the IRS. There are free booklets available that provide specific information, such as allowable deductions and tax rate structure:

- Tax Guide for Small Business, IRS Publication 334
- Travel, Entertainment, Gift, and Car Expenses, IRS Publication 463
- Tax Withholding and Estimated Tax, IRS Publication 505
- Business Expenses, IRS Publication 535
- Accounting Periods and Methods, IRS Publication 538
- Business Use of Your Home, IRS Publication 587

To order any of these booklets, phone the IRS at (800)829-3676. IRS forms and publications, as well as answers to questions and links to help, are available on the Internet at www.irs.gov.

employment income. Normally, when you are employed by someone else, the employer shares responsibility for the taxes due. However, when you are self-employed, you must pay the entire amount yourself.

Freelancers frequently overlook self-employment taxes and fail to set aside a sufficient amount of money. They also tend to forget state and local taxes. If the volume of your photo sales reaches a point where it becomes a substantial percentage of your income, then you are required to pay estimated tax on a quarterly basis. This requires you to project the amount of money you expect to generate in a three-month period. However burdensome this may be in the short run, it works to your advantage in that you plan for and stay current with the various taxes you are required to pay. Read IRS Publication 505 (Tax Withholding and Estimated Tax).

Deductions

Many deductions can be claimed by self-employed photographers. It's in your best interest to be aware of them. Examples of 100-percent-deductible claims include production costs of résumé, business cards, and brochures; photographer's rep commissions; membership dues; costs of purchasing portfolio materials; education/business-related magazines and books; insurance; and legal and professional services.

Additional deductions can be taken if your office or studio is home-based. The catch here is that your work area must be used only on a professional basis; your office can't double as a family room after hours. The IRS also wants to see evidence that you use the work space on a regular basis via established business hours and proof that you've actively marketed your work. If you can satisfy these criteria, then a percentage of mortgage interests, real estate taxes, rent, maintenance costs, utilities, and homeowner's insurance, plus office furniture and equipment, can be claimed on your tax form at year's end.

In the past, to qualify for a home-office deduction, the space you worked in had to be "the most important, consequential, or influential location" you used to conduct your business. This meant that if you had a separate studio location for shooting but did scheduling, billing, and record keeping in your home office, you could not claim a deduction. However, as of 1999, your home office will qualify for a deduction if you "use it exclusively and regularly for administrative or management activities of your trade or business and you have no other fixed location where you conduct substantial administrative or management activities of your trade or business." Read IRS Publication 587 (Business Use of Your Home) for more details.

If you are working out of your home, keep separate records and bank accounts for personal and business finances, as well as a separate business phone. Since the IRS can audit tax records as far back as seven years, it's vital to keep all paperwork related to your business. This includes invoices, vouchers, expenditures and sales receipts, canceled checks, deposit

slips, register tapes, and business ledger entries for this period. The burden of proof will be on you if the IRS questions any deductions claimed. To maintain professional status in the eyes of the IRS, you will need to show a profit for three years out of a five-year period.

Sales Tax

Sales taxes are complicated and need special consideration. For instance, if you work in more than one state, use models or work with reps in one or more states, or work in one state and store equipment in another, you may be required to pay sales tax in each of the states that apply. In particular, if you work with an out-of-state stock photo agency that has clients over a wide geographic area, you should explore your tax liability with a tax professional.

As with all taxes, sales taxes must be reported and paid on a timely basis to avoid audits and/or penalties. In regard to sales tax, you should:

- Always register your business at the tax offices with jurisdiction in your city and state.
- Always charge and collect sales tax on the full amount of the invoice unless an exemption applies.
- If an exemption applies because of resale, you must provide a copy of the customer's resale certificate. If an exemption applies because of other conditions, such as selling one-time reproduction rights or working for a tax-exempt, nonprofit organization, you must also provide documentation.

SELF-PROMOTION

There are basically three ways to acquaint photo buyers with your work: through the mail, over the Internet, or in person. No one way is better or more effective than another. They each serve an individual function and should be used in concert to increase your visibility and, with a little luck, your sales.

IDEAS FOR GREAT SELF-PROMOTION

Where to find ideas for great self-promotion:
- *HOW* magazine's self-promotion annual (October issue)
- *Photo District News* magazine's self-promotion issue (October issue)
- *The Photographer's Guide to Marketing & Self-Promotion* by Maria Piscopo (Allworth Press)
- *The Business of Photography: Principles and Practices* by Mary Virginia Swanson, available at www.mvswanson.com

Self-Promotion Mailers

When you are just starting to get your name out there and want to begin generating assignments and stock sales, it's time to design a self-promotion campaign. This is your chance to do your best, most creative work and package it in an unforgettable way to get the attention of busy photo buyers. Self-promotions traditionally are sample images printed on card stock and sent through the mail to potential clients. If the image you choose is strong and you carefully target your mailing, a traditional self-promotion can work.

But don't be afraid to go out on a limb here. You want to show just how amazing and creative you are, and you want the photo buyer to hang on to your sample for as long as possible. Why not make it impossible to throw away? Instead of a simple postcard, maybe you could send a small, usable notepad with one of your images at the top, or a calendar the photo buyer can hang up and use all year. If you target your mailing carefully, this kind of special promotion needn't be expensive.

If you're worried that a single image can't do justice to your unique style, you have two options. One way to get multiple images in front of photo buyers without sending an overwhelming package is to design a campaign of promotions that builds from a single image to a small group of related photos. Make the images tell a story and indicate that there are more to follow. If you are computer savvy, the other way to showcase a sampling of your work is to point photo buyers to an online portfolio of your best work. Send a single sample that includes your Internet address, and ask buyers to take a look.

Websites

Websites are steadily becoming more important in the photographer's self-promotion repertory. If you have a good collection of digital photographs—whether they have been scanned from film or are from a digital camera—you should consider creating a website to showcase samples of your work, provide information about the type of work you do, and display your contact information. The website does not have to be elaborate or contain every photograph you've ever taken. In fact, it is best if you edit your work very carefully and choose only the best images to display on your website. The benefit of having a website is that it makes it so easy for photo buyers to see your work. You can send e-mails to targeted photo buyers and include a link to your website. Many photo buyers report that this is how they prefer to be contacted. Of course, your URL should also be included on any print materials, such as postcards, brochures, business cards, and stationery. Some photographers even include their URL in their credit line.

Portfolio Presentations

Once you've actually made contact with potential buyers and piqued their interest, they'll want to see a larger selection of your work—your portfolio. Once again, there's more than

one way to get this sampling of images in front of buyers. Portfolios can be digital—stored on a disk or CD-ROM, or posted on the Internet. They can take the form of a large box or binder and require a special visit and presentation by you. Or they can come in a small binder and be sent through the mail. Whichever ways you choose to showcase your best work, you should always have more than one portfolio, and each should be customized for potential clients.

Keep in mind that your portfolios should contain your best work (dupes only). Never put originals in anything that will be out of your hands for more than a few minutes. Also, don't include more than twenty images. If you try to show too many pieces, you'll overwhelm the buyer, and any image that is less than your best will detract from the impact of your strongest work. Finally, be sure to show only work a buyer is likely to use. It won't do any good to show a shoe manufacturer your shots of farm animals or a clothing company your food pictures. For more detailed information on the various types of portfolios and how to select which photos to include and which ones to leave out, see *Photo Portfolio Success* by John Kaplan (Writer's Digest Books).

Do You Need a Résumé?

Some of the listings in this book say to submit a résumé with samples. If you are a freelancer, a résumé may not always be necessary. Sometimes a stock list or a list of your clients may suffice and may be all the photo buyer is really looking for. If you do include a résumé, limit the details to your photographic experience and credits. If you are applying for a position teaching photography or for a full-time photography position at a studio, corporation, newspaper, etc., you will need the résumé. Galleries that want to show your work may also want to see a résumé, but, again, confine the details of your life to significant photographic achievements.

ORGANIZING & LABELING YOUR IMAGES

It will be very difficult for you to make sales of your work if you aren't able to locate a particular image in your files when a buyer needs it. It is imperative that you find a way to organize your images—a way that can adapt to a growing file of images. There are probably as many ways to catalog photographs as there are photographers. However, most photogra-

IMAGE ORGANIZATION & STORAGE

To learn more about selecting, organizing, labeling, and storing images, see:

- *Photo Portfolio Success* by John Kaplan (Writer's Digest Books)
- *Sell & Re-Sell Your Photos* by Rohn Engh & Mikael Karlsson, 6th edition (North Light Books)

phers begin by placing their photographs into large, general categories such as landscapes, wildlife, countries, cities, etc. They then break these down further into subcategories. If you specialize in a particular subject—birds, for instance—you may want to break the bird category down further into cardinal, eagle, robin, osprey, etc. Find a coding system that works for your particular set of photographs. For example, nature and travel photographer William Manning says, "I might have slide pages for Washington, DC (WDC), Kentucky (KY), or Italy (ITY). I divide my mammal subcategory into African wildlife (AWL), North American wildlife (NAW), zoo animals (ZOO)."

After you figure out a coding system that works for you, find a method for naming your digital files or captioning your slides. Images with complete information often prompt sales; photo editors appreciate having as much information as possible. Always remember to include your name and the copyright symbol © on each image. If you're working with slides, computer software can make this job a lot easier. Programs such as Caption Writer (www.hindsightltd.com) allow photographers to easily create and print labels for their slides.

The computer also makes managing your photo files much easier. Programs such as fotoBiz (www.cradocfotosoftware.com) and StockView (www.hindsightltd.com) are popular with freelance assignment and stock photographers. FotoBiz has an image log and is capable of creating labels. It can also track your images and allows you to create documents such as delivery memos and invoices. StockView also tracks your images, has labeling options, and can create business documents.

PROTECTING YOUR COPYRIGHT

There is one major misconception about copyright: Many photographers don't realize that once you create a photo, it becomes yours. You (or your heirs) own the copyright, regardless of whether you register it for the duration of your lifetime plus seventy years.

The fact that an image is automatically copyrighted does not mean that it shouldn't be registered. Quite the contrary. You cannot even file a copyright infringement suit until you've registered your work. Also, without timely registration of your images, you can only recover actual damages—money lost as a result of sales by the infringer plus any profits the infringer earned. For example, recovering $2,000 for an ad sale can be minimal when weighed against the expense of hiring a copyright attorney. Often this deters photographers from filing lawsuits if they haven't registered their work. They know that the attorney's fees will be more than the actual damages recovered, and, therefore, infringers go unpunished.

Registration allows you to recover certain damages to which you otherwise would not be legally entitled. For instance, attorney fees and court costs can be recovered. So too can statutory damages—awards based on how deliberate and harmful the infringement was.

PROTECTING YOUR COPYRIGHT

How to learn more about protecting your copyright:
- Call the United States Copyright Office at (202)707-3000 or check out their website, www.copyright.gov, for answers to frequently asked questions.
- American Society of Media Photographers (ASMP), www.asmp.org/professional-development/tutorial-form/copyright-tutorial/
- Editorial Photographers (EP), www.editorialphoto.com
- *Legal Guide for the Visual Artist* by Tad Crawford, Allworth Press

Statutory damages can run as high as $100,000. These are the fees that make registration so important.

In order to recover these fees, there are rules regarding registration that you must follow. The rules have to do with the timeliness of your registration in relation to the infringement:

- **Unpublished images** must be registered before the infringement takes place.
- **Published images** must be registered within three months of the first date of publication or before the infringement began.

The process of registering your work is simple. Visit the United States Copyright Office's website at www.copyright.gov to file electronically. Registration costs $35, but you can register photographs in large quantities for that fee. For bulk registration, your images must be organized under one title, for example, "The works of John Photographer, 2013–2018." It's still possible to register with paper forms, but this method requires a higher filing fee ($65). To request paper forms, contact the Library of Congress, Copyright Office-COPUBS, 101 Independence Avenue SE, Washington, DC 20559-6304, (202)707-9100, and ask for Form VA (works of visual art).

The Copyright Notice

Another way to protect your copyright is to mark each image with a copyright notice. This informs everyone reviewing your work that you own the copyright. It may seem basic, but in court this can be very important. In a lawsuit, one avenue of defense for an infringer is "innocent infringement"—basically the "I didn't know" argument. By placing a copyright notice on your images, you negate this defense for an infringer.

The copyright notice basically consists of three elements: the symbol, the year of first publication, and the copyright holder's name. Here's an example of a copyright notice for an image published in 2018: © 2018 John Q. Photographer. Instead of the symbol ©, you

can use the word "Copyright" or simply "Copr." However, most foreign countries prefer © as a common designation.

Also consider adding the notation "All rights reserved" after your copyright notice. This phrase is not necessary in the U.S. since all rights are automatically reserved, but it is recommended in other parts of the world.

Know Your Rights

The digital era is making copyright protection more difficult. As this technology grows, more and more clients will want digital versions of your photos. Don't be alarmed, just be careful. Your clients don't want to steal your work. When you negotiate the usage of your work, consider adding to your contract a phrase that limits the rights of buyers who want digital versions of your photos. You might want them to guarantee that images will be removed from their computer files once the work appears in print. You might say it's okay to perform limited digital manipulation and then specify what can be done. The important thing is to discuss what the client intends to do and spell it out in writing.

It's essential not only to know your rights under the copyright law, but also to make sure that every photo buyer you deal with understands them. The following list of typical image rights should help you in your dealings with clients:

- **One-time rights.** These photos are leased or licensed on a one-time basis; one fee is paid for one use.
- **First rights.** This is generally the same as purchase of one-time rights, though the photo buyer is paying a bit more for the privilege of being the first to use the image. He may use it only once unless other rights are negotiated.
- **Serial rights.** The photographer has sold the right to use the photo in a periodical. This shouldn't be confused with using the photo in "installments." Most magazines will want to be sure the photo won't be running in a competing publication.
- **Exclusive rights.** Exclusive rights guarantee the buyer's exclusive right to use the photo in his particular market or for a particular product. A greeting card company, for example, may purchase these rights to an image with the stipulation that it not be sold to a competing company for a certain time period. The photographer, however, may retain rights to sell the image to other markets. Conditions should always be put in writing to avoid any misunderstandings.
- **Electronic rights.** These rights allow a buyer to place your work on electronic media such as CD-ROMs or websites. Often these rights are requested with print rights.
- **Promotion rights.** Such rights allow a publisher to use a photo for promotion of a publication in which the photo appears. The photographer should be paid for promotional use in addition to the rights first sold to reproduce the image. Another

form of this—agency promotion rights—is common among stock photo agencies. Likewise, the terms of this need to be negotiated separately.

- **Work for hire.** Under the Copyright Act of 1976, section 101, a "work for hire" is defined as "(1) a work prepared by an employee within the scope of his or her employment; or (2) a work … specially ordered or commissioned for use as a contribution to a collective, as part of a motion picture or audiovisual work or as a supplementary work … if the parties expressly agree in a written instrument signed by them that the work shall be considered a work made for hire."
- **All rights.** This involves selling or assigning all rights to a photo for a specified period of time. This differs from work for hire, which always means the photographer permanently surrenders all rights to a photo and any claims to royalties or other future compensation. Terms for all rights, including time period of usage and compensation, should only be negotiated and confirmed in a written agreement with the client.

It is understandable for a client not to want a photo to appear in a competitor's ad. Skillful negotiation usually can result in an agreement between the photographer and the client that says the images will not be sold to a competitor, but could be sold to other industries, possibly offering regional exclusivity for a stated time period.

SO YOU WANT TO BE A PROFESSIONAL PHOTOGRAPHER

Scott Trees

Talent and desire are not enough to make photography a steady job. It also requires perseverance, good customer service, patience, and some degree of business sense.

For many people, the idea of being a photographer traveling around the world, camera in hand, sounds exotic and exciting. Certainly, it can be. However, it is also a *lot* of work. Most of the time, it's not all that glamorous and taking pictures can be the least time consuming aspect of it all.

Advances in photographic technology have made the act of taking a picture very simple. Whether you're using an iPhone or a sophisticated professional camera, pointing a camera at your intended subject, pressing the shutter and getting reliable results in terms of overall exposure and image quality has never been easier. Additionally, the fact that producing digital images is much less expensive than developing film has given everyone the ability to take an unlimited quantity of pictures.

Walk into a restaurant today and ask for a pro photographer and about half the people in the room might raise their hands. Today, everyone is a photographer. With so many people taking pictures, and with platforms like Facebook where everyone can share their work with an admiring public, the world is inundated with images. For this reason, the perceived value of a good photographic image has dramatically declined.

As someone who has been taking photographs for over forty-five years, I would have to say it's more challenging to make a living as a photographer today than it was when I start-

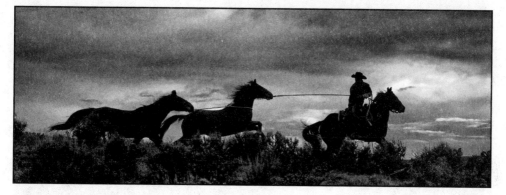

Hestitation, shot during one of Scott Trees' workshops.

ed. There is far more competition for work, and this era has brought about a mentality that "good enough" is the acceptable norm. Certainly, there are a lot of talented photographers who can, and do, make a great living with a camera. But over the years, more of them have been struggling to make ends meet in a highly competitive marketplace.

Talent and desire are not enough to make photography a steady job. It also requires perseverance, good customer service, patience and some degree of business sense. Indeed, once you find yourself trying to make this your full-time job you will soon learn that taking pictures is actually the easy part. What requires a tremendous amount of time is actually running the business. There is a lot of time that goes into the day-to-day operations of any business, and photography is no exception.

In my Business of Photography class, I share with my students that it's the little things that can contribute to the failing of a business. Many photographers don't consider all of the costs involved in making a business profitable, and as a result, they don't charge enough to cover all of the costs.

You have to charge enough to pay your overhead, your taxes and leave something for yourself. For simple math, the rule of thirds can be applied. A third should be set aside for self-employment taxes, a third goes to overhead, and the last third is yours to keep. Simply put, for every dollar you want to produce for yourself, you have to generate a minimum of three dollars. Most of my students are shocked at what they would have to generate in terms of income to pay themselves what they're earning at their current jobs.

The NPPA Cost of Doing Business Calculator is one of the best I have ever seen in terms of providing a realistic perspective of what it costs to run a photography business and pay yourself a salary. This calculator can be found on the NPPA site: nppa.org/page/3275.

When I'm asked for advice by beginning professionals, I encourage them to be realistic about what it costs to create their images and to reflect that in their pricing. I often see too many who willingly work for next to nothing just to get the job. Something that needs to

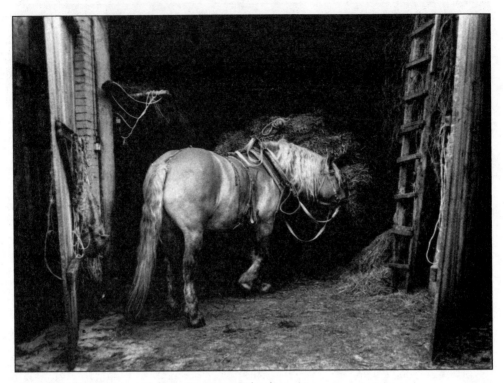

End Of The Day, shot on assignment in Janow, Poland.

be taken into consideration is the fact that it's not easy to increase your prices from free. If you don't value your work, neither will your clients.

Having said all that, I never want to discourage anyone who has the desire to become a full-time photographer. Many say they want to pursue the "art" of it all, and that's a fine goal, but you still need to make the money necessary to create your art. Once the numbers have been reviewed, you can more easily determine whether you want to pursue becoming a full-time photographer or continue to photograph as a hobby.

I mentioned earlier that the perceived value of a good photograph has decreased. The sheer volume of images available in the marketplace today is staggering. For example, *Sports Illustrated* laid off the majority of its staff photographers partly because it was more cost effective to select images from the high volume of freelance work submitted to the magazine rather than pay the salaries and benefits of their full-time staff photographers.

Picture takers are a dime a dozen, but picture *creators* are the exception, and their work stands apart from the rest. Strive to set yourself apart from what everyone else is doing. Here are a few things to remember:

- **Find your niche.** Specializing can help you focus on a target market and narrow your competition.

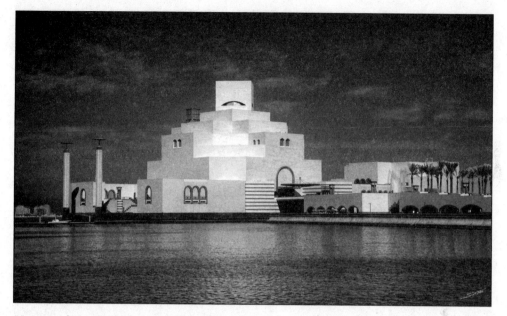

Museum of Islamic Art, Doha Qatar, shot on assignment.

- **Good customer service is critical.** Word of mouth will make or break you.
- **Patience is vital.** It takes time to develop your style and reputation, both of which help you build a solid client base.
- **Maintain relationships.** If you're a halfway decent photographer, you can sell anyone one time. It's the repeat customer who is going to keep you in business.

Most importantly, remember to run your business as a business. Self-employment is never easy, but it's certainly doable and can be very rewarding. If you take this path, be prepared for great success, as well as failure, along the way to growing your business and choose to learn equally from both.

Scott Trees has been traveling the world and creating images for over four decades. While best known for his iconic advertising and editorial images in the equestrian world, he has also done a variety of commercial work, particularly in Dubai where he lived for eight years. Scott resides in Ft. Worth, Texas. He travels in a custom tour bus, shooting for clients, teaching seminars, and giving motivational speeches. Visit www.treesmedia.com to see more of Scott's work and follow his Facebook page, Scott Trees Photography.

KEEPING RECORDS
Knowing Where Everything Is

..

by Rohn Engh and Mikael Karlsson

The Lazy Person's Way to Extra Sales—Knowing What's Selling

I'm lazy at heart. I like to put the lawn rake back when I'm done with it because I've learned if I don't, it's a lot more work next time to search for it, and possibly not even find it when I need it.

This lazy kind of thinking got me into a very good habit after a while. By having (or finding) a place for everything here at the office, I got into the habit of putting everything away.

I take the same approach to filing computer discs, slides and color and black-and-white prints. If something's worth having, I figure, it's worth knowing where it is when you need it.

I was happily spurred along in this principle when I inherited several hundred used file folders from a businessman who was retiring. By using a separate folder for each separate photo illustration, I could note right on the folder whenever a picture sold. For black-and-whites or color negatives, I put a matching contact print on each folder, thus giving myself an immediate visual reminder of what was selling.

After a few years, my record-keeping system was teaching me what pictures sold best and therefore, which pictures I should take more of. By continually supplying my Market List's buyers with the kind of pictures they needed, I survived as a stock photographer.

File It! How to Avoid Excessive Record Keeping

This record-keeping system also extends to my everyday office activities.

One method I use to minimize record keeping is to put new projects into a mini-file rather than into the central files. I find that I usually complete mini-projects in about a year. Researching for and purchasing a new computer network was a mini-project, so was

remodeling our office in the barn. Other mini-projects revolve around collecting material for future photo stories or photo essays.

Here's a simple technique for a mini-file. The essential ingredients: two sets of two indexes numbered 1 through 24 and lettered A to Z; a temporary portable open file cabinet (like a box), usually made of pressed cardboard or metal and available at stationery stores; and two sheets of 8½" × 11" (22cm × 28cm) paper, one numbered in two columns from 1 through 24 and the other set up in two columns from A through Z.

Let's say you're compiling some research on CD-ROM stock photography disc producers. Each entry is given a numerical designation, filed numerically and entered on the number sheet. The category also is cross-referenced by title and subject on the alphabetical sheet, with its numbered designation under the appropriate alphabet letter. The alphabetical listing also allows you to cross-reference the subject of the project or category. For example, if a Corel stock photo disc advertisement that you've torn from a magazine is filed under the number 34 (that's the numerical designation for Corel Corporation in your filing system) and it contains three categories (birds, reptiles and horses), you would list those three categories on the alphabetical list and designate 34 as the file folder you could find those categories in.

Since the file box is small and portable, you can carry it between home and office or store it in a regular file drawer. I often have six or seven projects going at one time, with information building in twelve to fifteen others, and the mini-file system aids me in being a lazy shopkeeper. I never have to work at finding anything. When the project is completed, the file either earns a spot on my central files or is tossed away.

Knowing How to Put Your Finger on It: Cataloging Your Black and Whites and Transparencies

No cataloging system is better than the keywords it utilizes for its search function. Make sure your keywords are accurate. In the long run this will be well worth it. For example, in the future, stock photographers will make their keyword database available to certain photo buyers or search engines for highly specialized images. A sale or no sale might be the result of what kind of attention you give to proper keywording.

Many different software systems are available, and we'll touch on all of them from the simplest to the more advanced. Picking a system is often a matter of personal preference, but it's crucial for you to keep in mind that changing systems down the road is a lot of work. Take time to pick the system that's right for you.

Software products change constantly. Thus, as you review the guides to software catalog systems in this chapter, think of them as rough guides only. Before you decide on any software for your cataloging needs, check with the manufacturer to make certain the current version is what you need.

Now then, do you need to be computerized to be able to catalog your images? Absolutely not. Even though cataloging software is a wonderful help—especially as your photo file grows—it's not a necessity.

The Basics

A cataloging system should make it easy for you to find a specific photograph. The system also should let you quickly and accurately search for photographs in particular categories in your files. You want a system that's easily expandable, versatile, and able to handle a large amount of entries so that you can keep on using it as your files grow.

The Systems

The two main elements in any cataloging software are ease of data entry and ease of data retrieval (search). It should be easy for you to enter data about your photographs into the system, and it should be easy for you to search the system to find the photographs you're looking for.

Choose a known, reliable software company to have the best chance for having support and upgrades available in the future. Over the years I have seen at least a dozen cataloging software companies go out of business—leaving their customers stranded.

The most basic of the computerized systems actually is not a software system in the true meaning of the word. This system will cost you little money, you will not need any special software, and you'll be able to start right away. I'm talking about the easiest and simplest of them all: the "Do It Yourself" (DIY) system. Before I go into the various software systems made specifically for cataloging photographs, I'll explain how you can set up a simple DIY system that can get you started right away.

DIY SYSTEM

This system assumes that you have a computer, a printer, and some basic word-processing software like Microsoft Word, Corel WordPerfect or something similar. You need to make sure that you can use your word-processing software to make labels. In Word, check under the "Tools" header, and in WordPerfect, check under "Format." At www.avery.com or at your local office supply store look for Avery Return Address Labels #8167 or #8667, ½" × ¾" (13mm × 19mm), the perfect size for use on slide mounts. Each package will cost you approximately $13 (at this writing). There are twenty-five sheets in a package and eighty labels per sheet, making two thousand labels. Cost per label is $0.0065.

For ease of use and readability, use two labels per slide mount. One label should have a copyright symbol, your name and your contact information. Here is where it's crucial that you plan ahead. Unless you know for sure that you will not move, change phone numbers or change your e-mail address in the next ten years, limit the contact information you put on these labels. Instead of putting your home phone, consider getting an 800 number

that can move with you. Most phone carriers offer inexpensive 800 residential number services.

The second label should carry the identification number and the caption for the individual photographs. This label will change from photograph to photograph.

The next step is to figure out how you want your identification number system to work. Say that you photograph pure-breed dogs. One way you could organize the system is to give each breed its own number: German Shepherd is #01, Belgian Malanois is #02, Bernese Mountain Dog is #03 and so on. Then arrange all photographs of German Shepherds and catalog them in whatever order you want starting with Photo #01-0001; the next one will be #01-0002 and so on. Your photos of Belgian Malanois would be #02-0001, #02-0002, #02-0003 and so on.

Cute animal photos are typically used in decor photography, but if you add people in the mix, a slew of new opportunities come knocking on the door. Instead of just another portrait of a cute Bernese Mountain dog, take the dog to the vet. Instead of just a paw or just the tool by itself, put it all together and you get a photo of a dog having his claws trimmed.

You can keep your cataloged slides in slide sleeves in metal or cardboard filing cabinets, hanging file folders or three-ring binders. The most popular among stock photographers seem to be the larger binders with D-shaped rings, which will hold around 1,000 slides per binder.

You can adapt this system to prints as well. Instead of two labels per slide, use one (bigger) label, one per print, on the back.

THE SOFTWARE SYSTEMS

If you don't feel like building your own system, or if you need something a little bit more advanced, a software cataloging/database product might be right for you.

Existing software products vary in price, from under $75 for a basic system without many frills, to several hundred dollars or more for a high-end system that offers image tracking, delivery memos, invoicing capabilities, bar coding, and so on.

Again, software products come and go, and you should make sure to buy a reliable system that has promise to be around for a long time in case you need to expand and/or upgrade in the future.

Some products with solid reputations in the business that I feel comfortable recommending are: PROSLIDE II—distributed by Ellenco (www.proslide.ipower.com); StockView and InView—distributed by HindSight Ltd. (www.hsltd.us); PhotoLibrary—distributed by PKZSoftware (www.pkzsoftware.com); FileMaker—distributed by FileMaker Inc. (www.filemaker.com).

Remember that you want a system that can grow with you and a system that you feel comfortable working with. Most of the software products mentioned here have free demo versions on their websites available for downloading. It's not a bad idea to test-drive the demo version of many different products before you decide what to purchase.

If you belong to a camera club, ask fellow members who are working stock photographers what product they would recommend. Best bets are those who have used their software for at least three years.

Counting the Beans

Knowing where the dollars are coming from and how many are staying at home is an important part of your operation. By not having an accounting system, you could be pouring dollars into the wrong area of marketing. Bad business decisions usually come from faulty information.

At an office supply store, you can buy an accounting ledger that you can tailor to your needs. If you're computerized, you can start with an accounting program such as Quicken (www.quicken.com). We did this originally and have since upgraded to the networked version. Other good accounting software products are Intuit's QuickBooks and Quicken Deluxe (www.intuit.com) and Sage 50c Accounting (www.sage.com/us/sage-50-accounting).

Photographer William Hopkins uses a simple graphics program to chart progress. He tracks the number of submissions he makes and then charts the number of photos sold and dollars that come in. He puts these figures together in a pie chart (see Table 13-1).

Everything Has Its Place

We've all seen cartoons picturing busy editors, their desks piled high with paper. The caption usually quotes the editor defending her "filing" system.

You can't afford the luxury of an editor's haphazard filing system. As your stock photo library grows, so will your need to be able to locate everything, from addresses to contact sheets, negatives to notes.

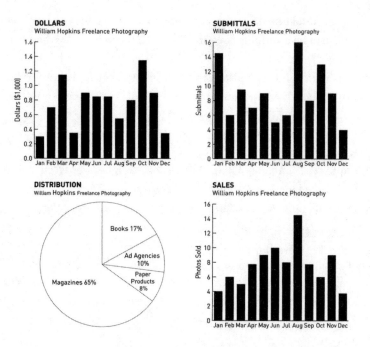

Table 13-1: Simple charts let you see where you're going and where you've been.

Keep in control. If everything has its place, nothing should get lost. If you use an item, put it back when you're finished. In contrast, the editor's desk got that way because she didn't follow these two principles:

1. Make a place for it.
2. Put it back in its place when you're finished.

Is the editor lazy? On the contrary. It takes a lot more work to shuffle through that heap on her desk to locate something.

Time lost can mean lost sales for the stock photographer. Take the lazy person's approach—know where everything is.

Protecting Your Files

Humidity is the greatest enemy of your transparencies (and sometimes of your prints). For $10 you can buy a humidistat (from the hardware store) to place near your storage area; it should read between 55–58° F (13–14° C). If the reading is lower, you'll need a humidifier; if it's higher, a dehumidifier. Moisture settles to the lower part of a room. Depending on the area of the country you live in, store your negatives and transparencies accordingly.

Damage from fire, smoke or water can put you out of business. Locate your backup discs, negatives, and transparencies near an exit with easy access. If you live in a flood-prone area, store your film as high as possible.

Excessive temperatures also will damage your transparencies and negatives. Store them where the range of temperature is between 60–80° F (16–27° C).

Digital Storage

Do yourself a big favor and add captions to your high-resolution digital files. When you select cataloguing software, find one that allows you to search keywords and captions. This will help immensely when you need to find specific images.

Back up your digital files often, preferably in at least three different places using removable hard drives. I keep one in my office, one in a fire-retardant safe in the basement and one in a safety deposit box at my bank. But a back-up system is only as good as the practical usage it is put through, and you want to find a way that works for you and that is simple enough that you will actually make the backups as frequently as you need in your specific situation. I try to back up my high-resolution files after each shoot but I have to admit that I sometimes fail. I also use automatic backup software on all my computers as an added safety should something happen to the hard drives.

I'm often asked if I recommend solid external hard drives as opposed to the traditional kind with moving parts. Personally I use both (at the time of writing this). Solid drives have the benefit of no moving parts and hence there are fewer things that potentially can go wrong with them compared to traditional drives. This is why I'm moving towards using all solid drives.

For me, Adobe Photoshop Lightroom is my go-to software for both processing my RAW files and cataloging my photographs. It does everything I need and want it to do and suits my situation and me. Most software allows you to download a trial version these days. Do a search for photo cataloging software and try out a few different ones until you find something that works for you and your specific situation.

Mikael Karlsson is a professional photographer specializing in law enforcement photography. You can see his work at arrestingimages.com.

Rohn Engh was a veteran editorial stock photographer who sold in national and worldwide markets. He was the founder and publisher of PhotoStockNotes, PHOTOLETTER, and PhotoDaily—market letters that post photo-editor picture needs. Engh also conducted photo-marketing seminars worldwide.

Excerpted from *Sell & Re-Sell Your Photos* © 2016 by Rohn Engh and Mikael Karlsson. Used with the kind permission of North Light Books, an imprint of F+W Media, Inc.

THE POSITIVE SIDE TO NEGATIVES

..

by Daniel Grant

There are many reasons photographers return to negatives from decades earlier.

Artist Cindy Sherman is renowned for the sixty-nine black-and-white photographs in her *Untitled Film Stills* series, owned both in its entirety by New York's Museum of Modern Art and individually by the various collectors who were able to acquire a print or two when the images were first exhibited in the early 1980s. These sixty-nine photographs were printed in limited editions and all sold out. To buy one now, you would have to buy them on the secondary market, paying what these days might be called "Cindy Sherman prices." However, like many other photographers, she did not take only sixty-nine images, all of which coincidentally turned out to be great works of art. In reality, Sherman took rolls of film and selected the ones she liked best from among the images on her contact sheets—sixty-nine in total.

So, what happened to the other images on her contact sheets? The negatives are still available and can be printed from, and on occasion the artist does just that. Sherman not only has the contacts of the Untitled Film Stills, she also has negatives from the Bus Riders series and the Murder Mystery series, both shot in the mid-1970s. One image, an untitled 1980 work from her Rear Screen Projection series "didn't really work for her at the time," according to her dealer Janelle Reiring of Manhattan's Metro Pictures. However, when a benefit group, the Estate Project for Artists with AIDS, asked her for a photograph that was to be part of a portfolio of ten images by ten artists to be used as a fundraiser, Sherman went back to the Rear Screen Projection negatives and decided to print an edition of that for the portfolio. It may not have been up to her standards, but it was good enough to help a worthy

cause. Each time the artist has returned to her old negatives, Reiring claimed, it was "done as benefit prints for charities."

Other successful photographers also go to the former rejects of their old contact sheets for new prints, and not just for charity donations. Well-established artists frequently find that there may be greater interest in their earlier work by collectors than in their more recent material, but that early work is now almost entirely on the secondary market. More recently produced images from old contact sheets still sell, often for more money than the original pieces brought in decades earlier. These prices are still lower than those charged for the decades-old vintage photographs, however, especially on the secondary market. Additionally, photographers often find that there is less excitement about, and often fewer buyers at, exhibitions of their more current work.

European photographers have come up with a solution to the problem of older images being more sought-after than newer ones by instituting resale royalty laws that guarantee them a percentage of the profits earned from secondary market sales of their work. Resale royalty statutes exist throughout Europe, providing artists with a sliding scale of the net profits from the resales of their art, but efforts to enact similar legislation in the United States have found little support.

For photographers who don't have the legal opportunities of European artists, it's common to keep *all* of their old negatives, not only the ones that were previously printed. This gives them the ability to produce new editions of older imagery when needed. Galleries describe these kinds of images as "never before seen" or "never before printed" as a way to suggest their freshness to the market. "The early part of a career is always full of energy," Manhattan photography dealer Deborah Bell says. "It's going back to a period that everyone loves."

There are many reasons photographers return to negatives from decades earlier. The renown of Saul Leiter (1923-2013) gained significantly with the growing collector interest in the color photographs he took in the 1950s and 1960s but only began printing in the late 1990s and 2000s. "When he shot the images, printing color was very expensive, and there was no reason to make prints as there was no market for them," says Karen Marks, director of the Howard Greenberg Gallery. The desire to buy these works, which reflect the influence of abstract expressionist painting styles on Leiter, "developed late in life, and that's when most of his prints were made."

On the other hand, Louis Faurer (1916-2001), a fashion photographer who has become better known for his New York City street photography of the 1940s, 1950s and 1960s, sold most of his "vintage" prints (images printed near the time they were taken) to a dealer in the 1970s and had very few on hand when collector interest in these works developed in the 1980s. As a result, he returned to his 1940s-1960s negatives and began making new print

editions in the 1990s "as a way to generate some income and to help make himself better known," Bell says.

The difference in price between those vintage and later prints is considerable, with earlier photographs costing three to five times that of the later ones.

"As the older iconic works get bought up, finding their way onto the secondary market where they are more expensive, you see that collectors are foraging for images," says Kevin Moore, a Manhattan art advisor and independent curator. "Photographers are combing through their old negatives for things to print, because of the demand. Some people just shake their heads and say, 'crass materialism,' but if artists and their galleries handle this properly, it doesn't have to be so."

The span of time between taking a picture and printing it can be long indeed. William Christenberry, a photographer who made editions of images over a fifty-year career, continued to generate new work until his death in 2016. All the while, he produced between two and five new editions per year of images that sometimes dated back to the 1960s. "It scares me how many collectors want the older work," Christenberry says. "I could spend all my time on this."

Periodically, Christenberry would take one or another box of negatives out of his frost-free refrigerator (stored there to preserve them) in order "to acclimate it to room temperature," and then make prints, numbering twenty-five in an edition, selling generally at the same prices as new work of the same size.

The question may linger as to why a photograph wasn't printed until much later. "I think there is an assumption that the artist didn't love it enough at the time," Deborah Bell says. While that may be true in select cases, for some photographers, however, these old negatives can seem like a pension or rainy day fund. A waiting market is provided with previously unseen images, generally for less money. For photographer William Eggleston, there is an enormous catalog of work from the 1970s that was never published, according to his dealer. The prices for newer editions of older images is considerably higher than those of his more

recently produced photographs, but is still less than prices for vintage 1970s prints by the artist, some of which have reached more than $1 million at auction.

Unfortunately though, with some artists, there simply aren't many vintage prints to be found. Edward Weston developed Parkinson's Disease in the 1940s, making him increasingly unable to do any of his own darkroom work and reliant on his two sons Brett and Cole to print his images. Even though Edward Weston died in 1958, Cole Weston, who died in 2003, produced an estimated five thousand prints of his father's images, feeding a market that had relatively few vintage Westons to buy. Likewise, Matthew Adams, the grandson of Ansel Adams (1902–84), continues to produce new prints from his grandfather's old negatives.

The premature death of an artist also may lead to a shortage of vintage material. Francesca Woodman (1958–81) had very few exhibitions of her black-and-white photography during her short career, and it was partly her lack of success that led to her suicide. The rediscovery of her work came later, based on editions of posthumous prints that her mother, ceramic sculptor Betty Woodman, authorized in order to bring attention to that work. On a larger scale, Diane Arbus was just starting to produce more prints of her images when she died in 1971 at the age of 48. Shortly after her death, Arbus' daughter Doon directed Neil Selkirk, who had worked with Arbus on her printings, to produce editions (of up to seventy-five) of many of her images. Between 1972 and 2003, Selkirk produced these editions. "There are far more posthumous than lifetime prints for Arbus," says Frish Brandt, executive director of San Francisco's Fraenkel Gallery, which has sold lifetime and posthumous Arbus prints for more than thirty years. The price difference between those created during Arbus' lifetime and those printed by Selkirk is significant, Brandt notes, with lifetime images starting at $25,000 and extending to "the mid six figures, and some have gone for over $1 million," while those produced by Selkirk fall in the $5,500-$100,000 range.

The concept of a vintage print was developed in the 1970s and is associated with the photography dealer Harry Lunn, who sought to establish a basis for one print having a higher price than another. Prints made shortly after an image was taken presumably reflect a truer vision of the photographer's intention than one produced many years later. So, when Lunn began to represent Ansel Adams in the 1970s, the dealer pressured the artist to stop printing from his 1941 negative "Moonrise, Hernandez, New Mexico" in order to keep prices higher. (There are estimated to be at least nine hundred of them, although Adams kept no records on what he did or when. No one knows just how many "Moonrise, Hernandez" prints were made.) However, with the work of contemporary photographers, in part because of the backlog of images that these artists have to go through and due to the more fragile nature of color prints (as opposed to black-and-whites), the issue of whether or not a print is "vintage" has become less significant.

Photographers may revisit their published older images in a somewhat different way, too. Both William Christenberry and Stephen Shore created new editions of images that were previously produced as editions but re-released now in larger formats, at sizes comparable

to some paintings, charging considerably more. (These new editions of previously limited editions skirt rather than violate laws regulating the sale of prints, because of the size difference.) Photographer "Lee Friedlander says his printing gets better and better," Bell noted. Similarly, "Stephen Shore has gone back to print new images from older negatives, which he thinks are better than those he made in the past. So, if you like Stephen Shore's work, are you going to demand and pay more for a vintage print or one that the artist thinks is superior?"

There are many reasons why a photographer may not print an image close to the time that the picture was taken. He or she may have been concerned with a particular subject and wasn't focusing on the image that had just been taken; perhaps, the photographer was just too busy with other projects or just forgot about them. Herman Leonard took hundreds of images of actors and jazz performers during the 1940s and 1950s, but did not start printing editions of photographs until the 1980s when he was "discovered," according to his Chicago dealer, Catherine Edelman. The year in which Leonard took the picture is noted on the back of the photograph, along with the notation "'Printed Later,' since I don't know and he doesn't remember if he printed it in 1997 or 2002."

Some other dealers only note the year in which the image was taken, completely disregarding the printing date. At New York City's Staley-Wise Gallery, which represents Lillian Bassman (1917-2012), a fashion photographer most active in the 1940s-1960s who "reinterpreted" her earlier images through darkroom manipulations in the 1990s and 2000s in order to print more abstract versions, "we label them with the title and the date when the photographs were taken, not when they were reinterpreted," says the gallery's director George Kocis. The labeling does not confuse collectors, he claimed, "because we explain the process" that Bassman used to prospective buyers. "Vintage" has long been a key price-determining word in the photography field, but new printing technology and reinterpretations and a new-found market for some artists have made dealers back away from the term. "We're kind of soft around the word 'vintage,'" Karen Marks said. Or, more generally, "there is no norm in the photography field," Catherine Edelman said.

For some photographers, their old contact sheets are tantamount to a pension, affording them the opportunity to create more individual prints and whole editions, which has greater value to those artists whose work from decades earlier is still in demand. Additionally, as some photographers have discovered, they may produce (or reproduce) their images at a larger scale through the new digital printing technology that has come into existence since they first began taking pictures and developing them in dark rooms. The larger scale and new technology can also be employed on previously printed images without running afoul of laws governing "limited editions." In short, keep your old film and contact sheets refrigerated in preparation for the day when you might want to make use of them again.

Daniel Grant is the author of several books, including *The Business of Being an Artist* and *The Fine Artist's Career Guide* (Allworth Press).

NEW TECH RULES

How Technology Is Transforming the Photography Scene

by Matt Koesters

> "I embrace the change. Change is the only constant in any field, in any industry." —Kareem Elgazzar

If there's an industry that understands the transformative power of technology, it's the photography business. With the exception of anachronism enthusiasts and artistic statement makers, film users are all but extinct. The days of dark rooms are over. Digital technology has made cameras better in nearly every way: Computerized adjustments, sharper images, and—thanks to the cloud—an endless supply of storage.

For professionals, it's a mixed bag. On the one hand, they have access to tools that are better and less expensive than ever before. But the other edge of that sword is that everyone else does, too. That's led some photographers to walk away from business niches that they used to consider their bread and butter.

"I can't charge what I need to charge for a wedding," says Glenn Hartong, now co-owner of Chili Dog Pictures in Cincinnati, "because somebody will say, 'My niece can do it for $75.' And that's really happening. The equipment's gotten so good and so inexpensive—and I don't mean it to sound badly, because there are good ones out there—but everyone thinks they're a photographer."

Where twenty-plus-year veterans like Hartong see that as a problem, millennials like Kareem Elgazzar, a staff photographer for *The Cincinnati Enquirer*, see it as an opportunity for those with sufficient ability.

"Back in the day, only one percent of the population could actually make pictures," Elgazzar says. "Now, everybody can make a picture. If you're going to hire a photographer, the photos must be excellent."

Smart Phones

Smart phones have put cameras in the hands of anyone of even modest means. And they're not junk, either—today's phone cameras have capabilities that would make professional-grade cameras of a decade ago seem inadequate by comparison. Companies like Apple and Samsung would have everyone believe they already have the tools they need in their possession to make a living taking pictures.

In a world where everyone is a photographer, no one is a pro. But that's not how Elgazzar sees it. "There's two ways of looking at it," he says. "A young guy like me, I embrace the technology. I embrace the change. Change is the only constant in any field, in any industry."

Elgazzar owns an Apple iPhone 7 Plus, and he's not afraid to use it. He considers it a stopgap, though. When he finds himself in a position where a photo opportunity suddenly reveals itself, the camera phone can take a decent, technically sound photo. That gives him what he needs to capture something quickly and upload it to social media.

"But then I'll turn to my SLR camera to produce the high-quality images that people expect," he explains. "Some people will look at it as a concern, like, 'It's cheapening the in-

dustry, it's taking away jobs, it's cheapening the art of photography.' But actually, I think the new technology with cell phones—you're able to set yourself apart from standard images with with high-quality images."

And camera phones aren't just good for taking pictures. Jacob Hand, owner of Jacob Hand Photography in Chicago, doesn't even think of camera phones as cameras first. To him, they're a great, versatile replacement for light readers and other handheld tools that used to be sold as standalone devices. Hand's a fan of an app called Sun Seeker, which helps him plan natural-light shots by using geolocation and weather data. He also sees the smartphone as a way to manage his business on the go—tracking receipts, business transactions, invoicing, and the like.

But the ability of smart phones to quickly upload images to the web is what concerns Hand. "You can be a fairly crappy photographer, but if you have lots of Instagram followers, you'll be hired for jobs these days," he says. "Being social helps with your work." And it can work against you, too—some prospects may make decisions solely on the number of followers a photographer has online.

Drones

Nearly unimaginable less than a decade ago, drones offer a unique opportunity to capture images and video from angles that not too many people can reach. And, as with other emerging technologies, the cost of entry has plummeted as innovation accelerates. But is it photography? Well, sort of.

"It's less about your ability to use a camera, and more about your ability to spend the money," says Hand, who said he'd be more likely to hire a third-party drone operator than buy one himself. He confesses that part of his apprehension toward drones stems from his lack of video game acumen. "I don't think there's anything wrong with that, necessarily, but it's more like a technician than an image-maker, specifically."

Hartong's business, which films promotional videos and commercials for businesses and nonprofits, has contracted drone operators on occasion. But, like Hand, Chili Dog Pictures isn't likely to get into the drone business itself, at least for now. Between licensure, insurance, and liability issues, Hartong's happy to let someone else assume the risk.

"All you have to do is hurt someone one time, and you're done," Hartong says. "You're out of business. The liability, I believe, is a real thing."

The possibilities commercial drones offer are still being explored by some. There are uses that go beyond photography, like inspection of dangerous buildings, law enforcement, surveying, and inspecting large fields of crops. But for a photographer, drones add only a limited amount of value, Hartong says. "You've got to be careful that you don't overuse it," Hartong said. "It's like any other tool in your toolbox; you've got to be judicious in its use. Otherwise, it loses its impact."

Safety is surely a concern, but newer drones have features that minimize risk. Commercial-grade quadcopters are often equipped with sensors that will prevent the drone from colliding with scenery, and navigation software can be used to plot a predetermined route for the drone using geolocation. And some drones can be programmed to track a transponder signal emitted by a phone or smartwatch, which presents some intriguing possibilities.

But there's also the possibility that someone will shoot it down.

"It's probably something to revisit as they become more common and more accepted," Hartong says. "There's a lot of people who still have the thought that, 'Oh, you're spying on me.' There's some resistance."

360 Photography and Virtual Reality

Like the possibilities offered by camera-equipped drones, 360-degree photography and videography are still in their infancy. From a storytelling perspective, there are times when 360-degree video might make sense. But other times, it could feel forced.

"Lots of things aren't suited to 360, but people are doing it anyway," Hartong says. During his time in the newspaper business, Hartong and his colleagues were early adapters of the technology as they looked for new ways to attract page views and new advertising revenue. "People are still learning what makes a good 360. It's more than just stick it out there. You have to be immersed in something really interesting in order to make a good 360."

There's good news and bad news for those looking to take advantage of the 360-degree video niche. The good news: The equipment to produce 360-degree footage is coming down in price and works better than ever. That means that it's easier than ever to reach a growing contingent of virtual-reality users.

Now the bad news: The list of cons is still pretty long. First: Because of its inherently immersive nature, 360 is primarily suited to video, which limits its utility. Second: The vast majority of people who will see it likely will be seeing it in two dimensions, which is a less than ideal method of consumption. Tablet and phone viewers will at least be able to tilt to view in different directions, but desktop interfaces will be limited to clicking and dragging. Finally, and perhaps most important: Virtual-reality headset ownership is lagging far behind the production of content.

According to a July 2016 *Fortune* magazine article ("It Doesn't Look Like Virtual Reality is a Thing Yet"), HTC sold about 100,000 Vive VR headsets during the first three months it was available. At $800 a pop, that's more than $60 million in revenue—hardly a failure, but not exactly the kind of news HTC was likely hoping for. As noted in the *Fortune* article, analysts' sales estimates across all brands in 2016 varied wildly, from as many as twenty million to as few as just 300,000.

Why the confusion?

"I don't think the technology is really quite there yet to capture people's imagination," speculates Hand, "but it's close. It's in that stage of things where everyone is developing the technology, but the artistry isn't there yet."

Hartong has another theory. Putting on a VR headset requires effort. It's bulky. It takes up space. It's not very portable, in most cases. "It's asking a lot of your viewer," says Hartong. "If you disappoint them, they're not coming back. I've asked a lot of you, to take the time out of your day to get ready for this immersive experience, and I've let you down."

Other Advancements

Anyone can take a picture, but what sets a professional photographer apart from everyone else in the industry is being able to set up and capture a truly beautiful image. And although many of today's cameras do well without much help from external light sources, an understanding of how to use light can be a pro's ace in the hole.

That's why Hand gets excited when he discusses the options available to photographers from a lighting standpoint. It wasn't long ago that professional-grade lighting was heavy, fragile, and prone to overheating. It also wasn't very versatile from a portability standpoint, thanks to its heavy power consumption. Today's professional lights couldn't be more different. LEDs have made it possible to produce an enormous amount of light without much heat. They're light. They're eminently portable, and their power needs can be addressed with today's smaller, more efficient batteries. "You can do neat shots in the middle of a field," he says.

Phone technology has blurred the lines between photography and videography. Video recording is now a standard option on the smart phone, and anyone can upload a simple video to social media. But editing requires skill, time, and patience, qualities that novices generally lack. That's why Hartong's business is primarily focused on video production, and Hand has added it to his repertoire to give himself another competitive edge.

The best video cameras still have a relatively high cost of entry, with 4K cameras costing hundreds, and sometimes thousands, of dollars. But Hartong has noticed something interesting with the latest crop of videocameras: The quality of 4K video is game-changing. "With 4K, true frame captures off the video are really good," he says. "You couldn't tell the difference between a still frame from a 4K and a DSLR." That means someone with a 4K video camera and a little patience is assured to capture everything that unfolds in front of them, and they'll find shots when they review their footage that other photogs might have missed.

Is that the end of still photography? Time will tell.

Matt Koesters is a business writer and an award-winning journalist. He lives in his native Cincinnati, Ohio, where his work has been published by several of the city's most respected media outlets.

DIY MARKETING

Shed Light on Marketing in the Age of Social Media

by Elizabeth St. Hilaire and McKenzie Graham

Be flexible and learn new things. Sometimes it makes sense to seek out an expert to assist or advise you. If you take small steps and little bites, you'll usually find that it's not difficult to learn new technology.

Q: McKenzie Graham: Explain the most notable differences between traditional and modern marketing.

A: Elizabeth St. Hilaire: Traditional marketing makes use of printed materials: postcards, brochures, business cards, posters, and flyers. Printing these materials is costly and often, in order to keep to a budget, artists use design templates. Templates are cost effective but are often used by many others, resulting in materials that may not stand out in a sea of advertising. Vistaprint's online templates provide a good example; the designs are professional and varied, but you'll find repetition in the art market.

Online marketing is making use of social media, such as Facebook, Pinterest, Instagram, Twitter, blogging platforms, and more. These are all free to use in their most basic forms and have a wide reach, as they not only reach your own contacts but can also be forwarded to your contacts' contacts, friends, and family who may not be in your network already. There's no initial cost to upload to and maintain such social media platforms; however, graphic design is a huge help. If you're unable to create digital postcards or email blasts, you might consider hiring a design student to help.

Visit bit.ly/paperpeacock to see a video of St. Hilaire creating *Poised Peacock #1* (collage of hand-painted papers on birch panel, 20" × 24" [51cm × 61cm]).

Q: Artists have had to be extremely flexible. That being said, have there been unsuccessful strategies?

A: Paying for printed material is expensive and outdated. Instead, pay someone to sit with you and teach you the basics of social media. For example, I chose to hire someone to design a website for me on WordPress (an online blogging platform where I was already blogging) and then to show me how she was setting it up and how I could maintain and make changes to the site in the future. This was money much better spent than on printed materials that have a short shelf life or on having someone set up a website to which I couldn't make changes. The key is to continually change and update your materials with new images, new messages, and new information. We're in an age of information and dynamic change; you must keep up with that pace to stay relevant.

Q: How does an artist balance self-promotion and over-saturation in the market?

A: Don't worry about self-promotion through your Facebook page. It's not over-saturating your market because your followers can choose to make your posts visible. As

far as your e-mail recipient list goes and the information you're sending directly to your subscribers, that can lead to over-saturation, so artists needs to be mindful not to send out too many e-mails. I try to limit my correspondence with e-mail subscribers to once or twice a month. By law, you have to have an unsubscribe option at the bottom of any unsolicited e-mail. If you send out too many e-mail blasts, subscribers will choose that option and drop off your mailing list. That's not always a bad thing, however, as most e-mail services charge account holders based on their number of subscribers; so if your subscriber no longer wants to read your updates, it's best they unsubscribe so that you're not paying for leads that aren't viable.

Q: Which are the platforms worth an artist's time?

A: My favorite platform is Facebook, because it reaches my target market and it's easy to use. I typically update and monitor my Facebook activity on my iPhone as I'm often working remotely from my studio or my home, or I'm on the go. On Facebook business pages, Facebook states the administrator's response rate and the average time it takes for them to respond to customers. My response rate to Facebook activity is typically 100 percent and within ten minutes. That's only achievable because of the immediacy of smart phones (mine is an iPhone) combined with the Facebook Pages Manager app. My second favorite platform is my e-mailing list, which targets specific people interested in what I'm sending out—available, original artwork and workshop opportunities. This list is continually being weeded, as subscribers can use the "opt-out" feature mentioned above when and if they prefer being removed; this ensures that everyone on the e-mail list wants to be there.

Q: What do you see as up-and-coming in fine-art marketing?

A: My next push is going to be reaching out to more online forums in mixed media where I might find people that I'm not currently reaching. By seeking out groups with similar interests, I can expand my target audience. I was recently published on Huffington Post, which drove a lot of traffic to my Facebook page and mailing list. Getting published is always a good way to reach new people, but then you have to make sure that your website and various online landing/social media pages are updated when traffic is inevitably generated from the article.

Q: How do you mentally prepare for the rapidly changing digital market?

A: Go with the flow; be flexible and learn new things. Sometimes it makes sense to seek out an expert to assist or advise you. If you take small steps and little bites, you'll usually find that it's not difficult to learn new technology—much of it is intuitive and easy to navigate, otherwise it would not be so successful! My demographic on Facebook is primarily women ages fifty-five to sixty-five. That's a fact provided to me by Facebook, so it's not just young people who are making use of new technology!

Q: Are certain media or styles more likely to be successful online?

A: I'm a collage artist. I create painterly, impressionistic collages from torn tidbits of hand-painted paper. My medium reproduces well online as I utilize a strong sense of composition, vibrant colors, and a feeling of whimsy that makes people smile! I also engage with my followers on a personal level, answering every comment that's made about my work. Plus, I give folks a look into my personal sense of style with photos of my quirky shoes and socks. This gesture extends an offer of personal connection between my followers and me. Building relationships helps to keep people engaged.

Q: You've been a winner in our All Media Competition. Would you encourage entering, and how have contests affected your career?

A: I would absolutely encourage any and all artists to enter contests that promise winners space in a publication where your reach can expand to new viewers. When my work won and was published in magazines and books, I was able to let readers know that I offer workshops around the world as well as the sale of prints and originals. Being published through contests even made way for having my own book published by North Light Books (on international book stands this August) which will only continue to expand my brand.

Q: Time balance is something all creatives struggle with. How do you balance your create vs. promote time, and do you give yourself time each day to be totally unplugged, or is that unrealistic?

A: I'm never totally unplugged. I can't do it. I find that you have to constantly feed the machine in order to keep the wheels turning. When I don't publish to my Facebook, Pinterest, or Instagram, my engagement numbers drop. Those accounts require constant monitoring, which means making new work, talking about new opportunities, or sharing information. Even when I'm in the studio, I typically have my iPhone and laptop with me so that I can bounce back and forth between promoting, checking email, answering inquiries, and painting. It's a multitasking scenario all the way around.

Q: Another struggle is always market expectations vs. personal creativity and goals. How do you please both your audience and yourself?

A: Recently I had this conversation with an artist, and we agreed that personal creativity has to take a backseat to market expectations when you're making a living as a fine artist. In order to support ourselves, pay the bills, and avoid part-time work as a barista, we have to cater to the market. Personal creativity needs to be plugged into the spaces in between. I have a large portrait of my son on an easel in my studio that I haven't worked on in weeks. I have ideas jotted on scraps of paper in my studio and in my car, ideas for paintings that are completely and totally born from my imagination

and things that I'd like to do regardless of whether or not they're saleable—but those projects are second to what's selling and paying my bills.

Q: We all know how important a beautiful photo is in today's image-heavy social media world. Do you have any photography tips?

A: I would suggest that every artist take a basic photography class or workshop at a local art center. Ideally, the class focus would be on photographing for reference and capturing images of artwork. Otherwise, consider finding an expert and paying that person to spend a couple of hours with you or at least find a place to start experimenting and learning on your own. I've learned how to capture images of my own work for licensing this way and also by spending time with photographer friends.

Don't discount the importance of continued education. When I can, I like to take classes by other artists, attend gallery events, and visit art fairs. I look for inspiration and motivation by getting outside my own work and being inspired and encouraged by the work of others.

Elizabeth St. Hilaire is a paper collage artist. See her work at paperpaintings.com.

Adapted from the July/August 2016 issue of *The Artist's Magazine*. Used with the kind permission of *The Artist's Magazine*, a publication of F+W Media, Inc. Visit artistsnetwork.com to subscribe.

PHOTOGRAPHY PARTNERSHIP: BEHIND THE SCENES

by Britta Hages

Regardless of what some opinion blogs may lead readers to believe, the colossal number of website articles and step-by-step directives discussing how photographers and other artists should go about gaining the attention of galleries speaks of the enormity of what galleries can do for one person's career.

Long before the days of photography, galleries have been making and breaking artistic careers. In many ways, they are an art unto themselves as they continue to promote and garner the attention of the masses.

Attention that artists are eager to attain.

With the introduction of social media to most artistic careers, it can be tempting for photographers to cut out the middleman and jump right into the mix of creating and selling. But galleries are skilled at what they do and have long since mastered the art of seducing potential buyers into emptying their pockets for just the right piece.

No one knows this better than Meghan Kelly, the Executive Director of the Buckham Fine Arts Project, otherwise known as Buckham Gallery. Based in Flint, Michigan, the Buckham Gallery has an eclectic mix of photographers and other artists who depend on the gallery as a major source of revenue for their work.

Buckham Gallery features a wide assortment of photographers and artists whose work is often arranged side by side during exhibits.

But not just anyone can showcase their artwork in a gallery. It's a mutually skilled partnership that requires give and take from both sides. The gallery itself is an artist-run business, composed of over forty members who identify as artists and are, therefore, well versed in all areas of the artistic community. This makes for a well-rounded hub that naturally attracts photographers and other artists from around the globe.

With a steady stream of interest coming in from other states and countries, it's no wonder that photographers are itching to pair up with the gallery in hopes of making a name for themselves. But, like all wishes, there's a price to pay. And in the art world, that price is attracting and maintaining high expectations from all involved.

"Since our gallery is composed of artist members, we expect artists to be constantly working and practicing in the arts," Meghan says. "We have deadlines and contracts in order to ensure work is ready in time for an exhibition, easy to publicize, and up to the standard our artist members set."

For most galleries, there are standard rules that apply that all photographers must adhere to, with communication being key in all areas. Whether it be basic paperwork and deadlines, or photograph hanging specifications, a steady form of dialogue must never be underrated. Meghan is the first to admit that deadlines and paperwork aren't glamourous or appealing to the senses, but they're a necessary evil.

"As an artist myself, I know deadlines and rules are inside the box, and many artists and photographers tend to think outside of the box," Meghan says. "But when it comes to completing paperwork properly and on time, it's the best thing a photographer can do. We can put together a list of exhibitions for potential sponsors to see, outline exhibitions for the public to see, and it helps us help the photographer in return."

All of the rules are set in motion to ensure the gallery is a well-oiled machine. With so many moving parts, it's critical that everything is arranged in advance. In the gallery world, if it appears effortless to the customer, then it wasn't effortless on behalf of the photographer or gallery. In other words, the exhibit or show was, indeed, demanding behind the scenes in ways that only the photographers, other artists, and galleries are really aware of and can sympathize over.

"A lot of behind-the-scenes things go on to make it all seem so effortless," Meghan says. "Putting together shows takes time, so we schedule over a year in advance. We send out a call for entry, have a deadline, review entries, score them, and place them with artist members who would complement one another. Hanging exhibitions also takes time. It takes time to take down a show, pack work, fix the walls, lay out the show, and hang it all over again."

Therefore, it's important that each photographer meets the expectations of the gallery they're working with. If not, they could easily get the boot.

But sometimes, even if photographers meet all of the gallery's expectations, complications can arise. Though uncommon, they usually come in the form of conflicts between the artist and gallery. Again, Meghan reiterates the need for communication, as it often goes a long way in fixing any potential problems before they get started. Still, sometimes confrontation is unavoidable. Meghan finds that, usually, it's the same two or three problems that she sees popping up repeatedly throughout her career.

For instance, "theories in how shows should be hung," Meghan says. "The old school theory is that each photographer should be hung alone. Likewise, some believe that nothing should be stacked, versus those who think intermixing sometimes works."

With like-minded sensibilities in the design, layout, and overall appeal of a composition, photographers get a lot of bang for their buck when they pair with a gallery. The professionals who work within a gallery know how best to market and promote work, which is information that photographers might not be as privy to because they may not have a seller's eye.

"There is an art to hanging art in a gallery," Meghan says. "Sometimes we have four artists and they're each working on a series, and it's easy. Sometimes we have a big group show, and there can be fifty artists. Trying to make each piece look as good as the next piece is the key. Something small and black-and-white shouldn't go next to something huge and colorful. It's all about playing with what compliments the work next to it the best."

Ultimately, the main goal of a gallery is to make the art inside its studios as appealing as possible to potential consumers, which means that photographers and other artists in gal-

lery shows have an added bonus that stock sites and social media can't give. And that bonus comes in the form of deep-rooted affection.

"We love them! We try to really showcase their talent in real life," Meghan says. "By helping the artist, they help us."

There are many ways a gallery can help an artist that mainstream media cannot. The most notable is in the gallery's ability to have the one-on-one undivided attention of a potential buyer for a longer period of time. All galleries cater their window decors, sidewalk arrangements, and more to draw the eyes of passersby in order to lure them in to look at their works of art. Some galleries take further initiative and develop a marketing plan centered around drawing in larger crowds of people.

"All of our show openings coincide with Flint's second Friday Art Walk each month," Meghan says. "This typically brings a few hundred people to the gallery each opening. We also host monthly music events and poetry or spoken word events. And an annual arts lecture series, called the Smallidge Family Speaker Series, also brings people into the gallery who might not otherwise visit."

Modern galleries are used to having to combat the mainstreaming of art online, especially with popular social media sites like DeviantArt, Instagram, and Pinterest. However, many have learned to adapt and evolve the interactions with social media to benefit them, such as when their events are advertised online through these websites to garner interest that otherwise wouldn't be accessible to them.

"We try to stay up-to-date on social media sites such as Facebook, Instagram, Twitter, and we are currently updating our website as well," Meghan says. "By having a presence online, we hope to reach that audience, and show them that we are a place to see amazing artwork and photography in person."

According to Meghan, web isn't the gallery's biggest competitor, mainly because they've developed ways to make it work for them, including releasing photos on the internet, publishing exhibition press releases, or etc. In fact, she considers the biggest threat to the gallery to be other in-person art experiences offered to the public.

"At this point in time, I think our biggest competitors are the places that host the painting parties," Meghan says. "People get to make artwork and take it home or give it as a gift, which is great! But the downside is that people aren't buying other artwork. This DIY trend is very cool, and the more who create, the better. But it does make people want to create things on their own rather than purchase or see what other people have made."

This growing phenomenon has branched out into other areas, such as publishers that create painting party bundles that package a step-by-step book, video, and all of the painting supplies together for an in-house painting party experience. With more and more companies skipping the middleman, it's hard to imagine that galleries can keep afloat.

Tracie K-Hilder's *Dancing Magnolia* is set against a minimal background to allow viewers to reveal and revel in the details beyond the petals.

Yet photographers like Tracie K-Hilder don't seem to be threatened by this growing sensation. Although she understands the do-it-yourself appeal since she, too, started out as a hobbyist in the world of photography, Tracie is continually reassured by the numbers of customers who flock to her work via the gallery.

"The gallery has helped increase clients and a customer base," Tracie says. "It has helped to focus marketing to the clients who are specific to the work that is exhibited. Further, working with a gallery is important for bringing work to clients who may become collectors in the future."

The niche appeal of galleries is ideal for photographers and other artists, alike. Though most freelance photographers shoot commercial products, portraits, weddings, engagements, and families on location—over time, some photographers lean toward a select subject to focus on. Tracie, in particular, is fascinated by nature and the play of natural light in her photos.

"I photograph different genres and have many themes going at the same time," Tracie says. "Though there is a common thread of nature in most all of my work."

Those themes are what Buckham Gallery caters to when displaying Tracie's work to the public. And it's not just Buckham Gallery—but all galleries. It's a photographer's expecta-

tion that the gallery presents their work, while on exhibit, in the best possible way to bring out the original intent of the pieces and attract attention.

"I believe that to experience and appreciate art, it's crucial to see it in person," Tracie says. "It's also important to note that in the digital world, we have little control on how a piece is displayed on a computer monitor. To have work exhibited at a gallery, it is how the artist intended the piece to be. The gallery provides the space and ambiance that enables more of a personal interaction with the artwork. There is nothing that compares with experiencing the artwork up close and personal."

Outside of the monetary aspect, working with galleries can be beneficial to photographers in other ways. The most notable is that in keeping with their own mission to attract the right clientele and produce sales, galleries are direct in telling photographers what their customers want. In effect, many photographers tend to improve their skills in a bid to attract business from particular customers, whether it be improving on their actual shooting or social skills—it all tends to be open to suggestion.

"Working with the gallery has improved my work dramatically," Tracie says. "It has created a social environment for me to create work that is quality more than quantity. It has caused me to step up and create work that will increase traffic and compliment the other artists in a group showing. Likewise, it has improved my skills socially as I talk with other artists and build up a unique camaraderie. Similarly, I chat with collectors and visitors to answer their questions or just converse on life."

Tracie continues to spread her wings by submitting to newspapers, contests, magazines and other publications outside of Buckham Gallery, but she still loves her partnership with the gallery.

"The gallery not only provides space, but also an environment that is specifically conducive and focuses on fine art that satisfies both the collectors as well as the artists," Tracie says. "The gallery also put together artists (sometimes of different mediums) that compliment the theme as well as enhance the work that has been displayed."

In an effort to continually evolve as a photographer, Tracie is always taking classes, workshops, and photographic tours. She insists on partaking in anything that will expand her knowledge base, technique, or inspiration as a photographer. She attributes working with the gallery as a means of approaching her photography differently than she once had as a newbie in the photography business.

"It has helped to expand genre, quality of work, and prompted me to take risks," Tracie says. "It's opened up a different world perspective by the other artists that confirm places, objectives, and materials."

As someone who has been growing in the photography field for some time, Tracie is quick to offer advice to new shutterbugs in the business. Moreover, she enjoys sharing her

Tracie K-Hilder captures the sand-swept shore along a row of concrete pillars to illustrate how nature provides onlookers with a sense of humor through the lens.

experiences of working in partnership with a gallery, especially with those who view the relationship as something "old-school" or otherwise outdated.

"The best advice I can offer to anyone thinking about approaching and working with a gallery is to research the artists they may represent," Tracie says. "Ask yourself: Does my work fit into their mission? Is the gallery in a location that would best represent the work that I create? Also, be willing to create work that is cohesive in theme and genre."

Photographs are powerful representations of intimate moments, shared between a photographer and his or her audience. With the help of galleries, people get a sense of intimacy that is all but extinct with digital art online. According to Tracie, it's the difference between "up close and personal" and "online and flat." For this reason, many photographers opt to try and fill that open white wall of commercial real-estate with their favorite attractive showpiece.

"It creates an atmosphere to experience the artwork, talk to other artists, and provides a space to share stories," Tracie says.

This ability to swap stories with people of all backgrounds, walks of life, and trades is just one of the many advantages of the gallery relationship. It's no wonder that Tracie doesn't regret partnering with a gallery for even a minute—she's too busy enjoying the perks that come with having her photos featured in a gallery.

In the end, regardless of what some opinion blogs may lead readers to believe, the colossal number of website articles and step-by-step directives discussing how photographers and other artists should go about gaining the attention of galleries speaks of the enormity of what galleries can do for one person's career.

When it's all says and done, this unique collaborative partnership gives photographers the chance to walk into a creative space and see their blood, sweat, and tears hanging on the wall in a beautiful array while onlookers admire their work. Many might say that moment alone would be worth pursuing a partnership.

But that's ultimately up to you.

Britta Hages is a former fulltime book and video editor who has worked on a handful of bestsellers. Now she spends her time freelance writing for magazines, books, and other print and digital media. Visit www.BrittaHages.com to learn more about her fiction and nonfiction content, and to read her writerly musings.

THE NEW LANGUAGE OF PHOTOGRAPHY

Daniel Grant

These proprietary-sounding terms—giclées, archival pigment, digital chromogenic, digital color coupler and various others—seem to be employed not to provide helpful information about the process used but, instead, to suggest that the artist has produced something that is highly technical, even magical.

Until about fifteen years ago, we would call the thing created through the use of a camera a "photograph." One could choose between black-and-white or color photographs, with the occasional platinum print or photogravure available, but that was when everyone had cameras that used film to record an image and traditional photographic paper to print it. We still refer to photographs, but now there are more ways than ever to classify them. Photographers, more often than not, use digital cameras and print on photographic paper, or produce a photographic negative on film but print on an inkjet printer, while others are digital all the way. Should there be new language to describe what we used to just call photographs when selling works to buyers?

There is, but to date, it isn't a shared language. Take, for instance, fine art photographer Emmet Gowin, who refers to some of his computer-enhanced work as "digital inkjet prints," which tells the type of machine used to produce the final work. Meanwhile, Judith Joy Ross describes her work as "archival pigment prints," which means the same thing but informs prospective buyers that something about the paper and inks will make the artwork last

longer than what comes out of your office printer. Laurent Baheux creates what he calls "giclées" (pronounced ZHEE-clays, a French term coined in the 1980s to describe inkjet prints), while Chuck Close uses the phrase "digital pigment" prints to describe the same process. Shoja Azari has created "digital C-prints," which is the the same thing as Alec Soth's "digital chromogenic" prints and Edward Burtynsky's "digital color coupler" prints, each referring to the process used.

When people see William Christenberry's "digital pigment" photographs, "they don't know what that means," he once said, but it is actually rare these days that anyone even asks. His process was to take pictures on film, scan the image into a computer and then print the digital file on a high-end inkjet printer. Most of the time his images were printed by a photo lab onto Cibachrome photographic paper, but by the end of his career he used the inkjet more and more. The digital prints look a little different because there is a larger range of papers and other surfaces on which to print images than the traditional glossy photographic paper, and Christenberry liked the variation. Just as satisfying, the inkjet prints are "priced the same as my C-prints and sell just as well," he says.

All of these proprietary-sounding terms—giclées, archival pigment, digital chromogenic, digital color coupler and various others—seem to be employed not to provide helpful information about the process used but, instead, to suggest that the artist has produced something that is highly technical, even magical. "Archival pigment" prints simply indi-

cate that the inks used contain actual pigments rather than dyes and that the image is re-produced on acid-free paper, while "chromogenic" prints are produced in a darkroom with traditional chemicals and processes. It is the rare photographer these days who actually is involved in physically producing a print, which may be the reason for the obfuscating lan-guage. The battle to establish photography as an art form, no less important than paintings or graphic prints, had been won decades before the new technology appeared, but the lack of an agreed-upon language to describe digital photography suggests fears on the part of artists and their dealers that the buying public with its camera-equipped cellphones might change its mind. One hopes that the word soup of terms that largely identify the same pro-cesses in digital photography will be pared down to just a few meaningful phrases that ac-tually tell people what's going on.

It might seem easy to dismiss these various phrases as jargon, but the terms may mat-ter to people who purchase photographs, believing that the people who take pictures for a living are doing something more than any joe on the street with his cell phone and desktop printer. Or, perhaps, the people who buy fine art photography don't particularly care what the process is and just want a good picture.

"There's an old saying, 'Photography collectors only care about what is on the back of the picture and art collectors only care about what's on the front,'" says New York City pho-tography dealer Lawrence Miller. It is on the back of the traditional photograph that price-determining information is provided, for instance, the printing process (albumen, Ciba-chrome, daguerreotype, dye transfer, palladium, and photogravure, among others); when the image was first created and how soon after the print was made (if within a year or two or three the print is considered "vintage"); who did the actual printing (the artist, someone else under the artist's supervision, someone trained to know what the artist wanted or just someone else); if the print has been signed and numbered (by the artist); if the print is part of a "limited" or "open" edition; and whether or not it has been wet stamped (containing information about the photographer, the print, the edition, and the copyright). For photog-raphy collectors of images from the 19th and much of the 20th centuries, that kind of in-formation still matters. However, for buyers of contemporary photography, "the audience couldn't give a damn," Miller says. "They see a large-scale photograph, and they assume—rightly, in most cases—that it has some digital component."

The largest change may not be the terms used to describe the photographs, but rather that there are fewer pure photography collectors and more buyers who purchase two-dimen-sional artworks in a variety of media, including photography. Signed and numbered still tends to matter, but less and less the process by which the photographic print was made. "No one ever asks what 'digital chromogenic' or 'pigment print' means," says Maureen Bray, di-rector of the Sean Kelly Gallery in New York, which represents Alec Soth. "I assume that they know the meaning of these terms, or maybe they don't care and just want a work by Soth."

That assumption may not be completely true. Digital C-prints seems like a transitional technology, since it uses new technology (the digital file, in which images are manipulated and adjusted within the computer rather than in a darkroom) to print on traditional photographic paper, giving buyers the look (continuous color rather than lots of dots) and feel of what they may be more used to seeing.

The process of capturing images may be in an in-between stage as well, since many photographers whose work is produced by digital means continue to use traditional cameras and film. "It is advantageous to use film," Emmet Gowin says, "so you can overexpose to gain more lights and darks, and then scan it into a computer where you have a greater amount of control in making adjustments, and you don't have to deal with chemical baths."

As go artists, so go their collectors who have been purchasing the new and hybrid photographic media more and more. Not only have the art galleries seen this, but the auction houses have, too.

"Over the past few years we have sold a good number of digital prints in our auctions to excellent results," said Vanessa Kramer, worldwide director of photographs at Phillips auction house. She noted that in one recent sale of contemporary photography in New York City, the catalog cover lot was a digital composite image (a mounted color coupler print) by Desiree Dolron, estimated at $40,000–$60,000, which achieved $194,500 at the sale, a world auction record for the artist. "In the same sale, in fact, we established world records for digital

prints by Pieter Hugo, Barry Frydlender, Gavin Bond, and Ahmet Ertug, among a number of other photographers. The works sold for anywhere between $27,000 and $70,000, which places them within a very competitive price range. It seems that some collectors are not so much concerned with the printing method as much as the artist, the rarity of their work on the market, and the subject matter, to name but a few variables."

Lest you think photography is the only artistic field in which the language has become overwhelmed with the technology, we see this in sculpture, too. Artists refer to "cold-cast" artworks that suggest traditional bronze but actually are composed of other materials, such as Aqua-Resin, concrete, Fiberglass, gypsum- and polyurethane-based resins, which are less expensive and sometimes can be produced into sculptures right in the studio, without the high labor costs of a foundry. Mark Fields, owner of The Compleat Sculptor, a sculpture supply store in Manhattan, noted that a growing number of artists are buying metal and mica powders that are poured into molds or applied as a patina to give a "faux finish" that resembles bronze or other metals.

My recommendation? Just use the words "photograph" or "sculpture" and allow prospective buyers to be won over by the images themselves. For those who care, artists and their representatives may answer technical questions if asked.

Daniel Grant is the author of several books, including *The Business of Being an Artist* (Allworth Press) and *The Fine Artist's Career Guide* (Allworth Press).

WHAT PHOTOS SELL AND RE-SELL?

..

by Rohn Engh and Mikael Karlsson

The Difference Between a Good Photo and a Good Marketable Photo

What kind of photo can you be sure will sell for you—consistently? And what kind of photo will disappoint you—consistently?

You may be surprised at the answer to these two questions. The heart of the matter is that one type is a good photo, and the other type is a good marketable photo. It's surprising because the good photos seem like they ought to be marketable; we see them everywhere, looking at us from billboards, magazine covers, brochures, advertisements, and greeting cards. These good pictures are lovely scenics, beautiful flower close-ups, sunsets, and dramatic silhouettes—those excellent Kodak-ad shots and contest winners. These photos also could be called "standard excellent pictures."

"But why do they consistently ring up no sale when I try to market them?" you ask. Because the ad agencies, graphic design studios, and top magazines who use these standard excellent shots don't need them; 99 percent of the time their photo buyers have hundreds, indeed thousands, of these beauties at their fingertips—in inventory, at their favorite stock photo agencies, or from the list of stock photographers they've worked with and know are reliable. Ninety-nine percent of the "good" pictures you see published in major newsstand magazines or in calendars, brochures, or posters are obtained from one of those two sources: stock photo agencies or top established professionals.

The established professional usually has a better supply of standard excellent pictures than the average photographer or serious amateur, even though the latter may have been photographing for years. Professionals have work schedules and assignments that afford

them hundreds of opportunities to supplement their stock files. The professionals can shoot more easily and less expensively because an assignment already has them in an out-of-the-way, timely, or exotic location, and they can piggyback stock-file photos with their original assignments. Getting the same shots could cost you a great deal in travel and operations expense. Moreover, when buyers of these photos want a good photo, they don't turn to a photographer with a limited—albeit excellent—stock file who's unknown to them and has a limited or nonexistent track record.

The best place for your standard excellent photos, then, is in a midsized stock agency. You may need to start in one or more small agencies and work your way gradually into a major agency. This, too, is a form of sweepstakes marketing, but chances are that even amid the tough competition (by virtue of the sheer number of photos), you'll find that a sale now and then nicely complements the sales from your own direct marketing efforts. The key phrase here is now and then. It's not a case of the checks just rolling in once you put your photos in an agency.

I realize there are a dozen books on the market that report that you can sell the standard excellent picture to buyers. There also are books that assert that you can write a blockbuster novel or write a top-forty hit song and make a hit record that sells a million copies. I don't doubt that the authors of these books have hit the jackpot themselves or know someone who has. However, you open yourself up to two disadvantages when you attempt to appeal to the common denominator of the public's taste.

1. First, the romance and appeal of commercial stock photography soon fades after you've snapped an angle of the Washington Monument or a sunset in Monterey Bay for the twentieth time, likewise with a standard symbol of power (ocean waves), hope (sunlight streaming through rolling dark clouds), and so on.

 The original exhilaration of stock photography diminishes when you realize that you're following someone else's tracks, when you know the identical pictures are in other photographers' files. On the one hand, it can be money in the bank when you snap the standard shot of the Maroon Bells in Colorado, but it's disheartening to discover tripod marks or chewing gum wrappers in a spot where you had thought you were experiencing a moment of discovery. Eventually you come back to your starting point and say, "There must be more to stock photography than this."

 If you were to continue to snap these exquisite clichés as your standard stock in trade, what would you have after two or three decades? Would a publisher aggressively seek you out to publish an anthology of your work? Not if your photos were cookie-cutter versions of standard subject matter, making you indistinguishable from hordes of other commercial stock photographers.

Illustration 2-1

2. The second disadvantage is economic. The law of supply and demand indicates that it's dangerous to count on consistent sales to the markets that buy the standard "excellents." The market is so flooded with these pictures—in commercial stock agency catalogs, CD-ROM "click art" and online digital portfolios—that the idea that your particular versions would hit every time, or most of the time, enters the realm of high optimism—admirable perhaps, but not too practical. No viable business can survive on the occasional sale, so even though it might be useful to take the old cliché photo should the opportunity present itself, don't count on these kinds of images for your bread-and-butter sales.

I like to call these exquisite clichés "unbelievable." Although the elements of a marketable picture are there, they are missing one major element: believability.

Enduring Images

Look at the two editorial pictures, Illustrations 2-1 and 2-2. Can you read into these pictures? Do they evoke a mood? When they were first made in the thirties, few photo buyers considered them blockbusters. Instead, photo buyers at the time probably were purchasing the standard decorative photos of the day. Today, the pictures endure and are included in anthologies. Are you aiming your stock photography activities at pictures that will endure and create long-term value?

Good Market-able Photos

What, then, are the good market-able photos that will be the mainstay of your photomarketing success and will supplement your retirement income as well as be an asset to pass on to your heirs? These pictures are the consistent marketing bets—the photos you can count on to be dependable sellers. These photos have buyers with ample purchasing budgets eager to purchase them right away and over and over.

Illustration 2-2

No-Risk Marketing

These good marketable pictures are the ones photo buyers need. Let the pictures in the magazines and informational books in your local library and on the websites of these publishers be your guide. These editorial (nonadvertising or noncommercial) photos show ordinary people laughing, thinking, enjoying, crying, working, playing, sharing, helping each other, and building things or tearing them down. The world moves on and on, and our books, magazines, and online media provide us with a chronicle. About fifty thousand such photo illustrations are published every day. They are pictures of all the things people do at all ages, in all stations of life, and in all the countries of the world. These pictures are what editors need constantly. These are good, marketable stock photos—the best-sellers. They may not sell for $750 apiece, but if you plan your marketing system wisely, you can easily sell ten for $75 each.

To clarify the difference in your chances of selling these good marketable pictures compared with standard excellent pictures, consider the Los Angeles or Boston Marathon. Out of thousands of dedicated runners, there's only one winner. The trophy goes to the top pro-

fessional who practices day in and day out, rain or shine, and who makes running a full-time occupation. Anyone can get lucky, so I can't deny that you might win the Boston Marathon—that is, you might score with one of your standard excellent pictures in a national magazine. However, for someone just starting out, the odds weigh heavily against you.

The first step, then, toward consistent success in marketing your photographs is to get out of the marathon and start running your own race.

I once asked a photo buyer, "Why do newcomers always submit standard excellent pictures, instead of on-target, marketable pictures?" His answer: "I think the photography industry itself is partly at fault. Their multimillion-dollar instructional materials, their ads, their video programs, are always aimed at how to take the 'good picture.' Photographers believe they have reached professional status if they can duplicate that kind of picture."

Well-meaning advice from commercial stock photographers sometimes adds to this misconception. In their books, seminars, and conversations, successful stock photographers sometimes forget how many years they spent paying their dues before they could sell standard "excellents" consistently. Successful people in any field—medicine, theater, professional sports, photography—often dispense advice based on the opportunities open to them at their current status. They fail to put themselves in the shoes of a newcomer who has yet to establish a track record.

In running your own race, you'll be up against competition, too, but it's manageable competition. Target your pictures to specific markets and take pictures built around your particular mix of interests, your expertise and what you have access to.

Mikael Karlsson is a professional photographer specializing in law enforcement photography. You can see his work at arrestingimaes.com.

Rohn Engh was a veteran editorial stock photographer who sold in national and worldwide markets. He was the founder and publisher of PhotoStockNotes, PHOTOLETTER, and PhotoDaily—market letters that post photo-editor picture needs. Engh also conducted photo-marketing seminars worldwide.

KNOW YOUR RIGHTS!

by Leonard D. Duboff

Expand your understanding of copyright law in two specialized areas that could affect you: orphan works and instructional demonstrations.

Q: Please give me an update on orphan works legislation in the United States and Europe.

A: Orphan works are creative materials that are protected by copyright, but the copyright owner either is unknown or cannot be located. Those who would like to license the right to use those works, such as cultural institutions or publishers, are faced with a dilemma: Because they cannot locate the owner to request permission, they must either risk a copyright infringement lawsuit or choose not to use the work.

This problem has plagued the copyright community throughout the world. While the United States attempted to adopt an orphan works law, it has still not done so. The European Union (EU) and United Kingdom (UK) have led the world in dealing with this thorny dilemma by enacting new orphan works licensing rules that took effect in October 2014.

The EU directive is rather limited and applies only to certain cultural organizations, such as museums, within the EU. The primary purpose of this directive is to allow those organizations to digitize orphan work materials and to add those to their websites. The EU directive covers books, journals, newspapers, and magazines or other writings, as well as cinematographic or audiovisual works and phonograms, but not stand-alone photographs and other images. In order to use a copyrighted work, the cultural orga-

nization must have first diligently searched for the copyright owner, and the use must be in pursuit of its public interest mission.

The UK regulations for orphan work use are much broader. Anyone who wants to use a copyrighted work can, for a fee, apply to the UK Intellectual Property Office (IPO) for a license to do so once a "diligent" search for the copyright owner has been conducted. The IPO has published guidelines for diligent searches (see bit.ly/UKOrphanWorksSearch) and an applicant must submit a completed search checklist along with the application. The orphan-works license allows the licensee to use the orphan work in the UK for commercial or noncommercial purposes for up to seven years. All such licenses are nonexclusive. The IPO reserves the right to refuse licenses for what it deems "inappropriate uses" or "derogatory treatment." It also may reject an application for any use it does not believe is in the public interest. In order to use an orphan work, the licensee must pay a "reasonable" license fee set by the IPO. The IPO will hold all orphan works royalties it receives in a segregated account for eight years from the date of the license; it will pay those royalties to the copyright owner if the owner comes forward during that period.

In the United States, no orphan works legislation is pending at this time. Although legislation was proposed in 2008, it did not pass. Since that time, the Copyright Office has continued to study orphan works and mass digitization. On numerous occasions in 2012, 2013 and 2014, the Copyright Office requested written comments on issues surrounding orphan works and mass digitization. In the spring of 2014, it held public roundtables on these issues, and in June 2015, the Copyright Office released its final analysis, along with recommendations for legislation. The report, "Orphan Works and Mass Digitization," is available at bit.ly/OrphanWorks2015. Unfortunately, there is a great deal of disagreement among interested parties about how best to address these problems in the U.S. If you're interested in following this debate, visit the Copyright Office's webpage at copyright.gov/orphan, where you can review transcripts and videos of the roundtables as well as copies of comments.

Because the U.S. currently has no orphan works laws, libraries and archives have written statements of best practices for fair use of orphan works. The most recent is the "Statement of Best Practices in Fair Use of Collections Containing Orphan Works for Libraries, Archives, and Other Memory Institutions." This statement was released by American University and University of California, Berkeley researchers in December 2014 and is available online at bit.ly/OrphanWorksBestPractices. Another "best practices" document, the "Code of Best Practices in Fair Use for the Visual Arts," is available at bit.ly/FairUseBestPractices.

Q: Many how-to-paint books or digital media include step-by-step exercises clearly encouraging the reader to reproduce the artwork in the lesson for the purpose of practicing a particular skill. Apparently, the reader can create such a painting without infringing any copyrights, but can he or she then legally sell the painting, enter it in a contest or publish it?

ANTHONY L. MEDLEY, PELHAM, TENN.

A: The owner of the copyright in the image retains the copyright to that image and is merely granting the reader permission, that is, a license, to use the image for the purposes described in the book or digital medium.

A copyright is actually a bundle of five exclusive rights: (1) the right to reproduce the work, (2) the right to prepare derivative works based on the copyrighted work, (3) the right to distribute copies to the public for sale or lease, (4) the right to perform the work publicly, and (5) the right to display the work publicly.

In the situation you've described, the copyright owner is expressly granting the reader permission to reproduce that image for the purpose of practicing his or her artistic skills. The answer to the question of what the reader/artist can legally do with the reproduction of the image is not as clear as one would like and depends on the terms of the license being granted. To determine this, the artist will need to review the instructions as well as any introductory materials that describe what can be done with the image.

If the artist is expressly permitted to use the work produced in any way desired, then, of course, there is no restriction and anything goes. The artist could legally sell the painting, enter it in a contest, publish it or do anything else with it he or she desires (providing these actions don't violate some other restriction, such as contest rules or an agreement with a buyer or publisher).

If, on the other hand, the instructions make it clear that the images are to be copied only for purposes of educating the copier, then selling the copy, entering it into a contest, or publishing it would not be allowed. It is, therefore, important for the artist to carefully read the instructions provided and do what is permitted.

If there is a question about whether a particular use would be legally permissible, then the artist should send the publisher a letter or e-mail asking for clarification of the licensed rights. Anything else would be risky, and obtaining a written clarification would provide the artist with a defense in the event the use was ever challenged.

Leonard D. Duboff has testified in Congress in support of laws for creative people, including the Visual Artists Rights Act of 1990. A practicing attorney and pioneer in the field of art law, he has also assisted in drafting numerous states' art laws and has authored more than twenty books. His survey on art law, presented at the Berglund Center, Pacific University, may be viewed at vimeo.com/37984601. For further information, visit dubofflaw.com.

JUGGLING LIFE AS A FREELANCER

An Interview With Jaky Janine

......................................

by Britta Hages

"You have to know your reality. You don't get to go to work, punch in, and punch out when you have a side business. —Jaky Janine

There are countless how-to articles, videos, and even entire websites dedicated to helping photographers drop their day jobs to pursue freelance photography full time, but where is the content describing how to escape the frenzied freelancing trenches to pursue a different career? Better yet, what happens if someone gets the crazy notion to actively pursue both?

Jaky Janine is one such individual. After years of pursuing a degree in photography, as well as building up her portfolio as a full-time freelance photographer, all of her plans came to a screeching halt when her husband experienced an unexpected work injury.

"We didn't have insurance so we ended up paying thousands out of pocket to cover the cost of his surgery," Jaky says. "Then came this full-time job opportunity. They just happened to offer it to me during my slow season as a freelancer, and with my husband being off work, it came at the perfect time."

According to the Bureau of Labor Statistics, around half of professional photographers are freelancers. Top that off with an average hourly wage of about $27, according to PetaPixel, and freelance photographers seem to have a pretty great deal.

At least, that appears to be the case until you factor in that freelancers don't work every day and are completely on their own to cover the costs of insurance, equipment, studio rentals, travel, and so much more. After a while, these costs add up into what is commonly referred to as the feast-or-famine world of artistry. A world Jaky came face-to-face with when

her husband had his accident and they had no way to cover the costs.

Taking the Plunge

In January of 2015, Jaky accepted the position of full-time photographer for the tribal government of the Nottawaseppi Huron Band of the Potawatomi (NHBP). She acted as the main photographer for the organization while also working on graphic design projects.

"I was originally hired to do some graphic design work while they were rebranding," Jaky says. "But mostly to do photography for them, such as employee head shots and covering big events like Pow Wow."

With a country backdrop, Jaky worked with a florist, makeup artist, dress boutique, and woodworker to bring this bridal inspired shoot together.

But this career change was never about giving up her freelance business. In fact, that was never an option. Jaky had spent too many hours developing her brand via her website and social media to simply let it fall by the wayside. Customers in her region had come to respect and recognize Jaky Janine Photography as the go-to for portraiture and candid photographs for everything from engagement sessions to maternal moments.

Jaky was also well known for her creative shooting talents when it came to weddings, and it's no secret that weddings are the crème de la crème for shutterbugs near and far. According to *The Wedding Report*, a popular wedding databank website, the average amount an American couple is willing to spend on a wedding is well over $25,000. This means a bigger piece of the pie for photographers like Jaky.

"Weddings are the biggest income for me," Jaky says. "And they were also a big challenge for me when I first started my nine-to-five job, which required working on

Jaky jumped feet first into this editorial shoot at the Felt Mansion in Holland, Michigan, put on by The Bloom Workshop.

the weekends to cover major events. I never knew if I could book them because I didn't know my NHBP schedule far enough in advance."

According to the popular wedding website *The Knot*, about 14 percent of a couple's wedding budget is spent on photography and videography. That makes photography the third largest wedding expense, surpassed only by the venue and the band, and this doesn't take into account the added expense of engagement photography, which urges new couples to dig deeper into their pocket books. In fact, more than half of all engaged couples recently surveyed in a Thumbtack Wedding Trends report plan to spend over $250 for the engage-

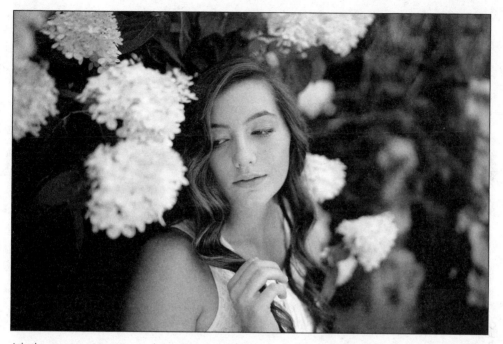

Jaky loves capturing unique elements in her senior school photos. This shot was captured at Southern Exposure, a wedding venue in Battle Creek, Michigan, known for amazing florals.

ment photos alone. This doesn't include the additional costs associated with remote or otherwise uncommon photoshoot locations that are starting to pop up as couples continue to compete for that special factor to make them stand out.

"Although there was some initial overlap with tribal events and weddings, NHBP was very understanding of prior commitments that I had made," Jaky says. "They were able to send other photographers to cover the events, and I became more conscientious of scheduling and making commitments with both businesses in mind."

Additionally, Jaky received the unexpected bonus of gaining new customers due to her introduction to the tribal community.

"My interactions with so many new people inspired new business as tribal members began contacting me for photography sessions," Jaky says. "I soon found myself booking sessions with people who liked me because of the work I've done with the Tribe."

Getting Into a Rhythm

In theory, working two jobs and bringing in extra money sounds peachy, but the reality requires a lot more effort than most freelancers anticipate. Working two jobs necessitates a versatility that not everyone can commit to for the long haul.

Jaky's newborn nephew shares one of his first cuddles with the camera in Jaky's home studio.

"Juggling a full-time job on top of managing a photography business is stressful," Jaky says. "It means getting home from working a full day and then either rushing off to a session or going home to edit sessions."

Oftentimes, Jaky is forced to choose whether or not to spend her afternoons and weekends with her friends and family, or whether she should dedicate that time to furthering her photography business.

"The push and pull of work and personal life was very difficult in the beginning," Jaky says. "But things got easier for me to schedule after I was promoted to a new position within NHBP."

In November of 2016, Jaky accepted a graphic design position within the tribal government, with the understanding that she would continue to assist with photography when needed. Although Jaky has always been adamant that her full-time job takes priority over her photography business, it was a welcome relief when her new position came with additional perks.

"Since I moved into my new position, I don't have to work weekends as often," Jaky says. "This was a significant change in schedule, which allows me to book more of my sessions on weekends."

As Jaky grew accustomed to her new routine, she was able to more fully embrace the advantages that each career offered to the other.

In this 2017 senior school photo, Jaky and her client hiked to a wooded location near her studio in Climax, Michigan.

"The photography I do for the Tribe is so different from what I would do personally," Jaky says. "It gives me a different perspective and makes me an overall more well-rounded photographer."

Jaky is continually trying to grow her knowledge base by taking classes, seminars, and webinars that may help her to grow in her chosen fields. In her private time, she's taken classes that focus on creative areas such as calligraphy, floral design, and arranging styled shoots. Similarly, she takes the time to follow and study top-notch designers in the industry via webinars and other tutorials to help her with her designing skills at NHBP.

"I've noticed that, over time, I've begun to incorporate the skills I've learned as a photographer into my job as a graphic designer," Jaky says. "I'll add floral touches and more stylized calligraphy that I never would have dared to use prior."

Likewise, her design skills have given her a keen eye for layout and what works best within compositions before a page spread has even been planned.

"Coming into this job at the Tribe with my education in photography has been humbling," Jaky says. "I like being able to share my knowledge with others and put it to good use."

Making Tough Decisions

Juggling two jobs is not for the faint of heart and requires a substantial amount of self-discipline. Sometimes the sacrifices freelance photographers have to make affect other areas of their life, especially at inconvenient times.

"On my breaks at NHBP I usually have to spend time responding to clients and setting up sessions," Jaky says. "Occasionally I have to spend my lunch breaks editing sessions or posting sneak peeks for my clients."

In other words, even on breaks from her regular nine-to-five workday, Jaky must utilize her time as wisely as possible. And, sometimes, those long hours still don't make a dent in a freelancer's workload, which leads to late nights staring at a computer screen.

"Most of my late nights are because I am trying to finish editing a session and my timeline is crunched," Jaky says. "I tell my clients that they will have their photos by a certain day and I make sure I meet those deadlines."

Jaky is adamant that freelancers don't have the luxury of skipping deadlines and must know their own limitations.

"You have to know your reality," Jaky says. "You don't get to go to work, punch in, and punch out when you have a side business. Instead, you keep working when you get home. Because when you're your own boss and working for yourself, the work never ends. You don't have set hours. When you know you have client e-mails waiting for a response or sessions that need to be edited, you're thinking about it. When you're thinking about it, you're stressing about it."

To alleviate some of that stress, Jaky decided to hire a private editor to help with her overwhelming workload.

"She's great," Jaky says. "I send her work that I can't get to or stuff I need done on days when I'm feeling overwhelmed."

Over time, Jaky has developed other methods of ensuring she doesn't get burnt-out from working nonstop. Like every average Jane, she loves binge watching her favorite shows on Netflix and Hulu, having a big family dinner every Sunday with no technology allowed, and getting her nails done with friends. Her main change, however, has been in her after-work activities and setting a new ground rule of not editing after work every day.

"It's important for all people to just make time to be present," Jaky says. "I do this by spending time with my husband and family."

Living the Dream

As Jaky continues to check off more achievements, new goals are never far from her mind. She's recently taken it upon herself to start submitting to different magazines and online blogs. Although she's been featured on a handful of websites, she's most proud of her latest

pieces, which were spotlighted in *Inspired By This*, *WeddingDay* magazine, and *The Black Tie Bride*.

In her spare time, she enjoys submitting her work to various contests. Her favorite is Shoot & Share, and she's submitted her work continuously for over three years.

"It's huge," Jaky says. "This year, more than 350,000 images across twenty-five different categories were submitted. The first year I entered, I had several photos in the top 20 and 30 percentile. Over the past two years, I have made it into the top 10 percent. The rankings for this year haven't been announced yet, but I'm encouraged by my continual show of improvement."

Her networking expertise has only continued to grow alongside her photography skills, as she actively participates in a group called The Rising Tide Society. It's a large network of creative individuals who openly discuss a variety of topics, provide and request referrals, and much more. The group has multiple chapters with weekly meet up groups where members swap the latest happenings in their chosen fields.

Likewise, Jaky has recently started working with Be Inspired, a public relations company in California.

"They send me emails with specifics that blogs are looking for and, if I have any work that meets that criteria, then I send it to them and the work may end up being featured. They also share my work across their different social media accounts to help promote me."

But Jaky isn't leaving all of the promotions to the big fish—that just isn't her style. Instead, she continues to actively search for ways to creatively catch a potential client's attention. One way that's proved fruitful is by participating in stylized photoshoots.

"Styled shoots are becoming more common for me," Jaky says. "Generally, I reach out to other vendors in the area with an idea and offer them photos in exchange for their services."

Whether she's submitting her work to publications, increasing her network, entering contests, or experimenting with new photography methods, one thing is for sure: this photographer is going places.

"I don't know if I will always work two jobs," Jaky is quick to say. "But I have big goals in life and have set some pretty high expectations for myself. So, I don't know where I will end up. I do know that working two jobs has been exhausting, rewarding, exciting, and very eye opening though. I'm discovering that it's all about the mindset that you go in with."

Advice to Newbies

There are a million-and-one tips for photographers who are looking to start their freelance careers, but in order to have any kind of success, it's critical that photographers dive into freelance with a plan in place—one they've created long before quitting their day jobs.

According to *The Huffington Post*, 95 percent of startups fail. That includes like-minded freelance photographers looking to strike gold with their new businesses. The website em-

phasizes the need for entrepreneurs to set their minds to whatever business they're trying to grow. In other words, make a plan. Then come to an understanding (hopefully as soon as possible) that your plan isn't going to realize itself into fruition.

"If you're looking to seriously pursue a photography business, you have to know your priorities and plan according to them or else you will be a stressed-out mess," Jaky says. "And worse, your clients will be upset if you're not giving them what they either expect or were promised."

Although financial freedom is a big reason freelance photographers try so hard to hit it big, it's not something that comes easy to everyone. In fact, Jaky is adamant that only truly passionate photographers should turn to freelance full time because, in the end, you can't always count on a paycheck.

"If you are truly passionate about photography, do it," Jaky says. "It doesn't always have to be for profit, but if you make some money and you aren't killing yourself doing it, then you'll be happy with the extra financial freedom."

Few photographers get to claim that they've beaten the 95 percent statistic of doom, but Jaky's story is a testament to the five percent of startups that thrive. Not only has she overcome the common pitfalls acknowledged by freelancers worldwide, but she's flourished in spite of them, all while maintaining a full-time job.

Every day Jaky proves that freelancers don't have to have a frenzied and chaotic career. Because, in the end, it's all about having passion and a plan.

Britta Hages is a former fulltime book and video editor who has worked on a handful of bestsellers. Now she spends her time freelance writing for magazines, books, and other print and digital media. Visit www.BrittaHages.com to learn more about her fiction and nonfiction content, and to read her writerly musings.

FINDING YOUR OWN NICHE

An Interview With Laura Dark

by Tina Topping

"I would tell new photographers to listen to their hearts and shoot what they love. It's easy to perfect something that you really want to do." —Laura Dark

Laura Dark has been creating her stunning, surreal photographs for over twenty years in Columbus, Ohio. With more than fifty magazine covers under her belt, her work has been featured in *Gothic Beauty* magazine, *Bizarre* magazine, and *Auxiliary* magazine, where she was voted Photographer of the Year for 2016. Highlighting her makeup and wardrobe skills, she also spent two years as senior fashion and beauty editor with the avant-garde fashion magazine *Dark Beauty*. Laura's detailed approach to her elaborate photoshoots keeps her in-demand and allows her to earn a living on her own terms. She shares her insights for staying on the cutting edge of her craft, while remaining true to her vision.

The Lady Behind the Lens

Laura began her photography career working for her high school yearbook. "I had to borrow a camera from my grandfather to even do the job, because I didn't own one myself." She is now known for her avant-garde fashion and beauty portraits, as well as her highly stylized brand of conceptual photography. Her images consistently win awards in a variety of publications and photography groups. But, if you ask her how it feels to be a fashion photographer, Laura will quickly tell you she's always seen herself as a conceptual photographer.

"My favorite images are super conceptual, out-there images. Images that make people stare at all the little details. Images that make people question what they are seeing." She's passionate about the entire process of conceptual work, ironing out the details from begin-

ning to end. This includes developing the concept, building the wardrobe, doing the makeup and hair, then shooting and editing the images herself. "When I get to do those types of shoots, I really feel like it's *my* art. There is something about building a concept and seeing all the way through each process to the end that is super exciting to me." It's a tremendous amount of work and a testament to her talent that she can execute every facet of these projects.

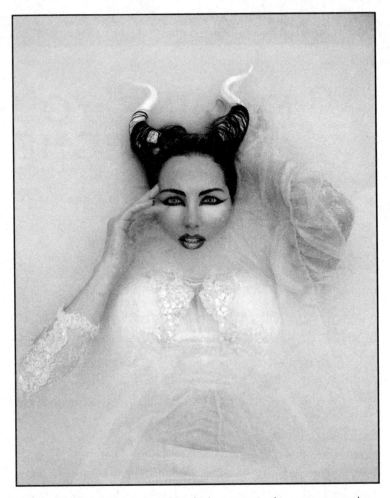

Intense black makeup and brunette locks appear in sharp contrast to the pale horns and lace in this foggy image from Laura's Floating series.

Laura does an incredible job of creating interesting special effects in her photographs. In one example of her "floating" series of fantasy shoots, the model is drifting in a milky white haze, with her brunette hair spiraling around white horns and kohl makeup on her porcelain skin. These dark elements stand in stark contrast to the rest of the pale imagery. But even in the sea of ivory, Laura captures plenty of detail. You can see the lace and beadwork delicately framing the model's forearm, and the layers of pale chiffon become more apparent upon closer examination. The woman appears to be rising from an ethereal mist, creating a hauntingly beautiful portrait.

Laura Dark is also one of the few photographers who is incredibly gifted when it comes to crafting the perfect shot quickly. On her website is a statement that rings true to everyone who's worked with her. It has been said that "what Laura can do in a half a dozen frames would make grown men cry." Her ability to capture not just usable images, but truly gorgeous shots in a short amount of time is impressive. I wasn't sure if she would be willing to share this secret with us, but I had to ask her how she does it. "I started in film photography. Every snap I shot cost me money. I learned real fast to shoot as few frames as possible. That means getting it right in camera and doing it with very few frames. I shot a Facebook live *Beauty*

This shot features many shades of gray, from the model's eye makeup and dress to the nooks and crannies of the stone background.

shoot a few weeks ago, and I shot about thirty frames in ten minutes. That included stopping to talk to my fans. I got fifteen usable images for my editorial." Even with the appreciated distraction of adoring fans, Laura is still able to capture amazing images in very little time!

Laura actively participates in the Model Mayhem community online, where models and photographers can connect to share ideas, book gigs, and learn tips. She's won "Picture of the Day" sixty-two times and "Concept of the Day" thirty times. When you consider the images she creates herself, plus those of her clients, she has a large body of work. One way Laura makes good use of these interesting pictures is to create and sell her own photography books and magazines. These are not calendars that risk being thrown away at the end of the year. They're gorgeous works of art, highlighting her favorite shots in genres ranging from fashion and romance to horror. "They sell quite well. I would recommend them to photographers who have shot a lot of content."

From Conception to Perfection

While Laura is often recognized for her cover work in fashion magazines, she's never considered herself to be only a fashion photographer. "I'm just a photographer who happens to shoot fashion every now and again. I have always considered myself a conceptual photographer." This is how Laura has found her niche in the competitive field of photography. She's completely at ease when it comes to working with broad conceptual ideas (her own or her client's), bringing them to life digitally or in print. "We do work on our own concepts, and those are for publishing with magazines and promo works. But I also enjoy the challenge of clients bringing me new and fun concepts to work on."

Featuring layers of imagery, this goddess and her wolf piece is a fan favorite.

Some photographers would find it much easier to identify with just one industry, such as weddings. But Laura doesn't aspire to only provide covers for magazines, no matter how striking or glamorous each image turns out to be. Identifying herself as a conceptual photographer has enabled her to span across genres, gaining clients from all walks of life and keeping herself busy with the process of creating and not just the final product for one segment of the market. She's as comfortable taking wedding pictures as she is doing a pinup shoot for the bride-to-be, because she's not limiting her focus to either "weddings" or "pinups". She's focused on the overall concept of what that person wants portrayed (fantasy, fairy tale, romance, etc.).

One favorite conceptual shot shows a goddess with a wolf. The multiple layers in this shot give the viewer the impression they're peering through veils and fog, glimpsing a moment in time that's supposed to be private and, perhaps, a little dangerous. This surreal

This mind-boggling photograph from Laura's Levitation series required several team members to bring it to life.

photograph incorporates various effects, which Laura feels are important to continue experimenting with, no matter how many shots she's edited over the years. "I feel it's always important to experiment! After twenty years of being a professional photographer, I still do test shoots, and I still take classes and workshops on photography. My art teacher always said, 'When an artist thinks he's the best at his craft, there is someone else learning a new technique and taking that artist's jobs.' I don't think anyone should ever stop learning new things about their craft."

Building a Team

In order to bring her visions to life more quickly, Laura created "Team Dark" in 2009. The amount of work that goes into creating her images is staggering. Each team member brings something special to the shoot. They strive to create an experience, not just a typical portrait sitting. Each client is unique, and Team Dark goes out of their way to make that person feel special and pampered.

Team Dark is a vital element of Laura's success. She's assembled some of the best people in her area to assist during shoots, whether they're collaborating to bring one of Laura's concepts to life, or working with a client to create his or her ideal fantasy portraits. "I believe it's very important have a great team to back you up. I have several makeup artists, hairstylists, assistants, and pose coaches." These individuals have proven themselves to Laura over

Laura's attention to detail is apparent in this romantic shot featuring delicate flowers and wispy tulle.

the years. "I take adding new members to my team very seriously. They are the backbone of my business, they are the ones who apply the vision to the client/model, and so they have to be very talented and professional." Putting together this team took her a long time, but her business has grown well beyond what she would be able to accomplish on her own. It takes a lot of time to do each part of the concept, so it's helpful for her to have people she trusts to do hair and makeup (for example), while she's working on the set design or costuming. Each team member checks in with the client to be sure they're exceeding expectations.

One of my favorite Laura Dark photographs depicts a lady floating in the air, elegantly rising up over a field. As she's said, Laura loves to create images that make viewers question what they're seeing, and this levitating lady is no exception. Every detail is in place, from her hair, to the drape of the dress fabric, to the position of each hand and foot. This particular shot called for one of Laura's posing coaches, another integral member on her team. "Pose coaches are essential for shots like that, not only just for posing the client, but for safety purposes. When you are doing floating sets, the client is standing on something (a chair or ladder), so having an extra hand to be there to stabilize is important. Also my pose coaches on staff are dancers (ballet and modern) so they understand that changing a hand or foot position, even just slightly, can change an image." Like many photographers, she recognizes the value of interesting body positioning in her line of work. But taking this a step further by employing a posing coach frees Laura so she can focus on taking the pictures, rather than run-

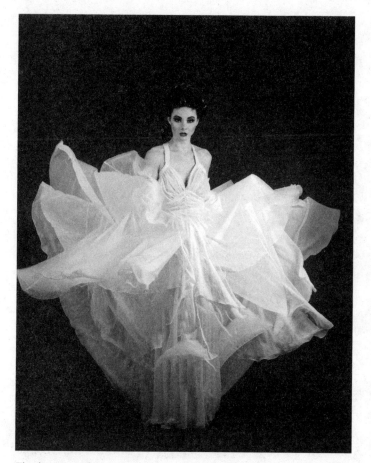

This haunting shot captures some amazing fabric work and interesting lighting.

ning back and forth between positioning the client and getting behind the camera.

The Value of Apprenticing

After so many years in the business, it appears Laura has it all. Yet there are still things she wished she had known before going into business for herself. A big area that has changed over the last couple of decades is the explosion of digital photography. "I wish I would have known digital was going to dominate the industry. I spent a lot of years in a dark room for nothing." And while she's been very successful in marketing her business, she wishes that instead of attending art school, she had gone to business school. "Running a photography studio is more about marketing and business than actual photography."

Laura also wishes she had spent more time apprenticing before striking out on her own. "Apprenticing is still popular, especially with college students. A lot of colleges will actually give credits toward graduating for apprenticing under someone working in the field you are studying." It's important that new photographers not be put off by the idea of performing unpaid tasks while they apprentice. They will be gaining a lot of wisdom about what works in the business, and what doesn't. A mentor can show them where to spend their time, how to effectively market their company, and possibly network with some of the mentor's contacts. Most importantly, they will learn from someone else's mistakes without having made those

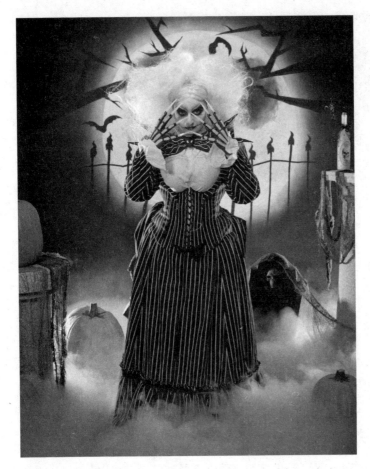

Cosplay has become a recent addition to Laura's portfolio, including this whimsical Lady Jack Skellington.

missteps themselves (including any costly mistakes the mentor made along his or her journey).

Creating a Niche

Laura Dark has delved into themes in a variety of genres, including fantasy, science fiction, retro pinups, and gothic romance. Her latest genres include Steampunk (a subculture built around Victorian-era science fiction) and cosplay (for "costume play," where fans dress up as famous characters from pop culture, including comic books, television, and movies). What crosses all of these genres is her ability to navigate the creative process required to bring each concept to life. And it's the enjoyment of this creative process that has given Laura Dark her niche in the photography world. "I've been lucky as my niche found me rather than me finding it. I had posted my work online and was contacted by a fashion photographer of a large alternative fashion magazine. She asked me to shoot some wardrobe and that is when I started shooting fashion. My conceptual photography, however, I've been doing for over twenty years."

One example of a cosplay image is her female version of Jack Skellington, complete with signature black and white pinstripe wardrobe and skull makeup. Every element reflects the essence of that character, from the moon in the background that bears a resemblance to Jack's face, to the fog and pumpkins on the ground. It's interesting that the only vibrant

color in the shot is provided by the pumpkins, which add appropriate splashes of color in this otherwise black-and-white image.

Laura Dark not only works with professional models, she also shoots portraits of local artists and fans who want a more edgy photo of themselves, delving into their personal concepts of who they are and how they want to be portrayed. Whether the client is a musician, dancer, singer, actor, or a busy mom who'd like to show a different side of herself, Laura and her team consistently rise to the challenge and bring each unique vision to life, no matter how far-fetched their ideas may sound. If the client wants a fantasy shoot with wolves, or to be a retro pinup queen, or lounge in romantic gardens, or fly in gossamer mists, Laura and her team are up for the challenge. This versatility is what keeps her employed and successful.

So what other advice does Laura Dark have for photographers wanting to discover their own specialties? "I would tell new photographers to listen to their hearts and shoot what they love. It's easy to perfect something that you really want to do. Also, find another photographer whose style you really love and practice learning techniques close to theirs. If you can, ask if you can apprentice for them. Once you have that, you can perfect it by adding your own creative flairs and ideas." Each photographer brings something special to his or her craft, especially if you define what type of photography (or genre or market) brings you the most joy. Reach out to a fellow professional and learn as much as you can, now and always.

Tina Topping is a writer and performer who lives in Cincinnati, Ohio with her husband and daughter. She's currently the Art Editor for *Carpe Nocturne* magazine.

For more information about Laura Dark, visit lauradark.net or facebook.com/lauradarkphotography.

TAKE IT ON FAITH

An Interview With Natalie Marquis

..

by Matt Koesters

"When I go the extra mile and sew a button back on a dress or something, then it's like, 'Wow, that photographer cares about me, and not just the pictures.' For me, that's what it's about." —Natalie Marquis

Natalie Marquis didn't pursue a career in professional photography the traditional way. She didn't go to college to receive formal training. She didn't have any internships or apprenticeships. She shot her first wedding when she was nineteen with a 35mm SLR camera she had received from her then-boyfriend, Vince, as a gift before her junior year of high school. The sum of her photography-related education to that point had been a high school film class.

"Man, it was terrifying," says Marquis, thirty-two, of Cincinnati, "I mean, just because I didn't really know what I was doing. I had no training, and I was shooting it all in automatic. This is somebody's wedding day, and these are the photos that they're going to look at forever."

That's something Marquis thinks about a lot these days. For the past five-plus years, Marquis has run Veritas Studio, a photography business primarily focused on weddings and family portraits. Her business has grown year over year, despite being a stay-at-home mother of two young children. After all, it was her children, Lucy, six, and Max, three, who inspired her to become a professional to begin with.

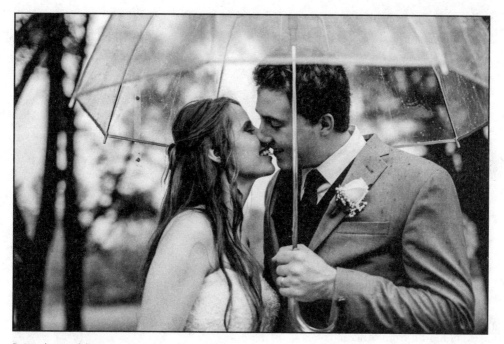

Rainy day wedding

GETTING STARTED

After her first, underwhelming experience shooting a wedding, Marquis didn't immediately pursue a career in the business. She married Vince when she was eighteen. She waited tables for years. But as Marquis made the transition to being a full-time mother, she knew that her family would need a second source of income. Thinking that being able to stay at home with the kids during the week and shoot during the weekends sounded "amazing," she decided to take a photography class at Scarlet Oaks, a local vocational school.

"Once I did the Scarlet Oaks thing, things changed a lot," Marquis recalls. "I was comfortable with my camera and familiar with my settings, so my photos improved a lot." Although the vocational class was very basic, it helped Marquis break bad habits, like trying to create a more artistic shot by tilting the camera. "It was so 2001," Marquis muses.

In Latin, *veritas* means "truth." Marquis says she chose the name Veritas Studio because of her shooting style, which focuses on the honest, candid moments of a wedding or family photo session. "For me, the goal is to be able to portray someone's true self, as they are and not just, 'Hey, you guys smile and look at the camera,'" she says.

The word *veritas* also has long-standing religious connotations, and Marquis' faith contributed to her early success in photography. Her husband is a part-time pastor, and Marquis is very involved at their church. When word got out among the congregation that Marquis

was shooting family photos, it wasn't long before she had to start thinking about saving her receipts and approaching her hobby as a business. "It lit a fire under me and made me even more excited," Marquis says.

In each of the first four years she was in business, Marquis reinvested all of her earnings back into equipment. More recently, she's begun to allow herself a modest salary. Along with more than sixty family photo shoots, Marquis has sold about a dozen wedding packages in each of the last two years. Unlike in previous years, more and more of her leads are coming from sources not affiliated with the church— word of mouth from other clients, social media, and fellow photographers. She works with other local photographers as a second shooter on weekends she doesn't have her own gig, and that has led to overflow business from her pro clients. For a part-time photographer with little in the way of training, Marquis' business is steady. And it's growing.

Dress details

BUILDING HER BRAND

Marquis understands just how important it is to have a professional document the union of a couple in marriage. When she and Vince got married, they had a small ceremony on a Florida beach. "The pictures weren't amazing," she says. "I don't think I even have the negatives for most of them. I have one album of pictures, and that's all; they're good enough, but if I could do one thing differently, it would be to hire a professional photographer."

Most of the pictures are in an album on a shelf in her basement; the only one that's not hangs in a frame on the first floor. "My husband asked me one time, 'If there was a fire in our house, what would you save?'" says Marquis. "I said, 'The wedding album, my external hard drive that has all of our family pictures on it, and that's it. Everything else? Who cares.' Those are things that you can't replace if there's a natural disaster."

Groom's attire

Maybe it's that memory that motivates Marquis on wedding days. Most photographers have a standard set of equipment that they pack for a wedding, and she's no different. But for Marquis, a needle and thread are counted among the standard items in her bag. She doesn't see herself as just a photographer on a wedding day; she sees herself as a coordinator, someone who makes sure things go smoothly. And she's good at it.

"I don't know what she didn't do the day of the wedding," says Macy Meyer, a wedding client and friend. "She helped out quite a bit. The day of, she was the go-to person for pretty much anything, and was on top of everything the whole day. We had a girl that lost some beads from her dress, and Natalie sewed them back on. She had her hand in absolutely everything. I even had wedding coordinators there so she could focus on the photography, and she ended up doing more and getting extra photos, even while doing all this extra stuff."

Marquis knows that approach is something that sets her apart. "When I go the extra mile and sew a button back on a dress or something, then it's like, 'Wow, that photographer cares about me, and not just the pictures.' For me, that's what it's about."

Marquis doesn't eschew getting personal with her clients. She embraces it. Her ideal client is someone she could see becoming friends with, someone who shares her qualities: fun, creative, bubbly, talkative, and outside-the-box thinking. Marquis has yet to turn down a wedding, but she's bracing for the day when she has to say no to someone she doesn't click

Engaged

with. "I think that's something I should be able to do, and something any photographer should be able to do," she says.

Being comfortable with her clients lets Marquis be at her best. Christen Endicott, owner of Cincinnati-based Everleigh Photography, met Marquis on a Facebook group for Cincinnati photographers. The two were fast friends and have been second-shooting for one another ever since.

"She's just very laid back," Endicott says. "She's somebody who's just a little more relaxed and lets the day kind of flow. I think that helps her capture who the couple really is in their everyday moments, which is huge for actually capturing a story, rather than picture-perfect things that belong in frames. She does really well at capturing details and capturing a couple's story, which is something you cannot teach."

Unlike Marquis, Endicott does have formal photography training in her educational background. But Endicott is happy to note that some of her personal favorite photographers aren't formally trained, and Marquis is Exhibit A. "Natalie has a really good way of capturing raw, real moments," she says. "There are things that can't be taught, like just having a natural eye for photography."

Baby smirk

MAINTAINING MOMENTUM

Although she once was not a fan of the business end of the photography business, Marquis has hit her stride. Her online presence isn't robust—she's only active on Facebook, Instagram, and her business website—but she's prolific within her channels. She knows that she's concentrating on the places most likely to earn her attention.

And as for education? Although Marquis hasn't taken any traditional courses, she makes a point of attending seminars annually. She has twice attended workshops taught by globetrotting wedding photographer Bobbi Sheridan, and most recently attended the Indianapolis Reset Conference.

For now, the plan is to keep things moving. Veritas Studio is heading in the right direction, and Marquis stays active enough on her blog and social media channels to make sure people know she's still doing business. It'll be a few years, though, before she takes a more aggressive stance. She's waiting for both of her children to become school-age first. "My end goal isn't to have five teams of shooters and shoot two hundred weddings. It's not to be one of those companies," she says. "I want to stay small and independent."

Matt Koesters is a business writer and an award-winning journalist. He lives in his native Cincinnati, Ohio, where his work has been published by several of the city's most respected media outlets.

For more information about Natalie Marquis and Veritas Studios, visit veritas-studio.com.

THE ROAD TO SUCCESS

An Interview With Scott Trees

//

"I am extremely lucky in that I have been able to make a good living from my passion. I never dread going to my job." —Scott Trees

Q: How long have you been in business?

A: This year (2018) will mark my 48th year in the photography business.

Q: That is certainly a long time, how did you get started?

A: Well, I got interested in photography while a sophomore in college. I had borrowed my mom's SLR, a Minolta SRT 101, which of course was a film-based camera. I was shooting black-and-white film and I loved the darkroom process. That is what really got me hooked. I returned her camera three months later, got a job in a camera store, and started learning about photography equipment. I had that job all through college. I also started a business photographing fraternity and sorority parties. I was the first one to do it on my campus, Colorado State University, and the business did so well that it helped me buy more equipment and pay for school.

Q: Did you major in photography?

A: No, my major was in psychology! I didn't even take any photography classes. I got some books from the campus library about taking pictures and darkroom technique. I have always been the type of person who jumps in and learns how to swim.

Q: Do you think a photography education is necessary?

A: Well, certainly from my own experience, it wasn't! Having said that, I don't think it can hurt. When I lived in California there were a couple of excellent photography schools that certainly taught the technical side of photography. However, my innate strength is my eye, and that is something that can't really be

Head Study in Black and White, shot on assignment.

taught. I think schools can help build confidence from the technical aspect, but they may not teach a lot about what it takes to make photography a successful full-time business.

Q: Would you care to elaborate?

A: Sure. A lot of people look at how I travel the world taking pictures and think it must be a glamorous life. Certainly, parts of it are, but the majority of it is a lot of grunt work. The truth of the matter is the majority of time is not spent taking pictures. There is a lot that goes into making any business work, and photography is no exception. Talent alone does not assure you of success as a photographer. It takes a disciplined work ethic, willingness to put in the time (often years) to build a good client base, some business sense, and a thicker skin to deal with the rejection of your portfolio from potential clients.

Photography, especially today, is a very competitive field. In my workshops, I often share with my students that if you want to make a million dollars in photography you better start with two million dollars. The point to that being, you need to have some cash reserves to keep your business going. You aren't going to start making a profit right out of the gate, and there is going to be an ebb and flow to your business. So, having something in the bank to cover the slow times is important.

Q: That doesn't sound very optimistic…

A: As I said, today photography is very competitive. The digital age has made the act of taking a picture exponentially easier and less costly. Today, everyone seems to be a photographer, which means there is much more competition than when I started. One of the

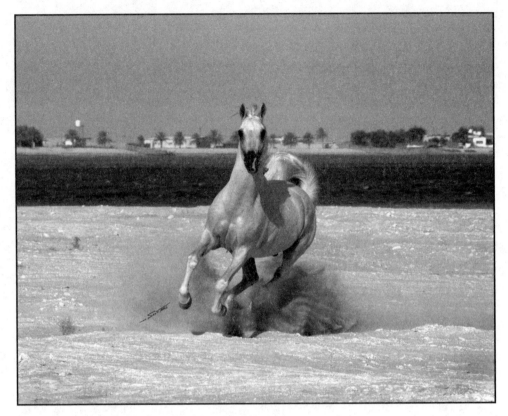

Danton on the Beach, shot for a magazine advertisement.

main reasons I started the party picture business was because it was expensive to buy the film and darkroom supplies—I needed the money to be able to keep taking pictures.

With today's digital cameras, film and processing is not a monetary factor. Other considerations like having to constantly upgrade equipment exist, but in general once the gear is purchased it isn't as expensive as film.

So, with this proliferation of photographers and the millions of images that are posted on a daily basis on the internet, the perception of what a picture is worth has declined. For that reason, it is a lot more difficult to make a living with a camera.

I would never discourage anybody from following their dream to try and become a photographer, but I certainly would want them to be aware that it is not an easy road to travel.

Q: Why do you think you succeeded?

A: Like I said earlier, it was a lot less competitive then. But it also helped that I specialized in a field working with horses which had even less competition. I grew up in the horse

Portrait shot during one of Scott's workshops.

industry, and there was a demand for photographers who could shoot horses well and I had a knack for it. I started out doing a lot of what everyone else did, but then I created my own style, which was vastly different from what my competition was doing. Essentially, I was an advertising photographer but my subjects happened to have four legs and whinny! It also helped that I came along at a time when the Arabian horse industry had a huge surge of financial growth. I knew I had the skills, talent, and excellent customer service to be successful in the door opening before me and I jumped through it!

Another key factor is that I am very tenacious. Regardless of what happens, good or bad, and I have had plenty of both, I kept moving forward and didn't look back.

Q You said good and bad, did you have failures?

A: Of course, I had a lot of failures. I made just about every mistake you could make. I didn't have any mentors, no formal training in photography, took no business classes while I was in college, and for much of my early career was scrambling to make ends meet. Probably the first ten years of my career were that way. But I hung in there, and kept learning from both my successes and failures. Frankly, I probably learned more from the failures than the successes. While I specialized in horses, I did a lot of other work as well, commercial, portrait, wedding, architecture, anything I could to make a buck with a camera. While horses opened a lot of doors throughout the world, I took advantage of those opportunities to photograph other subjects, mainly people and architecture. I still do.

Q: What was the turning point?

A: As I said, the Arabian horse industry had a huge surge and I was in the right place at the right time. My style was very different from my competition. There was also a high

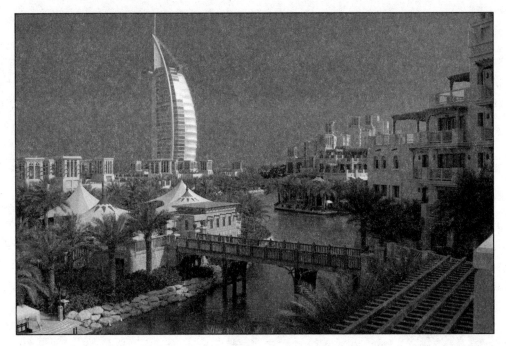

Madinat Jumeirah, Dubai UAE, shot on assignment.

demand and low supply. I made a ton of money; I was just too young and stupid to realize it would not last forever!

Q What do you mean?

A: I was on a huge roll for about ten years. Then the tax laws changed which had a detrimental impact on the industry. A lot of my clients went out of business, I got divorced, and then I had cancer. To be frank, I took a pretty good beating from all of it, and my little empire came crashing down around my ears.

Q What did you do?

A: Rolled up my sleeves and went back to work! This time a bit wiser. It doesn't matter what your subject is with a camera, if you want to make it work as a business you have to be willing to get back up when you are knocked down. Actually, that is true about life.

While I was dealing with cancer, I had to sell a lot of my camera gear as I couldn't work for several months. That was actually worse than dealing with the cancer! But I just started out one step at a time, reconnecting with old clients, and going out to find new ones. The internet was not in place yet, so I spent a lot of time on the telephone.

I still had a strong eye and a creative approach to my work, so it wasn't that long before the work started coming back in. But it was pretty lean for a while; it took time to build back up.

Earlier I mentioned my excellent customer service. I believe it is cheaper to keep a client than to get a new one. For that reason, my attitude, which I shared with my staff, was that the customer is always right. If the post office damaged a print, I would replace it at no charge. I would make follow-up calls to make certain my clients were pleased with the prints they ordered. Things like that really make an impact. For those just starting out as photographers, it is very important to remember one thing: word of mouth can make or break you.

I am very proud of the fact that within my industry today I have a great reputation for integrity.

Sonja, shot on assignment.

Q: Having gone through all of that, how do you balance work/personal schedules and stress?

A: Some days are better than others! You can work for somebody else eight hours a day or work for yourself eighteen hours. Fortunately, I love what I do so it never really feels like work. Like I mentioned earlier, only about 25 percent of my time is actually spent taking pictures. The rest of it is spent in front of a computer working on files, responding to emails, talking on the phone, and running the financial side of the business.

As far as stress, that varies. I learned from cancer to focus on what I can affect in terms of change. If something is bothering me and I can say or do something that will

bring about change, then I figure out what I need to do. If I can't do anything about it, I let it go. That was a huge lesson for me and I have become very good at it.

It is important to step away from the work side and do something else. I spent several years working in the Middle East, and really got burned out. I found that I was only picking up a camera when I got paid, and I never wanted that to happen. So, I stepped away from it for a couple of months, didn't take a picture, and recharged my batteries. The lesson there was remember to take a break!

Q: What has been the largest challenge you have had to overcome in your business?

A: There have been several at different times of my life and career. Today a big challenge is the sheer volume of people wanting to be photographers. Many of them are so desperate for work they essentially work for free. That makes it very difficult for established photographers to compete. What these people don't understand is that it is very difficult to increase their prices from free and for that reason, they won't be able to sustain a business for long.

Q: How do you handle fees?

A: Well that is the key question, isn't it! First of all, you have to understand what it actually costs to run your business. There are so many little things like office supplies, phone service, internet service, banking fees, camera equipment, and so on. So first and foremost, you need to know what it costs you to open your doors, which is called your overhead. From that point you have to figure in what your potential tax obligation is. The sad part for most self-employed people is that they pay a 15 percent tax rate on their Schedule C profits. That same profit number is also placed in your Form 1040 and you are taxed again. It can be as high as a combined 30 percent rate. I advise starting photographers to use a very simple formula. One third is going to your overhead, one third to the IRS, and the remaining third is yours! Simply put, for every dollar you want to pay yourself you need to make three. And that is at the minimum.

Based upon the numbers you come up with, you can start to figure out how much you need to charge. There are two types of photographers: studio shooters and location shooters. The studio shooters have a walk-in business, a consistent location and have a bit more traffic potential. This category includes your portrait, commercial, and wedding photographers. Their overhead is a bit more predictable in terms of consistent costs like rent, utilities, staff, etc. This makes it a bit easier for them to calculate their cost of doing business.

Location shooters usually work from their home, or have a small office, as their studio is the location they shoot. Generally they have one day of prep and one day of follow-up for every day of shooting they do. On average, if location shooters are really busy,

they shoot one hundred days a year. That means in those one hundred days, you have to generate a year's-worth of income. Realistically there are going to be fewer days than that for most location shooters.

Pricing is going to vary depending upon your overhead, your experience, and what type of photographer you are. A great place to start is an online resource that is free. The NPPA Cost of Doing Business Calculator has national averages you can put in your own numbers, and then put in what you want to pay yourself based upon the number of days you think you will shoot. This is one of the first things I direct my students to during my business workshops, and for many it is an eye-opener! (You can fnd the calculator at nppa.org/page/3275.)

Q: What has been the most rewarding aspect of your career?

A: There are many, however, I think the biggest thing I have enjoyed is being my own boss. Except for the job I had in college, I have never worked for anyone else. That offers a great sense of freedom. On the flip side, I have never had a regular paycheck either! I also get a great sense of satisfaction from a job well done. I am extremely lucky in that I have been able to make a good living from my passion. I never dread going to my job. Certainly, it has its highs and lows, but it has provided a wonderful lifestyle and experiences throughout the world. I can't ever see myself retiring. I have always told my friends "You will know I am dead if you wave a camera under my nose and I don't quiver!"

Scott Trees has been traveling the world and creating images for over four decades. While best known for his iconic advertising and editorial images in the equestrian world, he has also done a variety of commercial work, particularly in Dubai where he lived for eight years. Scott resides in Ft. Worth, Texas. He travels in a custom tour bus, shooting for clients, teaching seminars, and giving motivational speeches. Visit www.treesmedia.com to see more of Scott's work and follow his Facebook page, Scott Trees Photography.

CONSUMER PUBLICATIONS

//

Research is the key to selling any kind of photography. If you want your work to appear in a consumer publication, you're in luck. Magazines are the easiest market to research because they're available on newsstands and at the library and at your doctor's office and . . . you get the picture. So, do your homework. Before you send your query or cover letter and samples, and before you drop off your portfolio on the prescribed day, look at a copy of the magazine. The library is a good place to see sample copies because they're free, and there will be at least a year's worth of back issues right on the shelf.

Once you've read a few issues and feel confident your work is appropriate for a particular magazine, it's time to hit the keyboard. Most first submissions take the form of a query or cover letter and samples. So, what kind of letter do you send? That depends on what kind of work you're selling. If you simply want to let an editor know you're available for assignments or have a list of stock images appropriate for the publication, send a cover letter, a short business letter that introduces you and your work and tells the editor why your photos are right for the magazine. If you have an idea for a photo essay or plan to provide the text and photos for an article, you should send a query letter, a one- to one-and-a-half-page letter explaining your story or essay idea and why you're qualified to shoot it. You can send your query letter through the U.S. postal system, or you can e-mail it along with a few JPEG samples of your work. Check the listing for the magazine to see how they prefer to be contacted initially.

Both kinds of letters can include a brief list of publication credits and any other relevant information about yourself. Both also should include a sample of your work—a tearsheet, a slide, or a printed piece, but never an original negative. Be sure your sample

photo is of something the magazine might publish. It will be difficult for the editor of a biking magazine to appreciate your skills if you send a sample of your fashion work.

If your letter piques the interest of an editor, she may want to see more. If you live near the editorial office, you might be able to schedule an appointment to show your portfolio in person. Or you can inquire about the drop-off policy—many magazines have a day or two each week when artists can leave their portfolios for art directors to review. If you're in Wichita and the magazine is in New York, you'll have to send your portfolio through the mail. Consider using FedEx or UPS; both have tracking services that can locate your book if it gets waylaid on its journey. If the publication accepts images in a digital format (most do these days), you can send more samples of your work via e-mail or on a CD—whatever the publication prefers. Make sure you ask first. Better yet, if you have a website, you can provide the photo buyer with the link.

To make your search for markets easier, consult the Subject Index. The index is divided into topics, and markets are listed according to the types of photographs they want to see.

⑤⭕ 4-WHEEL ATV ACTION

25233 Anza Dr., Valencia CA 91355. (661)295-1910. **Fax:** (661)295-1278. **E-mail:** atv@hi-torque.com. **Website:** www.4wheelatv.com. **Contact:** Joe Kosch, editor-at-large (joeatvaction@yahoo.com); Tim Tolleson, editor (timt@hi-torque.com). Estab. 1986. Circ. 65,000. Monthly. Emphasizing all-terrain vehicles and anything closely related to them.

NEEDS Buys 4 photos from freelancers/issue; 50 photos/year. Needs photos of adventure, events, hobbies, sports. "We are interested only in ATVs and UTVs and very closely related ride-on machines with more than two wheels—no cars, trucks, buggies or motorcycles. We're looking for scenic riding areas with ATVs or UTVs in every shot, plus unusual or great looking ATVs." Reviews photos with or without a ms. Model/property release preferred. Photo captions preferred; include location, names.

SPECS Uses 8×10 glossy color prints; 35mm transparencies. Accepts images in digital format. Send via ZIP, e-mail as JPEG files at 300 dpi.

MAKING CONTACT & TERMS Send query letter with photocopies or e-mail JPEGs. Does not keep samples on file; cannot return material. Responds only if interested; send nonreturnable samples. Simultaneous submissions and previously published work OK. Pays $50-100 for color cover; $15-25 for color inside. Credit line given. Buys one-time rights, first rights; negotiable.

TIPS "*4-Wheel ATV Action* offers a good opportunity for amateur but serious photographers to get a credit line in a national publication."

⑤◑ ADIRONDACK LIFE

P.O. Box 410, Rt. 9N, Jay NY 12941-0410. (518)946-2191. **Fax:** (518)946-7461. **E-mail:** astoltie@adirondacklife.com; khofschneider@adirondacklife.com. **Website:** adirondacklifemag.com. **Contact:** Annie Stoltie, editor; Kelly Hofschneider, photo editor. Estab. 1970. Circ. 50,000.

NEEDS Photos of environmental, landscapes/scenics, wildlife. Reviews photos with or without a ms.

SPECS Accepts color transparencies of any size; b&w prints no larger than 8×10. Digital images output to paper may be submitted.

ADVENTURE CYCLIST

Adventure Cycling Association, P.O. Box 8308, Missoula MT 59807. **Fax:** (406)721-8754. **E-mail:** magazine@adventurecycling.org. **Website:** www.adventurecycling.org/adventure-cyclist. **Contact:** Alex Strickland. Estab. 1975. Circ. 51,000.

NEEDS Looking for photos of people riding bicycles while bicycle touring, cultural, detail, architectural, people historic, vertical, horizontal. Identification of subjects, model releases required.

SPECS Reviews digital files.

TIPS Sample copy and photo guidelines free with 9×12 SAE and 4 first-class stamps.

ADVOCATE, PKA'S PUBLICATION

PKA Publications, 1881 Little Westkill Rd., Prattsville NY 12468, USA. (518)299-3103. **Website:** advocatepka.weebly.com; www.facebook.com/Advocate/PKAPublications. **Contact:** Patricia Keller, publisher. Estab. 1987. Circ. 5,000. Pays in contributor copies. Wants horses, nature, art, animals.

NEEDS Equine is of strong interest but looks at many different types and styles.

SPECS Now a full color publication. Accepts print photos in b&w and color, no larger than 8×10. Can query through website and then e-mail, too.

⭕ AFRICAN AMERICAN GOLFER'S DIGEST

80 Wall St., Suite 720, New York NY 10005. (212)571-6559. **E-mail:** debertcook@aol.com. **Website:** www.africanamericangolfersdigest.com. **Contact:** Debert Cook, publisher. Estab. 2003. Circ. 20,000. Quarterly. Emphasizes golf lifestyle, health, travel destinations, golfer profiles, golf equipment reviews. Editorial content focuses on the "interests of our market demographic of African Americans and categories of high interest to them—historical, artistic, musical, educational (higher learning), automotive, sports, fashion, entertainment." Sample copy available for $6.

NEEDS Photos of golf, golfers, automobiles, entertainment, health/fitness/beauty, sports. Interested in lifestyle.

SPECS Accepts images in digital format. Send JPEG or GIF files, 4×6 at 300 dpi.

TIPS Reviews photos with or without a ms.

⑤◎◑ AFRICAN PILOT

Wavelengths 10 (Pty) Ltd., 6 Barbeque Heights, 9 Dytchley Rd., Barbeque Downs, Midrand 1684, South Africa. +27(0)11-466-8524/6. **Fax:** +27(0)86-767-4333. **E-mail:** editor@africanpilot.co.za. **Website:** www.africanpilot.co.za. **Contact:** Athol Franz, editor.

Estab. 2001. Circ. 7,000+ online; 6,600+ print. "*African Pilot* is southern Africa's premier monthly aviation magazine. It publishes a high-quality magazine that is well known and respected within the aviation community of southern Africa. The magazine offers a number of benefits to readers and advertisers, including a weekly e-mail Aviation News, annual service guide, aviation training supplement, executive wall calendar and an extensive website. The monthly aviation magazine is also available online as an exact replica of the paper edition, but where all major advertising pages are hyperlinked to the advertisers' websites. The magazine offers clean layouts with outstanding photography and reflects editorial professionalism as well as a responsible approach to journalism. The magazine offers a complete and tailored promotional solution for all aviation businesses operating in the African region."

MAKING CONTACT & TERMS Send e-mail with samples. Samples are kept on file. Portfolio not required. Credit line given.

TIPS "*African Pilot* is an African aviation specific publication, and, therefore, preference is given to articles, illustrations, and photographs that have an African theme. The entire magazine is online in exactly the same format as the printed copy for the viewing of our style and quality. Contact me for specific details on our publishing requirements for work to be submitted. Submit articles together with a selection of about 10 thumbnail pictures so that a decision can be made on the relevance of the article and what pictures are available to illustrate the article. If we decide to go ahead with the article, we will request high-resolution images from the portfolio already submitted as thumbnails."

AKRON LIFE

Baker Media Group, 1653 Merriman Rd., Suite 116, Akron OH 44313. (330)253-0056. **Fax:** (330)253-5868. **E-mail:** editor@bakermediagroup.com; acymerman@bakermediagroup.com; dbakerjr@bakermediagroup.com. **Website:** www.akronlife.com. **Contact:** Abby Cymerman, managing editor. Estab. 2002. Circ. 15,000. "*Akron Life* is a monthly lifestyles publication committed to providing information that enhances and enriches the experience of living in or visiting Akron and the surrounding region of Summit, Portage, Medina, and Stark counties. Each colorful, thoughtfully designed issue profiles interesting places, personalities, and events in the arts, sports, entertainment, business, politics, and social scene. We cover issues important to the Greater Akron area and significant trends affecting the lives of those who live here."

NEEDS Essays, general interest, historical, how-to, humor, interview, photo feature, travel. Query with published clips.

⑤❶ ALABAMA LIVING

Alabama Rural Electric Association, 340 TechnaCenter Dr., Montgomery AL 36117. (800)410-2737. **E-mail:** agriffin@areapower.com. **Website:** http://areapower.coop. **Contact:** Allison Griffin, editor. Estab. 1948. Circ. 400,000.

NEEDS Needs photos of Alabama-specific scenes, particularly seasonal. Special photo needs include vertical scenic cover shots. Photo captions preferred; include place and date.

SPECS Accepts images in digital format. Send via CD, ZIP as EPS, JPEG files at 400 dpi.

MAKING CONTACT & TERMS Send query letter with stock list or transparencies ("dupes are fine") in negative sleeves. Keeps samples on file; include SASE for return of material. Responds in 1 month. Simultaneous submissions and previously published work OK "if previously published out-of-state."

ALARM

Alarm Press, 900 N. Franklin St., Suite 300, Chicago IL 60610. (312)341-1290. **E-mail:** info@alarmpress.com; akoellner@alarmpress.com. **Website:** www.alarmpress.com/alarm-magazine. **Contact:** Amanda Koellner. Published 6 times/year. "It does one thing, and it does it very well: it publishes the best new music and art. From our headquarters in a small Chicago office, along with a cast of contributing writers spread across the country, we listen to thousands of CDs, view hundreds of gallery openings, and attend lectures and live concerts in order to present inspirational artists who are fueled by an honest and contagious obsession with their art."

MAKING CONTACT & TERMS Submit by e-mail with the subject line "ALARM Magazine Submissions." "Please send your work as part of the body of an e-mail; we cannot accept attachments." Alternatively, submissions may be sent by regular mail to Submissions Dept. "*ALARM* is not responsible for the return, loss of, or damage to unsolicited manuscripts, unsolicited artwork, or any other unsolicited materials. Those submitting manuscripts, artwork, or any other materials

should not send originals." Art event listings should be e-mailed to artlistings@alarmpress.com.

❸❸❸ ALASKA

Morris Communications, 301 Arctic Slope Ave., Suite 300, Anchorage AK 99518-3035. **E-mail:** editor@ alaskamagazine.com. **Website:** www.alaskamagazine. com. **Contact:** Michelle Theall, editor Corrynn Cochran, photo editor. Estab. 1935. Circ. 180,000. "*Alaska* actively solicits photo-feature ideas having in-depth treatments of single subjects. The ideal photo essay would tell a story of a subject while having compelling content with vibrant color and contrast, and would include both the macro and the micro." Buys 500 photos/year, supplied mainly by freelancers. Photo captions required.

NEEDS Photographic submissions must be high-res digital images that are sharp and properly exposed. Please note: slides, transparencies, and prints will not be accepted. Also, no digital composites, please. Historical b&w prints for which negatives are not available can be submitted in any size. All photo submissions will be carefully packaged before being returned. *Alaska* assumes no responsibility for unsolicited photographs.

SPECS Images made with a digital camera of 5 megapixels or better are acceptable. Images may be submitted on CD, DVD, or flash drive. Photo manipulations of any kind must be clearly noted and defined. Digital composites will not be accepted.

MAKING CONTACT & TERMS Send carefully edited, captioned submission of 35mm, 2¼×2¼, or 4×5 transparencies. Include SASE for return of material. Also accepts images in digital format; check guidelines before submitting. Responds in 1 month. Send submissions to Alaska Magazine Photo Submissions.

✪ ALTERNATIVES JOURNAL

Alternatives Inc., 195 King St., Kitchener Ontario N2H 3X7, Canada. (519)588-4505. **E-mail:** david@ alternativesjournal.ca, megan@alternativesjournal. ca. **Website:** www.alternativesjournal.ca. **Contact:** David McConnachie, publisher. Estab. 1971. Circ. 5,000. Quarterly plus special issues. Emphasizes environmental issues. Readers are activists, academics, professionals, policy makers. Sample copy free with 9×12 SASE and 2 first-class stamps.

○ "*Alternatives* is a nonprofit organization whose contributors are all volunteer. We are only able to give a small stipend to artists and photographers. This in no way should reflect the value of the work. It symbolizes our thanks for their contribution to *Alternatives*."

NEEDS Buys 4-8 photos from freelancers/issue; 48-96 photos/year. Subjects vary widely depending on theme of each issue. "Strong action photos or topical environmental issues are needed—preferably with people. We also print animal shots. We look for positive solutions to problems and prefer to illustrate the solutions rather than the problems. Freelancers need a good background understanding of environmental issues." Check website for upcoming themes. Reviews photos with or without ms. Photo captions preferred; include who, when, where, environmental significance of shot.

SPECS Accepts images in digital format. Send via CD, e-mail as JPEG files at 300 dpi. "E-mail your Web address/electronic portfolio." Simultaneous submissions and previously published work OK. Pays on publication. Buys one-time rights; negotiable.

TIPS "You need to know the significance of your subject before you can powerfully present its visual perspective."

❸○ AMC OUTDOORS

Appalachian Mountain Club, 5 Joy St., Boston MA 02108. (617)523-0636. **Fax:** (617)523-0722. **E-mail:** amcpublications@outdoors.org. **Website:** www .outdoors.org. Estab. 1908. Circ. 70,000. Published 6 times/year. "Our 94,000 members do more than just read about the outdoors; they get out and play. More than just another regional magazine, *AMC Outdoors* provides information on hundreds of AMC-sponsored adventure and education programs. With award-winning editorial, advice on Northeast destinations and trip planning, recommendations and reviews of the latest gear, AMC chapter news and more, *AMC Outdoors* is the primary source of information about the Northeast outdoors for most of our members." Photo guidelines available at www.outdoors. org/publications/outdoors/contributor-guidelines. cfm.

NEEDS Buys 6-12 photos from freelancers/issue; 75 photos/year. Needs photos of adventure, environmental, landscapes/scenics, wildlife, health/fitness/beauty, sports, travel. Other specific photo needs: people, including older adults (50+ years), being active outdoors. "We seek powerful outdoor images from the Northeast

US, or non-location-specific action shots (hiking, skiing, snowshoeing, paddling, cycling, etc.). Our needs vary from issue to issue, based on content, but are often tied to the season."

SPECS Uses color prints or 35mm slides. Prefers images in digital format. Send via CD or e-mail as TIFF, JPEG files at 300 dpi. Low-res OK for review of digital photos.

MAKING CONTACT & TERMS Previously published work OK. Pays $300 (negotiable) for color cover; $50-100 (negotiable) for color inside. Pays on publication. Credit line given.

TIPS "We do not run images from other parts of the U.S. or from outside the U.S. unless the landscape background is 'generic.' Most of our readers live and play in the Northeast, are intimately familiar with the region in which they live, and enjoy seeing the area and activities reflected in living color in the pages of their magazines."

⬤⬤ AMERICAN ANGLER

Morris Communications Company, LLC, 735 Broad St., Augusta GA 30904. (706)828-3971. **E-mail:** editor@americanangler.com. **Website:** www .americanangler.com. **Contact:** Ben Romans, editor; Wayne Knight, art director. Estab. 1976. Circ. 32,000. Bimonthly. Covers fly fishing. "More how-to than where-to, but we need shots from all over. More domestic than foreign. More trout, salmon, and steelhead than bass or saltwater." Photo guidelines available on website. Buys 20 photos from freelancers/issue; 100 photos/year. "Most of our photos come from writers of articles."

NEEDS Photos that convey "the spirit, essence, and exhilaration of fly fishing. Always need good fish-behavioral stuff—spawning, rising, riseforms, etc."

SPECS Digital images at 300 dpi; must be very sharp with good contrast. Can submit to editor via FTP or online file-transfer service (DropBox, WeTransfer, etc.). Please do not submit image CDs.

MAKING CONTACT & TERMS "We prefer to work from e-mailed queries whenever possible, and you should send an e-mail outlining your article before submitting a ms. A query can save you the frustration and disappointment of making a futile submission, and it allows us to fine-tune an idea to suit our editorial needs. We read and respond to all queries, but expect at least a 6-week wait for that response. Be patient, please. But squeak gently if you don't hear

from us within 6-8 weeks. Send query letter with samples, brochure, stock photo list, tearsheets. Provide résumé, business card, self-promotion piece, or tearsheets to be kept on file for possible future assignments." Portfolio review by prior arrangement. Query deadline: 6-10 months prior to cover date. Submission deadline: 5 months prior to cover date. Responds in 6 weeks to queries; 1 month to samples. Simultaneous submissions considered only with notification, and previously published work OK but "only for inside 'editorial' use—not for covers, prominent feature openers, etc."

TIPS "We don't want the same old shots: grip and grin, angler casting, angler with bent rod, fish being released. Sure, we need them, but there's a lot more to fly fishing. Don't send us photos that look exactly like the ones you see in most fishing magazines. Think like a storyteller. Let me know where the photos were taken, at what time of year, and anything else that's pertinent to a fly fisher."

AMERICAN ARCHAEOLOGY

The Archaeological Conservancy, 1717 Girard Blvd. NE, Albuquerque NM 87106. (505)266-9668. **Fax:** (505)266-0311. **E-mail:** tacmag@nm.net. **Website:** www.americanarchaeology.org. **Contact:** Michael Bawaya, editor; Vicki Singer, art director. Estab. 1997. Circ. 35,000. Quarterly. "We're a popular archaeology magazine. Our readers are very interested in this science. Our features cover important digs, prominent archaeologists, and most any aspect of the science. We only cover North America." Sample copies available.

SPECS Uses 35mm, 2¼×2¼, 4×5 transparencies. Accepts images in digital format.

MAKING CONTACT & TERMS Prefers digital submissions at 300 dpi or higher. Send query letter with résumé, photocopies, and tearsheets. Provide résumé, business card, self-promotion piece to be kept on file for possible future assignments. Responds in 2 months to queries. Previously published work OK.

TIPS "Read our magazine. Include accurate and detailed captions."

AMERICAN DIGGER

The Publication for Diggers and Collectors, Greybird Publishers, P.O. Box 126, Acworth GA 30101. (770)362-8671. **E-mail:** publisher@americandigger .com. **Website:** americandigger.com. **Contact:** Butch Holcombe, publisher. Estab. 2005. Circ. 15,000.

⑤ AMERICAN FITNESS

1750 E. Northrop Blvd., Suite 200, Chandler AZ 85286. (800)446-2322, ext. 200. **E-mail:** americanfitness@afaa.com. **Website:** www.afaa.com. **Contact:** Meg Jordan, editor. Estab. 1983. Circ. 42,900. Buys 20-40 photos from freelancers/issue; 120-240 photos/year. Assigns 90% of work. Payment is issued post-publication. Send query letter with samples, list of stock photo subjects; include SASE for return of material. Responds in 2 weeks. Simultaneous submissions and previously published work OK. Pays $10-35 for b&w or color photo; $50 for text/photo package. Pays 4-6 weeks after publication. Credit line given. Buys first North American serial rights.

NEEDS Action photography of runners, aerobic classes, swimmers, bicyclists, speedwalkers, in-liners, volleyball players, etc. Also needs food choices, babies/children/teens, celebrities, couples, multicultural, families, parents, senior fitness, people enjoying recreation, cities/urban, rural, adventure, entertainment, events, hobbies, humor, performing arts, sports, travel, medicine, product shots/still life, science. Interested in alternative process, fashion/glamour, seasonal. Model release required.

SPECS Uses b&w prints; 35mm, 2¼×2¼ transparencies. Cover: color slides, transparencies (2" preferred size) or high-res 300 dpi, TIFF, or PDF files of at least 8.75×11.5. Interior/editorial: color slides, transparencies or high-res 300 dpi, TIFF, PDF, or JPEG files; glossy print.

TIPS "Over-40 sports leagues, youth fitness, family fitness, and senior fitness are hot trends. Wants high-quality, professional photos of people participating in high-energy activities—anything that conveys the essence of a fabulous fitness lifestyle. Also accepts highly stylized studio shots to run as lead artwork for feature stories. Since we don't have a big art budget, freelancers usually submit spin-off projects from their larger photo assignments."

⑩⑤ THE AMERICAN GARDENER

American Horticultural Society, 7931 E. Boulevard Dr., Alexandria VA 22308-1300. (703)768-5700. **E-mail:** editor@ahsgardening.org. **Website:** www.ahsgardening.org. **Contact:** David Ellis, Editor. Estab. 1922. Circ. 20,000. Bimonthly. "This is the official publication of the American Horticultural Society (AHS), a national, nonprofit, membership organization for gardeners, founded in 1922." Sample copy available for $8. Photo guidelines via e-mail request or online. Uses 35-50 photos/issue. Reviews photos with or without a ms. "Lists of plant species for which photographs are needed are sent out to a selected list of photographers approximately 6 weeks before publication. We currently have about 20 photographers on that list. Most of them have photo libraries representing thousands of species. Before adding photographers to our list, we need to determine both the quality and quantity of their collections. Therefore, we ask all photographers to submit digital samples of their work and a list indicating the types and number of plants in their collection. After reviewing both, we may decide to add the photographer to our photo call for a trial period of 6 issues (1 year)."

NEEDS Photos of plants, gardens, landscapes.

SPECS Digital images—high-res JPEG or TIFF files with a minimum size of 5×7 at 300 dpi—posted in an online photo gallery.

MAKING CONTACT & TERMS Send query letter with samples, stock list via mail or e-mail. Will contact for portfolio review if interested.

⑩⑤ AMERICAN HUNTER

11250 Waples Mill Rd., Fairfax VA 22030-9400. (800)672-3888. **E-mail:** Publications@nrahq.org; americanhunter@nrahq.org; EmediaHunter@nrahq.org. **Website:** www.americanhunter.org. **Contact:** editor-in-chief. Circ. 1,000,000. Monthly magazine of the National Rifle Association. "*American Hunter* contains articles dealing with various sport hunting and related activities both at home and abroad. With the encouragement of the sport as a prime game management tool, emphasis is on technique, sportsmanship, and safety. In each issue hunting equipment and firearms are evaluated, legislative happenings affecting the sport are reported, lore and legend are retold, and the business of the Association is recorded in the Official Journal section." Uses wildlife shots and hunting action scenes. Seeks general hunting stories on North American and African game.

SPECS Send via CD as TIFF, GIF, or RAW files at 300 dpi. Vertical format required for cover.

MAKING CONTACT & TERMS Sample copy and photo guidelines free with 9×12 SASE. Send material by mail for consideration; include SASE for return of material.

TIPS "Most successful photographers maintain a file in our offices so editors can select photos to fill holes when needed. We keep files on most North American big game, small game, waterfowl, upland birds, and some exotics. We need live hunting shots as well as profiles and portraits in all settings. Many times there is not enough time to call photographers for special needs. This practice puts your name in front of the editors more often and increases the chances of sales."

AMERICAN MOTORCYCLIST

American Motorcyclist Association, 13515 Yarmouth Dr., Pickerington OH 43147. (614)856-1900. **E-mail:** submissions@ama-cycle.org. **Website:** www.americanmotorcyclist.com. **Contact:** Grant Parsons, director of communications; James Holter, managing editor. Estab. 1947. Circ. 200,000. Monthly. Emphasizes people involved in, and events dealing with, all aspects of motorcycling. Readers are "enthusiastic motorcyclists, investing considerable time in road riding or all aspects of the sport."

NEEDS "The cover shot is tied in with the main story or theme of that issue and generally needs to be submitted with accompanying manuscript. Show us experience in motorcycling photography, and suggest your ability to meet our editorial needs and complement our philosophy."

SPECS Prefers images in digital format. Send via CD as TIFF, GIF, JPEG files at 300 dpi.

MAKING CONTACT & TERMS Send query letter with samples to be kept on file for possible future assignments. Responds in 3 weeks.

❶❸❶ AMERICAN TURF MONTHLY

747 Middle Neck Rd., Great Neck NY 11024. (516)773-4075. **Fax:** (516)773-2944. **E-mail:** jcorbett@americanturf.com; editor@americanturf.com. **Website:** www.americanturf.com. **Contact:** Joe Girardi, editor. Estab. 1946. Circ. 30,000. Monthly. Covers Thoroughbred horse racing, especially aimed at horseplayers and handicappers.

NEEDS Buys 10 photos from freelancers/issue; 120 photos/year. Needs photos of celebrities, racing action, horses, owners, trainers, jockeys. Reviews photos with or without a manuscript. Photo captions preferred; include who, what, where.

SPECS Uses glossy color prints. Accepts images in digital format. Send via CD, floppy disk, ZIP as TIFF, JPEG files at 300 dpi.

MAKING CONTACT & TERMS Send query letter with CD, prints. Provide business card to be kept on file for possible future assignments. Responds only if interested; send nonreturnable samples.

TIPS Like horses and horse racing.

ANCHOR NEWS

75 Maritime Dr., Manitowoc WI 54220. (920)684-0218; (866)724-2356. **Fax:** (920)684-0219. **E-mail:** nbishop@wisconsinmaritime.org; museum@wisconsinmaritime.org; rjohnson@wisconsinmaritime.org. **Website:** www.wisconsinmaritime.org. Circ. 1,100. Quarterly publication of the Wisconsin Maritime Museum. Emphasizes Great Lakes maritime history. Readers include learned and lay readers interested in Great Lakes history. Sample copy available with 9×12 SASE and $3 postage. Photo guidelines free with SASE.

NEEDS Uses 8-10 photos/issue; infrequently supplied by freelance photographers. Needs historic/nostalgic; personal experience; Great Lakes environmental issues, including aquatic invasive species and other topics of interest to environmental educators; and general interest articles on Great Lakes maritime topics. How-to and technical pieces and model ships and shipbuilding are OK. Special needs include historic photography or photos that show current historic trends of the Great Lakes; photos of waterfront development, bulk carriers, sailors, recreational boating, etc. Model release required. Photo captions required.

SPECS Accepts images in digital format. Send via CD, e-mail as JPEG files at 300 dpi minimum.

MAKING CONTACT & TERMS Send 4×5 or 8×10 glossy b&w prints by mail for consideration; include SASE for return of material. Simultaneous submissions and previously published work OK. Pays in copies on publication. Credit line given. Buys first North American serial rights.

TIPS "Besides historic photographs, I see a growing interest in underwater archaeology, especially on the Great Lakes, and underwater exploration—also on the Great Lakes. Sharp, clear photographs are a must. Our publication deals with a wide variety of subjects; however, we take a historical slant with our publication. Therefore, photos should be related to a historical topic in some respect. Also, there are current trends in Great Lakes shipping. A query is most helpful. This will let the photographer know exactly

what we are looking for and will help save a lot of time and wasted effort."

ANIMAL TRAILS MAGAZINE

E-mail: animaltrails@yahoo.com. **Contact:** Shannon Bridget Murphy. Quarterly. "*Animal Trails* is an anchor for memories that are made as a result of experiences with animals. Through writing, photography, and illustrations, animals are given a voice."

NEEDS Photos of environmental, landscapes/scenics, wildlife, architecture, cities/urban, gardening, interiors/decorating, pets, religious, rural, performing arts, agriculture, product shots/still life—as related to animals. Interested in alternative process, avant garde, documentary, fashion/glamour, fine art, historical/vintage, seasonal. Reviews photos with or without a ms. Model/property release preferred.

SPECS Uses glossy or matte color and b&w prints.

MAKING CONTACT & TERMS Send query letter via e-mail. Provide résumé, business card, self-promotion piece to be kept on file for possible future assignments. "A photograph or two is requested but not required. Illustrations and artwork are also accepted." Responds within 1 month to queries; 1 week to portfolios. Simultaneous submissions and previously published work OK. **Pays on acceptance.** Credit line given. Buys one-time rights, first rights; negotiable.

APERTURE

547 W. 27th St., 4th Floor, New York NY 10001. (212)505-5555. **E-mail:** magazine@aperture.org; customerservice@aperture.org. **Website:** www.aperture.org. **Contact:** Michael Famigehtti, managing editor. Circ. 18,500. Quarterly. Emphasizes fine-art and contemporary photography, as well as social reportage. Readers include photographers, artists, collectors, writers. "Published by the the not-for-profit Aperture Foundation, which also publishes books, produces exhibitions, and has a gallery and bookstore in New York City."

NEEDS Uses about 60 photos/issue; biannual portfolio review. Model release required. Photo captions required.

MAKING CONTACT & TERMS To submit work, enter the annual Aperture Portfolio Prize competition "developed to bring work by emerging photographers to a wider audience. The next Portfolio Prize should be open for submissions in the fall. You can also enter your photobook in the First PhotoBook or PhotoBook of the Year categories of the Paris Photo-

Aperture Foundation PhotoBook Awards. The next photobook competition should be open for submissions in the summer."

TIPS "We are a nonprofit foundation. Do not send unsolicited materials as they cannot be returned."

APOGEE PHOTO MAGAZINE

24 Holborn Viaduct, City of London EC1A 2BN, UK. (0)(333)360-1054. **E-mail:** editor.sales@apogeephoto.com. **Website:** apogeephoto.com. **Contact:** Marla Meier, owner. A free online magazine designed to inspire, educate, and inform photographers of all ages and levels.

NEEDS Digital photography, photo technique articles, product reviews, business and marketing, nature and wildlife photography, photographer profiles/interviews, and all other photography-related articles.

TIPS "Please do a search by subject before submitting your article to see if your article covers a new subject or brings a new perspective on a particular subject or theme."

APPALACHIAN TRAIL JOURNEYS

P.O. Box 807, Harpers Ferry WV 25425. (304)535-6331. **Fax:** (304)535-2667. **E-mail:** jfolgar@appalachiantrail.org; info@appalachiantrail.org. **Website:** www.appalachiantrail.org. Estab. 2005. Circ. 45,000. Bimonthly publication of the Appalachian Trail Conservancy. Uses only photos related to the Appalachian Trail. Readers are conservationists, hikers. Photo guidelines available on website.

NEEDS Buys 4-5 photos from freelancers/issue in addition to 2- to 4-page "Vistas" spread each issue; 50-60 photos/year. Most frequent need is for candids of hikers enjoying the trail. Photo captions and release required.

SPECS Accepts high-res digital images (300 dpi). Uses 35mm transparencies.

MAKING CONTACT & TERMS Send query letter with ideas by mail, e-mail. Duplicate slides preferred over originals for query. Responds in 3 weeks. Simultaneous submissions and previously published work OK. Pays on publication. Pays $300 for cover; variable for inside. Credit line given. Rights negotiable.

APPALOOSA JOURNAL

2720 W. Pullman Rd., Moscow ID 83843. (208)882-5578. **Fax:** (208)882-8150. **E-mail:** editor@appaloosajournal.com; designer2@appaloosajournal.com. **Website:** www.appaloosajournal.com. **Contact:**

Dana Russell, editor; John Langston, art director. Estab. 1946. Circ. 25,000.

NEEDS Photos for cover and to accompany features and articles. Specifically wants photographs of high-quality Appaloosa horses, especially in winter scenes. Model release required. Photo captions required.

SPECS Uses glossy color prints; 35mm transparencies; digital images 300 dpi at 5×7 or larger, depending on use. Send query letter with résumé, slides, prints, or e-mail as PDF or GIF. Keeps samples on file. Responds only if interested; send nonreturnable samples. Simultaneous submissions OK.

MAKING CONTACT & TERMS "Send a letter introducing yourself and briefly explaining your work. If you have inflexible preset fees, be upfront and include that information."

TIPS "Be patient. We are located at the headquarters; although an image might not work for the magazine, it might work for other printed materials. Work has a better chance of being used if allowed to keep on file. If work must be returned promptly, please specify. Otherwise, we will keep it for other departments' consideration."

ARCHAEOLOGY

Archaeological Institute of America, 36 33rd St., Suite 301, Long Island City NY 11106 (718)472-3050. **Fax:** (718)472-3051. **E-mail:** cvalentino@archaeology.org; editorial@archaeology.org. **Website:** www.archaeology.org. **Contact:** Editor-in-chief. Estab. 1948. Circ. 750,000. *ARCHAEOLOGY* covers current excavations and recent discoveries, and includes technology updates and studies of ancient cultures.

✪ ARC POETRY MAGAZINE

Arc Poetry Society, P.O. Box 81060, Ottawa, Ontario K1P 1B1 Canada. **E-mail:** managingeditor@arcpoetry.ca; coordinatingeditor@arcpoetry.ca; arc@arcpoetry.ca. **Website:** www.arcpoetry.ca. **Contact:** Monty Reid, managing editor; Chris Johnson, coordinating editor. Estab. 1978. Circ. 1,500. *Arc*'s visual art is selected by an Editorial Board committee. Canadian artists are encouraged to bring their work to our board's attention by e-mailing a URL to Kevin Matthews, art editor. *Arc* generally does not accept or reject individual works, but chooses artists to work with and then asks for a range of works from which up to 10 pieces are selected for publication, including 2 for use on the front and back covers. Most often, only 1 artist is featured per issue.

ARIZONA WILDLIFE VIEWS

5000 W. Carefree Hwy., Phoenix AZ 85086. (800)777-0015. **E-mail:** awv@azgfd.gov; hrayment@azgfd.gov. **Website:** www.azgfd.gov/magazine. **Contact:** Heidi Rayment. Circ. 22,000. Bimonthly official magazine of the Arizona Game and Fish Department. *"Arizona Wildlife Views* is a general interest magazine about Arizona wildlife, wildlife management, and outdoor recreation (specifically hunting, fishing, wildlife watching, boating, and off-highway vehicle recreation). We publish material that conforms to the mission and policies of the Arizona Game and Fish Department. Topics also include habitat issues and historical articles about wildlife and wildlife management."

NEEDS Photos of sports, environmental, landscapes/scenics, wildlife in Arizona. Reviews photos with or without a manuscript. Model release required only if the subject matter is of a delicate or sensitive nature. Captions required.

SPECS "We prefer and primarily use professional-quality 35mm and larger color transparencies. Submitted transparencies must be numbered, identified by artist, and an inventory list must accompany each shipment. The highest resolution digital images are occasionally used." Send JPEG or GIF files. See new information for photographers online at website.

MAKING CONTACT & TERMS Before contacting, please read the appropriate submission guidelines: www.azgfd.gov/i_e/pubs/contributorguidelines.shtml. "Half of the written content of *Arizona Wildlife Views* magazine is generated by freelance writers and photographers. Payment is made upon publication. We prefer queries by e-mail. Sample copies are available on request. The magazine does not accept responsibility for any submissions. It is the artist's responsibility to insure his work." Pays $400 for front cover; $350 for back cover; $250 for inside half-page or larger; $150 for inside smaller than half-page. Pays following publication. Credit line given. Buys one-time rights.

TIPS "Unsolicited material without proper identification will be returned immediately."

☉ ASTRONOMY

Kalmbach Publishing, 21027 Crossroads Circle, P.O. Box 1612, Waukesha WI 53187-1612. (800)533-6644. **Fax:** (262)798-6468. **Website:** www.astronomy.com. **Contact:** David J. Eicher, editor; LuAnn Williams Belter, art director (for art and photography). Estab.

1973. Circ. 108,000. Monthly. Emphasizes astronomy, science and hobby. Median reader: 52 years old, 86% male. Submission guidelines on website. Buys 70 images from freelancers/issue, 840 images/year.

NEEDS Send high-res digital files. Captions, photo details, and identification of subjects required; model/property releases preferred. Pays $25/photo, $200 for cover image. Photos of astronomical images.

SPECS "If you are submitting digital images, please send TIFF or JPEG files to us via our FTP site. Send duplicate images by mail for consideration." Keeps samples on file. Responds in 1 month. Pays on publication. Credit line given.

A.T. JOURNEYS

Appalachian Trail Conservancy, P.O. Box 807, 799 Washington St., Harpers Ferry WV 25425-0807. (304)535-6331. **Fax:** (304)535-2667. **E-mail:** editor@appalachiantrail.org. **Website:** www.appalachiantrail.org. Estab. 1925.

MAKING CONTACT & TERMS "All images should be identified as either 'donation' or 'permission and payment required.'"

ATLANTA HOMES AND LIFESTYLES

Esteem Media, 1117 Perimeter Center W., Suite N118, Atlanta GA 30338. (404)252-6670. **E-mail:** editor@atlantahomesmag.com. **Website:** www.atlantahomesmag.com. **Contact:** Elizabeth Ralls, editor in chief; Elizabeth Anderson, art director. Estab. 1983. Circ. 30,000. Monthly. Covers residential design (home and garden); food, wine, and entertaining; people, lifestyle subjects in the metro Atlanta area. Sample copy available online.

NEEDS Photos of homes (interior/exterior), people, decorating ideas, products, gardens. Model/property release required. Photo captions preferred.

SPECS Accepts images in digital format only.

MAKING CONTACT & TERMS Contact creative director to review portfolio. Provide résumé, business card, brochure, flyer, or tearsheets to be kept on file for possible future assignments. Responds in 2 months. Simultaneous submissions and previously published work OK. Pays $150-750/job. **Pays on acceptance.** Credit line given.

ATLANTA PARENT

2346 Perimeter Park Dr., Atlanta GA 30341. (770)454-7599. **E-mail:** editor@atlantaparent.com; atlantaparent@atlantaparent.com. **Website:** www.

atlantaparent.com. **Contact:** Editor. Estab. 1983. "*Atlanta Parent* magazine has been a valuable resource for Atlanta families since 1983. It is the only magazine in the Atlanta area providing pertinent, local, and award-winning family-oriented articles and information. Atlanta parents rely on us for features that are timely, informative, and reader-friendly on important issues such as childcare, family life, education, adolescence, motherhood, health, and teens. Fun, easy, and inexpensive family activities and crafts as well as the humorous side of parenting are also important to our readers."

MAKING CONTACT & TERMS State availability of or send photos. Offers $10/photo. Buys one-time rights.

◑ THE ATLANTIC SALMON JOURNAL

The Atlantic Salmon Federation, P.O. Box 5200, St. Andrews, New Brunswick E5B 3S8 Canada. (514)457-8737. **Fax:** (506)529-1070. **E-mail:** savesalmon@asf.ca; martinsilverstone@videotron.ca. **Website:** www.asf.ca. **Contact:** Martin Silverstone, editor. Circ. 11,000.

BACKPACKER MAGAZINE

Cruz Bay Publishing, Inc., Active Interest Media Co., 5720 Flatiron Pkwy., Boulder CO 80301. **E-mail:** dlewon@backpacker.com; mhorjus@aimmedia.com; caseylyons@aimmedia.com; mleister@aimmedia.com. **Website:** www.backpacker.com. **Contact:** Dennis Lewon, editor-in-chief; Casey Lyons, deputy editor; Maren Horjus, destinations editor; Mike Leister, art director; Giovanni C. Leone, assistant art director; Louisa Albanese, photo assistant; Genny Fullerton, photography director. Estab. 1973. Circ. 340,000.

MAKING CONTACT & TERMS Sometimes considers simultaneous submissions and previously published work. Pays $500-1,000 for color cover; $100-600 for color inside. Pays on publication. Credit line given. Rights negotiable.

◑ BASEBALL

E-mail: shannonaswriter@yahoo.com. **Contact:** Shannon Bridget Murphy. Quarterly. Covers baseball. Photo guidelines available by e-mail request.

NEEDS Photos of baseball scenes featuring children and teens; photos of celebrities, couples, multicultural, families, parents, environmental, landscapes/scenics, wildlife, agriculture—as related to the sport of baseball. Interested in alternative process, avant garde,

documentary, fine art, historical/vintage, seasonal. Reviews photos with or without a ms.

SPECS Uses glossy or matte color and b&w prints.

MAKING CONTACT & TERMS Send query letter via e-mail. "If possible, please do not include photographs in files if they are sent through e-mail. A disk with your photographs is acceptable. If you plan to send a disk, photographs, or portfolio, please send an e-mail stating this." Provide résumé, business card, self-promotion piece to be kept on file for possible future assignments. "Photographs sent with CDs are requested but not required. Write to request guidelines for artwork and illustrations." Responds within 1 month to queries; 1 week to portfolios. Simultaneous submissions and previously published work OK. **Pays on acceptance.** Credit line given. Buys one-time, first rights; negotiable.

○ BC OUTDOORS SPORT FISHING

Outdoor Media Group, 7261 River Place, 201 A, Mission, British Columbia V4S 0AZ Canada. (604)820-3400. **E-mail:** production@outdoorgroupmedia.com; editor@bcmag.ca. **Website:** www.bcosportfishing.com. **Contact:** Paul Bielicky. Estab. 1945. Circ. 35,000. Published 7 times/year. Emphasizes fishing, both fresh and salt water. Sample copy available for $4.95 Canadian.

NEEDS Buys 30-35 photos from freelancers/issue; 180-210 photos/year. "Fishing (in our territory) is a big need—people in the act of catching or releasing fish. Family oriented. By far, most photos accompany manuscripts. We are always on the lookout for good covers—fishing, wildlife, recreational activities, people in the outdoors—of British Columbia, vertical and square format. Photos with manuscripts must, of course, illustrate the story. There should, as far as possible, be something happening. Photos generally dominate lead spread of each story. They are used in everything from double-page bleeds to thumbnails. Column needs basically supplied in-house." Model/property release preferred. Photo captions or at least full identification required.

SPECS Prefers images in digital format. Send via e-mail at 300 dpi.

MAKING CONTACT & TERMS *No unsolicited submissions.* Send by mail for consideration actual 5×7 or 8×10 color prints; 35mm, 2¼×2¼, 4×5, or 8×10 color transparencies; color contact sheet. If color negative, send jumbo prints, then negatives only on re-

quest. E-mail high-resolution electronic images. Send query letter with list of stock photo subjects. Include SASE or IRC. Pays in Canadian currency. Simultaneous submissions not acceptable if competitor. Editor determines payments. Pays on publication. Credit line given. Buys one-time rights for inside shots; for covers, "we retain the right for subsequent promotional use."

⊖⦿ THE BEAR DELUXE MAGAZINE

Orlo, 240 N. Broadway, #112, Portland OR 97227. **E-mail:** beardeluxe@orlo.org. **Website:** www.orlo.org. **Contact:** Tom Webb, editor-in-chief; Kristin Rogers Brown, art director. Estab. 1993. Circ. 19,000. "*The Bear Deluxe Magazine* is a national independent environmental arts magazine publishing significant works of reporting, creative nonfiction, literature, visual art, and design. Based in the Pacific Northwest, it reaches across cultural and political divides to engage readers on vital issues effecting the environment. Published twice per year, *The Bear Deluxe* includes a wider array and a higher percentage of visual artwork and design than many other publications. Artwork is included both as editorial support and as standalone or independent art. It has included nationally recognized artists as well as emerging artists. As with any publication, artists are encouraged to review a sample copy for a clearer understanding of the magazine's approach. Unsolicited submissions and samples are accepted and encouraged. *The Bear Deluxe* has been recognized for both its editorial and design excellence."

MAKING CONTACT & TERMS "Send us your current work samples and a brief cover letter outlining your availability and turn-around time estimates. Let us know if you'd like to be considered for editorial illustration/photography or only for independent art. Send slides (not more than one sheet), prints, high-quality photocopies, or high-res scans (TIFF files please) on a ZIP drive or CD. If you submit via e-mail, send PDF format files only, or a URL address for us to visit. (Note on e-mail submissions and URL suggestions we prefer hard-copy work samples but will consider electronic submissions and links. We cannot, however, guarantee a response to electronic submissions.) Send SASE for the return of materials. No faxes. Assumes no liability for submitted work samples."

○ ⊕ BELLINGHAM REVIEW

Mail Stop 9053, Western Washington University, Bellingham WA 98225. (360)650-4863. **E-mail:** bellingham.review@wwu.edu. **Website:** www

.bhreview.org. **Contact:** Susanne Paola Antonetta, editor-in-chief; Dayna Patterson, managing editor. Estab. 1977. Circ. 2,000. Annual nonprofit magazine. "Literature of palpable quality: poems, stories, and essays so beguiling they invite us to touch their essence. *Bellingham Review* hungers for a kind of writing that nudges the limits of form or executes traditional forms exquisitely.".

NEEDS We are not currently accepting photography or art.

⊕⊕⊙ BIRD WATCHER'S DIGEST

P.O. Box 110, Marietta OH 45750. (740)373-5285; (800)879-2473. **E-mail:** submissions@ birdwatchersdigest.com. **Website:** www.bird watchersdigest.com. **Contact:** Bill Thompson III, editor; Dawn Hewitt, managing editor. Estab. 1978. Circ. 42,000. Bimonthly; digest size. Emphasizes birds and bird watchers. "We use images to augment our magazine's content, so we often look for nontraditional shots of birds, including images capturing unusual behavior or settings. For our species profiles of birds, we look for more traditional images: sharp, well-composed portraits of wild birds in their natural habitat." Readers are bird watchers/birders (backyard and field, veterans and novices). Sample copy available for $4.99. Photo guidelines available online.

NEEDS Buys 10-15 photos from freelancers/issue, primarily photos of North American bird species but also of bird watchers and birding hotspots.

SPECS Accepts high-res (300 dpi) digital images via Dropbox or HighTail. See guidelines online.

⊙⊙⊙⊕⊙ BIRD WATCHING

Bauer Active, Media House, Lynch Wood, Peterborough PE2 6EA, Wales. 01733 468 201. **E-mail:** trevor. ward@bauermedia.co.uk; birdwatching@bauermedia. co.uk. **Website:** www.birdwatching.co.uk. **Contact:** Trevor Ward, art editor. Estab. 1986. Circ. 22,000. Monthly hobby magazine for bird watchers. Sample copy free with SASE (first-class postage/IRC).

NEEDS Photos of "wild birds photographed in the wild, mainly in action or showing interesting aspects of behavior. Also stunning landscape pictures in birding areas and images of people with binoculars, telescopes, etc." Also considers travel, hobby and gardening shots related to bird watching. Reviews photos with or without a manuscript. Photo captions preferred.

SPECS Uses 35mm, 2¼×2¼ transparencies. Accepts images in digital format. Send via CD, e-mail as TIFF, EPS, JPEG files at 200 dpi.

MAKING CONTACT & TERMS Provide résumé, business card, self-promotion piece, or tearsheets to be kept on file for possible future assignments. Returns unsolicited material if SASE enclosed. Responds in 1 month. Simultaneous submissions OK. Pays on publication. Buys one-time rights.

TIPS "All photos are held on file here in the office once they have been selected. They are returned when used or a request for their return is made. Make sure all slides are well labeled: bird, name, date, place taken, photographer's name, and address. Send sample of images to show full range of subject and photographic techniques."

⊙⊙⊙ BLACKFLASH MAGAZINE

Buffaloberry Press, P.O. Box 7381, Station Main, Saskatoon Saskatchewan S7K 4J3 Canada. (306)374-5115. **E-mail:** bf.info@blackflash.ca; travis.cole@blackflash. ca. **Website:** www.blackflash.ca. **Contact:** Travis Cole, managing editor. Estab. 1983. Circ. 1,500. Canadian journal of photo-based and electronic arts published 3 times/year.

NEEDS Lens-based and new media contemporary fine art and electronic arts practitioners. Reviews photos with or without a manuscript.

SPECS Accepts images in digital format. Send via CD, ZIP, e-mail as TIFF, EPS, BMP, JPEG files at 300 dpi.

MAKING CONTACT & TERMS Send query letter with résumé, digital images. Does not keep samples on file; will return material with SASE only. Simultaneous submissions OK. Pays when copy has been proofed and edited. Credit line given. One-time rights for print and digital editions.

TIPS "We are continuously seeking out visual artists that work within the mediums of photography, experimental/expanded cinema and contemporary art. Please review our mandate and read our magazine prior to submitting."

BOYS' LIFE

Boy Scouts of America, P.O. Box 152079, 1325 W. Walnut Hill Ln., Irving TX 75015. **Website:** www.boyslife. org. **Contact:** Paula Murphey, senior editor; Clay Swartz, associate editor. Estab. 1911. Circ. 1.1 million. Photo guidelines free with SASE. Boy Scouts of

America Magazine Division also publishes *Scouting* magazine. "Most photographs are from specific assignments that freelance photojournalists shoot for *Boys' Life*. Interested in all photographers, but do not send unsolicited images."

MAKING CONTACT & TERMS Send query letter with list of credits. Pays $500 base editorial day rate against placement fees, plus expenses. **Pays on acceptance.** Buys one-time rights.

TIPS "Learn and read our publications before submitting anything."

❸❶ BRIDAL GUIDES MAGAZINE

E-mail: BridalGuides@yahoo.com. **Contact:** Shannon Bridget Murphy. Estab. 1998. Quarterly. Photo guidelines available by e-mail request.

NEEDS Buys 12 photos from freelancers/issue; 48-72 photos/year. Photos of babies/children/teens, celebrities, couples, multicultural, families, parents, cities/urban, environmental, landscapes/scenics, wildlife, architecture, gardening, interiors/decorating, pets, religious, rural, adventure, entertainment, events, food/drink, health/fitness, performing arts, travel, agriculture—as related to weddings. Interested in alternative process, avant garde, documentary, fashion/glamour, fine art, historical/vintage, seasonal. Also wants photos of weddings "and those who make it all happen, both behind and in front of the scene." Reviews photos with or without a manuscript. Model/property release preferred.

SPECS Uses glossy or matte color and b&w prints.

MAKING CONTACT & TERMS Send query letter via e-mail. "If possible, please do not include photographs in files if they are sent through e-mail. A disc with your photographs is acceptable. If you plan to send a disc, photographs, or portfolio, please send an e-mail stating this." Provide résumé, business card, or self-promotion piece to be kept on file for possible future assignments. A photograph or 2 sent with CD is requested but not required. Illustrations and artwork are also accepted. Write to request guidelines for artwork and illustrations. Responds within 1 month to queries; 1 week to portfolios. Simultaneous submissions and previously published work OK. **Pays on acceptance.** Credit line given. Buys one-time rights, first rights; negotiable.

❸❸ BUSINESS NH MAGAZINE

Millyard Communications, 55 S. Commercial St., Manchester NH 03101. (603)626-6354. **Fax:** (603)626-6359. **E-mail:** edit@businessnhmagazine.com. **Website:** www.millyardcommunications.com. **Contact:** Matt Mowry, editor. Estab. 1983. Circ. 14,800. Monthly. Covers business, politics, and people of New Hampshire. Readers are male and female top management, average age 45. Sample copy free with 9×12 SASE and 5 first-class stamps. Offers internships for photographers. Looks for "people in environment shots, interesting lighting, lots of creative interpretations, a definite personal style."

NEEDS Photos of entertainment, food/drink, health/fitness, performing arts, travel, business concepts, industry, science, technology/computers.

SPECS Uses 3-6 photos/issue. Accepts images in digital format.

MAKING CONTACT & TERMS Send via CD, ZIP as TIFF, JPEG files at 300 dpi. Arrange personal interview to show portfolio. Provide résumé, business card, brochure, flyer, or tearsheets to be kept on file for possible future assignments. Responds in 3 weeks.

TIPS "If you're just starting out and want excellent statewide exposure to the leading executives in New Hampshire, you should talk to us. Send letter and samples, then arrange for a portfolio showing."

CAMAS: THE NATURE OF THE WEST

The University of Montana, Environmental Studies Program, Rankin Hall 1016, Missoula MT 59812. (406)243-6273. **Fax:** (406)243-6090. **E-mail:** camas@mso.umt.edu. **Website:** www.camasmagazine.org. **Contact:** Co-editor. Estab. 1992. Circ. 400.

SPECS Needs hi-res photos, at least 300 dpi, preferably a grayscaled TIFF image.

MAKING CONTACT & TERMS Enclose or attach a description of the photo or art as well as any other relevant information.

❷❸❶ CANADA LUTHERAN

302-393 Portage Ave., Winnipeg, Manitoba R3B 3H6 Canada. (204)984-9171; (204)984-9172. **Fax:** (204)984-9185. **E-mail:** editor@elcic.ca. **Website:** www.elcic.ca/clweb. **Contact:** Kenn Ward, editor. Estab. 1986. Circ. 8,000. Monthly publication of Evangelical Lutheran Church in Canada. Emphasizes faith/religious content, Lutheran denomination. Readers are members of the Evangelical Lutheran Church in

Canada. Sample copy available for $5 Canadian (includes postage).

NEEDS Buys 1-2 photos from freelancers/issue; 12-24 photos/year. Photos of people in worship, at work/play, diversity, advocacy, youth/young people, etc. Canadian sources preferred.

SPECS Accepts images in digital format. Send via CD, e-mail as JPEG at 300 dpi minimum.

MAKING CONTACT & TERMS Send sample prints and photo CDs by mail (include SASE for return of material) or send low-res images by e-mail. Pays on publication (in Canadian dollars). Credit line given. Buys one-time rights.

TIPS "Portfolio submissions welcome. We keep photographer contacts on file for approximately one year."

☯☺☉$◑ CANADIAN RODEO NEWS

272245 RR2, Airdrie, Alberta T4A 2L5 Canada. (403)945-7393. **Fax:** (403)945-0936. **E-mail:** editor@rodeocanada.com. **Website:** www.rodeocanada.com. **Contact:** Darell Hartlen, editor. Estab. 1964. Circ. 4,000. Monthly tabloid. Promotes professional rodeo in Canada. Readers are male and female rodeo contestants and fans of all ages.

NEEDS Photos of professional rodeo action or profiles.

SPECS Uses color and b&w prints. Accepts images in digital format. Send via CD or e-mail as JPEG or TIFF files at 300 dpi.

MAKING CONTACT & TERMS Send low-res unsolicited photos by e-mail for consideration. Call to confirm if photos are usable. Keeps samples on file. Simultaneous submissions and previously published work OK. Pays on publication. Credit line given. Rights negotiable. Media/photographer release form available online.

TIPS "Photos must be from or pertain to professional rodeo in Canada. Phone to confirm if subject/material is suitable before submitting. *CRN* is very specific in subject."

☯$ CANADIAN YACHTING

538 Elizabeth St., Midland, Ontario L4R 2A3 Canada. (705)527-7666. **E-mail:** aadams@kerrwil.com; elissacampbell@kerrwil.com. **Website:** www.canadianyachting.ca. **Contact:** Andy Adams, managing editor. Estab. 1976. Circ. 26,000. Published 6 times per year. Emphasizes sailing and powerboats, destination features, and lifestyle. Readers are mostly male,

highly educated, high income, well read. Sample copy free upon request.

NEEDS Occasionally buys photos from freelancers; approx. 10 photos/year. Needs photos of all sailing/boating-related (keelboats, dinghies, racing, cruising, etc.). Model/property release preferred. Photo captions preferred.

MAKING CONTACT & TERMS Submit portfolio electronically for review with photo list. Responds in 1 month. Simultaneous submissions and previously published work OK. Pays 60 days after publication. Buys one-time rights.

CAPE COD LIFE PUBLICATIONS

13 Steeple St., Suite 204, P.O. Box 1439, Mashpee MA 02649. (508)419-7381. **Fax:** (508)477-1225. **Website:** www.capecodlife.com. **Contact:** Jen Dow, Creative Director; Matthew Gill, *Cape Cod LIFE* Editor, Julie Wagner, *Cape Cod HOME* Editor. Estab. 1979. Circ. 45,000. Emphasizes Cape Cod lifestyle. Also publishes *Cape Cod HOME* and *Cape Cod ART*. Readers are 55% female, 45% male, upper income, second home, vacation homeowners. Sample copy available for $4.95, photo guidelines free, send SASE. Buys 30 photos from freelancers/issue; 180 photos/year.

NEEDS "Photos of Cape and island scenes, South shore, people, places, general interest of this area." Subjects include boating, beaches, celebrities, families, environmental, landscapes/scenics, wildlife, architecture, gardening, interiors/decorating, rural, adventure, events, travel. Interested in fine art, historical/vintage, seasonal. Reviews photos with or without a manuscript. Model release required; property release preferred. Photo captions required, include location.

SPECS Uses 35mm, 2¼×2¼, 4×5 transparencies. Accepts images in digital format. Send via e-mail or FTP as TIFF files at 300 dpi.

MAKING CONTACT & TERMS "Photographers should not drop by unannounced. We prefer photographers to mail portfolio, then follow up with a phone call 1-2 weeks later." Send unsolicited photos by mail for consideration. Keeps samples on file. Simultaneous submissions and previously published work OK. Pays $225 for color cover; $25-175 for b&w or color inside, depending on size. Pays 30 days after publication. Credit line given. Buys one-time rights, reprint rights for *Cape Cod Life* reprints, negotiable.

TIPS Write for photo guidelines. Photographers who do not have images of Cape Cod, Martha's Vineyard,

Nantucket, or the Elizabeth Islands should not submit. Looks for "clear, somewhat graphic slides. Show us scenes we've seen hundreds of times with a different twist and elements of surprise. Photographers should have a familiarity with the magazine and the region first. Prior to submitting, photographers should send a SASE to receive our guidelines. They can then submit works (via mail) and follow up with a brief phone call. We love to see images by professional-calibre photographers who are new to us, and prefer it if the photographer can leave images with us at least 2 months if possible."

✪ $ $ THE CAPILANO REVIEW

102-281 Industrial Ave., Vancouver, British Columbia V6A 2P2 Canada. **E-mail:** contact@ thecapilanoreview.ca. **E-mail:** online through submittable. **Website:** www.thecapilanoreview.ca. **Contact:** Matea Kulic, managing editor. Estab. 1972. Circ. 800. Publishes an 8- to 16-page visual section by 1 or 2 artists/issue. "Read the magazine before submitting. *TCR* is an avant garde literary and visual arts publication that wants innovative work. We've previously published photography by Barrie Jones, Roy Kiyooka, Robert Keziere, Laiwan, and Colin Browne."

NEEDS Work that is new in concept and in execution.

MAKING CONTACT & TERMS Send an artist statement and list of exhibitions. Submit a group of photos with SASE (with Canadian postage or IRCs). "We do *not* accept submissions via e-mail or on disc."

$ CAREERFOCUS

7300 W. 110th St., 7th Floor, Overland Park KS 66210. (913)317-2888. **Fax:** (913)317-1505. **E-mail:** michelle. webb@cpgcommunications.com. **Website:** www. cpgpublications.com/focus.php. **Contact:** N. Michelle Paige, executive editor. Estab. 1988. Circ. 250,000. Bimonthly. Emphasizes career development. Readers are male and female African-American and Hispanic professionals, ages 21-45. Sample copy free with 9×12 SASE and 4 first-class stamps. Photo guidelines available online.

NEEDS Uses approximately 40 photos/issue. Needs technology photos and shots of personalities; career people in computer, science, teaching, finance, engineering, law, law enforcement, government, high-tech, leisure. Model release preferred. Photo captions required; include name, date, place, why.

MAKING CONTACT & TERMS Send query letter via e-mail with résumé of credits and list of stock photo subjects. Keeps samples on file. Simultaneous submissions and previously published work OK. Responds in 1 month. Pays $10-50 for color photos; $5-25 for b&w photos. Pays on publication. Credit line given. Buys one-time rights.

TIPS "Freelancer must be familiar with our magazine to be able to submit appropriate manuscripts and photos."

$ $ CARIBBEAN TRAVEL & LIFE

460 N. Orlando Ave., Suite 200, Winter Park FL 32789. (407)571-4704; (407)628-4802. **E-mail:** editor@ caribbeantravelmag.com. **Website:** www.caribbean travelmag.com. Estab. 1985. Circ. 150,000. Published 9 times/year. Emphasizes travel, culture and recreation in islands of Caribbean, Bahamas, and Bermuda. Readers are male and female, frequent Caribbean travelers, ages 32-52. Sample copy available for $4.95. Photo guidelines free with SASE.

NEEDS Uses about 100 photos/issue; 90% supplied by freelance photographers: 10% assignment and 90% freelance stock. "We combine scenics with people shots. Where applicable, we show interiors, food shots, resorts, water sports, cultural events, shopping, and wildlife/underwater shots. We want images that show intimacy between people and place. Provide thorough caption information. Don't submit stock that is mediocre."

SPECS Uses 4-color photography.

MAKING CONTACT & TERMS Query by mail or e-mail with list of stock photo subjects and tearsheets. Responds in 3 weeks. Pays after publication. Buys one-time rights. Does not pay shipping, research, or holding fees.

TIPS Seeing trend toward "fewer but larger photos with more impact and drama. We are looking for particularly strong images of color and style, beautiful island scenics, and people shots—images that are powerful enough to make the reader want to travel to the region; photos that show people doing things in the destinations we cover; originality in approach, composition, subject matter. Good composition, lighting, and creative flair. Images that are evocative of a place, creating story mood. Good use of people. Submit stock photography for specific story needs; if good enough can lead to possible assignments. Let us know exactly what coverage you have on a stock list so we can contact you when certain photo needs arise."

🌕🟢 CHARISMA

600 Rinehart Rd., Lake Mary FL 32746. (407)333-0600. **Fax:** (407)333-7100. **E-mail:** charisma@charismamedia.com; sean.roberts@charismamedia.com. **Website:** www.charismamedia.com. **Contact:** Joe Deleon, magazine design director. Circ. 200,000. Monthly. Emphasizes Christian life. General readership. Sample copy available for $2.50.

NEEDS Buys 3-4 photos from freelancers/issue; 36-48 photos/year. Needs editorial photos—appropriate for each article. Model release required. Photo captions preferred.

SPECS Accepts images in digital format. Send via CD as TIFF, JPEG, EPS files at 300 dpi. Low-res images accepted for sample submissions.

MAKING CONTACT & TERMS Send unsolicited photos by mail for consideration. Provide brochure, flyer or tearsheets to be kept on file for possible future assignments. Simultaneous submissions and previously published work OK. Cannot return material. Responds ASAP. Pays $650 for color cover; $150 for b&w inside; $50-150/hour or $400-750/day. Pays on publication. Credit line given. Buys all rights; negotiable.

TIPS In portfolio or samples, looking for "good color and composition with great technical ability."

CHESAPEAKE BAY MAGAZINE

601 Sixth St., Annapolis MD 21403. (410)263-2662. **Fax:** (410)267-6924. **E-mail:** joe@chesapeakebaymagazine.com. **E-mail:** editor@chesapeakebaymagazine.com. **Website:** www.chesapeakebaymagazine.com. **Contact:** Ann Levelle, managing editor; Joe Evans, editor. Estab. 1972. Circ. 25,000. "Interested in reviewing work from newer, lesser-known photographers."

○ *Chesapeake Bay* is CD-equipped and does corrections and manipulates photos in-house.

NEEDS Buys 27 photos from freelancers/issue; 324 photos/year. Needs photos that are Chesapeake Bay-related (must); "vertical powerboat shots are badly needed (color)." Special needs include "vertical 4-color slides showing boats and people on Bay."

SPECS Accepts images in digital format. Send via CD as TIFF files at 300 dpi, at least 8×10 (16×10 for spreads). "A proof sheet would be helpful."

MAKING CONTACT & TERMS Send query letter with samples or list of stock photo subjects. Responds only if interested. Simultaneous submissions OK.

TIPS "Looking for boating, bay, and water-oriented subject matter. Qualities and abilities include fresh ideas, clarity, exciting angles, and true color. We're using larger photos—more double-page spreads. Photos should be able to hold up to that degree of enlargement. When photographing boats on the Bay, keep safety in mind. People hanging off the boat, drinking, women 'perched' on the bow are a no-no! Children must be wearing life jackets on moving boats. We must have IDs for *all* people in close-up to medium-view images."

🟢 CHESS LIFE KIDS

United States Chess Federation, P.O. Box 3967, Crossville TN 38557. (732)252-8388; (931)787-1234. **E-mail:** gpetersen@uschess.org. **Website:** www.uschess.org. **Contact:** Glenn Petersen, editor. Estab. 2006. Circ. 9,000 print; 17,000 online. Bimonthly association magazine geared for the young reader, age 12 and under, interested in chess; fellow chess players; tournament results; and instruction. Sample copy available with SASE and first-class postage. Photo guidelines available via e-mail.

NEEDS Photos of babies/children/teens, celebrities, multicultural, families, senior citizens, events, humor. Some aspect of chess must be present: playing, watching, young/old contrast. Reviews photos with or without a manuscript. Property release is required. Captions required.

SPECS Accepts images in digital format. Send via ZIP or e-mail. Contact Frankie Butler at catseyephotography@mac.com for more information on digital specs. Uses glossy color prints.

MAKING CONTACT & TERMS E-mail query letter with link to photographer's website. Provide self-promotion piece to be kept on file. Responds in 1 week to queries and portfolios. Simultaneous submissions and previously published work OK. Pays $150 minimum/$300 maximum for color cover. Pays $35 for color inside. Pays on publication. Credit line given. Rights are negotiable. Will negotiate with a photographer unwilling to sell all rights.

TIPS "Read the magazine. What would appeal to *your* 10-year-old? Be original. We have plenty of people to shoot headshots and award ceremonies. And remember, you're competing against proud parents as well."

✪◐ CHICKADEE

10 Lower Spadina Ave., Suite 400, Toronto Ontario M5V 2Z2 Canada. (416)340-2700, ext. 318. **Fax:** (416)340-9769. **E-mail:** owl@owlkids.com. **Website:** www.owlkids.com. **Contact:** Tracey Jacklin. Estab. 1979. Circ. 79,800. Published 10 times/year. A discovery magazine for children ages 6-9. Sample copy available for $4.95 with 9×12 SASE and $1.50 money order to cover postage. Photo guidelines available with SASE or via e-mail.

○ *chickaDEE* has received Magazine of the Year, Parents' Choice, Silver Honor, Canadian Children's Book Centre Choice and several Distinguished Achievement awards from the Association of Educational Publishers.

NEEDS Photo stories, photo puzzles, children ages 6-10, multicultural, environmental, wildlife, pets, adventure, events, hobbies, humor, performing arts, sports, travel, science, technology, animals in their natural habitats. Interested in documentary, seasonal. Model/property release required. Photo captions required.

SPECS Prefers images in digital format. E-mail as JPEG files at 72 dpi; 300 dpi required for publication.

MAKING CONTACT & TERMS Previously published work OK. Credit line given. Buys one-time rights.

✪◐ CHIRP

10 Lower Spadina Ave., Suite 400, Toronto, Ontario M5V 2Z2 Canada. (416)340-2700, ext. 318. **Fax:** (416)340-9769. **E-mail:** owl@owlkids.com. **Website:** www.owlkids.com. **Contact:** Tracey Jacklin. Estab. 1997. Circ. 64,700. Published 10 times/year. A discovery magazine for children ages 3-6. Sample copy available for $4.95 with 9×12 SASE and $1.50 money order to cover postage. Photo guidelines available with SASE or via e-mail.

○ *Chirp* has received Best New Magazine of the Year, Parents' Choice, Canadian Children's Book Centre Choice and Distinguished Achievement awards from the Association of Educational Publishers.

NEEDS Photo stories, photo puzzles, children ages 5-7, multicultural, environmental, wildlife, adventure, events, hobbies, humor, animals in their natural habitats. Interested in documentary, seasonal. Model/property release required. Photo captions required.

SPECS Prefers images in digital format. E-mail as

TIFF, JPEG files at 72 dpi; 300 dpi required for publication.

MAKING CONTACT & TERMS Request photo packages before sending photos for review. Responds in 3 months. Previously published work OK. Credit line given. Buys one-time rights.

⑨◐ CHRONOGRAM

314 Wall St., Kingston NY 12401. (845)334-8600. **E-mail:** dperry@chronogram.com. **Website:** www.chronogram.com. **Contact:** David Perry, art director. Estab. 1993. Circ. 50,000. Monthly arts and culture magazine with a focus on green living and progressive community building in the Hudson Valley. Tends to hire regional photographers, or photographers who are showing work regionally. Sample copy available for $5. Photo guidelines available on website.

NEEDS Buys 16 photos from regional freelancers/issue; 192 photos/year. Interested in alternative process, avant garde, fashion/glamour, fine art, historical/vintage, artistic representations of anything. "Striking, minimalistic and good! Great covers!" Reviews photos with or without a manuscript. Model/property release preferred. Photo captions required; include title, date, artist, medium.

SPECS Prefers images in digital format. Send via CD as TIFF files at 300 dpi or larger at printed size.

MAKING CONTACT & TERMS E-mail sample work at 72 dpi or mail work with SASE for return. Provide self-promotion piece to be kept on file for possible future assignments. Responds only if interested; send nonreturnable samples. Credit line given. Buys one-time rights; negotiable.

TIPS "Colorful, edgy, great art! See our website—look at the back issues and our covers, and check out back issues and our covers before submitting."

⑨◐ COLLECTIBLE AUTOMOBILE

7373 N. Cicero Ave., Lincolnwood IL 60712. (847)676-3470. **Fax:** (847)329-5690. **E-mail:** jbiel@pubint.com. **Contact:** John Biel, editor-in-chief. Estab. 1984. Bimonthly. "*CA* features profiles of collectible automobiles and their designers as well as articles on literature, scale models, and other topics of interest to automotive enthusiasts." Sample copy available for $8 and 10½×14 SASE with $3.50 first-class postage. Photo guidelines available with #10 SASE.

NEEDS "For digital photography, we require our files to have a minimum resolution of A) no less than

25MB in their uncompressed state or B) approximately 3,500-4,000 pixels on the largest side or C) 12-14" on the largest side at 300 dpi. Raw TIFF is best, but lightly compressed JPEGs are acceptable as well. For film shoots, 2-3 rolls of 35mm, 2-3 rolls of 2¼×2¼, and 4-8 4×5 exposures. Complete exterior views, interior and engine views, and close-up detail shots of the subject vehicle are required."

SPECS Uses 35mm, 2¼×2¼, 4×5 transparencies.

MAKING CONTACT & TERMS Send query letter with transparencies and stock list. Provide business card to be kept on file for possible future assignments. Responds only if interested; send nonreturnable samples. Previously published work OK. Pays bonus if image is used as cover photo; $300-350 plus costs for standard auto shoot. **Pays on acceptance.** Photography is credited on an article-by-article basis in an "Acknowledgments" section at the front of the magazine. Buys all intellectual and digital property rights.

TIPS "Read our magazine for good examples of the types of backgrounds, shot angles, and overall quality that we are looking for."

⑤ COLLEGE PREVIEW

7300 W. 110th St., 7th Floor, Overland Park KS 66210. (913)317-2888. **E-mail:** michelle.webb@cpg communications.com; nmpaige@collegepreview magazine.com; editorial@collegepreview magazine.com. **Website:** www.collegepreview magazine.com. **Contact:** Michelle Paige, executive editor. Circ. 600,000. Quarterly. Emphasizes college and college-bound African-American and Hispanic students. Readers are African American, Hispanic, ages 16-24. Sample copy free with 9×12 SASE and 4 first-class stamps.

NEEDS Uses 30 photos/issue. Needs photos of students in class, at work, in interesting careers, on campus. Special photo needs include computers, military, law and law enforcement, business, aerospace and aviation, health care. Model/property release required. Photo captions required; include name, age, location, subject.

MAKING CONTACT & TERMS Send query letter with résumé of credits. Simultaneous submissions and previously published work OK. Pays $10-50 for color photos; $5-25 for b&w inside. Pays on publication. Buys first North American serial rights.

COMMUNITY OBSERVER

Ann Arbor Observer Co., 2390 Winewood, Ann Arbor MI 48103. (734)769-3175. **Fax:** (734)769-3375. **E-mail:** editor@arborweb.com. **Website:** www. washtenawguide.com. John Hilton, editor. Circ. 20,000. Quarterly. "*Community Observer* serves 3 historic communities facing rapid change. We provide an intelligent, informed perspective on the most important news and events in the communities we cover." Sample copy available for $2.

SPECS Uses contact sheets, negatives, transparencies, prints. Accepts images in digital format; GIF or JPEG files.

MAKING CONTACT & TERMS Negotiates payment individually. Pays on publication. Buys one-time rights.

CONDÉ NAST TRAVELER

4 Times Square, 14th Floor, New York NY 10036. (800)777-0700. **E-mail:** web@condenasttraveler. com; letters@condenasttraveler.com. **Website:** www. cntraveler.com. **Contact:** Laura Garvey and Maeve Nicholson, editorial assistant; Greg Ferro, managing editor. Estab. 1987. Circ. 800,000. Provides the experienced traveler with an array of diverse travel experiences encompassing art, architecture, fashion, culture, cuisine, and shopping. This magazine has very specific needs and contacts a stock agency when seeking photos.

CONTEMPORARY WEDDINGS

North East Publishing, Inc., 150 South Maple Ave., #133, South Plainfield NJ 07080. (908)756-0123. **E-mail:** valerie@contemporarybride.com; gary@ contemporarybride.com. **Website:** www. cweddingsmag.com. **Contact:** Gary Paris, publisher. Estab. 1994. Circ. 120,000. Biannual bridal magazine; 4-color publication with feature editorials, real weddings, latest fashion, honeymoon hot spots, and style inspiration. Sample copy available for first-class postage.

NEEDS Reviews photos with accompanying manuscript only. Model/property release preferred. Photo captions preferred; include photo credits.

SPECS Accepts images in digital format. Send as high-res files at 300 dpi.

MAKING CONTACT & TERMS Send query letter with samples. Art director will contact photographer for portfolio review if interested. Keeps samples on file; cannot return material. Responds only if inter-

ested; send nonreturnable samples. Simultaneous submissions and previously published work OK. Payment negotiable. Buys all rights, electronic rights.

TIPS "Digital images preferred with a creative eye for all wedding-related photos. Give us the *best* presentation."

CONVERGENCE: AN ONLINE JOURNAL OF POETRY AND ART

E-mail: clinville@csus.edu. **Website:** www. convergence-journal.com. **Contact:** Cynthia Linville, managing editor/designer. Estab. 2003.

NEEDS Ethnic/multicultural, experimental, feminist, gay/lesbian, seasonal.

MAKING CONTACT & TERMS Send up to 6 JPEGs, 72 dpi, medium-sized, to clinville@csus.edu with "Convergence" in the subject line. Include full name, preferred e-mail address, and a 75-word bio (bios may be edited for length and clarity). A cover letter is not needed. Absolutely no simultaneous or previously published submissions. Acquires electronic rights.

TIPS "Work from a series or with a common theme has a greater chance of being accepted. Seasonally themed work is appreciated (spring and summer for the January deadline, fall and winter for the June deadline)."

COSMOPOLITAN

Hearst Corporation, 300 W. 57th St., New York NY 10019-3791. **E-mail:** inbox@cosmopolitan.com. **Website:** www.cosmopolitan.com. Estab. 1886. Circ. 3 million. *Cosmopolitan* targets young women for whom beauty, fashion, fitness, career, relationships, and personal growth are top priorities. It includes articles and columns on nutrition and food, travel, personal finance, home/lifestyle, and celebrities. Query before submitting.

CYCLE CALIFORNIA! MAGAZINE

1702 Meridian Ave. Suite L, #289, San Jose CA 95125. (408)924-0270. **E-mail:** tcorral@cyclecalifornia. com; bmack@cyclecalifornia.com. **Website:** www. cyclecalifornia.com. **Contact:** Tracy L. Corral, publisher. Estab. 1995. Circ. 32,000 print; 2,800 digital subscribers. Monthly. Provides readers with a comprehensive source of bicycling information, emphasizing the bicycling life in northern California, southern Oregon, and northern Nevada; promotes bicycling in all its facets. "While we do not exclude writers from other parts of the country, articles should reflect a Californian slant." Sample copy available with 9×12 SASE and $1.50 first-class postage. Photo guidelines available with SASE.

NEEDS Buys 3-5 photos from freelancers/issue; 45 photos/year. Needs photos of recreational bicycling, bicycle racing, triathlons, bicycle touring, and adventure racing. Cover photos must be vertical format, color. All cyclists must be wearing a helmet if riding. Reviews photos with or without ms. Model release required; property release preferred. Photo captions preferred; include when and where photo is taken; if an event, include name, date, and location of event; for nonevent photos, location is important.

SPECS High-res TIFF images preferred (2,000×3,000 pixel minimum). Cover photos are 7×9, minimum.

MAKING CONTACT & TERMS Query letter via e-mail. Keeps usable images on file. Responds in 6 weeks. Simultaneous submissions OK. Pays $125 for color cover; $50 for interior photos. Pays on publication.

TIPS "We are looking for photographic images that depict the fun of bicycle riding. Your submissions should show people enjoying the sport. Read the magazine to get a feel for what we do. Label images so we can tell what description goes with which image."

⑤ CYCLE WORLD

15255 Alton Pkwy., Irvine CA 92618. (760)707-0100. **E-mail:** hotshots@cycleworld.com; intake@ cycleworld.com. **Website:** www.cycleworld.com. **Contact:** Mark Hoyer, editor-in-chief. Circ. 300,000. Monthly. Readers are active motorcyclists who are "affluent, educated, and very perceptive."

NEEDS Buys 10 photos/issue. Wants "outstanding" photos relating to motorcycling. Prefers to buy photos with manuscripts. For "Slipstream" column, see instructions in a recent issue.

SPECS Prefers high-res digital images at 300 dpi or quality 35mm color transparencies.

MAKING CONTACT & TERMS Send photos for consideration; include SASE for return of material. Responds in 6 weeks. "Cover shots are generally done by the staff or on assignment." Pays on publication. Buys first publication rights.

TIPS "Editorial contributions are welcomed, but must be guaranteed exclusive to *Cycle World*. We are not responsible for the return of unsolicited material unless accompanied by SASE."

❶ DANCE

E-mail: shannonaswriter@yahoo.com. **Contact:** Shannon Bridget Murphy. Quarterly. Features international dancers.

NEEDS Performing arts, product shots/still life as related to international dance for children and teens. Interested in alternative process, avant garde, documentary, fashion/glamour, fine art, historical/vintage, seasonal. Reviews photos with or without a manuscript. Model/property release preferred.

SPECS Uses glossy or matte color and b&w prints.

MAKING CONTACT & TERMS Send query letter via e-mail. Provide résumé, business card, self-promotion piece to be kept on file for possible future assignments. "Photographs sent along with CDs are requested but not required. Write to request guidelines for artwork and illustrations." Responds within 1 month to queries; 1 week to portfolios. Simultaneous submissions and previously published work OK. **Pays on acceptance.** Credit line given. Buys one-time rights, first rights; negotiable.

❶❸❶ DIGITAL PHOTO

Bauer Consumer Media, Media House, Lynch Wood, Peterborough PE2 6EA, United Kingdom. 44 1733 468 000. **E-mail:** dp@bauerconsumer.co.uk. **Website:** www.photoanswers.co.uk. Estab. 1997. Circ. 35,281. Monthly. "UK's best-selling photography and imaging magazine."

NEEDS Stunning, digitally manipulated images of any subject and Photoshop or Elements step-by-step tutorials of any subject. Reviews photos with or without a manuscript. Model/property release preferred. Photo captions preferred.

SPECS Accepts images in digital format. Send via e-mail as JPEG.

MAKING CONTACT & TERMS Send e-mail with résumé, low-res tearsheets, low-res JPEGs. Responds in 1 month to queries. Rates negotiable, but typically 50 GBP per page. Pays on publication. Credit line given. Buys first rights.

TIPS "Study the magazine to check the type of images we use, and send a sample of images you think would be suitable. The broader your style, the better for general acceptance, while individual styles appeal to our Planet Photo section. Step-by-step technique pieces must be formatted to house style, so check magazine before submitting. Supply a contact sheet or thumb-nail of all the images supplied in electronic form to make it easier for us to make a quick decision on the work."

DOWNBEAT

102 N. Haven Rd., Elmhurst IL 60126. (651)251-9682; (877)904-5299. **E-mail:** editor@downbeat.com. **Website:** www.downbeat.com. Estab. 1934. Circ. 90,000. Monthly. Emphasizes jazz musicians. Sample copy available with SASE.

NEEDS Buys 20 photos from freelancers/issue; 240 photos/year. Needs photos of live music performers/posed musicians/equipment, primarily jazz and blues. Photo captions preferred.

SPECS Accepts images in digital format. "Do not send unsolicited high-res images via e-mail!"

MAKING CONTACT & TERMS Send 8×10 b&w prints; 35mm, 2¼×2¼, 4×5, 8×10 transparencies; b&w or color contact sheets by mail. Unsolicited samples will not be returned unless accompanied by SASE. Provide résumé, business card, brochure, flyer or tearsheets to be kept on file for possible future assignments. Responds only when needed. Simultaneous submissions and previously published work OK. Pay rates vary by size. Credit line given. Buys one-time rights.

TIPS "We prefer live shots and interesting candids to studio work."

❶❸ DUCKS UNLIMITED MAGAZINE

Matt Young, One Waterfowl Way, Memphis TN 38120. (901)758-3776. **E-mail:** myoung@ducks.org. **Website:** www.ducks.org. **Contact:** John Hoffman, Photo Editor. Estab. 1937. Circ. 700,000. Bimonthly association magazine of Ducks Unlimited Inc., a nonprofit organization. Emphasizes waterfowl hunting and conservation. Readers are professional males, ages 40-50. Sample copy available for $3. Photo guidelines available on website: www.ducks.org, via e-mail, or with SASE.

NEEDS Images of wild ducks and geese, waterfowling, and scenic wetlands. Special photo needs include waterfowl hunters, dynamic shots of waterfowl interacting in natural habitat. Buys 84 photos from freelancers/issue; 504 photos/year.

SPECS Accepts images in digital format. Send via CD as TIFF, JPEG, EPS files at 300 dpi; include thumbnails.

MAKING CONTACT & TERMS Responds in 1

month. Previously published work *will not be considered.* Pays on publication. Credit line given. Buys one-time rights "plus permission to reprint in our Mexican and Canadian publications."

⊖ EASYRIDERS

P.O. Box 3000, Agoura Hills CA 91376. (818)889-8740. **E-mail:** davenichols@easyriders.net. **Website:** www. easyriders.com. **Contact:** Dave Nichols, editorial director. Estab. 1971. Monthly. Emphasizes "motorcycles (Harley-Davidsons in particular), motorcycle women, bikers having fun." Readers are "adult men who own, or desire to own, custom motorcycles; the individualist—a rugged guy who enjoys riding a custom motorcycle and all the good times derived from it." Sample copy free. Photo guidelines free with SASE.

NEEDS Uses about 60 photos/issue; majority supplied by freelancers; 70% assigned. Photos of "motorcycle riding (rugged chopper riders), motorcycle women, good times had by bikers, etc." Model release required. Also interested in technical articles relating to Harley-Davidsons.

SPECS Prefers images in digital format ("raw from camera, no effects added").

MAKING CONTACT & TERMS Use online submission form. 3 megapixel, 300 dpi minimum. "Acceptable formats: TIFF, Photoshop (PSD), Kodak Photo CDs, JPEG. GIF format is NOT acceptable." Other terms for bike features with models to satisfaction of editors. Pays 30 days after publication. Credit line given. Buys all rights. All material must be exclusive.

TIPS Trend is toward "more action photos, bikes being photographed by photographers on bikes to create a feeling of motion." In samples, wants photos "clear, in-focus, eye-catching, and showing some emotion. Read magazine before making submissions. Be critical of your own work. Check for sharpness. Also, label photos/slides clearly with name and address."

⊖⊖⊕ ENTREPRENEUR

2445 McCabe Way, Suite 400, Irvine CA 92614. (949)261-2325. **Website:** www.entrepreneur.com. **Contact:** Richard R. Olson, design director; Megan Roy, creative director. Estab. 1977. Circ. 650,000. Monthly. Emphasizes business. Readers are existing and aspiring small business owners.

NEEDS Uses 40 photos/issue; 10% supplied by freelance photographers; 80% on assignment; 10% from stock. Needs people at work, home office, business situations. "I want to see colorful shots in all formats and styles." Model/property release preferred. Photo captions required; include names of subjects.

SPECS Accepts images in digital format and film. Send via ZIP, CD, e-mail as TIFF, EPS, JPEG files at 300 dpi.

MAKING CONTACT & TERMS All magazine queries should be e-mailed to: queries@entrepreneur. com. Responds in 6 weeks. No phone calls, please. Entrepreneur Media Inc. assumes no responsibility for unsolicited manuscripts or photos. Provide résumé, business card, brochure, flyer, or tearsheets to be kept on file for possible future assignments. **Pays on acceptance.** Credit line given. Buys one-time North American rights; negotiable.

TIPS "I am looking for photographers who use the environment creatively; I do not like blank walls for backgrounds. Lighting is also important. I prefer medium-format for most shoots. I think photographers are going back to the basics—a good, clean shot, different angles, and bright colors. I also like gelled lighting. I prefer examples of your work—promo cards and tearsheets—along with business cards and résumés."

⊖⊖⊕ EOS MAGAZINE

Robert Scott Publishing, The Old Barn, Ball Lane, Tackley, Kidlington, Oxfordshire OX5 3AG United Kingdom. (44)(186)933-1741. **Fax:** (44)(186)933-1641. **E-mail:** editorial@eos-magazine.com. **Website:** www.eos-magazine.com. **Contact:** Robert Scott, editor. Estab. 1993. Circ. 20,000. Quarterly. For all users of Canon EOS cameras. Photo guidelines at www. eos-magazine.com/contributors/home.html.

NEEDS Looking for quality stand-alone images as well as photos showing specific photographic techniques and comparison pictures. All images must be taken with EOS cameras but not necessarily with Canon lenses. Photo captions required; include technical details of photo equipment and techniques used.

SPECS Accepts images in digital format exclusively.

MAKING CONTACT & TERMS Pays on publication. Credit line given. Buys one-time rights.

⊘ EVENT

Douglas College, P.O. Box 2503, New Westminster, British Columbia V3L 5B2 Canada. (604)527-5293. **Fax:** (604)527-5095. **E-mail:** event@douglascollege. ca. **Website:** www.eventmags.com. Estab. 1971. Circ.

1,000. Published every 4 months. Emphasizes literature (short stories, reviews, poetry, creative nonfiction).

NEEDS Only publishes photography by B.C.-based artists. Buys approximately 3 photographs/year. Has featured photographs by Mark Mushet, Lee Hutzulak, and Anne de Haas. Assigns 50% of photographs to new and emerging photographers. Uses freelancers mainly for covers. "We look for art that is adaptable to a cover, particularly images that are self-sufficient and don't lead the reader to expect further artwork within the journal."

MAKING CONTACT & TERMS "Please send photography/artwork (no more than 10 images) to *EVENT*, along with SASE (Canadian postage, or IRCs, or USD $1) for return of your work. We also accept e-mail submissions of cover art. We recommend that you send low-res versions of your photography/art as small JPEG or PDF attachments. If we are interested, we will request high-res files. We do not buy the actual piece of art; we only pay for the use of the image." Simultaneous submissions OK. Pays $150 on publication. Credit line given. Buys one-time rights.

❂❹⊙ FAITH & FRIENDS

The Salvation Army, 2 Overlea Blvd., Toronto, Ontario M4H 1P4 Canada. (416)422-6226. **Fax:** (416)422-6120. **E-mail:** faithandfriends@can.salvationarmy.org. **Website:** www.faithandfriends.ca. **Contact:** Ken Ramstead, editor. Circ. 50,000. Monthly. "Our mission: To show Jesus Christ at work in the lives of real people, and to provide spiritual resources for those who are new to the Christian faith."

NEEDS Photos of religion.

SPECS Accepts images in digital format. Send JPEG or GIF files. Uses prints.

MAKING CONTACT & TERMS Payment negotiated. Captions required. Buys one-time rights.

FAMILY MOTOR COACHING

Family Motor Coach Association, 8291 Clough Pike, Cincinnati OH 45244. (513)474-3622; (800)543-3622. **Fax:** (513)474-2332. **E-mail:** rgould@fmca.com; magazine@fmca.com. **Website:** www.fmca.com. **Contact:** Robbin Gould, editor. Estab. 1963. Circ. 75,000. Monthly publication of the Family Motor Coach Association. Emphasizes all aspects of motorhomes: motorhome models, maintenance/technical, lifestyle, and travel. Readers are members of international association of motorhome owners. Sample copy available for $3.99 ($5 if paying by credit card). Writer's/photographer's guidelines free with SASE or via e-mail.

NEEDS Typically buys photos from freelancers to tie in with submitted articles (e.g., motorhome travel and scenic shots; RVing couples, families, and seniors; hobbies/recreation; and how-to/technical/maintenance material related to motorhomes). Photos purchased with accompanying ms. Model release preferred. Photo captions and credits required.

SPECS Digital format preferred. E-mail as EPS, TIFF, or JPG files at 300 dpi minimum; upload to Dropbox or similar file-sharing service; send via mail on CD or USB. Captions requested.

MAKING CONTACT & TERMS Send query letter with résumé of credits and samples of work. Responds in approximately 1 month. Pays $100-150 for color cover; $25-100 for b&w and color inside; $125-500 for text/photo package. **Pays on acceptance.** Credit line given if requested.

TIPS "Photographers are welcome to submit copies of their work. We'll keep them in mind should a freelance photography need arise."

FAMILY TREE MAGAZINE

F+W, a Content and eCommerce Company, 10151 Carver Rd., Suite 200, Blue Ash OH 45242. (513)531-2690. **Fax:** (513)891-7153. **Website:** www.familytreemagazine.com. Estab. 1999. Circ. 75,000. "*Family Tree Magazine* is a special-interest consumer magazine that helps readers discover, preserve, and celebrate their family's history. We cover genealogy, ethnic heritage, genealogy websites and software, photography and photo preservation, and other ways that families connect with their past."

MAKING CONTACT & TERMS Captions required. Negotiates payment individually. Buys all rights.

FCA MAGAZINE

Fellowship of Christian Athletes, 8701 Leeds Rd., Kansas City MO 64129. (816)921-0909; (800)289-0909. **Fax:** (816)921-8755. **E-mail:** mag@fca.org. **Website:** www.fca.org/mag. **Contact:** Clay Meyer, editor; Matheau Casner, creative director. Estab. 1959. Circ. 75,000. Monthly association magazine featuring stories and testimonials of prominent athletes and coaches in sports who proclaim a relationship with Jesus Christ. Sample copy available for $1 and 9×12

SASE. Photo guidelines available at www.fca.org/mag/media-kit.

NEEDS Photos of sports. "We buy photos of persons being featured in our magazine. We don't buy photos without story being suggested first." Reviews photos with accompanying manuscript only. "All submitted stories must be connected to the FCA Ministry." Model release preferred; property release required. Photo captions preferred.

SPECS Uses glossy or matte color prints; 35mm, 2¼×2¼ transparencies. Accepts images in digital format. Send via CD, ZIP, e-mail as TIFF, JPEG files at 300 dpi.

MAKING CONTACT & TERMS Contact through e-mail with a list of types of sports photographs in stock. Do not send samples. Simultaneous submissions OK. Pays $150 maximum for color cover; $100 maximum for color inside. Pays on publication. Credit line given. Buys one-time rights.

TIPS "We would like to increase our supply of photographers who can do contract work."

❸❍ FELLOWSHIP

P.O. Box 271, Nyack NY 10960. (845)358-4601, ext. 35. **E-mail:** lkelly@forusa.org. **Website:** www.forusa.org. **Contact:** Linda Kelly, communications director. Estab. 1935. Circ. 5,000. Publication of the Fellowship of Reconciliation published 2 times/year. Emphasizes peace-making, social justice, nonviolent social change. Readers are interested in peace, justice, nonviolence, and spirituality. Sample copy available for $7.50.

NEEDS Buys up to 2 photos from freelancers/issue. Needs stock photos of people, civil disobedience, demonstrations—Middle East, Latin America, Caribbean, prisons, anti-nuclear, children, gay/lesbian, human rights issues, Asia/Pacific. Captions required.

MAKING CONTACT & TERMS Provide résumé, business card, brochure, flyer, or tearsheets to be kept on file for possible future assignments. "Call for specs." Responds in 4-6 weeks. Simultaneous submissions and previously published work OK. Pays $100 for color cover; $35 for b&w inside. Pays on publication. Credit line given. Buys one-time rights.

TIPS "You must want to make a contribution to peace movements. Money is simply token."

FIELD & STREAM

2 Park Ave., New York NY 10016. (212)779-5296. **Fax:** (212)779-5114. **E-mail:** fsletters@bonniercorp.com. **Website:** www.fieldandstream.com. Estab. 1895. Circ. 1,500,000. Broad-based monthly service magazine published 11 times/year. Editorial content ranges from very basic "how it's done" filler stories that tell in pictures and words how an outdoor technique is accomplished or device is made, to feature articles of penetrating depth about national conservation, game management and resource management issues; also recreational hunting, fishing, travel, nature, and outdoor equipment.

NEEDS Photos using action and a variety of subjects and angles in color and occasionally b&w. "We are always looking for cover photographs, in color, vertical or horizontal. Remember, a cover picture must have room for cover lines." Also looking for interesting photo essay ideas related to hunting and fishing. Query photo editor by e-mail. Needs photo information regarding subjects, the area, the nature of the activity, and the point the picture makes. First Shots: these photos appear every month (2/issue). Prime space, 2-page spread. One-of-a-kind, dramatic, impactful images, capturing the action and excitement of hunting and fishing. Great beauty shots. Unique wildlife images. See recent issues.

MAKING CONTACT & TERMS "Please do not submit images without reviewing past issues and having a strong understanding of our audience." Uses 35mm slides. Will also consider large-format photography. Accepts images in digital format. Send via CD, e-mail as JPEG files at 300 dpi. Submit photos by registered mail. Send slides in 8½×11 plastic sheets and pack slides and prints between cardboard. Include SASE for return of material. Drop portfolios at receptionist's desk, 9th floor. Buys first North American rights.

FINESCALE MODELER

Kalmbach Publishing Co., 21027 Crossroads Circle, P.O. Box 1612, Waukesha WI 53187-1612. (414)796-8776. **Website:** www.finescale.com. Circ. 60,000. Published 10 times/year. Emphasizes "how-to information for hobbyists who build non-operating scale models." Readers are "adult and juvenile hobbyists who build non-operating model aircraft, ships, tanks and military vehicles, cars, and figures." Photo and submission guidelines free with SASE or online.

NEEDS Buys 10 photos from freelancers/issue; 100 photos/year. Needs "in-progress how-to photos illustrating a specific modeling technique; photos of full-size aircraft, cars, trucks, tanks, and ships." Model release required. Photo captions required.

SPECS Prefers prints and transparencies; will accept digital images if submission guidelines are followed.

MAKING CONTACT & TERMS Provide résumé, business card, brochure, flyer, or tearsheets to be kept on file for possible future assignments. "Will sometimes accept previously published work if copyright is clear. Pays for photos on publication, for text/photo package on acceptance. Credit line given. Buys all rights.

TIPS Looks for "sharp color prints or slides of model aircraft, ships, cars, trucks, tanks, figures, and science-fiction subjects. In addition to photographic talent, must have comprehensive knowledge of objects photographed and provide complete caption material. Freelance photographers should provide a catalog stating subject, date, place, format, conditions of sale, and desired credit line before attempting to sell us photos. We're most likely to purchase color photos of outstanding models of all types for our regular feature, 'Showcase.'"

✪⑤◐ FLY ROD & REEL

P.O. Box 370, Camden ME 04843. (207)594-9544. **Fax:** (207)594-5144. **E-mail:** gthomas@flyrodreel.com; editor@flyrodreel.com. **Website:** www.flyrodreel. com. **Contact:** Greg Thomas, editor. Estab. 1979. Circ. 61,941. Quarterly. Emphasizes fly-fishing. Readers are primarily fly-fishers ages 30-60. Sample copy and photo guidelines free with SASE; photo guidelines also available via e-mail.

NEEDS Buys 15-20 photos from freelancers/issue; 90-120 photos/year. Needs "photos of fish, scenics (preferably with anglers in shot), equipment." Photo captions preferred; include location, name of model (if applicable).

SPECS Uses 35mm slides; 2¼×2¼, 4×5 transparencies.

MAKING CONTACT & TERMS Send query letter with list of stock photo subjects. Send unsolicited photos by mail for consideration; include SASE for return of material. Provide résumé, business card, brochure, flier, or tearsheets to be kept on file for possible future assignments. Responds in 1 month. Pays $600-800 for color cover photo; $75 for b&w inside (seldom needed); $75-200 for color inside. Pays on publication. Credit line given. Buys one-time rights.

TIPS "Photos should avoid appearance of being too 'staged.' We look for bright color (especially on covers), and unusual, visually appealing settings. Trout and salmon are preferred for covers. Also looking for saltwater fly-fishing subjects. Ask for guidelines, then send 20 to 40 shots showing breadth of work."

✪ FOGGED CLARITY

(231)670-7033. **E-mail:** editor@foggedclarity.com; submissions@foggedclarity.com. **Website:** www. foggedclarity.com. **Contact:** Editors. Estab. 2008. Circ. between 15,000 and 22,000 visitors per month. "*Fogged Clarity* is an arts review that accepts submissions of poetry, fiction, nonfiction, music, visual art, and reviews of work in all mediums. We seek art that is stabbingly eloquent. Our print edition is released once every year, while new issues of our online journal come out at the beginning of every month. Artists maintain the copyrights to their work until they are monetarily compensated for said work. If your work is selected for our print edition and you consent to its publication, you will be compensated."

MAKING CONTACT & TERMS Reviews GIF, JPEG, PNG, TIFF, PSD, AI, and PDF files, at least 700 pixels.

✪ FOLIATE OAK LITERARY MAGAZINE

University of Arkansas-Monticello, P.O. Box 3460, Monticello AR 71656. (870)460-1247. **E-mail:** foliateoak@uamont.edu. **Website:** www.foliateoak. com. **Contact:** Online submission manager. Estab. 1973. Circ. 500. "We are a university general literary magazine publishing new and established artists." Has featured Terry Wright, Brett Svelik, Lucita Peek, David Swartz, and Fariel Shafee. No samples kept on file.

NEEDS People, architecture, cities, gardening, landscapes, wildlife, environmental, natural disasters, adventure, humor, alternative, avant garde, documentary, erotic, fashion/glamour, fine art, historical, and lifestyle photographs. Photo captions are preferred.

MAKING CONTACT & TERMS Online submission manager must be used to submit all artwork.

TIPS "We are unable to pay our contributors but we love to support freelancers. We solicit work for our online magazine and our annual print anthology. Read submission guidelines online."

FOLIO

10 Gate St., Lincoln's Inn Fields, London WCZA 3HP United Kingdom. +44 (0)20 7242 9562. **Fax:** +44 (0)20 7242 1816. **E-mail:** info@folioart.co.uk. **Website:** www.folioart.co.uk. "Folio is an illustration agency based in London. We pride ourselves on representing illustrators and artists of a particularly high quality and versatility." Exclusive representation required. Finds new talent through submissions and recommendations.

NEEDS "We look after around 50 artists who cover the entire spectrum of styles. These styles range from classic oil and acrylic painting, water colour techniques, classic airbrush, model making, through to contemporary illustration and digital multi-media."

FOOD & WINE

Time Inc., Affluent Media Group, 1120 Avenue of the Americas, 9th Floor, New York NY 10036. (212)522-1387. **Fax:** (212)764-2177. **Website:** www.foodandwine.com. **Contact:** Morgan Goldberg. Circ. 964,000. Monthly. Emphasizes food and wine. Readers are "upscale people who cook, entertain, dine out, and travel stylishly."

NEEDS Uses 25-30 photos/issue; 85% freelance photography on assignment basis, 15% freelance stock. "We look for editorial reportage specialists who do restaurants, food on location, and travel photography." Model release required. Photo captions required.

MAKING CONTACT & TERMS Drop off portfolio on Wednesday. Call for pickup. Submit fliers, tearsheets, etc., to be kept on file for future assignments and stock usage. **Pays on acceptance.** Credit line given. Buys one-time world rights.

FORTUNE

Time, Inc., 225 Liberty St., New York NY 10281. (212)522-1212. **Fax:** (212)522-0810. **E-mail:** letters@fortune.com. **Website:** www.fortune.com. Circ. 1,066,000. Emphasizes analysis of news in the business world for management personnel.

MAKING CONTACT & TERMS Picture editor reviews photographers' portfolios on an overnight drop-off basis. Photos purchased on assignment only. Day rate on assignment (against space rate): $500; page rate for space: $400; minimum for b&w or color usage: $200.

FRANCE MAGAZINE

Archant House, Oriel Rd., Cheltenham, Gloucestershire GL50 1BB United Kingdom. +44 1242 216050. **E-mail:** editorial@francemag.com. **Website:** www.francemag.com. **Contact:** art editor. Estab. 1990. Circ. 40,000. Monthly about France. Readers are male and female, ages 45 and over; people who holiday in France.

NEEDS Photos of France and French subjects: people, places, customs, curiosities, produce, towns, cities, countryside. Photo captions required; include location and as much information as is practical.

SPECS Uses 35mm, medium-format transparencies; high-quality digital.

MAKING CONTACT & TERMS "E-mail in the first instance with list of subjects. Please do not send digital images. We will add you to our photographer list and contact you on an ad-hoc basis for photographic requirements."

FT. MYERS MAGAZINE

(516)652-6072. **E-mail:** ftmyers@optonline.net. **E-mail:** ftmyers2@optonline.net. **Website:** www.ftmyersmagazine.com. **Contact:** Andrew Elias. Estab. 2001. Circ. 20,000. Bimonthly. Covers regional arts and living for educated, active, successful, and creative residents of Lee and Collier counties (FL) and guests at resorts and hotels in Lee County.

NEEDS Buys 3-6 photos from freelancers/year. Photos of celebrities, architecture, gardening, interiors/decorating, medicine, product shots/still life, environmental, landscapes/scenics, wildlife, entertainment, events, food/drink, health/fitness/beauty, performing arts, sports, travel. Interested in alternative process, avant garde, documentary, fashion/glamour, fine art, historical/vintage. Also needs beaches, beach scenes/sunsets over beaches, boating/fishing, palm trees. Reviews photos with or without a ms. Model release required. Photo captions preferred; include description of image and photo credit.

SPECS Uses images at least 4×5 to 8×10 at 300 dpi. E-mail JPGs or TIFFs or send via Dropbox.

MAKING CONTACT & TERMS Send query letter via e-mail with digital images and stock list. Responds only if interested. Buys one-time rights.

FUR-FISH-GAME

2878 E. Main St., Columbus OH 43209-9947. **E-mail:** ffgcox@ameritech.net; subs@furfishgame.com. **Web-**

site: www.furfishgame.com. **Contact:** Mitch Cox, editor. Estab. 1900. Circ. 118,000. Monthly. For outdoorsmen of all ages who are interested in hunting, fishing, trapping, dogs, camping, conservation, and related topics.

NEEDS Buys 4 photos from freelancers/issue; 50 photos/year. Photos of freshwater fish, wildlife, wilderness, and rural scenes. Reviews photos with or without a ms. Photo captions required; include subject.

SPECS Reviews transparencies, color 5×7 or 8×10 prints, digital photos on CD only with thumbnail sheet of small images and a numbered caption sheet.

MAKING CONTACT & TERMS Send query letter "and nothing more." Does not keep samples on file; include SASE for return of material. Responds in 1 month to queries. Simultaneous submissions (but no previously published work) OK. Pays $35 minimum for b&w and color inside. Pays on publication. Credit line given. Buys first North American serial rights, print and digital publication one-time rights.

GARDENING HOW-TO

12301 Whitewater Dr., Minnetonka MN 55343. **E-mail:** editors@gardeningclub.com. **Website:** www. gardeningclub.com. **Contact:** Jennifer Mahoney, art director. Estab. 1996. Circ. 400,000. Special interest magazine published 5 times/year. For the avid home gardener, from beginner to expert. Readers are 78% female, average age of 49. Sample copies available.

NEEDS Buys 50 photos from freelancers/issue; 450 photos/year. Needs photos related to all aspects of gardening, including plants, garden profiles, landscaping, hardscaping, and more. Photos are typically requested as needed; profiles can be sent unsolicited. Photo captions preferred.

SPECS Images must be in digital format. Send via CD as TIFF, EPS, JPEG files at 300 dpi. "FTP site available for digital images."

MAKING CONTACT & TERMS Query art director. Provide self-promotion piece to be kept on file for possible future assignments. Responds only if interested; send nonreturnable samples. Previously published work may be considered. **Pays on acceptance.** Credit line given. Buys one-time rights, first rights, electronic rights; negotiable.

TIPS "Looking for well-lit, sharp, colorful photos and will send specific wants if interested in your work. Send a complete list of photos along with CD in package."

GEORGIA STRAIGHT

1701 W. Broadway, Vancouver, British Columbia V6J 1Y3 Canada. (604)730-7000. **Fax:** (604)730-7010. **E-mail:** contact@straight.com; photos@straight.com. **Website:** www.straight.com. **Contact:** Charlie Smith, editor. Estab. 1967. Circ. 117,000. Weekly tabloid. Emphasizes entertainment. Readers are generally well-educated people, ages 20-45. Sample copy free with 10×12 SASE.

NEEDS Buys 3 photos from freelancers/issue; 364 photos/year. Needs photos of entertainment events and personalities. Photo captions essential.

MAKING CONTACT & TERMS Send query letter with list of stock photo subjects. Provide résumé, business card, brochure, flyer, or tearsheets to be kept on file for possible future assignments. Responds in 1 month. Simultaneous submissions and previously published work OK. Include SASE for return of material. Pays on publication. Credit line given. Buys one-time rights.

TIPS "Almost all needs are for in-Vancouver assigned photos, except for high-quality portraits of film stars. We rarely use unsolicited photos, except for Vancouver photos for our content page."

GERMAN LIFE

Zeitgeist Publishing, Inc., 1068 National Hwy., LaVale MD 21502. **E-mail:** editor@germanlife.com. **Website:** www.germanlife.com. **Contact:** Mark Slider. Estab. 1994. Circ. 40,000. Bimonthly. Focusing on history, culture, and travel relating to German-speaking Europe and German-American heritage. Sample copy available for $5.95.

MAKING CONTACT & TERMS Reviews color transparencies, 5×7 color or b&w prints, and digital images. Buys one-time rights.

GHOST TOWN

E-mail: shannonsdustytrails@yahoo.com. **Contact:** Shannon Bridget Murphy. Estab. 1998. Quarterly. Photo guidelines available by e-mail request.

NEEDS Buys 12 photos from freelancers/issue; 48-72 photos/year. Photos of babies/children/teens, celebrities, couples, multicultural, families, parents, disasters, environmental, landscapes/scenics, wildlife, architecture, cities/urban, education, gardening, interiors/decorating, pets, religious, rural, adventure,

events, food/drink, sports, travel, agriculture, medicine, military, political, product shots/still life, science, technology—as they are related to archaeology and ghost towns. Interested in alternative process, avant garde, documentary, fashion/glamour, fine art, historical/vintage, seasonal. Wants photos of archaeology sites and excavations in progress of American ghost towns. "Would like photographs from ghost towns and western archaeological sites." Reviews photos with or without a manuscript. Model/property release preferred.

SPECS Uses glossy or matte color and b&w prints.

MAKING CONTACT & TERMS Send query letter via e-mail. "If possible, please do not include photographs in files if they are sent through e-mail. A CD sent with your photographs is acceptable." Provide résumé, business card, or self-promotion piece to be kept on file for possible future assignments. "Photographs sent with CDs are requested but not required. Illustrations and artwork are also accepted." Responds within 1 month to queries; 1 week to portfolios. Simultaneous submissions and previously published work OK. **Pays on acceptance.** Credit line given. Buys one-time rights, first rights; negotiable.

GIRLS' LIFE

3 S. Frederick St., Suite 806, Baltimore MD 21202. (410)426-9600. **Fax:** (866)793-1531. **E-mail:** writeforgl@girlslife.com. **Website:** www.girlslife.com. **Contact:** Karen Bokram, founding editor and publisher; Kelsey Haywood, senior editor; Chun Kim, art director. Estab. 1994. Circ. 2.16 million. Emphasizes advice, relationships, school, current news issues, entertainment, quizzes, fashion, and beauty pertaining to preteen girls. Readers are preteen girls (ages 10-15). *Girls' Life* accepts unsolicited mss on a speculative basis only. First, send an e-mail or letter query with detailed story ideas. No telephone solicitations, please. Guidelines available online.

NEEDS Buys 65 photos from freelancers/issue. Submit seasonal materials 3 months in advance. Uses 5×8, 8½×11 color and b&w prints; 35mm, 4×5 transparencies.

MAKING CONTACT & TERMS Send query letter with stock list. E-mail queries are responded to within 90 days. Works on assignment only. Keeps samples on file. Responds in 3 weeks. Simultaneous submissions and previously published work OK. Pays on usage. Credit line given. Please familiarize yourself with the voice and content of *Girls' Life* before submitting.

GOLF TIPS

Madavor Media, 25 Braintree Hill Office Park, Suite 404, Braintree MA 02184. (617)706-9110. **Fax:** (617)536-0102. **E-mail:** editors@golftipsmag.com; vwilliams@madavor.com. **Website:** www.golftipsmag.com. **Contact:** Vic Williams, editor. Estab. 1986. Circ. 300,000. Published 9 times/year. Readers are "hardcore golf enthusiasts." Sample copy free with SASE. Submission guidelines at www.golftipsmag.com/submissions.html.

NEEDS Buys 40 photos from freelancers/issue; 360 photos/year. Photos of golf instruction (usually pre-arranged, on-course), equipment; health/fitness, travel. Interested in alternative process, documentary, fashion/glamour. Reviews photos with accompanying ms only. Model/property release preferred. Photo captions required.

SPECS Uses prints; 35mm, 2¼×2¼, 4×5, 8×10 transparencies. Accepts images in digital format. Send via ZIP as TIFF files at 300 dpi.

MAKING CONTACT & TERMS Send query letter with résumé of credits. Submit portfolio for review. Cannot return material. Responds in 1 month. Pays $500-1,000 for b&w or color cover; $100-300 for b&w inside; $150-450 for color inside. Pays on publication. Buys one-time rights; negotiable.

GOOD HOUSEKEEPING

Hearst Corporation, Article Submissions, 300 W. 57th St., 28th Floor, New York NY 10019. **Website:** www.goodhousekeeping.com. Circ. 4.3 million. Articles focus on food, fitness, beauty, and childcare, drawing upon the resources of the Good Housekeeping Institute. Editorial includes human interest stories and articles that focus on social issues, money management, health news, and travel. Photos purchased mainly on assignment. *Query before submitting.*

✪❍ GOSPEL HERALD

5 Lankin Blvd., Toronto, Ontario M4J 4W7 Canada. (416)461-7406. **E-mail:** editorial@gospelherald.org. **Website:** www.gospelherald.org. **Contact:** Max Craddock, managing editor. Estab. 1936. Circ. 1,000.

GUERNICA MAGAZINE

112 W. 27th St., Suite 600, New York NY 10001. **E-mail:** editors@guernicamag.com; publisher@guernicamag.com. **Website:** www.guernicamag.com. **Contact:** see masthead online for specific editors. Es-

tab. 2004. Publishes new content every month. *Guernica* is one of the Web's most acclaimed new magazines. *Guernica* is called a 'great online literary magazine' by *Esquire*. Contributors come from dozens of countries and write in nearly as many languages.

⑤⑤⓪ GUIDEPOSTS

P.O. Box 5814, Harlan IA 51593. (800)431-2344. **E-mail:** submissions@guidepostsmag.com. **Website:** www.guideposts.org. **Contact:** Kevin Eans, photo editor. Estab. 1945. Circ. 2.6 million. Monthly. True stories of hope and inspiration. Emphasizes tested methods for developing courage, strength, and positive attitudes through faith in God.

NEEDS Uses 90% assignment, 10% stock on a story-by-story basis. Photos are mostly environmental portraiture, editorial reportage. Stock can be scenic, sports, fine art, mixed variety. Model release required.

SPECS Vertical for cover, horizontal or vertical for inside. Accepts images in digital format. Send via CD at 300 dpi.

MAKING CONTACT & TERMS Send photos or arrange a personal interview. Responds in 1 month. Simultaneous submissions OK. Pays by job or on a per-photo basis. **Pays on acceptance.** Credit line given. Buys one-time rights.

TIPS "I'm looking for photographs that show people in their environment; straight portraiture and people interacting. We're trying to appear more contemporary. We want to attract a younger audience and yet maintain a homey feel. For stock—scenics; graphic images in color. *Guideposts* is an 'inspirational' magazine. No violence, nudity, sex. No more than 20 images at a time. Write first and ask for a sample issue; this will give you a better idea of what we're looking for."

HADASSAH MAGAZINE

Hadassah, WZOA, 40 Wall St., Eighth Floor, New York NY 10005. **Fax:** (212)451-6257. **E-mail:** magazine@hadassah.org. **Website:** www.hadassah magazine.org. **Contact:** Elizabeth Barnea. Circ. 255,000. Bimonthly publication of the Hadassah Women's Zionist Organization of America. Emphasizes Jewish life, Israel. Readers are 85% females who travel and are interested in Jewish affairs, average age 59. Photo guidelines free with SASE.

NEEDS Uses 10 photos/issue; most supplied by freelancers. Photos of travel, Israel, and general Jewish life. Photo captions preferred; include where, when, who, and credit line.

SPECS Accepts images in digital format. Send via CD as JPEG files at 300 dpi. High-res, digital photos preferred.

MAKING CONTACT & TERMS Submit portfolio for review. Send unsolicited photos by e-mail for consideration. Keeps samples on file. Responds in 3 months. Payment depends on size and usage. Pays on publication. Credit line given. Buys one-time rights with Web use.

TIPS "We frequently need travel photos, especially of places of Jewish interest."

⓪ HEALING LIFESTYLES & SPAS MAGAZINE

JLD Publications, P.O. Box 271207, Louisville CO 80027. (303)917-7124. **Fax:** (303)926-4099. **E-mail:** melissa@healinglifestyles.com. **Website:** www. healinglifestyles.com. **Contact:** Melissa B. Williams, editorial director. Estab. 1997. "*HL&S* is an online-only publication—a trusted leading social media platform for the spa/wellness industry, focusing on spas, retreats, therapies, food, and beauty geared toward a mostly female audience, offering a more holistic and alternative approach to healthy living." Photo guidelines available with SASE.

NEEDS Buys 3 photos from freelancers/issue; 6-12 photos/year. Photos of multicultural, environmental, landscapes/scenics, adventure, health/fitness/beauty, food, yoga, travel. Reviews photos with or without a manuscript. Model/property release preferred. Photo captions required; include subject, location, etc.

SPECS Prefers images in digital format. Send via CD, ZIP, e-mail as TIFF, EPS, JPEG files at 300 dpi. Also uses 35mm or large-format transparencies.

MAKING CONTACT & TERMS Send query letter with résumé, prints, tearsheets. Provide résumé, business card, self-promotion piece to be kept on file for possible future assignments. Responds in 1 month. Responds only if interested; send nonreturnable samples. Simultaneous submissions OK. Pays on assignment. Credit line given. Buys one-time rights.

TIPS "We strongly prefer digital submissions, but will accept all formats. We're looking for something other than the typical resort/spa shots—everything from at-home spa treatments to far-off, exotic locations. We're also looking for reliable lifestyle photographers who can shoot yoga-inspired shots, healthy cuisine, ingredients, and spa modalities in an interesting and enlightening way."

◉○ HEARTLAND BOATING

The Waterways Journal, Inc., 319 N. Fourth St., Suite 650, St. Louis MO 63102. (314)241-4310. **Fax:** (314)241-4207. **E-mail:** brad@heartlandboating.com. **Website:** www.heartlandboating.com. Zac Metcalf, regional sales manager. **Contact:** Brad Kovach, editor. Estab. 1989. Circ. 10,000. "*HeartLand Boating*'s content is both informative and inspirational—describing boating life as the heartland boater knows it. The content reflects the challenge, joy, and excitement of our way of life afloat. We are devoted to both power and sailboating enthusiasts throughout middle America. The focus is on the freshwater inland rivers and lakes of the heartland, primarily the waters of the Arkansas, Tennessee, Cumberland, Ohio, Missouri, Illinois, and Mississippi rivers, the Tennessee-Tombigbee Waterway, the Gulf Intracoastal Waterway, and the lakes along these waterways and throughout the region."

NEEDS Hobby or sports photos, primarily boating.

MAKING CONTACT & TERMS No follow-ups. Samples kept on file. Portfolio not required. Credit line given.

TIPS "Please read the magazine first. Our rates are low, but we do our best to take care of and promote our contributors."

● HERITAGE RAILWAY MAGAZINE

P.O. Box 43, Horncastle, Lincolnshire LN9 6JR United Kingdom. (44)(507)529529. **Fax:** (44)(507)529301. **Website:** www.heritagerailway.co.uk. **Contact:** Mr. Robin Jones, editor. Circ. 15,000. Monthly leisure magazine emphasizing preserved railways; covering heritage steam, diesel, and electric trains with over 30 pages of news in each issue.

NEEDS Interested in railway preservation. Reviews photos with or without a manuscript. Photo captions required.

SPECS Uses glossy or matte color and b&w prints; 35mm, 2¼×2¼, 4×5, 8×10 transparencies. No digital images accepted.

MAKING CONTACT & TERMS Send query letter with slides, prints, transparencies. Query with online contact form. Does not keep samples on file; include SASE for return of material. Responds in 1 month to queries. Simultaneous submissions OK. Buys one-time rights.

HIGHLIGHTS FOR CHILDREN

803 Church St., Honesdale PA 18431. (570)253-1080. **Fax:** (570)251-7847. **E-mail:** customerservice@highlights.com. **Website:** www.highlights.com. **Contact:** Christine French Cully, editor-in-chief. Estab. 1946. Circ. approximately 1.5 million.

NEEDS "We will consider outstanding photo essays on subjects of high interest to children." Reviews photos with accompanying ms only. Wants no single photos without captions or accompanying ms.

SPECS Accepts images in digital format. Send via CD at 300 dpi. Also accepts transparencies of all sizes.

MAKING CONTACT & TERMS Send photo essays with SASE for consideration. Pays $50 minimum for color photos; $100 minimum for ms. Buys all rights.

TIPS "Tell a story that is exciting to children. We also need mystery photos, puzzles that use photography/collage, special effects, anything unusual that will visually and mentally challenge children."

HOOF BEATS

U.S. Trotting Association, 6130 S. Sunbury Rd., Westerville OH 43081-9309. **E-mail:** hoofbeats@ustrotting.com. **Website:** www.hoofbeatsmagazine.com. **Contact:** T.J. Burkett. Estab. 1933. Circ. 7,000. Monthly publication of the US Trotting Association. Emphasizes harness racing. Readers are participants in the sport of harness racing. Sample copy free.

NEEDS Buys 6 photos from freelancers/issue; 72 photos/year. Needs artistic or striking photos that feature harness horses for covers; other photos on specific horses and drivers by assignment only.

MAKING CONTACT & TERMS Send query letter with samples; include SASE for return of material. Responds in 3 weeks. Simultaneous submissions OK. Pays $150 minimum for color cover; $25-150 for b&w inside; $50-200 for color inside; freelance assignments negotiable. Pays on publication. Credit line given if requested. Buys one-time rights.

TIPS "We look for photos with unique perspective and that display unusual techniques or use of light. Send query letter first. Know the publication and its needs before submitting. Be sure to shoot pictures of harness horses only, not thoroughbred or riding horses. We always need good night racing action or creative photography."

HORSE ILLUSTRATED

I-5 Publishing, 470 Conway Ct., Suite b-6, Lexington KY 40511. (800)546-7730. **E-mail:** horseillustrated@luminamedia.com. **Website:** www.horseillustrated.com. **Contact:** Elizabeth Moyer, editor. Estab. 1976. Circ. 160,660. Readers are "primarily adult horse-women, ages 18-40, who ride and show mostly for pleasure, and who are very concerned about the well being of their horses. Editorial focus covers all breeds and all riding disciplines." Sample copy available for $4.99. Photo guidelines on website.

NEEDS Buys 30-50 photos from freelancers/issue. Needs stock photos of riding and horse care. "Photos must reflect safe, responsible horsekeeping practices. We prefer all riders to wear protective helmets; prefer people to be shown only in action shots (riding, grooming, treating, etc.). We like all riders—especially those jumping—to be wearing protective headgear."

SPECS Prefer digital images—high-res JPEGs on a CD with printout of thumbnails.

MAKING CONTACT & TERMS Send by mail for consideration. Responds in 2 months. Pays $250 for color cover; $65-250 for color inside. Credit line given. Buys one-time rights.

TIPS "Looks for clear, sharp color shots of horse care and training. Healthy horses, safe riding, and care atmosphere is standard in our publication. Send SASE for a list of photography needs, photo guidelines, and to submit work. Photo guidelines are also available on our website."

❶❷❸ HUNGER MOUNTAIN

Vermont College of Fine Arts, 36 College St., Montpelier VT 05602. (802)828-8517. **E-mail:** hungermtn@vcfa.edu. **Website:** www.hungermtn.org. Miciah Gault, Editor. **Contact:** Katie Stromme, Assistant Editor. Estab. 2002. Circ. 1,000. No unsolicited photos.

NEEDS Buys no more than 10 photos/year. Interested in avant garde, documentary, fine art, seasonal. Reviews photos with or without a manuscript.

MAKING CONTACT & TERMS Send query letter with résumé, slides, prints, tearsheets. Does not keep samples on file; include SASE for return of material. Responds in 3 months to queries and portfolios. Simultaneous submissions OK. Pays $30-45 for inside photos; cover negotiable. Pays on publication. Credit line given. Buys first rights.

HYDE PARK LIVING

Community Publications, Inc., 179 Fairfield Ave., Bellevue KY 41073. (859)291-1412. **E-mail:** hydepark@livingmagazines.com. **Website:** www.livingmagazines.com. **Contact:** Grace DeGregorio. Estab. 1983. Circ. 6,800.

MAKING CONTACT & TERMS Reviews contact sheets, negatives, transparencies, prints, GIF/JPEG files. Captions, identification of subjects, model releases required. Negotiates payment individually. Buys all rights.

❶❷❸ INSIGHT MAGAZINE

55 W. Oak Ridge Dr., Hagerstown MD 21740. (301)393-4038. **E-mail:** insight.magazine@pacificpress.com. **Website:** www.insightmagazine.org. Estab. 1970. Circ. 16,000. Weekly Seventh-Day Adventist teen magazine. "We print teens' true stories about God's involvement in their lives. All stories, if illustrated by a photo, must uphold moral and church organization standards while capturing a hip, teen style." Sample copy $2 and #10 SASE.

NEEDS Model/property release required. Photo captions preferred; include who, what, where, when.

MAKING CONTACT & TERMS "Send query letter with photo samples so we can evaluate style." Provide résumé, business card, self-promotion piece, or tearsheets to be kept on file for possible future assignments. Responds only if interested; send nonreturnable samples. Simultaneous submissions and previously published work OK. Pays $200-300 for color cover; $200-400 for color inside. Pays 30-45 days after receiving invoice and contract. Credit line given. Buys first rights. Submission guidelines available online.

INTERVAL WORLD

P.O. Box 431920, Miami FL 33243-1920. (305)666-1861. **E-mail:** kimberly.dewees@intervalintl.com. **Website:** www.intervalworld.com. **Contact:** Kimberly Dewees, photo editor. Estab. 1982. Circ. 1,080,000. Quarterly publication of Interval International. Emphasizes vacation exchange and travel. Readers are members of the Interval International vacation exchange network.

NEEDS Uses 100 or more photos/issue. Needs photos of travel destinations, vacation activities. Model/property release required. Photo captions required; all relevant to full identification.

MAKING CONTACT & TERMS Send query letter

with stock list. Provide business card, brochure, flier or tearsheets to be kept on file for possible future assignments. Cannot return materials. Simultaneous submissions and previously published work OK. Payment negotiable. Pays on publication. Credit line given for editorial use. Buys one-time rights; negotiable.

TIPS Looking for beautiful scenics; family-oriented, fun travel shots; superior technical quality.

IN THE FRAY

113 Schumacher Dr., New Hyde Park NY 11040-3644. (347)850-3935. **E-mail:** art@inthefray.org. **Website:** www.inthefray.org. **Contact:** Benjamin Gottlieb, art director. Estab. 2001.

NEEDS Buys stock photos and offers assignments. Encourages beginning or unpublished photographers to submit work for consideration. Publishes new photographers, may only pay in copies or have a low pay rate. Buys 2 photos from freelancers/issue. 24 photos/year.

SPECS Accepts images in digital format. Send e-mail with JPEG samples at 72 dpi. Keeps samples on file, please provide business card to be kept on file for possible future assignments. Responds only if interested, send nonreturnable samples. Company will contact artist for portfolio review if interested.

MAKING CONTACT & TERMS Reviews photos with or without a manuscript. Photo captions are preferred. Finds freelancers through submissions, word-of-mouth and Internet. Payment range: $20-75. Paid on publication.

⑨⑩ THE IOWAN MAGAZINE

300 Walnut, Suite 6, Des Moines IA 50309. (515)246-0402; (877)899-9977. **E-mail:** brussie@pioneermagazines.com. **Website:** www.iowan.com. **Contact:** Bobbie Russie, art director. Estab. 1952. Circ. 22,000. Bimonthly. Emphasizes "Iowa's people, places, events, nature, and history." Readers are over age 40, college-educated, middle-to-upper income. Sample copy available for $4.50 plus shipping/handling; call the distribution center toll-free at (877)899-9977. Photo guidelines available on website or via e-mail.

NEEDS "We print only Iowa-related images from Iowa photographers, illustrators, and artists. Show us Iowa's residents, towns, environmental, landscape/scenics, wildlife, architecture, rural, entertainment, events, performing arts, travel." Interested in Iowa heritage, historical/vintage, seasonal. Accepts unsolicited stock photos related to above. Editorial stock photo needs available on website or via e-mail. Model/property release preferred. Photo captions required.

SPECS Digital format preferred, see website for details. Press resolution is 300 dpi at 9×12. "If electronic means are not available, mail protected prints with complete contact information and details of items enclosed. NOTE: *The Iowan* does not return any mailed materials."

MAKING CONTACT & TERMS Pays $50-150 for stock photo one-time use, depending on size printed; pays on publication.

⑥⑧⓿ ISLANDS

Bonnier Corporation, 460 N. Orlando Ave., Suite 200, Winter Park FL 32789. (407)628-4802. **Fax:** (407)628-7061. **E-mail:** editor@islands.com. **Website:** www.islands.com. **Contact:** Audrey St. Clair, managing editor. Circ. 200,000. Published 8 times/year. "From Bora Bora to the Caribbean, Tahiti to Bali and beyond, *Islands* is your passport to the world's most extraordinary destinations. Each issue is filled with breathtaking photography and detailed first-hand accounts of the fascinating cultural experiences and tranquil, relaxing escapes unique to each vibrant locale."

NEEDS Buys 25 photos from freelancers/issue; 200 photos/year. Needs photos of island travel. Reviews photos with or without a manuscript. Model/property release preferred. Detailed captions required (please use metadata); include name, phone, address, subject information.

SPECS Only accepts images in digital format. Send via e-mail, web gallery, FTP site as JPEG files at 72 dpi (must have 300 dpi file available if image is selected for use). Film is not accepted.

MAKING CONTACT & TERMS Send query letter with tearsheets. Provide business card and self-promotion piece or tearsheets to be kept on file for possible future assignments. You will be contacted if additional information or a portfolio is desired. Simultaneous submissions OK. Pays $600-1,000 for color cover; $100-500 for inside. Pays 45 days after publication. Credit line given. Buys one-time rights. No phone calls.

ITALIAN AMERICA

219 E St. NE, Washington DC 20002. (202)547-2900. **Fax:** (202)546-8168. **E-mail:** ddesanctis@osia.org; mfisher@osia.org. **Website:** www.osia.org. **Contact:** Dona De Sanctis, editor; Miles Ryan Fisher, Editor-in-Chief. Estab. 1996. Circ. 65,000. *Italian America*

is the official publication of the Order Sons of Italy in America, the nation's oldest and largest organization of American men and women of Italian heritage. Italian America strives to provide timely information about OSIA, while reporting on individuals, institutions, issues and events of current or historical significance in the Italian-American community. Sample copy and photo guidelines free and available online.

NEEDS Buys 5-10 photos from freelancers/issue, 25 photos/year. Needs photos of travel, history, personalities, anything Italian or Italian-American. Reviews photos with or without a manuscript. Special photo needs include travel in Italy. Model releases preferred. Photo captions required.

MAKING CONTACT & TERMS Accepts images in digital format. Send via CD, e-mail as TIFF, EPS, PICT, BMP, GIF, or JPEG files at 400 dpi. Send query letter with tearsheets. Provide résumé, business card, self-promotion piece, or tearsheets to be kept on file for possible future assignments. Art director will contact photographer for portfolio review if interested. Portfolio should include color tearsheets. Responds only if interested, send nonreturnable samples. Simultaneous submissions OK. Pays on publication. Credit line given. Buys one-time rights.

⊛⊛❶ KANSAS!

1020 S. Kansas Ave., Suite 200, Topeka KS 66612-1354. (785)296-8478. **Fax:** (785)296-6988. **E-mail:** ksmagazine@sunflowerpub.com. **Website:** www.travelks.com/ks-mag. **Contact:** Andrea Etzel, editor. Estab. 1945. Circ. 45,000. Quarterly magazine published by the Travel & Tourism Development Division of the Kansas Department of Commerce. Emphasizes Kansas travel, scenery, arts, recreation, and people. Photo guidelines available on website.

NEEDS Buys 60-80 photos from freelancers/year. Subjects include animal, human interest, nature, seasonal, rural, scenic, sport, travel, wildlife, photo essay/photo feature, all from Kansas. No nudes, still life, or fashion photos. Will review photographs with or without a ms. Model/property release mandatory.

SPECS Images must be digital at 300 dpi for 8x10.

MAKING CONTACT & TERMS Send material by mail for consideration. Previously published work is accepted if no longer under contract. Pays on acceptance. Credit line given. Buys one-time first North American reprint for 90 days or perpetual rights depending on assignment/gallery/cover/calendar.

TIPS Kansas-oriented material only. Prefers Kansas photographers. "Follow guidelines, submission dates specifically. Shoot a lot of seasonal scenics."

⊛❶ KASHRUS MAGAZINE

The Kashrus Institute, P.O. Box 204, Brooklyn NY 11204. (718)336-8544. **Fax:** (718)336-8550. **E-mail:** editorial@kashrusmagazine.com. **Website:** www.kashrusmagazine.com. **Contact:** Rabbi Yosef Wikler, editor. Estab. 1981. Circ. 10,000. "The periodical for the kosher consumer. We feature updates including mislabeled kosher products and recalls. Important for vegetarians, lactose intolerant, and others with allergies."

SPECS Uses 2¼×2¼, 3½×3½, or 7½×7½ matte b&w and color prints.

MAKING CONTACT & TERMS Send unsolicited photos by mail with SASE for consideration. Provide business card, brochure, flyer, or tearsheets to be kept on file for possible future assignments. Responds in 2 weeks. Simultaneous submissions and previously published work OK. Pays $40-75 for b&w cover; $50-100 for color cover; $25-50 for b&w inside; $75-200/job; $50-200 for text for photo package. Pays part on acceptance, part on publication. Buys one-time rights, first North American serial rights, all rights; negotiable. Byline given. Submit seasonal materials 2 months in advance.

TIPS "Seriously in need of new photo sources, but *call first* to see if your work is appropriate before submitting samples."

⊛❶ KENTUCKY MONTHLY

Vested Interest Publications, P.O. Box 559, 100 Consumer Lane, Frankfort KY 40602-0559. (502)227-0053; (888)329-0053. **Fax:** (502)227-5009. **E-mail:** kymonthly@kentuckymonthly.com; steve@kentuckymonthly.com. **E-mail:** patty@kentuckymonthly.com. **Website:** www.kentuckymonthly.com. **Contact:** Stephen Vest, editor; Patricia Ranft, associate editor. Estab. 1998. Circ. 40,000. Monthly. Focuses on Kentucky and Kentucky-related stories. Sample copy available online.

NEEDS Buys average of 10-20 photos from freelancers/issue; 120-300 photos/year. Photos of celebrities, wildlife, entertainment, landscapes. Reviews photos with or without a ms. Model release and photo captions required.

SPECS Accepts images in digital format only. Send

via CD, e-mail at 300 dpi, sized minimum of 4×6, larger preferred.

MAKING CONTACT & TERMS Send query letter. Provide self-promotion piece to be kept on file for possible future assignments. Responds in 1-3 months. Simultaneous submissions OK. Pays $25 minimum for inside photos. Pays the 15th of the month within 3 months of issue publication. Credit line given.

⑤⑤ KNOWATLANTA

450 Northridge Pkwy., Suite 202, Atlanta GA 30350. (770)650-1102 ext. 100. **Fax:** (770)650-2848. **E-mail:** http://lindsay@knowatlanta.com. **Website:** www. knowatlanta.com. **Contact:** Lindsay Penticuff, editor. Estab. 1986. Circ. 48,000. Quarterly. Serves as a relocation guide to the Atlanta metro area with a corporate audience. Photography reflects regional and local material as well as corporate-style imagery.

NEEDS Buys more than 10 photos from freelancers/issue; more than 40 photos/year. Photos of cities/urban, events, performing arts, business concepts, medicine, technology/computers. Reviews photos with or without a manuscript. Model release required; property release preferred. Photo captions preferred.

SPECS Uses 8×10 glossy color prints; 35mm, transparencies. Accepts images in digital format. Send via CD, ZIP, e-mail as TIFF, EPS, JPEG files at 300 dpi.

MAKING CONTACT & TERMS Send query letter with photocopies. Provide résumé, business card, self-promotion piece to be kept on file for possible future assignments. Responds only if interested; send nonreturnable samples. Pays $600 maximum for color cover; $300 maximum for color inside. Pays on publication. Credit line given. Buys first rights.

TIPS "Think like our readers. What would they want to know about or see in this magazine? Try to represent the relocated person if using subjects in photography."

⑤⑤ LADIES HOME JOURNAL

805 Third Ave., 26th Floor, New York NY 10022. (212)499-2087. **Website:** www.lhj.com. Circ. 6 million. Monthly. Features women's issues. Readership consists of women with children and working women in 30s age group.

NEEDS Uses 90 photos/issue; 100% supplied by freelancers. Needs photos of children, celebrities, and women's lifestyles/situations. Reviews photos only without manuscript. Model release preferred. Photo captions preferred.

MAKING CONTACT & TERMS Provide résumé, business card, brochure, flier, or tearsheet to be kept on file for possible assignment. "Do not send slides or original work; send only promo cards or disks." Responds in 3 weeks. **Pays on acceptance.** Credit line given. Buys one-time rights.

⑤ LAKELAND BOATING MAGAZINE

727 South Dearborn St., Suite 812, Chicago IL 60605. (312)276-0610. **Fax:** (312)276-0619. **E-mail:** cbauhs@lakelandboating.com; ljohnson@lakelandboating.com. **Website:** www.lakelandboating.com. **Contact:** Lindsay Johnson, editor. Estab. 1945. Circ. 60,000. Monthly magazine. Emphasizes powerboating in the Great Lakes. Readers are affluent professionals, predominantly men over age 35.

NEEDS Shots of particular Great Lakes ports and waterfront communities. Model release preferred. Photo captions preferred.

MAKING CONTACT & TERMS Send query letter with list of stock photo subjects. Provide résumé, business card, brochure, flyer, or tearsheets to be kept on file for possible future assignments. Pays on publication. Credit line given.

⑤◐ LAKE SUPERIOR MAGAZINE

Lake Superior Port Cities, Inc., P.O. Box 16417, Duluth MN 55816-0417. (218)722-5002. **Fax:** (218)722-4096. **E-mail:** edit@lakesuperior.com. **Website:** www.lakesuperior.com. **Contact:** Konnie LeMay, editor. Estab. 1979. Circ. 20,000. Bimonthly. "Beautiful picture magazine about Lake Superior." Readers are male and female, ages 35-55, highly educated, upper-middle and upper-management level through working. Sample copy available for $4.95 plus $5.95 S&H. Photo guidelines free with SASE or via website.

NEEDS Buys 21 photos from freelancers/issue; 126 photos/year. Also buys photos for calendars and books. Needs photos of landscapes/scenics, travel, wildlife, personalities, boats, underwater—all Lake Superior related. Photo captions preferred.

SPECS Uses mainly images in digital format. Send via CD with thumbnails on a printout or online link to your photo website.

MAKING CONTACT & TERMS Send unsolicited photo feature idea and samples by e-mail. Pays $150 for color cover; $50 for b&w or color inside. Pays on

publication. Credit line given. Buys first North American serial rights; reserves second rights for future use.

TIPS "Be aware of the focus of our publication—Lake Superior. Photo features concern only that. Features with text can be related. We are known for our fine color photography and reproduction. It has to be tops. We try to use images large; therefore, detail quality and resolution must be good. We look for unique outlook on subject, not just snapshots. Must communicate emotionally. Some photographers send material we can keep in-house and refer to, and these will often get used."

🟢 LINCOLNSHIRE LIFE

9 Checkpoint Court, Sadler Rd., Lincoln LN6 3PW United Kingdom. (44)(152)252-7127. **Fax:** (44)(152)228-2000. **E-mail:** editorial@lincolnshirelife.co.uk; studio@lincolnshirelife.co.uk. **Website:** www.lincolnshirelife.co.uk. Estab. 1961. Circ. 10,000. Monthly county magazine featuring the culture and history of Lincolnshire. Sample copy available for £2. Photo guidelines free.

NEEDS Buys 10 photos from freelancers/issue; 120 photos/year. Needs photos of Lincolnshire scenes, animals, people. Photo captions required.

SPECS Color transparencies with vertical orientation for cover. Accepts color prints for inside.

MAKING CONTACT & TERMS Send query letter with samples. Art director will contact photographer for portfolio review if interested. Portfolio should include slides or transparencies. Keeps samples on file. Responds in 1 month. Previously published work OK. Payment negotiable. Pays on publication. Credit line given. Buys first rights.

LION

Lions Clubs International, 300 W. 22nd St., Oak Brook IL 60523-8842. (630)468-6909. **Fax:** (630)571-1685. **E-mail:** magazine@lionsclubs.org. **Website:** www.lionsclubs.org. **Contact:** Jay Copp, senior editor. Estab. 1918. Circ. 350,000. Monthly magazine for members of the Lions Club and their families. Emphasizes Lions Club activities and membership. Sample copy and photo guidelines free.

NEEDS Uses 50-60 photos/issue. Needs photos of Lions Club service or fundraising projects. All photos must be as candid as possible, showing an activity in progress. Please, no award presentations, meetings, speeches, etc. Generally, photos are purchased with manuscript (300-1,500 words) and used as a photo story. Model release needed for young or disabled children. Photo caption is required. Uses 5×7, 8×10 glossy color prints, 35mm transparencies, also accepts digital images in JPEG or TIFF format via e-mail at 300 dpi or larger.

MAKING CONTACT & TERMS Works with freelancers on assignment only. Provide résumé to be kept on file for possible future assignments. Query first with résumé of credits or story idea. Must accompany story on the service or fundraising project of the Lions Club. Pays on acceptance. Buys all rights, negotiable.

TIPS Query on specific project and photos to accompany ms.

🟢⭕ LIVING FREE

Liberty Media, LLC, 125 Summer Street, Bristol NH 03289. (603)455-7368. **E-mail:** free@natnh.com; lfeditor@icloud.com. **Website:** http://www.natnh.com/living-free.html. **Contact:** Tom Caldwell, editor-in-chief. Estab. 1987. Quarterly electronic magazine succeeding Naturist Life International's online e-zine. Emphasizes nudism/naturism. Readers are male and female nudists/naturists. Sample copy available on CD for $10. We periodically organize naturist photo safaris to shoot nudes in nature.

NEEDS Buys 36 photos from freelancers/issue; 144 photos/year. Photos depicting family-oriented nudist/naturist work, recreational activity and travel. Reviews photos with or without a manuscript. Model release required (including Internet use) for recognizable nude subjects. Photo captions preferred.

SPECS Prefers digital images, minimum 1MB in size, submitted on CD or via e-mail.

MAKING CONTACT & TERMS Send query letter with résumé of credits. Send unsolicited photos by mail or e-mail for consideration; include SASE for return of material. Provide résumé, business card, brochure, flier, or tearsheets to be kept on file for possible future assignments. Responds in 2 weeks. Pays $50 for color cover; $10-25 for others. Pays on publication. Credit line given. "Prefer to own all rights but sometimes agree to one-time publication rights."

TIPS "The ideal photo shows ordinary-looking people of all ages doing everyday activities, in the joy of nudism. We do not want 'cheesecake' glamour images or anything that emphasizes the erotic."

⊖⊖❶ LOG HOME LIVING

Home Buyer Publications, Inc., 5720 Flatiron Parkway, Boulder CO 80301. (703)222-9411; (800)826-3893. **Fax:** (703)222-3209. **E-mail:** editor@timberhome living.com. **Website:** www.loghome.com. Estab. 1989. Circ. 132,000. Monthly. Emphasizes planning, building, and buying a log home. Sample copy available for $4. Photo guidelines available online.

NEEDS Buys 90 photos from freelancers/issue; 120 photos/year. Needs photos of homes—living room, dining room, kitchen, bedroom, bathroom, exterior, portrait of owners, design/décor—tile sunrooms, furniture, fireplaces, lighting, porch and deck, doors. Close-up shots of details (roof trusses, log stairs, railings, dormers, porches, window/door treatments) are appreciated. Model release required.

SPECS Prefers to use digital images or 4×5 color transparencies/Kodachrome or Ektachrome color slides; smaller color transparencies and 35mm color prints also acceptable.

MAKING CONTACT & TERMS Send unsolicited photos by mail for consideration. Keeps samples on file. Responds only if interested. Previously published work OK. Pays $2,000 maximum for color feature. Cover shot submissions also accepted; fee varies, negotiable. **Pays on acceptance.** Credit line given. Buys first world one-time stock serial rights; negotiable.

TIPS "Send photos of log homes, both interiors and exteriors."

LOST LAKE FOLK OPERA

Shipwreckt Books Publishing Company, 309 W. Stevens Ave., Rushford MN 55971. **E-mail:** contact@ shipwrecktbooks.com. **Website:** www.shipwreckt books.com. **Contact:** Tom Driscoll, managing editor. Estab. 2013. Circ. 500. *Lost Lake Folk Opera* magazine, published twice annually, accepts submissions of critical journalism, short fiction, poetry, and graphic art. Covers rural mid-American arts, politics, economics, and opinions.

NEEDS See back issues online for current needs.

⊖ LOYOLA MAGAZINE

820 N. Michigan Ave., Chicago IL 60611. (312)915-6930. **E-mail:** abusiek@luc.edu. **Website:** www.luc. edu/loyolamagazine. **Contact:** Anastasia Busiek, editor. Estab. 1971. Circ. 120,000. Loyola University alumni magazine. Quarterly. Emphasizes issues related to Loyola University Chicago. Readers are Loyola University Chicago alumni—professionals, ages 22 and up.

NEEDS Buys 20 photos from freelancers/issue; 60 photos/year. Needs Loyola-related or Loyola alumni-related photos only. Model release preferred. Photo captions preferred.

SPECS Uses 8×10 b&w and color prints; 35mm, 2¼×2¼ transparencies. Accepts high-res digital images. Query before submitting.

MAKING CONTACT & TERMS Best to query by mail before making any submissions. If interested, will ask for résumé, business card, brochure, flier, or tearsheets to be kept on file for possible future assignments. Simultaneous submissions and previously published work OK. **Pays on acceptance.** Credit line given.

TIPS "Send us information, but don't call."

❶⊖ LULLWATER REVIEW

Emory University, P.O. Box 122036, Atlanta GA 30322. **E-mail:** emorylullwaterreview@gmail.com. **Website:** emorylullwaterreview.com. **Contact:** Aneyn M. O'Grady, editor in chief. Estab. 1990. Circ. 2,000. "We're a small, student-run literary magazine published out of Emory University in Atlanta with 2 issues yearly—1 in the fall and 1 in the spring. You can find us in the *Index of American Periodical Verse*, the *American Humanities Index* and as a member of the Council of Literary Magazines and Presses. We welcome work that brings a fresh perspective, whether through language or the visual arts." Magazine: 5×8; 60 pages; photos. "*Lullwater Review* seeks submissions that are strong and original. We require no specific genre or subject."

NEEDS Architecture, cities/urban, rural, landscapes, wildlife, alternative process, avant garde, fine art, and historical/vintage photos.

MAKING CONTACT & TERMS Send an e-mail with photographs. Samples kept on file. Portfolio should include b&w, color photographs, and finished original art. Credit line given when appropriate.

TIPS "Read our magazine. We welcome work of all different types, and we encourage submissions that bring a fresh or alternative perspective. Submit at least 5 works. We frequently accept 3-5 pieces from a single artist and like to see a selection."

⑤⑤⓪ THE LUTHERAN

8765 W. Higgins Rd., 5th Floor, Chicago IL 60631-4183. (800)638-3522, ext. 2540. **Fax:** (773)380-2409. **E-mail:** michael.watson@thelutheran.org; lutheran@thelutheran.org. **Website:** www.thelutheran.org. **Contact:** Michael Watson, art director. Estab. 1988. Circ. 300,000. Monthly publication of Evangelical Lutheran Church in America. "Please send samples of your work that we can keep in our files. Though we prefer to review online portfolios, a small number of slides, prints or tearsheets, a brochure, or even a few photocopies are acceptable as long as you feel they represent you."

NEEDS Buys 10-15 photos from freelancers/issue; 120-180 photos/year. Current news, mood shots. Subjects include babies/children/teens, couples, multicultural, families, parents, senior citizens, disasters, landscapes/scenics, cities/urban, education, religious. Interested in fine art, seasonal. "We usually assign work with exception of 'Reflections' section." Model release required. Photo captions preferred.

SPECS Accepts images in digital format. Send via CD or e-mail as TIFF or JPEG files at 300 dpi.

MAKING CONTACT & TERMS Send query letter with list of stock photo subjects. Provide résumé, brochure, flier, or tearsheets to be kept on file for possible future assignments. Pays on publication. Credit line given. Buys one-time rights; credits the photographer.

TIPS Trend toward "more dramatic lighting; careful composition." In portfolio or samples, wants to see "candid shots of people active in church life, preferably Lutheran. Church-only photos have little chance of publication. Submit sharp, well-composed photos with borders for cropping. Send printed or duplicate samples to be kept on file; no originals. If we like your style, we will call you when we have a job in your area."

THE MACGUFFIN

Schoolcraft College, 18600 Haggerty Rd., Livonia MI 48152. (734)462-4400, ext. 5327. **E-mail:** macguffin@schoolcraft.edu. **Website:** www.schoolcraft.edu/macguffin. **Contact:** Steven A. Dolgin, editor; Gordon Krupsky, managing editor. Estab. 1984. Circ. 500. Magazine covering the best new work in contemporary poetry, prose, and visual art. "Our purpose is to encourage, support, and enhance the literary arts in the Schoolcraft College community, the region, the state, and the nation. We also sponsor annual literary events and give voice to deserving new writers as well as established writers."

NEEDS Reviews photos in TIFF, EPS, JPEG formats. Captions required.

SPECS Specs: at least 9" tall at 300 dpi.

MAKING CONTACT & TERMS Send an e-mail with samples. Please submit name and contact information with your work, along with captions. Portfolio not required. Credit line given.

◎⑤⓪ MINNESOTA GOLFER

Minnesota Golf Association, 6550 York Ave. S., Suite 211, Edina MN 55435. (952)927-4643; (800)642-4405. **Fax:** (952)927-9642. **E-mail:** editor@mngolf.org; wp@mngolf.org. **Website:** www.mngolf.org. **Contact:** W.P. Ryan, editor. Estab. 1970. Circ. 55,000. Quarterly association magazine covering Minnesota golf scene. Sample copies available online at mngolf.org/magazine.

NEEDS Works on assignment only. Buys 25 photos from freelancers/issue; 100 photos/year. Photos of golf, golfers, and golf courses only. Will accept exceptional photography that tells a story or takes specific point of view. Reviews photos with or without manuscript. Model/property release required. Photo captions required; include date, location, name, and hometowns of all subjects.

SPECS Accepts images in digital format. Send via DVD or CD, e-mail as TIFF files.

MAKING CONTACT & TERMS Send query letter with digital medium. Provide business card or self-promotion piece to be kept on file for possible future assignments. Responds only if interested; send non-returnable samples. Pays on publication. Credit line given. Buys one-time rights. Will negotiate one-time or all rights, depending on needs of the magazine and the MGA.

TIPS "We use beautiful golf course photography to promote the game and Minnesota courses to our readers. We expect all submissions to be technically correct in terms of lighting, exposure, and color. We are interested in photos that portray the game and golf courses in new, unexpected ways. For assignments, submit work with invoice and all expenses. For unsolicited work, please include contact, fee, and rights terms submitted with photos; include captions where necessary."

MISSOURI LIFE

501 High St., Suite A, Boonville MO 65233. (660)882-9898. **Fax:** (660)882-9899. **E-mail:** dcawthon@ missourilife.com. **Website:** www.missourilife.com. **Contact:** David Cawthon, associate editor. Estab. 1973. Circ. 96,800. Bimonthly. "*Missouri Life* celebrates Missouri people and places, past and present, and the unique qualities of our great state with interesting stories and bold, colorful photography." Sample copy available for $4.95 and SASE with $2.44 first-class postage. Photo guidelines available on website.

NEEDS Buys 80 photos from freelancers/issue; more than 500 photos/year. Needs photos of environmental, seasonal, landscapes/scenics, wildlife, architecture, cities/urban, rural, adventure, historical sites, entertainment, events, hobbies, performing arts, travel. Reviews photos with or without manuscript. Model/ property release required. Photo captions required; include location, names, and detailed identification (including any title and hometown) of subjects.

SPECS Prefers images in high-res digital format (minimum 300 ppi at 8×10). Send via e-mail, CD, ZIP as EPS, JPEG, TIFF files.

MAKING CONTACT & TERMS Send query letter with résumé, stock list. Provide self-promotion piece to be kept on file for possible future assignments. Responds in 1 month. Pays $100-150 for color cover; $50 for color inside. Pays on publication. Credit line given. Buys first rights, nonexclusive rights, limited rights.

TIPS "Be familiar with our magazine and the state of Missouri. Provide well-labeled images with detailed caption and credit information."

○ MONDAY MAGAZINE

Black Press Ltd., 818 Broughton St., Victoria British Columbia V8W 1E4 Canada. (250)382-6188. **E-mail:** editor@mondaymag.com. **Website:** www.monday mag.com. **Contact:** Sarah Wilson, editor. Estab. 1975. Circ. 20,000. "*Monday Magazine* is Victoria's only alternative newsweekly. For more than 35 years, we have published fresh, informative, and alternative perspectives on local events. We prefer lively, concise writing with a sense of humor and insight."

MAKING CONTACT & TERMS Reviews GIF/ JPEG files (300 dpi at 4×6). Captions, identification of subjects required. Offers no additional payment for photos accepted with ms. Buys one-time rights.

●◎♦◑ MORPHEUS TALES

E-mail: morpheustales@gmail.com. **Website:** morpheustales.wixsite.com/morpheustales. **Contact:** Adam Bradley, publisher. Estab. 2008. Circ. 1,000. Publishes experimental fiction, fantasy, horror, and science fiction. Publishes 4-6 titles/year.

NEEDS "Look at magazine and website for style."

MAKING CONTACT & TERMS Portfolio should include b&w, color, finished, and original art. Responds within 30 days. Model and property release are required.

MOTHER JONES

Foundation for National Progress, 222 Sutter St., Suite 600, San Francisco CA 94108. (415)321-1700. **E-mail:** query@motherjones.com. **Website:** www.mother jones.com. **Contact:** Mark Murrmann, photo editor; Ivylise Simones, creative director; Monika Bauerlein and Clara Jeffery, editors. Estab. 1976. Circ. 240,000. "Recognized worldwide for publishing groundbreaking work by some of the most talented photographers, *Mother Jones* is proud to include the likes of Antonin Kratochvil, Eugene Richards, Sebastião Salgado, Lana Šlezić, and Larry Sultan as past contributors. We remain committed to championing the best in photography and are always looking for exceptional photographers with a unique visual style. It's best to give us a URL for a portfolio website. For photo essays, describe the work that you've done or propose to do; and if possible, provide a link to view the project online. We will contact you if we are interested in seeing more work."

TIPS "Please do not submit original artwork or any samples that will need to be returned. *Mother Jones* cannot be responsible for the return or loss of unsolicited artwork."

●♦○ MOTORING & LEISURE

Britannia House, 21 Station St., Brighton BN1 4DE, United Kingdom. **E-mail:** magazine@csmaclub.co.uk. **Website:** www.csma.uk.com. Circ. 300,000. In-house magazine of CSMA (Civil Service Motoring Association); 144 pages printed 10 times/year (double issue July/August and November/December). Covers car reviews, worldwide travel features, lifestyle and leisure, gardening. Sample copy available.

NEEDS Innovative photos of cars and motorbikes, old and new, to give greater choice than usual stock shots; motoring components (tires, steering wheels,

windscreens); car manufacturer logos; UK traffic signs, road markings, general traffic, minor roads and motorways; worldwide travel images; UK villages, towns and cities; families on UK outdoor holidays; caravans, motor homes, camping, picnics sites. Reviews photos with or without manuscript. Photo captions preferred; include location.

SPECS Prefers images in digital format. Send JPEG files via e-mail, 300 dpi where possible, or 72 dpi at the largest possible image size. Maximum limit per e-mail is 8MB so may need to send images in separate e-mails or compress byte size. Most file formats (EPS, TIFF, PDF, PSD) accepted for PC use. Unable to open Mac files. TIFFs and very large files should be sent on a CD.

MAKING CONTACT & TERMS Prefers to be contacted via e-mail. Simultaneous submissions and previously published work OK. Payment negotiated with individual photographers and image libraries. Credit line sometimes given if asked. Buys one-time rights.

⊛⊛ MOUNTAIN LIVING

Wiesner Media Network Communications, Inc., 1780 S. Bellaire St., Suite 505, Denver CO 80222. (303)248-2060. **Fax:** (303)248-2066. **E-mail:** greatideas@ mountainliving.com; hscott@mountainliving.com; cdeorio@mountainliving.com. **Website:** www. mountainliving.com. **Contact:** Holly Scott, publisher; Christine DeOrio, editor-in-chief. Estab. 1994. Circ. 40,000. Published 7 times/year covering architecture, interior design, and lifestyle issues for people who live in, visit, or hope to live in the mountains.

NEEDS Photos of home interiors, architecture. Model/property release required.

SPECS Prefers images in digital format. Send via CD as TIFF files at 300 dpi.

MAKING CONTACT & TERMS Submit portfolio for review. Send query letter with stock list. Provide résumé, business card, brochure, flyer or tearsheets to be kept on file for possible future assignments. Responds in 6-8 weeks. Pays $400/half day; $800/full day. **Pays on acceptance.** Credit line given. Buys one-time and first North American serial rights as well as rights to use photos on the *Mountain Living* website and in promotional materials; negotiable.

⊕⊛⊙ MUSHING MAGAZINE

2300 Black Spruce Ct., Fairbanks AK 99709. (907)495-2468. **E-mail:** editor@mushing.com; jake@mushing.

com. **Website:** www.mushing.com. **Contact:** Greg Sellentin, publisher and executive editor. Estab. 1987. Circ. 10,000.

NEEDS Uses 50 photos/issue; most supplied by freelancers. Needs action photos: all-season and wilderness; still and close-up photos: specific focus (sledding, carting, dog care, equipment, etc.). Special photo needs include skijoring, feeding, caring for dogs, summer carting or packing, 1- to 3-dog-sledding, and kids mushing. Model release preferred. Photo captions preferred.

SPECS Accepts images in digital format. Send via CD, ZIP, e-mail as JPEG files at 300 dpi.

MAKING CONTACT & TERMS Send unsolicited photos by mail for consideration. Responds in 6 months. Pays $175 maximum for color cover; $15-40 for b&w inside; $40-50 for color inside. Pays $10 extra for 1 year of electronic use rights on the Web. Pays within 60 days after publication. Credit line given. Buys first serial rights and second reprint rights.

TIPS Wants to see work that shows "the total mushing adventure/lifestyle from environment to dog house." To break in, one's work must show "simplicity, balance, and harmony. Strive for unique, provocative shots that lure readers and publishers. Send 10-40 images for review. Allow for 2-6 months' review time for at least a screened selection of these."

MUSKY HUNTER MAGAZINE

P.O. Box 340, 7978 Hwy. 70 E., St. Germain WI 54558. (715)477-2178. **Fax:** (715)477-8858. **E-mail:** editor@ muskyhunter.com. **Website:** www.muskyhunter.com. **Contact:** Jim Saric, editor. Estab. 1988. Circ. 37,000. Serves the vertical market of musky fishing enthusiasts. "We're interested in how-to, where-to articles."

⊕⊛ MUZZLE BLASTS

P.O. Box 67, Friendship IN 47021. (812)667-5131. **Fax:** (812)667-5136. **E-mail:** llarkin@nmlra.org. **Website:** www.nmlra.org. **Contact:** Lee A. Larkin, editor. Estab. 1939. Circ. 17,500. Publication of the National Muzzle Loading Rifle Association. Monthly. Emphasizes muzzleloading. Sample copy free. Photo guidelines free with SASE.

NEEDS Interested in muzzleloading, muzzleloading hunting, primitive camping. "Ours is a specialized association magazine. We buy some big-game wildlife photos but are more interested in photos featuring muzzleloaders, hunting, powder horns, and accou-

trements." Model/property release required. Photo captions preferred.

SPECS Accepts images in digital format. Send via e-mail or on a CD in JPEG or TIFF format. Also accepts 3×5 color transparencies, quality color and b&w prints. Sharply contrasting 35mm color slides are acceptable.

MAKING CONTACT & TERMS Send query letter with stock list. Keeps samples on file; include SASE for return of material. Responds in 2 weeks. Simultaneous submissions OK. Pays $300 for color cover; $25-50 for b&w inside. Pays on publication. Credit line given. Buys one-time rights.

🄢🄞 NA'AMAT WOMAN

21515 Vanowen Street, Suite 102, Canoga Park CA 91303. (818)431-2200. **E-mail:** naamat@naamat.org; judith@naamat.org. **Website:** www.naamat.org. **Contact:** Judith Sokoloff, editor. Estab. 1926. Circ. 10,000. Published three times per year, focusing on issues of concern to contemporary Jewish families and women.

NEEDS Buys 5-10 photos from freelancers/issue; 50 photos/year. Photos of Jewish themes, Israel, women, babies/children/teens, families, parents, senior citizens, landscapes/scenics, architecture, religious, travel. Interested in documentary, fine art, historical/vintage, seasonal. Reviews photos with or without manuscript. Photo captions preferred.

SPECS Uses color and b&w prints. Accepts images in digital format. Contact editor before sending.

MAKING CONTACT & TERMS Provide résumé, business card, self-promotion piece, or tearsheets to be kept on file for possible future assignments. Art director will contact photographer for portfolio review if interested. Keeps samples on file; include SASE for return of material. Responds in 6 weeks. Pays $200 maximum for cover; $35-75 for inside. Pays on publication. Credit line given. Buys one-time, first rights.

NATIONAL GEOGRAPHIC

P.O. Box 98199, Washington DC 20090-8199. (202)857-7000. **Fax:** (202)828-5460. **Website:** www. nationalgeographic.com. **Contact:** Susan Goldberg, editor in chief; David Brindley, managing editor. Estab. 1888. Circ. 3.1 million. Monthly publication of the National Geographic Society. "Our magazine and website editors do not accept any unsolicited photographs for publication. They plan articles and features months and sometimes years in advance and make assignments based on the coverage envisioned. The

one exception is "Your Shot," a monthly column in *National Geographic*, which features readers' digital photographs. Only digital photographs related to our specified monthly theme will be accepted. Get submission forms, the current theme, and more information online."

🄞 This is a premiere market that demands photographic excellence. *National Geographic* does not accept unsolicited work from freelance photographers. Photography internships and faculty fellowships are available. Contact Susan Smith, deputy director of photography, for application information.

THE NATIONAL NOTARY

9350 De Soto Ave., Chatsworth CA 91311-4926. 800-876-6827. **E-mail:** publications@nationalnotary.org. **Website:** www.nationalnotary.org. Circ. 300,000. Bimonthly association magazine. Emphasizes "Notaries Public and notarization—goal is to impart knowledge, understanding, and unity among notaries nationwide and internationally." Readers are employed primarily in the following areas: law, government, finance, and real estate.

NEEDS Number of photos purchased varies with each issue. "Photo subject depends on accompanying story/theme; some product shots used." Reviews photos with accompanying manuscript only. Model release required.

MAKING CONTACT & TERMS Send query letter with samples. Provide business card, tearsheets, résumé, or samples to be kept on file for possible future assignments. Prefers to see prints as samples. Cannot return material. Previously published work OK. Pays on publication. Credit line given "with editor's approval of quality." Buys all rights.

TIPS "Since photography is often the art of a story, the photographer must understand the story to be able to produce the most useful photographs."

🄞🄞🄞🄞 NATIONAL PARKS MAGAZINE

National Parks Conservation Association, 777 Sixth St. NW, Suite 700, Washington DC 20001. (202)223-6722; (800)628-7275. **Fax:** (202)454-3333. **E-mail:** npmag@npca.org. **Website:** www.npca.org/magazine. **Contact:** Scott Kirkwood, editor-in-chief. Estab. 1919. Circ. 340,000. Quarterly. Emphasizes the preservation of national parks and wildlife. Sample copy available for $3 and 8½×11 or larger SASE. Photo guidelines available online.

SPECS "Photographers who are new to *National Parks* may submit digitally ONLY for an initial review—we prefer links to clean, easily-navigable and searchable websites, or lightboxes with well-captioned images. We DO NOT accept and are not responsible for unsolicited slides, prints, or CDs."

MAKING CONTACT & TERMS "The best way to break in is to send a brief, concise e-mail message to Sarah Rutherford. See guidelines online. Less than 1 percent of our image needs are generated from unsolicited photographs, yet we receive dozens of submissions every week. Photographers are welcome to send postcards or other simple promotional materials that we do not have to return or respond to." Photographers who are regular contributors may submit images in the following forms: digitally via CD, DVD, or e-mail (as in attachments or a link to a lightbox or FTP site), physically as slides or prints via courier mail. Pays within 30 days after publication. Buys one-time rights.

TIPS "When searching for photos, we frequently use www.agpix.com to find photographers who fit our needs. If you're interested in breaking into the magazine, we suggest setting up a profile and posting your absolute best parks images there."

⚫⊙ NATIVE PEOPLES MAGAZINE

5333 N. Seventh St., Suite C-224, Phoenix AZ 85014. (602)265-4855. **Fax:** (602)265-3113. **E-mail:** sphillips @nativepeoples.com. **Website:** www.nativepeoples. com. **Contact:** Stephen Phillips, Publisher. Estab. 1987. Circ. 40,000. Bimonthly. "Dedicated to the sensitive portrayal of the arts and lifeways of the native peoples of the Americas." Photo guidelines upon request.

NEEDS Buys 20-50 photos from freelancers/issue; 120-300 photos/year. Needs Native American lifeways photos (babies/children/teens, celebrities, couples, multicultural, families, parents, senior citizens, events). Also uses photos of entertainment, performing arts, travel. Interested in fine art. Model/property release preferred. Photo captions preferred; include names, location and circumstances.

SPECS Accepts images in digital format. Send via CD, ZIP, e-mail as TIFF, JPEG, EPS files at 300 dpi.

MAKING CONTACT & TERMS Submit portfolio for review. Responds in 1 month. Pays on publication. Buys one-time rights.

⚫⚫ NATURAL HISTORY

P.O. Box 110623, Research Triangle Park NC 27709-5623. **E-mail:** nhmag@naturalhistorymag.com. **Website:** www.nhmag.com. Circ. 50,000. Printed 10 times/year. Readers are primarily well-educated people with interests in the sciences. Free photo guidelines available by request.

NEEDS Buys 400-450 photos/year. Subjects include animal behavior, photo essay, documentary, plant and landscape. "We are interested in photo essays that give an in-depth look at plants, animals, or people and that are visually superior. We are also looking for photos for our photographic feature, 'The Natural Moment.' This feature focuses on images that are both visually arresting and behaviorally interesting." Photos used must relate to the social or natural sciences with an ecological framework. Accurate, detailed captions required.

SPECS Prefers digital submissions; Uses 35mm, 2¼×2¼, 4×5, 6×7, 8×10 color transparencies. Covers are always related to an article in the issue.

MAKING CONTACT & TERMS Send query letter with résumé of credits. "We prefer that you send digital images. Please don't send us any non-digital photographs without a query first, describing the work you would like to send. No submission should exceed 30 original transparencies or negatives. However, please let us know if you have additional images that we might consider. Potential liability for submissions that exceed 30 originals shall be no more than $100 per slide." Responds in 2 weeks if possible. Previously published work OK but must be indicated on delivery memo. Pays (for color and b&w) $400-600 for cover; $350-500 for spread; $300-400 for oversize; $250-350 for full page; $200-300 for ¼ page; $175-250 for less than ¼ page. Pays $50 for usage on contents page. Pays on publication. Credit line given. Buys one-time rights (which includes rights for web reproduction accompanying magazine digital publication formats).

⊕⚫⊙ NATURE FRIEND MAGAZINE

4253 Woodcock Lane, Dayton VA 22821. (540)867-0764. **E-mail:** info@naturefriendmagazine.com; editor@naturefriendmagazine.com; photos@nature friendmagazine.com. **Website:** www.naturefriend magazine.com. **Contact:** Kevin Shank, editor. Estab. 1983. Circ. 8,000.

NEEDS Buys 5-10 photos from freelancers/issue; 100 photos/year. Photos of wildlife, wildlife interact-

ing with each other, humorous wildlife, all natural habitat appearance. Reviews photos with or without ms. Model/property release preferred. Photo captions preferred.

SPECS Prefers images in digital format. Send via CD or DVD as TIFF files at 300 dpi at 8×10 size; provide color thumbnails when submitting photos. "Transparencies are handled and stored carefully; however, we do not accept liability for them so discourage submissions of them."

MAKING CONTACT & TERMS Responds in 1 month to queries; 2 weeks to portfolios. "Label contact prints and digital media with your name, address, and phone number so we can easily know how to contact you if we select your photo for use. Please send articles rather than queries." Credit line given.

TIPS "We're always looking for photos of wild animals doing something unusual or humorous. Please label every sheet of paper or digital media with name, address, and phone number. We may need to contact you on short notice, and you do not want to miss a sale. Also, photos are selected on a monthly basis, after the articles. What this means to a photographer is that photos are secondary to writings and cannot be selected far in advance. High-res photos in our files the day we are making selections will stand the greatest chance of being published."

🟢 NATURE PHOTOGRAPHER

P.O. Box 220, Lubec ME 04652. (207)733-4201. E-mail: nature_photographer@yahoo.com. **Website:** www.naturephotographermag.com. Estab. 1990. Circ. 41,000. Quarterly 4-color, high-quality magazine. Emphasizes "conservation-oriented, low-impact nature photography" with strong how-to focus. Readers are male and female nature photographers of all ages. Sample copy available with 10×13 SASE with 6 first-class stamps.

◯ *Nature Photographer* charges $80/year to be a "field contributor."

NEEDS Buys 90-120 photos from freelancers/issue; 400 photos/year. Needs nature shots of "all types—abstracts, animals/wildlife, flowers, plants, scenics, environmental images, etc. Shots must be in natural settings; no set-ups, zoo, or captive animal shots accepted." Reviews photos (slides or digital images on CD) with or without ms 4 times/year: May (for fall issue); August (for winter issue); November (for spring issue); and January (for summer issue). Photo cap-

tions required; include description of subject, location, type of equipment, how photographed.

MAKING CONTACT & TERMS Contact by e-mail or with SASE for guidelines before submitting images. Prefers to see 35mm transparencies or CD of digital images. Send digital images via CD.

TIPS Recommends working with "the best lens you can afford and slow-speed slide film; or, if shooting digital, using the RAW mode." Suggests editing with a 4× or 8× loupe (magnifier) on a light board to check for sharpness, color saturation, etc. "Color prints are not normally used for publication in our magazine. When editing digital captured images, please enlarge to the point that you are certain that the focal point is tack sharp. Also avoid having grain in the final image."

💲💲 NEW MEXICO MAGAZINE

Lew Wallace Bldg., 495 Old Santa Fe Trail, Santa Fe NM 87501-2750. (505)827-7447. **E-mail:** artdirector@nmmagazine.com. **Website:** www.nmmagazine.com. Estab. 1923. Circ. 100,000. Monthly. For affluent people ages 35-65 interested in the Southwest or who have lived in or visited New Mexico. Sample copy available for $4.95 with 9×12 SASE and 3 first-class stamps. Photo guidelines available online.

NEEDS Buys 10 photos from freelancers/issue; 120 photos/year. Needs New Mexico photos only—landscapes, people, events, architecture, etc. Model release preferred.

SPECS Uses 300 dpi digital files with contact sheets (8-12 per page). Photographers must be in photodata. Photo captions required; include who, what, where.

MAKING CONTACT & TERMS Submit portfolio; include SASE for return of material, or e-mail with web gallery link. Pays $450/day; $300 for color or b&w cover; $60-100 for color or b&w stock. Pays on publication. Credit line given. Buys one-time rights.

TIPS *"New Mexico Magazine* is the official magazine for the state of New Mexico. Photographers should know New Mexico. We are interested in the less common stock of the state. The magazine is editorial driven, and all photos directly relate to a story in the magazine." Cover photos usually relate to the main feature in the magazine.

💲◯ NEW YORK STATE CONSERVATIONIST MAGAZINE

NYSDEC, 625 Broadway, Albany NY 12233-4502. (518)402-8047. **E-mail:** magazine@gw.dec.state.ny.us.

Website: www.dec.ny.gov. **Contact:** Eileen Stegemann, assistant editor. Estab. 1946. Circ. 100,000. Bimonthly nonprofit, New York State government publication. Emphasizes natural history, environmental and outdoor interests pertinent to New York State. Sample copy available for $3.50. Photo guidelines free with SASE or online.

NEEDS Uses 40 photos/issue; 80% supplied by freelancers. Needs wildlife shots, people in the environment, outdoor recreation, forest and land management, fisheries and fisheries management, environmental subjects. Also needs landscapes/scenics, cities, travel, historical/vintage, seasonal. Model release preferred. Photo captions required.

SPECS Accepts images in digital format. Send via CD as TIFF files at 300 dpi. Also uses 35mm, 2¼×2¼, 4×5, 8×10 transparencies.

MAKING CONTACT & TERMS Send material by mail for consideration, or submit portfolio for review. Provide résumé, bio, business card, brochure, flyer or tearsheets to be kept on file for possible future assignments. Responds in 3 weeks. Simultaneous submissions and previously published work OK. Pays $50 for cover photos; $15 for b&w or color inside. Pays on publication. Buys one-time rights.

TIPS Looks for "artistic interpretation of nature and the environment; unusual ways of picturing environmental subjects (even pollution, oil spills, trash, air pollution, etc.); wildlife and fishing subjects at all seasons. Try for unique composition, lighting. Technical excellence a must."

🌑🌓 NORTH AMERICAN WHITETAIL

2250 Newmarket Pkwy., Suite 110, Marietta GA 30067. (678)589-2000. **Fax:** (678)279-7512. **E-mail:** patrick.hogan@imoutdoors.com; whitetail@imoutdoors.com. **Website:** www.northamericanwhitetail.com. Estab. 1982. Circ. 125,000. Published 7 times/year (July-February) by InterMedia Outdoors. Emphasizes trophy whitetail deer hunting. Sample copy available for $4. Photo guidelines free with SASE.

NEEDS Buys 5 photos from freelancers/issue; 35 photos/year. Needs photos of large, live whitetail deer, hunter posing with or approaching downed trophy deer, or hunter posing with mounted head. Also uses photos of deer habitats and signs. Model release preferred. Photo captions preferred; include when and where scene was photographed.

SPECS Accepts images in digital format. Send via CD at 300 dpi with output of 8×12 inches. Also uses 35mm transparencies.

MAKING CONTACT & TERMS Send query letter with résumé of credits and list of stock photo subjects. Will return unsolicited material in 1 month if accompanied by SASE. Simultaneous submissions not accepted. Tearsheets provided. Pays 60 days prior to publication. Credit line given. Buys one-time rights.

TIPS "In samples we look for extremely sharp, well-composed photos of whitetaile deer in natural settings. We also use photos depicting deer hunting scenes. Please study the photos we are using before making submission. We'll return photos we don't expect to use and hold the remainder for potential use. Please do not send dupes. Use an 8×10 envelope to ensure sharpness of images, and put name and identifying number on all slides and prints. Photos returned at time of publication or at photographer's request."

🌑 NORTH CAROLINA LITERARY REVIEW

East Carolina University, Mailstop 555 English, Greenville NC 27858-4353. (252)328-1537. **Fax:** (252)328-4889. **E-mail:** nclrsubmissions@ecu.edu; bauerm@ecu.edu. **Website:** www.nclr.ecu.edu. **Contact:** Margaret Bauer. Estab. 1992. Circ. 750. Annual literary magazine with North Carolina focus. *NCLR* publishes poetry, fiction and nonfiction by and interviews with NC writers, and articles and essays about NC literature, literary history, and culture. Photographs must be NC-related. Sample copy available for $15. Photo guidelines available on website.

SPECS Accepts images in digital format, 5×7 at 300 dpi. Inquire first; submit TIFF or GIF files at 300 dpi to nclrsubmissions@ecu.edu only after requested.

MAKING CONTACT & TERMS Send query with website address to show sample of work. If selected, art editor will be in touch.

TIPS "Only NC photographers. See our website."

🌑🌑🌓 NORTH DAKOTA HORIZONS

1605 E. Capitol Ave., Suite 101, Bismarck ND 58502. (866)462-0744. **Fax:** (701)223-4645. **E-mail:** ndhorizons@btinet.net. **Website:** www.ndhorizons.com. **Contact:** Angela Magstadt, editor. Estab. 1971. Quality regional magazine. Photos used in magazines, audiovisual, calendars.

NEEDS Buys 50 photos/year; offers 10 assignments/year. Scenics of North Dakota events, places, and people. Also wildlife, cities/urban, rural, adventure, en-

tertainment, events, hobbies, performing arts, travel, agriculture, industry. Interested in historical/vintage, seasonal. Model/property release preferred. Photo captions preferred.

SPECS Prefers images in digital format. Send via CD, as TIFF, EPS files at 600 dpi.

MAKING CONTACT & TERMS Prefers e-mail query letter. Pays by the project, varies ($125-300); negotiable. Pays on usage. Credit line given. Buys one-time rights; negotiable.

◎❶❶ NOTRE DAME MAGAZINE

University of Notre Dame, 500 Grace Hall, Notre Dame IN 46556-5612. (574)631-5335. **Fax:** (574)631-6767. **E-mail:** ndmag@nd.edu. **Website:** magazine. nd.edu. **Contact:** Kerry Temple, editor; Kerry Prugh, art director. Estab. 1972. Circ. 150,000. "We are a university magazine with a scope as broad as that found at a university, but we place our discussion in a moral, ethical, and spiritual context reflecting our Catholic heritage."

NEEDS People, cities, education, architecture, business, science, environmental, and landscapes. Model and property releases are required. Photo captions are required.

MAKING CONTACT & TERMS E-mail (JPEG samples at 72 dpi) or send a postcard sample.

NOW & THEN: THE APPALACHIAN MAGAZINE

East Tennessee State University, Box 70556, Johnson City TN 37614-1707. (423)439-5348. **Fax:** (423)439-7074. **E-mail:** nowandthen@etsu.edu; sandersr@etsu. edu. **Website:** www.etsu.edu/cas/cass/nowandthen. **Contact:** Randy Sanders, managing editor. Estab. 1984. Circ. 1,000.

TIPS We cover only the Appalachian region (see the website for a definition of the region).

OFF THE COAST

Resolute Bear Press, P.O. Box 14, Robbinston ME 04671. (207)454-8026. **E-mail:** poetrylane2@gmail. com. **Website:** www.off-the-coast.com. **Contact:** Valerie Lawson, editor/publisher. Estab. 1994. "The mission of *Off the Coast* is to become recognized around the world as Maine's international poetry journal, a publication that prizes quality, diversity, and honesty in its publications and in its dealings with poets. *Off the Coast*, a quarterly journal, publishes poetry, artwork, and reviews. Arranged much like an anthology,

each issue bears a title drawn from a line or phrase from one of its poems."

MAKING CONTACT & TERMS "We accept b&w graphics and photos to grace the pages of *Off the Coast*, and color or b&w for the cover. Send 3-6 images in TIFF, PNG, or JPEG format, minimum 300 dpi resolution. We prefer you select and send images rather than send a link to your website."

❸❸❶ OKLAHOMA TODAY

Oklahoma Tourism & Recreation Department, P.O. Box 1468, Oklahoma City OK 73101-1468. (405)230-8450. **Fax:** (405)230-8650. **E-mail:** editorial@travelok. com. **Website:** www.oklahomatoday.com. **Contact:** Nathan Gunter, managing editor; Megan Rossman, photography editor. Estab. 1956. Circ. 35,000. Bimonthly. "We cover all aspects of Oklahoma, from history to people profiles, but we emphasize travel." Readers are "Oklahomans, whether they live in or out of state. Studies show them to be above average in education and income." Sample copy available for $4.95. Photo guidelines free with SASE or online.

NEEDS Buys 45 photos from freelancers/issue; 270 photos/year. Needs photos of "Oklahoma subjects only; the greatest number are used to illustrate a specific story on a person, place, or thing in the state. We are also interested in stock scenics of the state." Other areas of focus are adventure—sport/travel, reenactment, historical and cultural activities. Photo captions required.

SPECS Uses 8×10 glossy b&w prints; 35mm, 2¼×2¼, 4×5, 8×10 transparencies. "Strongly prefer images in digital format, though we can accept high-quality transparencies."

MAKING CONTACT & TERMS Send query letter with samples; include SASE for return of material. Responds in 2 months. Simultaneous submissions and previously published work OK (on occasion). Pays $125-1,000/job or $50-$200 per individual photo. Pays on publication. Buys one-time rights with a 4-month from publication exclusive, plus right to reproduce photo in promotions for magazine and on oklahomatoday.com without additional payment with credit line.

TIPS Look at the magazine.

❶ ONBOARD MEDIA

1691 Michigan Ave., Suite 600, Miami Beach FL 33139. (305)673-0400. **Fax:** (305)673-3575. **E-mail:** virginia.

valls@onboardmedia.com. **Website:** www.onboard media.com. **Contact:** Virginia Valls, director design & production. Estab. 1990. Circ. 792,184. Close to 100 annual and quarterly publications. Emphasize travel in the Caribbean, Europe, Mexican Riviera, Bahamas, Alaska, Bermuda, Las Vegas. Custom in-cabin/in-room publications reach cruise vacationers and vacation/resort audience. Photo guidelines free with SASE.

NEEDS Photos of scenics, nature, prominent landmarks based in Caribbean, Mexican Riviera, Bahamas, Alaska, Europe, and Las Vegas. Model/property release required. Photo captions required; include where the photo was taken and explain the subject matter. Credit line information requested.

SPECS Uses 35mm, 2¼×2¼, 4×5, 8×10 transparencies. Prefers images in digital format RAW data. Send via FTP at 300 dpi.

MAKING CONTACT & TERMS Send query letter with stock list. Provide résumé, business card, brochure, flier, or tearsheets to be kept on file for possible future assignments. Keeps samples on file. Responds in 3 weeks. Previously published work OK. Rates negotiable per project. Pays on publication. Credit line given.

ONE

1011 First Ave., New York NY 10022-4195. (212)826-1480. **Fax:** (212)838-1344. **E-mail:** cnewa@cnewa.org; editorial@cnewa.org. **Website:** www.cnewa.org. **Contact:** Deacon Greg Kandra, executive editor. Estab. 1974. Circ. 100,000. Official publication of Catholic Near East Welfare Association, "a papal agency for humanitarian and pastoral support." *ONE* informs Americans about the traditions, faiths, cultures, and religious communities of the Middle East, Northeast Africa, India, and Eastern Europe. Sample copy and photo guidelines available for 7.5×10.5 SAE with 2 first-class stamps. Freelancers supply 80% of photos. Prefers to work with writer/photographer team.

NEEDS Looking for evocative photos of people—not posed—involved in activities: work, play, worship. Liturgical shots also welcome. Extensive captions required if text is not available.

MAKING CONTACT & TERMS Send query letter first. "Please do not send an inventory; rather, send a letter explaining your ideas." Include 8½×11 SASE. Responds in 3 weeks, acknowledges receipt of material immediately. Simultaneous submissions and previously published work OK, but "neither is preferred. If

previously published, please tell us when and where." Pays on publication. Credit line given. "Credits appear on page 3 with masthead and table of contents." Buys first North American serial rights.

TIPS Stories should weave current lifestyles with issues and needs. Avoid political subjects, stick with ordinary people. Photo essays are welcome. Write requesting sample issue and guidelines, then send query. We rarely use stock photos but have used articles and photos submitted by a single photojournalist or writer/photographer team.

OREGON COAST

4969 Hwy. 101 N, Suite 2, Florence OR 97439. (800)348-8401. **E-mail:** alispooner@gmail.com. **Website:** www.northwestmagazines.com. **Contact:** Alicia Spooner. Estab. 1982. Circ. 50,000. Bimonthly. Emphasizes Oregon coast life. Sample copy available for $6, including postage. Photo guidelines available with SASE or on website.

NEEDS Buys 3-5 photos from freelancers/issue; 18-30 photos/year. Needs scenics. Especially needs photos of typical subjects—waves, beaches, lighthouses—with a fresh perspective. Needs mostly vertical format. Model description in megadata and on caption sheet. "Now only accepting digital images. We recommend acquiring model releases for any photos that include people, but we don't require releases except for photos used on covers or in advertising. Photos must be current, shot within the last five years."

MAKING CONTACT & TERMS Digital photos must be sent on CDs as high-res (300 dpi) TIFF, JPEG, or EPS files without compression. Images should be 8½×11. Include clear, color contact sheets of all images (no more than 8 per page). CDs are not returned. To be considered for calendars, photos must have horizontal formats. The annual deadline for calendars is August 15. Responds in 3 months. Pays $425 for color cover; $100 for calendar usage; $25-50 for b&w inside; $25-100 for color inside; $100-250 for photo/text package. Credit line given. Buys one-time rights. We do not sign for personal delivery. SASE or return postage required.

OYEZ REVIEW

Roosevelt University, Dept. of Literature & Languages, 430 S. Michigan Ave., Chicago IL 60605. **E-mail:** oyezreview@roosevelt.edu. **Website:** oyez review.wordpress.com. Estab. 1965. Circ. 600 with an e-book available. Annual magazine of the Creative

Writing Program at Roosevelt University, publishing fiction, creative nonfiction, poetry, and art. There are no restrictions on style, theme, or subject matter. Each issue has 100 pages: 92 pages of text and an 8-page b&w or color spread of 1 artist's work (usually drawing, painting, or photography) with the front and back covers totaling 10 pieces. Accepts outstanding work from beginning and established photographers. Expects a high level of professionalism from all photographers who make contact. Reviews photos with or without a ms.

NEEDS Accepts 10 photos from freelancers/issue; 10 photos/year. Needs babies/children/teens, senior citizens, cities/urban, pets, religious, rural, military, political, product shots/still life, disasters, environmental, landscapes/scenics, wildlife, adventure, automobiles, events, hobbies, humor, performing arts, sports, travel, avant garde, documentary, fine art, seasonal.

SPECS Submit in b&w or color.

MAKING CONTACT & TERMS Now accepting submissions online as well as regular mail. No longer accepting e-mail submissions. Model and property release is preferred. Photo captions are preferred.

PACIFICA LITERARY REVIEW

E-mail: pacificalitreview@gmail.com. **Website:** www.pacificareview.com. **Contact:** Matt Muth, editor-in-chief; Sarina Sheth and Paul Vega, managing editors. "*Pacifica Literary Review* is a small literary arts magazine based in Seattle. Our print editions are published biannually in winter and summer. *PLR* is now accepting submissions of poetry, fiction, creative nonfiction, author interview, and b&w photography. Submission period: September 15-May 7."

NEEDS Looking for quality b&w photography.

SPECS Guidelines available online.

MAKING CONTACT & TERMS See online submission form, accepts simultaneous submissions, acquires first North American rights.

🕲🕲 PENNSYLVANIA ANGLER & BOATER

P.O. Box 67000, Harrisburg PA 17106-7000. (717)705-7835. **E-mail:** ra-pfbcmagazine@pa.gov. **Website:** www.fish.state.pa.us. Bimonthly. "*Pennsylvania Angler & Boater* is the Keystone State's official fishing and boating magazine, published by the Pennsylvania Fish & Boat Commission." Readers are anglers and boaters in Pennsylvania. Sample copy and photo guidelines free with 9×12 SASE and 9 oz. postage, or online.

NEEDS Buys 8 photos from freelancers/issue; 48 photos/year. Needs "action fishing and boating shots." Model release required. Photo captions required.

MAKING CONTACT & TERMS "Don't submit without first considering contributor guidelines, available online. Then send query letter with résumé of credits. Send low-res images on CD; we'll later request high-res images of those shots that interest us." Responds in about 8 weeks. Pays $400 maximum for color cover; $30 minimum for color inside; $50-300 for text/photo package. Pays between acceptance and publication. Credit line given.

🕲 PENNSYLVANIA GAME NEWS

2001 Elmerton Ave., Harrisburg PA 17110-9797. (717)787-3745. **Website:** www.pgc.state.pa.us. Circ. 75,000. Monthly. Published by the Pennsylvania Game Commission. Readers are people interested in hunting, wildlife management, and conservation in Pennsylvania. Sample copy available with 9×12 SASE. Editorial guidelines free.

NEEDS Considers photos of "any outdoor subject (Pennsylvania locale), except fishing and boating." Reviews photos with accompanying manuscript. Manuscript not required.

MAKING CONTACT & TERMS The agency expects all photos to be accompanied with a photo credit (e.g., Jake Dingel/PGC Photo). E-mail Robert Mitchell at robmitchel@state.pa.us with questions about images and policy. Send prints or slides. "No negatives, please." Include SASE for return of material. Will accept electronic images via CD only (no e-mail). Will also view photographer's website if available. Responds in 2 months. Pays $40-300. **Pays on acceptance.**

🕲🕲 PERIOD IDEAS

21-23 Phoenix Court, Hawkins Rd., Colchester, Essex CO2 8JY United Kingdom. (44)(1206)505976. **E-mail:** susan.dickerson@aceville.co.uk. **Website:** www.periodideas.com. **Contact:** Susan Dickerson. Circ. 38,000. Monthly home interest magazine for readers with period properties which they wish to renovate sympathetically.

NEEDS Photos of architecture, interiors/decorating, gardens. Reviews photos with or without ms.

SPECS Uses images in digital format. Send via CD as

TIFF, JPEG files at 300 dpi.

MAKING CONTACT & TERMS Send query letter with prints or send low res images by e-mail with your query. Does not keep samples on file; include SASE for return of material. Responds only if interested; send nonreturnable samples. Accepts second rights work photos and copy; covers/packages/single shots negotiated one-on-one (please indicate expectations). Processes payment at the end of the cover-dated publication date and payment comes to contributors the following month. Credit line sometimes given. Buys one-time rights.

TIPS "Label each image with what it is, name and contact address/telephone number of photographer."

⊙⊙⊛⊙⦿ PHOTO LIFE

Apex Publications, 171 St. Paul St., Suite 102, Quebec City, Quebec G1K 3W2 Canada. (418)-692-3392. **Fax:** (800)664-2739. **E-mail:** editor@photolife.com. **Website:** www.photolife.com. **Contact:** editor. Circ. 30,000. Published 6 times/year. Readers are amateur, advanced amateur, and professional photographers. Photo submission guidelines available on website. Priority is given to Canadian photographers.

NEEDS Needs landscape/wildlife shots, fashion, scenics, b&w images, and so on.

SPECS Accepts images in digital format, must be TIFF or high-res JPEG. Send via CD at 300 dpi.

MAKING CONTACT & TERMS Send query letter with résumé of credits, SASE. Pays on publication. Buys one-time rights.

TIPS "Looking for good writers to cover any subject of interest to the amateur and advanced photographer. Fine art photos should be striking, innovative. General stock and outdoor photos should be presented with a strong technical theme."

⊙⊛ PILOT MAGAZINE

Evolution House, 2-6 Easthampstead Road, Wokingham RG40 2EG United Kingdom. +44(0)1189 742 527. **Fax:** +44(0)7834 104843. **Website:** www.pilotweb. aero. Estab. 1966. Circ. 11,500. "The UK's best-selling monthly general aviation magazine.".

NEEDS Photos of aviation. Reviews photos with or without a manuscript. Photo captions required.

SPECS Accepts images in digital format. Send via web or CD as JPEG files at 300 dpi.

MAKING CONTACT & TERMS Does not keep samples on file; include SAE for return of material.

Previously published work OK. Pays from £25 for color inside. Pays on publication. Credit line given. Buys first UK publication rights.

TIPS "Read our magazine. Label all photos with name and address. Supply generous captions."

⊙⊛⦿ PLANET

P.O. Box 44, Aberystwyth SY23 3ZZ, Wales. (44) (1970)611255. **Fax:** (44)(1970)611197. **E-mail:** planet. enquiries@planetmagazine.org.uk. **Website:** www. planetmagazine.org.uk. Estab. 1970. Circ. 1,400. Bimonthly cultural magazine devoted to Welsh culture, current affairs, the arts, the environment, but set in broader international context. Audience based mostly in Wales.

NEEDS Photos of environmental, performing arts, sports, agriculture, industry, political, science. Interested in fine art, historical/vintage. Reviews photos with or without manuscript. Model/property release preferred. Photo captions required; include subject, copyright holder.

SPECS Uses glossy color and b&w prints; 4×5 transparencies. Accepts images in digital format. Send as JPEG files at 300 dpi.

MAKING CONTACT & TERMS Send query letter with résumé, slides, prints, photocopies. Does not keep samples on file; include SASE for return of material. Simultaneous submissions and previously published work OK. Pays on publication. Credit line given. Buys first rights.

TIPS "Read the magazine first to get an idea of the kind of areas we cover so incompatible/unsuitable material is not submitted. Submission guidelines available online."

POCKETS

The Upper Room, P.O. Box 340004, Nashville TN 37203. (615)340-7333. **E-mail:** pockets@upperroom. org. **Website:** pockets.upperroom.org. **Contact:** Lynn W. Gilliam, editor. Estab. 1981. Magazine published 11 times/year. "*Pockets* is a Christian devotional magazine for children ages 6-12. All submissions should address the broad theme of the magazine. Each issue is built around one theme with material which can be used by children in a variety of ways. Scripture stories, fiction, poetry, prayers, art, graphics, puzzles, and activities are included. Submissions do not need to be overtly religious. They should help children experience a Christian lifestyle that is not always a neatly-wrapped moral package, but is open to the continu-

ing revelation of God's will. Seasonal material, both secular and liturgical, is desired."

⬤ Add name, address of photographer, and statement of parents' permission to use photos of all children appearing in the photos.

POINT

Converge (Baptist General Conference), 11002 Lake Hart Dr., Mail Code 200, Orlando FL 32832. (407)563-6083. **Fax:** (866)990-8980. **E-mail:** bob.putman@converge.org. **Website:** www.converge.org. **Contact:** Bob Putman, editor. Circ. 43,000. *Point* is the official magazine of Converge (BGC). Almost exclusively uses articles related to Converge, their churches, or by/about Converge people.

MAKING CONTACT & TERMS Reviews prints, some high-resolution digital. Captions, identification of subjects, model releases required. Offers $15-60/photo. Buys one-time rights.

✺◗◉◎ THE PRAIRIE JOURNAL

P.O. Box 68073, 28 Crowfoot Terrace NW, Calgary, Alberta T3G 3N8 Canada. **E-mail:** editor@prairiejournal.org (queries only); prairiejournal@yahoo.com. **Website:** www.prairiejournal.org. **Contact:** Anne Burke, literary editor. Estab. 1983. Circ. 650-750. Literary magazine published twice/year. Features mainly poetry and artwork. Sample copy available for $6 and 7×8½ SAE. Photo guidelines available for SAE and IRC.

NEEDS Buys 4 photos/year. Needs literary only, artistic.

SPECS Uses b&w prints. Accepts images in digital format. Send via e-mail "if your query is successful."

MAKING CONTACT & TERMS Send query letter with photocopies only (no originals) by mail. Provide self-promotion piece to be kept on file. Responds in 6 months, only if interested; send nonreturnable samples. Pays $10-50 for b&w cover or inside. Pays on publication. Credit line given. Buys first rights.

TIPS "B&w literary, artistic work preferred; not commercial. We especially like newcomers. Read our publication, or check out our website. You need to own copyright for your work and have permission to reproduce it. We are open to subjects that would be suitable for a literary arts magazine containing poetry, fiction, reviews, interviews. We do not commission but choose from your samples."

◎◗◉ PRAIRIE MESSENGER

Benedictine Monks of St. Peter's Abbey, P.O. Box 190, 100 College Dr., Muenster, Saskatchewan S0K 2Y0 Canada. (306)682-1772. **Fax:** (306)682-5285. **E-mail:** pm.canadian@stpeterspress.ca. **Website:** www.prairie messenger.ca. **Contact:** Maureen Weber, associate editor. Estab. 1904. Circ. 4,000. Weekly Catholic publication published by the Benedictine Monks of St. Peter's Abbey in Muenster, Saskatchewan, Canada. Has a strong focus on ecumenism, social justice, interfaith relations, aboriginal issues, arts, and culture.

NEEDS People, religious, agriculture, industry, military, environmental, entertainment, performing arts, lifestyle, seasonal photographs. Buys 50 photos/year. "I usually need photos to illustrate columns and occasionally use 'filler' feature photos with captions I either make up or seek quotations for. This means a range of themes is possible, including seasonal, environmental, religious, etc. Also, we carry a weekly poem submitted by freelancers, but I use stock photos to illustrate the poems."

MAKING CONTACT & TERMS Accepts photos as TIFF or JPEG format. E-mail with JPEG samples at 72 dpi. Credit line given.

PRINCETON ALUMNI WEEKLY

194 Nassau St., Suite 38, Princeton NJ 08542. 609-258-4931. **E-mail:** mmarks@princeton.edu. **Website:** www.princeton.edu/paw. **Contact:** Marilyn Marks, editor. Circ. 60,000. Published 15 times/year. Emphasizes Princeton University and higher education. Readers are alumni, faculty, students, staff, and friends of Princeton University. Sample copy available for $2 with 9×12 SASE and 2 first-class stamps.

NEEDS Assigns local and out-of-state photographers and purchases stock. Needs photos of people, campus scenes; subjects vary greatly with content of each issue.

MAKING CONTACT & TERMS Arrange a personal interview to show portfolio. Provide sample card to be kept on file for possible future assignments. Payment varies according to usage, size, etc. Pays on publication. Buys one-time rights.

◎◉◗ RACQUETBALL MAGAZINE

1685 W. Uintah, Suite 103, Colorado Springs CO 80904-2906. (719)635-5396. **Fax:** (719)635-0685. **E-mail:** membership@usra.org. **Website:** www.usa racquetball.com. Estab. 1990. Circ. 30,000. Bimonthly magazine of USA Racquetball. Emphasizes racquet-

ball. Sample copy available for $4.50. Photo guidelines available.

NEEDS Buys 6-12 photos from freelancers/issue; 36-72 photos/year. Needs photos of action racquetball. Model/property release preferred. Photo captions required.

SPECS Accepts images in digital format. Send via CD as EPS files at 900 dpi.

MAKING CONTACT & TERMS Provide résumé, business card, brochure, flyer, or tearsheets to be kept on file for possible future assignments. Responds in 1 month. Previously published work OK. Pays on publication. Credit line given. Buys all rights; negotiable.

🐾🐾 RANGER RICK

1100 Wildlife Center Dr., Reston VA 20190. **E-mail:** Use online contact form. **Website:** www.nwf.org/ Kids/Ranger-Rick.aspx. Estab. 1967. Monthly educational magazine published by the National Wildlife Federation for children ages 8-12. Uses 3-5 assignments per issues.

NEEDS Photos of children, multicultural, environmental, wildlife, adventure, science.

MAKING CONTACT & TERMS Send nonreturnable printed samples or website address. *Ranger Rick* space rates: $300 (¼page) to $1,000 (cover).

TIPS "NWF's mission is to inspire Americans to protect wildlife for our children's future. Seeking experienced photographers with substantial publishing history only."

REVOLUTIONARY WAR TRACKS

E-mail: revolutionarywartracks@yahoo.com. **Contact:** Shannon Bridget Murphy. Estab. 2005. Quarterly. "Bringing Revolutionary War history alive for children and teens." Photo guidelines available by e-mail request.

NEEDS Buys 12-24 photos/year. Photos of babies/ children/teens, multicultural, families, parents, disasters, environmental, landscapes/scenics, wildlife, cities/urban, education, religious, rural, adventure, events, food/drink, sports, travel, agriculture, medicine, military, political, product shots/still life, science, technology—as related to Revolutionary War history. Interested in alternative process, avant garde, documentary, fashion/glamour, fine art, historical/ vintage, seasonal. Reviews photos with or without a manuscript. Model/property release preferred.

SPECS Uses glossy or matte color and b&w prints.

MAKING CONTACT & TERMS Send query letter via e-mail. "If possible, please do not include photographs in files if they are sent through e-mail. A disc with your photographs is acceptable." Provide résumé, business card, or self-promotion piece to be kept on file for possible future assignments. "Photographs sent with CDs are requested but not required." Responds within 1 month to queries; 1 week to portfolios. Simultaneous submissions and previously published work OK. **Pays on acceptance.** Credit line given. Buys one-time rights, first rights; negotiable.

THE ROCKFORD REVIEW

Rockford Writers' Guild, Rockford Writers' Guild, P.O. Box 858, Rockford IL 61105. **E-mail:** editor@ rockfordwritersguild.org. **E-mail:** editor@rockford writersguild.org. **Website:** www.rockfordwriters guild.org. **Contact:** Connie Kuntz. Estab. 1947. Circ. 600. Association publication of Rockford Writers' Guild. Published twice/year, members only edition in summer-fall; winter-spring edition is open to all writers. Open season to submit for winter/spring edition of *The Rockford Review* is July 15-October 15. Sample copy available for $12.

NEEDS At this time, we are not accepting photographs. We have a cover artist.

TIPS "Check website for frequent updates. We are also on Facebook under 'Rockford Writers' Guild. Follow us on Twitter and Instagram @guildypleasures."

ROLLING STONE

Wenner Media, 1290 Avenue of the Americas, New York NY 10104. (212)484-1616. **Fax:** (212)484-1664. **E-mail:** rseditors@rollingstone.com. **Website:** www. rollingstone.com. **Contact:** Caryn Ganz, editorial director. Circ. 1.46 million. Monthly. Emphasizes film, CD reviews, music groups, celebrities, fashion. Readers are young adults interested in news of popular music, politics, and culture.

NEEDS Photos of celebrities, political, entertainment, events. Interested in alternative process, avant garde, documentary, fashion/glamour.

SPECS Accepts images in digital format. Send as TIFF, JPEG files at 300 dpi.

MAKING CONTACT & TERMS Portfolio may be dropped off every Wednesday and picked up on Friday afternoon. Provide business card, self-promotion piece to be kept on file for possible future assignments. Responds only if interested; send nonreturnable samples.

TIPS "It's not about a photographer's experience, it's about a photographer's talent and eye. Lots of photographers have years of professional experience, but their work isn't for us. Others might not have years of experience, but they have this amazing eye."

SALT HILL LITERARY JOURNAL

E-mail: salthillart@gmail.com. **Website:** www.salthilljournal.net. **Contact:** art editor. Circ. 1,000. "*Salt Hill* seeks unpublished 2D art: drawings, paintings, photography, mixed media, documentation of 3D art, typographic art diagrams, maps, etc., for its semiannual publication. We offer all colors, shapes, and stripes."

NEEDS Seeking graphic novels, literary and experimental art. Sample copy available for $6. Responds in 3 months.

MAKING CONTACT & TERMS See website for specifications.

SANDLAPPER MAGAZINE

Sandlapper Society, Inc., 3007 Millwood Ave., Columbia SC 29205. (803)779-8763. **Fax:** (803)254-4833. **E-mail:** elaine@sandlapper.org. **Website:** www.sandlapper.org. **Contact:** Elaine Gillespie, executive director. Estab. 1969. Circ. 8,000. Quarterly. Emphasizes South Carolina topics only.

NEEDS Uses about 10 photographers/issue. Photos of anything related to South Carolina in any style, "as long as they're not in bad taste." Model release preferred. Photo captions required; include places and people.

SPECS Uses 8×10 color and b&w prints; 35mm, 2¼×2¼, 4×5, 8×10 transparencies. Accepts images in digital format. Send via CD, ZIP as TIFF, JPEG files at 300 dpi. "Do not format exclusively for PC. RGB preferred. Submit low- and high-res files, and label them as such."

MAKING CONTACT & TERMS Send query letter with samples. Keeps samples on file; include SASE for return of material. Responds in 1 month. Pays 1 month *after* publication. Credit line given. Buys first rights plus right to reprint.

TIPS "We see plenty of beach sunsets, mountain waterfalls, and shore birds. Would like fresh images of people working and playing in the Palmetto state."

SANTA BARBARA MAGAZINE

2064 Alameda Padre Serra, Suite 120, Santa Barbara CA 93103. (805)965-5999. **Fax:** (805)965-7627. **E-mail:** alisa@sbmag.com. **Website:** www.sbmag.com. **Contact:** Alisa Baur, art director; Gina Tolleson, editor. Estab. 1975. Circ. 40,000. Bimonthly. Emphasizes Santa Barbara community and culture. Sample copy available for $4.95 with 9×12 SASE.

NEEDS Buys 64-80 photos from freelancers/issue; 384-480 photos/year. Needs portrait, environmental, architectural, travel, celebrity, etc. Reviews photos with accompanying manuscript only. Model release required. Photo captions preferred.

MAKING CONTACT & TERMS Provide résumé, business card, brochure, flier, or tearsheets to be kept on file for possible future assignments; "portfolio drop-off 24 hours." Cannot return unsolicited material. Pays $75-250 for b&w or color. Pays on publication. Credit line given. Buys first North American serial rights.

SCHOLASTIC MAGAZINES

557 Broadway, New York NY 10012. (212)343-7147. **Fax:** (212)389-3913. **E-mail:** sdiamond@scholastic.com. **Website:** www.scholastic.com. **Contact:** Steven Diamond, executive director of photography. Estab. 1920. Publication of magazines varies from weekly to monthly. "We publish 27 titles on topics from current events, science, math, fine art, literature, and social studies. Interested in featuring high-quality, well-composed images of students of all ages and all ethnic backgrounds. We publish hundreds of books on all topics, educational programs, Internet products, and new media."

NEEDS Photos of various subjects depending upon educational topics planned for academic year. Model release required. Photo captions required. "Images must be interesting, bright, and lively!"

SPECS Accepts images in digital format. Send via CD, e-mail.

MAKING CONTACT & TERMS Send query letter with résumé, business card, brochure, flier, or tearsheets to be kept on file for possible future assignments. Material cannot be returned. Previously published work OK. Pays on publication.

TIPS Especially interested in good photography of all ages of student population. All images must have model/property releases.

SCRAP

1615 L St. NW, Suite 600, Washington DC 20036-5664. (202)662-8547; (202) 662-8500. **Fax:** (202)626-0947.

E-mail: kentkiser@scrap.org. **Website:** www.scrap.org. **Contact:** Kent Kiser, publisher. Estab. 1987. Circ. 9,600. Bimonthly magazine of the Institute of Scrap Recycling Industries. Emphasizes scrap recycling for owners and managers of recycling operations worldwide. Sample copy available for $8.

NEEDS Buys 0-15 photos from freelancers/issue; 15-70 photos/year. Needs operation shots of companies being profiled and studio concept shots. Model release required. Photo captions required.

SPECS Accepts images in digital format. Send via CD, ZIP, e-mail as JPEG or TIFF file at 300 dpi.

MAKING CONTACT & TERMS Provide résumé, business card, brochure, flier, or tearsheets to be kept on file for possible future assignments. Previously published work OK. Pays $800-1,500/day; $100-400 for b&w inside; $200-600 for color inside. Pays on delivery of images. Credit line given. Rights negotiable.

TIPS Photographers must possess "ability to photograph people in corporate atmosphere, as well as industrial operations; ability to work well with executives, as well as laborers. We are always looking for good color photographers to accompany our staff writers on visits to companies being profiled. We try to keep travel costs to a minimum by hiring photographers located in the general vicinity of the profiled company. Other photography (primarily studio work) is usually assigned through freelance art director."

❸◯ SEA

Duncan McIntosh Co., 17782 Cowan, Suite C, Irvine CA 92614. (949)660-6150. **Fax:** (949)660-6172. **E-mail:** editorial@seamag.com; mikew@seamag.com. **Website:** seamag.com. **Contact:** Mike Werling, managing editor. Circ. 50,000. Monthly. Emphasizes "recreational boating in 13 Western states (including some coverage of Mexico and British Columbia) for owners of recreational power boats." Sample copy and photo guidelines free with 10×13 SASE.

NEEDS Uses about 50-75 photos/issue; most supplied by freelancers; 10% assignment; 75% requested from freelancers, existing photo files, or submitted unsolicited. Needs "people enjoying boating activity (families, parents, senior citizens) and scenic shots (travel, regional); shots that include parts or all of a boat are preferred." Photos should have West Coast angle. Model release required. Photo captions required.

SPECS Accepts images in digital format. Send via

CD, FTP, e-mail as TIFF, EPS, JPEG files at least 300 dpi. Contact via online form to query.

MAKING CONTACT & TERMS Send query letter with samples; include SASE for return of material. Responds in 1 month. Pay rate varies according to size published. Pays on publication. Credit line given. Buys one-time North American rights and retains reprint rights via print and electronic media.

TIPS "We are looking for sharp images with good composition showing pleasure boats in action, and people having fun aboard boats in a West Coast location. Digital shots are preferred; they must be at least 5" wide and a minimum of 300 dpi. We also use studio shots of marine products and do personality profiles. Send samples of work with a query letter and a résumé or clips of previously published photos. *Sea* does not pay for shipping; will hold photos up to 6 weeks."

SEVENTEEN MAGAZINE

300 W. 57th St., 17th Floor, New York NY 10019. (917)934-6500. **Fax:** (917)934-6574. **E-mail:** mail@seventeen.com. **Website:** www.seventeen.com. **Contact:** Consult masthead to contact appropriate editor. Estab. 1944. Circ. 2,000,000. *Seventeen* is a young women's fashion and beauty magazine. Tailored to young women in their teens and early 20s, *Seventeen* covers fashion, beauty, health, fitness, food, cars, college, careers, talent, entertainment, plus crucial personal and global issues. Photos purchased on assignment only. Query before submitting.

SHINE BRIGHTLY

GEMS Girls' Clubs, 1333 Alger St., SE, Grand Rapids MI 49507. (616)241-5616. **Fax:** (616)241-5558. **E-mail:** shinebrightly@gemsgc.org. **Website:** www.gemsgc.org. **Contact:** Kelli Gilmore, managing editor. Estab. 1970. Circ. 14,000. Monthly publication of GEMS Girls' Club. Emphasizes girls ages 9-14 in action. The magazine is a Christian girls' publication that inspires, motivates, and equips girls to become world changers. Sample copy and photo guidelines available for $1 with 9×12 SASE.

NEEDS Uses about 5-6 photos/issue. "Photos suitable for illustrating stories and articles: photos of babies/children/teens, multicultural, religious, girls aged 9-14 from multicultural backgrounds, close-up shots with eye contact." Model/property release preferred.

SPECS Uses 5×7 glossy color prints. Accepts images in digital format. Send via ZIP, CD as TIFF, BMP files

at 300 dpi.

MAKING CONTACT & TERMS Send 5×7 glossy color prints by mail (include SASE), electronic images by CD only (no e-mail) for consideration. Will view photographer's website if available. Responds in 2 months. Simultaneous submissions OK. Pays $50-75 for cover; $35 for color inside. Pays on publication. Credit line given. Buys one-time rights.

TIPS "Make the photos simple. We prefer to get a spec sheet or CDs rather than photos, and we'd really like to hold photos for our annual theme update and try to get photos to fit the theme of each issue." Recommends that photographers "be concerned about current trends in fashions, hair styles, and realize that all girls don't belong to 'families.' Please, no slides, no negatives, and no e-mail submissions."

❸❸❶ SHOOTING SPORTS USA

11250 Waples Mill Rd., Fairfax VA 22030. (703)267-1310; (800)672-3888. **E-mail:** shootingsportsusa@nrahq.org; publications@nrahq.org; clohman@nrahq.org. **Website:** www.nrapublications.org. **Contact:** Chip Lohman, editor. Monthly publication of the National Rifle Association of America. Emphasizes competitive shooting sports (rifle, pistol, and shotgun). Readers range from beginner to high master. Past issues available online. Editorial guidelines free via e-mail.

NEEDS 15-25 photos from freelancers/issue; 180-300 photos/year. Needs photos of how-to, shooting positions, specific shooters. Quality photos preferred with accompanying manuscript. Model release required. Photo captions preferred.

SPECS Accepts images in digital format. Send via CD or e-mail as TIFF files at 300 dpi.

MAKING CONTACT & TERMS Send query letter with photo and editorial ideas by e-mail. Include SASE. Responds in 1 week. Previously published work OK when cleared with editor. Pays $150-400 for color cover; $50-150 for color inside; $250-500 for photo/text package; amount varies for photos alone. Pays on publication. Credit line given. Buys first North American serial rights.

TIPS Looks for "generic photos of shooters shooting, obeying all safety rules and using proper eye protection and hearing protection. If text concerns certain how-to advice, photos are needed to illuminate this. Always query first. We are in search of quality photos to interest both beginning and experienced shooters."

❶ SHOTS

P.O. Box 27755, Minneapolis MN 55427-0755. **E-mail:** shots@shotsmag.com. **Website:** www.shotsmag.com. **Contact:** Russell Joslin, editor/publisher. Circ. 2,000. Quarterly fine art photography magazine. "We publish b&w fine art photography by photographers with an innate passion for personal, creative work." Sample copy available for $7.25. Photo guidelines free with SASE or on website.

NEEDS Fine art photography of all types accepted for consideration (but not bought). Reviews photos with or without a manuscript. Model/property release preferred. Photo captions preferred.

SPECS Uses 8×10 b&w prints. Accepts images in digital format. Send via CD as TIFF files at 300 dpi. "See website for further specifications."

MAKING CONTACT & TERMS Send query letter with prints. There is a $16 submission fee for non-subscribers (free for subscribers). Include SASE for return of material. Responds in 3 months. Credit line given. Does not buy photographs/rights.

❷❸❸ SKI CANADA

117 Indian Rd., Toronto Ontario M6R 2V5, Canada. (416)538-2293. **E-mail:** mac@skicanadamag.com; design@skicanadamag.com. **Website:** www.skicanadamag.com. **Contact:** Iain MacMillan, editor. Circ. 46,438. Published monthly, September-January. Readership is 65% male, ages 25-44, with high income. Sample copy free with SASE.

NEEDS Buys 80 photos from freelancers/issue; 480 photos/year. Needs photos of skiing—travel (within Canada and abroad), new school, competition, equipment, instruction, news, and trends.

SPECS Accepts images in digital format. Send via e-mail to norm@k9designco.com.

MAKING CONTACT & TERMS "The publisher assumes no responsibility for the return of unsolicited material." Provide résumé, business card, brochure, flyer, or tearsheets to be kept on file for possible future assignments. Responds in 1 month. Simultaneous submissions OK. Pays within 30 days of publication. Credit line given. Editorial lineup available online.

◎❹ SKIPPING STONES: A MULTICULTURAL LITERARY MAGAZINE

P.O. Box 3939, Eugene OR 97403-0939. (541)342-4956. **E-mail:** editor@skippingstones.org. **Website:** www.skippingstones.org. **Contact:** Arun Toké, editor. Es-

tab. 1988. Circ. 1,600 print, plus Web. "We promote multicultural awareness, international understanding, nature appreciation, and social responsibility. We suggest authors, artists, and photographers not make stereotypical generalizations in their contributions. We like when they include their own experiences, or base their articles on their personal immersion experiences in a culture or country." Has featured Xuan Thu Pham, Soma Han, Jon Bush, Zarouhie Abdalian, Paul Dix, Elizabeth Zunon, and Najah Clemmons.

NEEDS Buys teens/children, celebrities, multicultural, families, disasters, environmental, landscapes, wildlife, cities, education, gardening, rural, events, health/fitness/beauty, travel, documentary, and seasonal. Reviews 4×6 prints, low-res JPEG files. Captions required.

MAKING CONTACT & TERMS Send query letter or e-mail with photographs (digital JPEGs at 72 dpi).

TIPS "We are a multicultural magazine for youth and teens. We consider your work as a labor of love that contributes to the education of youth. We publish photoessays on various cultures and countries/regions of the world in each issue of the magazine to promote international and intercultural (and nature) understanding. Tell us a little bit about yourself, your motivation, goals, and mission."

◉ SMITHSONIAN MAGAZINE

Capital Gallery, Suite 6001, MRC 513, P.O. Box 37012, Washington DC 20013. (202)275-2000. **E-mail:** smithsonianmagazine@si.edu. **Website:** www.smithsonianmag.com. **Contact:** Molly Roberts, photo editor; Jeff Campagna, art services coordinator. Circ. 2.3 million. Monthly. "*Smithsonian* chronicles the arts, environment, sciences, and popular culture of the times for today's well-rounded individuals with diverse, general interests, providing its readers with information and knowledge in an entertaining way." Visit website for photo submission guidelines. *Does not accept unsolicited photos or portfolios.* Use online submission form. Query before submitting.

❸❸❸❶ SOUTHWEST AIRLINES SPIRIT

Spirit Magazine Editorial Office, Pace Communications, Inc., 2811 McKinney Ave., Suite 360, Dallas TX 75204. (214)580-8070. **Fax:** (214)580-2491. **Website:** www.spiritmag.com. **Contact:** Emily Kimbro, art director. Circ. 350,000. Monthly in-flight magazine. "Reader is college-educated business person, median age of 45, median household income of $82,000. Spirit targets the flying affluent. Adventurous perspective on contemporary themes." Sample copy available for $3. Photo guidelines available.

NEEDS Buys 5-10 photos from freelancers/issue; 120 photos/year. Needs photos of celebrities, couples, multicultural, environmental, landscapes/scenics, wildlife, architecture, cities/urban, adventure, automobiles, entertainment, events, food/drink, health/fitness, hobbies, humor, performing arts, sports, travel, business concepts, industry, medicine, political, product shots/still life, science, technology. Interested in alternative process, avant garde, documentary, fashion/glamour. Reviews photos with or without a manuscript. Model/property release required. Photo captions required; include names of people in shot, location, names of buildings in shot.

SPECS Uses 35mm, 2¼×2¼, 4×5 transparencies. Accepts images in digital format. Send via CD as TIFF, EPS files at 300 dpi.

MAKING CONTACT & TERMS "Queries are accepted by mail only; e-mail and phone calls are strongly discouraged." Send query letter with slides, prints, photocopies, tearsheets, transparencies, SASE. Portfolio may be dropped off Monday through Friday. Provide self-promotion piece to be kept on file for possible future assignments. Responds only if interested; send nonreturnable samples. Pays $1,000-1,500 for cover; $900-2,500 for inside. **Pays on acceptance.** Credit line given. Buys one-time rights.

TIPS "Read our magazine. We have high standards set for ourselves and expect our freelancers to have the same or higher standards."

SPORTS ILLUSTRATED

Time, Inc., 1271 Avenue of the Americas, New York NY 10020. (212)522-1212. **E-mail:** story_queries@simail.com. **Website:** www.si.com. Estab. 1954. Circ. 3 million. *Sports Illustrated* reports and interprets the world of sports, recreation, and active leisure. It previews, analyzes, and comments on major games and events, as well as those noteworthy for character and spirit alone. In addition, the magazine has articles on such subjects as fashion, physical fitness, and conservation. Query before submitting.

❸◉ STICKMAN REVIEW

E-mail: art@stickmanreview.com. **Website:** www.stickmanreview.com. **Contact:** Anthony Brown, editor. Estab. 2001. Biannual literary magazine publish-

ing fiction, poetry, essays, and art for a literary audience. Sample copies available on website.

NEEDS Accepts 1-2 photos from freelancers/issue; 4 photos/year. Interested in alternative process, avant garde, documentary, erotic, fine art. Reviews photos with or without a manuscript.

SPECS Accepts images in digital format. Send via e-mail as JPEG, GIF, TIFF, PSD files.

MAKING CONTACT & TERMS Contact through e-mail only. Does not keep samples on file; cannot return material. Do not query, just submit the work you would like considered. Responds 2 months to portfolios. Simultaneous submissions OK. Credit line given.

TIPS "Please check out the magazine on our website. We are open to anything, so long as its intent is artistic expression."

STIRRING: A LITERARY COLLECTION

Sundress Publications, **E-mail:** stirring@sundress publications.com. **E-mail:** stirring.nonfiction@gmail.com; reviews@sundresspublications.com; stirring.fiction@gmail.com; stirring.poetry@gmail.com; stirring.artphoto@gmail.com. **Website:** www.stirringlit.com. **Contact:** Luci Brown and Andrew Koch, managing editors and poetry editors; Kat Saunders, fiction editor; Donna Vorreyer, reviews editor; Gabe Montesanti, nonfiction editor. Estab. 1999. Circ. 2,500/month.

MAKING CONTACT & TERMS For photography, send all submissions as JPEG attachments to stirring photo@sundresspublications.com.

SUBTERRAIN

Strong Words for a Polite Nation, P.O. Box 3008, MPO, Vancouver, British Columbia V6B 3X5 Canada. (604)876-8710. **Fax:** (604)879-2667. **E-mail:** subter@portal.ca. **Website:** www.subterrain.ca. **Contact:** Brian Kaufman, editor-in-chief; Natasha Sanders-Kay, managing editor. Estab. 1988. Circ. 3,500.

THE SUN

107 N. Roberson St., Chapel Hill NC 27516. (919)942-5282. **Fax:** (919)932-3101. **Website:** www.thesun magazine.org. **Contact:** Sy Safransky, editor. Estab. 1974. Circ. 72,000. Needs b&w photos and photo essays. Sample copy available online. Photo guidelines free with SASE or on website.

NEEDS Buys 10-30 photos/issue; 200-300 photos/year. Needs photo essays and individual photographs that relate to political, spiritual, environmental, and social themes. "We're looking for artful and sensitive photographs that aren't overly sentimental. Most of our photos of people feature unrecognizable individuals, although we do run portraits in specific places, including the cover." Model/property release strongly preferred.

SPECS Uses 5×7 to 11×17 glossy or matte b&w prints. Slides are not accepted, and color photos are discouraged. "We began accepting digital photo submissions in early 2014. If you are submitting digital images, please send high-quality digital prints first. If we accept your images for publication, we will request the image files on CD or DVD media (Mac or PC) in uncompressed TIFF grayscale format at 300 dpi or greater."

MAKING CONTACT & TERMS Include SASE for return of material. Responds in 3-6 months. Simultaneous submissions and previously published work OK. "Submit no more than 30 of your best b&w prints." Pays $500 for b&w cover; $100-250 for b&w inside. Pays on publication. Credit line given. Buys one-time rights.

SURFACE MAGAZINE

140 W. 26th St., Street Level W., New York NY 10001. (212)229-1500. **E-mail:** editorial@surfacemag.com. **Website:** www.surfacemag.com. Estab. 1994. Circ. 112,000. Published 6 times/year. "*Surface* is the definitive American source for engaging, curated content covering all that is inventive and compelling in the design world. Contains profiles of emerging designers and provocative projects that are reshaping the creative landscape."

NEEDS Buys 200 photos from freelancers/issue; 1,600 photos/year. Needs photos of environmental, landscapes/scenics, architecture, cities/urban, interiors/decorating, performing arts, travel, product shots/still life, technology. Interested in avant garde, fashion, portraits, fine art, seasonal.

SPECS Uses 11×17 glossy matte prints; 35mm, 2¼×2¼, 4×5, 8×10 transparencies. Accepts images in digital format. Send via CD, ZIP as TIFF, JPEG files at 300 dpi.

MAKING CONTACT & TERMS Contact through rep or send query letter with prints, photocopies, tearsheets. Provide self-promotion piece to be kept on file for possible future assignments. "Portfolios are reviewed on Friday each week. Submitted portfolios must be clearly labeled and include a shipping

account number or postage for return. Please call for more details." Responds only if interested; send non-returnable samples. Simultaneous submissions OK. Credit line given.

💲❸❶ SURFING MAGAZINE

E-mail: tony.perez@sorc.com; peter@surfing magazine.com. **Website:** www.surfingthemag.com. **Contact:** Tony Perez, publisher; Peter Taras, photo editor. Circ. 180,000. Monthly. "Emphasizes surfing action and related aspects of beach lifestyle. Travel to new surfing areas covered as well. Average age of readers is 17 with 95% being male. Nearly all drawn to publication due to high-quality, action-packed photographs." Sample copy available with legal-size SASE and 9 first-class stamps. Photo guidelines free with SASE or via e-mail.

NEEDS Buys an average of 10 photos from freelancers/issue. Needs "in-tight, front-lit surfing action photos, as well as travel-related scenics. Beach lifestyle photos always in demand."

SPECS Uses 35mm transparencies. Accepts digital images via CD; contact for digital requirements before submitting digital images.

MAKING CONTACT & TERMS Send samples by mail for consideration; include SASE for return of material. Responds in 1 month. Pays on publication. Credit line given. Buys one-time rights.

TIPS Prefers to see "well-exposed, sharp images showing both the ability to capture peak action, as well as beach scenes depicting the surfing lifestyle. Color, lighting, composition, and proper film usage are important. Ask for our photo guidelines prior to making any film/camera/lens choices."

TERRAIN.ORG: A JOURNAL OF THE BUILT & NATURAL ENVIRONMENTS

(520)241-7390. **E-mail:** contact2@terrain.org. **Website:** www.terrain.org. **Contact:** Simmons Buntin, editor-in-chief. Estab. 1997. Circ. 250,000 visits/year. Tri-annual online literary journal. Terrain.org publishes a mix of literary and technical work—editorials, poetry, essays, fiction, articles, reviews, interviews and unsprawl case studies; plus artwork (the ARTerrain gallery plus photo essays and the like); only online for free at www.terrain.org. Terrain has an international audience. Sample copies available online. Art and photo submission guidelines available on website or via mail with SASE. Very general guidelines, query first for artwork.

NEEDS Does not purchase art, but does publish photography. Encourages beginning or unpublished photographers to submit work for consideration. Publishes new photographers, may only pay in copies or have a low pay rate. Reviews photos with or without a manuscript. Model and property releases not required, but preferred. Photo captions are required if submitted as a gallery for ARTerrain or as a photo essay. Otherwise, captions are preferred.

SPECS Accepts images in digital format. Send via CD, zip, e-mail, Dropbox or yousendit.com. Formats preferred: TIFF, GIF, JPEG, PNG at 72 dpi, at least 1,200 pixels high and/or wide.

MAKING CONTACT & TERMS Keeps samples on file, include self-promotion piece to be kept on file for possible future assignments. Responds in 4 weeks. Considers simultaneous submissions and previously published work. Portfolio not required. Generally do not pay for photographs. Buys electronic rights. Credit line given. Paid on publication. Finds freelancers through submissions, word-of-mouth, and Internet.

TIPS "Because Terrain.org is a self-funded, nonprofit endeavor, we currently do not pay for contributions, whether artwork, photographs, or narrative. However, we truly value high-quality artwork and provide broad international exposure to work, particularly in each issue's ARTerrain gallery. We seek photo essays, hybrid forms and other work that takes advantage of our online medium (photo essays with audio, for example). Submit direct samples, or at least URLs to specific artwork. We unfortunately don't have time to investigate a full website or portfolio if all the artist sends is the home page link."

TEXAS GARDENER

Suntex Communications, Inc., P.O. Box 9005, Waco TX 76714. (254)848-9393. **Fax:** (254)848-9779. **E-mail:** info@texasgardener.com. **Website:** www.texas gardener.com. **Contact:** Chris Corby. Estab. 1981. Circ. 20,000. Bimonthly. Emphasizes gardening. Readers are 51% male, 49% female, home gardeners, 98% Texas residents. Sample copy available for $6.00 (includes postage).

NEEDS Buys 18-27 photos from freelancers/issue; 108-162 photos/year. Needs color photos of gardening activities in Texas. Special needs include cover photos shot in vertical format. Must be taken in Texas. Photo captions required.

SPECS Prefers high-res digital images. Send accept-

ed images as JPEG or TIFF files by e-mail or Dropbox to michael@texasgardener.com.

MAKING CONTACT & TERMS Send query letter with samples, SASE. Responds in 3 weeks. Pays $100-200 for color cover; $25-100 for color inside. Pays on publication. Credit line given. Buys one-time rights.

TIPS "Provide complete information on photos. For example, if you submit a photo of watermelons growing in a garden, we need to know what variety they are and when and where the picture was taken."

THEMA

Thema Literary Society, P.O. Box 8747, Metairie LA 70011-8747. **E-mail:** thema@cox.net, only for writers living outside the U.S. **Website:** themaliterarysociety.com. **Contact:** Virginia Howard, editor; Gail Howard, poetry editor. Estab. 1988. Literary magazine published 3 times/year emphasizing theme-related short stories, poetry, creative nonfiction, photography, and art. Sample copy available for $15.

NEEDS Photo must relate to one of *THEMA*'s upcoming themes (**indicate the target theme on submission of photo**). See website for themes.

SPECS Uses 5×7 glossy color and/or b&w prints. Accepts images in digital format. Send via ZIP as TIFF files at 200 dpi. Portrait orientation preferred.

MAKING CONTACT & TERMS Send query letter with prints, photocopies. Does not keep samples on file; include SASE for return of material. Responds in 1 week to queries; 3 months after deadline to submissions. Simultaneous submissions and previously published work OK. Pays $25 for cover; $10 for b&w inside, plus one contributor's copy. **Pays on acceptance.** Credit line given. Buys one-time rights.

TIPS "Submit only work that relates to one of *THEMA*'s upcoming themes. **Be sure to specify target theme in cover letter.** Contact by snail mail preferred."

THIN AIR MAGAZINE

English Department, Northern Arizona University, Bldg. 18, Room 133, Flagstaff AZ 86011. (928)523-0469. **E-mail:** editors@thinairmagazine.com; jmh522@nau.edu. **Website:** thinairmagazine.com. Estab. 1995. Circ. 400. Annual literary magazine. Emphasizes arts and literature—poetry, fiction, and essays. Readers are collegiate, academic, writerly adult males and females interested in arts and literature. Sample copy available for $6.

NEEDS Buys 2-4 photos from freelancers/issue; 4-8 photos/year. Needs scenic/wildlife shots and b&w photos that portray a statement or tell a story. Looking for b&w or color cover shots. Model/property release preferred. Photo captions preferred; include name of photographer, date of photo.

SPECS Uses 8×10 b&w prints.

MAKING CONTACT & TERMS Send unsolicited photos by mail with SASE for consideration. Photos accepted August through May only. Keeps samples on file. Responds in 3 months. Simultaneous submissions and previously published work OK. Pays 2 contributor's copies. Credit line given. Buys one-time rights.

TIDE MAGAZINE

6919 Portwest Dr., Suite 100, Houston TX 77024. (713)626-4234; (800)201-FISH. **Fax:** (713)626-5852. **E-mail:** ccantl@joincca.org. **Website:** www.joincca.org. Estab. 1979. Circ. 80,000. Bimonthly magazine of the Coastal Conservation Association. Emphasizes coastal fishing, conservation issues—exclusively along the Gulf and Atlantic Coasts. Readers are mostly male, ages 25-50, coastal anglers, and professionals.

NEEDS Buys 12-16 photos from freelancers/issue; 72-96 photos/year. Needs photos of *only* Gulf and Atlantic coastal activity, recreational fishing and coastal scenics/habitat, tight shots of fish (saltwater only). Model/property release preferred. Photo captions not required, but include names, dates, places and specific equipment, or other key information.

MAKING CONTACT & TERMS Send query letter with stock list. Responds in 1 month. Simultaneous submissions and previously published work OK. Pays on publication. Credit line given. Buys one-time rights; negotiable.

TIPS Wants to see "fresh twists on old themes—unique lighting, subjects of interest to my readers. Take time to discover new angles for fishing shots. Avoid the usual poses, 'grip-and-grin.' We see too much of that already."

TIKKUN

2342 Shattuck Ave., Suite 1200, Berkeley CA 94704. (510)644-1200. **Fax:** (510)644-1255. **E-mail:** magazine@tikkun.org. **Website:** www.tikkun.org. **Contact:** managing editor. Estab. 1986. Circ. 41,000. Quarterly. Jewish and interfaith critique of politics, culture, and society.

NEEDS Uses 70 photos/issue, mostly from the public domain; 5% supplied by freelancers. Needs political, social commentary; Middle East and US photos. "Looks for photos that show hope, suffering, oppression, poverty, or struggle to change the world." Reviews photos with or without a manuscript.

SPECS Uses b&w and color prints. Accepts images in digital format for Mac.

MAKING CONTACT & TERMS Response time varies. "Turnaround is 4 months, unless artist specifies other." Previously published work OK. As a nonprofit publication with barely any image budget, we seek donation of most images. Pays on publication. Credit line given. Artists must agree to these terms: Nonexclusive worldwide publishing rights for use of the images in *Tikkun* is, in the whole or in part, distributed, displayed, and archived, with no time restriction. Art guidelines are available online.

TIPS "Look at our magazine and suggest how your photos can enhance our articles and subject material. Send samples."

TIME

1271 Avenue of the Americas, New York NY 10020. **E-mail:** letters@time.com. **Website:** www.time.com. **Contact:** Nancy Gibbs, editor. Estab. 1923. Circ. 4 million. *TIME* is edited to report and analyze a complete and compelling picture of the world, including national and world affairs, news of business, science, society and the arts, and the people who make the news. Query before submitting.

⑤◐ TRACK & FIELD NEWS

2570 El Camino Real, Suite 220, Mountain View CA 94040. (650)948-8188. **Fax:** (650)948-9445. **E-mail:** editorial@trackandfieldnews.com. **Website:** www.trackandfieldnews.com. **Contact:** Jon Hendershott, associate editor (features/photography). Estab. 1948. Circ. 18,000. Monthly. Emphasizes national and world-class track and field competition and participants at those levels for athletes, coaches, administrators, and fans. Sample copy free with 9×12 SASE. Photo guidelines free.

NEEDS Buys 10-15 photos from freelancers/issue; 120-180 photos/year. Wants, on a regular basis, photos of national-class athletes, men and women, preferably in action. "We are always looking for quality pictures of track and field action, as well as offbeat and different feature photos. We also welcome shots from road and cross-country races for both men and women.

Any photos may eventually be used to illustrate news stories in *T&FN*, feature stories in *T&FN*, or may be used in our other publications (books, technical journals, etc.). Any such editorial use will be paid for, regardless of whether material is used directly in *T&FN*. About all we don't want to see are pictures taken with someone's Instamatic. No shots of someone's child or grandparent running. Professional work only." Photo captions required; include subject name (last name first), meet date/name.

SPECS Images must be in digital format. Send via CD, e-mail; all files at 300 dpi.

MAKING CONTACT & TERMS Send query letter with samples, SASE. Responds in 10–14 days. Pays $225 for color cover; $25 for b&w inside (rarely used); $50 for color inside ($100 for full-page interior color; $175 for interior 4-color poster). Payment is made monthly. Credit line given. Buys one-time rights.

TIPS "No photographer is going to get rich via *T&FN*. We can offer a credit line, nominal payment and, in some cases, credentials to major track and field meets. Also, we can offer the chance for competent photographers to shoot major competitions and competitors up close, as well as being the most highly regarded publication in the track world as a forum to display a photographer's talents."

TRAVEL + LEISURE

1120 Avenue of the Americas, 9th Floor, New York NY 10036. (212)382-5600. **E-mail:** TLPhoto@aexp.com. **Website:** www.travelandleisure.com. Monthly magazine emphasizing travel, resorts, dining, and entertainment.

MAKING CONTACT & TERMS "If mailing a portfolio, include a SASE package for its safe return. You may also send it by messenger Monday–Friday, 11-5. We accept work in book form exclusively—no transparencies, loose prints, nor scans on CD, disk, or e-mail. Send photocopies or photo prints, not originals, as we are not responsible for lost or damaged images in unsolicited portfolios. We do not meet with photographers if we haven't seen their book. However, please include a promo card in your portfolio with contact information, so we may get in touch with you if necessary."

⑨⑤ TRAVELLER MAGAZINE & PUBLISHING

3rd Floor, Dorset House, 27-45 Stamford St., London SE1 9NT United Kingdom. (44)(207)838 5998.

E-mail: traveller@and-publishing.co.uk. **Website:** www.wexas.com/traveller-magazine. **Contact:** Amy Sohanpaul, editor. Circ. 18,000. Quarterly. Readers are predominantly male, professional, ages 35 and older. Sample copy available for £6.95.

NEEDS Uses 75-100 photos/issue; all supplied by freelancers. Needs photos of travel, wildlife, tribes. Reviews photos with or without a manuscript. Photo captions preferred.

MAKING CONTACT & TERMS Send at least 20 original color slides or b&w prints. Or send at least 20 low-res scans by e-mail or CD (include printout of thumbnails); high-res (300 dpi) scans will be required for final publication. Does not keep samples on file; include SASE for return of material. Responds in 3 months. Pays £150 for color cover; £80 for full page; from £40 for other sizes. Pays on publication. Buys one-time rights.

TIPS Look at guidelines for contributors on website.

🟢🔵 TRAVELWORLD INTERNATIONAL MAGAZINE

3579 Foothill Blvd., #744, Pasadena CA 91107. (626)376-9754. **E-mail:** helen@natja.org. **Website:** www.natja.org, www.travelworldmagazine.com. **Contact:** Helen Hernandez, CEO. Estab. 1992. Circ. 75,000. Quarterly online magazine of the North American Travel Journalists Association (NATJA). Emphasizes travel, food, wine, and hospitality industries.

NEEDS Photos of food/drink, travel.

SPECS Uses color and b&w. Prefers digital images.

MAKING CONTACT & TERMS Send query via e-mail.

TIPS Only accepts submissions/queries from members.

TV GUIDE

11 W. 42nd St., 16th Floor, New York NY 10036. (212)852-7500. **Fax:** (212)852-7470. **Website:** www.tvguide.com. **Contact:** Mickey O'Connor, editor-in-chief. Estab. 1953. Circ. 9 million. *TV Guide* watches television with an eye for how TV programming affects and reflects society. It looks at the shows and the stars, and covers the medium's impact on news, sports, politics, literature, the arts, science, and social issues through reports, profiles, features, and commentaries.

MAKING CONTACT & TERMS Works only with celebrity freelance photographers. "Photos are for one-time publication use. Mail self-promo cards to photo editor at above address. No calls, please."

🟢🔵 WAKEBOARDING MAGAZINE

TMB Publications, P.O. Box 1156, Lake Oswego OR 97035. **E-mail:** shawn.perry@wakeboardingmag.com. **Website:** www.wakeboardingmag.com. Estab. 2002. Circ. 100,000. Quarterly. Emphasizes action sports for youth: snowboarding, skateboarding, and other board sports. Features high school teams, results, events, training, "and kids that just like to ride." Sample copy available with 8×10 SASE and 75¢ first-class postage. Photo guidelines available by e-mail request or online.

NEEDS Buys 10-20 photos from freelancers/issue; 40-80 photos/year. Needs photos of sports. Reviews photos with or without a manuscript. Model/property release preferred. Photo captions preferred.

SPECS Accepts images in digital format only. Send via CD as TIFF files at 300 dpi.

MAKING CONTACT & TERMS Send query via e-mail. Provide self-promotion piece to be kept on file for possible future assignments. Responds only if interested; send nonreturnable samples. Simultaneous submissions OK. Pays $25 minimum for b&w and color covers and inside photos. Pays on publication. Credit line given. Buys all rights.

TIPS "Send an e-mail ahead of time to discuss. Send us stuff that even you don't like, because we just might like it."

WASHINGTON TRAILS

705 Second Ave., Suite 300, Seattle WA 98104. (206)625-1367. **E-mail:** eli@wta.org. **Website:** www.wta.org/trail-news/magazine. **Contact:** Eli Boschetto, editor. Estab. 1966. Circ. 9,000. Magazine of the Washington Trails Association. Published 6 times/year. Emphasizes "backpacking, hiking, cross-country skiing, all nonmotorized trail use, outdoor equipment and minimum-impact camping techniques." Readers are "people active in outdoor activities, primarily backpacking; residents of the Pacific Northwest, mostly Washington; age group: 9-90; family-oriented; interested in wilderness preservation, trail maintenance." Photo guidelines free with SASE or online.

NEEDS Uses 10–15 photos from volunteers/issue; 100–150 photos/year. Needs "wilderness/scenic; people involved in hiking, backpacking, skiing, snow-

shoeing, wildlife; outdoor equipment photos, all with Pacific Northwest emphasis." Photo captions required.

MAKING CONTACT & TERMS Send JPEGs by e-mail for consideration. Responds in 1–2 months. Simultaneous submissions and previously published work OK. No payment for photos. A 1–year subscription offered for use of color cover shot. Credit line given.

TIPS "Photos must have a Pacific Northwest slant. Photos that meet our cover specifications are always of interest to us. Familiarity with our magazine will greatly aid the photographer in submitting material to us. Contributing to *Washington Trails* won't help pay your bills, but sharing your photos with other backpackers and skiers has its own rewards."

❸❾❶⚪ WATERCRAFT WORLD

(805)667-4100. **Fax:** (805)667-4336. **E-mail:** gmansfield@affinitygroup.com. **Website:** www.watercraft world.com. **Contact:** Gregg Mansfield, editorial director. Estab. 1987. Circ. 75,000. Published 6 times/year. Emphasizes personal watercraft (Jet Skis, Wave Runners, Sea-Doo). Readers are 95% male, average age 37, boaters, outdoor enthusiasts. Sample copy available for $4.

NEEDS Buys 7-12 photos from freelancers/issue; 42-72 photos/year. Needs photos of personal watercraft travel, race coverage. Model/property release required. Photo captions preferred.

SPECS Accepts images in digital format. Send via CD, ZIP, e-mail as TIFF, EPS, GIF, JPEG files at 300 dpi.

MAKING CONTACT & TERMS Send query letter with résumé of credits. Provide résumé, business card, brochure, flier, or tearsheets to be kept on file for possible future assignments. "Call with ideas." Responds in 1 month. Pays on publication. Credit line given. Rights negotiable.

TIPS "Call to discuss project. We take and use many travel photos from all over the United States (very little foreign). We also cover many regional events (e.g., charity rides, races)."

❸❾ WATERSKI

460 N. Orlando Ave., Suite 200, Winter Park FL 32789. (407)628-4802. **Fax:** (407)628-7061. **E-mail:** todd. ristorcelli@bonniercorp.com. **Website:** www.water skimag.com. **Contact:** Todd Ristorcelli, editor. Estab. 1978. Circ. 105,000. Published 8 times/year. Empha-

sizes water skiing instruction, lifestyle, competition, travel. Readers are 36-year-old males, average household income $65,000. Sample copy available for $2.95. Photo guidelines free with SASE.

NEEDS Buys 20 photos from freelancers/issue; 160 photos/year. Needs photos of instruction, travel, personality. Model/property release preferred. Photo captions preferred; include person, trick described.

MAKING CONTACT & TERMS Query with good samples, SASE. Keeps samples on file. Responds within 2 months. Pays $200–500/day; $500 for color cover; $50–75 for b&w inside; $75–300 for color inside; $150/color page rate; $50–75/b&w page rate. Pays on publication. Credit line given. Buys first North American serial rights.

TIPS "Clean, clear, tight images. Plenty of vibrant action, colorful travel scenics and personality. Must be able to shoot action photography. Looking for photographers in other geographic regions for diverse coverage."

⊙ WESTERN JOURNEY MAGAZINE

AAA Washington, 3605 132nd Ave SE also 1745 114th Ave. SE, Bellevue WA 98004. **E-mail:** robbhatt@ aaawa.com; sueboylan@aaawa.com. **Website:** www. wa.aaa.com/journey. Sue Boylan, art director. **Contact:** Rob Bhatt, editor. Circ. 670,000. Bimonthly. For members of AAA Washington; reaches readers in Washington and North Idaho.

◗ "Photographers interested in submitting work to *Journey* magazine are encouraged to send a link to their website, along with a stock listing of regions and subjects of specialty for us to review. You are encouraged to familiarize yourself with *Journey* before sending submissions. We review photographers' stock lists and samples and keep the names of potential contributors on file to contact as needed. We do not post our photo needs online or elsewhere. To be considered for an assignment, send links to journey@aaawa.com."

MAKING CONTACT & TERMS "We run all articles with high-quality photographs and illustrations. If you are a published photographer, let us know, but please do not submit any photos unless requested. To be considered for an assignment, mail a query along with 3 samples of published work, or send links to journey@aaawa.com."

💲💲💲⚫ WESTERN OUTDOORS

185 Avenida La Pata, San Clemente CA 92673. (949)366-0030. **E-mail:** rich@wonews.com. **Website:** www.wonews.com. **Contact:** Rich Holland, editor. Estab. 1961. Circ. 100,000. Published 9 times/year. Emphasizes fishing and boating "for Far West states." Sample copy free. Editorial and photo guidelines free with SASE.

NEEDS Uses 80-85 photos/issue; 70% supplied by freelancers; 80% comes from assignments, 25% from stock. Needs photos of fishing in California, Oregon, Washington, Baja. Most photos purchased with accompanying manuscript. Model/property release preferred for women and men in brief attire. Photo captions required.

SPECS Prefers images in digital format.

MAKING CONTACT & TERMS Query or send photos with SASE for consideration. Responds in 3 weeks. **Pays on acceptance.** Buys one-time rights for photos only; first North American serial rights for articles; electronic rights are negotiable.

TIPS "Submissions should be of interest to Western fishermen, and should include a 1,120- to 1,500-word manuscript; a Trip Facts Box (where to stay, costs, special information); photos; captions; and a map of the area. Emphasis is on fishing how-to, somewhere-to-go. Submit seasonal material 6 months in advance. Query only; no unsolicited manuscripts. Make your photos tell the story, and don't depend on captions to explain what is pictured. Get action shots, live fish. In fishing, we seek individual action or underwater shots. For cover photos, use vertical format composed with action entering picture from right; leave enough left-hand margin for cover blurbs, space at top of frame for magazine logo. Add human element to scenics to lend scale. Get to know the magazine and its editors. Ask for the year's editorial schedule (available through advertising department), and offer cover photos to match the theme of an issue. In samples, looks for color saturation, pleasing use of color components; originality, creativity; attractiveness of human subjects, as well as fish; above all—sharp, sharp, sharp focus!"

💲⚫ WEST SUBURBAN LIVING MAGAZINE

C2 Publishing, Inc., P.O. Box 111, Elmhurst IL 60126. (630)834-4995. **Fax:** (630)834-4996. **E-mail:** wsl@westsuburbanliving.net. **Website:** www.westsuburbanliving.net. Estab. 1995. Circ. 25,000. Bimonthly regional magazine serving the western suburbs of Chicago. Sample copies available.

NEEDS Photos of babies/children/teens, couples, families, senior citizens, landscapes/scenics, architecture, gardening, interiors/decorating, entertainment, events, food/drink, health/fitness/beauty, performing arts, travel. Interested in seasonal. Model release required. Photo captions required.

MAKING CONTACT & TERMS Responds only if interested; send nonreturnable samples. Simultaneous submissions and previously published work OK. Credit line given. Buys one-time rights, first rights, all rights; negotiable.

WHISKEY ISLAND MAGAZINE

English Dept., Cleveland State University, 2121 Euclid Ave., Cleveland OH 44115. (216)687-3951. **E-mail:** whiskeyisland@csuohio.edu. **Website:** whiskeyislandmagazine.com. **Contact:** Dan Dorman. "This is a nonprofit literary magazine that has been published (in one form or another) by students of Cleveland State University for over 30 years." Biannual literary magazine publishing extremely contemporary writing. Sample copy: $6. Photo guidelines available with SASE.

NEEDS Uses 10 photos/issue; 20 photos/year. Interested in mixed media, alternative process, avant garde, fine art. Surreal and abstract are welcome. Do not send sentimental images, "rust-belt" scenes, photos of Cleveland, straight landscapes, or anything that can be viewed as "romantic." Model/property release preferred. Photo captions required; include title of work, photographer's name, address, phone number, e-mail, etc.

SPECS Accepts images in digital format. Send via e-mail attachment as individual, high-res JPEG files. No TIFFs. No disks.

MAKING CONTACT & TERMS E-mail with sample images. Do not just send your website link. Does not keep samples on file; responds in 3 months. Pays 2 contributor's copies and a one-year subscription. Credit line given. Include as much contact information as possible.

💲💲 WINE & SPIRITS

2 W. 32nd St., Suite 601, New York NY 10001. (212)695-4660, ext. 15. **E-mail:** elenab@wineandspiritsmagazine.com; info@wineandspiritsmagazine.com. **Website:** www.wineandspiritsmagazine.com. **Contact:** Elena Bessarabova-Leone,

art director. Estab. 1985. Circ. 70,000. Bimonthly. Emphasizes wine. Readers are male, ages 39-60, married, parents, $70,000-plus income, wine consumers. Sample copy available for $4.95; Special issues are $4.95-6.50 each.

NEEDS Buys 0-30 photos from freelancers/issue; 0-180 photos/year. Needs photos of food, wine, travel, people. Photo captions preferred; include date, location.

SPECS Accepts images in digital format. Send via SyQuest, ZIP at 300 dpi.

MAKING CONTACT & TERMS Submit portfolio for review. Provide résumé, business card, brochure, flyer or tearsheets to be kept on file for possible future assignments. Responds in 2 weeks, if interested. Simultaneous submissions OK. Pays on publication. Credit line given. Buys one-time rights.

🟢 WISCONSIN SNOWMOBILE NEWS

P.O. Box 182, Rio WI 53960-0182. (920)992-6370. **Website:** www.sledder.net. **Contact:** Cathy Hanson, editor. Estab. 1969. Circ. 28,000. Published 7 times/year. Official publication of the Association of Wisconsin Snowmobile Clubs. Emphasizes snowmobiling. Sample copy free with 9×12 SASE and 5 first-class stamps.

NEEDS Buys very few stand-alone photos from freelancers. "Most photos are purchased in conjunction with a story (photo/text) package. Photos need to be Midwest region only!" Needs photos of family-oriented snowmobile action, travel. Model/property release preferred. Photo captions preferred; include where, what, when.

SPECS Uses 8×10 glossy color and b&w prints; 35mm, 2¼×2¼, 4×5, 8×10 transparencies. Digital files accepted at 300 dpi.

MAKING CONTACT & TERMS Submit portfolio for review. Send unsolicited photos by mail for consideration; include SASE for return of material. Provide résumé, business card, brochure, flier, or tearsheets to be kept on file for possible future assignments. Responds in 2 weeks. Pays on publication. Credit line given. Buys one-time rights, all rights; negotiable.

🟢🟢 WOODMEN LIVING

Woodmen Tower, 1700 Farnam St., Omaha NE 68102. (402)342-1890. **Fax:** (402)271-7269. **E-mail:** service@woodmen.com. **Website:** www.woodmen.org. **Contact:** Billie Jo Foust, editor. Estab. 1890. Circ. 480,000.

Quarterly magazine published by Woodmen of the World/Omaha Woodmen Life Insurance Society. Emphasizes American family life. Sample copy and photo guidelines free.

NEEDS Buys 10-12 photos/year. Needs photos of the following themes: historic, family, insurance, humorous, photo essay/photo feature, human interest, and health. Model release required. Photo captions preferred.

SPECS Uses 8×10 glossy b&w prints on occasion; 35mm, 2¼×2¼, 4×5 transparencies; for cover: 4×5 transparencies, vertical format preferred. Accepts images in digital format. Send high-res scans via CD.

MAKING CONTACT & TERMS Send material by mail with SASE for consideration. Responds in 1 month. Previously published work OK. **Pays on acceptance.** Credit line given on request. Buys one-time rights.

TIPS "Submit good, sharp pictures that will reproduce well."

🎯🟢🟢 YANKEE MAGAZINE

1121 Main St., P.O. Box 520, Dublin NH 03444. (603)563-8111. **E-mail:** heatherm@yankeepub.com. **Website:** www.yankeemagazine.com. **Contact:** Heather Marcus, photo editor; Lori Pedrick, art director. Estab. 1935. Circ. 350,000. Monthly. Emphasizes general interest within New England, with national distribution. Readers are of all ages and backgrounds; majority are actually outside of New England. Sample copy may be viewed on our website. "We give assignments to experienced professionals. If you want to work with us, show us a portfolio of your best work. Contact our photo editor before sending any photography to our art department. Please do not send any unsolicited original photography or artwork."

NEEDS Buys 10-30 photos from freelancers/issue; 60–180 photos/year. Needs photos of landscapes/scenics, wildlife, gardening, interiors/decorating. "Always looking for outstanding photo essays or portfolios shot in New England." Model/property release preferred. Photo captions required; include name, locale, pertinent details.

MAKING CONTACT & TERMS Submit portfolio for review. Keeps samples on file; include SASE for return of material. Responds in 1 month. Simultaneous submissions and previously published work OK. Credit line given. Buys one–time rights; negotiable.

YOUTH RUNNER MAGAZINE

P.O. Box 1156, Lake Oswego OR 97035. (503)236-2524. **Fax:** (503)620-3800. **E-mail:** photos@youthrunner. com. **Website:** www.youthrunner.com. Estab. 1996. Circ. 100,000. Publishes 10 issues per year. Features track, cross country, and road racing for young athletes, ages 8-18. Photo guidelines available on website.

NEEDS Uses 30–50 photos/issue. Also uses photos on website daily. Needs action shots from track, cross country, and indoor meets. Model release preferred; property release required. Photo captions preferred.

SPECS Accepts images in digital format only. Ask for Dropbox link. Only InDesign.

MAKING CONTACT & TERMS Send low-res photos via e-mail first or link to gallery for consideration. Responds to e-mail submissions immediately. Simultaneous submissions OK. Pays $25 minimum. Credit line given. Buys electronic rights, all rights.

NEWSPAPERS

When working with newspapers, always remember that time is of the essence. Newspapers have various deadlines for each of their sections. An interesting feature or news photo has a better chance of getting in the next edition if the subject is timely and has local appeal. Most of the markets in this section are interested in regional coverage. Find publications near you and contact editors to get an understanding of their deadline schedules.

More and more newspapers are accepting submissions in digital format. In fact, most newspapers prefer digital images. However, if you submit to a newspaper that still uses film, ask the editors if they prefer certain types of film or if they want color slides or black-and-white prints. Many smaller newspapers do not have the capability to run color images, so black-and-white prints are preferred. However, color slides and prints can be converted to black-and-white. Editors who have the option of running color or black-and-white photos often prefer color film because of its versatility.

Although most newspapers rely on staff photographers, some hire freelancers as stringers for certain stories. Act professionally and build an editor's confidence in you by supplying innovative images. For example, don't get caught in the trap of shooting "grip-and-grin" photos when a corporation executive is handing over a check to a nonprofit organization. Turn the scene into an interesting portrait. Capture some spontaneous interaction between the recipient and the donor. By planning ahead you can be creative.

When you receive assignments, think about the image before you snap your first photo. If you are scheduled to meet someone at a specific location, arrive early and scout around. Find a proper setting or locate some props to use in the shoot. Do whatever you can to show the editor you are willing to make that extra effort.

Always try to retain resale rights to shots of major news events. High news value means high resale value, and strong news photos can be resold repeatedly. If you have an image with national appeal, search for larger markets, possibly through the wire services. You also may find buyers among national news magazines such as *Time* or *Newsweek*.

While most newspapers offer low payment for images, they are willing to negotiate if the image will have a major impact. Front-page artwork often sells newspapers, so don't underestimate the worth of your images.

✇ ⊛ ⊛ AMERICAN SPORTS NETWORK

Box 6100, Rosemead CA 91770. (626)280-0000. **Fax:** (626)280-0001. **E-mail:** info@asntv.com. **Website:** www.fitnessamerica.com. Circ. 873,007. Publishes 4 newspapers covering "general collegiate, amateur and professional sports, e.g., football, baseball, basketball, wrestling, boxing, powerlifting and bodybuilding, fitness, health contests." Also publishes special bodybuilder annual calendar, collegiate and professional football pre-season and post-season editions.

NEEDS Buys 10–80 photos from freelancers/issue for various publications. Needs "sport action, hard-hitting contact, emotion-filled photos." Model release preferred. Photo captions preferred.

MAKING CONTACT & TERMS Send 8×10 glossy b&w prints, 4×5 transparencies, video demo reel, or film work by mail for consideration. Include SASE for return of material. Provide résumé, business card, brochure, flier, or tearsheets to be kept on file for possible future assignments. Simultaneous submissions and previously published work OK. Negotiates rates by the job and hour. Pays on publication. Buys first North American serial rights.

✇ THE ANGLICAN JOURNAL

The Anglican Journal Committee, 80 Hayden St., Toronto, Ontario M4Y 3G2 Canada. (416)924-9192. **E-mail:** editor@anglicanjournal.com; story queries: jthomas@national.anglican.ca; editor@anglican journal.com; photography queries: sfielder@national.anglican.ca. **Website:** www.anglicanjournal.com. **Contact:** Janet Thomas; Saskia Rowley Fielder. Estab. 1875. Circ. 141,000. Covers news of interest to Anglicans in Canada and abroad.

SPECS Reviews GIF/JPEG files (high res at 300 dpi).

MAKING CONTACT & TERMS Identification of subjects required. Negotiates payment individually. Buys all rights.

✇ ○ AQUARIUS

Aquarius Media Network, 2408 Druid Oaks NE, Atlanta GA 30329. (770)641-9055. **E-mail:** donmartin@aquarius-atlanta.com. **Website:** www.aquarius-atlanta.com. **Contact:** Don Martin. Estab. 1991. Circ. 20,000; readership online: 50,000. Monthly. "Emphasizes New Age, metaphysical, holistic health, alternative religion; environmental audience primarily middle-aged, college-educated, computer-literate, open to exploring new ideas. Our mission is to publish a newspaper for the purpose of expanding awareness and supporting all those seeking spiritual growth. We are committed to excellence and integrity in an atmosphere of harmony and love." Sample copy available with SASE.

NEEDS "We use photos of authors, musicians, and photos that relate to our articles, but we have no budget to pay photographers at this time. We offer byline in paper, website, and copies." Needs photos of New Age and holistic health, celebrities, multicultural, environmental, religious, adventure, entertainment, events, health/fitness, performing arts, travel, medicine, technology, alternative healing processes. Interested in coverage on environmental issues, genetically altered foods, photos of "anything from Sufi Dancers to Zen Masters." Model/property release required. Photo captions required; include photographer's name, subject's name, and description of content.

SPECS Uses color and b&w photos. Accepts images in digital format. Send via ZIP, e-mail as JPEG files at 300 dpi.

MAKING CONTACT & TERMS Send e-mail samples with cover letter. Provide résumé, business card or self-promotion piece to be kept on file for possible future assignments. Pays in copies, byline with contact info (phone number, e-mail address published if photographer agrees).

◎ ✇ ○ CATHOLIC SENTINEL

P.O. Box 18030, Portland OR 97218. (503)281-1191 or (800)548-8749. **E-mail:** sentinel@catholicsentinel.org. **E-mail:** bobp@ocp.org. **Website:** www.catholicsentinel.org. **Contact:** Robert Pfohman, editor. Estab. 1870. Circ. 20,000. Twice monthly. "We are the newspaper for the Catholic community in Oregon." Sample copies available with SASE. Photo guidelines available via e-mail.

NEEDS Buys 15 photos from freelancers/issue; 800 photos/year. Needs photos of religious and political subjects. Interested in seasonal. Model/property release preferred. Photo captions required; include names of people shown in photos, spelled correctly.

SPECS Prefers images in digital format. Send via e-mail or FTP as TIFF or JPEG files at 300 dpi.

MAKING CONTACT & TERMS Send query letter with résumé and tearsheets. Portfolio may be dropped off every Thursday. Keeps samples on file. Responds only if interested; send nonreturnable samples. Simultaneous submissions and previously published work

OK. Pays on publication or on receipt of photographer's invoice. Credit line given. Buys first rights and electronic rights.

TIPS "We use photos to illustrate editorial material, so all photography is on assignment. Basic knowledge of Catholic Church (e.g., don't climb on the altar) is a big plus. Send accurately spelled cutlines. Prefer images in digital format."

CHILDREN'S DEFENSE FUND

25 E St. NW, Washington DC 20001. (800)233-1200. **E-mail:** cdfinfo@childrensdefense.org. **Website:** www.childrensdefense.org. Children's advocacy organization.

NEEDS Buys 20 photos/year. Buys stock and assigns work. Wants to see photos of children of all ages and ethnicity—serious, playful, poor, middle class, school setting, home setting, and health setting. Subjects include babies/children/teens, families, education, health/fitness/beauty. Some location work. Domestic photos only. Model/property release required.

SPECS Uses b&w and some color prints. Accepts images in digital format. Send via e-mail as TIFF, EPS, JPEG files at 300 dpi or better.

MAKING CONTACT & TERMS Provide résumé, business card, self-promotion piece, or tearsheets to be kept on file for possible future assignments. Keeps photocopy samples on file. Previously published work OK. Pays on usage. Credit line given. Buys one-time rights; occasionally buys all rights.

TIPS Looks for "good, clear focus, nice composition, variety of settings, and good expressions on faces."

THE CHURCH OF ENGLAND NEWSPAPER

14 Great College St., London SW1P 3RX United Kingdom. 44 20 7222 8700. **E-mail:** cen@churchnewspaper.com; colin.blakely@churchnewspaper.com. **Website:** www.churchnewspaper.com. **Contact:** Colin Blakely, editor; Peter May, graphic designer. Estab. 1828. Circ. 12,000. Weekly religious newspaper. Sample copies available.

NEEDS Buys 2-3 photos from freelancers/issue; 100 photos/year. Needs political photos. Reviews photos with or without a manuscript. Photo captions required.

SPECS Uses glossy color prints; 35mm transparencies.

MAKING CONTACT & TERMS Does not keep samples on file; include SASE for return of material. Responds only if interested; send nonreturnable samples. Pays on publication. Credit line given. Buys one-right rights.

THE CLARION-LEDGER

P.O. Box 40, Jackson MS 39205. (601)961-7000; (601)961-7175; (877)850-5343. **E-mail:** publisher@clarionledger.com; srhall@jackson.gannett.com. **Website:** www.clarionledger.com. **Contact:** Sam R. Hall, executive editor. Circ. 95,000. Daily. Emphasizes photojournalism: news, sports, features, fashion, food, and portraits. Readers are in a very broad age range of 18-70 years, male and female. Sample copies available.

NEEDS Buys 1-5 photos from freelancers/issue; 365-1,825 photos/year. Needs news, sports, features, portraits, fashion, and food photos. Special photo needs include food and fashion. Model release required. Photo captions required.

SPECS Uses 8×10 matte b&w and color prints; 35mm slides/color negatives. Accepts images in digital format. Send via CD, e-mail as JPEG files at 200 dpi.

MAKING CONTACT & TERMS Provide résumé, business card, brochure, flier, or tearsheets to be kept on file for possible future assignments. Pays on publication. Credit line given. Buys one-time or all rights; negotiable.

FULTON COUNTY DAILY REPORT

190 Pryor St. SW, Atlanta GA 30303. (404)521-1227. **Fax:** (404)659-4739. **E-mail:** jbennitt@alm.com. **Website:** www.dailyreportonline.com. **Contact:** Jason R. Bennitt, marketing manager. Estab. 1890. Daily (5 times/week). Emphasizes legal news and business. Readers are male and female professionals, age 25+, involved in legal field, court system, legislature, etc. Sample copy available for $2 with 9¾×12¾ SASE and 6 first-class stamps.

NEEDS Buys approx. 50 photos from freelancers or wire per year. Needs informal environmental photographs of lawyers, judges, and others involved in legal news and business. Some real estate, etc. Photo captions necessary; include complete name of subject and date shot, along with other pertinent information. Two or more people should be identified from left to right.

SPECS Accepts images in digital format. Send via CD or e-mail as JPEG files at 200–600 dpi.

MAKING CONTACT & TERMS Submit portfolio

for review. Mail or e-mail samples. Keeps samples on file. Simultaneous submissions and previously published work OK. "Freelance work generally done on an assignment-only basis." Pays $75–125 for color cover; $50–75 for color inside. Credit line given.

TIPS Wants to see ability with "casual, environmental portraiture, people—especially in office settings, urban environment, courtrooms, etc.—and photojournalistic coverage of people in law or courtroom settings." In general, needs "competent, fast freelancers from time to time around the state of Georgia who can be called in at the last minute. We keep a list of them for reference. Good work keeps you on the list." Recommends that "when shooting for *FCDR*, it's best to avoid law-book-type photos if possible, along with other overused legal clichés."

⊚❸❶ GRAND RAPIDS BUSINESS JOURNAL

549 Ottawa Ave. NW, Suite 201, Grand Rapids MI 49503-1444. (616)459-4545. **Fax:** (616)459-4800. **E-mail:** knugent@grbj.com; editorial@grbj.com. **Website:** www.grbj.com. Estab. 1983. Circ. 6,000. Weekly tabloid. Emphasizes West Michigan business community. Sample copy available for $1.

NEEDS Buys 5–10 photos from freelancers/issue; 520 photos/year. Needs photos of local community, manufacturing, world trade, stock market, etc. Model/property release required. Photo captions required.

MAKING CONTACT & TERMS Send query letter with résumé of credits, stock list. Responds in 1 month. Simultaneous submissions and previously published work OK. Pays on publication. Credit line given. Buys one-time rights and first North American serial rights; negotiable.

⊚❸❶ THE LAWYERS WEEKLY

123 Commerce Valley Dr. E., Suite 700, Markham, Ontario L3T 7W8 Canada. (905)479-2665; (800)668-6481. **Fax:** (905)479-3758. **E-mail:** robert.kelly@lexisnexis.ca. **Website:** www.thelawyersweekly.ca. **Contact:** Rob Kelly, editor-in-chief. Estab. 1983. Circ. 20,300.

NEEDS Uses 12-20 photos/issue; 1 supplied by freelancers. Needs head shots of lawyers and judges mentioned in stories, as well as photos of legal events.

SPECS Accepts images in digital format. Send as JPEG, TIFF files.

MAKING CONTACT & TERMS Deadlines: 1- to 2-day turnaround time. Does not keep samples on file; include SASE for return of material. Responds only when interested. **Pays on acceptance.**

TIPS "We need photographers across Canada to shoot lawyers and judges on an as-needed basis. Send a résumé, and we will keep your name on file."

⊚❸❶ THE LOG NEWSPAPER

17782 Cowan, Suite C, Irvine CA 92614. (949)660-6150. **Fax:** (949)660-6172. **E-mail:** eston@thelog.com. **Website:** www.thelog.com. **Contact:** Eston Ellis, editor. Estab. 1971. Circ. 41,018.

NEEDS Buys 5-10 photos from freelancers/issue; 130-260 photos/year. Needs photos of marine-related, recreational sailing/powerboating in Southern California. Photo captions required: include location, name, and type of boat; owner's name; race description if applicable.

SPECS Accepts images in digital format. Send via e-mail as TIFF, EPS, JPEG files at 300 dpi or greater.

MAKING CONTACT & TERMS Simultaneous submissions and previously published work OK. Pays on publication. Credit line given. Buys all rights; negotiable.

TIPS "We want timely and newsworthy photographs! We always need photographs of people enjoying boating, especially power boating. 95% of our images are of California subjects."

❸ NATIONAL MASTERS NEWS

P.O. Box 1117, Orangevale CA 95662. (916)989-6667. **E-mail:** nminfo@nationalmastersnews.com. **Website:** www.nationalmastersnews.com. **Contact:** Randy Sturgeon. Estab. 1977. Circ. 8,000. Monthly tabloid. Official world and US publication for Masters (ages 30 and over) track and field, long distance running, and race walking.

NEEDS Uses 25 photos/issue; 30% assigned and 70% from freelance stock. Needs photos of Masters athletes (men and women over age 30) competing in track and field events, long distance running races, or racewalking competitions. Photo captions required.

MAKING CONTACT & TERMS Send photos digitally by e-mail for consideration. Responds in 1 month. Simultaneous submissions and previously published work OK. Pays on publication. Credit line given. Buys one-time rights.

THE NEW YORK TIMES ON THE WEB

620 Eighth Ave., New York NY 10018. **E-mail:** general mgr@nytimes.com; nytnews@nytimes.com; executive -editor@nytimes.com. **Website:** www.nytimes.com. Circ. 1.3 million. Daily newspaper. "Covers breaking news and general interest." Sample copy available with SASE or online.

NEEDS Photos of celebrities, architecture, cities/urban, gardening, interiors/decorating, industry, medicine, military, political, product shots/still life, science, technology/computers, disasters, environmental, landscapes/scenics, wildlife, automobiles, entertainment, events, food/drink, health/fitness/beauty, hobbies, performing arts, sports, travel, alternative process, avant garde, documentary, fashion/glamour, fine art, breaking news. Model release required. Photo captions required.

SPECS Accepts images in digital format. Send via CD, e-mail as TIFF, JPEG files.

MAKING CONTACT & TERMS E-mail query letter with link to photographer's website. Provide business card, self-promotion piece to be kept on file for possible future assignments. Simultaneous submissions OK. Pays on publication. Credit line given. Buys one-time rights and electronic rights.

●●● THE SUNDAY POST

80 Kingsway E., Dundee DD4 8SL, Scotland. (44) (1382)223131. **E-mail:** mail@sundaypost.com. **Website:** www.sundaypost.com. Estab. 1919. Circ. 328,129. Readership 901,000. Weekly family newspaper.

NEEDS Photos of "UK news and news involving Scots," sports. Other specific needs: exclusive news pictures from the UK, especially Scotland. Reviews photos with accompanying manuscript only. Model/ property release preferred. Photo captions required; include contact details, subjects, date. "Save in the caption field of the file info metadata, so they can be viewed on our picture desk system. Mac users should ensure attachments are PC-compatible as we use PCs."

SPECS Prefers images in digital format. Send via e-mail as JPEG files. "We need a minimum 11MB file saved at quality level 9/70% or above, ideally at 200 ppi/dpi."

MAKING CONTACT & TERMS Send query letter with tearsheets, stock list. Does not keep samples on file; include SASE for return of material. Responds in 2 weeks to queries. Simultaneous submissions OK. Pays $150 (USD) for b&w or color cover; $100 (USD)

for b&w or color inside. Pays on publication. Credit line not given. Buys single use, all editions, one date, worldwide rights; negotiable.

TIPS "Offer pictures by e-mail before sending: low-res only, please—72 ppi, 800 pixels on the widest side; no more than 10 at a time. Make sure the daily papers aren't running the story first and that it's not being covered by the Press Association (PA). We get their pictures on our contracted feed."

SYRACUSE NEW TIMES

Alltimes Publishing, LLC, 1415 W. Genesee St., Syracuse NY 13204. **E-mail:** bdelapp@syracusenewtimes. com; editorial@syracusenewtimes.com. **Website:** www.syracusenewtimes.com. **Contact:** Bill DeLapp. Estab. 1969. Circ. 40,000. *"Syracuse New Times* is an alternative weekly that is topical, provocative, irreverent, and intensely local." 50% freelance written. Publishes ms an average of 1 month after acceptance. Submit seasonal material 3 months in advance. Sample copy available with 8×10 SASE.

NEEDS Photos of performing arts. Interested in alternative process, fine art, seasonal. Reviews photos with or without a manuscript. Model/property release required. Photo captions required; include names of subjects.

SPECS Uses 5×7 b&w prints; 35mm transparencies.

MAKING CONTACT & TERMS Send query letter with résumé, stock list. Does not keep samples on file; include SASE for return of material. Responds in 6 weeks. Responds only if interested; send nonreturnable samples. Previously published work OK. Pays on publication. Credit line given. Buys one-time rights.

TIPS "Realize the editor is busy and responds as promptly as possible."

●●● TORONTO SUN PUBLISHING

333 King St. E., Toronto, Ontario M5A 3X5 Canada. (416)947-2399. **Fax:** (416)947-1664. **E-mail:** kevin. hann@sunmedia.ca. **E-mail:** torsun.photoeditor@ sunmedia.ca. **Website:** www.torontosun.com. **Contact:** Kevin Hann, deputy editor. Estab. 1971. Circ. 180,000. Daily. Emphasizes sports, news, and entertainment. Sample copy free with SASE.

NEEDS Uses 30–50 photos/issue; occasionally uses freelancers (spot news pics only). Needs photos of Toronto personalities making news out of town. Also disasters, beauty, sports, fashion/glamour. Reviews

photos with or without a manuscript. Photo captions preferred.

SPECS Accepts images in digital format. Send via CD or e-mail.

MAKING CONTACT & TERMS Arrange a personal interview to show portfolio. Send any size color prints; 35mm transparencies; press link digital format. Deadline: 11 p.m. daily. Does not keep samples on file. Responds in 1–2 weeks. Simultaneous submissions and previously published work OK. Pays on publication. Credit line given. Buys one-time and other negotiated rights.

TIPS "The squeaky wheel gets the grease when it delivers the goods. Don't try to oversell a questionable photo. Return calls promptly."

VENTURA COUNTY REPORTER

700 E. Main St., Ventura CA 93001. (805)648-2244. **E-mail:** editor@vcreporter.com. **Website:** www.vcreporter.com. **Contact:** Michael Sullivan, editor. Circ. 35,000. Weekly tabloid covering local news (entertainment and environment).

NEEDS Uses 12-14 photos/issue; 40-45% supplied by freelancers. "We require locally slanted photos (Ventura County CA)." Model release required.

SPECS Accepts images in digital format. Send via e-mail or CD.

MAKING CONTACT & TERMS Send sample b&w or color original photos; include SASE for return of material. Simultaneous submissions OK. Pays on publication. Credit line given. Buys one-time rights.

⑤ WATERTOWN PUBLIC OPINION

120 Third Ave. NW, P.O. Box 10, Watertown SD 57201. (605)886-6901. **Fax:** (605)886-4280. **E-mail:** maryt@thepublicopinion.com; rogerwhittle@thepublicopinion.com. **Website:** www.thepublicopinion.com. **Contact:** Mary Tuff, editorial assistant; Roger Whittle, managing editor. Estab. 1887. Circ. 15,000. Daily.

Emphasizes general news of the region; state, national, and international news.

NEEDS Uses up to 8 photos/issue. Reviews photos with or without a manuscript. Model release required. Photo captions required.

SPECS Uses b&w or color prints. Accepts images in digital format. Send via CD.

MAKING CONTACT & TERMS Send unsolicited photos by mail for consideration. Does not keep samples on file; include SASE for return of material. Responds in 1-2 weeks. Simultaneous submissions OK. Pays on publication. Credit line given. Buys one-time rights; negotiable.

⦿⑤❶ THE WESTERN PRODUCER

P.O. Box 2500, 2310 Millar Ave., Saskatoon, Saskatchewan S7K 2C4 Canada. (306)665-3544. **Fax:** (306)934-2401. **E-mail:** newsroom@producer.com. **Website:** www.producer.com. Estab. 1923. Circ. 48,000. Weekly. Emphasizes agriculture and rural living in western Canada.

NEEDS Photos of various farm situations with people engaged in some activity—repairing equipment, feeding livestock, enjoying leisure time on the farm, etc., or of animals in natural behavior—are more appealing than horizons, antiques, or derelict buildings.

SPECS Photos must be current (taken within the last month). Submissions should include as much cutline information as possible—who, what, where, when, and why. Include the date when the picture was taken. Accepts digital images at 200 dpi and at least 2MB. Save images in JPEG format. Send digital images to newsroom@producer.com. Photo guidelines mailed or e-mailed.

MAKING CONTACT & TERMS Address submissions sent by mail to the attention of the news editor; include SASE for return of material. Pays on publication. Credit line given. Buys one–time rights.

TRADE PUBLICATIONS

Most trade publications are directed toward the business community in an effort to keep readers abreast of the ever-changing trends and events in their specific professions. For photographers, shooting for these publications can be financially rewarding and can serve as a stepping stone toward acquiring future assignments.

As often happens with this category, the number of trade publications produced increases or decreases as professions develop or deteriorate. In recent years, for example, magazines involving new technology have flourished as the technology continues to grow and change.

Trade publication readers are usually very knowledgeable about their businesses or professions. The editors and photo editors, too, are often experts in their particular fields. So, with both the readers and the publications' staffs, you are dealing with a much more discriminating audience. To be taken seriously, your photos must not be merely technically good pictures, but also should communicate a solid understanding of the subject and reveal greater insights.

In particular, photographers who can communicate their knowledge in both verbal and visual form will often find their work more in demand. If you have such expertise, you may wish to query about submitting a photo/text package that highlights a unique aspect of working in a particular profession or that deals with a current issue of interest to that field.

Many photos purchased by these publications come from stock—both freelance inventories and stock photo agencies. Generally, these publications are more conservative with their freelance budgets and use stock as an economical alternative. For this

reason, some listings in this section will advise sending a stock list as an initial method of contact. (See sample stock list in "Running Your Business.") Some of the more established publications with larger circulations and advertising bases will sometimes offer assignments as they become familiar with a particular photographer's work. For the most part, though, stock remains the primary means of breaking in and doing business with this market.

⊕⑤❶ AAP NEWS

141 Northwest Point Blvd., Elk Grove Village IL 60007. (847)434-4755. **Fax:** (847)434-8000. **E-mail:** mhayes@aap.org. **Website:** www.aapnews.org. **Contact:** Michael Hayes, art director/production coordinator. Estab. 1985. Monthly tabloid newspaper. Publication of American Academy of Pediatrics.

NEEDS Uses 60 photos/year. Needs photos of babies/children/teens, families, health/fitness, sports, travel, medicine, pediatricians, health care providers—news magazine style. Interested in documentary. Model/property release required as needed. Photo captions required; include names, dates, locations, and explanations of situations.

SPECS Accepts images in digital format. Send via CD or e-mail as TIFF, EPS, or JPEG files at 300 dpi.

MAKING CONTACT & TERMS Provide résumé, business card, or tearsheets to be kept on file (for 1 year) for possible future assignments. Cannot return material. Simultaneous submissions and previously published work OK. Pays $50–150 for one-time use of photo. Pays on publication. Buys one-time or all rights; negotiable.

TIPS "We want great photos of real children in real-life situations—the more diverse the better."

ACRES U.S.A.

P.O. Box 301209, Austin TX 78703. (512)892-4400. **Fax:** (512)892-4448. **E-mail:** editor@acresusa.com. **Website:** www.acresusa.com. **Contact:** Tara Maxwell. Estab. 1970. Circ. 25,000. "Monthly trade journal written by people who have a sincere interest in the principles of organic and sustainable agriculture."

AG WEEKLY

Lee Agri-Media, P.O. Box 918, Bismarck ND 58501. (701)255-4905. **Fax:** (701)255-2312. **E-mail:** editor@theprairiestar.com. **Website:** www.agweekly.com. *Ag Weekly* is an agricultural publication covering production, markets, regulation, politics.

SPECS Reviews GIF/JPEG files.

MAKING CONTACT & TERMS Captions required. Offers $10/photo. Buys one-time rights.

ALABAMA FORESTS

Alabama Foresty Association, 555 Alabama St., Montgomery AL 36104-4395. **Website:** www.alaforestry.org. **Contact:** Sam Duvall, director of communications. Estab. 1948. Circ. 3,500-4,000.

⑤ AMERICAN BEE JOURNAL

51 S. Second St., Hamilton IL 62341. (217)847-3324. **Fax:** (217)847-3660. **E-mail:** editor@americanbeejournal.com; info@americanbeejournal.com. **Website:** www.americanbeejournal.com. **Contact:** Joe B. Graham, editor. Estab. 1861. Circ. 13,500. Monthly magazine. Emphasizes beekeeping for hobby and professional beekeepers. Sample copy free with SASE.

NEEDS Buys 1–2 photos from freelancers/issue; 12–24 photos/year. Needs photos of beekeeping and related topics, beehive products, honey, and cooking with honey. Special needs include color photos of seasonal beekeeping scenes. Model release preferred. Photo captions preferred.

MAKING CONTACT & TERMS Send query e-mail with samples. Send thumbnail samples to e-mail. Send 5×7 or 8½×11 color prints by mail for consideration; include SASE for return of material. Responds in 2 weeks. Pays on publication. Credit line given. Buys all rights. Submission guidelines available online.

◎⑤❶ AMERICAN POWER BOAT ASSOCIATION

17640 E. Nine Mile Rd., P.O. Box 377, Eastpointe MI 48021-0377. (586)773-9700. **Fax:** (586)773-6490. **E-mail:** apbahq@apba.org. **Website:** www.apba.org. Estab. 1903. Sanctioning body for US power boat racing; monthly online magazine printed quarterly. Majority of assignments made on annual basis. Photos used in monthly magazine, brochures, audiovisual presentations, press releases, programs, and website.

NEEDS Photos of APBA boat racing—action and candid. Interested in documentary, historical/vintage. Photo captions or class/driver ID required.

SPECS Accepts images in digital format. Send via CD, e-mail as TIFF, EPS, JPEG files at 300 dpi.

MAKING CONTACT & TERMS Initial personal contact preferred. Suggests initial contact by e-mail; JPEG samples or link to website welcome. Responds in 2 weeks when needed. Payment varies. Standard is $25 for color cover; $15 for interior pages. Credit line given. Buys one-time rights; negotiable. Photo usage must be invoiced by photographer within the month incurred.

TIPS Prefers to see selection of shots of power boats in action or pit shots, candids, etc., (all identified). Must show ability to produce clear color action shots of racing events. "Send a few samples with e-mail, especially if related to boat racing."

ANGUS JOURNAL

Angus Productions, Inc., 3201 Frederick Ave., St. Joseph MO 64506-2997. (816)383-5270. **E-mail:** shermel@angusjournal.com. **Website:** www.angusjournal.com. Estab. 1919. Circ. 13,500. *Angus Journal* is the official magazine of the American Angus Association. Its primary function as such is to report to the membership association activities and information pertinent to raising Angus cattle.

SPECS Reviews 5×7 glossy prints.

MAKING CONTACT & TERMS Identification of subjects required. Offers $25-400/photo. Buys all rights.

❸❶ ANIMAL SHELTERING

The Humane Society of the United States, P.O. Box 15276, North Hollywood CA 91615. (800)565-9226. **E-mail:** asm@humanesociety.org. **Website:** www.animalsheltering.org. **Contact:** Shevaun Brannigan, production/marketing manager; Carrie Allan, editor. Estab. 1978. Circ. 6,000. Published 6 times a year. Magazine of the Humane Society of the United States. Magazine for animal care professionals and volunteers dealing with animal welfare issues faced by animal shelters, animal control agencies, and rescue groups. Emphasis on news for the field and professional, hands-on work. Readers are shelter and animal control directors, kennel staff, field officers, humane investigators, animal control officers, animal rescuers, foster care volunteers, general volunteers, shelter veterinarians, and anyone concerned with local animal welfare issues. Sample copy free.

NEEDS Buys about 2–10 photos from freelancers/issue; 30 photos/year. Needs photos of pets interacting with animal control and shelter workers; animals in shelters, including farm animals and wildlife; general public visiting shelters and adopting animals; humane society work, functions, and equipment. Photo captions preferred.

SPECS Accepts color images in digital or print format. Send via CD, ZIP, e-mail as TIFF, JPEG files at 300 dpi.

MAKING CONTACT & TERMS Provide samples of work to be kept on file for possible future use or assignments; include SASE for return of material. Responds in 1 month. Pays $150 for cover; $75 for inside. Pays on publication. Credit line given. Buys one-time and electronic rights.

TIPS "We almost always need good photos of people working with animals in an animal shelter or in the field. We do not use photos of individual dogs, cats, and other companion animals as often as we use photos of people working to protect, rescue, or care for dogs, cats, and other companion animals. Contact us for upcoming needs."

❸❸❶ AOPA PILOT

421 Aviation Way, Frederick MD 21701. (301)695-2371. **Fax:** (301)695-2375. **E-mail:** pilot@aopa.org; ben.wilver@aopa.org. **Website:** www.aopa.org. **Contact:** Ben Wilver. Estab. 1958. Circ. 400,000. Monthly association magazine. "The world's largest aviation magazine. The audience is primarily pilot and aircraft owners of General Aviation airplanes." Sample copies and photo guidelines available online.

NEEDS Buys 5–25 photos from freelancers/issue; 60–300 photos/year. Photos of couples, adventure, travel, industry, technology. Interested in documentary. Reviews photos with or without a manuscript. Model/property release preferred. Photo captions preferred.

SPECS Uses images in digital format. Send via CD, DVD as TIFF, EPS, JPEG files at 300 dpi. "*AOPA Pilot* prefers original 35mm color transparencies (or larger), although high-quality color enlargements sometimes can be used if they are clear, sharp, and properly exposed. (If prints are accepted, the original negatives should be made available.) Avoid the distortion inherent in wide-angle lenses. Most of the photographs used are made with lenses in the 85mm to 135mm focal length range. Frame the picture to the focal length rather than the other way around, and avoid the use of zoom lenses unless they are of professional optical quality. Slides should be sharp and properly exposed; slower-speed films (ISO 25 to ISO 100) generally provide the best results. We are not responsible for unsolicited original photographs; send duplicate slides and keep the original until we request it."

MAKING CONTACT & TERMS Send query letter. Provide self-promotion piece to be kept on file for possible future assignments. Responds only if interested; send nonreturnable samples. Pays $800–2,000 for color cover; $200–720 for color inside. **Pays on acceptance.** Credit line given. Buys one-time, all rights; negotiable.

TIPS "A knowledge of our subject matter, airplanes, is a plus. Show range of work and not just one image."

APA MONITOR

750 First St. NE, Washington DC 20002-4242. (202)336-5500; (800)374-2721. **Website:** www.apa.org/monitor. Circ. 150,000. Monthly magazine. Emphasizes "news and features of interest to psychologists and other behavioral scientists and professionals, including legislation and agency action affecting science and health, and major issues facing psychology both as a science and a mental health profession." Sample copy available for $3 and 9×12 SASE envelope.

NEEDS Buys 60-90 photos/year. Photos purchased on assignment. Needs portraits, feature illustrations, and spot news.

SPECS Prefers images in digital format; send TIFF files at 300 dpi via e-mail. Uses 5×7 and 8×10 glossy prints.

MAKING CONTACT & TERMS Arrange a personal interview to show portfolio or query with samples. Pays by the job. Pays on receipt of invoice. Credit line given. Buys first serial rights.

TIPS "Become good at developing ideas for illustrating abstract concepts and innovative approaches to clichés such as meetings and speeches. We look for quality in technical reproduction and innovative approaches to subjects."

⊛⊛ AQUA MAGAZINE

22 E. Mifflin St., Suite 910, Madison WI 53703. (608)249-0186. **E-mail:** scott@aquamagazine.com. **Website:** www.aquamagazine.com. **Contact:** Scott Webb, executive editor; Eric Herman, senior editor; Cailley Hammel, associate editor; Scott Maurer, art director. Estab. 1976. Circ. 15,000. AB Media (formerly Athletic Business Publications). Business publication for spa and pool professionals. Monthly magazine. "*AQUA* serves spa dealers, swimming pool dealers and/or builders, spa/swimming pool maintenance and service, casual furniture/patio dealers, landscape architects/designers and others allied to the spa/swimming pool market. Readers are qualified owners, GM, sales directors, titled personnel."

NEEDS Photos of residential swimming pools and/or spas (hot tubs) that show all or part of pool/spa. "The images may include grills, furniture, gazebos, ponds, water features." Photo captions including architect/builder/designer preferred.

MAKING CONTACT & TERMS "OK to send promotional literature and to e-mail contact sheets, web gallery, or low-res samples, but do not send anything

that has to be returned (e.g., slides, prints) unless asked for." Simultaneous submissions and previously published work OK, "but should be explained." Pays $400 for color cover (negotiable); $200 for color inside. Pays on publication. Credit line given. Buys all rights; negotiable.

TIPS Wants to see "visually arresting images, high-quality, multiple angles, day/night lighting situations. Photos including people are rarely published."

⊕⊛⊕⊙ ARCHITECTURAL LIGHTING

One Thomas Circle NW, Suite 600, Washington DC 20005. (202)452-0800. **Fax:** (202)785-1974. **E-mail:** edonoff@hanleywood.com; rogle@hanleywood.com. **Website:** www.archlighting.com. **Contact:** Elizabeth Donoff, editor-in-chief; Robb Ogle, art director. Estab. 1981. Circ. 25,000. Published 7 times/year. Emphasizes architecture and architectural lighting. Readers are architects and lighting designers. Sample copy free.

NEEDS Buys 3-5 photos/feature story. Needs photos of architecture and architectural lighting.

SPECS Prefers images in digital format. Send via e-mail as TIFF files at 300 dpi, minimum 4×6.

MAKING CONTACT & TERMS Query *first* by e-mail to obtain permission to e-mail digital samples. Keeps samples on file. Cannot return material. Responds in 1-2 weeks. Simultaneous submissions OK. Pays $300-400 for color cover; $50-125 for color inside. Pays net 40 days point of invoice submission. Credit line given. Buys all rights for all media, including electronic media.

TIPS "Looking for a strong combination of architecture and architectural lighting."

⊕⊛⊙ ASIAN ENTERPRISE MAGAZINE

Asian Business Ventures, Inc., P.O. Box 1126, Walnut CA 91788. (909)896-2865; (909)319-2306. **E-mail:** willyb@asianenterprise.com; alma.asianent@gmail.com; almag@asianenterprise.com. **Website:** www.asianenterprise.com. Estab. 1993. Circ. 100,000. Monthly trade magazine. "Largest Asian-American small business focus magazine in US." Sample copy available with SASE and first-class postage. Editorial calendar available online.

NEEDS Buys 3-5 photos from freelancers/issue; 36-60 photos/year. Needs photos of multicultural, business concepts, senior citizens, environmental, architecture, cities/urban, education, travel, military, political, technology/computers. Reviews photos with

or without a manuscript. Model/property release required.

SPECS Uses 4×6 matte b&w prints. Accepts images in digital format. Send via ZIP as TIFF, JPEG files at 300-700 dpi.

MAKING CONTACT & TERMS Send query letter with prints. Provide self-promotion piece to be kept on file for possible future assignments. Responds only if interested; send nonreturnable samples. Simultaneous submissions OK. Pays $50-200 for color cover; $25-100 for b&w inside. Pays on publication. Credit line given. Buys one-time rights.

○ THE ATA MAGAZINE

11010 142nd St. NW, Edmonton, Alberta T5N 2R1 Canada. (780)447-9400. **Fax:** (780)455-6481. **E-mail:** government@teachers.ab.ca. **Website:** www.teachers. ab.ca. Estab. 1920. Circ. 42,100. Quarterly magazine covering education.

SPECS Reviews 4×6 prints.

MAKING CONTACT & TERMS Captions required. Negotiates payment individually. Negotiates rights.

○○ ATHLETIC BUSINESS

Athletic Business Media, Inc., 22 E. Mifflin St., Suite 910, Madison WI 53703. (800)722-8764, ext. 119. **Fax:** (608)249-1153. **E-mail:** editors@athleticbusiness.com. **Website:** www.athleticbusiness.com. **Contact:** Sadye Ring, graphic designer. Estab. 1977. Circ. 42,000. The leading resource for athletic, fitness, and recreation professionals. Monthly magazine. Emphasizes athletics, fitness, and recreation. Readers are athletic, park, and recreational directors and club managers, ages 30-65. Sample copy available for $8. The magazine can also be viewed digitally at www.athleticbusiness.com. Become a fan on Facebook or LinkedIn.

NEEDS Buys 2-3 photos from freelancers per issue; 24-26 photos/year. Needs photos of college and high school team sports, coaches, athletic equipment, recreational parks, and health club/multi-sport interiors. Model/property release preferred. Photo captions preferred.

MAKING CONTACT & TERMS Use online e-mail to contact. "Feel free to send promotional literature, but do not send anything that has to be returned (e.g., slides, prints) unless asked for." Simultaneous submissions and previously published work OK, "but should be explained." Pays $300 for color cover (ne-

gotiable); $100 for color inside. Pays on publication. Credit line given. Buys all rights; negotiable.

TIPS Wants to see "visually arresting images, ability with subject and high-quality photography." To break in, "shoot a quality and creative shot (that is part of our market) from more than one angle and at different depths."

○ ATHLETIC MANAGEMENT

20 East Lake Rd., Ithaca NY 14850-9785. (607)257-6970. **Fax:** (607)257-7328. **E-mail:** ef@momentum media.com. **Website:** www.athleticmanagement.com. **Contact:** Eleanor Frankel, editor-in-chief. Estab. 1989. Circ. 30,000. Bimonthly magazine. Emphasizes the management of athletics. Readers are managers of high school and college athletic programs.

NEEDS Uses 10–20 photos/issue; 50% supplied by freelancers. Needs photos of athletic events and athletic equipment/facility shots; college and high school sports action photos. Model release preferred.

MAKING CONTACT & TERMS Previously published work OK. Pays on publication. Credit line given. Buys first North American serial rights; negotiable.

AUTOINC.

Automotive Service Association, 8209 Mid Cities Blvd., North Richland Hills TX 76182. (817)514-2900, ext. 119. Direct line: (817)514-2919. **Fax:** (817)514-0770. **E-mail:** editor@asashop.org; leonad@asashop. org. **E-mail:** editor@asashop.org. **Website:** www .autoinc.org. Leona Dalavai Scott, Director of Marketing & Communications. **Contact:** John Clark, Editor. Estab. 1952. Circ. 5,700. The mission of *AutoInc.*, ASA's official publication, is to be the informational authority for ASA and industry members nationwide. Its purpose is to enhance the professionalism of these members through management, technical, and legislative articles, researched and written with the highest regard for accuracy, quality, and integrity.

SPECS High resolution digital images.

MAKING CONTACT & TERMS Captions, identification of subjects, model releases required (if applicable). Negotiates payment individually. Buys electronic rights.

○ AUTOMATED BUILDER

CMN Associates, Inc., 2401 Grapevine Dr., Oxnard CA 93036. (805)351-5931. **Fax:** (805)351-5755. **E-mail:** cms03@pacbell.net. **Website:** www.automatedbuilder. com. **Contact:** Don O. Carlson, editor/publisher. Es-

tab. 1964. Circ. 75,000 when printed. Published bi-monthly on the Internet. Emphasizes home, apartment, and commercial in-plant construction. Each Automated Builder has 2 segments, In-Plant and At-Home.

NEEDS Needs in-plant and/or job site construction photos with the stories.

SPECS Photos may be 4/C prints or disks.

AUTOMOTIVE NEWS

1155 Gratiot Ave., Detroit MI 48207-2997. (313)446-0363. **E-mail:** dversical@crain.com. **Website:** www.autonews.com. Estab. 1926. Circ. 77,000. Weekly tabloid. Emphasizes the global automotive industry. Readers are automotive industry executives, including people in manufacturing and retail. Sample copies available.

NEEDS Buys 5 photos from freelancers/issue; 260 photos/year. Needs photos of automotive executives (environmental portraits), auto plants, new vehicles, auto dealer features. Photo captions required; include identification of individuals and event details.

SPECS Uses 8×10 color prints; 35mm, 2¼×2¼, 4×5 transparencies. Accepts images in digital format. Send as JPEG files at 300 dpi (at least 6" wide).

MAKING CONTACT & TERMS Send unsolicited photos by mail with SASE for consideration. Provide résumé, business card, brochure, flier, or tearsheets to be kept on file for possible future assignments. Keeps samples on file. Responds in 2 weeks. Simultaneous submissions and previously published work OK. Pays on publication. Credit line given. Buys one-time rights, possible secondary rights for other Crain publications.

AUTO RESTORER

i5 Publishing, Inc., 3 Burroughs, Irvine CA 92618. (213)385-2222. **Fax:** (213)385-8565. **E-mail:** tkade@i5publishing.com. **Website:** www.autorestorermagazine.com. **Contact:** Ted Kade, editor. Estab. 1989. Circ. 60,000. Offers no additional payment for photos accepted with ms. "Interview the owner of a restored car. Present advice to others on how to do a similar restoration. Seek advice from experts. Go light on history and nonspecific details. Make it something that the magazine regularly uses. Do automotive how-tos."

NEEDS Photos of auto restoration projects and restored cars.

SPECS Prefers images in high-res digital format.

Send via CD at 240 dpi with minimum width of 5". Uses transparencies, mostly 35mm, 2¼×2¼.

MAKING CONTACT & TERMS Submit inquiry and portfolio for review. Provide résumé, business card, brochure, flier, or tearsheets to be kept on file for possible future assignments. Responds in 1 month. Simultaneous submissions OK.

AVIONICS MAGAZINE

(310) 354-1820. **E-mail:** mholmes@accessintel.com. **Website:** www.avionicsmagazine.com. **Contact:** Mark Holmes, editor. Estab. 1978. Circ. 20,000. Monthly magazine. Emphasizes aviation electronics. Readers are avionics and air traffic management engineers, technicians, executives. Sample copy free with 9×12 SASE.

NEEDS Buys 1–2 photos from freelancers/issue; 12–24 photos/year. Needs photos of travel, business concepts, industry, technology, aviation. Interested in alternative process, avant garde. Reviews photos with or without a manuscript. Photo captions required.

SPECS Prefers images in digital format. Send as JPEG files at 300 dpi minimum.

MAKING CONTACT & TERMS Query by e-mail. Provide résumé, business card, brochure, flier, or tearsheets to be kept on file for possible future assignments. Simultaneous submissions OK. Responds in 2 months. Pay varies; negotiable. **Pays on acceptance.** Credit line given. Rights negotiable.

BALLINGER PUBLISHING

41 N. Jefferson St., Suite 402, Pensacola FL 32502. (850)433-1166. **E-mail:** rita@ballingerpublishing.com; info@ballingerpublishing.com. **Website:** www.ballingerpublishing.com. **Contact:** Rita Laymon, art director. Estab. 1990. Circ. 15,000. Monthly magazines. Emphasize business, lifestyle. Readers are executives, ages 35-54, with average annual income of $80,000. Sample copy available for $1.

NEEDS Photos of Florida topics: technology, government, ecology, global trade, finance, travel, regional, and life shots. Model/property release required. Photo captions preferred.

SPECS Uses 5×7 b&w and color prints; 35mm. Prefers images in digital format. Send via CD, ZIP as TIFF, EPS files at 300 dpi.

MAKING CONTACT & TERMS Send unsolicited photos by mail or e-mail for consideration; include SASE for return of material sent by mail. Provide ré-

sumé, business card, brochure, flier, or tearsheets to be kept on file for possible future assignments. Pays on publication. Buys one-time rights.

◉ BARTENDER® MAGAZINE

Foley Publishing, P.O. Box 157, Spring Lake NJ 07762. (732)449-4499. **E-mail:** info@bartender.com. **Website:** bartender.com/mixologist.com. **Contact:** Jackie Foley, editor. Estab. 1979. Circ. 150,000. Magazine published 4 times/year. *Bartender Magazine* serves full-service drinking establishments (full-service means able to serve liquor, beer, and wine). "We serve single locations, including individual restaurants, hotels, motels, bars, taverns, lounges, and all other full-service on-premises licensees." Sample copy available for $2.50. Number of photos/issue varies; number supplied by freelancers varies. Reviews photos with or without a ms.

NEEDS Photos of liquor-related topics, drinks, bars/bartenders.

MAKING CONTACT & TERMS Model/property release required. Photo captions preferred. Provide résumé, business card, brochure, flier, or tearsheets to be kept on file for possible future assignments; include SASE for return of material. Previously published work OK. Payment negotiable. Pays on publication. Credit line given. Buys all rights; negotiable.

⑤⑤⓿ BEDTIMES

501 Wythe St., Alexandria VA 22314-1917. (571)482-5442. **Fax:** (703)683-4503. **E-mail:** jkitchen@sleepproducts.org; mbest@sleepproducts.org. **Website:** www.bedtimesmagazine.com. **Contact:** Jane Kitchen, editor-in-chief. Estab. 1917. Monthly association magazine; 40% of readership is overseas. Readers are manufacturers and suppliers in bedding industry. Sample copies available.

NEEDS Head shots, events, product shots/still life, conventions, shows, annual meetings. Reviews photos with or without a manuscript. Photo captions required; include correct spelling of name, title, company, return address for photos.

SPECS Prefers digital images sent as JPEGs via e-mail.

MAKING CONTACT & TERMS Send query letter with résumé, photocopies. Responds in 3 weeks to queries. Simultaneous submissions and previously published work may be OK—depends on type of assignment. Pays on publication. Credit line given. Buys

one-time rights; negotiable.

BEE CULTURE

623 W Liberty St., Medina OH 44256-0706. (330)725-6677; (800)289-7668. **Fax:** (330)725-5624. **E-mail:** kim@beeculture.com; info@beeculture.com. **Website:** www.beeculture.com. **Contact:** Mr. Kim Flottum, editor. Estab. 1873. Monthly trade magazine emphasizing beekeeping industry—how-to, politics, news and events. Sample copies available. Photo guidelines available on website. Buys 1-2 photos from freelancers/issue; 6-8 photos/year.

NEEDS Needs photos of honey bees and beekeeping, honey bees on flowers, etc.

SPECS Send via e-mail as TIFF, EPS, JPEG files at 300 dpi. Low-res for review encouraged.

MAKING CONTACT & TERMS Reviews photos with or without a manuscript. Accepts images in digital format. Does not keep samples on file; include SASE for return of material. E-mail contact preferred. Responds in 2 weeks to queries. Payment negotiable. **Pays on acceptance.** Credit line given.

TIPS "Read 2-3 issues for layout and topics. Think in vertical!"

BEEF TODAY

P.O. Box 958, Mexico MO 65265. (913)871-9066. **E-mail:** ghenderson@farmjournal.com; customer service@farmjournal.com; editors@agweb.com. **Website:** www.beeftoday.com. **Contact:** Greg Henderson, editorial director. Circ. 220,000. Monthly magazine. Emphasizes American agriculture. Readers are active farmers, ranchers, or agribusiness people. Sample copy and photo guidelines free with SASE.

NEEDS Buys 5–10 photos from freelancers/issue; 180–240 photos/year. "We use studio-type portraiture (environmental portraits), technical, details, scenics." Wants photos of environmental, livestock (feeding transporting, worming cattle), landscapes/scenics (from different regions of the US). Model release preferred. Photo captions required.

SPECS Accepts images in digital format. Send via CD or e-mail as TIFF, EPS, JPEG files, color RGB only.

MAKING CONTACT & TERMS Arrange a personal interview to show portfolio. Send query letter with résumé of credits along with business card, brochure, flier, or tearsheets to be kept on file for possible future assignments. Do not send originals! Responds in 2 weeks. Simultaneous submissions OK. Payment

negotiable. "We pay a cover bonus." **Pays on acceptance.** Credit line given. Buys one-time rights.

TIPS In portfolio or samples, likes to see "about 20 images showing photographer's use of lighting and ability to work with people. Know your intended market. Familiarize yourself with the magazine and keep abreast of how photos are used in the general magazine field."

⑤⑤ BEVERAGE DYNAMICS

17 High St., 2nd Floor, Norwalk CT 06851. (203)855-8499. **E-mail:** alane@specialtyim.com; rbrandes@specialtyim.com. **Website:** www.adamsbevgroup.com. **Contact:** Adam Lane, art director; Richard Brandes, editor. Circ. 67,000. Quarterly. Emphasizes distilled spirits, wine, and beer. Readers are retailers (liquor stores, supermarkets, etc.), wholesalers, distillers, vintners, brewers, ad agencies, and media.

NEEDS Uses 5-10 photos/issue. Needs photos of retailers, products, concepts, and profiles. Special needs include good retail environments, interesting store settings, special effect photos. Model/property release required. Photo captions required.

MAKING CONTACT & TERMS Send query letter with samples and list of stock photo subjects. Provide business card to be kept on file for possible future assignments. Keeps samples on file; send nonreturnable samples, slides, tearsheets, etc. Simultaneous submissions OK. Pays on publication. Credit line given. Buys one-time rights or all rights.

TIPS "We're looking for good location photographers who can style their own photo shoots or have staff stylists. It also helps if they are resourceful with props."

⑤○ BIZTIMES MILWAUKEE

BizTimes Media, 126 N. Jefferson St., Suite 403, Milwaukee WI 53202-6120. (414) 277-8181. **Fax:** (414) 277-8191. **E-mail:** shelly.tabor@biztimes.com. **Website:** www.biztimes.com. **Contact:** Shelly Tabor, art director. Estab. 1995. Circ. 13,500. Biweekly business news magazine covering southeastern Wisconsin region.

NEEDS Buys 2-3 photos from freelancers/issue; 200 photos/year; mostly by assignment. Needs photos of Milwaukee, including cities/urban, business men and women, business concepts. Interested in documentary/photo-journalistic style.

SPECS Accepts images in digital format only.

MAKING CONTACT & TERMS Provide résumé,

business card, self-promotion piece to be kept on file for possible future assignments. Responds only if interested; send nonreturnable samples. Simultaneous submissions and previously published work OK. Pays $250 maximum for color cover; $100 maximum for inside. Pays on publication.

TIPS "Readers are owners/managers/CEOs. Cover stories and special reports often need conceptual images and portraits. Clean, modern, and cutting edge with good composition. Covers have lots of possibility! Approximate 1-week turnaround. Most assignments are for the Milwaukee area."

BRAND PACKAGING

BNP Media, 2401 W. Big Beaver Rd., Suite 700, Troy MI 48084. (248)362-3700. **Fax:** (847)362-0317. **E-mail:** kalkowskij@bnpmedia.com. **Website:** www.brandpackaging.com. **Contact:** John Kalkowski, editor-in-chief. Estab. 1997. Circ. 33,000. Publishes strategies and tactics to make products stand out on the shelf. Market is brand managers who are marketers but need to know something about packaging.

MAKING CONTACT & TERMS Identification of subjects required. Negotiates payment individually. Buys one-time rights.

◎ CANADIAN GUERNSEY JOURNAL

5653 Hwy. 6 N, RR 5, Guelph, Ontario N1H 6J2 Canada. (519)836-2141. **Fax:** (519)763-6582. **E-mail:** info@guernseycanada.ca. **Website:** www.guernseycanada.ca. **Contact:** Jessie Weir. Estab. 1927. Annual journal of the Canadian Guernsey Association. Emphasizes dairy cattle, purebred and grade Guernseys. Readers are dairy farmers and agriculture-related companies. Sample copy available for $15.

NEEDS Photos of Guernsey cattle: posed, informal scenes. Photo captions preferred.

MAKING CONTACT & TERMS Contact through administration office. Keeps samples on file.

⑤ CASINO JOURNAL

2401 W. Big Weaver Rd., Troy MI 48084. (248)786-1728;(248)244-6425. **Fax:** (248)362-0317. **E-mail:** gizickit@bnpmedia.com. **Website:** www.casinojournal.com. **Contact:** Tammie Gizicki, art director. Estab. 1985. Circ. 35,000. Monthly journal. Emphasizes casino operations. Readers are casino executives, employees, and vendors. Sample copy free with 11×14 SASE. Ascend Media Gaming Group also publishes

IGWB, Slot Manager, and *Indian Gaming Business.* Each magazine has its own photo needs.

NEEDS Buys 0-2 photos from freelancers/issue; 12-24 photos/year. Needs photos of gaming tables and slot machines, casinos, and portraits of executives. Model release required for gamblers, employees. Photo captions required.

MAKING CONTACT & TERMS Send query letter with résumé of credits, stock list. Pays on publication. Credit line given. Buys all rights; negotiable.

TIPS "Read and study photos in current issues."

CATHOLIC LIBRARY WORLD

205 W. Monroe St., Suite 314, Chicago IL 60606. (312)739-1776. **Fax:** (312)739-1778. **E-mail:** mmccarthy @cathla.org; cla@cathla.org. **Website:** www.cathla. org/cathlibworld.html. **Contact:** Malachy R. McCarthy, acting executive director. Estab. 1929. Circ. 1,100. Quarterly magazine of the Catholic Library Association. Emphasizes libraries and librarians (community/school libraries; academic/research librarians; archivists). Readers are librarians who belong to the Catholic Library Association; other subscribers are generally employed in Catholic institutions or academic settings. Sample copy available for $25.

NEEDS Uses 2-5 photos/issue. Needs photos of authors of children's books, and librarians who have done something to contribute to the community at large. Special needs include photos of annual conferences. Model release preferred for photos of authors. Photo captions preferred.

MAKING CONTACT & TERMS Send electronically in high-res, 450 dpi or greater. Deadlines: January 2, April 1, July 1, October 1. Responds in 2 weeks. Credit line given. Acquires one-time rights.

CEA ADVISOR

Connecticut Education Association, Capitol Place, Suite 500, 21 Oak St., Hartford CT 06106. (860)525-5641; (800)842-4316. **Fax:** (860)725-6356; (860)725-6323. **E-mail:** kathyf@cea.org. **Website:** www.cea. org. **Contact:** Kathy Frega, director of communications; Michael Lydick, managing editor. Circ. 42,000. Monthly tabloid. Emphasizes education. Readers are public school teachers. Sample copy free with 6 first-class stamps.

NEEDS Buys 1-2 photos from freelancers/issue; 12-24 photos/year. Needs "classroom scenes, students,

school buildings." Model release preferred. Photo captions preferred.

MAKING CONTACT & TERMS Send b&w contact sheet by mail for consideration. Provide résumé, business card, brochure, flier, or tearsheets to be kept on file for possible future assignments. Cannot return material. Responds in 1 month. Simultaneous submissions and previously published work OK. Pays $50 for b&w cover; $25 for b&w inside. Pays on publication. Credit line given. Buys all rights.

CHILDHOOD EDUCATION

1101 16th St. NW, Suite 300, Washington DC 20036. (202)372-9986; (800)423-3563. **Fax:** (202)372-9989. **E-mail:** editorial@acei.org. **Website:** www.acei.org. **Contact:** Anne Watson Bauer, editor/director of publications. Estab. 1924. Circ. 15,000. Bimonthly journal of the Association for Childhood Education International. Emphasizes the education of children from infancy through early adolescence. Readers include teachers, administrators, day-care workers, parents, psychologists, student teachers, etc. Sample copy free with 9×12 SASE and $1.44 postage. Submission guidelines available online.

NEEDS Uses 1 photos/issue; 2-3 supplied by freelance photographers. Uses freelancers mostly for covers. Subject matter includes children, infancy-14 years, in groups or alone, in or out of the classroom, at play, in study groups; boys and girls of all races and in all cities and countries. Wants close-ups of children, unposed. Reviews photos with or without accompanying manuscript. Special needs include photos of minority children; photos of children from different ethnic groups together in one shot; boys and girls together. Model release required.

SPECS Accepts images in digital format, 300 dpi.

MAKING CONTACT & TERMS Send unsolicited photos by e-mail to abauer@acei.org and bherzig@ acei.org. Responds in 1 month. Simultaneous submissions and previously published work are discouraged but negotiable. Pays on publication. Credit line given. Buys one-time rights.

TIPS "Send pictures of unposed children in educational settings, please."

THE CHRONICLE OF PHILANTHROPY

1255 23rd St. NW, 7th Floor, Washington DC 20037. (202)466-1200. **Fax:** (202)452-1033. **E-mail:** creative@ chronicle.com; editor@philanthropy.com. **Website:**

philanthropy.com. **Contact:** Sue LaLumia, art director. Estab. 1988. Biweekly tabloid. Readers come from all aspects of the nonprofit world such as charities, foundations, and relief agencies such as the Red Cross. Sample copy free.

NEEDS Buys 10-15 photos from freelancers/issue; 260-390 photos/year. Needs photos of people (profiles) making the news in philanthropy and environmental shots related to person(s)/organization. Most shots arranged with freelancers are specific. Model release required. Photo caption required.

SPECS Accepts images in digital format. Send via CD, ZIP.

MAKING CONTACT & TERMS Arrange a personal interview to show portfolio. Send 35mm, 2¼×2¼ transparencies and prints by mail for consideration. Provide résumé, business card, brochure, flyer, or tearsheets to be kept on file for possible future assignments. Responds in 2 days. Previously published work OK. Pays (color and b&w) $275 plus expenses/half day; $450 plus expenses/full day; $100 for web publication (2-week period). Pays on publication. Buys one-time rights.

❹❸❶ CIVITAN MAGAZINE

P.O. Box 130744, Birmingham AL 35213-0744. (205)591-8910. **E-mail:** civitan@civitan.org. **Website:** www.civitan.org. Estab. 1920. Circ. 24,000. Quarterly publication of Civitan International. Emphasizes work with mental retardation/developmental disabilities. Readers are men and women, college age to retirement, usually managers or owners of businesses. Sample copy free with 9×12 SASE and 2 first-class stamps.

NEEDS Buys 1-2 photos from freelancers/issue; 6-12 photos/year. Always looking for good cover shots (multicultural, travel, scenic, how-to), babies/children/teens, families, religious, disasters, environmental, landscapes/scenics. Model release required. Photo captions preferred.

SPECS Accepts images in digital format. Send via CD or e-mail at 300 dpi only.

MAKING CONTACT & TERMS Send sample of unsolicited 2¼×2¼ or 4×5 transparencies by mail for consideration. Provide résumé, business card, brochure, flier, or tearsheets to be kept on file for possible future assignments. Responds in 1 month. Simultaneous submissions and previously published work OK. Pays $50-200 for color cover; $20 for color inside. **Pays on acceptance.** Buys one-time rights.

❸ CLASSICAL SINGER

P.O. Box 1710, Draper UT 84020. (801)254-1025; (877)515-9800. **Fax:** (801)254-3139. **E-mail:** info@classicalsinger.com. **Website:** www.classicalsinger.com. **Contact:** Blaine Hawkes. Estab. 1988. Circ. 9,000. Glossy monthly trade magazine for classical singers. Sample copy free.

NEEDS Looking for photos in opera or classical singing. E-mail for calendar and ideas. Photo captions preferred; include where, when, who.

SPECS Uses b&w and color prints or high-res digital photos.

MAKING CONTACT & TERMS Responds in 1 month to queries. Simultaneous submissions and previously published work OK. Pays honorarium plus 10 copies. Pays on publication. Credit line given. Buys one-time rights. Photo may be used in a reprint of an article on paper or website. "In an effort to reduce spam, we are no longer providing our e-mail addresses from our website. Please use the online form to contact individual staff members."

TIPS "Our publication is expanding rapidly. We want to make insightful photographs a big part of that expansion."

❸❶ CLEANING & MAINTENANCE MANAGEMENT

NTP Media, 19 British American Blvd. W., Latham NY 12110. (518)783-1281, ext. 3137. **Fax:** (518)783-1386. **E-mail:** marty@grandviewmedia.com; rdipaolo@ntpmedia.com. **Website:** www.cmmonline.com. **Contact:** Marty Harris, art director. Estab. 1963. Circ. 38,300. Monthly. Emphasizes management of cleaning/custodial/housekeeping operations for commercial buildings, schools, hospitals, shopping malls, airports, etc. Readers are middle- to upper-level managers of in-house cleaning/custodial departments, and managers/owners of contract cleaning companies. Sample copy free (limited) with SASE.

NEEDS Uses 10-15 photos/issue. Needs photos of cleaning personnel working on carpets, hardwood floors, tile, windows, restrooms, large buildings, etc. Model release preferred. Photo captions required.

MAKING CONTACT & TERMS Provide résumé, business card, brochure, flier, or tearsheets to be kept on file for possible future assignments. "Send query letter with specific ideas for photos related to our field." Responds in 1-2 weeks. Simultaneous submissions and previously published work OK. Pays $25 for

b&w inside. Credit line given. Rights negotiable.

TIPS "Query first and shoot what the publication needs."

⊘ COMMERCIAL CARRIER JOURNAL

3200 Rice Mine Rd. NE, Tuscaloosa AL 35406. (800)633-5953. **Fax:** (205)750-8070. **E-mail:** production@ccjdigital.com. **Website:** www.ccj magazine.com. **Contact:** David Watson, art director. Estab. 1911. Circ. 105,000. Monthly magazine. Emphasizes truck and bus fleet maintenance operations and management.

NEEDS Spot news (of truck accidents, Teamster activities, and highway scenes involving trucks). Photos purchased with or without accompanying manuscript, or on assignment. Model release required. Detailed captions required.

SPECS Prefers images in digital format. Send via e-mail as JPEG files at 300 dpi. For covers, uses medium-format transparencies (vertical only).

MAKING CONTACT & TERMS Does not accept unsolicited photos. Query first; send material by mail with SASE for consideration. Responds in 3 months. Pays on a per-job or per-photo basis. **Pays on acceptance.** Credit line given. Buys all rights.

TIPS Needs accompanying features on truck fleets and news features involving trucking companies.

CONSTRUCTION EQUIPMENT GUIDE

470 Maryland Dr., Ft. Washington PA 19034. (215)885-2900 or (800)523-2200. **E-mail:** production @cegltd.com; editorial@cegltd.com. **Website:** www.constructionequipmentguide.com. **Contact:** Craig Mongeau, editor-in-chief. Estab. 1957. Circ. 120,000. Biweekly trade newspaper. Emphasizes construction equipment industry, including projects ongoing throughout the country. Readers are males and females of all ages; many are construction executives, contractors, dealers, and manufacturers. Free sample copy.

NEEDS Buys 35 photos from freelancers/issue; 910 photos/year. Needs photos of construction job sites and special event coverage illustrating new equipment applications and interesting projects. Call to inquire about special photo needs for coming year. Model/property release preferred. Photo captions required for subject identification.

MAKING CONTACT & TERMS Send any size matte or glossy b&w prints by mail with SASE for con-

sideration. Provide résumé, business card, brochure, flyer, or tearsheets to be kept on file for possible future assignments. Responds in 3 weeks. Payment negotiable. Pays on publication. Credit line given. Buys all rights; negotiable.

THE COOLING JOURNAL

3000 Village Run Rd., Suite 103, #221, Wexford PA 15090. (724)799-8415. **Fax:** (724)799-8416. **E-mail:** info@narsa.org. **Website:** www.narsa.org. Estab. 1956. Published 10 times a year. Magazine of NARSA—The International Heat Exchange Association. Emphasis on thermal management products and services for transportation, energy, and industry.

NEEDS Buys photos, images, and stories about people, organizations, processes, technologies, and products in heat exchange industry which includes: automotive, heavy truck, and mobile machinery engine and transmission cooling; automotive, heavy truck, and mobile machinery air conditioning and cabin heating; engine and transmission cooling for marine applications; engine and transmission cooling for vehicle high performance and racing; heat exchange for energy exploration and generation; construction, mining, agricultural applications for heat exchange products and services; metals joining including welding and brazing; heat exchange product fabrication, design, and engineering.

MAKING CONTACT & TERMS Send inquiry for current story board, rates, and deadlines. Pays on publication.

COTTON GROWER MAGAZINE

Meister Media Worldwide, Cotton Media Group, 8000 Centerview Pkwy., Suite 114, Cordova TN 38018-4246. (901)756-8822. **E-mail:** mccue@meister media.com. **Website:** www.cotton247.com. **Contact:** Mike McCue, editor. Circ. 43,000. Monthly magazine. Emphasizes "cotton production; for cotton farmers." Sample copies and photo guidelines available.

NEEDS Photos of agriculture. "Our main photo needs are cover shots of growers. We write cover stories on each issue."

SPECS Prefers high-res digital images; send JPEGs at 300 dpi via e-mail or CD. Uses high-quality glossy prints from 35mm.

MAKING CONTACT & TERMS Send query letter with slides, prints, tearsheets. Pays on acceptance. Credit line given. Buys all rights.

TIPS Most photography hired is for cover shots of cotton growers.

CROPLIFE

37733 Euclid Ave., Willoughby OH 44094. (440)942-2000. **E-mail:** erics@croplife.com. **Website:** www.croplife.com. Estab. 1894. Circ. 24,500. Monthly magazine. Serves the agricultural distribution channel delivering fertilizer, chemicals, and seed from manufacturer to farmer. Sample copy and photo guidelines free with 9×12 SASE.

NEEDS Buys 6-7 photos/year; 5-30% supplied by freelancers. Needs photos of agricultural chemical and fertilizer application scenes (of commercial—not farmer—applicators), people shots of distribution channel executives and managers. Model release preferred. Photo captions required.

SPECS Uses 8×10 glossy b&w and color prints; 35mm slides, transparencies.

MAKING CONTACT & TERMS Send query letter first with résumé of credits. Simultaneous submissions and previously published work OK. **Pays on acceptance.** Buys one-time rights.

DAIRY TODAY

P.O. Box 1167, 261 E. Broadway, Monticello MN 55362. (763)271-3363. **E-mail:** jdickrell@farmjournal.com; editors@farmjournal.com. **Website:** www.agweb.com/livestock/dairy/. **Contact:** Jim Dickrell, editor. Circ. 20,000. Monthly magazine. Emphasizes American agriculture. Readers are active farmers, ranchers, or agribusiness people. Sample copy and photo guidelines free with SASE.

NEEDS Buys 5-10 photos from freelancers/issue; 60-120 photos/year. "We use studio-type portraiture (environmental portraits), technical, details, scenics." Wants photos of environmental, landscapes/scenics, agriculture, business concepts. Model release preferred. Photo captions required.

MAKING CONTACT & TERMS Arrange a personal interview to show portfolio. Send query letter with résumé of credits along with business card, brochure, flier, or tearsheets to be kept on file for possible future assignments. "Portfolios may be submitted via CD." *Do not send originals!* Responds in 2 weeks. Simultaneous submissions OK. "We pay a cover bonus." **Pays on acceptance.** Credit line given, except in advertorials. Buys one-time rights.

TIPS In portfolio or samples, likes to see "about 40 slides showing photographer's use of lighting and ability to work with people. Know your intended market. Familiarize yourself with the magazine and keep abreast of how photos are used in the general magazine field."

DERMASCOPE MAGAZINE

Aesthetics International Association, 310 E. Interstate 30, Suite B107, Garland TX 75043. (469)429-9300. **Fax:** (469)429-9301. **E-mail:** amanda@dermascope.com. **Website:** www.dermascope.com. **Contact:** Amanda Strunk-Miller, managing editor. Estab. 1978. Circ. 16,000. *Dermascope* is a source of practical advice and continuing education for skin care, body, and spa therapy professionals. Main readers are salon, day spa, and destination spa owners, managers, or technicians and aesthetics students.

MAKING CONTACT & TERMS Accepts disk submissions. Electronic images should be 300 dpi, CMYK, and either JPEG, TIFF, PSD, or EPS format. Photo credits, model releases, and identification of subjects or techniques shown in photos are required. Samples are not filed. Photos will not be returned; do not send original artwork. Responds only if interested. Rights purchased vary according to project. Pays on publication.

DESIGN:RETAIL MAGAZINE

1145 Sanctuary Pkwy., Suite 355, Alpharetta GA 30009. (770)291-5520. **E-mail:** wendi.vaneldik@emeraldexpo.com. **Website:** www.designretailonline.com. **Contact:** Wendi Van Eldik, art director. Estab. 1988. Circ. 21,500. Monthly magazine. Emphasizes retail design, store planning, visual merchandising. Readers are retail architects, designers, and retail executives. Sample copies available.

NEEDS Buys 7 or fewer photos from freelancers/issue; 84 or fewer photos/year. Needs photos of architecture, mostly interior. Property release preferred.

SPECS Prefers digital submissions. Send as TIFF or JPEG files at 300 dpi.

MAKING CONTACT & TERMS Send query letter with résumé of credits. Provide résumé, business card, brochure, flyer, or tearsheets to be kept on file for possible future assignments. Responds in 3 weeks. Credit line given. Rights negotiable.

TIPS Looks for architectural interiors, ability to work with different lighting. "Send samples (photocopies OK) and résumé."

DM NEWS

Haymarket Media, Inc., 114 W. 26th St., New York NY 10001. (646)638-6186. **E-mail:** James.Jarnot@ dmnews.com; news@dmnews.com; Ginger.Conlon@ dmnews.com. **Website:** www.dmnews.com. **Contact:** Ginger Conlon. Estab. 1979. Circ. 50,300. Company publication for Courtenay Communications Corporation. Weekly newspaper. Emphasizes direct, interactive, and database marketing. Readers are decision makers and marketing executives, ages 25-55. Sample copy available for $2.

NEEDS Uses 20 photos/issue; 3-5 supplied by freelancers. Needs news head shots, product shots. Reviews photos purchased with accompanying manuscript only. Photo captions required.

MAKING CONTACT & TERMS Provide résumé, business card, brochure, flier, or tearsheets to be kept on file for possible future assignments. Responds in 1-2 weeks. Payment negotiable. **Pays on acceptance.** Buys worldwide rights.

TIPS "News and business background are a prerequisite."

ELECTRICAL APPARATUS

Barks Publications, Inc., Suite 901, 500 N. Michigan Ave., Chicago IL 60611. (312)321-9440. **Fax:** (312)321-1288. **E-mail:** eamagazine@barks.com. **Website:** www.barks.com. **Contact:** Elizabeth Van Ness, publisher; Kevin N. Jones, senior editor. Estab. 1967. Circ. 16,000. Monthly magazine. Emphasizes industrial electrical machinery maintenance and repair for the electrical aftermarket. Readers are "persons engaged in the application, maintenance, and servicing of industrial and commercial electrical and electronic equipment." Sample copies available.

NEEDS "Assigned materials only. We welcome innovative industrial photography, but most of our material is staff-prepared." Photos purchased with accompanying manuscript or on assignment. Model release required "when requested." Photo captions required.

MAKING CONTACT & TERMS Send query letter with résumé of credits. Contact sheet OK; include SASE for return of material. Responds in 3 weeks. Pays up to $200, digital format only. Pays on publication. Credit line given. Buys all rights, but exceptions are occasionally made.

ELECTRIC PERSPECTIVES

701 Pennsylvania Ave. NW, Washington DC 20004. (202)508-5065. **E-mail:** cjohnson@eei.org. **Website:** www.eei.org/magazine/Pages/ElectricPerspectives Issues.aspx. **Contact:** Clare James Johnson. Estab. 1976. Circ. 11,000. Bimonthly magazine of the Edison Electric Institute. Emphasizes issues and subjects related to shareholder-owned electric utilities. Sample copy available on request.

NEEDS Photos relating to the business and operational life of electric utilities—from customer service to engineering, from executive to blue collar. Model release required. Photo captions preferred.

SPECS Uses 8×10 glossy color prints; 35mm, 2¼×2¼, 4×5 transparencies. Accepts images in digital format. All high-res non-postscript formats accepted. Send via ZIP, e-mail as TIFF, JPEG files at 300 dpi and scanned at a large size, at least 4×5.

MAKING CONTACT & TERMS Send query letter with stock list or send unsolicited photos by mail for consideration. Provide electronic résumé, business card, or brochure to be kept on file for possible future assignments. Keeps samples on file. Pays on publication. Buys one-time rights; negotiable (for reprints).

TIPS "We're interested in annual-report-quality images in particular. Quality and creativity are often more important than subject."

EL RESTAURANTE

P.O. Box 2249, Oak Park IL 60303-2249. (708)267-0023. **E-mail:** kfurore@comcast.net. **Website:** www. restmex.com. **Contact:** Kathleen Furore, editor. Estab. 1997. Circ. 25,000. Formerly *El Restorante Mexicano*. Bimonthly magazine for restaurants that serve Mexican, Tex-Mex, Southwestern, and Latin cuisine. Sample copies available.

NEEDS Buys very few photos from freelancers. Needs photos of food/drink. Reviews photos with or without a manuscript.

SPECS Accepts digital submissions only. Send via e-mail as TIFF, JPEG files of at least 300 dpi.

MAKING CONTACT & TERMS Previously published work OK. Pays $450 maximum for color cover; $125 maximum for color inside. Pays on publication. Credit line given. Buys all rights; negotiable.

TIPS "We look for outstanding food photography; the more creatively styled, the better."

ESL TEACHER TODAY

E-mail: shannonaswriter@yahoo.com. **Contact:** Shannon Bridget Murphy. Quarterly magazine. Photo guidelines available via e-mail.

NEEDS Buys 12-24 photos/year. Photos of babies/children/teens, multicultural, families, parents, disasters, environmental, landscapes/scenics, wildlife, cities/urban, education, religious, rural, adventure, events, food/drink, sports, travel, agriculture, medicine, military, political, product shots/still life, science, technology—as related to teaching ESL (English as a Second Language) around the globe. Interested in alternative process, avant garde, documentary, fashion/glamour, fine art, historical/vintage, seasonal. Reviews photos with or without a manuscript. Model/property release preferred.

SPECS Uses glossy or matte color and b&w prints.

MAKING CONTACT & TERMS Send query letter via e-mail. "If possible, please do not include photographs in files if they are sent through e-mail. A disc with your photographs sent to *ESL Teacher Today* is acceptable." Provide résumé, business card, or self-promotion piece to be kept on file for possible future assignments. Responds within 1 month to queries; 1 week to portfolios. Simultaneous submissions and previously published work OK. **Pays on acceptance.** Credit line given. Buys one-time rights, first rights; negotiable.

⊛⊛ FARM JOURNAL

P.O. Box 958, Mexico MO 65265. **E-mail:** lbenne@farmjournal.com. **Website:** www.agweb.com/farmjournal. Estab. 1877. Circ. 375,000. *Farm Journal,* the largest national US farm magazine, is a prime source of practical information on crops and livestock for farm families. Published 12 times a year, the magazine emphasizes agricultural production, technology, and policy.

NEEDS Photos having to do with the basics of raising, harvesting, and marketing of all the farm commodities (primarily corn, soybeans, and wheat) and farm animals. All photos must relate to agriculture.

SPECS Accepts images in digital format.

MAKING CONTACT & TERMS Send online portfolios to the e-mail address above or send photo/thumbnails by mail.

TIPS Provide calling card and samples to be kept on file for possible future assignments.

FIRE CHIEF

Primedia Business, 330 N. Wabash Ave., Suite 2300, Chicago IL 60611. (312)595-1080. **Fax:** (312)595-0295. **E-mail:** Rick.Markley@praetoriangroup.com. **Website:** www.firechief.com. **Contact:** Rick Markley, editor in chief. Estab. 1956. Circ. 53,000. Monthly magazine. Focus on fire department management and operations. Readers are primarily fire officers and predominantly chiefs of departments. Sample copy free. Request photo guidelines via e-mail.

NEEDS Needs "fire and emergency response, especially leadership themes—if you do not have fire or EMS experience, please do not contact."

SPECS Digital format preferred, file name less than 15 characters. Send via e-mail, CD, ZIP as TIFF, EPS files at highest possible resolution.

MAKING CONTACT & TERMS Send JPEGs or TIFFs at no larger than 300 dpi for consideration along with caption, date, time, and location. Samples are kept on file. Expect confirmation/response within 1 month. Payment 90 days after publication. Buys first serial rights; negotiable.

TIPS "As the name *Fire Chief* implies, we prefer images showing a leading officer (white, yellow, or red helmet) in action—on scene of a fire, disaster, accident/rescue, hazmat, etc. Other subjects: administration, communications, decontamination, dispatch, EMS, foam, heavy rescue, incident command, live fire training, public education, SCBA, water rescue, wildland fire."

FIRE ENGINEERING

PennWell Corporation, 21-00 Rt. 208 S., Fair Lawn NJ 07410-2602. (973)251-5054. **E-mail:** dianer@pennwell.com. **Website:** www.fireengineering.com. **Contact:** Diane Rothschild, executive editor. Estab. 1877. Training magazine for firefighters. Photo guidelines free.

NEEDS Uses 400 photos/year. Needs action photos of disasters, firefighting, EMS, public safety, fire investigation and prevention, rescue. Photo captions required; include date, what is happening, location, and fire department contact.

SPECS Accepts images in digital format. Send via e-mail or mail on CD as JPEG files at 300 dpi minimum.

MAKING CONTACT & TERMS Send unsolicited photos by mail for consideration. Pays on publication. Credit line given. "We retain copyright."

TIPS "Firefighters must be doing something. Our focus is on training and learning lessons from photos."

⊕❸§❶ FIREHOUSE MAGAZINE

3 Huntington Quadrangle, Suite 301N, Melville NY 11747. (631)845-2700; (800)547-7377, ext. 6262. **E-mail:** marianne.mcintyre@cygnuspub.com. **Website:** www.firehouse.comin. **Contact:** Marianne McIntyre, art director. Estab. 1976. Circ. 90,000. Monthly. Emphasizes "firefighting—notable fires, techniques, dramatic fires and rescues, etc." Readers are "paid and volunteer firefighters, EMTs." Sample copy available for $5 with 9×12 SASE and 7 first-class stamps. Photo guidelines free with SASE or online.

NEEDS Buys 20 photos from freelancers/issue; 240 photos/year. Needs photos of fires, terrorism, firefighter training, natural disasters, highway incidents, hazardous materials, dramatic rescues. Model release preferred.

SPECS Uses 3×5, 5×7, 8×10 matte or glossy b&w or color prints; 35mm transparencies. Accepts images in digital format. Send via CD, e-mail as TIFF, EPS, JPEG files at 300 dpi.

MAKING CONTACT & TERMS "Photos must not be more than 30 days old." Include SASE. "Photos cannot be returned without SASE." Responds ASAP. Pays on publication. Credit line given. Buys one-time rights.

TIPS "Mostly we are looking for action-packed photos—the more fire, the better the shot. Show firefighters in full gear; do not show spectators. Fire safety is a big concern. Much of our photo work is freelance. Try to be in the right place at the right time as the fire occurs. Be sure that photos are clear, in focus, and show firefighters/EMTs at work. Firehouse encourages submissions of high-quality action photos that relate to the firefighting/EMS field. Please understand that while we encourage first-time photographers, a minimum waiting period of 3-6 months is not unusual. Although we are capable of receiving photos online, please be advised that there are color variations. Include captions. Photographers must include a SASE, and we cannot guarantee the return of unsolicited photos. Mark name and address on the back of each photo."

§❶ FIRERESCUE

PennWell Corporation, 21-00 Route 208 South, Fair Lawn NJ 07410. (973)251-5055. **E-mail:** frm.editor@pennwell.com; dianer@pennwell.com. **Website:** www.firefighternation.com. **Contact:** Diane Rothschild, executive editor. Estab. 1997. Circ. 50,000. Monthly. Emphasizes techniques, equipment, action stories of fire and rescue incidents. Editorial slant: "Read it today, use it tomorrow."

NEEDS Photos of fires, fire ground scenes, commanders operating at fires, company officers/crews fighting fires, disasters, emergency medical services, rescue scenes, transport, injured victims, equipment and personnel, training, earthquake rescue operations. Special photo needs include strong color shots showing newsworthy rescue operations, including a unique or difficult firefighting, rescue/extrication, treatment, transport, personnel, etc.; b&w showing same. Photo captions required.

SPECS Accepts images in digital format. Prefers digital format submitted via e-mail or FTP (www.firefighternation.com/content/photographer-guidelines). Send via ZIP, e-mail, CD as TIFF, EPS, JPEG files at 300 dpi.

MAKING CONTACT & TERMS Pays $300 for cover; $22-137 for color inside. Pays on publication. Credit line given. Buys one-time rights.

✲◎§§❶ FLORAL MANAGEMENT MAGAZINE

1601 Duke St., Alexandria VA 22314. (703)836-8700; (800) 336-4743. **Fax:** (703)836-8705. **E-mail:** kpenn@safnow.org; info@safnow.org. **Website:** www.safnow.org. **Contact:** Kate Penn, editor-in-chief. Estab. 1894. National trade association magazine representing growers, wholesalers and retailers of flowers and plants. Photos used in magazine and promotional materials.

NEEDS Offers 15-20 assignments/year. Needs photos of floral business owners, employees on location, and retail environmental portraits. Reviews stock photos. Model release required. Photo captions preferred.

SPECS Prefers images in digital format. Send via CD or e-mail as TIFF files at 300 dpi. Also uses b&w prints; transparencies.

MAKING CONTACT & TERMS Send query letter with samples. Provide résumé, business card, brochure, flier, or tearsheets to be kept on file for possible future assignments. Responds in 1 week. Credit line given. Buys one-time rights.

TIPS "We shoot a lot of tightly composed, dramatic shots of people, so we look for these skills. We also welcome input from the photographer on the concept of the shot. Our readers, as business owners, like to see photos of other business owners. Therefore, people photography, on location, is particularly popular." Photographers should approach magazine "via letter of introduction and sample. We'll keep name in file and use if we have a shoot near photographer's location."

⊕Ⓢ◯ FOREST LANDOWNER

900 Circle 75 Pkwy., Suite 205, Atlanta GA 30339. (800)325-2954; (404)325-2954. **Fax:** (404)325-2955. **E-mail:** info@forestlandowners.com. **Website:** www. forestlandowners.com. Estab. 1942. Circ. 10,000. Bi-monthly magazine of the Forest Landowners Association. Emphasizes forest management and policy issues for private forest landowners. Readers are forest landowners and forest industry consultants; 94% male between the ages of 46 and 55. Sample copy available for $3 (magazine), $30 (manual).

NEEDS Uses 15-25 photos/issue; 3-4 supplied by freelancers. Needs photos of unique or interesting private southern forests. Other subjects: environmental, regional, wildlife, landscapes/scenics. Model/property release preferred. Photo captions preferred.

SPECS Accepts images in digital format. Send via CD, ZIP, e-mail as TIFF, EPS files at 300 dpi.

MAKING CONTACT & TERMS Send ZIP disk, color prints, negatives, or transparencies by mail or e-mail for consideration. Send query letter with stock list. Keeps samples on file. SASE. Responds in 3 weeks. Simultaneous submissions and previously published work OK. Pays on publication. Credit line given. Buys one-time and all rights; negotiable.

TIPS "We most often use photos of timber management, seedlings, aerial shots of forests, and unique southern forest landscapes. Mail ZIP, CD or slides of sample images. Captions are important."

FRUIT GROWERS NEWS

Great American Publishing, P.O. Box 128, Sparta MI 49345. (616)887-9008. **Fax:** (616)887-2666. **E-mail:** fgnedit@fruitgrowersnews.com. **Website:** www.fruit growersnews.com. **Contact:** Matt Milkovich, managing editor; Lee Dean, editorial director. Estab. 1961. Circ. 16,429. Monthly. Emphasizes all aspects of tree fruit and small fruit growing as well as farm market-ing. Readers are growers but include anybody associated with the field. Sample copy available.

NEEDS Buys 3 photos from freelancers/issue; 25 photos/year. Needs portraits of growers, harvesting, manufacturing, field shots for stock photography—anything associated with fruit growing. Photo captions required.

SPECS Accepts images in digital format. Send via CD as JPEG, TIFF, or EPS files at 300 dpi, at least 4×6.

MAKING CONTACT & TERMS Query about prospective jobs. Simultaneous submissions and previously published work OK. Payment rates to be negotiated between editorial director and individual photographer. Pays on publication. Credit line given. Buys first North American rights.

TIPS "Learn about the field. Great American Publishing also publishes *The Vegetable Growers News*, *Spudman*, *Fresh Cut*, *Museums & More*, *Party & Paper Retailer*, and *Stationery Trends*. Contact the editorial director for information on these publications."

GEOSYNTHETICS

1801 County Rd. B W, Roseville MN 55113. (651)222-2508 or (800)225-4324. **Fax:** (651)631-9334; (651)225-6966. **E-mail:** generalinfo@ifai.com; rwbygness@ifai. com. **Website:** www.geosyntheticsmagazine.com; www.ifai.com. **Contact:** Ron Bygness, editor. Estab. 1983. Circ. 18,000. Association magazine published 6 times/year. Emphasizes geosynthetics in civil engineering applications. Readers are civil engineers, professors, and consulting engineers. Sample copies available.

NEEDS Uses 10-15 photos/issue; various number supplied by freelancers. Needs photos of finished applications using geosynthetics; photos of the application process. Reviews photos with accompanying manuscript only. Model release required. Photo captions required; include project, type of geosynthetics used and location.

SPECS Prefers images in high-res digital format.

MAKING CONTACT & TERMS "Please call before submitting samples!" Keeps samples on file. Responds in 1 month. Simultaneous submissions OK. Credit line given. Buys all rights; negotiable.

Ⓢ◐ GOVERNMENT TECHNOLOGY

100 Blue Ravine Rd., Folsom CA 95630. (916)932-1300. **Fax:** (916)932-1470. **E-mail:** mhamm@govtech. com. **Website:** www.govtech.com. **Contact:** Michelle

Hamm, creative director. Estab. 2001. Circ. 60,000. Monthly trade magazine. Emphasizes information technology as it applies to state and local government. Readers are government executives.

NEEDS Buys 2 photos from freelancers/issue; 20 photos/year. Needs photos of government officials, disasters, environmental, political, technology/computers. Reviews photos with accompanying manuscript only. Model release required; property release preferred. Photo captions required.

SPECS Accepts images in digital format only. Send via DVD, CD, ZIP, e-mail as TIFF, JPEG files at 300 dpi.

MAKING CONTACT & TERMS Send query letter with résumé, prints, tearsheets. Provide business card, self-promotion piece to be kept on file for possible future assignments. Responds only if interested; send nonreturnable samples. Simultaneous submissions and previously published work OK. Payment is dependent upon pre-publication agreement between photographer and *Government Technology*. Pays on publication. Credit line given. Buys one-time rights, electronic rights.

TIPS "View samples of magazines for style, available online at www.govtech.com/gt/magazines."

GRAIN JOURNAL

Country Journal Publishing Co., 3065 Pershing Court, Decatur IL 62526. (800)728-7511. **E-mail:** ed@grain net.com. **Website:** www.grainnet.com. **Contact:** Ed Zdrojewski, editor. Estab. 1972. Circ. 12,000. Bimonthly magazine. Emphasizes grain industry. Readers are "elevator and feed mill managers primarily, as well as suppliers and others in the industry." Sample copy free with #10 SASE.

NEEDS Uses about 1-2 photos/issue. "We need photos concerning industry practices and activities. We look for clear, high-quality images without a lot of extraneous material." Photo captions preferred.

SPECS Accepts images in digital format minimum 300 dpi resolution. Send via e-mail, floppy disk, ZIP.

MAKING CONTACT & TERMS Send query letter with samples and list of stock photo subjects. Responds in 1 week. Pays $100 for color cover; $30 for b&w inside. Pays on publication. Credit line given. Buys all rights; negotiable.

HARD HAT NEWS

Lee Publications, Inc., 6113 State Highway 5, P.O. Box 121, Palatine Bridge NY 13428. (518)673-3763 or (800)218-5586. **Fax:** (518)673-2381. **E-mail:** jcasey@ leepub.com. **Website:** www.hardhat.com. **Contact:** Jon Casey, editor. Estab. 1980. Circ. 15,000. Biweekly trade newspaper for heavy construction. "Our readers are contractors and heavy construction workers involved in excavation, highways, bridges, utility construction, and underground construction." Readership includes owners, managers, senior construction trades. Photo guidelines available via e-mail only.

NEEDS Buys 12 photos from freelancers/issue; 280 photos/year. Specific photo needs: heavy construction in progress, construction people. Reviews photos with accompanying ms only. Property release preferred. Photo captions required.

SPECS Only high-res digital photographs. Send via e-mail as JPEG files at 300 dpi.

MAKING CONTACT & TERMS E-mail only. Simultaneous submissions OK. Pays on publication. Credit line given. Buys first rights.

TIPS "Include caption and brief explanation of what picture is about."

⑤ HEARTH AND HOME

P.O. Box 1288, Laconia NH 03247. (800)258-3772; (603)528-4285. **Fax:** (888)873-3610; (603)527-3404. **E-mail:** production@villagewest.com. **Website:** hearthandhome.com. **Contact:** Erica Paquette, art director. Circ. 16,000. Monthly magazine. Emphasizes hearth, barbecue, and patio news and industry trends for specialty retailers and manufacturers of solid fuel and gas appliances, barbeque grills, hearth appliances inside and outside and casual furnishings. Sample copy available for $5.

NEEDS Buys 3 photos from freelancers/issue; 36 photos/year. Photos of inside and outside fireplace and patio furnishings, gas grills, outdoor room shots emphasizing BBQs, furniture, and outdoor fireplaces. Assignments available for conferences." Model release required. Photo captions preferred.

SPECS Accepts digital images with color proof; high-res, 300 dpi preferred.

MAKING CONTACT & TERMS Contact before submitting material. Responds in 2 weeks. Simultaneous and photocopied submissions OK. Pays within 30 days after publication prints. Credit line given. Buys various rights.

TIPS "Call first and ask what we need. We're *always* on the lookout for gorgeous outdoor room material."

ⓢ HEREFORD WORLD

Hereford Cattle Association, P.O. Box 014059, Kansas City MO 64101. (816)842-3757. **Fax:** (816)842-6931. **E-mail:** lgraber@hereford.org. **Website:** www.hereford world.org. **Contact:** Lindsay Graber, creative services coordinator. Estab. 1947. Circ. 5,600. Monthly (11 issues with 7 glossy issues) association magazine. Emphasizes Hereford cattle for registered breeders, commercial cattle breeders, and agribusinessmen in related fields. A tabloid-type issue is produced 4 times—January, February, August, and October—and mailed to an additional 20,000 commercial cattlemen. "We also publish a commercial edition with a circulation of 20,000."

NEEDS "*Hereford World* includes timely articles and editorial columns that provide readers information to help them make sound management and marketing decisions. From basic how-to articles to in-depth reports on cutting-edge technologies, *Hereford World* offers its readers a solid package of beef industry information."

SPECS Uses b&w and color prints.

MAKING CONTACT & TERMS Query. Responds in 2 weeks. Pays on publication.

TIPS Wants to see "Hereford cattle in quantities, in seasonal and scenic settings."

ⓦ HPAC: HEATING PLUMBING AIR CONDITIONING

80 Valleybrook Dr., Toronto Ontario M3B 2S9, Canada. (416)510-5218. **Fax:** (416)510-5140. **E-mail:** smacisaac@hpacmag.com; kturner@hpacmag.com. **Website:** www.hpacmag.com. **Contact:** Sandy MacIsaac, art director; Kerry Turner, editor. Estab. 1923. Circ. 19,500. Bimonthly magazine plus annual buyers guide. Emphasizes heating, plumbing, air conditioning, refrigeration. Readers are predominantly male mechanical contractors, ages 30-60. Sample copy available for $4.

NEEDS Photos of mechanical contractors at work, site shots, product shots. Model/property release preferred. Photo captions preferred.

SPECS Images in digital format. E-mail as TIFF, JPEG files at 300 dpi minimum.

MAKING CONTACT & TERMS Pays on publication. Credit line given. Buys one-time rights; negotiable.

ⓢⓢⓞ IEEE SPECTRUM

3 Park Ave., New York NY 10016. (212)419-7555. **E-mail:** r.silberman@ieee.org. **Website:** www.spectrum. ieee.org. **Contact:** Randi Silberman Klett, photo editor. Circ. 375,000. Monthly magazine of the Institute of Electrical and Electronics Engineers, Inc. (IEEE). Emphasizes electrical and electronics field and high technology for technology innovators, business leaders, and the intellectually curious. *Spectrum* explores future technology trends and the impact of those trends on society and business. Readers are technology professionals and senior executives worldwide in the high technology sectors of industry, government, and academia. Subscribers include engineering managers and corporate and financial executives, deans and provosts at every major engineering university and college throughout the world; males/females, educated, ages 20-70.

NEEDS Uses 20-30 photos/issue. Purchases stock photos in following areas: technology, energy, medicine, military, sciences, and business concepts. Hires assignment photographers for location shots and portraiture, as well as product shots. Model/property release required. Photo captions required.

SPECS Accepts images in digital format. Send via CD as TIFF, JPEG files at 300 dpi.

MAKING CONTACT & TERMS Provide promos or tearsheets to be kept on file for possible future assignments. Pays $1,200 for color cover; $200-600 for inside. **Pays on acceptance.** Credit line given. Buys one-time rights.

TIPS Wants photographers who are consistent, have an ability to shoot color and b&w, display a unique vision, and are receptive to their subjects. "As our subject matter is varied, *Spectrum* uses a variety of imagemakers."

ⓞ IGA GROCERGRAM

8745 W. Higgins Rd., Suite 350, Chicago IL 60631. (773)693-5902. **E-mail:** apage@igainc.com. **Website:** www.iga.com/igagrocergram.aspx. **Contact:** Ashley Page, communications. Quarterly magazine of the Independent Grocers Alliance. This comprehensive quarterly magazine—which evolved from the monthly that has chronicled the Alliance since its birth in 1926—is published in 4 seasonal editions each year and distributed to a worldwide audience. The glossy keep-sake issues profile IGA and its members through in-depth stories featuring stimulating interviews

and informative analyses. Emphasizes food industry. Readers are IGA retailers. Sample copy available upon request.

NEEDS Needs in-store shots, food (appetite appeal). Prefers shots of IGA stores. Model/property release required. Photo captions required.

SPECS Accepts images in digital format. Send as TIFF files at 300 dpi.

MAKING CONTACT & TERMS Send samples by e-mail or link to website for consideration. Provide résumé, business card, brochure, flier, or tearsheets to be kept on file for possible future assignments. Keeps samples on file. Responds in 3 weeks. Simultaneous submissions and previously published work OK. Pay negotiable. **Pays on acceptance.** Credit line given. Buys one-time rights.

◑ INDEPENDENT RESTAURATEUR

P.O. Box 917, Newark OH 43058. (740)345-5542. **Fax:** (740)345-5557. **E-mail:** editor@theindependent restaurateur.com; jim@theindependentrestaurateur. com. **Website:** www.theindependentrestaurateur. com. **Contact:** Jim Young, publisher. Estab. 1986. Circ. 32,000.

NEEDS Upon request.

SPECS Accepts images in digital format only. Send via CD, e-mail as JPEG files at 300-800 dpi.

MAKING CONTACT & TERMS Send e-mail. Provide self-promotion piece to be kept on file for possible future assignments. Responds only if interested; send nonreturnable samples. Simultaneous submissions OK. Pay is based on experience. Pays on publication. Credit line given. Buys first rights.

◑◐ JOURNAL OF ADVENTIST EDUCATION

12501 Old Columbia Pike, Silver Spring MD 20904-6600. (301)680-5069. **Fax:** (301)622-9627. **E-mail:** goffc@gc.adventist.org. **Website:** jae.adventist.org. **Contact:** Faith-Ann McGarrell, editor. Estab. 1939. Circ. 14,000 in English; 13,000 in other languages. Published 5 times/year in English, 2 times/year in French, Spanish, and Portuguese. Emphasizes procedures, philosophy, and subject matter of Christian education. Official professional organization of the Department of Education covering elementary, secondary, and higher education for all Seventh-day Adventist educational personnel (worldwide).

NEEDS Buys 5-15 photos from freelancers/issue; up to 75 photos/year. Photos of children/teens, multicultural, parents, education, religious, health/fitness, technology/computers with people, committees, offices, school photos of teachers, students, parents, activities at all levels, elementary though graduate school. Reviews photos with or without a ms. Model release preferred. Photo captions preferred.

SPECS Uses mostly digital color images but also accepts color prints; 35mm, 2¼×2¼, 4×5 transparencies. Send digital photos via ZIP, CD or DVD (preferred); e-mail as TIFF, GIF, JPEG files at 300 dpi. Do not send large numbers of photos as e-mail attachments.

MAKING CONTACT & TERMS Send query letter with prints, photocopies, transparencies. Provide self-promotion piece to be kept on file for possible future assignments. Responds in 1 month to queries. Simultaneous submissions and previously published work OK. Pays $100-350 for color cover; $50-100 for color inside. Willing to negotiate on electronic usage of photos. Pays on publication. Credit line given. Buys one-time rights for use in magazine and on website.

TIPS "Get good-quality people shots—close-ups, verticals especially; use interesting props in classroom shots; include teacher and students together, teachers in groups, parents and teachers, cooperative learning and multiage, multicultural children. Pay attention to backgrounds (not too busy) and understand the need for high-res photos!"

◑ JOURNAL OF PSYCHOACTIVE DRUGS

856 Stanyan St., San Francisco CA 94117. (415)752-7601. **E-mail:** hajpdeditor@comcast.net; hajournal@ comcast.net. **Website:** www.hajpd.com. Estab. 1967. Circ. 1,400. Quarterly. Emphasizes "psychoactive substances (both legal and illegal)." Readers are "professionals (primarily health) in the drug abuse treatment field."

NEEDS Uses 1 photo/issue; supplied by freelancers. Needs "full-color abstract, surreal, avant garde or computer graphics."

MAKING CONTACT & TERMS Send query letter with 4×6 color prints or 35mm slides. Online and e-mail submissions are accepted. Include SASE for return of material. Responds in 2 weeks. Simultaneous submissions and previously published work OK. Pays $50 for color cover. Pays on publication. Credit line given. Buys one-time rights.

THE LAND

Free Press Co., P.O. Box 3169, Mankato MN 56002-3169. (507)345-4523. **E-mail:** editor@thelandonline.com. **Website:** www.thelandonline.com. Estab. 1976. Circ. 33,000. Weekly tabloid covering farming and rural life in Minnesota and Northern Iowa.

SPECS Reviews contact sheets.

MAKING CONTACT & TERMS Negotiates payment individually. Buys one-time rights.

⑤ LANDSCAPE ARCHITECTURE

636 Eye St. NW, Washington DC 20001-3736. (888) 999-2752; (202)898-2444. **Fax:** (202)898-1185. **E-mail:** lspeckhardt@asla.org. **Website:** www.asla.org. Estab. 1910. Circ. 22,000. Monthly magazine of the American Society of Landscape Architects. Emphasizes "landscape architecture, urban design, parks and recreation, architecture, sculpture" for professional planners and designers.

NEEDS Buys 5-10 photos from freelancers/issue; 50-120 photos/year. Needs photos of landscape- and architecture-related subjects as described above. Special needs include aerial photography and environmental portraits. Model release required. Credit, caption information required.

MAKING CONTACT & TERMS Send query letter with samples or list of stock photo subjects. Provide brochure, flyer, or tearsheets to be kept on file for possible future assignments. Response time varies. Previously published work OK. Pays on publication. Credit line given. Buys one-time rights.

✪◎⑤ THE MANITOBA TEACHER

191 Harcourt St., Winnipeg, Manitoba R3J 3H2 Canada. (204)888-7961; (800)262-8803. **Fax:** (204)831-0877; (800)665-0584. **E-mail:** gstephenson@mbteach.org. **Website:** www.mbteach.org. **Contact:** George Stephenson, editor. Magazine of the Manitoba Teachers' Society published 7 times/year. Emphasizes education in Manitoba—specifically teachers' interests. Readers are teachers and others in education. Sample copy free with 10×12 SASE and Canadian stamps.

NEEDS Buys 3 photos from freelancers/issue; 21 photos/year. Needs action shots of students and teachers in education-related settings. Model release required.

MAKING CONTACT & TERMS Send 8×10 glossy b&w prints by mail for consideration; include SASE for return of material. Submit portfolio for review.

Provide résumé, business card, brochure, flier, or tearsheets to be kept on file for possible future assignments. Responds in 1 month.

TIPS "Always submit action shots directly related to major subject matter of publication and interests of readership."

✪⑤⑤⑥ MANUFACTURING AUTOMATION

Annex Publishing and Printing, 222 Edward St., Aurora, Ontario L4G 1W6 Canada. (905)727-0077. **E-mail:** editor@automationmag.com. **Website:** www.automationmag.com. **Contact:** Alyssa Dalton, editor. Circ. 19,020. Published 7 times a year, providing a window into the world of advanced manufacturing and industrial automation. Sample copies available for SASE with first-class postage.

NEEDS Occasionally buys photos from freelancers. Subjects include industry and technology. Reviews photos with or without a manuscript. Model release required. Photo captions preferred.

SPECS Uses 5×7 color prints; 4×5 transparencies. "We prefer images in high-res digital format. Send as FTP files at a minimum of 300 dpi."

TIPS "Read our magazine. Put yourself in your clients' shoes. Meet their needs and you will excel. Understand your audience and the editors' needs. Meet deadlines, be reasonable and professional."

⑤⑤◐ MARKETING & TECHNOLOGY GROUP

1415 N. Dayton, Chicago IL 60622. (312)274-2216. **E-mail:** qburns@mtgmediagroup.com. **Website:** www.meatingplace.com. **Contact:** Queenie Burns, vice president of design and production. Estab. 1993. Circ. 18,000. Publishes magazines that emphasize meat and poultry processing. Readers are predominantly male, ages 35-65, generally conservative. Sample copy available for $4.

NEEDS Buys 1-6 photos from freelancers/issue. Needs photos of processing plant tours and product shots. Model/property release preferred. Photo captions preferred.

MAKING CONTACT & TERMS Provide résumé, business card, brochure, flyer, or tearsheets to be kept on file for possible future assignments. Submit portfolio for review. Keeps samples on file. Responds in 1 month. Simultaneous submissions and previously published work OK. Payment negotiable. Pays on publication. Credit line given.

TIPS "Work quickly and meet deadlines. Follow directions when given; and when none are given, be creative while using your best judgment."

✪◐ MEETINGS & INCENTIVE TRAVEL

(416)442-5600, ext. 3239; (416)764-1635. **E-mail:** lsmith@meetingscanada.com. **Website:** www.meetingscanada.com. **Contact:** Lori Smith, editor. Estab. 1970. Circ. 10,500. Bimonthly trade magazine emphasizing meetings and travel.

NEEDS Buys 1-5 photos from freelancers/issue; 7-30 photos/year. Needs photos of environmental, landscapes/scenics, cities/urban, interiors/decorating, events, food/drink, travel, business concepts, technology/computers. Reviews photos with or without a manuscript. Model/property release required. Photo captions required; include location and date.

SPECS Uses 8×12 prints depending on shoot and size of photo in magazine. Accepts images in digital format. Send via CD as TIFF files at 300 dpi.

MAKING CONTACT & TERMS Contact through rep or send query letter with tearsheets. Portfolio may be dropped off every Tuesday. Provide résumé, business card, self-promotion piece to be kept on file for possible future assignments. Responds only if interested; send nonreturnable samples. Simultaneous submissions and previously published work OK. "Payment depends on many factors." Credit line given. Buys one-time rights.

TIPS "Send samples to keep on file."

MIDWEST MEETINGS®

Hennen Publishing, 302 Sixth St. W., Suite A, Brookings SD 57006. (605)692-9559. **Fax:** (605)692-9031. **E-mail:** info@midwestmeetings.com; editor@midwestmeetings.com. **Website:** www.midwestmeetings.com. **Contact:** Randy Hennen. Estab. 1996. Circ. 28,500. "We provide information and resources to meeting/convention planners with a Midwest focus."

MAKING CONTACT & TERMS Reviews JPEG, EPS, TIFF files (300 dpi). Captions, identification of subjects and permission statements/photo releases required. Offers no additional payment for photos accepted with ms. Buys one-time rights.

✪ MILITARY OFFICER MAGAZINE

201 N. Washington St., Alexandria VA 22314. (800)234-6622. **E-mail:** editor@moaa.org. **Website:** www.moaa.org/militaryofficer. **Contact:** Jill Akers, photo editor. Estab. 1945. Circ. 400,000. Monthly publication of the Military Officers Association of America. Represents the interests of military officers from the 7 uniformed services: Army, Navy, Air Force, Marine Corps, Coast Guard, Public Health Service, and National Oceanic and Atmospheric Administration. Emphasizes military history (particularly Vietnam and Korea), travel, health, second-career job opportunities, military family lifestyle, and current military/political affairs. Readers are commissioned officers or warrant officers and their families. Sample copy available on request with 9×12 SASE.

NEEDS Buys 8 photos from freelancers/issue; 96 photos/year. "We're always looking for good color images of active-duty military people and healthy, active mature adults with a young 50s look—our readers are 55-65."

SPECS Uses digital images as well as 2¼×2¼ or 4×5 transparencies. Send digital images via e-mail as JPEG files at 300 dpi.

MAKING CONTACT & TERMS Send query letter with list of stock photo subjects. Provide résumé, brochure, flyer to be kept on file. "Do NOT send original photos unless requested to do so." Payment negotiated. "Photo rates vary with size and position." Pays on publication. Credit line given. Buys one-time rights. Pays $75 for ⅛ page; $125 for ¼ page; $175 for ½ page; $250 for full page. 5×7 or 8×10 b&w glossies occasionally acceptable. $20 for each b&w photo used. Captions and credit lines should be on separate sheets of paper. Include SASE for return. Submission guidelines available online.

✪✪◐ NAILPRO

Creative Age Publications, 7628 Densmore Ave., Van Nuys CA 91406. (800)442-5667; (818)782-7328. **Fax:** (818)782-7450. **E-mail:** nailpro@creativeage.com. **Website:** www.nailpro.com. **Contact:** Stephanie Lavery, executive editor. Estab. 1989. Circ. 65,000. Monthly magazine. Emphasizes topics for professional manicurists and nail salon owners. Readers are predominantly females of all ages. Sample copy available for $2 with 9×12 SASE.

NEEDS Buys 10-12 photos from freelancers/issue; 120-144 photos/year. Needs photos of beautiful nails illustrating all kinds of nail extensions and enhancements; photographs showing process of creating and decorating nails, both natural and artificial. Also needs salon interiors, health/fitness, fashion/glam-

our. Model release required. Photo captions required; identify people and process if applicable.

SPECS Accepts images in digital format. Send via ZIP, e-mail as TIFF, EPS files at 300 dpi or better.

MAKING CONTACT & TERMS Send query letter; responds only if interested. Call for portfolio review. "Art directors are rarely available, but photographers can leave materials and pick up later (or leave nonreturnable samples)." Send color prints; 35mm, 2¼×2¼, 4×5 transparencies. Keeps samples on file. Responds in 1 month. Previously published work OK. $50-250 for color inside. Does not accept submissions for cover.

TIPS "Talk to the person in charge of choosing art about photo needs for the next issue and try to satisfy that immediate need; that often leads to assignments. Submit samples and portfolios with letter stating specialties or strong points."

⑤ NAILS MAGAZINE

Bobit Business Media, 3520 Challenger St., Torrance CA 90503. (310)533-2400 (main); (310)533-2537 (art director). **Fax:** (310)533-2507. **E-mail:** danielle.parisi@bobit.com. **Website:** www.nailsmag.com. **Contact:** Danielle Parisi, art director. Estab. 1982. Circ. 60,000. Monthly trade publication for nail technicians and beauty salon owners. Sample copies available.

NEEDS Buys up to 10 photos from freelancers/issue. Needs photos of celebrities, buildings, historical/vintage. Other specific photo needs: salon interiors, product shots, celebrity nail photos. Reviews photos with or without a ms. Model release required. Photo captions preferred.

SPECS Uses 35mm transparencies. Accepts images in digital format. Send via CD, Zip as TIFF, EPS files at 266 dpi.

MAKING CONTACT & TERMS Send query letter with résumé, slides, prints. Keep samples on file. Responds in 1 month on queries. **Pays on acceptance.** Credit line sometimes given if it's requested. Buys all rights.

➋⑤⑤❶ NAVAL HISTORY

US Naval Institute, 291 Wood Rd., Annapolis MD 21402. (410)295-1048. **Fax:** (410)295-1049. **E-mail:** avoight@usni.org; customer@usni.org. **Website:** www.usni.org/magazines/navalhistory. **Contact:** Amy Voight, photo editor. Estab. 1873. Circ. 50,000.

Bimonthly association publication. Emphasizes Navy, Marine Corps, Coast Guard. Readers are male and female naval officers (enlisted, retirees), civilians. Photo guidelines free with SASE.

NEEDS Needs 40 photos from freelancers/issue; 240 photos/year. Needs photos of foreign and US Naval, Coast Guard, and Marine Corps vessels, industry, military, personnel and aircraft. Interested in historical/vintage. Photo captions required.

SPECS Uses 8×10 glossy or matte b&w and color prints (color preferred); transparencies. Accepts images in digital format. Send via CD, ZIP, e-mail as JPEG files at 300 dpi.

MAKING CONTACT & TERMS "We prefer to receive photo images digitally. We accept cross-platform (must be Mac and PC compatible) CDs with CMYK images at 300 dpi resolution (TIFF or JPEG). If e-mailing an image, send submissions to photo editor. We do not return prints or slides unless specified with a SASE, so please do not send original photographs. We negotiate fees with photographers who provide a volume of images for publication in books or as magazine pictorials. We sponsor 3 annual photo contests." For additional information please contact the photo editor. Responds in 1 month. Simultaneous submissions and previously published work OK. Pays on publication. Credit line given. Buys one-time and electronic rights.

⑤ NEVADA FARM BUREAU AGRICULTURE AND LIVESTOCK JOURNAL

2165 Green Vista Dr., Suite 205, Sparks NV 89431. (775)674-4000; (800)992-1106. **E-mail:** zacha@nvfb.org; nvfarmbureau@nvfb.org. **Website:** www.nvfb.org. **Contact:** Zach Allen, editor. Circ. 1,500. Monthly magazine. Emphasizes Nevada agriculture. Readers are primarily Nevada Farm Bureau members and their families: men, women, and youth of various ages. Members are farmers and ranchers. Sample copy free with 10×13 SASE with 3 first-class stamps.

NEEDS Uses 5 photos/issue; 30% occasionally supplied by freelancers. Needs photos of Nevada agriculture people, scenes and events. Model release preferred. Photo captions required.

MAKING CONTACT & TERMS Send 3×5 and larger b&w or color prints, any format and finish, by mail with SASE for consideration. Responds in 1 week. Pays $10 for b&w cover, $50 for color cover; $5 for b&w inside. **Pays on acceptance.** Credit line given.

Buys one-time rights.

TIPS In portfolio or samples, wants to see "newsworthiness, 50%; good composition, 20%; interesting action, 20%; photo contrast/resolution, 10%. Try for new angles on stock shots: awards, speakers, etc. We like 'Great Basin' agricultural scenery such as cows on the rangelands and high desert cropping. We pay little, but we offer credits for your résumé."

●◉❶ NEWDESIGN

Media Culture 46 Pure Offices, Plate Close Leamington Spa, Warwick, Warwickshire CV34 6WE United Kingdom. +44 (0)1926 671338. **E-mail:** info@newdesignmagazine.co.uk; tanya@newdesignmagazine.co.uk; steve@newdesignmagazine.co.uk. **Website:** www.newdesignmagazine.co.uk. Estab. 2000. Circ. 5,000. Published 10 times/year. Emphasizes product design for product designers: informative, inspirational. Sample copies available.

NEEDS Photos of product shots/still life, technology. Reviews photos with or without a manuscript.

SPECS Uses glossy color prints; 35mm transparencies. Accepts images in digital format. Send via CD as TIFF, JPEG files at 300 dpi.

MAKING CONTACT & TERMS Send query letter with résumé. Provide self-promotion piece to be kept on file for possible future assignments. Cannot return material. Responds only if interested; send nonreturnable samples. Pays on publication. Credit line given.

NFPA JOURNAL

1 Batterymarch Park, Quincy MA 02169-7471. (617) 770-3000; (617)984-7568. **E-mail:** ssutherland@nfpa.org. **Website:** www.nfpa.org. **Contact:** Scott Sutherland, executive editor. Circ. 85,000. Bimonthly magazine of the National Fire Protection Association. Emphasizes fire and life safety information. Readers are fire professionals, engineers, architects, building code officials, ages 20-65. Sample copy free with 9×12 SASE or via e-mail.

NEEDS Buys 5-7 photos from freelancers/issue; 30-42 photos/year. Needs photos of fires and fire-related incidents. Model release preferred. Photo captions preferred.

MAKING CONTACT & TERMS Send query letter with list of stock photo subjects. Provide résumé, business card, brochure, flier, or tearsheets to be kept on file for possible future assignments. Send color prints and 35mm transparencies in 3-ring slide sleeve with

date. Responds in 3 weeks. Payment negotiated. Pays on publication. Credit line given.

TIPS "Send cover letter, 35mm color slides, preferably with manuscripts and photo captions."

◉ NORTHWEST TERRITORIES EXPLORER'S GUIDE

P.O. Box 610, Yellowknife, Northwest Territories X1A 2N5 Canada. (867)873-5007; (800)661-0788. **Fax:** (867)873-4059. **E-mail:** info@spectacularnwt.com. **Website:** www.spectacularnwt.com. Estab. 1996. Circ. 90,000. Annual tourism publication for Northwest Territories. Sample copies available.

NEEDS Photos of babies/children/teens, couples, multicultural, families, senior citizens, landscapes/scenics, wildlife, adventure, automobiles, events, travel. Interested in historical/vintage, seasonal. Also needs photos of Northwest Territories, winter and road touring.

SPECS Uses 35mm transparencies.

MAKING CONTACT & TERMS Send query letter with résumé, slides, prints, photocopies, tearsheets, transparencies, stock list. Portfolio may be dropped off Monday–Saturday. Provide résumé, business card, self-promotion piece to be kept on file for possible future assignments. Responds in 1 week to queries. Simultaneous submissions OK. **Pays on acceptance.**

◉◉ THE ONTARIO TECHNOLOGIST

10 Four Seasons Place, Suite 404, Etobicoke, Ontario M9B 6H7, Canada. (416)621-9621. **Fax:** (416)621-8694. **E-mail:** editor@oacett.org; info@oacett.org. **Website:** www.oacett.org. Circ. 24,000. Bimonthly publication of the Ontario Association of Certified Engineering Technicians and Technologists. Emphasizes engineering and applied science technology. Sample copy free with SASE and IRC.

NEEDS Uses 10-12 photos/issue. Needs how-to photos—"building and installation of equipment; similar technical subjects." Model release preferred. Photo captions preferred.

MAKING CONTACT & TERMS Prefers business card and brochure for files. Send high-res digital images at 300 dpi for consideration. Responds in 1 month. Previously published work OK. Credit line given.

❶◉◉ PEDIATRIC ANNALS

6900 Grove Rd., Thorofare NJ 08086. (856)848-1000. **Fax:** (856)848-6091. **E-mail:** pedann@healio.

com. **Website:** www.healio.com/pediatrics/journals/ PedAnn. Monthly journal. Readers are practicing pediatricians. Sample copy free with SASE.

NEEDS Uses 5-7 photos/issue; primarily stock. Occasionally uses original photos of children in medical settings.

SPECS Color photos preferred. Accepts images in digital format. Send as EPS, JPEG files at 300 dpi.

MAKING CONTACT & TERMS Request editorial calendar for topic suggestions. E-mail query with links to samples. Simultaneous submissions and previously published work OK. Pays varies; negotiable. Pays on publication. Credit line given. Buys unlimited North American rights including any and all subsidiary forms of publication, such as electronic media and promotional pieces.

🌑⑤❶ PEOPLE MANAGEMENT

151 The Broadway London, London SW19 1JQ United Kingdom. **E-mail:** pmeditorial@haymarket.com. **Website:** www.peoplemanagement.co.uk. **Contact:** Rob MacLachlan, editor. Circ. 120,000. Official publication of the Chartered Institute of Personnel and Development. Biweekly trade journal for professionals in personnel, training, and development.

NEEDS Photos of industry, medicine. Interested in alternative process, documentary. Reviews photos with or without a manuscript. Model release preferred. Photo captions preferred.

SPECS Accepts images in digital format. Send via CD, Jaz, ZIP, e-mail, ISDN as TIFF, EPS, JPEG files at 300 dpi.

MAKING CONTACT & TERMS Send query letter with samples. To show portfolio, photographer should follow up with call. Portfolio should include b&w prints, slides, transparencies. Keeps samples on file. Responds only if interested; send nonreturnable samples. Pays on publication. Rights negotiable.

⑤❶ PET PRODUCT NEWS

BowTie, Inc., P.O. Box 6050, Mission Viejo CA 92690-6040. (949)855-8822. **Fax:** (949)855-3045. **E-mail:** erothrock@i5publishing.com. **Website:** www.pet productnews.com. **Contact:** Ellyce Rothrock, editor. Monthly B2B tabloid. Emphasizes pets and the pet retail business. Readers are pet store owners and managers. Sample copy available for $5. Photo guidelines upon request via e-mail.

NEEDS Buys 5-10 photos from freelancers/issue; 60-120 photos/year. Needs photos of retailers interacting with customers and pets, pet stores, and pet product displays. Also needs wildlife, events, industry, product shots/still life. Interested in seasonal. Reviews photos with or without a manuscript. Model/property release preferred. "Enclose a shipment description with each set of photos detailing the type of animal, name of pet store, names of well-known subjects and any procedures being performed on an animal that are not self-explanatory."

SPECS Accepts images in digital format only. Send via CD, ZIP, e-mail as TIFF, EPS, JPEG files at 300 dpi.

MAKING CONTACT & TERMS "We cannot assume responsibility for submitted material, but care is taken with all work. Freelancers must include a SASE for returned work." Send sharp 35mm color slides or prints by mail for consideration. Responds in 2 months. Previously published work OK. Pays $75 for cover; $50 for inside. Pays on publication. Photographer also receives 1 complimentary copy of issue in which their work appears. Credit line given; name and identification of subject must appear on each image. Buys one-time rights.

TIPS Looks for "appropriate subjects, clarity and framing, sensitivity to the subject. No avant garde or special effects. We need clear, straight-forward photography. Definitely no 'staged' photos; keep it natural. Read the magazine before submission. We are a trade publication and need business-like, but not boring, photos that will add to our subjects."

THE PHOTO REVIEW

200 East Maple Avenue, Suite 200, Langhorne PA 19047. (215)891-0214. **Fax:** (215)891-9358. **E-mail:** info@photoreview.org. **Website:** www.photoreview. org. Estab. 1976. Circ. 2,000. "*The Photo Review* publishes critical reviews of photography exhibitions and books, critical essays, and interviews. We do not publish how-to or technical articles."

MAKING CONTACT & TERMS Reviews electronic images. Captions required. Offers no additional payment for photos accepted with ms. Buys all rights.

⑤⑤ PLANNING

American Planning Association, 205 N. Michigan Ave., Suite 1200, Chicago IL 60601. (312)431-9100. **Fax:** (312)786-6700. **E-mail:** mstromberg@planning. org. **Website:** www.planning.org. **Contact:** Meghan Stromberg, executive editor; Sylvia Lewis, editor;

Joan Cairney, art director. Estab. 1972. Circ. 44,000. Monthly magazine. "We focus on urban and regional planning, reaching most of the nation's professional planners and others interested in the topic." Published 11 times/year.

NEEDS Buys 4-5 photos from freelancers/issue; 60 photos/year. Photos purchased with accompanying manuscript and on assignment. Photo essay/photo feature (architecture, neighborhoods, historic preservation, agriculture); scenic (mountains, wilderness, rivers, oceans, lakes); housing; transportation (cars, railroads, trolleys, highways). "No cheesecake; no sentimental shots of dogs, children, etc. High artistic quality is very important. We publish high-quality nonfiction stories on city planning and land use. Ours is an association magazine but not a house organ, and we use the standard journalistic techniques: interviews, anecdotes, quotes. Topics include energy, the environment, housing, transportation, land use, agriculture, neighborhoods, and urban affairs." Photo captions required.

SPECS Accepts images in digital format. Send via ZIP, CD as TIFF, EPS, JPEG files at 300 dpi and around 5×7 in physical size.

MAKING CONTACT & TERMS Send query letter with samples; include SASE for return of material. Responds in 1 month. Previously published work OK. Pays on publication. Credit line given.

TIPS "Subject lists are only minimally useful. How the work looks is of paramount importance. Your best chance is to send addresses for your website showing samples of your work. We no longer keep paper on file. If we like your style we will commission work from you."

PLASTICS NEWS

1155 Gratiot, Detroit MI 48207-2997. (313)446-6000. E-mail: dloepp@crain.com. **Website:** www.plastics news.com. **Contact:** Don Loepp, editor. Estab. 1989. Circ. 45,000. Weekly tabloid. Emphasizes plastics industry business news. Readers are male and female executives of companies that manufacture a broad range of plastics products; suppliers and customers of the plastics processing industry. Sample copy available for $1.95.

NEEDS Buys 1-3 photos from freelancers/issue; 52-156 photos/year. Needs photos of technology related to use and manufacturing of plastic products. Model/property release preferred. Photo captions required.

MAKING CONTACT & TERMS Send unsolicited photos by mail for consideration. Provide résumé, business card, brochure, flier, or tearsheets to be kept on file for possible future assignments. Send query letter with stock list. Keeps samples on file; include SASE for return of material. Responds in 2 weeks. Simultaneous submissions and previously published work OK. Pays $125-175 for color cover; $100-150 for b&w inside; $125-175 for color inside. Pays on publication. Credit line given. Buys one-time and all rights.

PLASTICS TECHNOLOGY

Gardner Business Media Inc., 6915 Valley Ave., Cincinnati OH 45244. (513)527-8800, (800)950-8020. **Fax:** (646)827-4859. **E-mail:** sbriggs@gardnerweb. com. **Website:** www.ptonline.com. **Contact:** Sheri Briggs, art director. Estab. 1954. Circ. 50,000. Monthly trade magazine. Sample copy available for first-class postage.

NEEDS Buys 1-3 photos/issue. Needs photos of agriculture, business concepts, industry, science, technology. Model release required. Photo captions required.

SPECS Accepts images in digital format. Send via e-mail as TIFF, EPS, JPEG files at 300 dpi.

MAKING CONTACT & TERMS Send query letter with résumé, photocopies, tearsheets. Provide business card, self-promotion piece to be kept on file for possible future assignments. Responds only if interested; send nonreturnable samples. Simultaneous submissions OK. Pays $1,000-1,300 for color cover; $300 minimum for color inside. Pays on publication. Credit line given. Buys one-time rights, all rights; negotiable.

POETS & WRITERS MAGAZINE

90 Broad St., Suite 2100, New York NY 10004. (212)226-3586. **E-mail:** editor@pw.org. **Website:** www.pw.org/magazine. **Contact:** Kevin Larimer, editor. Estab. 1987. Circ. 60,000. Bimonthly literary trade magazine. "We offer poets and literary prose writers in-depth information about the publishing industry, details about writers conferences and workshops, practical advice about how to get published, essays about the writing life, listings of grants and awards available to writers, as well as interviews and profiles of contemporary authors."

NEEDS Needs photos of contemporary writers: poets, fiction writers, writers of creative nonfiction. Photo captions required.

SPECS Digital format.

MAKING CONTACT & TERMS Provide URL, self-promotion piece, or tearsheets to be kept on file for possible future assignments. Pays on publication. Credit line given.

POLICE AND SECURITY NEWS

DAYS Communications, Inc., 1208 Juniper St., Quakertown PA 18951-1520. (215)538-1240. **Fax:** (215)538-1208. **E-mail:** amenear@policeandsecuritynews.com. **Website:** www.policeandsecuritynews.com. **Contact:** Al Menear, publisher. Estab. 1984. Circ. 24,000. Bimonthly trade journal. *"Police and Security News* is edited for middle and upper management and top administration. Editorial content is a combination of articles and columns ranging from the latest in technology, innovative managerial concepts, training, and industry news in the areas of both public law enforcement and Homeland security." Sample copy free with 13×10" SASE and $2.24 first-class postage.

NEEDS Buys 2 photos from freelancers/issue; 12 photos/year. Needs photos of law enforcement and security related. Reviews photos with or without a manuscript. Photo captions preferred.

SPECS Uses color and b&w prints.

MAKING CONTACT & TERMS Provide résumé, business card, self-promotion piece, or tearsheets to be kept on file for possible future assignments. Art director will contact photographer for portfolio review if interested. Portfolio should include b&w and/or color prints or tearsheets. Keeps samples on file; include SASE for return of material. Simultaneous submissions and previously published work OK. Pays $20-40 for color inside. Pays on publication. Credit line given. Buys one-time rights; negotiable.

🌐⭕ POLICE TIMES/CHIEF OF POLICE

6350 Horizon Dr., Titusville FL 32780. (321)264-0911. **E-mail:** peterc@aphf.org; jshepherd@aphf.org. **Website:** www.aphf.org. **Contact:** Peter Connolly, publications editor. Circ. *Police Times:* quarterly trade magazine (circ. 155,000); *Chief of Police:* bimonthly trade magazine (circ. 33,000). Readers are law enforcement officers at all levels. *Police Times* is the official journal of the American Federation of Police and Concerned Citizens. Sample copy available for $2.50. Photo guidelines free with SASE.

NEEDS Buys 60-90 photos/year. Needs photos of police officers in action, civilian volunteers working with the police, and group shots of police department personnel. Wants no photos that promote other associa-

tions. Police-oriented cartoons also accepted on spec. Model release preferred. Photo captions preferred.

MAKING CONTACT & TERMS Send glossy b&w and color prints for consideration; include SASE for return of material. Responds in 3 weeks. Simultaneous submissions and previously published work OK. **Pays on acceptance.** Credit line given if requested; editor's option. Buys all rights, but may reassign to photographer after publication; includes online publication rights.

TIPS "We are open to new and unknowns in small communities where police are not given publicity."

➍🌐⭕ PROCEEDINGS

U.S. Naval Institute, 291 Wood Rd., Annapolis MD 21402-5034. (410)268-6110. **Fax:** (410)571-1703. **E-mail:** articlesubmissions@usni.org. **Website:** www.usni.org/magazines/proceedings. **Contact:** Fred H. Rainbow, editor-in-chief; Emily Martin, photo researcher. Estab. 1873. Circ. 60,000. Monthly trade magazine dedicated to providing an open forum for national defense. Sample copy available online. Photo guidelines on website.

NEEDS Buys 10 photos from freelancers/issue; 120 photos/year. Needs photos of industry, military, political. Model release preferred. Photo captions required; include time, location, subject matter, service represented—if necessary.

SPECS Uses glossy color prints. Prefers images in digital format. Send via CD, ZIP as TIFF, JPEG files at 300 dpi.

MAKING CONTACT & TERMS Send query letter with résumé, prints. Does not keep samples on file; include SASE for return of material. Responds only if interested; send nonreturnable samples. Simultaneous submissions and previously published work OK. Pays $200 for color cover; $25-50 for color inside. Pays on publication. Credit line given. Buys one-time and sometimes electronic rights.

TIPS "We look for original work. The best place to get a feel for our imagery is to see our magazine or look at our website."

©🌐 PRODUCE RETAILER

Vance Publishing Corp., 10901 W. 84th Ter., Suite 200, Lenexa KS 66214. (913)438-0603; (512)906-0733. **E-mail:** PamelaR@produceretailer.com; treyes@produceretailer.com. **Website:** produceretailer.com. **Contact:** Pamela Riemenschneider, editor; Tony

Reyes, art director. Estab. 1988. Circ. 12,000. Monthly magazine, e-mail newsletters, and online. Emphasizes the retail end of the fresh produce industry. Readers are male and female executives who oversee produce operations in US and Canadian supermarkets as well as in-store produce department personnel. Sample copies available.

NEEDS Buys 2-5 photos from freelancers/issue; 24-60 photos/year. Needs in-store shots, environmental portraits for cover photos or display pictures. "Photo captions required; include subject's name, job title, and company title—all verified and correctly spelled."

SPECS Accepts images in digital format. Send via e-mail as TIFF, JPEG files.

MAKING CONTACT & TERMS E-mail only. Response time "depends on when we will be in a specific photographer's area and have a need." Pays $500-750 for color cover; $25-50/color photo. **Pays on acceptance.** Credit line given. Buys all rights.

TIPS "We seek photographers who serve as our onsite 'art director' to ensure capture of creative angles and quality images."

PROFESSIONAL PHOTOGRAPHER

Professional Photographers of America, 229 Peachtree St. NE, Suite 2200, International Tower, Atlanta GA 30303. (404)522-8600, ext. 260. **Fax:** (404)614-6406. **E-mail:** editors@ppa.com. **Website:** www.ppmag.com. Estab. 1907. Circ. 26,000. Monthly magazine. Emphasizes professional photography in the fields of portrait, wedding, editorial, photojournalism, travel, commercial/advertising, sports, corporate and industrial. Readers include professional photographers and photographic services and educators. Approximately half the circulation is Professional Photographers of America members. Sample copy available for $5 postpaid.

◒ PPA members submit material unpaid to promote their photo businesses and obtain recognition. Images sent to *Professional Photographer* should be technically perfect, and photographers should include information about how the photo was produced.

NEEDS Reviews photos with accompanying manuscript only.

SPECS Accepts images in digital format only. Send via CD, e-mail as TIFF, EPS, JPEG files at 72 dpi minimum.

MAKING CONTACT & TERMS "We prefer a story query, or complete manuscript if writer feels subject fits our magazine. Photos will be part of manuscript package." Responds in 2 months. Credit line given.

⊚ PUBLIC POWER

2451 Crystal Dr., Suite 1000, Arlington VA 22202-4804. (202)467-2900. **Fax:** (202)467-2910. **E-mail:** news@publicpower.org; ldalessandro@publicpower.org; rthomas@publicpower.org. **Website:** www.publicpower.org. **Contact:** Laura D'Alessandro, editor; Robert Thomas, art director. Estab. 1942. Circ. 14,000. Publication of the American Public Power Association, published 6 times a year. Emphasizes electric power provided by cities, towns, and utility districts. Sample copy and photo guidelines free.

NEEDS Buys photos on assignment only.

SPECS Prefers digital images; call art director (Robert Thomas) at (202)467-2983 to discuss.

MAKING CONTACT & TERMS Send query letter with samples. Provide résumé, business card, brochure, flyer, or tearsheets to be kept on file for possible future assignments. **Pays on acceptance.** Credit line given. Buys one-time rights.

❸❸❶ QSR

101 Europa Dr., Suite 150, Durham NC 27707. (919)945-0700. **Fax:** (919)489-4767. **E-mail:** mitch@qsrmagazine.com. **Website:** www.qsrmagazine.com. **Contact:** Mitch Avery, production manager. Estab. 1997. Trade magazine directed toward the business aspects of quick-service restaurants (fast food). "Our readership is primarily management level and above, usually franchisors and franchisees. Our goal is to cover the quick-service and fast, casual restaurant industries objectively, offering our readers the latest news and information pertinent to their business." Photo guidelines free.

NEEDS Buys 10-15 photos/year. Needs corporate identity portraits, images associated with fast food, general food images for feature illustration. Reviews photos with or without a ms. Model/property release preferred.

SPECS Prefers images in digital format. Send via CD/DVD, ZIP as TIFF, EPS files at 300 dpi.

MAKING CONTACT & TERMS Send query letter with samples, brochure, stock list, tearsheets. Art director will contact photographer for portfolio review if interested. Portfolio should include slides and

digital sample files. Keeps samples on file. Responds only if interested; send nonreturnable samples. Simultaneous submissions and previously published work OK. Pays on publication. Publisher only interested in acquiring all rights unless otherwise specified.

TIPS "Willingness to work with subject and magazine deadlines essential. Willingness to follow artistic guidelines necessary but should be able to rely on one's own eye. Our covers always feature quick-service restaurant executives with some sort of name recognition (e.g., a location shot with signage in the background, use of product props which display company logo)."

⑤❶ QUICK FROZEN FOODS INTERNATIONAL

2125 Center Ave., Suite 305, Fort Lee NJ 07024-5898. (201)592-7007. **Fax:** (201)592-7171. **E-mail:** John QFFI@aol.com. **Website:** www.qffintl.com. **Contact:** John M. Saulnier, chief editor/publisher. Circ. 15,000. Quarterly magazine. Emphasizes retailing, marketing, processing, packaging, and distribution of frozen foods around the world. Readers are international executives involved in the frozen food industry: manufacturers, distributors, retailers, brokers, importers/exporters, warehousemen, etc. Sample copy available for $20.

NEEDS Buys 10-25 photos/year. Uses photos of agriculture, plant exterior shots, step-by-step in-plant processing shots, photos of retail store frozen food cases, head shots of industry executives, etc. Photo captions required.

SPECS Accepts digital images via CD at 300 dpi, CMYK. Also accepts 5×7 glossy b&w or color prints.

MAKING CONTACT & TERMS Send query letter with résumé of credits. Responds in 1 month. Payment negotiable. Pays on publication. Buys all rights but may reassign to photographer after publication.

TIPS A file of photographers' names is maintained; if an assignment comes up in an area close to a particular photographer, she/he may be contacted. "When submitting your name, inform us if you are capable of writing a story if needed."

RANGEFINDER

85 Broad St., 11th Floor, New York NY 10004. (646)654-4500. **Fax:** (310)481-8037. **E-mail:** Jacqueline .Tobin@Emeraldexpo.com. **Website:** www.range findermag.com. **Contact:** Jacqueline Tobin. Estab. 1952. Circ. 61,000. Monthly magazine. Emphasizes topics, developments, and products of interest to the professional photographer. Readers are professionals in all phases of photography. Sample copy free with 11×14 SASE and 2 first-class stamps. Photo guidelines free with SASE.

NEEDS Buys very few photos from freelancers/issue. Needs all kinds of photos; almost always run in conjunction with articles. "We prefer photos accompanying 'how-to' or special interest stories from the photographer." No pictorials. Special needs include seasonal cover shots (vertical format only). Model release required; property release preferred. Photo captions preferred.

MAKING CONTACT & TERMS Send query letter with résumé of credits. Keeps samples on file; include SASE for return of material. Responds in 1 month. Previously published work occasionally OK; give details. Payment varies. Covers submitted gratis. Pays on publication. Credit line given. Buys first North American serial rights; negotiable.

⑤❶ RECOMMEND

Worth International Media Group, 5979 NW 151st St., Suite 120, Miami Lakes FL 33014. (305)828-0123; (800)447-0123. **Fax:** (305)826-6950. **E-mail:** paloma@ recommend.com. **Website:** www.recommend.com; www.worthit.com. **Contact:** Paloma de Rico, editor-in-chief. Estab. 1985. Circ. 55,000. Monthly. Emphasizes travel. Readers are travel agents, meeting planners, hoteliers, ad agencies.

NEEDS Buys 16 photos from freelancers/issue; 192 photos/year. "Our publication divides the world into 7 regions. Every month we use travel destination-oriented photos of animals, cities, resorts, and cruise lines; feature all types of travel photography from all over the world." Model/property release required. Photo captions preferred; identification required on every photo.

SPECS Accepts images in digital format. Send via CD, ZIP as TIFF, EPS files at 300 dpi minimum. "We do not accept 35mm slides or transparencies."

MAKING CONTACT & TERMS "Contact via e-mail to view sample of photography." Simultaneous submissions and previously published work OK. Pays 30 days after publication. Credit line given. Buys one-time rights.

TIPS Prefers to see high-res digital files.

⊕❸❹ REFEREE

Referee Enterprises, Inc., 2017 Lathrop Ave., Racine WI 53405. (800)733-6100. **Fax:** (262)632-5460. **E-mail:** submissions@referee.com. **Website:** www.referee.com. **Contact:** Julie Sternberg, managing editor. Estab. 1976. Circ. 40,000. Monthly magazine. Readers are mostly male, ages 30-50. Sample copy free with 9×12 SASE and appropriate postage. Photo guidelines free with SASE.

NEEDS Buys 25-40 photos from freelancers/issue; 300-400 photos/year. Needs action officiating shots—all sports. Photo needs are ongoing. Photo captions required; include officials' names and hometowns.

SPECS Prefers to use digital files (minimum 300 dpi submitted on CD or DVDs).

MAKING CONTACT & TERMS Send unsolicited photos by mail or to submissions@referee.com for consideration. Responds in 2 weeks. Simultaneous submissions and previously published work OK. Pays $100 for color cover; $35 for color inside. Pays on publication. Credit line given. Rights purchased negotiable.

TIPS "Prefer photos that bring out the uniqueness of being a sports official. Need photos primarily of officials at or above the high school level in baseball, football, basketball, softball, volleyball, and soccer in action. Other sports acceptable, but used less frequently. When at sporting events, take a few shots with the officials in mind, even though you may be on assignment for another reason. Don't be afraid to give it a try. We're receptive, always looking for new freelance contributors. We are constantly looking for pictures of officials/umpires. Our needs in this area have increased. Names and hometowns of officials are required."

RELAY MAGAZINE

P.O. Box 10114, Tallahassee FL 32302. (850)224-3314, ext. 4 or ext. 5. **Fax:** (850)224-2831. **E-mail:** gholmes@ publicpower.com; relay@publicpower.org. **Website:** relaymagazine.org. **Contact:** Garnie Holmes, editor. Estab. 1957. Circ. 5,000. Quarterly industry magazine of the Florida Municipal Electric Association. Emphasizes energy, electric, utility, and telecom industries in Florida. Readers are utility professionals, local elected officials, state and national legislators, and other state power associations.

NEEDS Number of photos/issue varies; various number supplied by freelancers. Needs photos of electric utilities in Florida (hurricane/storm damage to lines, utility workers, power plants, infrastructure, telecom, etc.); cityscapes of member utility cities. Model/property release preferred. Photo captions required.

SPECS Uses 3×5, 4×6, 5×7, 8×10 b&w and color prints. Accepts images in digital format.

MAKING CONTACT & TERMS Send query letter with description of photo or photocopy. Keeps samples on file. Simultaneous submissions and previously published work OK. Payment negotiable. Rates negotiable. Pays on use. Credit line given. Buys one-time rights, repeated use (stock); negotiable.

TIPS "Must relate to our industry. Clarity and contrast important. Always query first."

❸❹ REMODELING

HanleyWood, LLC, One Thomas Circle NW, Suite 600, Washington DC 20005. (202)452-0800. **Fax:** (202)785-1974. **E-mail:** cwebb@hanleywood.com. **Website:** www.remodelingmagazine.com. **Contact:** Craig Webb, editor. Estab. 1985. Circ. 80,000. Published 13 times/year. "Business magazine for remodeling contractors. Readers are small contractors involved in residential and commercial remodeling." Sample copy free with 8×11 SASE.

NEEDS Uses 10-15 photos/issue; number supplied by freelancers varies. Photos of remodeled residences, both before and after. Interior and exterior photos of residences that emphasize the architecture over the furnishings. Reviews photos with "short description of project, including architect's or contractor's name and phone number. We have 1 regular photo feature: 'Before and After' describes a whole-house remodel. Request editorial calendar to see upcoming design features."

SPECS Accepts images in digital format. Send via ZIP as TIFF, GIF, JPEG files at 300 dpi.

MAKING CONTACT & TERMS Provide résumé, business card, brochure, flier, or tearsheets to be kept on file for possible future assignments. Responds in 1 month. **Pays on acceptance.** Credit line given. Buys one-time rights; Web rights.

❸❸❹ RESTAURANT HOSPITALITY

Penton Media, 1100 Superior Ave., Cleveland OH 44114. (216)931-9942. **E-mail:** chris.roberto@penton.com. **Website:** www.restaurant-hospitality.com. **Contact:** Chris Roberto, group creative director; Michael Sanson, editor-in-chief. Estab. 1919. Circ.

100,000. Monthly. Emphasizes "ideas for full-service restaurants" including business strategies and industry menu trends. Readers are restaurant owners/operators and chefs for full-service independent and chain concepts.

NEEDS Assignment needs vary; 10-15 photos from freelancers/issue, plus stock; 120 photos/year. Needs "on-location portraits, restaurant interiors and details, and occasional project-specific food photos." Special needs include subject-related photos: industry chefs, personalities, and food trends. Model release preferred. Photo captions preferred.

SPECS Accepts images in digital format. Send finals via download link or e-mail.

MAKING CONTACT & TERMS Send postcard samples and e-mail with link to website. Previously published work OK. Pay varies; negotiable. Cover fees on per project basis. **Pays on acceptance.** Credit line given. Buys one-time rights plus usage in all media.

TIPS "Send a postcard that highlights your work and website."

⑤ RETAILERS FORUM

383 E. Main St., Centerport NY 11721. (800)635-7654. **E-mail:** forumpublishing@aol.com. **Website:** www.forum123.com. **Contact:** Martin Stevens, publisher. Estab. 1981. Circ. 70,000. Monthly magazine. Readers are entrepreneurs and retail store owners. Sample copy available for $7.50.

NEEDS Buys 3-6 photos from freelancers/issue; 36-72 photos/year. "We publish trade magazines for retail variety goods stores and flea market vendors. Items include jewelry, cosmetics, novelties, toys, etc. (five-and-dime-type goods). We are interested in creative and abstract impressions—not straight-on product shots. Humor a plus." Model/property release required.

SPECS Uses color prints. Accepts images in digital format. Send via e-mail at 300 dpi.

MAKING CONTACT & TERMS Send unsolicited photos by mail or e-mail for consideration. Does not keep samples on file; include SASE for return of material. Responds in 2 weeks. Simultaneous submissions and previously published work OK. Pays $100 for color cover; $50 for color inside. **Pays on acceptance.** Buys one-time rights.

RTOHQ: THE MAGAZINE

1504 Robin Hood Trail, Austin TX 78703. (800)204-2776. **Fax:** (512)794-0097. **E-mail:** nferguson@rtohq.org; bkeese@rtohq.org. **Website:** www.rtohq.org. **Contact:** Neil Ferguson, art director; Bill Keese, executive editor. Estab. 1980. Circ. 5,500. Bimonthly magazine published by the Association of Progressive Rental Organizations. Emphasizes the rental-purchase industry. Readers are owners and managers of rental-purchase stores in North America, Canada, Great Britain, and Australia.

NEEDS Buys 1-2 photos from freelancers/issue; 6-12 photos/year. Needs "strongly conceptual, cutting-edge photos that relate to editorial articles on business/management issues. Also looking for photographers to capture unique and creative environmental portraits of our members." Model/property release preferred.

MAKING CONTACT & TERMS Provide brochure, flyer, or tearsheets to be kept on file for possible future assignments. Simultaneous submissions and previously published work OK. Pays $200-450/job; $350-450 for cover; $200-450 for inside. Pays on publication. Credit line given. Buys one-time and electronic rights.

TIPS "Understand the industry and the specific editorial needs of the publication, e.g., don't send beautiful still-life photography to a trade association publication."

⑤ SCIENCE SCOPE

National Science Teachers Association, 1840 Wilson Blvd., Arlington VA 22201. (703)243-7100. **Fax:** (703)243-7177. **E-mail:** wthomas@nsta.org; scope@nsta.org. **Website:** www.nsta.org. **Contact:** Will Thomas, art director. Journal published 9 times/year during the school year. Emphasizes "activity-oriented ideas—ideas that teachers can take directly from articles." Readers are mostly middle school science teachers. Sample copy available for $6.25. Photo guidelines free with SASE.

NEEDS About half our photos are supplied by freelancers. Needs photos of classroom activities with students participating. "In some cases, say for interdisciplinary studies articles, we'll need a specialized photo." Model release required. Need for photo captions "depends on the type of photo."

SPECS Uses slides, negatives, prints. Accepts images in digital format. Send via CD, e-mail as TIFF, EPS

files at 300 dpi minimum.

MAKING CONTACT & TERMS Arrange a personal interview to show portfolio. Send query letter with stock list. Provide résumé, business card, brochure, fliser, or tearsheets to be kept on file for possible future assignments. Considers previously published work; "prefer not to, although in some cases there are exceptions." Pays on publication. Sometimes pays kill fee. Credit line given. Buys one-time rights; negotiable.

TIPS "We look for clear, crisp photos of middle-level students working in the classroom. Shots should be candid with students genuinely interested in their activity. (The activity is chosen to accompany manuscript.) Please send photocopies of sample shots along with listing of preferred subjects and/or listing of stock photo topics."

SECURITY DEALER & INTEGRATOR

Southcomm, 12735 Morris Road Bldg. 200 Suite 180, Alpharetta GA 30004. (800)547-7377, ext 2226. **E-mail:** paul.rothman@cygnus.com. **Website:** www .securityinfowatch.com/magazine. **Contact:** Paul Rothman, editor-in-chief. Circ. 25,000. Monthly. Emphasizes security subjects. Readers are business owners who install alarm, security, CCTV, home automation, and access control systems. Sample copy free with SASE. "*SD&I* seeks credible, reputable thought leaders to provide timely, original editorial content for our readers—security value-added resellers, integrators, systems designers, central station companies, electrical contractors, consultants, and others—on rapidly morphing new communications and signaling technologies, networking, standards, business acumen, project information, and other topics to hone new skills and build business. Content must add value to our pages and provide thought-provoking insights on the industry and its future. In most cases, content must be vendor-neutral, unless the discussion is on a patented or proprietary technology."

○ "Photographs and graphics, drawings, and white papers are encouraged."

NEEDS Uses 2-5 photos/issue; none at present supplied by freelance photographers. Photos of security-application equipment. Model release preferred. Photo captions required.

SPECS Photos must be JPEG, TIFF, or EPS form for any section of the magazine, including product sections (refer to the editorial calendar). "We require a

300 dpi image at a minimum 100% size of 2×3 for product submissions."

MAKING CONTACT & TERMS Send b&w and color prints by mail for consideration; include SASE for return of material. Responds "immediately." Simultaneous submissions and/or previously published work OK.

TIPS "Do not send originals; send dupes only, and only after discussion with editor."

SPECIALTY TRAVEL INDEX

Alpine Hansen, P.O. Box 458, San Anselmo CA 94979. (415)455-1643. **E-mail:** info@specialtytravel.com; aalpine@specialtytravel.com. **Website:** www.specialty travel.com. **Contact:** Andy Alpine. Estab. 1980. Circ. 35,000. Biannual trade magazine. Directory of special interest travel. Readers are travel agents. Sample copy available for $6.

NEEDS Contact for want list. Buys photo/ms packages. Photo captions preferred.

SPECS Uses digital images. Send via CD or photographer's website. "No e-mails for photo submissions."

MAKING CONTACT & TERMS Send query letter with résumé, stock list, and website link to view samples. Does not keep samples on file; include SASE for return of material. Responds in 2 months to queries. Simultaneous submissions and previously published work OK. Pays $25/photo. **Pays on acceptance.** Credit line given.

🟦🟦 SUCCESSFUL MEETINGS

Northstar Travel Media, 100 Lighting Way, Secaucus NJ 07094. (646)380-6247. **E-mail:** valonzo@ ntmllc.com; jruf@ntmllc.com. **Website:** www .successfulmeetings.com. **Contact:** Vincent Alonzo, editor-in-chief; Jennifer Ruf, art director. Estab. 1955. Circ. 70,000. Monthly. Emphasizes business group travel for all sorts of meetings. Readers are business and association executives who plan meetings, exhibits, conventions, and incentive travel. Sample copy available for $10.

NEEDS Special needs include high-quality corporate portraits; conceptual, out-of-state shoots.

MAKING CONTACT & TERMS Arrange a personal interview to show portfolio. Send query letter with résumé of credits and list of stock photo subjects. Responds in 2 weeks. Simultaneous submissions and previously published work OK, "only if you let us know." Pays $500-750 for color cover; $50-150 for

b&w inside; $75-200 for color inside; $150-250/b&w page; $200-300/color page; $50-100/hour; $175-350/¾ day. **Pays on acceptance.** Credit line given. Buys one-time rights.

THE SURGICAL TECHNOLOGIST

6 W. Dry Creek Circle, Suite 200, Littleton CO 80120-8031. (303)694-9130. **Fax:** (303)694-9169. **E-mail:** kludwig@ast.org. **Website:** www.ast.org. **Contact:** Karen Ludwig, editor/publisher. Circ. 23,000. Monthly journal of the Association of Surgical Technologists. Emphasizes surgery. Readers are operating room professionals, well educated in surgical procedures, ages 20-60. Sample copy free with 9×12 SASE and 5 first-class stamps. Photo guidelines free with SASE.

NEEDS Needs "surgical, operating room photos that show members of the surgical team in action." Model release required.

MAKING CONTACT & TERMS Send low-res JPEGs with query via e-mail. Responds in 4 weeks after review by editorial board. Simultaneous submissions and previously published work OK. Payment negotiable. **Pays on acceptance.** Credit line given. Buys all rights.

⑤❶ TECHNIQUES

1410 King St., Alexandria VA 22314. (703)683-3111; 800-826-9972. **Fax:** (703)683-7424. **E-mail:** techniques @acteonline.org. **Website:** www.acteonline.org. **Contact:** Jennifer Hirt, Sr. Director of Programs and Communications. Estab. 1926. Circ. 25,000.

❶ This publication uses stock photography or artwork accompanying an article and offers no opportunity for freelance photography.

⑤⑤ TEXAS REALTOR MAGAZINE

P.O. Box 2246, Austin TX 78768. (800)873-9155; (512)370-2286. **Fax:** (512)370-2390. **E-mail:** jmathews@texasrealtors.com. **Website:** www.texas realtors.com. **Contact:** Joel Mathews, art director; Brandi Alderetti. Estab. 1972. Circ. 50,000. Monthly magazine of the Texas Association of Realtors. Emphasizes real estate sales and related industries. Readers are male and female realtors, ages 20-70. Sample copy free with SASE.

NEEDS Buys 10 photos from freelancers/issue; 120 photos/year. Needs photos of architectural details, business, office management, telesales, real estate sales, commercial real estate, nature. Property release required.

MAKING CONTACT & TERMS Buys one-time rights; negotiable.

◎⑤ TEXTILE SERVICES MAGAZINE

1800 Diagonal Rd., Suite 200, Alexandria VA 22314. (703)519-0029; (877)770-9274. **Fax:** (703)519-0026. **E-mail:** jmorgan@trsa.org. **Website:** www.trsa.org. Jason Risley, managing editor. Estab. 1917. Monthly magazine of the Textile Rental Services Association of America. Emphasizes the linen supply, industrial and commercial textile rental and service industry. Readers are "heads of companies, general managers of facilities, predominantly male; national and international readers."

NEEDS Photos needed on assignment basis only. Model release preferred. Photo captions preferred or required "depending on subject."

MAKING CONTACT & TERMS "We contact photographers on an as-needed basis from a directory. We also welcome inquiries and submissions." Cannot return material. Previously published work OK. Pays $350 for color cover plus processing; "depends on the job." **Pays on acceptance.** Credit line given if requested. Buys all rights.

⑤ TOBACCO INTERNATIONAL

Lockwood Publications, Inc., 3743 Crescent St., 2nd Floor, Long Island City NY 11101. (212)391-2060. **Fax:** (212)827-0945. **E-mail:** editor@tobaccointernational .com. **Website:** www.tobaccointernational.com. **Contact:** Murdoch McBride. Estab. 1886. Circ. 5,000. Monthly international business magazine. Emphasizes cigarettes, tobacco products, tobacco machinery, supplies, and services. Readers are executives, ages 35-60. Sample copy free with SASE.

NEEDS Uses 20-30 photos/issue. "Photography that represents tobacco industry activity, processing or growing tobacco products from all around the world, but any interesting newsworthy photos relevant to subject matter is considered." Model or property release preferred.

MAKING CONTACT & TERMS Send query letter with photocopies, transparencies, slides or prints. Does not keep samples on file; include SASE for return of material. Responds in 3 weeks. Simultaneous submissions OK (not if competing journal). Pays $50/ color photo. Pays on publication. Credit line may be given.

🌑🌓🌗🌕🌕 TOBACCO JOURNAL INTERNATIONAL

Konradin Selection, Erich-Dombrowski-Strasse 2, Mainz 55127 Germany. +49 6131 5841 138. **Fax:** +49 711 7594 194 38. **E-mail:** jeremy.booth@konradin.de. **Website:** www.tobaccojournal.com. **Contact:** Jeremy Booth, editor. Circ. 4,300. Trade magazine. "Focuses on all aspects of the tobacco industry from international trends to national markets, offering news and views on the entire industry from leaf farming to primary and secondary manufacturing, to packaging, distribution, and marketing." Sample copies available. Request photo guidelines via e-mail.

NEEDS Buys 5-10 photos from freelancers/issue; agriculture, product shots/still life. "Anything related to tobacco and smoking. Abstract smoking images considered, as well as international images."

SPECS Accepts almost all formats. Minimum resolution of 300 dpi at the size to be printed. Prefers TIFFs to JPEGs, but can accept either.

MAKING CONTACT & TERMS E-mail query letter with link to photographer's website, JPEG samples at 72 dpi. Provide self-promotion piece to be kept on file for possible future assignments. Pays £200 maximum for cover photo. **Pays on acceptance.** Credit line given.

TIPS "Check the features list on our website."

🌕 TODAY'S PHOTOGRAPHER

American Image Press, P.O. Box 42, Hamptonville NC 27020-0042. (336)468-1138. **Fax:** (336)468-1899. **E-mail:** homeoffice@ainewsservice.net. **Website:** www.aipress.com. **Contact:** Vonda H. Blackburn, editor-in-chief. Estab. 1986. Circ. 78,000. Published 1/year in print, 2/year online. Magazine of the International Freelance Photographers Organization. Emphasizes making money with photography. Readers are 90% male photographers. Sample copy available for 9×12 SASE. Photo guidelines free with SASE.

NEEDS Buys 40 photos from freelancers/issue; 240 photos/year. Model release required. Photo captions preferred. Only buys content from members of IFPO ($74 membership fee, plus $7 shipping).

MAKING CONTACT & TERMS Send 35mm, 2¼×2¼, 4×5, 8×10 b&w and color prints or transparencies by mail for consideration; include SASE for return of material. Responds at end of quarter. Simultaneous submissions and previously published work OK. Payment negotiable. Credit line given. Buys one-

time rights, per contract.

🌓🌗 TOP PRODUCER

110 Kent Rd., Springfield PA 19064. **E-mail:** drafferty@farmjournal.com. **Website:** www.agweb.com. **Contact:** Dana Rafferty, art director. Circ. 120,000. Monthly. Emphasizes American agriculture. Readers are active farmers, ranchers, or agribusiness people. Sample copy and photo guidelines free with SASE.

NEEDS Buys 5-10 photos from freelancers/issue; 60-100 photos/year. "We use studio-type portraiture (environmental portraits), technical, details, and scenics." Model release preferred. Photo captions required.

MAKING CONTACT & TERMS Send query letter with résumé of credits along with business card, brochure, flyer, or tearsheets to be kept on file for possible future assignments. "Do not send originals." Please send information for online portfolios/websites, as we often search for stock images on such sites. Digital files and portfolios may be sent via CD to the address noted above." Simultaneous submissions and previously published work OK. **Pays on acceptance.** Credit line given. Buys one-time rights.

TIPS In portfolio or samples, likes to see "about 40 samples showing photographer's use of lighting and ability to work with people. Know your intended market. Familiarize yourself with the magazine and keep abreast of how photos are used in the general magazine field."

🌗 TRANSPORTATION MANAGEMENT & ENGINEERING

Scranton Gillette Communications, Inc., 3030 W. Salt Creek Lane, Suite 201, Arlington Heights IL 60005. (847)391-1029. **E-mail:** bwilson@sgcmail.com. **Website:** www.roadsbridges.com. **Contact:** Bill Wilson, editor. Estab. 1994. Circ. 18,000. Quarterly supplement. "*TM&E* is a controlled publication targeted toward 18,000 traffic/transit system planners, designers, engineers, and managers in North America." Sample copies available.

NEEDS Buys 1-2 photos from freelancers/issue; 5-10 photos/year. Needs photos of landscapes/scenics, transportation-related, traffic, transit. Reviews photos with or without ms. Property release preferred. Photo captions preferred.

SPECS Uses 5×7 glossy prints; 35mm transparencies. Accepts images in digital format. Send via CD as TIFF, EPS files at 300 dpi.

MAKING CONTACT & TERMS Send query letter with prints. Portfolio may be dropped off every Monday. Responds in 3 weeks to queries. Responds only if interested; send nonreturnable samples. Pays on publication. Credit line sometimes given. Buys all rights; negotiable.

TIPS "Read our magazine."

TRANSPORT TOPICS

950 N. Glebe Rd., Suite 210, Arlington VA 22203. (703)838-1770. **Fax:** (703)838-7916. **E-mail:** gdively @ttnews.com. **Website:** www.ttnews.com. **Contact:** George Dively, art director. Estab. 1935. Circ. 31,000. Weekly tabloid. Publication of American Trucking Associations. Emphasizes the trucking industry and freight transportation. Readers are executives, ages 35-65.

NEEDS Uses approximately 12 photos/issue; amount supplied by freelancers "depends on need." Needs photos of truck transportation in all modes. Model/property release preferred. Photo captions preferred.

MAKING CONTACT & TERMS Send unsolicited JPEGs by e-mail for consideration. Provide résumé, business card, brochure, flier, or tearsheets to be kept on file for possible future assignments. Does not keep samples on file; include SASE for return of material. Responds in 1 month. Simultaneous submissions and previously published work OK. Payment negotiable. Pays standard "market rate" for color cover photo. **Pays on acceptance.** Credit line given. Buys one-time or permanent rights; negotiable.

TIPS "Trucks/trucking must be dominant element in the photograph—not an incidental part of an environmental scene."

TREE CARE INDUSTRY MAGAZINE

Tree Care Industry Association, 136 Harvey Rd., Suite 101, Londonderry NH 03053. (800)733-2622 or (603)314-5380. **Fax:** (603)314-5386. **E-mail:** editor@ tcia.org; dstaruk@TCIA.org. **Website:** www.tcia.org. **Contact:** Don Staruk, editor. Estab. 1990. Circ. 24,000. Monthly trade magazine for arborists, landscapers, and golf course superintendents interested in professional tree care practices. Sample copy available for $5.

NEEDS Buys 3-6 photos/year. Needs photos of tree work, landscapes, and gardening. Reviews photos with or without a ms.

SPECS Accepts images in digital format. Send via e-mail or FTP as JPEG or TIFF files at 300 dpi.

MAKING CONTACT & TERMS Send query letter with stock list. Does not keep samples on file; include SASE for return of material. Pays $100 maximum for color cover; $25 minimum for color inside. Pays on publication. Credit line given. Buys one-time and on-line rights.

UNDERGROUND CONSTRUCTION

Oildom Publishing Company of Texas, Inc., P.O. Box 941669, Houston TX 77094-8669. (281)558-6930, ext. 220. **Fax:** (281)558-7029. **E-mail:** rcarpenter@oildom. com; efitzpatrick@oildom.com. **Website:** www.under groundconstructionmagazine.com. **Contact:** Robert Carpenter, editor-in-chief; Cleve Hogarth, publisher; Elizabeth Fitzpatrick, art director. Circ. 40,000. Monthly trade journal. Emphasizes construction and rehabilitation of sewer, water, gas, telecom, electric, and oil underground pipelines/conduit. Readers are contractors, utilities, and engineers. Sample copy available for $3.

NEEDS Uses photos of underground construction and rehabilitation.

SPECS Uses high-resolution digital images (minimum 300 dpi); large-format negatives or transparencies.

MAKING CONTACT & TERMS Query before sending photos. Generally responds within 30 days. Pays $100-400 for color cover; $50-250 for color inside. Buys one-time rights.

TIPS "Freelancers are competing with staff as well as complimentary photos supplied by equipment manufacturers. Subject matter must be unique, striking, and/or off the beaten track. People on the job are always desirable."

💲 UNITED AUTO WORKERS (UAW)

UAW Solidarity House, 8000 E. Jefferson Ave., Detroit MI 48214. (313)926-5291. **E-mail:** uawsolidarity @uaw.net. **Website:** www.uaw.org. **Contact:** Vince Piscopo, editor. Trade union representing 650,000 workers in auto, aerospace, agricultural-implement industries, government, and other areas. Publishes *Solidarity* magazine. Photos used for magazine, brochures, newsletters, posters, and calendars.

NEEDS Buys 85 freelance photos/year; offers 12-18 freelance assignments/year. Needs photos of workers at their place of employment, and social issues for magazine story illustrations. Reviews stock photos. Model release preferred. Photo captions preferred.

SPECS Uses 8×10 prints.

MAKING CONTACT & TERMS Arrange a personal interview to show portfolio. In portfolio, prefers to see b&w and color workplace shots. Send query letter with samples and SASE by mail for consideration. Prefers to see published photos as samples. Provide résumé or tearsheets to be kept on file for possible future assignments. Notifies photographer if future assignments can be expected. Responds in 2 weeks. Credit line given. Buys one-time rights and all rights; negotiable.

VETERINARY ECONOMICS

8033 Flint St., Lenexa KS 66214. (800)255-6864. **Fax:** (913)871-3808. **E-mail:** dvmnews@advanstar.com. **Website:** veterinarybusiness.dvm360.com. Estab. 1960. Circ. 54,000. Monthly trade magazine emphasizing practice management for veterinarians.

NEEDS Photographers on an "as needed" basis for editorial portraits; must be willing to sign license agreement; 2-3 photo portraits/year. License agreement required. Photo captions preferred.

SPECS Prefers images in digital format. Send via FTP, e-mail as JPEG files at 300 dpi.

MAKING CONTACT & TERMS Send 1 e-mail with sample image less than 1 MB; repeat e-mails are deleted. Does not keep samples on file. **Pays on acceptance.** Credit line given.

WATER WELL JOURNAL

National Ground Water Association, 601 Dempsey Rd., Westerville OH 43081. **Fax:** (614)898-7786. **E-mail:** tplumley@ngwa.org. **Website:** www.waterwelljournal.org. **Contact:** Thad Plumley, director of publications/editor; Mike Price, senior editor. Circ. 24,000. Monthly association publication. Emphasizes construction of water wells, development of ground water resources, and ground water cleanup. Readers are water well drilling contractors, manufacturers, suppliers, and ground water scientists. Sample copy available for $15 U.S., $36 foreign.

NEEDS Buys 1-3 freelance photos/issue plus cover photos; 12-36 photos/year. Needs photos of installations and how-to illustrations. Model release preferred. Photo captions required.

SPECS Accepts images in digital format. Send via CD, ZIP as TIFF files at 300 dpi.

MAKING CONTACT & TERMS Send query letter with samples. "We'll contact you." Pays $250 for color

cover; $50 for b&w or color inside; "flat rate for assignment." Pays on publication. Credit line given. Buys all rights.

TIPS "E-mail or send written inquiries; we'll reply if interested. Unsolicited materials will not be returned."

THE WHOLESALER

2615 Shermer Rd., Suite A, Northbrook IL 60062. (847)564-1127. **E-mail:** editor@thewholesaler.com. **Website:** www.thewholesaler.com. Estab. 1946. Circ. 35,000. Monthly news tabloid. Emphasizes wholesaling/distribution in the plumbing, heating, air conditioning, piping (including valves), fire protection industry. Readers are owners and managers of wholesale distribution businesses; manufacturer representatives. Sample copy free with 11×15¾ SASE and 5 first-class stamps.

NEEDS Buys 3 photos from freelancers/issue; 36 photos/year. Interested in field and action shots in the warehouse, on the loading dock, at the job site. Property release preferred. Photo captions preferred—"just give us the facts."

MAKING CONTACT & TERMS Send query letter with stock list. Send any size glossy color and b&w prints by mail with SASE for consideration. Responds in 2 weeks. Simultaneous submissions and previously published work OK. Pays on publication. Buys one-time rights.

WINES & VINES

Wine Communications Group, 65 Mitchell Blvd., Suite A, San Rafael CA 94903. (415)453-9700; (866)453-9701. **Fax:** (415)453-2517. **E-mail:** edit@winesandvines.com; info@winesandvines.com. **Website:** www.winesandvines.com. **Contact:** Jim Gordon, editor; Kate Lavin, managing editor. Estab. 1919. Circ. 5,000. Monthly. Emphasizes winemaking, grape growing, and marketing in North America and internationally for wine industry professionals, including winemakers, grape growers, wine merchants, and suppliers.

NEEDS Color cover subjects—on a regular basis.

SPECS Accepts images in digital format. Send via CD, ZIP, e-mail as TIFF, or JPEG files at 400 dpi.

MAKING CONTACT & TERMS Prefers e-mail query with link to portfolio; or send material by mail for consideration. Will e-mail if interested in reviewing photographer's portfolio. Provide business card to be kept on file for possible future assignments. Responds in 3 months. Previously published work con-

sidered. Pays $100-350 for color cover, or negotiable ad trade-out. Pays on publication. Credit line given. Buys one-time rights.

ⓢ WISCONSIN ARCHITECT

321 S. Hamilton St., Madison WI 53703-4000. (608)257-8477. **E-mail:** editor@aiaw.org. **Website:** www.aiaw.org. Estab. 1931. Circ. 3,700. Annual magazine of the American Institute of Architects Wisconsin. Emphasizes architecture. Readers are design/construction professionals.

NEEDS Uses approximately 100 photos/issue. "Photos are almost exclusively supplied by architects who are submitting projects for publication. Of these, approximately 65% are professional photographers hired by the architect."

MAKING CONTACT & TERMS "Contact us using online submission/contact form." Keeps samples on file. Responds when interested. Simultaneous submissions and previously published work OK. Pays on publication. Credit line given. Rights negotiable.

WOMAN ENGINEER

Equal Opportunity Publications, Inc., 445 Broad Hollow Rd., Suite 425, Melville NY 11747. (631)421-9421. **Fax:** (631)421-1352. **E-mail:** info@eop.com; bloehr@eop.com. **Website:** www.eop.com. **Contact:** Barbara Capella Loehr, editor. Estab. 1968. Circ. 16,000. Magazine published 3 times/year. Emphasizes career guidance for women engineers at the college and professional levels. Readers are college-age and professional women in engineering. Sample copy free with 9×12 SAE and 6 first-class stamps.

NEEDS Uses at least 1 photo/issue (cover); planning to use freelance work for covers and possibly editorial; most of the photos are submitted by freelance writers with their articles. Model release preferred. Photo captions required.

TIPS "We are looking for strong, sharply focused photos or slides of women engineers. The photo should show a woman engineer at work, but the background should be uncluttered. The photo subject should be dressed and groomed in a professional manner. Cover photo should represent a professional woman engineer at work and convey a positive and professional image. Read our magazine, and find actual women engineers to photograph. We're not against using cover models, but we prefer cover subjects to be women engineers working in the field."

WOODSHOP NEWS

Cruz Bay Publishing, Inc., 10 Bokum Rd., Essex CT 06426. (860)767-8227. **Fax:** (860)767-1048. **E-mail:** editorial@woodshopnews.com. **Website:** www.woodshopnews.com. **Contact:** Tod Riggio, editor. Estab. 1986. Circ. 60,000. Monthly trade magazine (tabloid format) covering all areas of professional woodworking. Sample copies available.

NEEDS Buys 12 sets of cover photos from freelancers/year. Photos of celebrities, architecture, interiors/decorating, industry, product shots/still life. Interested in documentary. "We assign our cover story, which is always a profile of a professional woodworker. These photo shoots are done in the subject's shop and feature working shots, portraits, and photos of subject's finished work." Photo captions required; include description of activity contained in shots. "Photo captions will be written in-house based on this information."

SPECS Prefers digital photos.

MAKING CONTACT & TERMS Send query letter with résumé, photocopies, tearsheets. Provide self-promotion piece to be kept on file for possible future assignments. Responds only if interested; send nonreturnable samples. Previously published work OK occasionally. Pays $600-800 for color cover. Note: "We want a cover photo 'package'—one shot for the cover, others for use inside with the cover story." **Pays on acceptance.** Credit line given. Buys "perpetual" rights, but will pay a lower fee for one-time rights.

TIPS "I need a list of photographers in every geographical region of the country—I never know where our next cover profile will be done, so I need to have options everywhere. Familiarity with woodworking is a definite plus. Listen to our instructions! We have very specific lighting and composition needs, but some photographers ignore instructions in favor of creating 'artsy' photos, which we do not use, or poorly lighted photos, which we cannot use."

BOOK PUBLISHERS

//

There are diverse needs for photography in the book publishing industry. Publishers need photos for the obvious (covers, jackets, text illustrations, and promotional materials), but they may also need them for use on CD-ROMs and websites. Generally, though, publishers either buy individual or groups of photos for text illustration, or they publish entire books of photography.

Those in need of text illustration use photos for cover art and interiors of textbooks, travel books, and nonfiction books. For illustration, photographs may be purchased from a stock agency or from a photographer's stock, or the publisher may make assignments. Publishers usually pay for photography used in book illustration or on covers on a per-image or per-project basis. Some pay photographers hourly or day rates, if on an assignment basis. No matter how payment is made, however, the competitive publishing market requires freelancers to remain flexible.

To approach book publishers for illustration jobs, send a cover letter with photographs or slides and a stock photo list with prices, if available. (See sample stock list in "Running Your Business.") If you have a website, provide a link to it. If you have published work, tearsheets are very helpful in showing publishers how your work translates to the printed page.

PHOTO BOOKS

Publishers who produce photography books usually publish books with a theme, featuring the work of one or several photographers. It is not always necessary to be well-known to publish your photographs as a book. What you do need, however, is a unique perspective, a salable idea, and quality work.

For entire books, publishers may pay in one lump sum or with an advance plus royalties (a percentage of the book sales). When approaching a publisher for your own book of photographs, query first with a brief letter describing the project, and include sample photographs. If the publisher is interested in seeing the complete proposal, you can send additional information in one of two ways depending on the complexity of the project.

Prints placed in sequence in a protective box, along with an outline, will do for easy-to-describe, straightforward book projects. For more complex projects, you may want to create a book dummy. A dummy is basically a book model with photographs and text arranged as they will appear in finished book form. Book dummies show exactly how a book will look, including the sequence, size, format, and layout of photographs and accompanying text. The quality of the dummy is important, but keep in mind that the expense can be prohibitive.

To find the right publisher for your work, first check the Subject Index in the back of the book to help narrow your search, then read the appropriate listings carefully. Send for catalogs and guidelines for those publishers that interest you. You may find guidelines on publishers' websites as well. Also, become familiar with your local bookstore or visit the site of an online bookstore such as Amazon.com. By examining the books already published, you can find those publishers who produce your type of work. Check for both large and small publishers. While smaller firms may not have as much money to spend, they are often more willing to take risks, especially on the work of new photographers. Keep in mind that photo books are expensive to produce and may have a limited market.

⊛⊛◑ ALLYN & BACON PUBLISHERS

445 Hutchinson Ave., Columbus OH 43235. **Website:** www.allynbaconmerrill.com. Find local rep to submit materials via online rep locator. Publishes college textbooks. Photos used for text illustrations, book covers. Examples of recently published titles: *Criminal Justice; Including Students With Special Needs; Social Psychology* (text illustrations and promotional materials). Offers one assignment plus 80 stock projects/year.

NEEDS Photos of babies/children/teens, celebrities, couples, multicultural, families, parents, senior citizens, disasters, education, special education, science, technology/computers. Interested in fine art, historical/vintage. Also uses multi-ethnic photos in education, health and fitness, people with disabilities, business, social sciences, and good abstracts. Reviews stock photos. Model/property release required.

SPECS Uses b&w prints, any format; all transparencies. Accepts images in digital format.

MAKING CONTACT & TERMS Send via CD, ZIP, e-mail as TIFF, EPS, PICT, GIF, JPEG files at 72 dpi for review, 300 dpi for use. See photo and art specifications online.

TIPS "Send tearsheets and promotion pieces. Need bright, strong, clean abstracts and unstaged, nicely lit people photos."

◎⊛⊛◑ APPALACHIAN MOUNTAIN CLUB BOOKS

5 Joy St., Boston MA 02138. (617)523-0636. **Fax:** (617)523-0722. **E-mail:** amcbooks@outdoors.org. **Website:** www.outdoors.org. Estab. 1876. Publishes hardcovers and trade paperbacks. Photos used for text illustrations, book covers. Examples of recently published titles: Quiet Water series, Best Day Hikes series, Trail Guide series. Model release required. Photo captions preferred; include location, description of subject, photographer's name, and phone number. Uses print-quality color and gray-scale images.

NEEDS Looking for photos of nature, hiking, backpacking, biking, paddling, skiing in the Northeast.

MAKING CONTACT & TERMS E-mail lightboxes. Art director will contact photographer if interested. Keeps samples on file. Responds only if interested.

◎ AUTONOMEDIA

P.O. Box 568, Williamsburg Station, Brooklyn NY 11211. **Website:** www.autonomedia.org. Estab. 1974.

Publishes books on radical culture and politics. Photos used for text illustrations, book covers. Examples of recently published titles: *TAZ* (cover illustration); *Cracking the Movement* (cover illustration); *Zapatistas* (cover and photo essay).

NEEDS "The number of photos bought annually varies, as does the number of assignments offered." Model/property release preferred. Photo captions preferred.

MAKING CONTACT & TERMS Send query letter with samples. Does not keep samples on file; include SASE for return of material. Responds in 1 month. Works on assignment only. Payment negotiable. Pays on publication. Buys one-time and electronic rights.

BARBOUR PUBLISHING, INC.

P.O. Box 719, Urichsville OH 44683. **E-mail:** submissions@barbourbooks.com. **Website:** www.barbourbooks.com. Estab. 1981. "Barbour Books publishes inspirational/devotional material that is nondenominational and evangelical in nature. We're a Christian evangelical publisher." Specializes in short, easy-to-read Christian bargain books. "Faithfulness to the Bible and Jesus Christ are the bedrock values behind every book Barbour's staff produces."

BEARMANOR MEDIA

P.O. Box 71426, Albany GA 31708. **E-mail:** books@benohmart.com. **Website:** www.bearmanormedia.com. **Contact:** Ben Ohmart, publisher. Estab. 2000. Publishes 70 titles/year. Payment negotiable. Responds only if interested. Catalog available online or free with a 8×10 SASE submission.

TIPS "Potential freelancers should be familiar with our catalog and be computer savvy."

◎⊕ BENTLEY PUBLISHERS

1734 Massachusetts Ave., Cambridge MA 02138. (617)547-4170. **Fax:** (617)876-9235. **Website:** www.bentleypublishers.com. Estab. 1950. Publishes professional, technical, consumer how-to books. Photos used for text illustrations, promotional materials, book covers, dust jackets. Examples of published titles: *Porsche: Genesis of Genius; Toyota Prius Repair and Maintenance Manual.*

NEEDS Buys 70-100 photos/year; offers 5-10 freelance assignments/year. Looking for motorsport, automotive technical and engineering photos. Reviews stock photos. Model/property release required. Photo captions required; include date and subject matter.

SPECS Uses 8×10 transparencies. Accepts images in digital format.

MAKING CONTACT & TERMS Send query letter with samples. Provide résumé, business card, brochure, flier or tearsheets to be kept on file for possible future assignments. Keeps samples on file; cannot return material. Works on assignment only. Responds in 6 weeks. Simultaneous submissions and previously published work OK. Payment negotiable. Credit line given. Buys electronic and one-time rights.

TIPS "Bentley Publishers publishes books for automotive enthusiasts. We are interested in books that showcase good research, strong illustrations, and valuable technical information."

ⓢⓞ CAPSTONE PRESS

1710 Roe Crest Dr., North Mankato MN 56003. (800)747-4992. **Fax:** (888)262-0705. **E-mail:** nf.il. sub@capstonepub.com; il.sub@capstonepub.com. **Website:** www.capstonepress.com. **Contact:** Dede Barton, photo director. Estab. 1991. Publishes juvenile nonfiction and educational books. Subjects include animals, ethnic groups, vehicles, sports, history, scenics. Photos used for text illustrations, promotional materials, book covers. "To see examples of our products, please visit our website." Submission guidelines available online.

NEEDS Buys about 3,000 photos/year. "Our subject matter varies (usually 100 or more different subjects/year); editorial-type imagery preferable although always looking for new ways to show an overused subject or title (fresh)." Model/property release preferred. Photo captions preferred; include "basic description; if people of color, state ethnic group; if scenic, state location and date of image."

SPECS Accepts images in digital format for submissions as well as for use. Digital images must be at least 8×10 at 300 dpi for publishing quality (TIFF, EPS or original camera file format preferred).

MAKING CONTACT & TERMS Send query letter with stock list. E-mail résumé, sample artwork, and a list of previous publishing credits if applicable. Keeps samples on file. Responds in 6 months. Simultaneous submissions and previously published work OK. Pays after publication. Credit line given. Looking to buy worldwide all language rights for print and digital rights. Producing online projects (interactive websites and books); printed books may be bound up into binders.

TIPS "Be flexible. Book publishing usually takes at least 6 months. Capstone does not pay holding fees. Be prompt. The first photos in are considered for covers first."

ⓞⓞ CENTERSTREAM PUBLICATION LLC

P.O. Box 17878, Anaheim CA 92817. (714)779-9390. **E-mail:** centerstrm@aol.com. **Website:** www. centerstream-usa.com. **Contact:** Ron Middlebrook, owner. Estab. 1982. "Centerstream is known for its unique publications for a variety of instruments. From instructional and reference books and biographies to fun song collections and DVDs, our products are created by experts who offer insight and invaluable information to players and collectors." Publishes music history, biographies, DVDs, music instruction (all instruments). Photos used for text illustrations, book covers. Examples of published titles: *Dobro Techniques*; *History of Leedy Drums*; *History of National Guitars*; *Blues Dobro*; *Jazz Guitar Christmas* (book covers).

NEEDS Reviews stock photos of music. Model release preferred. Photo captions preferred.

SPECS Uses color and b&w prints; 35mm, 2¼×2¼, 4×5 transparencies. Accepts images in digital format. Send via ZIP as TIFF files.

MAKING CONTACT & TERMS Send query letter with samples and stock list. Send unsolicited photos by mail for consideration. Provide résumé, business card, brochure, flier, or tearsheets to be kept on file for possible future assignments. Works on assignment only. Responds in 1 month. Simultaneous submissions and previously published work OK. Payment negotiable. Pays on receipt of invoice. Credit line given. Buys all rights.

ⓞⓢⓢ CLEIS PRESS

101 Hudson St., 37th Floor, Suite 3705, Jersey City NJ 07302. **Fax:** (510)845-8001. **Website:** www.cleispress. com. Estab. 1980. Cleis Press publishes provocative, intelligent books in the areas of sexuality, gay and lesbian studies, erotica fiction, gender studies, and human rights. Publishes fiction, nonfiction, trade, and gay/lesbian erotica. Photos used for book covers. Buys 20 photos/year. Reviews stock photos. Works with freelancers on assignment only. Keeps samples on file. Pays on publication.

NEEDS Fiction, nonfiction, trade, and gay/lesbian erotica; photos used for book covers.

SPECS Uses color and/or b&w prints.

MAKING CONTACT & TERMS Query via e-mail only. Provide résumé, business card, brochure, flier, or tearsheets to be kept on file for possible future assignments.

ⓈⓈ CONARI PRESS

Red Wheel/Weiser, LLC., 665 Third Street Suite 400, San Fransisco CA 94107. **E-mail:** submissions@rwwbooks.com: info@rwwbooks.com. **Website:** www.redwheelweiser.com. Estab. 1987.

SPECS Prefers images in digital format.

Ⓢ CRABTREE PUBLISHING COMPANY

350 Fifth Ave., 59th Floor, New York NY 10118. (212)496-5040; (800)387-7650. **Fax:** (800)355-7166. **Website:** www.crabtreebooks.com. Estab. 1978. Publishes juvenile nonfiction, library and trade. Subjects include science, cultural events, history, geography (including cultural geography), sports. Photos used for text illustrations, book covers. Examples of recently published titles: *The Mystery of the Bermuda Triangle, Environmental Activist, Paralympic Sports Events, Presidents' Day, Plant Cells, Bomb and Mine Disposal Officers.*

💬 This publisher also has offices in Canada, United Kingdom, and Australia.

NEEDS Buys 20-50 photos/year. Wants photos of cultural events around the world, animals (exotic and domestic). Model/property release required for children, photos of artwork, etc. Photo captions preferred; include place, name of subject, date photographed, animal behavior.

SPECS Uses high-res digital files (no compressed JPEG files).

MAKING CONTACT & TERMS *Does not accept unsolicited photos.* Provide résumé, business card, brochure, flier, or tearsheets to be kept on file for possible future assignments. Simultaneous submissions and previously published work OK. Pays $100 for color photos. Pays on publication. Credit line given. Buys non-exclusive, worldwide, and electronic rights.

TIPS "Since our books are for younger readers, lively photos of children and animals are always excellent." Portfolio should be diverse and encompass several subjects, rather than just 1 or 2; depth of coverage of subject should be intense so that any publishing company could, conceivably, use all or many of a photographer's photos in a book on a particular subject."

CREATIVE WITH WORDS PUBLICATIONS (CWW)

P.O. Box 223226, Carmel CA 93922. **Fax:** (831)655-8627. **E-mail:** geltrich@mbay.net. **Website:** members.tripod.com/CreativeWithWords. Estab. 1975. Publishes 2 poetry and prose anthologies per year according to set themes. B&w photos used for text illustrations, book covers. Photo guidelines, theme list, and submittal forms free with SASE.

NEEDS Needs theme-related b&w photos. Currently looking for spring and fall themes. Model/property release preferred.

SPECS Uses any size b&w photos. "We will reduce to fit the page."

MAKING CONTACT & TERMS Request theme list, then query with photos. Does not keep samples on file; include SASE for return of material. Responds 3 weeks after deadline if submitted for a specific theme. Payment for illustrations negotiable. Pays on publication. Credit line given. Buys one-time rights.

DOWN THE SHORE PUBLISHING

P.O. Box 100, West Creek NJ 08092. **Fax:** (609)812-5098. **E-mail:** info@down-the-shore.com. **Website:** www.down-the-shore.com. **Contact:** Acquisitions Editor. Publishes regional calendars; seashore, coastal, and regional books (specific to the mid-Atlantic shore and New Jersey). Photos used for text illustrations, scenic calendars (New Jersey and mid-Atlantic only). Examples of recently published titles include *Great Storms of the Jersey Shore* (text illustrations); *NJ Lighthouse Calendar* (illustrations, cover); *Shore Stories* (text illustrations, dust jacket). Photo guidelines free with SASE or on website.

NEEDS Buys 30-50 photos/year. For calendars, needs scenic coastal shots, photos of beaches and New Jersey lighthouses (New Jersey and mid-Atlantic region). Interested in seasonal. Reviews stock photos. Model release required, property release preferred. Photo captions preferred, specific location identification essential. Digital submissions via high-res files on DVD/CD. Provide reference prints. Accepts 35mm, 2¼×2¼, 4×5, transparencies.

MAKING CONTACT & TERMS Refer to guidelines before submitting. Send query letter with stock list. Provide résumé, business card, brochure, flyer, or tearsheets to be kept on file for possible future requests. Responds in 6 weeks. Previously published work OK. Pays $100-200 for b&w or cover color;

$10-100 for b&w or color inside. Pays 90 days from publication. Credit line given. Buys one-time or book rights, negotiable.

TIPS "We are looking for an honest depiction of familiar scenes from an unfamiliar and imaginative perspective. Images must be specific to our very regional needs. Limit your submissions to your best work. Edit your work very carefully."

✪⊕⊛⊛⊙⊙ ECW PRESS

665 Gerrard Street East, Toronto, Ontario M4M 1Y2 Canada. (416)694-3348. **E-mail:** info@ecwpress.com. **Website:** www.ecwpress.com. **Contact:** David Caron, publisher. Estab. 1974. Publishes hardcover and trade paperback originals. Subjects include entertainment, biography, sports, travel, fiction, poetry. Photos used for text illustrations, book covers, dust jackets.

NEEDS Buys hundreds of freelance photos/year. Looking for color, b&w, fan/backstage, paparazzi, action, original, rarely used. Reviews stock photos. Property release required for entertainment or star shots. Photo captions required; include identification of all people.

SPECS Accepts images in digital format only.

MAKING CONTACT & TERMS "It is best to contact us by e-mail and direct us to your work online. Please also describe what area(s) you specialize in. Since our projects vary in topic, we will keep you on file in case we publish something along the lines of your subject(s)." Pays by the project: $250-600 for color cover; $50-125 for color inside. Pays on publication. Credit line given. Buys one-time book rights (all markets).

FARCOUNTRY PRESS

P.O. Box 5630, Helena MT 59604. (800)821-3874. **Fax:** (406)443-5480. **E-mail:** will@farcountrypress.com. **Website:** www.farcountrypress.com. **Contact:** Will Harmon, Sr. Editor. Estab. 1980. Photographer guidelines are available on our website.

NEEDS Color photography of landscapes (including recreation), cityscapes, and wildlife in the US.

SPECS For digital photo submissions, please send 8- or 16-bit TIFF files (higher preferred), at least 350 dpi or higher, formatted for Mac, RGB profile. All images should be flattened—no channels or layers. Information, including watermarks, should not appear directly on the images. Include either a contact sheet or a folder with low-res files for quick editing.

Include copyright and caption data. Model releases are required for all images featuring recognizable individuals. Note on the mount or in the metadata that a model release is available. Do not submit images that do not have model releases.

MAKING CONTACT & TERMS Send query letter with stock list. Simultaneous submissions and previously published work OK.

✪ FIREFLY BOOKS

50 Staples Ave., Unit 1, Richmond Hill, Ontario L4B 0A7 Canada. (416)499-8412. **E-mail:** service@fireflybooks.com. **Website:** www.fireflybooks.com. Estab. 1974. Publishes high-quality nonfiction. Photos used for text illustrations, book covers, and dust jackets.

NEEDS "We're looking for book-length ideas, *not* stock. We pay a royalty on books sold, plus advance."

SPECS Prefers images in digital format, but will accept 35mm transparencies.

MAKING CONTACT & TERMS Send query letter with résumé of credits. Does not keep samples on file; include SAE/IRC for return of material. Simultaneous submissions OK. Payment negotiated with contract. Credit line given.

FOCAL PRESS

Taylor & Francis Group, 7625 Empire Dr., Florence KY 41042. (800)634-7064. **Fax:** (800)248-4724. **E-mail:** jessie.taylor@taylorandfrancis.com. **Website:** www.focalpress.com. Estab. 1938.

NEEDS "We publish professional reference titles, practical guides, and student textbooks in all areas of media and communications technology, including photography and digital imaging. We are always looking for new proposals for book ideas. Send e-mail for proposal guidelines."

MAKING CONTACT & TERMS Simultaneous submissions and previously published work OK. Buys all rights; negotiable.

GRYPHON HOUSE, INC.

P.O. Box 10, 6848 Leon's Way, Lewisville NC 27023. (800)638-0928. **E-mail:** info@ghbooks.com. **Website:** www.gryphonhouse.com. Estab. 1981.

NEEDS Model release required.

SPECS Uses 5×7 glossy color (cover only) and b&w prints. Accepts images in digital format. Send via CD, ZIP, e-mail as TIFF files at 300 dpi.

MAKING CONTACT & TERMS Send query let-

ter with samples and stock list. Keeps samples on file. Simultaneous submissions OK. Payment negotiable. Pays on receipt of invoice. Credit line given. Buys book rights.

⚙ GUERNICA EDITIONS

1569 Heritage Way, Oakville, Ontario L6M 2Z7 Canada. (905)599-5304. **Fax:** (416)981-7606. **E-mail:** michaelmirolla@guernicaeditions.com or annageisler@guernicaeditions.com. **Website:** www.guernicaeditions.com. **Contact:** Michael Mirolla, editor/publisher (poetry, nonfiction, short stories, novels) or Anna Geisler (publicist). Estab. 1978. Publishes adult trade (literary). Photos used for book covers. Examples of recently published titles: *Writing Poetry to Save Your Life* by Maria Mazziotti Gillan (how to); *The Magic Dogs of San Vicente* by Mark Fishman (novel); *The Canticles I* by George Elliott Clarke (poems); *McKinley's Ghost & The Little Tin Truck* by Anthony M. Graziano (creative nonfiction).

SPECS Uses color or b&w prints. Accepts images in digital format. Send via CD, ZIP as TIFF, GIF files at 300 dpi minimum.

MAKING CONTACT & TERMS Manuscript queries by e-mail only (via online contact form). "Before inquiring, please check our website to determine the type of material that best fits our publishing house."

❶❷ HARPERCOLLINS CHILDREN'S BOOKS/HARPERCOLLINS PUBLISHERS

195 Broadway, New York NY 10007. (212)207-7000. **Website:** www.harpercollins.com. Publishes hardcover originals and reprints, trade paperback originals and reprints, mass market paperback originals and reprints, and audiobooks. 500 titles/year.

NEEDS Babies/children/teens, couples, multicultural, pets, food/drink, fashion, lifestyle. Send links to work. No attachments, please. "We are interested in seeing samples of map illustrations, chapter spots, full-page pieces, etc. We are open to half-tone and line art illustrations for our interiors." Negotiates a flat payment fee upon acceptance. Will contact if interested. Catalog available online.

MAKING CONTACT & TERMS Art only, no ms. Submission of texts to editorial departments only; no attachments please. Send links to artwork only.

TIPS "Be flexible and responsive to comments and corrections. Hold to scheduled due dates for work. Show work that reflects the kinds of projects you *want*

to get, be focused on your best technique and showcase the strongest, most successful examples."

❸❹❺ HOLT MCDOUGAL

1900 S. Batavia Ave., Geneva IL 60134. (800)462-6595. **Fax:** (888)872-8380. **E-mail:** k12orders@hmhpub.com. **Website:** www.hmhco.com. Estab. 1866. Publishes textbooks in multiple formats. Photos are used for text illustrations, promotional materials, and book covers.

NEEDS Uses 6,500+ photos/year. Wants photos that illustrate content for mathematics, sciences, social studies, world languages, and language arts. Model/property release preferred. Photo captions required; include scientific explanation, location, and/or other detailed information.

SPECS Prefers images in digital format. Send via CD or broadband transmission.

MAKING CONTACT & TERMS Send a query letter with a sample of work (nonreturnable photocopies, tearsheets, printed promos) and a list of subjects in stock. Self-promotion pieces kept on file for future reference. Include promotional website link if available. "Do not call!" Will respond only if interested. Payment negotiable depending on format and number of uses. Credit line given.

TIPS "Our book image programs yield an emphasis on rights-managed stock imagery, with a focus on teens and a balanced ethnic mix. Though we commission assignment photography, we maintain an in-house studio with 2 full-time photographers. We are interested in natural-looking, uncluttered photographs labeled with exact descriptions that are technically correct and include no evidence of liquor, drugs, cigarettes, or brand names."

❻❼ HUMAN KINETICS PUBLISHERS

E-mail: support@hkusa.com; lauraaf@hkusa.com. **Website:** www.humankinetics.com. **Contact:** Laura Fitch, photo asset manager. Estab. 1979. Publishes consumer books and textbooks in various formats, online courses, websites, and DVD. Subjects include sports, fitness, physical therapy, sports medicine, nutrition, dance, and physical activity. Photos used for text illustrations, promotional materials, catalogs, web content, book covers. Photo guidelines available via e-mail.

NEEDS Buys stock photography for many products. "We have an in-house photo studio with 1 full-time

photographer but hire freelance photographers when needed." Stock subject matter varies but often includes: sports (all ages, abilities and levels, from elite to intramural), health and fitness, nutrition, K-12 education, active aging and dance. Emphasis on diversity. Model releases preferred.

SPECS Accepts digital submissions only. Prefers links to lightboxes but will accept JPEGs via e-mail, FTP, or CD. CDs will not be returned. High resolution files should be available 9×12 at 300 dpi if selected. Full guidelines available via e-mail.

MAKING CONTACT & TERMS Send query e-mail with URL to your work online for placement onto our photo research request mailing list or to be considered for future photo assignment work. Responds only if interested. Simultaneous submissions and previously published work OK. Pays on publication. Credit line given. Buys one-time rights. Prefers world rights, all languages, for one edition in both print and e-book formats; negotiable. Pay for covers ranges from $200-500; pay for interior photos ranges from $75-125.

TIPS "View our products at our website humankinetics.com or at your local bookstore to decide if your work matches our content. We lean toward editorial style photography focused on people and lifestyle. Photographs generally should be well composed and natural looking. Diversity in race, ethnicity, age, and ability is important. Also note that book production is a lengthy process. A time frame of 6 months from photo selection to finished layout is typical. We request invoices once layout is final and ready for print. Changes to photo selections can and do happen within that time period."

⊚ HYPERION BOOKS FOR CHILDREN

44 S. Broadway, Floor 16, White Plains NY 10601. (914)288-4100. **Website:** www.disneybooks.com. Publishes children's books, including picture books and books for young readers. Subjects include adventure, animals, history, multicultural, sports. Catalog available with 9×12 SASE and 3 first-class stamps.

NEEDS Photos of multicultural subjects.

MAKING CONTACT & TERMS Provide résumé, business card, self-promotion piece to be kept on file for possible future assignments. Pays royalties based on retail price of book, or a flat fee.

⊕⊜⊙ IMMEDIUM

P.O. Box 31846, San Francisco CA 94131. (415)452-8546. **Fax:** (360)937-6272. **Website:** www.immedium. com. **Contact:** Submissions Editor. Estab. 2005. "*Immedium* focuses on publishing eye-catching children's picture books, Asian American topics, and contemporary arts, popular culture, and multicultural issues."

NEEDS Babies/children/teens, multicultural, families, parents, entertainment, lifestyle. Photos for dust jackets, promotional materials and book covers.

MAKING CONTACT & TERMS Send query letter with résumé, samples, and/or SASE. Photo captions and property releases are required. Rights are negotiated and will vary with project.

TIPS "Look at our catalog—it's colorful and a little edgy. Tailor your submission to our catalog. We need responsive workers."

⊚⊜⊙⊙ INNER TRADITIONS/BEAR & COMPANY

1 Park St., Rochester VT 05767. (802)767-3174. **Fax:** (802)767-3726. **E-mail:** peris@innertraditions. com; customerservice@InnerTraditions.com; customerservice@innertraditions.com. **Website:** www.innertraditions.com. **Contact:** Peri Ann Swan, art director. Estab. 1975. Publishes adult trade and teen self-help. Subjects include new age, health, self-help, esoteric philosophy. Photos used for text illustrations, book covers. Examples of recently published titles: *Tibetan Sacred Dance* (cover, interior); *Tutankhamun Prophecies* (cover); *Animal Voices* (cover, interior).

NEEDS Buys 10-50 photos/year; offers 5-10 freelance assignments/year. Photos of babies/children/ teens, multicultural, families, parents, religious, alternative medicine, environmental, landscapes/scenics. Interested in fine art, historical/vintage. Reviews stock photos. Model/property release required. Photo captions preferred.

SPECS Prefers images in digital format. Send via CD, ZIP as TIFF, EPS, JPEG files at 300 dpi or provide comps via e-mail.

MAKING CONTACT & TERMS Provide résumé, business card, brochure, flier, or tearsheets to be kept on file for possible future assignments. Works with freelancers on assignment only. Simultaneous submissions OK. Pays $150-600 for color cover; $50-200 for b&w and color inside. Pays on publication. Credit line given. Buys book rights; negotiable.

⊕ KAR-BEN PUBLISHING

Lerner Publishing Group, 241 First Ave. N., Minneapolis MN 55401. (612)215-6229. **E-mail:** editorial@karben.com. **Website:** www.karben.com. **Contact:** Joni Sussman. Estab. 1974.

SPECS Prefers images in digital format. Send via FTP, CD, or e-mail as TIFF or JPEG files at 300 dpi.

☯ MAGENTA FOUNDATION

151 Winchester St., Toronto, Ontario M4X 1B5 Canada. **E-mail:** info@magentafoundation.org. **Website:** www.magentafoundation.org. **Contact:** Submissions. Estab. 2004. "Established in 2004, The Magenta Foundation is Canada's pioneering nonprofit, charitable arts publishing house. Magenta was created to organize promotional opportunities for artists, in an international context, through circulated exhibitions and publications. Projects mounted by Magenta are supported by credible international media coverage and critical reviews in all mainstream-media formats (radio, television and print). Magenta works with respected individuals and international organizations to help increase recognition for artists while uniting the global photography community."

⚲ Magenta works with key international organizations and individuals to help increase recognition for Canadian artists around the world, uniting the global photography community. Through its partnerships, Magenta sets a standard for community collaboration while developing both a domestic and international presence vital to the success of Canadian artists. Magenta's good reputation is growing with each project. The attention our artists receive reinforces our organization's mandate to remain dedicated to increasing Canada's visual arts profile around the world.

⊚ MBI, INC.

47 Richards Ave., Norwalk CT 06857. (203)853-2000. **E-mail:** webmail@mbi-inc.com. **Website:** www.mbi-inc.com/publishing.asp. Estab. 1965.

⚲ Our Book Division is Easton Press. Maintains one of America's largest private archives of specially commissioned illustrations, book introductions, and literary criticism.

⑧⑧⑧⑩ MCGRAW-HILL

1333 Burr Ridge Pkwy., Burr Ridge IL 60527. (630)789-4000. **Fax:** (800)634-3963. **E-mail:** cheryl_georgas@ mcgraw-hill.com. **Website:** www.mheducation.com. Publishes hardcover originals, textbooks, CDs. Photos used for book covers.

NEEDS Buys 20 freelance photos/year. Needs photos of business concepts, industry, technology/computers.

SPECS Uses 8×10 glossy prints; 35mm, 2¼×2¼, 4×5 transparencies. Accepts images in digital format. Send via CD.

MAKING CONTACT & TERMS Contact through local sales rep (see submission guidelines online) or via online form. Provide business card, self-promotion piece to be kept on file for possible future assignments. Responds only if interested. Previously published work OK. Pays extra for electronic usage of photos. Pays on publication. Credit line given. Buys one-time rights.

⊕⑧ MITCHELL LANE PUBLISHERS, INC.

P.O. Box 196, Hockessin DE 33009. (302) 234-9426. **Fax:** (866) 834-4164. **E-mail:** barbaramitchell@mitchelllane.com; customerservice@mitchelllane.com. **Website:** www.mitchelllane.com. **Contact:** Barbara Mitchell. Estab. 1993. Publishes hardcover originals for library market. Subjects include biography and other nonfiction for children and young adults. Photos used for text illustrations, book covers. Examples of recently published titles: *Your Land and My Land: Africa*; Abby Wambach and Kevin Durant (text illustrations, book cover).

NEEDS Photo captions required.

SPECS Accepts images in digital format. Send via CD as TIFF, JPEG files at 300 dpi.

MAKING CONTACT & TERMS Send query letter with stock list (stock photo agencies only). Does not keep samples on file; cannot return material. Responds only if interested. Pays on publication. Credit line given. Buys one-time editorial rights.

⊖ MONDIAL

203 W. 107th St., Suite 6C, New York NY 10025. 212-864-7095. **Fax:** (208)361-2863. **E-mail:** contact@ mondialbooks.com. **Website:** www.mondialbooks.com; www.librejo.com. **Contact:** Andrew Moore, editor. Estab. 1996. Publishes mainstream fiction, romance, history, and reference books. Specializes in linguistics.

NEEDS Landscapes, travel, and erotic. Printing rights are negotiated according to project. Illustrations are used for text illustration, promotional ma-

terials, and book covers. Publishes 20 titles/year. Responds only if interested.

MAKING CONTACT & TERMS Payment on acceptance.

⊛ MUSEUM OF NORTHERN ARIZONA

3101 N. Fort Valley Rd., Flagstaff AZ 86001. (928)774-5213. **E-mail:** publications@mna.mus.az.us. **Website:** www.musnaz.org. **Contact:** publications department. Estab. 1928. Subjects include biology, geology, archaeology, anthropology, and history. Photos used for *Plateau: Land and People of the Colorado Plateau* magazine, published 2 times/year (May, October).

NEEDS Buys approximately 80 photos/year. Biology, geology, history, archaeology, and anthropology—subjects on the Colorado Plateau. Reviews stock photos. Photo captions preferred; include location, description, and context.

SPECS Uses 8×10 glossy b&w prints; 35mm, 2¼×2¼, 4×5, and 8×10 transparencies. Prefers 2¼×2¼ transparencies or larger. Possibly accepts images in digital format. Submit via ZIP.

MAKING CONTACT & TERMS Send query letter with samples, SASE. Responds in 1 month. Simultaneous submissions and previously published work OK. Credit line given. Buys one-time and all rights; negotiable. Offers internships for photographers.

TIPS Wants to see top-quality, natural history work. To break in, send only pre-edited photos.

⊛⊛⊛ MUSIC SALES GROUP

14-15 Berners St., London W1T 3LJ United Kingdom. 44(020)7612-7400. **Fax:** 44(020)7612-7547. **E-mail:** chris.charlesworth@musicsales.co.uk; info@omnibuspress.com. **Website:** www.musicsales.com; www.omnibuspress.com. Publishes instructional music books, song collections, and books on music. Photos used for covers and interiors. Examples of recently published titles: *Bob Dylan: 100 Songs and Photos*; *Paul Simon: Surprise*; *AC/DC: Backtracks*.

NEEDS Buys 400 photos/year. Model release required on acceptance of photo. Photo captions required.

SPECS Uses 8×10 glossy prints; 35mm, 2×2, 5×7 transparencies. High-res digital 3,000×4,000 pixels.

MAKING CONTACT & TERMS Send query letter first with résumé of credits. Provide business card, brochure, flier, or tearsheets to be kept on file for possible future assignments. Responds in 2 months.

Simultaneous submissions and previously published work OK.

TIPS In samples, wants to see "the ability to capture the artist in motion with a sharp eye for framing the shot well. Portraits must reveal what makes the artist unique. We need rock, jazz, classical—onstage and impromptu shots. Please send us an inventory list of available stock photos of musicians. We rarely send photographers on assignment and buy mostly from material on hand. Send business card and tearsheets or prints stamped 'proof' across them. Due to the nature of record releases and concert events, we never know exactly when we may need a photo. We keep photos on permanent file for possible future use."

⊕⊛⊛ NICOLAS-HAYS, INC.

P.O. Box 540206, Lake Worth FL 33454-0206. **E-mail:** info@nicolashays.com; info@ibispress.net. **Website:** www.nicolashays.com. Estab. 1976. Publishes trade paperback originals and reprints. Subjects include Eastern philosophy, Jungian psychology, New Age how-to. Photos used for book covers. Example of recently published title: *Dervish Yoga for Health and Longevity: Samadeva Gestual Euphony—The Seven Major Arkanas* (book cover). Catalog available upon request.

NEEDS Buys 1 freelance photo/year. Needs photos of landscapes/scenics.

SPECS Uses color prints; 35mm, 2¼×2¼, 4×5 transparencies. Accepts images in digital format.

MAKING CONTACT & TERMS Send query letter with photocopies, tearsheets. Provide self-promotion piece to be kept on file for possible future assignments. Responds only if interested; send nonreturnable samples. Simultaneous submissions and previously published work OK. **Pays on acceptance.** Credit line given. Buys one-time rights.

TIPS "We are a small company and do not use many photos. We keep landscapes/seascapes/skyscapes on hand—images need to be inspirational."

⊕⊛ W.W. NORTON & COMPANY, INC.

500 Fifth Ave., New York NY 10110. (212)354-5500. **Fax:** (212)869-0856. **Website:** www.wwnorton.com. Estab. 1923. Photos used for text illustrations, book covers, dust jackets.

NEEDS Variable. Photo captions preferred.

SPECS Accepts images in all formats; digital images at a minimum of 300 dpi for reproduction and

archival work.

MAKING CONTACT & TERMS "Due to the workload of our editorial staff and the large volume of materials we receive, we are no longer able to accept unsolicited submissions. If you are seeking publication, we suggest working with a literary agent who will represent you to the house."

⊙❸◐ RICHARD C. OWEN PUBLISHERS, INC.

P.O. Box 585, Katonah NY 10536. (914)232-3903; (800)262-0787. **E-mail:** richardowen@rcowen.com. **Website:** www.rcowen.com. **Contact:** Richard Owen, publisher. Estab. 1982. Publishes picture/storybook fiction and nonfiction for 5- to 7-year-olds; author autobiographies for 7- to 12-year-olds; professional books for educators. Photos used for text illustrations, promotional materials, book covers. Check website for examples of titles.

NEEDS Number of photos bought annually varies; offers 3-10 freelance assignments/year. Needs unposed people shots and nature photos that suggest storyline. "For children's books, must be child-appealing with rich, bright colors and scenes, no distortions or special effects. For professional books, similar, but often of classroom scenes, including teachers. Nothing posed; should look natural and realistic." Reviews stock photos of children involved with books and classroom activities, ranging from kindergarten to 6th grade. Also wants photos of babies/children/teens, multicultural, families, environmental, landscapes/scenics, wildlife, architecture, cities/urban, pets, adventure, automobiles, sports, travel, science. Interested in documentary. (All must be of interest to children ages 5-9.) Model release required for children and adults. Children (under the age of 21) must have signature of legal guardian. Property release preferred. Photo captions required; include "any information we would need for acknowledgments, including if special permission was needed to use a location."

SPECS "For materials that are to be used, we need 35mm mounted transparencies or high-definition color prints. We usually use full-color photos."

MAKING CONTACT & TERMS Submit copies of samples by mail for review. Provide brochure, flyer, or tearsheets to be kept on file for possible future assignments; no slides or disks. Include a brief cover letter with name, address, and daytime phone number, and indicate *Photographer's Market* as a source for correspondence. Works with freelancers on assignment only. "For samples, we like to see any size color prints (or color copies)." Keeps samples on file "if appropriate to our needs." Responds in 1 month. Simultaneous submissions OK. Pays $10-100 for color cover; $10-100 for color inside; $250-800 for multiple photo projects. "Each job has its own payment rate and arrangements." **Pays on acceptance.** Credit line sometimes given, depending on the project. "Photographers' credits appear in children's books and in professional books, but not in promotional materials for books or company." For children's books, publisher retains ownership, possession, and world rights, which apply to first and all subsequent editions of a particular title and to all promotional materials. "After a project, (children's books) photos can be used by photographer for portfolio."

TIPS Wants to see "real people in natural, real-life situations. No distortion or special effects. Bright, clear images with jewel tones and rich colors. Keep in mind what would appeal to children. Be familiar with what the publishing company has already done. Listen to the needs of the company. Send tearsheets, color photocopies with a mailer. No slides, please."

PELICAN PUBLISHING COMPANY

1000 Burmaster St., Gretna LA 70053. (504)368-1175. **Fax:** (504)368-1195. **E-mail:** editorial@pelicanpub.com. **Website:** www.pelicanpub.com. Estab. 1926. Publishes adult trade, cooking, and art books.

NEEDS Buys 8 photos/year; offers 3 freelance assignments/year. Needs photos of cooking/food, business concepts, nature/inspirational. Reviews royalty-free stock photos of people, nature, etc. Model/property release required. Photo captions required.

SPECS Uses 8×10 glossy color prints; 35mm, 4×5 transparencies. Accepts images in digital format. Send via CD as TIFF files at 300 dpi or higher.

❺❸◐ QUARTO PUBLISHING PLC.

The Old Brewery, 6 Blundell St., London N7 9BH United Kingdom. 44(020)7700-6700. **Fax:** 44(020)7700-8066. **E-mail:** info@quarto.com. **Website:** www.quarto.com. Publishes nonfiction books on a wide variety of topics including arts, crafts, natural history, home and garden, reference. Photos used for text illustrations, book covers, dust jackets. Examples of recently published titles: *The Color Mixing Bible*; *Garden Birds*; *The Practical Geologist*. Contact for photo guidelines.

NEEDS Buys 1,000 photos/year. Subjects vary with current projects. Needs photos of multicultural, environmental, wildlife, architecture, gardening, interiors/decorating, pets, religious, adventure, food/drink, health/fitness, hobbies, performing arts, sports, travel, product shots/still life, science, technology/computers. Interested in fashion/glamour, fine art, historical/vintage. Special photo needs include arts, crafts, alternative therapies, New Age, natural history. Model/property release required. Photo captions required; include full details of subject and name of photographer.

SPECS Uses all types of prints. Accepts images in digital format. Send via CD, floppy disk, ZIP, e-mail as TIFF, EPS, JPEG files at 72 dpi for viewing, 300 dpi for reproduction.

MAKING CONTACT & TERMS Provide résumé, business card, samples, brochure, flyer, or tearsheets to be kept on file for future reference. Arrange a personal interview to show portfolio. Simultaneous submissions and previously published work OK. Pays on publication. Credit line given. Buys one-time rights; negotiable.

TIPS "Be prepared to negotiate!"

❂❸❺ RED DEER PRESS

195 Allstate Pkwy., Markham, Ontario L3R 4TB Canada. (905)477-9700. **Fax:** (905)477-9179. **E-mail:** rdp@reddeerpress.com. **Website:** www.reddeerpress.com. **Contact:** Richard Dionne, publisher. Estab. 1975.

MAKING CONTACT & TERMS Pays illustrators and photographers by the project or royalty (depends on the project). Originals returned to artist at job's completion.

ROBERTS PRESS

False Bay Books, 685 Spring St., #PMB 161, 330 False Bay Dr., Harbor WA 98250. **E-mail:** submit-robertspress@falsebaybooks.com. **Website:** www.robertsbookpress.com. Estab. 2004. Publishes ebook originals and reprints, trade paperback originals and reprints, and audio books. Publishes fiction, including Christian fiction, fantasy, thrillers, mystery, women's fiction, family drama, juvenile fiction, mainstream fiction, science fiction, young adult and literary fiction, anthologies, and multi-author collaborations. Recent titles include *The End of Law, Elemental, Drowning, Camouflage.*

❸❸❶ RUNNING PRESS BOOK PUBLISHERS

2300 Chestnut St., Suite 200, Philadelphia PA 19103. (215)567-5080. **Fax:** (215)568-2919. **E-mail:** frances.soopingchow@perseusbooks.com; perseus.promos@perseusbooks.com. **Website:** www.runningpress.com. **Contact:** Frances Soo Ping Chow, design director. Estab. 1972. Publishes hardcover originals, trade paperback originals. Subjects include adult and children's fiction and nonfiction; cooking; crafts, lifestyle, kits; miniature editions used for text illustrations, promotional materials, book covers, dust jackets. Examples of recently published titles: *Skinny Bitch, Eat What You Love, The Ultimate Book of Gangster Movies, Fenway Park, The Speedy Sneaky Chef, Les Petits Macarons, New York Fashion Week, I Love Lucy: A Celebration of All Things Lucy, Upcycling.*

NEEDS Buys a few hundred freelance photos/year and lots of stock images. Photos for gift books; photos of wine, food, lifestyle, hobbies, and sports. Model/property release preferred. Photo captions preferred; include exact locations, names of pertinent items or buildings, names and dates for antiques or special items of interest.

SPECS Prefers images in digital format. Send via CD/DVD, via FTP/e-mail as TIFF, EPS files at 300 dpi.

MAKING CONTACT & TERMS Send URL and provide contact info. Do not send original art or anything that needs to be returned. Responds only if interested. Simultaneous submissions and previously published work OK. Pays $500-1,000 for color cover; $100-250 for inside. Pays 45 days after receipt of invoice. Credits listed on separate copyright or credit pages. Buys one-time rights.

TIPS Submission guidelines available online.

SCHOLASTIC LIBRARY PUBLISHING

90 Old Sherman Turnpike, Danbury CT 6816. (203)797-3500. **Fax:** (203)797-3197. **E-mail:** slpservice@scholastic.com. **Website:** www.scholastic.com/librarypublishing. **Contact:** Phil Friedman, vice president/publisher; Kate Nunn, editor-in-chief; Marie O'Neil, art director. Estab. 1895. "Scholastic Library is a leading publisher of reference, educational, and children's books. We provide parents, teachers, and librarians with the tools they need to enlighten children to the pleasure of learning and prepare them for the road ahead." Publishes 7 encyclopedias

plus specialty reference sets in print and online versions. Photos used for text illustrations. Examples of published titles: *The New Book of Knowledge*; *Encyclopedia Americana*.

NEEDS Buys 5,000 images/year. Needs excellent-quality editorial photographs of all subjects A-Z and current events worldwide. All images must have clear captions and specific dates and locations, and natural history subjects should carry Latin identification. **SPECS** Uses 8×10 glossy b&w and/or color prints; 35mm, 4×5, 8×10 (reproduction-quality dupes preferred) transparencies. Accepts images in digital format. Send via photo CD, floppy disk, ZIP as JPEG files at requested resolution. **MAKING CONTACT & TERMS** Send query letter, stock lists, and printed examples of work. Cannot return unsolicited material and does not send guidelines. Include SASE only if you want material returned. Pricing to be discussed if/when you are contacted to submit images for specific project. Please note, encyclopedias are printed every year, but rights are requested for continuous usage until a major revision of the article in which an image is used (including online images). **TIPS** "Send subject lists and small selection of samples. Printed samples *only*, please. In reviewing samples, we consider the quality of the photographs, range of subjects, and editorial approach. Keep in touch, but don't overdo it—quarterly e-mails are more than enough for updates on subject matter."

SCHOOL GUIDE PUBLICATIONS

606 Halstead Ave., Mamaroneck NY 10543. (800)433-7771. **E-mail:** mridder@schoolguides.com; info@schoolguides.com. **Website:** www.schoolguides.com. **Contact:** Myles Ridder, publisher. Estab. 1935. Publishes mass market paperback originals. Photos used for promotional materials, book covers. **NEEDS** Needs photos of college students. **SPECS** Accepts images in digital format; send via CD, ZIP, e-mail as TIFF or JPEG files. **MAKING CONTACT & TERMS** E-mail query letter. **Pays on acceptance.**

TIGHTROPE BOOKS

#207-2 College St., Toronto, Ontario M5G 1K3 Canada. (416)928-6666. **E-mail:** tightropeasst@gmail.com. **Website:** www.tightropebooks.com. Estab. 2005.

NEEDS Publishes 12 titles/year. SASE returned. Responds only if interested. Catalog and guidelines free upon request and online. **MAKING CONTACT & TERMS** Send an e-mail with résumé and artist's website, if available.

TILBURY HOUSE PUBLISHERS

WordSplice Studio, Inc., 12 Starr St., Thomaston ME 04861. (800)582-1899. **Fax:** (207)582-8772. **E-mail:** info@tilburyhouse.com. **Website:** www.tilburyhouse.com. Estab. 1990.

MAKING CONTACT & TERMS Send photocopies of photos/artwork.

VINTAGE BOOKS

1745 Broadway, New York NY 10019. **E-mail:** vintageanchorpublicity@randomhouse.com; jgall@randomhouse.com; customerservice@penguinrandomhouse.com. **Website:** www.randomhouse.com. **Contact:** John Gall, art director. Publishes trade paperback reprints; fiction. Photos used for book covers. Examples of recently published titles: *Selected Stories* by Alice Munro (cover); *The Fight* by Norman Mailer (cover); *Bad Boy* by Jim Thompson (cover).

NEEDS Buys 100 freelance photos/year. Model/property release required. Photo captions preferred. **MAKING CONTACT & TERMS** Send query letter with samples, stock list. Portfolios may be dropped off every Wednesday. Keeps samples on file. Responds only if interested; send nonreturnable samples. Pays by the project, per use negotiation. Pays on publication. Credit line given. Buys one-time and first North American serial rights. **TIPS** "Show what you love. Include samples with name, address, and phone number."

✪ VISITOR'S CHOICE MAGAZINE

2151 Ontario St., Vancouver, British Columbia V5T 2X1 Canada. (604)608-5180; (604)688-2398. **E-mail:** art@visitorschoice.com; publisher@visitorschoice.com. **Website:** www.visitorschoice.com. Estab. 1977. Publishes full-color visitor guides for 16 communities and areas of British Columbia. Photos used for text illustrations, book covers, websites. Photo guidelines available via e-mail upon request.

NEEDS Looking for photos of attractions, mountains, lakes, views, lifestyle, architecture, festivals, people, sports, and recreation—specific to British Columbia region. Specifically looking for people/ac-

tivity shots. Model release required; property release preferred. Photo captions required—make them detailed but brief.

SPECS Uses color prints; 35mm transparencies. Prefers images in digital format.

MAKING CONTACT & TERMS Send query letter or e-mail with samples; include SASE for return of material. Works with Canadian photographers. Keeps digital images on file. Responds in 3 weeks. Previously published work OK. Payment varies with size of photo published. Pays in 30-60 days. Credit line given.

VOYAGEUR PRESS

401 Second Ave. N., Suite 310, Minneapolis MN 55401. (800)458-0454. **Fax:** (612)344-8691. **Website:** www.quartoknows.com/Voyageur-Press. Publisher: Jeff Serena. Estab. 1972. Publishes adult trade books, hardcover originals, and reprints. Subjects include regional history, nature, popular culture, travel, wildlife, Americana, collectibles, lighthouses, quilts, tractors, barns, and farms. Photos used for text illustrations, book covers, dust jackets, calendars. Examples of recently published titles: *Legendary Route 66: A Journey Through Time Along America's Mother Road*; *Illinois Central Railroad*; *Birds in Love: The Secret Courting & Mating Rituals of Extraordinary Birds*; *Backroads of New York*; *How to Raise Cattle*; *Knitknacks*; *Much Ado About Knitting*; *Farmall: The Red Tractor That Revolutionized Farming*; *Backroads of Ohio*; *Farmer's Wife Baking Cookbook*; *John Deere Two-Cylinder Tractor Encyclopedia* (text illustrations, book covers, dust jackets). Photo guidelines free with SASE.

○ Voyageur Press is an imprint of MBI Publishing Company (see separate listing in this section).

NEEDS Buys 500 photos/year. Wants photos of wildlife, Americana, environmental, landscapes/scenics, cities/urban, gardening, rural, hobbies, humor, travel, farm equipment, agricultural. Interested in fine art, historical/vintage, seasonal. "Artistic angle is crucial—books often emphasize high-quality photos." Model release required. Photo captions preferred; include location, species, "interesting nuggets," depending on situation.

MAKING CONTACT & TERMS "Photographic dupes must be of good quality for us to fairly evaluate your photography. We prefer 35mm and large format transparencies; will accept images in digital format for review only; prefers transparencies for production.

Send via CD, ZIP, e-mail as TIFF, BMP, GIF, JPEG files at 300 dpi." Simultaneous submissions OK. Pays $300 for cover; $75-175 for inside. Pays on publication. Credit line given, "but photographer's website will not be listed." Buys all rights; negotiable.

TIPS "We are often looking for specific material (crocodiles in the Florida Keys; farm scenics in the Midwest; wolf research in Yellowstone), so subject matter is important. However, outstanding color and angles and interesting patterns and perspectives are strongly preferred whenever possible. If you have the capability and stock to put together an entire book, your chances with us are much better. Though we use some freelance material, we publish many more single-photographer works. Include detailed captioning info on the mounts."

❶❸❶ WAVELAND PRESS, INC.

4180 Illinois Rt. 83, Suite 101, Long Grove IL 60047. (847)634-0081. **Fax:** (847)634-9501. **E-mail:** info@waveland.com. **Website:** www.waveland.com. Estab. 1975. Publishes college-level textbooks and supplements. Photos used for text illustrations, book covers. Examples of recently published titles: *Our Global Environment: A Health Perspective*, 7th ed.; *Juvenile Justice*, 2nd ed.

NEEDS Number of photos purchased varies depending on type of project and subject matter. Subject matter should relate to college disciplines: criminal justice, anthropology, speech/communication, sociology, archaeology, etc. Photos of multicultural, disasters, environmental, cities/urban, education, religious, rural, health/fitness, agriculture, political, technology. Interested in fine art, historical/vintage. Model/property release required. Photo captions preferred.

SPECS Accepts images in digital format. Send via CD, ZIP, e-mail as TIFF, EPS, JPEG files at 300 dpi.

MAKING CONTACT & TERMS Send query letter with stock list. Provide résumé, business card, brochure, flier, or tearsheets to be kept on file for possible future assignments. Simultaneous submissions and previously published work OK. Pays $100-200 for cover; $50-100 for inside. Pays on publication. Credit line given. Buys one-time and book rights.

WILLOW CREEK PRESS

P.O. Box 147, Minocqua WI 54548. (715)358-7010. **Fax:** (715)358-2807. **Website:** www.willowcreekpress.com. **Contact:** Sara Olson, Designer. Estab. 1986. Publishes hardcover, paperback, and trade paperback originals;

hardcover and paperback reprints, and calendars. Subjects include pets, outdoor sports, gardening, cooking, birding, wildlife. Photos used for text illustrations, promotional materials, book covers, dust jackets, and calendars. Examples of recently published titles: *101 Uses for a Yorkie*, *Cow Yoga*, *Moose*, *Nature's Notes*, *Western Wings*, and *What Chickens Teach Us*. Catalog free with No. 10 SASE. Photo guidelines free with No. 10 SASE or on website.

NEEDS Buys 2,000 freelance photos/year. Needs photos of gardening, pets, outdoors, recreation, landscapes/scenics, wildlife. Model/property release required. Photo captions required.

MAKING CONTACT & TERMS Send query letter with sample of work. Provide self-promotion piece to be kept on file. Responds only if interested. Simultaneous submissions and previously published work OK. Pays by the project. Pays on publication. Credit line given. Buys one-time rights.

TIPS "We specialize in nature, outdoor, and sporting topics, including gardening, wildlife, and animal books. Pets, cookbooks, and a few humor books and essays round out our titles. Currently emphasizing pets (mainly dogs and cats), wildlife, outdoor sports (hunting, fishing). De-emphasizing essays, fiction."

❸ WOMEN'S HEALTH GROUP

Rodale, 400 S. 10th St., Emmaus PA 18098. (212)573-0296. **Website:** www.rodaleinc.com. **Contact:** Yelena Nesbit, communications director. Publishes hardcover originals and reprints, trade paperback originals and reprints, one-shots. Subjects include healthy, active living for women, including diet, cooking, health, beauty, fitness, and lifestyle.

NEEDS Photos of babies/children/teens, couples, multicultural, families, parents, senior citizens, food/drink, health/fitness/beauty, sports, travel, women, Spanish women, intimacy/sexuality, alternative medicine, herbs, home remedies. Model/property release preferred.

SPECS Uses color and b&w prints; 35mm, $2\frac{1}{4} \times 2\frac{1}{4}$, 4×5 transparencies. Accepts images in digital format. Send via CD, ZIP, e-mail as TIFF, EPS, JPEG files at 300 dpi.

MAKING CONTACT & TERMS Send query letter with résumé, prints, photocopies, tearsheets, stock list. Provide résumé, business card, self-promotion piece to be kept on file for possible future assignments. Responds only if interested; send nonreturnable samples. Simultaneous submissions and previously published work OK. Pays additional 20% for electronic promotion of book cover and designs for retail of book. **Pays on acceptance.** Credit line given. Buys one-time rights, electronic rights; negotiable.

TIPS "Include your contact information on each item that is submitted."

GREETING CARDS, POSTERS & RELATED PRODUCTS

The greeting card industry takes in more than $7.5 billion per year—the lion's share through the giants American Greetings and Hallmark Cards. Naturally, these big companies are difficult to break into, but there is plenty of opportunity to license your images to smaller companies.

There are more than 3,000 greeting card companies in the United States, many of which produce low-priced cards that fill a niche in the market, focusing on anything from the cute to the risqué to seasonal topics. A number of listings in this section produce items like calendars, mugs, and posters, as well as greeting cards.

Before approaching greeting card, poster, or calendar companies, it's important to research the industry to see what's being bought and sold. Start by checking out card, gift, and specialty stores that carry greeting cards and posters. Pay attention to the selections of calendars, especially the large seasonal displays during December. Studying what you see on store shelves will give you an idea of what types of photos are marketable.

Greetings etc., published by Edgell Publications, is a trade publication for marketers, publishers, designers, and retailers of greeting cards. The magazine offers industry news and information on trends, new products, and trade shows. Look for the magazine at your library or visit their website: www.greetingsmagazine.com. Also the National Stationery Show (www.nationalstationeryshow.com) is a large trade show held every year in New York City. It is the main event of the greeting card industry.

APPROACHING THE MARKET

After your initial research, query companies you are interested in working with and send a stock photo list. (See sample stock list in "Running Your Business.") You can help nar-

row your search by consulting the Subject Index in the back of this book. Check the index for companies interested in the subjects you shoot.

Since these companies receive large volumes of submissions, they often appreciate knowing what is available rather than actually receiving samples. This kind of query can lead to future sales even if your stock inventory doesn't meet their immediate needs. Buyers know they can request additional submissions as their needs change. Some listings in this section advise sending quality samples along with your query while others specifically request only a list. As you plan your queries, follow the instructions to establish a good rapport with companies from the start.

Some larger companies have staff photographers for routine assignments but also look for freelance images. Usually, this is in the form of stock, and images are especially desirable if they are of unusual subject matter or remote scenic areas for which assignments—even to staff shooters—would be too costly. Freelancers are usually offered assignments once they have established track records and demonstrated a flair for certain techniques, subject matter, or locations. Smaller companies are more receptive to working with freelancers, though they are less likely to assign work because of smaller budgets for photography.

The pay in this market can be quite lucrative if you provide the right image at the right time for a client in need of it, or if you develop a working relationship with one or a few of the better-paying markets. You should be aware, though, that one reason for higher rates of payment in this market is that these companies may want to buy all rights to images. But with changes in the copyright law, many companies are more willing to negotiate sales that specify all rights for limited time periods or exclusive product rights rather than complete surrender of copyright. Some companies pay royalties, which means you will earn the money over a period of time based on the sales of the product.

❸❸❶ ADVANCED GRAPHICS

466 N. Marshall Way, Layton UT 84041. (801)499-5000 or (800)488-4144. **Fax:** (801)499-5001. **E-mail:** info@advancedgraphics.com. **Website:** www.advancedgraphics.com. Estab. 1984. Specializes in life-size standups and cardboard displays, decorations, and party supplies.

NEEDS Photos of celebrities (movie and TV stars, entertainers), babies/children/teens, couples, multicultural, families, parents, senior citizens, wildlife. Interested in seasonal. Reviews stock photos.

SPECS Uses 4×5, 8×10 transparencies. Accepts images in digital format. Send via CD, ZIP, e-mail.

MAKING CONTACT & TERMS Send query letter with stock list. Keeps samples on file. Responds in 1 month. Pays $400 maximum/image; royalties of 7-10%. Simultaneous submissions and previously published work OK. **Pays on acceptance.** Credit line given. Buys exclusive product rights; negotiable.

TIPS "We specialize in publishing life-size, standup cardboard displays of celebrities. Any pictures we use must show the entire person, head to toe. We must also obtain a license for each image that we use from the celebrity pictured or from that celebrity's estate. The image should be vertical and not too wide."

❍ ART IN MOTION

425-625 Agnes St., New Westminster, British Columbia V3M 5Y4 Canada. (604)525-3900 or (800)663-1308. **Fax:** (604)525-6166 or (877)525-6166. **E-mail:** artistrelations@artinmotion.com; contactus@artinmotion.com. **Website:** www.artinmotion.com. **Contact:** art relations. Specializes in open edition reproductions, framing prints, wall decor and licensing.

NEEDS "We are publishers of fine art reproductions, specializing in the decorative and gallery market. In photography, we often look for alternative techniques such as hand coloring, Polaroid transfer, or any process that gives the photograph a unique look."

SPECS Accepts unzipped digital images sent via e-mail as JPEG files at 72 dpi.

MAKING CONTACT & TERMS Submit portfolio for review. Pays royalties of 10%. Royalties paid monthly. "Art In Motion covers all associated costs to reproduce and promote your artwork."

TIPS "Contact us via e-mail, or direct us to your website; also send slides or color copies of your work (all submissions will be returned)."

❷ ARTVISIONS: FINE ART LICENSING

E-mail: See website for contact form. **Website:** www.artvisions.com. **Contact:** Neil Miller, president. Estab. 1993. Licenses "fashionable, decorative fine art photography and high-quality art to the commercial print, décor, and puzzle/game markets."

NEEDS Handles fine art and photography licensing only.

MAKING CONTACT & TERMS "See website. Not currently seeking new talent. However, we are always willing to view the work of top-notch established artists and photographers. If you fit this category, please contact ArtVisions via e-mail and include a link to a website where your art can be seen." Exclusive worldwide representation for licensing is required. Written contract provided.

TIPS "To gain an idea of the type of art we license, please view our website. Animals, children, people, and pretty places should be generic, rather than readily identifiable (this also prevents potential copyright issues and problems caused by not having personal releases for use of a 'likeness'). We prefer that your original work be in the form of high-resolution TIFF files from a 'pro-quality' digital camera. Note: scans/digital files are not to be interpolated or compressed in any way. We are firmly entrenched in the digital world; if you are not, then we cannot represent you. If you need advice about marketing your art, please visit: www.artistsconsult.com."

❸❸❶ AVANTI PRESS, INC.

6 W. 18th St., 6th Floor, New York NY 10011. (212)414-1025; (800)228-2684. **E-mail:** artsubmissions@avantipress.com. **Website:** www.avantipress.com. Estab. 1980. Specializes in photographic greeting cards. Photo guidelines free with SASE or on website.

NEEDS Buys approximately 200 images/year; all are supplied by freelancers. Interested in humorous, narrative, colorful, simple, to-the-point photos of babies, children (4 years old and younger), mature adults, human characters (not models), animals (in humorous situations), and exceptional florals. Has specific deadlines for seasonal material. Does not want travel, sunsets, landscapes, nudes, high-tech. Reviews stock photos. Model/property release required.

SPECS Accepts all mediums and formats. Accepts images in digital format. Send via CD as TIFF, JPEG files.

MAKING CONTACT & TERMS Please submit lo-res JPEGs using the e-mail submission form at avantipress.com. Do not submit original material. Pays on license. Credit line given. Buys 5-year worldwide, exclusive card rights.

● BENTLEY PUBLISHING GROUP

11100 Metric Blvd., Suite 100, Austin TX 78758. (512)467-9400 or (888)456-2254. **Fax:** (512)467-9411. **E-mail:** artist@bentleyglobalarts.com; info@bentleyglobalarts.com. **Website:** www.bentleyglobalarts.com. Estab. 1986. Publishes posters.

NEEDS Interested in figurative, architecture, cities, urban, gardening, interiors/decorating, rural, food/drink, travel—b&w, color or hand-tinted photography. Interested in alternative process, avant garde, fine art, historical/vintage. Reviews stock photos and slides. Model/property release required. Include location, date, subject matter, or special information.

SPECS Mainly uses 16×20, 22×28, 18×24, 24×30, 24×36 color and b&w prints; 4×5 transparencies from high-quality photos. Accepts images in digital format. Send via CD as TIFF or JPEG files.

MAKING CONTACT & TERMS "Prefers digital submissions. But also accepts mail with the online artist submission form—include photos, printouts, transparencies, disks, or other marketing materials. If you send a disk, please include a printout showing thumbnail images of the contents. Please do not include orginal artwork. You can also e-mail JPEGs, along with contact information, to artist@benteyglobalarts.com. All submissions will be considered. Due to the large volume of submissions received, we can only respond if interested." For mail, send to Bentley Global Arts Group at address listed, ATTN: Artist Submissions.

◎● BON ART

66 Fort Point St., Norwalk CT 06855. (203)845-8888. **E-mail:** sales@bonartique.com. **Website:** www.bonartique.com. **Contact:** Brett Bonnist. Estab. 1980. Art publisher, poster company, licensing and design studio. Publishes/distributes fine art prints, canvas transfers, unlimited editions, offset reproductions and posters. Clients: Internet purveyors of art, picture frame manufacturers, catalog companies, distributors.

NEEDS Licenses hundreds of images/year. Artistic/decorative photos (not stock photos) of landscapes/scenics, wildlife, architecture, cities/urban, gardening, interiors/decorating, rural, adventure, health/fitness, extreme sports. Interested in fine art, cutting edge b&w, sepia photography. Model release required. Photo captions preferred.

SPECS Uses high-res digital files.

MAKING CONTACT & TERMS Prefers e-mail but will accept website links. Works on assignment only. Responds in 3 months. Simultaneous submissions and previously published work OK. Pays advance against royalties—specific dollar amount is subjective to project. Pays on publication. Credit line given if required. Buys all rights; exclusive reproduction rights. Royalties are paid quarterly according to the agreement.

TIPS "Send us new and exciting material; subject matter with universal appeal. Submit color copies, slides, transparencies, actual photos of your work; if we feel the subject matter is relevant to the projects we are currently working on, we'll contact you."

● THE BOREALIS PRESS

35 Tenney Hill, Blue Hill ME 04614. (207)370-6020 or (800)669-6845. **E-mail:** art@borealispress.net. **Website:** www.borealispress.net. **Contact:** Mark Baldwin. Estab. 1989. Specializes in greeting cards, magnets, and "other products for thoughtful people." Photo guidelines available for SASE.

NEEDS Buys more than 100 images/year; 90% are supplied by freelancers. Needs photos of humor, babies/children/teens, couples, families, parents, senior citizens, adventure, events, hobbies, pets/animals. Interested in documentary, historical/vintage, seasonal. Photos must tell a story. Model/property release preferred.

SPECS Low-res files are fine for review. Any media OK for finals. Uses 5×7 to 8×10 prints; 35mm, 2¼×2¼, 4×5, 8×10 transparencies. Accepts images in digital format. Send via CD. Send low-res files if e-mailing. Send images to art@borealispress.net.

MAKING CONTACT & TERMS Send query letter with slides (if necessary), prints, photocopies, SASE. Send no originals on initial submissions. "Artist's name must be on every image submitted." Responds in 2 weeks to queries; 3 weeks to portfolios. Previous-

ly published work OK. Pays by the project, royalties. **Pays on acceptance**, receipt of contract.

TIPS "Photos should have some sort of story, in the loosest sense. They can be in any form. We do not want multiple submissions to other card companies. Include SASE, and put your name on every image you submit."

⊛◯ CENTRIC CORP.

6712 Melrose Ave., Los Angeles CA 90038. (323)936-2100. **Fax:** (323)936-2101. **E-mail:** centric@juno.com. **Website:** www.centriccorp.com. Estab. 1986. Specializes in products that have nostalgic, humorous, thought-provoking images or sayings on them and in the following product categories: T-shirts, watches, pens, clocks, pillows, and drinkware.

NEEDS Photos of cities' major landmarks, attractions and things for which areas are well-known, and humorous or thought-provoking images. Submit seasonal material 5 months in advance. Reviews stock photos.

SPECS Uses 8×12 color and/or b&w prints; 35mm transparencies. Accepts images in digital format. Send via CD as PDF or JPEG files.

MAKING CONTACT & TERMS Submit portfolio online for review or query with résumé of credits. Provide résumé, business card, self-promotion piece, or tearsheets to be kept on file for possible future assignments. Responds in 2 weeks. Works mainly with local freelancers. Pays by the job; negotiable. **Pays on acceptance.** Rights negotiable.

TIPS "Research the demographics of buyers who purchase Elvis, Lucy, Marilyn Monroe, James Dean, Betty Boop, and Bettie Page products to know how to 'communicate a message' to the buyer."

DELJOU ART GROUP

1616 Huber St., Atlanta GA 30318. (404)350-7190 or (800)237-4638. **Fax:** (404)350-7195. **E-mail:** submit@ deljouartgroup.com. **Website:** www.deljouartgroup. com. Estab. 1980. Specializes in wall decor, fine art.

NEEDS All images supplied by freelancers. Specializes in artistic images for reproduction for high-end art market. Work sold through art galleries as photos or prints. Needs nature photos, architectural images, or other subjects with artistic quality. Reviews stock photos of graphics, b&w photos. No tourist photos: only high-quality, artistic photos.

SPECS Uses color and/or b&w prints. Accepts images in digital format. Prefers initial digital submissions via e-mail, but will accept CDs. Final, accepted images must be high-res, of at least 300 dpi.

MAKING CONTACT & TERMS Submit portfolio for review; include SASE for return of material. Also send portfolio via e-mail. Simultaneous submissions and previously published work OK. Pays royalties on sales. Credit line sometimes given depending upon the product. Rights negotiable.

TIPS "Abstract-looking photographs OK. Digitally created images are OK. Hand-colored b&w photographs needed."

DESIGN DESIGN, INC.

19 La Grave Ave., Grand Rapids MI 49503. (616)771-8319; (866)935-2648. **E-mail:** susan.birnbaum@ designdesign.us; retailhelp@designdesign.us; tom.vituj@designdesign.us. **Website:** www. designdesign.us. Estab. 1986. Specializes in greeting cards and paper-related product development.

NEEDS Licenses stock images from freelancers and assigns work. Specializes in humorous topics. Submit seasonal material 1 year in advance. Model/property release required.

SPECS Uses 35mm transparencies. Accepts images in digital format. Send via ZIP.

MAKING CONTACT & TERMS Submit portfolio for review. Provide résumé, business card, self-promotion piece, or tearsheets to be kept on file for possible future assignments. Do not send original work. Pays royalties. Pays upon sales. Credit line given.

FOTOFOLIO, INC.

561 Broadway, New York NY 10012. (212)226-0923. **E-mail:** contact@fotofolio.com; submissions@fotofolio. com. **Website:** www.fotofolio.com. **Contact:** Submissions department. Estab. 1976. Publishes art and photographic postcards, greeting cards, notebooks, books, T-shirts, and postcard books.

NEEDS Buys 60-120 freelance designs and illustrations/year. Reproduces existing works. Primarily interested in photography and contemporary art. Produces material for Christmas, Valentine's Day, birthday, and everyday. Submit seasonal material 8 months in advance. Art guidelines with SASE with first-class postage.

MAKING CONTACT & TERMS "Fotofolio, Inc. reviews color and b&w photography for publication in postcard, notecard, poster, and T-shirt formats. To

submit your work, please make a well-edited selection of no more than 40 images, attn: Submissions. Fotofolio will accept photocopies, laser copies, and promotional pieces only. Fotofolio will not accept digital images via e-mail to be downloaded or digital files submitted on disk. You may e-mail a website address where your work may be viewed. You'll be contacted if we are interested in seeing further work. Please note that Fotofolio, Inc. is not responsible for any lost or damaged submissions."

TIPS "When submitting materials, present a variety of your work (no more than 40 images) rather than one subject/genre."

GALLANT GREETINGS CORP.

5730 N. Tripp Ave., Chicago IL 60646. (800)621-4279; (847)671-6500. **Fax:** (847)671-7500. **E-mail:** info@gallantgreetings.com; custserv@gallantgreetings.com. **Website:** www.gallantgreetings.com. Estab. 1966. Specializes in greeting cards.

NEEDS Buys vertical images; all are supplied by freelancers. Photos of landscapes/scenics, wildlife, gardening, pets, religious, automobiles, humor, sports, travel, product shots/still life. Interested in alternative process, avant garde, fine art. Submit seasonal material 1 year in advance. Model release required. Photo captions preferred.

SPECS Accepts images in digital format. Send via CD, e-mail as TIFF files at 300 dpi. No slides accepted.

MAKING CONTACT & TERMS Send query letter with photocopies. Provide self-promotion piece to be kept on file for possible future assignments. Send nonreturnable samples. Pays by the project. Buys U.S. greeting card and allied product rights; negotiable.

💲💲 GLM CONSULTING

366 Amsterdam Ave., #159, New York NY 10024. (212)683-5830. **Fax:** (212)779-8564. **E-mail:** george@glmconsultart.com. **Website:** www.glmconsultart.com. Estab. 1967. Sells reproduction rights of designs to manufacturers of multiple products around the world. Represents artists in 50 different countries. "Our clients specialize in greeting cards, giftware, gift-wrap, calendars, postcards, prints, posters, stationery, paper goods, food tins, playing cards, tabletop, bath and service ware, and much more."

NEEDS Approached by several hundred artists/year. Seeking creative decorative art in traditional and computer media (Photoshop and Illustrator work accepted). Prefers artwork previously made with few or no rights pending. Graphics, sports, occasions (e.g., Christmas, baby, birthday, wedding), humorous, "soft touch," romantic themes, animals. Accepts seasonal/holiday material any time. Prefers artists/designers experienced in greeting cards, paper products, tabletop, and giftware.

MAKING CONTACT & TERMS Please submit via e-mail, a link to your website, or a sampling of your work, consisting of 6-10 designs which represent your collection as a whole. The sampling should show all range of subject matter, technique, style, and medium that may exist in your collection. Digital files should be submitted as e-mail attachments and in low-res. Low-res (LR) image files are typically 5×7, 72 dpi, CMYK, JPEG/TIFF/PDF format and are under 100 KB. "Once your art is accepted, we require original color art—Photoshop files on disc (TIFF, 300 dpi). We will respond only if interested." Pays on publication. No credit line given. Offers advance when appropriate. Sells one-time rights and exclusive product rights. Simultaneous submissions and previously published work OK. "Please state reserved rights, if any."

TIPS Recommends the annual New York SURTEX and Licensing shows. In photographer's portfolio samples, wants to see "a neat presentation, perhaps thematic in arrangement."

MARIAN HEATH GREETING CARDS

9 Kendrick Rd., Wareham MA 02571. **E-mail:** info@viabella.com. **Website:** http://viabella.com/marianheath/contact.php. **Contact:** Diane Reposa, licensing agent. Publishes greeting cards.

NEEDS Model and property release preferred. Art guidelines available with SASE.

MAKING CONTACT & TERMS Send color copies via e-mail or on CD as JPEG files. Submission should be clearly labeled with artist's name and identifying number or title if available. Approached by 100 freelancers/year. Works with 35-45 freelancers/year. Buys 500 freelance designs and illustrations/year. Prefers freelancers with experience in social expression. Art guidelines free for SASE with first-class postage or e-mail requesting guidelines. Uses freelancers mainly for greeting cards. Considers all media and styles. Generally 5¼×7¼ unless otherwise directed. Will accept various sizes due to digital production/manipulation. 30% of freelance design and illustration work demands knowledge of Photoshop, Illustrator, QuarkXPress. Produces material for all holidays and

seasons and everyday. Submit seasonal material 1 year in advance. "If you wish samples to be returned, please indicate so and include postage-paid packaging."

◐⊘ IMPACT PHOTOGRAPHICS

4961 Windplay Dr., El Dorado Hills CA 95762. (916)939-9333. **E-mail:** sandeea@impactphotographics.com. **Website:** www.impactphotographics.com. **Contact:** Sandee Ashley. Estab. 1975. Specializes in photographic souvenir products for the tourist industry. Photo guidelines and fee schedule available.

○ This company sells to specific tourist destinations; their products are not sold nationally. They need material that will be sold for at least a 5-year period.

NEEDS Photos of wildlife, scenics, US travel destinations, national parks, theme parks, and animals. Buys stock. Buys 3,000+ photos/year. Submit seasonal material 4-5 months in advance. Model/property release required. Photo captions preferred.

SPECS Can print from digital or film. Accepts images in digital format (for initial review). Send via CD, ZIP (or Dropbox such as you send it) as TIFF, JPEG files at 120 dpi for review purposes. Please make sure they can print out nicely at 4×6 for final review purposes. Will need 300 dpi for final printing.

MAKING CONTACT & TERMS "Must have submissions request before submitting samples. No unsolicited submissions." Send query letter with stock list. Provide business card, self-promotion piece, or tearsheets to be kept on file for possible future assignments. Simultaneous submissions and previously published work OK. Request fee schedule; rates vary by size. Pays on usage. Credit line and printed samples of work given. Buys one-time and nonexclusive product rights.

JILLSON & ROBERTS

3300 W. Castor St., Santa Ana CA 92704-3908. (714)424-0111. **Fax:** (714)424-0054. **E-mail:** sales@jillsonroberts.com. **Website:** www.jillsonroberts.com. **Contact:** art director. Estab. 1974. Specializes in gift wrap, totes, printed tissues, accessories. Photo guidelines free with SASE. Eco-friendly products.

NEEDS Specializes in everyday and holiday products. Themes include babies, sports, pets, seasonal, weddings. Submit seasonal material 3-6 months in advance.

MAKING CONTACT & TERMS Submit portfolio for review or query with samples. Provide résumé, business card, self-promotion piece or tearsheets to be kept on file for possible future assignments. The review process can take up to 4 months. Pays average flat fee of $250.

TIPS "Please follow our guidelines!"

LANTERN COURT, LLC

P.O. Box 61613, Irvine CA 92602. (800)454-4018; (714)798-2270. **Fax:** (714)798-2281. **E-mail:** art@lanterncourt.com; customerservice@lanterncourt.com; seher.zaman@lanterncourt.com. **Website:** www.lanterncourt.com. **Contact:** Seher Zaman, creative director. Estab. 2011. Lantern Court specializes in party supplies and paper goods for the Muslim community or anyone who appreciates Islamic art and design. Produces balloons, calendars, decorations, e-cards, giftbags, giftwrap/wrapping paper, greeting cards, paper tableware, and part supplies. Buys 10-30 freelance designs/illustrations each year. Prefers freelancers with experience in stationery design. Buys stock photos and offers assignments.

NEEDS Islamic-themed and Muslim holiday-related designs. Seasonal material should be submitted 10-12 months in advance. 100% of freelance work demands computer skills. Artists should be familiar with Illustrator, Photoshop, InDesign, and QuarkXPress.

SPECS Accepts images in digital format on CD as TIFF files at 300 dpi.

MAKING CONTACT & TERMS Guidelines available free online. Requires model and property release. Photo captions are preferred. E-mail query letter with link to photographer's website or with JPEG samples at 72 dpi. Keeps samples on file. Please provide a résumé. Responds only if interested. Buys one-time rights. Pays by the project. Maximum payment $750.

◑ NEW YORK GRAPHIC SOCIETY PUBLISHING GROUP

129 Glover Ave., Norwalk CT 06850. (203)847-2000 or (800)677-6947. **Fax:** (203)757-5526. **Website:** www.nygs.com. Estab. 1925. Specializes in fine art reproductions, prints, posters, canvases.

NEEDS Buys 150 images/year; 125 are supplied by freelancers. "Looking for variety of images."

SPECS Prefers digital format. Send low-res JPEGs via e-mail; no ZIP files.

MAKING CONTACT & TERMS Send query letter with samples to Attn: Artist Submissions. Does not

keep samples on file; include SASE for return of material. Responds in 3 months. Payment negotiable. Pays on usage. Credit line given. Buys exclusive product rights. No phone calls.

TIPS "Visit website to review artist submission guidelines and to see appropriate types of imagery for publication."

❸❶ NOVA MEDIA, INC.

1724 N. State St., Big Rapids MI 49307-9073. (231)796-4637. **E-mail:** trund@netonecom.net. **Website:** www.novamediainc.com. **Contact:** Thomas J. Rundquist, chairman. Estab. 1981. Specializes in CDs, CDs/tapes, games, limited edition plates, posters, school supplies, T-shirts. Photo guidelines free with SASE.

NEEDS Buys 100 images/year; most are supplied by freelancers. Offers 20 assignments/year. Seeking art fantasy photos. Photos of children/teens, celebrities, multicultural, families, landscapes/scenics, education, religious, rural, entertainment, health/fitness/beauty, military, political, technology/computers. Interested in documentary, erotic, fashion/glamour, fine art, historical/vintage. Submit seasonal material 2 months in advance. Reviews stock photos. Model release required. Photo captions preferred.

SPECS Uses color and b&w prints. Accepts images in digital format. Send via CD.

MAKING CONTACT & TERMS Send query letter with samples. Accepts e-mail submissions. Responds in 1 month. Keeps samples on file; does not return material. Simultaneous submissions and previously published work OK. Payment negotiable. Pays extra for electronic usage of photos. Pays on usage. Credit line given. Buys electronic rights; negotiable.

TIPS "The most effective way to contact us is by e-mail or regular mail. Visit our website."

OHIO WHOLESALE, INC./KENNEDY'S COUNTRY COLLECTION

286 W. Greenwich Rd., Seville OH 44273. (330)769-5050. **Fax:** (330)769-5566. **E-mail:** annes@ohiowholesale.com; AnneV@ohiowholesale.com. **Website:** www.ohiowholesale.com. **Contact:** Anne Secoy, vice president of product development. Estab. 1978. Home décor, giftware, seasonal. Produces home décor, wall art, canvas, tabletop, seasonal decorations, gifts, ornaments, and textiles.

MAKING CONTACT & TERMS Send an e-mail query with brochure, photographs, and SASE. Samples not kept on file. Company will contact artist for portfolio if interested. Pays by the project. Rights negotiated.

TIPS "Be able to work independently with your own ideas—use your 'gift' and think outside the box. *Wow me!*"

❶ PAPER PRODUCTS DESIGN

60 Galli Dr., Suite 1, Novato CA 94949. (800)370-9998; (415)883-1888. **Fax:** (415)883-1999. **E-mail:** carol@ppd.co. **Website:** www.paperproductsdesign.com. **Contact:** Carol Florsheim. Estab. 1992. Specializes in napkins, plates, candles, porcelain.

NEEDS Buys 500 images/year; all are supplied by freelancers. Needs photos of babies/children/teens, architecture, gardening, pets, food/drink, humor, travel. Interested in avant garde, fashion/glamour, fine art, historical/vintage, seasonal. Submit seasonal material 6 months in advance. Model release required. Photo captions preferred.

SPECS Uses glossy color and b&w prints; 35mm, 2¼×2¼, 4×5, 8×10 transparencies. Accepts images in digital format. Send via ZIP, e-mail at 350 dpi.

MAKING CONTACT & TERMS Send query letter with photocopies, tearsheets. Responds in 1 month to queries, only if interested. Simultaneous submissions and previously published work OK.

❹❶ PORTFOLIO GRAPHICS, INC.

(801)266-4844. **E-mail:** info@portfoliographics.com. **Website:** www.nygs.com. **Contact:** Kent Barton, creative director. Estab. 1986. Publishes and distributes prints, posters, and canvases (through contract framers, furniture stores, designers, as well as all major retailers), as well as images and designs on alternative substrates such as metal, wooden plaques, and wall decals.

NEEDS Buys 100 images/year; nearly all are supplied by freelancers. "Seeking inspiring artists with unique vision and distinctive imagery. Our company leads the way in defining trends and inspiring fresh perspectives. We are a top resource to all buyers of art in the wall décor industry—selling to the trade only." Reviews stock photos.

SPECS High-res digital files recommended.

MAKING CONTACT & TERMS E-mail JPEGs, PDF, or website links. Will responds if interested. Pays royalties of 10%. Quarterly royalties paid per pieces sold. Credit line given. Buys exclusive wall decor product rights license per piece.

TIPS "We find artists through galleries, magazines, art exhibits, and submissions."

⊕ ⊗ ◐ RECYCLED PAPER GREETINGS, INC.

111 N. Canal St., Suite 700, Chicago IL 60606-7206. (800)777-3331. **Website:** www.recycledpapergreetings.com. **Contact:** art director. Estab. 1971. "Since the beginning, we've always worked with independent artists because we value the power of true individual expression. Together, we create the most productive (and awesome) greeting cards out there. We take great pride in our family of independent artists, a family we are always looking to grow. Want to join our family?"

MAKING CONTACT & TERMS "Artwork should be designed to mimic a complete greeting card—message included (vertical 5×7). Please send up to 10 birthday ideas (labeled with your name, address, and phone number). Please do not send holiday-specific cards, as we work far in advance of holidays. Do not send slides, disks, tearsheets, or original artwork. Recycled Paper Greetings is not responsible for any damage to artwork submitted. We suggest submitting color copies or photographs of your art. Do not send previously published cards. The review process can take up to 2 months. Simultaneous submissions to other companies are perfectly acceptable. If your work is chosen, we will contact you to discuss all of the details. If your work is not selected, we will return it to you. Thank you for your interest in Recycled Paper Greetings. Send submissions to the art department. E-mail low-res files (less than 2MB total) of formatted designs or links to your portfolio to: newartistsubs@prgreetings.com."

◐ ⊗ ⊗ RIG

500 Paterson Plank Rd., Union City NJ 07087. (201)863-4500. **E-mail:** info@rightsinternational.com. **Website:** www.rightsinternational.com. Estab. 1996. Licensing agency specializing in the representation of photographers and artists to manufacturers for licensing purposes. Manufacturers include greeting card, calendar, poster, and home furnishing companies.

NEEDS Photos of architecture, entertainment, humor, travel, floral, coastal. "Globally influenced—not specific to one culture. Moody feel." See website for up-to-date needs. Reviews stock photos. Model/property release required.

SPECS Uses prints, slides, transparencies. Accepts images in digital format. Send via CD, e-mail as JPEG files.

MAKING CONTACT & TERMS Submit portfolio for review. Keeps samples on file. Simultaneous submissions and previously published work OK. Payment negotiable. Pays on license deal. Credit line given. Buys exclusive product rights.

◑ SANTORO LTD.

Rotunda Point, 11 Hartfield Crescent, Wimbledon, London SW19 3RL United Kingdom. 44(208)781-1100. **Fax:** (44)(208)781-1101. **E-mail:** submissions@santorographics.com. **Website:** www.santoro-london.com. **Contact:** Submissions. Estab. 1983. Features wildlife, humor, and historical/vintage photography.

MAKING CONTACT & TERMS Model/property release required. E-mail query letter. Accepts EPS files at 300 dpi.

SPENCER'S

6826 Black Horse Pike, Egg Harbor Twp. NJ 08234-4197. **Website:** www.spencersonline.com. Estab. 1947. Specializes in packaging design, full-color art, novelty gifts, brochure design, poster design, logo design, promotional P-O-P.

◐ Products offered by store chain include posters, T-shirts, games, mugs, novelty items, cards, 14K jewelry, neon art, novelty stationery. Spencer's is moving into a lot of different product lines, such as custom lava lights and Halloween costumes and products. Visit a store if you can to get a sense of what they offer.

NEEDS Photos of babies/children/teens, couples, party scenes (must have releases), jewelry (gold, sterling silver, body jewelry—earrings, chains, etc.). Interested in fashion/glamour. Model/property release required. Photo captions preferred.

SPECS Uses transparencies. Accepts images in digital format. Send via CD, DVD at 300 dpi. Contracts some illustrative artwork. All styles considered.

MAKING CONTACT & TERMS Send query letter with photocopies. Portfolio may be dropped off any weekday, 9-5. Provide self-promotion piece to be kept on file for possible future assignments. Responds only if interested; send *only* nonreturnable samples. Pays by the project, $250-850/image. Pays on receipt of invoice. Buys all rights; negotiable. Will respond upon need of services.

⚖☀ TRAILS MEDIA GROUP

333 W. State St., Milwaukee WI 53201. **Fax:** (414)647-4723. **E-mail:** editor@wistrails.com; clewis@jrn.com; customercare@jrn.com. **Website:** www.wisconsintrails.com. Estab. 1960. Specializes in calendars (horizontal and vertical) portraying seasonal scenics. Also publishes regional books and magazines, including *Wisconsin Trails.*

NEEDS Buys 300 photos/year. Needs photos of nature, landscapes, wildlife, and regional (Wisconsin, Michigan, Iowa, Minnesota, Indiana, Illinois) activities. Makes selections in January for calendars, 6 months ahead for magazine issues. Photo captions required.

SPECS No longer accepts film submissions, only digital.

MAKING CONTACT & TERMS Submit via e-mail. Send your contact information including address, phone, e-mail, and website to editor@wistrails.com. Information gets entered into our database and will be added to our "photo call" e-mail list. Photos are credited and the photographer retains all rights.

TIPS "Be sure to inform us how you want materials returned and include proper postage. Calendar scenes must be horizontal to fit 8¾×11 format, but we also want vertical formats for engagement calendars. See our magazine and books and be aware of our type of photography. E-mail for an appointment."

◎⚖☀ ZITI CARDS

601 S. Sixth St., St. Charles MO 63301. (800)497-5908. **Fax:** (636)352-2146. **E-mail:** mail@ziticards.com. **Website:** www.ziticards.com. **Contact:** Salvatore Ventura, owner. Estab. 2006. Produces greeting cards. Specializes in holiday cards for architects, construction businesses, and medical professionals. Art guidelines available via e-mail.

NEEDS Buys 30+ freelance photographs per year. Produces material for greeting cards, mainly Christmas. Submit seasonal material at any time. Final art size should be proportional to and at least 5×7. "We purchase exclusive rights for the use of photographs on greeting cards and do not prevent photographers from using images on other non-greeting card items. Photographers retain all copyrights and can end the agreement for any reason." Pays $50 advance and 5% royalties at the end of the season. Finds freelancers through submissions. Accepts prints, transparencies, and digital formats.

MAKING CONTACT & TERMS E-mail query letter with résumé, link, and samples or send a query letter with résumé slides, prints, tearsheets, and/or transparencies. Samples not kept on file, include SASE for return of material.

TIPS "Pay attention to details, look at other work that publishers use, follow up on submissions, have good presentations. We need unusual and imaginative photographs for general greeting cards and especially the Christmas holiday season. Architecture plus snow, holiday decorations/colors/symbols, etc. Present your ideas for cards if your portfolio does not include such work."

⚖⚖☀ THE ZOLAN COMPANY, LLC

32857 N. 74th Way, Scottsdale AZ 85266. (203)300-3290. **E-mail:** jenniferzolan@yahoo.com; donaldz798@aol.com. **Website:** www.zolan.com. **Contact:** Jennifer Zolan, president/art director. Commercial and fine art business. Photos used for artist reference in oil paintings.

NEEDS Buys 8-10 images/year; works on assignment; looking for photographs of Farmall tractors, especially models M, C, H, 1066, 460, 1566, 1026, Farmall 1206, Farmall tractor models from the 1960s and 1970s. John Deere tractors are also needed. Looking for photos of puppies and dogs for paintings. Reviews stock photos.

SPECS Will only review images in digital format. Send via e-mail, PDF, GIF, JPEG files at 72 dpi for preview.

MAKING CONTACT & TERMS Request photo guidelines by e-mail. Will only review submissions in electronic files. If submissions are sent by mail or other shipping services, they will not be returned. Does not keep samples on file. Pays up to $100 per photo. **Pays on acceptance.**

TIPS "We are happy to work with amateur and professional photographers. Will work on assignment shoots with photographers who have access to Farmall tractors. Will also purchase what is in stock if it fits the needs."

STOCK PHOTO AGENCIES

If you are unfamiliar with how stock agencies work, the concept is easy to understand. Stock agencies house large files of images from contracted photographers and market the photos to potential clients. In exchange for licensing the images, agencies typically extract a 50-percent commission from each use. The photographer receives the other 50 percent.

In recent years, the stock industry has witnessed enormous growth, with agencies popping up worldwide. Many of these agencies, large and small, are listed in this section. However, as more and more agencies compete for sales, there has been a trend toward partnerships among some small to mid-size agencies. Other agencies have been acquired by larger agencies and essentially turned into subsidiaries. Often these subsidiaries are strategically located to cover different portions of the world. Typically, smaller agencies are bought if they have images that fill a need for the parent company. For example, a small agency might specialize in animal photographs and be purchased by a larger agency that needs those images but doesn't want to search for individual wildlife photographers.

The stock industry is extremely competitive, and if you intend to sell stock through an agency, you must know how they work. Below is a checklist that can help you land a contract with an agency.

- Build a solid base of quality images before contacting any agency. If you send an agency 50–100 images, they are going to want more if they're interested. You must have enough quality images in your files to withstand the initial review and get a contract.
- Be prepared to supply new images on a regular basis. Most contracts stipulate that photographers must send additional submissions periodically—perhaps quarterly, monthly, or annually. Unless you are committed to shooting regularly, or unless you

have amassed a gigantic collection of images, don't pursue a stock agency.

- Make sure all of your work is properly cataloged and identified with a file number. Start this process early so that you're prepared when agencies ask for this information. They'll need to know what is contained in each photograph so that the images can be properly keyworded on websites.
- Research those agencies that might be interested in your work. Smaller agencies tend to be more receptive to newcomers because they need to build their image files. When larger agencies seek new photographers, they usually want to see specific subjects in which photographers specialize. If you specialize in a certain subject area, be sure to check out our Subject Index in the back of the book, which lists companies according to the types of images they need.
- Conduct reference checks on any agencies you plan to approach to make sure they conduct business in a professional manner. Talk to current clients and other contracted photographers to see if they are happy with the agency. Also, some stock agencies are run by photographers who market their own work through their own agencies. If you are interested in working with such an agency, be certain that your work will be given fair marketing treatment.
- Once you've selected a stock agency, contact them via e-mail or whatever means they have stipulated in their listing or on their website. Today, almost all stock agencies have websites and want images submitted in digital format. If the agency accepts slides, write a brief cover letter explaining that you are searching for an agency and that you would like to send some images for review. Wait to hear back from the agency before you send samples. Then send only duplicates for review so that important work won't get lost or damaged. Always include a SASE when sending samples by regular mail. It is best to send images in digital format; some agencies will only accept digital submissions.
- Finally, don't expect sales to roll in the minute a contract is signed. It usually takes a few years before initial sales are made.

SIGNING AN AGREEMENT

There are several points to consider when reviewing stock agency contracts. First, it's common practice among many agencies to charge photographers fees, such as catalog insertion rates or image duping fees. Don't be alarmed and think the agency is trying to cheat you when you see these clauses. Besides, it might be possible to reduce or eliminate these fees through negotiation.

Another important item in most contracts deals with exclusive rights to market your images. Some agencies require exclusivity to sales of images they are marketing for you. In other words, you can't market the same images they have on file. This prevents photog-

raphers from undercutting agencies on sales. Such clauses are fair to both sides as long as you can continue marketing images that are not in the agency's files.

An agency also may restrict your rights to sign with another stock agency. Usually such clauses are designed merely to keep you from signing with a competitor. Be certain your contract allows you to work with other agencies. This may mean limiting the area of distribution for each agency. For example, one agency may get to sell your work in the United States, while the other gets Europe. Or it could mean that one agency sells only to commercial clients, while the other handles editorial work. Before you sign any agency contract, make sure you can live with the conditions, including 40/60 fee splits favoring the agency.

Finally, be certain you understand the term limitations of your contract. Some agreements renew automatically with each submission of images. Others renew automatically after a period of time unless you terminate your contract in writing. This might be a problem if you and your agency are at odds for any reason. Make sure you understand the contractual language before signing anything.

REACHING CLIENTS

One thing to keep in mind when looking for a stock agent is how they plan to market your work. A combination of marketing methods seems the best way to attract buyers, and most large stock agencies are moving in that direction by offering catalogs, CDs, and websites.

But don't discount small, specialized agencies. Even if they don't have the marketing muscle of big companies, they do know their clients well and often offer personalized service and deep image files that can't be matched by more general agencies. If you specialize in regional or scientific imagery, you may want to consider a specialized agency.

MICROSTOCK

A relatively new force in the stock photography business is microstock. The term *microstock* comes from the "micro payments" that these agencies charge their clients—often as little as one dollar (the photographer gets only half of that), depending on the size of the image. Compare that to a traditional stock photo agency, where a rights-managed image could be licensed for hundreds of dollars, depending on the image and its use. Unlike the traditional stock agencies, microstock agencies are more willing to look at work from amateur photographers, and they consider their content "member generated." However, they do not accept all photos or all photographers; images must still be vetted by the microstock site before the photographer can upload his collection and begin selling. Microstock sites are looking for the lifestyle, people, and business images that their traditional

counterparts often seek. Unlike most traditional stock agencies, microstock sites offer no rights-managed images; all images are royalty free.

So if photographers stand to make only fifty cents from licensing an image, how are they supposed to make money from this arrangement? The idea is to sell a huge quantity of photos at these low prices. Microstock agencies have tapped into a budget-minded client that the traditional agencies have not normally attracted—the small business, nonprofit organization, and even the individual who could not afford to spend $300 for a photo for their newsletter or brochure. There is currently a debate in the photography community about the viability of microstock as a business model for stock photographers. Some say it is driving down the value of all photography and making it harder for all photographers to make a living selling their stock photos. While others might agree that it is driving down the value of photography, they say that microstock is here to stay and photographers should find a way to make it work for them or find other revenue streams to counteract any loss of income due to the effects of microstock. Still others feel no pinch from microstock: They feel their clients would never purchase from a microstock site and that they are secure in knowing they can offer their clients something unique.

If you want to see how a microstock site works, see the following websites, which are some of the more prominent microstock sites. You'll find directions on how to open an account and start uploading photos.

- www.shutterstock.com
- www.istockphoto.com
- www.bigstockphoto.com
- www.fotolia.com
- www.dreamstime.com

DIGITAL IMAGING GUIDELINES AND SYSTEMS

The photography industry is in a state of flux as it grapples with the ongoing changes that digital imaging has brought. In an effort to identify and promote digital imaging standards, the Universal Photographic Digital Imaging Guidelines (UPDIG, www.updig.org) were established. The objectives of UPDIG are to:

- Make digital imaging practices more clear and reliable
- Develop an Internet resource for imaging professionals (including photo buyers, photographers, and nonprofit organizations related to the photography industry)
- Demonstrate the creative and economic benefits of the guidelines to clients
- Develop industry guidelines and workflows for various types of image reproduction, including RAW file delivery, batch-converted files, color-managed master files, and CMYK with proofs.

PLUS (Picture Licensing Universal System) is a cooperative, multi-industry initiative designed to define and categorize image usage around the world. It does not address pricing or negotiations, but deals solely with defining licensing language and managing license data so that photographers and those who license photography can work with the same systems and use the same language when licensing images. To learn more about PLUS, visit www.useplus.com.

MARKETING YOUR OWN STOCK

If you find the terms of traditional agencies unacceptable, there are alternatives available. Many photographers are turning to the Internet as a way to sell their stock images without an agent and are doing very well. Your other option is to join with other photographers sharing space on the Internet. Check out PhotoSource International at www.photosource.com and www.agpix.com.

If you want to market your own stock, it is not absolutely necessary that you have your own website, but it will help tremendously. Photo buyers often "google" the keyword they're searching for—that is, they use an Internet search engine, keying in the keyword plus "photo." Many photo buyers, from advertising firms to magazines, at one time or another, either have found the big stock agencies too unwieldy to deal with, or they simply did not have exactly what the photo buyer was looking for. Googling can lead a photo buyer straight to your site; be sure you have adequate contact information on your website so the photo buyer can contact you and possibly negotiate the use of your photos.

One of the best ways to get into stock is to sell outtakes from assignments. The use of stock images in advertising, design, and editorial work has risen in the last five years. As the quality of stock images continues to improve, even more creatives will embrace stock as an inexpensive and effective means of incorporating art into their designs. Retaining the rights to your assignment work will provide income even when you are no longer able to work as a photographer.

⊛ 911 PICTURES

P.O. Box 1679, Sag Harbor NY, 11963. (631)804-4540. **E-mail:** info@911pictures.com. **Website:** www.911pictures.com. **Contact:** Michael Heller, president. Estab. 1996. Stock agency. Has 3,500 photos in files. Clients include: advertising agencies, public relations firms, audiovisual firms, businesses, book publishers, magazine publishers, calendar companies, insurance companies, public safety training facilities.

NEEDS Photos of disaster services, public safety/emergency services, fire, police, EMS, rescue, hazmat. Interested in documentary.

SPECS Accepts images in digital format on CD at minimum 300 dpi, 8" minimum short dimension. Images for review may be sent via e-mail, CD as BMP, GIF, JPEG files at 72 dpi.

PAYMENT & TERMS Pays 50% commission for b&w and color photos; 75% for film and videotape. Enforces minimum prices. Offers volume discounts to customers. Works with photographers on contract basis only. Offers nonexclusive contract. Charges any print fee (from negative or slide) or dupe fee (from slide). Statements issued/sale. Payment made/sale. Photographers allowed to review account records in cases of discrepancies only. Offers one-time rights. Informs photographers and allows them to negotiate when client requests all rights. Model release preferred. Photo captions preferred; include photographer's name and a short caption as to what is occurring in photo.

HOW TO CONTACT Send query letter with résumé, slides, prints, photocopies, tearsheets. "Photographers can also send e-mail with thumbnail (low-res) attachments." Does not keep samples on file; include SASE for return of material. Responds only if interested; send nonreturnable samples. Photo guidelines sheet free with SASE.

TIPS "Keep in mind that there are hundreds of photographers shooting hundreds of fires, car accidents, rescues, etc., every day. Take the time to edit your own material, so that you are only sending in your best work. We are especially in need of hazmat, police, and natural disaster images. At this time, 911 Pictures is only soliciting work from those photographers who shoot professionally or who shoot public safety on a regular basis. We are not interested in occasional submissions of 1 or 2 images."

◗ A+E

9 Hochgernstr, Stein D-83371, Germany. (49)8621-63876. **Fax:** (49)8621-63875. **E-mail:** apluse@aol.com. **Website:** www.apluse.de. **Contact:** Elisabeth Pauli, director. Estab. 1987. Picture library. Clients include newspapers, postcard publishers, book publishers, calendar companies, magazine publishers.

NEEDS Photos of nature/landscapes/scenics, pets, "only your best material."

SPECS Uses 35mm, 6×6 transparencies, digital. Accepts images in digital format. Send via CD as JPEG files at 100 dpi for referencing purposes only.

PAYMENT & TERMS Pays 50% commission. Offers volume discounts to customers. Works with photographers on contract basis only. Offers nonexclusive contract. Subject exclusivity may be negotiated. Statements issued annually. Payment made annually. Photographers allowed to review account records in cases of discrepancies only. Offers one-time rights. Model/property release required. Photo captions must include country, date, name of object (person, town, landmark, etc.).

HOW TO CONTACT Send query letter with your qualification, description of your equipment, transparencies or CD, stock list. Include SASE for return of material in Europe. Cannot return material outside Europe. Expects minimum initial submission of 100 images with annual submissions of at least 100 images. Responds in 1 month.

TIPS "Judge your work critically. Only technically perfect photos will attract a photo editor's attention! Sharp focus, high colors, creative views."

ACCENT ALASKA/KEN GRAHAM AGENCY

P.O. Box 272, Girdwood AK, 99587. (907)561-5531; (800)661-6171. **Fax:** (907)783-3247. **E-mail:** info@accentalaska.com. **Website:** www.accentalaska.com; www.alaska-in-pictures.com. **Contact:** Ken Graham, owner. Estab. 1979. Stock agency. Has 80,000 photos online. Clients include: advertising agencies, public relations firms, audiovisual firms, businesses, book publishers, magazine publishers, newspapers, calendar companies, greeting card companies, postcard publishers.

NEEDS Modern stock images of Alaska, Antarctica. "Please do not submit material we already have in our files."

SPECS Uses images from digital cameras 10 megapixels or greater; no longer accepting film. Send via

CD, ZIP, e-mail lightbox URL.

PAYMENT & TERMS Pays 50% commission. Negotiates fees at industry-standard prices. Works with photographers on contract basis only. Offers nonexclusive contract. Payment made quarterly. "We are a rights-managed agency."

HOW TO CONTACT "See our website contact page. Any material must include SASE for returns." Expects minimum initial submission of 60 images. Prefers online web gallery for initial review.

TIPS "Realize we specialize in Alaska although we do accept images from Antarctica. The bulk of our sales are Alaska-related. We are always interested in seeing submissions of sharp, colorful, and professional-quality images with model-released people when applicable. Do not want to see same material repeated in our library."

⊘ ACE STOCK LIMITED

E-mail: web@acestock.com. **Website:** www.acestock.com. **Contact:** John Panton, director. Estab. 1980. Stock photo agency. Has approximately 500,000 photos on file; over 40,000 online. Clients include: ad agencies, audiovisual firms, businesses, book/encyclopedia publishers, magazine publishers, postcard companies, calendar companies, greeting card companies, design companies, direct mail companies.

NEEDS Photos of babies/children/teens, couples, multicultural, families, parents, senior citizens, environmental, landscapes/scenics, wildlife, pets, adventure, automobiles, food/drink, health/fitness, hobbies, humor, sports, travel, business concepts, industry, medicine, product shots/still life, science, technology/computers. Interested in alternative process, avant garde, documentary, fashion/glamour, seasonal.

SPECS High-quality digital submissions only. Scanning resolutions for low-res at 72 dpi and high-res at 300 dpi with 30MB minimum size. Accepts online submissions only.

PAYMENT & TERMS Pays 50% commission on net receipts. Average price per image (to clients): $400. Works with photographers on contract basis only. Offers limited regional exclusivity. Contracts renew automatically for 2 years with each submission. No charges for scanning. Charges $200/image for catalog insertion. Statements issued quarterly. Payment made quarterly. Photographers permitted to review sales records with 1-month written notice. Offers one-time rights, first rights, or mostly nonexclusive

rights. Informs photographers when client requests to buy all rights, but agency negotiates for photographer. Model/property release required for people and buildings. Photo captions required; include place, date, and function. "Prefer data as IPTC-embedded within Photoshop File Info 'caption' for each scanned image."

HOW TO CONTACT Send e-mail with low-res attachments or website link or FTP. Alternatively, arrange a personal interview to show portfolio or post 50 sample transparencies. Responds within 1 month. Photo guidelines sheet free with SASE. Online tips sheet for contracted photographers.

TIPS Prefers to see "definitive cross-section of your collection that typifies your style and prowess. Must show originality, command of color, composition, and general rules of stock photography. All people must be mid-Atlantic to sell in UK. No dupes. Scanning and image manipulation is all done in-house. We market primarily via online search engines and e-mail promos. In addition, we distribute printed catalogs and CDs."

⊘ ACTION PLUS SPORTS IMAGES

Portray Limited, 30 Ashlands Rd., Cheltenham, Gloucestershire GL51 0DE United Kingdom. 44 (020) 7403-1558. **Fax:** 44 (020) 7403-1558. **E-mail:** info@actionplus.co.uk. **Website:** www.actionplus.co.uk. **Contact:** Stephen Hearn. Estab. 1976. News/feature syndicate. Has 2.8 million photos on file; 2 million transparencies and 800,000 digital images. Branch office in California (contact London office). Clients include: ad agencies, businesses, book publishers, magazine publishers, newspapers, calendar companies, greeting card companies.

NEEDS Photos of sports.

SPECS Submit images via ZIP or e-mail. Send as JPEG files.

PAYMENT & TERMS Pays commission: 50% for b&w photos. Average price per image (to clients): $10-10,000. Negotiates fees below stated minimums. Discount sales terms not negotiable. Works with photographers on contract basis only. Offers nonexclusive contract. Contracts renew automatically with additional submissions. Photographers permitted to review account records in cases of discrepancies only. Offers one-time rights. Informs photographers when client requests to buy all rights, but agency negotiates for photographer. Model/property release required

for people and buildings (for commercial images only-not editorial). Photo captions required; include place, date and function. "Prefer data as IPTC-embedded within Photoshop File Info 'caption' for each scanned image."

HOW TO CONTACT E-mail query letter with link to your website. JPEG samples at 72 dpi. Does not keep samples on file; cannot return material. Responds in 1 week. Photo guidelines available.

✪ AERIAL ARCHIVES

Petaluma Airport, 561 Sky Ranch Dr., Petaluma CA, 94954. (415)771-2555. **Website:** www.aerialarchives. com. **Contact:** Herb Lingl. Estab. 1989. Has 100,000 photos in files. Has 2,000 hours of film, video footage. Clients include: advertising agencies, public relations firms, audiovisual firms, businesses, book publishers, magazine publishers, newspapers, calendar companies.

NEEDS Aerial photography and videography only.

SPECS Accepts images in digital format only, unless they are historical. Uses 2¼×2¼, 4×5, 9×9 transparencies; 70mm, 5", and 9×9 (aerial film). Other media also accepted.

PAYMENT & TERMS Buys photos, film, videotape outright only in special situations where requested by submitting party. Pays on commission basis. Average price per image (to clients): $325. Enforces minimum prices. Offers volume discounts to customers. Photographers can choose not to sell images on discount terms. Works with photographers on contract basis only. Statements issued quarterly. Payment made monthly. Photographers allowed to review account records in cases of discrepancies only. Offers onetime rights, electronic media rights, agency promotion rights. Informs photographers and allows them to negotiate when client requests all rights. Property release preferred. Photo captions required; include date, location, and altitude if available.

HOW TO CONTACT Send query letter with stock list. Provide résumé, business card, self-promotion piece to be kept on file. Expects minimum initial submission of 100 images with quarterly submissions of at least 50 images. Responds only if interested; send nonreturnable samples. Photo guidelines sheet available via e-mail.

TIPS "Supply complete captions with date and location; aerial photography and videography only."

● AFLO FOTO AGENCY

7F Builnet 1, 6-16-9, Ginza, Chuo-ku Tokyo 104-0061, Japan. (81)3-5550-2120. **E-mail:** support@aflo.com. **Website:** www.aflo.com (Japanese); www.afloimages. com (English). Estab. 1980. Stock agency, picture library, and news/feature syndicate. Japan's largest photo agency, employing over 120 staff based in Tokyo and Osaka. Clients include: advertising agencies, designers, public relations firms, new media, book publishers, magazine publishers, educational users, and television. Member of the Picture Archive Council of America (PACA). Has 1 million photos in files. "We have other offices in Tokyo and Osaka."

NEEDS Photos of babies/children/teens, celebrities, couples, multicultural, families, parents, senior citizens, disasters, environmental, landscapes/scenics, wildlife, architecture, cities/urban, education, gardening, interiors/decorating, pets, religious, rural, adventure, automobiles, entertainment, events, food/drink, health/fitness, hobbies, humor, performing arts, sports, travel, agriculture, business concepts, industry, medicine, military, political, product shots/still life, science, technology/computers. Interested in alternative process, avant garde, documentary, erotic, fashion/glamour, fine art, historical/vintage, lifestyle, seasonal.

SPECS Uses 35mm, 2¼×2¼, 4×5, 8×10 transparencies. Accepts images in digital format. Send via CD, e-mail as TIFF, JPEG files. When making initial submission via e-mail, files should total less than 3MB.

PAYMENT & TERMS Pays commission. Average price per image (to clients): $195 minimum for b&w photos; $250 minimum for color photos, film, videotape. Offers volume discounts to customers; terms specified in photographers' contracts. Photographers can choose not to sell images on discount terms. Works with photographers with or without a contract; negotiable. Contract type varies. Statements issued quarterly. Payment made quarterly. Photographers allowed to review account records. Model/property release preferred. Photo captions required.

HOW TO CONTACT Send all inquiries regarding images or submissions to support@aflo.com. Any submission inquiries should be accompanied by gallery links or image sets.

● AGE FOTOSTOCK

Zurbano 45, 1ª planta, Madrid, 28010, Spain. (34)91 451 86 00. **Fax:** (34)91 451 86 01. **E-mail:** agemadrid@

agefotostock.com. **Website:** www.agefotostock.com. Estab. 1973. Stock agency. Photographers may submit their images to Barcelona directly. Clients include: advertising agencies, businesses, newspapers, postcard publishers, public relations firms, book publishers, calendar companies, audiovisual firms, magazine publishers, greeting card companies. See website for other locations.

NEEDS "We are a general stock agency and are constantly uploading images onto our website. Therefore, we constantly require creative new photos from all categories."

SPECS Accepts all formats. Details available upon request, or see website ("Photographers/submitting images").

PAYMENT & TERMS Pays 50% commission for all formats. Terms specified in photographer's contract. Works with photographers on contract basis only. Offers image exclusivity worldwide. Statements issued monthly. Payment made monthly. Photographers allowed to review account records. Model/property release required. Photo captions required.

HOW TO CONTACT "Send query letter with résumé and 100 images for selection. Download the photographer's info pack from our website."

ALAMY

127 Olympic Ave., Milton Park, Abingdon, Oxon OX14 4SA United Kingdom. UK: 44 (1235) 844-600; US: (866)671-7305. **Fax:** 44 (1235) 844-650. **E-mail:** info@alamy.com. **E-mail:** contributors: memberservices@alamy.com; Customers: sales@alamy.com. **Website:** www.alamy.com. Estab. 1999.

SPECS "Register at www.alamy.com. Upload digital files 17MB+ via the Alamy website. Comission is 50% for any sales you make. You will receive your own Alamy account, which shows sales figures and account details. Alamy's contract is non-exclusive. You can find more information at www.alamy.com/contributor/help/default.asp."

AMANAIMAGES INC.

2-2-43 Higashi-Shinagawa, Shinagawa-ku, Tokyo 140-0002, Japan. (81)3-3740-1018. **Fax:** (81)3-3740-4036. **E-mail:** planet_info@amanaimages.com; a.ito@amanaimages.com. **Website:** amanaimages.com. **Contact:** Mr. Akihiko Ito, partner relations. Estab. 1979. Stock photo agency. Member of the Picture Archive Council of America (PACA). Has 2,500,000 digital files and continuously growing. Clients include: advertising agencies, public relations firms, businesses, book/encyclopedia publishers, magazine publishers, newspapers, postcard publishers, calendar companies, greeting card companies, and TV stations.

NEEDS Photos of babies/children/teens, celebrities, couples, multicultural, families, parents, senior citizens, disasters, environmental, landscapes/scenics, wildlife, architecture, cities/urban, education, gardening, interiors/decorating, pets, religious, rural, adventure, automobiles, entertainment, events, food/drink, health/fitness, hobbies, humor, performing arts, sports, travel, agriculture, business concepts, medicine, military, political, industry, product shots/still life, science, technology/computers. Interested in documentary, erotic, fashion/glamour, fine art, historical/vintage, seasonal.

SPECS Digital format by single-lens reflex camera, data size should be larger than 30MB with 8-bit, Adobe RGB, JPEG format. Digital high-res image size: larger than 48MB for CG, 3D, etc., using editing software, e.g., Photoshop or Shade, digital change made by scanning, composed images, collage images.

PAYMENT & TERMS Based on agreement.

HOW TO CONTACT Send 30–50 sample images (shorter side has to be 600 pixel as JPEG file) and your profile by e-mail. "After inspection of your images we may offer you an agreement. Submissions are accepted only after signing the agreement."

AMERICAN MUSEUM OF NATURAL HISTORY LIBRARY, PHOTOGRAPHIC COLLECTION

Library Services, Central Park West at 79th St., New York NY, 10024. **E-mail:** speccol@amnh.org. **E-mail:** speccol@amnh.org. **Website:** www.amnh.org; www.amnh.org/our-research/research-library/reproduction-and-licensing. **Contact:** Gregory Raml, special collections librarian. Estab. 1869. Provides services for authors, film and TV producers, general public, government agencies, picture researchers, scholars, students, teachers and publishers.

NEEDS "We accept only donations with full rights (nonexclusive) to use; we offer visibility through credits." Model release required. Photo captions required.

PAYMENT & TERMS Credit line given. Buys all rights.

THE ANCIENT ART & ARCHITECTURE COLLECTION, LTD.

15 Heathfield Court, Heathfield Terrace, Chiswick, London W4 4LP United Kingdom. +44-20-89950895. **Fax:** +44-20-84294646. **E-mail:** library@aaacollection.co.uk. **Website:** www.aaacollection.com. Picture library. Has 150,000 photos in files. Represents C.M. Dixon Collection. Clients include: advertising agencies, book/encyclopedia publishers, magazine publishers, newspapers.

NEEDS Photos of ancient/archaeological site, sculptures, objects, artifacts of historical nature. Interested in fine art, historical/vintage.

SPECS Digital images only. JPEG format; minimum 34MB file size.

PAYMENT & TERMS Pays commission on quarterly basis. Works with photographers on contract basis only. Non-exclusive contract. Contracts renew automatically with additional submissions. Statements issued quarterly. Payment made quarterly. Photographers allowed to review account records. Offers one-time rights. Detailed photo captions required.

HOW TO CONTACT Send query letter with samples, stock list, SASE.

TIPS "Material must be suitable for our specialist requirements. We cover historical and archeological periods from 25,000 B.C. to the 19th century A.D., worldwide. All civilizations, cultures, religions, objects, and artifacts as well as art may be included. Pictures with tourists, cars, TV aerials, and other modern intrusions not accepted. Send us a submission of CD by mail with a list of other material that may be suitable for us."

ANDES PRESS AGENCY

26 Padbury Court, Shoreditch, London E2 7EH United Kingdom. +44-20-76135417. **Fax:** +44-20-77393159. **E-mail:** apa@andespressagency.com; val@andespressagency.com. **Website:** www.andespressagency.com. Picture library and news/feature syndicate. Has 300,000 photos in files. Clients include: magazine publishers, businesses, book publishers, non-governmental charities, newspapers.

NEEDS Photos of multicultural, senior citizens, disasters, environmental, landscapes/scenics, architecture, cities/urban, education, religious, rural, travel, agriculture, business, industry, political. "We have color and b&w photographs on social, political and economic aspects of Latin America, Africa, Asia, and Britain, specializing in contemporary world religions."

SPECS Uses 35mm and digital files.

PAYMENT & TERMS Works with photographers on contract basis only. Offers nonexclusive contract. Contracts renew with additional submissions. Statements issued bimonthly. Payment made bimonthly. Offers one-time rights. "We never sell all rights; photographer has to negotiate if interested." Model/property release preferred. Photo captions required.

HOW TO CONTACT Send query via e-mail. Do not send unsolicited images.

TIPS "We want to see that the photographer has mastered one subject in depth. Also, we have a market for photo features as well as stock photos. Please write to us first via e-mail."

ANTHRO-PHOTO FILE

133 Washington St., Belmont MA, 02478. (617)484-6490. **E-mail:** cdevore@anthrophoto.com. **Website:** www.anthrophoto.com. **Contact:** Claire DeVore. Estab. 1969. Stock photo agency specializing in anthropology and behavioral biology. Has 10,000 photos in files (including scientists at work, tribal peoples, peasant societies, hunter-gatherers, archeology, animal behavior, natural history). Clients include: book publishers, magazine publishers.

NEEDS Photos of anthropologists at work.

SPECS Uses b&w prints; 35mm transparencies. Accepts images in digital format.

PAYMENT & TERMS Pays 50% commission. Average price per image (to clients): $200 minimum for b&w photos; $225 minimum for color photos. Offers volume discounts to customers; discount terms negotiable. Works with photographers with contract. Contracts renew automatically. Statements issued annually. Payment made annually. Photographers allowed to review account records. Offers one-time rights. Photo captions required.

HOW TO CONTACT Send query letter with stock list. Keeps samples on file; include SASE for return of material. See website for image delivery options.

TIPS Photographers should e-mail first.

ARCHIVO CRIOLLO

Payamino e7-141, Av. 6 de Diciembre, Quito , Ecuador. +593-2-6038748. **E-mail:** info@archivocriollo.com; info@archivocriollo.com.ec. **Website:** www.archivocriollo.com. **Contact:** Diana Santander,

administrator. Estab. 1998. Picture library. Has 20,000 photos in files. Clients include: advertising agencies, businesses, newspapers, postcard publishers, calendar companies, magazine publishers, greeting card companies, travel agencies.

NEEDS Photos of multicultural, environmental, landscapes/scenics, wildlife, architecture, cities/urban, religious, rural, adventure, travel, art and culture, photo production, photo design, press photos. Interested in alternative process, documentary, fine art, historical/vintage.

SPECS Uses 35mm transparencies. Accepts images in digital format. Send via CD, ZIP, e-mail or FTP as JPEG files at 300 dpi, 11 inches.

PAYMENT & TERMS Enforces minimum prices. Offers volume discounts to customers; terms specified in photographers' contracts. Photographers can choose not to sell images on discount terms. Works with photographers with or without a contract; negotiable. Offers nonexclusive contract. Charges 50% sales fee. Payment made quarterly. Photographers allowed to review account records. Informs photographers and allows them to negotiate when client requests all rights. Photo captions preferred.

HOW TO CONTACT Send query letter with stock list. Responds only if interested. Catalog available.

ARGUS PHOTO, LTD. (APL)

Room 2007, Progress Commercial Bldg., 9 Irving St., Causeway Bay, Hong Kong. +852-28906970. **Fax:** +852-28816979. **E-mail:** argus@argusphoto.com. **Website:** www.argusphoto.com. **Contact:** Lydia Li, photo editor. Estab. 1992. Stock photo agency with branches in Beijing. Has over 1 million searchable photos online. Clients include: advertising agencies, graphic houses, corporations, real estate developers, book and magazine publishers, postcard, greeting card, calendar, and paper product manufacturers.

NEEDS "We are a quality images provider specializing in high-end lifestyle, luxurious interiors/home decor, club scene, food and travel, model in fashion and/or jewelry, well-being, gardenscape, and Asian/oriental images. High-quality features on home and garden, travel and leisure, fashion and accessories, and celebrities stories are welcome."

SPECS Accepts high-quality digital images only. Send 50MB JPEG files at 300 dpi via DVD or website link for review. English captions and keywords are required.

PAYMENT & TERMS Pays 50% commission. Average price per image (to US clients): $100-6,000. Offers volume discounts to customers. Works with photographers on contract basis only. Statement/payment made quarterly. Informs photographers and allows them to negotiate when client requests all rights. Model/property release may be required. Expects minimum initial submission of 200 images.

ART RESOURCE

536 Broadway, 5th Floor, New York NY 10012. (212)505-8700. **Fax:** (212)505-2053. **E-mail:** requests@artres.com. **Website:** www.artres.com. **Contact:** Ryan Jensen. Estab. 1970. Stock photo agency specializing in fine arts. Member of the Picture Archive Council of America (PACA). Has access to 3 million photos. Clients include: advertising agencies, public relations firms, audiovisual firms, businesses, book/encyclopedia publishers, magazine publishers, newspapers, postcard publishers, calendar companies, greeting card companies, all other publishing.

NEEDS Photos of painting, sculpture, architecture *only.*

SPECS Digital photos at 300 dpi.

PAYMENT & TERMS Pays 50% commission. Average price per image (to client): $185-10,000 for color photos. Negotiates fees below standard minimum prices. Offers volume discounts to customers; terms specified in photographer's contract. Discount sales terms not negotiable. Offers one-time rights, electronic media rights, agency promotion and other negotiated rights. Photo captions required.

HOW TO CONTACT Send query letter with stock list.

TIPS "We represent European fine art archives and museums in the US and Europe but occasionally represent a photographer with a specialty in photographing fine art."

ARTWERKS STOCK PHOTOGRAPHY

5045 Brennan Bend, Idaho Falls ID, 83401. (208)523-1545. **E-mail:** photojournalistjerry@msn.com. **Contact:** Jerry Sinkovec, owner. Estab. 1984. News/feature syndicate. Has 100,000 photos in files. Clients include: advertising agencies, public relations firms, businesses, book publishers, magazine publishers, calendar companies, postcard publishers.

NEEDS Photos of Native Americans, ski action, ballooning, British Isles, Europe, Southwest scenery, di-

sasters, environmental, landscapes/scenics, wildlife, adventure, events, food/drink, hobbies, performing arts, sports, travel, business concepts, industry, product shots/still life, science, technology/computers. Interested in documentary, fine art, historical/vintage, lifestyle.

SPECS Uses 8×10 glossy color and/or b&w prints; 35mm, 2¼×2¼, 4×5 transparencies. Accepts images in digital format. Send via CD, ZIP as JPEG files.

PAYMENT & TERMS Pays 50% commission. Average price per image (to clients): $125-800 for b&w photos; $150-2,000 for color photos; $250-5,000 for film and videotape. Negotiates fees below stated minimums depending on number of photos being used. Offers volume discounts to customers; terms not specified in photographers' contracts. Discount sales terms not negotiable. Works with photographers with or without a contract, negotiable. Offers nonexclusive contract. Charges 100% duping fee. Statements issued quarterly. Payment made quarterly. Offers one-time rights. Does not inform photographers or allow them to negotiate when a client requests all rights. Model/property release preferred. Photo captions preferred.

HOW TO CONTACT Send query letter with brochure, stock list, tearsheets. Provide résumé, business card. Portfolios may be dropped off every Monday. Agency will contact photographer for portfolio review if interested. Portfolio should include slides, tearsheets, transparencies. Works with freelancers on assignment only. Does not keep samples on file; include SASE for return of material. Expects minimum initial submission of 20 images. Responds in 2 weeks.

ASIA IMAGES GROUP

15 Shaw Rd., #08-02, Teo Bldg., 367953 Singapore. +65-6288-2119. **Fax:** +65-6288-2117. **E-mail:** info@asiaimagesgroup.com. **Website:** www.asiapix.com. **Contact:** Alexander Manton, founder and creative director. Estab. 2001. "We specialize in creating, distributing, and licensing locally relevant Asian model-released lifestyle and business images. Our image collections reflect the visual trends, styles, and issues that are current in Asia. We have 4 major collections: Asia Images (rights managed); AsiaPix (royalty free); Picture India (royalty free); and AXMotion (RM and RF video clips)." Clients include: advertising agencies, corporations, public relations firms, book publishers, calendar companies, magazine publishers.

NEEDS Photos of babies/children/teens, couples, families, parents, senior citizens, health/fitness/beauty, science, technology. "We are only interested in seeing images about or from Asia."

SPECS Accepts images in digital format. "We want to see 72 dpi JPEGs for editing and 300 dpi TIFF files for archiving and selling."

PAYMENT & TERMS "Works with photographers on image-exclusive contract basis only. We need worldwide exclusivity for the images we represent, but photographers are encouraged to work with other agencies with other images. Statements issued quarterly. Payment made quarterly. Offers one-time rights, electronic media rights. Model and property releases are required for all images."

AURORA PHOTOS

45 York St., Portland ME, 04101. (207)828-8787. **Fax:** (207)828-5524. **Website:** www.auroraphotos.com. **Contact:** José Azel, owner. Estab. 1993. 1.4 million digital photo archive. Clients include: advertising agencies, businesses, corporations, book publishers, magazine publishers, newspapers, calendar companies, and websites.

NEEDS Photos of outdoor adventure, travel, lifestyle, nature, landscape, wildlife, iPhone, culture, conceptual, environmental, portraits, sports, commercial, editorial, celebrities, news, multicultural, military, politics, agriculture, technology, extreme sports.

SPECS Accepts digital submissions only; contact for specs.

PAYMENT & TERMS Accepts digital submissions only; e-mail info@auroraphotos.com for specs. Offers volume discounts to customers. Statements issued monthly. Payment made monthly. Photographers allowed to review account records once/year. Offers one-time rights, electronic media rights. Model/property release preferred.

HOW TO CONTACT Aurora's Open Collection combines the user-friendliness of royalty-free licensing with a picture archive that captures the breadth of sports, recreation, and outdoor lifestyles. View Aurora's Open Collection online. If you are interested in having your images reviewed, please send a link to your website portfolio for review. Does not keep samples on file; does not return material. Responds in 1 month. Photo guidelines available after initial contact.

TIPS "Review our website closely. List area of photo expertise/interest and forward a personal website address where your photos can be found."

AUSCAPE INTERNATIONAL

P.O. Box 1024, Bowral NSW, 2576 Australia. +61-2-48852245. **E-mail:** sales@auscape.com.au. **Website:** www.auscape.com.au. **Contact:** Sarah Tahourdin, director. Has 250,000 photos in files. Clients include: advertising agencies, educational book publishers, magazine publishers, newspapers, calendar companies, greeting card companies, museums, tourism companies.

NEEDS Photos of environmental, landscapes/scenics, travel, wildlife, pets.

SPECS Uses 35mm, 6×6, 4×5 transparencies. Accepts images in digital format. Send via CD or DVD as TIFF files at 300 dpi.

PAYMENT & TERMS Pays 40% commission for color photos. Enforces minimum prices. Offers volume discounts to customers. Works with photographers on contract basis only. Requires exclusive contract. Statements issued quarterly. Payment made quarterly. Photographers allowed to review account records. Charges scan fees for all transparencies scanned in-house; all scans placed on website. Offers one-time rights. Photo captions required; include scientific names, common names, locations.

HOW TO CONTACT Does not keep samples on file. Expects minimum initial submission of 200 images with monthly submissions of at least 50 images. Responds in 3 weeks to samples. Photo guidelines sheet free.

TIPS "Send only informative, sharp, well-composed pictures. We are a specialist natural history agency and our clients mostly ask for pictures with content rather than empty-but-striking visual impact. There must be passion behind the images and a thorough knowledge of the subject."

THE BERGMAN COLLECTION

134 Leabrook Lane, Princeton NJ, 08540. (609)921-0749. **E-mail:** information@pmiprinceton.com. **Website:** pmiprinceton.com. **Contact:** Victoria B. Bergman, vice president. Estab. 1980. Collection established in the 1930s. Stock agency. Has 20,000 photos in files. Clients include: advertising agencies, book publishers, audiovisual firms, magazine publishers, other.

NEEDS "Specializes in medical, technical and scientific stock images of high quality and accuracy."

SPECS Uses digital formats.

PAYMENT & TERMS Pays on commission basis. Works with photographers on contract basis only. Offers one-time rights. Model/property release required. Photo captions required; must be medically, technically, scientifically accurate.

HOW TO CONTACT "Do not send unsolicited images. Please call, write, or e-mail if you have images that meet our criteria. Include a description of the field of medicine, technology, or science in which you have images. We contact photographers when a specific need arises."

TIPS "Our needs are for very specific images that usually will have been taken by specialists in the field as part of their own research or professional practice."

BLEND IMAGES

501 E. Pine St., Suite 200, Seattle WA, 98122. (888)721-8810, ext. 5. **Fax:** (206)749-9391. **E-mail:** jerome@blendimages.com. **Website:** www.blendimages.com. **Contact:** Jerome Montalto, submission and content manager. Estab. 2005. Stock agency. Clients include: advertising agencies, businesses, public relations firms, magazine publishers. Blend Images represents a "robust, high-quality collection of ethnically diverse lifestyle and business imagery."

NEEDS Photos of babies/children/teens, couples, multicultural, families, parents, senior citizens, business concepts; interested in lifestyle. Photos must be ethnically diverse.

SPECS Accepts images in digital format only. Images should be captured using professional-level SLRs of 11+ megapixels, pro digital backs, or high-end scanners that can deliver the required quality. Final media should be 48-52MB, 24-bit RGB (8 bits per channel), uncompressed TIFF files at 300 dpi. Images should be fully retouched, color-corrected, and free from dust, dirt, posterization, artifacing, or other flaws. Files should be produced in a color-managed environment with Adobe RGB 1998 as the desired color space.

HOW TO CONTACT E-mail your photographic background and professional experience, along with 30-50 tightly edited, low-res JPEGs in one of the following ways: 1. URL with your personal website. 2. Web photo gallery. (Web galleries can be created using your imaging software. Reference your owner's

manual for instructions.) 3. Spring-loaded hot link—a clickable link that provides downloadable JPEGs.

⬤ BSIP

36 rue Villiers-de-l'Isle-Adam, Paris 75020 France. 33(0)1 43 58 69 87. **Fax:** 33(0)1 43 58 62 14. **E-mail:** export@bsip.com; info@bsip.com. **Website:** www.bsip.com. Estab. 1990. Member of Coordination of European Picture Agencies Press Stock Heritage (CEPIC). Has 300,000 downloadable high-res images online. Clients include: advertising agencies, book publishers, magazine publishers, newspapers.

NEEDS Photos of environmental, food/drink, health/fitness, medicine, science, nature, and animals.

SPECS Accepts images in digital format only. Send via FTP as TIFF or JPEG files at 330 dpi, 3630×2420 pixels.

PAYMENT & TERMS Offers volume discounts to customers; terms specified in photographers' contracts. Discount sales terms not negotiable. Works with photographers with or without a contract; negotiable. Offers guaranteed subject exclusivity. Contracts renew automatically with additional submissions for 5 years. Statements issued monthly. Payment made monthly. Photographers allowed to review account records. Offers one-time rights, electronic media rights, agency promotion rights. Model release required. Photo captions required.

HOW TO CONTACT Send query letter. Portfolio may be dropped off Monday–Friday. Keeps samples on file. Expects minimum initial submission of 50 images with monthly submissions of at least 20 images. Photo guidelines sheet available on website. Catalog free with SASE. Market tips sheet available.

CALIFORNIA VIEWS/THE PAT HATHAWAY HISTORICAL PHOTO COLLECTION

469 Pacific St., Monterey CA, 93940-2702. (831)373-3811. **E-mail:** hathaway@caviews.com. **Website:** www.caviews.com. **Contact:** Mr. Pat Hathaway, photo archivist. Estab. 1970. Picture library; historical collection. Has 80,000 b&w images; 10,000 35mm color images in files. Clients include: advertising agencies, public relations firms, audiovisual firms, book/encyclopedia publishers, magazine publishers, museums, postcard companies, calendar companies, television companies, interior decorators, film companies.

NEEDS Historical photos of California from 1855 to today, including disasters, landscapes/scenics, rural,

agricultural, automobiles, travel, military, portraits, John Steinbeck, and Edward F. Rickets.

PAYMENT & TERMS Payment negotiable. Offers volume discounts to customers.

HOW TO CONTACT "We accept donations of California photographic material in order to maintain our position as one of California's largest archives. Please do not send unsolicited images." Does not keep samples on file; cannot return material.

CAL SPORT MEDIA

35557 Trevino Trail, Beaumont CA 92223. (805)895-6726. **Fax:** (323)908-4100. **E-mail:** calsportmedia@verizon.net. **Website:** www.csmimages.com. **Contact:** John Pyle/Editor. Estab. 2002. Stock agency. Has 750,000 photos in files. Clients include: magazine publishers, newspapers.

NEEDS Photos of sports.

SPECS Accepts images in digital format. Send as JPEG files.

PAYMENT & TERMS Payments made monthly. Photo captions required.

HOW TO CONTACT E-mail query letter JPEG samples at 72 dpi. Responds in 1 week.

TIPS "Please contact by e-mail only your best work (15–20 images), showing your ability to produce magazine-quality images. We receive many submissions, please be sure to include what type of equipment you use and list your experience as a professional photographer."

⬤⬤ CAMERA PRESS, LTD.

21 Queen Elizabeth St., London SE1 2PD United Kingdom. +44-20-73781300. **Fax:** +44-20-72785126. **E-mail:** info@camerapress.com. **Website:** www.camerapress.com. Quality syndication service and picture library. Clients include: advertising agencies, public relations firms, audiovisual firms, book/encyclopedia publishers, magazine publishers, newspapers, postcard companies, calendar companies, greeting card companies, and TV stations. Clients principally press but also advertising, publishers, etc.

⬤ Camera Press sends and receives images via ISDN, FTP, and e-mail. Has a fully operational electronic picture desk to receive/send digital images via modem/ISDN lines, FTP.

NEEDS Celebrities, world personalities (e.g., politics, sports, entertainment, arts), news/documentary,

scientific, human interest, humor, women's features, stock.

SPECS Accepts images in digital format as TIFF, JPEG files, as long as they are a minimum of 300 dpi or 16MB.

PAYMENT & TERMS Standard payment term: 50% net commission. Statements issued every 2 months along with payments.

HOW TO CONTACT "Images should then be sent to us high resolution, either on CD, or via e-mail or FTP. For FTP transmission we will need to set you up with a username and password. Images should ideally be submitted in JPEG format, and should be no smaller than 25MB, up to 50MB for lifestyle and studio images."

TIPS "Camera Press, one of the oldest and most celebrated family-owned picture agencies, represents some of the top names in the photographic world but also welcomes emerging talents and gifted newcomers. We seek quality celebrity images; lively, colorful features which tell a story; and individual portraits of world personalities, both established and up-and-coming. Accurate captions are essential. Remember there is a big worldwide demand for celebrity premieres and openings. Other needs include: scientific development and novelties; beauty, fashion, interiors, food and women's interests; humorous pictures featuring the weird, the wacky, and the wonderful."

CATHOLIC NEWS SERVICE

3211 Fourth St. NE, Washington DC, 20017. (202)541-3250. **Fax:** (202)541-3255. **E-mail:** cns@catholicnews.com; broller@catholicnews.com. **Website:** www.catholicnews.com. News service transmitting news, features, photos, and graphics to Catholic newspapers and religious publishers.

NEEDS Timely news and feature photos related to the Catholic Church or Catholics, head shots of Catholic newsmakers or politicians, and other religions or religious activities, including those that illustrate spirituality. Also interested in photos of family life, modern lifestyles, teenagers, poverty, and active seniors.

SPECS Prefers high-res JPEG files, 8×10 at 200 dpi. If sample images are available online, send URL via e-mail, or send samples via CD.

PAYMENT & TERMS Pays for unsolicited news or feature photos accepted for one-time editorial use in

the CNS photo service. Include full-caption information. Unsolicited photos can be submitted via e-mail for consideration. Some assignments made, mostly in large US cities and abroad, to experienced photojournalists; inquire about assignment terms and rates.

HOW TO CONTACT Query by mail or e-mail; include samples of work. Calls are fine, but be prepared to follow up with letter and samples.

TIPS "See our website for an idea of the type and scope of news covered. No scenic, still-life, or composite images."

CHARLTON PHOTOS, INC.

3605 Mountain Dr., Brookfield WI, 53045. (262)781-9328; (888)242-7586. **Fax:** (262)781-9390. **E-mail:** jim@charltonphotos.com. **Website:** www.charltonphotos.com. **Contact:** James Charlton, director of research. Estab. 1981. Stock photo agency. Has 475,000 photos. Clients include: ad agencies, public relations firms, audiovisual firms, businesses, book/encyclopedia publishers, magazine publishers, newspapers, calendar companies.

NEEDS "We handle photos of agriculture, rural lifestyles, and pets."

SPECS Uses color and b&w photos; digital only.

PAYMENT & TERMS Pays 60/40% commission. Average price per image (to clients): $500-650 for color photos. Offers volume discounts to customers; terms specified in photographers' contracts. Works with photographers on contract basis only. Prefers exclusive contract, but negotiable based on subject matter submitted. Contracts renew automatically with additional submissions for 3 years minimum. Charges duping fee, 50% catalog insertion fee, and materials fee. Statements issued monthly. Payment made monthly. Photographers allowed to review account records that relate to their work. Model/property release required for identifiable people and places. Photo captions required; include who, what, when, where.

HOW TO CONTACT Query by e-mail before sending any material. Expects initial submission of 1,000 images. Responds in 2 weeks. Photo guidelines free with SASE. Market tips sheet distributed quarterly to contract freelance photographers; free with SASE.

TIPS "Provide our agency with images we request by shooting a self-directed assignment each month. Visit our website."

CODY IMAGES

2 Reform St., Beith KA15 2AE, Scotland. 0845-223-5451. **E-mail:** ted@codyimages.com; info@codyimages.com. **Website:** www.codyimages.com. **Contact:** Ted Nevill. Estab. 1989. Picture library covering military history from the American Civil War to the 20th century and aviation, both civil and military. Included are personalities, armored fighting vehicles, weapons and warships.

NEEDS Photos of historical and modern civil and military aviation and warfare, including weapons, warships, and personalities.

SPECS Accepts images in ditigal format.

PAYMENT & TERMS Pays commission. Average price per image (to clients): $40 minimum. Offers volume discounts to customers. Discount sales terms not negotiable. Works with photographers with or without a contract; negotiable. Offers nonexclusive contract. Contracts renew automatically with additional submissions. Statements issued quarterly. Payment made quarterly. Photographers allowed to review account records. Offers one-time rights, electronic media rights. Informs photographers and allows them to negotiate when a client requests all rights. Model/property release preferred. Photo captions preferred.

HOW TO CONTACT Send e-mail with examples and stock list. Provide résumé, business card, self-promotion piece to be kept on file. Expects minimum initial submission of 1,000 images. Responds in 1 month.

EDUARDO COMESAÑA AGENCIA DE PRENSA/BANCO FOTOGRÁFICO

Av. Olleros 1850 4 to. "F", Buenos Aires C1426CRH Argentina. (54-11)4771-9418. **E-mail:** info@comesana.com. **Website:** www.comesana.com. **Contact:** Eduardo Comesaña, managing director. Estab. 1977. Stock agency, news/feature syndicate. Has 500,000 photos in files. Clients include: advertising agencies, businesses, newspapers, postcard publishers, book publishers, calendar companies, magazine publishers.

NEEDS Photos of babies/children/teens, celebrities, couples, families, parents, disasters, environmental, landscapes/scenics, wildlife, education, adventure, entertainment, events, health/fitness, humor, performing arts, travel, agriculture, business concepts, industry, medicine, political, science, technology/computers. Interested in documentary, fine art, historical/vintage.

SPECS Accepts images in JPEG format only, minimum 300 dpi.

PAYMENT & TERMS Offers volume discounts to customers; terms specified in photographer's contracts. Photographers can choose not to sell images on discount terms. Works with photographers with or without a contract; negotiable. Offers limited regional exclusivity. Contracts renew automatically with additional submissions. Statements issued quarterly. Payment made quarterly. Photographers allowed to review account records in cases of discrepancies only. Offers one-time rights. Model release preferred; property release required.

HOW TO CONTACT Send query letter with tearsheets, stock list. Provide self-promotion piece to be kept on file. Expects minimum initial submission of 200 images in low-res files with monthly submissions of at least 200 images. Responds only if interested; send nonreturnable samples.

CRESTOCK CORPORATION

3 Concorde Gate, 4th Floor, Toronto Ontario M3C 3N7 Canada. **E-mail:** help@crestock.com. **Website:** www.crestock.com. "Crestock is a growing player in micropayment royalty-free stock photography, helping clients with small budgets find creative images for their projects. With a fast and reliable image upload system, Crestock gives photographers and illustrators a great platform for licensing their creative work. Over 1,700,000 photographs, illustrations, and vectors are available for purchase and download online. Masterfile acquired the agency in 2010 and has since added the Crestock collection to www.masterfile.com. Crestock has a general collection of photographs, illustrations and vectors available in a wide-range of sizes. Crestock sells single images, as well offers a selection of subscription and credit packages. Clients include designers, advertising agencies, small business owners, corporations, newspapers, public relations firms, publishers, as well as greeting card and calendar companies."

NEEDS Looking for model-released photographs, as well as illustrations and vectors on a wide-range of subjects, including business, finance, holidays, sports and leisure, travel, nature, animals, technology, education, health and beauty, shopping, green living, architecture, still-life as well as conceptual and general lifestyle themes.

SPECS Accepts images in digital format. Submissions must be uploaded for review via website or FTP

as JPEG, EPS, or AI. For full technical requirements, see www.crestock.com/technical-requirements.aspx.

PAYMENT & TERMS Pays contributors based on request, once a minimum amount is reached. Requires model and/or property releases on certain images. For more information, see: www.crestock.com/modelrelease.aspx. Artists are required to caption and keyword their own material in English before submission. In order to join Crestock, register at www.crestock.com and submit photos for approval. To see general information for artists, see www.crestock.com/information-for-contributors.aspx.

TIPS "Crestock is among the most selective microstock agencies, so be prepared for strict quality standards."

DDB STOCK PHOTOGRAPHY, LLC

P.O. Box 80155, Baton Rouge LA 70898. (225)763-6235. **Fax:** (225)763-6894. **E-mail:** info@ddbstock.com. **Website:** www.ddbstock.com. **Contact:** Douglas D. Bryant, president. Estab. 1970. Stock photo agency. Member of American Society of Picture Professionals. Rights-managed stock only, no RF. Currently represents 105 professional photographers. Has 500,000 original color transparencies and 25,000 b&w prints in archive, and 125,000 high-res digital images with 45,000 available for download on website. Clients include: text-trade book/encyclopedia publishers, travel industry, museums, ad agencies, audiovisual firms, magazine publishers, CD publishers, and many foreign publishers.

NEEDS Specializes in picture coverage of Latin America with emphasis on Mexico, Central America, South America, and the Caribbean. Needs photos of anthropology/archeology, art, commerce, crafts, secondary and university education, festivals and ritual, geography, history, indigenous people and culture, museums, parks, political figures, religion. Also uses teens 6th-12th grade/young adults college age, couples, multicultural, families, parents, senior citizens, architecture, rural, adventure, entertainment, events, food/drink, restaurants, health/fitness, performing arts, business concepts, industry, science, technology/computers.

SPECS Prefers images in TIFF digital format on DVD at 10 megapixels or higher. Prepare digital submissions filling IPTC values. Caption, copyright, and keywords per instructions at: www.ddbstock.com/submissionguidelines.html. Accepts uncompressed

JPEGs, TIFFs, and original 35mm transparencies.

PAYMENT & TERMS "Rights to reproduction of color transparencies and b&w prints are sold on a 50% commission basis with remittance made to photographers within 2 weeks following receipt of payment. Exceptions to this include sales made through our affiliate offices around the world where we receive a 60% cut, leaving the photographer with 30%. DDB Stock negotiates only one-time use rights. The pictures on file remain the property of the photographer. The agency asks only that a photographer agree to place material in the files for at least 3 years. This ensures that the agency will have ample opportunity to recover the costs of placing a new photographer's material in the files. This also keeps the images in our files for the hottest selling period, which occurs from 12 to 36 months after they enter the files. It is important to have the images in the files when repeat interest is expressed by an editor. Photographers who want images returned from the files prior to the 3-year minimum must agree to pay a $15 hourly pull fee plus shipping charges for early return of pictures." Model/property release preferred for ad set-up shots. Photo captions required; include location and detailed description. "We have a geographic focus and need specific location info on captions (Geocode latitude/longitude if you carry a GPS unit, and include latitude/longitude in captions)."

HOW TO CONTACT Interested in receiving work from professional photographers who regularly visit Latin America. Send query letter with brochure, tearsheets, stock list. Expects minimum initial submission of 300 digital images/original transparencies and yearly submissions of at least 500 images. Responds in 6 weeks. Photo guidelines available on website.

TIPS "Speak Spanish and spend 1-6 months shooting in Latin America and the Caribbean every year. Follow our needs list closely. Call before leaving on assignment. Shoot digital TIFFs at 12 megapixels or larger. Shoot RAW/NEF/DNG adjust and convert to TIFF or Fuji professional transparency film if you have not converted to digital. Edit carefully. Eliminate images with focus, framing, excessive grain/noise, or exposure problems. The market is far too competitive for average pictures and amateur photographers. Review guidelines for photographers on our website. Include coverage from at least 3 Latin American countries or 5 Caribbean Islands. No one-

time vacation shots! Shoot subjects in demand listed on website."

DK STOCK, INC.

4531 Worthings Dr., Powder Springs GA, 30127. (866)362-4705. **Fax:** (678)384-1883. **E-mail:** david@ dkstock.com. **Website:** www.dkstock.com. **Contact:** David Deas, photo editor. Estab. 2000. "A multicultural stock photo company based in New York City. Prior to launching DK Stock, its founders worked for years in the advertising industry as a creative team specializing in connecting clients to the $1.6 trillion multicultural market. This market is growing, and DK Stock's goal is to service it with model-released, well composed, professional imagery." Member of the Picture Archive Council of America (PACA). Has 15,000 photos on file. Clients include: advertising agencies, public relations firms, graphic design businesses, book publishers, magazine publishers, newspapers, calendar companies, greeting card companies.

NEEDS "Looking for contemporary lifestyle images that reflect the black and Hispanic Diaspora." Wants photos of babies/children/teens, celebrities, couples, multicultural, families, parents, senior citizens, education, adventure, entertainment, health/ fitness/beauty, hobbies, humor, performing arts, sports, travel, agriculture, business concepts, industry, medicine, military, political, science, technology/ computers. Interested in historical/vintage, lifestyle. "Images should include models of Hispanics and/or people of African descent. Images of Caucasian models interacting with black people or Hispanic people can also be submitted. Be creative, selective, and current. Visit website to get an idea of the style and range of representative work. E-mail for a current copy of 'needs list.'"

SPECS Accepts images in digital format. 50MB, 300 dpi.

PAYMENT & TERMS Pays 50% commission for b&w or color photos. Average price per image (to clients): $485. Enforces minimum prices. Offers volume discounts to customers; terms specified in photographers' contracts. Photographers can choose not to sell images on discount terms. Works with photographers on contract basis only. Offers non-exclusive contract. Contracts renew automatically with additional submissions for 5 years. Statements issued monthly. Payment made monthly. Photographers allowed to review

account records. Model/property release required. Photo captions not necessary.

HOW TO CONTACT Send query letter with disc or DVD. Portfolio may be dropped off every Monday-Friday. Does not keep samples on file; include SASE for return of material. Expects minimum initial submission of 50 images with 5 times/year submissions of at least 200 images. Responds in 2 weeks to samples, portfolios. Photo guidelines free with SASE. Catalog free with SASE.

TIPS "We love working with talented people. If you have 10 incredible images, let's begin a relationship. Also, we're always looking for new and upcoming talent as well as photographers who can contribute often. There is an increasing demand for lifestyle photos of multicultural people. Our clients are based in the Americas, Europe, Asia and Africa. Be creative, original and technically proficient."

DRK PHOTO

100 Starlight Way, Sedona AZ, 86351. (928)284-9808. **E-mail:** info@drkphoto.com. **Website:** www. drkphoto.com. "We handle only the personal best of a select few photographers, not hundreds. This allows us to do a better job aggressively marketing the work of these photographers." Clients include: ad agencies; PR and AV firms; businesses; book, magazine, and textbook publishers; newspapers; postcard, calendar and greeting card companies; branches of the government; and nearly every facet of the publishing industry, both domestic and foreign.

NEEDS "Especially need marine and underwater coverage." Also interested in S.E.Ms, African, European and Far East wildlife, and good rainforest coverage.

SPECS Digital capture preferred, digital scans accepted.

PAYMENT & TERMS General price range (to clients): $100-"into thousands." Works with photographers on contract basis only. Contracts renew automatically. Statements issued quarterly. Payment made quarterly. Offers one-time rights; "other rights negotiable between agency/photographer and client." We are not interested in images being offered by anyone else as royalty-free images. We only accept and market rights-managed images. Model release preferred. Photo captions required.

HOW TO CONTACT "With the exception of established professional photographers shooting enough volume to support an agency relationship, we are not

soliciting open submissions at this time. Those professionals wishing to contact us in regards to representation should query with a brief letter of introduction."

DW STOCK PICTURE LIBRARY

108 Beecroft Rd., Beecroft NSW, 2119, Australia. (61)2 9869 0717. **E-mail:** info@dwpicture.com.au; admin@dwpicture.com.au. **Website:** www.dwpicture.com.au. Estab. 1997. Has more than 200,000 photos on file and 30,000 online. "Strengths include historical images, marine life, African wildlife, Australia, travel, horticulture, agriculture, people and lifestyles." Clients include: advertising agencies, designers, printers, book publishers, magazine publishers, calendar companies.

NEEDS Photos of babies/children/teens, families, parents, senior citizens, disasters, gardening, pets, rural, health/fitness, travel, industry. Interested in lifestyle.

SPECS Accepts images in digital format. Send as low-res JPEG files via CD.

PAYMENT & TERMS Average price per image (to clients): $200 for color photos. Enforces minimum prices. Offers volume discounts to customers. Works with photographers on contract basis only. Statements issued quarterly. Photographers allowed to review account records in cases of discrepancies only. Offers one-time rights. Model release preferred. Photo captions required.

HOW TO CONTACT Send query letter with images; include SASE if sending by mail. Expects minimum initial submission of 200 images.

ECOSCENE

Empire Farm, Throop Rd., Templecombe, Somerset BA8 0HR United Kingdom. +44-19-63371700. **E-mail:** sally@ecoscene.com; pictures@ecoscene.com. **Website:** www.ecoscene.com. **Contact:** Sally Morgan, director. Estab. 1988. Picture library. Has 80,000 photos in files. Clients include: advertising agencies, businesses, book/encyclopedia publishers, magazine publishers, newspapers, online, multimedia.

NEEDS Photos of disasters, environmental, energy issues, sustainable development, wildlife, gardening, rural, agriculture, medicine, science, pollution, industry, energy, indigenous peoples.

SPECS Accepts digital submissions only. High-quality JPEG at 300 dpi, minimum file size when opened of 50MB.

PAYMENT & TERMS Pays 55% commission for color photos. Negotiates fees below stated minimum prices, depending on quantity reproduced by a single client. Offers volume discounts to customers. Discount sales terms not negotiable. Works with photographers on contract basis only. Offers nonexclusive contract. Contracts renew automatically with additional submissions, 4 years minimum. Statements issued quarterly. Payment made quarterly. Offers one-time and electronic media rights. Informs photographers and allows them to negotiate when client requests all rights. Model/property release required. Photo captions required; include location, subject matter, keywords, and common and Latin names of wildlife, and any behavior shown in pictures.

HOW TO CONTACT Send e-mail with résumé of credits. Digital submissions only. Keeps samples on file; include SASE for return of material. Expects minimum initial submission of 100 images with annual submissions of at least 100 images. Responds in 2 months. Photo guidelines free with SASE. Market tips sheets distributed quarterly to anybody who requests, and to all contributors.

TIPS "Photographers should carry out a tight EDT, no fillers, and be critical of their own work."

ESTOCK PHOTO, LLC

27-28 Thomson Ave., Suite 628, Long Island City NY, 11101. (800)284-3399. **Fax:** (212)545-1185. **E-mail:** submissions@estockphoto.com. **Website:** www.estockphoto.com. Member of Picture Archive Council of America (PACA). Specialties include: world travel, cultures, landmarks, leisure, nature, and scenics. Has over 1 million photos in files. Clients include: ad agencies, public relations and AV firms; businesses; book, magazine and encyclopedia publishers; newspapers, calendar and greeting card companies; textile firms; travel agencies and poster companies.

NEEDS Exceptional travel-related imagery and people/leisure photography.

SPECS Submission guidelines available on our website under the "contact us" page.

HOW TO CONTACT Send query letter with samples, a list of stock photo subjects or submit portfolio for review. Response time depends; often the same day. Photo guidelines free with SASE.

TIPS "Photos should show what the photographer is all about. They should show technical competence—

photos that are sharp, well-composed, have impact; if color, they should show color."

🙬 FAMOUS PICTURES & FEATURES AGENCY

13 Harwood Rd., London SW6 4QP United Kingdom. +44-20-77319333. **Fax:** +44-20-77319330. **E-mail:** info@famous.uk.com; pictures@famous.uk.com. **Website:** www.famous.uk.com. Estab. 1985. Picture library, news/feature syndicate. Has more than 500,000 photos on database. Clients include: advertising agencies, book publishers, magazine publishers, newspapers, calendar companies, postcard publishers, and poster publishers.

NEEDS Photos of music, film, TV personalities; international celebrities; live, studio, party shots (paparazzi) with stars of all types.

SPECS Prefers images in digital format. Send via FTP or e-mail as JPEG files at 300 dpi or higher.

PAYMENT & TERMS Offers volume discounts to customers. Photographers can choose not to sell images on discount terms. Works with photographers with or without a contract; contracts available for all photographers. Offers limited regional exclusivity. Statements issued monthly. Payment made monthly. Photographers allowed to review account records. Offers one-time rights. Photo captions preferred.

HOW TO CONTACT E-mail, phone, or write, provide samples. Provide résumé, business card, self-promotion piece, or tearsheets to be kept on file. Agency will contact photographer for portfolio review if interested. Keeps samples in online database. Will return material with SAE/IRC.

TIPS "We are solely marketing images via computer networks. Our fully searchable archive of new and old pictures is online. Send details via e-mail for more information. When submitting work, please caption pictures correctly."

🙬 THE FLIGHT COLLECTION

Quadrant House, The Quadrant, Oxford Rd., Sutton Surrey SM2 5AS United Kingdom. +44-20-86528888. **E-mail:** flight@uniquedimension.com; flight@image-asset-management.com. **Website:** www.theflightcollection.com. Estab. 1983. Has 1 million+ photos in files. Clients include: advertising agencies, public relations firms, audiovisual firms, businesses, book publishers, magazine publishers, newspapers, calendar companies, greeting card companies, postcard publishers.

NEEDS Photos of aviation.

SPECS Accepts all transparency film sizes: Send a sample of 50 for viewing. Accepts images in digital format. Send via CD as TIFF files at 300 dpi.

PAYMENT & TERMS Enforces minimum prices. Offers volume discounts to customers. Discount sales terms not negotiable. Works with photographers on contract basis only. Offers nonexclusive contract. Contracts renew automatically with additional submissions, no specific time. Statements issued monthly. Payment made monthly. Offers one-time rights. Model/property release required. Photo captions required; include name, subject, location, date.

HOW TO CONTACT Send query letter with transparencies or CD. Does not keep samples on file; include SASE for return of material. Expects minimum initial submission of 50 images. Photo guidelines sheet free via e-mail.

TIPS "Caption slides/images properly. Provide a list of what's submitted."

🙬 FLOWERPHOTOS

P.O. Box 2190, Shoreham-by-Sea West Sussex BN43 9EZ, United Kingdom. +44-12-43864005. **E-mail:** stephen@flowerphotos.com. **Website:** www.flowerphotos.com. **Contact:** Stephen Rafferty, library manager. Estab. 1993. Stock photo agency. Has 30,000 photos in files. Clients include: ad agencies, businesses, book publishers, magazine publishers, postcard companies, calendar companies, greeting card companies, public relations firms, newspapers.

NEEDS Photos of gardening, rural, agriculture, business concepts, environmental, landscapes/scenics, wildlife, processes, environmental issues, food and food related images.

SPECS Send via CD or Dropbox. Minimum 50 MB at 300 dpi size 12 JPEGs only, full captions and keywords embedded.

PAYMENT & TERMS Pays commission for color photos, film and video. Negotiates fees below stated minimums; various price agreements based on market forces. Works with photographers on contract basis only. Offers exclusive contract, limited regional exclusivity, nonexclusive contract, and guaranteed subject exclusivity. Contracts renew automatically with each submission. Payment made quarterly. Photographers permitted to review sales records in cases of discrepancies only. Offers one-time rights, electronic media rights. Model/property release preferred. Pho-

to captions required; include correct botanical and common names.

HOW TO CONTACT E-mail query letter with JPEG samples at 72 dpi. Does not keep samples on file; cannot return material. Expects minimum initial submission of 100 images with quarterly submissions of at least 100 images. Photo guidelines available online. Market tips sheet available free via e-mail.

TIPS "Look at our stock and gauge our style and range and supply images that complement and/or expand the collection."

FOODPIX

Getty Images, 605 Fifth Ave. S., Suite 400, Seattle WA, 98104. (206)925-5000. **E-mail:** sales@gettyimages.com. **Website:** www.gettyimages.com. Estab. 1994. Stock agency. Member of the Picture Archive Council of America (PACA). Has 40,000 photos in files. Clients include: advertising agencies, businesses, newspapers, book publishers, calendar companies, design firms, magazine publishers.

NEEDS Food, beverage and food/lifestyle images.

SPECS Accepts analog and digital images. Review and complete the online submission questionnaire on the website before submitting work.

PAYMENT & TERMS Enforces minimum prices. Offers volume discounts to customers; terms specified in photographers' contracts. Works with photographers on contract basis only. Offers exclusive contract only. Statements issued monthly. Payment made quarterly. Offers one-time rights. Model/property release required. Photo captions required.

HOW TO CONTACT Send query e-mail with samples. Expects maximum initial submission of 50 images. Catalog available.

FOTOAGENT

E-mail: werner@fotoagent.com. **Website:** www.fotoagent.com. **Contact:** Werner J. Bertsch, president. Estab. 1985. Stock photo agency. Has 1.5 million photos in files. Clients include: magazines, advertising agencies, newspapers, publishers.

NEEDS General worldwide travel, medical, and industrial.

SPECS Uses digital files only. Upload your files on website.

PAYMENT & TERMS Pays 50% commission for b&w or color photos. Average price per image (to cli-

ents): $175 minimum for b&w or color photos. Works with photographers on contract basis only. Offers nonexclusive contract. Contracts renew automatically with each submission for 1 year. Statements issued monthly. Payment made monthly. Photographers allowed to review account records to verify sales figures. Offers one-time rights. Model release required. Photo captions required.

HOW TO CONTACT Use the "Contact Us" feature on website.

TIPS Wants to see "clear, bright colors and graphic style. Looking for photographs with people of all ages with good composition, lighting, and color in any material for stock use."

⬤ FOTO-PRESS TIMMERMANN

Speckweg 34A, Moehrendorf D-91096 Germany. +49-9131-42801. **Fax:** +49-9131-450528. **E-mail:** info @f-pt.com. **Website:** www.f-pt.com. **Contact:** Wolfgage Timmermann. Stock photo agency. Has 750,000 photos in files. Clients include: advertising agencies, audiovisual firms, businesses, book/encyclopedia publishers, magazine publishers, newspapers, calendar companies.

NEEDS Landscapes, countries, travel, tourism, towns, people, business, nature, babies/children/teens, couples, families, parents, senior citizens, adventure, entertainment, health/fitness/beauty, hobbies, industry, medicine, technology/computers. Interested in erotic, fine art, seasonal, lifestyle.

SPECS Uses 2¼×2¼, 4×5, 8×10 transparencies (no prints). Accepts images in digital format. Send via CD, ZIP as TIFF files.

PAYMENT & TERMS Pays 50% commission for color photos. Works on nonexclusive contract basis (limited regional exclusivity). First period: 3 years; contract automatically renewed for 1 year. Photographers allowed to review account records. Statements issued quarterly. Payment made quarterly. Offers one-time rights. Informs photographers and allows them to negotiate when a client requests to buy all rights. Model/property release preferred. Photo captions required; include state, country, city, subject, etc.

HOW TO CONTACT Send query letter with stock list. Send unsolicited photos by mail for consideration; include SAE/IRC for return of material. Responds in 1 month.

FUNDAMENTAL PHOTOGRAPHS

210 Forsyth St., Suite 2, New York NY, 10002. (212)473-5770. **E-mail:** mail@fphoto.com. **Website:** www.fphoto.com. **Contact:** Kip Peticolas, partner. Estab. 1979. Stock photo agency. Applied for membership into the Picture Archive Council of America (PACA). Member of ASPP. Has 100,000 photos in files. Searchable online database. Clients include: textbook/encyclopedia publishers, advertising agencies, science magazine publishers, travel guide book publishers, corporate industrial.

NEEDS Photos of medicine, biology, microbiology, environmental, industry, weather, disasters, science-related business concepts, agriculture, technology/computers, optics, advances in science and industry, green technologies, pollution, physics and chemistry concepts.

SPECS Accepts 35mm and all large-format transparencies but digital is strongly preferred. Send digital as RAW or TIFF unedited original files at 300 dpi, 11×14 or larger size. Please e-mail for current submission guidelines.

PAYMENT & TERMS Pays 50% commission for color photos. General price range (to clients): $100-500 for b&w photos; $150-1,200 for color photos; depends on rights needed. Enforces strict minimum prices. Offers volume discount to customers. Works with photographers on contract basis only. Offers guaranteed subject exclusivity. Contracts renew automatically with additional submissions for 2 or 3 years. Charges $5/image scanning fee; can increase to $15 if corrective Photoshop work required. Charges copyright registration fee (optional). Statements issued and payment made quarterly for any sales during previous quarter. Photographers allowed to review account records with written request submitted 2 months in advance. Offers one-time and electronic media rights. Gets photographer's approval when client requests all rights; negotiation conducted by the agency. Model release required. Photo captions required; include date and location.

HOW TO CONTACT E-mail request for current photo guidelines. Contact via e-mail to arrange digital submission. Submit link to web portfolio for review. Send query e-mail with résumé of credits, samples or list of stock photo subjects. Keeps samples on file; include SASE for return of material if sending by post. Expects minimum initial submission of 100 images. E-mail crucial for communicating current photo needs.

TIPS "Our primary market is science textbooks. Photographers should research the type of illustration used and tailor submissions to show awareness of salable material. We are looking for science subjects ranging from nature and rocks to industrials, medicine, chemistry, and physics; macro photography, photomicrography, stroboscopic; well-lit still-life shots are desirable. The biggest trend that affects us is the need for images that document new discoveries in sciences and ecology. Please avoid images that appear dated, images with heavy branding, soft focus or poorly lit subjects."

GETTY IMAGES

605 Fifth Ave. S., Seattle WA, 98104. (206)925-5000 or (800)462-4379. **E-mail:** sales@gettyimages.com, editorialsubmissions@gettyimages.com. **Website:** www.gettyimages.com. "Getty Images is the world's leading imagery company, creating and distributing the largest and most relevant collection of still and moving images to communication professionals around the globe and supporting their work with asset management services. From news and sports photography to contemporary and archival imagery, Getty Images' products are found each day in newspapers, magazines, advertising, films, television, books and websites. Gettyimages.com is the first place customers turn to search, purchase, download and manage powerful imagery. Seattle-headquartered Getty Images is a global company with customers in more than 100 countries."

HOW TO CONTACT Visit www.gettyimages.com/contributors.

◐⊛ GRANATAIMAGES.COM

Milestone Media SRL, Via Giuseppe Saragat, 11, Milan 20128 Italy. (39)(02)26680702. **Fax:** (39)(02)26681126. **E-mail:** redazione@milestonemedia.it; info@milestonemedia.it. **Website:** www.milestonemedia.it. Estab. 1985. Stock and press agency. Member of CEPIC. Has 2 million photos in files and 800,000 images online. Clients include: advertising agencies, newspapers, book publishers, calendar companies, audiovisual firms, magazine publishers, production houses.

NEEDS Photos of celebrities, people.

SPECS Uses high-res digital files. Send via ZIP, FTP, e-mail as TIFF, JPEG files.

PAYMENT & TERMS Negotiates fees below stated minimums in cases of volume deals. Offers volume discounts to customers. Photographers can choose not to sell images on discount terms. Works with photographers on contract basis only. Offers exclusive contract only. Contracts renew automatically with additional submissions for 1 year. Statements issued monthly. Photographers allowed to review account records in cases of discrepancies only. Offers one-time rights. Model/property release preferred. Photo captions required; include location, country, and any other relevant information.

HOW TO CONTACT Send query letter with digital files.

🌀 HERITAGE IMAGES

Clerks Court, 18-20 Farringdon Lane, London EC1R 3AU United Kingdom. UK: 08-0043-6867 or US: (888)761-9293. **Fax:** +44-20-74340673. **E-mail:** angela.davies@heritage-images.com. **Website:** www.heritage-images.com. Estab. 1998. Member of BAPLA (British Association of Picture Libraries and Agencies). Has 250,000+ images on file. Clients include: advertisers/designers, businesses, book publishers, magazine publishers, newspapers, calendar/card companies, merchandising, TV.

NEEDS Worldwide religion, faith, spiritual images, buildings, clergy, festivals, ceremony, objects, places, food, ritual, monks, nuns, stained glass, carvings, the unusual. Mormons, Shakers, all groups/sects, large or small. Death: burial, funerals, graves, gravediggers, green burial, commemorative. Ancient/heritage/Bible/lands/saints/eccentricities/festivals: curiosities, unusual oddities like follies, signs, symbols. Architecture, religious or secular. Manuscripts and illustrations, old and new, linked with any of the subjects above.

SPECS Accepts images in digital format. Send via CD, JPEG files in medium to high-res. Uses 35mm, 2¼×2¼, 4×5 transparencies.

PAYMENT & TERMS Average price per image (to clients): $140-200 for color photos. Offers volume discounts to customers. Works with photographers on contract basis for 5 years, offering exclusive/nonexclusive contract renewable automatically with additional submissions. Offers one-time rights. Model release where necessary. Photo captions very important and must be accurate; include what, where, any special features or connections, name, date (if possible), and religion.

HOW TO CONTACT Send query letter with slides, tearsheets, transparencies/CD. Expects minimum initial submission of 40 images. Photo guidelines sheet and "wants list" available via e-mail.

TIPS "Decide on exact subject of image. *Get in close and then closer.* Exclude all extraneous matter. Fill the frame. Dynamic shots. Interesting angles, light. No shadows or miniscule subject matter far away. Tell us what is important about the picture. No people in shot unless they have a role in the proceedings as in a festival or service, etc."

🌀 HUTCHISON PICTURE LIBRARY

P.O. Box 2190, Shoreham-by-Sea, West Sussex BN43 9EZ United Kingdom. **E-mail:** library@hutchisonpictures.co.uk. **Website:** www.hutchisonpictures.co.uk. **Contact:** Stephen Rafferty, manager. Stock photo agency, picture library. Has around 500,000 photos in files. Clients include: ad agencies, public relations firms, audiovisual firms, businesses, book/encyclopedia publishers, magazine publishers, newspapers, postcard companies, calendar companies, television and film companies.

NEEDS "We are a general, documentary library (no news or personalities). We file mainly by country and aim to have coverage of every country in the world. Within each country we cover such subjects as industry, agriculture, people, customs, urban, landscapes, etc. We have special files on many subjects such as medical (traditional, alternative, hospital, etc.), energy, environmental issues, human relations (relationships, childbirth, young children, etc., but all real people, not models). We constantly require images of Spain and Spanish-speaking countries. Also interested in babies/children/teens, couples, multicultural, families, parents, senior citizens, disasters, architecture, education, gardening, interiors/decorating, religious, rural, health/fitness, travel, military, political, science, technology/computers. Interested in documentary, seasonal. We are a color library."

SPECS Uses 35mm transparencies. Accepts images in digital format: 50MB at 300 dpi, cleaned of dust and scratches at 100%, color corrected.

PAYMENT & TERMS Pays 40% commission for exclusive; 35% for nonexclusive. Statements issued semiannually. Payment made semiannually. Sends statement with check in June and January. Offers one-

time rights. Model release preferred. Photo captions required.

HOW TO CONTACT Always willing to look at new material or collections. Arrange a personal interview to show portfolio. Send letter with brief description of collection and photographic intentions. Responds in about 2 weeks, depends on backlog of material to be reviewed. "We have letters outlining working practices and lists of particular needs (they change)." Distributes tips sheets to photographers who already have a relationship with the library.

TIPS Looks for "collections of reasonable size (rarely less than 1,000 transparencies) and variety; well captioned (or at least well indicated picture subjects; captions can be added to mounts later); sharp pictures, good color, composition; and informative pictures. Prettiness is rarely enough. Our clients want information, whether it is about what a landscape looks like or how people live, etc. The general rule of thumb is that we would consider a collection that has a subject we do not already have coverage of or a detailed and thorough specialist collection. Please do not send *any* photographs without prior agreement."

ICP DI ALESSANDRO MAROSA

Via Pico della Mirandola 8/A - 20151, Milano 20151,Italy. Milan: +39-02-89605794; Rome: +39-06-452217748; Torino: +39-011-23413919. **Fax:** +39-02-700565601. **E-mail:** icp@icponline.it; alessandro@icponline.it. **Website:** www.icponline.it. **Contact:** Mr. Alessandro Marosa, CEO. Estab. 1970. Stock photo agency. Clients include: advertising agencies, public relations firms, audiovisual firms, businesses, book/encyclopedia publishers, magazine publishers, postcard publishers, calendar companies, and greeting card companies.

SPECS High-res digital (A3-A4, 300 dpi), keyworded (English and, if possible, Italian).

PAYMENT & TERMS Pays 20% commission for color photos. Offers volume discounts to customers; terms specified in photographer's contract. Discount sales terms not negotiable. Contracts renew automatically with additional submissions, for 3 years. Statements issued monthly. Payment made monthly. Model/property release required. Photo captions required.

HOW TO CONTACT Arrange a personal interview to show portfolio. Send query letter with samples and stock list. Works on assignment only. No fixed minimum for initial submission. Responds in 3 weeks, if interested.

IMAGES.DE FULFILLMENT

Potsdamer Str. 96, Berlin D-10785, Germany. +49(0)30-2579 28980. **Fax:** +49(0)30-2579 28999. **E-mail:** info@images.de. **Website:** www.images.de. Estab. 1997. News/feature syndicate. Has 50,000 photos in files. Clients include: advertising agencies, newspapers, public relations firms, book publishers, magazine publishers. "We are a service company with 10 years experience on the picture market. We offer fulfillment services to picture agencies, including translation, distribution into Fotofiner and APIS picturemaxx, customer communication, invoicing, media control, cash delivery, and usage control."

NEEDS Photos of babies/children/teens, couples, multicultural, families, parents, senior citizens, environment, entertainment, events, food/drink, health/fitness, hobbies, travel, agriculture, business concepts, industry, medicine, political, science, technology/computers.

SPECS Accepts images in digital format. Send via FTP, CD.

PAYMENT & TERMS Pays 50% commission for b&w photos; 50% for color photos. Average price per image (to clients): $50-1,000 for b&w photos or color photos. Offers volume discounts to customers. Discount sales terms not negotiable. Works with photographers with or without a contract; negotiable. Offers limited regional exclusivity. Statements issued monthly. Payment made monthly. Photographers allowed to review account records in cases of discrepancies only. Offers one-time rights, electronic media rights. Informs photographers and allows them to negotiate when client requests all rights. Model release preferred; property release required. Photo captions required.

HOW TO CONTACT Send query letter with CD or link to website. Expects minimum initial submission of 100 images.

THE IMAGE WORKS

P.O. Box 443, Woodstock NY, 12498. (845)679-8500 or (800)475-8801. **Fax:** (845)679-0606. **E-mail:** info@theimageworks.com; mark@theimageworks.com. **Website:** www.theimageworks.com. **Contact:** Mark Antman, president. Estab. 1983. Stock photo agency. Member of Picture Archive Council of America (PACA). Has over 1 million photos in files. Clients

include: ad agencies, book/encyclopedia publishers, magazine publishers, newspapers, postcard publishers, greeting card companies, documentary video.

NEEDS "We are always looking for excellent documentary photography. Our prime subjects are people-related subjects like family, education, health care, workplace issues, worldwide historical, technology, fine arts."

SPECS All images must be in digital format; contact for digital guidelines. Rarely accepts 35mm, 2¼×2¼ transparencies, and prints.

PAYMENT & TERMS Works with photographers on contract basis only. Offers nonexclusive contract. Statements issued monthly. Payments made monthly. Photographers allowed to review account records to verify sales figures by appointment. Offers one-time, agency promotion and electronic media rights. Informs photographers and allows them to negotiate when clients request all rights. Model release preferred. Photo captions required.

HOW TO CONTACT Send e-mail with description of stock photo archives. Expects minimum initial submission of 500 images.

TIPS "The Image Works was one of the first agencies to market images digitally. All digital images from photographers must be of reproduction quality. When making a new submission to us, be sure to include a variety of images that show your range as a photographer. We also want to see some depth in specialized subject areas. Thorough captions are a must. We will not look at uncaptioned images. Write or call first."

❶❸❺ INMAGINE

315 Montgomery St., San Francisco CA, 94104. (832)632-9299 or (800)810-3888. **Fax:** (866)998-8383. **E-mail:** photo@inmagine.com. **Website:** www.inmagine.com. Estab. 2000. Stock agency, picture library. Member of the Picture Archive Council of America (PACA). Has 7 million photos in files. Branch offices in USA, Hong Kong, Australia, Malaysia, Thailand, Singapore, Indonesia, and China. Clients include: advertising agencies, businesses, newspapers, public relations firms, magazine publishers.

NEEDS Photos of babies, children, teens, couples, multicultural, families, parents, education, business concepts, industry, medicine, environmental and landscapes, adventure, entertainment, events, food and drink, health, fitness, beauty, hobbies, sports, travel, fashion/glamour, and lifestyle.

SPECS Accepts images in digital format. Submit online via submission.inmagine.com or send JPEG files at 300 dpi.

PAYMENT & TERMS Pays 50% commission for color photos. Average price per image (to clients): $100 minimum, maximum negotiable. Negotiates fees below stated minimums. Offers volume discounts to customers, terms specified in photographers' contracts. Works with photographers on a contract basis only. Offers nonexclusive contract. Payments made monthly. Photographers are allowed to view account records in cases of discrepancies only. Offers one-time rights. Model and property release required. Photo caption required.

HOW TO CONTACT Contact through website. Expects minimum initial submission of 5 images. Responds in 1 week to samples. Photo guidelines available online.

TIPS "Complete the steps as outlined in the IRIS submission pages. E-mail us if there are queries. Send only the best of your portfolio for submission, stock-oriented materials only. EXIF should reside in file with keywords and captions."

⊚ INTERNATIONAL PHOTO NEWS

2902 29th Way, West Palm Beach FL, 33407. (561)313-1465. **E-mail:** jay@jaykravetz.com. **Contact:** Jay Kravetz, photo editor. News/feature syndicate. Has 50,000 photos in files. Clients include: newspapers, magazines, book publishers. Previous/current clients include: newspapers that need celebrity photos with story.

NEEDS Photos of celebrities, entertainment, events, health/fitness/beauty, performing arts, travel, politics, movies, music and television, at work or play. Interested in avant garde, fashion/glamour.

SPECS Accepts images in digital format. Send via CD, ZIP, e-mail as TIFF, JPEG files at 300 dpi. Uses 5×7, 8×10 glossy b&w prints.

PAYMENT & TERMS Pays $10 for b&w photos; $25 for color photos; 5-10% commission. Average price per image (to clients): $25-100 for b&w photos; $50-500 for color photos. Works with photographers on contract basis only. Offers nonexclusive contract. Contracts renew automatically with additional submissions; 1-year renewal. Photographers allowed to review account records. Statements issued monthly.

Payment made monthly. Offers one-time rights. Model/property release preferred. Photo captions required.

HOW TO CONTACT Send query letter with résumé of credits. Solicits photos by assignment only. Responds in 1 week.

TIPS "We use celebrity photographs to coincide with our syndicated columns. Must be approved by the celebrity."

THE IRISH IMAGE COLLECTION

#101, 10464 - 176 St., Edmonton, Alberta T5S 1L3 Canada. (780)447-5433. **E-mail:** kristi@ theirishimagecollection.com. **Website:** www. theirishimagecollection.ie. **Contact:** Kristi Bennell, office manager. Stock photo agency and picture library. Has 50,000+ photos in files. Clients include: advertising agencies, public relations firms, businesses, book/encyclopedia publishers, magazine publishers, newspapers, and designers.

NEEDS Consideration is given only to Irish or Irish-connected subjects.

SPECS Uses 35mm and all medium-format transparencies.

PAYMENT & TERMS Pays 40% commission for color photos. Average price per image (to client): $85-2,000. Works on contract basis only. Offers exclusive contracts and limited regional exclusivity. Contracts renew automatically with additional submissions. Statements issued quarterly. Payment made quarterly. Photographers allowed to review account records. Offers one-time and electronic media rights. Informs photographer when client requests all rights, but "we take care of negotiations." Model release required. Photo captions required.

HOW TO CONTACT Send query letter with list of stock photo subjects. Does not return unsolicited material. Expects minimum initial submission of 250 transparencies; 1,000 images annually. "A return shipping fee is required: important that all similars are submitted together. We keep our contributor numbers down and the quantity and quality of submissions high. Send for information first by e-mail."

TIPS "Our market is Ireland and the rest of the world. However, our continued sales of Irish-oriented pictures need to be kept supplied. Pictures of Irish-Americans in Irish bars, folk singing, Irish dancing, in Ireland or anywhere else would prove to be useful. They would be required to be beautifully lit, carefully composed with attractive, model-released people."

THE IRISH PICTURE LIBRARY

69b Heather Rd., Sandyford Industrial Estate, Dublin 18, Ireland. (353)1295 0799. **Fax:** (353)1295 0705. **E-mail:** info@davison.com; ipl@davisonphoto.com. **Website:** www.davisonphoto.com/ipl. Estab. 1990. Picture library. Has 60,000+ photos in files. Clients include: advertising agencies, businesses, book publishers, magazine publishers, newspapers, calendar companies.

NEEDS Photos of historic Irish material. Interested in alternative process, fine art, historical/vintage.

SPECS Uses any prints. Accepts images in digital format. Send via CD as TIFF, JPEG files at 400 dpi.

PAYMENT & TERMS Enforces minimum prices. Offers volume discounts to customers. Photographers can choose not to sell images on discount terms. Works with photographers on contract basis only. Statements issued quarterly. Payment made quarterly. Photographers allowed to review account records. Offers one-time rights, electronic media rights. Property release required. Photo captions required.

HOW TO CONTACT Send query letter with photocopies. Does not keep samples on file; include SAE/IRC for return of material.

ISOPIX

Werkhuizenstraat 7-9 Rue des Ateliers, Brussel-Bruxelles 1080 Belgium. +32-2-420-30-50. **Fax:** +32-2-420-41-22. **E-mail:** isopix@isopix.be. **Website:** www. isopix.be. Estab. 1984. News/feature syndicate. Has 2.5 million photos on website, including press (celebrities, royalty, portraits, news sports, archival), stock (contemporary and creative photography) and royalty-free. Clients include: advertising agencies, public relations firms, businesses, book publishers, magazine publishers, newspapers, calendar companies, postcard publishers.

NEEDS Photos of teens, celebrities, couples, families, parents, senior citizens, disasters, environmental, landscapes/scenics, wildlife, education, religious, events, food/drink, health/fitness, hobbies, humor, agriculture, business concepts, industry, medicine, science, technology/computers. Interested in alternative process, avant garde, documentary, fashion/glamour, fine art, historical/vintage, seasonal.

SPECS Accepts images in digital format; JPEG files only.

PAYMENT & TERMS Enforces strict minimum prices. Works with photographers with or without a contract; negotiable. Offers limited regional exclusivity. Contracts renew automatically with additional submissions. Statements issued monthly. Payment made monthly. Photographers allowed to review account records in cases of discrepancies only. Model/property release preferred. Photo captions required.

HOW TO CONTACT Contact through rep. Does not keep samples on file; include SAE/IRC for return of material. Expects minimum initial submission of 1,000 images with quarterly submissions of at least 500 images.

ISRAELIMAGES.COM

POB 60, Kammon 20112 Israel. +972-3-6320374. **Fax:** +972-153-4-9082023. **E-mail:** israel@israelimages.com; info@israelimages.com. **Website:** www.israelimages.com. **Contact:** Israel Talby, managing director. Estab. 1991. Has 650,000 photos in files. Clients include: advertising agencies, web designers, businesses, book publishers, magazine publishers, newspapers, calendar companies, greeting card and postcard publishers, multimedia producers, schools and universities, etc.

NEEDS "We are interested in everything about Israel, Judaism (worldwide), and The Holy Land."

SPECS Uses digital material only, minimum accepted size 2,000×3,000 pixels. Simply upload your pictures directly to the site. "When accepted, we need TIFF or JPEG files at 300 dpi, RGB, saved at quality '11' in Photoshop."

PAYMENT & TERMS Average price per image (to clients): $50-3,000/picture. Negotiates fees below standard minimum against considerable volume that justifies it. Offers volume discounts to customers. Works with photographers on contract basis only. Offers limited regional exclusivity, nonexclusive contract. Contracts renew automatically with additional submissions. Sales reports are displayed on the site at the Contributor's personal account. Payments are constantly made. Photographers allowed to review account records. Offers one-time rights, electronic media rights, agency promotion rights. Informs photographers and allows them to negotiate when a client requests all rights. Model/property release preferred. Photo captions required (what, who, when, where).

HOW TO CONTACT E-mail any query to: Israel@israelimages.com. No minimum submission. Responds within 1-2 days.

TIPS "We strongly encourage everyone to send us images to review. When sending material, a strong edit is a must. We don't like to get 100 pictures with 50 similars. Last, don't overload our e-mail with submissions. Make an e-mail query, or better yet, view our submission guidelines on the website. Good luck and welcome!"

JEROBOAM

120 27th St., San Francisco CA, 94110. (415)312-0198. **E-mail:** jeroboamster@gmail.com. **Contact:** Ellen Bunning, owner. Estab. 1972. Has 200,000 b&w photos, 200,000 color slides in files. Clients include: text and trade book, magazine and encyclopedia publishers, editorial (mostly textbooks), greeting cards, and calendars.

NEEDS "We want people interacting, relating photos, comic, artistic/documentary/photojournalistic images, especially ethnic and handicapped. Images must have excellent print quality—contextually interesting and exciting and artistically stimulating." Photos of babies/children/teens, couples, multicultural, families, parents, senior citizens, disasters, environmental, cities/urban, education, gardening, pets, religious, rural, adventure, health/fitness, humor, performing arts, sports, travel, agriculture, industry, medicine, military, political, science, technology/computers. Interested in documentary, historical/vintage, seasonal. Needs shots of school, family, career and other living situations. Child development, growth and therapy, medical situations. No nature or studio shots.

SPECS Uses 35mm transparencies.

PAYMENT & TERMS Works on consignment only; pays 50% commission. Average price per image (to clients): $150 minimum for b&w and color photos. Works with photographers without a signed contract. Statements issued monthly. Payment made monthly. Photographers allowed to review account records to verify sales figures. Offers one-time and electronic media rights. Informs photographers and allows them to negotiate when client requests all rights. Model/property release preferred for people in contexts of special education, sexuality, etc. Photo captions preferred; include "age of subject, location, etc."

HOW TO CONTACT "Call if in the Bay Area; if not, query with samples and list of stock photo sub-

jects; send material by mail for consideration or submit portfolio for review. Let us know how long you've been shooting." Responds in 2 weeks.

TIPS "The Jeroboam photographers have shot professionally a minimum of 5 years, have experienced some success in marketing their talent, and care about their craft excellence and their own creative vision. New trends are toward more intimate, action shots; more ethnic images needed."

KIMBALL STOCK

1960 Colony St., Mountain View CA, 94043. (650)969-0682 or (888)562-5522. **Fax:** (650)969-0485. **E-mail:** sales@kimballstock.com; submissions@kimballstock.com. **Website:** www.kimballstock.com. Estab. 1970. Has 1 million photos in files. Clients include: advertising agencies, businesses, newspapers, postcard publishers, public relations firms, book publishers, calendar companies, magazine publishers, greeting card companies. "Kimball Stock strives to provide automotive and animal photographers with the best medium possible to sell their images. In addition, we work to give every photographer a safe, reliable, and pleasant experience."

NEEDS Photos of dogs, cats, lifestyle with cars and domestic animals, landscapes/scenics, wildlife (outside of North America). Interested in seasonal.

SPECS Prefers images in digital format, minimum of 12-megapixel digital camera, although 16-megapixel is preferred. Send via e-mail as JPEG files or send CD to mailing address. Uses 35mm, 120mm, 4×5 transparencies.

PAYMENT & TERMS Works with photographers with a contract; negotiable. Offers nonexclusive contract. Statements issued quarterly. Payments made quarterly. Photographers allowed to review account records. Offers one-time rights, electronic media rights. Model/property release required. Photo captions required.

HOW TO CONTACT Send query letter with transparencies, digital files, stock list. Provide self-promotion piece to be kept on file. Please limit your initial submission to no more than 200 images (with at least 100 images) showing the range and variety of your work. Responds only if interested in 5-6 weeks or 3 months during busy seasons; send nonreturnable samples. Photo guidelines available online at www.kimballstock.com/submissions.asp.

JOAN KRAMER AND ASSOCIATES, INC.

10490 Wilshire Blvd., Suite 1701, Los Angeles CA, 90024. (310)446-1866. **Fax:** (310)446-1856. **E-mail:** erwin@erwinkramer.com. **Website:** www.erwinkramer.com. Joan Kramer, president. **Contact:** Erwin Kramer. Member of Picture Archive Council of America (PACA). Has 1 million photos in files. Clients include: ad agencies, magazines, recording companies, photo researchers, book publishers, greeting card companies, promotional companies, AV producers.

NEEDS "We use any and all subjects! Stock slides must be of professional quality." Subjects on file include travel, cities, personalities, animals, flowers, lifestyles, underwater, scenics, sports, and couples.

SPECS Uses 8×10 glossy b&w prints; any size transparencies.

PAYMENT & TERMS Pays 50% commission. Offers all rights. Model release required.

HOW TO CONTACT Send query letter or call to arrange an appointment. Do not send photos before calling.

LAND OF THE BIBLE PHOTO ARCHIVE

P.O. Box 8441, Jerusalem 91084, Israel. +972-2-566-2167. **Fax:** +972-2-566-3451. **E-mail:** radovan@netvision.net.il. **Website:** www.biblelandpictures.com. **Contact:** Zev Radovan. Estab. 1975. Picture library. Has 50,000 photos in files. Clients include: book publishers, magazine publishers, newspapers, calendar companies, postcard publishers.

NEEDS Photos of museum objects, archaeological sites. Also multicultural, landscapes/scenics, architecture, religious, travel. Interested in documentary, fine art, historical/vintage.

SPECS Uses high-res digital system.

PAYMENT & TERMS Average price per image (to clients): $80-700 for b&w, color photos. Offers volume discounts to customers; terms specified in photographers' contracts.

TIPS "Our archives contain tens of thousands of color slides covering a wide range of subjects: historical and archaeological sites, aerial and close-up views, museum objects, mosaics, coins, inscriptions, the myriad ethnic and religious groups individually portrayed in their daily activities, colorful ceremonies, etc. Upon request, we accept assignments for in-field photography."

LATITUDE STOCK

Home Farm, Stratfield Saye, Hampshire, RG7 2BT, United Kingdom. +44-845-0940546. **E-mail:** stuart@latitudestock.com. **Website:** www.latitudestock.com. Has over 115,000 photos in files. Clients include: advertising agencies, businesses, newspapers, public relations firms, book publishers, calendar companies, audiovisual firms, magazine publishers, greeting card companies.

NEEDS Photos of multicultural, environmental, landscapes/scenics, wildlife, architecture, cities/urban, gardening, religious, rural, adventure, events, food/drink, health/fitness/beauty, hobbies, sports, travel.

SPECS Uses 35mm and medium-format transparencies. Accepts images in digital format. See website for details.

PAYMENT & TERMS Pays on a commission basis. Enforces minimum prices. Offers volume discounts to customers. Works with photographers on contract basis only. Offers exclusive contract only. Statements issued quarterly. Payment made quarterly. Photographers allowed to review account records. Offers one-time rights. Model/property release required. Photo captions required.

HOW TO CONTACT "Please e-mail first."

LEBRECHT MUSIC & ARTS PHOTO LIBRARY

3 Bolton Rd., London NW8 0RJ United Kingdom. +44-20-7625-5341 or (866)833-1793. **E-mail:** pictures@lebrecht.co.uk. **Website:** www.lebrecht.co.uk. **Contact:** Ms. E. Lebrecht. Estab. 1992. Picture library has 300,000 high-res images online—musicians, artists, authors, politicians, scientists. Clients include: newspapers, public relations firms, book publishers, calendar companies, magazine publishers, greeting card companies.

NEEDS Photos of arts personalities, performing arts, instruments, musicians, dance (ballet, comtemporary and folk), orchestras, opera, concert halls, jazz, blues, rock, authors, artists, theater, comedy, art, writers, historians, plays, playwrights, philosophers, etc. Interested in historical/vintage.

SPECS Accepts images in digital format only.

PAYMENT & TERMS Pays 50% commission for b&w and color photos. Offers volume discounts to customers. Works with photographers on contract basis only. Offers limited regional exclusivity. State-

ments issued quarterly. Offers one-time rights. Informs photographers and allows them to negotiate when a client requests all rights. Model release preferred. Photo captions required; include who is in photo, location, date.

HOW TO CONTACT Send e-mail to pictures@lebrecht.co.uk.

LIGHTROCKET

LightRocket Pte Ltd, 30 Cecil St., Prudential Tower Level 15, 049712, Singapore. **E-mail:** info@lightrocket.com. **Website:** www.lightrocket.com. **Contact:** Peter Charlesworth or Yvan Cohen, directors. Estab. 2001. LightRocket is a browser based platform that provides comprehensive tools and services for Photographers and Visual Artists. For a small subscription contributors are provided with their own configurable website, storage and backup, archive management and contact management tools; along with promotion of their work to thousands of clients around the globe. Our contributors can sign up for a FREE account and need only subscribe if they like our system and want to expand their subscription plan.

SPECS Accepts all file formats for Images and Videos. Also accepts other file types such as PDF, Word, Excel, you name it.. No limit to the number of files and storage can be added in 'blocks'. Premium accounts get 100 GBs of storage to start with.

PAYMENT & TERMS Contributors get 100% of all sales. Clients contact them directly to negotiate and pay license fees.

HOW TO CONTACT "No need to contact us - just sign up for a FREE contributor account on www.lightrocket.com and if you like our service, you can subscribe."

LIGHTWAVE PHOTOGRAPHY

(781)354-7747. **E-mail:** paul@lightwavephoto.com. **Website:** www.lightwavephoto.com. **Contact:** Paul Light. Has 250,000 photos in files. Clients include: advertising agencies, textbook publishers.

NEEDS Candid photos of people in school, work and leisure activities, lifestyle.

SPECS Uses digital photographs.

PAYMENT & TERMS Pays $210/photo; 50% commission. Works with photographers on contract basis only. Offers nonexclusive contract. Contracts renew automatically each year. Statements issued annually. Payments made "after each usage." Offers one-time

rights. Informs photographers and allows them to negotiate when client requests all rights. Model/property release preferred. Photo captions preferred.

HOW TO CONTACT "Create a small website and send us the URL."

TIPS "Photographers should enjoy photographing people in everyday activities. Work should be carefully edited before submission. Shoot constantly and watch what is being published. We are looking for photographers who can photograph daily life with compassion and originality."

● LINEAIR FOTOARCHIEF BV

Lineair Beeldresearch, Raapopseweg 66, Arnhem 6824DT Netherlands. +31-26-4456713. **E-mail:** info@ lineairfoto.nl. **Website:** www.lineairfoto.nl. **Contact:** Ron Giling, manager. Estab. 1990. Stock photo agency and since 2001 also an image-research department as service to publishers and other customers. Has nearly 2 million downloadable images available through the website. Clients include advertising agencies, public relations firms, book/encyclopedia publishers, magazine publishers. Library specializes in images from Asia, Africa, Latin America, Eastern Europe, and nature in all forms on all continents. Member of WEA, a group of international libraries that use the same server to market each other's images, uploading only once.

NEEDS Photos of disasters, environment, landscapes/scenics, wildlife, cities/urban, education, religious, adventure, travel, agriculture, business concepts, industry, political, science, technology/computers, health, education. Interested in everything that has to do with the development of countries all over the world, especially in Asia, Africa, and Latin America.

SPECS Accepts images in digital format only. Send via CD, DVD (or use our FTP) as high-quality JPEG files at 300 dpi. "Photo files need to have IPTC information!"

PAYMENT & TERMS Pays 50% commission. Average price per image (to clients): $80-250. Enforces minimum prices. Offers volume discounts to customers; inquire about specific terms. Photographers can choose not to sell images on discount terms. Works with or without a signed contract; negotiable. Offers limited regional exclusivity. Statements issued quarterly. Payments made quarterly. Photographers allowed to review account records. "They can review bills to clients involved." Offers one-time rights. Informs photographers and allows them to negotiate when client requests all rights. Photo captions required; include country, city or region, description of the image.

HOW TO CONTACT Submit portfolio or e-mail thumbnails (20KB files) for review. There is no minimum for initial submissions. Responds in 3 weeks. Market tips sheet available upon request. View website to see subject matter and quality.

TIPS "We like to see high-quality pictures in all aspects of photography. So we'd rather see 50 good ones than 500 for us to select the 50 out of. Send contact sheets upon our request. We will mark the selected pictures for you to send as high-res, including the very important IPTC (caption and keywords)."

LIVED IN IMAGES

1401 N. El Camino Real,, Suite 203, San Clemente CA 92672. (949)361-3959. **Fax:** (949)492-1370. **E-mail:** jonathan@livedinimages.com. **Website:** www.livedinimages.com. **Contact:** Jonathan Thomas, president. Estab. 2004. Stock agency and news/feature syndicate. Member of the Picture Archive Council of America. Has 500,000+ photos on file. Clients include: advertising agencies, businesses, book publishers, magazine publishers, newspapers.

SPECS Accepts images in digital format. Send via CD, ZIP as TIFF or JPEG files at 300 dpi.

PAYMENT & TERMS Pays 50% commission for b&w photos; 50% for color photos; 50% for film; 50% for video. Offers volume discount to customers. Discount sales terms not negotiable. Works with photographers on contract basis only. Offers exclusive contract. Statements issued monthly. Payment made monthly. Photographers allowed to review account records. Offers one-time rights, electronic media and agency promotion rights. Model/property release required.

HOW TO CONTACT E-mail query letter with link to photographer's website. Samples not kept on file. Materials cannot be returned. Expects minimum initial submission of 100 images with monthly submissions of at least 50 images. Photo guidelines available online. Market tips sheet distributed monthly to contributors under contract (also available online or free via e-mail).

TIPS "Think about your submission and why you are submitting to the agency. Who is the end user? We receive a great deal of work that has absolutely no value.

Also, continue to submit! To make a decent monthly income, photographers need to continually submit their work. It's a numbers game. The more you have, the better you will do!"

LONELY PLANET IMAGES

Getty Images, 6300 Wilshire Blvd., 16th Floor, Los Angeles CA 90048. (510)250-6400 or (800)275-8555. **Fax:** (510)893-8572. **Website:** www.lonelyplanetimages.com; www.lonelyplanet.com. International stock photo agency with offices in Oakland, London, and Footscray (outside Melbourne). Clients include: advertising agencies, public relations firms, book/encyclopedia publishers, magazine publishers, newspapers, calendar companies, greeting card companies, design firms.

NEEDS Photos of international travel destinations.

SPECS Uses original color transparencies in all formats; digital images from 10-megapixel and higher DSLRs.

PAYMENT & TERMS Pays 40% commission. Works with photographers on contract basis only. Offers image exclusive contract. Contract renews automatically. Model/property release preferred. Photo captions required.

HOW TO CONTACT Download submission guidelines from website—click on "work for us" at the bottom of www.lonelyplanet.com page.

TIPS "Photographers must be technically proficient, productive, and show interest and involvement in their work."

LONE PINE PHOTO

22 Robinson Crescent, Saskatoon, Saskatchewan S7L 6N9 Canada. (306)683-0889. **Fax:** (306)242-1892. **E-mail:** lonepinephoto@shaw.ca. **Website:** www.lonepinephoto.ca. **Contact:** Clarence W. Norris. Estab. 1991. "Lone Pine Photo is a photo stock agency specializing in well-edited images of Canada. Our library consists of: 60,000+ 35mm slides, 20,000+ digital images. All images are rights managed. A licensing fee is required for the use of all of our images. All images provided are copyrighted to the photographers that we represent. We have updated our website on which clients may browse through a variety of galleries. Each gallery bears a gallery description summarizing the contents and useful search tips. Full caption information is displayed.

Click on a thumbnail for larger image and more image info. Keywords allow clients to refine their searches."

SPECS "We are seeking stock photographers who have the following attributes: Excellent technical and creative skills to produce top-quality images based on our submission guidelines, subject want lists and on their specific photographic interests and travels. The ability to carefully edit their own work and to send us only the very best with detailed captions. An existing image file to provide us with 500+ images to start. The time and resources to photograph regularly and to submit 500+ images annually for our review. The ability to work together as part of a team to develop a top-quality Canadian stock photo agency." All rights managed. Credit line.

LUCKYPIX

1132 W. Fulton Market, Chicago IL 60607. (773)235-2000. **E-mail:** info@luckypix.com; mmoore@luckypix.com. **Website:** www.luckypix.com. **Contact:** Megan Moore. Estab. 2001. Stock agency. Has 9,000 photos in files (adding constantly). Clients include: advertising agencies, businesses, book publishers, design companies, magazine publishers.

NEEDS Outstanding people/lifestyle images.

SPECS 50+MB TIFFs, 300 dpi, 8-bit files. Photos for review: upload to website or e-mail info@luckypix.com. Final: CD/DVD as TIFF files.

PAYMENT & TERMS Enforces minimum prices. Offers exclusivity by image and similars. Contracts renew automatically annually. Statements and payments issued quarterly. Model/property release required.

HOW TO CONTACT Call or upload sample from website (preferred). Responds in 1 week. See website for guidelines.

TIPS "Have fun shooting. Search the archives before deciding what pictures to send."

MASTERFILE

3 Concorde Gate, 4th Floor, Toronto, Ontario M3C 3N7 Canada. (800)387-9010. **E-mail:** info@masterfile.com. **Website:** www.masterfile.com. General stock agency offering photos, illustrations, and vectors under different licenses, including rights-managed, royalty-free, budget royalty-free, and a subscription model. The combined online collection exceeds 5 million images. Clients include: major advertising agencies, broadcasters, graphic designers, public relations

firms, book and magazine publishers, producers of greeting cards, calendars, and packaging.

SPECS Accepts images in digital format only, in accordance with submission guidelines.

PAYMENT & TERMS Contributor terms outlined in photographer's contract, which is image-exclusive. Photographer sales statements and royalty payments issued monthly.

HOW TO CONTACT Refer to www.masterfile.com/info/artists/submissions.html for submission guidelines.

TIPS "Do not send transparencies, prints, or discs as a first-time submission. If we like what we see, you will be contacted by Artist Recruitment to submit additional work, and high resolution files for a technical review. Due to the large volume of submissions, we contact only those artists we are interested in."

✪ MICHELE MATTEI PHOTOGRAPHY

1714 Wilton Place, Los Angeles CA 90028. (323)462-6342. **Fax:** (323)462-7568. **E-mail:** michele@michelemattei.com. **Website:** michelemattei.net. **Contact:** Michele Mattei, director. Estab. 1974. Stock photo agency. Clients include: book/encyclopedia publishers, magazine publishers, television, film.

TIPS "Shots of celebrities and home/family stories are frequently requested." In samples, looking for "high-quality, recognizable personalities and current newsmaking material. We are interested mostly in celebrity photography. Written material on personality or event helps us to distribute material faster and more efficiently."

☯✪ MAXX IMAGES, INC.

P.O. Box 30064, North Vancouver, British Columbia V7H 2Y8 Canada. 604-985-2560. **E-mail:** newsubmissions@maxximages.com; info@maxximages.com. **Website:** www.maxximages.com. **Contact:** Dave Maquignaz, president. Estab. 1994. Stock agency. Member of the Picture Archive Council of America (PACA). Has 32 million images online. Has 30,000+ video clips. Clients include: advertising agencies, public relations firms, audiovisual firms, businesses, book publishers, magazine publishers, newspapers, calendar companies, postcard publishers, video production, graphic design studios.

NEEDS Photos of people, lifestyle, business, recreation, leisure.

SPECS Uses all formats.

HOW TO CONTACT Send e-mail.

THE MEDICAL FILE, INC.

279 E. 44th St., 21st Floor, New York NY 10017. (212)883-0820 or (917)215-6301. **E-mail:** themedicalfile@gmail.com. **Website:** www.themedicalfile.com. **Contact:** Barbara Gottlieb, president. Estab. 2005. Clients include: advertising agencies, public relations firms, businesses, book/encyclopedia publishers, magazine publishers, postcard companies, calendar companies, greeting card companies.

NEEDS Any medically related imagery including fitness and food in relation to health care.

SPECS Accepts digital format images only on CD or hard drive. Images can be uploaded to an FTP site.

PAYMENT & TERMS Average price per image (for clients): $250 and up. Accepted work will be distributed through our partner agents worldwide. Works on exclusive and nonexclusive contract basis. Contracts renew automatically with each submission for length of original contract. Payments made quarterly. Offers one-time rights. Informs photographers when clients request all rights or exclusivity. Model release required. Photo captions required.

HOW TO CONTACT Arrange a personal interview to show portfolio. Submit portfolio or samples for review. Tip sheets distributed as needed to contract photographers only.

TIPS Wants to see a cross-section of images for style and subject. "Photographers should not photograph people *before* getting a model release. The day of the 'grab shot' is over. We only accept digital submissions."

☯✪ MEDISCAN

2nd Floor Patman House, 23-27 Electric Parade, George Lane South Woodford, London E18 2LS, United Kingdom. +44-20-8530-7589. **Fax:** +44-20- 8989-7795. **E-mail:** info@mediscan.co.uk. **Website:** www.mediscan.co.uk. Estab. 2001. Picture library. Has over 1 million photos and over 2,000 hours of film/video footage on file. Subject matter includes medical personnel and environment, diseases and medical conditions, surgical procedures, microscopic, scientific, ultrasound/CT/MRI scans and x-rays. Online catalog on website. Clients include: advertising and design agencies, business-to-business, newspapers, public relations, book and magazine publishers in the health care, medical, and science arenas.

NEEDS Photos of babies/children/teens/senior citizens; health/lifestyle/fitness/beauty; medicine, especially plastic surgery, rare medical conditions; model-released images; science, including microscopic imagery, botanical and natural history.

SPECS Accepts negatives; 35mm and medium format transparencies; digital images (make contact before submitting samples).

PAYMENT & TERMS Pays up to 50% commission. Statements issued quarterly. Payment made quarterly. Model/property release required, where necessary.

HOW TO CONTACT E-mail or call.

☉ MEGAPRESS IMAGES

1751 Richardson, Suite 2205, Montreal, Quebec H3K 1G6 Canada. (514)279-9859. **Fax:** (514)279-9859. **E-mail:** info@megapress.ca. **Website:** www.megapress.ca. Estab. 1992. Stock photo agency. Has 500,000 photos in files. Has 2 branch offices. Clients include: book/encyclopedia publishers, magazine publishers, postcard publishers, calendar companies, greeting card companies, advertising agencies.

NEEDS Photos of people (babies/children/teens, couples, people at work, medical); animals including puppies in studio; industries; celebrities and general stock. Also needs families, parents, senior citizens, disasters, environmental, landscapes/scenics, wildlife, gardening, pets, religious, adventure, automobile, food/drink, health/fitness/beauty, sports, travel, business concepts, still life, science. "Looking only for the latest trends in photography and very high-quality images. A part of our market is Quebec's local French market."

SPECS Accepts images in digital format only. Send via CD, floppy disk, ZIP as JPEG files at 300 dpi.

PAYMENT & TERMS Pays 50% commission for color photos. Average price per image (to client): $100. Enforces minimum prices. Will not negotiate below $60. Works with photographers with or without a contract. Statements issued semiannually. Payments made semiannually. Offers one-time rights. Model release required for people and controversial news.

HOW TO CONTACT Submit link first by e-mail. "If interested, we'll get back to you." Does not keep samples on file; include SAE/IRC for return of material. Expects minimum initial submission of 250 images with periodic submission of at least 1,000 digital pictures per year. Make first contact by e-mail. Accepts digital submissions only.

TIPS "Pictures must be very sharp. Work must be consistent. We also like photographers who are specialized in particular subjects. We are always interested in Canadian content. Lots of our clients are based in Canada."

MIRA

716 Iron Post Rd., Moorestown NJ 08057. (856)231-0594. **E-mail:** mira@mira.com. **Website:** library.mira.com/gallery-list. "Mira is the stock photo agency of the Creative Eye, a photographers' cooperative. Mira seeks premium rights-protected images and contributors who are committed to building the Mira archive into a first-choice buyer resource. Mira offers a broad and deep online collection where buyers can search, price, purchase, and download on a 24/7 basis. Mira sales and research support are also available via phone and e-mail. "Our commitment to customer care is something we take very seriously and is a distinguishing trait." Client industries include: advertising, publishing, corporate, marketing, education.

NEEDS Mira features premium stock photo images depicting a wide variety of subjects including travel, Americana, business, underwater, food, landscape, cityscapes, lifestyle, education, wildlife, conceptual and adventure sports, among many others.

SPECS "We require you to use the enhanced version of the Online Captioning software or to embed your captions and keywords using the Photoshop File Info feature, or an application such as Extensis Portfolio 7 or iView MediaPro 2.6 to embed this info in the IPTC metadata fields. Please read over the Mira Keywording Guidelines (download PDF) before preparing your submission. For additional suggestions on Captioning and Keywording, see the Metalogging section of the Controlled Vocabulary site."

HOW TO CONTACT "E-mail, call, or visit our websites to learn more about participation in Mira."

TIPS "Review the submission guidelines completely. Failure to follow the submission guidelines will result in the return of your submission for appropriate corrections."

MPTV

16735 Saticoy St., Suite 109, Van Nuys CA 91406. (818)997-8292. **Fax:** (818)997-3998. **E-mail:** sales@mptvimages.com. **Website:** www.mptvimages.com. Estab. 1988. "Established over 20 years ago, mptv is a unique stock photo agency that is passionate about preserving the memory of some of the greatest leg-

ends of our time through the art of still photography. We offer one of the largest and continually expanding collections of entertainment photography in the world—images from Hollywood's Golden Age and all the way up to the present day. Our unbelievable collection includes some 1 million celebrity and entertainment-related images taken by more than 60 photographers from around the world. Many of these photographers are represented exclusively through mptv and can't be found anywhere else. While mptv is located in Los Angeles, our images are used worldwide and can be seen in galleries, magazines, books, advertising, online and in various products."

HOW TO CONTACT If interested in representation, send an e-mail to photographers@mptvimages.com.

NATURIMAGES

8 rue de l'Auditoire, Charenton du Cher 18210 France. **E-mail:** annelaure.robert@naturimages.com. **Website:** www.naturimages.com. **Contact:** Annelaure Robert. Estab. 2007. Picture library with 300,000 photos in files. Clients include: advertising agencies, public relations firms, book publishers, magazine publishers, newspapers, calendar companies, postcard publishers.

NEEDS Photos of cities/urban, gardening, pets, agriculture, environmental, landscapes/scenics, wildlife, science.

SPECS Accepts images in digital format only. Send via CD, ZIP or e-mail as JPEG files at 300 dpi.

PAYMENT & TERMS Pays on commission. 50% b&w; 50% color. Average price to clients for photos: $10-1,000. Offers volume discounts to customers. Discount sales terms not negotiable. Works with photographers with or without a contract; negotiable. Offers exclusivity on French agency. Statements issued semiannually. Payment made semiannually. Photographers allowed to review account records by request. Offers one-time rights. Model release and property release preferred. Photo captions required. Include location, species.

HOW TO CONTACT E-mail query letter with JPEG samples at 72 dpi. Expects minimum initial submission of 30 images. Responds in 4 weeks.

NOVASTOCK

1306 Matthews Plantation Dr., Matthews NC 28105-2463. **E-mail:** Novastock@aol.com. **Website:** www.portfolios.com/novastock. **Contact:** Anne Clark, submission department. Estab. 1993. Stock agency. Cli-

ents include: advertising agencies, businesses, postcard publishers, public relations firms, book publishers, calendar companies, magazine publishers, greeting card companies, and large international network of subagents.

NEEDS "We need commercial stock subjects such as lifestyles, fitness, business, science, medical, family, etc. We also are looking for unique and unusual imagery. Wants photos of babies/children/teens, couples, multicultural, families, parents, senior citizens, disasters, environmental, wildlife, rural, adventure, health/fitness, travel, business concepts, military, science, technology/computers."

SPECS Prefers images in digital format as follows: (1) Original digital camera files. (2) Scanned images in the 30-50MB range. "When sending files for editing, please send small files only. Once we make our picks, you can supply larger files. Final large files should be JPEGs. *Never* sharpen or use contrast and saturation filters. Always flatten layers. Files and disks must be readable on Windows PC."

PAYMENT & TERMS Pays 50% commission for b&w and color photos. "We never charge the photographer for any expenses whatsoever." Works with photographers on contract basis only. "We need exclusivity only for images accepted, and similars." Photographer is allowed to market work not represented by Novastock. Statements and payments are made in the month following receipt of income from sales. Informs photographers and discusses with photographer when client requests all rights. Model/property release required. Photo captions required; include who, what and where. "Science and technology need detailed and accurate captions. Model releases must be cross-referenced with the appropriate images."

HOW TO CONTACT Contact by e-mail or send query letter with digital files, tearsheets.

TIPS "Digital files on CD/DVD are preferred. All images must be labeled with caption and marked with model release information and your name and copyright. We market agency material through more than 50 agencies in our international subagency network. The photographer is permitted to freely market nonsimilar work any way he/she wishes."

OPÇÃO BRASIL IMAGENS

Rua Barata Ribeiro, No. 370 Gr. 215/216, Copacabana, Rio de Janeiro 22040-901 Brazil. +55-21-2256-9007. **Fax:** +55-21-2256-9007. **E-mail:** pesquisa@

opcaobrasil.com.br. **Website:** www.opcaobrasil.com. br. Estab. 1993. Has 600,000+ photos in files. Clients include: advertising agencies, book publishers, magazine publishers, calendar companies, postcard publishers, publishing houses.

NEEDS Photos of babies/children/teens, couples, families, parents, wildlife, health/fitness, beauty, education, hobbies, sports, industry, medicine. "We need photos of wild animals, mostly from the Brazilian fauna. We are looking for photographers who have images of people who live in tropical countries and must be brunette."

SPECS Accepts images in digital format.

PAYMENT & TERMS Pays 50% commission for b&w or color photos. Negotiates fees below standard minimum prices only in cases of renting at least 20 images. Offers volume discounts to customers. Works with photographers on contract basis only. Offers limited regional exclusivity. Contracts renew automatically with additional submissions for 3 years. Charges $200/image for catalog insertion. Statements issued quarterly. Payment made quarterly. Photographers allowed to review account records in cases of discrepancies only. Offers one-time rights, electronic media rights, agency promotion rights. Model release required; property release preferred. Photo captions required.

HOW TO CONTACT Initial contact should be by e-mail or fax. Explain what kind of material you have. Provide business card, self-promotion piece to be kept on file. "If not interested, we return the samples." Expects minimum initial submission of 500 images with quarterly submissions of at least 300 images.

TIPS "We need creative photos presenting the unique look of the photographer on active and healthy people in everyday life at home, at work, etc., showing modern and up-to-date individuals. We are looking for photographers who have images of people with the characteristics of Latin American citizens."

⟲ OUTDOORIA OUTDOOR IMAGE AGENCY

Valfiskengata 800, Haninge 13664 Sweden. +46-707833785. **E-mail:** info@outdooria.com; contributor@outdooria.com. **Website:** www.outdooria.com. **Contact:** Patrik Lindqvist, CEO. Estab. 2009. Stock agency and picture library. Has over 6,500 photos on file. Clients include advertising agencies, businesses, newspapers, postcard publishers,

public relations firms, book publishers, calendar companies, magazine publishers, and greeting card companies.

SPECS Model and property release preferred. Photo captions required.

PAYMENT & TERMS Does not offer volume discounts to customers. Works with photographers on a contract basis only. Agency contracts review automatically with additional submissions.

HOW TO CONTACT E-mail query letter with link to photographer's website or JPEG samples at 72 dpi. Accepts images in digital format. Please send via CD, or ZIP as a TIFF or JPEG file. Expects minimum initial submission of 40 images. Responds in 1 week to samples and portfolios. Guidelines available online.

OUTSIDE IMAGERY LLC

Boulder CO 80301. (303)530-3357. **E-mail:** John@outsideimagery.com. **Website:** www.outsideimagery.com. **Contact:** John Kieffer, president. Estab. 1986. Outside Imagery has provided private and customized photos tours for the past 20 years. Locales include Denver, Boulder, and Colorado's mountains. Tours can include instruction in nature photography, natural history, and local sites.

NEEDS Photo tours are designed for individuals and small groups of all levels of photography and outdoor experience.

SPECS High resolution digital files, JPEG format.

PAYMENT & TERMS Pays 50% commission for all imagery. Offers nonexclusive contract. Payments made quarterly. Model release required; property release preferred. Photo captions and keywords required.

HOW TO CONTACT Contact by e-mail.

PANORAMIC IMAGES

2302 Main St., Evanston IL 60202. (847)324-7000 or (800)543-5250. **Fax:** (847)324-7004. **Website:** www.panoramicimages.com. Estab. 1987. Stock photo agency. Member of ASPP, NANPA, and IAPP. Clients include: design firms, graphic designers, advertising agencies, corporate art consultants, postcard companies, magazine publishers, newspapers, and calendar companies.

NEEDS Photos of landscapes/scenics, wildlife, architecture, cities/urban, cityscapes and skylines, gardens, rural, adventure, health/fitness, sports, travel, business concepts, industry, science, technology/com-

puters. Interested in alternative process, avant garde, documentary, fine art, historical/vintage, seasonal. Works only with *panoramic formats* (2:1 aspect ratio or greater). Subjects include: cityscapes/skylines, international travel, nature, backgrounds, conceptual.

SPECS "E-mail for digital and film submission guidelines or see website."

PAYMENT & TERMS Pays 40% commission for photos. Average price per image (to clients): $300. No charge for scanning, metadata or inclusion on website. Statements issued quarterly. Payments made quarterly. Offers one-time, electronic rights and limited exclusive usage. Model release preferred "and property release, if necessary." Photo captions required. See website for submission guidelines before submitting.

HOW TO CONTACT Send e-mail with stock list or low-res scans/lightbox. Specific want lists created for contributing photographers. Photographer's work is represented on full e-commerce website and distributed worldwide through image distribution partnerships with Getty Images, National Geographic Society Image Collection, Amana, etc. See website for more detailed submission guidelines.

TIPS Wants to see "well-exposed chromes or very high-res stitched pans. Panoramic views of well-known locations nationwide and worldwide. Also, generic beauty panoramics."

PAPILIO

155 Station Rd., Herne Bay, Kent CT6 5QA United Kingdom. +44-122-736-0996. **E-mail:** library@papiliophotos.com. **Website:** www.papiliophotos.com. **Contact:** Justine Pickett. Estab. 1984. Has 120,000 photos in files. Clients include: advertising agencies, book publishers, magazine publishers, newspapers, calendar companies, greeting card companies, postcard publishers.

NEEDS Photos of wildlife.

SPECS Prefers digital submissions. Uses digital shot in-camera as RAW and converted to TIFF for submission, minimum file size 17MB. See webpage for further details or contact for a full information sheet about shooting and supplying digital photos.

PAYMENT & TERMS Works with photographers on contract basis only. Offers nonexclusive contract. Statements issued quarterly. Payment made quarterly. Offers one-time rights, electronic media rights. Photo captions required; include Latin names and behavioral information and keywords.

HOW TO CONTACT Send query letter with résumé. Does not keep samples on file. Expects minimum initial submission of 150 images. Responds in 1 month to samples. Returns all unsuitable material with letter. Photo guidelines sheet free with SASE.

TIPS "Contact first for information about digital. Send digitial submissions on either CD or DVD. Supply full caption listing for all images. Wildlife photography is very competitive. Photographers are advised to send only top-quality images."

PHOTO AGORA

3711 Hidden Meadow Lane, Keezletown VA 22832. (540)269-8283. **Fax:** (540)269-8283. **E-mail:** photoagora@aol.com. **Website:** www.photoagora.com. **Contact:** Robert Maust. Estab. 1972. Stock photo agency. Has over 65,000 photos in files. Clients include: businesses, book/encyclopedia and textbook publishers, magazine publishers, calendar companies.

NEEDS Photos of families, children, students, Virginia, Africa and other Third World areas, work situations, etc. Also needs babies/children/teens, couples, multicultural, parents, senior citizens, disasters, environmental, landscapes/scenics, wildlife, cities/urban, education, gardening, pets, religious, rural, health/fitness, travel, agriculture, industry, medicine, science, technology/computers.

SPECS Send high-res digital images. Ask for password to download agreement and submission guidelines from website. "NOTE: For the next 2-3 years we are being VERY selective and not doing marketing full time. Submit only if you understand this."

PAYMENT & TERMS Pays 50% commission for b&w and color photos. Average price per image (to clients): $40 minimum for b&w photos; $100 minimum for color photos. Negotiates fees below standard minimum prices. Offers volume discounts to customers; inquire about specific terms. Photographers can choose not to sell images on discount terms. Works with photographers with or without a contract. Offers nonexclusive contract. Payment made quarterly. Photographers allowed to review account records. Offers one-time rights. Informs photographers and allows them to negotiate when client requests all rights. Model/property release preferred. Embedded photo captions required; include location, important dates, scientific names, etc.

HOW TO CONTACT Call, write or e-mail. No minimum number of images required in initial submis-

sion. Responds in 3 weeks. Photo guidelines free with SASE or download from website.

PHOTOEDIT, INC.

3505 Cadillac Ave., Suite P-101, Costa Mesa CA 92626. (800)860-2098. **Fax:** (714)434-5937. **E-mail:** submissions@photoeditinc.com. **Website:** www. photoeditinc.com. Estab. 1987. Stock photo agency. Member of Picture Archive Council of America (PACA). Has 600,000 photos. Clients include: textbook/encyclopedia publishers, magazine publishers, advertising agencies, government agencies. "PhotoEdit Inc. is a leading multiethnic and multicultural stock agency specializing in diverse, culturally relevant imagery. Whether our images are used commercially, or as positive education tools, we keep in mind all of our clients' unique needs when selecting images for our 100% digital rights-managed collection. Our images capture real life as it happens all over the globe. We're in search of photographers who have access to models of every ethnicity who will shoot actively and on spec."

SPECS Uses digital images only.

PAYMENT & TERMS Pays 40% commission for color images. Works on contract basis only. Offers nonexclusive contract. Payments and statements issued monthly. Model release preferred.

HOW TO CONTACT Submit digital portfolio for review. Photo guidelines available on website.

THE PHOTOLIBRARY GROUP

Getty Images, 75 Varick St., New York NY 10013. (646)613-4000 or (800)462-4379. **Fax:** (212)633-1914. **E-mail:** sales@gettyimages.com. **Website:** www. gettyimages.com/photolibrary. "The Photolibrary Group represents the world's leading stock brands and the finest photographers around the world, to bring memorable, workable content to the creative communities in America, Europe, Asia, and the Pacific. We provide customers with access to over 5 million images and thousands of hours of footage and full composition music. The Photolibrary Group was founded in 1967 and, 40 years on has a global presence with offices in the United Kingdom (London), the USA (New York), Australia (Sydney and Melbourne), Singapore, India, Malaysia, the Philippines, Thailand, New Zealand, and the United Arab Emirates. Photolibrary is always on the lookout for new and innovative photographers and footage

producers. Due to the highly competitive market for stock imagery we are very selective about the types of work that we choose to take on. We specialize in high quality, creative imagery primarily orientated to advertising, business-to-business, and the editorial and publishing markets. Interested contributors should go to the website and click on the Artists tab for submission information. For additional information regarding our house brands, follow the 'About Us' link."

PHOTOLIFE CORPORATION, LTD.

513 Hennessy Rd., 20/F Wellable Commercial Bldg., Causeway Bay Hong Kong. +852-2808-0012. **Fax:** +852-3511-9002. **E-mail:** info@aimageworks.com. **Website:** www.hktdc.com/sourcing/hk_company_ directory.htm?companyid=1X03HEJB&locale=en. Estab. 1994. Stock photo library. Has over 1.6 million photos in files. Clients include: advertising agencies, newspapers, book publishers, calendar companies, magazine publishers, greeting card companies, corporations, production houses, graphic design firms.

NEEDS Contemporary images of architecture, interiors, garden, infrastructure, concepts, business, finance, sports, lifestyle, nature, travel, animal, marine life, foods, medical.

SPECS Accepts images in digital format only. "Use only professional digital cameras (capable of producing 24MB+ images) with high-quality interchangeable lenses; or images from high-end scanners producing a file up to 50 MB."

PAYMENT & TERMS Pays 50% commission for b&w and color photos. Average price per image (to clients): $105-1,550 for b&w photos; $105-10,000 for color photos. Offers volume discounts to customers; terms specified in photographers' contracts. Works with photographers on contract basis only. Contract can be initiated with minimum 300 selected images. Quarterly submissions needed. Informs photographers and allows them to negotiate when client requests all rights. Model release required; property release preferred. Photo captions required; include destination and country.

HOW TO CONTACT E-mail 50 low-res images (1,000 pixels or less), or send CD with 50 images.

TIPS "Visit our website. Edit your work tightly. Send images that can keep up with current trends in advertising and print photography."

PHOTO RESOURCE HAWAII

PO Box 1082, Honokaa HI 96727. (808)599-7773. **E-mail:** prh@photoresourcehawaii.com. **Website:** www.PhotoResourceHawaii.com. **Contact:** Tami Kauakea Winston, owner. Estab. 1985. Stock photo agency. Has e-commerce website with electronic delivery of over 20,000 images. Clients include: ad agencies, audiovisual firms, businesses, book/encyclopedia publishers, magazine publishers, calendar companies, greeting card companies, postcard publishers.

NEEDS Photos of Hawaii and the South Pacific.

SPECS Accepts images online only via website submission in digital format only; 48 MB or larger; JPEG files from RAW files preferred.

PAYMENT & TERMS Pays 40% commission. Enforces minimum prices. Offers volume discounts to customers. Discount sales terms not negotiable. Works with photographers on contract basis only. Offers nonexclusive contract. Contracts renew automatically with additional submissions. Statements issued bimonthly. Payment made bimonthly. Offers royalty-free and rights-managed images. Model/property release preferred. Photo captions and keywording online required.

HOW TO CONTACT Send query e-mail with samples. Expects minimum initial submission of 100 images with periodic submissions at least 3 times/year. Responds in 2 weeks. Offers photographer retreats in Hawaii to learn how to become a contributor and enjoy a healthy Hawaiian vacation.

PIX INTERNATIONAL

(773)975-0158. **E-mail:** editorial@pixintl.com. **Website:** www.pixintl.com. **Contact:** Linda Matlow, president. Estab. 1978. Stock agency, news/feature syndicate. Has 200,000 photos in files. Clients include: advertising agencies, public relations firms, businesses, book publishers, magazine publishers, newspapers.

NEEDS Photos of celebrities, entertainment, performing arts.

SPECS We are not accepting submissions at this time.

● PLANS, LTD. (PHOTO LIBRARIES AND NEWS SERVICES)

5-17-2 Inamura, Kamakura 248-0024 Japan. +81-467-31-0330. **Fax:** +81-467-31-0330. **E-mail:** yoshida@plans.jp. **Website:** www.plans.jp. **Contact:** Takashi Yoshida, president. Estab. 1982. Was a stock agency. Now representing ProImageExperts as ProImageExperts Japan as a joint project such as scanning, keywording, dust busting, or color correction for photographers in the stock photo market. Has 100,000 photos in files. Clients include: photo agencies, newspapers, book publishers, magazine publishers, advertising agencies.

NEEDS "We do consulting for photo agencies for the Japanese market."

HOW TO CONTACT Send query e-mail. Responds only if interested.

PONKAWONKA, INC.

(416)638-2475. **E-mail:** contact@ponkawonka.com. **Website:** www.ponkawonka.com. Estab. 2002. Stock agency. Has 60,000+ photos in files. Clients include: advertising agencies, businesses, newspapers, public relations firms, book publishers, calendar companies, magazine publishers.

NEEDS Photos of religious events and holy places. Interested in avant garde, documentary, historical/vintage. "Interested in images of a religious or spiritual nature. Looking for photos of ritual, places of worship, families, religious leaders, ritual objects, historical, archaeological, anything religious, especially in North America."

SPECS Accepts images in digital format. Send via CD or DVD as TIFF or JPEG files.

PAYMENT & TERMS Pays 50% commission for any images. Offers volume discounts to customers. Works with photographers on contract basis only. Charges only apply if negatives or transparencies have to be scanned. Statements issued quarterly. Payments made quarterly. Offers one-time rights. Informs photographers and allows them to negotiate when client requests all rights. Model/property release preferred. Photo captions required; include complete description and cutline for editorial images.

HOW TO CONTACT Send query e-mail. Does not keep samples on file; cannot return material. Expects minimum initial submission of 200 images with annual submissions of at least 100 images. Responds only if interested; send 30-40 low-res samples by e-mail. Photo guidelines available on website.

TIPS "We are always looking for good, quality images of religions of the world. We are also looking for photos of people, scenics and holy places of all religions. Send us sample images. First send us an e-mail introducing yourself, and tell us about your work. Let us know how many images you have that fit our niche

and what cameras you are using. If it looks promising, we will ask you to e-mail us 30-40 low-res images (72 dpi, no larger than 6 inches on the long side). We will review them and decide if a contract will be offered. Make sure the images are technically and aesthetically salable. Images must be well-exposed and a large file size. We are an all-digital agency and expect scans to be high-quality files. Tell us if you are shooting digitally with a professional DSLR or if scanning from negatives with a professional slide scanner."

POSITIVE IMAGES

53 Wingate St., Haverhill MA 01832. (978)556-9366. **Fax:** (978)556-9448. **E-mail:** pat@positiveimagesphoto.com. **Website:** www.agpix.com/positiveimages. **Contact:** Patricia Bruno, owner. Stock photo agency and fine art gallery. Member of ASPP, GWAA. Clients include: advertising agencies, public relations firms, book/encyclopedia publishers, magazine publishers, greeting card and calendar companies, sales/promotion firms, design firms.

NEEDS Horticultural images showing technique and lifestyle, photo essays on property-released homes and gardens, travel images from around the globe, classy and funky pet photography, health and nutrition, sensitive and thought-provoking images suitable for high-end greeting cards, calendar-quality landscapes, castles, lighthouses, country churches. Model/property releases preferred.

PAYMENT & TERMS Pays 50% commission for stock photos; 60% commision for fine art. Average price per image (to clients): $250. Works with photographers on contract basis only. Offers limited regional exclusivity. Payments made quarterly. Offers one-time and electronic media rights. "We never sell all rights."

HOW TO CONTACT "Positive Images Stock is accepting limited new collections; however, if your images are unique and well organized digitally, we will be happy to review online after making e-mail contact. Our gallery will review fine art photography portfolios online as well and will consider exhibiting non-members' work."

TIPS "Positive Images has taken on more of a boutique approach, limiting our number of photographers so that we can better service them and offer a more in-depth and unique collection to our clients. The gallery is a storefront in a small historic arts district. Our plan is to evolve this into an online gallery

as well. We are always in search of new talent, so we welcome anyone with a fresh approach to contact us!"

⬛ PRESS ASSOCIATION IMAGES

Pearl House, Friar Lane, Nottingham NG1 6BT United Kingdom. +44-20-7963-7000. **Fax:** +44-115-844-7448. **E-mail:** joel.tegerdine@pressassociation.com. **Website:** www.pressassociation.com. Formerly Empics Sports Photo Agency. Picture library. Has over 3 million news, sports, and entertainment photos (from around the world, past and present) online. Clients include: advertising agencies, newspapers, public relations firms, book publishers, magazine publishers, web publishers, television broadcasters, sporting bodies, rights holders.

NEEDS Photos of news, sports, and entertainment.

SPECS Uses glossy or matte color and b&w prints; 35mm transparencies. Accepts the majority of images in digital format.

PAYMENT & TERMS Negotiates fees below stated minimums. Offers volume discounts to customers. Works with photographers on contract basis only. Rights offered varies.

HOW TO CONTACT Send query letter or e-mail. Does not keep samples on file; cannot return material.

PURESTOCK

6622 Southpoint Dr. S, Suite 240, Jacksonville FL 32216. (904)565-0066 or (800)828-4545. **Fax:** (904)565-1620. **E-mail:** yourfriends@superstock.com. **Website:** www.purestock.com. "The Purestock royalty-free brand is designed to provide the professional creative community with high-quality images at high resolution and very competitive pricing. Purestock offers CDs and single-image downloads in a wide range of categories including lifestyle, business, education, and sports to distributors in over 100 countries. Bold and fresh beyond the usual stock images."

NEEDS "A variety of categories including lifestyle, business, education, medical, industry, etc."

SPECS "Digital files which are capable of being output at 80MB with minimal interpolation. File must be 300 dpi, RGB, TIFF at 8-bit color."

PAYMENT & TERMS Statements issued monthly to contracted image providers. Model release required. Photo captions required.

HOW TO CONTACT Submit a portfolio including a subject-focused collection of 300+ images. Photo

guidelines available on website at www.superstock.com/submissions.asp.

TIPS "Please review our website to see the style and quality of our imagery before submitting."

RAILPHOTOLIBRARY.COM

+44-116-259-2068. **Website:** www.railphotolibrary.com. Estab. 1969. Has 400,000 photos in files relating to railways worldwide. Clients include: advertising agencies, businesses, newspapers, postcard publishers, public relations firms, book publishers, calendar companies, audiovisual firms, magazine publishers, greeting card companies.

NEEDS Photos of railways.

SPECS Uses digital images; glossy b&w prints; 35mm, 2¼×2¼ transparencies.

PAYMENT & TERMS Buys photos, film, or videotape outright depending on subject; negotiable. Pays 50% commission for b&w and color photos. Average price per image (to clients): $125 maximum for b&w and color photos. Works with photographers with or without a contract; negotiable. Statements issued quarterly. Photographers allowed to review account records in cases of discrepancies only. Photo captions preferred.

HOW TO CONTACT Send query letter with slides, prints. Portfolio may be dropped off Monday-Saturday. Does not keep samples on file; include SAE/IRC for return of material. Unlimited initial submission.

TIPS "Submit well-composed pictures of all aspects of railways worldwide: past, present and future; captioned digital files, prints or slides. We are the world's leading railway picture library, and photographers to the railway industry."

REX USA

1133 Broadway, Suite 1626, New York NY 10010. (212)586-4432. **E-mail:** requests@rexusa.com; orderdesk@berlinerphotography.com. **Website:** www.rexusa.com. Estab. 1935. Stock photo agency, news/feature syndicate. Affiliated with Rex Features in London. Member of Picture Archive Council of America (PACA). Has 1.5 million photos. Clients include: advertising agencies, public relations firms, audiovisual firms, businesses, book/encyclopedia publishers, magazine publishers, newspapers, postcard companies, calendar companies, greeting card companies, TV, film, and record companies.

NEEDS Primarily editorial material: celebrities, personalities (studio portraits, candid, paparazzi), human interest, news features, movie stills, glamour, historical, geographic, general stock, sports, and scientific.

SPECS Digital only.

PAYMENT & TERMS Payment varies depending on quality of subject matter and exclusivity. "We obtain highest possible prices, starting at $100-100,000 for one-time sale." Works with or without contract. Offers nonexclusive contract. Statements issued monthly. Payments made monthly. Photographers allowed to review account records. Offers one-time, first and all rights. Informs photographers and allows them to negotiate when client requests all rights. Model release required. Photo captions required.

HOW TO CONTACT E-mail query letter with samples and list of stock photo subjects. Or fill out online submission form to offer material and discuss terms for representation.

SCIENCE PHOTO LIBRARY, LTD.

327-329 Harrow Rd., London W9 3RB United Kingdom. +44-20-7432-1100. **Fax:** +44-20-7286-8668. **E-mail:** info@sciencephoto.com. **Website:** www.sciencephoto.com. Stock photo agency. Clients include: book publishers, magazines, newspapers, medical journals, advertising, design, TV and online in the UK and abroad. "We currently work with agents in over 30 countries, including America, Japan, and in Europe."

NEEDS Specializes in all aspects of science, medicine, and technology.

SPECS Digital only via CD/DVD. File sizes at least 38MB with no interpolation. Captions, model, and property releases required.

PAYMENT & TERMS Pays 50% commission. Works on contract basis only. Agreement made for 5 years; general continuation is assured unless otherwise advised. Offers exclusivity. Statements issued quarterly. Payments made quarterly. Photographers allowed to review account records to verify sales figures; fully computerized accounts/commission handling system. Model and property release required. Photo captions required. "Detailed captions can also increase sales so please provide us with as much information as possible."

HOW TO CONTACT "Please complete the inquiry form on our website so that we are better able to ad-

vise you on the salability of your work for our market. You may e-mail us low-res examples of your work. Once you have provided us with information, the editing team will be in contact within 2-3 business weeks. Full photo guidelines available on website."

SCIENCE SOURCE/PHOTO RESEARCHERS, INC.

307 Fifth Ave., New York NY 10016. (212)758-3420 or (800)833-9033. **E-mail:** info@sciencesource.com. **Website:** www.sciencesource.com. Stock agency. Has over 1 million photos and illustrations in files, with 250,000 images in a searchable online database. Clients include: advertising agencies; graphic designers; publishers of textbooks, encyclopedias, trade books, magazines, newspapers, calendars, greeting cards; foreign markets.

NEEDS Images of all aspects of science, astronomy, medicine, people (especially contemporary shots of teens, couples and seniors). Particularly needs model-released people, European wildlife, up-to-date travel and scientific subjects. Lifestyle images must be no older than 2 years; travel images must be no older than 5 years.

SPECS Prefers images in digital format.

PAYMENT & TERMS Rarely buys outright; pays 50% commission on stock sales. General price range (to clients): $150-7,500. Works with photographers on contract basis only. Offers limited regional exclusivity. Contracts renew automatically with additional submissions for 5 years (initial term; 1 year thereafter). Photographers allowed to review account records upon reasonable notice during normal business hours. Statements issued monthly, bimonthly or quarterly, depending on volume. Informs photographers and allows them to negotiate when a client requests to buy all rights, but does not allow direct negotiation with customer. Model/property release required for advertising; preferred for editorial. Photo captions required; include who, what, where, when. Indicate model release.

HOW TO CONTACT See submission guidelines on website.

TIPS "We seek the photographer who is highly imaginative or into a specialty (particularly in the scientific or medical fields). We are looking for serious contributors who have many hundreds of images to offer for a first submission and who are able to contribute often."

SILVER IMAGE® PHOTO AGENCY

4104 NW 70th Terrace, Gainesville FL 32606. (352)373-5771. **E-mail:** carla@silverimagephotoagency.com. **Website:** www.silverimagephotoagency.com. **Contact:** Carla Hotvedt, president/owner. Estab. 1987. Stock photo agency and assignments rep for award-winning photojournalists. Photographers are based in Florida, but available for worldwide travel. Has 5,000 photos in files. Clients include: public relations firms, brides and grooms, magazine publishers, newspapers, rebranding campaigns, and convention coverage.

NEEDS Stock photos from Florida only: nature, travel, tourism, news, people.

SPECS Accepts images in digital format only. No longer accepting new photographers.

PAYMENT & TERMS Pays 50% commission for image licensing fees. Average price per image (to clients): $150-600. Works with photographers on contract basis only. Offers non-exclusive contract. Payment made monthly. Statements provided when payment is made. Photographers allowed to review account records. Offers one-time rights. Informs photographer and allows them to be involved when client requests all rights. Model release preferred. Photo captions required; include name, year shot, city, state, etc.

HOW TO CONTACT Communication via e-mail is preferred.

SKYSCAN PHOTOLIBRARY

Oak House, Toddington, Cheltenham, Gloucestershire GL54 5BY United Kingdom. +44-124-262-1357. **Fax:** +44-124-262-1343. **E-mail:** info@skyscan.co.uk. **Website:** www.skyscan.co.uk. **Contact:** Brenda Marks, library manager. Estab. 1984. Picture library & aerial photo research. Has more than 450,000 photos in files. Clients include: marketing agencies and publishers. Also members of the public and legal and planning consultants relating to property disputes.

NEEDS "Air-to-ground photos of U.K. and worldwide. As well as holding images ourselves, we also wish to make contact with holders of other aerial collections worldwide to exchange information."

SPECS Uses color and b&w prints; any format transparencies. Accepts images in digital format. Send via CD, e-mail.

PAYMENT & TERMS Pays 50% commission for b&w and color photos. Average price per image (to clients): $100 minimum. Enforces strict minimum prices. Offers volume discounts to customers. Pho-

tographers can choose not to sell images on discount terms. Works with photographers with or without a contract; negotiable. Offers guaranteed subject exclusivity (within files); negotiable to suit both parties. Statements issued quarterly. Payment made quarterly. Photographers allowed to review account records in cases of discrepancies only. Offers one-time, electronic media and agency promotion rights. Informs photographers and allows them to negotiate when a client requests all rights. Will inform photographers and act with photographer's agreement. Photo captions required; include subject matter, date of photography, location, interesting features/notes.

HOW TO CONTACT Send query letter or e-mail. Provide résumé, business card, self-promotion piece or tearsheets to be kept on file. Agency will contact photographer for portfolio review if interested. No minimum submissions. Photo guidelines sheet and catalog both free with SASE. Market tips sheet free quarterly to contributors only.

TIPS "We have invested heavily in suitable technology and training for in-house scanning, color management, and keywording, which are essential skills in today's market. Contact first by letter or e-mail with résumé of material held and subjects covered."

SOVFOTO/EASTFOTO, INC.

263 W. 20th St. #3, New York NY 10011. (212)727-8170. **Fax:** (212)727-8228. **E-mail:** info@sovfoto.com. **Website:** sovfoto.com. Estab. 1935. Stock photo agency. Has 500,000+ photos in files. Clients include: advertising firms, audiovisual firms, book/encyclopedia publishers, magazine publishers, newspapers.

NEEDS All subjects acceptable as long as they pertain to Russia, Eastern European countries, Central Asian countries or China.

SPECS Uses b&w historical; color prints; 35mm transparencies. Digital submissions preferred.

PAYMENT & TERMS Pays 50% commission. Statements issued quarterly. Payment made quarterly. Photographers allowed to review account records to verify sales figures or account for various deductions. Offers one-time print, electronic media, and nonexclusive rights. Model/property release preferred. Photo captions required.

STILL MEDIA

714 Mission Park Dr., Santa Barbara CA 93105. (805)682-2868. **Fax:** (805)682-2659. **E-mail:** info@stillmedia.com; images@stillmedia.com. **Website:** www.stillmedia.com. Photojournalism and stock photography agency. Has 500,000 photos in files. Clients include: advertising agencies, public relations firms, businesses, book/encyclopedia publishers, magazine publishers, newspapers, calendar companies.

NEEDS Reportage, world events, travel, cultures, business, the environment, sports, people, industry.

SPECS Accepts images in digital format only. Contact via e-mail.

PAYMENT & TERMS Pays 50% commission for color photos. Works with photographers on contract basis only. Offers nonexclusive and guaranteed subject exclusivity contracts. Statements issued quarterly. Payment made quarterly. Photographers allowed to review account records. Offers one-time and electronic media rights. Model/property release preferred. Photo captions required.

STOCK CONNECTION

10319 Westlake Dr., Suite 162, Bethesda MD 20817. (301)530-8518. **Fax:** Please call first. **E-mail:** photos@scphotos.com. **Website:** www.scphotos.com. **Contact:** Cheryl DiFrank, president and photographer relations. Stock photo agency. Member of the Picture Archive Council of America (PACA). Has over 220,000 photos in files. Clients: advertising agencies, graphic design firms, magazine and textbook publishers, greeting card companies.

NEEDS "We handle many subject categories including lifestyles, business, concepts, sports and recreation, travel, landscapes, and wildlife. We will help photographers place their images into our extensive network of over 35 distributors throughout the world. We specialize in placing images where photo buyers can find them."

SPECS Accepts images in digital format (high-res JPEG), minimum 50MB uncompressed, 300 dpi, Adobe RGB.

PAYMENT & TERMS Pays 65% commission. Average price per image (to client): $450-500. Works with photographers on contract basis only. Offers nonexclusive contract. Contracts renew automatically with additional submissions. Photographers may cancel contract with 60 days written notice. Charges for keywording average $2 per image, depending on volume. If photographer provides acceptable scans and keywords, no upload charges apply. Statements issued monthly. Photographers allowed to review account

records. Offers rights-managed and royalty-free. Informs photographers when a client requests exclusive rights. Model/property release required. Photo captions required.

HOW TO CONTACT Please e-mail for submission guidelines. Prefer a minimum of 100 images as an initial submission.

TIPS "The key to success in today's market is wide distribution of your images. We offer an extensive network reaching a large variety of buyers all over the world. Increase your sales by increasing your exposure."

STOCKFOOD

2 Storer St., Suite 109, Kennebunk ME, 04043. (800)967-0229. **Website:** www.stockfood.com. Estab. 1979. Stock agency, picture library. Member of the Digital Media Licensing Association (DMLA). Has over 500,000 photos in files. Clients include: advertising agencies, businesses, newspapers, postcard publishers, public relations firms, book publishers, calendar companies, magazine publishers, greeting card companies.

NEEDS Photos and video clips of food/drink, health/fitness/food, wellness/spa, people eating and drinking, interiors, nice flowers and garden images, eating and drinking outside, table settings.

SPECS Accepts only digital format. Submission guidelines on our website.

PAYMENT & TERMS Enforces minimum prices. Works with photographers on contract basis only. Offers limited regional exclusivity, guaranteed subject exclusivity (within files). Contracts renew automatically. Statements issued quarterly. Photographers allowed to review account records. Offers one-time rights. Model release required; photo captions required.

HOW TO CONTACT Send e-mail with new examples of your work as JPEG files.

☼☻ STOCK FOUNDRY IMAGES

Artzooks Multimedia Inc., P.O. Box 78089, Ottawa Ontario K2E 1B1 Canada. (613)258-1551 or (866)644-1644. **E-mail:** info@stockfoundry.com; submissions@stockfoundry.com; sales@stockfoundry.com. **Website:** www.stockfoundry.com. Estab. 2006. Stock agency. Clients include: advertising agencies, businesses, newspapers, public relations firms, book publishers, audiovisual firms, magazine publishers.

NEEDS Photos of babies/children/teens, celebrities, couples, multicultural, families, parents, senior citizens, architecture, cities/urban, education, gardening, interiors/decorating, pets, religious, rural, agriculture, business concepts, industry, medicine, military, political, product shots/still life, science, technology/computers, disasters, environmental, landscapes/scenics, wildlife, adventure, automobiles, entertainment, events, food/drink, health/fitness/beauty, hobbies, humor, performing arts, sports, travel. Interested in alternative process, avant garde, documentary, erotic, fashion/glamour, fine art, historical/vintage, lifestyle, seasonal.

SPECS Accepts images in digital format. Send via CD. Save as EPS, JPEG files at 300 dpi. For film and video: .MOV.

PAYMENT & TERMS Buys photos/film/video outright. Pays 50% commission. Average price per image (to clients): $60 minimum for all photos, film, and videotape. Negotiates fees below stated minimums. Offers volume discounts to customers. Terms specified in photographer's contracts. Works with photographers on contract basis only. Offers guaranteed subject exclusivity (within files). Contracts renew automatically with additional submissions. "Term lengths are set on each submission from the time new image submissions are received and accepted. There is no formal obligation for photographers to pay for inclusion into catalogs, advertising, etc.; however, we do plan to make this an optional item." Statements issued monthly or in real time online. Payment made monthly. Photographers allowed to review account records in cases of discrepancies only. Informs photographers and allows them to negotiate when a client requests all rights. Negotiates fees below stated minimums. "Volume discounts sometimes apply for preferred customers." Model/property release required. Captions preferred: include actions, location, event, and date (if relevant to the images, such as in the case of vintage collections).

HOW TO CONTACT E-mail query letter with link to photographer's website. Send query letter with tearsheets, stocklist. Portfolio may be dropped off Monday–Friday. Expects initial submission of 100 images with monthly submission of at least 25 images. Responds only if interested; send nonreturnable samples. Provide résumé to be kept on file. Photo guide-

lines sheet available online. Market tips sheet is free annually via e-mail to all contributors.

TIPS "Submit to us contemporary work that is at once compelling and suitable for advertising. We prefer sets of images that are linked stylistically and by subject matter (better for campaigns). It is acceptable to shoot variations of the same scene (orientation, different angles, with copy space and without, etc.); in fact, we encourage it. Please try to provide us with accurate descriptions, especially as they pertain to specific locations, places, dates, etc. Our wish list for the submission process would be to receive a PDF tearsheet containing small thumbnails of all the high-res images. This would save us time, and speed up the evaluation process."

STOCK OPTIONS

P.O. Box 1048, Fort Davis TX 79734. (432)426-2777. **Fax:** (432)426-2779. **E-mail:** stockoptions@sbcglobal.net. **Contact:** Karen Hughes, owner. Estab. 1985. Stock photo agency. Member of Digital Media Licensing Association (DMLA). Has 80,000 photos in files. Clients include: advertising agencies, public relations firms, audiovisual firms, corporations, book/encyclopedia and magazine publishers, newspapers, postcard companies, calendar companies, greeting card companies.

NEEDS Emphasizes the southern US. Files include Gulf Coast scenics, wildlife, fishing, festivals, food, industry, business, people, etc. Also western folklore and the Southwest.

SPECS Uses 35mm, 2¼×2¼, 4×5 transparencies.

PAYMENT & TERMS Pays 50% commission for color photos. Average price per image (to client): $300-3,000. Works with photographers on contract basis only. Offers nonexclusive contract. Contracts renew automatically with each submission for 5 years from expiration date. When contract ends photographer must renew within 60 days. Charges catalog insertion fee of $300/image and marketing fee of $15/hour. Statements issued upon receipt of payment from client. Payment made immediately. Photographers allowed to review account records to verify sales figures. Offers one-time and electronic media rights. "We will inform photographers for their consent only when a client requests all rights, but we will handle all negotiations." Model/property release preferred for people, some properties, all models. Photo captions required; include subject and location.

HOW TO CONTACT Interested in receiving work from full-time commercial photographers. Arrange a personal interview to show portfolio. Send query letter with stock list. Contact by phone and submit 200 sample photos. Tips sheet distributed annually to all photographers.

TIPS Wants to see "clean, in-focus, relevant, and current materials." Current stock requests include industry, environmental subjects, people in up-beat situations, minorities, food, cityscapes, and rural scenics.

STOCKYARD PHOTOS

Jim Olive Photography, 1520 Center St. #2, Houston TX 77007. (713)520-0898. **E-mail:** jim2stockyard@gmail.com. **Website:** www.stockyard.com. **Contact:** Jim Olive; Ryan Hollaway, studio assistant; Moira McMahon, digital assistant. Estab. 1992. Stock agency. Niche agency specializing in images of Houston, Texas; energy, environment/nature, outdoor recreation including fishing and China. Has thousands of photos in files. Clients include: advertising agencies, businesses, newspapers, postcard publishers, public relations firms, book publishers, calendar companies, audiovisual firms, magazine publishers, greeting card companies, real estate firms, interior designers, retail catalogs environmental organizations.

NEEDS Photos relating to Houston and the Gulf Coast. Energy stock including oil & gas, wind, and solar.

SPECS Accepts images in digital format only. To be considered, e-mail link to photographer's website, showing a sample of 20 images for review.

PAYMENT & TERMS Average price per image (to clients): $250-1,500 for color photos. Offers volume discounts to customers. Photographers can choose not to sell images on discount terms.

HOW TO CONTACT jim2stockyard@gmail.com.

🌐✖ STSIMAGES

225, Neha Industrial Estate, Off Dattapada Rd., Borivali (East) Mumbai 400 066, India. +91-22-2870-1609. **E-mail:** stsimages@gmail.com. **Website:** www.stsimages.com. **Contact:** Mr. Pawan Tikku. Estab. 1993. Clients include: advertising agencies, businesses, postcard publishers, public relations firms, book publishers, calendar companies, freelance web designers, audiovisual firms, magazine publishers, greeting card companies.

NEEDS Royalty-free and rights-managed images of babies/children/teens, celebrities, couples, multicultural, families, parents, senior citizens, disasters, environmental, landscapes/scenics, wildlife, architecture, cities/urban,

education, gardening, interiors/decorating, pets, religious, rural, adventure, automobiles, entertainment, events, food/drink, health/fitness, hobbies, humor, performing arts, sports, travel, agriculture, business concepts, industry, medicine, military, political, product shots/still life, science, technology/computers. Interested in alternative process, avant garde, documentary, fashion/glamour, fine art, historical/vintage, seasonal. Also needs vector images.

SPECS Accepts images in digital format only. Send via DVD or direct upload to website, JPEG files at 300 dpi. Minimum file size 25MB, preferred 50MB or more. Image submissions should be made separately for royalty-free and rights-managed images

PAYMENT & TERMS Pays 30% commission. Enforces minimum prices. Offers to customers. Works with photographers on contract basis only. Offers nonexclusive contract, limited regional exclusivity. Contracts renew automatically with additional submissions for 3 years. Statements issued quarterly. Payment made monthly. Photographers allowed to review account records. Offers royalty-free images as well as one-time rights. Model release required; property release preferred. Photo captions and keyword are mandatory in the file info area of the image. Include names, description, location.

HOW TO CONTACT Send e-mail with image thumbnails. Expects minimum initial submission of 50 images with regular submissions of at least some images every month. Responds in 1 month to queries. Ask for photo guidelines by e-mail. Market tips available to regular contributors only.

TIPS 1) Strict self-editing of images for technical faults. 2) Proper keywording is essential. 3) All images should have the photographer's name in the IPTC(XMP) area. 4) All digital images must contain necessary keywords and caption information within the "file info" section of the image file. 5) Send images in both vertical and horizontal formats.

SUGAR DADDY PHOTOS

Website: www.facebook.com/sugardaddyphotos; www.twitter.com/sugardaddyphoto. **Contact:** Henry Salazar, editor-in-chief. Estab. 2000. Art collector and stock agency. Target audience includes advertising agencies, businesses, newspapers, postcard publishers, public relations firms, book publishers, calendar companies, audiovisual firms, magazine publishers, and greeting card companies.

NEEDS Photos of babies/children/teens, celebrities, couples, multicultural, families, parents, senior citizens, architecture, cities/urban, education, gardening, interiors/decorating, pets, religious, rural, agriculture, business concepts, industry, medicine, military, political, product shots/still life, science, technology/computers, disasters, environmental, landscapes/scenics, wildlife, adventure, automobiles, entertainment, events, food/drink, health/fitness/beauty, hobbies, humor, performing arts, sports (football, baseball, soccer, basketball, hockey), travel/family travel, hotels, beaches, exotic locations. Interested in alternative process, avant garde, documentary, erotic, fashion/glamour, fine art, historical/vintage, lifestyle, seasonal.

SPECS Accepts images in digital format. Send RAW, TIFF or JPEG files at minimum 300 dpi. Pay 15% commission level. Average price per image (to clients): $100-1,000 for photos and streaming video. Enforces strict minimum prices. "We have set prices; however, they are subject to change without notice." Negotiable. Offers nonexclusive contract. Payments made monthly. Offers one-time rights. Informs photographers and allows them to negotiate when a client requests all rights. Model/property release required. Photo captions required; include location, city, state, country, full description, related keywords, date image was taken.

HOW TO CONTACT "All prospects are to submit work from agencies or a person via any online social media (Facebook, Twitter, etc.), including websites."

TIPS "Arrange your work in categories to view. Clients expect the very best in professional-quality material."

SUPERSTOCK, INC.

6622 Southpoint Dr. S, Suite 240, Jacksonville FL 32216. (904)565-0066 or (800)828-4545. **Fax:** (904)565-1620. **E-mail:** yourfriends@superstock.com. **Website:** www.superstock.com. International stock photo agency represented in 192 countries. Offices in Jacksonville, New York, and London. Extensive rights-managed and royalty-free content within 3 unique collections: contemporary, vintage and fine art. Clients include: advertising agencies, businesses, book and magazine publishers, newspapers, greeting card, and calendar companies.

NEEDS "SuperStock is looking for dynamic lifestyle, travel, sports and business imagery, as well as fine art content and vintage images with releases."

SPECS Accepts images in digital format only. Digital

files must be a minimum of 50MB (up-sized), 300 dpi, 8-bit color, RGB, JPEG format.

PAYMENT & TERMS Statements issued monthly to contracted contributors. "Rights offered vary, depending on image quality, type of content, and experience." Informs photographers when client requests all rights. Model release required. Photo captions required.

TIPS "Please review our website to see the style and quality of our imagery before submitting."

⟳ ULLSTEIN BILD

Schützenstr. 15-17, Berlin 10117 Germany. +49-30-2591-72547. **Fax:** +49-30-2591-73896. **E-mail:** ramershoven@ullsteinbild.de. **Website:** www.ullsteinbild.de. Estab. 1900. Stock agency, picture library, and news/feature syndicate. Has approximately 12 million photos in files. Clients include: advertising agencies, public relations firms, audiovisual firms, businesses, book publishers, magazine publishers, newspapers, calendar companies, greeting card companies, postcard publishers, TV companies.

NEEDS Photos of celebrities, couples, multicultural, families, parents, senior citizens, wildlife, disasters, environmental, landscapes/scenics, architecture, cities/urban, education, pets, religious, rural, adventure, automobiles, entertainment, events, health/fitness, hobbies, humor, performing arts, sports, travel, agriculture, buildings, computers, industry, medicine, military, political, portraits, science, technology/computers. Interested in digital, documentary, fashion/glamour, historical/vintage, regional, seasonal. Other specific photo needs: German history.

SPECS Accepts images in digital format only. Send via FTP, CD, e-mail as TIFF, JPEG files at minimum 25MB decompressed.

PAYMENT & TERMS Pays on commission basis. Works with photographers on contract basis only. Offers nonexclusive contract for 5 years minimum. Statements issued monthly, quarterly, annually. Payments made monthly, quarterly, annually. Photographers allowed to review account records in cases of discrepancies only. Offers one-time rights. Photo captions required; include date, names, events, place.

HOW TO CONTACT "Please contact Mr. Ulrich Ramershoven (ramershoven@ullsteinbild.de) before sending pictures."

VIEWFINDERS STOCK PHOTOGRAPHY

3245 SE Ankeny St., Portland OR 97214. (503)222-5222. **Fax:** (503)274-7995. **E-mail:** studio@viewfindersnw.com. **Website:** www.viewfindersnw.com. **Contact:** Bruce Forster, owner. Estab. 1996. Stock agency. Member of the Picture Archive Council of America (PACA). Has 70,000 photos in files. Clients include: advertising agencies, public relations firms, businesses, book publishers, magazine publishers, design agencies.

NEEDS "We are a stock photography agency providing images of the Pacific Northwest. Founded by Bruce Forster in 1996, our image collection has content from over 10 locally known photographers. Whether you're looking for landscapes and landmarks, aerials, cityscapes, urban living, industry, recreation, agriculture, or green energy images, our photography collection covers it all. Contact us for your image needs."

VIREO (VISUAL RESOURCES FOR ORNITHOLOGY)

The Academy of Natural Sciences of Drexel University, 1900 Ben Franklin Pkwy., Philadelphia PA 19103. (215)299-1069. **E-mail:** vireo@ansp.org. **Website:** vireo.ansp.org. **Contact:** Dan Thomas. Estab. 1979. Picture library. "We specialize in birds only." Has 180,000 photos in files. Clients include: advertising agencies, businesses, book publishers, magazine publishers, newspapers, calendar companies, CD publishers.

NEEDS High-quality photographs of birds from around the world with special emphasis on behavior. All photos must be related to birds or ornithology.

SPECS Uses digital format. See website for specs.

PAYMENT & TERMS Pays 50% commission for b&w and color photos. Average price per image (to clients): $125. Negotiates fees below stated minimums; "we deal with many small nonprofits as well as commercial clients." Offers volume discounts to customers. Discount sales terms negotiable. Works with photographers on contract basis only. Offers nonexclusive contract. Statements issued semiannually. Payments made semiannually. Offers one-time rights. Model release preferred for people. Photo captions required; include location.

HOW TO CONTACT Read guidelines on website. To show portfolio, photographer should send 10

JPEGs or a link to web pages with the images. Follow up with a call. Responds in 1 month to queries.

TIPS "Study our website and show us some bird photos we don't have or better images than those we do have. Write to us describing the types of bird photographs you have, the type of equipment you use, and where you do most of your bird photography. Please send us a web link to a portfolio of your work if you have one. Edit work carefully."

VWPICS.COM

Luis Bermejo 8, 7-B, Zaragoza 50009 Spain. **E-mail:** vwpics.office@gmail.com. **Website:** www.vwpics. com. **Contact:** Spanish office: Reyes, office manager; Nano Calvo, director. Estab. 1997. Digital and news stock agency. Has 750,000 photos in files. Has branch office in New York. Clients include: advertising agencies, businesses, newspapers, postcard publishers, public relations firms, book publishers, calendar companies, audiovisual firms, magazine publishers, greeting card companies, zoos, aquariums.

NEEDS Wants photos of babies/children/teens, celebrities, couples, multicultural, families, parents, senior citizens, disasters, environmental, landscapes/scenics, wildlife, architecture, cities/urban, education, pets, religious, rural, adventure, travel, agriculture, business concepts, industry, science, technology/computers. Interested in documentary, erotic, fashion/glamour, fine art. Also needs underwater imagery: reefs, sharks, whales, dolphins and colorful creatures, divers, and anything related to oceans. Images that show the human impact on the environment. Very interested in people images with model releases.

SPECS Accepts images in digital format. Send an e-mail with portfolio or website to vwpics.office3@gmail.com. Once accepted, the photographers submit images via FTP.

PAYMENT & TERMS Pays 50% commission for photos. Enforces minimum prices. Works with photographers with or without contract; negotiable. "E-mail us to be added to our mailing list. You will get almost daily requests from our current photo needs." Offers nonexclusive contract. Statements issued quarterly. Payment made quarterly. Any deductions are itemized. Offers one-time rights. Informs photographers and allows them to negotiate when client requests all rights. Model release required. Photo caption required. Photo essays should include location, Latin name, what, why, when, how, who.

HOW TO CONTACT "The best way is to send an e-mail with your website." Send query letter with résumé, tearsheets, stock list. Expects minimum initial submission of 100 images with periodic submissions of at least 50 images.

TIPS "Interested in reaching Spanish-speaking countries? We might be able to help you. We look for composition, color, and a unique approach. Images that have a mood or feeling. Tight, quality editing. We send a want list via e-mail."

WESTEND61

Schwanthalerstr. 86, Munich 80336, Germany. +49-89-4524426-0. **Fax:** +49-89-4524426-20. **E-mail:** service@westend61.de. **Website:** www.westend61.de. **Contact:** Oliver Marquardt, contributor relations. Estab. 2003. Stock photo agency. Has 250,000 photos on file. Clients include: ad agencies, businesses, book publishers, magazine publishers, newspapers, postcard companies, calendar companies, greeting card companies.

NEEDS Photos of couples, multicultural, families, parents, senior citizens, architecture, cities/urban, education, gardening, interiors/decorating, adventure, agriculture, health/fitness/beauty, hobbies, business concepts, industry, medicine, product shots/still life, science, technology/computers, lifestyle

SPECS Accepts images in digital format; upload on website. Send as JPEGs at 300 dpi.

PAYMENT & TERMS Pays commission: 40-50% for b&w photos; 40-50% for color photos. Average price per image (to clients): $75-500. Negotiates fees below stated minimums. Offers volume discounts to customers; discount sales terms not negotiable. Works with photographers on contract basis only. Offers guaranteed subject exclusivity. Contracts renew automatically (initial 5-year term, 1-year terms afterwards) with submissions. Statements issued quarterly. Payment made quarterly. Photographers permitted to review account records in cases of discrepancies only. Offers one-time rights and royalty-free rights. Informs photographers when client requests to buy all rights. Model/property release required. Photo captions required.

HOW TO CONTACT E-mail query letter with link to your website. Does not keep files on sample; cannot return material. Responds in 1 week. Photo guidelines available online. Market tips sheet available on website.

ADVERTISING, DESIGN & RELATED MARKETS

Advertising photography is always "commercial" in the sense that it is used to sell a product or service. Assignments from ad agencies and graphic design firms can be some of the most creative, exciting, and lucrative that you'll ever receive.

Prospective clients want to see your most creative work—not necessarily your advertising work. Mary Virginia Swanson, an expert in the field of licensing and marketing fine art photography, says that the portfolio you take to the Museum of Modern Art is also the portfolio that Nike would like to see. Your clients in advertising and design will certainly expect your work to show, at the least, your technical proficiency. They may also expect you to be able to develop a concept or to execute one of their concepts to their satisfaction. Of course, it depends on the client and their needs: Read the tips given in many of the listings on the following pages to learn what a particular client expects.

When you're beginning your career in advertising photography, it is usually best to start close to home. That way, you can make appointments to show your portfolio to art directors. Meeting the photo buyers in person can show them that you are not only a great photographer but that you'll be easy to work with as well. This section is organized by region to make it easy to find agencies close to home.

When you're just starting out, you should also look closely at the agency descriptions at the beginning of each listing. Agencies with smaller annual billings and fewer employees are more likely to work with newcomers. On the flip side, if you have a sizable list of ad and design credits, larger firms may be more receptive to your work and be able to pay what you're worth.

Trade magazines such as *HOW*, *Print*, *Communication Arts*, and *Graphis* are good places to start when learning about design firms. These magazines not only provide information about how designers operate, but they also explain how creatives use photography. For ad agencies, try *Adweek* and *Advertising Age*. These magazines are more business oriented, but they reveal facts about the top agencies and about specific successful campaigns. (See Publications in the Resources section for ordering information.) The website of American Photographic Artists (APA) contains information on business practices and standards for advertising photographers (www.apanational.org).

✦⊙○ THE AMERICAN YOUTH PHILHARMONIC ORCHESTRAS

4026 Hummer Rd., Annandale VA 22003. (703)642-8051, ext. 25. **Fax:** (703)642-8054. **E-mail:** exec@aypo.org. **Website:** www.aypo.org. **Contact:** Dr. Graham Elliott, executive director. Estab. 1964. Nonprofit organization that promotes and sponsors 4 youth orchestras. Photos used in newsletters, posters, audiovisual, and other forms of promotion.

NEEDS Photographers usually donate their talents. Offers 8 assignments/year. Photos taken of orchestras, conductors, and soloists. Photo captions preferred.

AUDIOVISUAL NEEDS Uses slides and videotape.

SPECS Uses 5×7 glossy color and b&w prints.

MAKING CONTACT & TERMS Arrange a personal interview to show portfolio. Works with local freelancers on assignment only. Keeps samples on file. Payment negotiable. "We're a résumé-builder, a nonprofit that can cover expenses but not service fees." **Pays on acceptance.** Credit line given. Rights negotiable.

AMPM, INC.

P.O. Box 1887, Midland MI 48641. (989)837-8800. **E-mail:** solutions@ampminc.com. **Website:** www.ampminc.com. Estab. 1969. Member of Art Directors Club, Illustrators Club, National Association of Advertising Agencies, and Type Directors Club. Ad agency. Approximate annual billing: $125 million. Number of employees: 265. Firm specializes in display design, direct mail, magazine ads, packaging. Types of clients: food, industrial, retail, pharmaceutical, health and beauty, and entertainment. Examples of recent clients: Cadillac (ads for TV); Oxford (ads for magazines).

NEEDS Works with 6 photographers/month. Uses photos for consumer and trade magazines, direct mail, P-O-P displays, catalogs, posters, newspapers, and audiovisual. Subjects include: landscapes/scenics, wildlife, commercials, celebrities, couples, architecture, gardening, interiors/decorating, pets, adventure, automobiles, entertainment, events, food/drink, health/fitness, humor, performing arts, agriculture, business concepts, industry, medicine, product shots/still life. Interested in avant garde, erotic, fashion/glamour, historical/vintage, seasonal. Reviews stock photos of food and beauty products. Model release required. Photo caption preferred.

AUDIOVISUAL NEEDS "We use multimedia slide shows and multimedia video shows."

SPECS Uses 8×10 color and/or b&w prints; 35mm, 2¼×2¼, 4×5, 8×10 transparencies; 8×10 film; broadcast videotape. Accepts images in digital format. Send via e-mail.

MAKING CONTACT & TERMS Arrange personal interview to show portfolio. Send unsolicited photos by mail for consideration. Provide résumé, business card, brochure, flier, or tearsheets to be kept on file. Keeps samples on file. Responds in 2 weeks. Pays $50-250/hour; $500-2,000/day; $2,000-5,000/job; $50-300 for b&w photos; $50-300 for color photos; $50-300 for film; $250-1,000 for videotape. Pays on receipt of invoice. Credit line sometimes given, depending upon client and use. Buys one-time, exclusive product, electronic and all rights; negotiable.

TIPS Wants to see originality in portfolio or samples. Sees trend toward more use of special lighting. Photographers should "show their work with the time it took and the fee."

BERSON, DEAN, STEVENS

P.O. Box 3997, Westlake Village CA 91359. (877)447-0134, ext. 111. **E-mail:** info@bersondeanstevens.com. **Website:** www.bersondeanstevens.com. **Contact:** Lori Berson, owner. Estab. 1981. Specializes in marketing automation, branding, website design and development, content marketing, e-mail marketing, social media marketing, video production, collateral, direct mail, exhibits, signage, promotions, and packaging.

NEEDS Works with 4 photographers/month. Uses photos for billboards, trade magazines, direct mail, P-O-P displays, catalogs, posters, packaging, signage, and web. Subjects include: product shots and food. Reviews stock photos. Model/property release required.

SPECS Accepts images in digital format only. Send via FTP, DropBox as TIFF, EPS, JPEG files at 300 dpi.

MAKING CONTACT & TERMS Provide résumé, business card, brochure, flier, or tearsheets to be kept on file. Works on assignment only. Responds in 1-2 weeks. Payment negotiable. Pays within 30 days after receipt of invoice. Credit line not given. Rights negotiable.

⊙⊙● BOB BOEBERITZ DESIGN

247 Charlotte St., Asheville NC 28801. (828)258-0316. **E-mail:** bboeberitz@gmail.com. **Website:** www.bobboeberitzdesign.com. **Contact:** Bob

Boeberitz, owner. Estab. 1984. Member of American Advertising Federation—Asheville Chapter, Asheville Freelance Network, and Asheville Creative Services Group. Graphic design studio. Approximate annual billing: $100,000. Number of employees: 1. Firm specializes in annual reports, collateral, direct mail, magazine ads, packaging, publication design, signage, websites. Types of clients: management consultants, retail, recording artists, mail-order firms, industrial, nonprofit, restaurants, hotels, book publishers.

NEEDS Works with 1 freelance photographer "every 6 months or so." Uses photos for consumer and trade magazines, direct mail, brochures, catalogs, posters. Subjects include: babies/children/teens, couples, multicultural, families, parents, senior citizens, environmental, landscapes/scenics, wildlife, architecture, cities/urban, education, pets, rural, adventure, entertainment, events, food/drink, health/fitness/beauty, hobbies, performing arts, sports, travel, business concepts, industry, medicine, product shots/still life, science, technology/computers; some location, some stock photos. Interested in fashion/glamour, seasonal. Model/property release required.

SPECS Accepts images in digital format. Send via CD, e-mail as TIFF, BMP, JPEG, GIF files at 300 dpi. E-mail samples at 72 dpi. No EPS attachments.

MAKING CONTACT & TERMS Provide résumé, business card, brochure, flier or postcard to be kept on file. Cannot return unsolicited material. Responds "when there is a need." Pays $75-200 for b&w photos; $100-500 for color photos; $75-150/hour; $500-1,500/day. Pays on per-job basis. Buys all rights; negotiable.

TIPS "Send promotional piece to keep on file. Do not send anything that has to be returned. I usually look for a specific specialty; no photographer is good at everything. I also consider studio space and equipment. Show me something different, unusual, something that sets you apart from any average local photographer. If I'm going out of town for something, it has to be for something I can't get done locally. I keep and file direct mail pieces (especially postcards). I do not keep anything sent by e-mail. If you want me to remember your website, send a postcard."

✪❸❶ BYNUMS MARKETING AND COMMUNICATIONS, INC.

301 Grant St., Suite 4300, Pittsburgh PA 15219. (412)471-4332. **Fax:** (412)471-1383. **E-mail:** rbynum2124@earthlink.net; russell@bynums.com.

Website: www.bynums.com. Estab. 1985. Ad agency. Number of employees: 8-10. Firm specializes in annual reports, collateral, direct mail, magazine ads, packaging, publication design, signage. Types of clients: financial, health care, consumer goods, nonprofit.

NEEDS Works with 1 photographer/month. Uses photos for billboards, brochures, direct mail, newspapers, posters. Subjects include: babies/children/teens, couples, multicultural, families, parents, senior citizens, environmental, wildlife, cities/urban, education, religious, adventure, automobiles, events, food/drink, health/fitness, performing arts, sports, medicine, product shots/still life, science, technology/computers. Interested in fine art, seasonal. Model/property release required. Photo captions preferred.

AUDIOVISUAL NEEDS Works with 1 videographer and 1 filmmaker/year. Uses slides, film, videotape.

SPECS Uses 8×10 glossy or matte color and b&w prints; 35mm, 4×5 transparencies. Accepts images in digital format. Send via ZIP, e-mail as TIFF files.

MAKING CONTACT & TERMS Send query letter with résumé, prints, tearsheets, stock list. Provide business card, self-promotion piece to be kept on file. Responds only if interested, send nonreturnable samples. Pays $150-300 for b&w and color photos. "Payment may depend on quote and assignment requirements." Buys electronic rights.

✪ CARMICHAEL LYNCH

Spong PR, IPG, 110 N. Fifth St., Minneapolis MN 55403. (612)334-6000. **Fax:** (612)334-6090. **E-mail:** inquiry@clynch.com. **Website:** www. carmichaellynch.com. **Contact:** Sandy Boss Febbo, executive art producer; Bonnie Brown, Jill Kahn, Jenny Barnes, art producers. Estab. 1962. Member of American Association of Advertising Agencies. Ad agency. Number of employees: 250. Firm specializes in magazine ads, packaging. Types of clients: automotive, finance, sports and recreation, beverage, outdoor recreational. Examples of recent clients: Subaru, U.S. Bank, Jack Link's Beef Jerky, Harley-Davidson, Porsche, Northwest Airlines, American Standard.

NEEDS Uses many photographers/month. Uses photos for billboards, consumer and trade magazines, online display, social media, newspapers and other media as needs arise. Subjects include: environmental,

landscapes/scenics, architecture, interiors/decorating, rural, adventure, automobiles, travel, product shots/still life. Model/property release required for all visually recognizable subjects.

SPECS Uses all print formats. Accepts images in digital format. Send TIFF, GIF, JPEG files at 72 dpi or higher.

MAKING CONTACT & TERMS Submit portfolio for review. Provide résumé, business card, brochure, flier, or tearsheets to be kept on file. Payment negotiable. Pay depends on contract. Buys all, one-time or exclusive product rights, "depending on agreement."

TIPS "No 'babes on bikes'! In a portfolio, we prefer to see the photographer's most creative work—not necessarily ads. Show only your most technically, artistically satisfying work."

✴🅶🅐 DYKEMAN ASSOCIATES, INC.

4115 Rawlins St., Dallas TX 75219. (214)587-2995. **E-mail:** info@dykemanassociates.com. **Website:** www.dykemanassociates.com. Estab. 1974. Member of Public Relations Society of America. PR, marketing, video production firm. Firm specializes in website creation and promotion, crisis communication plans, media training, collateral, direct marketing. Types of clients: industrial, financial, sports, technology.

NEEDS Works with 4-5 photographers and videographers. Uses photos for publicity, consumer and trade magazines, direct mail, catalogs, posters, newspapers, signage, websites.

AUDIOVISUAL NEEDS "We produce and direct video. Just need crew with good equipment and people and ability to do their part."

MAKING CONTACT & TERMS Arrange a personal interview to show portfolio. Pays $800-1,200/day; $250-400/1-2 days. "Currently we work only with photographers who are willing to be part of our trade dollar network. Call if you don't understand this term." Pays up to 30 days after receipt of invoice.

TIPS Reviews portfolios with current needs in mind. "If video, we would want to see examples. If for news story, we would need to see photojournalism capabilities."

✴🅶🅢🅓 FLINT COMMUNICATIONS

101 Tenth St. N., Suite 300, Fargo ND 58102. (701)237-4850. **Fax:** (701)234-9680. **E-mail:** jodi.duncan@flintcom.com. **Website:** www.flintcom.com. **Contact:** Jodi Duncan, business inquiries. Estab. 1946. Ad agency. Approximate annual billing: $9 million. Number of employees: 30. Firm specializes in display design, direct mail, magazine ads, publication design, signage, annual reports. Types of clients: industrial, financial, agriculture, health care, and tourism.

NEEDS Works with 2-3 photographers/month. Uses photos for direct mail, P-O-P displays, posters and audiovisual. Subjects include: babies/children/teens, couples, parents, senior citizens, architecture, rural, adventure, automobiles, events, food/drink, health/fitness, sports, travel, agriculture, industry, medicine, political, product shots/still life, science, technology, manufacturing, finance, health care, business. Interested in documentary, historical/vintage, seasonal. Reviews stock photos. Model release preferred.

AUDIOVISUAL NEEDS Works with 1-2 filmmakers and 1-2 videographers/month. Uses slides and film.

SPECS Uses 35mm, 2¼×2¼, 4×5 transparencies. Accepts images in digital format. Send via CD, ZIP as TIFF, EPS, JPEG files.

MAKING CONTACT & TERMS Send query letter with stock list. Submit portfolio for review. Provide résumé, business card, brochure, flier, or tearsheets to be kept on file. Responds in 1-2 weeks. Pays $50-150 for b&w photos; $50-1,500 for color photos; $50-130/hour; $400-1,200/day; $100-2,000/job. Pays on receipt of invoice. Buys one-time rights.

✴🅢🅘🅓 FRIEDENTAG PHOTOGRAPHICS

314 S. Niagara St., Denver CO 80224-1324. (303)333-0570. **E-mail:** harveyfriedentag@msn.com. Estab. 1957. AV firm. Approximate annual billing: $500,000. Number of employees: 3. Firm specializes in direct mail, annual reports, publication design, magazine ads. Types of clients: business, industry, financial, publishing, government, trade and union organizations. Produces slide sets, motion pictures, and videotape. Examples of recent clients: Perry Realtors annual report (advertising, mailing); Lighting Unlimited catalog (illustrations).

NEEDS Works with 5-10 photographers/month on assignment only. Buys 1,000 photos and 25 films/year. Reviews stock photos of business, training, public relations, and industrial plants showing people and equipment or products in use. Other subjects include agriculture, business concepts, industry, medicine, military, political, science, technology/computers. Interested in avant garde, documentary, erotic, fashion/glamour. Model release required.

AUDIOVISUAL NEEDS Uses freelance photos in color slide sets and motion pictures. "No posed looks." Also produces mostly 16mm Ektachrome and some 16mm × ¾" and VHS videotape. Length requirement: 3-30 minutes. Interested in stock footage on business, industry, education and unusual information. "No scenics, please!"

SPECS Uses 8×10 glossy b&w and color prints; 35mm, 2¼×2¼, 4×5 color transparencies. Accepts images in digital format. Send via CD as JPEG files.

MAKING CONTACT & TERMS Send material by mail for consideration. Provide flier, business card, brochure, and nonreturnable samples to show clients. Responds in 3 weeks. Pays $500/day for still; $700/day for motion picture plus expenses; $100 maximum for b&w photos; $200 maximum for color photos; $700 maximum for film; $700 maximum for videotape. **Pays on acceptance.** Buys rights as required by clients.

TIPS "More imagination needed—be different; *no scenics, pets or portraits.* Above all, technical quality is a must. There are more opportunities now than ever, especially for new people. We are looking to strengthen our file of talent across the nation."

⊛⊙⊖ GIBSON ADVERTISING

P.O. Box 20735, Billings MT 59104. (406)670-3412. **E-mail:** mike@gibsonad.com. **Website:** www.gibsonad. com. **Contact:** Mike Curtis, president. Estab. 1984. Ad agency. Number of employees: 2. Types of clients: industrial, financial, retail, food, medical.

NEEDS Works with 1-3 freelance photographers and 1-2 videographers/month. Uses photos for direct mail, P-O-P displays, catalogs, posters, newspapers, signage, audiovisual. Subjects vary with job. Reviews stock photos. "We would like to see more Western photos." Model release required. Property release preferred.

AUDIOVISUAL NEEDS Uses slides and videotape.

SPECS Uses color and b&w prints; 35mm, 2¼×2¼, 4×5, 8×10 transparencies; 16mm, VHS, Betacam videotape; and digital formats.

MAKING CONTACT & TERMS Send query letter with résumé of credits or samples. Provide résumé, business card, brochure, flier, or tearsheets to be kept on file. Works with local freelancers on assignment only. Keeps samples on file. Cannot return material. Responds in 2 weeks. Pays $75-150/job; $150-250 for color photo; $75-150 for b&w photo; $100-150/ hour for video. Pays on receipt of invoice, net 30 days.

Credit line sometimes given. Buys one-time and electronic rights. Rights negotiable.

⊛ HALLOWES PRODUCTIONS & ADVERTISING

750 W. 15th Ave., Escondido CA 92925. (310) 753-9381 or (310)390-4767. **E-mail:** Jim@HallowesProductions. com; adjim@aol.com. **Website:** www.jimhallowes. com; www.hallowesproductions.com; www. highlysensitivepeople.com. **Contact:** Jim Hallowes, creative director/producer-director/owner. Estab. 1996. Creates and produces TV commercials, corporate films/videos, and print and electronic advertising. Coaches creative people or Highly Sensitive Persons to have a happier and healthier life!

NEEDS Buys 8-10 photos/year. Uses photos for magazines, posters, newspapers, and brochures. Reviews stock photos; subjects vary.

AUDIOVISUAL NEEDS Uses film and video for TV commercials and corporate films.

SPECS Uses 35mm, 4×5 transparencies; 35mm/ 16mm film; Beta SP videotape; all digital formats.

MAKING CONTACT & TERMS Send query letter with résumé of credits. "Do not fax unless requested." Keeps samples on file. Responds if interested. Payment negotiable. Pays on usage. Credit line sometimes given, depending upon usage, usually not. Buys first and all rights; rights vary depending on client.

⊖⊖⊖❶ HAMPTON DESIGN GROUP

417 Haines Mill Rd., Allentown PA 18104. **E-mail:** wendy@hamptondesigngroup.com. **Website:** www. hamptondesigngroup.com. **Contact:** Wendy Ronga, creative director. Estab. 1997. Member of Type Director Club, Society of Illustrators, Art Directors Club, Society for Publication Designers. Design firm. Approximate annual billing: $100,000. Number of employees: 3. Firm specializes in annual reports, magazine and book design, editorial packaging, advertising, collateral, direct mail. Examples of recent clients: Conference for the Aging, Duke University/Templeton Foundation (photo shoot/5 images); Religion and Science, UCSB University (9 images for conference brochure).

NEEDS Works with 2 photographers/month. Uses photos for billboards, brochures, catalogs, consumer magazines, direct mail, newspapers, posters, trade magazines. Subjects include: babies/children/teens, multicultural, senior citizens, environmental, landscapes/scenics, wildlife, pets, religious, health/fitness/

beauty, business concepts, medicine, science. Interested in alternative process, avant garde, fine art, historical/vintage, seasonal. Model/property release required. Photo captions preferred.

SPECS Prefers images in digital format. Send via CD as TIFF, EPS, JPEG files at 300 dpi.

MAKING CONTACT & TERMS Send query letter. Keeps samples on file. Responds only if interested; send nonreturnable samples or web address to see examples. Pays $150-1,500 for color photos; $75-1,000 for b&w photos. Pays extra for electronic usage of photos, varies depending on usage. Price is determined by size, how long the image is used and if it is on the home page. **Pays on receipt of invoice.** Credit line given. Buys one-time rights, all rights, electronic rights; negotiable.

TIPS "Use different angles and perspectives, a new way to view the same old boring subject. Try different films and processes."

⑤❶ HOWARD/MERRELL, INC.

4800 Falls Neuse Rd., Suite 300, Raleigh NC 27609. 919-844-2775. **Fax:** (919)845-9845. **Website:** www. howardmerrell.com. **Contact:** Stephanie Styons. Estab. 1945. Number of employees: 25.

NEEDS Works with approximately 1 photographer/month. Uses photos for consumer and trade magazines, newspapers, collateral, outdoor boards, and websites. Purchases stock images. Model/property release required.

MAKING CONTACT & TERMS Works on assignment and buys stock photos. Pays on receipt of invoice. Buys one-time and all rights.

✪◎⑤ IDEA BANK MARKETING

P.O. Box 2117, Hastings NE 68902. (402)463-0588. **Fax:** (402)463-2187. **Website:** www. ideabankmarketing.com. **Contact:** Sherma Jones, vice president/creative director. Estab. 1982. Member of Lincoln Ad Federation. Ad agency. Approximate annual billing: $1.5 million. Number of employees: 14. Types of clients: industrial, financial, tourism, and retail.

NEEDS Works with 1-2 photographers/quarter. Uses photos for direct mail, catalogs, posters, and newspapers. Subjects include people and products. Reviews stock photos. Model release required; property release preferred.

AUDIOVISUAL NEEDS Works with 1 videographer/quarter. Uses slides and videotape for presentations.

SPECS Uses digital images.

MAKING CONTACT & TERMS Provide résumé, business card, brochure, flier, or tearsheets to be kept on file. Works with freelancers on assignment only. Responds in 2 weeks. Pays $75-125/hour; $650-1,000/day. Pays on acceptance with receipt of invoice. Credit line sometimes given depending on client and project. Buys all rights; negotiable.

✪ IMAGE INTEGRATION

2619 Benvenue Ave. #A, Berkeley CA 94704. (510)504-2605. **E-mail:** vincesail@aol.com. **Contact:** Vince Casalaina, owner. Estab. 1971. Firm specializes in material for TV productions and Internet sites. Approximate annual billing: $100,000. Examples of recent clients: "Internet coverage of Melges 32 World Championship, 505 World Championship, Snipe World Championship, Snipe Women's World Championship. 30-Minute Documentary on the Snipe Class as it turns 80 in 2011."

NEEDS Works with 1 photographer/month. Reviews stock photos of sailing only. Property release preferred. Photo captions required; include regatta name, regatta location, date.

AUDIOVISUAL NEEDS Works with 1 videographer/month. Uses videotape. Subjects include: sailing only.

SPECS Uses 4×5 or larger matte color and b&w prints; 35mm transparencies; 16mm film and Betacam videotape. Prefers images in digital format. Send via e-mail, ZIP, CD (preferred).

MAKING CONTACT & TERMS Send unsolicited photos of sailing by mail with SASE for consideration. Keeps samples on file. Responds in 2 weeks. Payment depends on distribution. Pays on publication. Credit line sometimes given, depending upon whether any credits included. Buys nonexclusive rights; negotiable.

❶ JUDE STUDIOS

8000 Research Forest, Suite 115-266, The Woodlands TX 77382. (281)364-9366. **E-mail:** frontdesk@ judestudios.com. **Contact:** Judith Dollar, art director. Estab. 1994. Number of employees: 2. Firm specializes in collateral, direct mail, packaging. Types of clients: nonprofits, builder, retail, destination marketing, event marketing, service. Examples of recent

clients: home builder; festivals and events; corporate collateral; banking.

NEEDS Works with 1 photographer/month. Uses photos for newsletters, brochures, catalogs, direct mail, trade and trade show graphics. Needs photos of families, active adults, shopping, recreation, concert, music, education, business concepts, industry, product shots/still life. Stock photos also used. Model release required; property release preferred.

SPECS Accepts images in digital format. Do not e-mail attachments.

MAKING CONTACT & TERMS Send e-mail with link to website, blog, or portfolio. Provide business card, self-promotion piece to be kept on file. Responds only if interested; send nonreturnable samples. Pays by the project. Pays on receipt of invoice.

⊗⊗ LOHRE & ASSOCIATES, INC.

126A W. 14th St., 2nd Floor, Cincinnati OH 45202-7535. (513)961-1174. **Website:** www.lohre.com. **Contact:** Chuck Lohre, president. Ad agency. Types of clients: industrial.

NEEDS Uses photos for trade magazines, direct mail, catalogs, and prints. Subjects include: machine-industrial themes and various eye-catchers.

SPECS Uses high-res digital images.

MAKING CONTACT & TERMS Send query letter with résumé of credits. Provide business card, brochure, flier, or tearsheets to be kept on file.

⊘ THE MILLER GROUP

1516 Bundy Dr., Suite 200, Los Angeles CA 90025. **E-mail:** gary@millergroupmarketing.com; info@millergroupmarketing.com. **Website:** www.millergroupmarketing.com. **Contact:** Gary Bettman, vice president. Estab. 1990. Member of WSAAA. Approximate annual billing: $12 million. Number of employees: 10. Firm specializes in print advertising. Types of clients: consumer.

NEEDS Uses photos for billboards, brochures, consumer magazines, direct mail, newspapers. Model release required.

MAKING CONTACT & TERMS Contact through rep or send digital submissions. Provide self-promotion piece to be kept on file. Buys all rights; negotiable.

TIPS "Please, no calls!"

⊗⊚⊗⊗◑ NOVUS VISUAL COMMUNICATIONS

59 Page Ave., Suite 300, Tower One, Yonkers NY 10704. (212)473-1377. **E-mail:** novuscom@aol.com. **Website:** www.novuscommunications.com. **Contact:** Robert Antonik, managing director. Estab. 1988. Integrated marketing company. Lectures on new marketing tools and techniques. Clients include B2B, B2C, and nonprofits. Uses the services of music houses, independent songwriters/composers and lyricists for scoring, background music for documentaries, commercials, multimedia applications, website, film shorts, and commercials for radio and TV. Commissions 2 composers and 4 lyricists/year. Pay varies per job. Buys one-time rights.

NEEDS Works with 1 photographer/month. Uses photos for integrated campaigns, business-to-business, B2C, direct mail, digital displays, online and print catalogs, posters, packaging, and signage. Subjects include: babies/children/teens, couples, multicultural, families, parents, senior citizens, environmental, landscapes/scenics, wildlife, architecture, cities/urban, education, gardening, interiors/decorating, pets, religious, rural, adventure, automobiles, entertainment, events, food/drink, health/fitness, hobbies, humor, performing arts, sports, travel, agriculture, business concepts, industry, medicine, military, political, product shots/still life, science, technology/computers. Interested in alternative process, avant garde, documentary, fashion/glamour, fine art, historical/vintage, seasonal. Reviews stock photos. Model/property release required. Photo captions preferred.

SPECS Digital and film, videotape, DVD. Prefers links to websites to review content.

MAKING CONTACT & TERMS Works on assignment only. Keeps samples on file. Cannot return material. Responds in 1-2 weeks. Pays $150-200 for b&w photos; $275-800 for color photos; $500-1,500 for digital film; $500-1,500 for videotape. Pays upon client's payment. Credit line given. Rights negotiable.

TIPS "The marriage of photos and illustrations continues to evolve. Being knowledgeable in Photoshop is very important. It helps shape the vision and enhances the visual. More illustrators and photographers add stock usage as part of their creative business plan. E-

mail with link to website. Send a sample postcard; follow up with phone call. Use low-tech marketing like direct mail, it works."

OMNI PRODUCTIONS

P.O. Box 302, Carmel IN 46082-0302. (317)846-2345. **Fax:** (317)846-6664. **E-mail:** omni@omniproductions. com. **Website:** www.omniproductions.com. **Contact:** Winston Long, president. Estab. 1984. AV firm. Types of clients: industrial, corporate, educational, government, medical.

NEEDS Works with 6-12 photographers/month. Uses photos for AV presentations. Subject matter varies. Also works with freelance filmmakers to produce training films and commercials. Model release required.

SPECS Uses b&w and color prints; 35mm transparencies; 16mm and 35mm film and videotape. Prefers high resolution images in digital format.

MAKING CONTACT & TERMS Provide complete contact info, rates, business card, brochure, flier, digital samples, or tearsheets to be kept on file. Works with freelance photographers on assignment basis only. Cannot return unsolicited material. Payment negotiable. **Pays on acceptance.** Credit line given "sometimes, as specified in production agreement with client." Buys all rights on most work; will purchase one-time use on some projects.

⊚ POINTBLANK AGENCY

(818)539-2282. **Fax:** (818)551-9681. **E-mail:** valn@pointblankagency.com. **Website:** www. pointblankagency.com. **Contact:** Valod Nazarian. Ad and design agency. Serves travel, high-technology, and consumer-technology clients.

NEEDS Uses photos for trade show graphics, websites, consumer and trade magazines, direct mail, P-O-P displays, newspapers. Subject matter of photography purchased includes: conceptual shots of people and table top (tight shots of electronics products). Model release required. Photo captions preferred.

SPECS Uses 8×10 matte b&w and color prints; 35mm, 2¼×2¼, 4×5, 8×10 transparencies. Accepts images in digital format. Send via CD.

MAKING CONTACT & TERMS Arrange a personal interview to show portfolio. Provide résumé, business card, brochure, flier, or tearsheets to be kept on file. Works on assignment basis only. Does not re-

turn unsolicited material. Responds in 3 weeks. Pay is negotiable. Pays on receipt of invoice. Buys one-time, exclusive product, electronic, buy-outs, and all rights (work-for-hire); negotiable.

TIPS Prefers to see "originality, creativity, uniqueness, technical expertise" in work submitted. There is more use of "photo composites, dramatic lighting and more attention to detail" in photography.

🟢⚫ POSEY SCHOOL

57 Main St., Northport NY 11768. (631)757-2700. **E-mail:** PoseySchoolOfDance@gmail.com; msposey@ optonline.net. **Website:** www.poseyschool.com. **Contact:** Elsa Posey, president. Estab. 1953. Sponsors a school of dance, art, music, drama; regional dance company and acting company. Uses photos for brochures, news releases, newspapers.

NEEDS Buys 12-15 photos/year; offers 4 assignments/year. Special subject needs include children dancing, ballet, modern dance, jazz/tap (theater dance) and "photos showing class situations in any subjects we offer. Photos must include girls and boys, women and men." Interested in documentary, fine art, historical/vintage. Reviews stock photos. Model release required.

SPECS Uses 8×10 glossy b&w prints. Accepts images in digital format. Send via CD, e-mail.

MAKING CONTACT & TERMS "Call us." Responds in 1 week. Pays $35-50 for most photos, b&w or color. Credit line given if requested. Buys one-time rights; negotiable.

TIPS "We are small but interested in quality (professional) work. Capture the joy of dance in a photo of children or adults. Show artists, actors, or musicians at work. We prefer informal action photos, not posed pictures. We need photos of *real* dancers dancing. Call first. Be prepared to send photos on request."

QUALLY & CO., INC.

(312)280-1898. **E-mail:** iva@quallycompany.com; michael@quallycompany.com. **Website:** www. quallycompany.com. **Contact:** Michael Iva, creative director. Estab. 1979. Ad agency. Types of clients: new product development and launches.

NEEDS Uses photos for every media. "Subject matter varies, but it must always be a "quality image" regardless of what it portrays." Model/property release required. Photo captions preferred.

SPECS Uses b&w and color prints; 35mm, 4×5, 8×10 transparencies. Accepts images in digital format.

MAKING CONTACT & TERMS Send query letter with photocopies, tearsheets. Provide résumé, business card, brochure, flier, or tearsheets to be kept on file. Responds only if interested; send nonreturnable samples. Payment negotiable. Pays net 30 days from receipt of invoice. Credit line sometimes given, depending on client's cooperation. Rights purchased depend on circumstances.

◑ QUON DESIGN

543 River Rd., Fair Haven NJ 07704-3227. (732)212-9200. **E-mail:** studio@quondesign.com. **Website:** www.quondesign.com; www.quonart.com. **Contact:** Mike Quon, president/creative director. Specializes in corporate identity, brand image, publications, and web design. Types of clients: industrial, financial, retail, publishers, nonprofit.

NEEDS Limited use of stock photography. Works with 1-3 photographers/year.

SPECS Uses color and b&w digital images.

MAKING CONTACT & TERMS Contact through mail or e-mail only. Pays net 30 days. Buys first rights, one-time rights; negotiable.

◑◐◑ TED ROGGEN ADVERTISING AND PUBLIC RELATIONS

101 Westcott St., Unit 306, Houston TX 77007. (713)426-2314. **Fax:** (713)869-3563. **E-mail:** ted@tedroggen-advertising.com. **Website:** www.tedroggen-advertising.com. **Contact:** Ted Roggen. Estab. 1945. Ad agency and PR firm. Number of employees: 3. Firm specializes in magazine ads, direct mail. Types of clients: construction, entertainment, food, finance, publishing, travel.

NEEDS Buys 25-50 photos/year; offers 50-75 assignments/year. Uses photos for billboards, direct mail, radio, TV, P-O-P displays, brochures, annual reports, PR releases, sales literature, and trade magazines. Subjects include adventure, health/fitness, sports, travel. Interested in fashion/glamour. Model release required. Photo captions required.

SPECS Uses 5×7 glossy or matte b&w and color prints; 4×5 transparencies. "Contact sheet OK."

MAKING CONTACT & TERMS Provide résumé to be kept on file. Pays $75-250 for b&w photos; $125-300 for color photos; $150/hour. **Pays on acceptance.** Rights negotiable.

✺◐◑◑ SIDES & ASSOCIATES

222 Jefferson St., Suite B, Lafayette LA 70501. (337)233-6473. **E-mail:** info@sides.com. **Website:** www.sides.com. **Contact:** Larry Sides, agency president. Estab. 1976. Member of AAAA, PRSA, Association for Strategic Planning, Chamber of Commerce, Better Business Bureau. Ad agency. Number of employees: 13. Firm specializes in publication design, display design, signage, video and radio production. Types of clients: governmental, healthcare, financial, retail, nonprofit. Examples of recent clients: US Dept of Homeland Security, ESF #14 (web, brochure, and special event planning); Lafayette Regional Airport (signs, brochures), Our Lady of Lourdes Regional Medical Center (TV, outdoor, print ads, brochures).

NEEDS Works with 2 photographers/month. Uses photos for billboards, brochures, newspapers, P-O-P displays, posters, signage. Subjects include: setup shots of people. Reviews stock photos of everything. Model/property release required.

AUDIOVISUAL NEEDS Works with 2 filmmakers and 2 videographers/month. Uses slides and/or film or video for broadcast, TV, newspaper.

SPECS Uses 35mm, 2¼×2¼, 4×5 transparencies.

MAKING CONTACT & TERMS Provide résumé, business card, self-promotion piece, or tearsheets to be kept on file. Works with local freelancers only. Responds only if interested; send nonreturnable samples. Payment determined by client and usage. Pays "when paid by our client." Rights negotiable.

✺◐ VIDEO I-D, TELEPRODUCTIONS

105 Muller Rd., Washington IL 61571. (309)444-4323. **E-mail:** videoid@videoid.com. **Website:** www.videoid.com. **Contact:** Sam B. Wagner, president. Estab. 1977. Number of employees: 10. Types of clients: health, education, industry, service, cable and broadcast.

NEEDS Works with 2 photographers/month to shoot digital stills, multimedia backgrounds and materials, films and videotapes. Subjects "vary from commercial to industrial—always high quality." Somewhat interested in stock photos/footage. Model release required.

AUDIOVISUAL NEEDS Uses digital stills, videotape, DVD, CD.

SPECS Uses digital still extension, Beta SP, HDV and HD. Accepts images in digital format. Send via DVD, CD, e-mail, FTP.

MAKING CONTACT & TERMS Provide résumé, business card, self-promotion piece, or tearsheets to be kept on file. Also send video sample reel. Include SASE for return of material. Works with freelancers on assignment only. Responds in 3 weeks. Pays $10-65/hour; $160-650/day. Usually pays by the job; negotiable. **Pays on acceptance.** Credit line sometimes given. Buys all rights; negotiable.

TIPS "Sample reel—indicate goal for specific pieces. Show good lighting and visualization skills. Show me you can communicate what I need to see, and have a willingness to put out effort to get top quality."

O WORCESTER POLYTECHNIC INSTITUTE

100 Institute Rd., Worcester MA 01609-2280. (508)831-6715 or (508)831-5099. **Fax:** (508)831-5820. **E-mail:** mdeiana@wpi.edu. **Website:** www.wpi.edu. **Contact:** Maureen Deiana, director of marketing programs. Estab. 1865. Publishes periodicals; promotional, recruiting and fund-raising printed materials. Photos used in brochures, newsletters, posters, audiovisual presentations, annual reports, catalogs, magazines, press releases, online.

NEEDS On-campus, comprehensive and specific views of all elements of the WPI experience.

SPECS Prefers images in digital format, but will use 5×7 (minimum) glossy b&w and color prints.

MAKING CONTACT & TERMS Arrange a personal interview to show portfolio or query with website link. Provide résumé, business card, brochure, flier, or tearsheets to be kept on file. "No phone calls." Responds in 6 weeks. Payment negotiable. Credit line given in some publications. Buys one-time or all rights; negotiable.

GALLERIES

///

The popularity of photography as a collectible art form has improved the market for fine art photographs over the last decade. Collectors now recognize the investment value of prints by Ansel Adams, Irving Penn, and Henri Cartier-Bresson, and therefore frequently turn to galleries for photographs to place in their private collections.

The gallery/fine art market can make money for many photographers. However, unlike commercial and editorial markets, galleries seldom generate quick income for artists. Galleries should be considered venues for important, thought-provoking imagery, rather than markets through which you can make a substantial living.

More than any other market, this area is filled with photographers who are interested in delivering a message. Many photography exhibits focus on one theme by a single artist. Group exhibits feature the work of several artists, and they often explore a theme from many perspectives, though not always. These group exhibits may be juried (i.e., the photographs in the exhibit are selected by a committee of judges who are knowledgeable about photography). Some group exhibits also may include other mediums such as painting, drawing, or sculpture. In any case, galleries want artists who can excite viewers and make them think about important subjects. They, of course, also hope that viewers will buy the photographs shown in their galleries.

As with picture buyers and art directors, gallery directors love to see strong, well-organized portfolios. Limit your portfolio to twenty top-notch images. When putting together your portfolio, focus on one overriding theme. A director wants to be certain you have enough quality work to carry an entire show. After the portfolio review, if the director likes your style, then you might discuss future projects or past work that you've done.

Directors who see promise in your work, but don't think you're ready for a solo exhibition, may place your photographs in a group exhibition.

HOW GALLERIES OPERATE

In exchange for brokering images, a gallery often receives a commission of 40–50 percent. They usually exhibit work for a month, sometimes longer, and hold openings to kick off new shows. They also frequently provide pre-exhibition publicity. Some smaller galleries require exhibiting photographers to help with opening night reception expenses. Galleries also may require photographers to appear during the show or opening. Be certain that such policies are put in writing before you allow them to show your work.

Gallery directors who foresee a bright future for you might want exclusive rights to represent your work. This type of arrangement forces buyers to get your images directly from the gallery that represents you. Such contracts are quite common, usually limiting the exclusive rights to specified distances. For example, a gallery in Tulsa, Oklahoma, may have exclusive rights to distribute your work within a 200-mile radius of the gallery. This would allow you to sign similar contracts with galleries outside the 200-mile range.

FIND THE RIGHT FIT

As you search for the perfect gallery, it's important to understand the different types of exhibition spaces and how they operate. The route you choose depends on your needs, the type of work you do, your long-term goals, and the audience you're trying to reach.

- **Retail or commercial galleries.** The goal of the retail gallery is to sell and promote artists while turning a profit. Retail galleries take a commission of 40–50 percent of all sales.
- **Co-op galleries.** Co-ops exist to sell and promote artists' work, but they are run by artists. Members exhibit their own work in exchange for a fee, which covers the gallery's overhead. Some co-ops also take a commission of 20–30 percent to cover expenses. Members share the responsibilities of gallery-sitting, sales, housekeeping, and maintenance.
- **Rental galleries.** The rental gallery makes its profit primarily through renting space to artists and consequently may not take a commission on sales (or will take only a very small commission). Some rental spaces provide publicity for artists, while others do not. Showing in this type of gallery is risky. Rental galleries are sometimes thought of as "vanity galleries," and, consequently, they do not have the credibility other galleries enjoy.
- **Nonprofit galleries.** Nonprofit spaces will provide you with an opportunity to sell work and gain publicity, but will not market your work aggressively, because their

goals are not necessarily sales-oriented. Nonprofits normally take a commission of 20–30 percent.

- **Museums.** Don't approach museums unless you have already exhibited in galleries. The work in museums is by established artists and is usually donated by collectors or purchased through art dealers.
- **Art consultancies.** Generally, art consultants act as liaisons between fine artists and buyers. Most take a commission on sales (as would a gallery). Some maintain small gallery spaces and show work to clients by appointment.

If you've never exhibited your work in a traditional gallery space before, you may want to start with a less traditional kind of show. Alternative spaces are becoming a viable way to help the public see your work. Try bookstores (even large chains), restaurants, coffee shops, upscale home furnishings stores, and boutiques. The art will help give their business a more pleasant, interesting environment at no cost to them, and you may generate a few fans or even a few sales.

Think carefully about what you take pictures of and what kinds of businesses might benefit from displaying them. If you shoot flowers and other plant life, perhaps you could approach a nursery about hanging your work in their sales office. If you shoot landscapes of exotic locations, maybe a travel agent would like to take you on. Think creatively and don't be afraid to approach a business person with a proposal. Just make sure the final agreement is spelled out in writing so there will be no misunderstandings, especially about who gets what money from sales.

COMPOSING AN ARTIST'S STATEMENT

When you approach a gallery about a solo exhibition, they will usually expect your body of work to be organized around a theme. To present your work and its theme to the public, the gallery will expect you to write an artist's statement, a brief essay about how and why you make photographic images. There are several things to keep in mind when writing your statement: Be brief. Most statements should be 100–300 words long. You shouldn't try to tell your life's story leading up to this moment. Write as you speak. There is no reason to make up complicated motivations for your work if there aren't any. Just be honest about why you shoot the way you do. Stay focused. Limit your thoughts to those that deal directly with the specific exhibit for which you're preparing.

Before you start writing your statement, consider your answers to the following questions: Why do you make photographs (as opposed to using some other medium)? What are your photographs about? What are the subjects in your photographs? What are you trying to communicate through your work?

440 GALLERY

440 Sixth Ave., Brooklyn NY 11215. (718)499-3844. **E-mail:** gallery440@verizon.net. **Website:** www.440gallery.com. **Contact:** Amy Williams, administrative director. Estab. 2005. "440 is an artist-run gallery. We maintain our membership at approximately 15 artists and occasionally seek a new member when an individual moves or leaves the gallery. There is a membership fee plus a donation of time. All prospective members must submit a portfolio and be interviewed. In addition to members' solo exhibitions, we host 2 national juried exhibitions each year, in the summer and winter, with an outside curator making selections. Located in Park Slope (Brooklyn), the gallery is approximately 400 sq. ft. with two exhibition areas (the solo gallery in the front and Project Space in the back). Open Tuesday-Friday, 4-7; weekends 11-7. Patrons are primarily from the New York regions, especially Brooklyn. Due to our proximity to popular Brooklyn destinations, we are visited often by tourists interested in culture and art." Overall price range $100-12,000 with prices set by the artist. Average length of an exhibition is 4 weeks.

EXHIBITS "Our artists most frequently exhibit painting, collage/assemblage, photography, printmaking, and sculpture."

MAKING CONTACT & TERMS Artwork is accepted on consignment and there is a 30% commission on sales for members and sales in juried shows. Gallery installs and promotes online and with e-mails and print materials.

SUBMISSIONS "For consideration as a member, please e-mail a query including a link to your website, which should include a résumé. For an application to our juried shows, visit our website for more information."

ADDISON/RIPLEY FINE ART

1670 Wisconsin Ave. NW, Washington DC 20007. (202)338-5180. **Fax:** (202)338-2341. **E-mail:** addisonrip@aol.com. **Website:** www.addisonripleyfineart.com. **Contact:** Christopher Addison, owner. Estab. 1981. Art consultancy, for-profit gallery. Approached by 100 artists/year; represents or exhibits 25 artists. Average display time 6 weeks. Gallery open Tuesday–Saturday, 11-5:30 and by appointment. Closed end of summer. Located in Georgetown in a large, open, light-filled gallery space.

Overall price range $500-80,000. Most work sold at $2,500-10,000.

EXHIBITS Works of all media.

MAKING CONTACT & TERMS Gallery provides insurance, promotion, contract. Accepted work should be framed, mounted, matted.

SUBMISSIONS Mail portfolio for review. Send query letter with artist's statement, bio, photocopies, résumé, SASE. Responds in 1 month.

TIPS "Submit organized, professional-looking materials."

ADIRONDACK LAKES CENTER FOR THE ARTS

3446 St. Rt. 28, Blue Mountain Lake NY 12812. (518)752-7715 or (518)352-7715. **Fax:** (518)352-7333. **E-mail:** office@adirondackarts.org. **Website:** www.adirondackarts.org. **Contact:** Jamie Strader, interim executive director. Estab. 1967. "ALCA is a 501c, non-profit organization showing national and international work of emerging to established artists. A tourist and second-home market, demographics profile our client as highly educated, moderately affluent, environmentally oriented, and well-traveled. In addition to its public programs, the Arts Center also administers the New York State Decentralization Regrant Program for Hamilton County. This program provides grants to local nonprofit organizations to sponsor art and cultural events, including concerts, workshops, and lectures in their own communities. The area served by the Arts Center includes Hamilton County, and parts of Essex, Franklin, Warren, and Herkimer counties. Our intent, with this diversity, is to enrich and unite the entire Adirondacks via the arts. The busy season is June through September."

EXHIBITS Solo, group, call for entry exhibits of color and b&w work. Sponsors 15-20 exhibits/year. Average display time 1 month. Overall price range $100-2,000. Most work sold at $250.

MAKING CONTACT & TERMS Consignment gallery, fee structure on request. Payment for sales follows within 30 days of close of exhibit. White mat and black frame required, except under prior agreement. ALCA pays return shipping only or cover work in transit.

SUBMISSIONS Apply by CD or slides, résumé, and bio. Must include SASE for return of materials. Upon acceptance notification, price sheet and artist statement required.

AKEGO AND SAHARA GALLERY

50 Washington Ave., Endicott NY 13760. (607)821-2540. **E-mail:** info@africaresource.com. **Website:** www.africaresource.com/house. **Contact:** Azuka Nzegwu, managing director. Estab. 2007. A for-profit, alternative space, for-rent gallery, and art consultancy. Exhibits emerging, mid-career, and established artists. Represents or exhibits 3-4 artists per year. Sponsors 3 total exhibits a year. Average display time 3-4 months. Model release and property release required. Open Monday-Friday, 9-6. Clients include local community, students, tourists, and upscale. Has contests and residencies available. See website for further details.

MAKING CONTACT & TERMS Artwork is accepted on consignment and there is a 40% commission. There is a rental fee for space covering 1 month. Retail price set by the gallery and the artist. Gallery provides insurance, promotion, and contract. Does not require exclusive representation locally. Artists should call, e-mail query letter with a link to the artist's website, mail portfolio for review, or send query letter with artist's statement, bio, résumé, and reviews. Responds in 1 week. Finds artists through word of mouth, submissions, portfolio reviews, referrals by other artists, as well as other means.

⊘ AKRON ART MUSEUM

1 S. High St., Akron OH 44308. (330)376-9185. **Fax:** (330)376-1180. **E-mail:** mail@akronartmuseum.org. **Website:** www.akronartmuseum.org. Located on the corner of East Market and South High Streets in the heart of downtown Akron. Open Friday–Sunday, 11-5; Thursday, 11-9. Closed Monday and Tuesday. Closed holidays.

○ Annually awards the Knight Purchase Award to a living artist working with photographic media.

EXHIBITS To exhibit, photographers must possess "a notable record of exhibitions, inclusion in publications, and/or a role in the historical development of photography. We also feature area photographers (northeast Ohio)." Interested in innovative works by contemporary photographers; any subject matter. Interested in alternative process, documentary, fine art, historical/vintage.

MAKING CONTACT & TERMS Payment negotiable. Buys photography outright.

SUBMISSIONS "Please submit a brief letter of inter-est, résumé, and 20-25 representative images (slides, snapshots, JPEGs on CD, DVDs or website links). Do not send original artworks. If you would like your material returned, please include a SASE." Allow 2-3 months for review.

TIPS "Send professional-looking materials with high-quality images, a résumé and an artist's statement. Never send original prints."

ALASKA STATE MUSEUM

395 Whittier St., Juneau AK 99801-1718. (907)465-2901. **Fax:** (907)465-2151. **E-mail:** jackie.manning@alaska.gov. **Website:** www.museums.alaska.gov. **Contact:** Jackie Manning, curator of exhibitions. Estab. 1900. Approached by 80 artists/year. Sponsors at least 1 photography exhibit every 2 years. Average display time 10 weeks. Exhibit travels statewide. Downtown location.

EXHIBITS Interested in historical and fine art.

SUBMISSIONS Finds Alaskan artists through submissions and portfolio reviews every 2 years.

ALBUQUERQUE MUSEUM

2000 Mountain Rd., NW, Albuquerque NM 87104. (505)243-7255. **Website:** www.cabq.gov/museum. **Contact:** Andrew Connors, curator of art; Glenn Fye, photo archivist. Estab. 1967.

SUBMISSIONS Submit portfolio of slides, photos, or disk for review. Responds in 2 months.

CHARLES ALLIS ART MUSEUM

1801 N. Prospect Ave., Milwaukee WI 53202. (414)278-8295. **E-mail:** jsterr@cavtmuseums.org. **Website:** www.charlesallis.org. **Contact:** John Sterr, executive director. Estab. 1947. The Charles Allis Art Museum exhibits emerging, mid-career and established artists that have lived or studied in Wisconsin. Exhibited artists include Anne Miotke (watercolor); Evelyn Patricia Terry (pastel, acrylic, multi-media). Sponsors 3 exhibits/year. Average display time: 3 months. Open all year; Wednesday–Sunday, 1-5. Located in an urban area, historical home, 3 galleries. Clients include local community, students, and tourists. 10% of sales are to corporate collectors. Overall price range: $200-6,000.

EXHIBITS Considers acrylic, collage, drawing, installation, mixed media, oil, pastel, pen & ink, sculpture, watercolor, and photography. Print types include engravings, etchings, linocuts, lithographs, serigraphs, and woodcuts.

MAKING CONTACT & TERMS Artwork can be

purchased during run of an exhibition; a 30% commission fee applies. Retail price set by the artist. Museum provides insurance, promotion, and contract. Accepted work should be framed. Does not require exclusive representation locally. Accepts only artists from or with a connection to Wisconsin.

SUBMISSIONS Finds artists through submissions to Request for Proposals which can be found at www. charlesallis.org/news.html.

AMERICAN PRINT ALLIANCE

302 Larkspur Turn, Peachtree City GA 30269-2210. **E-mail:** director@printalliance.org. **Website:** www. printalliance.org. **Contact:** Carol Pulin, director. Estab. 1992.

EXHIBITS "We only exhibit original prints, artists' books, and paperworks." Usually sponsors 2 travelling exhibits/year—all prints, paperworks, and artists' books; photography within printmaking processes but not as a separate medium. Most exhibits travel for 2 years. Hours depend on the host gallery/museum/arts center. "We travel exhibits throughout the US and occasionally to Canada." Overall price range for Print Bin: $150-3,200; most work sold at $300-500. "We accept all styles, genres and subjects; the decisions are made on quality of work." Individual subscription: $32-39. Print Bin is free with subscription."

MAKING CONTACT & TERMS Subscribe to journal, *Contemporary Impressions* (www. printalliance.org/alliance/al_subform.html), send 1 slide and signed permission form (www.printalliance. org/gallery/printbin_info.html). Returns slide if requested with SASE. Usually does not respond to queries from nonsubscribers. Files slides and permission forms. Finds artists through submissions to the gallery or Print Bin, and especially portfolio reviews at printmakers conferences.

THE ANN ARBOR ART CENTER GALLERY SHOP

117 W. Liberty St., Ann Arbor MI 48104. (734)994-8004. **Fax:** (734)994-3610. **E-mail:** nrice@annarborartcenter.org; sbingham@annarborartcenter.org. **Website:** www.annarborartcenter.org. **Contact:** Nathan Rice, gallery curator; Samantha Bingham, gallery curator. Estab. 1909. Represents over 350 artists, primarily Michigan and regional. Gallery shop purchases support the Art Center's community outreach programs. "We are the only organization in Ann Arbor that offers hands-on art education, art appreciation programs, and exhibitions all in one facility." Open Monday–Friday, 10-7; Saturday, 10-6; Sunday, 12-5.

The Ann Arbor Art Center also has exhibition opportunities for Michigan artists in its exhibition gallery and art consulting program.

EXHIBITS Considers original work in virtually all 2D and 3D media, including jewelry, prints and etchings, ceramics, glass, fiber, wood, photography, and painting.

MAKING CONTACT & TERMS Submission guidelines available online. Accepts work on consignment. Retail price set by artist. Offers member discounts and payment by installments. Exclusive area representation not required. Gallery provides contract; artist pays for shipping.

SUBMISSIONS "The Art Center seeks out artists through the exhibition visitation, wholesale and retail craft shows, networking with graduate and undergraduate schools, word of mouth, in addition to artist referral and submissions."

ARC GALLERY

Attn: Exhibition Committee, 2156 N. Damen Ave., Chicago IL 60647. (773)252-2232. **E-mail:** info@arcgallery.org. **Website:** www.arcgallery.org. **Contact:** Carolyne King, president. Estab. 1973. Sponsors 5-8 exhibits/year. Average display time 1 month. Overall price range $100-1,200.

"ARC Gallery and Educational Foundation is a not-for-profit gallery and foundation whose mission is to bring innovative, experimental visual art to a wide range of viewers, and to provide an atmosphere for the continued development of artistic potential, experimentation, and dialogue. ARC serves to educate the public on various community-based issues by presenting exhibits, workshops, discussion groups, and programs for, and by, underserved populations."

EXHIBITS All styles considered. Contemporary fine art photography, documentary, and journalism.

MAKING CONTACT & TERMS Charges no commission, but there is a space rental fee.

SUBMISSIONS Apply online via gallery website with JPEGS, résumé, and statement for gallery to review. Responds in 1 month.

TIPS Artists "should have a consistent body of work. Shows emerging through late-in-career artists."

ARIZONA STATE UNIVERSITY ART MUSEUM

P.O. Box 872911, Tenth St. and Mill Ave., Tempe AZ 85287-2911. (480)965-2787. **Fax:** (480)965-5254. **Website:** asuartmuseum.asu.edu. **Contact:** Gordon Knox, director. Estab. 1950. Has 3 facilities and approximately 8 galleries of 2,500 sq. ft. each; mounts approximately 15 exhibitions/year. Average display time: 3-4 months.

EXHIBITS Proposals are reviewed by curatorial staff.

MAKING CONTACT & TERMS Accepted work should be framed, mounted, matted.

SUBMISSIONS E-mail or send query letter with résumé, reviews, images of current work, and SASE for return of materials. "Allow several months for a response since we receive many proposals and review monthly."

ARNOLD ART

210 Thames St., Newport RI 02840. (401)847-2273; (800)352-2234. **Fax:** (401)848-0156. **E-mail:** info@arnoldart.com. **Website:** www.arnoldart.com. **Contact:** William Rommel, owner. Estab. 1870. For-profit gallery. Represents or exhibits 40 artists. Average display time 1 month. Gallery open Monday–Saturday, 9:30-5:30; Sunday, 12-5. Closed Christmas, Thanksgiving, Easter. Art gallery is 17×50 ft., open gallery space (3rd floor). Overall price range $100-35,000. Most work sold at $300.

EXHIBITS Marine (sailing), classic yachts, America's Cup, wooden boats, sailing/racing. Artwork is accepted on consignment, and there is a 45% commission. Gallery provides promotion. Accepted work should be framed.

MAKING CONTACT & TERMS E-mail to arrange personal interview to show portfolio.

THE ARSENAL GALLERY

The Arsenal Bldg., Room 20, Central Park, 830 Fifth Ave., New York NY 10065. (212)360-8163. **Fax:** (212)360-1329. **E-mail:** artandantiquities@parks.nyc. gov; jennifer.lantzas@parks.nyc.gov. **Website:** www. nycgovparks.org/art. Jennifer Lantzas, public art coordinator. Estab. 1971.

EXHIBITS Exhibits photos of environmental, landscapes/scenics, wildlife, architecture, cities/urban, adventure, NYC parks. Interested in alternative process, avant garde, documentary, fine art, historical/vintage. Artwork is accepted on consignment, and there is a 15% commission. Gallery provides promotion. Contact parks for submission deadlines.

MAKING CONTACT & TERMS Mail portfolio for review. Send query letter with artist's statement, bio, brochure, business card, photocopies, résumé, reviews, SASE. Responds within 6 months, only if interested. Finds artists through word of mouth, portfolio reviews, art exhibits, referrals by other artists.

ART@NET INTERNATIONAL GALLERY

E-mail: artnetg@yahoo.com. **Website:** www.artnet. com. **Contact:** Yavor Shopov-Bulgari, director. Estab. 1998. Artwork is accepted on consignment; there is a 10% commission and a rental fee for space of $1/image per month or $5/image per year. First 6 images are displayed free of rental fee. Gallery provides promotion. Accepted work should be matted. Main usage of all works exhibited in our gallery is for limited edition (photos) or original (paintings) wall decoration of offices and homes, so photos must have quality of paintings.

EXHIBITS Photos of creative photography including: travel, landscapes/scenics, fashion/glamour, erotic, figure landscapes, beauty, abstracts, avant garde, fine art, silhouettes, architecture, buildings, cities/urban, science, astronomy, education, seasonal, wildlife, sports, adventure, caves, crystals, minerals and luminescence.

MAKING CONTACT & TERMS "We accept computer scans only; no slides, please. E-mail attached scans, 900×1200 pixels (300 dpi for prints or 900 dpi for 36mm slides), as JPEG files for PCs." E-mail query letter with artist's statement, bio, résumé. Responds in 6 weeks. Finds artists through submissions, portfolio reviews, art exhibits, art fairs, referrals by other artists." E-mail a tightly edited selection of less than 20 scans of your best work. All work must force any person to look over it again and again.

TIPS "We like to see strong artistic sense of mood, composition, light, color, and strong graphic impact or expression of emotions. For us, only quality of work is important, so newer, lesser-known artists are welcome."

ARTEFACT/ROBERT PARDO GALLERY

805 Lake Ave., Lake Worth FL 33460. (561)329-6264. **E-mail:** robert@theartefactgallery.com. **Website:** www.theartefactgallery.com. **Contact:** Robert Pardo. Estab. 1986. Approached by 500 artists/year; represents or exhibits 18 artists. Sponsors 3 photography

exhibits/year. Average display time 4-5 weeks. Gallery open 7 days a week until 6.

EXHIBITS Interested in avant garde, fashion/glamour, fine art.

SUBMISSIONS Arrange personal interview to show portfolio of slides, transparencies. Responds in 1 month.

ARTISTS' COOPERATIVE GALLERY

405 S. 11th St., Omaha NE 68102. (402)342-9617. **E-mail:** artistscoopgallery@gmail.com. **Website:** www.artistsco-opgallery.com. Estab. 1974. Gallery sponsors all-member exhibits and outreach exhibits; individual artists sponsor their own small group exhibits throughout the year. Overall price range $100-5,000. "Artist must be willing to work 13 days per year at the gallery. Sponsors 12 exhibits/year. Average display time 1 month. Fine art photography only. We are a member-owned-and-operated cooperative. Artist must also serve on one committee. Write for membership application. Membership committee screens applicants August 1-15 each year. Responds by September 1. New membership year begins October 1. Members must pay annual fee of $400. Our community outreach exhibits include local high school photographers and art from local elementary schools." Open Tuesday–Thursday, 11-5; Friday-Saturday, 11-10; Sunday, 12-6. Thursdays during holiday season and summer hours until 10 p.m.

EXHIBITS Interested in all types, styles, and subject matter. Charges no commission. Reviews transparencies. Accepted work should be framed work only.

SUBMISSIONS Send query letter with résumé, SASE. Responds in 2 months.

THE ARTS COMPANY

215 Fifth Ave., Nashville TN 37219. (615)254-2040 or (877)694-2040. **Fax:** (615)254-9289. **E-mail:** art@theartscompany.com. **Website:** www.theartscompany.com. **Contact:** Anne Brown, owner. Estab. 1996. Art consultancy, for-profit gallery. Sponsors 6-10 photography exhibits/year. Average display time 1 month. Open Tuesday-Saturday, 11-5. Located in downtown Nashville, the gallery has 6,000 sq. ft. of contemporary space in a historic building. Overall price range $10-35,000. Most work sold at $300-3,000.

EXHIBITS Photos of celebrities, architecture, cities/urban, rural, environmental, landscapes/scenics, entertainment, performing arts. Interested in documentary, fine art, historical/vintage.

MAKING CONTACT & TERMS "We prefer an initial info packet via e-mail." Send query letter with artist's statement, bio, brochure, business card, photocopies, résumé, reviews, SASE, CD. Returns material with SASE.

SUBMISSIONS "Provide professional images on a CD along with a professional bio, résumé." Artwork is accepted on consignment. Gallery provides insurance, contract. Accepted work should be framed.

TIPS Finds artists through word of mouth, art fairs, art exhibits, submissions, referrals by other artists.

ARTS ON DOUGLAS

Atlantic Center for the Arts, 123 Douglas St., New Smyrna Beach FL 32168. (386)428-1133. **Fax:** (386)428-5008. **E-mail:** mmartin@artsondouglas.net. **Website:** www.artsondouglas.net. **Contact:** Meghan Martin, gallery director. Estab. 1996. Represents 40 Florida artists in solo and group exhibits. Features 18 exhibitions per year Average display time 1 month. Gallery open Tuesday-Friday, 10-5; Saturday, 11-3; by appointment. Location has 3500 sq. ft. of exhibition space. Overall price range varies.

EXHIBITS Interested in alternative process, documentary, fine art.

MAKING CONTACT & TERMS Artwork is accepted on consignment, and there is a 50% commission. Gallery provides insurance, promotion. Accepted work should be framed. Requires exclusive representation locally. Accepts only professional artists from Florida.

SUBMISSIONS Call in advance to inquire about submissions/reviews. Send a query letter and include a CD with 6 current images, bio, CV, and artist's statement. Finds artists through referrals by other artists.

ART SOURCE L.A., INC.

2801 Ocean Park Blvd., #7, Santa Monica CA 90405. (310)452-4411 or (800)721-8477. **Fax:** (310)452-0300. **E-mail:** info@artsourcela.com. **Website:** www.artsourcela.com. **Contact:** Francine Ellman, president. Estab. 1980. Overall price range $300-15,000. Most work sold at $600.

EXHIBITS Photos of multicultural, environmental, landscapes/scenics, wildlife, architecture, cities/urban, gardening, interiors/decorating, rural, automobiles, food/drink, travel, technology/computers. Interested in alternative process, avant garde, fine art, historical/vintage, seasonal. "We do projects worldwide, putting

together fine art for corporations, health care, hospitality, government, and public space. We use a lot of photography."

MAKING CONTACT & TERMS Interested in receiving work from emerging and established photographers. Charges 50% commission.

SUBMISSIONS Digital submissions only via e-mail to info@artsourcela.com.

TIPS "Show a consistent body of work, well marked and presented so it may be viewed to see its merits."

[ARTSPACE] AT UNTITLED

1 NE Third St., Oklahoma City OK 73104. (405)815-9995. **E-mail:** info@artspaceatuntitled.org. **Website:** www.artspaceatuntitled.org. Estab. 2003. Alternative space, nonprofit art center. Contemporary art center. Average display time: 6weeks. Gallery is open to the public Tuesday–Saturday, 10-6. Closed Sunday-Monday. The [Press] at Untitled, an open printmaking studio, located within Artspace, offers memberships for artists and other creatives. The [Press] also engages photographers through demo sessions and workshops on how to create their works as hand-pulled prints. The [Press] at Untitled is open Tuesday-Wednesday, 10-6 and Thursday-Saturday 10-10. "Located in a reclaimed industrial space abandoned by decades of urban flight. Damaged in the 1995 Murrah Federal Building bombing, [Artspace] at Untitled has emerged as a force for creative thought. As part of the Deep Deuce historic district in downtown Oklahoma City, Artspace at Untitled brings together visual arts, performance, music, film, design, and architecture with a focus on innovation, works on paper, and new media art. Our mission is to stimulate creative thought and new ideas through contemporary art. We are committed to providing access to quality exhibitions, educational programs, performances, publications, and to engaging the community in collaborative outreach efforts." Most work sold at $500-2,500, but not primarily a sales gallery.

MAKING CONTACT & TERMS There is a 50% commission for any works sold.

SUBMISSIONS Mail portfolio for review. Send query letter with artist's statement, bio, résumé, and CD of images. Prefers 10-15 images on a CD. Include SASE for return of materials or permission to file the portfolio. Reviews occur twice annually, in January and July. Finds artists through submissions and portfolio reviews. Responds to queries within 3 months.

TIPS "Review our previous programming to evaluate if your work is along the lines of our mission. Take the time to type and proof all written submissions. Make sure your best work is represented in the images you choose to show. Nothing takes away from the review like poorly scanned or photographed work."

THE ART STORE

233 Hale St., Charleston WV 25301. (304)345-1038. **Fax:** (304)345-1858. **E-mail:** gallery@theartstorewv.com. **Website:** www.theartstorewv.com. "The Art Store is dedicated to showing original 20th-century and contemporary American art by leading local, regional and nationally recognized artists. Professional integrity, commitment, and vision are the criteria for artist selection, with many artists having a history of exhibitions and museum placement. Painting, sculpture, photography, fine art prints, and ceramics are among the disciplines presented. A diverse series of solo, group and invitational shows are exhibited throughout the year in the gallery." Retail gallery. Represents 50 mid-career and established artists. Sponsors 11 shows/year. Average display time 4 weeks. Open Tuesday–Friday, 10-5:30; Saturday, 10-5; anytime by appointment. Located in a upscale shopping area; 2,000 sq. ft.; 50% of space for special exhibitions. Clientele: professionals, executives, decorators. 80% private collectors, 20% corporate collectors. Overall price range $200-8,000; most work sold at $2,000.

MAKING CONTACT & TERMS Accepts artwork on consignment (50% commission). Retail price set by gallery and artist. Gallery provides insurance, promotion, and shipping costs from gallery. Prefers artwork unframed.

TIPS Send query e-mail.

ASIAN AMERICAN ARTS CENTRE

111 Norfolk St., New York NY 10002. **Fax:** (360)283-2154. **E-mail:** aaacinfo@artspiral.org. **Website:** www.artspiral.org. Estab. 1974. "Our mission is to promote the preservation and creative vitality of Asian-American cultural growth through the arts, and its historical and aesthetic linkage to other communities." Exhibits should be Asian American or significantly influenced by Asian culture and should be entered into the archive-a historical record of the presence of Asia in the US. Interested in "creative art pieces." Average display time 6 weeks. Open Monday–Friday, 12:30-6:30 (by appointment).

MAKING CONTACT & TERMS To be consid-

ered for the AAAC Artist Archive and artasiamerica. org, please submit 20 images either as 35mm slides (labeled with artist's name, title, date, materials, techniques, and dimensions) or digital images of work as TIFF or JPEG on CD or DVD, at minimum 2,000 pixel width with resolution of 300 dpi; corresponding artwork list with artist's name, title, date, materials, techniques, and dimensions; 1-page artist statement (to be dated); artists not of Asian descent should mention specifically how they consider themselves influenced by Asia; artist bio and résumé (to be dated); other support materials (catalogs, newspaper/journal articles, reviews, announcement cards, press releases, project plans, etc.); completed AAAC information form located at www.artspiral.org/archive_submission.

ATELIER GALLERY

153 King St., Charleston SC 29401. **E-mail:** gabrielle@theateliergalleries.com. **Website:** www. theateliergalleries.com. **Contact:** Gabrielle Egan, curator and owner. Estab. 2008. Fine art gallery. Exhibits mid-career, and established artists. Represents or exhibits 60 artists. For exhibited artists, see website at www.theatelilergalleries.com. Open Monday-Friday, 10-6; Sundays, by chance. Closed Holidays. Clients include local community, students, tourists, upscale, and artists and designers. Overall price range: $50-15,000. Most work sold in the $2,500-5,000 range.

MAKING CONTACT & TERMS Artwork is accepted on consignment with a 50% commission. Retail price set by the gallery and artist. Gallery provides insurance, promotion, and contract. Atelier requires exclusive representation within 250 miles of the gallery in downtown Charleston SC.

SUBMISSIONS E-mail query letter along with 6 images of the most current body of work. Please include medium, dimensions, framing specifications, pricing. Also provide all artist contact information to include website, e-mail, and telephone number. Atelier Gallery will contact each artist via e-mail once the submission has been reviewed. If more information is needed, the gallery will request it directly.

ATLANTIC GALLERY

548 W. 28th St., Suite 540, New York NY 10001. (212)219-3183. **E-mail:** info@atlanticgallery.org. **Website:** www.atlanticgallery.org. **Contact:** Jeff Miller, president. Estab. 1974. Cooperative gallery. There is a co-op membership plus a donation of time required.

Approached by 50 artists/year; represents 24 emerging, mid-career, and established artists. Exhibited artists include Ragnar Naess (sculptor), Sally Brody (oil, acrylic), and Whitney Hansen (oil). Average display time 4 weeks. Gallery open Tuesday, Wednesday, Friday, Saturday, 12-6; Thursday, 12-9. Closed August. Located in Chelsea. Has kitchenette. Clients include local community, tourists, and upscale clients. 2% of sales are to corporate collectors. Overall price range $100-13,000. Most work sold at $1,500-5,000. Finds artists through word of mouth, submissions, art exhibits, referrals by other artists.

EXHIBITS Interested in fine art.

MAKING CONTACT & TERMS Call or write to arrange a personal interview.

SUBMISSIONS "Submit an organized folder with slides, CD, bio, and 3 pieces of actual work. If we respond with interest, we then review again." Responds in 1 month. Views submitted works monthly.

AXIS GALLERY

71 Burnett Terr., West Orange NJ 07052. (212)741-2582. **E-mail:** info@axisgallery.com. **Website:** www. axisgallery.com. **Contact:** Lisa Brittan, director. Estab. 1997. For-profit gallery. Approached by 30 African artists/year; representative of 20 artists. Check gallery hours and show locations online; other times by appointment. Closed during summer. Overall price range $500-50,000.

EXHIBITS Interested in alternative process, avant garde, documentary, erotic, fine art, historical/vintage. Also interested in photojournalism, resistance.

MAKING CONTACT & TERMS Artwork is accepted on consignment, and there is a 50% commission. Gallery provides insurance, promotion, contract. *Only accepts artists from Africa.*

SUBMISSIONS Send digital submission with letter, résumé, reviews, and images via e-mail. Responds in 3 months. Finds artists through research, recommendations, submissions, portfolio reviews, art exhibits, referrals by other artists.

TIPS "Photographers should research gallery first to check if their work fits the gallery program. Avoid bulk mailings."

BAKER ARTS CENTER

624 N. Pershing Ave., Liberal KS 67901. (620)624-2810. **Fax:** (620)624-7726. **E-mail:** dianemarsh@ bakerartscenter.org. **Website:** www.bakerartscenter.

org. **Contact:** Diane Marsh, art director. Estab. 1986. Nonprofit gallery. Exhibits emerging, mid-career, and established artists. Approached by 6-10 artists a year. Represents of exhibits 6-10 artists. Exhibited artists include J. McDonald (glass) and J. Gustafson (assorted). Sponsors 5 total exhibits/year. 1 photography exhibit/year. Model and property release are preferred. Average display time 40-50 days. Open Tuesday-Friday, 9-5; Saturdays, 2-5. Closed Christmas, Thanksgiving and New Year's Eve. Clients include local community, students, and tourists. Overall price range $10-1,000. Most work sold at $400.

MAKING CONTACT & TERMS Artwork is accepted on consignment and there is a 30% commission fee. Retail price set by the artist. Gallery provides insurance, promotion, and contract. Accepted work should be framed, mounted, and matted.

SUBMISSIONS Write to arrange personal interview to show portfolio or e-mail query letter with link to artist's website or JPEG samples at 72 dpi. Returns material with SASE. Responds in 2-4 weeks. Finds artists through word of mouth, submissions, art exhibits, and referrals by other artists.

BALZEKAS MUSEUM OF LITHUANIAN CULTURE ART GALLERY

6500 S. Pulaski Rd., Chicago IL 60629. (773)582-6500. **Fax:** (773)582-5133. **E-mail:** info@balzekasmuseum.org. **Website:** www.balzekasmuseum.org. **Contact:** Stanley Balzekas, Jr., president. Estab. 1996. Museum, museum retail shop, nonprofit gallery, rental gallery. Approached by 20 artists/year. Sponsors 2 photography exhibits/year. Average display time 6 weeks. Open daily, 10-4. Closed Christmas, Easter, and New Year's Day. Overall price range $150-6,000. Most work sold at $545.

EXHIBITS Photos of babies/children/teens, celebrities, couples, multicultural, families, parents, senior citizens, disasters, environmental, landscapes/scenics, wildlife, architecture, cities/urban, education, gardening, interiors/decorating, pets, religious, rural, adventure, automobiles, entertainment, events, food/drink, health/fitness, hobbies, humor, performing arts, sports, travel, agriculture, buildings, business concepts, industry, medicine, military, political, product shots/still life, science, technology/computers. Interested in alternative process, avant garde, documentary, erotic, fashion/glamour, fine art, historical/vintage, seasonal.

MAKING CONTACT & TERMS Artwork is accepted on consignment, and there is a 33-1/3% commission. Gallery provides promotion. Accepted work should be framed.

SUBMISSIONS Write to arrange personal interview to show portfolio. Responds in 2 months. Finds artists through word of mouth, art exhibits, referrals by other artists.

✪BASILICA HUDSON, THE BACK GALLERY

110 S. Front St., Hudson NY 12534, U.S.. (518)822-1050. **E-mail:** info@basilicahudson.org. **Website:** www.basilicahudson.org. Estab. 2014.

BELIAN ART CENTER

5980 Rochester Rd., Troy MI 48085. (248)828-1001. **E-mail:** zabelbelian@gmail.com. **Website:** www.belianart.com. **Contact:** Zabel Belian, gallery director. Estab. 1985. Sponsors 1-2 exhibits/year. Average display time 3 weeks. Sponsors openings. Average price range $200-2,000.

EXHIBITS Looks for originality, capturing the intended mood, perfect copy, mostly original editions. Subjects include landscapes, cities, rural, events, agriculture, buildings, still life.

MAKING CONTACT & TERMS Charges 40-50% commission. Buys photos outright. Reviews transparencies. Requires exclusive representation locally. Arrange a personal interview to show portfolio. Send query letter with résumé and SASE.

CECELIA COKER BELL GALLERY

Coker College Art Dept., 300 E. College Ave., Hartsville SC 29550. (843)383-8150. **E-mail:** artgallery@coker.edu. **Website:** www.ceceliacokerbellgallery.com. **Contact:** Jean Grosser, gallery director & department chair. "A campus-located teaching gallery that exhibits a variety of media and styles to expose students and the community to the breadth of possibility for expression in art. Exhibits include regional, national, and international artists with an emphasis on quality and originality. Shows include work from emerging, mid-, and late-career artists." Sponsors 5 solo shows/year, with a 4-week run for each show. Open Monday–Friday, 10-4 (when classes are in session).

EXHIBITS Considers all media including installation and graphic design. Most frequently exhibits painting, photography, sculpture/installation, and mixed media.

MAKING CONTACT & TERMS Retail price set by artist (sales are not common). Exclusive area representation not required. Gallery provides insurance, promotion and contract; shipping costs are shared.

SUBMISSIONS Send résumé, 15-20 JPEG files on CD (or upload them to a Dropbox account) with a list of images, statement, résumé, and SASE. Reviews, web pages, and catalogues are welcome, though not required. If you would like response, but not your submission items returned, simply include an e-mail address. Visits by artists are welcome; however, the exhibition committee will review and select all shows from the JPEGs submitted by the artists.

BENNETT GALLERIES AND COMPANY

5308 Kingston Pike, Knoxville TN 37919. (865)584-6791. **Fax:** (865)588-6130. **E-mail:** info@bennettgalleries.com. **Website:** www.bennettgalleries.com. Estab. 1985. For-profit gallery. Represents or exhibits 40 artists/year. Sponsors 1-2 photography exhibits/year. Average display time 1 month. Gallery open Monday–Thursday, 10-6; Friday–Saturday, 10-5:30. Conveniently located a few miles from downtown Knoxville in the Bearden area. The formal art gallery has over 2,000 sq. ft. and 20,000 sq. ft. of additional space. Overall price range $100-12,000. Most work sold at $400-600.

EXHIBITS Photos of landscapes/scenics, architecture, cities/urban, humor, sports, travel. Interested in alternative process, fine art, historical/vintage.

MAKING CONTACT & TERMS Artwork is accepted on consignment, and there is a 50% commission. Gallery provides insurance, promotion, contract. Accepted work should be framed. Requires exclusive representation locally.

SUBMISSIONS Mail portfolio for review. Send query letter with artist's statement, bio, photographs, SASE, CD. Responds within 1 month, only if interested. Finds artists through word of mouth, submissions, art exhibits, referrals by other artists.

TIPS When submitting material to a gallery for review, the package should include information about the artist (neatly written or typed), photographic material, and SASE if you want your materials back.

BENRUBI GALLERY

521 W. 26th St., 2nd Floor, New York NY 10001. (212)888-6007. **Fax:** (212)751-0819. **E-mail:** info@benrubigallery.com. **Website:** www.benrubigallery.com. Estab. 1987. Sponsors 7-8 exhibits/year. Average display time 6 weeks. Overall price range $500-50,000.

EXHIBITS Interested in 19th- and 20th-century photography, mainly contemporary.

MAKING CONTACT & TERMS Charges commission. Buys photos outright. Accepted work should be matted. Requires exclusive representation locally. No manipulated work.

SUBMISSIONS Not currently accepting submissions. Submit portfolio for review; include SASE. Responds in 2 weeks. Portfolio review is the first Thursday of every month. Out-of-towners can send slides with SASE, and work will be returned.

BIRMINGHAM BLOOMFIELD ART CENTER

1516 S. Cranbrook Rd., Birmingham MI 48009. (248)644-0866. **E-mail:** annievangelderen@bbartcenter.org. **Website:** www.bbartcenter.org. **Contact:** Annie VanGelderen, president and CEO. Estab. 1962. Nonprofit gallery shop and gallery exhibit space. Represents emerging, mid-career, and established artists. Presents ongoing exhibitions in 4 galleries. Open all year; Monday-Thursday, 9-6; Friday-Saturday, 9-5; second Sundays, 1-4. Suburban location. 70% of space for gallery artists. Clientele upscale, local. 100% private collectors. Overall price range $50-25,000.

EXHIBITS Considers 2D and 3D fine art in all media. Most frequently exhibits 3D work: jewelry, glass, ceramics, fiber, mixed media sculpture; and 2D work: painting, printmaking, drawing, mixed media, and video.

MAKING CONTACT & TERMS Accepts work on consignment (45% commission). Retail price set by the artist. Gallery provides contract and some promotion; artist pays for shipping costs to gallery.

SUBMISSIONS Send query letter with résumé, website address, digital images (preferred), photographs, review, artist's statement, and bio.

TIPS "We consider conceptual content, technique, media, presentation, and condition of work as well as professionalism of the artist."

BLOUNT-BRIDGERS HOUSE/HOBSON PITTMAN MEMORIAL GALLERY

130 Bridgers St., Tarboro NC 27886. (252)823-4159. **E-mail:** edgecombearts@embarqmail.com; info@BBArtCenter.org. **Website:** www.edgecombearts.org. Estab. 1982. Museum. Gallery hours vary by time of year, see website for details. Closed major holidays,

Christmas-New Year. Located in historic house in residential area of small town. Gallery is approximately 48×20 ft. Overall price range $250-5,000. Most work sold at $500.

○ Interested in fine art, historical/vintage.

EXHIBITS Photos of landscapes/scenics, wildlife. Approached by 1-2 artists/year; represents or exhibits 6 artists. Sponsors 1 exhibit/year. Average display time 6 weeks.

MAKING CONTACT & TERMS Artwork is accepted on consignment, and there is a 30% commission. Gallery provides insurance, limited promotion. Accepted work should be framed. Accepts artists from the Southeast and Pennsylvania. Finds artists through word of mouth, submissions, art exhibits, referrals by other artists.

SUBMISSIONS Mail portfolio review. Send query letter with artist's statement, bio, SASE, slides. Responds in 3 months.

BLUE SKY/OREGON CENTER FOR THE PHOTOGRAPHIC ARTS

122 NW Eighth Ave., Portland OR 97209. (503)225-0210. **E-mail:** bluesky@blueskygallery.org. **Website:** www.blueskygallery.org. **Contact:** Zemie Barr, exhibitions manager. Estab. 1975.

EXHIBITS All photography and videography considered. Exhibits documentary, photojournalism, and conceptual art. Considers all genres.

MAKING CONTACT & TERMS Artwork is accepted on consignment and there is a 50% commission. Retail price set by the artist. Gallery provides insurance, promotion, and contract. Does not require exclusive local representation.

SUBMISSIONS Submit CD of JPEG samples at 72 dpi. Include artist's statement, bio, and résumé. Returns materials with SASE. Responds in 6 weeks. Finds artists through submissions, portfolio reviews, and art fairs.

TIPS "Follow website instructions."

BOOK BEAT GALLERY

26010 Greenfield, Oak Park MI 48237. (248)968-1190. **Fax:** (248)968-3102. **E-mail:** info@thebookbeat.com; bookbeat@aol.com. **Website:** www.thebookbeat.com. **Contact:** Cary Loren, director. Estab. 1982. Sponsors 6 exhibits/year. Average display time 6-8 weeks. Overall price range $300-5,000. Most work sold at $600.

EXHIBITS "Book Beat is a bookstore specializing in fine art and photography. We have a backroom gallery devoted to photography and folk art. Our inventory includes vintage work from 19th- to 20th-century, rare books, issues of *Camerawork*, and artist books. Book Beat Gallery is looking for courageous and astonishing image makers; high-quality digital work is acceptable. Artists are welcome to submit a handwritten or typed proposal for an exhibition, include artist bio, statement, and website, book, or CD with sample images. We are especially interested in photographers who have published book works or work with originals in the book format, also those who work in 'dead media' and extinct processes."

SUBMISSIONS Responds in 6 weeks.

J.J. BROOKINGS GALLERY

330 Commercial St., San Jose CA 95112. (408)287-3311. **Fax:** (408)275-1777. **E-mail:** info@jjbrookings.com. **Website:** www.jjbrookings.com. Sponsors rotating group exhibits. Sponsors openings. Overall price range $500-30,000.

EXHIBITS Interested in photography created with a "painterly eye."

MAKING CONTACT & TERMS Charges 50% commission.

SUBMISSIONS Send material by mail for consideration. Responds in 3-5 weeks if interested; immediately if not acceptable.

TIPS Wants to see "professional presentation, realistic pricing, numerous quality images. We're interested in whatever the artist thinks will impress us the most. 'Painterly' work is best. No documentary or politically oriented work."

THE CAROLE CALO GALLERY

320 Washington St., Easton MA 02357. **Website:** www.stonehill.edu/community-global-engagement/carole-calo-gallery/. **Contact:** Candice Smith Corby, gallery director. Nonprofit, college gallery (formerly the Cushing-Martin Gallery). Approached by 4-8 artists/year, represents/exhibits 10-20 artists/year. Closed during the summer when school is not in session. Clients include local community and students.

MAKING CONTACT & TERMS Proceeds of sales go to the artist; sales are not common. Price set by the artist. Gallery provides insurance and promotion. Accepted work should be framed and mounted.

SUBMISSIONS Mail portfolio for review. Include artist's statement, bio, résumé, SASE, and CD. Returns

material with SASE. Responds in 6 months. Files "interesting" materials. Finds artists through word of mouth, submissions, art exhibits, and referrals by other artists.

WILLIAM CAMPBELL CONTEMPORARY ART

4935 Byers Ave., Ft. Worth TX 76107. (817)737-9566. **Fax:** (817)737-5466. **E-mail:** wcca@flash.net. **Website:** www.williamcampbellcontemporaryart.com. **Contact:** William Campbell, owner/director. Estab. 1974. Sponsors 8-10 exhibits/year. Average display time 5 weeks. Sponsors openings; provides announcements, press releases, installation of work, insurance, cost of exhibition. Overall price range $500-20,000.

MAKING CONTACT & TERMS Charges 50% commission. Reviews transparencies. Accepted work should be mounted. Requires exclusive representation within metropolitan area.

SUBMISSIONS Send CD (preferred) and résumé by mail with SASE. Responds in 1 month.

CAPITOL COMPLEX EXHIBITIONS

500 S. Bronough St., R.A. Gray Bldg., Department of State, The Capitol, Tallahassee FL 32399-0250. (850)245-6490. **Fax:** (850)245-6454. **E-mail:** rachelle.ashmore@dos.myflorida.com; webmaster@florida-arts.org. **Website:** www.florida-arts.org. Average display time: 3 months. Overall price range: $200-1,000. Most work sold at $400.

EXHIBITS "The Capitol Complex Exhibitions Program is designed to showcase Florida artists and art organizations. Exhibitions are displayed in the Capitol Gallery (22nd floor) and the Cabinet Meeting Room in Florida's capitol. Exhibitions are selected based on quality, diversity of media, and regional representation."

MAKING CONTACT & TERMS Does not charge commission. Accepted work should be framed. *Interested only in Florida artists or arts organizations.*

SUBMISSIONS Download application from website, complete and send with image CD. Responds in 3 weeks.

CENTER FOR CREATIVE PHOTOGRAPHY

University of Arizona, P.O. Box 210103,, 1030 North Olive Rd., Tucson AZ 85721-0103. (520)621-7968. **Fax:** (520)621-9444. **E-mail:** info@ccp.library.arizona.edu. **Website:** www.creativephotography.org. Estab. 1975. Museum/archive, research center, museum retail shop. Sponsors 3-4 photography exhibits/year. Average display time 3-4 months. Gallery open Monday–Friday, 9-5; weekends, 1-4. Closed most holidays. 5,500 sq. ft.

CENTER FOR DIVERSIFIED ART

P.O. Box 641062, Beverly Hills FL 34465. **E-mail:** diversifiedart101@gmail.com. **Website:** www.diversifiedart.org. **Contact:** Anita Walker, founder and director. Estab. 2010. Nonprofit gallery. Exhibits emerging, mid-career, and established artists. Approached by 12 artists/year; represents or exhibits about 24 artists currently. Exhibited artists include David Kontra (acrylics) and Linda Litteral (sculptor). "We specialize in visual art that has a social and/or environmental theme that raises awareness. Sponsors 1 exhibit/year, photography is included in our annual exhibit. One piece from each of our artists is shown indefinitely in our online gallery and publications. We are a web-based gallery and sponsor 1 brick-and-mortar exhibition a year. We also use visual art to go with educational material that we produce and publish. Many of our artists have a strong commitment to raising awareness. Clients include the local community and students." Overall price range: $150-4,000.

EXHIBITS Considers all media and all types of prints (prints must be a limited edition and include a certificate of authenticity).

MAKING CONTACT & TERMS Artwork is accepted on consignment and there is a 20% commission. Retail price set by the artist. Gallery provides promotion. Accepted work should be framed.

SUBMISSIONS Please make sure your work has a social and/or environmental theme that raises awareness before submitting. E-mail query letter with link to artist's website, 3 JPEG samples at 72 dpi, résumé and how your work relates to raising awareness on social and/or environmental issues. Responds only if interested within 1 month. Finds artists through word of mouth, art exhibits, submissions, portfolio reviews, and referrals by other artists.

TIPS Follow the directions above.

✪ CENTER FOR EXPLORATORY AND PERCEPTUAL ART

617 Main St., Suite 201, Buffalo NY 14203. (716)856-2717. **Fax:** (716)270-0184. **E-mail:** info@cepagallery.com. **Website:** www.cepagallery.org. **Contact:** Sean J. Donaher, executive director. Estab. 1974. "CEPA is an

artist-run space dedicated to presenting photographically based work that is under-represented in traditional cultural institutions." Sponsors 5-6 exhibits/year. Average display time 6 weeks. Call or see website for hours. Total gallery space is approximately 6,500 sq. ft. Overall price range $200-3,500.

CEPA conducts an annual Emerging Artist Exhibition for its members. You must join the gallery in order to participate.

EXHIBITS Interested in political, digital, video, culturally diverse, contemporary, and conceptual works. Extremely interested in exhibiting work of newer, lesser-known photographers.

MAKING CONTACT & TERMS Sponsors openings; reception with lecture. Accepted work should be framed or unframed, mounted or unmounted, matted or unmatted.

SUBMISSIONS Send query letter with artist's statement, résumé that will give insight into your work. "Up to 20 numbered slides with a separate checklist (work will not be considered without a complete checklist). Each slide must have your name, a number, and an indication of 'top.' The checklist must have your name, address, phone/fax/e-mail, title of the work, date, image size, process, and presentation size. Do not send prints or original works. CDs running on a MAC platform may be submitted." Include SASE for return of material. Responds in 3 months.

TIPS "We review CD portfolios and encourage digital imagery. We will be showcasing work on our website."

CENTER FOR PHOTOGRAPHIC ART

Sunset Cultural Center, P.O. Box 1100, Carmel CA 93921. (831)625-5181. **Fax:** (831)625-5199. **E-mail:** info@photography.org. **Website:** www.photography.org. Estab. 1988. Nonprofit gallery. Sponsors 7-8 exhibits/year. Average display time 5-7 weeks. Hours: Wednesday-Saturday, 12-4.

EXHIBITS Interested in fine art photography.

SUBMISSIONS "Currently not accepting unsolicited submissions. Please e-mail the center and ask to be added to our submissions contact list if you are not a member." Photographers should see website for more information.

THE CENTER FOR PHOTOGRAPHY AT WOODSTOCK

59 Tinker St., Woodstock NY 12498. (845)679-9957. **Fax:** (845)679-6337. **E-mail:** info@cpw.org. **Website:** www.cpw.org. **Contact:** Ariel Shanberg, executive director. Estab. 1977. Alternative space, nonprofit arts and education center. Approached by more than 500 artists/year. Hosts 10 photography exhibits/year. Average display time 7 weeks. Gallery open all year; Wednesday–Sunday, 12-5.

EXHIBITS Interested in presenting all aspects of contemporary creative photography including digital media, film, video, and installation by emerging and under-recognized artists. "We host 5 group exhibitions and 5 solo exhibitions annually. Group exhibitions are curated by guest jurors, curators, and CPW staff. Solo exhibition artists are selected by CPW staff. Visit the exhibition archives on our website to learn more."

MAKING CONTACT & TERMS CPW hosts exhibition and opening reception; provides insurance, promotion, a percentage of shipping costs, installation and de-installation, and honorariaum for solo exhibition artists who give gallery talks. CPW receives 25% commission on exhibition-related sales. Accepted work should be framed and ready for hanging.

SUBMISSIONS Send introductory letter with samples, résumé, artist's statement, SASE. Responds in 4 months. Finds artists through word of mouth, art exhibits, open calls, portfolio reviews, referrals by other artists.

TIPS "CPW accepts submissions on thumbdrives, CD-ROMs and accepts video works in DVD format. Please send 10-20 digital work samples on CD (3×5 no larger than 300 dpi), by mail (include an image script with your name, telephone number, image title, image media, size). Include a current résumé, statement, SASE for return. We are not responsible for unlabeled submission. We *do not* welcome solicitations to visit websites. We *do* advise artists to visit our website and become familiar with our offerings."

CENTRAL MICHIGAN UNIVERSITY ART GALLERY

Wightman 132, Central Michigan University, Mt. Pleasant MI 48859. (989)774-3800. **E-mail:** goche1as@cmich.edu. **Website:** www.uag.cmich.edu. **Contact:** Anne Gochenour, gallery director. Estab. 1970. Nonprofit academic gallery. Exhibits emerging, mid-career and established contemporary artists. Past artists include Sandy Skoglund, Michael Ferris, Blake Williams, John Richardson, Valerie Allen, Randal Crawford, Jane Gilmor, Denise Whitebread Fanning, Alynn Guerra, Dylan Miner, Mark Menjivar, Jason

DeMarte, Paho Mann, Al Wildey, Hillerbrand and Magsamen, Susana Raab, Peter Menzel. Sponsors 12 exhibits/year (2-4 curated). Average display time: 1 month. Open August-May while exhibits are present; Tuesday–Friday, 11-6; Saturday, 11-3. Clients include local community, students, and tourists.

EXHIBITS Considers all media and all types of prints. Most frequently exhibits sculpture, prints, ceramics, painting, and photography.

MAKING CONTACT & TERMS Buyers are referred to the artist. Gallery provides insurance, promotion, and contract. Accepted work should be framed. Does not require exclusive representation locally.

SUBMISSIONS Send query letter with artist's statement, bio, résumé, reviews, and images on CD. Responds within 2 months, only if interested. Finds artists through word of mouth, submissions, portfolio reviews, art exhibits, and referrals by other artists.

CHABOT FINE ART GALLERY

P.O. Box 623, Greenville RI 02828. (401)432-7783. **Fax:** (401)432-7783. **E-mail:** chris@chabotgallery. com. **Website:** www.chabotgallery.com. **Contact:** Chris Chabot, director. Estab. 2007. Fine art rental gallery. Approached by 50 artists/year; represents 30 emerging, mid-career, and established artists. Exhibited artists include Lee Chabot (owner of the gallery). Sponsors 12 total exhibits/year; 1 photography exhibit/year. Average display time 30 days. Open Tuesday-Saturday, 12-6, or by appointment or chance. The gallery is located on Historic Federal Hill in Providence. It has over 1,000 sq. ft. of exhibition space and a courtyard sculpture garden that is open in the warmer months. Clients include local community, tourists, upscale. 10% corporate collectors. Overall price range: $1,200-10,000. Most work sold at $3,500.

EXHIBITS Considers all media except craft. Most frequently exhibits oil, acrylics, and watercolor. Considers all styles and genres. Most frequently exhibits abstract, impressionism, abstract expressionism.

MAKING CONTACT & TERMS Artwork is accepted on consignment with a 50% commission. Retail price is set by the gallery and artist. Gallery provides insurance, promotion, and contract. Accepted work should be framed, mounted, and matted.

SUBMISSIONS Mail portfolio for review. Send query letter with artist's statement, bio, résumé, CD with images, and SASE. Returns material with SASE. Re-

sponds in 1 month. Files all submitted material. Finds artist through word of mouth, submissions, portfolio reviews, art exhibits, and referrals by other artists. "We are not taking submissions at this time. We will announce when we are looking for artists to display their works on the new site."

TIPS Be professional in your presentation, have good images in your portfolio, and submit all necessary information.

○ THE CHAIT GALLERIES DOWNTOWN

218 E. Washington St., Iowa City IA 52240. (319)338-4442. **Fax:** (319)338-3380. **E-mail:** attendant@thegalleriesdowntown.com; terri@ thegalleriesdowntown.com; bpchait@aol.com. **Website:** www.chaitgalleries.com. **Contact:** Benjamin Chait, director. Estab. 2003. For-profit gallery. Approached by 100 artists/year; represents or exhibits 150 artists. Open Monday–Friday, 10-6; Saturday, 10-5; Sunday, 12-4. Located in a downtown building renovated to its original look of 1883 with 14-ft.-high molded ceiling and original 9-ft. front door. Professional museum lighting and Scamozzi-capped columns complete the elegant gallery. Overall price range: $50-10,000.

EXHIBITS Landscapes, oil and acrylic paintings, sculpture, fused glass wall pieces, jewelry, all types of prints.

MAKING CONTACT & TERMS Artwork is accepted on consignment, and there is a 50% commission. Gallery provides insurance, promotion, and contract. Accepted work should be framed.

SUBMISSIONS Call; mail portfolio for review. Responds to queries in 2 weeks. Or, stop in anytime during normal business hours with a couple samples. Finds artists through art fairs, art exhibits, portfolio reviews, and referrals by other artists.

CHAPMAN FRIEDMAN GALLERY

1835 Hampden Court, Louisville KY 40205. (502)584-7954. **E-mail:** friedman@imagesol.com. **Website:** www.imagesol.com. **Contact:** Julius Friedman, owner. Estab. 1992. For-profit gallery. Approached by 100 or more artists/year; represents or exhibits 25 artists. Sponsors 1 photography exhibit/year. Average display time 1 month. Open by appointment only. Located downtown; approximately 3,500 sq. ft. with 15-ft. ceilings and white walls. Overall price range: $75-10,000. Most work sold at more than $1,000.

EXHIBITS Photos of landscapes/scenics, architec-

ture. Interested in alternative process, avant garde, erotic, fine art.

MAKING CONTACT & TERMS Artwork is accepted on consignment, and there is a 50% commission. Gallery provides insurance, promotion, and contract. Accepted work should be framed. Requires exclusive representation locally.

SUBMISSIONS Send query letter with artist's statement, bio, brochure, photographs, résumé, slides, and SASE. Responds to queries within 1 month, only if interested. Finds artists through portfolio reviews and referrals by other artists.

CATHARINE CLARK GALLERY

248 Utah St., San Francisco CA 94103. (415)399-1439. **Fax:** (415)543-1338. **E-mail:** info@cclarkgallery.com; associate@cclarkgallery.com; cc@cclarkgallery.com. **Website:** www.cclarkgallery.com. **Contact:** Catherine Clark, owner/director. Estab. 1991. For-profit gallery. Approached by 1,000 artists/year; represents or exhibits 28 artists. Sponsors 1-3 photography exhibits/year. Average display time 4-6 weeks. Overall price range $200-150,000. Most work sold at $5,000. Charges 50% commission. Gallery provides insurance, promotion.

SUBMISSIONS Accepted work should be ready to hang. Requires exclusive representation locally. "Do not call." No unsolicited submissions. Finds artists through word of mouth, art exhibits, art fairs, referrals by other artists and colleagues.

TIPS Interested in alternative process, avant garde. "The work shown tends to be vanguard with respect to medium, concept, and process."

STEPHEN COHEN GALLERY

7354 Beverly Blvd., Los Angeles CA 90036. (323)937-5525. **Fax:** (323)937-5523. **E-mail:** info@stephencohengallery.com; claudia@ stephencohengallery.com. **Website:** www. stephencohengallery.com. Estab. 1992. Photography, photo-related art, works on paper gallery. Exhibits vintage and contemporary photography and photo-based art from the US, Europe, Asia, and Latin America. The gallery is also able to locate work by photographers not represented in the gallery. The Cohen Gallery works with contemporary artists/photographers and has a large inventory of classic photography. Average display time 7-8 weeks. Open Tuesday-Saturday, 11-6. Overall price range $500-20,000. Most work sold at $2,000.

EXHIBITS All styles of photography and photo-based art. "The Gallery has exhibited vintage and contemporary photography and photo-based art from the United States, Europe, and Latin America. The gallery is also able to locate work by photographers not represented by the gallery. As host gallery for Photo LA, the gallery has helped to expand the awareness of photography as an art form to be appreciated by the serious collector."

SUBMISSIONS Send query letter, or e-mail, with artist's statement, bio, brochure, photographs, résumé, reviews, SASE. Responds within 3 months, only if interested. Finds artists through word of mouth, published work.

TIPS "Photography is still the best bargain in 20th-century art. There are more people collecting photography now, increasingly sophisticated and knowledgeable people aware of the beauty and variety of the medium."

THE CONTEMPORARY ARTS CENTER (CINCINNATI)

44 E. Sixth St., Cincinnati OH 45202. (513)345-8400. **Fax:** (513)721-7418. **E-mail:** jludwig@ contemporaryartscenter.org. **Website:** www. contemporaryartscenter.org. **Contact:** Justine Ludwig, adjunct curator. Nonprofit arts center. Without a permanent collection, all exhibitions on view are temporary and ever-changing. Sponsors 9 exhibits/year. Average display time 6-12 weeks. Sponsors openings; provides printed invitations, music, refreshments, cash bar. Open Saturday-Monday, 10-4; Wednesday–Friday, 10-9. Closed Thanksgiving, Christmas, and New Year's Day.

EXHIBITS Photographer must be selected by the curator and approved by the board. Exhibits photos of multicultural, disasters, environmental, landscapes/scenics, gardening, technology/computers. Interested in avant garde, innovative photography, fine art.

MAKING CONTACT & TERMS Photography sometimes sold in gallery. Charges 15% commission.

SUBMISSIONS Send query with résumé, slides, SASE. Responds in 2 months.

CONTEMPORARY ARTS CENTER (LAS VEGAS)

CAC @ Emergency Arts, 6th and Fremont, Suite 154, P.O. Box 582, Las Vegas NV 89125. (702)496-0569. **E-mail:** info@lasvegascac.org. **Website:** www. lasvegascac.org. Estab. 1989. "The CAC is a nonprofit 501(c)3 art organization dedicated to presenting

new, high-quality, visual, and performing art, while striving to build, educate, and sustain audiences for contemporary art." Sponsors more than 9 exhibits/year. Average display time: 1 month. Gallery open Thursday-Friday, 3-7; Saturday-Sunday, 2-7, and by appointment. Preview Thursday, 6-9; 1st Friday, 6-8. Closed Thanksgiving, Christmas, New Year's Day. 1,200 sq. ft. Overall price range $200-4,000. Most work sold at $400.

○ The CAC is accepting submissions of work for East Side Projects, a series of monthly projects in the gallery's front window space facing Charleston Blvd. This ongoing call is open to all contemporary artists working in any media. Artists must be current CAC members (defined as dues-paying members starting at the $25 level) in order to be eligible for consideration. To become a member go to lasvegascac.org/support/join. Site-specific work for the space is encouraged. We encourage artists to visit or e-mail the gallery to see the space.

MAKING CONTACT & TERMS Artwork is accepted through annual call for proposals of individual or group shows. Gallery provides insurance, promotion, contract.

SUBMISSIONS Finds artists through annual call for proposals, membership, word of mouth, submissions, portfolio reviews, art exhibits, art fairs, referrals by other artists, and walk-ins. Check website for dates and submission guidelines. Submissions must include a proposal, current CV/résumé, artist bio/statement, disc with JPEG images of original artwork (300 dpi) and image reference sheet (including artist, title, media, dimensions, and filename). Send SASE for return.

TIPS Submitted slides should be "well labeled and properly exposed with correct color balance."

CONTEMPORARY ARTS CENTER (NEW ORLEANS)

900 Camp St., New Orleans LA 70130. (504)528-3805. **Fax:** (504)528-3828. **E-mail:** jfrancino@cacno.org; info@cacno.org. **Website:** www.cacno.org. **Contact:** Jennifer Francino, visual arts manager. Estab. 1976.

EXHIBITS Interested in alternative process, avant garde, fine art. Cutting-edge contemporary preferred.

MAKING CONTACT & TERMS Send query letter with bio, SASE, slides, or CD. Responds in 4 months. Finds artists through word of mouth, submissions, art exhibits, art fairs, referrals by other artists, professional contacts, art periodicals.

TIPS Submit only 1 slide sheet with proper labels (title, date, media, dimensions) or CD-ROM with the same information.

CORCORAN FINE ARTS LIMITED, INC.

12610 Larchmere Blvd., Cleveland OH 44120. (216)767-0770. **Fax:** (216)767-0774. **E-mail:** corcoranfinearts@gmail.com; gallery@corcoranfinearts.com. **Website:** www.corcoranfinearts.com. **Contact:** James Corcoran, director/owner. Estab. 1986. 36 years of gallery and certified appraisal expertise. Represents 30 artists, many Cleveland School 1900-2013 paintings, drawings, prints, and graphics. 18th-, 19th- and 20th-century American, Canadian, and European art. Open Monday-Friday, 12-6; Saturday, 12-5 and by appointment.

EXHIBITS Interested in fine art. Specializes in representing high-quality 19th- and 20th-century work.

MAKING CONTACT & TERMS Gallery receives 50% commission. Requires exclusive representation. Few contemporary artists represented locally.

SUBMISSIONS For first contact, send a query letter, résumé, bio, slides, JPEGs, and catalog details, SASE. Responds within 1 month. After initial contact, drop-off or mail-in appropriate materials for review by gallery director Gary Marshall and owner James Corcoran. Portfolio should include photographs/slides. Additionally finds artists through solicitation.

CO|SO: COPLEY SOCIETY OF ART

158 Newbury St., Boston MA 02116. (617)536-5049. **Fax:** (617)267-9396. **E-mail:** info@copleysociety.org. **Website:** www.copleysociety.org. **Contact:** Suzan Redgate, executive director. Estab. 1879. Co|So is the oldest nonprofit art association in the US. Sponsors 20-30 exhibits/year, including solo exhibitions, thematic group shows, juried competitions, and fundraising events. Average display time: 4-6 weeks. Open Tuesday–Saturday, 11-6; Sunday, 12-5; Monday by appointment. Overall price range: $100-10,000. Most work sold at $700.

EXHIBITS Interested in all styles.

MAKING CONTACT & TERMS Must apply and be accepted as an artist member. "Once accepted, artists are eligible to compete in juried competitions. Artists can also display or show smaller works in the lower gallery throughout the year." Guaranteed showing in annual Small Works Show. There is a possibility of group or individual show, on an invitational basis, if

merit exists. Charges 40% commission. Reviews digital images only with application. Preliminary application available via website. "If invited to apply to membership committee, a date would be agreed upon."

SUBMISSIONS Digital images must be saved on CD as JPEG files of 300 dpi resolution (approx. size: 4×6) with file names in the format: "LastName_FirstName_Title_Number" (for example: Doe_John_TitleofFirstPiece_1). Three views of each 3D artwork are recommended. All images must be professionally presented: frames should not be visible, and colors should match those of the original piece as closely as possible.

TIPS Wants to see "professional, concise and informative completion of application. The weight of the judgment for admission is based on quality of work. Only the strongest work is accepted."

COURTHOUSE GALLERY, LAKE GEORGE ARTS PROJECT

1 Amherst St., Lake George NY 12845. (518)668-2616. **E-mail:** mail@lakegeorgearts.org. **Website:** www.lakegeorgearts.org. **Contact:** Laura Von Rosk, gallery director. Estab. 1986. Nonprofit gallery. Approached by more than 200 artists/year; represents or exhibits 10-15 artists. Sponsors 1-2 photography exhibits/year. Average display time 5-6 weeks. Gallery open Tuesday-Friday, 12-5; weekends, 12-4. Closed mid-December to mid-January. Overall price range $100-5,000. Most work sold at $500.

MAKING CONTACT & TERMS Artwork is accepted on consignment and there is a 25% commission. Gallery provides insurance, promotion, contract. Accepted work should be framed, mounted, matted.

SUBMISSIONS Mail portfolio for review. Deadline: January 31. Send query letter with artist's statement, bio, résumé, 10-12 JPEG images (approximately 4-6 inches and no more than 1200×1200 pixels) on a CD, SASE. Responds in 4 months. Finds artists through word of mouth, submissions, portfolio reviews, art exhibits, art fairs, referrals by other artists.

CATHERINE COUTURIER GALLERY

2635 Colquitt St., Houston TX 77098. (713)524-5070. **E-mail:** gallery@catherinecouturier.com. **Website:** www.catherinecouturier.com. Estab. 1996. Fine art photography. Average display time 5 weeks. Open Tuesday–Saturday, 10-5 and by appointment. Located in upper Kirby District of Houston, Texas. Overall price range $500-40,000. Most work sold at $1,000-2,500.

EXHIBITS Photos of babies/children/teens, celebrities, couples, multicultural, families, parents, senior citizens, landscapes/scenics, wildlife, architecture, cities/urban, education, pets, religious, rural, adventure, automobiles, entertainment, events, humor, performing arts, travel, agriculture, industry, military, political, portraits, product shots/still life, science, technology/computers. Interested in alternative process, documentary, fashion/glamour, fine art, historical/vintage.

MAKING CONTACT & TERMS Artwork is bought outright or accepted on consignment with a 50% commission. Gallery provides insurance, promotion, contract.

SUBMISSIONS Call to show portfolio of photographs. Finds artists through submissions, art exhibits. Due to the volume of submissions, only able to review work once or twice a year. We only accept submissions via mail. E-mailed submissions will not be viewed. Send at least one printed sample of your work so that we may judge the quality of print you produce. Enclose a SASE with your submission so we may return the work to you if we decide it is not suited for Catherine Couturier Gallery. Any unsolicited work sent without return postage will not be returned.

Ⓞ CREALDÉ SCHOOL OF ART

600 St. Andrews Blvd., Winter Park FL 32792. (407)671-1886. **Fax:** (407)671-0311. **E-mail:** btiffany2000@yahoo.com. **Website:** www.crealde.org. **Contact:** Barbara Tiffany, director of painting and drawing. Estab. 1975. "The school's gallery holds 6-7 exhibitions/year, representing artists from regional/national stature." Open Monday–Thursday, 9-4; Friday–Saturday, 9-1.

EXHIBITS All media.

MAKING CONTACT & TERMS Send 20 slides or digital images, résumé, statement, and return postage.

CROSSMAN GALLERY

950 W. Main St., Whitewater WI 53190. (262)472-5708 (office) or (262)472-1207 (gallery). **E-mail:** flanagam@uww.edu. **Website:** blogs.uww.edu/crossman. **Contact:** Michael Flanagan, director. Estab. 1971. Photography is regularly featured in thematic exhibits at the gallery. Average display time: 1 month. Overall price range: $250-3,000. Located on the 1st floor of the Center of the Arts on the campus of the University of Wisconsin-Whitewater. Open

Monday–Friday, 10-5; Monday–Thursday evening, 6-8; Saturday, 1-4. Special hours may apply when classes are not in session. Please call before visiting to insure access.

EXHIBITS "We primarily exhibit artists from the Midwest but do include some from national and international venues. Works by Latino artists are also featured in a regular series of ongoing exhibits." Interested in all types of innovative approaches to photography. Sponsors openings; provides food, beverage, show announcement, mailing, shipping (partial) and possible visiting artist lecture/demo.

SUBMISSIONS Submit 10-20 images via online links, artist's statement, and brief résumé.

TIPS "The Crossman Gallery operates within a university environment. The focus is on exhibits that have the potential to educate viewers about processes and techniques and have interesting thematic content."

DARKROOM GALLERY

12 Main St., Essex Junction VT 05452. (802)777-3686. **E-mail:** info@darkroomgallery.com; submissions@darkroomgallery.com. **Website:** www.darkroomgallery.com. **Contact:** Ken Signorello, owner. Estab. 2010. For-profit and rental gallery. Exhibits 300 emerging, mid-career, and established artists. Sponsors 14 photography exhibits/year. Average display time 3½ weeks. Open Monday-Sunday, 11-4; closed on major holidays. The gallery is a freshly renovated 1300-sq.-ft. first floor store front air conditioned space with hardwood floors and an 11-ft. ceiling. Our lighting system uses 3,000 LED flood lights. Nearly every image has a dedicated light and hangs from a fully adjustable hanging system. We are located at the "Five Corners" right next to Martone's Market and Café. The Village of Essex Junction is located within 10 miles of the University of Vermont and 3 other colleges, downtown Burlington, and Burlington International Airport. Clients include local community, students, tourists, and upscale. Overall price range $50-300. Most work sold at $200.

EXHIBITS Most frequently exhibits photography. Considers all styles.

MAKING CONTACT & TERMS Artwork is accepted on consignment and there is a 34-66% commission. Retail price of the art is set by the artist. Accepted work should be framed, mounted, and matted.

SUBMISSIONS Returns material with SASE. Responds in 1 week. Files prints up to 13×19. Finds artists through submissions.

THE DAYTON ART INSTITUTE

456 Belmonte Park N., Dayton OH 45405-4700. (937)223-5277. **Fax:** (937)223-3140. **E-mail:** info@daytonart.org. **Website:** www.daytonartinstitute.org. Estab. 1919. Museum. Galleries open Tuesday-Saturday, 11-5; Thursday, 11-8; Sunday, 12-5.

EXHIBITS Interested in fine art.

DEMUTH MUSEUM

120 E. King St., Lancaster PA 17602. (717)299-9940. **E-mail:** information@demuth.org. **Website:** www.demuth.org. **Contact:** gallery director. Estab. 1981. Museum. Average display time 2 months. Open Tuesday–Saturday, 10-4; Sunday, 1-4. Located in the home and studio of Modernist artist Charles Demuth (1883-1935). Exhibitions feature the museum's permanent collection of Demuth's works with changing, temporary exhibitions.

DETROIT FOCUS

P.O. Box 843, Royal Oak MI 48068-0843. (248)541-2210. **E-mail:** michael@sarnacki.com. **Website:** www.detroitfocus.org. Estab. 1978. Artist alliance. Approached by 100 artists/year; represents or exhibits 100 artists. Sponsors 1 or more photography exhibit/year.

EXHIBITS Interested in photojournalism, avant garde, documentary, erotic, fashion/glamour, fine art.

MAKING CONTACT & TERMS No charge or commission.

SUBMISSIONS Call or e-mail. Responds in 1 week. Finds artists through word of mouth, submissions, art exhibits, referrals by other artists.

SAMUEL DORSKY MUSEUM OF ART

1 Hawk Dr., New Paltz NY 12561. (845)257-3844. **Fax:** (845)257-3854. **E-mail:** sdma@newpaltz.edu. **Website:** www.newpaltz.edu/museum. **Contact:** Committee. Estab. 1964. Sponsors ongoing photography exhibits throughout the year. Average display time: 4 months. Museum open Wednesday–Sunday, 11-5. Closed legal and school holidays and during intersession; check website to confirm your visit.

EXHIBITS Interested in alternative process, avant garde, documentary, fine art, historical/vintage.

SUBMISSIONS "If you are an artist or a curator and you would like to submit a proposal, please review our mission statement and past and upcoming exhibitions web pages. If you feel that your exhibition is relevant

to our mission and programming and wish to propose an exhibition, please submit a proposal that includes the following: Cover letter with contact information, exhibition proposal detailing the themes and artist(s) included in the exhibit, and the exhibition's relevance to the mission of The Dorsky Museum. Organizer's CV, illustrated checklist with artist name, date, medium, and dimensions for each entry, images/videos on disk, high-resolution prints, or link to Dropbox or targeted website, an SASE for materials to be returned. Please mail submissions to: Curator, Samuel Dorsky Museum of Art State University of New York at New Paltz, 1 Hawk Drive, New Paltz, NY 12561. Submissions can also be e-mailed, Attn: Curator, to sdma@newpaltz.edu. Attachments may not exceed 10 MB in total. Exhibition proposals are reviewed by the staff on an ongoing basis. Materials sent without a SASE will not be returned." Finds artists through art exhibits.

O DOT FIFTYONE GALLERY

187 NW 27th St., Miami FL 33127. (305)573-9994, ext. 450. **E-mail:** info@dotfiftyone.com; dot@dotfiftyone.com. **Website:** www.dotfiftyone.com. Estab. 2003. Sponsors 6 photography exhibits per year. Average display time: 30 days. Clients include the local community, tourists, and upscale corporate collectors. Art sold for $1,000-20,000 (avg. $5,000) with a 50% commission. Prices are set by the gallery and the artist. Gallery provides insurance, promotion, and contract. Work should be framed, mounted, and matted. Will respond within 1 month if interested.

MAKING CONTACT & TERMS E-mail 5 JPEG samples at 72 dpi.

GEORGE EASTMAN HOUSE

900 East Ave., Rochester NY 14607. (585)271-3361. **Website:** www.eastmanhouse.org. Estab. 1947. Museum. "As the world's preeminent museum of photography, Eastman House cares for and interprets hundreds of thousands of photographs encompassing the full history of this medium. We are also one of the oldest film archives in the US and now considered to be among the top cinematic collections worldwide." Approached by more than 400 artists/year. Sponsors more than 12 photography exhibits/year. Average display time 3 months. Gallery open Tuesday-Saturday, 10-5; Sunday, 11-5. Closed Thanksgiving and Christmas. Museum has 7 galleries that host exhibitions, ranging from 50- to 300-print displays.

EXHIBITS GEH is a museum that exhibits the vast subjects, themes and processes of historical and contemporary photography.

SUBMISSIONS See website for detailed information: eastmanhouse.org/inc/collections/submissions.php. Mail portfolio for review. Send query letter with artist's statement, résumé, SASE, slides, digital prints. Responds in 3 months. Finds artists through word of mouth, art exhibits, referrals by other artists, books, catalogs, conferences, etc.

TIPS "Consider as if you are applying for a job. You must have succinct, well-written documents; a well-selected number of visual treats that speak well with written document provided; an easel for reviewer to use."

CATHERINE EDELMAN GALLERY

300 W. Superior St., Lower Level, Chicago IL 60654. (312)266-2350. **Website:** www.edelmangallery.com. **Contact:** Tim Campos, Gallery Manager. Estab. 1987. Sponsors 7 exhibits/year. Average display time 8-10 weeks. Open Tuesday–Saturday, 10-5:30. Overall price range $1,500-25,000.

EXHIBITS "We exhibit works ranging from traditional photography to mixed media photo-based work."

MAKING CONTACT & TERMS Charges 50% commission. Requires exclusive representation in the Midwest.

SUBMISSIONS Currently not accepting unsolicited submissions. Submissions policy on the website.

TIPS Looks for "consistency, dedication, and honesty. Try to not be overly eager and realize that the process of arranging an exhibition takes a long time. The relationship between gallery and photographer is a partnership."

PAUL EDELSTEIN STUDIO AND GALLERY

Edelstein Dattel Art Investments, 540 Hawthorne St., Memphis TN 38112-5029. (901)496-8122. **E-mail:** henrygrove@yahoo.com. **Website:** www.pauledelsteinstudioandgallery.com. **Contact:** Paul R. Edelstein, director/owner. Estab. 1985. "Shows are presented continually throughout the year." Overall price range: $700-10,000. Most work sold at $2,000.

EXHIBITS Photos of celebrities, children, multicultural, families. Interested in avant garde, historical/vintage, C-print, dye transfer, ever color, fine art, and 20th-century photography that intrigues the viewer—

figurative still life, landscape, abstract—by upcoming and established photographers.

MAKING CONTACT & TERMS Charges 40% commission. Reviews transparencies. Accepted work should be framed or unframed, mounted or unmounted, matted or unmatted work. There are no size limitations. Submit portfolio for review. Send query letter with samples. Cannot return material. Responds in 6

TIPS "Looking for figurative and abstract figurative work."

EDWYNN HOUK GALLERY

745 Fifth Ave., Suite 407, New York NY 10151. (212)750-7070. **Fax:** (212)688-4848. **E-mail:** info@ houkgallery.com; julie@houkgallery.com; tess@ houkgallery.com. **Website:** www.houkgallery.com. **Contact:** Julie Castellano, director; Tess Vinnedge, assistant director. For-profit gallery. The gallery is a member of the Art Dealers Association of America and Association of International Photography Art Dealers. The gallery represents the Estates of Ilse Bing, Bill Brandt, Brassaï and Dorothea Lange, and is the representative for such major contemporary photographers as Robert Polidori, Joel Meyerowitz, Sally Mann, Herb Ritts, Bettina Rheims, Lalla Essaydi, Hannes Schmid, Sebastiaan Bremer, Danny Lyon, and Elliott Erwitt. Open Tuesday–Saturday, 11-6.

EXHIBITS Specializes in masters of 20th-century photography with an emphasis on the 1920s and 1930s and contemporary photography.

THOMAS ERBEN GALLERY

526 W. 26th St., Floor 4, New York NY 10001. (212)645-8701. **Fax:** (212)645-9630. **E-mail:** info@ thomaserben.com. **Website:** www.thomaserben.com. Estab. 1996. For-profit gallery. Approached by 100 artists/year; represents or exhibits 15 artists. Average display time 5-6 weeks. Gallery open Tuesday–Saturday, 10-6 (Monday–Friday in July). Closed Christmas/ New Year's Day and August.

SUBMISSIONS Mail portfolio for review. Responds in 1 month.

ETHERTON GALLERY

135 S. Sixth Ave., Tucson AZ 85701. (520)624-7370. **Fax:** (520)792-4569. **E-mail:** info@ethertongallery. com. **Website:** www.ethertongallery.com. Hannah Glasson, Daphne Srinivasan. **Contact:** Terry Etherton. Estab. 1981. Retail gallery and art consultancy. Specializes in vintage, modern, and contemporary photography. Represents 50+ emerging, mid-career, and established artists. Exhibited artists include Kate Breakey, Harry Callahan, Jack Dykinga, Elliott Erwitt, Mark Klett, Danny Lyon, Rodrigo Moya, Luis Gonzalez Palma, Lisa M. Robinson, Frederick Sommer, Joel-Peter Witkin, and Alex Webb. Sponsors 3-5 shows/year. Average display time: 8 weeks. Open year round. Located in downtown Tucson; 3,000-sq.-ft. gallery in historic building with wood floors and 16-ft. ceilings. Clientele: 50% private collectors, 25% corporate collectors, 25% museums. Overall price range: $800-50,000; most work sold at $2,000-7,500. Media: Considers all types of photography, painting, works on paper. Etherton Gallery purchases vintage and classic photography; occasionally purchases contemporary photography and artwork. Interested in seeing work that is "well-crafted, cutting-edge, contemporary, issue-oriented."

MAKING CONTACT & TERMS Usually accepts work on consignment (50% commission). Retail price set by gallery and artist. Gallery provides insurance and promotion; shipping costs are shared; prefers framed artwork.

SUBMISSIONS Send 10-20 JPEGs, artist statement, résumé, reviews, bio. Materials not returned. No unprepared, incomplete or unfocused work. Responds in 6 weeks if interested.

TIPS "Become familiar with the style of our gallery and with contemporary art scene in general."

EVERSON MUSEUM OF ART

401 Harrison St., Syracuse NY 13202. (315)474-6064. **Fax:** (315)474-6943. **E-mail:** everson@everson.org; smassett@everson.org. **Website:** www.everson.org. **Contact:** Sarah Massett, assistant director. Estab. 1897. "In fitting with the works it houses, the Everson Museum building is a sculptural work of art in its own right. Designed by renowned architect I.M. Pei, the building itself is internationally acclaimed for its uniqueness. Within its walls, Everson houses roughly 11,000 pieces of art; American paintings, sculpture, drawings, graphics, and one of the largest holdings of American ceramics in the nation." Open all year; Wednesday, Friday, and Sunday, noon-5; Thursday, noon-8; Saturday, 10-5; closed Monday and Tuesday. The museum features 4 large galleries with 24-ft. ceilings, back lighting, and oak hardwood, a sculpture

court, Art Zone for children, a ceramic study center and 5 smaller gallery spaces.

EVOLVE THE GALLERY

P.O. Box 5944, Sacramento CA 95817. (916) 572-5123. **E-mail:** info@evolvethegallery.com. **Website:** www. evolvethegallery.com. **Contact:** A. Michelle Blakeley, co-owner. Estab. 2010. For-profit and art consultancy gallery. Approached by 250+ artists/year. Represents emerging, mid-career, and established artists. Exhibited artists include Richard Mayhew (master fine artist, watercolor), Corinne Whitaker (pioneer digital painter), Ben F. Jones (prominent international artist). Sponsors 12+ exhibits/year. Model and property release required. Average display time: 1 month. Open Thursday-Saturday, by appointment. Clients include local community, students, tourists, upscale. 1% of sales are to corporate collectors. Overall price range: $1-10,000. Most work sold at $3,000.

EXHIBITS Considers all media (except craft), all types of prints, conceptualism, geometric abstraction, neo-expressionism, postmodernism, and painterly abstraction.

MAKING CONTACT & TERMS Artwork is accepted on consignment and there is a 50% commission. Retail price of the art set by the artist; reviewed by the gallery. Gallery provides insurance, promotion, contract. Accepted work should be framed, mounted.

SUBMISSIONS E-mail with link to artist's website, JPEG samples at 72 dpi. Must include artist statement and CV. Materials returned with SASE. Responds only if interested (within weeks). Finds artists through word of mouth, submissions, portfolio reviews, art exhibits, art fairs, referrals by other artists.

FAHEY/KLEIN GALLERY

148 N. La Brea Ave., Los Angeles CA 90036. (323)934-2250. **Fax:** (323)934-4243. **E-mail:** contact@faheykleingallery.com. **Website:** www. faheykleingallery.com. **Contact:** David Fahey or Ken Devlin, co-owners. Estab. 1986. For-profit gallery. "Devoted to the enhancement of the public's appreciation of the medium of photography through the exhibition and sale of 20th-century and contemporary fine art photography. The gallery, with over 8,000 photographs in stock, deals extensively in photographs as works of art in all genres including portraits, nudes, landscapes, still-life, reportage, and contemporary photography. The website contains a broad range of over 10,000 images." Approached

by 200 artists/year; represents or exhibits 60 artists. Sponsors 10 exhibits/year. Average display time 5-6 weeks. Open Tuesday–Saturday, 10-6. Closed on all major holidays. Sponsors openings; provides announcements and beverages served at reception. Overall price range $500-500,000. Most work sold at $2,500. Located in Hollywood; gallery features 2 exhibition spaces with extensive work in back presentation room.

EXHIBITS Interested in established work; photos of celebrities, landscapes/scenics, wildlife, architecture, entertainment, humor, performing arts, sports. Interested in alternative process, avant garde, documentary, erotic, fashion/glamour, fine art, historical/vintage. Specific photo needs include iconic photographs, Hollywood celebrities, photojournalism, music-related, reportage, and still life.

MAKING CONTACT & TERMS Artwork is accepted on consignment, and the commission is negotiated. Gallery provides insurance, promotion, contract. Accepted work should be unframed, unmounted, and unmatted. Requires exclusive representation within metropolitan area. Photographer must be established for a minimum of 5 years; preferably published.

SUBMISSIONS Prefers website URLs for initial contact, or send material (CD, reproductions, no originals) by mail with SASE for consideration. Responds in 2 months. Finds artists through art fairs, exhibits, portfolio reviews, submissions, word of mouth, referrals by other artists.

TIPS "Please be professional and organized. Have a comprehensive sample of innovative work. Interested in seeing mature work with resolved photographic ideas and viewing complete portfolios addressing one idea."

FALKIRK CULTURAL CENTER

1408 Mission Ave. at E St., San Rafael CA 94901. (415)485-3328. **E-mail:** Beth. Goldberg@cityofsanrafael.org. **Website:** www. falkirkculturalcenter.org. **Contact:** Beth Goldberg, curator. Estab. 1974. Nonprofit gallery and national historic place (1888 Victorian) converted to multi-use cultural center. Approached by 500 artists/year; exhibits 300 artists. Sponsors 2 photography exhibits/year. Average display time: 2 months. Open Tuesday–Friday, 1-5; Saturday, 10-1; by appointment.

MAKING CONTACT & TERMS Gallery provides insurance.

SUBMISSIONS Submit digital entries only. Limit of 3 digital images per artist. Label each digital image with your LAST NAME, FIRST NAME, and TITLE OF WORK. E-mail images to: beth.goldberg@ cityofsanrafael.org. Send images as JPEGs at 72 dpi with approximately 2500 ppi as largest dimension. Not to exceed 2.0 MB for each image submitted. Finds artists through word of mouth, submissions, portfolio reviews, art exhibits, art fairs, referrals by other artists.

FAVA (FIRELANDS ASSOCIATION FOR THE VISUAL ARTS)

New Union Center for the Arts, 39 S. Main St., Oberlin OH 44074. (440)774-7158. **Fax:** (440)775-1107. **E-mail:** favagallery@oberlin.net. **Website:** www.favagallery.org. Estab. 1979. Nonprofit gallery. Features changing exhibits of high-quality artwork in a variety of styles and media. Sponsors 1 photography exhibit/year. Average display time 1 month. Open Tuesday–Saturday, 11-5; Sunday, 1-5. Overall price range $75-3,000. Most work sold at $200.

EXHIBITS Open to all media, including photography. Exhibits a variety of subject matter and styles.

MAKING CONTACT & TERMS Charges 30% commission. Accepted work should be framed or matted. Sponsors 1 regional juried photo exhibit/year: Six-State Photography, open to residents of Ohio, Kentucky, West Virginia, Pennsylvania, Indiana, Michigan. Deadline for applications: March. Send annual application for 6 invitational shows by mid-December of each year; include 15-20 slides, slide list, résumé.

SUBMISSIONS Interested artists should send a proposal to the attention of the Gallery Coordinator by December 15 to be considered by the Exhibitions Committee for the following year's season (Sept.-Aug.). Include: cover letter with complete contact information (address, phone, e-mail, website if available), current résumé with your background and exhibition experience, 15-20 professional quality high-res digital images on a CD of your recent work; additional images may be included to show essential detail or installation information; images should be numbered, list of works—list the number, title, medium, and size (H×W×D) of each image; designate detail and installation images if provided, artist statement/exhibition concept with past reviews. Application materials will only be returned if prepaid return mailer is included with the application.

TIPS "As a nonprofit gallery, we do not represent artists except during the juried show. Present the work in a professional format; the work, frame and/or mounting should be clean, undamaged, and (in cases of more complicated work) well organized."

FINE ARTS CENTER GALLERY

P.O. Box 1920, Jonesboro AR 72467. (870)972-3050. **Fax:** (870)972-3932. **Website:** www.astate.edu/college/fine-arts/art. Estab. 1968. Represents/exhibits 3-4 emerging, mid-career and established artists/year. Sponsors 3-4 shows/year. Average display time: 1 month. Open fall, winter and spring, Monday-Friday 10-5. Located on Arkansas State University campus; 1,868 sq. ft.; 60% of time devoted to special exhibitions, 40% to student work. Clientele include students and community.

EXHIBITS Considers all media and prints. Most frequently exhibits painting, sculpture, and photography.

MAKING CONTACT & TERMS Exhibition space only, artist responsible for sales. Retail price set by the artist. Gallery provides promotion and contract; shipping costs are shared. Prefers artwork framed.

SUBMISSIONS Send query letter with résumé, CD/DVD and SASE to: FAC Gallery Director, c/o Department of Art, Arkansas State University, P.O. Box 1920, State University AR 72467. Portfolio should be submitted on CD/DVD only. Responds only if interested within 2 months. Files résumé. Finds artists through call for artists published in regional and national art journals.

TIPS Show us 20 digital images of your best work. Don't overload us with lots of collateral materials (reprints of reviews, articles, etc.). Make your vita as clear as possible.

HOWARD FINSTER VISION HOUSE

177 Greeson St., Summerville GA 30747. (706)857-2926. **E-mail:** david@dlg-gallery.com. **Website:** www.howardfinstervisionhouse.com. **Contact:** David Leonardis, owner. Estab. 1992. For-profit gallery. Approached by 100 artists/year; represents or exhibits 12 artists. Average display time 30 days. Gallery open Tuesday–Saturday, 12-7; Sunday, 12-6. "One big room, four big walls." Overall price range $50-5,000. Most work sold at $500.

EXHIBITS Photos of celebrities. Interested in fine art.

MAKING CONTACT & TERMS Artwork is accepted on consignment, and there is a 50% commis-

sion. Gallery provides promotion. Accepted work should be framed.

SUBMISSIONS E-mail to arrange a personal interview to show portfolio. Mail portfolio for review. Send query letter via e-mail. Responds only if interested. Finds artists through word of mouth, art exhibits, referrals by other artists.

TIPS "Artists should be professional and easy to deal with."

FLORIDA STATE UNIVERSITY MUSEUM OF FINE ARTS

530 W. Call St., Room 250, Fine Arts Bldg., Tallahassee FL 32306-1140. (850)644-6836. **Fax:** (850)644-7229. **E-mail:** mofa@fsu.edu. **Website:** www.mofa.fsu.edu. Estab. 1970. Shows work by over 100 artists/year; emerging, mid-career, and established. Sponsors 12-22 shows/year. Average display time: 3-4 weeks. Located on the university campus; 16,000 sq. ft. 50% for special exhibitions.

EXHIBITS Considers all media, including electronic imaging and performance art. Most frequently exhibits painting, sculpture, and photography.

MAKING CONTACT & TERMS "Interested collectors are placed into direct contact with the artists; the museum takes no commission." Retail price set by the artist. Museum provides promotion and shipping costs to and from the museum for invited artists.

TIPS "The museum offers a yearly international competition and catalog: The Tallahassee International. Visit website for more information."

FOCAL POINT GALLERY

321 City Island Ave., City Island NY 10464. (718)885-1403. **E-mail:** ronterner@gmail.com. **Website:** www.focalpointgallery.net. **Contact:** Ron Terner, photographer/director. Estab. 1974. Overall price range $175-750. Most work sold at $300-500.

EXHIBITS All mediums and subjects accepted.

MAKING CONTACT & TERMS Retail gallery and alternative space. Interested in emerging and mid-career artists. Sponsors 12 group shows/year. Average display time: 3-4 weeks. Clients include locals and tourists. Overall price range: $175-750; most work sold at $300-500. Charges 30% commission.

FREEPORT ART MUSEUM

121 N. Harlem Ave., Freeport IL 61032. (815)235-9755. **Fax:** (815)235-6015. **E-mail:** info@freeportartmuseum.org. **Website:** www.freeportartmuseum.org. **Contact:** Jessica J. Modica, director. Estab. 1975. Formerly Freeport Arts Center. Sponsors approx. 6 exhibits/year. Average display time: 8 weeks.

EXHIBITS All artists are eligible to submit exhibition proposals. Exhibits contemporary, abstract, avant garde, multicultural, families, landscapes/scenics, architecture, cities/urban, rural, performing arts, travel, agriculture. Interested in fine art.

MAKING CONTACT & TERMS Charges 30% commission. Accepted work should beready to hang.

SUBMISSIONS Visit FAM's website for directions on sending exhibition proposal materials. Retains exhibition proposal on file for future inquiries.

⊘ THE G2 GALLERY

1503 Abbot Kinney Blvd., Venice CA 90291. (310)452-2842. **Fax:** (310)452-0915. **E-mail:** info@theg2gallery.com. **Website:** www.theg2gallery.com. **Contact:** Jolene Hanson, gallery director. Estab. 2008. For-profit gallery exhibiting emerging, mid-career, and established artists. Approached by 150+ artists/year; represents or exhibits 45 artists. Exhibited photography by Ansel Adams and Robert Glenn Ketchum. Average display time is 6 weeks. Open Monday-Saturday, 10-7; Sunday, 10-6. "The G2 Gallery is a green art space. The first floor features a gift shop and some additional exhibition space. In 2008, before the gallery opened, the building was renovated to be as eco-friendly as possible. The space is rich in natural light with high ceilings and there are large-screen televisions and monitors for exhibition-related media. The G2 Gallery donates 100% of all proceeds to environmental causes and partners with conservation organizations related to exhibition themes. Our motto is 'Supporting Art and the Environment.'" Clients include local community, tourists, upscale. Price range of work: $150-15,000.

EXHIBITS Photography featuring environmental, landscapes/scenics, wildlife, alternative process, documentary, fine art, historical/vintage.

MAKING CONTACT & TERMS Art is accepted on consignment with a 40% commission. Retail price of the art is set by the artist. Gallery provides insurance, promotion, and contract. Accepted work should be framed, mounted, matted. Accepts photography only.

SUBMISSIONS All prospective artists are vetted through a juried application process. Please e-mail

to request an application or download the application from website. Responds only if interested. "The G2 Gallery will contact artist with a confirmation that application materials have been received." Accepts only electronic materials. Physical portfolios are not accepted. Finds artists through word of mouth, submissions.

TIPS "Preferred applicants have a website with images of their work, inventory list, and pricing. Please do not contact the gallery once we have confirmed that your application has been received."

GALLERY 72

1806 Vinton St., Omaha NE 68108. (402) 496-4797. **E-mail:** info@gallery72.com. **Website:** www.gallery72.com. **Contact:** John A. Rogers, owner. Estab. 1972. Represents or exhibits 20 artists. Sponsors 4 solo and 6 group shows/year. Average display time: 4-5 weeks. Gallery open Wednesday-Saturday, 10:00 am to 6:00 pm, by appointment and for special events. 1,800 sq. ft. of gallery space, 160 ft. of wall space.

EXHIBITS Photos of fine art, landscapes, cities/urban, interiors/decorating, rural, performing arts, travel.

MAKING CONTACT & TERMS Artwork is accepted on consignment, and there is a 50% commission. Gallery provides insurance, promotion. Requires exclusive representation locally. "No Western art."

SUBMISSIONS "Please consider making your submission of works to Gallery 72 as easy as possible to view and to be considered. We can and will accept information images that (1) are mailed via the US postal service, (2) are e-mailed, but be aware of possible limits for total size of e-mail messages, and (3) are delivered by personal contact. If you plan to visit Gallery 72 please contact the gallery or director for an appointment prior to stopping in. Please include a brief artist's biography, statement, and resume with your submission of images or artwork. Send images in the following format: lastname, firstname_title.jpg." Finds artists through word of mouth, submissions, art exhibits.

GALLERY 110 COLLECTIVE

110 Third Ave. S., Seattle WA 98104. (206)624-9336. **E-mail:** director@gallery110.com. **Website:** www.gallery110.com. **Contact:** Paula Maratea Fuld, director. Estab. 2002. "Gallery 110 is a 501(c)(3), established in 2002, as a space dedicated to providing dynamic opportunities for established and emerging professional artists. Gallery 110 plays an important role in Seattle's Pioneer Square Art district by connecting artists to curators, collectors and other artists with a valuable alternative space to exhibit their work. Hundreds of artists in the Northwest and throughout the country have participated in Gallery 110 programming, through juried exhibitions, artist talks, workshops, membership, as special guests and more. Our artists are emerging and established professionals, actively engaged in their artistic careers. We aspire to present fresh exhibitions of the highest professional caliber. The exhibitions change monthly and consist of solo, group and/or thematic shows." Open Wednesday-Saturday, 12-5; hosts receptions every first Thursday of the month, 6-8. Overall price range: $125-3,000; most work sold at $500-800.

MAKING CONTACT & TERMS Yearly active membership with dues, art on consignment, or available for rent.

TIPS "The artist should research the gallery to confirm it is a good fit for their work. The artist should be interested in being an active member, collaborating with other artists and participating in the success of the gallery. The work should challenge the viewer through concept, a high sense of craftsmanship, artistry, and expressed understanding of contemporary art culture and history. Artists should be emerging or established individuals with a serious focus on their work and participation in the field."

GALLERY 218

207 E. Buffalo St., Suite 218, Milwaukee WI 53202. (414)643-1732. **E-mail:** director@gallery218.com. **Website:** www.gallery218.com. **Contact:** Judith Hooks, president/director. Estab. 1990. Located in the Marshall Building of Milwaukee's historic Third Ward. Sponsors 12 exhibits/year. Average display time: 1 month. Sponsors openings. "If a group show, we make arrangements and all artists contribute. If a solo show, artist provides everything." Overall price range: $200-5,000. Most work sold at $200-600.

EXHIBITS Interested in alternative process, avant garde, abstract, fine art. Membership dues: $55/year plus $55/month rent. Artists help run the gallery. Group and solo shows. Photography is shown alongside fine arts painting, printmaking, sculpture, etc.

MAKING CONTACT & TERMS Charges 25% commission. There is an entry fee for each month. Fee covers the rent for 1 month. Accepted work must be framed.

SUBMISSIONS Send SASE for an application. "This is a cooperative space. A fee is required."

TIPS "Get involved in the process if the gallery will let you. We require artists to help promote their show so that they learn what and why certain things are required. Have inventory ready. Read and follow instructions on entry forms; be aware of deadlines. Attend openings for shows you are accepted into locally."

GALLERY 825

Los Angeles Art Association, 825 N. La Cienega Blvd., Los Angeles CA 90069. (310)652-8272. **E-mail:** peter@laaa.org. **Website:** www.laaa.org. **Contact:** Peter Mays, executive director. Estab. 1925. Holds approximately 1 exhibition/month. Average display time: 4-5 weeks. Fine art only. Exhibits all media.

MAKING CONTACT & TERMS Gallery provides promotion, exhibition venues and resources.

SUBMISSIONS To become an LAAA Artist member, visit website for screening dates and submission requirements.

O THE GALLERY AT PETERS VALLEY SCHOOL OF CRAFT

19 Kuhn Rd., Layton NJ 07851. (973)948-5202. **Fax:** (973)948-0011. **E-mail:** gallery@petersvalley.org. **Website:** www.petersvalley.org. **Contact:** Brienne Rosner, gallery manager. Estab. 1977. "National Delaware Water Gap Recreation Area in the Historic Village of Bevans, Peters Valley School of Craft hosts a large variety of workshops in the spring and summer. The Gallery is located in an old general store; first floor retail space and second floor rotating exhibition gallery."

GALLERY NORTH

90 N. Country Rd., Setauket NY 11733. (631)751-2676. **E-mail:** info@gallerynorth.org. **Website:** www.gallerynorth.org. **Contact:** Judith Levy, director. Regional arts center. "Our mission is to present exhibitions of exceptional contemporary artists and artisans, especially those from Long Island and the nearby regions; to assist and encourage artists by bringing their work to the attention of the public; and to stimulate interest in the arts by presenting innovative educational programs. Exhibits the work of emerging, mid-career, and established artists from Long Island and throughout the Northeast. The Gallery North community involves regional and local artists, collectors, art dealers, corporate sponsors, art consultants, businesses and schools, ranging from local elementary students to the faculty and staff at Long Island's many colleges and universities including our neighbor, Stony Brook University and the Stony Brook Medical Center. With our proximity to New York City and the East End, our region attracts a wealth of talent and interest in the arts." Located in the Historic District of Setauket, Long Island, NY, in an 1840s farm house, 1 mile from the State University at Stony Brook. Open year-round; Tuesday–Saturday, 10-5; Sunday, 12-5; closed Monday.

EXHIBITS "Works to be exhibited are selected by our director, Judith Levy, with input from our Artist Advisory Board. We encourage artist dialogue and participation in gallery events and community activities and many artists associated with our gallery offer ArTrips and ArTalks, as well as teaching in our education programs. Along with monthly exhibitions in our 1,000-sq.-ft. space, our Gallery Shop strives to present the finest handmade jewelry and craft by local and nationally recognized artisans."

SUBMISSIONS To present work to the gallery, send an e-mail with 2-5 medium-sized images, price list (indicating title, size, medium, and date), artist's statement, biography, and link to website. "We encourage artists to visit the gallery and interact with our exhibitions." Visit the website for more information.

GIERTZ GALLERY AT PARKLAND COLLEGE

2400 W. Bradley Ave., Champaign IL 61821. **E-mail:** GiertzGallery@parkland.edu. **Website:** www.parkland.edu/gallery. **Contact:** Lisa Costello, director. Estab. 1981. Nonprofit gallery. Approached by 130 artists/year; 7 exhibitions per year. Average display time 4- 6 weeks. Open Monday–Thursday, 10-7; Friday. 10-3; Saturday, 12-2 (fall and spring semesters). Summer: Monday-Thursday, 10-7. Parkland Art Gallery at Parkland College seeks exhibition proposals in all genres of contemporary approaches to art making by single artists, collaborative groups, or curators. Parkland Art Gallery is a professionally designed gallery devoted primarily to education through contemporary art. Parkland Art Gallery hosts 7 exhibitions per year including 2 student exhibitions, one art and design faculty show, and a Biennial Watercolor Invitational that alternates with a National Ceramics Invitational. Other shows vary depending on applications and the vision of the Art Gallery Advisory Board. Exhibits are scheduled on

a 4- to 6-week rotation. Closed college and official holidays. Overall price range $100-5,000. Most work sold at $900.

EXHIBITS Interested in alternative process, avant garde, documentary, fine art, historical/vintage.

MAKING CONTACT & TERMS Gallery provides insurance, promotion. Accepted work should be framed.

SUBMISSIONS Visit Gallery website for instructions.

GLOUCESTER ARTS ON MAIN

6580-B Main St., Gloucester VA 23061. (804)824-9464. **Fax:** (804)824-9469. **E-mail:** curator@gloucesterarts. org. **Website:** www.gloucesterarts.org. **Contact:** Kay Van Dyke, founder. Estab. 2010. Nonprofit, rental gallery. Alternative space. Exhibits emerging, mid-career, and established artists. Approached by 15 artists/year; represents or exhibits 60 artists currently. Exhibited artists include Harriett McGee (repoussé and mixed media) and Victoria Watson (animal drawings). Sponsors 12 exhibits/year, 1-2 photography exhibits/year. There are always photos on exhibit. Average display time: 1 month or length of rental contract. Open Tuesday-Saturday, 12-6; weekend events, 6-9. Located on walkable Main Street near restaurants and other shops, small town near major cities in Eastern Virginia. Very flexible gallery space with 120+ ft. of perimeter exhibition space and 96 ft. of movable walls. 4,000 sq. ft. total exhibition space. Clients include the local community, students, tourists, and upscale clients. 10% of sales are to corporate collectors. Overall price range: $20-7,500; most work sold at $300.

EXHIBITS Considers all media. Most frequently exhibits paintings (oil, acrylic, and watercolor), 2D and 3D metal work, and photography. Considers all types of prints except posters.

MAKING CONTACT & TERMS Artwork is accepted on consignment and there is a 30% commission with a rental fee for wall or shelf space. Retail price set by the artist. Gallery provides promotion and contract. Accepted work should be framed, matted, and mounted.

SUBMISSIONS E-mail query letter with link to artist's website, JPEG samples at 72 dpi, résumé, artist's statement, and bio; or call for appointment to show portfolio. Jury system responds within 2 weeks. Finds artists through word of mouth, art exhibits, submissions, portfolio reviews, and referrals by other artists.

TIPS Work should be presented for jury ready to exhibit, i.e., framed or mounted appropriately. Digital images presented for review should be clear, cropped, and professional in appearance at high resolution.

GRAND RAPIDS ART MUSEUM

101 Monroe Center St. NW, Grand Rapids MI 49503. (616)831-1000. **E-mail:** rplatt@artmuseumgr. org; info@artmuseumgr.org. **Website:** www. artmuseumgr.org. Estab. 1910. Museum. Usually sponsors 1 photography exhibit/year. Average display time: 4 months. Open all year; Tuesday, Wednesday, Friday, Saturday, 10-5; Thursday, 10-9; Sunday, 12-5; closed Mondays and major holidays. Located in the heart of downtown Grand Rapids, the Grand Rapids Art Museum presents exhibitions of national caliber and regional distinction.

EXHIBITS Interested in fine art, historical/vintage.

ANTON HAARDT GALLERY

2858 Magazine St., New Orleans LA 70130. (504)891-9080. **E-mail:** anton3@earthlink.net. **Website:** www. antonart.com. Estab. 2001. For profit gallery. Represents or exhibits 25 artists. Overall price range $500-5,000. Most work sold at $1,000.

EXHIBITS Exhibits photos of celebrities. Mainly photographs (portraits of folk artists).

MAKING CONTACT & TERMS Prefers only artists from the South. Self-taught artists who are original and pure, specifically art created from 1945 to 1980. "I rarely take on new artists, but I am interested in buying estates of deceased artist's work or an entire body of work by artist."

SUBMISSIONS Send query letter with artist's statement.

TIPS "I am only interested in a very short description if the artist has work from early in his or her career."

CARRIE HADDAD GALLERY

622 Warren St., Hudson NY 12534. (518)828-1915. **E-mail:** carriehaddadgallery@verizon.net. **Website:** www.carriehaddadgallery.com. **Contact:** Carrie Haddad, owner; Linden Scheff, director. Estab. 1991. Art consultancy, for-profit gallery. "Hailed as the premier gallery of the Hudson Valley, the Carrie Haddad Gallery presents 7 large exhibits/year and includes all types of painting, both large and small sculpture, works on paper and a variety of techniques in photography." Carrie Haddad Gallery also offers art consultation services, collaborating with design professionals

and architects across the country to procure compelling works for private residences and corporate collections. Our diverse inventory offers solutions to fit all criteria and a small staff ensures direct and dedicated project management." Open daily, 11-5. Overall price range $500-$10,000. Most work sold at $2,500.

EXHIBITS Photos of nudes, landscapes/scenics, architecture, pets, rural, product shots/still life.

MAKING CONTACT & TERMS Artwork is accepted on consignment, and there is a 50% commission. Gallery provides insurance, promotion. Requires exclusive representation locally.

SUBMISSIONS Send query letter with bio, photocopies, photographs, price list, SASE. Responds in 1 month. Finds artists through word of mouth, submissions, art exhibits, referrals by other artists.

THE HALSTED GALLERY INC.

Tom Halsted, 3658 Pheasant Run Bloomfield Hills, MI 48302, (248)894-0353. **E-mail:** tomhalsted@ hotmail.com;. **Contact:** Thomas Halsted. Private Dealer: Shows at Photo LA Antiquarian Book Fair, Ann Arbor MI, and board member of The Michigan Historical Photographic Society.

EXHIBITS Interested in 19th- and 20th-century photographs.

SUBMISSIONS Call to arrange a personal interview to show portfolio only. Prefers to see scans. Send no slides or samples. Unframed work only.

TIPS No limitations on subjects. Wants to see creativity, consistency, depth, and emotional work.

LEE HANSLEY GALLERY

225 Glenwood Ave., Raleigh NC 27603. (919)828-7557. **Fax:** (919)828-7550. **Website:** www.leehansleygallery. com. **Contact:** Lee Hansley, gallery director. Estab. 1993. "Located in Raleigh's bustling Glenwood South, we are dedicated to showcasing quality fine art through a series of changing exhibitions, both group and solo shows, featuring works from professional artists from North Carolina, the Southeast, and the nation. There are 35 artists in the gallery whose works are shown on a rotating basis. The gallery also hosts invitational exhibitions in which non-gallery artists show alongside stable artists. The gallery organizes at least 1 historical exhibition annually exploring the work of a single artist or group of stylistically related artists." Sponsors 3 exhibits/year. Average display time 4-6 weeks. Overall price range $250-1,600. Most

work sold at $400. Open Tuesday–Saturday, 11-6; 1st Friday, 11-10; or by appointment.

EXHIBITS Photos of environmental, landscapes/scenics, architecture, cities/urban, gardening, rural, performing arts. Interested in alternative process, avant garde, erotic, fine art. Interested in new images using the camera as a tool of manipulation; also wants minimalist works. Looks for top-quality work with an artistic vision.

MAKING CONTACT & TERMS Charges 50% commission. Payment within 1 month of sale.

SUBMISSIONS Send material by mail for consideration; include SASE. May be on CD. Does not accept e-mails. Responds in 2 months.

TIPS "Looks for originality and creativity—someone who sees with the camera and uses the parameters of the format to extract slices of life, architecture, and nature."

JOEL AND LILA HARNETT MUSEUM OF ART AND PRINT STUDY CENTER

University of Richmond Museums, 28 Westhampton Way, Richmond VA 23173. (804)289-8276. **Fax:** (804)287-1894. **E-mail:** rwaller@richmond.edu; museums@richmond.edu. **Website:** museums. richmond.edu. **Contact:** Richard Waller, executive director. Estab. 1968. Represents emerging, mid-career, and established artists. Sponsors 6 exhibitions/year. Average display time: 6 weeks. Open academic year; limited summer hours May-August. Located on university campus; 5,000 sq. ft. 100% of space for special exhibitions.

EXHIBITS Considers all media and all types of prints. Most frequently exhibits painting, sculpture, prints, photography, and drawing.

MAKING CONTACT & TERMS Work accepted on loan for duration of special exhibition. Retail price set by the artist. Museum provides insurance, promotion, contract, and shipping costs. Prefers artwork framed.

SUBMISSIONS Send query letter with résumé, 8-12 images on CD, brochure, SASE, reviews, and printed material if available. Write for appointment to show portfolio of "whatever is appropriate to understanding the artist's work." Responds in 1 month. Files résumé and other materials the artist does not want returned (printed material, CD, reviews, etc.).

WILLIAM HAVU GALLERY

1040 Cherokee St., Denver CO 80204. (303)893-2360. **Fax:** (303)893-2813. **E-mail:** info@williamhavugallery. com. **Website:** www.williamhavugallery.com. **Contact:** Bill Havu, owner and director; Nick Ryan, gallery administrator. For-profit gallery. "Engaged in an ongoing dialogue through its 7 exhibitions a year with regionalism as it affects and is affected by both national and international trends in realism and abstraction. Strong emphasis on mid-career and established artists." Approached by 120 artists/ year; represents or exhibits 50 artists. Sponsors 1 photography exhibit/year. Average display time: 6-8 weeks. Open Tuesday–Friday, 10-6; Saturday, 11-5; 1st Friday of each month, 10-8; Sundays and Mondays by appointment; closed Christmas and New Year's Day. Overall price range: $250-15,000; most work sold at $1,000-4,000.

EXHIBITS Photos of multicultural, landscapes/scenics, religious, rural. Interested in alternative process, documentary, fine art.

MAKING CONTACT & TERMS Gallery provides insurance, promotion, contract. Accepted work should be framed. Requires exclusive representation locally. Accepts only artists from Rocky Mountain, Southwestern region.

SUBMISSIONS "Please submit a representative sampling of your current body of work. We prefer to receive digital printouts, printed cards, and invitations, or other easily reviewed formats. If you prefer, you may submit CDs, e-mail a link to your website or include these materials in an e-mail. Mailed materials will only be returned if you have provided an SASE. Please also include the following: a current résumé listing your contact information, education, exhibition history, collections, and awards. An artist statement. Any other supporting materials (reviews, articles, etc.). An SASE for the return of your materials. (If you do not provide an SASE, your materials will not be returned to you.) We ask that you please not contact the gallery regarding the status of your portfolio review. Portfolios are reviewed only periodically, so it may be many months before the gallery reviews your materials. If, after evaluating your materials, we have an interest, we will be in touch with you to discuss next steps."

TIPS "Always mail a portfolio packet. We do not accept walk-ins or phone calls to review work. Explore website or visit gallery to make sure work would fit with the gallery's objective. We only frame work with archival quality materials and feel its inclusion in work can 'make' the sale."

⊘ HEMPHILL

1515 14th St. NW, Suite 300, Washington DC 20005. (202)234-5601. **Fax:** (202)234-5607. **E-mail:** gallery@hemphillfinearts.com. **Website:** www. hemphillfinearts.com. Estab. 1993. Art consultancy and for-profit gallery. Represents or exhibits 30 artists/year. Hemphill is a member of the Association of International Photography Art Dealers (AIPAD). Gallery open Tuesday–Saturday, 10-5, and by appointment. Overall price range $900-300,000.

EXHIBITS Photos of landscapes/scenics, architecture, cities/urban, rural. Interested in alternative process, fine art, historical/vintage.

SUBMISSIONS Gallery does not accept or review portfolio submissions.

HENRY ART GALLERY

University of Washington, 15th Ave. NE and NE 41st St., Seattle WA 98195. (206)543-2280. **Fax:** (206)685-3123. **E-mail:** press@henryart.org. **Website:** www. henryart.org. **Contact:** Luis Croquer, deputy director of exhibitions, collections and programs. Estab. 1927. Contemporary Art Museum. Exhibits emerging, mid-career, and established domestic and international artists. Presents approx. 20 exhibitions/year. Open Wednesday, Saturday, Sunday 11-4; Thursday-Friday, 11-9. Located on the University of Washington campus. Visitors include local community, students, and tourists.

EXHIBITS Considers all media. Most frequently exhibits photography, video, and installation work. Exhibits all types of prints.

MAKING CONTACT & TERMS Does not require exclusive representation locally.

SUBMISSIONS Send query letter with artist statement, résumé, SASE, 10-15 images. Returns material with SASE. Finds artists through art exhibitions, exhibition announcements, individualized research, periodicals, portfolio reviews, referrals by other artists, submissions, and word of mouth.

HENRY STREET SETTLEMENT/ABRONS ART CENTER

466 Grand St., New York NY 10002. (212)598-0400 or (212)766-9200. **E-mail:** info@henrystreet.

org; jdurham@henrystreet.org. **Website:** www. abronsartscenter.org. **Contact:** Jonathan Durham, director of exhibitions and AIRspace. Alternative space, nonprofit gallery, community center. "The Abrons Art Center brings innovative artistic excellence to Manhattan's Lower East Side through diverse performances, exhibitions, residencies, classes, and workshops for all ages and arts-in-education programming at public schools. Holds 9 solo photography exhibits/year. Open Tuesday–Friday, 10-10; Saturday, 9-10; Sunday, 11-6; closed major holidays.

EXHIBITS Photos of multicultural, environmental, landscapes/scenics, architecture, cities/urban, rural. Interested in alternative process, avant garde, documentary, fine art, historical/vintage.

MAKING CONTACT & TERMS Artwork is accepted on consignment, and there is a 20% commission. Gallery provides insurance, space, contract.

SUBMISSIONS Send query letter with artist's statement, SASE. Finds artists through word of mouth, submissions, referrals by other artists.

HERA GALLERY

P.O. Box 336, Wakefield RI 02880. (401)789-1488. **E-mail:** info@heragallery.org. **Website:** www. heragallery.org. Estab. 1974. Cooperative gallery. Hera Gallery/Hera Educational Foundation was a pioneer in the development of alternative exhibition spaces across the US in the 1970s and one of the earliest women's cooperative galleries. Although many of these galleries no longer exist, Hera is proud to have not only continued, but also expanded our programs, exhibitions, and events." The number of photo exhibits varies each year. Average display time: 6 weeks. Open Wednesday-Friday, 1-5; Saturday, 10-4; or by appointment; closed during the month of January. Sponsors openings; provides refreshments and entertainment or lectures, demonstrations, and symposia for some exhibits. Call for information on exhibitions. Overall price range: $100-10,000.

EXHIBITS Photos of disasters, environmental, landscapes/scenics. Interested in all types of innovative contemporary art that explores social and artistic issues. Interested in fine art.

MAKING CONTACT & TERMS Charges 30% commission. Works must fit inside a 6'6"×2'6" door. Photographer must show a portfolio before attaining membership.

SUBMISSIONS Inquire about membership and shows. Membership guidelines and application available on website or mailed on request.

TIPS "Hera exhibits a culturally diverse range of visual and emerging artists. Please follow the application procedure listed in the Membership Guidelines. Applications are welcome at any time of the year."

GERTRUDE HERBERT INSTITUTE OF ART

506 Telfair St., Augusta GA 30901-2310. (706)722-5495. **Fax:** (706)722-3670. **E-mail:** ghia@ghia.org. **Website:** www.ghia.org. **Contact:** Rebekah Henry, executive director. Estab. 1937. Nonprofit gallery. Has 5 solo or group shows annually; exhibits approximately 40 artists annually. Average display time: 6-8 weeks. Open Monday–Friday, 10-5; weekends by appointment only. Closed 1st week in August, and December 17-31. Located in historic 1818 Ware's Folly mansion.

MAKING CONTACT & TERMS Artwork is accepted on consignment, and there is a 35% commission.

SUBMISSIONS Send query letter with artist's statement, bio, brochure, résumé, reviews, slides, or CD of work, SASE. Responds to queries in 1-3 months. Finds artists through art exhibits, submissions, referrals by other artists.

HEUSER ART CENTER GALLERY & HARTMANN CENTER ART GALLERY

Bradley University Galleries, 1400 W. Bradley Ave., Peoria IL 61625. (309)677-2989. **Website:** art.bradley. edu/bug. **Contact:** Erin Buczynski, director of galleries, exhibitions and collections. Estab. 1984. Alternative space, nonprofit gallery, educational. "We have 2 formal exhibition spaces, one in the Heuser Art Center, where the art department is located, and one in the Hartmann Center, where the theater department is housed." Approached by 260 artists/year; represents or exhibits 50 artists. Sponsors 1 photography exhibit/year. Average display time: 4-6 weeks. Heuser Art Gallery hours: Monday–Thursday, 9-7; Friday, 9-4:30; and by appointment. Hartmann Center Gallery hours: Monday–Friday, 9-5; and by appointment. See website for more information.

EXHIBITS Photos of babies/children/teens, celebrities, couples, multicultural, families, parents, senior citizens, disasters, environmental, landscapes/scenics, wildlife, architecture, cities/urban, education, rural, entertainment, events, performing arts, travel, agriculture, business concepts, industry, medicine, mili-

tary, political, product shots/still life, science, technology/computers. Interested in alternative process, avant garde, documentary, fashion/glamour, fine art, historical/vintage, large-format Polaroid.

MAKING CONTACT & TERMS Artwork is accepted on consignment, and there is a 30% commission. Gallery provides promotion and contract. Accepted work should be framed or glazed with Plexiglas. "We consider all professional artists."

SUBMISSIONS Mail portfolio of 20 slides for review. Send query letter with artist's statement, bio, brochure, business card, photocopies, photographs, résumé, reviews, SASE, slides, and CD. Finds artists through art exhibits, portfolio reviews, referrals by other artists and critics, submissions, and national calls.

TIPS "No handwritten letters. Print or type slide labels. Send only 20 images total."

EDWARD HOPPER HOUSE ART CENTER

82 N. Broadway, Nyack NY 10960. (845)358-0774. **E-mail:** info@hopperhouse.org; caroleperry@edwardhopperhouse.org. **Website:** www.edwardhopperhouse.org. **Contact:** Carole Perry, director. Estab. 1971. Nonprofit gallery and historic house. Approached by 200 artists/year; exhibits 100 artists. Sponsors 1-2 photography exhibits/year. Average display time: 1 month. Also offers an annual summer jazz concert series. Open Thursday–Sunday, 1-5; or by appointment. The house was built in 1858; there are 4 gallery rooms on the 1st floor. Overall price range: $100-12,000. Most work sold at $750.

EXHIBITS Photos of all subjects. Interested in alternative process, avant garde, documentary, fine art, historical/vintage, seasonal.

MAKING CONTACT & TERMS Artwork is accepted on consignment, and there is a 35% commission. Gallery provides insurance, promotion, and contract. Accepted work should be framed, mounted, and matted.

SUBMISSIONS "Exhibits are scheduled 18 months to 2 years in advance. E-mail 10 images identifying each image with your name, title of work, medium, and dimensions, as well as a résumé/bio and artist statement."

HUDSON GALLERY

5645 N. Main St., Sylvania OH 43560. (419)885-8381. **Fax:** (419)885-8381. **E-mail:** info@hudsongallery.net. **Website:** www.hudsongallery.net. **Contact:** Scott Hudson, director. Estab. 2003. For-profit gallery. Approached by 30 artists/year; represents or exhibits 90 emerging, mid-career, and established artists. Sponsors 10 exhibits/year. Average display time: 1 month. Open Tuesday-Friday, 10-6; Saturday, 10-3. This street-level gallery has over 2,000 sq. ft. of primary exhibition space. Clients include local community, tourists, and upscale. 5% of sales are to corporate collectors. Overall price range: $50-10,000.

EXHIBITS Considers acrylic, ceramics, collage, drawing, fiber, glass, mixed media, oil, paper, pastel, sculpture, watercolor, engravings, etchings, linocuts, lithographs, mezzotints, serigraphs, woodcuts. Most frequently exhibits acrylic, oil, ceramics; considers all styles and genres.

MAKING CONTACT & TERMS Artwork is accepted on consignment and there is a 40% commission. Retail price of the art set by the gallery and artist. Gallery provides insurance, promotion, and contract.

SUBMISSIONS Call, e-mail, write or send query letter with artist's statement, bio, JPEGs; include SASE. Material returned with SASE. Responds within 4 months. Finds artists through word of mouth, submissions, portfolio reviews and referrals by other artists.

TIPS Follow guidelines on our website.

HUNTSVILLE MUSEUM OF ART

300 Church St. SW., Huntsville AL 35801-4910. (256)535-4350. **E-mail:** cmadkour@hsvmuseum.org. **Website:** www.hsvmuseum.org. **Contact:** Christopher Madkour, executive director. Estab. 1970. This nationally-accredited museum fills its 13 galleries with a variety of exhibitions throughout the year, including prestigious traveling exhibits and the work of nationally and regionally acclaimed artists. The museum's own 2,522-piece permanent collection also forms the basis for several exhibitions each year. Sponsors 1-2 exhibits/year. Average display time 2-3 months. Open Sunday, noon-5; Tuesday, Wednesday, Friday, Saturday, 11-5; Thursday, 11-8; closed Monday.

EXHIBITS No specific stylistic or thematic criteria. Interested in alternative process, avant garde, documentary, fine art, historical/vintage.

MAKING CONTACT & TERMS Buys photos outright. Accepted work may be framed or unframed, mounted or unmounted, matted or unmatted. Must have professional track record and résumé, slides, critical reviews in package (for curatorial review).

SUBMISSIONS Regional connection strongly pre-

ferred. Send material by mail with SASE for consideration.

INDIANAPOLIS ART CENTER

820 E. 67th St., Indianapolis IN 46220. (317)255-2464. **E-mail:** kyleh@indplsartcenter.org. **Website:** www.indplsartcenter.org. **Contact:** Kyle Herrington, director of exhibitions. Estab. 1934. "The Indianapolis Art Center is one of the largest community art facilities in the United States not connected with a university, welcoming more than 250,000 visitors a year. The mission of the Indianapolis Art Center is to engage, enlighten and inspire our community by providing interactive art education, outreach to underserved audiences, support of artists, and exposure to the visual arts. The Art Center's campus includes the Marilyn K. Glick School of Art, a 40,000-sq.-ft. facility designed by renowned architect Michael Graves. The building houses 11 state-of-the-art studios, 5 public art galleries, a 224-seat auditorium, and a library. It also features ArtsPark, a 9-acre outdoor creativity and sculpture garden that includes public art and is located in one of Indianapolis' most popular and diverse neighborhoods. The park is connected to one of the city's most utilized greenway trail systems, the Monan Trail."

MAKING CONTACT & TERMS "The Indianapolis Art Center Exhibitions Department accepts proposals for gallery and ArtsPark exhibits from June–December each year. Generally we are looking for exhibits to book 2 years out or more. Proposals will be accepted starting June 1–December 31. All works insured while on site and a stipend may be available in curated exhibitions. For further information about the gallery sizes and contract terms, please contact us."

SUBMISSIONS "Any artist may submit a proposal to be considered for a solo or group exhibition by sending a complete artist's packet to: Indianapolis Art Center, ATTN: Exhibits Department, 820 E. 67th St., Indianapolis, IN 46220. Your proposal should include the following items on a CD or DVD: an artist statement, not to exceed 1 page; a résumé or biography, not to exceed 3 pages; 12-15 images of individual works (details may be included); a list with title, medium, size, and year completed for each image. Videos may also be submitted, as well as videos of interactive and/or performance work. NOTE: your proposal materials WILL NOT be returned to you. While all proposals will be given equal consideration, artists living or working within 250 miles of Indianapolis are especially encouraged to apply. All proposals collected during the year will be reviewed on a rolling basis. Proposals may be kept for upwards of 3 years by the exhibitions department for future consideration."

INDIVIDUAL ARTISTS OF OKLAHOMA

P.O. Box 60824, Oklahoma City OK 73146. (405)232-6060. **Fax:** (405)232-6061. **E-mail:** kbrown@iaogallery.org. **Website:** www.iaogallery.org. **Contact:** Kendall Brown. Estab. 1979. Alternative space. "IAO creates opportunities for Oklahoma artists by curating and developing socially relevant exhibitions in one of the finest gallery spaces in the region." Approached by 60 artists/year; represents or exhibits 30 artists. Sponsors 10 photography exhibits/year. Average display time: 3-4 weeks. Open Tuesday–Saturday, 12-6. Gallery is located in downtown art district, 3,500 sq. ft. with 10-ft. ceilings and track lighting. Overall price range: $100-2,000; most work sold at $400.

EXHIBITS Interested in alternative process, avant garde, documentary, fine art, historical/vintage photography. Other specific subjects/processes: contemporary approach to variety of subjects.

MAKING CONTACT & TERMS Charges 30% commission. Gallery provides insurance, promotion, contract. Accepted work must be framed.

SUBMISSIONS Mail portfolio for review with artist's statement, bio, photocopies or slides, résumé, SASE. Reviews quarterly. Finds artists through word of mouth, art exhibits, referrals by other artists.

INTERNATIONAL CENTER OF PHOTOGRAPHY

1133 Avenue of the Americas, New York NY 10036. (212)857-0000; (212)857-9707. **E-mail:** portfolio@icp.org; kheisler@icp.org; info@icp.org. **Website:** www.icp.org. **Contact:** Department of Exhibitions & Collections. Estab. 1974.

SUBMISSIONS "Due to the volume of work submitted, we are only able to accept portfolios in the form of CDs or e-mail attachments. JPEG files are preferable; each image file should be a maximum of 1000 pixels at the longest dimension, at 72 dpi. CDs must be labeled with a name and address. Submissions must be limited to no more than 20 images. All files should be accompanied by a list of titles and dates. Portfolios of more than 20 images will not be accepted. Photographers may also wish to include the following information: cover letter, résumè or curriculum vitae,

artist's statement, and/or project description. ICP can only accept portfolio submissions via e-mail with "portfolio review" in the subject line or mail (or FedEx, etc.). Please include a SASE for the return of materials. ICP cannot return portfolios submitted without return postage."

INTERNATIONAL VISIONS GALLERY

2629 Connecticut Ave. NW Suite 301, Washington DC 20008. **E-mail:** intvisionsgallery@gmail.com. **Website:** www.inter-visions.com. **Contact:** Timothy Davis, owner/director. Estab. 1997. Private art and consulting firm. Overall price range: $500-10,000.

EXHIBITS Photos of babies/children/teens, multicultural.

MAKING CONTACT & TERMS Interested photographers may send images or web address to intvisions2@gmail.com

JACKSON FINE ART

3115 E. Shadowlawn Ave., Atlanta GA 30305. (404)233-3739. **Fax:** (404)233-1205. **Website:** www.jacksonfineart.com. **Contact:** Sarah Durning, director. Estab. 1990. Specializes in 20th-century and contemporary photography. Exhibitions are rotated every 2 months. Gallery open Tuesday-Saturday, 10-5. Overall price range $600-500,000. Most work sold at $5,000.

EXHIBITS Interested in innovative photography, avant garde, fine art.

MAKING CONTACT & TERMS Only buys vintage photos outright. Requires exclusive representation locally. Exhibits only nationally known artists and emerging artists who show long-term potential. "Photographers must be established, preferably published in books or national art publications. They must also have a strong biography, preferably museum exhibitions, national grants."

SUBMISSIONS Send JPEG files via e-mail. Responds in 3 months, only if interested. Unsolicited original work is not accepted.

ELAINE L. JACOB GALLERY AND ART DEPARTMENT GALLERY

480 W. Hancock St., Detroit MI 48202. (313)577-2423 or (313)993-7813. **E-mail:** tpyrzewski@wayne.edu. **Website:** www.art.wayne.edu. **Contact:** Tom Pyrzewski. Estab. 1995. "The Elaine L. Jacob Gallery serves as a forum for the display of national and international contemporary art. The Art Department Gallery serves as an exhibition venue for the Department of Art and Art History's faculty, students, alumni, and community-based groups."

JADITE GALLERIES

413 W. 50th St., New York NY 10019. (212)315-2740. **Fax:** (212)315-2793. **Website:** www.jadite.com. **Contact:** Roland Sainz, director. Estab. 1985. "Exhibitions cover the spectrum of art form created by a myriad of talented artists from the US, Europe, Latin America, and Asia. With 3 exhibition spaces, we have fostered a number of promising artists and attracted many serious collectors over the years." Sponsors 3-4 exhibits/year. Average display time 1 month. Open Tuesday–Saturday, 12-6. Overall price range $300-5,000. Most work sold at $1,500.

EXHIBITS Photos of landscapes/scenics, architecture, cities/urban, travel. Interested in avant garde, documentary, and b&w, color, and mixed media.

MAKING CONTACT & TERMS Gallery receives 30% commission. There is a rental fee for space (50/50 split of expenses such as invitations, advertising, opening reception, etc.). Accepted work should be framed.

SUBMISSIONS Arrange a personal interview to show portfolio. Responds in 5 weeks.

ALICE AND WILLIAM JENKINS GALLERY

600 St. Andrews Blvd., Winter Park FL 32792. (407)671-1886. **Fax:** (407)671-0311. **E-mail:** btiffany2000@yahoo.com. **Website:** www.crealde.org. **Contact:** Barbara Tiffany, director of painting and drawing department. Estab. 1980. "The Jenkins Gallery mission is to exhibit the work of noted and established Florida artists, as well as to introduce national and international artists to the Central Florida region." Each of the four to six annual exhibitions are professionally curated by a member of the Crealdé Gallery Committee or a guest curator.

JHB GALLERY

26 Grove St., Suite #4C, New York NY 10014. (212)255-9286. **Fax:** (212)229-8998. **E-mail:** info@jhbgallery.com. **Website:** www.jhbgallery.com. **Contact:** Jayne Baum. Estab. 1982. Private art dealer and consultant. Gallery open by appointment only. Overall price range $1,500-40,000. Most work sold at $1,500-100,000.

MAKING CONTACT & TERMS Artwork is accepted on consignment, and there is a 50% commission. Gallery provides promotion.

SUBMISSIONS Accepts online submissions. Send query letter with résumé, CD, slides, artist's statement, reviews, SASE. Finds artists through submissions, portfolio reviews, art exhibits, art fairs, referrals by other curators.

STELLA JONES GALLERY

201 St. Charles Ave., New Orleans LA 70170. (504)568-9050. **Website:** www.stellajonesgallery.com. **Contact:** Stella Jones. Estab. 1996. For-profit gallery. "The gallery provides a venue for artists of the African diaspora to exhibit superior works of art. The gallery fulfills its educational goals through lectures, panel discussions, intimate gallery talks, and exhibitions with artists in attendance." Approached by 40 artists/year; represents or exhibits 45 artists. Sponsors 1 photography exhibit/year. Average display time: 6-8 weeks. Open Tues–Saturday, 10-5. Located on 1st floor of corporate 53-story office building downtown, 1 block from French Quarter. Overall price range: $500-150,000. Most work sold at $5,000.

EXHIBITS Photos of babies/children/teens, multicultural, families, cities/urban, education, religious, rural.

MAKING CONTACT & TERMS Artwork is accepted on consignment, and there is a 50% commission. Gallery provides insurance, promotion, contract. Accepted work should be framed. Requires exclusive representation locally.

SUBMISSIONS Call to show portfolio of photographs, slides, transparencies. Mail portfolio for review. Send query letter with artist's statement, bio, brochure, business card, photocopies, photographs, résumé, reviews, slides, SASE. Responds in 1 month. Finds artists through word of mouth, submissions, portfolio reviews, art exhibits, referrals by other artists.

TIPS "Photographers should be organized with good visuals."

KENT STATE UNIVERSITY SCHOOL OF ART GALLERIES

P.O. Box 5190, Kent OH 44242. (330)672-1379. **E-mail:** haturner@kent.edu; schoolofartgalleries@kent.edu. **Website:** www.kent.edu/galleries. **Contact:** Anderson Turner, director of galleries. Located in six locations throughout northeast Ohio, please see website for location and hours. Sponsors at least 6 photography exhibits/year. Average display time 4 weeks.

EXHIBITS Interested in all types, styles, and subject matter of photography. Photographer must present quality work.

MAKING CONTACT & TERMS Photography can be sold in gallery. Charges 40% commission. Buys photography outright.

SUBMISSIONS Send proposal, résumé, and a CD of 10-20 digital images of work to be included in the exhibition. Send material by mail for consideration; include SASE. Responds "usually in 4 months, but it depends on time submitted."

KIRCHMAN GALLERY

P.O. Box 115, 213 N. Nugent St., Johnson City TX 78636. 512 851 8199. **E-mail:** susan@kirchmangallery.com. **Website:** www.kirchmangallery.com. **Contact:** Susan Kirchman, owner/director. Estab. 2005. Art consultancy and for-profit gallery. Represents or exhibits 25 artists. Average display time 1 month. Sponsors 4 photography exhibits/year. Open Sunday, 12-5; Monday 11-5; Thursday 12-6; Friday & Saturday, 11-6; anytime by appointment. Located across from Johnson City's historic Courthouse Square in the heart of Texas hill country. Overall price range $250-25,000. Most work sold at $500-1,000.

EXHIBITS Photos of landscapes/scenics. Interested in alternative process, avant garde, fine art.

MAKING CONTACT & TERMS Artwork is accepted on consignment, and there is a 50% commission.

SUBMISSIONS "Send 20 digital-format examples of your work, along with a résumé and artist's statement."

ROBERT KLEIN GALLERY

38 Newbury St., 4th Floor, Boston MA 02116. (617)267-7997. **Fax:** (617)267-5567. **E-mail:** inquiry@robertkleingallery.com. **Website:** www.robertkleingallery.com. **Contact:** Robert L. Klein, owner; Eunice Hurd, director. Estab. 1980. Devoted exclusively to fine art photography, specifically 19th and 20th century and contemporary. Sponsors 10 exhibits/year. Average display time 5 weeks. Overall price range $1,000-200,000. Open Tuesday–Friday, 10-5:30; Saturday, 11-5 and by appointment.

EXHIBITS Interested in fashion, documentary, nudes, portraiture, and work that has been fabricated to be photographs.

MAKING CONTACT & TERMS Charges 50% commission. Buys photos outright. Accepted work

should be unframed, unmmatted, unmounted. Requires exclusive representation locally. Must be established a minimum of 5 years; preferably published.

SUBMISSIONS "The Robert Klein Gallery is not accepting any unsolicited submissions. Unsolicited submissions will not be reviewed or returned."

ROBERT KOCH GALLERY

49 Geary St., 5th Floor, San Francisco CA 94108. (415)421-0122. **Fax:** (415)421-6306. **E-mail:** info@ kochgallery.com. **Website:** www.kochgallery.com. Estab. 1979. "Our gallery has exhibited and offered a wide range of museum quality photography that spans the history of the medium from the 19th century to the present. Our extensive inventory emphasizes Modernist and experimental work from the 1920s and 1930s, 19th-century and contemporary photography." Sponsors 6-8 photography exhibits/ year. Average display time 2 months. Located in the heart of San Francisco's downtown Union Square. Open Tuesday–Saturday, 11-5:30.

MAKING CONTACT & TERMS Artwork is accepted on consignment. "E-mail artist, title or description of subject matter, date, medium, dimensions, and any other pertinent information with a low-res JPEG. Also include your name, e-mail address, phone number, and the best time to reach you." Gallery provides insurance, promotion, contract. Requires West Coast or national representation.

SUBMISSIONS Finds artists through publications, art exhibits, art fairs, referrals by other artists and curators, collectors, critics.

LAWNDALE ART CENTER

4912 Main St., Houston TX 77002. (713)528-5858. **Fax:** (713)528-4140. **E-mail:** askus@lawndaleartcenter. org. **Website:** www.lawndaleartcenter.org. **Contact:** Dennis Nance, exhibitions and programming director. Estab. 1979. Nonprofit gallery, museum, alternative space. Exhibits emerging, mid-career, and established artists. Approached by 1,200 artists/ year. Exhibits 150 artists. Sponsors 25 exhibits/year; approx. 5 photography exhibits/year. Model/property release preferred. Average display time: 5 weeks. Open Monday—Friday, 10–5; Saturday, 12–5; closed Sunday, Christmas Eve until New Year's Day, Presidents' Day, Memorial Day, Independence Day, Labor Day, Columbus Day, and Thanksgiving. "Located at the edge of downtown in the Museum District, Lawndale includes 4 museum-quality galleries, 3 artist studios, an outdoor sculpture garden, and annual rotating mural wall." Clients include: local community, students, tourists, upscale, artists, collectors, art enthusiasts, volunteers, young professionals.

EXHIBITS Considers all media. Gallery provides insurance, promotion, contract. Prefers artists from Houston TX and surrounding area.

MAKING CONTACT & TERMS "Visit the proposal section of our website: www.lawndaleartcenter. org/exhibitions/proposals.shtml." Does not accept mailed proposals. All proposals must be made online.

SUBMISSIONS Finds artists through word of mouth, submissions, referrals by other artists.

TIPS "Please visit us or our website to learn about what type of work we exhibit and how we accept submissions to artists before contacting."

LAW WARSCHAW GALLERY

Macalester College, Janet Wallace Fine Arts Center, 1600 Grand Ave., St. Paul MN 55105. (651)696-6416. **Fax:** (651)696-6266. **E-mail:** gallery@macalester. edu. **Website:** www.macalester.edu/gallery. **Contact:** Gregory Fitz, curator. Estab. 1964. Nonprofit gallery. Approached by 15 artists/year; represents or exhibits 3 artists. Sponsors 1 photography exhibit/year. Average display time 4-5 weeks. Gallery open Monday-Friday, 10-4; Thursdays, 12-8; weekends, 12-4. Closed major holidays, summer, and school holidays. Located in the core of the Janet Wallace Fine Arts Center on the campus of Macalester College. While emphasizing contemporary, the gallery also hosts exhibitions on a wide-range of historical and sociological topics. Gallery is approx. 1,100 sq. ft. and newly renovated. Overall price range: $200-1,000. Most work sold at $350.

EXHIBITS Photos of multicultural, environmental, landscapes/scenics, architecture, rural. Interested in avant garde, documentary, fine art, historical/vintage.

MAKING CONTACT & TERMS Gallery provides insurance. Accepted work should be framed, mounted, matted.

SUBMISSIONS Send query letter with artist's statement, bio, brochure, business card, photocopies, photographs, résumé, reviews, SASE, slides. Finds artists through word of mouth, portfolio reviews, referrals by other artists.

TIPS "Photographers should present quality slides which are clearly labeled. Include a concise artist's statement. Always include a SASE. No form letters or mass mailings."

⊘ ELIZABETH LEACH GALLERY

417 NW Ninth Ave., Portland OR 97209-3308. (503)224-0521. **Fax:** (503)224-0844. **Website:** www. elizabethleach.com. Currently not accepted unsolicited submissions. Sponsors 3-4 exhibits/year. Average display time 1 month. "The gallery has extended hours every first Thursday of the month for our openings." Overall price range $300-5,000.

EXHIBITS Photographers must meet museum conservation standards. Interested in "high-quality concept and fine craftmanship."

MAKING CONTACT & TERMS Charges 50% commission. Accepted work should be framed or unframed, matted. Requires exclusive representation locally.

SUBMISSIONS Not accepting submissions at this time.

SHERRY LEEDY CONTEMPORARY ART

2004 Baltimore Ave., Kansas City MO 64108. (816)221-2626. **Fax:** (816)221-8689. **E-mail:** sherryleedy@ sherryleedy.com. **Website:** www.sherryleedy.com. **Contact:** Sherry Leedy, director. Estab. 1985. Retail gallery. Represents 50 mid-career and established artists. Exhibited artists include Jun Kaneko, Mike Schultz, Vera Mercer, and more. Sponsors 6 shows/year. Average display time: 6 weeks. Open Tuesday–Saturday, 11-5, and by appointment. 5,000 sq. ft. of exhibit area in 3 galleries. Clients include established and beginning collectors. 50% of sales are to private collectors, 50% corporate clients. Overall price range: $50-100,000; most work sold at $3,500-35,000.

EXHIBITS Considers all media and one-of-a-kind or limited-edition prints; no posters. Most frequently exhibits painting, photography, ceramic sculpture, and glass.

MAKING CONTACT & TERMS Accepts work on consignment (50% commission). Retail price set by gallery in counsultation with the artist. Sometimes offers customer discounts and payment by installment. Exclusive area representation required. Gallery provides insurance, promotion; shipping costs are shared. Prefers artwork framed.

SUBMISSIONS E-mail query letter, résumé, artist's statement, and digital images or link to website. No work will be reviewed in person without a prior appointment.

TIPS "Please allow 3 months for gallery to review submissions."

LEGION ARTS

1103 Third St., SE, Cedar Rapids IA 52401-2305. (319)364-1580. **Fax:** (319)362-9156. **E-mail:** info@ legionarts.org. **Website:** www.legionarts.org. **Contact:** Mel Andringa, producing director. Estab. 1991. Alternative space. Approached by 50 artists/year; represents or exhibits 15 artists. Sponsors 4 photography exhibits/year. Average display time: 2 months. Open Wednesday–Sunday, 11-6; closed July and August. Overall price range: $50-500. Most work sold at $200.

EXHIBITS Interested in alternative process, avant garde, documentary, fine art.

MAKING CONTACT & TERMS Artwork is accepted on consignment and there is a 30% commission. Gallery provides insurance, promotion. Accepted work should be framed.

SUBMISSIONS Send query letter with artist's statement, bio, slides, SASE. Responds in 6 months. Finds artists through word of mouth, art exhibits, referrals by other artists, art trade magazine.

LEHIGH UNIVERSITY ART GALLERIES

420 E. Packer Ave., Bethlehem PA 18015. (610)758-3619; (610)758-3615. **Fax:** (610)758-4580. **E-mail:** rv02@lehigh.edu. **Website:** www.luag.org. **Contact:** Ricardo Viera, director/curator. Sponsors 5-8 exhibits/year. Average display time 6-12 weeks. Sponsors openings.

EXHIBITS Fine art/multicultural, Latin American. Interested in all types of works. The photographer should "preferably be an established professional."

MAKING CONTACT & TERMS Reviews transparencies. Arrange a personal interview to show portfolio. Send query letter with SASE. Responds in 1 month.

TIPS "Don't send more than 10 slides or a CD."

DAVID LEONARDIS GALLERY

1346 N. Paulina St., Chicago IL 60622. (312)863-9045. **E-mail:** info@DLGalleries.com. **Website:** www.DLGalleries.com. **Contact:** David Leonardis, owner. Estab. 1992. For-profit gallery. Approached by 100 artists/year. Represents 12 emerging, mid-career, and established artists. Average display time: 90 days. Open by appointment. Clients include local community, tourists, upscale. 10% of sales are to corporate collectors. Overall price range: $50-5,000; most work sold at $500.

EXHIBITS Photos of celebrities. Interested in fine art.

MAKING CONTACT & TERMS Artwork is accepted on consignment, and there is a 50% commission. Gallery provides promotion. Accepted work should be framed.

SUBMISSIONS E-mail to arrange a personal interview to show portfolio. E-mail portfolio for review. Send query letter via e-mail. Responds only if interested. Finds artists through word of mouth, art exhibits, referrals by other artists.

TIPS "Artists should be professional and easy to deal with."

LEOPOLD GALLERY

324 W. 63rd St., Kansas City MO 64113. (816)333-3111. **Fax:** (816)333-3616. **E-mail:** e-mail@leopoldgallery. com. **Website:** www.leopoldgallery.com. **Contact:** Paula Busser, assistant director. Estab. 1991. For-profit gallery. Approached by 100+ artists/year; represents 40 artists/year. Sponsors 8 exhibits/year. Average display time 4 weeks. Open Monday–Friday, 10-6; Saturday, 10-5. Closed holidays. The gallery has 2 levels of exhibition space. Clients include H&R Block, Warner Bros., Kansas City Royals, local community, tourists. 65% of sales are to corporate collectors. Overall price range: $50-25,000; most work sold at $1,500. "We are located in Brookside, a charming retail district built in 1920 with more than 70 shops and restaurants. The gallery has 2 levels of exhibition space, with the upper level dedicated to artist openings/exhibitions."

EXHIBITS Photos of architecture, cities/urban, rural, environmental, landscapes/scenics, wildlife, entertainment, performing arts. Interested in alternative process, avant garde, documentary, fine art.

MAKING CONTACT & TERMS Artwork is accepted on consignment; there is a 50% commission. Gallery provides insurance, promotion, contract. Accepted work should be framed, mounted, matted. **Accepts artists from Kansas City area only.** Send query letter with artist's statement, bio, brochure, business card, résumé, reviews, SASE, disk with images. Responds in 2 weeks. Finds artists through word of mouth, art exhibitions, submissions, art fairs, portfolio reviews, referrals by other artists.

SUBMISSIONS E-mail 5-10 JPEG images of your body of work to e-mail@leopoldgallery.com. Before sending, please scan your e-mail for viruses, as any viral e-mails will be deleted upon receipt. Images should be saved at 72 dpi, approximately 5×7 and compressed to level 3 JPEG. Please save for Windows. Or, send e-mail query letter with link to artist's website.

LICHTENSTEIN CENTER FOR THE ARTS

28 Renne Ave., Pittsfield MA 01201. (413)499-9348. **Fax:** (413)442-8043. **Website:** www.discoverpittsfield. com. **Contact:** Dan Gigliotti, gallery manager. Estab. 1975. Sponsors 10 exhibits/year. Open Wednesday–Saturday, 12-5. Overall price range $50+.

MAKING CONTACT & TERMS Charges 20% commission. Will review transparencies of photographic work. Accepted work should be framed, mounted, matted.

SUBMISSIONS "Photographer should send SASE with 20 slides or prints, résumé, and statement by mail only to gallery."

TIPS "To break in, send portfolio, slides, and SASE. We accept all art photography. Work must be professionally presented and framed. Send in by July 1 each year. Expect exhibition 2-3 years from submission date. We have a professional juror look at slide entries once a year (usually July-September). Expect that work to be tied up for 2-3 months in jury."

LIMNER GALLERY

123 Warren St., Hudson NY 12534. (518)828-2343. **E-mail:** thelimner@aol.com. **Website:** www.slowart. com. **Contact:** Tim Slowinski, director. Estab. 1987. Alternative space. Established in Manhattan's East Village. Approached by 200-250 artists/year; represents or exhibits 90-100 artists. Sponsors 2 photography exhibits/year. Average display time: 4 weeks. Open Thursday-Saturday, 12-5; Sunday, 12-4. Closed January, July-August (weekends only). Located in the art and antiques center of the Hudson Valley. Exhibition space is 1,000 sq. ft.

EXHIBITS Interested in alternative process, avant garde, documentary, erotic, fine art, historical/vintage.

SUBMISSIONS Artists should e-mail a link to their website; or download exhibition application at www. slowart.com/prospectus; or send query letter with artist's statement, bio, brochure, or photographs/slides, SASE. Finds artists through submissions.

TIPS "Artist's website should be simple and easy to view. Complicated animations and scripted design should be avoided, as it is a distraction and prevents direct viewing of the work. Not all galleries and art buyers have cable modems. The website should either work on a telephone line connection or 2 versions of

the site should be offered—one for telephone, one for cable/high-speed Internet access."

ANNE LLOYD GALLERY

125 N. Water St., Decatur IL 62523-1025. **E-mail:** sue@decaturarts.org. **Website:** www.decaturarts.org. **Contact:** Sue Powell, gallery director. Estab. 2004. Nonprofit gallery. Approached by 10 artists/year. Represents 20 artists. Exhibits emerging, mid-career and established artists. Exhibited artists include Seth Casteel (photographer) and Rob O'Dell (watercolor). Sponsors 8 exhibits/year, 1 photography exhibit. Average display time: 1 month. Open Monday–Friday, 8:30-4:30; Saturday, 10-2. Closed major holidays. Located within the Madden Arts Center (community arts center owned/operated by Decatur Area Arts Council) in downtown Decatur IL. Approx. 1,500-sq.-ft. space with 113 linear feet wall space; 14 ft. ceilings; 10-ft.-high gallery cloth walls. Excellent track/grid lighting. Clients include local community, students and tourists. 1% of sales are to corporate collectors. Overall price range: $100-5,000. Most work sold at $100-500.

EXHIBITS Considers alternative process, avant garde, fine art. Most frequently exhibits acrylic, oil, and watercolor. Considers all media except installation. Considers all types of prints. Considers all styles. Considers all genres. Most frequently exhibits painting, mixed media, sculpture.

MAKING CONTACT & TERMS Artwork is accepted on consignment and there is a 35% commission. Retail price set by the artist. Museum provides insurance, promotion, and contract. Accepted work should be framed or mounted. Does not require exclusive representation locally. Art must be appropriate for a family-type venue.

SUBMISSIONS Call; e-mail query letter with link to website and JPEG samples at 72 dpi; or send query letter with artist's statement, bio, CD with images. Can also mail portfolio for review. Material is returned with SASE. Responds in 4 weeks. Files bio, statement, images, contact info. Finds artists through art exhibits, referrals by other artists, portfolio reviews, art fairs, research online, submissions, and word of mouth.

TIPS "Please include 6-10 images on a CD. This is important."

LOS ANGELES MUNICIPAL ART GALLERY

4800 Hollywood Blvd., Los Angeles CA 90027. **E-mail:** exh_scanty@sbcglobal.net; info@lamag.com.

Website: www.lamag.org. **Contact:** Scott Canty, curator. Estab. gallery 1971; support group LAMAGA 1954. City-run, municipally-owned gallery. Nonprofit. Exhibits emerging, mid-career, and established artists. Sponsors 8 total exhibits/year. Average display time: 8 weeks. Open Thursday-Sunday, 12-5. 10,000-sq.-ft. city-run facility located in Barnsdall Park in Hollywood, CA. Clients include local community, students, tourists, and upscale clientele.

EXHIBITS Accepts all media.

SUBMISSIONS "Visit our website at lamag.org for upcoming show opportunities." Files artists and proposals of interests. Finds artists through word of mouth, submissions, portfolio review, art exhibits, art fairs, referrals by other artists, and the DCA Slide Registry.

BILL LOWE GALLERY

764 Miami Circle, Suite 210, Atlanta GA 30324. (404)352-8114. **Fax:** (404)352-0564. **E-mail:** contact@lowegallery.com; alexis@lowegallery.com. **Website:** www.lowegallery.com. For-profit gallery. Approached by 300 artists/year; represents or exhibits approximately 67 artists. Average display time: 4-6 weeks. Open Tuesday–Friday, 10-5:30; Saturday, 11-5:30; Sunday by appointment. Exhibition space is 6,000 sq. ft. with great architectural details, such as 22-ft.-high ceilings. Exhibition spaces range from monumental to intimate.

EXHIBITS Photos of babies/children/teens, multicultural. Interested in alternative process, mixed media.

MAKING CONTACT & TERMS Artwork is accepted on consignment, and there is a 50% commission. Requires exclusive representation locally.

SUBMISSIONS Send query letter with artist's statement, bio, images on CD (including titles, media, dimensions, retail price), résumé, reviews, SASE. Prefers mail to e-mail. If submitting through e-mail, it should not exceed 2MB. Include contact information website link, biographical information, exhibition history, artist statement, reviews, or any other supplemental material (within reason). Response time approximately 6 weeks. Finds artists through word of mouth, art exhibits, submissions, art fairs, portfolio reviews, referrals by other artists. Submission guidelines available online.

TIPS "Look at the type of work that the gallery already represents, and make sure your work is an aesthetic

fit first! Send lots of great images with dimensions and pricing."

LUX CENTER FOR THE ARTS

2601 N. 48th St., Lincoln NE 68504. (402)466-8692. **Fax:** (402)466-3786. **E-mail:** info@luxcenter.org. **Website:** www.luxcenter.org. Estab. 1978. Nonprofit gallery. Over 450 fine arts prints collected by the art center's benefactor are preserved in the Gladys M. Lux Historical Gallery. Exhibited artists include Guy Pene DuBois, Joseph Hirsch, Doris Emrick Lee, Fletcher Martin, Georges Schreiber, Marguerite Zorach, and many more. Represents or exhibits 60+ artists. Sponsors 3-4 photography exhibits/year. Average display time 1 month. Open Tuesday–Friday, 11-5; Saturday, 10-5; 1st Friday, 11-8.

EXHIBITS Photos of landscapes/scenics. Interested in alternative process, avant garde, fine art.

MAKING CONTACT & TERMS Artwork is accepted on consignment, and there is a 50% commission.

SUBMISSIONS Mail current résumé, artist's statement, biography, 10-20 digital images of your work, and accompanying image identification information.

TIPS "To make your submission professional, you should have high-quality images (either slides or high-res digital images), cover letter, bio, résumé, artist's statement, and SASE."

MACNIDER ART MUSEUM

303 Second St. SE, Mason City IA 50401. (641)421-3666. **Fax:** (641)422-9612. **E-mail:** eblanchard@masoncity.net; macniderinformation@masoncity.net. **Website:** www.macniderart.org. Estab. 1966. Nonprofit gallery. Represents or exhibits 1-10 artists. Sponsors 2-5 photography exhibits/year (1 is competitive for the county). Average display time: 2 months. Gallery open Wednesday, Friday, and Saturday, 9-5; Tuesday and Thursday, 9-8; closed Sunday and Monday. Overall price range: $50-2,500. Most work sold at $200.

MAKING CONTACT & TERMS Artwork is accepted on consignment, and there is a 40% commission. Gallery provides insurance, promotion, contract. Accepted work should be framed.

SUBMISSIONS Mail portfolio for review. Responds within 3 months, only if interested. Finds artists through word of mouth, submissions, portfolio reviews, art exhibits, art fairs, referrals by other artists. Exhibition opportunities: exhibition in galleries, presence in museum shop on consignment, or booth at Festival Art Market in June.

MAIN STREET GALLERY

330 Main St., Ketchikan AK 99901. (907)225-2211. **E-mail:** info@ketchikanarts.org; marnir@ketchikanarts.org. **Website:** www.ketchikanarts.org. **Contact:** Marni Rickelmann, program director. Estab. 1953. Nonprofit gallery. Exhibits emerging, mid-career, and established artists. Number of artists represented or exhibited varies based on applications. Applications annually accepted for March 1 deadline. Sponsors 11 total exhibits/year. Model and property release are preferred. Average display time: 20 days-1 month. Open Monday-Friday, 9-5; Saturday, 11-3; closed last 2 weeks of December. Located in downtown Ketchikan, housed in renovated church. 800 sq. ft. Clients include local community, students, tourists, upscale. Overall price range: $20-4,000; most work sold at $150.

MAKING CONTACT & TERMS There is a membership fee plus a donation of time. There is a 25% commission. Retail price set by the artist. Gallery provides insurance, promotion, and contract. Accepted work should be framed and mounted.

SUBMISSIONS E-mail query letter with link to artist's website, 10 JPEG samples at 72 dpi, or résumé and proposal. March 1 gallery exhibit deadline for September-August season. Returns material with SASE. Responds in 2 months from March 1 deadline. Files all application materials. Finds artists through word of mouth, submissions, art exhibits, and referrals from other artists.

TIPS Respond clearly to application.

BEN MALTZ GALLERY

Otis College of Art & Design, Ground Floor, Bronya and Andy Galef Center for Fine Arts, 9045 Lincoln Blvd., Los Angeles CA 90045. (310)665-6905. **E-mail:** galleryinfo@otis.edu. **Website:** www.otis.edu/benmaltzgallery. Estab. 1957. Nonprofit gallery. Exhibits local, national and international emerging, mid-career and established artists. Sponsors 4-6 exhibits/year. Average display time: 1-2 months. Open Tuesday–Friday, 10-5 (Thursday, 10-9); Saturday-Sunday, 12-4; closed Mondays and major holidays. Located near Los Angeles International Airport (LAX); approximately 3,520 sq. ft.; 14-ft. walls. Clients include students, Otis community, local and

city community, regional art community, artists, collectors, and tourists.

EXHIBITS Fine art/design. Considers all media, most frequently exhibits paintings, drawings, mixed media, sculpture, and video.

SUBMISSIONS Submission guidelines available online. Submissions via internet only. Do not send other materials unless requested by the gallery after your initial submission has been reviewed.

TIPS "Follow submission guidelines and be patient. Attend opening receptions when possible to familiarize yourself with the gallery, director, curators, and artists."

MANITOU ART CENTER

513 Manitou Ave., Manitou Springs CO 80829. (719)685-1861. **E-mail:** director@thebac.org. **Website:** www.thebac.org. Estab. 1988. The MAC is a nonprofit gallery situated in 2 renovated landmark buildings in the Manitou Springs National Historic District, located at 513 and 515 Manitou Ave. Art studios are available for rent and often include equipment. The Manitou Art Center sponsors 16 exhibits/year in 5 galleries. Average display time: 6 weeks-2 months. Gallery open most days, 8-8; closed Tuesday. Overall price range $50-3,000. Most work sold at $300.

EXHIBITS Photos of environmental, landscapes/scenics, wildlife, gardening, rural, adventure, health/fitness, performing arts, travel. Interested in alternative process, avant garde, documentary, fashion/glamour, fine art.

MAKING CONTACT & TERMS "Artwork is accepted for our open submission and shows and there is a 30% commission." The gallery provides insurance, promotion, and a basic contract. Accepted work should be framed and ready to hang.

SUBMISSIONS Write to arrange a personal interview to show portfolio. "We often find artists through word of mouth, submissions, art exhibits, and referrals by other artists."

MARIN MUSEUM OF CONTEMPORARY ART

500 Palm Dr., Novato CA 94949. (415)506-0137. **Fax:** (415)506-0139. **E-mail:** info@marinmoca.org. **Website:** www.marinmoca.org. **Contact:** Heidi LaGrasta, executive director. Estab. 2007. Nonprofit gallery. Exhibits emerging, mid-career, and established artists. Sponsors 15+ exhibits/year. Model and property release is preferred. Average display time: 5 weeks.

Open Wednesday-Sunday, 11-4; closed Thanksgiving, Christmas, New Year's Day. MarinMOCA is located in historic Hamilton Field, a former Army Air Base. The Spanish-inspired architecture makes for a unique and inviting exterior and interior space. Houses 2 exhibition spaces—the Main Gallery (1,633 sq. ft.) and the Ron Collins Gallery (750 sq. ft.). Part of the Novato Arts Center, which also contains approximately 50 artist studios and a classroom (offers adult classes and a summer camp for children). Clients include local community, students, tourists, upscale. Overall price range: $200-20,000; most work sold at $500-1,000.

EXHIBITS Considers all media except video. Most frequently exhibits acrylic, oil, sculpture/installation. Considers all prints, styles, and genres.

MAKING CONTACT & TERMS Artwork is accepted on consignment and there is a 40% commission. Retail price of the art set by the artist. Gallery provides insurance, promotion (for single exhibition only, not representation), contract (for consignment only, not representation). Accepted work should be framed (canvas can be unframed, but prints/collage/photos should be framed). "We do not have exclusive contracts with, nor do we represent artists."

SUBMISSIONS "We are currently not accepting portfolio submissions at this time. Please visit our website for updates. If you are interested in gallery rental, please contact Heidi LaGrasta." Finds artists through word of mouth and portfolio reviews.

TIPS "Keep everything clean and concise. Avoid lengthy, flowery language and choose clear explanations instead. Submit only what is requested and shoot for a confident, yet humble tone. Make sure images are good quality (300 dpi) and easily identifiable regarding title, size, medium."

MARKEIM ARTS CENTER

104 Walnut St., Haddonfield NJ 08033. (856)429-8585. **E-mail:** markeim@verizon.net. **Website:** www.markeimartcenter.org. **Contact:** Elizabeth H. Madden, executive director. Estab. 1956. Sponsors 10-11 exhibits/year. Average display time: 4 weeks. The exhibiting artist is responsible for all details of the opening. Overall price range: $75-1,000. Most work sold at $350.

EXHIBITS Interested in all types of work. Exhibits photos of babies/children/teens, celebrities, couples, multicultural, families, parents, senior citizens, environmental, landscapes/scenics, wildlife, architecture,

cities/urban, education, rural, adventure, automobiles, entertainment, performing arts, sports, travel, agriculture, product shots/still life. Interested in alternative process, avant garde, documentary, fine art, historical/vintage, seasonal.

MAKING CONTACT & TERMS Charges 30% commission. Accepted work should be framed and wired, ready to hang, mounted or unmounted, matted or unmatted. Artists from New Jersey and Delaware Valley region are preferred. Work must be professional and high quality.

SUBMISSIONS Send slides by mail or e-mail for consideration. Include SASE, résumé, and letter of intent. Responds in 1 month.

TIPS "Be patient and flexible with scheduling. Look not only for one-time shows, but for opportunities to develop working relationships with a gallery. Establish yourself locally and market yourself outward."

MARLBORO GALLERY

Prince George's Community College, Largo MD 20477. (301)645-0965. **E-mail:** beraulta@pgcc.edu. **Website:** academic.pgcc.edu/art/gallery. **Contact:** Thomas Berault, curator/director. Estab. 1976. Average display time 5 weeks. Overall price range $50-4,000. Most work sells at $300-2,500.

EXHIBITS Fine art, photos of celebrities, portraiture, landscapes/scenics, wildlife/adventure, entertainment, events, and travel. Also interested in alternative processes, experimental/manipulated, avant garde photographs. Not interested in commercial work.

MAKING CONTACT & TERMS "We do not take commission on artwork sold." Accepted work must be framed and suitable for hanging.

SUBMISSIONS "We are most interested in fine art photos and need 15-20 examples to make assessment. Reviews are done on an ongoing basis. We prefer to receive submissions February through April." Please send cover letter with résumé, CD, or digital media with 15 to 20 JPEGs (approx 1200×800 pixels), image list with titles, media and dimensions, artist's statement, and SASE to return. Responds in 1 month.

TIPS "Send examples of what you wish to display, and explanations if photos do not meet normal standards (e.g., out-of-focus, experimental subject matter)."

MASUR MUSEUM OF ART

1400 S. Grand St., Monroe LA 71202. (318)329-2237. **Fax:** (318)329-2847. **E-mail:** info@masurmuseum.

org; evelyn.stewart@ci.monroe.la.us. **Website:** www.masurmuseum.org. **Contact:** Evelyn Stewart, director. Estab. 1963. Approached by 500 artists/year; represents or exhibits 150 artists. Sponsors 2 photography exhibits/year. Average display time 2 months. Museum open Tuesday–Friday, 9-5; Saturday, 12-5. Closed Mondays, between exhibitions and on major holidays. Located in historic home, 3,000 sq. ft. Overall price range $100-12,000. Most work sold at $300.

EXHIBITS Photos of babies/children/teens, celebrities, environmental, landscapes/scenics. Interested in alternative process, avant garde, documentary, fine art, historical/vintage.

MAKING CONTACT & TERMS Artwork is accepted on consignment, and there is a 20% commission. Gallery provides insurance, promotion. Accepted work should be framed.

SUBMISSIONS Send query letter with artist's statement, bio, résumé, reviews, slides, SASE. Responds in 6 months. Finds artists through word of mouth, submissions, art exhibits, referrals by other artists.

MAUI HANDS

1169 Makawao Ave., Makawao, HI 96768 (808)573-2021. **Fax:** (808)573-2022. **E-mail:** panna@mauihands.com. **Website:** www.mauihands.com. **Contact:** Panna Cappelli, owner. Estab. 1992. For-profit gallery. Approached by 50-60 artists/year. Continuously exhibits 300 emerging, mid-career, and established artists. Exhibited artists include Linda Whittemore (abstract monotypes) and Steven Smeltzer (ceramic sculpture). Sponsors 15-20 exhibits/year; 2 photography exhibits/year. Average display time: 1 month. Open Monday-Sunday, 10-7; weekends, 10-6; closed on Christmas and Thanksgiving. Four spaces: #1 on Main Highway, 1,200-sq.-ft. gallery, 165-sq.-ft. exhibition; #2 on Main Highway, 1,000-sq.-ft. gallery, 80-sq.-ft. exhibition; #3 in resort, 900-sq.-ft. gallery, 50-sq.-ft. exhibition; #4 1169 Makawao Ave., Makawao HI 96768. Clients include local community, tourists, and upscale. 3% of sales are to corporate collectors. Overall price range: $10-7,000. Most work sold at $350.

EXHIBITS Considers all media. Most frequently exhibits oils, pastels, and mixed media. Considers engravings, etchings, linocuts, lithographs, and serigraphs. Styles considered are painterly abstraction, impressionism, and primitivism realism. Most frequently exhibits impressionism and painterly abstrac-

tion. Genres include figurative work, florals, landscapes, and portraits.

MAKING CONTACT & TERMS Artwork accepted on consignment with a 55% commission. Retail price of the art set by the gallery and artist. Gallery provides insurance and promotion. Artwork should be framed, mounted, and matted, as applicable. Only accepts artists from Hawaii.

SUBMISSIONS Artists should call, write to arrange personal interview to show portfolio of original pieces, e-mail query letter with link to artist's website (JPEG samples at 72 dpi) or send query letter with artist's statement, bio, brochure, photographs, résumé, business cards, and reviews. Responds in days. All materials filed. Finds artists through word of mouth, submissions, portfolio reviews, art exhibits, art fairs, and referrals by other artists.

TIPS "Best to submit your work via e-mail."

ERNESTO MAYANS GALLERY

601 Canyon Rd., Santa Fe NM 87501. (505)983-8068. **E-mail:** arte2@aol.com; ernestomayansgallery@gmail.com. **Website:** ernestomayansgallery.com. **Contact:** Ernesto Mayans, director. Estab. 1977. Publishers, retail gallery, and art consultancy. Publishes books, catalogs, and portfolios. Overall price range: $200-$5,000. Considers oil, acrylic, watercolor, pastel, pen & ink, drawings, mixed media, sculpture, photography, and original, handpulled prints. Most frequently exhibits oil, photography, and lithographs. Exhibits 20th-century American and Latin American art. Genres include landscapes and figurative work. "We exhibit Digital Chromogenic prints on Metallic Paper by Sibylle Szaggars-Redford, Photogravures by Unai San Martin, Pigment prints by Pablo Mayans, Digital prints by Eric Olson, Silver Gelatin prints by Richard Faller (Vintage Southwest Works), and Johanna Saretzki and Sean McGann (Nudes)."

MAKING CONTACT & TERMS Accepts work on consignment (50% commission). Retail price set by gallery and artist. Requires exclusive representation within area. "Please call before submitting." Arrange a personal interview to show portfolio. Send query by mail with SASE for consideration. Size limited to 11×20 maximum. Responds in 2 weeks.

MCDONOUGH MUSEUM OF ART

525 Wick Ave., Youngstown OH 44502. (330)941-1400. **E-mail:** mcdonoughmuseumofart@gmail.com. **Web-site:** mcdonoughmuseum.ysu.edu. **Contact:** Leslie Brothers, director. Estab. 1991. A center for contemporary art, education, and community, the museum offers exhibitions in all media, experimental installation, performance, and regional outreach programs to the public. The museum is also the public outreach facility for the Department of Art and supports student and faculty work through exhibitions, collaborations, courses, and ongoing discussion. Open Tuesday-Saturday, 11-4.

SUBMISSIONS Send exhibition proposal.

MESA CONTEMPORARY ARTS AT MESA ARTS CENTER

P.O. Box 1466, Mesa AZ 85211. (480)644-6561; (480)644-6567. **E-mail:** patty.haberman@mesaartscenter.com; boxoffice@mesaartscenter.com. **Website:** www.mesaartscenter.com. **Contact:** Patty Haberman, curator. Estab. 1980. Not-for-profit art space. "Mesa Contemporary Arts is the dynamic visual art exhibition space at Mesa Arts Center. In 5 stunning galleries, Mesa Contemporary Arts showcases curated and juried exhibitions of contemporary art by emerging and internationally recognized artists. We also offer lectures by significant artists and arts professionals, art workshops, and a volunteer docent program." Public admission: $3.50; free for children ages 7 and under; free on Thursdays (sponsored by Salt River Project); free on the first Sunday of each month, via the "3 for Free" program sponsored by Target (also includes free admission to the Arizona Museum for Youth and the Arizona Museum of Natural History). "Currently not accepting unsolicited proposals. Artists who do not follow the guidelines outlined in the Prospectus and were not contracted directly by Mesa Contemporary Arts staff about participating in an exhibition are considered unsolicited artists. Artists who apply for an opportunity and follow the guidelines in the Prospectus are not considered unsolicited. Unsolicited materials will be returned without comment."

EXHIBITS Photos of babies/children/teens, celebrities, couples, multicultural, families, parents, senior citizens, disasters, environmental, landscapes/scenics, wildlife, architecture, cities/urban, interiors/decorating, rural, adventure, automobiles, entertainment, events, performing arts, travel, industry, political, science, technology/computers. Interested in alternative

process, avant garde, documentary, fine art, historical/vintage, seasonal, and contemporary photography.

MAKING CONTACT & TERMS Charges $25 entry fee, 25% commission.

TIPS "We do invitational or national juried exhibits. Submit professional-quality slides."

⊘ R. MICHELSON GALLERIES

132 Main St., Northampton MA 01060. (413)586-3964. **Fax:** (413)587-9811. **E-mail:** RM@rmichelson.com; PG@RMichelson.com. **Website:** www.rmichelson.com. **Contact:** Richard Michelson, owner and president. Estab. 1976. Retail gallery. Sponsors 1 exhibit/year. Average display time: 6 weeks. Open all year; Monday-Wednesday, 10-6; Thursday-Saturday, 10-9; Sunday, 12-5. Located downtown; Northampton gallery has 5,500 sq. ft.; 50% of space for special exhibitions. Clientele 80% private collectors, 20% corporate collectors. Sponsors openings. Overall price range: $1,200-25,000.

EXHIBITS Interested in contemporary, landscape, and/or figure work.

MAKING CONTACT & TERMS Sometimes buys photos outright. Accepted work can be framed or unframed, mounted or unmounted, matted or unmatted. Requires exclusive representation. Not taking on new photographers at this time. Represents the photography of Jeanne Birdsall and Leonard Nimoy.

MILL BROOK GALLERY & SCULPTURE GARDEN

236 Hopkinton Rd., Concord NH 03301. (603)226-2046. **E-mail:** artsculpt@mindspring.com. **Website:** www.themillbrookgallery.com. Estab. 1996. Exhibits 70 artists. Sponsors 1 photography exhibit/year. Average display time 6 weeks. Gallery open Tuesday–Sunday, 11-5, April 1–December 24; and by appointment. Outdoor juried sculpture exhibit. Three rooms inside for exhibitions, 1,800 sq. ft. Overall price range $8-30,000. Most work sold at $500-1,000.

MAKING CONTACT & TERMS Artwork is accepted on consignment, and there is a 50% commission. Gallery provides insurance, promotion, contract. Accepted work should be framed, matted.

SUBMISSIONS Write to arrange a personal interview to show portfolio of photographs, slides. Send query letter with artist's statement, bio, photocopies, photographs, résumé, slides, SASE. Responds within 1 month, only if interested. Finds artists through word of mouth, submissions, art exhibits, referrals by other artists.

MOBILE MUSEUM OF ART

4850 Museum Dr., Mobile AL 36608-1917. (251)208-5200; (251)208-5221. **E-mail:** dklooz@mobilemuseumofart.com. **Website:** www.mobilemuseumofart.com. **Contact:** Donan Klooz, curator of exhibitions. Sponsors 4 exhibits/year. Average display time: 3 months. Sponsors openings; provides light hors d'oeuvres and cash bar.

EXHIBITS Open to all types and styles.

MAKING CONTACT & TERMS Photography sold in gallery. Charges 20% commission. Occasionally buys photos outright. Accepted work should be framed.

SUBMISSIONS Arrange a personal interview to show portfolio; send material by mail for consideration. Returns material when SASE is provided "unless photographer specifically points out that it's not required."

TIPS "We look for personal point of view beyond technical mastery."

MONTEREY MUSEUM OF ART

559 Pacific St., Monterey CA 93940. (831)372-5477. **Fax:** (831)372-5680. **E-mail:** info@montereyart.org. **Website:** www.montereyart.org. Estab. 1959. Additional location at 720 Via Mirada, Monterey CA 93940. Featuring special exhibitions and presentations of the Museum's collection. Open Thursday-Monday, 11-5. Closed Thanksgiving, Christmas, New Year's, and July 4. Check website for location details, exhibition schedule, and calendar of events including free-admission days, family day activities and programs for children, and more.

MULTIPLE EXPOSURES GALLERY

Torpedo Factory Art Center, 105 N. Union St. #312, Alexandria VA 22314. (703)683-2205. **E-mail:** info@multipleexposuresgallery.com. **Website:** www.multipleexposuresgallery.com. Estab. 1986. Cooperative gallery. Represents or exhibits 15 artists. Sponsors 12 photography exhibits/year. Average display time 1-2 months. Open daily, 11-5; Thursday 2-8. Closed on 5 major holidays throughout the year. Located in Torpedo Factory Art Center; 10-ft. walls with about 40 ft. of running wall space; 1 bin for each artist's matted photos, up to 20×24 in size with space for 25 pieces.

EXHIBITS Photos of landscapes/scenics, architec-

ture, beauty, cities/urban, religious, rural, adventure, automobiles, events, travel, buildings. Interested in alternative process, documentary, fine art. Other specific subjects/processes: "We have on display roughly 300 images that run the gamut from platinum and older alternative processes through digital capture and output."

MAKING CONTACT & TERMS There is a co-op membership fee, a time requirement, a rental fee, and a 15% commission. Accepted work should be matted. *Accepts only artists from Washington DC region.* Accepts only photography. "Membership is by jury of active current members. Membership is limited. Jurying for membership is only done when a space becomes available; on average, 1 member is brought in about every 2 years."

SUBMISSIONS Send query letter with SASE to arrange a personal interview to show portfolio of photographs, slides. Responds in 2 months. Finds artists through word of mouth, referrals by other artists, ads in local art/photography publications.

TIPS "Have a unified portfolio of images mounted and matted to archival standards."

MICHAEL MURPHY GALLERY M

2701 S. MacDill Ave., Tampa FL 33629. (813)902-1414. **Fax:** (813)835-5526. **Website:** www.michaelmurphygallery.com. **Contact:** Michael Murphy. Estab. 1988. (Formerly Michael Murphy Gallery, Inc.) For-profit gallery. Approached by 100 artists/year; exhibits 35 artists. Sponsors 1 photography exhibit/year. Average display time: 1 month. See website for current gallery hours. Overall price range: $500-15,000; most work sold at less than $1,000. "We provide elegant, timeless artwork for our clients' home and office environment as well as unique and classic framing design. We strongly believe in the preservation of art through the latest technology in archival framing."

EXHIBITS Photos of babies/children/teens, celebrities, couples, multicultural, families, parents, senior citizens, disasters, environmental, landscapes/scenics, wildlife, architecture, cities/urban, education, gardening, interiors/decorating, pets, religious, rural, agriculture, business concepts, industry, medicine, military, political, product shots/still life, science, technology/computers. Interested in alternative process, avant garde, documentary, erotic, fashion/glamour, fine art, historical/vintage, seasonal.

MAKING CONTACT & TERMS Artwork is accepted on consignment, and there is a 50% commission. Accepted work should be framed. Requires exclusive representation locally.

SUBMISSIONS Send query with artist's statement, bio, brochure, business card, photocopies, photographs, résumé, reviews, slides, and SASE. Responds to queries in 1 month, only if interested.

MUSEO DE ARTE DE PONCE

2325 Blvd. Luis A. Ferre, Ponce Puerto Rico 00717-0776. (787)840-1510. **Fax:** (787)841-7309. **E-mail:** info@museoarteponce.org. **Website:** www.museoarteponce.org. **Contact:** curatorial department. Estab. 1959. Museum. Approached by 50 artists/year; mounts 3 exhibitions/year. Open Wednesday-Monday, 10-5; Sunday, 12-5. Closed New Year's Day, January 6, Good Friday, Thanksgiving, and Christmas Day. Admission: $6 for adults, $3 for senior citizens, students with an ID card, and children.

EXHIBITS Interested in avant garde, fine art, European and Old Masters.

SUBMISSIONS Send query letter with artist's statement, résumé, images, reviews, publications. Responds in 3 months. Finds artists through research, art exhibits, studio and gallery visits, word of mouth, referrals by other artists.

MUSEO ITALOAMERICANO

Fort Mason Center, Bldg. C, San Francisco CA 94123. (415)673-2200. **Fax:** (415)673-2292. **E-mail:** sfmuseo@sbcglobal.net. **Website:** www.museoitaloamericano.org. Estab. 1978. Museum. "The first museum in the US devoted exclusively to Italian and Italian-American art and culture." Approached by 80 artists/year; exhibits 15 artists. Sponsors 1 photography exhibit/year (depending on the year). Average display time: 2-3 months. Open Tuesday–Sunday, 12-4; Monday by appointment; closed major holidays. Gallery is located in the San Francisco Marina District, with a beautiful view of the Golden Gate Bridge, Sausalito, Tiburon, and Alcatraz; 3,500 sq. ft. of exhibition space.

EXHIBITS Photos of babies/children/teens, celebrities, couples, multicultural, families, parents, senior citizens, environmental, landscapes/scenics, architecture, cities/urban, education, religious, rural, entertainment, events, food/drink, hobbies, humor, performing arts, sports, travel, product shots/still life. Interested in alternative process, avant garde, documentary, fine art, historical/vintage.

MAKING CONTACT & TERMS "The museum rarely sells pieces. If it does, it takes 20% of the sale." Museum provides insurance, promotion. Accepted work should be framed, mounted, matted. *Accepts only Italian or Italian-American artists.*

SUBMISSIONS Call or write to arrange a personal interview to show portfolio of photographs, slides, catalogs. Send query letter with artist's statement, bio, brochure, photographs, résumé, reviews, slides, SASE. Responds in 6 months. Finds artists through word of mouth, submissions.

TIPS "Photographers should have good, quality reproduction of their work with slides, and clarity in writing their statements and résumés. Be concise."

MUSEUM OF CONTEMPORARY ART SAN DIEGO

700 Prospect St., La Jolla CA 92037-4291. (858)454-3541. **E-mail:** info@mcasd.org. **Website:** www.mcasd.org. Estab. 1941. Located in the heart of downtown San Diego and in the coastal community of La Jolla, MCASD provides an unprecedented variety of exhibition spaces and experiences for the community. With two locations, the Museum of Contemporary Art San Diego (MCASD) is the region's foremost forum devoted to the exploration and presentation of the art of our time, presenting works across all media since 1950. Open daily, 11–5; closed Wednesdays and during installation.

EXHIBITS Interested in avant garde, documentary, fine art.

SUBMISSIONS See artist proposal guidelines at mcasd.org/about/artist-proposals.

MUSEUM OF CONTEMPORARY PHOTOGRAPHY, COLUMBIA COLLEGE CHICAGO

600 S. Michigan Ave., Chicago IL 60605. (312)663-5554. **Fax:** (312)369-8067. **E-mail:** curatorialcommittee@colum.edu. **Website:** www.mocp.org. **Contact:** Portfolio review coordinator. Estab. 1976. The Museum of Contemporary Photography (MoCP) is a stimulating and innovative forum for the collection, creation and examination of contemporary imagemaking in its camera tradition and in its expanded vocabulary of digital processes. "We present approx. 4 exhibits/year." Average display time: 2-3 months. Open Monday–Friday, 10-5; Thursday, 10-8; Saturday, 10-5; Sunday 12-5.

EXHIBITS Exhibits and collects national and international works including portraits, environment, architecture, urban, rural, performance art, political issues, journalism, social documentary, mixed media, video. Primarily interested in experimental work of the past ten years.

SUBMISSIONS Reviews of portfolios for purchase and/or exhibition held monthly. Submission protocols on website. Responds in 2-3 months. No critical review guaranteed.

TIPS "Professional standards apply; only very high-quality work considered."

MUSEUM OF PHOTOGRAPHIC ARTS

1649 El Prado, San Diego CA 92101. (619)238-7559. **Fax:** (619)238-8777. **E-mail:** curate@mopa.org. **Website:** www.mopa.org. **Contact:** Debra Klochko, executive director. Estab. 1983. "The Museum of Photographic Arts (MOPA) is one of the leading museums in the U.S. devoted exclusively to photography, film, and video. Since its founding, MOPA has been dedicated to collecting, preserving, and exhibiting the entire spectrum of the photographic medium. The museum's endeavors consistently address cultural, historical, and social issues through its exhibitions and educational programs." Sponsors 8-10 exhibits/year. Average display time: 3 months.

EXHIBITS Interested in the history of photography, from the 19th century to the present.

MAKING CONTACT & TERMS "The criteria is simply that the photography be of advanced artistic caliber, relative to other fine art photography. MOPA is a museum and therefore does not sell works in exhibitions." Exhibition schedules planned 2-3 years in advance. Holds a private members' opening reception each exhibition cycle.

SUBMISSIONS Portfolios can be submitted by e-mail to curate@mopa.org or direct mail to the above address. Materials are not accepted at the museum admission desk. All artist submissions should include: website, digital or print portfolio, additional materials, such as press reviews, exhibition catalogs, or print-on-demand books. Please include résumé, artist's statement, and other supporting materials with your submission. If materials require return, please include postage and appropriate packaging. Submissions sent without return postage are considered property of the museum, and will be held or disposed of at will. All submitted materials must be no larger than 8½×11. Learn more at mopa.org/content/artist-submissions.

TIPS "Exhibitions presented by the museum represent the full range of artistic and journalistic photographic works. There are no specific requirements. The executive director and curator make all decisions on works that will be included in exhibitions. There is an enormous stylistic diversity in the photographic arts. The museum does not place an emphasis on one style or technique over another."

MUSEUM OF PRINTING HISTORY

1324 W. Clay, Houston TX 77019. (713)522-4652, ext. 207. **E-mail:** kburrows@printingmuseum.org. **Website:** www.printingmuseum.org. **Contact:** Keelin Burrows, curator. Estab. 1982. "The mission of the museum is to promote, preserve, and share the knowledge of printed communication and art as the greatest contributors to the development of the civilized world and the continuing advancement of freedom and literacy." Represents or exhibits approximately 12 exhibitions/year. Sponsors 1 photography exhibit/year. Average display time 12 weeks. Open Tuesday–Saturday, 10-5. Closed 4th of July, Thanksgiving, Christmas Eve, Christmas, New Year's Eve/Day.

MUSEUM OF THE PLAINS INDIAN

P.O. Box 410, Browning MT 59417. (406)338-2230. **Fax:** (406)338-7404. **E-mail:** mpi@3rivers.net; mpi@ios.doi.gov. Estab. 1941. Open Tuesday-Saturday, 9-4:45 (June-September); Monday–Friday, 10-4:30 (October-May). Admission is free of charge October–May. Contact for additional information.

M.G. NELSON FAMILY GALLERY AT THE SAA

Springfield Art Association, 700 N. Fourth St., Springfield IL 62702. (217)523-2631. **Fax:** (217)523-3866. **E-mail:** director@springfieldart.org. **Website:** www.springfieldart.org. **Contact:** Betsy Dollar, executive director. Estab. 1913. Nonprofit gallery. Exhibits emerging, mid-career, and established artists. Sponsors 13 total exhibits/year, including theme-based shows 2-3 times/year. 1 exclusive photo show every couple of years. Average display time: 1 month. Open Monday-Friday, 9-5; Saturday, 10-3; closed Sundays and Christmas-New Year's Day. Located at the Springfield Art Association, campus includes a historic house, museum, and community art school. Clients include local community, students, tourists, and upscale clients. 5% of sales are to corporate collectors. Overall price range: $10-5,000; most work sold under $100.

EXHIBITS Considers all media.

MAKING CONTACT & TERMS Model and property release are required. Artwork is accepted on consignment and there is a 30% commission. Retail price set by the artist. Gallery provides insurance, promotion, and contract. Accepted work should be framed, mounted, and matted—ready to hang.

SUBMISSIONS Call or e-mail query letter with link to artist's website or JPEG samples at 72 dpi. Responds in 2 weeks. Will return material with SASE. Files CV, résumé, printed samples, and business cards. Find artists through word of mouth, submissions, portfolio reviews, art exhibits, art fairs, and referrals by other artists.

TIPS "Good quality images with artist's name included in file name."

NEVADA MUSEUM OF ART

160 W. Liberty St., Reno NV 89501. (775)329-3333. **Fax:** (775)329-1541. **Website:** www.nevadaart.org. **Contact:** Ann Wolfe, senior curator and deputy director. Estab. 1931. Sponsors 12-15 exhibits/year in various media. Average display time: 4-5 months.

SUBMISSIONS See website for detailed submission instructions. "No phone calls, please."

TIPS "We are a museum of ideas. While building upon our founding collections and values, we cultivate meaningful art and societal experiences, and foster new knowledge in the visual arts by encouraging interdisciplinary investigation. The Nevada Museum of Art serves as a cultural and educational resource for everyone."

NEW MEXICO STATE UNIVERSITY ART GALLERY

P.O. Box 30001, Las Cruces NM 88003-8001. (575)646-2545. **Fax:** (575)646-8036. **E-mail:** artglry@nmsu.edu. **Contact:** director. Estab. 1969. Museum. Average display time 2-3 months. Gallery open Tuesday–Saturday, 10-4. Closed Christmas through New Year's Day and university holidays. See website for summer hours. Located on university campus, 3,900 sq. ft. of exhibit space.

NEW ORLEANS MUSEUM OF ART

P.O. Box 19123, New Orleans LA 70179-0123. (504)658-4100. **Fax:** (504)658-4199. **E-mail:** staylor@noma.org. **Website:** www.noma.org. **Contact:** Susan Taylor, director. Estab. 1973. "The city's oldest fine arts institution, NOMA has a magnificent permanent col-

lection of more than 40,000 objects. The collection, noted for its extraordinary strengths in French and American art, photography, glass, African and Japanese works, continues to grow." Sponsors exhibits continuously. Average display time 1-3 months. Open Tuesday–Thursday, 10-6; Friday, 10-9; Saturday and Sunday, 11-5.

EXHIBITS Interested in all types of photography.

MAKING CONTACT & TERMS Buys photography outright; payment negotiable. "Current budget for purchasing contemporary photography is very small." Sometimes accepts donations from established artists, collectors or dealers.

SUBMISSIONS Send query letter with color photocopies (preferred) or slides, résumé, SASE. Accepts images in digital format; submit via website. Responds in 3 months.

TIPS "Send thought-out images with originality and expertise. Do not send commercial-looking images."

NEXUS/FOUNDATION FOR TODAY'S ART

1400 N. American St., Philadelphia PA 19122. **E-mail:** info@nexusphiladelphia.org. **Website:** www.nexusphiladelphia.org. Estab. 1975. Alternative space; cooperative, nonprofit gallery. Approached by 40 artists/year; represents or exhibits 20 artists. Sponsors 2 photography exhibits/year. Average display time: 1 month. Open Wednesday–Sunday, 12-6; closed July and August. Located in Fishtown, Philadelphia; 2 gallery spaces, approximately 750 sq. ft. each. Overall price range: $75-1,200; most work sold at $200-400.

EXHIBITS Photos of multicultural, families, environmental, architecture, rural, entertainment, humor, performing arts, industry, political. Interested in alternative process, documentary, fine art.

SUBMISSIONS Send query letter with artist's statement, bio, photocopies, photographs, slides, SASE. Finds artists through portfolio reviews, referrals by other artists, submissions, and juried reviews 2 times/year. "Please visit our website for submission dates."

TIPS "Learn how to write a cohesive artist's statement."

NICOLAYSEN ART MUSEUM

400 E. Collins St., Casper WY 82601. (307)235-5247. **E-mail:** info@thenic.org. **Website:** www.thenic.org. **Contact:** Brooks Joyner, executive director. Estab. 1967. Regional contemporary art museum. Average display time: 3-4 months. Interested in emerging, mid-career, and established artists. Sponsors 10 solo and 10 group shows/year. Open all year. Clientele 90% private collectors, 10% corporate clients.

EXHIBITS Considers all media with special attention to regional art.

SUBMISSIONS Send résumé, statement, and biography as well as images in digital format. "Due to the volume of correspondence we receive, we may not be able to respond directly to each and every submission, and we cannot assume responsibility for or guarantee the return of any materials that are submitted."

NICOLET COLLEGE ART GALLERY

5355 College Dr., P.O. Box 518, Rhinelander WI 54501. (715)365-4556. **E-mail:** kralph@nicoletcollege.edu; inquire@nicoletcollege.edu. **Website:** www.nicoletcollege.edu/about/creative-arts-series/art-gallery/index.html. **Contact:** Katy Ralph, gallery director. Exhibits 9-11 different shows each year including the Northern National Art Competition. The deadline for the annual competition is in May. For a prospectus, or more information, contact gallery director, Katy Ralph.

MAKING CONTACT & TERMS Call or e-mail for further information.

NKU GALLERY

Northern Kentucky University, Nunn Dr., Highland Heights KY 41099. (859)572-5148. **Fax:** (859)572-6501. **E-mail:** knight@nku.edu. **Website:** artscience.nku.edu/departments/art/galleries.html. **Contact:** David Knight, director of collections and exhibitions. Estab. 1970. The NKU Art Department Galleries are located on the 3rd floor of the Fine Arts Center. There are 2 gallery spaces: The Main Gallery and the Third Floor Gallery. Approached by 30 artists/year; represents or exhibits 5-6 artists. Average display time 1 month. Open Monday–Friday, 9-9; closed weekends and major holidays. Main Gallery is 2,500 sq. ft.; Third Floor Gallery is 600 sq. ft. Overall price range $25-3,000. Most work sold at $500.

MAKING CONTACT & TERMS Gallery provides insurance, promotion, contract. Accepted work should be framed, mounted, matted.

SUBMISSIONS Finds artists through word of mouth, art exhibits, referrals by other faculty.

TIPS "Submission guidelines, current exhibitions, and complete information available on our website."

NORTHWEST ART CENTER

Minot State University, 500 University Ave. W., Minot ND 58707. (701)858-3264. **Fax:** (701)858-3894. **E-mail:** nac@minotstateu.edu. **Website:** www.minotstateu.edu/nac. Estab. 1969. Nonprofit gallery. Represents emerging, mid-career, and established artists. Represents 20 artists. Sponsors 20 total exhibits/year; 2 photography exhibits/year. Model and property release preferred. Average display time: 4 weeks. Open Monday-Friday, 9-4. Two galleries located on university campus, each gallery approximately 100 linear feet. Clients include local community and students. 50% of sales are to corporate collectors. Overall price range: $100-1,000; most work sold at $350.

EXHIBITS Special interest in printmaking, works on paper, contemporary art, and drawings.

MAKING CONTACT & TERMS Accepted work should be framed and mounted. Artwork is accepted on consignment with a 30% commission. Retail price set by the artist. Gallery provides insurance, promotion, and contract.

SUBMISSIONS Send query letter with artist's statement, photocopies bio, résumé, and reviews. Returns material with SASE. Responds, if interested, within 3 months. Finds artists through art exhibits, submissions, referrals by other artists, and entries in our juried competitions.

NORTHWESTERN UNIVERSITY DITTMAR MEMORIAL GALLERY

1999 Campus Dr., Norris University Center, Evanston IL 60208. (847)491-2348. **E-mail:** dittmargallery@u.northwestern.edu. **Website:** www.dittmar.northwestern.edu. **Contact:** gallery coordinator. Estab. 1972. Nonprofit, student-operated gallery. Approached by over 100 artists/year, including 10-15 photographers; represents or exhibits more than 10 artists. Sponsors 1-2 photography exhibits/year. Average display time 6 weeks. Open daily 10-10. Closed in December during winter break. The gallery is located within the Norris Student Center on the main floor behind the information desk.

EXHIBITS Photos of babies/children/teens, couples, multicultural, families, parents, disasters, environmental, landscapes/scenics, wildlife, architecture, cities/urban, education, gardening, adventure, automobiles, entertainment, events, food/drink, health/fitness, hobbies, humor, performing arts, sports, travel. Interested in avant garde, fashion/glamour, fine art, historical/vintage, seasonal.

MAKING CONTACT & TERMS Artwork is accepted on consignment, and there is a 20% commission. Gallery provides promotion, contract. Accepted work should be mounted.

SUBMISSIONS Mail portfolio for review. Send query letter with 5 images that "demonstrate the work you are proposing for a show" or previous work with proposal for a new show, work list for the images including title, medium, size, and year, artist's statement, résumé, and any available contact information. Responds in 3 months. Finds artists through word of mouth, submissions, referrals by other artists.

TIPS "Do not send photocopies. Send a typed letter and good photos, images need to be high resolution. Send résumé of past exhibits, or if emerging, a typed statement."

THE NOYES MUSEUM OF ART

733 Lily Lake Rd., Oceanville NJ 08231. (609)652-8848. **Fax:** (609)652-6166. **E-mail:** info@noyesmuseum.org. **Website:** www.noyesmuseum.org. **Contact:** Michael Cagno, executive director; Dorrie Papademetriou, director of exhibitions. Estab. 1983. Sponsors 10-12 exhibits/year. Average display time 12 weeks. The Noyes Museum of Art of The Richard Stockton College of New Jersey presents exhibitions and events that benefit students and enthusiasts of the arts, as well as the entire southern New Jersey community. In 2010, Stockton partnered with the Noyes Museum, bringing an expanded array of educational opportunities, events, exhibits, and performances to the nearby off-campus facility. Stockton is also home to one of the area's top performing arts centers and its own art gallery.

EXHIBITS Interested in alternative process, avant garde, fine art, historical/vintage.

MAKING CONTACT & TERMS Charges commission. Accepted work must be ready for hanging, preferably framed. Infrequently buys photos for permanent collection.

SUBMISSIONS Any format OK for initial review; most desirable is a challenging, cohesive body of work. Send material by mail for consideration; include résumé, artist's statement, slide samples or CD; handwritten proposals not accepted. May include photography and mixed media. See website for further details.

TIPS "Send a challenging, cohesive body of work."

OAKLAND UNIVERSITY ART GALLERY

2200 N. Squirrel Rd., 208 Wilson Hall, Oakland University, Rochester MI 48309-4401. (248)370-3006. **Fax:** (248)370-4368. **E-mail:** jaleow@oakland.edu; goody@oakland.edu. **Website:** www.oakland.edu/ouag. Estab. 1962. Nonprofit gallery. Represents 10-25 artists/year. Sponsors 4-6 exhibits/year. Open September–May: Tuesday–Sunday, 12-5; evenings during special events and theater performances (Wednesday–Friday, 7 p.m. through 1st intermission, weekends, 5 p.m. through 1st intermission). Closed Monday and holidays. Located on the campus of Oakland University; exhibition space is approximately 2,350 sq. ft. of floor space, 301-ft. linear wall space, with 10-ft. 7-in. ceiling. The gallery is situated across the hall from the Meadow Brook Theatre. "We do not sell work, but do make available price lists for visitors with contact information noted for inquiries."

EXHIBITS Considers all styles and all types of prints and media.

MAKING CONTACT & TERMS Charges no commission. Gallery provides insurance, promotion, and contract. Accepted work should be framed, mounted, matted.

SUBMISSIONS E-mail bio, education, artist's statement and link to web site. Send query letter with artist's statement, bio, photocopies, curriculum vitae. Artist referrals by other artists, word of mouth, art community, advisory board, and other arts organizations.

OPALKA GALLERY

The Sage Colleges, 140 New Scotland Ave., Albany NY 12208. (518)292-7742. **E-mail:** opalka@sage.edu; lynchj2@sage.edu. **Website:** www.sage.edu/opalka. **Contact:** Jacqueline Lynch, assistant to the director and gallery operations. Estab. 2002. Nonprofit gallery. Approached by 90-120 artists/year; mounts 3-4 exhibitions per academic calendar year. Average display time 5 weeks. Open Tuesday-Friday, 10-8; weekends, 12-5; June-July, 10-4 and by appointment only during installations and when classes are not in session. Closed July 4. Located on the Sage Albany campus, The gallery's primary concentration is on work by professional artists from outside the region. The gallery frequently features multidisciplinary projects and hosts poetry readings, recitals, and symposia in conjunction with exhibitions. The 7,400-sq.-ft. facility includes a vaulted gallery and a 75-seat lecture/presentation hall with Internet connectivity.

EXHIBITS Interested in fine art.

MAKING CONTACT & TERMS Reviews work by artists from outside the region and those who have ties to the Sage Colleges. A local photography regional is hosted every 3 years requiring artists to have exclusive local representation.

SUBMISSIONS Under terms of an exhibition loan agreement, artwork may be sold by the artist while on exhibit. The gallery does not take commissions or sell artwork.

TIPS "Contact the gallery by e-mail or phone to inquire about submission policy."

OPENING NIGHT GALLERY

2836 Lyndale Ave. S., Minneapolis MN 55408-2108. (612)872-2325. **Fax:** (612)872-2385. **E-mail:** deen@onframe-art.com; info@onframe-art.com. **Website:** www.onframe-art.com. **Contact:** Deen Braathen. Estab. 1975. Rental gallery. Approached by 40 artists/year; represents or exhibits 15 artists. Sponsors 1 photography exhibit/year. Average display time: 6-10 weeks. Gallery open Monday–Friday, 8:30-5; Saturday, 10:30-4. Overall price range: $300-12,000; most work sold at $2,500.

EXHIBITS Photos of landscapes/scenics, architecture, cities/urban.

MAKING CONTACT & TERMS Artwork is accepted on consignment, and there is a 50% commission. Gallery provides insurance, promotion, contract. "Accepted work should be framed by our frame shop." Requires exclusive representation locally.

SUBMISSIONS Mail slides for review. Send query letter with artist's statement, bio, résumé, slides, SASE. Responds in 2 months. Finds artists through word of mouth, submissions, portfolio reviews.

PALLADIO GALLERY

2231 Central Ave., Memphis TN 38104. (901)276-1251. **E-mail:** rollin@galleryfiftysix.com. **Website:** www.galleryfiftysix.com. Blog: www.galleryfiftysix.blogspot.com. **Contact:** Rollin Kocsis, director. Estab. 2008. For-profit gallery. Approached by 35 artists/year; represents or exhibits 24 emerging, mid-career, and established artists. Exhibited artists include John Armistead (oil on canvas), Bryan Blankenship (painting and ceramics), Terry Kenney and Joseph Morzuch (painting). Sponsors 12 exhibits/year. Model and

property release are preferred. Average display time: 1 month. Open Monday-Saturday, 10-5. Contains 1 large room with 1 level. Clients include local community, students, tourists, and upscale. Overall price range: $200-3,000. Most work sold at $750.

EXHIBITS Considers acrylic, ceramics, collage, drawing, fiber, glass, mixed media, oil, pastel, sculpture. Most frequently exhibits oil on canvas, acrylic on canvas, assemblages. Considers engravings, etchings, linocuts, serigraphs, woodcuts. Considers color field, expressionism, geometric abstraction, imagism, impressionism, pattern painting, postmodernism, primitivism realism, surrealism, painterly abstraction. Most frequently exhibits realism, abstract, expressionism. Considers all genres. No nudes.

MAKING CONTACT & TERMS Artwork is accepted on consignment and there is a 50% commission. Gallery provides promotion and contract. Accepted work should be gallery wrapped or frames with black or natural wood finish. Requires exclusive representation locally.

SUBMISSIONS E-mail 8-12 JPEGs. Write to arrange personal interview to show portfolio of photographs, e-mail JPEG samples at 72 dpi or send query letter with artist's statement, bio, brochure, business card, photographs, résumé, reviews, and SASE. Material returned with SASE. Responds in 2 weeks. Files JPEGs, CDs, photos. Finds artists through word of mouth, submissions, portfolio reviews, art exhibits, and referrals by other artists.

TIPS "Send good quality photos, by e-mail, with all important information included. Not interested in installations or subject matter that is offensive, political, sexual, or religious."

PALO ALTO ART CENTER

1313 Newell Rd., Palo Alto CA 94303. (650)329-2366. **Fax:** (650)326-6165. **E-mail:** artcenter@cityofpaloalto. org. **Website:** www.cityofpaloalto.org/artcenter. **Contact:** exhibitions department. Estab. 1971. Average display time: 1-3 months. Hours: Tuesday, Wednesday, Friday, Saturday, 10-5; Thursday, 10-9; Sunday, 1-5. Sponsors openings.

EXHIBITS "Exhibit needs vary according to curatorial context." Seeks "imagery unique to individual artist. No standard policy. Photography may be integrated in group exhibits." Interested in alternative process, avant garde, fine art; emphasis on art of the Bay Area.

SUBMISSIONS Send slides/CD, bio, artist's state-ment, SASE.

PANAMA CITY CENTRE FOR THE ARTS

19 E. Fourth St., Panama City FL 32401. 850-640-3670. **E-mail:** info@pccentreforthearts.com. **Website:** www. pccentreforthearts.com/. Estab. 1988. Approached by 20 artists/year; represents local and national artists. Sponsors 1-2 photography exhibits/year. Average display time 6 weeks. Open Tuesday and Thursday, 10-8; Wednesday, Friday and Saturday, 10-6; closed Sunday and Monday. The Center features a large gallery (200 running ft.) upstairs and a smaller gallery (80 running ft.) downstairs. Overall price range $50-1,500.

EXHIBITS Photos of all subject matter, including babies/children/teens, couples, families, parents, senior citizens, environmental, landscapes/scenics, wildlife, architecture, product shots/still life. Interested in alternative process, avant garde, documentary, fashion/glamour, fine art, historical/vintage, seasonal, digital, underwater.

MAKING CONTACT & TERMS Artwork is accepted on consignment, and there is a 30% commission. Gallery provides promotion, contract, insurance. Accepted work must be framed, mounted, matted.

SUBMISSIONS Send query letter with artist's statement, bio, résumé, SASE, 10-12 slides or images on CD. Responds within 4 months. Finds artists through word of mouth, submissions, art exhibits.

LEONARD PEARLSTEIN GALLERY

Drexel University, 3401 Filbert St., Philadelphia PA 19104. (215)895-2414. **E-mail:** gallery@drexel.edu; lcc48@drexel.edu. **Contact:** Lynn Clouser, assistant curator. Estab. 1986. Nonprofit gallery. Located in Nesbitt Hall in the Antoinette Westphal College of Media Arts and Design at Drexel. Committed to exhibiting the work of local, national, and international contemporary artists and designers. Sponsors 8 total exhibits/year; 1 or 2 photography exhibits/year. Average display time 1 month. Open Monday–Saturday, 11-5. Closed during summer.

MAKING CONTACT & TERMS Artwork is bought outright. Gallery takes 20% commission. Gallery provides insurance, promotion. Accepted work should be framed, mounted, matted. "We will not pay transport fees."

SUBMISSIONS Write to arrange a personal interview to show portfolio. Send query letter with artist's statement, bio, résumé, SASE. Returns material with SASE. Responds by February, only if interested. Finds

artists through referrals by other artists, academic instructors.

PETERS VALLEY SCHOOL OF CRAFT

19 Kuhn Rd., Layton NJ 07851. (973)948-5202. **Fax:** (973)948-0011. **E-mail:** gallery@petersvalley.org; info@petersvalley.org. **Website:** www.petersvalley.org. **Contact:** Brienne Rosner, gallery manager. Estab. 1970. Nonprofit exhibition and retail gallery. Approached by about 100 artists/year; represents about 350 artists. Average display time varies for store items. Gallery exhibitions approx. 1 month. Open year round; call for hours. Located in northwestern New Jersey in Delaware Water Gap National Recreation Area; 2 floors, approximately 3,000 sq. ft. Overall price range: $5-3,000. Most work sold at $100-300. "Focuses its programs on fine contemporary crafts in mediums such as ceramics, metals (both fine and forged), glass, wood, photography, fibers (surface design and structural), print."

EXHIBITS Considers all media and all types of prints. Also exhibits non-referential, mixed media, collage, and sculpture.

MAKING CONTACT & TERMS Artwork is accepted on consignment, and there is a 60% commission to artist. "Retail price set by the gallery in conjunction with artist." Gallery provides insurance and promotion. Accepted work should be framed, mounted, and matted.

SUBMISSIONS Submissions reviewed on an ongoing basis. Send query letter with artist's statement, bio, résumé, and images. Responds in 2 months. Finds artists through submissions, art exhibits, art fairs, referrals by other artists.

TIPS "Submissions must be neat and well-organized throughout."

PHILLIPS GALLERY

444 E. 200 S., Salt Lake City UT 84111. (801)364-8284. **Fax:** (801)364-8293. **Website:** www.phillips-gallery.com. **Contact:** Meri DeCaria, director/curator. Estab. 1965. Commercial gallery. We represent artists working in a variety of media including painting, drawing, sculpture, photography, ceramics, printmaking, jewelry, and mixed media. Our artists, many of whom have been with us since 1965, are primarily from Utah or the surrounding area. Phillips Gallery also represents national and international artists who have an association with Utah. You will discover a full range of subject matter from traditional to contemporary.

Average display time: 4 weeks. Sponsors openings; provides refreshments, advertisement, and half of mailing costs. Overall price range: $100-18,000; most work sold at $600.

EXHIBITS Accepts all types and styles.

MAKING CONTACT & TERMS Charges 50% commission. Accepted work should be matted. Requires exclusive representation locally. *Photographers must have Utah connection.* Must be actively pursuing photography.

SUBMISSIONS Submit portfolio for review digitally; include SASE. Responds in 2 weeks.

PHOTO-EYE GALLERY

541 S. Guadalupe St., Santa Fe NM 87501. (505)988-5152, ext. 202 or (505)988-5159, ext. 121 or (800)227-6941. **Fax:** (505)988-4487. **E-mail:** gallery@photoeye.com. **Website:** www.photoeye.com. **Contact:** Anne Kelly, gallery director. Estab. 1991. Approached by 40+ artists/year. Exhibits 30 established artists/year. Exhibited artists include Nick Brandt, Julie Blackmon, Tom Chambers (all fine-art photographers). Sponsors 6 photography exhibits/year. Average display time: 6 weeks. Open Tuesday–Saturday, 10-5:30. Closed Sunday and Monday. The gallery is located approximately 1 mile from The Plaza; approximately 1,400 sq. ft. Clients include: local community, tourists, upscale, and collectors. 30% of sales are to corporate collectors. Overall price range: $900-50,000. Most work sold at $2,500.

EXHIBITS Photography only. Fine-art photographs using only archival methods. Considers all styles. Most frequently exhibits contemporary photography projects and bodies of work.

MAKING CONTACT & TERMS Retail price of the art set by the artist. Gallery provides insurance, promotion, and contract. Accepted work should be matted. "Prefers fine-art photography with exciting, fresh projects that are cohesive and growing."

SUBMISSIONS "Submit your work via 'The Photographer's Showcase' on our website." Material cannot be returned. Responds in 2 weeks if dropped off at gallery, but prefers online submissions. Finds artists through word of mouth, art fairs, portfolio review, and online through "The Photographer's Showcase."

TIPS "Be consistent, professional and only submit approximately 20 images. Call or e-mail gallery to find out the submission policy."

PHOTOGRAPHIC RESOURCE CENTER

832 Commonwealth Ave., Boston MA 02215. (617)975-0600. **Fax:** (617)975-0606. **E-mail:** info@prcboston.org. **Website:** www.prcboston.org. "The PRC is a nonprofit arts organization founded to facilitate the study and dissemination of information relating to photography." The PRC brings in nationally recognized artists to lecture to large audiences and host workshops on photography. Please check our website for the current exhibition schedule and hours. Offers monthly portfolio reviews for PRC members. "Due to overwhelming numbers, we do not review unsolicited submissions for exhibitions on the web or through the mail. Please do not send materials unless they are specifically requested; please do not expect a response to unrequested submissions."

THE PHOTOMEDIA CENTER

P.O. Box 8518, Erie PA 16505. (617)990-7867. **E-mail:** info@photomediacenter.org. **Website:** www.photomediacenter.org. **Contact:** Eric Grignol, executive director. Estab. 2004. Nonprofit gallery. Sponsors 12 several new photography exhibits/year. "Previously featured exhibits are archived online. We offer many opportunities for artists, including sales, networking, creative collaboration and promotional resources, active social networking forum, and hold an open annual juried show in the summer."

EXHIBITS Interested in alternative process, avant garde, documentary, fine art.

MAKING CONTACT & TERMS Gallery provides promotion. Prefers only artists working in photographic, digital, and new media.

SUBMISSIONS "For portfolio reviews, which happen on a rolling basis, send query letter with artist's statement, bio, résumé, slides, SASE." Responds in 2-6 months. Finds artists through word of mouth, submissions, portfolio reviews, art exhibits, referrals by other artists.

TIPS "We are looking for artists who have excellent technical skills, a strong sense of voice and cohesive body of work. Pay careful attention to our guidelines for submissions on our website. Label everything. Must include a SASE for reply."

POLK MUSEUM OF ART

800 E. Palmetto St., Lakeland FL 33801-5529. (863)688-7743, ext. 241 or 289. **Fax:** (863)688-2611. **E-mail:** kpope@polkmuseumofart.org. **Website:** www.polkmuseumofart.org. **Contact:** Kalisa Pope, curatorial assistant. Estab. 1966. Approached by 75 artists/year; represents or exhibits 3 artists. Sponsors 1-3 photography exhibits/year. Galleries open Tuesday–Saturday, 10-5; Sunday, 1-5; closed Mondays and major holidays. Four different galleries of various sizes and configurations.

EXHIBITS Interested in alternative process, avant garde, documentary, fine art, historical/vintage.

MAKING CONTACT & TERMS Museum provides insurance, promotion, contract. Accepted work should be framed.

SUBMISSIONS Mail portfolio for review. Send query letter with artist's statement, bio, résumé, slides or CD, SASE.

THE PRINT CENTER

1614 Latimer St., Philadelphia PA 19103. (215)735-6090. **Fax:** (215)735-5511. **E-mail:** info@printcenter.org. **Website:** www.printcenter.org. Estab. 1915. Nonprofit gallery and Gallery Store. Represents over 75 artists from around the world in Gallery Store. Sponsors 5 photography exhibits/year. Average display time 2 months. Open all year Tuesday-Saturday, 11-6; closed Christmas Eve to New Year's Day. Three galleries. Overall price range $15-15,000. Most work sold at $200.

EXHIBITS Contemporary prints and photographs of all processes. Accepts original artwork only—no reproductions.

MAKING CONTACT & TERMS Accepts artwork on consignment (50%). Gallery provides insurance, promotion, contract. Artists must be printmakers or photographers.

SUBMISSIONS Must be member to submit work. Member's work is reviewed by curator and gallery store manager. See website for membership application. Finds artists through submissions, art exhibits, and membership.

PUMP HOUSE CENTER FOR THE ARTS

P.O. Box 1613, Chillicothe OH 45601. **E-mail:** pumphouseartgallery@aol.com. **Website:** www.pumphouseartgallery.com. **Contact:** Priscilla V. Smith, director. Estab. 1991. Nonprofit gallery. Approached by 6 artists/year; represents or exhibits more than 50 artists. Average display time 6 weeks. Open Tuesday-Saturday, 11-4; Sunday, 1-4. Overall price range $150-600. Most work sold at $300. Facility is also available for rent (business, meetings, reunions, weddings, receptions, or rehearsals, etc.).

EXHIBITS Photos of landscapes/scenics, wildlife, architecture, gardening, travel, agriculture. Interested in fine art, historical/vintage.

MAKING CONTACT & TERMS Artwork is accepted on consignment, and there is a 30% commission. Gallery provides insurance, promotion. Accepted work should be framed, matted, wired for hanging. Call or stop in to show portfolio of photographs, slides. Send query letter with bio, photographs, slides, SASE. Responds in 1 month. Finds artists through word of mouth, submissions, portfolio reviews, art exhibits, art fairs, referrals by other artists.

TIPS "All artwork must be original designs, framed, ready to hang (wired—no sawtooth hangers)."

QUEENS COLLEGE ART CENTER

Benjamin S. Rosenthal Library, Flushing NY 11367. (718)997-3770. **Fax:** (718)997-3753. **E-mail:** tara.mathison@qc.cuny.edu; artcenter@qc.cuny.edu. **Website:** www.queenscollegeartcenter.org. **Contact:** Tara Tye Mathison, director and curator. Estab. 1955. Queens College Art Center is a successor since 1987 of the Klapper Library Art Center that was based in the Queens College Art Library's gallery founded in 1960. Focuses on modern and contemporary art, presenting the works of both emerging and established artists in diverse media, in programming expressive of the best of the art of our time. Open Monday–Friday, 9-5; closed weekends and holidays. Average display time approximately 6-8 weeks. Overall price range $100-3,000.

EXHIBITS Open to all types, styles, subject matter; decisive factor is quality.

MAKING CONTACT & TERMS Charges 40% commission. Accepted work can be framed or unframed, mounted or unmounted, matted or unmatted. Sponsors openings. Photographer is responsible for providing/arranging refreshments and cleanup.

SUBMISSIONS Online preferred, or send query letter with résumé, samples, and SASE, as appropriate. Responds within 1-2 months.

⚙ MARCIA RAFELMAN FINE ARTS

10 Clarendon Ave., Toronto Ontario M4V 1H9, Canada. (416)920-4468. **Fax:** (416)968-6715. **E-mail:** info@mrfinearts.com. **Website:** www.mrfinearts.com. **Contact:** Marcia Rafelman, president; Meghan Richardson, gallery director. Estab. 1984. Semiprivate gallery. Average display time 1 month. Gallery is centrally located in Toronto; 2,000 sq. ft. on 2 floors. Overall price range $800-25,000. Most work sold at $1,500.

EXHIBITS Photos of environmental, landscapes. Interested in alternative process, documentary, fine art, historical/vintage.

MAKING CONTACT & TERMS Charges 50% commission. Gallery provides insurance, promotion, contract. Requires exclusive representation locally.

SUBMISSIONS Mail (must include SASE) or e-mail portfolio (preferred) for review; include bio, photographs, reviews. Responds only if interested. Finds artists through word of mouth, submissions, art fairs, referrals by other artists.

TIPS "We only accept work that is archival."

RIVER GALLERY

400 E. Second St., Chattanooga TN 37403. (423)265-5033, ext. 5. **E-mail:** art@river-gallery.com; details@river-gallery.com. **Website:** www.river-gallery.com. **Contact:** Mary R. Portera, owner/director. Estab. 1992. Retail gallery. Represents 100 emerging, mid-career and established artists/year. Exhibited artists include Michael Kessler and Scott E. Hill. Sponsors 12 shows/year. Open Monday–Saturday, 10-5; Sunday, 1-5; and by appointment. Located in Bluff View Art District in downtown area; 2,500 sq. ft.; restored early New Orleans-style 1900s home; arched openings into rooms. 20% of space for special exhibitions; 80% of space for gallery artists. Clients include upscale tourists, local community. 95% of sales are to private collectors, 5% corporate collectors. Overall price range $5-10,000; most work sold at $200-2,000.

EXHIBITS Considers all media. Most frequently exhibits oil, original prints, photography, watercolor, mixed media, fiber, clay, jewelry, wood, glass, and sculpture.

MAKING CONTACT & TERMS Accepts work on consignment (50% commission). Retail price set by the gallery. Gallery provides free gift wrap, insurance, promotion, and contract; shipping costs are shared. Prefers artwork framed.

SUBMISSIONS Send query letter with résumé, slides, bio, photographs, SASE, reviews, and artist's statement. Call or e-mail for appointment to show portfolio of photographs and slides. Files all material unless we are not interested then we return all information. Can also submit via form on website. Finds artists through word of mouth, referrals by other art-

ists, visiting art fairs and exhibitions, submissions, ads in art publications.

ROCHESTER CONTEMPORARY ART CENTER

RoCo, 137 East Ave., Rochester NY 14604. (585)461-2222. **Fax:** (585)461-2223. **E-mail:** info@rochestercontemporary.org; bleu@ rochestercontemporary.org. **Website:** www. rochestercontemporary.org. **Contact:** Bleu Cease, executive director. Estab. 1977. Located in Rochester's downtown "East End" cultural district. The 4,500-sq.-ft. space is handicap-accessible. Sponsors 10-12 exhibits/year. Average display time 4-6 weeks. Gallery open Wednesday–Sunday, 1-5; Friday, 1-10.

MAKING CONTACT & TERMS Charges 25% commission.

SUBMISSIONS Send up to 20 images via CD/DVD. Discs "must be labeled with your name and contact information. The checklist must have your name, address, phone number, e-mail address, and website (if available) at the top, followed by the title of the work, date, materials, and presentation size for each image submitted. Do not send prints or original works." Also include letter of intent, résumé, and statement.

ROCKPORT CENTER FOR THE ARTS

902 Navigation Circle, Rockport TX 78382. (361)729-5519. **Fax:** (361)729-3551. **E-mail:** info@rockportartcenter.com. **Website:** www. rockportartcenter.com. Estab. 1969. "Rockport Center for the Arts is a hub of creative activity on the Texas Gulf Coast. Two parlor galleries are dedicated entirely to the works of its member artists, while the main gallery allows the center to host local, regional, national, and internationally acclaimed artists in both solo and group exhibitions. In 2000, the Garden Gallery was added, allowing the center for the first time to simultaneously feature 3 distinct exhibitions, at times displaying over 100 original works of art. Today, the building also houses 2 visual arts classrooms, and an outdoor sculpture garden featuring works by internationally acclaimed artists. A well-furnished pottery studio is always active, and includes a kiln room which hosts daily firings. Visitors enjoy the exhibitions, education programs, and gift shop, as well as the Annual Rockport Art Festival every July 4th weekend." Gallery hours vary. Call, e-mail, or visit website for more information.

THE ROTUNDA GALLERY

647 Fulton St., Brooklyn NY 11217. (718)683-5600. **E-mail:** bric@bricartsmedia.org. **Website:** www. bricartsmedia.org/. Estab. 1981. Nonprofit gallery. Average display time 6 weeks. Open Tuesday–Saturday, 12-6.

EXHIBITS Interested in contemporary works.

MAKING CONTACT & TERMS Gallery provides photographer's contact information to prospective buyers. Shows are limited by walls that are 22 feet high.

SUBMISSIONS Send material by mail for consideration; include SASE. "View our website for guidelines and artist registry form."

SAN DIEGO ART INSTITUTE

1439 El Prado, San Diego CA 92101. (619)236-0011. **Fax:** (619) 236-1974. **E-mail:** cgold@sandiego-art.org. **Website:** www.sandiego-art.org. **Contact:** Celia Gold. Estab. 1941. San Diego Art Institute was founded in 1941 and has since remained the premier organization showcasing artists from the Southern California/Baja Norte region, with a focus on San Diego County. We feature rotating exhibitions of contemporary artwork in our 8,000 foot gallery space, initiate frequent youth art education programs, and partner with like organizations to host professional development workshops. San Diego Art Institute as the only contemporary art space in Balboa Park. Open Tuesday–Saturday, 10-5; Sunday, 12-5.

EXHIBITS Contemporary, multimedia art from Southern California and Baja Norte.

MAKING CONTACT & TERMS Artwork is accepted on consignment with a 40% commission. JPEG online submission.

SUBMISSIONS Membership not required for submission. Average submission fee is $15.

⊘ THE JOSEPH SAXTON GALLERY OF PHOTOGRAPHY

520 Cleveland Ave. NW, Canton OH 44702. (330)438-0030. **Fax:** (330)456-9566. **E-mail:** maria@josephsaxton.com; gallery@josephsaxton. com. **Website:** www.josephsaxton.com. **Contact:** Maria Hadjian, manager. Estab. 2009. A premier photography gallery with nearly 7,000 sq. ft. of display space. "We house over 200 pieces by more than 160 master photographers and represented artists. Predominantly, we serve upscale clients, but welcome the general public. Prices range from

$69-20,000, with the average piece selling for $1,500. Approached by numerous artists each year, new shows vary in number and length." Exhibited artists include: Steve McCurry, Art Wolfe, Lewis Wickes Hine, Eddie Adams, Annie Leibovitz, Sally Mann, Edward Weston, Berenice Abbott, Lisa Law, and more. In addition to books, our Book Nook offers magazines, DVDs, apparel, novelty cameras, and accessories. Open Wednesday–Saturday, 12-5 pm. Tim Belden, owner. The gallery considers and exhibits various styles and genres of photography.

EXHIBITS "Our subject matter is inclusive by exhibiting photographs of celebrities, families, architecture, cities/urban life, agriculture, industry, military, political figures, product shots/still life, disasters, landscapes, wildlife, automobiles, entertainment, events, performing arts, sports, travel, fashion/glamour, fine art and those of historical content/vintage."

MAKING CONTACT & TERMS Artwork is accepted on consignment with a commission fee. The retail price of the art is set by the artist. The Gallery provides insurance and promotion *along* with a contract. We require exclusive representation locally. Model and property releases are preferred.

SUBMISSIONS "Accepted work should be matted and framed. Please e-mail inquiry letter along with link to artists website. We will respond to all, but may request a nonreturnable disc (or will return materials with a SASE). We locate artists through word of mouth, portfolio reviews, referrals, and by other means."

SCHLUMBERGER GALLERY

Website: www.schlumbergergallery.com. P.O. Box 2864, Santa Rosa CA 95405. (707)544-8356. **Fax:** (707)538-1953. **E-mail:** sande@schlumberger.org. **Contact:** Sande Schlumberger, owner. Estab. 1986. Art publisher/distributor and gallery. Publishes and distributes limited editions, posters, original paintings, and sculpture. Specializes in decorative and museum-quality art and photographs.

EXHIBITS Interested in fine art.

MAKING CONTACT & TERMS Send query letter with tearsheets and photographs. Samples are not filed and are returned by SASE if requested by artist. Publisher/distributor will contact artist for portfolio review if interested. Portfolio should include color photographs and transparencies. Negotiates payment. Offers advance when appropriate. Rights purchased

vary according to project. Provides advertising, in-transit insurance, insurance while work is at firm, promotion, shipping to and from firm, written contract and shows. Finds artists through exhibits, referrals, submissions, and "pure blind luck."

TIPS "Strive for quality, clarity, clean lines, and light. Bring spirit into your images. It translates!"

WILLIAM & FLORENCE SCHMIDT ART CENTER

Southwestern Illinois College, 2500 Carlyle Ave., Belleville IL 62221. (618)222-5278. **Website:** www.swic.edu/TheSchmidt. **Contact:** Jessica Mannisi. Estab. 2002. Nonprofit gallery. Features approximately 1-2 photography exhibitions/year.

EXHIBITS Interested in fine art and historical/vintage photography.

SUBMISSIONS Mail portfolio for review. Send query letter with artist's statement, bio and 12-20 digital images on a CD with image list. Finds artists through art fairs and exhibits, portfolio reviews, referrals by other artists, submissions, and word of mouth. May e-mail portfolio submission to Jessica.Mannisi@swic.edu.

SCHMIDT/DEAN

1719 Chestnut St., Philadelphia PA 19103. (215)569-9433. **Fax:** (215)569-9434. **E-mail:** schmidtdean@netzero.com. **Website:** www.schmidtdean.com. **Contact:** Christopher Schmidt, director. Estab. 1988. For-profit gallery. Houses eclectic art. Sponsors 4 photography exhibits/year. Average display time 6 weeks. Gallery open Tuesday–Saturday, 10:30-6. August hours are Tuesday–Friday, 10:30-6. Overall price range $1,000-70,000.

EXHIBITS Interested in alternative process, documentary, fine art.

MAKING CONTACT & TERMS Charges 50% commission. Gallery provides insurance, promotion. Accepted work should be framed, mounted, matted. Requires exclusive representation locally.

SUBMISSIONS Call/write to arrange a personal interview to show portfolio. Send query letter with SASE. "Send digital images on CD and a résumé that gives a sense of your working history. Include a SASE."

SIOUX CITY ART CENTER

225 Nebraska St., Sioux City IA 51101-1712. (712)279-6272. **Fax:** (712)255-2921. **E-mail:** siouxcityartcenter@sioux-city.org; aharris@sioux-city.org; tbehrens@

sioux-city.org. **Website:** www.siouxcityartcenter. org. **Contact:** Todd Behrens, curator. Estab. 1938. Museum. Exhibits emerging, mid-career, and established artists. Approached by 50 artists/year; represents or exhibits 2-3 artists. Sponsors 15 total exhibits/year. Average display time: 10-12 weeks. Gallery open Tuesday, Wednesday, Friday, Saturday, 10-4; Thursday, 10-9; Sunday, 1-4. Closed on Mondays and municipal holidays. Located in downtown Sioux City; 2 galleries, each 40×80 ft. Clients include local community, students, and tourists.

EXHIBITS Considers all media and types of prints. Most frequently exhibits paintings, sculpture, and mixed media.

MAKING CONTACT & TERMS Artwork is accepted on consignment with a 30% commission. "However, the purpose of our exhibitions is not sales." Retail price of the art set by the artist. Gallery provides insurance, promotion, and contract.

SUBMISSIONS Artwork should be framed. Only accepts artwork from upper-Midwestern states. E-mail query letter with link to artist's website; 15-20 JPEG samples at 72 dpi. Or send query letter with artist's statement, résumé, and digital images. Returns materials if SASE is enclosed. Do not send original works. Responds, only if interested, within 6 months. Files résumé, statement, and images if artist is suitable. Finds artists through word of mouth, art exhibits, submissions, art fairs, portfolio reviews, and referrals by other artists.

TIPS "Submit good photography with an honest and clear statement."

SOHN FINE ART—GALLERY & GICLÉE PRINTING

69 Church St., Lenox MA 01240. (413)551-7353. **E-mail:** info@sohnfineart.com. **Website:** www. sohnfineart.com. **Contact:** Cassandra Sohn, owner. Estab. 2011. Alternative space and for-profit gallery. Approached by 25-50 artists/year; represents or exhibits 12-20 emerging, mid-career, and established artists. Exhibited artists include Greg Gorman, Matchuska, Fran Forman, John Atchley, Seth Resnick, Savannah Spirit, Bruce Checefsky, Cassandra Sohn, etc. Average display time: 1-3 months. Open Thursday-Monday, 11-5. Located in the Berkshires of Western Massachusetts. The area is known for arts and culture and full of tourists. 80% of the population are 2nd-home owners from New York and Boston. Clients include

local community, tourists, and upscale. Overall price range: $300-6,000; most work sold for $300-2,500.

EXHIBITS Considers photography and sculpture. Considers all styles and genres.

MAKING CONTACT & TERMS Artwork is accepted on consignment and there is a 50% commission. Retail price of the art set by the artist. Gallery provides insurance, promotion, and contract. Accepted work should be framed, mounted, and matted. Requires exclusive representation locally.

SUBMISSIONS E-mail query letter with link to artist's website and JPEG samples at 72 dpi. Material cannot be returned. Responds only if interested. Finds artists through word of mouth, art exhibits, submissions, art fairs, portfolio reviews, and referrals by other artists.

SOHO MYRIAD

1250 Menlo Dr., Atlanta GA 30318. (404)351-5656. **Fax:** (404)351-8284. **E-mail:** info@sohomyriad.com. **Website:** www.sohomyriad.com. Estab. 1977. Art consulting firm and for-profit gallery. Represents and/or exhibits over 2,000 artists. Sponsors 1 photography exhibit/year. Average display time: 2 months. Overall price range $500-20,000. Most work sold at $500-5,000.

Additional offices in Los Angeles and London. See website for contact information.

EXHIBITS Photos of landscapes/scenics, architecture, floral/botanical and abstracts. Interested in alternative process, avant garde, fine art, historical/vintage.

MAKING CONTACT & TERMS Artwork is accepted on consignment, and there is a 50% commission. Gallery provides insurance.

SOUTH DAKOTA ART MUSEUM

South Dakota State University, Medary Ave. and Harvey Dunn St., P.O. Box 2250, Brookings SD 57007. (605)688-5423. **Fax:** (605)688-4445. **E-mail:** pam.adler@sdsate.edu. **Website:** www. southdakotaartmuseum.com. **Contact:** Pam Adler, museum store manager. Museum. Sponsors 1-2 photography exhibits/year. Average display time: 4 months. Gallery open Monday-Friday, 10-5; Saturday, 10-4; Sunday, 12-4; closed state holidays and Sundays, January–March. Seven galleries offer 26,000 sq. ft. of exhibition space.

EXHIBITS Interested in alternative process, documentary, fine art.

MAKING CONTACT & TERMS Please visit website for additional details.

SOUTHSIDE GALLERY

150 Courthouse Square, Oxford MS 38655. (662)234-9090. **E-mail:** southside@southsideartgallery.com. **Website:** www.southsideartgallery.com. **Contact:** Duncan Bass, director. Estab. 1993. For-profit gallery. Average display time 4 weeks. Gallery open Tuesday–Saturday, 10-6. Overall price range $300-20,000. Most work sold at $425.

EXHIBITS Photos of landscapes/scenics, architecture, cities/urban, rural, entertainment, events, performing arts, sports, travel, agriculture, political. Interested in avant garde, fine art.

MAKING CONTACT & TERMS Artwork is accepted on consignment, and there is a 55% commission. Gallery provides promotion. Accepted work should be framed.

SUBMISSIONS Mail between 10 and 25 slides that reflect current work with SASE for review. CDs are also accepted with images in JPEG or TIFF format. Include artist statement, biography, and résumé. Responds within 4-6 months. Finds artists through submissions.

SRO PHOTO GALLERY AT LANDMARK ARTS

School of Art, Texas Tech University, Box 42081, Lubbock TX 79409-2081. (806)742-1947. **Fax:** (806)742-1971. **E-mail:** srophotogallery.art@ttu.edu. **Website:** www.landmarkarts.org. **Contact:** Joe R. Arredondo, director. Estab. 1984. Nonprofit gallery. Hosts an annual competition to fill 8 solo photography exhibition slots each year. Average display time 4 weeks. Open Monday–Friday, 8-5; Saturday, 10-5; Sunday, 12-4. Closed university holidays.

EXHIBITS Interested in art utilizing photographic processes.

MAKING CONTACT & TERMS "Exhibits are for scholarly purposes. Gallery will provide artist's contact information to potential buyers." Gallery provides insurance, promotion, contract. Accepted work should be matted.

SUBMISSIONS Exhibitions are determined by juried process. See website for details (under call for entries). Deadline for submissions is end of March.

THE STATE MUSEUM OF PENNSYLVANIA

300 North St., Harrisburg PA 17120. (717)787-4980. **E-mail:** ra-phstatemuseum@pa.gov. **Website:** www.statemuseumpa.org. Offers visitors 4 floors representing Pennsylvania's story, from Earth's beginning to the present. Features archaeological artifacts, minerals, paintings, animal dioramas, industrial and technological innovations, and military objects representing the Commonwealth's heritage. Number of exhibits varies. Average display time: 3 months. Open Wednesday–Saturday, 9-5; Sunday 12-5.

MAKING CONTACT & TERMS Artwork is sold in gallery as part of annual Art of the State exhibition only. Overall price range: $50-3,000. Connects artists with interested buyers. Art must be created by a native or resident of Pennsylvania to be considered for Art of the State, and/or contain subject matter relevant to Pennsylvania to be considered for permanent collection. Send material by mail for consideration; include SASE. Responds in 1 month.

STATE OF THE ART GALLERY

120 W. State St., Ithaca NY 14850. (607)277-1626. **E-mail:** gallery@soag.org. **Website:** www.soag.org. Estab. 1989. Cooperative gallery. Sponsors 2 juried exhibits/year. Average display time 1 month. Gallery open Wednesday–Friday, 12-6; weekends, 12-5. Located in downtown Ithaca, 2 rooms about 1,100 sq. ft. Overall price range $100-6,000. Most work sold at $200-500.

EXHIBITS Photos in all media and subjects. Interested in alternative process, avant garde, fine art, computer-assisted photographic processes.

MAKING CONTACT & TERMS There is a co-op membership fee plus a donation of time. There is a 10% commission for members, 30% for nonmembers. Gallery provides promotion, contract. Accepted work must be ready to hang. Write for membership application. See website for further details.

STATE STREET GALLERY

1804 State St., La Crosse WI 54601. (608)782-0101. **Contact:** Ellen Kallies, president. Estab. 2000. Wholesale, retail, and trade gallery. Approached by 15 artists/year; exhibits 12-14 artists/quarter in gallery. Average display time: 4-6 months. Open Tuesday, Thursday, and Friday, 10-4, Saturday, 10-2; other times by chance or appointment. Located across from the University of Wisconsin/La Crosse. Overall price range: $50-12,000; most work sold at $500-1,200 and above.

EXHIBITS Photos of environmental, landscapes/scenics, architecture, cities/urban, gardening, rural, travel, medicine.

MAKING CONTACT & TERMS Artwork is accepted on consignment, and there is a 40% commission. Gallery provides insurance, promotion, contract. Accepted work should be framed, matted.

SUBMISSIONS Call or mail portfolio for review. Send query letter with artist's statement, photographs, slides, SASE. Responds in 1 month. Finds artists through word of mouth, art exhibits, art fairs, referrals by other artists.

TIPS "Be organized, professional in presentation, flexible."

PHILIP J. STEELE GALLERY

Rocky Mt. College of Art + Design, 1600 Pierce St., Denver CO 80214. (303)753-6046. **Fax:** (303)759-4970. **Website:** www.rmcad.edu/exhibitions/gallery/philip-j-steele. **Contact:** Lisa Spivak, director. Estab. 1962. Located in the Mary Harris Auditorium building on the southeast corner of the quad. Approached by 25 artists/year; represents or exhibits 6-9 artists. Sponsors 1 photography exhibit/year. Average display time 1 month. Open Monday-Friday, 11-4. Photographers should call or visit website for more information.

EXHIBITS No restrictions on subject matter.

MAKING CONTACT & TERMS No fee or percentage taken. Gallery provides insurance, promotion. Accepted work should be framed.

SUBMISSIONS Send query letter with artist's statement, bio, slides, résumé, reviews, SASE. Reviews in May, deadline April 15. Finds artists through word of mouth, submissions, referrals by other artists.

STEVENSON UNIVERSITY ART GALLERY

1525 Greenspring Valley Rd., Stevenson MD 21153. (443)352-4491. **Fax:** (410)352-4500. **E-mail:** exhibitions@stevenson.edu. **Website:** www.stevenson.edu/stuarteffects. **Contact:** Matt Laumann, cultural programs manager. Estab. 1997. Sponsors 10 exhibits/year across 3 museum quality gallery spaces, University Art Gallery, St. Paul Companies Pavilion, and the new School of Design Gallery. Average display time: 6 weeks. Gallery open Monday-Wednesday, Friday, 11-5; Thursday, 11-8; Saturday, 1-4. "Since its 1997 inaugural season, the Stevenson University Art Gallery has presented a dynamic series of substantive exhibitions in diverse media and has achieved the reputation as a significant venue for regional artists and collectors. The museum quality space was designed to support the Baltimore arts community, provide greater opportunities for artists, and be integral to the educational experience of Stevenson students."

EXHIBITS Interested in alternative process, avant garde, documentary, fine art, historical/vintage. "We are looking for artwork of substance by artists from the mid-Atlantic region."

MAKING CONTACT & TERMS "We facilitate inquiries directly to the artist." Gallery provides insurance. *Accepts artists from mid-Atlantic states only; emphasis on Baltimore artists.*

SUBMISSIONS Write to show portfolio. Send artist's statement, bio, résumé, reviews, portfolio link or CD. Responds in 3 months. Finds artists through word of mouth, submissions, portfolio reviews, referrals by other artists.

TIPS "Be clear, concise. Have good representation of your images."

STILL POINT ART GALLERY

Shanti Arts LLC, 193 Hillside Rd., Brunswick ME 04011. (207)837-5760. **Fax:** (207)725-4909. **E-mail:** info@stillpointartgallery.com. **Website:** www.stillpointartgallery.com. **Contact:** Christine Cote, owner/director. Estab. 2009. For-profit online gallery. Exhibits emerging, mid-career, and established artists. Approached by 300 artists/year. Represents 25 artists. Sponsors 4 juried shows/year. Distinguished artists earn representation and publication in gallery's art journal, *Still Point Arts Quarterly*. Model and property release preferred. Average display time: 14 months.

EXHIBITS Considers all media and styles. Most frequently exhibits painting and photography. Considers engravings, etchings, serigraphs, linocuts, woodcuts, lithographs, and mezzotints. Considers all genres.

MAKING CONTACT & TERMS Retail price set by the artist. Gallery takes no commission from sales. Gallery provides promotion. Respond to calls for artists posted on website.

TIPS "Follow the instructions posted on our website."

SYNCHRONICITY FINE ARTS

106 W. 13th St., New York NY 10011. (646)230-8199. **E-mail:** jsa@synchronicityspace.com;

contact@synchronicityspace.com. **Website:** www. synchronicityspace.com. **Contact:** John Amato, director. Estab. 1989. Nonprofit gallery. Approached by hundreds of artists/year; represents or exhibits over 60 artists. Sponsors 2-3 photography exhibits/year. Gallery open Wednesday-Saturday, 1-7. Closed 2 weeks in August. Overall price range $1,500-20,000. Most work sold at $3,000.

EXHIBITS Photos of multicultural, environmental, landscapes/scenics, architecture, cities/urban, education, rural, events, agriculture, industry, medicine, political. Interested in avant garde, documentary, fine art, historical/vintage.

MAKING CONTACT & TERMS Gallery provides insurance, promotion, contract. Accepted work should be framed, mounted, matted.

SUBMISSIONS Submissions may be made via electronic or e-mail as JPEG small files as well as the other means. Write to arrange a personal interview to show portfolio of photographs, transparencies, slides. Send query letter with photocopies, SASE, photographs, slides, résumé. Responds in 3 weeks. Finds artists through art exhibits, submissions, portfolio reviews, referrals by other artists.

LILLIAN & COLEMAN TAUBE MUSEUM OF ART

2 N. Main St., Minot ND 58703. (701)838-4445. E-mail: taube@srt.com; taube2@srt.com. **Website:** www.taubemuseum.org. **Contact:** Nancy Walter, executive director; Doug Pfliger, gallery manager. Estab. 1970. Established nonprofit organization. Sponsors 1-2 photography exhibits/year. Average display time: 4-6 weeks. Located in a renovated historic landmark building with room to show 2 exhibits simultaneously. Overall price range: $15-225. Most work sold at $40-100.

EXHIBITS Photos of babies/children/teens, couples, multicultural, families, parents, senior citizens, disasters, landscapes/scenics, wildlife, beauty, rural, travel, agriculture, buildings, military, portraits. Interested in avant garde, fine art.

MAKING CONTACT & TERMS Charges 30% commission for members; 40% for nonmembers. Sponsors openings.

SUBMISSIONS Submit portfolio along with a minimum of 6 examples of work in digital format for review. Responds in 3 months.

TIPS "Wildlife, landscapes and floral pieces seem to be the trend in North Dakota. We get many portfolios to review for our photography exhibits each year. We also appreciate figurative, unusual, and creative photography work."

THE DELAWARE CONTEMPORARY

200 S. Madison St., Wilmington DE 19801, USA. (302)656-6466. **E-mail:** kscarlett@thedcca.org. **Website:** www.thedcca.org. **Contact:** Katy Scarlett, curatorial assistant. Estab. 1980. Alternative space, museum retail store, nonprofit gallery. Approached by more than 800 artists/year; exhibits 50 artists. Sponsors 30 total exhibits/year. Average display time: 6 weeks. Gallery open Tuesday, Thursday, Friday, and Saturday, 10-5; Wednesday and Sunday, 12-5. Closed on Monday and major holidays. 7 galleries located along Wilmington riverfront.

EXHIBITS Interested in alternative process, avant garde.

MAKING CONTACT & TERMS Gallery provides PR and contract. Accepted work should be framed, mounted, matted. Prefers only contemporary art.

SUBMISSIONS Send query letter with artist's statement, bio, SASE, 10 digital images. Returns material with SASE. Does not accept original artwork or slides for consideration. Responds within 6 months. Finds artists through calls for entry, word of mouth, submissions, portfolio reviews, art exhibits, referrals by other artists.

THROCKMORTON FINE ART

145 E. 57th St., 3rd Floor, New York NY 10022. (212)223-1059. **Fax:** (212)223-1937. **E-mail:** info@throckmorton-nyc.com. **Website:** www. throckmorton-nyc.com. **Contact:** Spencer Throckmorton, owner; Norberto Rivera, photography. Estab. 1993. For-profit gallery. A New York-based gallery specializing in vintage and contemporary photography of the Americas for over 25 years. Its primary focus is Latin American photographers. The gallery also specializes in Chinese jades and antiquities, as well as pre-Columbian art. Located in the Hammacher Schlemmer Building; 4,000 sq. ft.; 1,000 sq. ft. exhibition space. Clients include local community and upscale. Approached by 50 artists/year; represents or exhibits 20 artists. Sponsors 5 photography exhibits/year. Average display time: 2 months. Open Tuesday–Saturday, 11-5. Overall price range: $1,000-10,000; most work sold at $2,500.

EXHIBITS Photos of babies/children/teens, landscapes/scenics, architecture, cities/urban, rural. Interested in erotic, fine art, historical/vintage, Latin American photography.

MAKING CONTACT & TERMS Charges 50% commission. Gallery provides insurance, promotion.

SUBMISSIONS Write to arrange a personal interview to show portfolio of photographs/slides/CD, or send query letter with artist's statement, bio, photocopies, slides, CD, SASE. Responds in 3 weeks. Finds artists through word of mouth, portfolio reviews.

TIPS "Present your work nice and clean."

TILT GALLERY

7077 E. Main St., Suite 14, Scottsdale AZ 85251. (602)716-5667. **E-mail:** info@tiltgallery.com. **E-mail:** melanie@tiltgallery.com. **Website:** www.tiltgallery. com. **Contact:** Melanie Craven, gallery owner. Estab. 2005. For-profit gallery. "A contemporary fine art gallery specializing in hand applied photographic processes and mixed media projects." Represents or exhibits 30 emerging and established artists. Exhibited artists include France Scully Osterman and Mark Osterman, Aline Smithson, Jill Enfield, Anna Strickland. Sponsors 8 exhibits/year; 7 photography exhibits/year. Average display time: 1 month. Open Tuesday-Saturday, 10:30-5:30; Thursday (night art walk), 7-9; and by appointment. Please inquire about our designer packages and Young Collectors Program.

TOUCHSTONE GALLERY

901 New York Ave. NW, Washington DC 20001-2217. (202)347-2787. **E-mail:** info@touchstonegallery.com. **Website:** www.touchstonegallery.com. Estab. 1976. Contemporary fine art gallery featuring 50 artists working in a variety of original art in all media—oil, acrylic, sculpture, photography, printing, engraving, etc.—exhibiting a new show monthly. This brand-new 1,000+ sq.-ft. space features tall ceilings, great lighting, and polished flooring. The gallery is available for rent for brunch meetings, rehearsal dinners, cocktail parties, and life celebrations of all kinds. Located near the heart of the bustling Penn Quarter district in downtown Washington DC one block from the Washington Convention Center, the gallery is easily accessible at street level. Open Wednesday-Friday, 11-6; Saturday-Sunday, 12-5. Overall price range: $100-20,000. Visit the website or contact the gallery directly for further information.

UAB VISUAL ARTS GALLERY

Abroms-Engel Institute for the Visual Arts, 1221 Tenth Ave. S, Birmingham AL 35205. (205)975-6436. **Fax:** (205)975-2836. **E-mail:** aeiva@uab.edu. **Website:** www.uab.edu/cas/aeiva. Nonprofit university gallery. Sponsors 1-3 photography exhibits/year. Average display time: 3-4 weeks. Gallery open Monday–Friday, 10-6; Saturday, 12-6; closed major holidays and last 2 weeks of December.

EXHIBITS Photos of multicultural. Interested in alternative process, avant garde, fine art, historical/vintage.

MAKING CONTACT & TERMS Gallery provides insurance, promotion. Accepted work should be framed.

SUBMISSIONS Does not accept unsolicited exhibition proposals. Write to arrange a personal interview to show portfolio of slides. Send query letter with artist's statement, bio, brochure, photographs, résumé, reviews, slides, SASE.

UCR/CALIFORNIA MUSEUM OF PHOTOGRAPHY

University of California, 3824 Main St., Riverside CA 92501. **E-mail:** cmpcollections@ucr.edu; cmppress@ucr.edu; tyler.stallings@ucr.edu. **Website:** www.cmp.ucr.edu. **Contact:** Tyler Stallings, interim director. Sponsors 10-15 exhibits/year. Average display time 8-14 weeks. Open Tuesday–Saturday, 12-5. Located in a renovated 23,000-sq.-ft. building. "It is the largest exhibition space devoted to photography in the West."

EXHIBITS Interested in technology/computers, alternative process, avant garde, documentary, fine art, historical/vintage.

MAKING CONTACT & TERMS Curatorial committee reviews CDs, slides, and/or matted or unmatted work. Photographer must have highest-quality work.

SUBMISSIONS Exhibition proposals should include a project description, cover letter, résumé, and selection of images. Artists can send either a link to a website or e-mail up to 10MB of digital files for consideration by the curatorial committee. These proposals will be reviewed as they are received. The museum's curators will actively solicit submissions for individuals whose work they would like to consider for future projects.

TIPS "This museum attempts to balance exhibitions among historical, technological, contemporary, etc.

We do not sell photos but provide photographers with exposure. The museum is always interested in newer, lesser-known photographers who are producing interesting work. We're especially interested in work relevant to underserved communities. We can show only a small percent of what we see in a year."

UNI GALLERY OF ART

University of Northern Iowa, 104 Kamerick Art Bldg., Cedar Falls IA 50614-0362. (319)273-6134. **Fax:** (319)273-7333. **E-mail:** galleryofart@uni.edu. **Website:** www.uni.edu/artdept/gallery/Home.html. **Contact:** Darrell Taylor, director. Estab. 1978. Sponsors 9 exhibits/year. Average display time 1 month. Approximately 4,000 sq. ft. of space and 350 ft. of usable wall space. Interested in all styles of high-quality contemporary artwork.

MAKING CONTACT & TERMS "We do not sell work."

SUBMISSIONS Please provide a cover letter and proposal as well as an artist's statement, CV, and samples. Send material by mail for consideration or submit portfolio for review; include SASE for return of material. Response time varies.

UNION STREET GALLERY

1527 Otto Blvd., Chicago Heights IL 60411. (708)754-2601. **E-mail:** unionstreetart@gmail.com. **Website:** www.unionstreetgallery.org. **Contact:** Jessica Segal, gallery director. Estab. 1995. Nonprofit gallery. Represents or exhibits more than 100 artists. "We offer group invitations and juried exhibits every year." Average display time 5 weeks. Hours: Wednesday and Thursday, 12-5; Friday, 12-6; Saturday, 11-4. Overall price range $30-3,000. Most work sold at $300-500.

SUBMISSIONS Finds artists through submissions, referrals by other artists and juried exhibits at the gallery. "To receive prospectus for all juried events, call, write or e-mail to be added to our mailing list. Prospectus also available on website. Artists interested in studio space or solo/group exhibitions should contact the gallery to request information packets."

UNIVERSITY OF KENTUCKY ART MUSEUM

405 Rose St., Lexington KY 40506. (859)257-5716. **Fax:** (859)323-1994. **E-mail:** janie.welker@uky.edu. **Website:** finearts.uky.edu/art-museum. **Contact:** Janie Welker, curator. Estab. 1979. Museum. In addition to the university community, the Art Museum serves the greater Lexington area and Central and Eastern Kentucky through art exhibitions, educational outreach, and other special events including lectures, symposia, and family festivals.

EXHIBITS The Museum has a strong photography collection, that is rotated in permanent collection installations and an annual photography lecture series with related exhibits.

SUBMISSIONS Prefers e-mail query with digital images.

UNIVERSITY OF RICHMOND MUSEUMS

28 Westhampton Way, Richmond VA 23173. (804)289-8276. **Fax:** (804)287-1894. **E-mail:** rwaller@richmond.edu; museums@richmond.edu. **Website:** museums.richmond.edu. **Contact:** Richard Waller, director. Estab. 1968. University Museums comprises Joel and Lila Harnett Museum of Art, Joel and Lila Harnett Print Study Center, and Lora Robins Gallery of Design from Nature. The museums are home to diverse collections and exhibitions of art, artifacts, and natural history specimens. Sponsors 14-18 exhibits/year. Average display time: 8-10 weeks. See website for hours for each gallery.

EXHIBITS Interested in all subjects.

MAKING CONTACT & TERMS Charges 10% commission. Work must be framed for exhibition.

SUBMISSIONS Send query letter with résumé, samples. Send material by e-mail for consideration. Responds in 1 month.

TIPS "We are a nonprofit university museum interested in presenting contemporary art as well as historical exhibitions."

UPSTREAM GALLERY

8 Main St., Hastings-on-Hudson NY 10706. (914)674-8548. **E-mail:** upstreamgallery26@gmail.com. **Website:** www.upstreamgallery.com. Estab. 1990. "Upstream Gallery is a cooperative with up to 25 members practicing various disciplines including sculpture, painting, printmaking, photography, digital imagery, and more." Requires membership to exhibit. Annual dues reflect an equal sharing of the yearly expenses of maintaining the gallery. See website for more details.

EXHIBITS Only fine art. Accepts all subject matters and genres for jurying.

MAKING CONTACT & TERMS There is a co-op membership fee plus a donation of time. There is a 20% commission. Accepted work should be framed, mounted, and matted. Check website for full informa-

tion about gallery membership.

SUBMISSIONS Yearly photography exhibit every February. Check website for details.

UPSTREAM PEOPLE GALLERY

5607 Howard St., Omaha NE 68106-1257. (402)991-4741. **E-mail:** shows@upstreampeoplegallery.com. **Website:** www.upstreampeoplegallery.com. **Contact:** Laurence Bradshaw, curator. Estab. 1998. Exclusive online virtual gallery with over 40 international exhibitions in the archives section of the website. Represents mid-career and established artists. Approached by approximately 250-500 artists/year; exhibits 20,000 artists. Sponsors appx. 12 total exhibits/year and 7 photography exhibits/year. Average display time: 12 months to 4 years. Overall price range: $100-60,000; most work sold at $300.

EXHIBITS Considers all media except video and film. Most frequently exhibits oil, acrylic, and ceramics. Considers all prints, styles, and genres. Most frequently exhibits Neo-Expressionism, Realism, and Surrealism.

MAKING CONTACT & TERMS Artwork is accepted on consignment; there is no commission if the artists sells, but a 20% commission if the gallery sells. Retail price set by the artist. Gallery provides promotion and contract.

SUBMISSIONS Accepted work should be photographed. Call or write to arrange personal interview to show portfolio, e-mail query letter with link to website and JPEG samples at 72 dpi, or send query letter with artist's statement and CD/DVD. Returns material with SASE. Responds to queries within 1 week. Files résumés. Finds artists through art exhibits, referrals, online, and magazine advertising.

TIPS "Make sure all photographs of works are in focus."

VIRIDIAN ARTISTS, INC.

548 W. 28th St., Suite 632, New York NY 10001. (212)414-4040. **Website:** www.viridianartists.com. **Contact:** Vernita Nemec, director. Estab. 1968. Artist-owned gallery. Approached by 200 artists/year. Exhibits 25-30 emerging, mid-career, and established artists/year. Sponsors 15 total exhibits/year; 2-4 photography exhibits/year. Average display time: 3 weeks. Open Tuesday–Saturday, 12-6; closed in August. "Classic gallery space with 3 columns, hardwood floor, white walls, and track lights, approximately 1,100 sq. ft. The gallery is located in Chelsea, the prime area of contemporary art galleries in New York City." Clients include: local community, students, tourists, upscale, and artists. 15% of sales are to corporate collectors. Overall price range: $100-8,000; most work sold at $1,500.

EXHIBITS Considers all media except craft, traditional glass, and ceramic, unless it is sculpture. Most frequently exhibits paintings, photography, and sculpture. Considers engravings, etchings, linocuts, lithographs, mezzotints, serigraphs, woodcuts, and monoprints/limited edition digital prints. Considers all styles (mostly contemporary). Most frequently exhibits painterly abstraction, imagism, and neo-expressionism. "We are not interested in particular styles, but in professionally conceived and professionally executed contemporary art. Eclecticism is our policy. The only unifying factor is quality. Work must be of the highest technical and aesthetic standards."

MAKING CONTACT & TERMS Artwork accepted on consignment with a 30% commission. There is a co-op membership fee plus a donation of time with a 30% commission. Retail price of the art is set by the gallery and artist. Gallery provides promotion and contract. "Viridian is an artist-owned gallery with a director and gallery assistant. Artists pay gallery expenses through monthly dues, but the staff takes care of running the gallery and selling the art. The director writes the press releases, helps install exhibits, and advises artists on all aspects of their career. We try to take care of everything but making the art and framing it." Prefers artists who are familiar with the NYC art world and are working professionally in a contemporary mode which can range from realistic to abstract to conceptual and anything in between.

SUBMISSIONS Submitting art for consideration is a 2-step process: first through website or JPEGs, then if accepted at that level, by seeing 4-6 samples of the actual art. Artists should call, e-mail query letter with link to artist's website or JPEG samples at 72 dpi (include image list), or send query letter with artist's statement, bio, reviews, CD with images, and SASE. Materials returned with SASE. Responds in 2-4 weeks. Files materials of artists who become members. Finds artists through word of mouth, submissions, art exhibits, portfolio reviews, or referrals by other artists.

TIPS "Present current art completed within the last 2 years. Our submission procedure is in 2 stages: first we look at websites, JPEGs that have been e-mailed,

or CDs that have been mailed to the gallery. When e-mailing JPEGs, include an image list with title, date of execution, size, media. Also, include a bio and artist's statement. Reviews about your work are helpful if you have them, but not necessary. If you make it through the first level, then you will be asked to submit 4-6 actual artworks. These should be framed or matted, and similar to the work you want to show. Realize it is important to present a consistency in your vision. If you do more than one kind of art, select what you feel best represents you, for the art you show will be a reflection of who you are."

WASHINGTON PROJECT FOR THE ARTS

10 I St. SW, Washington DC 20024. (202)234-7103. **Fax:** (202)234-7106. **E-mail:** info@wpadc.org; pnesbett@wpadc.org; smay@wpadc.org; lgold@wpadc.org. **Website:** www.wpadc.org. **Contact:** Christopher Cunetto, membership manager. Estab. 1975. Alternative space that exhibits emerging, mid-career, and established artists. Approached by 1,500 artists/year, exhibits 800 artists. Sponsors 12 exhibits/year. Average display time: 4 weeks. WPA is located in the Capitol Skyline Hotel. We exhibit throughout the hotel and in various museums and venues throughout the region. Clients include local community, students, tourists, and upscale. 5% of sales are to corporate collectors. Overall price range: $100-5,000; most work sold at $500-1,000.

EXHIBITS Considers all media. Most frequently exhibits performance, painting, drawing, and photography.

MAKING CONTACT & TERMS Artwork is accepted on consignment and there is a 50% commission. Retail price set by the artist. Gallery provides insurance, promotion, and contract. Accepted work should be framed.

SUBMISSIONS E-mail query letter with link to artist's website. Responds in 2 months. Finds artists through word of mouth, submissions, portfolio reviews, art exhibits, and referrals by other artists.

TIPS Use correct spelling, make sure packages/submissions are tidy.

⊘ WEINSTEIN GALLERY

908 W. 46th St., Minneapolis MN 55419. (612)822-1722. **Fax:** (612)822-1745. **E-mail:** weinsteingallery@gmail.com. **Website:** www.weinstein-gallery.com. **Contact:** Leslie Hammons, director. Estab. 1996. For-profit gallery. Approached by hundreds of artists/year;

represents or exhibits 12 artists. Average display time 6 weeks. Open Tuesday–Saturday, 12-5, or by appointment. Overall price range $4,000-250,000.

EXHIBITS Interested in fine art. Most frequently exhibits contemporary photography.

SUBMISSIONS "We do not accept unsolicited submissions."

WISCONSIN UNION GALLERIES

WUD Art Committee, 1308 W. Dayton St., Room 235, Madison WI 53715. (608)890-4432; (608)262-7592. **Fax:** (608)890-4411. **E-mail:** art@union.wisc.edu; schmoldt@wisc.edu; union@union.wisc.edu. **Website:** www.union.wisc.edu/wud/art-events.htm. **Contact:** Robin Schmoldt, art collection manager. Estab. 1928. Nonprofit gallery. Estab. 1928. Approached by 100 artists/year; exhibits 30 shows/year. Average display time 4-6 weeks. Open 10-8 daily. Gallery 1308 in Union South is open 7 a.m.-10 p.m. weekdays and 8 a.m.-10 p.m. weekends. Closed during winter break and when gallery exhibitions turn over. Visit the website for the gallery's features.

EXHIBITS Interested in fine art. "Photography exhibitions vary based on the artist proposals submitted."

MAKING CONTACT & TERMS All sales through gallery during exhibition only.

SUBMISSIONS Current submission guidelines available at www.union.wisc.edu/wud/art-submissions.htm. Finds artists through art fairs, art exhibits, referrals by other artists, submissions, word of mouth.

WOMEN & THEIR WORK ART SPACE

1710 Lavaca St., Austin TX 78701. (512)477-1064. **Fax:** (512)477-1090. **Website:** www.womenandtheirwork.org. **Contact:** Chris Cowden, executive director. Estab. 1978. Alternative space, nonprofit gallery. Approached by more than 400 artists/year; represents or exhibits 6 solo exhibitions from Texas artists and 1 show/year for artists outside of Texas. Encourages the creation of new work. Types of media vary. Average display time: 6 weeks. Open Monday–Friday, 10-6; Saturday, 12-5; closed December 24–January 2, and other major holidays. Exhibition space is 2,000 sq. ft. Overall price range: $500-5,000; most work sold at $800-2,000.

EXHIBITS Interested in contemporary, alternative process, avant garde, fine art.

MAKING CONTACT & TERMS "We select art-

ists through a juried process and pay them to exhibit. We take 25% commission if something is sold." Gallery provides catalog, insurance, promotion, contract. Texas women in majority of solo shows. "Online Artist Slide Registry on website."

SUBMISSIONS Finds artists through nomination by art professional.

TIPS "Provide quality images, typed résumé, and a clear statement of artistic intent."

WORLD FINE ART

179 E. Third St., Suite 16, New York NY 10009-7705, USA. (646)539-9622. **E-mail:** info@worldfineart.com. **Website:** www.worldfineart.com. **Contact:** O'Delle Abney, director. Estab. 1992. Features photos by Sandra Gottlieb. Publishes a weekly video newsletter at nycgalleryopenings.com. Services listed at www.worldfineart.com/join.html and personal marketing. Arranges group exhibitions around the New York City area.

SUBMISSIONS Responds to queries in 1 week. Nonexclusive agent to 12 current portfolio artists. Finds artists online.

TIPS "Have website available or send JPEG images for review."

YESHIVA UNIVERSITY MUSEUM

15 W. 16th St., New York NY 10011. (212)294-8330. **Fax:** (212)294-8335. **E-mail:** info@yum.cjh.org. **Website:** www.yumuseum.org. Estab. 1973. The museum's changing exhibits celebrate the culturally diverse intellectual and artistic achievements of 3,000 years of Jewish experience. Sponsors 6-8 exhibits/year; at least 1 photography exhibit/year. Average display time 4-6 months. The museum occupies 4 galleries and several exhibition arcades. All galleries are handicapped accessible. Open Sunday, Tuesday and Thursday, 11-5; Monday and Wednesday, 11-8; Friday, 11-2:30.

EXHIBITS Seeks "individual or group exhibits focusing on Jewish themes and interests; exhibition-ready work essential."

MAKING CONTACT & TERMS Accepts images in digital format. Send CD and accompanying text with SASE for return. Send color slide portfolio of 10-12 slides or photos, exhibition proposal, résumé with SASE for consideration. Reviews take place 3 times/year.

TIPS "We exhibit contemporary art and photography based on Jewish themes. We look for excellent quality, individuality, and work that reveals a connection to Jewish identity and/or spirituality."

MIKHAIL ZAKIN GALLERY

The Art School at Old Church, 561 Piermont Rd., Demarest NJ 07627. (201)767-7160. **Fax:** (201)767-0497. **E-mail:** maria@tasoc.org; exhibitions@tasoc.org. **Website:** www.tasoc.org. **Contact:** Maria Danziger, executive director. Estab. 1974. Nonprofit gallery associated with the Art School at Old Church. "Ten-exhibition season includes contemporary, emerging, and established regional artists, NJ Annual Small Works show, student and faculty group exhibitions, among others." Open Monday–Friday, 9:30-5; call for weekend and evening hours. Exhibitions are mainly curated by invitation. However, unsolicited materials are reviewed. The gallery does not review artist websites, e-mail attachments or portfolios in the presence of the artist. Please follow the submission guidelines on website.

EXHIBITS All styles and genres are considered.

MAKING CONTACT & TERMS Charges 35% commission fee on all gallery sales. Gallery provides promotion and contract. Accepted work should be framed, mounted.

SUBMISSIONS Guidelines are available on gallery's website. Small Works prospectus is available online. Mainly finds artists through referrals by other artists and artist registries.

TIPS "Follow guidelines available online."

ART FAIRS

//

How would you like to sell your art from New York to California, showcasing it to thousands of eager art collectors? Art fairs (also called art festivals or art shows) are not only a good source of income for artists but an opportunity to see how people react to their work. If you like to travel, enjoy meeting people, and can do your own matting and framing, this could be a great market for you.

Many outdoor fairs occur during the spring, summer, and fall months to take advantage of warmer temperatures. However, depending on the region, temperatures could be hot and humid, and not all that pleasant! And, of course, there is always the chance of rain. Indoor art fairs held in November and December are popular because they capitalize on the holiday shopping season.

To start selling at art fairs, you will need an inventory of work—some framed, some unframed. Even if customers do not buy the framed paintings or prints, having some framed work displayed in your booth will give buyers an idea of how your work looks framed, which could spur sales of your unframed prints. The most successful art fair exhibitors try to show a range of sizes and prices for customers to choose from.

When looking at the art fairs listed in this section, first consider local shows and shows in your neighboring cities and states. Once you find a show you'd like to enter, visit its website or contact the appropriate person for a more detailed prospectus. A prospectus is an application that will offer additional information not provided in the art fair's listing.

Ideally, most of your prints should be matted and stored in protective wraps or bags so that customers can look through your inventory without damaging prints and mats. You will also need a canopy or tent to protect yourself and your wares from the elements as well as some bins in which to store the prints. A display wall will allow you to show off

your best framed prints. Generally, artists will have 100 square feet of space in which to set up their tents and canopies. Most listings will specify the dimensions of the exhibition space for each artist.

If you see the ☻ icon before a listing in this section, it means that the art fair is a juried event. In other words, there is a selection process artists must go through to be admitted into the fair. Many art fairs have quotas for the categories of exhibitors. For example, one art fair may accept the mediums of photography, sculpture, painting, metal work, and jewelry. Once each category fills with qualified exhibitors, no more will be admitted to the show that year. The jurying process also ensures that the artists who sell their work at the fair meet the sponsor's criteria for quality. So, overall, a juried art fair is good for artists because it means they will be exhibiting their work along with other artists of equal caliber.

Be aware there are fees associated with entering art fairs. Most fairs have an application fee or a space fee, or sometimes both. The space fee is essentially a rental fee for the space your booth will occupy for the art fair's duration. These fees can vary greatly from show to show, so be sure to check this information in each listing before you apply to any art fair.

Most art fair sponsors want to exhibit only work that is handmade by the artist, no matter what medium. Unfortunately, some people try to sell work that they purchased elsewhere as their own original artwork. In the art fair trade, this is known as "buy/sell." It is an undesirable situation because it tends to bring down the quality of the whole show. Some listings will make a point to say "no buy/sell" or "no manufactured work."

For more information on art fairs, pick up a copy of *Sunshine Artist* (www.sunshine artist.com) or *Professional Artist* (www.artcalendar.com), and consult online sources such as www.artfairsource.com.

4 BRIDGES ARTS FESTIVAL

30 Frazier Ave., Chattanooga TN 37405. (423)265-4282 ext. 3. **Fax:** (423)265-5233. **E-mail:** katdunn@avarts.org. **Website:** www.4bridgesartsfestival.org. **Contact:** Kat Dunn. Estab. 2000. 2-day fine arts & crafts show held annually in mid-April. Held in a covered, open-air pavilion. Accepts photography and 24 different mediums. Juried by 3 different art professionals each year. Awards: $10,000 in artist merit awards; the on-site jurying for merit awards will take place Saturday morning. Number of exhibitors: 150. Public attendance: 13,000. Public admission: $7/day or a 2-day pass for $10; children under 18 are free. Artists should apply at www.zapplication.org. Deadline for entry: early November (see website for details). Application fee: $40. Space fee: $450-550 for 10×12 ft.; $900-1,000 for 20×12 ft. Average gross sales/exhibitor: $2,923. For more information, e-mail, call, or visit website. The event is held at First Tennessee Pavilion.

57TH STREET ART FAIR

1507 E. 53rd St., PMB 296, Chicago IL 60615. (773)234-3247. **E-mail:** info@57thstartfair.org. **Website:** www.57thstreetartfair.org. **Contact:** Linda or Ron Mulick, owners/promoters. Estab. 1948. Fine art & craft show held annually in June. Outdoors. Accepts painting, sculpture, photography, glass, jewelry, leather, wood, ceramics, fiber, printmaking. Juried. Free to public. Apply via www.zapplication.org. Deadline for entry: January 15. Application fee: $35. Space fee: $300. Exhibition space: 10×10 ft. For more information, e-mail or visit website.

AKRON ARTS EXPO

220 Balch St., Akron OH 44302. (330)375-2836. **Fax:** (330)375-2883. **E-mail:** PBomba@akronohio.gov. **Website:** www.akronartsexpo.org. **Contact:** Penny Bomba, artist coordinator. Estab. 1979. Held in late July. "The Akron Arts Expo is a nationally recognized juried fine arts & crafts show held outside with over 160 artists, ribbon and cash awards, great food, an interactive children's area, and entertainment for the entire family. Participants in this festival present quality fine arts and crafts that are offered for sale at reasonable prices. For more information, see the website." Application fee $10. Booth fee: $200. Event held in Hardesty Park.

ALLEN PARK ARTS & CRAFTS STREET FAIR

City of Allen Park, P.O. Box 70, Allen Park MI 48101. (734)258-7720. **E-mail:** applications@allenparkstreetfair.org. **Website:** www.allenparkstreetfair.org. **Contact:** Allen Park Festivities Commission. Estab. 1981. Arts & crafts show held annually the 1st Friday and Saturday in August. Outdoors. Accepts photography, sculpture, ceramics, jewelry, glass, wood, prints, drawings, paintings. All work must be of fine quality and original work of entrant. Such items as imports, velvet paintings, manufactured or kit jewelry and any commercially produced merchandise are not eligible for exhibit or sale. Juried by 5 photos of work. Number of exhibitors: 200. Free to the public. Deadline: March 15 (first review) and May 13 (second review). Application fee: $25. Space fee: $175-$200. Exhibition space: 10×10 ft. Apply via www.zapplication.org. Artists should call or see website for more information.

ALLENTOWN ART FESTIVAL

P.O. Box 1566, Buffalo NY 14205. (716)881-4269. **E-mail:** allentownartfestival@verizon.net. **Website:** www.allentownartfestival.com. **Contact:** Mary Myszkiewicz, president. Estab. 1958. Fine arts & crafts show held annually 2nd full weekend in June. Outdoors. Accepts photography, painting, watercolor, drawing, graphics, sculpture, mixed media, clay, glass, acrylic, jewelry, creative craft (hard/soft). Slides juried by hired professionals that change yearly. Awards/prizes: 41 cash prizes totaling over $20,000; includes Best of Show awarding $1,000. Number of exhibitors: 450. Public attendance: 300,000. Free to public. Artists should apply by downloading application from website. Deadline for entry: late January. Exhibition space: 10×13 ft. Application fee: $15. Booth fee $275. For more information, artists should e-mail, visit website, call, or send SASE. Show held in Allentown Historic Preservation District.

TIPS "Artists must have attractive booth and interact with the public."

AMERICAN ARTISAN FESTIVAL

P.O. Box 41743, Nashville TN 37204. (615)429-7708. **E-mail:** americanartisanfestival@gmail.com. **Website:** www.facebook.com/theamericanartisanfestival. Estab. 1971. Fine arts & crafts show held annually mid-June, Father's Day weekend. Outdoors. Accepts

photography and 21 different medium categories. Juried by 3 different art professionals each year. 3 cash awards presented. Number of exhibitors: 165. Public attendance: 30,000. No admission fee for the public. Artists should apply online at www.zapplication.org. Deadline for entry: early March (see website for details). For more information, e-mail or visit the website. Festival held at Centennial Park, Nashville TN.

ANACORTES ARTS FESTIVAL

505 O Ave., Anacortes WA 98221. (360)293-6211. **Fax:** (360)299-0722. **E-mail:** staff@anacortesartsfestival. com. **Website:** www.anacortesartsfestival.com. Fine arts & crafts show held annually 1st full weekend in August. Accepts photography, painting, drawings, prints, ceramics, fiber art, paper art, glass, jewelry, sculpture, yard art, woodworking. Juried by projecting 3 images on a large screen. Works are evaluated on originality, quality, and marketability. Each applicant must provide 5 high-quality digital images, including a booth shot. Awards/prizes: festival offers awards totaling $3,500. Number of exhibitors: 270. Apply via www.zapplication.org. Application fee: $30. Deadline for entry: early March. Space fee: $325. Exhibition space: 10×10 ft. For more information, artists should see website. Show is located on Commercial Ave. from 4th to 10th St.

THE ANNA MARIA ISLAND ARTS & CRAFTS FESTIVAL

270 Central Blvd., Suite 107B, Jupiter FL 33458. (561)746-6615. **Fax:** (561)746-6528. **E-mail:** info@ artfestival.com. **Website:** www.artfestival.com. **Contact:** Malinda Ratliff, communications manager. Fine art & craft fair held annually in mid-November. Outdoors. Accepts photography, jewelry, mixed media, sculpture, wood, ceramic, glass, painting, digital, fiber, metal. Juried. Number of exhibitors: 106. Number of attendees: 10,000. Free to public. Apply online via www.zapplication.org. Deadline: see website. Application fee: $15; free to mail in paper application. Space fee: $250. Exhibition space: 10×10 ft. and 10×20 ft. For more information, artists should e-mail, call, or visit website.

TIPS "You have to start somewhere. First, assess where you are, and what you'll need to get things off the ground. Next, make a plan of action. Outdoor street art shows are a great way to begin your career and lifetime as a working artist. You'll meet a lot of

other artists who have been where you are now. Network with them!"

ANN ARBOR SUMMER ART FAIR

118 N. Fourth Ave., Ann Arbor MI 48104. (734)662-3382. **Fax:** (734)662-0339. **E-mail:** info@theguild.org. **Website:** www.theguild.org. Estab. 1970. Fine arts and craft show held annually on the third Wednesday through Saturday in July. Outdoors. Accepts all fine art categories. Juried. Number of exhibitors: 325. Attendance: 500,000-750,000. Free to public. Deadline for entry is January; enter online at www.juried artservices.com. Exhibition space: 10×10, 10×13, 10×17 ft. For information, artists should visit the website, call, or e-mail. Show is located on University of Michigan campus and in downtown Ann Arbor.

APPLE ANNIE CRAFTS & ARTS SHOW

4905 Roswell Rd., Marietta GA 30062. (770)552-6400, ext. 6110. **Fax:** (770)552-6420. **E-mail:** sagw4905@ gmail.com. **Website:** www.st-ann.org/womens-guild/ apple-annie. Estab. 1981. Handmade arts & crafts show held annually the 1st weekend in December. Juried. Indoors. Accepts handmade arts and crafts like photography, woodworking, ceramics, pottery, painting, fabrics, glass, etc. Number of exhibitors: 120. Public attendance: 4,000. Artists should apply by visiting website to print application form. Deadline: March 1 (see website for details). Application fee: $20, nonrefundable. Booth fee $200. Exhibition space: 80 sq. ft. minimum, may be more. For more information, artists may visit website.

TIPS "We are looking for vendors with an open, welcoming booth, who are accessible and friendly to customers."

ARLINGTON FESTIVAL OF THE ARTS

270 Central Blvd., Suite 107B, Jupiter FL 33458. (561)746-6615. **Fax:** (561)746-6528. **E-mail:** info@ artfestival.com. **Website:** www.artfestival.com. **Contact:** Malinda Ratliff, communications manager. Estab. 2013. Fine art & craft fair held annually in mid-April. Outdoors. Accepts photography, jewelry, mixed media, sculpture, wood, ceramic, glass, painting, digital, fiber, metal. Juried. Number of exhibitors: 140. Number of attendees: 50,000. Free to public. Apply online via www.zapplication.org. Deadline: see website. Application fee: $25. Space fee: $395. Exhibition space: 10×10 and 10×20 ft. For more information, artists should e-mail, call or visit website. Festi-

val located at Highland St. in the Clarendon district of Arlington, VA.

TIPS "You have to start somewhere. First, assess where you are, and what you'll need to get things off the ground. Next, make a plan of action. Outdoor street art shows are a great way to begin your career and lifetime as a working artist. You'll meet a lot of other artists who have been where you are now. Network with them!"

ART-A-FAIR

P.O. Box 547, Laguna Beach CA 92652. (949)494-4514. **E-mail:** marketing@art-a-fair.com. **Website:** www. art-a-fair.com. Estab. 1967. Fine arts show held annually in June-August. Outoors. Accepts painting, sculpture, ceramics, jewelry, printmaking, photography, master crafts, digital art, fiber, glass, pencil, wood. Juried. Exhibitors: 125. Number of attendees: see website. Admission: $7.50 adults; $4.50 seniors; children 12 & under free. Apply online. Deadline for entry: see website. Application fee: $40 (per medium). Space fee: $200 + $35 membership fee. Exhibition space: see website. For more information, e-mail, call, or visit website.

ART BIRMINGHAM

118 N. Fourth Ave., Ann Arbor MI 48104. (734)662-3382. **Fax:** (734)662-0339. **E-mail:** info@theguild.org. **Website:** www.theguild.org. Estab. 1981. Arts & crafts show held annually in May. Outoors. Accepts handmade crafts painting, ceramics, photography, jewelry, glass, wood, sculpture, mixed media, fiber, metal, and more. Juried. Exhibitors: 150. Number of attendees: see website. Free to public. Apply online. Deadline for entry: see website. Application fee: see website. Space fee: see website. Exhibition space: see website. For more information, call or visit website.

ART FAIR AT QUEENY PARK

GSLAA-Vic Barr, 1668 Rishon Hill Dr., St. Louis MO 63146. (636)724-5968. **Website:** www.artfair atqueenypark.com. Arts & crafts show held annually in August. Indoors. Accepts handmade crafts, clay, digital (computer) art, drawing/print, fiber (basketry, paper, wearable, woven), glass, jewelry, 2D/3D mixed media, oil/acrylic, photography, sculpture, water media, wood. Juried. Exhibitors: 140. Number of attendees: see website. Free to public. Apply online. Deadline for entry: see website. Application fee: $25; $50 for late

application. Space fee: $225. Exhibition space: 10×8 ft. For more information, call or visit website.

ART FAIR JACKSON HOLE

Art Association of Jackson Hole, Art Association of Jackson Hole, P.O. Box 1248, Jackson WY 83001. (307)733-6379. **Fax:** (307)733-6694. **E-mail:** artist info@jhartfair.org. **Website:** www.jhartfair.org. **Contact:** Elisse La May, Events Director. Estab. 1965. Arts & crafts show held annually the second weekends of July & August in Miller Park, Jackson Hole, WY. Outdoors. Accepts handmade crafts, ceramic, drawing, fiber, furniture, glass, graphics & printmaking, jewelry, leather, metalwork, 2D/3D mixed media, painting, photography, sculpture, toys & games, wearable fiber, wood. Juried. Exhibitors: 145. Number of attendees: 12,000. Free for art association members; $5 per day for non-members. Apply via Zapplication.org. Deadline for entry: see website. Application fee: $35. Space fee: Standard Booth space is 10×10 ft. Other booth options vary. Exhibition space: varies. For more information, e-mail, visit website, or call.

ART FAIR OFF THE SQUARE

P.O. Box 1791, Madison WI 53701-1791. 262-537-4610. **E-mail:** wiartcraft@gmail.com. **Website:** www.art craftwis.org/AFOS.html. Estab. 1965. Arts & crafts show held annually in July. Outoors. Accepts handmade crafts ceramics, art glass, painting, fiber, sculpture, jewelry, graphics, papermaking, photography, wood and more. Juried. Awards/prizes: Best of Category. Exhibitors: 140. Number of attendees: see website. Free to public. Apply via Zapplication.org. Deadline for entry: see website. Application fee: $25. Space fee: $300. Exhibition space: 10×10 ft. For more information, e-mail, visit website, or call.

ART FAIR ON THE COURTHOUSE LAWN

P.O. Box 795, Rhinelander WI 54501. (715)365-7464. **E-mail:** assistant@rhinelanderchamber.com. **Website:** www.explorerhinelander.com. **Contact:** events coordinator. Estab. 1985. Arts & crafts show held annually in June. Outdoors. Accepts woodworking (includes furniture), jewelry, glass items, metal, paintings, and photography. Number of exhibitors: 150. Public attendance: 3,000. Free to the public. Space fee: $75-300. Exhibit space: 10×10 to 10×30 ft. For more information, artists should e-mail, call, or visit website. Show located at Oneida County Courthouse.

TIPS "We accept only items handmade by the exhibitor."

ART FAIR ON THE SQUARE

July 9-10, 2016, Madison Museum of Contemporary Art, 227 State St., Madison WI 53703, USA. (608)257-0158, ext 229. **Fax:** (608) 257-5722. **E-mail:** artfair@mmoca.org. **Website:** www.mmoca.org/events/special-events/art-fair-square/art-fair-square. **Contact:** Annik Dupaty. Estab. 1958. Arts & crafts show held annually in July. Outoors. Accepts handmade crafts, ceramics, fiber, leather, furniture, jewelry, glass, digital art, metal, sculpture, 2D/3D mixed media, painting, photography, printmaking/graphics/drawing, wood. Juried. Awards/prizes: Best of Show; Invitational Award. Exhibitors: varies. Number of attendees: 150,000+. Free to public. Apply via www.zapplication.org. Deadline for entry: see website. Application fee: $35. Space fee: $520 (single); $1,075 (double). Exhibition space: 10×10 ft. (single); 20×10 ft. (double). For more information, e-mail, call, or visit website.

ART FEST BY THE SEA

270 Central Blvd., Suite 107B, Jupiter FL 33458. (561)746-6615. **Fax:** (561)746-6528. **E-mail:** info@artfestival.com. **Website:** www.artfestival.com. **Contact:** Malinda Ratliff, communications manager. Estab. 1958. Fine art & craft fair held annually in early March. Outdoors. Accepts photography, jewelry, mixed media, sculpture, wood, ceramic, glass, painting, digital, fiber, metal. Juried. Number of exhibitors: 340. Number of attendees: 125,000. Free to public. Apply online via www.zapplication.org. Deadline: see website. Application fee: $25. Space fee: $415. Exhibition space: 10×10 and 10×20 ft. For more information, artists should e-mail, call, or visit website. Fair located along A1A between Donald Ross Rd. and Marcinski in Juno Beach FL.

TIPS "You have to start somewhere. First, assess where you are, and what you'll need to get things off the ground. Next, make a plan of action. Outdoor street art shows are a great way to begin your career and lifetime as a working artist. You'll meet a lot of other artists who have been where you are now. Network with them!"

ARTFEST FORT MYERS

1375 Jackson St., Suite 401, Fort Myers FL 33901. (239)768-3602. **E-mail:** info@artfestfortmyers.com.

Website: www.artfestfortmyers.com. Fine arts & crafts fair held annually in February. Outdoors. Accepts handmade crafts, ceramics, digital, drawing/graphics, fiber, glass, jewelry, metal, 2D/3D mixed media, painting, photography, printmaking, sculpture, wearable, wood. Juried. Awards/prizes: $5,000 in cash. Exhibitors: 200. Number of attendees: 85,000. Free to public. Apply online. Deadline for entry: September 15. Application fee: $35. Space fee: $460.50. Exhibition space: 10×10 ft. For more information, e-mail, call or visit website.

ART FESTIVAL BETH-EL

400 Pasadena Ave. S, St. Petersburg FL 33707. (727)347-6136. **Fax:** (727)343-8982. **E-mail:** annsoble@gmail.com. **Website:** www.artfestivalbethel.com. Estab. 1972. Fine arts & crafts show held annually the last weekend in January. Indoors. Accepts photography, painting, jewelry, sculpture, woodworking, glass. Juried by special committee on-site or through slides. Awards/prizes: over $7,000 prize money. Number of exhibitors: over 170. Public attendance: 8,000-10,000. Free to the public. Artists should apply by application with photos or slides; show is invitational. Deadline for entry: September. For more information, artists should call or visit website. A commission is taken.

TIPS "Don't crowd display panels with artwork. Make sure your prices are on your pictures. Speak to customers about your work."

ART FESTIVAL OF HENDERSON

P.O. Box 95050, Henderson NV 89009-5050. (702)267-2171. **E-mail:** info@artfestival.com. **Website:** www.cityofhenderson.com. Arts & crafts show held annually in May. Outdoors. Accepts handmade crafts, paintings, pottery, jewelry, photography, and much more. Juried. Exhibitors: varies. Number of attendees: 25,000. Free to public. Apply online. Deadline for entry: see website. Application fee: see website. Space fee: see website. Exhibition space: see website. For more information, call or visit website.

ARTFEST MIDWEST—"THE OTHER ART SHOW"

Stookey Companies, P.O. Box 31083, Des Moines IA 50310. (515)278-6200. **Fax:** (515)276-7513. **E-mail:** suestookey@att.net. **Website:** www.artfestmidwest.com. Fine art fair held annually in June. Indoors & outdoors. Accepts handmade fine art, ceramic, fiber,

drawing, glass, jewelry, metal, 2D/3D mixed media, painting, photography, wood. Juried. Exhibitors: 240. Number of attendees: 30,000. Free to public. Apply via www.zapplication.org. Deadline for entry: March. Application fee: $30. Space fee: varies. Exhibition space: see website. For more information, e-mail suestookey@att.net, visit website at www.artfestmidwest.com, or call (515) 278-6200.

ARTIGRAS FINE ARTS FESTIVAL

5520 PGA Blvd., Suite 200, Palm Beach Gardens FL 33418. (561)746-7111. **E-mail:** info@artigras.org. **Website:** www.artigras.org. **Contact:** Hannah Sosa, director of special events. Estab. 2008. Annual fine arts festival held in February during Presidents' Day weekend. Outdoors. Accepts all fine art (including photography). Juried. $17,000 in cash awards and prizes. Average number of exhibitors: 300. Average number of attendees: 85,000. Admission: $10. Artists should apply by enclosing a copy of prospectus or by application form, if available; can also apply via www.zapplication.org. Deadline: September. Application fee: $40. Space fee: $450. Space is 12×12 ft. For more information artists should e-mail or visit website.

ART IN BLOOM—CATIGNY PARK

630.668.5161. **E-mail:** info@cantigny.org. **Website:** www.cantigny.org/calendar/signature-events/art-in-bloom. Fine arts & crafts show held annually in June. Outdoors. Accepts handmade crafts, ceramics, drawing, fiber nonfunctional, fiber wearable, paper nonfunctional, furniture, glass, jewelry, acrylic, oil, watercolor, pastel, sculpture, wood, mixed media, collage, photography, and printmaking. Juried. Exhibitors: 80. Number of attendees: 8,000. Free to public. Apply online. Deadline for entry: see website. Application fee: $10. Space fee: $300. Exhibition space: 10×10 ft. For more information, e-mail, call, or visit website.

ART IN THE BARN—BARRINGTON

Advocate Good Shepherd Hospital, Art in the Barn Artist Committee, 450 W. Highway 22, Barrington IL 60010. (847)842-4496. **E-mail:** artinthebarn.barrington@gmail.com. **Website:** www.artinthebarn-barrington.com. Estab. 1974. Fine arts & crafts show held annually in September. Indoors & outdoors. Accepts handmade crafts, ceramics, painting, jewelry, glass, sculpture, fiber, drawing, photography, digital media, printmaking, scratchboard, mixed media,

wood. Juried. Awards/prizes: Best of Show; Best of Medium; Purchase Awards. Exhibitors: 185. Number of attendees: 8,500. Admission: $5; children 12 & under free. Apply online. Deadline for entry: see website. Application fee: $20. Space fee: $100 (indoors); $85 (outdoors). Exhibition space: varies. For more information, e-mail, call, or visit website.

ART IN THE PARK (ARIZONA)

P.O. Box 748, Sierra Vista AZ 85636-0247. (520)803-0584. **E-mail:** Libravo@live.com. **Website:** www.artintheparksierravista.com. Estab. 1972. Oldest longest running arts & crafts fair in Southern Arizona. Fine arts & crafts show held annually 1st full weekend in October. Outdoors. Accepts photography, all fine arts and crafts created by vendor. No resale retail strictly applied. Juried by Huachaca Art Association Board. Artists submit 5 photos. Returnable with SASE. Number of exhibitors: 203. Public attendance: 15,000. Free to public. Artists should apply by downloading the application www.artintheparksierravista.com. Deadline for entry: postmarked by late June. Last minute/late entries always considered. No application fee. Space fee: $200-275, includes jury fee. Exhibition space: 15×30 ft. Some electrical; additional cost of $25. Some RV space available at $15/night. For more information, artists should see website, e-mail, call, or send SASE. Show located in Veteran's Memorial Park.

ART IN THE PARK (GEORGIA)

P.O. Box 1540, Thomasville GA 31799. (229)227-7020. **Fax:** (229)227-3320. **E-mail:** roseshowfest@rose.net; karens@thomasville.org. **Website:** www.downtownthomasville.com. **Contact:** Laura Beggs. Estab. 1998-1999. Art in the Park (an event of Thomasville's Rose Show and Festival) is a 1-day arts & crafts show held annually in April. Outdoors. Accepts photography, handcrafted items, oils, acrylics, woodworking, stained glass, other varieties. Juried by a selection committee. Number of exhibitors: 60. Public attendance: 2,500. Free to public. Artists should apply by submitting official application. Deadline for entry: early February. Space fee varies by year. Exhibition space: 20×20 ft. For more information, artists should e-mail, call, or visit website. Show located in Paradise Park.

TIPS "Most important, be friendly to the public and have an attractive booth display."

ART IN THE PARK (HOLLAND, MICHIGAN)

Holland Friends of Art, P.O. Box 1052, Holland MI 49422. **E-mail:** info@hollandfriendsofart.com. **Website:** www.hollandfriendsofart.com. **Contact:** Beth Canaan, art fair chairperson. Estab. 1969. This annual fine arts and crafts fair is held on the first Saturday of August in Holland. The event draws one of the largest influx of visitors to the city on a single day, second only to Tulip Time. More than 300 fine artists and artisans from 8 states will be on hand to display and sell their work. Juried. All items for sale must be original. Public attendance: 10,000+. Entry fee: $90 includes a $20 application fee. Deadline: late March. Space fee: $160 for a double-wide space. Exhibition space: 12×12 ft. Details of the jury and entry process are explained on the application. Application available online. E-mail or visit website for more information. Event held in Centennial Park.

TIPS "Create an inviting and neat booth. Offer well-made quality artwork and crafts at a variety of prices."

ART IN THE PARK (KEARNY)

Kearney Artist Guild, P.O. Box 1368, Kearney NE 68848-1368. (308)708-0510. **E-mail:** artinthepark kearney@charter.net. **Website:** www.kearneyartists guild.com. **Contact:** Daniel Garringer (308)708-0510. Estab. 1971. Fine arts held annually in July. Outdoors. Accepts handmade fine crafts, ceramics, drawing, fiber, mixed media, glass, jewelry, painting, photography, sculpture. Juried. Exhibitors: 90. Number of attendees: estimated 7,000. Free to public. Apply online. Deadline for entry: early June. Application fee: $10. Space fee: $50-$100. Exhibition space: 12×12 ft. or 12×24 ft. For more information, e-mail, visit website at kearneyartaistsguild.com, or call.

ART IN THE PARK (PLYMOUTH, MICHIGAN)

P.O. Box 702490, Plymouth MI 48170. (734)454-1314. **Fax:** (734)454-3670. **E-mail:** info@artinthepark.com. **Website:** www.artinthepark.com. Estab. 1979. Arts & crafts show held annually in July. Outdoors. Accepts handmade crafts, paintings, sculpture, ceramics, jewelry, fiber, fine glass, woodwork, mixed media, photography, and folk art. Juried. Exhibitors: 400. Number of attendees: 300,000. Free to public. Apply online. Deadline for entry: see website. Application fee: $20. Space fee: $580. Exhibition space: 10×10 ft. For more information, e-mail, visit website, or call.

ART IN THE PARK (VIRGINIA)

20 S. New St., Staunton VA 24401. (540) 885-2028. **E-mail:** director@saartcenter.org. **Website:** www.sa artcenter.org. **Contact:** Beth Hodges, exec. director. Estab. 1961. Fine arts & crafts show held annually every Memorial Day weekend. Outdoors. Juried by submitting 4 photos representative of the work to be sold. Award/prizes: $1,500. Number of exhibitors: 60. Public attendance: 3,000-4,000. Free to public. Artists should apply by sending in application. Exhibition space: 10×10 ft. For more information, artists should e-mail, call, or visit website. Show located at Gypsy Hill Park.

ART IN THE PARK—FINE ARTS FESTIVAL

Swartz Creek Kiwanis, 5023 Holland Dr., Swartz Creek MI 48473. (810)282 7641. **E-mail:** aitp@hsaa. com. **E-mail:** aitp@hsaa.com. **Website:** www.swartz creekkiwanis.org/art. **Contact:** Doug Stephens. Estab. 2008. Annual outdoor fine art festival held in August. Accepts all fine art. Juried by art professionals hired by the committee, monetary prizes given. Average number of exhibitors: 50. Average number of attendees: 2,500-3,000. Free admission. Artists should apply by accessing the website. Deadline: early July. Space fee of $125; $175 for late applications. Space is 144 sq. ft. For more information artists should e-mail or visit the website. Festival held at Elms Park.

TIPS "Bring unique products."

ART IN THE PARK FALL FOLIAGE FESTIVAL

Rutland Area Art Association, P.O. Box 1447, Rutland VT 05701. (802)775-0356. **E-mail:** info@chaffeeart center.org; artinthapark@chaffeeartcenter.org. **Website:** www.chaffeeartcenter.org. **Contact:** Meg Barros. Estab. 1961. A fine arts & crafts show held at Main Street Park in Rutland VT annually in October over Columbus Day weekend. Accepts fine art, specialty foods, fiber, jewelry, glass, metal, wood, photography, clay, floral, etc. All applications will be juried by a panel of experts. The Art in the Park Festivals are dedicated to high-quality art and craft products. Number of exhibitors: 100. Public attendance: 9,000-10,000. Public admission: voluntary donation. Artists should apply online and either e-mail or submit a CD with 3 photos of work and 1 of booth (photos upon preapproval). Deadline for entry: early bird discount of $25 per show for applications received by March 31. Space

fee: $200-350. Exhibit space: 10×12 or 20×12 ft. For more information, artists should e-mail, visit website, or call. Show located in Main Street Park.

TIPS "Have a good presentation, variety, if possible (in pricing also), to appeal to a large group of people. Apply early, as there are a limited amount of accepted vendors per category. Applications will be juried on a first come, first served basis until the category is determined to be filled."

○ ART IN THE VILLAGE WITH CRAFT MARKETPLACE

270 Central Blvd., Suite 107B, Jupiter FL 33458. (561)746-6615. **Fax:** (561)746-6528. **E-mail:** info@artfestival.com. **Website:** www.artfestival.com. **Contact:** Malinda Ratliff, communications manager. Estab. 1991. Fine art & craft fair held annually in early June. Outdoors. Accepts photography, jewelry, mixed media, sculpture, wood, ceramic, glass, painting, digital, fiber, metal. Juried. Number of exhibitors: 150. Number of attendees: 70,000. Free to public. Apply online via www.zapplication.org. Deadline: see website. Application fee: $25. Space fee: $450. Exhibition space: 10×10 and 10×20 ft. For more information, artists should e-mail, call or visit website. Show located at Legacy Village in Cleveland, OH.

TIPS "You have to start somewhere. First, assess where you are, and what you'll need to get things off the ground. Next, make a plan of action. Outdoor street art shows are a great way to begin your career and lifetime as a working artist. You'll meet a lot of other artists who have been where you are now. Network with them!"

○ ARTISPHERE

101B Augusta St., Greenville SC 29601. (864) 412-1040. **Fax:** (864)283-6580. **E-mail:** polly@artisphere.org. **Website:** www.artisphere.org. **Contact:** Polly Gaillard. Fine arts & crafts art festival held annually second weekend in May (see website for details). Showcases local and national fine art and fine craft artists on Artist Row along South Main Street. Accepts digital art and photography. Apply via www.zapplication.org. Free to public. E-mail, call, or visit website for more information.

○ ○ ARTIST PROJECT 2017

10 Alcorn Ave., Suite 100, Toronto, Ontario M4V-3A9 Canada. (416)960-5396. **Fax:** (416)927-8032. **E-mail:** info@theartistproject.com. **Website:** www.theartist

project.com. **Contact:** Claire Taylor, show director. Estab. 2007. Event held every February. Fine art event. Event held indoors. Accepts photography. Accepts all fine art mediums. Juried event. Awards and prizes given: Untapped Artist Competition and Travel Grants. Average number of exhibitors: 300. Average number of attendees: 14,000. Admission fee for public: $10-$15. Artists should apply online. Application fee: $25. Space fee: Depends on booth size. Artists should e-mail, visit website, or call for more information.

○ ART ON THE LAWN

Village Artisans, 100 Corry St., Yellow Springs OH 45387. (937)767-1209. **E-mail:** villageartisans.email@yahoo.com. **Website:** www.villageartisans.blogspot.com. **Contact:** Village Artisans. Estab. 1983. Fine arts & crafts show held annually the 2nd Saturday in August. Outdoors. Accepts photography, all hand-made media and original artwork. Juried, as received, from photos accompanying the application. Awards: Best of Show receives a free booth space at next year's event. Number of exhibitors: 90-100. Free to public. Request an application by calling or e-mailing, or download an application from the website. Deadline for entry: July 31; however, the sooner received, the better the chances of acceptance. Jury fee: $15. Space fee: $75 before May; $85 until late July; $105 thereafter. Exhibition space: 10×10 ft. Average gross sales vary. For more information, artists should visit website, e-mail, call, send SASE, or stop by Village Artisans at above address.

○ ○ ART ON THE MALL

The University of Toledo, Office of Alumni Relations, 2801 W. Bancroft St., Mail Stop 301, Toledo OH 43606-3390. (419)530-2586. **Fax:** 419.530.4994. **E-mail:** artonthemall@utoledo.edu; ansley.abrams@utoledo.edu. **Website:** www.toledoalumni.org. Shirley Grzecki. **Contact:** Ansley Abrams-Frederick. Estab. 1992. Art show held annually on the last Sunday in July in Centennial Mall in the heart of the Main Campus of The University of Toledo. Outdoor juried art show. This show accepts submissions in the following categories: acrylic, glass, jewelry, mixed media, pen & ink, photography, pottery, oil, textiles/fibers/basketry, watercolors, wood, and other. Awards/prizes: UT Best of Show (has to have a UT connection), 1st place, 2nd place, 3rd place, Purchase Award. Number of exhibitors: 105-115. Number of attendees: 12,000. Free to public. Apply online or call the office to have an

application mailed to you. Deadline for entry: April 30. Application fee: $25. Space fee: $100. Exhibition space: 10×10 ft. For more information, e-mail, call, or visit website. "The purpose of the University of Toledo Alumni Association shall be to support the University by fostering a spirit of loyalty to the university among its alumni. This is accomplished by providing a communications link between alumni and the university, encouraging and establishing activities for alumni and promoting programs to assist int he academic and cultural development of the University of Toledo."

ART ON THE SQUARE

P.O. Box 23561, Belleville IL 62223. (618)233-6769. **E-mail:** clindauer@bellevillechamber.org. **Website:** www.artonthesquare.com. Estab. 2002. Fine arts & crafts show held annually in May. Outdoors. Accepts handmade crafts, photography, glass, jewelry, clay, sculpture, fine craft, mixed media, wood, and digital art. Juried. Awards/prizes: over $30,000 in cash. Exhibitors: 105. Number of attendees: varies. Free to public. Apply online. Deadline for entry: see website. Application fee: see website. Space fee: see website. Exhibition space: see website. For more information, e-mail, visit website, or call.

ART RAPIDS!

P.O. Box 301, Elk Rapids MI 49629. (231)264-6660. **E-mail:** art@mullalys128.com. **Website:** www.artrapids.org. **Contact:** Barb Mullaly. Art fair held annually last Saturday in June. Outdoors. Accepts handmade crafts, ceramic, drawing, fiber, glass, jewelry, painting, photography, printmaking, sculpture, wood, metal, paper, or mixed media. Juried. Awards/prizes: Best of Show, Honorable Mention, People's Choice. Exhibitors: 70. Number of attendees: 4,000. Free to public. Apply online. Deadline for entry: early April. Application fee: $20. Space fee: varies. Exhibition space: 10×10 ft. For more information, e-mail, visit website, or call.

AN ARTS & CRAFTS AFFAIR, AUTUMN & SPRING TOURS

P.O. Box 655, Antioch IL 60002. (402)331-2889. **E-mail:** hpifestivals@cox.net. **Website:** www.hpifestivals.com. **Contact:** Huffman Productions. Estab. 1983. An arts & crafts show that tours different cities and states. Autumn Festival tours annually October-November; Spring Festival tours annually in March & April. Artists should visit website to see list of states and schedule. Indoors. Accepts photography, pottery, stained glass, jewelry, clothing, wood, baskets. All artwork must be handcrafted by the actual artist exhibiting at the show. Juried by sending in 2 photos of work and 1 of display. Awards/prizes: 4 $30 show gift certificates; $50, $100 and $150 certificates off future booth fees. Number of exhibitors: 300-500 depending on location. Public attendance: 15,000-35,000. Public admission: $8-9/adults; $7-8/seniors; 10 & under, free. Artists should apply by calling to request an application. Deadline for entry: varies for date and location. Space fee: $350-1,350. Exhibition space: 8×11 ft. up to 8×22 ft. For more information, artists should e-mail, call, or visit website.

TIPS "Have a nice display, make sure business name is visible, dress professionally, have different price points, and be willing to talk to your customers."

ARTS & CRAFTS FESTIVAL

Simsbury Woman's Club, P.O. Box 903, Simsbury CT 06070. (860)658-2684. **E-mail:** simsburywomansclub@hotmail.com; swc_artsandcrafts@yahoo.com. **Website:** www.simsburywomansclub.org. **Contact:** Shirley Barsness, co-chairman. Estab. 1978. Arts & crafts show held in mid-September. Juried event. Outdoors rain or shine. Original artwork, photography, clothing, accessories, jewelry, toys, wood objects, and floral arrangements accepted. Manufactured items or items made from kits not accepted. Individuals should apply by submitting completed application, 4 photos or JPEG files, including 1 of display booth. Exhibition space: 11×14 ft. or 15×14 ft. frontage. Space fee: $160-175; late applications $170-185. Number of exhibitors: 120. Public attendance: 5,000-7,000. Free to public. Deadline for entry: August 15. For more information, artists should e-mail swc_artsandcrafts@yahoo.com or call Jean at (860)658-4490 or Shirley at (860)658-2684. Applications available on website. Show located in Simsbury Center.

TIPS "Display artwork in an attractive setting."

ARTS, BEATS & EATS

301 W. Fourth St., Suite LL-150, Royal Oak MI 48067. (248) 541-7550. **Fax:** (248)541-7560. **E-mail:** lisa@artsbeatseats.com. **Website:** www.artsbeatseats.com. **Contact:** Lisa Konikow, art director. Estab. 1997. Fine arts & crafts fair held annually in September. Outdoors. Accepts handmade crafts, ceramic, digital art, fiber, drawing, glass, jewelry, metal, 2D/3D mixed media, painting, photography, printmaking, wood. Juried. Awards/prizes: $7,500 in cash awards. Exhibitors: 145. Number of attendees: 400,000. Free to public.

Apply online. Deadline for entry: March. Application fee: $25. Space fee: $490. Exhibition space: 10×10 ft. For more information, artists should send e-mail, call, or visit website.

ART'S ALIVE

200 125th St., Ocean City MD 21842. (410)250-0125. **Website:** oceancitymd.gov/recreation_and_parks/specialevents.html. **Contact:** Brenda Moore, event coordinator. Estab. 2000. Fine art show held annually in mid-June. Outdoors. Accepts photography, ceramics, drawing, fiber, furniture, glass, printmaking, jewelry, mixed media, painting, sculpture, fine wood. Juried. Awards/prizes: $5,250 in cash prizes. Number of exhibitors: 100. Public attendance: 10,000. Free to public. Artists should apply by downloading application from website or call. Deadline for entry: February 28. Space fee: $200. Jury Fee: $25. Exhibition space: 10×10 ft. For more information, artists should visit website, call, or send SASE. Show located in Northside Park.

TIPS Apply early.

ARTSFEST

P.O. Box 99, 13480 Dowell Rd., Dowell MD 20629. (410)326-4640. **Fax:** (410)326-4887. **E-mail:** info@annmariegarden.org. **Website:** www.annmariegarden.org. Estab. 1984. Fine arts & crafts fair held annually in September. Indoors & outdoors. Accepts handmade crafts, ceramic, digital art, fiber, drawing, furniture, glass, jewelry, metal, 2D/3D mixed media, painting, photography, printmaking, wood. Juried. Awards/prizes: Best of Show, Best Demonstration, Wooded Path Award, Best New Artsfest Artist Award. Exhibitors: 170. Number of attendees: varies. Admission: $6 adults; children 11 & under free; members free. Apply online. Deadline for entry: March. Application fee: $25. Space fee: varies. Exhibition space: varies. For more information, artists should send e-mail, visit website or call.

ARTS IN THE PARK

302 Second Ave. E., Kalispell MT 59901. (406)755-5268. **E-mail:** information@hockadaymuseum.com. **Website:** www.hockadaymuseum.org. Estab. 1968. Fine arts & crafts show held annually 4th weekend in July (see website for details). Outdoors. Accepts photography, jewelry, clothing, paintings, pottery, glass, wood, furniture, baskets. Juried by a panel of 5 members. Artwork is evaluated for quality, creativity, and originality. Jurors attempt to achieve a balance of mediums in the show. Number of exhibitors: 100. Public attendance: 10,000. Artists should apply by completing the online application form and sending 5 images in JPEG format; 4 images of work and 1 of booth. Application fee: $25. Exhibition space: 10×10 or 10×20 ft. Booth fees: $170-435. For more information, artists should e-mail, call, or visit website. Show located in Depot Park.

ARTS ON THE GREEN

Arts Association of Oldham County, 104 E. Main St., LaGrange KY 40031. (502) 222-3822;. **E-mail:** maryklausing@bellsouth.net. **Website:** www.aaooc.org. **Contact:** Mary Klausing, director. Estab. 1999. Fine arts & crafts festival held annually 1st weekend in June. Outdoors. Accepts photography, painting, clay, sculpture, metal, wood, fabric, glass, jewelry. Juried by a panel. Awards/prizes: cash prizes for Best of Show and category awards. Number of exhibitors: 130. Public attendance: 10,000. Free to the public. Artists should apply online with website, call or visit www.zapplication.org. Deadline for entry: April 15. Jury fee: $25. Space fee: $200. Electricity fee: $20. Exhibition space: 10×10 or 10×12 ft. For more information, artists should e-mail, visit website, call. Show located on the lawn of the Oldham County Courthouse Square.

TIPS "Make potential customers feel welcome in your space. Don't overcrowd your work. Smile!"

ARTSPLOSURE—THE RALEIGH ART FESTIVAL

313 W. Blount St., Ste 200B, Raleigh NC 27601. (919)832-8699. **Fax:** (919)832-0890. **E-mail:** info@artsplosure.org; sarah@artsplosure.org. **Website:** www.artsplosure.org. **Contact:** Sarah Wolfe, art market coordinator. Estab. 1979. Arts & craft show held annually 3rd weekend of May. Outdoors. Accepts handmade crafts, 2D/3D, glass, jewelry, ceramics, wood, metal, fiber, photography, painting. Juried. Awards/prizes: $3,500 in cash. Exhibitors: 175. Number of attendees: 75,000. Free to public. Apply via www.application.org. Deadline for entry: January 16.

TIPS "We use entrythingy.com for processing applications."

ARTSQUEST FINE ARTS FESTIVAL

Cultural Arts Alliance of Walton County, Bayou Arts Center, 105 Hogtown Bayou Lane, Santa Rosa Beach FL 32459. (850)622-5970. **E-mail:** info@culturalarts

alliance.com; jennifersmith@culturalartsalliance.com. **Website:** www.artsquestflorida.com. **Contact:** Jennifer Smith. Estab. 1988. Fine arts & crafts fair held anually in May. Outdoors. Accepts handmade crafts, ceramic, digital art, fiber, drawing, glass, jewelry, metal, 2D/3D mixed media, painting, photography, printmaking, sculpture, wood. Juried. Awards/prizes: Best in Show, Awards of Excellence, and Awards of Merit. Exhibitors: 125. Number of attendees: varies. Free to public. Apply online. Deadline for entry: February. Application fee: $40. Space fee: $300. Exhibition space: 10×10 ft. For more information, artists should send e-mail, call, or visit website.

ART UNDER THE ELMS

415 Main St., Lewiston ID 83501. (208)792-2447. **Fax:** (208)792-2850. **E-mail:** aue@lcsc.edu. **Website:** www.lcsc.edu/ce/aue/. **Contact:** Amanda Coleman. Estab. 1984. Fine arts & crafts fair held annually in April. Outdoors. Accepts handmade crafts, ceramic, digital art, fiber, drawing, furniture, glass, jewelry, metal, 2D/3D mixed media, painting, photography, prepackaged food, printmaking, wood. Juried. Awards/prizes: announced after jury. Exhibitors: 100. Number of attendees: varies. Free to public. Apply online. Deadline for entry: early January. Application fee: $20. Space fee: varies. Exhibition space: 10×10 ft. For more information, artists should send e-mail, visit website, or call.

ARTWORKS OF EAU GALLIE FINE ARTS FESTIVAL

P.O. Box 361081, Melbourne FL 32936-1081. (321) 242-1456. **E-mail:** artworksfestival@gmail.com. **Website:** www.artworksofeaugallie.org. **Contact:** Sharon Dwyer, president. Estab. 1996. Fine art & fine crafts show held annually in November the weekend before Thanksgiving. Outdoors. Accepts various medium categories: clay, digital art, drawing & pastel, fiber, glass, graphics & printing making, jewelry, leather, metal, mixed media, painting, photography, sculpture, watercolor, wood. Original artists' works only. Juried. Awards/prizes: Art Awards, Demonstrators' Awards, Sponsor Purchase Program. Number of exhibitors: 100. Public attendance: 15,000. Free to public. Artists apply online. Applications accepted beginning March 1. Deadline for entry: September 1. Application fee: $25. Space fee: $160. Exhibition space: 10×10 ft. Average gross sales/exhibitor varies. For more information, artists should visit website.

TIPS "Artists must be prepared to demonstrate their methods of work by creating works of art in their booths."

ATLANTA ARTS FESTIVAL

P.O. Box 724694, Atlanta GA 31139. (770)941-9660. **Fax:** (866)519-2918. **E-mail:** info@atlantaartsfestival.com. **Website:** www.atlantaartsfestival.com. Estab. 2006. Fine arts & crafts fair held annually in September. Outdoors. Accepts handmade crafts, ceramic, digital art, fiber, drawing, glass, jewelry, metal, 2D/3D mixed media, painting, photography, printmaking, wood. Juried. Awards/prizes: Best in Category, Best in Show. Exhibitors: 200. Number of attendees: varies. Free to public. Apply online. Deadline for entry: April. Application fee: $25. Space fee: varies. Exhibition space: 10×10 ft. For more information, artists should send e-mail, visit website or call.

BARTLETT FESTIVAL OF THE ARTS

118 W. Bartlett Ave., Suite 2, Bartlett IL 60103. (630) 372-4152. **E-mail:** art@artsinbartlett.org. **Website:** www.artsinbartlett.org. Estab. 2002. Fine arts & crafts fair held annually in June. Outdoors. Accepts handmade crafts, paintings, photography, fiber, sculpture, glass, jewelry, wood, and more. Juried. Exhibitors: see website. Number of attendees: 3,000. Free to public. Apply online. Deadline for entry: April. Application fee: see website. Space fee: $150. Exhibition space: 10×10 ft. For more information, artists should send e-mail, call, or visit website.

BAYOU CITY ART FESTIVAL

38 Charles St., Rochester NH 03867. (713)521-0133. **E-mail:** info@bayoucityartfestival.com; carrie@bayoucityartfestival.com. **Website:** www.artcolonyassociation.org/bayou-city-art-festival-memorial-park. Fine arts & crafts fair held annually in March. Outdoors. Accepts handmade crafts, ceramic, digital art, fiber, drawing, furniture, glass, jewelry, metal, 2D/3D mixed media, painting, photography, printmaking, sculpture, wood. Juried. Awards/prizes: Best of Show, 2nd place, 3rd place, Best Booth, Award of Excellence. Exhibitors: see website. Number of attendees: varies. Admission: $15 adults; $3 children 4-12; children 3 & under free. Apply online. Deadline for entry: November. Application fee: see website. Space fee: varies. Exhibition space: varies. For more information, artists should send e-mail, call, or visit website.

BEAVER CREEK ART FESTIVAL

270 Central Blvd., Suite 107B, Jupiter FL 33458. (561)746-6615. **Fax:** (561)746-6528. **E-mail:** info@artfestival.com. **Website:** www.artfestival.com. **Contact:** Malinda Ratliff, communications manager. Fine arts & crafts fair held annually in August. Outdoors. Accepts handmade crafts, clay, digital, fiber, glass, jewelry, mixed media, painting, photography, printmaking/drawing, sculpture, wood. Juried. Awards/prizes: announced after jury. Exhibitors: 150. Number of attendees: varies. Free to public. Apply online. Deadline for entry: see website. Application fee: $35. Space fee: $475. Exhibition space: 10×10 and 10×20 ft. For more information, artists should send e-mail, call, or visit website. Festival located at Beaver Creek Village in Avon, CO.

TIPS "You have to start somewhere. First, assess where you are, and what you'll need to get things off the ground. Next, make a plan of action. Outdoor street art shows are a great way to begin your career and lifetime as a working artist. You'll meet a lot of other artists who have been where you are now. Network with them!"

BEST OF THE NORTHWEST FALL ART & FINE CRAFT SHOW

Northwest Art Alliance, 7777 62nd Ave., NE, Suite 103, Seattle WA 98115. (206) 525-5926. **E-mail:** info@nwartalliance.com. **Website:** www.nwartalliance.com. Fine art & craft show held annually in October & November. Indoors. Accepts handmade crafts, ceramics, paintings, jewelry, glass, photography, wearable art, and other mediums. Juried. Number of exhibitors: 110. Number of attendees: varies. Admission: $5 online; $6 at door; children 12 & under free. Apply via www.zapplication.org. Deadline for entry: May. Application fee: $35. Space fee: varies. Exhibition space: varies. For more information, artists should call, e-mail, or visit website.

BEST OF THE NORTHWEST SPRING ART & FINE CRAFT SHOW

Northwest Art Alliance, 7777 62nd Ave., NE, Suite 103, Seattle WA 98115. (206)525-5926. **E-mail:** info@nwartalliance.com. **Website:** www.nwartalliance.com. Fine art & craft show held annually in March. Indoors. Accepts handmade crafts, ceramics, paintings, jewelry, glass, photography, wearable art, and other mediums. Juried. Number of exhibitors: 110. Number of attendees: varies. Admission: $5 online;

$6 at door; children 12 & under free. Apply via www.zapplication.org. Deadline for entry: January. Application fee: $35. Space fee: varies. Exhibition space: varies. For more information, artists should call, e-mail, or visit website.

BLACK SWAMP ARTS FESTIVAL

P.O. Box 532, Bowling Green OH 43402. **E-mail:** info@blackswamparts.org. **Website:** www.blackswamparts.org. The Black Swamp Arts Festival (BSAF), held early September, connects art and the community by presenting an annual arts festival and by promoting the arts in the Bowling Green community. Awards: Best in Show ($1,500); Best 2D ($1,000); Best 3D ($1,000); 2nd place ($750); 3rd place ($500); honorable mentions (3 awards, $200 each). Apply online at www.zapplication.org. Call, e-mail, or visit website for more information. Application fee: $35. Single booth fee: $275. Double booth fee: $550. Show located in downtown Bowling Green.

BOCA FEST

270 Central Blvd., Suite 107B, Jupiter FL 33458. (561)746-6615. **Fax:** (561)746-6528. **E-mail:** info@artfestival.com. **Website:** www.artfestival.com. **Contact:** Malinda Ratliff, communications manager. Estab. 1988. Fine art & craft fair held annually in January. Outdoors. Accepts photography, jewelry, mixed media, sculpture, wood, ceramic, glass, painting, digital, fiber, metal. Juried. Number of exhibitors: 210. Number of attendees: 80,000. Free to public. Apply online via www.zapplication.org. Deadline: see website. Application fee: $25. Space fee: $395. Exhibition space: 10×10 and 10×20 ft. For more information, artists should e-mail, call, or visit website. Festival located at The Shops at Boca Center in Boca Raton, FL.

TIPS "You have to start somewhere. First, assess where you are, and what you'll need to get things off the ground. Next, make a plan of action. Outdoor street art shows are a great way to begin your career and lifetime as a working artist. You'll meet a lot of other artists who have been where you are now. Network with them!"

BOCA RATON FINE ART SHOW

Hot Works, P.O. Box 1425, Sarasota FL 34230. 248-684-2613. **E-mail:** info@hotworks.org; patty@hotworks.org. **Website:** www.hotworks.org. **Contact:** Patty Naronzny. Estab. 2008. The annual Boca Raton Fine Art Show brings high-quality juried artists to sell

their artworks in the heart of downtown Boca Raton. "The event takes place in a premium location on Federal Highway/US-1 at Palmetto Park Road. In its 3rd year, the Boca Raton Fine Art Show was voted no. 68 in the country by *Art Fair Source Book*." All work is original and personally handmade by the artist. "We offer awards to attract the nation's best artists. Our goal is to create an atmosphere that enhances the artwork and creates a relaxing environment for art lovers." All types of disciplines for sale including sculpture, paintings, clay, glass, printmaking, fiber, wood, jewelry, photography, and more. Art show also has artist demonstrations, live entertainment, and food. Awards: 2 $500 Juror's Awards, 5 $100 Awards of Excellence. "In addition to the professional artists, as part of our commitment to bring art education into the event, there is a Budding Artists Art Competition, sponsored by the Institute for the Arts & Education, Inc., the 501(c)(3) nonprofit organization behind the event." For more information, see www.hotworks.org.

BONITA SPRINGS NATIONAL ART FESTIVAL

P.O. Box 367465, Bonita Springs FL 34136-7465. (239)992-1213. **Fax:** (239)495-3999. **E-mail:** artfest@ artinusa.com. **Website:** www.artinusa.com/bonita. **Contact:** Barry Witt, director. Fine arts & crafts fair held annually 3 times a year. Outdoors. Accepts handmade crafts, paintings, glass, jewelry, clay works, photography, sculpture, wood, and more. Juried. Awards/prizes: Best of Show, Best 2D, Best 3D, Distinction Award. Exhibitors: see website. Number of attendees: varies. Free to public. Apply online. Deadline for entry: early January. Application fee: $30. Space fee: $400. Exhibition space: 10×12 ft. For more information, artists should send e-mail, call, or visit website.

BOSTON MILLS ARTFEST

330-467-2242. **Website:** www.bmbw.com. Fine arts & crafts fair held annually in June and July. Outdoors. Accepts handmade crafts, ceramic, digital art, fiber, drawing, furniture, glass, jewelry, metal, 2D/3D mixed media, painting, photography, printmaking, wood. Juried. Awards/prizes: First in Category, Award of Excellence. Exhibitors: see website. Number of attendees: varies. Free to public. Apply online. Deadline for entry: see website. Application fee: see website. Space fee: see website. Exhibition space: see website. For more information, artists should send e-mail, call, or visit website.

BROWNWOOD PADDOCK SQUARE ART & CRAFT FESTIVAL

270 Central Blvd., Suite 107B, Jupiter FL 33458. (561)746-6615. **Fax:** (561)746-6528. **E-mail:** info@ artfestival.com. **Website:** www.artfestival.com. **Contact:** Malinda Ratliff, communications manager. Estab. 1997. Fine art & craft fair held annually in mid-April. Outdoors. Accepts photography, jewelry, mixed media, sculpture, wood, ceramic, glass, painting, digital, fiber, metal. Juried. Number of exhibitors: 205. Number of attendees: 20,000. Free to public. Apply online via www.zapplication.org or visit website for paper application. Deadline: see website. Application fee: $15. Space fee: $265. Exhibition space: 10×10 and 10×20 ft. For more information, artists should e-mail, call, or visit website. Festival located at Brownwood in The Villages, FL.

TIPS "You have to start somewhere. First, assess where you are, and what you'll need to get things off the ground. Next, make a plan of action. Outdoor street art shows are a great way to begin your career and lifetime as a working artist. You'll meet a lot of other artists who have been where you are now. Network with them!"

BRUCE MUSEUM OUTDOOR ARTS FESTIVAL

1 Museum Dr., Greenwich CT 06830-7157. (203)869-0376, ext. 336. **E-mail:** cynthiae@brucemuseum.org; sue@brucemuseum.org. **Website:** www.brucemuseum.org. **Contact:** Sue Brown Gordon, festival director. Estab. 1981. Fine arts fair held annually in October & fine crafts fair in May. Outdoors. Accepts handmade crafts, painting, sculpture, mixed media, graphics/drawing (including computer-generated works), photography. Juried. Exhibitors: see website. Number of attendees: varies. Free/$8 to public. Apply online. Deadline for entry: June for October; November for May. Application fee: $25. Space fee: $370. Exhibition space: 10×12 ft. For more information, artists should send e-mail, call, or visit website.

BUFFALO RIVER ELK FESTIVAL

Jasper AR 72641. (870)446-2455. **E-mail:** chamber@ ritternet.com. **Website:** www.theozarkmountains. com. **Contact:** Patti or Nancy, vendor coordinators. Estab. 1997. Arts & crafts show held annually in June. Outdoors. Accepts fine art & handmade crafts, photography, on-site design. Exhibitors: 60. Number of attendees: 6,000. Free to public. Artists should apply via

website. Deadline for entry: June 1. Application fee: none. Space fee: $75. Exhibition space: 10×10 ft. For more information, artists should visit website.

○ Event located on the Jasper Square.

BY HAND FINE ART & CRAFT FAIR

1 I-X Center Dr., Cleveland OH 44135. (216)265-2663. **E-mail:** rattewell@ixcenter.com. **Website:** www.clevelandbyhand.com. **Contact:** Rob Attewell, show manager. Estab. 2004. Fine arts & crafts show held annually in November. Indoors. Accepts photography, 2D, 3D, clay, digital, fiber, furniture, glass, jewelry, leather, metal, oil/acrylics, printmaking, sculpture, watercolor, wood, wearable art. Juried; group reviews applications and photos. Awards/prizes: ribbons, booths. Number of exhibitors: 150-200. Number of attendees: 20,000. Admission: free. Artists should apply via www.zapplication.org. Deadline: June 15. Application fee: $25. Space fee: $399 (8×10 ft.); $425 (10×10 ft.). Exhibition space: 10×10, 15×10, 20×10 ft. For more information, artists should e-mail or go to www.zapplication.org.

CAIN PARK ARTS FESTIVAL

City of Cleveland Heights, 40 Severance Circle, Cleveland Heights OH 44118-9988. (216)291-3669. **Fax:** (216)291-3705. **E-mail:** jhoffman@clvhts.com; arts festival@clvhts.com. **Website:** www.cainpark.com. Estab. 1976. Fine arts & crafts show held annually 2nd weekend in July (3-day event). Outdoors. Accepts photography, painting, clay, sculpture, wood, jewelry, leather, glass, ceramics, clothes and other fiber, paper, block printing. Juried by a panel of professional artists; submit digital images online or mail CD. Awards/prizes: Artist to Artist Award, $450; also Judges' Selection, Director's Choice and Artists' Award. Number of exhibitors: 150. Public attendance: 15,000. Fee for public: $5; Free on Friday. "Applications are available online at our website www.cainpark.com." Artists should apply by requesting an application by mail, visiting website to download application or by calling. Deadline for entry: early March. Application fee: $40. Space fee: $450. Exhibition space: 10×10 ft. Average gross sales/exhibitor: $4,000. For more information, artists should e-mail, call, or visit website. Show located in Cain Park.

TIPS "Have an attractive booth to display your work. Have a variety of prices. Be available to answer questions about your work."

CALABASAS FINE ARTS FESTIVAL

100 Civic Center Way, Calabasas CA 91302. (818)224-1657. **E-mail:** artscouncil@cityofcalabasas.com. **Website:** www.calabasasartscouncil.com. Estab. 1997. Fine arts & crafts show held annually in late April/early May. Outdoors. Accepts photography, painting, sculpture, jewelry, mixed media. Juried. Number of exhibitors: 150. Public attendance: 10,000+. Free to public. Application fee: $25. Artists should apply online through www.zapplication.org; must include 3 photos of work and 1 photo of booth display. For more information, artists should call, e-mail, or visit website. Show located at the Commons at Calabasas and the Calabasas Civic Center.

CAREFREE FINE ART & WINE FESTIVAL

101 Easy St., Carefree AZ 85377. (480)837-5637. **Fax:** (480)837-2355. **E-mail:** info@thunderbirdartists.com. **Website:** www.thunderbirdartists.com. **Contact:** Denise Colter, president. Estab. 1993. This award-winning, spring Carefree Fine Art & Wine Festival is produced by Thunderbird Artists, in conjunction with the Carefree/Cave Creek Chamber of Commerce and officially named a 'Signature Event' by the Town of Carefree. This nationally acclaimed fine art festival in Carefree is widely known as "a collector's paradise." Thunderbird Artists' mission is to promote fine art and fine crafts, paralleled with the ambiance of unique wines and fine music, while supporting the artists, merchants, and surrounding communities. It is the mission of Thunderbird Artists to further enhance the art culture with the local communities by producing award-winning, sophisticated fine art festivals throughout the Phoenix metro area. Thunderbird Artists has played an important role in uniting nationally recognized and award-winning artists with patrons from across the globe."

TIPS "A clean gallery-type presentation is very important."

CAROUSEL FINE CRAFT SHOW

OCA Renaissance Arts Center & Theatre, 1200 E. Center St., Kingsport TN 37660. (423)392-8414. **E-mail:** stephanos@kingsporttn.gov. **Website:** www.engagekingsport.com. **Contact:** Will Stephanos, show director. Estab. 2012. Fine art show held annually in March. Indoors. Accepts fine art & handmade crafts, photography, clay, fiber, paintings, furniture, wood, metal, jewelry, glass. Juried. Exhibitors: 38. Number of attendees: 5,000-8,000. Admission: $5 (1 day pass);

$7 (2 day pass). Artists should apply online. Deadline for entry: December 1. Application fee: none. Space fee: $250. Exhibition space: 10×10. For more information, artists should e-mail, call, or visit website.

🔊 Event held at Kingsport Farmer's Market Facility, 308 Clinchfield St.

TIPS Start with good work, photos, display, and personal connections.

🎧 CEDARHURST ART & CRAFT FAIR

P.O. Box 923, 2600 Richview Rd., Mt. Vernon IL 62864. (618)242-1236, ext. 234. **Fax:** (618)242-9530. **E-mail:** linda@cedarhurst.org; sarah@cedarhurst. org. **Website:** www.cedarhurst.org. **Contact:** Linda Wheeler, staff coordinator. Estab. 1977. Arts & crafts show held annually on the 1st weekend after Labor Day each September. Outdoors. Accepts photography, paper, glass, metal, clay, wood, leather, jewelry, fiber, baskets, 2D art. Juried. Awards/prizes: Best of most category. Number of exhibitors: 125+. Public attendance: 8,000. Public admission: $5. Artists should apply by filling out online application form. Deadline for entry: March. Application fee: $25. Exhibition space: 10×15 ft. For more information, artists should e-mail, call, or visit website.

🎧 CENTERFEST: THE ART LOVERS FESTIVAL

Durham Arts Council, 120 Morris St., Durham NC 27701. (919)560-2722. **E-mail:** centerfest@durhamarts.org. **Website:** www.centerfest.durhamarts. org. Estab. 1974. Fine arts & crafts fair held annually in September. Outdoors. Accepts handmade crafts, clay, drawing, fibers, glass, painting, photography, printmaking, wood, jewelry, mixed media, sculpture. Juried. Awards/prizes: Best in Show, 1st place, 2nd place, 3rd place. Exhibitors: 140. Number of attendees: see website. Admission: $5 donation accepted at gate. Apply online. Deadline for entry: May. Application fee: see website. Space fee: $195 (single); $390 (double). Exhibition space: 10×10 ft.(single); 10×20 ft. (double). For more information, artists should send e-mail, call, or visit website.

CENTERVILLE–WASHINGTON TOWNSHIP AMERICANA FESTIVAL

P.O. Box 41794, Centerville OH 45441-0794. (937) 433-5898. **Fax:** (937)433-5898. **E-mail:** americana festival@sbcglobal.net. **Website:** www.americana festival.org. Estab. 1972. Arts, crafts and antiques show held annually on the 4th of July, except when

the 4th falls on a Sunday and then festival is held on Monday the 5th. Festival includes entertainment, parade, food, car show and other activities. Accepts arts, crafts, antiques, photography, and all mediums. "No factory-made items accepted." Awards/prizes: 1st, 2nd, 3rd places; certificates and ribbons for most attractive displays. Number of exhibitors: 275-300. Public attendance: 75,000. Free to the public. Exhibitors should send SASE for application form, or apply online. Deadline for entry: early June (see website for details). Space fee: $40-55 site specific. Exhibition space: 12×10 ft. For more information, artists should e-mail, call or visit website. Arts & crafts booths located on N. Main St., in Benham's Grove and limited spots in the Children's Activity area.

TIPS "Moderately priced products sell best. Bring business cards and have an eye-catching display."

🎧 CHAMBER SOUTH'S ANNUAL SOUTH MIAMI ART FESTIVAL

Sunset Dr. (SW 72nd St.) from US 1 to Red Rd. (SW 57th Ave.), South Miami FL 33143. (305)661-1621. **Fax:** (305)666-0508. **E-mail:** art@chambersouth. com. **Website:** www.chambersouth.com/events/south -miami-art-festival. **Contact:** Robin Stieglitz, art festival coordinator. Estab. 1971. Annual. Fine art & craft show held the 1st weekend in November. Outdoors. Accepts 2D & 3D mixed media, ceramics, clay, digital art, glass, jewelry, metalwork, painting (oil, acrylic, watercolor), printmaking, drawing, sculpture, textiles, wood. Juried by panel of jurors who meet to review work; includes artists and board members. Cash prizes, ribbons to display during event, exemption from jury in the following year's show. Average number of exhibitors: 130. Average number of attendees: 50,000. Admission: free. Artists should apply by www.zapplication.org. Deadline: July 31. Application fee: $25. Space fee: standard, $325; corner $375. Space is 10×10 ft. (10×20 ft. also available). For more information artists should e-mail, call or visit the website.

TIPS "Good, clean displays; interact with customers without hounding."

🎧 CHARDON SQUARE ARTS FESTIVAL

Chardon Square Association, P.O. Box 1063, Chardon OH 44024. (440)285-4548. **E-mail:** sgipson@aol.com. **Website:** www.chardonsquareassociation.org. **Contact:** Mariann Goodwin and Jan Gipson. Estab. 1980. Fine arts & crafts show held annually in early August (see website for details). Outdoors. Accepts photog-

raphy, pottery, weaving, wood, paintings, jewelry. Juried. Number of exhibitors: 110. Public attendance: 4,000. Free to public. Artists can find application on website. Exhibition space: 12×12 ft. For more information, artists should call or visit website.

TIPS "Make your booth attractive; be friendly and offer quality work."

CHARLEVOIX WATERFRONT ART FAIR

P.O. Box 57, Charlevoix MI 49720. (231)547-2675. **E-mail:** cwaf14@gmail.com. **Website:** www.charlevoixwaterfrontartfair.org. "The Annual Charlevoix Waterfront Art Fair is a juried and invitational show and sale. Categories are: ceramics, glass, fiber; drawing; wood; painting; mixed media 2D and 3D; jewelry, fine and other; printmaking; photography; sculpture. To apply, each entrant must submit 4 digital images (3 images of your art work and 1 booth image) sized 1920 × 1920 pixels at 72 dpi for consideration by the jury (ZAPP images are acceptable). A non-refundable processing fee of $25, plus $15 for each additional category entered, must accompany the artist's application."

CHASTAIN PARK FESTIVAL

4469 Stella Dr., Atlanta GA 30327. (404)873-1222. **E-mail:** info@affps.com. **Website:** www.chastainparkartsfestival.com. **Contact:** Randall Fox. Estab. 2008. Arts & crafts show held annually early November. Outdoors. Accepts handmade crafts, painting, photography, sculpture, leather, metal, glass, jewelry. Juried by a panel. Awards/prizes: ribbons. Number of exhibitors: 175. Number of attendees: 45,000. Free to public. Apply online at www.zapplication.org. Deadline for entry: August 26. Application fee: $25. Space fee: $300. Exhibition space: 10×10 ft. For more information, send e-mail, or see website.

CHATSWORTH CRANBERRY FESTIVAL

P.O. Box 286, Chatsworth NJ 08019. (609)726-9237. **Fax:** (609)726-1459. **E-mail:** lgiamalis@aol.com. **Website:** www.cranfest.org. **Contact:** Lynn Giamalis. Estab. 1983. Arts & crafts show held annually in mid-October (see website for details). Outdoors. The festival is a celebration of New Jersey's cranberry harvest, the 3rd largest in the country, and offers a tribute to the Pine Barrens and local culture. Accepts photography. Juried. Number of exhibitors: 200. Public attendance: 75,000-100,000. Free to public. Artists should apply by sending SASE to above address (ap-

plication form online). Requires 3 pictures of products and 1 of display. Deadline: September 1. Space fee: $225 for 2 days. Exhibition space: 15×15 ft. For more information, artists should visit website. Show located in downtown Chatsworth.

CHUN CAPITOL HILL PEOPLE'S FAIR

1290 Williams St., Suite 102, Denver CO 80218. (303)830-1651. **Fax:** (303)830-1782. **E-mail:** andreafurness@chundenver.org. **Website:** www.peoplesfair.com; www.chundenver.org. **Contact:** Andrea Furness, assistant director. Estab. 1972. Arts & music festival held annually 1st full weekend in June. Outdoors. Accepts photography, ceramics, jewelry, paintings, wearable art, glass, sculpture, wood, paper, fiber, children's items, and more. Juried by professional artisans representing a variety of mediums and selected members of fair management. The jury process is based on originality, quality, and expression. Awards/prizes: Best of Show. Number of exhibitors: 300. Public attendance: 200,000. Free to public. Artists should apply by downloading application from website. Deadline for entry: March. Application fee: $35. Space fee: $350-400, depending on type of art. Exhibition space: 10×10 ft. For more information, artists should e-mail, visit website, or call. Festival located at Civic Center Park.

CHURCH STREET ART & CRAFT SHOW

Downtown Waynesville Association, P.O. Box 1409, Waynesville NC 28786. (828)456-3517. **E-mail:** info@downtownwaynesville.com. **Website:** www.downtownwaynesville.com. Estab. 1983. Fine arts & crafts show held annually 2nd Saturday in October. Outdoors. Accepts photography, paintings, fiber, pottery, wood, jewelry. Juried by committee: submit 4 slides or digital photos of work and 1 of booth display. Number of exhibitors: 110. Public attendance: 15,000-18,000. Free to public. Entry fee: $25. Space fee: $110 ($200 for 2 booths). Exhibition space: 10×12 ft. (option of 2 booths for 12×20 space). For more information and application, see website. Deadline: mid-August. Show located in downtown Waynesville, NC on Main St.

TIPS Recommends "quality in work and display."

CITY OF FAIRFAX FALL FESTIVAL

10455 Armstrong St., Fairfax VA 22030. (703)385-7800. **Fax:** (703)246-6321. **E-mail:** leslie.herman@fairfaxva.gov; mitzi.taylor@fairfaxva.gov. **Website:** www.fairfaxva.gov. **Contact:** Mitzi Taylor, special event coordinator. Estab. 1985. Arts & crafts festi-

val held annually the 2nd weekend in October. Outdoors. Accepts photography, jewelry, glass, pottery, clay, wood, mixed media. Juried by a panel of 5 independent jurors. Number of exhibitors: 400. Public attendance: 25,000. Free to the public. Deadline for entry: mid-March. Artists should apply by contacting Mitzi Taylor for an application. Application fee: $12. Space fee: $160 10×10 ft. For more information, artists should e-mail. Festival located in historic downtown Fairfax.

CITY OF FAIRFAX HOLIDAY CRAFT SHOW

10455 Armstrong St., Fairfax VA 22030. (703)385-1710. **Fax:** (703)246-6321. **E-mail:** katherine.maccammon@fairfaxva.gov. **Website:** www.fairfaxva.gov. **Contact:** Katherine MacCammon. Estab. 1985. Arts & crafts show held annually 3rd weekend in November. Indoors. Accepts photography, jewelry, glass, pottery, clay, wood, mixed media. Juried by a panel of 5 independent jurors. Number of exhibitors: 247. Public attendance: 5,000. Public admission: $5 for age 18 and older. $8 for 2 day pass. Artists should apply by contacting Katie MacCammon for an application. Deadline for entry: early March (see website for details). Application fee: $15. Space fee: 10×6 ft. $195; 11×9 ft. $245; 10×10 ft. $270. For more information, artists should e-mail.

CITYPLACE ART FAIR

270 Central Blvd., Suite 107B, Jupiter FL 33458. (561)746-6615. **Fax:** (561)746-6528. **E-mail:** info@artfestival.com. **Website:** www.artfestival.com. **Contact:** Malinda Ratliff, communications manager. Fine art & craft fair held annually in early March. Outdoors. Accepts photography, jewelry, mixed media, sculpture, wood, ceramic, glass, painting, digital, fiber, metal. Juried. Number of exhibitors: 200. Number of attendees: 40,000. Free to public. Apply online via www.zapplication.org. Deadline: see website. Application fee: $25. Space fee: $395. Exhibition space: 10×10 ft.and 10×20 ft. For more information, artists should e-mail, call, or visit website. Fair located in CityPlace in downtown West Palm Beach, FL.

TIPS "You have to start somewhere. First, assess where you are, and what you'll need to get things off the ground. Next, make a plan of action. Outdoor street art shows are a great way to begin your career and lifetime as a working artist. You'll meet a lot of other artists who have been where you are now. Network with them!"

COCONUT GROVE ARTS FESTIVAL

3390 Mary St., Suite 128, Coconut Grove FL 33133. (305)447-0401. **E-mail:** katrina@cgaf.com. **Website:** www.coconutgroveartsfest.com. **Contact:** Katrina Delgado. The Coconut Grove Arts Festival showcases the works of 360 internationally recognized artists who are selected from nearly 1,300 applicants. Jurors evaluate the artist's work and displays to select participants in such categories as mixed media, painting, photography, digital art, printmaking & drawing, watercolor, clay work, glass, fiber, jewelry & metalwork, sculpture, and wood.

COCONUT POINT ART FESTIVAL

270 Central Blvd., Suite 107B, Jupiter FL 33458. (561)746-6615. **Fax:** (561)746-6528. **E-mail:** info@artfestival.com. **Website:** www.artfestival.com. **Contact:** Malinda Ratliff, communications manager. Estab. 2007. Fine art & craft fair held annually in late December/early January & February. Outdoors. Accepts photography, jewelry, mixed media, sculpture, wood, ceramic, glass, painting, digital, fiber, metal. Juried. Number of exhibitors: 200-280. Number of attendees: 90,000. Free to public. Apply online via www.zapplication.org. Deadline: see website. Application fee: $25. Space fee: $395-425. Exhibition space: 10×10 ft. and 10×20 ft. For more information, artists should e-mail, call, or visit website. Festival held at Coconut Point in Estero, FL.

TIPS "You have to start somewhere. First, assess where you are, and what you'll need to get things off the ground. Next, make a plan of action. Outdoor street art shows are a great way to begin your career and lifetime as a working artist. You'll meet a lot of other artists who have been where you are now. Network with them!"

COLORADO COUNTRY CHRISTMAS GIFT SHOW

Denver Mart, 451 E. 58th Ave., Denver CO , 80216. (800)521-7469. **Fax:** (425)889-8165. **E-mail:** denver@showcase.events.org. **Website:** www.showcaseevents.org. **Contact:** Kim Peck, show manager. Estab. 2003. Annual holiday show held early November. Indoors. Accepts handmade crafts, art, photography, pottery, glass, jewelry, fiber, clothing. Juried. Exhibitors: 400. Number of attendees: 25,000. Admission: see website. Apply by e-mail, call, or website. Deadline for

entry: see website. Space fee: see website. Exhibition space: 10×10 ft. For more information e-mail, call, send SASE, or see website.

COLORSCAPE CHENANGO ARTS FESTIVAL

P.O. Box 624, Norwich NY 13815. (607)336-3378. **E-mail:** info@colorscape.org; art@colorscape.org. **Website:** www.colorscape.org. **Contact:** Peggy Finnegan, visual arts coordinator. Estab. 1995. A juried exhibition of art & fine crafts held annually the weekend after Labor Day. Outdoors. Accepts photography and all types of media. Juried. Awards/prizes: $6,000. Number of exhibitors: 120. Public attendance: 10,000-12,000. Free to public. Deadline for entry: see website for details. Application fee: $15 jury fee. Space fee: $175. Exhibition space: 12×12 ft. For more information, artists should e-mail, call, visit website or send SASE. Show located in downtown Norwich.

TIPS "Interact with your audience. Talk to them about your work and how it is created. People like to be involved in the art they buy and are more likely to buy if you involve them."

COLUMBIANA ARTIST MARKET

104 Mildred St., P.O. Box 624, Columbiana AL 35051. (205)669-0044. **E-mail:** info@shelbycountyarts council.com. **Website:** www.shelbycountyarts council.com. Member artists gather to offer their original artwork. Work available includes oil paintings, acrylic paintings, photography, jewelry, fabric arts, printmaking, pottery, and more.

CONYERS CHERRY BLOSSOM FESTIVAL

1996 Centennial Olympic Pkwy., Conyers GA 30013. (770)860-4190; (770)860-4194. **E-mail:** rebecca.hill@conyersga.com. **Website:** www.conyerscherry blossomfest.com. **Contact:** Jill Miller. Estab. 1981. Arts & crafts show held annually in late March (see website for details). Outdoors. The festival is held at the Georgia International Horse Park at the Grand Prix Plaza overlooking the Grand Prix Stadium used during the 1996 Centennial Olympic Games. Accepts photography, paintings and any other handmade or original art. Juried. Submit 5 images: 1 picture must represent your work as it is displayed; 1 must represent a workshop photo of the artist creating their work; the other 3 need to represent your items as an accurate representation in size, style, and quality of work. Number of exhibitors: 300. Public attendance: 40,000. Free to public. Space fee: $135. Exhibition space: 10×10 ft. Electricity fee: $30. Application fee: $10; apply online. For more information, artists should e-mail, call, or visit website. Show located at the Georgia International Horse Park.

CORAL SPRINGS FESTIVAL OF THE ARTS

270 Central Blvd., Suite 107B, Jupiter FL 33458. (561)746-6615. **Fax:** (561)746-6528. **E-mail:** info@art festival.com. **Website:** www.artfestival.com. **Contact:** Malinda Ratliff, communications manager. "The Coral Springs Festival of the Arts has grown considerably over the years into a 2-day celebration of arts and culture with a fine art show, contemporary craft festival, theatrical performances, and full lineup of live music. Held in conjunction with the Coral Springs Art Festival Committee and the City, this event brings 250 of the nation's best artists and crafters to south Florida. Stroll amidst life-size sculptures, spectacular paintings, one-of-a-kind jewels, photography, ceramics, a separate craft festival, Green Market, and much more. No matter what you're looking for, you'll be sure to find it among the array of various artists and crafters participating in this arts and crafts fair."

TIPS "You have to start somewhere. First, assess where you are, and what you'll need to get things off the ground. Next, make a plan of action. Outdoor street art shows are a great way to begin your career and lifetime as a working artist. You'll meet a lot of other artists who have been where you are now. Network with them!"

COTTONWOOD ART FESTIVAL

2100 E. Campbell Rd. Suite 100, Richardson TX 75081. (972)744-458. **E-mail:** serri.ayers@cor.gov. **Website:** www.cottonwoodartfestival.com. **Contact:** Serri Ayers. The semiannual Cottonwood Art Festival is a juried show. Jurors have selected over 240 artists from 800 submissions to exhibit their museum-quality work at the festival. The artists compete in 14 categories: 2D mixed media, 3D mixed media, ceramics, digital, drawings/pastels, fiber, glass, jewelry, leather, metalwork, painting, photography, sculpture, and wood. Rated as 1 of the top art festivals in the United States, the prestigious show is the premier fine art event in north Texas.

CRAFT FAIR AT THE BAY

38 Charles St., Rochester NH 03867. (603)332-2616. **Fax:** (603)332-8413. **E-mail:** info@castleberryfairs. com. **Website:** www.castleberryfairs.com. Estab. 1988. Arts & crafts show held annually in July in Alton Bay NH. Outdoors. Accepts photography and all other mediums. Juried by photo, slide, or sample. Number of exhibitors: 85. Public attendance: 7,500. Free to the public. Artists should apply by downloading application from website. Deadline for entry: until full. Exhibition space: 100 sq. ft. For more information, artists should visit, call, e-mail, or visit website.

TIPS "Do not bring a book; do not bring a chair. Smile and make eye contact with everyone who enters your booth. Have them sign your guest book; get their e-mail address so you can let them know when you are in the area again. And, finally, make the sale—they are at the fair to shop, after all."

CRAFTS AT PURCHASE

P.O. Box 28, Woodstock NY 12498. (845)331-7900. **Fax:** (845)331-7484. **E-mail:** crafts@artrider.com. **Website:** www.artrider.com. **Contact:** Laura Kandel, assistant director. Estab. 2012. Boutique show of fine contemporary craft held annually in late October or early November. Indoors. Accepts photography, fine art, ceramics, wood, mixed media, leather, glass, metal, fiber, jewelry. Juried. Submit 5 images of work and 1 of booth. Exhibitors: 100. Attendance: 3,500. Admission: $10. Artists should apply online at www.artrider. com or www.zapplication.org. Deadline for entry: end of May. Application fee: $45. Space fee: $545. Exhibition space: 10×10 ft. For more information, artists should e-mail, call, or visit website.

CRAFTWESTPORT

P.O. Box 28, Woodstock NY 12498. (845)331-7484. **Fax:** (845)331-7484. **E-mail:** crafts@artrider.com. **Website:** www.artrider.com. Estab. 1975. Fine arts & craft show held annually in the 3rd weekend before Thanksgiving. Indoors. Accepts photography, wearable and nonwearable fiber, jewelry, clay, leather, wood, glass, painting, drawing, prints, mixed media. Juried by 5 images of work and 1 of booth, viewed sequentially. Number of exhibitors: 160. Public attendance: 5,000. Public admission: $10. Artists should apply online at www.artrider.com or at www.zapplication.org. Deadline for entry: end of May. Application fee: $45. Space fee: $525. Exhibition space: 10×10

ft. For more information, artists should e-mail, call, or visit website.

CROCKER PARK FINE ART FAIR WITH CRAFT MARKETPLACE

270 Central Blvd., Suite 107B, Jupiter FL 33458. (561)746-6615. **Fax:** (561)746-6528. **E-mail:** info@ artfestival.com. **Website:** www.artfestival.com. **Contact:** Malinda Ratliff, communications manager. Estab. 2006. Fine art & craft fair held annually in mid-June. Outdoors. Accepts photography, jewelry, mixed media, sculpture, wood, ceramic, glass, painting, digital, fiber, metal. Juried. Number of exhibitors: 125. Number of attendees: 50,000. Free to public. Apply online via www.zapplication.org. Deadline: see website. Application fee: $25. Space fee: $395. Exhibition space: 10×10 and 10×20 ft. For more information, artists should e-mail, call, or visit website. Fair located in Crocker Park in Westlake/Cleveland, OH.

TIPS "You have to start somewhere. First, assess where you are, and what you'll need to get things off the ground. Next, make a plan of action. Outdoor street art shows are a great way to begin your career and lifetime as a working artist. You'll meet a lot of other artists who have been where you are now. Network with them!"

CUSTER FAIR

Piccolo Theatre, inc., P.O. Box 6013, Evanston IL 60204. (847)328-2204. **E-mail:** office@custerfair.com. **Website:** www.custerfair.com. **Contact:** Amanda Kulczewski. Estab. 1972. Outdoor fine art craft show held in June. Accepts photography and all mediums. Number of exhibitors: 400. Public attendance: 60,000. Free to the public. Application fee: $10. Booth fee: $250-400. Space fee varies, e-mail, call, or visit website for more details.

TIPS "Turn your hobbies into profits! Be prepared to speak with patrons; invite them to look at your work and broaden your patron base!"

A DAY IN TOWNE

Boalsburg Village Conservancy, 230 W. Main St., Boalsburg PA 16827. (814)466 7813. **E-mail:** mgjohn@ comcast.net; fisherjeff13@gmail.com. **Website:** www. boalsburgvillage.com. fisherjeff13@gmail.com. **Contact:** John Wainright; Jeff Fisher. Estab. 1976. Arts & crafts show held annually on Memorial Day, the last Monday in May. Outdoors. Accepts photography, clothes, wood, wool knit, soap, jewelry, dried flow-

ers, children's toys, pottery, blown glass, other crafts. Vendors must make their own work. Number of exhibitors: 125-135. Public attendance: 20,000+. Artists should apply by sending an e-mail message to the above e-mail address. Deadline for application is Feb. 1 each year. Space fee: $75. Exhibition space: 10×15 ft.

TIPS "Please do not send fees until you receive an official contract. Have a neat booth and nice smile. Have fair prices—if too high, product will not sell here."

DEERFIELD FINE ARTS FESTIVAL

3417 R.F.D., Long Grove IL 60047. (847)726-8669. **E-mail:** dwevents@comcast.net. **Website:** www.dwevents.org. **Contact:** D&W Events, Inc. Estab. 2003. Fine art show held annually end of May/beginning of June. Outdoors. Accepts photography, fiber, oil, acrylic, watercolor, mixed media, jewelry, sculpture, metal, paper, ceramics, painting. Juried by 3 jurors. Awards/prizes: Best of Show; 1st place, awards of excellence. Number of exhibitors: 120-150. Public attendance: 20,000. Free to public. Free parking. Artists should apply via www.zapplication.com or our promoter website: www.dwevents.org. Exhibition space: 100 sq. ft. For more information artists should e-mail, call, or visit website. Show located at Park Avenue and Deerfield Road adjacent to Jewett Park in Deerfield IL.

TIPS "Artists should display professionally and attractively, and interact positively with everyone."

DELAWARE ARTS FESTIVAL

P.O. Box 589, Delaware OH 43015. **E-mail:** info@delawareartsfestival.org. **Website:** www.delawareartsfestival.org. Estab. 1973. Fine arts & crafts show held annually the Saturday and Sunday after Mother's Day. Outdoors. Accepts photography; all mediums, but no buy/sell. Juried by category panels who are also artists. Awards/prizes: Ribbons, cash awards, free booth for Best of Show the following year. Number of exhibitors: 160. Public attendance: 50,000. Free to the public. Submit 3 photographs per category that best represent your work. Your work will be juried in accordance with our guidelines. Photos (no slides) will be returned only if you provide a SASE. Artists should apply by visiting website for application. Jury fee: $10 per category, payable to the Delaware Arts Festival. Space fee: $140. Exhibition space: 120 sq. ft. For more information, artists should e-mail or visit website. Show located in historic downtown Delaware OH, just 2 blocks from the heart of Ohio Wesleyan University Campus.

TIPS "Have high-quality, original stuff. Engage the public. Applications will be screened according to originality, technique, craftsmanship, and design. Unaffiliated professional judges are hired to make all prize award decisions. The Delaware Arts Festival, Inc. will exercise the right to reject items during the show that are not the quality of the media submitted with the applications. No commercial buy and resell merchandise permitted. Set up a good booth."

DELRAY MARKETPLACE ART & CRAFT FESTIVAL

270 Central Blvd., Suite 107B, Jupiter FL 33458. (561)746-6615. **Fax:** (561)746-6528. **E-mail:** info@artfestival.com. **Website:** www.artfestival.com. **Contact:** Malinda Ratliff, communications manager. Estab. 2013. Fine art & craft fair held annually in November. Outdoors. Accepts photography, jewelry, mixed media, sculpture, wood, ceramic, glass, painting, digital, fiber, metal. Juried. Number of exhibitors: 100. Number of attendees: 40,000. Free to public. Apply online via www.zapplication.org. Deadline: see website. Application fee: $25. Space fee: $350. Exhibition space: 10×10 and 10×20 ft. For more information, artists should e-mail, call, or visit website. Festival located at Delray Marketplace off West Atlantic Ave. in Delray Beach, FL.

TIPS "You have to start somewhere. First, assess where you are, and what you'll need to get things off the ground. Next, make a plan of action. Outdoor street art shows are a great way to begin your career and lifetime as a working artist. You'll meet a lot of other artists who have been where you are now. Network with them!"

DICKENS CHRISTMAS SHOW & FESTIVAL

2101 N. Oak St., Myrtle Beach SC 29577. (843)448-9483. **Fax:** (843)626-1513. **E-mail:** dickensshow@sc.rr.com. **Website:** www.dickenschristmasshow.com. **Contact:** Samantha Bower, manager. Estab. 1981. Annual arts & crafts, seasonal/holiday show held in November. Indoors. Accepts all fine art. Average number of exhibitors: 350. Average number of attendees: 16,000. Admission: $8.50 (plus tax). Artists should apply by application. Deadline: see website. Space fee: $300-800. Space is 10×10 ft. For more information artists should e-mail, call, or visit the website. Show held at Myrtle Beach Convention Center.

TIPS "Make sure your products are good and your display is good."

DOLLAR BANK THREE RIVERS ARTS FESTIVAL

803 Liberty Ave., Pittsburgh PA 15222. (412)471-6070. **E-mail:** trafmarket@trustarts.org. **Website:** www.trustarts.org/traf. **Contact:** Melissa Franko, artist market manager. Estab. 1960. Fine art show held annually in June. Outdoors. Accepts fine art & handmade crafts, photography, clay, ceramics, fiber, paintings, furniture, wood, metal, leather, mixed media, jewelry, glass, sculpture, drawing, digital art, printmaking. Juried. Awards/prizes: $10,000 in awards/prizes given away. Exhibitors: 360. Number of attendees: 600,000. Free to public. Artists should apply via www.zapplication.org. Deadline for entry: February 1. Application fee: $35. Space fee: $360-485. Exhibition space: 10×10 ft. For more information, artists should visit website.

Event located at Gateway Center, Pittsburgh PA

TIPS "The only way to participate is to apply!"

ALDEN B. DOW MUSEUM SUMMER ART FAIR

Alden B. Dow Museum of Science & Art, Midland Center for the Arts, 1801 W. St. Andrews Rd., Midland MI 48640. **Fax:** (989)631-7890. **E-mail:** mills@mcfta.org. **Website:** www.mcfta.org. **Contact:** Emmy Mills, executive assistant/special events manager. Estab. 1966. Fine art & crafts show held annually in early June. Outdoors. Accepts photography, ceramics, fibers, jewelry, mixed media 3D, painting, wood, drawing, glass, leather, sculpture, basket, furniture. Juried by a panel. Awards: $1,000 1st place, $750 2nd place, $500 3rd place. Average number of exhibitors: 150. Public attendance: 5,000-8,000. Free to public. Artists should apply at www.mcfta.org/specialevents.html. Deadline for entry: late March; see website for details. Application fee: jury $35, second medium $5/each. Space fee: $195/single booth, $365/double booth. Exhibition space: approximately 12×12 ft. Average gross sales/exhibitor: $1,500. Artists should e-mail or visit website for more information. Event takes place at Midland Center for the Arts.

DOWNTOWN ASPEN ART FESTIVAL

270 Central Blvd., Suite 107B, Jupiter FL 33458. (561)746-6615. **Fax:** (561)746-6528. **E-mail:** info@art-festival.com. **Website:** www.artfestival.com. **Contact:** Malinda Ratliff, communications manager. Estab. 2003. Fine art & craft fair held annually in July. Outdoors. Accepts photography, jewelry, mixed media, sculpture, wood, ceramic, glass, painting, digital, fiber, metal. Juried. Number of exhibitors: 150. Number of attendees: 80,000. Free to public. Apply online via www.wzapplication.org. Deadline: see website. Application fee: $35. Space fee: $475. Exhibition space: 10×10 and 10×20 ft. For more information, artists should e-mail, call, or visit website. Festival located at Monarch Street in Aspen, CO.

TIPS "You have to start somewhere. First, assess where you are, and what you'll need to get things off the ground. Next, make a plan of action. Outdoor street art shows are a great way to begin your career and lifetime as a working artist. You'll meet a lot of other artists who have been where you are now. Network with them!"

DOWNTOWN DELRAY BEACH FESTIVAL OF THE ARTS

270 Central Blvd., Suite 107B, Jupiter FL 33458. (561)746-6615. **Fax:** (561)746-6528. **E-mail:** info@art-festival.com. **Website:** www.artfestival.com. **Contact:** Malinda Ratliff, communications manager. Estab. 2000. Fine art & craft fair held annually in mid-January. Outdoors. Accepts photography, jewelry, mixed media, sculpture, wood, ceramic, glass, painting, digital, fiber, metal. Juried. Number of exhibitors: 305. Number of attendees: 100,000. Free to public. Apply online via www.zapplication.org. Deadline: see website. Application fee: $25. Space fee: $395. Exhibition space: 10×10 and 10×20 ft. For more information, artists should e-mail, call, or visit website. Festival located at Atlantic Ave. in downtown Delray Beach, FL.

TIPS "You have to start somewhere. First, assess where you are, and what you'll need to get things off the ground. Next, make a plan of action. Outdoor street art shows are a great way to begin your career and lifetime as a working artist. You'll meet a lot of other artists who have been where you are now. Network with them!"

DOWNTOWN DELRAY BEACH THANKSGIVING WEEKEND ART FESTIVAL

270 Central Blvd., Suite 107B, Jupiter FL 33458. (561)746-6615. **Fax:** (561)746-6528. **E-mail:** info@artfestival.com. **Website:** www.artfestival.com. **Contact:** Malinda Ratliff, communications manager. Estab. 2000. Fine art & craft fair held annually in November. Outdoors. Accepts photography, jewelry, mixed media, sculpture, wood, ceramic, glass, painting, digital, fiber, metal. Juried. Number of exhibitors:

150. Number of attendees: 80,000. Free to public. Apply online via www.zapplication.org. Deadline: see website. Application fee: $25. Space fee: $395. Exhibition space: 10×10 and 10×20 ft. For more information, artists should e-mail, call, or visit website. Festival located at 4th Ave. & Atlantic Ave. in downtown Delray Beach FL.

TIPS "You have to start somewhere. First, assess where you are, and what you'll need to get things off the ground. Next, make a plan of action. Outdoor street art shows are a great way to begin your career and lifetime as a working artist. You'll meet a lot of other artists who have been where you are now. Network with them!"

DOWNTOWN DUNEDIN ART FESTIVAL

270 Central Blvd., Suite 107B, Jupiter FL 33458. (561)746-6615. **Fax:** (561)746-6528. **E-mail:** info@artfestival.com. **Website:** www.artfestival.com. **Contact:** Malinda Ratliff, communications manager. Estab. 1997. Fine art & craft fair held annually in January. Outdoors. Accepts photography, jewelry, mixed media, sculpture, wood, ceramic, glass, painting, digital, fiber, metal. Juried. Number of exhibitors: 130. Number of attendees: 40,000. Free to public. Apply online via www.zapplication.org. Deadline: see website. Application fee: $25. Space fee: $395. Exhibition space: 10×10 and 10×20 ft. For more information, artists should e-mail, call, or visit website. Festival located at Main St. in downtown Dunedin, FL.

TIPS "You have to start somewhere. First, assess where you are, and what you'll need to get things off the ground. Next, make a plan of action. Outdoor street art shows are a great way to begin your career and lifetime as a working artist. You'll meet a lot of other artists who have been where you are now. Network with them!"

DOWNTOWN FESTIVAL & ART SHOW

City of Gainesville, P.O. Box 490, Gainesville FL 32627. (352)393-8536. **Fax:** (352)334-2249. **E-mail:** piperlr@cityofgainesville.org. **Website:** www.gainesville-downtownartfest.org. **Contact:** Linda Piper, events coordinator. Estab. 1981. Fine arts & crafts show held annually in November (see website for more details). Outdoors. Accepts photography, wood, ceramic, fiber, glass, and all mediums. Juried by 3 digital images of artwork and 1 digital image of booth. Awards/prizes: $20,000 in cash awards; $2,000 in purchase awards. Number of exhibitors: 240. Public attendance:

100,000. Free to the public. Artists should apply by mailing 4 digital images. Deadline for entry: May. Space fee: $285, competitive, $260 non-competitive. Exhibition space: 12×12 ft. Average gross sales/exhibitor: $6,000. For more information, artists should e-mail, visit website, call.

TIPS "Submit the highest quality digital images. A proper booth image is very important."

DOWNTOWN SARASOTA CRAFT FAIR

270 Central Blvd., Suite 107B, Jupiter FL 33458. (561)746-6615. **Fax:** (561)746-6528. **E-mail:** info@artfestival.com. **Website:** www.artfestival.com. **Contact:** Malinda Ratliff, communications manager. "This popular annual craft festival has garnered crowds of fine craft lovers each year. Behold contemporary crafts from more than 100 of the nation's most talented artisans. A variety of jewelry, pottery, ceramics, photography, painting, clothing, and much more—all handmade in America—will be on display, ranging from $15 to $3,000. An expansive Green Market with plants, orchids, exotic flora, handmade soaps, gourmet spices, and freshly popped kettle corn further complements the weekend, blending nature with nurture."

TIPS "You have to start somewhere. First, assess where you are, and what you'll need to get things off the ground. Next, make a plan of action. Outdoor street art shows are a great way to begin your career and lifetime as a working artist. You'll meet a lot of other artists who have been where you are now. Network with them!"

DOWNTOWN SARASOTA FESTIVAL OF THE ARTS

270 Central Blvd., Suite 107B, Jupiter FL 33458. (561)746-6615. **Fax:** (561)746-6528. **E-mail:** info@artfestival.com. **Website:** www.artfestival.com. **Contact:** Malinda Ratliff, communications manager. Fine art & craft fair held annually in mid-February. Outdoors. Accepts photography, jewelry, mixed media, sculpture, wood, ceramic, glass, painting, digital, fiber, metal. Juried. Number of exhibitors: 305. Number of attendees: 80,000. Free to public. Apply online via zapplication.org. Deadline: see website. Application fee: $25. Space fee: $395. Exhibition space: 10×10 and 10×20 ft. For more information, artists should e-mail, call, or visit website. Festival located at Main St. at Orange Ave. heading east and ending at Links Ave. in downtown Sarasota, FL.

TIPS "You have to start somewhere. First, assess where you are, and what you'll need to get things off the ground. Next, make a plan of action. Outdoor street art shows are a great way to begin your career and lifetime as a working artist. You'll meet a lot of other artists who have been where you are now. Network with them!"

● DOWNTOWN STEAMBOAT SPRINGS ART FESTIVAL ON YAMPA STREET, THE YAMPA ART STROLL

270 Central Blvd., Suite 107B, Jupiter FL 33458. (561)746-6615. **Fax:** (561)746-6528. **E-mail:** info@ artfestival.com. **Website:** www.artfestival.com. **Contact:** Malinda Ratliff, communications manager. Estab. 2015. Fine art & craft fair held annually in August. Outdoors. Accepts photography, jewelry, mixed media, sculpture, wood, ceramic, glass, painting, digital, fiber, metal. Juried. Number of exhibitors: see website. Number of attendees: see website. Free to public. Apply online via www.zapplication.org. Deadline: see website. Application fee: $35. Space fee: $350. Exhibition space: 10×10 and 10×20 ft. For more information, artists should e-mail, call, or visit website. Festival located at Yampa Ave. in Steamboat Springs, CO.

TIPS "You have to start somewhere. First, assess where you are, and what you'll need to get things off the ground. Next, make a plan of action. Outdoor street art shows are a great way to begin your career and lifetime as a working artist. You'll meet a lot of other artists who have been where you are now. Network with them!"

● DOWNTOWN STUART ART FESTIVAL

270 Central Blvd., Suite 107B, Jupiter FL 33458. (561)746-6615. **Fax:** (561)746-6528. **E-mail:** info@artfestival.com. **Website:** www.artfestival.com. **Contact:** Malinda Ratliff, communications manager. Estab. 1991. Fine art & craft fair held annually in February. Outdoors. Accepts photography, jewelry, mixed media, sculpture, wood, ceramic, glass, painting, digital, fiber, metal. Juried. Number of exhibitors: 200. Number of attendees: 50,000. Free to public. Apply online via www.zapplication.org. Deadline: see website. Application fee: $25. Space fee: $395. Exhibition space: 10×10 and 10×20 ft. For more information, artists should e-mail, call, or visit website. Festival located at Osceola St. in Stuart, FL.

TIPS "You have to start somewhere. First, assess where you are, and what you'll need to get things off

the ground. Next, make a plan of action. Outdoor street art shows are a great way to begin your career and lifetime as a working artist. You'll meet a lot of other artists who have been where you are now. Network with them!"

● DOWNTOWN VENICE ART FESTIVAL

270 Central Blvd., Suite 107B, Jupiter FL 33458. (561)746-6615. **Fax:** (561)746-6528. **E-mail:** info@ artfestival.com. **Website:** www.artfestival.com. **Contact:** Malinda Ratliff, communications manager. Estab. 1987. Fine art & craft fair held semiannually in early March & mid-November. Outdoors. Accepts photography, jewelry, mixed media, sculpture, wood, ceramic, glass, painting, digital, fiber, metal. Juried. Number of exhibitors: 130-200. Number of attendees: 50,000. Free to public. Apply online via www.zapplication.org. Deadline: see website. Application fee: $25. Space fee: $350-395. Exhibition space: 10×10 and 10×20 ft. For more information, artists should e-mail, call, or visit website. Festival located at W. Venice Ave. in downtown Venice, FL.

TIPS "You have to start somewhere. First, assess where you are, and what you'll need to get things off the ground. Next, make a plan of action. Outdoor street art shows are a great way to begin your career and lifetime as a working artist. You'll meet a lot of other artists who have been where you are now. Network with them!"

● EDINA ART FAIR

(952)922-1524. **Fax:** (952)922-4413. **E-mail:** info@50thandfrance.com. **Website:** www.edinaartfair.com. Fine arts & crafts fair held annually in June. Outdoors. Accepts handmade crafts, ceramics, enamel, fiber, glass, jewelry, mixed media, photography, sculpture, wearable art, wood. Juried. Awards/prizes: Best of Show, Best Display, awards of excellence, merit awards. Number of exhibitors: 300. Number of attendees: 165,000. Free to public. Apply online. Deadline for entry: February. Application fee: $35. Space fee: $425 (single); $850 (double). Exhibition space: 10×10 ft. (single); 10×20 ft. (double). For more information, artists should visit website or call.

EL DORADO COUNTY FAIR

100 Placerville Dr., Placerville CA 95667. (530)621-5860. **Fax:** (530)295-2566. **E-mail:** fair@eldorado countyfair.org. **Website:** www.eldoradocountyfair. org. Estab. 1859. County fair held annually in June. In-

doors. Accepts photography, fine arts, and handicrafts. Awards/prizes given, see entry guide on website for details. Number of exhibitors: 350-450. Average number of attendees: 55,000. Admission fee: $9. Deadline: mid-May. Application fee: varies by class, see entry guide. For more information, visit website. Fair held at El Dorado County Fairgrounds in Placerville CA.

TIPS "Not a lot of selling at fair shows, competition mostly."

ELMWOOD AVENUE FESTIVAL OF THE ARTS, INC.

P.O. Box 786, Buffalo NY 14213-0786. (716)830-2484. **E-mail:** directoreafa@aol.com. **Website:** www.elmwoodartfest.org. Estab. 2000. Arts & crafts show held annually in late August, the weekend before Labor Day weekend. Outdoors. Accepts photography, metal, fiber, ceramics, glass, wood, jewelry, basketry, 2D media. Juried. Awards/prizes: to be determined. Number of exhibitors: 170. Public attendance: 80,000-120,000. Free to the public. Artists should apply by e-mailing their contact information or by downloading application from website. Deadline for entry: April. Application fee: $25. Space fee: $295. Exhibition space: 10×15 ft. Average gross sales/exhibitor: $3,000. For more information, artists should e-mail, call, or visit website. Show located on Elmwood Ave.

TIPS "Make sure your display is well designed, with clean lines that highlight your work. Have a variety of price points—even wealthy people don't always want to spend $500 at a booth where they may like the work."

ESTERO FINE ART SHOW

Hot Works, LLC, Miromar Outlets, 10801 Corkscrew Rd., Estero FL 33928. (941)755-3088. **E-mail:** patty@hotworks.org. **Website:** www.hotworks.org. **Contact:** Patty Narozny, executive director. Estab. 2008. Biannual fine art show held for 2 days in early January and early November. Outdoors. "This event showcases artists from around the globe. Art includes glass, clay, wood, fiber, jewelry, sculpture, painting, photography, and metal. There is artwork for every budget. Focus is on technique/execution, quality, and originality." Juried by art professionals in the industry. 3 images of work, 1 of booth. Awards: $1,500 distributed as follows: 2 $500 Juror's Award of Excellence (purchase awards) and 5 $100 Awards of Excellence. Number of exhibitors: 110. Average number of attendees: 10,000. Free admission and free parking. Application fee: $30.

Space fee: $385. Space: 11×11 ft. For more information, artists should e-mail, call, see website, or visit www.zapplication.org for details.

Show located at Miromar Design Center, 10800 Corkscrew Road, Estero FL 33928.

TIPS "Bring enough work to sell that people want to see—original work! Stay positive."

FAIRE ON THE SQUARE

117 W. Goodwin St., Prescott AZ 86303. (928)445-2000, ext. 112. **Fax:** (928)445-0068. **E-mail:** scott@prescott.org. **Website:** www.prescott.org. Estab. 1985. Arts & crafts show held annually Labor Day weekend. Outdoors. Accepts photography, ceramics, painting, sculpture, clothing, woodworking, metal art, glass, floral, home décor. No resale. Juried. Photos of work and artist creating work are required. Number of exhibitors: 160. Public attendance: 6,000-7,000. Free to public. Application can be printed from website or obtained by phone request. Deadline: spaces are sold until show is full. Exhibition space: $425; $460 for food booth; 10×15 ft. For more information, artist should e-mail, visit website, or call.

A FAIR IN THE PARK

6300 Fifth Ave., Pittsburgh PA 15232. **E-mail:** fairdirector@craftsmensguild.org. **Website:** www.afairinthepark.org. Estab. 1969. Contemporary fine arts & crafts show held annually the weekend after Labor Day outdoors. Accepts photography, clay, fiber, jewelry, metal, mixed media, wood, glass, 2D visual arts. Juried. Awards/prizes: 1 Best of Show and 4 Craftsmen's Guild Awards. Number of exhibitors: 105. Public attendance: 25,000+. Free to public. Submit 5 JPEG images; 4 of artwork, 1 of booth display. Application fee: $25. Booth fee: $350 or $400 for corner booth. Deadline for entry: see website. Exhibition space: 10×10 ft. Average gross sales/exhibitor: $1,000 and up. For more information artists should e-mail or visit website. Show located in Mellon Park.

TIPS "It is very important for artists to present their work to the public, to concentrate on the business aspect of their artist career. They will find that they can build a strong customer/collector base by exhibiting their work and by educating the public about their artistic process and passion for creativity."

FALL CRAFTS AT LYNDHURST

P.O. Box 28, Woodstock NY 12498. (845)331-7900. **Fax:** (845)331-7484. **E-mail:** crafts@artrider.com.

Website: www.artrider.com. Estab. 1984. Fine arts & crafts show held annually in early to mid September. Outdoors. Accepts photography, wearable and nonwearable fiber, jewelry, clay, leather, wood, glass, painting, drawing, prints, mixed media. Juried by 5 images of work and 1 of booth, viewed sequentially. Number of exhibitors: 275. Attendance: 14,000. Admission: $10. Artists should apply at www.artrider.com or www.zapplication.org. Deadline for entry: end of May. Application fee: $45. Space fee: $795-895. Exhibition space: 10×10 ft. For more information, artists should e-mail, call, or visit website.

🎧 FALL FEST IN THE PARK

117 W. Goodwin St., Prescott AZ 86303. (928)445-2000 or (800)266-7534. **E-mail:** chamber@prescott.org; scott@prescott.org. **Website:** www.prescott.org. Estab. 1981. Arts & crafts show held annually in mid-October. Outdoors. Accepts photography, ceramics, painting, sculpture, clothing, woodworking, metal art, glass, floral, home décor. No resale. Juried. Photos of work, booth, and artist creating work are required. Number of exhibitors: 150. Public attendance: 6,000-7,000. Free to public. Application can be printed from website or obtained by phone request. Deposit: $50, nonrefundable. Electricity is limited and has a fee of $15. Deadline: Spaces are sold until show is full. Exhibition space: $250; $275 for food booth; 10×15 ft. For more information, artists should e-mail, call, or visit website.

🎧 FALL FESTIVAL OF ART AT QUEENY PARK

P.O. Box 31265, St. Louis MO 63131. (314)889-0433. **E-mail:** info@gslaa.org. **Website:** artfairatqueenypark.com. Estab. 1976. Fine arts & crafts show held annually Labor Day weekend at Queeny Park. Indoors. Accepts photography, all fine art and fine craft categories. Juried by 4 jurors; 5 slides shown simultaneously. Awards/prizes: 3 levels, ribbons, $4,000+ total prizes. Number of exhibitors: 130-140. Public attendance: 4,000-6,000. Admission: $5. Artists should apply online. Application fee: $25. Booth fee: $225; $250 for corner booth. Deadline for entry: mid-June, see website for specific date. Exhibition space: 80 sq. ft. (8×10) For more information, artists should e-mail or visit website.

TIPS "Excellent, professional slides; neat, interesting booth. But most important—exciting, vibrant, eye-catching artwork."

🎧 FALL FESTIVAL ON PONCE

Olmstead Park, North Druid Hills, 1451 Ponce de Leon, Atlanta GA 30307. (404)873-1222. **E-mail:** lisa@affps.com. **Website:** www.festivalonponce.com. **Contact:** Lisa Windle, festival director. Estab. 2010. Arts & crafts show held annually mid-October. Outdoors. Accepts handmade crafts, painting, photography, sculpture, leather, metal, glass, jewelry. Juried by a panel. Awards/prizes: ribbons. Number of exhibitors: 125. Number of attendees: 45,000. Free to public. Apply online at www.zapplication.org. Application fee: $25. Space fee: $275. Exhibition space: 10×10 ft. For more information, e-mail, or see website.

🎧 FALL FINE ART & CRAFTS AT BROOKDALE PARK

Rose Squared Productions, Inc., 473 Watchung Ave., Bloomfield NJ 07003. (908)874-5247. **Fax:** (908)874-7098. **E-mail:** info@rosesquared.com. **Website:** www.rosesquared.com. **Contact:** Howard Rose, vice president. Estab. 1998. Fine arts & crafts show held annually in mid-October. Outdoors. Accepts photography and all other mediums. Juried. Number of exhibitors: 160. Public attendance: 12,000. Free to public. Artists should apply on the website. Deadline for entry: mid-September. Application fee: $30. Space fee: varies by booth size. Exhibitor space: 120 sq. ft. See application form on website for details. For more information, artists should visit the website. Promoters of fine art and craft shows that are successful for the exhibitors and enjoyable, tantalizing, satisfying artistic buying experiences for the supportive public.

TIPS "Have a range of products and prices."

🎧 FESTIVAL FETE

P.O. Box 2552, Newport RI 2840. (401)207-9729. **E-mail:** pilar@festivalfete.com. **Website:** www.festivalfete.com. Fine arts & crafts fair held annually in July. Outdoors. Accepts handmade crafts, painting, sculpture, photography, drawing, fabric, crafts, ceramics, glass, and jewelry. Juried. Awards/prizes: see website. Number of exhibitors: 150. Number of attendees: varies. Free to public. Apply online. Deadline for entry: see website. Application fee: see website. Space fee: $175. Exhibition space: 10×10 ft. For more information, artists should e-mail, call or visit website.

🎧 FIESTA ARTS FAIR

Southwest School of Art, 300 Augusta St., San Antonio TX 78205. (210)224-1848. **Fax:** (210)224-9337.

Website: www.swschool.org/fiestaartsfair. Art & craft market/show held annually in April. Outdoors. Accepts handmade crafts, ceramics, paintings, jewelry, glass, photography, wearable art, and other mediums. Juried. Number of exhibitors: 125. Number of attendees: 12,000. Admission: $16 weekend pass; $10 daily adult pass; $5 daily children pass; children 5 & under free. Apply via www.zapplication.org. Deadline for entry: November. Application fee: none. Space fee: varies. Exhibition space: varies. For more information, artists should call or visit website.

☻ FILLMORE JAZZ FESTIVAL

Steven Restivo Event Services, LLC, P.O. Box 151017, San Rafael CA 94915. (800)310-6563. **Fax:** (415)456-6436. **Website:** www.fillmorejazzfestival.com. Estab. 1984. Fine arts & crafts show and jazz festival held annually 1st weekend of July in San Francisco, between Jackson & Eddy Streets. Outdoors. Accepts photography, ceramics, glass, jewelry, paintings, sculpture, metal clay, wood, clothing. Juried by prescreened panel. Number of exhibitors: 250. Public attendance: 100,000. Free to public. Deadline for entry: ongoing; apply online. Exhibition space: 8×10 ft. or 10×10 ft. Average gross sales/exhibitor: $800-11,000. For more information, artists should visit website or call.

☻ FINE ART & CRAFTS AT VERONA PARK

Rose Squared Productions, Inc., 542 Bloomfield Ave., Verona NJ 07044, United States. (908)874-5247. **Fax:** (908)874-7098. **E-mail:** info@rosesquared.com. **Website:** www.rosesquared.com. **Contact:** Howard Rose, vice president. Estab. 1986. Fine arts & crafts show held annually in mid-May. Outdoors. Accepts photography and all other mediums. Juried. Number of exhibitors: 140. Public attendance: 10,000. Free to public. Artists should apply on the website. Deadline for entry: mid-April. Application fee: $25. Space fee varies by booth size; see application form on website for details. For more information, artists should visit the website. Promoters of fine art and craft shows that are successful for the exhibitors and enjoyable, tantalizing, satisfying artistic buying experiences for the supportive public.

TIPS "Have a range of sizes and price ranges."

☻ FINE ART FAIR

Foster Arts Center, 203 Harrison St., Peoria IL 61602. (309)637-2787. **E-mail:** fineartfair@peoriaartguild.org. **Website:** www.peoriaartguild.org. **Contact:** fine art fair coordinator. Estab. 1962. Fine art & fine craft fair held annually the last full weekend in September. Outdoors. Accepts handmade crafts, painting, sculpture, photography, drawing, fabric, ceramics, glass, and jewelry. Juried. Number of exhibitors: 150. Number of attendees: 25,000. Admission: $5 adults; children 12 & under free; Peoria Art Guild members free. Apply online. Deadline for entry: see website. Application fee: see website. Space fee: see website. Exhibition space: see website. For more information, artists should e-mail, call, or visit website.

☻ FIREFLY ART FAIR

Wauwatosa Historical Society, 7406 Hillcrest Drive, Wauwatosa WI 53213. (414)774-8672. **E-mail:** staff@wauwatosahistoricalsociety.org. **Website:** www.wauwatosahistoricalsociety.org. **Contact:** Janel Ruzicka. Estab. 1985. Fine arts & crafts fair held annually first weekend in August. Outdoors. Accepts painting, sculpture, photography, ceramics, jewelry, fiber, printmaking, glass, paper, leather, wood. Juried. Number of exhibitors: 90. Number of attendees: 4,000 to 5,000. $5.00 public admission. Apply online. Deadline for entry: March 15. Application fee: $15. Space fee: $140. Exhibition space: 10×10 ft. For more information, artists should e-mail, visit website, or call.

☻ FOUNTAIN HILLS FINE ART & WINE AFFAIRE

16810 E. Ave. of the Fountains, Fountain Hills AZ 85268. (480)837-5637. **Fax:** (480)837-2355. **E-mail:** info@thunderbirdartists.com. **Website:** www.thunderbirdartists.com. **Contact:** Denise Colter, president. Estab. 2005. "The 12th Annual Fountain Hills Fine Art & Wine Affaire is produced by Thunderbird Artists, in conjunction with Sunset Kiwanis and the town of Fountain Hills. Thunderbird Artists again unite with Sunset Kiwanis of Fountain Hills to celebrate 12 years! Held on the picturesque Avenue of the Fountains, the signature fountain attracts thousands of visitors every year and runs at the top of each hour for 15 minutes 9-9 daily. Thunderbird Artists Mission is to promote fine art and fine crafts (through an extensive and dedicated advertising campaign) paralleled with the ambiance of unique wines and fine music, while supporting the artists, merchants, and surrounding communities. It is the mission of Thunderbird Artists to further enhance the art culture with the local communities by producing award-winning, sophisticated fine art festivals throughout the Phoenix metro area.

Thunderbird Artists has played an important role in uniting nationally recognized and award-winning artists with patrons from across the globe."

TIPS "A clean, gallery-type presentation is very important."

🎧 FOURTH AVENUE STREET FAIR

434 E. Ninth St., Tucson AZ 85705. (520)624-5004 or (800)933-2477. **Fax:** (520)624-5933. **E-mail:** kurt@fourthavenue.org. **Website:** www.fourthavenue.org. **Contact:** Kurt. Estab. 1970. Arts & crafts fair held annually in late March/early April and December (see website for details). Outdoors. Accepts photography, drawing, painting, sculpture, arts & crafts. Juried by 5 jurors. Awards/prizes: Best of Show. Number of exhibitors: 400. Public attendance: 300,000. Free to the public. Artists should apply by completing the online application at www.zapplication.org. Requires 4 photos of art/craft and 1 booth photo. $35 application fee. Booth fee $505, additional $150 for corner booth. Deadline for entry: see website for details. Exhibition space: 10×10 ft. Average gross sales/exhibitor: $3,000. For more information, artists should e-mail, visit website, call, send SASE. Fair located on 4th Ave., between 9th St. and University Ave.

🎧 FOURTH STREET FESTIVAL FOR THE ARTS & CRAFTS

P.O. Box 1257, Bloomington IN 47402. (812)575-0484; (812)335-3814. **E-mail:** info@4thstreet.org. **Website:** www.4thstreet.org. Estab. 1976. Fine arts & crafts show held annually Labor Day weekend. Outdoors. Accepts photography, clay, glass, fiber, jewelry, painting, graphic, mixed media, wood. Juried by a 4-member panel. Awards/prizes: Best of Show ($750), 1st, 2nd, 3rd in 2D and 3D. Number of exhibitors: 105. Public attendance: 25,000. Free to public. Artists should apply by sending requests by mail, e-mail, or download application from website at www.zapplication.org. Exhibition space: 10×10 ft. Average gross sales/exhibitor: $2,700. For more information, artists should e-mail, visit website, call, or send for information with SASE. Show located at 4th St. and Grant St. adjacent to Indiana University.

TIPS Be professional.

🎧 FREDERICK FESTIVAL OF THE ARTS

11 W. Patrick St., Suite 201, Frederick MD 21701. (301)662-4190. **Fax:** (301)663-3084. **E-mail:** info@frederickartscouncil.org. **Website:** www.frederick-artscouncil.org. Juried 2-day fine arts festival held annually the 1st weekend of June along Carroll Creek Linear Park in downtown Frederick. Features approximately 110 artists from across the country, 2 stages of musical performances, children's crafts and activities, artist demonstrations, as well as interactive classical theater performances. For more information, including application deadlines and fees, visit website www.frederickartsfestival.org. Festival takes place in Carroll Creek Linear Park in downtown Frederick.

🎧 FUNKY FERNDALE ART SHOW

Integrity Shows, P.O. Box 1070, Ann Arbor MI 48106. **E-mail:** info@integrityshows.com. **Website:** www.funkyferndaleartfair.com. **Contact:** Mark Loeb. Estab. 2004. Fine arts & crafts show held annually in September. Outdoors. Accepts photography and all fine art and craft mediums; emphasis on fun, funky work. Juried by 3 independent jurors. Awards/prizes: purchase and merit awards. Number of exhibitors: 120. Public attendance: 30,000. Free to the public. Application fee: $25. Booth fee: $295. Electricity limited; fee: $100. For more information, artists should visit our website.

TIPS "Show enthusiasm. Keep a mailing list. Develop collectors."

🎧 GARRISON ART CENTER'S JURIED FINE CRAFTS FAIR

23 Garrison's Landing, P.O. Box 4, Garrison NY 10524. (845)424-3960. **Fax:** (845)424-4711. **E-mail:** info@garrisonartcenter.org. **Website:** www.garrisonartcenter.org. Outdoor, riverside fine crafts show held annually on the third weekend in August. 85 exhibitors are selected to exhibit and sell handmade original work. Entries are judged based on creativity, originality, and quality. Annual visitors 4,000-5,000. Visit our website for information, prospectus, and application. Fair located at Garrison's Landing.

TIPS "Have an inviting booth and be pleasant and accessible. Don't hide behind your product—engage the audience."

🎧 GASPARILLA FESTIVAL OF THE ARTS

P.O. Box 10591, Tampa FL 33679. (813)876-1747. **E-mail:** info@gasparillaarts.com. **Website:** www.gasparilla-arts.com. Estab. 1970. Fine arts & crafts fair held annually in March. Outdoors. Accepts handmade crafts, ceramic, digital, drawing, fiber, glass, jewelry, mixed media, painting, photography, printmak-

ing, sculpture, watercolor, and wood. Juried. Awards/prizes: $74,500 in cash awards. Number of exhibitors: 300. Number of attendees: 250,000. Free to public. Apply online. Deadline for entry: September. Application fee: $40. Space fee: $375. Exhibition space: 10×10 ft. For more information, artists should e-mail, visit website, or call.

🎧 GATHERING AT THE GREAT DIVIDE

Mountain Art Festivals, P.O. Box 3578, Breckenridge CO 80424. (970)547-9326. **E-mail:** info@mountainartfestivals.com. **Website:** www.mountainartfestivals.com. Estab. 1975. Fine arts & crafts fair held annually in August. Outdoors. Accepts handmade crafts, painting, sculpture, photography, drawing, fabric, crafts, ceramics, glass, and jewelry. Juried. Number of exhibitors: see website. Number of attendees: varies. Free to public. Apply online. Deadline for entry: March 31. Application fee: $35. Space fee: $500. Exhibition space: 10×10 ft. For more information, artists should e-mail, visit website, or call.

🎧 GENEVA ARTS FAIR

8 S. Third St., Geneva IL 60134. (630)232-6060. **E-mail:** chamberinfo@genevachamber.com; lrush@genevachamber.com. **Website:** www.genevachamber.com. Fine arts show held annually in late-July (see website for details). Outdoors. Juried. "The unprecedented Geneva Arts Fair transforms downtown Geneva into a venue for over 150 esteemed artists and draws a crowd of more than 20,000. The juried show was voted a Top 200 Fine Craft Fair by *Art Fair Source-Book* and a previous winner of 'Best Craft or Art Show' by *West Suburban Living* magazine." Accepts photography, ceramics, fiber, printmaking, mixed media, watercolor, wood, sculpture, and jewelry. Application deadline: early February. Please visit www.emevents.com to apply.

GERMANTOWN FESTIVAL

P.O. Box 381741, Germantown TN 38183. (901)757-9212. **E-mail:** gtownfestival@aol.com. **Website:** www.germantownfest.com. **Contact:** Melba Fristick, coordinator. Estab. 1971. Arts & crafts show held annually the weekend after Labor Day. Outdoors. Accepts photography, all arts & crafts mediums. Number of exhibitors: 400+. Public attendance: 65,000. Free to public. Artists should apply by sending applications by mail. Deadline for entry: until filled. Application/space fee: $200-250. Exhibition space: 10×10 ft. For more information, artists should e-mail, call, or send

SASE. Show located at Germantown Civic Club Complex 7745 Poplar Pike.

TIPS "Display and promote to the public. Price attractively."

🎧 GLAM INDIE CRAFT SHOW

E-mail: glamcraftshow@gmail.com. **Website:** www.glamcraftshow.com. Fine arts & crafts fair held annually in December. Outdoors. Accepts handmade crafts, painting, sculpture, photography, drawing, fabric, crafts, ceramics, glass, and jewelry. Juried. Number of exhibitors: varies. Number of attendees: varies. Admission: $3 adults; children 10 & under free. Apply online. Deadline for entry: September. Application fee: see website. Space fee: varies. Exhibition space: varies. For more information, artists should e-mail or visit website.

🎧 GLENVIEW OUTDOOR ART FAIR

Glenview Art League, P.O. Box 463, Glenview IL 60025-0463. (847)724-4007. **E-mail:** glenviewartleague@att.net. **Website:** www.glenviewartleague.org. Fine arts & crafts fair held annually in July. Outdoors. Accepts handmade crafts, paintings, sculpture, hand-pulled artist's prints (e.g., etchings), drawings, mixed media, ceramics, photography, and jewelry. Juried. Awards/prizes: Best of Show, awards of excellence, merit awards. Number of exhibitors: see website. Number of attendees: varies. Free to public. Apply online. Deadline for entry: May. Application fee: $10. Space fee: varies. Exhibition space: 12×12 ft. For more information, artists should e-mail, call, or visit website.

🎧 GLOUCESTER WATERFRONT FESTIVAL

38 Charles St., Rochester NH 03867. (603)332-2616. **E-mail:** info@castleberryfairs.com; terrym@worldpath.net. **Website:** www.castleberryfairs.com. **Contact:** Terry Mullen, events coordinator. Estab. 1971. Arts & crafts show held the 3rd weekend in August in Gloucester MA. Outdoors in Stage Fort Park. Accepts photography and all other mediums. Juried by photo, slide, or sample. Number of exhibitors: 225. Public attendance: 50,000. Free to the public. Artists should apply by downloading application from website. Deadline for entry: until full. Space fee: $375. Exhibition space: 10×10 ft. Average gross sales/exhibitor: "Generally, this is considered an 'excellent' show, so I would guess most exhibitors sell ten times their booth fee, or in this case, at least $3,500 in sales." For more

information, artists should visit website. Show located in Stage Fort Park, Hough Ave., Gloucester NH.

TIPS "Do not bring a book; do not bring a chair. Smile and make eye contact with everyone who enters your booth. Have them sign your guest book; get their e-mail address so you can let them know when you are in the area again. And, finally, make the sale—they are at the fair to shop, after all."

🎧 GOLDEN FINE ARTS FESTIVAL

1010 Washington Ave., Golden CO 80401. (303)279-3113. **E-mail:** info@goldencochamber.org. **Website:** www.goldenfineartsfestival.org. Fine arts & crafts fair held annually in August. Outdoors. Accepts handmade crafts, ceramics, fiber, glass, jewelry, mixed media, 2D, painting, photography, and sculpture. Juried. Number of exhibitors: see website. Number of attendees: 40,000. Free to public. Apply online. Deadline for entry: April. Application fee: $25. Space fee: $350. Exhibition space: 10×10 ft. For more information, artists should e-mail, call, or visit website.

GOLD RUSH DAYS

Dahlonega Jaycees, P.O. Box 774, Dahlonega GA 30533. **E-mail:** info@dahlonegajaycees.com. **Website:** www.dahlonegajaycees.com. Estab. 1954. Arts & crafts show held annually the 3rd full week in October. Accepts photography, paintings, and homemade, handcrafted items. No digitally originated artwork. Outdoors. Number of exhibitors: 300. Public attendance: 200,000. Free to the public. Artists should apply online at dahlonegajaycees.com. Deadline: June 1st. Exhibition space: 10×10 ft. Artists should e-mail or visit website for more information. Show located at the public square and historic district.

TIPS "Talk to other artists who have done other shows and festivals. Get tips and advice from those in the same line of work."

🎧 GOOD OLD SUMMERTIME ART FAIR

Friends of the Kenosha Art Association, P.O. Box 1753, Kenosha WI 53141. (262)654-0065. **E-mail:** info@kenoshaartassociation.org. **Website:** www.kenoshaartassociation.org. Estab. 1975. Fine arts show held annually the 1st Sunday in June. Outdoors. Accepts photography, paintings, drawings, mosaics, ceramics, pottery, sculpture, wood, stained glass. Juried by a panel. Photos or slides required with application. Number of exhibitors: 100. Public attendance: 3,000. Free to public. Artists should apply by completing application form, and including fees and SASE. Deadline for entry: early April. Exhibition space: 12×12 ft. For more information, artists should e-mail, visit website, or send SASE.

TIPS "Have a professional display, and be friendly."

🎧 GRAND LAKE FESTIVAL OF THE ARTS & CRAFTS

P.O. Box 429, Grand Lake CO 80447-0429. (970)627-3402. **Fax:** (970)627-8007. **E-mail:** glinfo@grandlakechamber.com. **Website:** www.grandlakechamber.com. Fine arts & crafts show held annually in June, July, and August. Outdoors. Accepts photography, jewelry, leather, mixed media, painting, paper, sculpture, wearable art. Juried by chamber committee. Awards/prizes: Best in Show and People's Choice. Number of exhibitors: 50-75. Public attendance: 1,000+. Free to public. Artists should apply by submitting slides or photos. Deadline for entry: early June, July, and August. Application fee: $190; includes space fee and business license. No electricity available. Exhibition space: 12×12 ft. For more information, artists should e-mail or call. Show held at Town Square Park on Grand Ave in Grand Lake, CO.

⭕ GREAT LAKES ART FAIR

46100 Grand River Ave., Novi MI 48374. (248)486-3424. **Fax:** (248)347-7720. **E-mail:** info@greatlakesartfair.com. **Website:** www.greatlakesartfair.com. **Contact:** Andrea Picklo, event manager. Estab. 2009. Held in April. Accepts paintings, sculptures, metal and fiber work, jewelry, 2D and 3D art, ceramics, and glass. Cash prizes are given. Number of exhibitors: 150-200. Public attendance: 12,000-15,000. Application fee: $30. Space fee: $400-800. Exhibition space: 10×12 ft.

TIPS E-mail, call, or visit website for more information.

🎧 GREAT NECK STREET FAIR

Showtiques Crafts, Inc., 1 Orient Way, Suite F, #127, Rutherford NJ 07070. (201)869-0406. **E-mail:** showtiques@gmail.com. **Website:** www.showtiques.com. Estab. 1978. Fine arts & crafts show held annually in early May (see website for details) in the Village of Great Neck. "Welcomes professional artists, craftspeople and vendors of upscale giftware." Outdoors. Accepts photography, all arts & crafts made by the exhibitor. Juried. Number of exhibitors: 250. Public attendance: 50,000. Free to public. Deadline for en-

try: until full. Space fee: $150-250. Exhibition space: 10×10 ft. For more information, artists should e-mail, call, or visit website.

GREENWICH VILLAGE ART FAIR

711 N. Main St., Rockford IL 61103. (815)968-2787. **Fax:** (815)316-2179. **E-mail:** nsauer@rockfordart museum.org. **Website:** www.rockfordartmuseum. org/gvaf.html. **Contact:** Nancy Sauer. Estab. 1948. Juried. 2-day outdoor fine art fair held annually in September. $4,500 in Best of Show and Judges' Choice Awards. Number of exhibitors: 155. Public attendance: 7,000. Application fee $30. Booth fee: $225. Deadline for entry: April 30. Exhibition space: 10×10 ft. Apply online through www.zapplication.org.

HALIFAX ART FESTIVAL

P.O. Box 2038, Ormond Beach FL 32175-2038. (386)304-7247 or (407)701-1184. **E-mail:** patabernathy 2012@hotmail.com. **Website:** www.halifaxart festival.com. Estab. 1962. Fine arts & crafts fair held annually in November. Outdoors. Accepts handmade crafts, ceramics, fiber, glass, jewelry, mixed media, 2D, painting, photography, and sculpture. Juried. Awards/prizes: Best of Show, Judges' Choice, Awards of Excellence, Awards of Distinction, Awards of Honor, Awards of Merit, Student Art Awards, Purchase Award, Patron Purchase Award. Number of exhibitors: 200. Number of attendees: 45,000. Free to public. Apply online. Deadline for entry: August. Application fee: $30. Space fee: $225 (competitive); $125 (noncompetitive). Exhibition space: see website. For more information, artists should e-mail, call, or visit website.

HERKIMER COUNTY ARTS & CRAFTS FAIR

100 Reservoir Rd., Herkimer NY 13350. (315)866-0300, ext. 8459. **Fax:** (315)866-1706. **E-mail:** fuhrerjm@herkimer.edu. **Website:** www.herkimer. edu/ac. **Contact:** Jan Fuhrer, coordinator. Estab. 1976. Fine art & craft show held annually in mid-November on Veterans Day weekend. Indoors. Accepts photography and all handcrafted artwork. Juried by a committee. Awards/prizes: ribbons. Number of exhibitors: 120+. Public attendance: 4,000. Admission: $4. Deadline: May 1 or until filled. Application fee: $10. Exhibition space: 10×6 ft. Space fee: $155. For more information, artists should call, e-mail, or send SASE.

HIGHLAND MAPLE FESTIVAL

P.O. Box 223, Monterey VA 24465. (540)468-2550. **Fax:** (540)468-2551. **E-mail:** findyourescape@high landcounty.org. **Website:** www.highlandcounty.org. Estab. 1958. Fine arts & crafts show held annually the 2nd and 3rd weekends in March. Indoors and outdoors. Accepts photography, pottery, weaving, jewelry, painting, wood crafts, furniture. Juried by 5 photos or slides. Photos need to include one of setup and your workshop. Number of exhibitors: 150. Public attendance: 35,000-50,000. "Vendors accepted until show is full." Exhibition space: 10×10 ft. For more information, artists should e-mail, call, or visit website.
TIPS "Have quality work and good salesmanship."

HIGHLANDS ART LEAGUE'S ANNUAL FINE ARTS & CRAFTS FESTIVAL

1989 Lakeview Dr., Sebring FL 33870. (863)385-6682. **E-mail:** director@highlandsartleague.org. **Website:** www.highlandsartleague.org. **Contact:** Martile Blackman, festival director. Estab. 1966. Fine arts & crafts show held annually first Saturday in November. Outdoors. Accepts photography, pottery, painting, jewelry, fabric. Juried based on quality of work. Awards/prizes: monetary awards. Number of exhibitors: 100+. Public attendance: more than 15,000. Free to the public. Artists should apply by calling or visiting website for application form. Deadline for entry: September 1. Exhibition space: 10×14 and 10×28 ft. Artists should e-mail for more information. Festival held in Circle Park in downtown Sebring.

HILTON HEAD ISLAND ART FESTIVAL WITH CRAFT MARKETPLACE

270 Central Blvd., Suite 107B, Jupiter FL 33458. (561)746-6615. **Fax:** (561)746-6528. **E-mail:** info@ artfestival.com. **Website:** www.artfestival.com. **Contact:** Malinda Ratliff, communications manager. Estab. 2009. Fine art & craft fair held annually in late May. Outdoors. Accepts photography, jewelry, mixed media, sculpture, wood, ceramic, glass, painting, digital, fiber, metal. Juried. Number of exhibitors: 100. Number of attendees: 60,000. Free to public. Apply online via www.zapplication.org. Deadline: see website. Application fee: $25. Space fee: $375. Exhibition space: 10×10 and 10×20 ft. For more information, artists should e-mail, call, or visit website. Festival located at Shelter Cove Harbour and Marina on Hilton Head Island.

TIPS "You have to start somewhere. First, assess where you are, and what you'll need to get things off the ground. Next, make a plan of action. Outdoor street art shows are a great way to begin your career and lifetime as a working artist. You'll meet a lot of other artists who have been where you are now. Network with them!"

🎧 HINSDALE FINE ARTS FESTIVAL

22 E. First St., Hinsdale IL 60521. (630)323-3952. **Fax:** (630)323-3953. **E-mail:** info@hinsdalechamber.com. **Website:** www.hinsdalechamber.com. Fine arts show held annually in mid-June. Outdoors. Accepts photography, ceramics, painting, sculpture, fiber arts, mixed media, jewelry. Juried by 3 images. Awards/prizes: Best in Show, President's Award and 1st, 2nd and 3rd place in 2D and 3D categories. Number of exhibitors: 140. Public attendance: 2,000-3,000. Free to public. Artists should apply online at www.zapplication.org. Deadline for entry: First week in March. Application fee: $30. Space fee: $275. Exhibition space: 10×10 ft. For more information, artists should e-mail or visit website.

TIPS "Original artwork sold by artist."

🎧 HISTORIC SHAW ART FAIR

(314)771-3101. **E-mail:** greg@gobdesign.com. **Website:** www.shawartfair.org. **Contact:** Greg Gobberdiel, coordinator. Fine arts & crafts fair held annually in October. Outdoors. Accepts handmade crafts, ceramics, fiber, glass, jewelry, mixed media, painting, photography, and sculpture. Juried. Number of exhibitors: see website. Number of attendees: varies. Free to public. Apply online. Deadline for entry: April. Application fee: $25. Space fee: $280. Exhibition space: 10×10 ft. For more information, artists should e-mail, call, or visit website.

🎧 HOBE SOUND FESTIVAL OF THE ARTS & CRAFT SHOW

270 Central Blvd., Suite 107B, Jupiter FL 33458. (561)746-6615. **Fax:** (561)746-6528. **E-mail:** info@artfestival.com. **Website:** www.artfestival.com. **Contact:** Malinda Ratliff, communications manager. Estab. 2006. Fine art & craft fair held annually in February. Outdoors. Accepts photography, jewelry, mixed media, sculpture, wood, ceramic, glass, painting, digital, fiber, metal. Juried. Number of exhibitors: 130. Number of attendees: 70,000. Free to public. Apply online via www.zapplication.org. Deadline: see website. Application fee: $25. Space fee: $395. Exhibition space: 10×10 and 10×20 ft. For more information, artists should e-mail, call, or visit website. Show located at A1A/Dixie Highway where the street intersects with Bridge Road in Hobe Sound, FL.

TIPS "You have to start somewhere. First, assess where you are, and what you'll need to get things off the ground. Next, make a plan of action. Outdoor street art shows are a great way to begin your career and lifetime as a working artist. You'll meet a lot of other artists who have been where you are now. Network with them!"

🎧 HOLIDAY CRAFTMORRISTOWN

P.O. Box 28, Woodstock NY 12498. (845)331-7900. **Fax:** (845)331-7484. **E-mail:** crafts@artrider.com. **Website:** www.artrider.com. Estab. 1990. Fine arts & crafts show held annually in early December. Indoors. Accepts photography, wearable and nonwearable fiber, jewelry, clay, leather, wood, glass, painting, drawing, prints, mixed media. Juried by 5 images of work and 1 of booth, viewed sequentially. Number of exhibitors: 165. Public attendance: 5,000. Public admission: $9. Artists should apply online at www.artrider.com or www.zapplication.org. Deadline for entry: end of May. Application fee: $45. Space fee: $545. Exhibition space: 10×10 ft. For more information, artists should e-mail, call, or visit website.

🎧 HOLIDAY FINE ARTS & CRAFTS SHOW

60 Ida Lee Dr., Leesburg VA 20176. (703)777-1368. **Fax:** (703)737-7165. **E-mail:** lfountain@leesburgva.gov. **Website:** www.idalee.org. **Contact:** Linda Fountain. Estab. 1990. Fine Arts & crafts show held annually the 1st full weekend in December. Indoors. Accepts handcrafted items only, including but not limited to: photography, jewelry, pottery, baskets, clothing, gourmet food products, wood work, fine art, accessories, pet items, soaps/lotions and florals. Juried. Number of exhibitors: 99. Public attendance: 2,500+. Free to public. Artists should apply by downloading application from website. Deadline for entry: August 18. Space fee: $110-150. Exhibition space: 10×7 ft. and 10×10 ft. For more information, artists should e-mail or visit website.

🎧 HOLLY ARTS & CRAFTS FESTIVAL

P.O. Box 64, Pinehurst NC 28370. (910)295-7462. **E-mail:** info@pinehurstbusinessguild.com. **Website:** www.pinehurstbusinessguild.com. Estab. 1978. An-

nual arts & crafts show held 3rd Saturday in October. Outdoors. Accepts quality photography, arts and crafts. Juried based on uniqueness, quality of product, and overall display. Number of exhibitors: 200. Public attendance: 7,000. Free to the public. Submit 3 color photos, 2 of work to be exhibited, 1 of booth. Deadline: Late March. Application fee: $25 by separate check. Space fee: $75. Electricity fee: $5 Exhibition space: 10×10 ft. For more information, artists should call or visit website.

HOME, CONDO AND OUTDOOR ART & CRAFT FAIR

P.O. Box 486, Ocean City MD 21843. (410)213-8090. **Fax:** (410)213-8092. **E-mail:** events@oceanpromo tions.info. **Website:** www.oceanpromotions.info. **Contact:** Starr or Mike. Estab. 1984. Fine arts & crafts show held annually in the Spring. Indoors. Accepts photography, carvings, pottery, ceramics, glass work, floral, watercolor, sculpture, prints, oils, pen and ink. Number of exhibitors: 50. Public attendance: 7,000. Public admission: $7/adults; $6/seniors & students; 13 and under free; military, fire, and police free. Artists should apply by e-mailing request for info and application. Deadline for entry: until full. Space fee: $250. Exhibition space: 10×10 ft. For more information, artists should e-mail, call, or visit website. Show held in the R.E. Powell Ocean City Convention Center.

HOME DECORATING & REMODELING SHOW

P.O. Box 230699, Las Vegas NV 89105-0699. (702)450-7984; (800)343-8344. **Fax:** (702)451-7305. **E-mail:** showprosadmin@cox.net. **Website:** www.nashvillehomeshow.com. Estab. 1983. Home show held annually in early September (see website for details). Indoors. Accepts photography, sculpture, watercolor, oils, mixed media, pottery. Awards/prizes: Outstanding Booth Award. Number of exhibitors: 350-400. Public attendance: 15,000. Public admission: $10 (discount coupon available on website); Seniors 62+ free on Friday; children 12 & under free with adult. Artists should apply by calling. Marketing is directed to middle and above income brackets. Deadline for entry: open until filled. Space fee: starts at $950. Exhibition space: 10×10 ft. or complements of 10×10 ft. For more information, artists should call or visit website.

HOT SPRINGS ARTS & CRAFTS FAIR

308 Pullman, Hot Springs AR 71901. (501)623-9592. **E-mail:** sephpipkin@aol.com. **Website:** www.hotspringsartsandcraftsfair.com. **Contact:** Peggy Barnett. Estab. 1968. Fine arts & crafts show held annually the 1st weekend in October at the Garland County Fairgrounds. Indoors and outdoors. Accepts photography and varied mediums ranging from heritage, crafts, jewelry, furniture. Juried by a committee of 12 volunteers. Number of exhibitors: 350+. Public attendance: 50,000+. Free to public. Deadline for entry: August. Space fee: $125 (single); $250 (double). Exhibition space: 10×10 or 10×20 ft. For more information, and to apply, artists should e-mail, call, or visit website. Fair located at Garland County Fairgrounds.

HYDE PARK SQUARE ART SHOW

P.O. Box 8402, Cincinnati OH 45208. **E-mail:** hpartshowinfo@aol.com. **Website:** www.hydepark square.org. Fine arts & crafts fair held annually in October. Outdoors. Accepts handmade crafts, ceramics, fiber, glass, jewelry, mixed media, 2D, painting, photography, and sculpture. Juried. Awards/prizes: Best of Show, 1st place, 2nd place, 3rd place, honorable mention. Number of exhibitors: see website. Number of attendees: see website. Free to public. Apply online. Deadline for entry: March. Application fee: $40. Space fee: $130. Exhibition space: see website. For more information, artists should e-mail, call, or visit website.

STAN HYWET HALL & GARDENS OHIO MART

714 N. Portage Path, Akron OH 44303. (330)315-3255. **E-mail:** ohiomart@stanhywet.org. **Website:** www.stanhywet.org. Estab. 1966. Artisan crafts show held annually 1st full weekend in October. Outdoors. Accepts photography and all mediums. Juried via mail application. Awards/prizes: Best Booth Display. Number of exhibitors: 150. Public attendance: 15,000-20,000. Deadline varies. Application fee: $25, nonrefundable. Application available online. Exhibition space: 10×10 or 10×15 ft. For more information, artists should visit website or call.

IMAGES – A FESTIVAL OF THE ARTS

386-423-4733. **E-mail:** images@imagesartfestival.org. **Website:** www.imagesartfestival.org. Fine arts & crafts fair held annually in January. Outdoors. Ac-

cepts handmade crafts, ceramics, fiber, glass, jewelry, mixed media, 2D, painting, photography, and sculpture. Juried. Awards/prizes: $100,000 in awards and prizes. Number of exhibitors: 225. Number of attendees: 45,000. Free to public. Apply online. Deadline for entry: October. Application fee: $40. Space fee: $250. Exhibition space: 11×12 ft. For more information, artists should e-mail, call, or visit website.

⊙ INDIANA ART FAIR

650 W. Washington St., Indianapolis IN 46204. (317)233-9348. **Fax:** (317)233-8268. **E-mail:** cmiller@indianamuseum.org. **Website:** www.indiana museum.org. Estab. 2004. Annual art/craft show held the 2nd weekend of February. Indoors. Juried; 5-6 judges award points in 3 categories. 60 exhibitors; 3,000 attendees. $13 admission for the public. Application fee $25. Space fee $165; 80 sq. ft. Accepts ceramics, glass, fiber, jewelry, painting, sculpture, mixed media, drawing/pastels, garden, leather, surface decoration, wood, metal, printmaking, and photography.

TIPS "Make sure that your booth space complements your product and presents well. Good photography can be key for juried shows."

⊙ INDIAN WELLS ARTS FESTIVAL

78-200 Miles Ave., Indian Wells CA 92210. (760)346-0042. **Fax:** (760)346-0042. **E-mail:** info@indianwells artsfestival.com. **Website:** www.indianwellsarts festival.com. **Contact:** Dianne Funk, producer. "A premier fine arts festival attracting thousands annually. The Indian Wells Arts Festival brings a splash of color to the beautiful grass concourse of the Indian Wells Tennis Garden. This spectacular venue transforms into an artisan village featuring 200 judged and juried artists and hundreds of pieces of one-of-a-kind artwork available for sale. Enjoy special exhibits and demonstrations. Watch glass blowing, monumental rock sculpting, wood carving, pottery wheel, weaving, and painting. Wine tasting, gourmet market, children's activities, entertainment, and refreshments add to the festival atmosphere." Apply online at www.indianwellsartsfestival.com/artists.html. See website for more information.

⊙ INTERNATIONAL FOLK FESTIVAL

Arts Council Fayetteville/Cumberland County, 301 Hay St., Fayetteville NC 28301. (910)323-1776. **Fax:** (910)323-1727. **E-mail:** bobp@theartscouncil.com. **Website:** www.theartscouncil.com. Estab. 1978. Fine arts & crafts show held annually the last weekend in September. Outdoors. Accepts photography, painting of all mediums, pottery, woodworking, sculptures. Work must be original. Number of exhibitors: 120+. Public attendance: 85,000-100,000 over 2 days. Free to public. Artists should apply on the website. Exhibition space: 10×10 ft. For more information, artists should e-mail or visit website. Festival held in Festival Park/downtown Fayetteville.

TIPS "Have reasonable prices."

⊙ ISLE OF EIGHT FLAGS SHRIMP FESTIVAL

P.O. Box 17251, Fernandina Beach FL 32035. (904)701-2786; (904)261-7020. **Website:** www.islandart.org. Estab. 1963. Fine arts & crafts show and community celebration held annually the 1st weekend in May. Outdoors. Accepts all mediums. Juried. Awards: $9,000 in cash prizes. Number of exhibitors: 300. Public attendance: 150,000. Free to public. Artists should apply by downloading application from website. Slides are not accepted. Digital images in JPEG format only must be submitted on a CD/DVD with application. Deadline for entry: January 31. Application fee: $30 (non-refundable). Space fee: $225. Exhibition space: 10×12 ft. Average gross sales/exhibitor: $1,500+. For more information, artists should visit website.

⊙ JOHNS HOPKINS UNIVERSITY SPRING FAIR

3400 N. Charles St., Mattin Suite 210, Baltimore MD 21218. (410)516-7692. **Fax:** (410)516-6185. **E-mail:** springfair@gmail.com. **Website:** www.jhuspringfair.com. Estab. 1972. Fine arts & crafts, campus-wide festival held annually in April. Outdoors. Accepts photography and all mediums. Juried. Number of exhibitors: 80. Public attendance: 20,000+. Free to public. Artists should apply via website. Deadline for entry: early March. Application and space fee: $200. Exhibition space: 10×10 ft. For more information, artists should e-mail, call, or visit website. Fair located on Johns Hopkins Homewood Campus.

TIPS "Artists should have fun displays, good prices, good variety and quality pieces."

⊙ JUBILEE FESTIVAL

Eastern Shore Chamber of Commerce, Olde Towne Daphne, P.O. Drawer 310, Daphne AL 36526. (251)621-8222 or (251)928-6387. **Fax:** (251)621-8001. **E-mail:** lroberts@eschamber.com; office@eschamber.

com. **Website:** www.eschamber.com. **Contact:** Liz R. Thomson. Estab. 1952. Fine arts & crafts show held in late September in Olde Towne of Daphne AL. Outdoors. Accepts photography and fine arts and crafts. Juried. Awards/prizes: ribbons and cash prizes total $4,300 with Best of Show $750. Number of exhibitors: 258. Free to the public. Jury fee: $20. Space fee: $100 for single; $200 for double. Exhibition space: 10×10 ft. or 10×20 ft. For more information and application form, artists should e-mail, call, see website. Festival located in "Olde Towne" Daphne on Main St.

KALAMAZOO INSTITUTE OF ARTS FAIR

Kalamazoo Institute of Arts, 314 S. Park St., Kalamazoo MI 49007. (269)349-7775. **Fax:** (269)349-9313. **E-mail:** joeb@kiarts.org. **Website:** www.kiarts.org/artfair. **Contact:** Joe Bower. Estab. 1951. Jurored fine art fair held annually in June. Outdoors. "The KIA's annual art fair has been going strong for 64 years. Still staged in shady, historic Bronson Park, the fair boasts more hours, more artists, and more activities. It now spans 2 full days. The art fair provides patrons with more time to visit and artists with an insurance day in case of rain. Some 190 artists will be invited to set up colorful booths. Numerous festivities are planned, including public art activities, musical performances, a beer garden, and an artist dinner. For more information, visit www.kiarts.org/artfair." Apply via www.zapplication.org. Application fee: $30. Booth fee: $275.

KENTUCK FESTIVAL OF THE ARTS

503 Main Ave., Northport AL 35476. (205)758-1257. **Fax:** (205)758-1258. **E-mail:** kentuck@kentuck.org. **Website:** www.kentuck.org. **Contact:** Amy Echols, executive director. Call or e-mail for more information. General information about the festival available on the website. "Celebrates a variety of artistic styles ranging from folk to contemporary arts as well as traditional crafts. Each of the 250+ artists participating in the festival is either invited as a guest artist or is juried based on the quality and originality of their work. The guest artists are nationally recognized folk and visionary artists whose powerful visual images continue to capture national and international acclaim." Festival held at Kentuck Park.

KETNER'S MILL COUNTY ARTS FAIR

P.O. Box 322, Lookout Mountain TN 37350. (423)267-5702. **E-mail:** contact@ketnersmill.org. **Website:** www.ketnersmill.org. **Contact:** Dee Nash, event coordinator. Estab. 1977. Arts & crafts show held annually the 3rd weekend in October on the grounds of the historic Ketner's Mills, in Whitwell TN, and the banks of the Sequatchie River. Outdoors. Accepts photography, painting, prints, dolls, fiber arts, baskets, folk art, wood crafts, jewelry, musical instruments, sculpture, pottery, glass. Juried. Number of exhibitors: 170. Number of attendees: 10,000/day, depending on weather. Artists should apply online. Space fee: $125. Electricity: $10 limited to light use. Exhibition space: 15×15 ft. Average gross sales/exhibitor: $1,500. Fair held at Ketner's Mill.

TIPS "Display your best and most expensive work, framed. But also have smaller unframed items to sell. Never underestimate a show: someone may come forward and buy a large item."

KEY BISCAYNE ART FESTIVAL

270 Central Blvd., Suite 107B, Jupiter FL 33458. (561)746-6615. **Fax:** (561)746-6528. **E-mail:** info@artfestival.com. **Website:** www.artfestival.com. **Contact:** Malinda Ratliff, communications manager. Estab. 1964. Fine art & craft fair held annually in March. Outdoors. Accepts photography, jewelry, mixed media, sculpture, wood, ceramic, glass, painting, digital, fiber, metal. Juried. Number of exhibitors: 125. Number of attendees: 50,000. Free to public. Apply online via www.zapplication.org. Deadline: see website. Application fee: $25. Space fee: $395. Exhibition space: 10×10 and 10×20 ft. For more information, artists should e-mail, call, or visit website. Festival located at Village Green Park in Key Biscayne, FL.

TIPS "You have to start somewhere. First, assess where you are, and what you'll need to get things off the ground. Next, make a plan of action. Outdoor street art shows are a great way to begin your career and lifetime as a working artist. You'll meet a lot of other artists who have been where you are now. Network with them!"

KINGS MOUNTAIN ART FAIR

13106 Skyline Blvd., Woodside CA 94062. (650)851-2710. **E-mail:** kmafsecty@aol.com. **Website:** www.kingsmountainartfair.org. **Contact:** Carrie German, administrative assistant. Estab. 1963. Fine arts & crafts show held annually Labor Day weekend. Fundraiser for volunteer fire dept. Accepts photography, ceramics, clothing, 2D, painting, glass, jewelry, leather, sculpture, textile/fiber, wood. Juried. Number of exhibitors: 138. Public attendance: 10,000. Free to

public. Deadline for entry: January 30. Application fee: $20 (online). Exhibition space: 10×10 ft. Average gross sales/exhibitor: $3,500. For more information, artists should e-mail or visit website.

TIPS "Located in Redwood Forest South of San Francisco. Keep an open mind and be flexible."

LAKE CITY ARTS & CRAFTS FESTIVAL

P.O. Box 1147, Lake City CO 81235. (817)343-3305. E-mail: info@lakecityarts.org; kerrycoy@aol.com. Website: www.lakecityarts.org. Estab. 1975. Fine arts/arts & craft show held annually 3rd Tuesday in July. One-day event. Outdoors. Accepts photography, jewelry, metal work, woodworking, painting, handmade items. Juried by 3-5 undisclosed jurors. Prize: Winners are entered in a drawing for a free booth space in the following year's show. Number of exhibitors: 85. Public attendance: 500. Free to the public. Space fee: $85. Jury fee: $10. Exhibition space: 12×12 ft. Deadline for submission: mid April. Average gross sales/exhibitor: $500-$1,000. For more information, and application form, artists should visit website. Festival located at the Lake City Town Park and along Silver St.

TIPS "Repeat vendors draw repeat customers. People like to see their favorite vendors each year or every other year. If you come every year, have new things as well as your best-selling products."

LAKEFRONT FESTIVAL OF ART

700 N. Art Museum Dr., Milwaukee WI 53202. (414)224-3853. E-mail: lfoa@mam.org. Website: www.mam.org/lfoa. Contact: Krista Renfrew, festival director. Estab. 1963. Fine art show held annually the 3rd week in June. Indoors & outdoors. Accepts printmaking, sculpture, wood, painting, jewelry, ceramics, digital, drawing/pastel, MM2, fiber-non, wearable fiber, glass, photography, metal, NM. Juried. Awards/prizes: Artist Awards (10), Honorable Mention (10), Sculpture Garden. Exhibitors: 176. Number of attendees: 25,000. Admission: $17 general; $10 members & advance; 12 & under free. Apply via www.zapplication.org. Deadline for entry: November 25. Application fee: $35. Space fee: $500; $600 corner. Exhibition space: 10×10 ft. For more information send e-mail or visit website.

THE LAKELAND CRAFT FESTIVAL

270 Central Blvd., Suite 107B, Jupiter FL 33458. (561)746-6615. Fax: (561)746-6528. E-mail: info@artfestival.com. Website: www.artfestival.com.

Contact: Malinda Ratliff, communications manager. Estab. 2013. Fine art & craft fair held annually in late March. Outdoors. Accepts photography, jewelry, mixed media, sculpture, wood, ceramic, glass, painting, digital, fiber, metal. Juried. Number of exhibitors: 110. Number of attendees: 18,000. Free to public. Apply online via www.zapplication.org or visit website for paper application. Deadline: see website. Application fee: $15. Space fee: $250. Exhibition space: 10×10 and 10×20 ft. For more information, artists should e-mail, call, or visit website. Festival located at Lakeside Village in Lakeland, FL.

TIPS "You have to start somewhere. First, assess where you are, and what you'll need to get things off the ground. Next, make a plan of action. Outdoor street art shows are a great way to begin your career and lifetime as a working artist. You'll meet a lot of other artists who have been where you are now. Network with them!"

LAKE SUMTER ART & CRAFT FESTIVAL

270 Central Blvd., Suite 107B, Jupiter FL 33458. (561)746-6615. Fax: (561)746-6528. E-mail: info@artfestival.com. Website: www.artfestival.com. Contact: Malinda Ratliff, communications manager. Estab. 2010. Fine art & craft fair held annually in mid February. Outdoors. Accepts photography, jewelry, mixed media, sculpture, wood, ceramic, glass, painting, digital, fiber, metal. Juried. Number of exhibitors: 205. Number of attendees: 20,000. Free to public. Apply online via www.zapplication.org or visit website for paper application. Deadline: see website. Application fee: $15. Space fee: $265. Exhibition space: 10×10 and 10×20 ft. For more information, artists should e-mail, call, or visit website. Festival located at Lake Sumter Landing in The Villages, FL.

TIPS "You have to start somewhere. First, assess where you are, and what you'll need to get things off the ground. Next, make a plan of action. Outdoor street art shows are a great way to begin your career and lifetime as a working artist. You'll meet a lot of other artists who have been where you are now. Network with them!"

LA QUINTA ARTS FESTIVAL

78150 Calle Tampico #215, La Quinta CA 92253. (760)564-1244. Fax: (760)564-6884. E-mail: helpline@lqaf.com. Website: www.lqaf.com. Contact: artists: Kathleen Hughes, events manager; photographers: Christi Salamone, executive director. Estab.

1983. Fine arts & crafts festival held annually. Outdoors. Accepts mixed-media 2D/3D, printmaking, photography, drawing and pastel, painting, jewelry, ceramics, fiber, sculpture, glass, wood. Juried over 3 days online by 5 jury members per each of the 11 media categories. Awards/prizes: cash, automatic acceptance into future show, gift cards from premier local restaurants, hotel package, ad in *SW Art*. Number of exhibitors: 230. Public attendance: 28,000+. Admission: $15-day pass; $20 multiday pass. Artists should apply via www.zapplication.org only. Deadline for entry: September 30. Jury fee: $50. Space fee: $275. Exhibition space: 12×12 ft. Average exhibitor sales: $13,450. For more information, artists should visit website.

TIPS "Make sure that booth image looks like an art gallery! Less is more."

🎧 LAS OLAS ART FAIR

270 Central Blvd., Suite 107B, Jupiter FL 33458. (561)746-6615. **Fax:** (561)746-6528. **E-mail:** info@artfestival.com. **Website:** www.artfestival.com. **Contact:** Malinda Ratliff, communications manager. Fine art & craft fair held annually in January, March, and mid-October. Outdoors. Accepts photography, jewelry, mixed media, sculpture, wood, ceramic, glass, painting, digital, fiber, metal. Juried. Number of exhibitors: 280/January, 260/March, 150/October. Number of attendees: 100,000/January, 100,000/March, 70,000/October. Free to public. Apply online via www.zapplication.org. Deadline: see website. Application fee: $25. Space fee: $400/January, $400/March, $395/October. Exhibition space: 10×10 and 10×20 ft. For more information, artists should e-mail, call, or visit website. Fair located on Las Olas Blvd. in Ft. Lauderdale, FL.

TIPS "You have to start somewhere. First, assess where you are, and what you'll need to get things off the ground. Next, make a plan of action. Outdoor street art shows are a great way to begin your career and lifetime as a working artist. You'll meet a lot of other artists who have been where you are now. Network with them!"

🎧 LEESBURG FINE ART FESTIVAL

Paragon Fine Art Festivals, 8258 Midnight Pass Rd., Sarasota FL 34242. (941)487-8061. **Fax:** (941)346-0302. **E-mail:** admin@paragonartfest.com; spadagraphix@yahoo.com. **Website:** www.paragonartevents.com/lee. **Contact:** Bill Kinney. Fine arts & crafts fair held annually in September. Outdoors. Accepts handmade crafts, ceramics, fiber, glass, jewelry, mixed media, painting, photography, and sculpture. Juried. Number of exhibitors: 115. Number of attendees: varies. Free to public. Apply online. Deadline for entry: July. Application fee: $30. Space fee: $395. Exhibition space: see website. For more information, artists should e-mail, call, or visit website.

🎧 LES CHENEAUX FESTIVAL OF ARTS

P.O. Box 147, Cedarville MI 49719. (517)282-4950. **E-mail:** lcifoa@gmail.com. **Website:** www.lescheneaux.net/?annualevents. **Contact:** Rick Sapero. Estab. 1976. Fine arts & crafts show held annually 2nd Saturday in August. Outdoors. Accepts photography and all other media; original work and design only; no kits or commercially manufactured goods. Juried by a committee of 10. Submit 4 slides (3 of the artwork, 1 of booth display). Awards: monetary prizes for excellent and original work. Number of exhibitors: 70. Public attendance: 8,000. Public admission: $7. Artists should fill out application form to apply. Deadline for entry: March 15. Booth fee: $75; Jury fee: $5. Exhibition space: 10×10 ft. Average gross sales/exhibitor: $5-500. For more information, artists should call, send SASE, or visit website.

🎧 LEVIS COMMONS FINE ART FAIR

The Guild of Artists & Artisans, 118 N. Fourth Ave., Ann Arbor MI 48104. (734)662-3382, ext. 101. **E-mail:** info@theguild.org; nicole@theguild.org. **Website:** www.theguild.org. **Contact:** Nicole McKay, artist relations director. Fine arts & crafts fair held annually in September. Outdoors. Accepts handmade crafts, jewelry, ceramics, painting, glass, photography, fiber, and more. Juried. Number of exhibitors: 130. Number of attendees: 35,000. Free to public. Apply online. Deadline for entry: April. Application fee: $25 members; $30 non-members. Space fee: varies. Exhibition space: varies. For more information, artists should e-mail, call, or visit website.

🅞🎧 LIBERTY ARTS SQUARED

P.O. Box 302, Liberty MO 64069. **E-mail:** staff@libertyartssquared.org. **Website:** www.libertyartssquared.org. Estab. 2010. Outdoor fine art/craft show held annually. Accepts all mediums. Awards: prizes totaling $4,000; Visual Arts for Awards $1,500; Folk Art for Awards $1,500; Overall Best of Show Award $500. Free admission to the public; free parking. Application fee: $25. Space fee: $200. Exhibition

space: 10×10 ft. For more information, e-mail or visit website.

🎧 LILAC FESTIVAL ARTS & CRAFTS SHOWS

26 Goodman St., Rochester NY 14607. (585)244-0951; (585)473-4482. **E-mail:** lyn@rochesterevents.com. **Website:** www.rochesterevents.com. Estab. 1985. Arts & crafts shows held annually in mid-May (see website for details). Outdoors. Accepts photography, painting, ceramics, woodworking, metal sculpture, fiber. Juried by a panel. Number of exhibitors: 120. Public attendance: 25,000. Free to public. Exhibition space: 10×10 ft. Space fee: $200. For more information, and to apply, artists should e-mail or visit website. Festival held at Highland Park in Rochester NY.

🎧 LINCOLN ARTS FESTIVAL

(402) 434-2787. **E-mail:** lori@artscene.org. **Website:** www.artscene.org/events/lincoln-arts-festival/. Fine arts & crafts fair held annually in September. Outdoors. Accepts handmade crafts, jewelry, ceramics, painting, glass, photography, fiber, and more. Juried. Awards/prizes: $6,000 in awards & prizes. Number of exhibitors: see website. Number of attendees: varies. Free to public. Apply online. Deadline for entry: May. Application fee: $25. Space fee: $190 (10×10 ft.); $310 (10×20 ft.). Exhibition space: 10×10 ft.; 10×20 ft. For more information, artists should e-mail or visit website.

LIONS CLUB ARTS & CRAFTS FESTIVAL

Henderson Lions Club, P.O. Box 842, Henderson KY 42419. **E-mail:** lionsartsandcrafts@gmail.com. **Website:** www.lionsartsandcrafts.com. Estab. 1972. Formerly Gradd Arts & Crafts Festival. Arts & crafts show held annually 1st full weekend in October. Outdoors. Accepts photography taken by crafter only. Number of exhibitors: 100-150. Public attendance: 10,000+. Artists should apply by calling to be put on mailing list. Space fee: $100. Exhibition space: 15×15 ft. For more information, artists should e-mail, visit website, or call. Festival located at John James Audubon State Park.

TIPS "Be sure that only hand-crafted items are sold. No buy/sell items will be allowed."

🎧 LOMPOC FLOWER FESTIVAL

414 W. Ocean Ave., Lompoc CA 93436. (805)735-8511. **Fax:** (805)7359228. **E-mail:** lompocvalle1@verizon.net. **Website:** lompocvalleyartassociation.

com/. **Contact:** Kathy Badrak. Estab. 1942. Sponsored by Lompoc Valley Art Association, Cyprus Gallery. Show held annually last week in June. Festival event includes a parade, food booths, entertainment, beer garden, and commercial center, which is not located near arts & crafts area. Outdoors. Accepts photography, fine art, woodworking, pottery, stained glass, fine jewelry. Juried by 5 members of the LVAA. Vendor must submit 3 photos of their work and a description on how they make their art. Artists should apply by downloading application from website. Deadline for entry: early May. Space fee: $375 (single); $575 (double); $100 cleaning deposit (to be refunded after show—see application for details). Exhibition space: 12×16 ft. For more information, artists should visit website.

🎧 LONG'S PARK ART & CRAFT FESTIVAL

Long's Park Amphitheater Foundation, 630 Janet Ave., Suite A-111, Lancaster PA 17601-4541. (717)735-8883. **Website:** www.longspark.org. Fine arts & crafts fair held annually Labor Day weekend. Outdoors. Accepts handmade crafts, jewelry, ceramics, painting, glass, photography, fiber, and more. Juried. Number of exhibitors: 200. Number of attendees: varies. Admission: see website. Apply online. Deadline for entry: February. Application fee: see website. Space fee: $510 (single); $645 (double). Exhibition space: 10×10 ft. (single); 10×20 ft. (double) . For more information, artists should call or visit website.

🎧 LOUISVILLE FESTIVAL OF THE ARTS WITH CRAFT MARKETPLACE AT PADDOCK SHOPS

270 Central Blvd., Suite 107B, Jupiter FL 33458. (561)746-6615. **Fax:** (561)746-6528. **E-mail:** info@art-festival.com. **Website:** www.artfestival.com. **Contact:** Malinda Ratliff, communications manager. Estab. 2008. Fine art & craft fair held annually in mid-June. Outdoors. Accepts photography, jewelry, mixed media, sculpture, wood, ceramic, glass, painting, digital, fiber, metal. Juried. Number of exhibitors: 130. Number of attendees: 50,000. Free to public. Apply online via www.zapplication.org. Deadline: see website. Application fee: $25. Space fee: $375. Exhibition space: 10×10 ft. and 10×20 ft. For more information, artists should e-mail, call, or visit website. Show located at Paddock Shops on Summit Plaza Dr. in Louisville, KY.

TIPS "You have to start somewhere. First, assess where you are, and what you'll need to get things off

the ground. Next, make a plan of action. Outdoor street art shows are a great way to begin your career and lifetime as a working artist. You'll meet a lot of other artists who have been where you are now. Network with them!"

🎧 MADEIRA BEACH THANKSGIVING WEEKEND CRAFT FESTIVAL

270 Central Blvd., Suite 107B, Jupiter FL 33458. (561)746-6615. **Fax:** (561)746-6528. **E-mail:** info@artfestival.com. **Website:** www.artfestival.com. **Contact:** Malinda Ratliff, communications manager. Estab. 2012. Fine art & craft fair held annually in November. Outdoors. Accepts photography, jewelry, mixed media, sculpture, wood, ceramic, glass, painting, digital, fiber, metal. Juried. Number of exhibitors: 80. Number of attendees: 13,000. Free to public. Apply online via www.zapplication.org or visit website for paper application. Deadline: see website. Application fee: $15. Space fee: $250. Exhibition space: 10×10 ft. and 10×20 ft. For more information, artists should e-mail, call, or visit website. Festival located at Madeira Way between Gulf Blvd. & 150th Ave.

TIPS "You have to start somewhere. First, assess where you are, and what you'll need to get things off the ground. Next, make a plan of action. Outdoor street art shows are a great way to begin your career and lifetime as a working artist. You'll meet a lot of other artists who have been where you are now. Network with them!"

MADISON CHAUTAUQUA FESTIVAL OF ART

601 W. First St., Madison IN 47250. (812)571-2752. **Fax:** (812)273-3694. **E-mail:** info@madisonchautauqua.com. **Website:** www.madisonchautauqua.com. **Contact:** Amy Fischmer and Jenny Youngblood, co-ordinators. Estab. 1971. Premier juried fine arts & crafts show, featuring painting, photography, stained glass, jewelry, textiles, pottery, and more, amid the tree-lined streets of Madison's historic district. Held annually the last weekend in September. Stop by the Riverfront FoodFest for a variety of foods to enjoy. Relax and listen to the live performances on the Lanier Mansion lawn, on the plaza, and along the riverfront. Takes place in late September. Painting (2D artists may sell prints, but must include originals as well), photography, pottery, sculpture, wearable, jewelry, fiber, wood, baskets, glass, paper, leather. The number of artists in each category is limited to protect the integrity of the show. Festival held in Madison's National Landmark Historic District.

🎧 MAGNOLIA BLOSSOM FESTIVAL

Magnolia/Columbia County Chamber of Commerce, P.O. Box 866, Magnolia AR 71754. (870)901-2216 or (870)693-5265; 870-234-4352. **E-mail:** jpate006@centurytel.net; jpate002@centurytel.net. **Website:** www.blossomfestival.org. Craft show held annually in May. Outdoors. Accepts handmade crafts, ceramics, paintings, jewelry, glass, photography, wearable art, and other mediums. Juried. Number of exhibitors: see website. Number of attendees: varies. Free to public. Apply online. Deadline for entry: late March. Application fee: none. Space fee: varies. Exhibition space: varies. For more information, artists should e-mail, call, or visit website.

🎧 MAINSAIL ARTS FESTIVAL

E-mail: artist@mainsailart.org. **Website:** www.mainsailart.org. Fine arts & crafts fair held annually in April. Outdoors. Accepts handmade crafts, ceramics, digital art, fibers, glass, graphics, jewelry, metal, mixed media, oil/acrylic, photography, sculpture, watercolor, and wood . Juried. Awards/prizes: $60,000 in cash awards. Number of exhibitors: 270. Number of attendees: 100,000. Free to public. Apply online. Deadline for entry: December. Application fee: $35. Space fee: $275. Exhibition space: 10×10 ft. For more information, artists should e-mail or visit website.

🎧 MAIN STREET TO THE ROCKIES ART FESTIVAL

270 Central Blvd., Suite 107B, Jupiter FL 33458. (561)746-6615. **Fax:** (561)746-6528. **E-mail:** info@artfestival.com. **Website:** www.artfestival.com. **Contact:** Malinda Ratliff, communications manager. Estab. 2007. Fine art & craft fair held annually in mid-August. Outdoors. Accepts photography, jewelry, mixed media, sculpture, wood, ceramic, glass, painting, digital, fiber, metal. Juried. Number of exhibitors: 100. Number of attendees: 60,000. Free to public. Apply online via www.zapplication.org. Deadline: see website. Application fee: $35. Space fee: $475. Exhibition space: 10×10 ft. and 10×20 ft. For more information, artists should e-mail, call, or visit website. Festival located at Main St. in Downtown Frisco, CO.

TIPS "You have to start somewhere. First, assess where you are, and what you'll need to get things off the ground. Next, make a plan of action. Outdoor

street art shows are a great way to begin your career and lifetime as a working artist. You'll meet a lot of other artists who have been where you are now. Network with them!"

🎧 MARCO ISLAND FESTIVAL OF THE ARTS

270 Central Blvd., Suite 107B, Jupiter FL 33458. (561)746-6615. **Fax:** (561)746-6528. **E-mail:** info@art-festival.com. **Website:** www.artfestival.com. **Contact:** Malinda Ratliff, communications manager. Estab. 2014. Fine art & craft fair held annually in mid-March. Outdoors. Accepts photography, jewelry, mixed media, sculpture, wood, ceramic, glass, painting, digital, fiber, metal. Juried. Number of exhibitors: 175. Number of attendees: 40,000. Free to public. Apply online via www.zapplication.org. Deadline: see website. Application fee: $25. Space fee: $415. Exhibition space: 10×10 ft. and 10×20 ft. For more information, artists should e-mail, call, or visit website. Festival located at Veteran's Park off N. Collier Blvd. in Marco Island, FL.

TIPS "You have to start somewhere. First, assess where you are, and what you'll need to get things off the ground. Next, make a plan of action. Outdoor street art shows are a great way to begin your career and lifetime as a working artist. You'll meet a lot of other artists who have been where you are now. Network with them!"

🎧 MARION ARTS FESTIVAL

1225 Sixth Ave., Suite 100, Marion IA 52302. **E-mail:** mafdirector@marioncc.org. **Website:** www.marion-artsfestival.com. Fine arts & crafts fair held annually in May. Outdoors. Accepts handmade crafts, jewelry, ceramics, painting, photography, digital, printmaking, and more. Juried. Awards/prizes: Best of Show, IDEA Award. Number of exhibitors: 50. Number of attendees: 14,000. Free to public. Apply via www.zapplication.org. Deadline for entry: January. Application fee: $25. Space fee: $225. Exhibition space: 10×10 ft. For more information, artists should visit website.

🎧 MASON ARTS FESTIVAL

Mason-Deerfield Arts Alliance, P.O. Box 381, Mason OH 45040. (513)309-8585. **E-mail:** masonarts@gmail.com; info@the-arts-alliance.org; mraffel@the-arts-alliance.org. **Website:** www.masonarts.org. Fine arts & crafts show held annually in mid-September (see website for details). Indoors and outdoors. Accepts photography, graphics, printmaking, mixed media; painting and drawing; ceramics, metal sculpture; fiber, glass, jewelry, wood, leather. Juried. Awards/prizes: $3,000+. Number of exhibitors: 75-100. Public attendance: 3,000-5,000. Free to the public. Artists should apply by visiting website for application, e-mailing, or calling. Deadline for entry: see website. Jury fee: $25. Space fee: $75. Exhibition space: 12×12 ft.; artist must provide 10×10 ft. pop-up tent.

🔇 City Gallery show is held indoors; these artists are not permitted to participate outdoors and vice versa. City Gallery is a juried show featuring approximately 30-50 artists who may show up to 2 pieces.

🎧 MCGREGOR SPRING ARTS & CRAFTS FESTIVAL

McGregor-Marquette Chamber of Commerce, P.O. Box 105, McGregor IA 52157. (800)896-0910 or (563)873-2186. **E-mail:** mcgregormarquettechamber@gmail.com. **Website:** www.mcgreg-marq.org. Fine arts & crafts fair held annually in May & October. Indoors & outdoors. Accepts handmade crafts, jewelry, ceramics, painting, photography, digital, printmaking, and more. Number of exhibitors: see website. Number of attendees: varies. Free to public. Apply via online. Deadline for entry: see website. Application fee: none. Space fee: $75 outdoor; $100 indoor. Exhibition space: 10×10 ft. For more information, artists should e-mail, call, or visit website.

🎧 MEMORIAL WEEKEND ARTS & CRAFTS FESTIVAL

38 Charles St., Rochester NH 03867. (603)332-2616. **Fax:** (603)332-8413. **E-mail:** info@castleberryfairs.com. **Website:** www.castleberryfairs.com. **Contact:** Sherry Mullen. Estab. 1989. Arts & crafts show held annually on Memorial Day weekend in Meredith NH. Outdoors. Accepts photography and all other mediums. Juried by photo, slide, or sample. Number of exhibitors: 85. Public attendance: 7,500. Free to the public. Artists should apply by downloading application from website. Deadline for entry: until full. Space fee: $225. Exhibition space: 10×10 ft. For more information, artists should visit website. Festival held at Mill Falls Marketplace.

TIPS "Do not bring a book; do not bring a chair. Smile and make eye contact with everyone who enters your booth. Have them sign your guest book; get their e-mail address so you can let them know when you are

in the area again. And, finally, make the sale—they are at the fair to shop, after all."

MESA ARTS FESTIVAL

Mesa Arts Center, One E. Main St., Mesa AZ 85201. (480)644-6627. **Fax:** (480)644-6503. **E-mail:** shawn. lawson@mesaartscenter.com. **Website:** www.mesa artscenter.com. Fine arts & crafts fair held annually in December. Outdoors. Accepts handmade crafts, jewelry, ceramics, painting, photography, digital, printmaking, and more. Number of exhibitors: see website. Number of attendees: varies. Free to public. Apply online. Deadline for entry: see website. Application fee: $25. Space fee: $250. Exhibition space: 10×10 ft. For more information, artists should e-mail, call or visit website.

MICHIGAN STATE UNIVERSITY HOLIDAY ARTS & CRAFTS SHOW

49 Abbot Rd., Room 26, MSU Union, East Lansing MI 48824. (517)355-3354. **E-mail:** uab@rhs.msu.edu; artsandcrafts@uabevents.com. **Website:** www.uab events.com. **Contact:** Brian D. Proffer. Estab. 1963. Arts & crafts show held annually the 1st weekend in December. Indoors. Accepts photography, basketry, candles, ceramics, clothing, sculpture, soaps, drawings, floral, fibers, glass, jewelry, metals, painting, graphics, pottery, wood. Selected by a committee using photographs submitted by each vendor to eliminate commercial products. They will evaluate on quality, creativity, and crowd appeal. Number of exhibitors: 139. Public attendance: 15,000. Free to public. Artists should apply online. Exhibition space: 8×5 ft. For more information, artists should visit website or call.

MICHIGAN STATE UNIVERSITY SPRING ARTS & CRAFTS SHOW

49 Abbot Rd., Room 26, MSU Union, East Lansing MI 48824. (517)355-3354. **E-mail:** artsandcrafts@uab events.com. **Website:** www.uabevents.com. **Contact:** Brian Proffer, 517-884-3338. Estab. 1963. In its 52nd year, the Spring Arts and Crafts show will take place, once again, on the grounds of the MSU Union, which is located on the corner of Grand River Avenue and Abbot Road in East Lansing, Michigan. This year's show is going to host more than 300 artisans with many new vendors as well as include many returning favorites! There will be a broad range of handmade items including candles, furniture, jewelry, home and yard décor, aromatherapy, clothing, children's toys,

paintings, graphics, pottery, sculpture, photography, and much more!

For more information about the show visit our website: uabevents.com/retailad/arts-and-crafts-show.

MID-MISSOURI ARTISTS CHRISTMAS ARTS & CRAFTS SALE

P.O. Box 116, Warrensburg MO 64093. (660)441-5075. **E-mail:** mbush22@yahoo.com. **Website:** www.mid-missouriartists.webs.com. **Contact:** Pam Comer or Mary Bush. Estab. 1970. Holiday arts & crafts show held annually in November. Indoors. Accepts photography and all artist/creator-made arts and crafts (no resale items). Juried by 3 good-quality color photos (2 of the artwork, 1 of the display). Number of exhibitors: 60. Public attendance: 1,200. Free to the public. Artists should apply by e-mailing or calling for an application form. Entry form also available at www.midmissouriartists.webs.com. Deadline for entry: early November. Space fee: $50. Exhibition space: 10×10 ft. For more information, artists should e-mail or call. 1-day show 9 a.m. Sat., Warrensburg Community Center, 445 E. Gay St.

TIPS "Items under $100 are most popular."

MIDSUMMER ARTS FAIRE

1515 Jersey St., Quincy IL 62301. (217)779-2285. **Fax:** (217)223-6950. **E-mail:** info@artsfaire.org. **Website:** www.artsfaire.org. **Contact:** Kayla Obert, coordinator. Fine art show held annually in June. Outdoors. Accepts photography, paintings, pottery, jewelry. Juried. Awards/prizes: various totaling $5,000. Exhibitors: 60. Number of attendees: 7,000. Free to public. Apply via www.zapplication.org. Deadline for entry: February 5. Application fee: $20. Space fee: $100. Exhibition space: 10×10. Average sales: $2,500. For more information, artists should e-mail, call, see Facebook page, or visit website.

TIPS "Variety of price points with several options at a lower price point as well."

MILWAUKEE DOMES ART FESTIVAL

Fine arts & crafts fair held annually in August. Indoors & outdoors. Accepts handmade crafts, jewelry, ceramics, painting, photography, digital, printmaking, and more. Juried. Awards/prizes: $10,500 in awards and prizes. Number of exhibitors: see website. Number of attendees: varies. Free to public. Apply online. Deadline for entry: see website. Application fee:

$35. Space fee: $250 outdoor; $450 indoor. Exhibition space: 10×10 ft. For more information visit website.

🎧 MISSION FEDERAL ARTWALK

2210 Columbia St., San Diego CA 92101. (619)615-1090. **Fax:** (619)615-1099. **E-mail:** info@artwalksandiego.org. **Website:** www.artwalksandiego.org. Fine arts & crafts fair held annually in April. Outdoors. Accepts handmade crafts, jewelry, ceramics, painting, photography, digital, printmaking, and more. Juried. Number of exhibitors: 350. Number of attendees: 90,000. Free to public. Apply online. Deadline for entry: January. Application fee: none. Space fee: varies. Exhibition space: varies. For more information, artists should e-mail, call, or visit website.

MONTAUK ARTISTS' ASSOCIATION, INC.

P.O. Box 2751, Montauk NY 11954. (631)668-5336. **E-mail:** montaukart@aol.com. **Website:** www.montaukartistsassociation.org; www.montaukchamber.com. **Contact:** Anne Weissman. Estab. 1970. Arts & crafts show held annually Memorial Day weekend; 3rd weekend in August. Outdoors. Accepts photography, paintings, prints (numbered and signed in bins), sculpture, limited fine art, jewelry, and ceremics. Number of exhibitors: 90. Public attendance: 8-10,000. Free to public. Exhibition space: 12×12 ft. For more information, artists should call or visit website.

🎧 MONTE SANO ART FESTIVAL

706 Randolph Ave., Huntsville AL 35801. (256) 519-2787. **E-mail:** amayfield@artshuntsville.org. **Website:** www.montesanoartfestival.com. Estab. 1987. Annual fine art show held the 3rd weekend in June. Outdoors. Accepts handmade crafts, sculpture, glass, ceramics, paper, wood, paint, mix, fiber/textile, photography, jewelry. Juried. Awards/prizes: Best of Show in each category. Exhibitors: 195. Number of attendees: 7,000. Admission: $9-$16. Apply via www.zapplication.org. Deadline for entry: March 1. Application fee: $25 Space fee: $500-$800. Exhibition space: 10×10, 10×20 ft. For more information see website.

MOUNTAIN STATE FOREST FESTIVAL

P.O. Box 388, 101 Lough St., Elkins WV 26241. (304)636-1824. **Fax:** (304)636-4020. **E-mail:** msff@forestfestival.com. **Website:** www.forestfestival.com. **Contact:** Cindy Nucilli, executive director. Estab. 1930. Arts, crafts & photography show held annually in early October. Accepts photography and homemade crafts. Awards/prizes: cash awards for photography only. Number of exhibitors: 50+. Public attendance: 75,000. Free to the public. Artists should apply by requesting an application form. For more information, artists should visit website, call, or visit Facebook page (search "Mountain State Forest Festival").

🎧 MOUNT DORA ARTS FESTIVAL

Mount Dora Center for the Arts, 138 E. Fifth Ave., Mount Dora FL 32757. (352)383-0880. **Fax:** (352)383-7753. **E-mail:** nancy@mountdoracenterforthearts.org or kristina@mountdoracenterforthearts.org. **Website:** www.mountdoracenterforthearts.org/arts-festival. **Contact:** Nancy Zinkofsky, artist/vendor submissions; Kristina Rosenburg, sponsors & marketing. Held the 1st weekend of February. A juried fine arts festival for art lovers, casual festival-goers, and families. In addition to the endless rows of fine art, including oil paintings, watercolors, acrylics, clay, sculpture, and photography, the festival features local and regional musical entertainment at a main stage in Donnelly Park. See website for more information.

🎧 NAMPA FESTIVAL OF ARTS

131 Constitution Way, Nampa ID 83686. (208)468-5858. **Fax:** (208)465-2282. **E-mail:** burkeyj@cityofnampa.us. **Website:** www.nampaparksandrecreation.org. **Contact:** Wendy Davis, program director. Estab. 1986. Fine art & craft show held annually mid-August. Outdoors. Accepts handmade crafts, fine art, photography, metal, anything handmade. Juried. Awards/prizes: cash. Exhibitors: 180. Number of attendees: 15,000. Free to public. See website for application. Deadline for entry: July 10. Space fee: $40-90. Exhibition space: 10×10, 15×15, 20×20 ft. For more information send e-mail, call, or visit website.

TIPS "Price things reasonably and have products displayed attractively."

🎧 NAPERVILLE WOMAN'S CLUB ART FAIR

(630)803-9171. **E-mail:** naperartfair@yahoo.com. **Website:** www.napervillewomansclub.org. **Contact:** Marie Gnesda. Over 100 local and national artists will be displaying original artwork in clay, fiber, glass, jewelry, mixed media, metal, painting, photography, sculpture, and wood. Ribbons and cash prizes are awarded to winning artists by local judges and NWC. The Naperville Woman's Club Art Fair is the longest continuously running art fair in Illinois. Activities at this event include entertainment, a silent auction,

artist demonstrations, the Empty Bowl Fundraiser to benefit local food pantries, and the Petite Picassos children's activities tent. This is the largest fundraiser of the year for the Naperville Woman's Club. Proceeds from the event help fund a local art scholarship and local charities. Admission and parking are free. For more information please e-mail us at: naperartfair@yahoo.com.

NEW ENGLAND CRAFT & SPECIALTY FOOD FAIR

38 Charles St., Rochester NH 03867. (603)332-2616. **Fax:** (603)332-8413. **E-mail:** info@castleberryfairs.com. **Website:** www.castleberryfairs.com. Estab. 1995. Arts & crafts show held annually on Veterans Day weekend in Salem NH. Indoors. Accepts photography and all other mediums. Juried by photo, slide, or sample. Number of exhibitors: 200. Public attendance: 15,000. Artists should apply by downloading application from website. Deadline for entry: until full. Space fee: $350-450. Exhibition space: 10×6 or 10×10 ft. Average gross sales/exhibitor: "Generally, this is considered an 'excellent' show, so I would guess most exhibitors sell 10 times their booth fee, or in this case, at least $3,000 in sales." For more information, artists should visit website. Fair is held at Rockingham Park Racetrack.

TIPS "Do not bring a book; do not bring a chair. Smile and make eye contact with everyone who enters your booth. Have them sign your guest book; get their e-mail address so you can let them know when you are in the area again. And, finally, make the sale—they are at the fair to shop, after all."

NEW MEXICO ARTS AND CRAFTS FAIR

2501 San Pedro St. NE, Suite 110, Albuquerque NM 87110. (505)884-9043. **E-mail:** info@nmartsandcraftsfair.org. **Website:** www.nmartsandcraftsfair.org. Estab. 1962. Fine arts & craft show held annually in June. Indoors. Accepts decorative and functional ceramics, digital art, drawing, fiber, precious and non-precious jewelry, photography, paintings, printmaking, mixed media, metal, sculpture and wood. *Only New Mexico residents 18 years and older are eligible.* See website for more details.

NEW SMYRNA BEACH ART FIESTA

City of New Smyrna Beach, 210 Sams Ave., New Smyrna Beach FL 32168. (386)424-2175. **Fax:** (386)424-2177. **E-mail:** kshelton@cityofnsb.com. **Website:** www.cityofnsb.com. **Contact:** Kimla Shelton. Estab.

1952. Arts & crafts show held annually in February. Outdoors. Accepts photography, oil, acrylics, pastel, drawings, graphics, sculpture, crafts, watercolor. Awards/prizes: $15,000 prize money; $1,600/category; Best of Show. Number of exhibitors: 250. Public attendance: 14,000. Free to public. Artists should apply by calling to get on mailing list. Applications are always mailed out the day before Thanksgiving. Deadline for entry: until full. Exhibition space: 10×10 ft. For more information, artists should call. Show held in the Old Fort Park area.

NEWTOWN ARTS FESTIVAL

Piper Promotions, 4 Old Green Rd., Sandy Hook CT 6482. (203)512-9100. **E-mail:** staceyolszewski@yahoo.com. **Website:** www.newtownartsfestival.com. **Contact:** Stacey Olszewski. Fine arts & crafts fair held annually in September. Outdoors. Accepts handmade crafts, jewelry, ceramics, painting, photography, digital, printmaking, and more. Juried. Number of exhibitors: see website. Number of attendees: varies. Admission: $5; children 12 & under free. Apply online. Deadline for entry: August. Application fee: none. Space fee: $105 (booth); $225 (festival tent). Exhibition space: 10×10 ft. For more information, artists should e-mail, call, or visit website.

NEW WORLD FESTIVAL OF THE ARTS

P.O. Box 2300, Manteo NC 27954. (252) 473-5558. **E-mail:** dareartsinfo@gmail.com. **Website:** dare-arts.org. Fay Davis Edwards. **Contact:** Louise Sanderlin. Estab. 1963. Fine arts & crafts show held annually in mid-August (see website for details). Outdoors. Juried. Location is the Waterfront in downtown Manteo. Features 80 selected artists from Vermont to Florida exhibiting and selling their works. Application fee: $15. Space fee: $85.

NIANTIC OUTDOOR ART & CRAFT SHOW

P.O. Box 227, Niantic CT 6357. (860)705-7800. **E-mail:** artshowwoody@yahoo.com. **Website:** www.niantic-artsandcraftshow.com. **Contact:** Craig Woody. Estab. 1960. Fine art & craft show held annually in July. Outdoors. Accepts handmade crafts, ceramics, fiber, glass, graphics, jewelry, leather, metal, mixed media, painting, photography, printmaking, sculpture, woodworking. Juried. Number of exhibitors: 142. Number of attendees: varies. Free to public. Apply online. Deadline for entry: March. Application fee: $20. Space fee: varies. Exhibition space: varies. For

more information, artists should e-mail, call, or visit website.

🎧 NORTH CHARLESTON ARTS FESTIVAL

P.O. Box 190016, North Charleston SC 29419-9016. (843)740-5854. **E-mail:** culturalarts@northcharleston.org. **Website:** www.northcharlestonartsfest.com. Fine arts & crafts fair held annually in May. Outdoors. Accepts handmade crafts, jewelry, ceramics, painting, photography, digital, printmaking, and more. Juried. Number of exhibitors: see website. Number of attendees: 30,000. Admission: see website. Apply online. Deadline for entry: January. Application fee: see website. Space fee: see website. Exhibition space: see website. For more information, artists should e-mail, call, or visit website.

NORTH CONGREGATIONAL PEACH & CRAFT FAIR

17 Church St., New Hartford CT 06057. (860)379-2466. **Website:** www.northchurchucc.com. **Contact:** K.T. "Sully" Sullivan. Estab. 1966. Arts & crafts show held annually in mid-August. Outdoors on the Green at Pine Meadow. Accepts photography, most arts and crafts. Number of exhibitors: 50. Public attendance: 500-2,000. Free to public. Artists should call for application form. Deadline for entry: August. Application fee: $60. Exhibition space: 11×11 ft.

TIPS "Be prepared for all kinds of weather."

🎧 NORTHERN VIRGINIA FINE ARTS FESTIVAL

(703)471-9242. **E-mail:** info@restonarts.org. **Website:** www.northernvirginiafineartsfestival.org. Fine arts & crafts fair held annually in May. Outdoors. Accepts handmade crafts, jewelry, ceramics, painting, photography, digital, printmaking, and more. Juried. Number of exhibitors: 200. Number of attendees: varies. Admission: $5; children 18 & under free. Apply online. Deadline for entry: see website. Application fee: see website. Space fee: see website. Exhibition space: see website. For more information, artists should e-mail, call, or visit website.

🎧 OC FAIR VISUAL ARTS COMPETITION

88 Fair Dr., Costa Mesa CA 92626. (714)708-1718. **E-mail:** sanderson@ocfair.com. **Website:** www.ocfair.com/competitions. **Contact:** Stephen Anderson. Annual fine art and craft show held from mid-July to mid-August. Indoors. Accepted media includes: photography, 2D media, sculpture, ceramics, graphic

arts, fine woodworking, and film. Juried event with cash and purchase awards. Digital submissions only. Over 2,000 exhibitors each year. 1.3 million attendees. 20,000 sq. ft. exhibition space. Fair admission fee: $12. Artists should apply online at www.ocfair.com/competitions after April 1. Deadline for entry: June 1. Application fee of $10 per entry. Open to California residents 19 and older; young adults 13-18. E-mail or visit website for more information.

🎧 OCONOMOWOC FESTIVAL OF THE ARTS

P.O. Box 651, Oconomowoc WI 53066. **Website:** www.oconomowocarts.org. Estab. 1970. Fine arts & crafts fair held annually in August. Outdoors. Accepts handmade crafts, jewelry, ceramics, painting, photography, digital, printmaking, and more. Juried. Awards/prizes: $3,500 in awards & prizes. Number of exhibitors: 140. Number of attendees: varies. Admission: Free to public. Apply online. Deadline for entry: March. Application fee: $40. Space fee: $250. Exhibition space: 10×10 ft. For more information, artists should visit website.

🎧 OHIO MART

Stan Hywet Hall and Gardens, 714 N. Portage Path, Akron OH 44303. (330)836-5533 or (888)836-5533. **E-mail:** info@stanhywet.org. **Website:** www.stanhywet.org. Estab. 1966. Fine arts & crafts fair held annually in October. Outdoors. Accepts handmade crafts, jewelry, ceramics, painting, photography, digital, printmaking, and more. Juried. Number of exhibitors: see website. Number of attendees: varies. Admission: $9 adults; $2 youth. Apply online. Deadline for entry: see website. Application fee: see website. Space fee: see website. Exhibition space: see website. For more information, artists should call, e-mail, or visit website.

🎧 OHIO SAUERKRAUT FESTIVAL

P.O. Box 281, Waynesville OH 45068. (513)897-8855, ext. 2. **Fax:** (513)897-9833. **E-mail:** barb@waynesvilleohio.com. **Website:** www.sauerkrautfestival.com. **Contact:** Barb Lindsay, office and event coordinator. Estab. 1969. Arts & crafts show held annually 2nd full weekend in October. Outdoors. Accepts photography and handcrafted items only. Juried by jury team. Number of exhibitors: 458. Public attendance: 350,000. Jury fee: $20. Space fee: $200 + $25 processing fee. Exhibition space: 10×10 ft. For more information, artists should visit website or call.

TIPS "Have reasonably priced items."

⊙ OKLAHOMA CITY FESTIVAL OF THE ARTS

Arts Council of Oklahoma City, 400 W. California, Oklahoma City OK 73102. (405)270-4848. **Fax:** (405)270-4888. **E-mail:** info@artscouncilokc.com. **Website:** www.artscouncilokc.com. Estab. 1967. Fine arts & crafts fair held annually in April. Outdoors. Accepts handmade crafts, jewelry, ceramics, painting, photography, digital, printmaking, and more. Juried. Number of exhibitors: 144. Number of attendees: varies. Free to public. Apply online. Deadline for entry: see website. Application fee: see website. Space fee: see website. Exhibition space: see website. For more information, artists should call, e-mail, or visit website.

⊙ OLD CAPITOL ART FAIR

P.O. Box 5701, Springfield IL 62705. (405)270-4848. **Fax:** (405)270-4888. **E-mail:** artistinfo@yahoo.com. **Website:** www.socaf.org. **Contact:** Kate Baima. Estab. 1961. Fine arts & crafts fair held annually in May. Outdoors. Accepts handmade crafts, jewelry, ceramics, painting, photography, digital, printmaking, and more. Juried. Awards/prizes: 1st place, 2nd place, 3rd place, awards of merit. Number of exhibitors: see website. Number of attendees: varies. Free to public. Apply online. Deadline for entry: November. Application fee: $35. Space fee: $300 (single); $550 (double). Exhibition space: 10×10 ft. (single); 10×20 ft. (double). For more information, artists should call, e-mail, or visit website.

⊙ OLD FOURTH WARD PARK ARTS FESTIVAL

592 N. Angier Ave. NE, Atlanta GA 30308. (404)873-1222. **E-mail:** info@affps.com. **Website:** www.old fourthwardparkartsfestival.com/. **Contact:** Randall Fox, festival director. Estab. 2013. Arts & crafts show held annually late June. Outdoors. Accepts handmade crafts, painting, photography, sculpture, leather, metal, glass, jewelry. Juried by a panel. Awards/prizes: ribbons. Number of exhibitors: 130. Number of attendees: 25,000. Free to public. Apply online at www.zap plication.com. Deadline for entry: late April. Application fee: $25. Space fee: $225. Exhibition space: 10×10 ft. For more information, send e-mail or see website.

OLD TOWN ART FAIR

1763 N. North Park Ave., Chicago IL 60614. (312)337-1938. **E-mail:** info@oldtowntriangle.com. **Website:** www.oldtownartfair.com. Estab. 1950. Fine art festival held annually in early June (see website for details). Located in the city's historic Old Town Triangle District. Artists featured are chosen by an independent jury of professional artists, gallery owners, and museum curators. Features a wide range of art mediums, including 2D and 3D mixed media, drawing, painting, photography, printmaking, ceramics, fiber, glass, jewelry, and works in metal, stone, and wood. Apply online at www.zappplication.org. For more information, call, e-mail, or visit website. Fair located in Old Town Triangle District.

⊙ OLD TOWN ART FESTIVAL

Old Town San Diego Chamber of Commerce, P.O. Box 82686, San Diego CA 92138. (619)233-5008. **Fax:** (619)233-0898. **E-mail:** rob-vslmedia@cox.net; otsd@aol.com. **Website:** www.oldtownartfestival. org. Fine arts & crafts fair held annually in September. Outdoors. Accepts handmade crafts, jewelry, ceramics, painting, photography, digital, printmaking, and more. Juried. Number of exhibitors: see website. Number of attendees: 15,000. Free to public. Apply online. Deadline for entry: September 1. Application fee: $25. Space fee: varies. Exhibition space: varies. For more information, artists should call, e-mail, or visit website.

⊙ OMAHA SUMMER ARTS FESTIVAL

P.O. Box 31036, Omaha NE 68131-0036. (402)345-5401. **Fax:** (402)342-4114. **E-mail:** ebalazs@vgagroup. com. **Website:** www.summerarts.org. **Contact:** Emily Peklo. Estab. 1975. Fine arts & crafts fair held annually in June. Outdoors. Accepts handmade crafts, jewelry, ceramics, painting, photography, digital, printmaking, and more. Juried. Number of exhibitors: 135. Number of attendees: varies. Free to public. Apply online. Deadline for entry: see website. Application fee: see website. Space fee: varies. Exhibition space: varies. For more information, artists should call, e-mail, or visit website.

⊙⊙ ONE OF A KIND CRAFT SHOW (ONTARIO)

10 Alcorn Ave., Suite 100, Toronto, Ontario M4V 3A9 Canada. (416)960-5399. **Fax:** (416)923-5624. **E-mail:** jill@oneofakindshow.com. **Website:** www.oneofakindshow.com. **Contact:** Jill Benson. Estab. 1975. Fine arts & crafts fair held annually 3 times a year. Outdoors. Accepts handmade crafts, jewelry, ceramics, painting, photography, digital, printmaking, and

more. Juried. Number of exhibitors: varies per show. Number of attendees: varies per show. Free to public. Apply online. Deadline for entry: see website. Application fee: see website. Space fee: varies. Exhibition space: varies. For more information, artists should call, e-mail, or visit website.

☺ ON THE GREEN FINE ART & CRAFT SHOW

P.O. Box 304, Glastonbury CT 06033. (860)659-1196. **Fax:** (860)633-4301. **E-mail:** info@glastonburyarts. org. **Website:** www.glastonburyarts.org. **Contact:** Jane Fox, administrator. Estab. 1961. Fine art & craft show held annually 2nd week of September. Outdoors. Accepts photography, pastel, prints, pottery, jewelry, drawing, sculpture, mixed media, oil, acrylic, glass, watercolor, graphic, wood, fiber, etc. Juried (with 3 photos of work, 1 photo of booth). Awards/prizes: $3,000 total prize money in different categories. Number of exhibitors: 200. Public attendance: 15,000. Free to public. Artists should apply online. Deadline for entry: early June. Jury fee: $15. Space fee: $275. Exhibition space: 12×15 ft. Average gross sales/exhibitor varies. For more information, artists should visit website. Show located at Hubbard Green.

☺ ORANGE BEACH FESTIVAL OF ART

26389 Canal Road, Orange Beach AL 36561. (251)981-2787. **Fax:** (251)981-6981. **E-mail:** helpdesk@orange beachartcenter.com. **Website:** www.orangebeacharts festival.com. Fine art & craft show held annually in March. Outdoors. Accepts handmade crafts, ceramics, paintings, jewelry, glass, photography, wearable art, and other mediums. Juried. Number of exhibitors: 90. Number of attendees: varies. Free to public. Apply online. Deadline for entry: See website. Application fee: see website. Space fee: varies. Exhibition space: varies. For more information, artists should call, e-mail, or visit website.

☺ ORCHARD LAKE FINE ART SHOW

P.O. Box 79, Milford MI 48381-0079. (248)684-2613. **E-mail:** info@hotworks.org. **Website:** www.hotworks. org. **Contact:** Patty Narozny, executive director and producer. Estab. 2003. Voted in the top 100 art fairs nationwide the last 8 years in the row by *Sunshine Magazine* out of more than 4,000 art fairs. "The Orchard Lake Fine Art Show takes place in the heart of West Bloomfield, located on a street with high visibility from Orchard Lake Road, south of Maple Road,

in an area that provides plenty of free parking for patrons and weekend access for local businesses. West Bloomfield MI is located adjacent to Bloomfiled Hills, listed as the #2 highest income city in the US, according to Wikipedia.org, and home of Cranbrook Art Institute. West Bloomfield has been voted one of *Money Magazine*'s 'Best Places to Live,' and is an upscale community with rolling hills that provide a tranquil setting for beautiful and lavish homes. $5 admission helps support the Institute for the Arts & Education, Inc., a 501(c)(3) nonprofit organization whose focus is visual arts and community enrichment. 12 & under free. This event follows Ann Arbor, has great event hours and provides ease of move-in and move-out. All work must be original and personally handmade by the artist. There is $2,500 in professional artist awards. We accept all disciplines including sculpture, paintings, clay, glass, wood, fiber, jewelry, photography, and more." Professional applications are accepted "manual" or via www.zapplication.org. Please include 3 images of your most compelling work, plus one of your booth presentation as you would set up at the show. Space fee: $375, 10×10 ft.; $525 10×15 ft.; $650 10×20 ft.; add $75 for corner. "Generators are permitted as long as they do not bother anyone for any reason." Deadline to apply is March 15. "No buy/sell/import permitted. As part of our commitment to bring art education into the community, there is the Chadwick Accounting Group's Youth Art Competition for grades K-8 or ages 5-12, in which we encourage budding artists to create their original and personally handmade artwork that is publicly displayed in the show the entire weekend." $250 in youth art awards. The deadline to apply for youth art is July 1. More information can be found on the web at www. hotworks.org.

☺ PALMER PARK ART FAIR

E-mail: info@integrityshows.com. **Website:** www. palmerparkartfair.com. **Contact:** Mark Loeb. Estab. 2014. Fine arts & crafts show held annually in May. Outdoors. Accepts photography and all fine art and craft mediums. Juried by 3 independent jurors. Awards/prizes: purchase and merit awards. Number of exhibitors: 80. Public attendance: 7,000. Free to the public. Apply online. Deadline for entry: see website. Application fee: $25. Booth fee: $295. Electricity limited; fee: $100. For more information, visit website.

PANOPLY ARTS FESTIVAL

The Arts Council, Inc., 700 Monroe St. SW, Suite 2, Huntsville AL 35801. (256)519-2787. **Fax:** (256)533-3811. **E-mail:** info@artshuntsville.org; vhinton@artshuntsville.org. **Website:** http://www.artshuntsville.org/panoply-arts-festival/. **Contact:** Lisa Bollinger, Events Manager. Estab. 1982. Fine arts show held annually the last weekend in April. Also features music and dance. Outdoors. Accepts photography, painting, sculpture, drawing, printmaking, mixed media, glass, fiber. Juried by a panel of judges chosen for their in-depth knowledge and experience in multiple mediums, and who jury from slides or disks in January. During the festival 1 judge awards various prizes. Number of exhibitors: 60-80. Public attendance: 140,000+. Public admission: $5/day or $10/weekend (children 12 and under free). Artists should e-mail, call, or go online for an application form. Deadline for entry: January. Space fee: $185. Exhibition space: 10×10 ft. (tent available, space fee $390). Average gross sales/exhibitor: $2,500. For more information, artists should e-mail or visit website. The festival is held in Big Spring International Park.

PARADISE CITY ARTS FESTIVALS

30 Industrial Dr. E, Northampton MA 01060. (413)587-0772. **Fax:** (413)587-0966. **E-mail:** artist@paradisecityarts.com. **Website:** www.paradisecityarts.com. Estab. 1995. 4 fine arts & crafts shows held annually in March, May, October, and November. Indoors. Accepts photography, all original art, and fine craft media. Juried by 5 digital images of work and an independent board of jury advisors. Number of exhibitors: 150-275. Public attendance: 5,000-20,000. Public admission: $12. Artists should apply by submitting name and address to be added to mailing list or print application from website. Deadlines for entry: April 1 (fall shows); September 9 (spring shows). Application fee: $30-45. Space fee: $855-1,365. Exhibition space varies by show, see website for more details. For more information, artists should e-mail, visit website, or call.

PARK POINT ART FAIR

(218)428-1916. **E-mail:** coordinator@parkpointartfair.org. **Website:** www.parkpointartfair.org. **Contact:** Carla Tamburro, art fair coordinator. Estab. 1970. Fine arts & crafts fair held annually the last full weekend in June. Outdoors. Accepts handmade crafts, jewelry, ceramics, painting, photography, digital printmaking, and more. Juried. Awards/prizes: $1,300 in awards. Number of exhibitors: 120. Number of attendees: 10,000. Free to public. Apply online. Deadline for entry: March. Application fee: $15. Space fee: $185. Exhibition space: 10×10 ft. For more information, artists should e-mail, call, or visit website.

PATTERSON APRICOT FIESTA

P.O. Box 442, Patterson CA 95363. (209)892-3118. **Fax:** (209)892-3388. **E-mail:** patterson_apricot_fiesta@hotmail.com. **Website:** www.apricotfiesta.com. **Contact:** Jaclyn Camara, chairperson. Estab. 1984. Arts & crafts show held annually in May/June. Outdoors. Accepts photography, oils, leather, various handcrafts. Juried by type of product. Number of exhibitors: 140-150. Public attendance: 30,000. Free to the public. Deadline for entry: mid-April. Application fee/space fee: $225/craft, $275/commerical. Exhibition space: 12×12 ft. For more information, artists should call, send SASE. Event held at Center Circle Plaza in downtown Patterson.

TIPS "Please get your applications in early!"

PEND OREILLE ARTS COUNCIL

P.O. Box 1694, Sandpoint ID 83864. (208)263-6139. **E-mail:** poactivities@gmail.com. **Website:** www.artsandpoint.org. Estab. 1978. Arts & crafts show held annually, second week in August. Outdoors. Accepts photography and all handmade, noncommercial works. Juried by 8-member jury. Number of exhibitors: 120. Public attendance: 5,000. Free to public. Artists should apply by sending in application, available in February, along with 4 images (3 of your work, 1 of your booth space). Deadline for entry: April. Application fee: $25. Space fee: $185-280, no commission taken. Electricity: $50. Exhibition space: 10×10 ft. or 10×15 ft. (shared booths available). For more information, artists should e-mail, call, or visit website. Show located in downtown Sandpoint.

PENNSYLVANIA GUILD OF CRAFTSMEN FINE CRAFT FAIRS

Center of American Craft, 335 N. Queen St., Lancaster PA 17603. (717)431-8706. **E-mail:** nick@pacrafts.org; handmade@pacrafts.org. **Website:** www.pacrafts.org/fine-craft-fairs. **Contact:** Nick Mohler. Fine arts & crafts fair held annually 5 times a year. Outdoors. Accepts handmade crafts, jewelry, ceramics, painting, photography, digital, printmaking, and more. Juried. Number of exhibitors: varies per show. Num-

ber of attendees: varies per show. Free to public. Apply online. Deadline for entry: January. Application fee: $25. Space fee: varies. Exhibition space: 10×10 ft. For more information, artists should call, e-mail, or visit website.

⦿ PETERS VALLEY FINE CRAFT FAIR

19 Kuhn Rd., Layton NJ 07851. (973)948-5200. **E-mail:** craftfair@petersvalley.org; info@petersvalley.org. **Website:** www.petersvalley.org. Estab. 1970. Fine craft show held annually in late September at the Sussex County Fairgrounds in Augusta NJ. Indoors/enclosed spaces. Accepts photography, ceramics, fiber, glass, basketry, metal, jewelry, sculpture, printmaking, paper, drawing, painting. Juried. Awards. Number of exhibitors: 150. Public attendance: 7,000-8,000. Public admission: $9. Artists should apply via www.juriedartservices.com. Deadline for entry: April 1. Application fee: $35. Space fee: $455 (includes electricity). Exhibition space: 10×10 ft. Average gross sales/exhibitor: $2,000-5,000. For more information, artists should e-mail, visit website, or call.

⦿ PIEDMONT PARK ARTS FESTIVAL

1701 Piedmont Ave., Atlanta GA 30306. (404)873-1222. **E-mail:** Info@affps.com. **Website:** www.piedmontparkartsfestival.com. **Contact:** Randall Fox. Estab. 2011. Arts & crafts show held annually in mid-August. Outdoors. Accepts handmade crafts, painting, photography, sculpture, leather, metal, glass, jewelry. Juried by a panel. Awards/prizes: ribbons. Number of exhibitors: 250. Number of attendees: 60,000. Free to public. Apply online at www.zapplication.com. Deadline for entry: June 3. Application fee: $25. Space fee: $300. Exhibition space: 10×10. For more information artists should visit website.

⦿ PRAIRIE ARTS FESTIVAL

201 Schaumburg Court, Schaumburg IL 60193, USA. (847)923-3605. **Fax:** (847)923-2458. **E-mail:** rbenvenuti@villageofschaumburg.com. **Website:** www.prairiecenter.org. **Contact:** Roxane Benvenuti, special events coordinator. Estab. 1988. Outdoor fine art & fine craft exhibition and sale featuring artists, food truck vendors, live entertainment, and children's activities. Held over Saturday-Sunday of Memorial Day weekend. Located in the Robert O. Atcher Municipal Center grounds, adjacent to the Schaumburg Prairie Center for the Arts. Artist applications available in mid-January; due online or postmarked by March 4.

150 spaces available. Application fee: $110 (for 15×10 ft. space); $220 (30×10 ft. space). No jury fee. "With thousands of patrons in attendance, an ad in the Prairie Arts Festival program is a great way to get your business noticed. Rates are reasonable, and an ad in the program gives you access to a select regional market. Sponsorship opportunities are also available." For more information, e-mail, call, or visit the website.

TIPS "Submit your best work for the jury since these images are selling your work."

PUNGO STRAWBERRY FESTIVAL

P.O. Box 6158, Virginia Beach VA 23456. (757)721-6001. **Fax:** (757)721-9335. **E-mail:** pungofestival@aol.com; leebackbay@gmail.com; robinwlee23@gmail.com. **Website:** www.pungostrawberryfestival.info. Estab. 1983. Arts & crafts show held annually on Memorial Day weekend. Outdoors. Accepts photography and all media. Number of exhibitors: 60. Public attendance: 120,000. Free to public; $5 parking fee. Artists should apply by calling for application or downloading a copy from the website and mail in. Deadline for entry: early March; applications accepted from that point until all spaces are full. Notice of acceptance or denial by early April. Application fee: $50 refundable deposit. Space fee: $200 (off-road location); $500 (on-road location). Exhibition space: 10×10 ft. For more information, artists should e-mail, call, or visit website.

○ PYRAMID HILL ANNUAL ART FAIR

1763 Hamilton Cleves Rd., Hamilton OH 45013. (513)868-8336. **Fax:** (513)868-3585. **E-mail:** pyramid@pyramidhill.org. **Website:** www.pyramidhill.org. Art fair held the last Saturday and Sunday of September. Application fee: $25. Booth fee: $100 for a single, $200 for a double. For more information, call, e-mail or visit website. Fair located at Pyramid Hill Sculpture Park and Museum.

TIPS "Make items affordable! Quality work at affordable prices will produce profit."

⦿ QUAKER ARTS FESTIVAL

P.O. Box 202, Orchard Park NY 14127. (716)667-2787. **E-mail:** opjaycees@aol.com; kelly@opjaycees.com. **Website:** www.opjaycees.com. Estab. 1961. Fine arts & crafts show held annually in mid-September (see website for details). 80% outdoors, 20% indoors. Accepts photography, painting, graphics, sculpture, crafts. Juried by 4 panelists during event. Awards/

prizes: over $10,000 total cash prizes, ribbons, and trophies. Number of exhibitors: up to 300. Public attendance: 75,000. Free to the public. Artists can obtain applications online or by sending SASE. Deadline for entry: May 31 for returning exhibitors and then first come, first serve up to festival date (see website for details). Space fee: Before September 1: $185 (single) or $370 (double); after September 1: $210 (single) or $420 (double). Exhibition space: 10×12 ft. (outdoor), 10×6 ft. (indoor). For more information, artists should visit website or send e-mail.

TIPS "Have an inviting booth with a variety of work at various price levels."

RATTLESNAKE AND WILDLIFE FESTIVAL

P.O. Box 292, Claxton GA 30417. (912)739-3820. **E-mail:** rattlesnakewildlifefestival@yahoo.com. **Website:** www.evanscountywildlifeclub.com; Facebook page: Rattlesnake & Wildlife Festival. **Contact:** Heather Dykes. Estab. 1968. Arts & crafts show held annually 2nd weekend in March. Outdoors. Accepts photography and various mediums. Number of exhibitors: 150-200. Public attendance: 15,000-20,000. Artists should apply by filling out an application. Click on the "Registration Tab" located on the Rattlesnake & Wildlife Festival home page. Deadline for entry: late February/early March (see website for details). Space fee: $100 (outdoor); $200 (indoor). Exhibition space: 10×16 ft. (indoor); 10×10 ft. (outdoor). For more information, artists should e-mail, call, or visit website.

TIPS "Your display is a major factor in whether people will stop to browse when passing by. Offer a variety."

🎧 RHINEBECK ARTS FESTIVAL

P.O. Box 28, Woodstock NY 12498. (845)331-7900. **Fax:** (845)331-7484. **E-mail:** crafts@artrider.com. **Website:** www.artrider.com. **Contact:** Stacey Jarit. Estab. 2013. Festival of fine contemporary craft and art held annually in late September or early October. 150 indoors and 40 outdoors. Accepts photography, fine art, ceramics, wood, mixed media, leather, glass, metal, fiber, jewelry, sculpture. Juried. Submit 5 images of your work and 1 of your booth. Public attendance: 10,000. Public admission: $10. Artists should apply online at www.artrider.com or www.zapplication.org. Deadline for entry: first Monday in January. Application fee: $45. For more information, artists should e-mail, visit website, or call. Application fees: $0 first time Artrider applicant, $40 mailed in or online, $65 late. Space fee: $495-545. Exhibition space: 10×10 ft. and 10×20 ft. For more information, artists should e-mail, call, or visit website.

🎧 RILEY FESTIVAL

312 E. Main St., Suite C, Greenfield IN 46140. (317)462-2141. **Fax:** (317)467-1449. **E-mail:** info@rileyfestival.com. **Website:** www.rileyfestival.com. **Contact:** Sarah Kesterson, public relations. Estab. 1970. Fine arts & crafts festival held in October. Outdoors. Accepts photography, fine arts, home arts, quilts. Juried. Awards/prizes: small monetary awards and ribbons. Number of exhibitors: 450. Public attendance: 75,000. Free to public. Artists should apply by downloading application on website. Deadline for entry: mid-September. Space fee: $185. Exhibition space: 10×10 ft. For more information, artists should visit website.

TIPS "Keep arts priced for middle-class viewers."

🎧 RIVERBANK CHEESE & WINE EXPOSITION

6618 Third St., Riverbank CA 95367-2317. (209)863-9600. **Fax:** (209)863-9601. **E-mail:** events@riverbankcheeseandwine.org. **Website:** www.riverbankcheeseandwine.org. **Contact:** Chris Elswick, event coordinator. Estab. 1977. Arts & crafts show and food show held annually 2nd weekend in October. Outdoors. Accepts photography, other mediums depends on the product. Juried by pictures and information about the artists. Number of exhibitors: 250. Public attendance: 60,000. Free to public. Artists should apply by calling and requesting an application. Applications also available on website. Deadline for entry: early September. Space fee: $300-500. Exhibition space: 12×12 ft. For more information, artists should e-mail, visit website, call, or send SASE. Show located at Santa Fe & 3rd St., Riverbank CA.

TIPS Make sure your display is pleasing to the eye.

ROTARY KEY BISCAYNE ART FESTIVAL

270 Central Blvd., Suite 107B, Jupiter FL 33458. (561)746-6615. **Fax:** (561)746-6528. **E-mail:** info@artfestival.com. **Website:** www.artfestival.com. **Contact:** Malinda Ratliff, communications manager. Estab. 1963. "The annual Key Biscayne Art Fair benefits our partner and co-producer, the Rotary Club of Key Biscayne. Held in Key Biscayne, an affluent island community in Miami-Dade County, just south of

downtown Miami, the annual Key Biscayne Art Festival is one not to be missed! In fact, visitors plan their springtime vacations to South Florida around this terrific outdoor festival that brings together longtime favorites and the newest names in the contemporary art scene. Life-size sculptures, spectacular paintings, one-of-a-kind jewels, photography, ceramics, and much more make for one fabulous weekend." See website for more information.

TIPS "You have to start somewhere. First, assess where you are, and what you'll need to get things off the ground. Next, make a plan of action. Outdoor street art shows are a great way to begin your career and lifetime as a working artist. You'll meet a lot of other artists who have been where you are now. Network with them!"

⊕ ROYAL OAK OUTDOOR ART FAIR

211 Williams St., P.O. Box 64, Royal Oak MI 48068. (248)246-3180. **E-mail:** artfair@ci.royal-oak.mi.us. **Website:** www.romi.gov. **Contact:** recreation office staff. Estab. 1970. Fine arts & crafts show held annually in July. Outdoors. Accepts photography, collage, jewelry, clay, drawing, painting, glass, fiber, wood, metal, leather, soft sculpture. Juried. Number of exhibitors: 125. Public attendance: 25,000. Free to public. Free adjacent parking. Artists should apply with online application form at www.royaloakarts.com and 3 images of current work. Space fee: $260 (plus a $20 nonrefundable processing fee per medium). Exhibition space: 15×15 ft. For more information, artists should e-mail, call, or visit website. Fair located at Memorial Park.

TIPS "Be sure to label your images on the front with name, size of work, and 'top.'"

⊕ SACO SIDEWALK ART FESTIVAL

P.O. Box 336, 12½ Pepperell Square, Suite 2A, Saco ME 04072. (207)286-3546. **E-mail:** sacospirit@hotmail.com. **Website:** www.sacospirit.com. Estab. 1970. Event held in late June. Annual event organized and managed by Saco Spirit, Inc., a nonprofit organization committed to making Saco a better place to live and work by enhancing the vitality of our downtown. Dedicated to promoting art and culture in our community. Space fee: $75. Exhibition space: 10×10 ft. See website for more details. Festival located in historic downtown Saco.

TIPS "Offer a variety of pieces priced at various levels."

⊕ SALT FORK ARTS & CRAFTS FESTIVAL

P.O. Box 250, Cambridge OH 43725. (740)439-9379; (740)732-2259. **E-mail:** director@saltforkfestival.org. **Website:** www.saltforkfestival.org. The Salt Fork Arts & Crafts Festival (SFACF) is a juried festival that showcases high-quality art in a variety of mediums, painting, pottery, ceramics, fiber art, metalwork, jewelry, acrylics, mixed media, photography, and more. Between 90 and 100 artists come from all over the U.S. for this 3-day event. In addition, the festival heralds Heritage of the Arts. This program offers a look at Early American and Appalachian arts and crafts, many of which are demonstrated by craftsmen practicing arts such as basket weaving, flint knapping, spindling, flute making, quilting, blacksmithing, and more. Area students are given the opportunity to display their work, visitors are entertained throughout the weekend by a variety of talented performing artists, concessionaires offer satisfying foods, and there are crafts for kids and adults. See website for more information.

⊕ SALT LAKE'S FAMILY CHRISTMAS GIFT SHOW

South Towne Exposition Center, 9575 S. State St., Sandy UT 84070. (800)521-7469. **Fax:** (425)889-8165. **E-mail:** saltlake@showcaseevents.org. **Website:** www.showcaseevents.org. **Contact:** Dena Sablan, show manager. Estab. 1999. Seasonal holiday show held annually in November. Indoors. Accepts gifts, handmade crafts, art, photography, pottery, glass, jewelry, clothing, fiber. Juried. Exhibitors: 450. Number of attendees: 25,000. Admission: $12.50 (for all 3 days); 13 & under free. Apply via website or call or e-mail for application. Deadline for entry: October 31. Space fee: contact via website, phone, e-mail. Exhibition space: 10×10 ft. For more information send e-mail, call, send SASE, or visit website.

TIPS "Competitive pricing, attractive booth display, quality product, something unique for sale, friendly & outgoing personality."

⊕ SANDY SPRINGS ARTSAPALOOZA

6100 Lake Forrest Dr. NE, Sand Springs GA 30328. (404)873-1222. **E-mail:** info@affps.com. **Website:** www.sandyspringsartsapalooza.com. **Contact:** Randall Fox, festival director. Estab. 2011. Arts & crafts show held annually mid-April. Outdoors. Accepts handmade crafts, painting, photography, sculpture, leather, metal, glass, jewelry. Juried by a panel. Awards/prizes: ribbons. Number of exhibitors: 150.

Number of attendees: 25,000. Free to public. Apply online at www.zapplication.org. Deadline for entry: February 2. Application fee: $25. Space fee: $225. Exhibition space: 10×10 ft. For more information, see website.

🎧 SANDY SPRINGS FESTIVAL & ARTISTS MARKET

6075 Sandy Springs Circle, Sandy Springs GA 30328. (404)873-1222. **E-mail:** info@affps.com. **Website:** www.sandyspringsartsapalooza.com. **Contact:** Randall Fox, festival director. Estab. 1986. Arts & crafts show held annually late June. Outdoors. Accepts handmade crafts, painting, photography, sculpture, leather, metal, glass, jewelry. Juried by a panel. Awards/prizes: ribbons. Number of exhibitors: 120. Number of attendees: 40,000. Free to public. Apply online at www.zapplication.com. Deadline for entry: July 26. Application fee: $25. Space fee: $250. Exhibition space: 10×10 ft. For more information, see website.

🎧 SANTA CALI GON DAYS FESTIVAL

210 W. Truman Rd., Independence MO 64050. (816)252-4745. **E-mail:** lois@ichamber.biz. **Website:** www.santacaligon.com. Estab. 1973. Market vendors 4-day show held annually Labor Day weekend. Outdoors. Ranked in top 20 for vendor profitability. Accepts handmade arts & crafts, photography, and other mediums. Juried by committee. Number of exhibitors: 250. Public attendance: 300,000. Free to public. Artists should apply online. Application requirements include completed application, full booth fee, $20 jury fee (via seperate check), 4 photos of product/art and 1 photo of display. Exhibition space: 10×10 ft. For more information, artists should e-mail, call, or visit website.

SANTA FE COLLEGE SPRING ARTS FESTIVAL

3000 NW 83rd St., Gainesville FL 32606. (352)395-5355. **Fax:** (352)336-2715. **E-mail:** kathryn.lehman@sfcollege.edu. **Website:** www.sfspringarts.com. **Contact:** Kathryn Lehman, cultural programs coordinator. Estab. 1969. Fine arts and crafts festival held in mid-April (see website for details). "The festival is one of the 3 largest annual events in Gainesville and is known for its high-quality, unique artwork." Held in the downtown historic district. Public attendance: 130,000+. For more information, e-mail, call, or visit website.

SARASOTA CRAFT FAIR

270 Central Blvd., Suite 107B, Jupiter FL 33458. (561)746-6615. **Fax:** (561)746-6528. **E-mail:** info@art-festival.com. **Website:** www.artfestival.com. **Contact:** Malinda Ratliff, communications manager. "Behold contemporary crafts from more than 100 of the nation's most talented artisans. A variety of jewelry, pottery, ceramics, photography, painting, clothing, and much more—all handmade in America—will be on display, ranging from $15-3,000. An expansive Green Market with plants, orchids, exotic flora, handmade soaps, gourmet spices, and freshly popped kettle corn further complements the weekend, blending nature with nurture." See website for more information.

TIPS "You have to start somewhere. First, assess where you are, and what you'll need to get things off the ground. Next, make a plan of action. Outdoor street art shows are a great way to begin your career and lifetime as a working artist. You'll meet a lot of other artists who have been where you are now. Network with them!"

🎧 SAUSALITO ART FESTIVAL

P.O. Box 10, Sausalito CA 94966. (415)332-3555. **Fax:** (415)331-1340. **E-mail:** info@sausalitoartfestival.org. **Website:** www.sausalitoartfestival.org. **Contact:** Paul Anderson, managing director; Lexi Matthews, operations coordinator. Estab. 1952. Premiere fine art festival held annually Labor Day weekend. Outdoors. Accepts painting, photography, 2D and 3D mixed media, ceramics, drawing, fiber, functional art, glass, jewelry, printmaking, sculpture, watercolor, woodwork. Juried. Jurors are elected by their peers from the previous year's show (1 from each category). They meet for a weekend at the end of March and give scores of 1, 2, 4, or 5 to each applicant (5 being the highest). 5 images must be submitted, 4 of art and 1 of booth. Number of exhibitors: 280. Public attendance: 40,000. Artists should apply by visiting website for instructions and application. Applications are through Juried Art Services. Deadline for entry: March. Exhibition space: 100 or 200 sq. ft. Application fee: $50; $100 for late applications. Booth fees range from $1,425-3,125. Average gross sales/exhibitor: $7,700. For more information, artists should visit website. Festival located in Marinship Park.

🎧 SCOTTSDALE ARTS FESTIVAL

7380 E. Second St., Scottsdale AZ 85251, USA. (480)874-4671. **Fax:** (480)874-4699. **E-mail:** festi-

val@sccarts.org. **Website:** www.scottsdaleartsfestival.org. Estab. 1970. Fine arts & crafts show held annually. Outdoors at the Scottsdale Civic Center Park. Accepts photography, jewelry, ceramics, digital art, sculpture, metal, glass, drawings, fiber, paintings, printmaking, mixed media, wood. Juried. Awards/prizes: 1st in each category and Best of Show. Number of exhibitors: 170. Public attendance: 25,000. Public admission: $10/single day; $15/2-day pass. Artists should apply through www.zapplication.org. Deadline for entry: see website. Exhibition space: 100 to 200 sq. ft. For more information, artists should visit website www.scottsdaleartsfestival.org.

SELL-A-RAMA

Tyson Wells Sell-A-Rama, P.O. Box 60, Quartzsite AZ 85346. (928)927-6364. **E-mail:** tysonwells@tds.net. **Website:** www.tysonwells.com. Arts & craft show held annually in January. Outdoors & indoors. Accepts handmade crafts, ceramics, paintings, jewelry, glass, photography, wearable art, and other mediums. Juried. Number of exhibitors: see website. Number of attendees: varies. Free to public. Apply online. Deadline for entry: see website for dates. Application fee: none. Space fee: varies. Exhibition space: varies. For more information, artists should e-mail, call, or visit website.

SHADYSIDE ART & CRAFT FESTIVAL

270 Central Blvd., Suite 107B, Jupiter FL 33458. (561)746-6615. **Fax:** (561)746-6528. **E-mail:** info@artfestival.com. **Website:** www.artfestival.com. **Contact:** Malinda Ratliff, communications manager. Estab. 1996. Fine art & craft fair held annually in late May. Outdoors. Accepts photography, jewelry, mixed media, sculpture, wood, ceramic, glass, painting, digital, fiber, metal. Juried. Number of exhibitors: 125. Number of attendees: 60,000. Free to public. Apply online via www.zapplication.org. Deadline: see website. Application fee: $25. Space fee: $395. Exhibition space: 10×10 ft. and 10×20 ft. For more information, artists should e-mail, call, or visit website. Festival located at Walnut St. in Shadyside (Pittsburgh, PA).

TIPS "You have to start somewhere. First, assess where you are, and what you'll need to get things off the ground. Next, make a plan of action. Outdoor street art shows are a great way to begin your career and lifetime as a working artist. You'll meet a lot of other artists who have been where you are now. Network with them!"

SHADYSIDE..THE ART FESTIVAL ON WALNUT STREET

270 Central Blvd., Suite 107B, Jupiter FL 33458. (561)746-6615. **Fax:** (561)746-6528. **E-mail:** info@artfestival.com. **Website:** www.artfestival.com. **Contact:** Malinda Ratliff, communications manager. Estab. 1996. Fine art & craft fair held annually in late August. Outdoors. Accepts photography, jewelry, mixed media, sculpture, wood, ceramic, glass, painting, digital, fiber, metal. Juried. Number of exhibitors: 125. Number of attendees: 100,000. Free to public. Apply online via zapplication.org. Deadline: see website. Application fee: $25. Space fee: $450. Exhibition space: 10×10 ft. and 10×20 ft. For more information, artists should e-mail, call, or visit website. Festival located at Walnut St. in Shadyside (Pittsburgh, PA).

TIPS "You have to start somewhere. First, assess where you are, and what you'll need to get things off the ground. Next, make a plan of action. Outdoor street art shows are a great way to begin your career and lifetime as a working artist. You'll meet a lot of other artists who have been where you are now. Network with them!"

SIDEWALK ART MART

Downtown Helena, Inc., Mount Helena Music Festival, 225 Cruse Ave., Suite B, Helena MT 59601. (406)447-1535. **Fax:** (406)447-1533. **E-mail:** jmchugh@mt.net. **Website:** www.downtownhelena.com. **Contact:** Jim McHugh. Estab. 1974. Arts, crafts, and music festival held annually in June. Outdoors. Accepts photography. No restrictions except to display appropriate work for all ages. Number of exhibitors: 50+. Public attendance: 5,000. Free to public. Artists should apply by visiting website to download application. Space fee: $100-125. Exhibition space: 10×10 ft. For more information, artists should e-mail, call, or visit website. Festival held at Women's Park in Helena MT.

TIPS "Greet people walking by and have an eye-catching product in front of booth. We have found that high-end artists or expensively priced art booths that had business cards with e-mail or website information received many contacts after the festival."

SIESTA FIESTA

270 Central Blvd., Suite 107B, Jupiter FL 33458. (561)746-6615. **Fax:** (561)746-6528. **E-mail:** info@artfestival.com. **Website:** www.artfestival.com. **Contact:** Malinda Ratliff, communications manager. Estab. 1978. Fine art & craft fair held annually in April.

Outdoors. Accepts photography, jewelry, mixed media, sculpture, wood, ceramic, glass, painting, digital, fiber, metal. Juried. Number of exhibitors: 85. Number of attendees: 40,000. Free to public. Apply online via www.zapplication.org. Deadline: see website. Application fee: $25. Space fee: $350. Exhibition space: 10×10 ft. and 10×20 ft. For more information, artists should e-mail, call, or visit website. Festival located at Ocean Blvd. in Siesta Key Village.

TIPS "You have to start somewhere. First, assess where you are, and what you'll need to get things off the ground. Next, make a plan of action. Outdoor street art shows are a great way to begin your career and lifetime as a working artist. You'll meet a lot of other artists who have been where you are now. Network with them!"

SKOKIE ART GUILD FINE ART EXPO

Devonshire Cultural Center, 4400 Greenwood St., Skokie IL 60077. (847)677-8163. **E-mail:** info@skokie artguild.org; skokieart@aol.com. **Website:** www. skokieartguild.org. Outdoor fine art/craft show open to all artists (18+) in the Chicagoland area. Held in mid-May. Entrance fee: $20 (members); $30 (nonmembers). Awards: 1st, 2nd, 3rd place ribbons, Purchase Awards. Deadline for application: early May. Event held at Oakton Park.

TIPS Display your work in a professional manner: matted, framed, etc.

SMITHVILLE FIDDLERS' JAMBOREE AND CRAFT FESTIVAL

P.O. Box 83, Smithville TN 37166. (615)597-8500. **E-mail:** eadkins@smithvillejamboree.com. **Website:** www.smithvillejamboree.com. **Contact:** Emma Adkins, craft coordinator. Estab. 1971. Arts & crafts show held annually the weekend nearest the Fourth of July holiday. Indoors. Juried by photos and personally talking with crafters. Awards/prizes: ribbons and free booth for following year for Best of Show, Best of Appalachian Craft, Best Display, Best New Comer. Number of exhibitors: 235. Public attendance: 130,000. Free to public. Artists should apply online. Deadline: May 1. Space fee: $125. Exhibition space: 12×12 ft. Average gross sales/exhibitor: $1,200+. For more information, artists should call or visit website. Festival held in downton Smithville.

SMOKY HILL RIVER FESTIVAL FINE ART SHOW

(785)309-5770. **E-mail:** sahc@salina.org. **Website:** www.riverfestival.com. Fine art & craft show held annually in June. Outdoors. Accepts handmade crafts, ceramics, jewelry, fiber, mixed media, painting, drawing/pastels, glass, metal, wood, graphics/printmaking, digital, paper, sculpture, and photography. Juried. Awards/prizes: Jurors' Merit Awards, Purchase Awards. Number of exhibitors: 90. Number of attendees: 60,000. Admission: $10 in advance; $15 at gate; children 11 & under free. Apply via www.zapplication.org. Deadline for entry: February. Application fee: $30. Space fee: $275. Exhibition space: 10×10 ft. For more information, artists should e-mail or visit website.

SOLANO AVENUE STROLL

1563 Solano Ave., #101, Berkeley CA 94707. (510)527-5358. **E-mail:** info@solanostroll.org. **Website:** www.solanostroll.org. **Contact:** Allen Cain. Estab. 1974. Fine arts & crafts show held annually 2nd Sunday in September. Outdoors. "Since 1974, the merchants, restaurants, and professionals, as well as the twin cities of Albany and Berkeley have hosted the Solano Avenue Stroll, the East Bay's largest street festival." Accepts photography and all other mediums. Juried by board of directors. Number of exhibitors: 150 spaces for crafts; 600 spaces total. Public attendance: 250,000. Free to the public. Artists should apply online in April, or send SASE. Space fee: $150. Exhibition space: 10×10 ft. For more information, artists should e-mail, visit website, or send SASE. Event takes place on Solano Ave. in Berkeley and Albany CA.

TIPS "Artists should have a clean presentation, small-ticket items as well as large-ticket items, great customer service and enjoy themselves."

THE SOUTHWEST ARTS FESTIVAL

Indio Chamber of Commerce, 82921 Indio Blvd., Indio CA 92201. (760)347-0676. **Fax:** (763)347-6069. **E-mail:** jonathan@indiochamber.org;swaf@indio chamber.org. **Website:** www.southwestartsfest.com. Estab. 1986. Featuring over 275 acclaimed artists showing traditional, contemporary, and abstract fine works of art and quality crafts, the festival is a major, internationally recognized cultural event attended by nearly 10,000 people. The event features a wide selec-

tion of clay, crafts, drawings, glass work, jewelry, metal works, paintings, photographs, printmaking, sculpture, and textiles. Application fee: $55. Easy check-in and check-out procedures with safe and secure access to festival grounds for setup and breakdown. Allow advance set-up for artists with special requirements (very large art requiring the use of cranes, forklifts, etc., or artists with special needs). Artist parking is free. Disabled artist parking is available. Apply online. For more information, artists should call, e-mail, or visit website. Show takes place in January.

⊙ SPANISH SPRINGS ART & CRAFT FESTIVAL

270 Central Blvd., Suite 107B, Jupiter FL 33458. (561)746-6615. **Fax:** (561)746-6528. **E-mail:** info@art-festival.com. **Website:** www.artfestival.com. **Contact:** Malinda Ratliff, communications manager. Estab. 1997. Fine art & craft fair held biannually in January & November. Outdoors. Accepts photography, jewelry, mixed media, sculpture, wood, ceramic, glass, painting, digital, fiber, metal. Juried. Number of exhibitors: 210. Number of attendees: 20,000. Free to public. Apply online via www.zapplication.org or visit website for paper application. Deadline: see website. Application fee: $15. Space fee: $265. Exhibition space: 10×10 ft. and 10×20 ft. For more information, artists should e-mail, call, or visit website. Festival located at Spanish Springs, The Villages, FL.

TIPS "You have to start somewhere. First, assess where you are, and what you'll need to get things off the ground. Next, make a plan of action. Outdoor street art shows are a great way to begin your career and lifetime as a working artist. You'll meet a lot of other artists who have been where you are now. Network with them!"

⊙ SPANKER CREEK FARM ARTS & CRAFTS FAIR

P.O. Box 5644, Bella Vista AR 72714. (479)685-5655. **E-mail:** info@spankercreekfarm.com. **Website:** www.spankercreekfarm.com. Arts & craft show held biannually in the spring & fall. Outdoors & indoors. Accepts handmade crafts, ceramics, paintings, jewelry, glass, photography, wearable art, and other mediums. Juried. Number of exhibitors: see website. Number of attendees: varies. Free to public. Apply online. Deadline for entry: see website for dates. Application fee: none. Space fee: varies. Exhibition space: varies. For more information, artists should call, e-mail, or visit website.

⊙ SPRING CRAFTMORRISTOWN

P.O. Box 28, Woodstock NY 12498. (845)331-7900. **Fax:** (845)331-7484. **E-mail:** crafts@artrider.com. **Website:** www.artrider.com. Estab. 1990. Fine arts & crafts show held annually in March. Indoors. Accepts photography, wearable and nonwearable fiber, jewelry, clay, leather, wood, glass, painting, drawing, prints, mixed media. Juried by 5 images of work and 1 of booth, viewed sequentially. Number of exhibitors: 150. Public attendance: 5,000. Public admission: $9. Artists should apply online at www.artrider.com or at www.zapplication.org. Deadline for entry: January 1. Application fee: $45. Space fee: $495. Exhibition space: 10×10 ft. For more information, artists should e-mail, call, or visit website.

⊙ SPRING CRAFTS AT LYNDHURST

P.O. Box 28, Woodstock NY 12498. (845)331-7900. **Fax:** (845)331-7484. **E-mail:** crafts@artrider.com. **Website:** www.artrider.com. Estab. 1984. Fine arts & crafts show held annually in early May. Outdoors. Accepts photography, wearable and nonwearable fiber, jewelry, clay, leather, wood, glass, painting, drawing, prints, mixed media. Juried by 5 images of work and 1 of booth, viewed sequentially. Number of exhibitors: 275. Public attendance: 14,000. Public admission: $10. Artists should apply at www.artrider.com or can apply online at www.zapplication.org. Deadline for entry: January 1. Application fee: $45. Space fee: $775-875. Exhibition space: 10×10 ft. For more information, artists should e-mail, call, or visit website.

SPRINGFEST

Southern Pines Business Association, P.O. Box 831, Southern Pines NC 28388. (910)315-6508. **E-mail:** spbainfo@southernpines.biz. **Website:** www.southernpines.biz. **Contact:** Susan Harris. Estab. 1979. Arts & crafts show held annually last Saturday in April. Outdoors. Accepts photography and crafts. We host over 160 vendors from all around North Carolina and the country. Enjoy beautiful artwork and crafts including paintings, jewelry, metal art, photography, woodwork, designs from nature and other amazing creations. Event is held in conjunction with Tour de Moore, an annual bicycle race in Moore County, and is co-sponsored by the town of Southern Pines. Public attendance: 8,000. Free to the public. Deadline: March (see website for more details). Space fee: $75. Exhibition space: 10×12 ft. For more information, artists should e-mail, call, visit website, or send SASE. Ap-

ply online. Event held in historic downtown Southern Pines on Broad St.

SPRING FESTIVAL ON PONCE

Olmstead Park, North Druid Hills, 1451 Ponce de Leon, Atlanta GA 30307. (404)873-1222. **E-mail:** info@affps.com. **Website:** www.festivalonponce.com. **Contact:** Randall Fox, festival director. Estab. 2011. Arts & crafts show held annually early April. Outdoors. Accepts handmade crafts, painting, photography, sculpture, leather, metal, glass, jewelry. Juried by a panel. Awards/prizes: ribbons. Number of exhibitors: 125. Number of attendees: 40,000. Free to public. Apply online at www.zapplication.org. Deadline for entry: February 6. Application fee: $25. Space fee: $275. Exhibition space: 10×10 ft. For more information, see website.

SPRING FINE ART & CRAFTS AT BROOKDALE PARK

Rose Squared Productions, Inc., 473 Watchung Ave., Bloomfield NJ 07003. (908)874-5247. **Fax:** (908)874-7098. **E-mail:** info@rosesquared.com. **Website:** www.rosesquared.com. **Contact:** Howard and Janet Rose. Estab. 1988. Fine arts & craft show held annually at Brookdale Park on the border of Bloomfield and Montclair NJ. Event takes place in mid-June on Father's Day weekend. Outdoors. Accepts photography and all other mediums. Juried. Number of exhibitors: 180. Public attendance: 16,000. Free to the public. Artists should apply by downloading application from website or call for application. Deadline: 1 month before show date. Application fee: $30. Space fee: varies by booth size. Exhibition space: 120 sq. ft. For more information, artists should e-mail, call, or visit website. Promoters of fine art and craft shows that are successful for the exhibitors and enjoyable, tantalizing, satisfying artistic buying experiences for the supportive public.

TIPS "Create a professional booth that is comfortable for the customer to enter. Be informative, friendly, and outgoing. People come to meet the artist."

SPRING GREEN ARTS & CRAFTS FAIR

P.O. Box 96, Spring Green WI 53588. **E-mail:** springgreenartfair@gmail.com. **Website:** www.springgreenartfair.com. Fine arts & crafts fair held annually June. Indoors. Accepts handmade crafts, glass, wood, painting, fiber, graphics, pottery, sculpture, jewelry, photography. Juried. Awards/prizes: Best of Show,

Award of Excellence. Number of exhibitors: see website. Number of attendees: varies per show. Admission: varies per show. Apply online. Deadline for entry: mid February. Application fee: $10-20. Space fee: $150. Exhibition space: 10×10. For more information, artists should send e-mail or visit website.

ST. ARMANDS CIRCLE CRAFT FESTIVAL

270 Central Blvd., Suite 107B, Jupiter FL 33458. (561)746-6615. **Fax:** (561)746-6528. **E-mail:** info@artfestival.com. **Website:** www.artfestival.com. **Contact:** Malinda Ratliff, communications manager. Estab. 2004. Fine art & craft fair held biannually in January & November. Outdoors. Accepts photography, jewelry, mixed media, sculpture, wood, ceramic, glass, painting, digital, fiber, metal. Juried. Number of exhibitors: 180-210. Number of attendees: 80,000-100,000. Free to public. Apply online via www.zapplication.org. Deadline: see website. Application fee: $25. Space fee: $415-435. Exhibition space: 10×10 ft. and 10×20 ft. For more information, artists should e-mail, call, or visit website. Fair held in St. Armands Circle in Sarasota FL.

TIPS "You have to start somewhere. First, assess where you are, and what you'll need to get things off the ground. Next, make a plan of action. Outdoor street art shows are a great way to begin your career and lifetime as a working artist. You'll meet a lot of other artists who have been where you are now. Network with them!"

ST. CHARLES FINE ART SHOW

2 E. Main St., St. Charles IL 60174. (630)443-3967. **E-mail:** info@downtownstcharles.org. **Website:** www.downtownstcharles.org/fineartshow. **Contact:** Jamie Blair. Fine art show held annually in May during Memorial Day weekend. Outdoors. Accepts photography, painting, sculpture, glass, ceramics, jewelry, nonwearable fiber art. Juried by committee: submit 4 slides of art and 1 slide of booth/display. Awards/prizes: Cash awards in several categories. Free to the public. Artists can apply via website. Deadline for entry: early January. Jury fee: $35. Space fee: $375. Exhibition space: 10×10 ft. For more information, artists should e-mail or visit website.

STEPPIN' OUT

Downtown Blacksburg, Inc., P.O. Box 233, Blacksburg VA 24063. (540)951-0454. **E-mail:** dbi@downtownblacksburg.com; events@downtownblacksburg.com.

Website: www.blacksburgsteppinout.com. **Contact:** Laureen Blakemore. Estab. 1980. Arts & crafts show held annually 1st Friday and Saturday in August. Outdoors. Accepts photography, pottery, painting, drawing, fiber arts, jewelry, general crafts. All arts and crafts must be handmade. Number of exhibitors: 230. Public attendance: 40,000. Free to public. Space fee: $200. An additional $10 is required for electricity. Exhibition space: 10×16 ft. Artists should apply by e-mailing, calling, or downloading an application on website. Deadline for entry: May 1. Downtown Blacksburg, Inc. (DBI) is a non-profit (501c6) association of merchants, property owners, and downtown advocates whose mission is to sustain a dynamic, vital, and diverse community through marketing, events, economic development, and leadership.

TIPS "Visit shows and consider the booth aesthetic—what appeals to you. Put the time, thought, energy, and money into your booth to draw people in to see your work."

ST. GEORGE ART FESTIVAL

50 S. Main, St. George UT 84770, USA. (435)627-4500. **E-mail:** artadmn@sgcity.org; gary.sanders@sgcity.org; leisure@sgcity.org. **Website:** www.sgcity.org/artfestival. **Contact:** Gary Sanders. Estab. 1979. Fine arts & crafts show held annually Easter weekend in either March or April. Outdoors. Accepts photography, painting, wood, jewelry, ceramics, sculpture, drawing, 3D mixed media, glass, metal, digital. Juried from digital submissions. Awards/prizes: $5,000 Purchase Awards. Art pieces selected will be placed in the city's permanent collections. Number of exhibitors: 110. Public attendance: 20,000/day. Free to public. Artists should apply by completing application form via EntryThingy, nonrefundable application fee, slides or digital format of 4 current works in each category and 1 of booth, and SASE. Deadline for entry: January 11. Exhibition space: 10×11 ft. For more information, artists should check website or e-mail.

TIPS "Artists should have more than 50% originals. Have quality booths and set-up to display art in best possible manner. Be outgoing and friendly with buyers."

ST. JAMES COURT ART SHOW

P.O. Box 3804, Louisville KY 40201. (502)635-1842. **Fax:** (502)635-1296. **E-mail:** mesrock@stjamescourtartshow.com. **Website:** www.stjamescourtartshow.com. **Contact:** Marguerite Esrock. Estab. 1957. Annual fine arts & crafts show held the first full weekend in October. Accepts photography; has 17 medium categories. Juried in April; there is also a street jury held during the art show. Number of exhibitors: 260. Public attendance: 200,000. Free to the public. Artists should apply by visiting website and printing out an application or via www.zapplication.org. Deadline for entry: March 31 (see website for details). Application fee: $40. Space fee: $575. Exhibition space: 10×12 ft. For more information, artists should visit website. Consistently in the top ten Fine Art and Craft Shows reported by Sunshine Artists Top 200 List (September issue).

TIPS "Have a variety of price points."

ST. JOHN MEDICAL CENTER FESTIVAL OF THE ARTS

(440)808-9201. **E-mail:** ardis.radak@csauh.com. **Website:** www.sjws.net/festival_of_arts.aspx. **Contact:** Ardis Radak. Art & craft show held annually in July. Outdoors. Accepts handmade crafts, ceramics, glass, fiber, glass, graphics, jewelry, leather, metal, mixed media, painting, photography, printmaking, sculpture, woodworking. Juried. Awards/prizes: Best of Show, 1st place, 2nd place, honorable mention. Number of exhibitors: 200. Number of attendees: 15,000. Free to public. Apply via www.zapplication.org. Deadline for entry: May. Application fee: $15. Space fee: $300 (single); $600 (double). Exhibition space: 10×10 (single); 10×20 (double). For more information, artists should e-mail, call, or visit website.

ST. LOUIS ART FAIR

225 S. Meramec Ave., Suite 105, St. Louis MO 63105. **E-mail:** info@culturalfestivals.com. **Website:** www.culturalfestivals.com. **Contact:** Laura Miller, director of operations. Estab. 1994. Fine art/craft show held annually in September, the weekend after Labor Day. Outdoors. Accepts photography, ceramics, drawings, digital, glass, fiber, jewelry, mixed-media, metalwork, printmaking, paintings, sculpture, and wood. Juried event, uses 5 jurors using 3 rounds, digital app. Total prize money available: $21,000—26 awards ranging from $500-1,000. Number of exhibitors: 180. Average attendance: 130,000. Admission free to the public. $40 application fee. Space fee: $625-725. 100 sq. ft. space. Average gross sales for exhibitor: $8,500. Apply at www.zapplication.org. For more information, call, e-mail, or visit website. Fair held in the central business district of Clayton MO.

TIPS "Look at shows and get a feel for what it is."

🎧 STOCKLEY GARDENS FALL ARTS FESTIVAL

801 Boush St., Suite 302, Norfolk VA 23510. (757)625-6161. **Fax:** (757)625-7775. **E-mail:** aknox@hope-house.org ljanosk@hope-house.org. **Website:** www.stockleygardens.com. **Contact:** Anne Knox, development coordinator. Estab. 1984. Fine arts & crafts show held biannually in the 3rd weekends in May and October. Outdoors. Accepts photography and all major fine art mediums. Juried. Number of exhibitors: 135. Public attendance: 25,000. Free to the public. Artists should apply by submitting application, jury, and booth fees, 5 slides. Deadline for entry: February and July. Exhibition space: 10×10 ft. For more information, artists should visit the website.

🎧 STONE ARCH BRIDGE FESTIVAL

(651)398-0590. **E-mail:** stacy@weimarketing.com; heatherwmpls@gmail.com. **Website:** www.stonearchbridgefestival.com. **Contact:** Sara Collins, manager. Estab. 1994. Fine arts & crafts and culinary arts show held annually on Father's Day weekend in the Riverfront District of Minneapolis. Outdoors. Accepts drawing/pastels, printmaking, ceramics, jewelry (metals/stone), mixed media, painting, photography, sculpture metal works, bead work (jewelry or sculpture), glass, fine craft, special consideration. Juried by committee. Awards/prizes: free booth the following year; $100 cash prize. Number of exhibitors: 250+. Public attendance: 80,000. Free to public. Artists should apply by application found on website or through www.zapplication.org. Application fee: $25. Deadline for entry: early April. Space fee: depends on booth location (see website for details). Exhibition space: 10×10 ft. For more information, artists should call (651)228-1664 or e-mail Stacy De Young at stacy@weimarketing.com.

TIPS "Have an attractive display and variety of prices."

ST. PATRICK'S DAY CRAFT SALE & FALL CRAFT SALE

P.O. Box 461, Maple Lake MN 55358-0461. **Website:** www.maplelakechamber.com. **Contact:** Kathy. Estab. 1988. Arts & crafts show held biannually in March and early November. Indoors. Number of exhibitors: 30-40. Public attendance: 300-600. Free to public. Deadline for entry: 2 weeks before the event. Exhibition space: 10×10 ft. For more information or an application, artists should visit website.

TIPS "Don't charge an arm and a leg for the items. Don't overcrowd your items. Be helpful, but not pushy."

🎧 STRAWBERRY FESTIVAL

Downtown Billings Alliance, 2815 Second Ave. N., Billings MT 59101. (406)294-5060. **Fax:** (406)294-5061. **E-mail:** inatashap@downtownbillings.com. **Website:** www.downtownbillings.com. **Contact:** Natasha. Estab. 1991. Fine arts & crafts show held annually 2nd Saturday in June. Outdoors. Accepts photography and only finely crafted work. Handcrafted works by the selling artist will be given priority. Requires photographs of booth set up and 2-3 of work. Juried. Public attendance: 15,000. Free to public. Artists should apply online. Deadline for entry: April. Space fee: $160-195. Exhibition space: 10×10 ft. For more information, artists should e-mail or visit website. Show located at N. Broadway & 2nd Ave. N. in downtown Billings.

🎧 SUMMER ART IN THE PARK FESTIVAL

16 S. Main St., Rutland VT 05701. (802)775-0356. **E-mail:** info@chaffeeartcenter.org. **Website:** www.chaffeeartcenter.org. Estab. 1961. A fine arts & crafts show held at Main Street Park in Rutland VT annually in mid-August. Accepts fine art, specialty foods, fiber, jewelry, glass, metal, wood, photography, clay, floral, etc. All applications will be juried by a panel of experts. The Art in the Park Festivals are dedicated to high-quality art and craft products. Number of exhibitors: 100. Public attendance: 9,000-10,000. Public admission: voluntary donation. Artists should apply online and either e-mail or submit a CD with 3 photos of work and 1 of booth (photos upon preapproval). Deadline for entry: early bird discount of $25 per show for applications received by March 31. Space fee: $200-350. Exhibit space: 10×12 ft. or 20×12 ft. For more information, artists should e-mail, call, or visit website. Festival held in Main Street Park.

TIPS "Have a good presentation, variety if possible (in price ranges, too) to appeal to a large group of people. Apply early as there may be a limited amount of accepted vendors per category. Applications will be juried on a first come, first served basis until the category is determined to be filled."

🎧 SUMMER ARTS & CRAFTS FESTIVAL

38 Charles St., Rochester NH 03867. **E-mail:** info@castleberryfairs.com. **Website:** www.castleberryfairs.com. Estab. 1992. Arts & crafts show held annually

2nd weekend in August in Lincoln NH. Outdoors. Accepts photography and all other mediums. Juried by photo, slide, or sample. Number of exhibitors: 100. Public attendance: 7,500. Free to the public. Artists should apply by downloading application from website. Application fee: $50. Space fee: $225. Exhibition space: 10×10 ft. For more information, artists should visit website. Festival held at Village Shops & Town Green, Main Street.

TIPS "Do not bring a book; do not bring a chair. Smile and make eye contact with everyone who enters your booth. Have them sign your guest book; get their e-mail address so you can let them know when you are in the area again. And, finally, make the sale—they are at the fair to shop, after all."

SUMMERFAIR

7850 Five Mile Rd., Cincinnati OH 45230. (513)531-0050. **E-mail:** exhibitors@summerfair.org. **Website:** www.summerfair.org. Estab. 1968. Fine arts & crafts show held annually the weekend after Memorial Day. Outdoors. Accepts photography, ceramics, drawing, printmaking, fiber, leather, glass, jewelry, painting, sculpture, metal, wood, and mixed media. Juried by a panel of judges selected by Summerfair, including artists and art educators with expertise in the categories offered at Summerfair. Submit application with 5 digital images (no booth image) through www.zapplication.org. Awards/prizes: $18,000 in cash awards. Number of exhibitors: 300. Public attendance: 20,000. Public admission: $10. Deadline: February. Application fee: $35. Space fee: $450, single; $900, double space; $125 canopy fee (optional—exhibitors can rent a canopy for all days of the fair). Exhibition space: 10×10 ft. for single space; 10×20 ft. for double space. For more information, artists should e-mail, visit website, call. Fair held at Cincinnati's historic Coney Island.

SUMMIT ART FESTIVAL

Website: www.summitartfest.org. Fine arts & crafts fair held annually October. Outdoors. Accepts handmade crafts, jewelry, ceramics, painting, glass, photography, fiber, and more. Juried. Awards/prizes: Best of Show, 2nd place, 3rd place, Mayor's Award, Jurors' Merit Award. Number of exhibitors: see website. Number of attendees: varies. Free to public. Apply online. Deadline for entry: July. Application fee: $25. Space fee: $255. Exhibition space: 10×10 ft. For more information, artists should visit website.

SUN FEST, INC.

P.O. Box 2404, Bartlesville OK 74005. (918)331-0456. **Fax:** (918)331-3217. **E-mail:** sunfestbville@gmail.com. **Website:** www.bartlesvillesunfest.org. Estab. 1982. Fine arts & crafts show held annually in early June. Outdoors. Accepts photography, painting, and other arts and crafts. Juried. Awards: $2,000 in cash awards along with a ribbon/award to be displayed. Number of exhibitors: 95-100. Number of attendees: 25,000-30,000. Free to the public. Artists should apply by e-mailing or calling for an entry form, or completing online, along with 3-5 photos showing your work and booth display. Deadline: April. Space fee: $125. An extra $20 is charged for use of electricity. Exhibition space: 10×10 ft. For more information, artists should e-mail, call, or visit website.

SUN VALLEY CENTER ARTS & CRAFTS FESTIVAL

Sun Valley Center for the Arts, P.O. Box 656, Sun Valley ID 83353, USA. (208)726-9491. **Fax:** (208)726-2344. **E-mail:** festival@sunvalleycenter.org. **Website:** www.sunvalleycenter.org. **Contact:** Sarah Kolash, festival director. Estab. 1968. Annual fine art & craft show held 2nd weekend in August. Outdoors. Accepts handmade crafts, ceramics, drawing, fiber, glass, jewelry, metalwork, mixed media, painting, photography, printmaking, sculpture, woodwork. Juried. Exhibitors: 140. Number of attendees: 10,000. Free to public. Apply via www.zapplication.org. Deadline for entry: see website. Application fee: $35. Space fee: $450 & $900, $500 or $1000 for corner spaces. Exhibition space: 10×10 ft. & 10×20 ft. Average sales: $3,700. For more information e-mail or see website.

SURPRISE FINE ART & WINE FESTIVAL

15940 N Bullard Ave., Surprise AZ 85374. (480)837-5637. **Fax:** (480)837-2355. **E-mail:** info@thunderbirdartists.com. **Website:** www.thunderbirdartists.com. **Contact:** Denise Colter, president. Estab. 2012. "The Surprise Fine Art & Wine Festival, produced by Thunderbird Artists and in conjunction with the City of Surprise and Surprise Sundancers, is back by popular demand! The sales, attendance, and support were spectacular for a newer event and the most popular quote used by vendors: "What a wonderful surprise!" This event will receive an extensive and dedicated advertising campaign, like all events produced by Thunderbird Artists. The Thunderbird Artists Mission is to promote fine art and fine crafts, paralleled with

the ambiance of unique wines and fine music, while supporting the artists, merchants, and surrounding community." It is the mission of Thunderbird Artists to further enhance the art culture with the local communities by producing award-winning, sophisticated fine art festivals throughout the Phoenix metro area. Thunderbird Artists has played an important role in uniting nationally recognized and award-winning artists with patrons from across the globe.

TIPS "A clean, gallery-type presentation is very important."

◎ SYRACUSE ARTS & CRAFTS FESTIVAL

115 W. Fayette St., Syracuse NY 13202. (315)422-8284. **Fax:** (315)471-4503. **E-mail:** mail@downtown syracuse.com. **Website:** www.syracuseartsandcrafts festival.com. **Contact:** Laurie Reed, director. Estab. 1970. Fine arts & crafts show held annually in late July. Outdoors. Accepts photography, ceramics, fabric/fiber, glass, jewelry, leather, metal, wood, computer art, drawing, printmaking, painting. Juried by 4 independent jurors. Jurors review 4 digital images of work and 1 digital image of booth display. Number of exhibitors: 165. Public attendance: 50,000. Free to public. Artists should apply online through www. zapplication.org. Application fee: $25. Space fee: $280. Exhibition space: 10×10 ft. For more information, artists should e-mail, call or visit website.

TALLMAN ARTS FESTIVAL

426 N. Jackson St., Janisville WI 53548. (608)756-4509. **E-mail:** astrobelwise@rchs.us. **Website:** www.rchs. us. **Contact:** Amanda Strobel Wise, volunteer and internship program manager. Estab. 1957. Held in early August. Fine art/craft show. Event held outdoors. Accepts photography, ceramics, fiber arts, painting, mixed media. Juried event. No awards or prizes given. Average number of exhibitors: 70-100. Average number of attendees: 1,800-2,000. Admission fee: $5 adults. Artists should apply online. Space: 10×10 ft. For more information, artists should e-mail, call, visit websit, or send SASE.

◎ TARPON SPRINGS FINE ARTS FESTIVAL

111 E. Tarpon Ave., Tarpon Springs FL 34689. (727)937-6109. **Fax:** (727)937-2879. **E-mail:** reggie@ tarponspringschamber.org. **Website:** www.tarpon springschamber.com. Estab. 1974. Fine arts & crafts show held annually in late March. Outdoors. Accepts photography, acrylic, oil, ceramics, digital, fi-

ber, glass, graphics, drawings, pastels, jewelry, leather, metal, mixed media, sculpture, watercolor, wood. Juried by CD or images e-mailed. Awards/prizes: cash, ribbons and Patron Awards. Number of exhibitors: 200. Public attendance: 20,000. Public admission: $5 (includes free drink ticket: wine, beer, soda, or water); free-age 12 and under and active duty military. Artists should apply by submitting signed application, CD or e-mailed images, fees, and SASE. Deadline for entry: late December. Jury fee: $30. Space fee: $230. Exhibition space: 10×12 ft. For more information, artists should e-mail, call, or send SASE.

TIPS "Produce good CDs for jurors."

THREE RIVERS ARTS FESTIVAL

803 Liberty Ave., Pittsburgh PA 15222. (412)456-6666. **Fax:** (412)471-6917. **Website:** www. 3riversartsfest.org. **Contact:** Sonja Sweterlitsch, director. Estab. 1960. "Three Rivers Arts Festival has presented, during its vast and varied history, more than 10,000 visual and performing artists and entertained millions of residents and visitors. Three Rivers Arts Festival faces a new turning point in its history as a division of the Pittsburgh Cultural Trust, further advancing the shared mission of each organization to foster economic development through the arts and to enhance the quality of life in the region." Application fee: $35. Booth fee: $340-410. See website for more information. Festival located at Point State Park in downtown Pittsburgh.

◎ TUBAC FESTIVAL OF THE ARTS

P.O. Box 1866, Tubac AZ 85646. (520)398-2704. **Fax:** (520)398-3287. **E-mail:** assistance@tubacaz.com. **Website:** www.tubacaz.com. Estab. 1959. Fine arts & crafts show held annually in early February (see website for details). Outdoors. Accepts photography and considers all fine arts and crafts. Juried. A 7-member panel reviews digital images and artist statement. Names are withheld from the jurists. Number of exhibitors: 170. Public attendance: 65,000. Free to the public; parking: $6. Deadline for entry: late October (see website for details). Application fee: $30. Artists should apply online and provide images on a labeled CD (see website for requirements). Space fee: $575. Electrical fee: $50. Exhibition space: 10×10 ft. (a limited number of double booths are available). For more information, artists should e-mail, call, or visit website.

🎧 TULSA INTERNATIONAL MAYFEST

2210 S. Main St., Tulsa OK 74114. (918)582-6435. **Fax:** (918)517-3518. **E-mail:** comments@tulsamayfest.org. **Website:** www.tulsamayfest.org. Estab. 1972. Fine arts & crafts show annually held in May. Outdoors. Accepts photography, clay, leather/fiber, mixed media, drawing, pastels, graphics, printmaking, jewelry, glass, metal, wood, painting. Juried by a blind jurying process. Artists should apply online at www.zapplication.org and submit 4 images of work and 1 photo of booth set-up. Awards/prizes: Best in Category and Best in Show. Number of exhibitors: 125. Public attendance: 350,000. Free to public. Artists should apply by downloading application in the fall. See website for deadline entry. Application fee: $35. Space fee: $350. Exhibition space: 10×10 ft. For more information, artists should e-mail or visit website.

🎧 UPPER ARLINGTON LABOR DAY ARTS FESTIVAL

(614)583-5310. **Fax:** (614)437-8656. **E-mail:** arts@uaoh.net. **Website:** www.uaoh.net/department/index.php?structureid=101. Fine art & craft show held annually in September. Outdoors. Accepts handmade crafts, ceramics, fiber, glass, graphics, jewelry, leather, metal, mixed media, painting, photography, printmaking, sculpture, woodworking. Juried. Awards/prizes: $1,350 in awards. Number of exhibitors: 200. Number of attendees: 25,000. Free to public. Apply via www.zapplication.org. Deadline for entry: February. Application fee: see website. Space fee: varies. Exhibition space: varies. For more information, artists should call or visit website.

🎧 UPTOWN ART FAIR

1406 W. Lake St., Lower Level C, Minneapolis MN 55408. (612)823-4581. **Fax:** (612)823-3158. **E-mail:** maude@uptownminneapolis.com; info@uptownminneapolis.com; jessica@uptownminneapolis.com; hannah@uptownminneapolis.com. **Website:** www.uptownartfair.com. **Contact:** Maude Lovelle. Estab. 1963. Fine arts & crafts show held annually 1st full weekend in August. Outdoors. Accepts photography, painting, printmaking, drawing, 2D and 3D mixed media, ceramics, fiber, sculpture, jewelry, wood, and glass. Juried by 4 images of artwork and 1 of booth display. Awards/prizes: Best in Show in each category; Best Artist. Number of exhibitors: 350. Public attendance: 375,000. Free to the public. The Uptown Art Fair uses www.zapplication.org. Each artist must submit 5 images of his or her work. All artwork must be in a high-quality digital format. Five highly qualified artists, instructors, and critics handpick Uptown Art Fair exhibitors after previewing projections of the images on 6-ft. screens. The identities of the artists remain anonymous during the entire review process. All submitted images must be free of signatures, headshots, or other identifying marks. Three rounds of scoring determine the final selection and waitlist for the show. Artists will be notified shortly after of their acceptance. For additional information, see the links on website. Deadline for entry: early March. Application fee: $40. Space fee: $550 for 10×10 ft. space; $1,100 for 10×20 ft. space. For more information, artists should call or visit website. Fair located at Lake St. and Hennepin Ave. and "The Mall" in Southwest Minneapolis.

🎧 A VICTORIAN CHAUTAUQUA

1101 E. Market St., Jeffersonville IN 47130. (812)283-3728 or (888)472-0606. **Fax:** (812)283-6049. **E-mail:** hsmsteam@aol.com. **Website:** www.steamboatmuseum.org. **Contact:** Roger Fisher, festival chairman. Estab. 1993. Fine arts & crafts show held annually 3rd weekend in May. Outdoors. Accepts photography, all mediums. Juried by a committee of 5. Number of exhibitors: 80. Public attendance: 3,000. Exhibition space: 12×12 ft. For more information, artists should e-mail, call, or visit website.

VILLAGE SQUARE ARTS & CRAFTS FAIR

P.O. Box 176, Saugatuck MI 49453. **E-mail:** artclub@saugatuckdouglasartclub.org. **Website:** www.saugatuckdouglasartclub.org. Estab. 2004. The art club offers 2 fairs each summer. See website for upcoming dates. This fair has some fine artists as well as crafters. Both fairs take place on the 2 busiest weekends in the resort town of Saugatuck's summer season. Both are extremely well attended. Generally the vendors do very well. Booth fee: $95-140. Fair located at corner of Butler and Main Streets, Saugatuck MI.

TIPS "Create an inviting booth. Offer well-made artwork and crafts for a variety of prices."

🎧 VIRGINIA BEACH DOWNTOWN ART FAIR

270 Central Blvd., Suite 107B, Jupiter FL 33458. (561)746-6615. **Fax:** (561)746-6528. **E-mail:** info@artfestival.com. **Website:** www.artfestival.com. **Contact:** Malinda Ratliff, communications manager. Estab. 2015. Fine art & craft fair held annually in April.

Outdoors. Accepts photography, jewelry, mixed media, sculpture, wood, ceramic, glass, painting, digital, fiber, metal. Juried. Number of exhibitors: 80. Number of attendees: see website. Free to public. Apply online via www.zapplication.org. Deadline: see website. Application fee: $25. Space fee: $395. Exhibition space: 10×10 ft. and 10×20 ft. For more information, artists should e-mail, call, or visit website. Festival located Main St. between Central Park Ave. and Constitution Dr.

TIPS "You have to start somewhere. First, assess where you are, and what you'll need to get things off the ground. Next, make a plan of action. Outdoor street art shows are a great way to begin your career and lifetime as a working artist. You'll meet a lot of other artists who have been where you are now. Network with them!"

VIRGINIA CHRISTMAS MARKET

The Exhibition Center at Meadow Event Park, 13111 Dawn Blvd., Doswell VA 23047. (804)253-6284. **Fax:** (804)253-6285. **E-mail:** bill.wagstaff@virginiashows.com. **Website:** www.virginiashows.com. Indoors. Virginia Christmas Market is held the last weekend in October at the Exhibition Center at Meadow Event Park. Virginia Christmas Market will showcase up to 300 quality artisans, crafters, boutiques, and specialty food shops. Features porcelain, pottery, quilts, folk art, fine art, reproduction furniture, flags, ironwork, carvings, leather, toys, tinware, candles, dollcraft, wovenwares, book authors, musicians, jewelry, basketry, gourmet foods—all set amid festive Christmas displays. Accepts photography and other arts and crafts. Juried by 3 photos of artwork and 1 of display. Attendance: 15,000. Public admission: $7; children free (under 10). Artists should apply by calling, e-mailing, or downloading application from website. Space fee: $335. Exhibit spaces: 10×10 ft. For more information, artists should e-mail, call, or visit website.

TIPS If possible, attend the show before you apply.

⊕ VIRGINIA SPRING MARKET

11050 Branch Rd., Glen Allen VA 23059. (804)253-6284. **Fax:** (804)253-6285. **E-mail:** bill.wagstaff@virginiashows.com. **Website:** www.virginiashows.com. **Contact:** Bill Wagstaff. Estab. 1988. Holiday arts & crafts show held annually 1st weekend in March at the Exhibition Center at Meadow Event Park, 13111 Dawn Blvd., Doswell VA. Virginia Spring Market will showcase up to 300 quality artisans, crafters, boutiques, and specialty food shops. Features porcelain, pottery, quilts, folk art, fine art, reproduction furniture, flags, ironwork, carvings, leather, toys, tinware, candles, dollcraft, wovenwares, book authors, musicians, jewelry, basketry, and gourmet foods, all set amid festive spring displays. Accepts photography and other arts and crafts. Juried by 3 images of artwork and 1 of display. Public attendance: 12,000. Public admission: $7; children free (under 10). Artists should apply by calling, e-mailing, or downloading application from website. Space fee: $335. Exhibition space: 10×10 ft. For more information, artists should e-mail, call, or visit website.

TIPS "If possible, attend the show before you apply."

⊕ WASHINGTON SQUARE OUTDOOR ART EXHIBIT

P.O. Box 1045, New York NY 10276. (212)982-6255. **Fax:** (212)982-6256. **E-mail:** jrm.wsoae@gmail.com. **Website:** www.wsoae.org. Estab. 1931. Fine arts & crafts show held semiannually Memorial Day weekend and Labor Day weekend. Outdoors. Accepts photography, oil, watercolor, graphics, mixed media, sculpture, crafts. Juried by submitting 5 slides of work and 1 of booth. Awards/prizes: certificates, ribbons and cash prizes. Number of exhibitors: 150. Public attendance: 100,000. Free to public. Artists should apply by sending a SASE or downloading application from website. Deadline for entry: March, spring show; July, fall show. Exhibition space: 5×10 ft. up to 10×10 ft., double spaces available. Jury fee of $20. First show weekend (3 days) fee of $410. Second show weekend (2 days) $310. Both weekends (all 5 days) fee of $525. For more information, artists should call or send SASE.

TIPS "Price work sensibly."

⊕ WATERFRONT FINE ART & WINE FESTIVAL

7135 E Camelback Rd, Scottsdale AZ 85251. (480)837-5637. **Fax:** (480)837-2355. **E-mail:** info@thunderbirdartists.com. **Website:** www.thunderbirdartists.com. **Contact:** Denise Colter, president. Estab. 2011. 125 juried fine artists will line the banks of Scottsdale Waterfront's pedestrian walkway, along with wineries, chocolate vendors, and musicians. The Waterfront is an elegant backdrop for this event, adding romantic reflections across the waters—mirroring tents, art, and patrons. Thunderbird Artists Mission is to pro-

mote fine arts and fine crafts, paralleled with the ambiance of unique wines and festive music, through a dedicated, extensive advertising campaign.

TIPS "A clean, gallery-type presentation is very important."

🎧 WATERFRONT FINE ART FAIR

P.O. Box 176, Saugatuck MI 49453. **E-mail:** art club@saugatuckdouglasartclub.org. **Website:** www .saugatuckdouglasartclub.org. Fee is $135. This includes application fee, booth fee, and city license. Applications juried in early April. For information, e-mail, call, or visit the website. Fair held at Cook Park.

TIPS "Create a pleasing, inviting booth. Offer well-made, top-quality fine art."

🎧 WHITEFISH ARTS FESTIVAL

P.O. Box 131, Whitefish MT 59937. (406)862-5875. **E-mail:** wafdirector@gmail.com. **Website:** www.white fishartsfestival.org. **Contact:** Clark Berg; Angie Scott. Estab. 1979. High-quality art show held annually the 1st full weekend in July. Outdoors. Accepts photography, pottery, jewelry, sculpture, paintings, woodworking. Art must be original and handcrafted. Work is evaluated for creativity, quality, and originality.120 booths. Public attendance: 3,000–5,000. Free to public. Juried entry fee: $35. Deadline: see website for details. Space fee: $230. Exhibition space: 10×10 ft. For more information and to apply, artists should visit website.

TIPS Recommends "variety of price range, professional display, early application for special requests."

🎧 WHITE OAK CRAFTS FAIR

1424 John Bragg Hwy, Woodbury TN 37190. (615)563-2787. **E-mail:** mary@artscenterofcc.com; artscenter@artscenterofcc.com; carol@artscenterofcc.com. **Website:** www.artscenterofcc.com. Estab. 1985. Arts & crafts show held annually in early September (see website for details) featuring the traditional and contemporary craft arts of Cannon County and Middle Tennessee. Outdoors. Accepts photography; all handmade crafts, traditional and contemporary. Must be handcrafted displaying excellence in concept and technique. Juried by committee. Send 3 slides or

photos. Awards/prizes: more than $1,000 cash in merit awards. Number of exhibitors: 80. Public attendance: 6,000. Free to public. Applications can be downloaded from website. Deadline: early July. Space fee: $120 ($90 for Artisan member) for a 10×10 ft. under tent; $95 ($65 for Artisan member) for a 12×12 ft. outside. For more information, artists should e-mail, call or visit website. Fair takes place along the banks of the East Fork Stones River just down from the Arts Center.

🎧 WYANDOTTE STREET ART FAIR

2624 Biddle Ave., Wyandotte MI 48192. (734)324-4502. **Fax:** (734)324-7283. **E-mail:** hthiede@wyan.org. **Website:** www.wyandottestreetartfair.org. **Contact:** Heather Thiede, special events coordinator. Estab. 1961. Fine arts & crafts show held annually 2nd week in July. Outdoors. Accepts photography, 2D mixed media, 3D mixed media, painting, pottery, basketry, sculpture, fiber, leather, digital cartoons, clothing, stitchery, metal, glass, wood, toys, prints, drawing. Juried. Awards/prizes: Best New Artist $500; Best Booth Design Award $500; Best of Show $1,200. Number of exhibitors: 300. Public attendance: 200,000. Free to the public. Artists may apply online or request application. Deadline for entry: early February. Application fee: $20 jury fee. Space fee: $250/single space; $475/double space. Exhibition space: 10×12 ft. Average gross sales/exhibitor: $2,000-$4,000. For more information, and to apply, artists should call, e-mail, visit website, or send SASE.

🎧🎧 YOUNG ART TAIPEI

3F, No. 295, Sec. 4, Zhong Xiao E. Rd. 10694, Taipei, Taiwan. (886) (2) 8772-6017. **E-mail:** info@youngart taipei.com. **Website:** www.youngarttaipei.com. Estab. 2009. Event held annually. Fine art/craft show. Event held indoors. Accepts photography. Accepts all mediums. Juried. Prizes given. Avg. number of exhibitors: 60-90. Avg. number of attendees: 10,000. Admission fee for public: $300 daily pass. We only accept applications from galleries. Deadline: see website. No application fee. Space fee: Upon request. Space size: 340-717 sq. ft. For more information, artists should e-mail or visit website.

CONTESTS

Whether you're a seasoned veteran or a newcomer still cutting your teeth, you should consider entering contests to see how your work compares to that of other photographers. The contests in this section range in scope from tiny juried county fairs to massive international competitions. When possible, we've included entry fees and other pertinent information in our limited space. Contact sponsors for entry forms and more details.

Once you receive rules and entry forms, pay particular attention to the sections describing rights. Some sponsors retain all rights to winning entries or even *submitted* images. Be wary of these. While you can benefit from the publicity and awards connected with winning prestigious competitions, you shouldn't unknowingly forfeit copyright. Granting limited rights for publicity is reasonable, but you should never assign rights of any kind without adequate financial compensation or a written agreement. If such terms are not stated in contest rules, ask sponsors for clarification.

If you're satisfied with the contest's copyright rules, check with contest officials to see what types of images won in previous years. By scrutinizing former winners, you might notice a trend in judging that could help when choosing your entries. If you can't view the images, ask what styles and subject matters have been popular.

10 INTERNATIONAL PHOTOGRAPHIC CALLS FOR ENTRY EACH YEAR

400 North College Ave., Fort Collins CO 80524. (970)22-1010. **E-mail:** coordinator@c4fap.org. **Website:** c4fap.org. **Contact:** Sunshine Divis, programs manager. Contests held: Ten Themed Contests Yearly, Annual Black and White, Portraits, Center Forward and Portfolio ShowCase, plus more. Open to everyone, please see our website for more information on current calls for entry. Open to all skill levels. Contestants should see website for more information. Monthly deadlines. Varies.

440 GALLERY ANNUAL SMALL WORKS SHOW

440 Sixth Ave., Brooklyn NY 11215. (718)499-3844. **E-mail:** gallery440@verizon.net. **Website:** www.440gallery.com. **Contact:** Nancy Lunsford, director. Annual juried exhibition hosted by 440 Gallery, a cooperative run by member artists. An exhibition opportunity for US artists whose work is selected by a different curator each year. All work, including frames and mounting materials, must be less than 12" in all directions. Open to all 2D and 3D media. Videos are considered if the monitor provided is also under 12". Three prizes awarded with small cash awards: The Curator's Choice Award (decided by the juror), the 440 Award (decided by the members of the cooperative), the People's Choice Award (decided by "liking" images posted on our Facebook page). Deadline: early November. For more information about entering submissions, visit website in late September/early October, go to "Call for Entry" page.

440 GALLERY ANNUAL THEMED SHOW

440 Sixth Ave., Brooklyn NY 11215. (718)449-3844. **E-mail:** gallery440@verizon.net. **Website:** www.440gallery.com. **Contact:** Nancy Lunsford. National juried exhibition with a stated theme, and the subject varies from year to year. Past themes have been: animals, Brooklyn, text. An outside curator is invited to judge entries. All media and styles welcome. There is no size limitation, but extremely large work is unlikely to be chosen. Open to all US artists ages 18 and over. Deadline: mid-May. Interested artists should see website for more information.

AESTHETICA ART PRIZE

Aesthetica Magazine, P.O. Box 371, York YO23 1WL United Kingdom. **E-mail:** info@aestheticamagazine.com; artprize@aestheticamagazine.com. **Website:** www.aestheticamagazine.com. There are 4 categories: Photograpic & Digital Art, Three-Dimensional Design & Sculpture, Painting & Drawing, Video Installation & Performance. See guidelines at www.aestheticamagazine.com. The Aesthetica Art Prize is a celebration of excellence in art from across the world and offers artists the opportunity to showcase their work to wider audiences and further their involvement in the international art world. Deadline: August 31. Prizes include: £5,000 main prize courtesy of Hiscox, £1,000 Student Prize courtesy of Hiscox, group exhibition and publication in the Aesthetica Art Prize Anthology. Entry is £15 and permits submission of 2 works in one category.

AFI FEST

2021 N. Western Ave., Los Angeles CA 90027. (323)856-7707; (323)856-7600. **E-mail:** programming@afi.com; afifest@afi.com. **Website:** www.afi.com/afifest. **Contact:** director of festivals. Cost: $50 shorts; $70 features. "LA's most prominent annual film festival." Various cash and product prizes are awarded. Open to filmmakers of all skill levels. Deadline: August (see website for details). Photographers should write, call, or e-mail for more information.

ALEXIA COMPETITION

S.I. Newhouse School of Communications, 215 University Place, Syracuse NY 13244-2100. (315)443-7388. **E-mail:** trkenned@syr.edul; mdavis@syr.edu; info@alexiafoundation.org. **Website:** www.alexiafoundation.org. **Contact:** Tom Kennedy. Annual contest. Provides financial ability for students to study photojournalism in England, and for professionals to produce a photo project promoting world peace and cultural understanding. Students win cash grants plus scholarships to study at workshops offered by Media storm: 1st Place and Momenta Workshops; 2nd Place and Award of Excellence—see website for updated description. Awards vary by year, $1,000–16,000. Photographers should e-mail or see website for more information.

ANNUAL HOYT REGIONAL ART COMPETITION

124 E. Leasure Ave., New Castle PA 16105. (724)652-8882. **Fax:** (724) 657-8786. **E-mail:** hoytexhibits@hoytartcenter.org. **Website:** www.hoytartcenter.org. **Contact:** Patricia, Exhibition Coordinator. Cost: $25. Contest held Annually. Open to artists within 250-

mile radius of New Castle, PA. All media except video and installation not previously exhibited before. 1st place: $500. 2nd place: $300. 3rd place: $150. 6 $50 Merits. Open to all skill levels. Contestants should e-mail.

APERTURE SUMMER OPEN

547 W. 27th St., 4th Floor, New York NY 10001. (212)505-5555. **Fax:** (212)979-7759. **E-mail:** summer open@aperture.org; customerservice@aperture.org. **Website:** www.aperture.org/summer-open. **Contact:** Ashley Strazzinski, education & public programs assistant. Cost: see website or e-mail for cost info. Annual photography contest. This contest is an open-submission exhibition for which all photographers are eligible to enter. Awards: Work will be displayed at Aperture Gallery in New York. Open to all skill levels. See website for deadline and for more information.

ARC AWARDS

500 Executive Blvd., Ossining-on-Hudson NY 10562. (914)923-9400. **Fax:** (914)923-9484. **E-mail:** info@ mercommawards.com. **Website:** www.mercomm awards.com. Cost: $210-330. Annual contest. The International ARC Awards, is the "Academy Awards of Annual Reports," according to the financial media. It is the largest international competition honoring excellence in annual reports. The competition is open to corporations, small companies, government agencies, nonprofit organizations, and associations, as well as agencies and individuals involved in producing annual reports. The purpose of the contest is to honor outstanding achievement in annual reports. Major category for photography of annual report covers and interiors. "Best of Show" receives a personalized trophy. Grand Award winners receive personalized award plaques. Gold, silver, bronze, and finalists receive a personalized award certificate. Every entrant receives complete judge score sheets and comments. Deadline is May. For more information, write, call, e-mail or visit website.

⊙ ARTIST FELLOWSHIP GRANTS

Oregon Arts Commission, 775 Summer St. NE, Suite 200, Salem OR 97301-1280. (503)986-0082. **Fax:** (503)986-0260. **E-mail:** oregon.artscomm@state. or.us. **Website:** www.oregonartscommission.org. A highly competitive juried grant process offering $3,000 in cash awards to Oregon visual artists, awarded annually. Deadline: October. See website for more information.

ARTIST FELLOWSHIPS/VIRGINIA COMMISSION FOR THE ARTS

1001 E. Broad St., Suite 330, Richmond VA 23219. (804)225-3132. **Fax:** (804)225-4327. **E-mail:** arts@ arts.virginia.gov; tiffany.ferreira@vca.virginia.gov. **Website:** www.arts.virginia.gov. The purpose of the Artist Fellowship program is to encourage significant development in the work of individual artists, to support the realization of specific artistic ideas, and to recognize the central contribution professional artists make to the creative environment of Virginia. Grant amounts: $5,000. Emerging and established artists are eligible. Open only to artists who are legal residents of Virginia and are at least 18 years of age. Applications are available in July. See Guidelines for Funding and application forms on the website or write for more information.

⊙ ARTISTS ALPINE HOLIDAY

Ouray County Arts Association, P.O. Box 167, Ouray CO 81427. (970)626-5513. **E-mail:** jbhazen@yahoo. com. **Website:** www.ourayarts.org. **Contact:** DeAnn McDaniel, registrar. Cost: $30, includes up to 2 entries. Annual fine arts show. Juried. Cash awards for 1st, 2nd and 3rd prizes in all categories total $7,200. Best of Show: $750; People's Choice Award: $50. Open to all skill levels. Photographers and artists should call or see website for more information.

ART OF PHOTOGRAPHY SHOW

1439 El Prado, San Diego CA 92101. (619)825-5575. **E-mail:** steven@artofphotographyshow.com. **Website:** www.artofphotographyshow.com. **Contact:** Steven Churchill, producer. Cost: $25 for 1st entry, $10 for each additional entry. Deadline: mid-June. International exhibition of photographic art which occurs each fall at the San Diego Art Institute in San Diego's beautiful Balboa Park. One of the distinguishing characteristics of this competition and exhibition is that the judge is always a highly acclaimed museum curator. "The Art of Photography Show is an established and critical force in the world of contemporary photography. The show provides tangible benefits to artists trying to break into the public eye. This well-thought-out exhibition provides value to artists at every turn, from first-rate viewing in the judging process, to exhibition and publication opportunities, well-attended exhibitions and lectures, photo industry connections, and monetary awards." This competition accepts for consideration images created

via any form of photography (e.g., shot on film, shot digitally, unaltered shots, alternative process, mixed media, digital manipulations, montages, photograms), so long as part of the image is photographically created. Upload via the website (preferred) or e-mail to entries@artofphotographyshow.com or mail a CD. Award: 1st place $2,000; 2nd place $1,600; 3rd place $1,200; 4th place $800; honorable mention $400 (11 HM awards). Photographers should e-mail or visit the website for more information.

ASTRID AWARDS

500 Executive Blvd., Ossining-on-Hudson NY 10562. (914)923-9400. **Fax:** (914)923-9484. **E-mail:** info@ mercommawards.com; contacts@mercommawards. com. **Website:** www.mercommawards.com. Annual contest. Cost: $330/classification; there is a multiple entry discount. The purpose of the contest is to honor outstanding achievement in design communications. Major category for photography, including books, brochures and publications. "Best of Show" receives a personalized trophy. Grand Award winners receive personalized award plaques. Gold, silver, bronze, and finalists receive a personalized award certificate. Every entrant receives complete judge score sheets and comments. Deadline: late February (see website for details). For more information, write, call, e-mail, or visit website.

ATLANTA PHOTOJOURNALISM SEMINAR CONTEST

PMB 420, 5579-B Chamblee Dunwoody Rd., Dunwoody GA 30338. **E-mail:** contest@photojournalism.org; info@photojournalism.org; erik@photojournalism.org. **Website:** www.photojournalism.org. **Contact:** Jeremy Brooks. Annual contest. This is an all-digital contest with several different categories (all related to news and photojournalism). Photographs may have been originally shot on film or with a digital camera, but the entries must be submitted in digital form. Photographs do not have to be published to qualify. No slide or print entries are accepted. Video frame grabs are not eligible. Rules are very specific. See website for official rules. Prizes start at $100, including $1,000 and Nikon camera gear for Best Portfolio. Open to all skill levels. Deadline: November (see website for more details).

◑ BANFF MOUNTAIN PHOTOGRAPHY COMPETITION

P.O. Box 1020, 107 Tunnel Mountain Dr., Banff Alberta T1L 1H5 Canada. (403)762-6347. **Fax:** (403)762-6277. **E-mail:** BanffMountainPhotos@banffcentre. ca. **Website:** www.banffcentre.ca/mountainfestival. **Contact:** competition coordinator. Annual contest. Maximum of 5 images (digital) in photo essay format. Entry fee: $10/essay. Entry form and regulations available on website. Approximately $5,000 in cash and prizes to be awarded. Open to all skill levels. For more information, write, call, e-mail, or visit website.

BUCKTOWN ARTS FEST POSTER CONTEST

2200 N. Oakley, Chicago IL 60647. **E-mail:** poster-contest@bucktownartsfest.com. **Website:** www.bucktownartsfest.com/posters. **Contact:** Amy Waldon, committee member. Annual contest. "We hope you wil share your creativity and passion for the Bucktown Arts Fest by entering our poster contest! The purpose of the contest is to design a poster promoting the Bucktown Arts Fest. Just create an original artwork in your media that you think best exemplefies the Bucktown Arts Fest and submit it in JPEG format. The deadline for entries is March 31. There is no fee to enter. Winners will receive a prize and complimentary admission into the festival. Plus, your artwork will be used to promote the Fest, including the Bucktown Arts Fest website, festival merchandise (posters, t-shirts, hangtags, postcards, program), collateral, press releases, and signage." One winner will be selected. Winner will be announced May 31 via an e-mail blast.

CAMERA USA: NATIONAL PHOTOGRAPHY EXHIBITION AND AWARD

585 Park St., Naples FL 34102-6611. (239)262-6517. **Fax:** (239)262-5404. **E-mail:** jack.obrien@naplesart. org. **Website:** www.naplesart.org/callforartistcat/exhibit-opportunities. **Contact:** Jack O'Brien, curator. Cost: $32 entry fee. Annual competition. "All photographers residing in the US are invited to submit one photograph taken in the US after January 1, 2012 for the Camera USA competition with a bricks & mortar exhibition held at the von Liebig Art Center in Naples, FL. A maximum of 50 photographers will be included in the exhibition. Three art professionals will review and select photographs online and nominate the Na-

tional Photography Award Winner. In addition to the $5,000 National Photography Award, the winning photographer will receive 2 nights hotel accomodations in Naples and round-trip economy class airfare. A winning photographer residing in Florida will receive a $300 travel stipend in lieu of airfare. Photographs must be exhibit ready and not exceed 40×40" in size, including frame if a frame is used." Open to all skill levels. Prize/Award: The National Photography Award-$5,000. Deadline for submissions: early March. Contestants should see website for more information.

THE CENTER FOR FINE ART PHOTOGRAPHY

400 North College Ave., Fort Collins CO 80524. (970)224-1010. **E-mail:** contact@c4fap.org. **Website:** www.c4fap.org. Cost: typically $35 for first 3 entries; $10 for each additional entry. Competitions held 10 times/year. "The center's competitions are designed to attract and exhibit quality fine art photography created by emerging and established artists working in traditional, digital, and mixed-media photography. The themes for each exhibition vary greatly. The themes, rules, details, and entry forms for each call for entry are posted on the center's website." All accepted work is exhibited in the center gallery. Additionally, the center offers monetary awards, scholarships, solo exhibitions, and other awards. Awards are stated with each call for entry. Open to all skill levels and to all domestic and international photographers working with digital or traditional photography or combinations of both. Photographers should see website for deadlines and more information.

COLLEGE & HIGH SCHOOL PHOTOGRAPHY CONTEST

Serbin Communications, 813 Reddick St., Santa Barbara CA 93103. (805)963-0439 or (800)876-6425. **Fax:** (805)965-0496. **E-mail:** admin@serbin.com; julie@serbin.com. **Website:** www.pfmagazine.com. **Contact:** Julie Simpson, managing editor. Annual student contest; runs September through mid-November. Sponsored by *Photographer's Forum Magazine.* Winners and finalists have their photos published in the hardcover book *Best of College & High School Photography.* See website for entry form.

COLLEGE PHOTOGRAPHER OF THE YEAR

101B Lee Hills Hall, University of Missouri, Columbia MO 65211-1370. (573)884-2188. **E-mail:** info@cpoy.org. **Website:** www.cpoy.org. **Contact:** Rita Reed, director. Annual contest to recognize excellent photography by currently enrolled college students. Portfolio winner receives a plaque, cash, and camera products. Other category winners receive cash and camera products. Open to beginning and intermediate photographers. Photographers should see website for more information.

COLORED PENCIL MAGAZINE ANNUAL ART COMPETITION

P.O. Box 183, Efland NC 27243. (919)400-8317. **E-mail:** admin@coloredpencilmag.com. **Website:** www.coloredpencilmag.com. **Contact:** Sally Robertson, editor-in-chief. Contest held annually. Open to all skill levels. Contestants should see website for more information. Submit your colored pencil artwork and have your art appear in our annual art gallery and compete for amazing prizes. 12 artists' work will appear in our annual *Colored Pencil* calendar, win subscriptions to *Colored Pencil Magazine,* and be awarded art supplies and gift certificates from our sponsors: Blick Art Materials, Prismacolor, and Legion Paper. Winning artwork and website link (if applicable) will also be displayed on our website and featured in the *Colored Pencil Magazine.*

COMMUNICATION ARTS ANNUAL PHOTOGRAPHY COMPETITION

110 Constitution Dr., Menlo Park CA 94025-1107. (650)326-6040. **E-mail:** competition@commarts.com. **Website:** www.commarts.com/competitions. Estab. 1959. Entries must be entered on website. "Entries may originate from any country but a description in English is very important to the judges. The work will be chosen on the basis of its creative excellence by a nationally representative jury of designers, art directors, and photographers." Cost: $40 single entry; $80 series. Categories include advertising, books, editorial, for sale, institutional, multimedia, self-promotion, unpublished, and student work. Deadline: March 13. See website for more information.

CREATIVE QUARTERLY CALL FOR ENTRIES

244 Fifth Ave., Suite F269, New York NY 10001-7604. (718)775-3943. **E-mail:** coordinator@cqjournal.com. **Website:** www.cqjournal.com. Entry fee: varies. Quarterly contest. "Our publication is all about inspiration. Open to all art directors, graphic designers, photographers, illustrators, and fine artists in all countries. Separate categories for professionals and students. We accept both commissioned and uncom-

missioned entries. Work is judged on the uniqueness of the image and how it best solves a marketing problem. Winners will be requested to submit an image of a person, place, or thing that inspires their work. We will reprint these in the issue and select one for our cover image. *Creative Quarterly* has the rights to promote the work through our publications and website. Complete rights and copyright belong to the individual artist, designer, or photographer who enters their work. Enter online or by sending a disc. Winners will be featured in the next issue of *Creative Quarterly* corresponding with the call for entries and will be displayed in our online gallery. Runners-up will be displayed online only. Winners and runners-up both receive a complimentary copy of the publication." Open to all skill levels. Deadline: Last Friday of January, April, July, and October. See website for more information.

CURATOR'S CHOICE AWARDS

P.O. Box 2483, Santa Fe NM 87504. (505)984-8353. **E-mail:** programs@visitcenter.org. **Website:** www.visitcenter.org. **Contact:** Laura Pressley, executive director. Annual contest. Curator's Choice Awards are in three different categories with different jurors and prizes. "You can submit to one, two, or all categories. Our jurors are some of the most important and influential people in the business. Photographers are invited to submit their most compelling images. Open to all skill levels." Prizes include exhibition and more. Photographers should see submissions guidelines at visitcenter.org.

DIRECT ART MAGAZINE

SlowArt Productions, 123 Warren St., Hudson NY 12534. (518)828-2343. **E-mail:** slowart@aol.com. **Website:** www.slowart.com. **Contact:** Tim Slowinski, director. Cost: $35. Annual contest. "This contest is to select artists for publication in the annual edition of *Direct Art Magazine*." Open to all skill levels. Awards: publication in *Direct Art Magazine*, front and back covers; 4-to-6 page coverage; full-page display awards. Value of awards: $22,000. Deadline: March 31, annually. E-mail or see website for more information.

DIRECT ART MAGAZINE PUBLICATION COMPETITION

SlowArt Productions, 123 Warren St., Hudson NY 12534. **E-mail:** slowart@aol.com; limnerentry@aol.com. **Website:** www.slowart.com. **Contact:** Tim Slowinski, director. Cost: $35. Annual contest. National magazine publication of new and emerging art in all media. Cover and feature article awards. Open to all skill levels. Send SASE or see website for more information. SlowArt Productions presents the annual group thematic exhibition. Open to all artists, national and international, working in all media. All forms of art are eligible. *Entrants must be 18 years of age or older to apply.* 96" maximum for wall-hung work, 72" for freestanding sculpture.

THE DIRECTOR'S CHOICE AWARDS

P.O. Box 2483, Santa Fe NM 87504. (505)984-8353. **E-mail:** programs@visitcenter.org. **Website:** www.visitcenter.org. Recognizes outstanding photographers through the dealer's perspective. Cost: $30/members, $40/non-members. Annual contest. Photographers are invited to submit their most compelling images. Open to all skill levels. Prizes include exhibition and more. Deadline: February (see website for details). Photographers should see website for more information.

THE EDITOR'S CHOICE AWARDS

P.O. Box 2483, Santa Fe NM 87504. (505)984-8353. **E-mail:** programs@visitcenter.org. **Website:** www.visitcenter.org. Annual contest. This award recognizes outstanding photographers working in all processes and subject matter. Open to all skill levels. Awards/prizes: 1st, 2nd, 3rd prizes and honorable mention awarded; 1st Prize includes exhibition at Center space, publication in *Lenscratch* magazine and online exhibition at VisitCenter.org; see website for listing of prizes. Photographers should see website for more information.

EMBRACING OUR DIFFERENCES

P.O. Box 2559, Sarasota FL 34230 (941)404-5710. **E-mail:** info@embracingourdifferences.org. **Website:** www.embracingourdifferences.org. **Contact:** Michael Shelton. No cost. Contest held annually. For rules, please see website. Prize: $4,000. Open to all skill levels. Deadline: January 9, 2018. Contestants should see website for more information.

EMERGING ARTISTS

SlowArt Productions, 123 Warren St., Hudson NY 12534. (518)828-2343. **E-mail:** slowart@aol.com. **Website:** www.slowart.com. **Contact:** Tim Slowinski, director. Cost: $35. Annual contest. "This contest is dedicated to the exhibition, publication, and promotion of emerging artists." Open to all skill levels.

Awards: exhibition at the Limner Gallery; $1,000 cash; $2,200 in publication awards. Deadline: November 30, annually. E-mail or see website for more information.

⊙ ENERGY GALLERY ART CALL

E-mail: info@energygallery.com. **Website:** www.energygallery.com. Cost: $35 for 5 images; additional images $10/each. Energy Gallery is an arts organization operated by professional artists, art instructors, and curators for promoting emerging and established artists globally. Energy Gallery is a virtual gallery as well as a physical gallery that organizes exhibitions at art galleries, trade shows, and public institutions. A jury selects artworks for the online exhibition at Energy Gallery's website for a period of 3 months and archived in Energy Gallery's website permanently. Selected artists also qualify to participate in Energy Gallery's annual exhibit. Photographers should visit website for submission form, current art calls, and more information. Deadline: late August.

⊙ EXHIBITIONS WITHOUT WALLS FOR PHOTOGRAPHERS AND DIGITAL ARTISTS

130 SW 20th St., Cape Coral FL 33991. (239)223-6824. **E-mail:** ewedman@exhibitionswithoutwalls.com. **Website:** www.exhibitionswithoutwalls.com. **Contact:** Ed Wedman, co-founder. Cost: $25 for up to 5 images, each additional image up to 10 is an additional charge of $4. Contest is held quarterly. Online international juried competitions for photographers and digital artists. Prizes vary, but a minimum of $900 in cash awards and additional prizes. Open to all skill levels. Deadline: 30 days after submissions open. Contestants should see website for more information.

⊙ FIRELANDS ASSOCIATION FOR THE VISUAL ARTS

39 S. Main St., Oberlin OH 44074. (440)774-7158. **Fax:** (440)775-1107. **E-mail:** favagallery@oberlin.net. **Website:** www.favagallery.org. Cost: $15/photographer; $12 for FAVA members. Biennial juried photography contest (odd-numbered years) for residents of OH, KY, IN, MI, PA, and WV. Both traditional and experimental techniques welcome. Photographers may submit up to 3 works completed in the last 3 years. Annual entry deadline: March-April (date varies, see website for details). Photographers should call, e-mail, or see website for entry form and more details.

◑ HUMANITY PHOTO AWARD (HPA)

World Folklore Photographers Association, Suite 1605, Shangzuo Building, Yi 97 Xuanwumen Xidajie, Beijing Xicheng District 100031 China. (86)(10)62252175. **Fax:** (86)(10)62252175. **E-mail:** hpa@worldfpa.org; link@hpa.org.cn. **Website:** www.worldfpa.org. **Contact:** organizing committee HPA. Cost: free. Biennial contest. Open to all skill levels. See website for more information and entry forms.

INFOCUS JURIED EXHIBITION

Palm Beach Photographic Centre, 415 Clematis St., West Palm Beach FL 33401. (561)253-2600. **E-mail:** info@workshop.org. **Website:** www.workshop.org. **Contact:** Fatima NeJame, CEO. Cost: $20/image, up to 5 images. Annual photography contest. Awards: Best of Show: $950. 2 merit awards: free tuition for a Fotofusion passport or a master photography workshop of your choice. Open to members of the Palm Beach Photographic Center. Interested parties can obtain an individual membership for $95. The Centre invites photographers working in all mediums and styles to participate. Experimental and mixed techniques are welcome. Photographers should call or visit website for more information.

KENTUCKY ARCHAEOLOGY MONTH POSTER CONTEST

109-A W. Poplar St., Elizabethtown KY 42701. (270)855-9780. **E-mail:** christywpritchard@gmail.com. **Website:** www.kyopa-org.org/kentucky_archaeology_month.html. **Contact:** Christy Pritchard, chair. Estab. 2014. Winning artwork and design will be used as the official poster for the first annual Kentucky Archaeology Month, "Celebrating Kentucky Archaeology." Calling all artists and graphic designers to submit poster designs that reflect their interpretation of Kentucky's rich heritage. The KAM steering committee will select 3 finalists from the designs submitted. Finalists will be e-mailed to the KyOPA membership and the winner will be selected by a membership vote. The official Kentucky Archaeology Month poster will be distributed to the Governor's office, members of Kentucky House, Kentucky Senate, as well as Kentucky libraries, schools, and various parks within the state. See website for submission deadline. Artists should submit proposed artwork in electronic, camera-ready format. Submitting artists must also complete the entry form. Sub-

mission must be original artwork. Submissions must be 2-dimensional artwork. No syndicated, copyrighted or clip art images may be submitted. Reproducibility will be a factor in the committee's decision. High contrast and bright colors are recommended, the estimated size of the poster will be 18×24". Selected artwork for the poster will be artistic, positive in approach, and informative for use as a teaching tool. Selected artwork for the poster will commemorate Kentucky Archaeology Month celebrating the long history of archaeology and heritage studies in Kentucky. Selected artwork for the poster will have broad appeal to Kentuckians, educators, students, those considering Kentucky for travel and vacation, historians, artists and the general public. A committee will select 3 finalists from the artwork submitted. The selection committee will consist of members from KyOPA, the Kentucky Heritage Council, and the Office of State Archaeology. Artwork will be judged based upon: quality of artwork, creativity and originality of artwork, positive and thematically appropriate artwork, reproducibility. The winner will be selected by electronic vote, via e-mail, from the KyOPA membership. The Kentucky Organization of Professional Archaeologists will retain rights of ownership for all final artwork commissioned via this solicitation. The committee reserves the right to use the artwork for additional purposes, such as websites and print materials.

LAKE SUPERIOR MAGAZINE PHOTO CONTEST

P.O. Box 16417, Duluth MN 55816-0417. (888)244-5253; (218)722-5002. **Fax:** (218)722-4096. **E-mail:** lsmphotosubmission@lakesuperior.com. **Website:** www.lakesuperior.com. **Contact:** Konnie LeMay, editor. Annual contest. Photos must be taken in the Lake Superior region and should be labeled for categories: lake/landscapes, nature, people/humor, artsy/altered, maritime. Accepts up to 10 b&w and color digital images. Images can be submitted online only. Grand Prize: $200 prize package, plus a 1-year subscription to *Lake Superior Magazine* and a Lake Superior wall calendar. Other prizes include subscriptions and calendars; all prize winners, including honorable mentions and finalists, receive a Certificate of Honor. See website for more information.

LARSON GALLERY JURIED BIENNUAL PHOTOGRAPHY EXHIBITION

Yakima Valley Community College, P.O. Box 22520, Yakima WA 98907. (509)574-4875. **E-mail:** gallery@yvcc.

edu. **Website:** www.larsongallery.org. **Contact:** Denise Olsen, assistant director. Cost: $20/entry (limit 4 entries). National juried competition. Awards: Approximately $3,000 in prize money. Held odd years in April. First jurying held in February. Photographers should write, fax, e-mail or visit the website for prospectus.

LOS ANGELES CENTER FOR DIGITAL JURIED COMPETITION

1515 Wilcox Ave., Los Angeles CA 90028. (323)646-9427. **E-mail:** info@lacphoto.org. **Website:** www.lacphoto.org. The Los Angeles Center of Photography (LACP) is dedicated to supporting photographers and the phtographic arts. LACP provides high-caliber classes, local and travel workshops, exhibitions, screenings, lectures, and community outreach efforts, including grants, need-based scholarships, and focused programming for youth and low-income families.

LOVE UNLIMITED FILM FESTIVAL & ART EXHIBITION

100 Cooper Point Rd., Suite 140-136, Olympia WA 98502. **E-mail:** entries1@loveanddiversity.org; volunteers@loveanddiversity.org. **Website:** www.communitygardenlove.org. **Contact:** submissions administrator. Accepts art (ceramics, drawings, fiber, functional, furniture, jewelry, metal, painting, printmaking, digital or graphics, mixed media 2D, mixed media 3D, sculpture, watercolor, wood, other or beyond categorization (specify), photography, music, writing, photos and all types of designs, as well as film and scripts. Accepts poetry, hip-hop, spoken word and zine excerpts, autobiography/memoir, children's, fiction, horror, humor, journalism, mystery, nature, novels, short stories, nonfiction, poetry, romance, science fiction/fantasy, screenwriting, travel, young adult and other topic areas. We accept writing in all these topic areas provided these topic areas are directly, indirectly, literally or symbolically related to love. Awards: over $30,000 in cash and prizes and 120 given out during a red carpet gala event in Los Angeles and in Austin TX. Photos and videos of past events are online. Open to all skill levels. Deadlines: October for art, November for all other categories. See website for more information.

THE MACQUARIE PHOTOGRAPHY PRIZE

P.O. Box 4689, Dubbo NSW 2830, Australia. (61) 0412638210. **E-mail:** mike.coward@australianartsales.com.au. **Website:** www.australianartsales.com.

au/MacquariePrize/Macquariephotographyprize. html. **Contact:** Mike Coward, owner/director. Cost: $8AUD per photograph. The Macquarie Prize is a global photography competition open to anyone from any country. The aim of the competition is to capture the world's best images. Each year the contest is divided into 4 categories and there is no limit to the number of photographs one person can enter. The winner is decided by public voting of 100 finalists both at exhibitions and online. The 100 finalists will be printed and exhibited in South East Australia. $20,000AUD in prizes. Open to all skill levels. Deadline: August. Contestants should see website for more information.

MERCURY EXCELLENCE AWARDS

500 Executive Blvd., Ossining-on-Hudson NY 10562. (914)923-9400. **Fax:** (914)923-9484. **E-mail:** info@ mercommawards.com. **Website:** www.mercomm awards.com. **Contact:** Ms. Reni L. Witt, president. Cost: $280-345/entry (depending on category). Annual contest. The purpose of the contest is to honor outstanding achievement in public relations and corporate communications. Major category for photography, including ads, brochures, magazines, etc. "Best of Show" receives a personalized trophy. Grand Award winners receive award plaques (personalized). Gold, silver, bronze, and honors receive a personalized award certificate. All nominators receive complete judge score sheets and evaluation comments. Deadline: mid-November. Please write, call, or e-mail for more information.

MICHIGAN ANNUAL XLIII (ART COMPETITION & EXHIBITION)

125 Macomb Place, Mt. Clemons MI 48043. (586)469-8666. **Fax:** (586)469-4529. **E-mail:** exhibitions@ theartcenter.org; sahazzard@theartcenter.org. **Website:** www.theartcenter.org. **Contact:** Stephanie Szmiot, exhibition manager. Cost: $35.00 per artist for up to two entries to be juried. Annual statewide juried art competition. Open to resident Michigan artists ages 18 and older. No size or media restrictions. Featuring new guest juror each year. Up to 50 selected artworks are on display for about 4 weeks in main gallery. Prize/Award: 1st place $1,000, 2nd place $600, 3rd place $400, in addition to 5 honorable mention awards. Deadline for submissions: late December-early January. Contestants should write, send SASE, call, e-mail, and see website for more information.

THE MOBIUS AWARDS FOR ADVERTISING

713 S. Pacific Coast Hwy., Suite B, Redondo Beach CA 90277-4233. (310)540-0959. **Fax:** (310)316-8905. **E-mail:** KristenSzabo@mobiusawards.com; mobius info@mobiusawards.com. **Website:** www.mobius awards.com. **Contact:** Kristen Szabo, manager entrant relations & operations. Annual international awards competition founded in 1971 for TV, cinema/in-flight and radio commercials, print, outdoor, new media, direct, logo/trademark, online, mixed media campaigns and package design. Student and spec work welcome. Deadline: October 1. Late entries accepted. "Entries are judged by an international jury on their effectiveness and creativity. Mobius Awards reflect the most current trends in the advertising industry by updating the competition regularly, such as adding new media types and categories. We are dedicated to consistently providing a fair competition with integrity."

MOTION IN ART AND ART IN MOTION

Art League of Long Island, 107 E. Deer Park Rd., Dix Hills NY 11746. (631)462-5400. **E-mail:** info@ artlagueli.org. **Website:** www.artlagueli.org. Sue Peragallo. Estab. 1955. Cost: 2 images, $40; $5 each additional image up to 3; total maximum 5 images. Non-members: First 2 images $50; $5 each additional image up to 3; total maximum 5 images. Open to artists residing in Suffolk, Nassau, Brooklyn, and Queens. 2D and 3D work in any medium may be submitted, including photography and fine craft. Prize/award: $500 awards of excellence and honorable mentions of 1 year memberships in ALLI will be given at the discretion of the judge. Deadline for submissions: late February. Contestants should call or see website for more information. The Art League of Long Island is a not-for-profit organization dedicated to broad-based visual arts education, providing a forum and showcase for artists of all ages and ability levels. Since its inception in 1955, the mission has focused on enhancing Long Island's cultural life by promoting the appreciation, practice, and enjoyment of the visual arts. Collaborative events and outreach programs spread the joy of creativity among every segment of the population. An art work may incorporate actual motion; that is, the artwork itself moves in some way. Kinetic art is live movement that displays actual motion when

we view it. Or it may incorporate the illusion of, or implied movement. In a non-moving image, the artist captures the sense of implied movement through the attributes present in the image. Movement can be suggested visually in a variety of ways: through the use of diagonal, gestural, and directional lines; repetition; position and size of objects; the position or implied eyeline of a figure, a symbolic representation of movement. For more explanations and examples of motion in art go to www.artsology.com/motion_in_art.php and www.sophia.org/tutorials/elements-of-artmovement-and-time. Marina Press, Associate Director, Bernarducci Meisel Gallery, NYC.

MYRON THE CAMERA BUG & THE SHUTTERBUGS FAMILY

E-mail: cambug8480@aol.com. **Website:** www.shutterbugstv.com. **Contact:** Len Friedman, director. Open to all photography students, educators, and snapshooters. Photographers should e-mail for details or questions.

NABA ARTISTS CONTEST

4 Delaware Rd., Morristown NJ 07960. **Website:** www.naba.org. Contest held annually. Photography contest held in 2016 and every 2nd year. Artist Contest held in 2017 and every 2nd year.See website. Open to all skill levels. Contestants should see website for more information. See website.

NEW YORK STATE FAIR PHOTOGRAPHY COMPETITION AND SHOW

581 State Fair Blvd., Syracuse NY 13209. (315)487-7711, ext. 1337. **Website:** www.nysfair.org/competitions. You may enter by downloading and mailing in the entry form, or directly online (any competition marked "N/A" is not available for online entry). All entry forms and fees must be received in person at the entry department office at the State Fairgrounds by 4:30 p.m. or online by midnight on the specified competition deadline date. See website for complete details, and to enter.

THE PARIS PHOTO-APERTURE FOUNDATION PHOTOBOOK AWARDS

547 W. 27th St., 4th Floor, New York NY 10001. (212)505-5555. **Fax:** (212)979-7759. **E-mail:** bookawards@aperture.org. **Website:** www.aperture.org/photobookawards. **Contact:** Katie Clifford. Cost: First PhotoBook, $30/book; PhotoBook of the Year, $60/book; Photography Catalouge of the Year, $60/book. Annual photography contest. The purpose of this competition is to celebrate the book's contribution to the evolving narrative of photography. Awards: First PhotoBook $10,000, book included in PhotoBook Review and exhibition; PhotoBook of the Year- book included in PhotoBook Review, exhibition and the Catalouge category. Open to all skill levels. See website for deadline and for more information.

PERKINS CENTER FOR THE ARTS JURIED PHOTOGRAPHY EXHIBITION

395 Kings Hwy., Moorestown NJ 08057. (856)235-6488 or (800)387-5226. **Fax:** (856)235-6624. **E-mail:** create@perkinscenter.org; pcarroll@perkinscenter.org. **Website:** www.perkinscenter.org; www.perkinsarts.org/artist-opportunities-2. Cost: $10/entry; up to 3 entries. Regional juried photography exhibition. Works from the exhibition are considered for inclusion in the permanent collection of the Philadelphia Museum of Art and the Woodmere Art Museum. Past jurors include Merry Foresta, former curator of photography at the Smithsonian American Art Museum; Katherine Ware, curator of photographs at the Philadelphia Museum of Art; and photographers Emmett Gowin, Ruth Thorne-Thomsen, Matthew Pillsbury, and Vik Muniz. All work must be framed with wiring in back and hand-delivered to Perkins Center. Prospectus must be downloaded from the Perkins site. Photographers should call, e-mail, or see website for more information.

PHOTOGRAPHY NOW

Center for Photography at Woodstock, 59 Tinker St., Woodstock NY 12498. (845)679-9957. **Fax:** (845)679-6337. **E-mail:** info@cpw.org. **Website:** www.cpw.org. **Contact:** Ariel Shanberg, executive director. Annual contest for exhibitions. Juried annually by renowned photographers, critics, museum and gallery curators. Deadline: January. General submission is ongoing. Photographers must call or write for guidelines.

THE PHOTO REVIEW ANNUAL PHOTOGRAPHY COMPETITION

340 E. Maple Ave., Suite 200, Langhorne PA 19047. (215)891-0214. **E-mail:** info@photoreview.org. **Website:** www.photoreview.org. **Contact:** Stephen Perloff, editor. Estab. 1976. Cost: $35 for up to 3 images; $8 each for each additional image. International annual contest. All types of photographs are eligible—b&w, color, nonsilver, computer-manipulated, etc. Submit images to smarterentry.com. Awards include an Olympus camera, SilverFast software from LaserSoft

Imaging, a 24×50" roll of Museo Silver Rag, a 20×24" silver gelatin fiber print from Digital Silver Imaging, camera bags, etc. All winners reproduced in the competition issue of *Photo Review* magazine and online, and prizewinners exhibited at photography gallery of The University of Arts/Philadelphia. Open to all skill levels. Deadline: May 31. Photographers should see www.photoreview.org for more information.

PHOTOSPIVA

George A. Spiva Center for the Arts, 222 W. Third St., Joplin MO 64801. (417)623-0183. **Fax:** (417)623-0183. **E-mail:** spiva@spivaarts.org. **Website:** www.spivaarts.org; www.photospiva.org. **Contact:** Jacqueline O'Dell, executive director. Estab. 1977. Annual national fine art photography competition. Awards: $1,000 cash for 1st place. Open to all photographers in the US and its territories; any photographic process welcome. Enter online. See website for updates on deadlines and exhibition dates. "Spiva is an independent community arts center that traces its roots to a group of artists who formed the Ozark Artists Guild in 1948. Businessman George A. Spiva, who believed opportunities in the arts should be available to all, helped the Guild procure its first home. Spiva serves a large geographic area that stretches from southwest Missouri into southeast Kansas, northeast Oklahoma, and northwest Arkansas. Its mission is to promote the arts, to nurture creative expression, and to stimulate and educate diverse audiences within the four-state region." Jurors listed on website.

Co-Founder Jim Mueller stated, "We have intentionally avoided any categorization of either photographers or their work in setting forth the criteria for this competitive." PhotoSpiva welcomes any photographic process as long as it is original artwork and has not been previously exhibited at Spiva Center for the Arts. This philosophy has created an unbiased forum for exhibiting and educating photographers. The PhotoSpiva prospectus, promotional materials and exhibition brochures are distributed to professional photographers, emerging artists, educators, students, and amateur photography enthusiasts throughout the United States.

Images need to be JPEG formatted and in RGB color mode. Sized images not required, but a good guideline is to make either the width or the height about 1600 pixels and maintain the aspect ratio.

PICTURES OF THE YEAR INTERNATIONAL

University of Missouri, 315 Reynolds Journalism Institute, Columbia MO 65211. (573)884-7351; (573)884-2188. **E-mail:** info@poyi.org. **Website:** www.poyi.org. **Contact:** Rick Shaw. Cost: $50/entrant. Annual contest to reward and recognize excellence in photojournalism, sponsored by the Missouri School of Journalism and the Donald W. Reynolds Journalism Institute. Over $20,000 in cash and product awards. Open to all skill levels. January deadline. Photographers should write, call, e-mail, or see website for more information.

PROFESSIONAL WOMEN PHOTOGRAPHERS INTERNATIONAL WOMEN'S CALL FOR ENTRY

119 W. 72nd St., #223, New York NY 10023. (212)410-4388. **E-mail:** open.calls@pwponline.org; pwp@pwponline.org. **Website:** www.pwponline.org. **Contact:** Terry Berenson, development director. Contest held annually. "Professional Women Photographers (PWP) helps fulfill its mission of advancing women in photography by hosting international Calls for Entry open to all women photographers around the world." Awards: "1st Prize: One photographer will receive $600 and her selected image will appear in the Spring/Summer issue of *Imprints* magazine. Her image will be exhibited in the Soho Photo Gallery show and the online exhibition. 2nd Prize: One photographer will receive $500 and her image will appear in *Imprints* Spring/Summer issue. Her image will be exhibited in the SohoPhoto Gallery show and the online exhibition. 3rd Prize: One photographer will receive $400 and her image will appear in the Spring/Summer issue of *Imprints*. Her image will be exhibited in the SohoPhoto Gallery show and the online exhibition." Deadlines vary; see website for details.

PROJECT LAUNCH

P.O. Box 2483, Santa Fe NM 87504. (505)984-8353. **Website:** www.visitcenter.org. Annual contest. Project Launch honors committed photographers working on documentary projects and fine-art series. Three jurors reach a consensus on the 1st prize and 10-25 honorable mentions. Each individual juror also selects a project to receive 1 of the 3 Juror's Choice Awards. Prizes include $5,000, 2 exhibitions and reception during Review Santa Fe, a year-long Photographer's Showcase at Photoeye.com, publication in

Lenscratch, workshop tuition vouchers, and an online exhibition at VisitCenter.org. Photographers should see website for more information.

RHODE ISLAND STATE COUNCIL ON THE ARTS FELLOWSHIPS

One Capitol Hill, 3rd Floor, Providence RI 02908. (401)222-3880. **Fax:** (401)222-3018. **Website:** www. arts.ri.gov/grants/guidelines/fellow.php. Rhode Island residents only. Cost: free. Annual contest "to encourage the creative development of Rhode Island artists by enabling them to set aside time to pursue their work and achieve specific career goals." Awards $5,000 fellowship; $1,000 merit award. Open to advanced photographers. Deadline: April 1. Photographers should go to www.arts.ri.gov/grants/guidelines/fellow.php for more information.

✖ THE MANUEL RIVERA-ORTIZ FOUNDATION FOR DOCUMENTARY PHOTOGRAPHY & FILM

1110 Park Ave., Rochester NY 14610-1729. (917)720-5769. **Fax:** (585)256-6462. **E-mail:** submissions@mrofoundation.org. **Website:** www.mrofoundation.org. **Contact:** competition coordinator, annual contest. Estab. 2009. "Our mission is to support underrepresented photographers in communities throughout the developing and developed world. We encourage emerging and established photographers and filmmakers in the fields of photojournalism/photo reportage and documentary film to submit their work on topics such as the plight of the poor, the forgotten, and the disenfranchised. Each year, shortlisted entries in two categories (selected from international submissions) in the genres of 'Documentary-Still Photography' and 'Documentary Short-Short Film,' will vie for our grant. Call is open to all skill levels. For more information, please see our website. There are no entry fees." A non-profit private operating foundation headquartered in Rochester, NY, the foundation was established in 2009 by documentary photographer Manuel Rivera-Ortiz to support underrepresented photographers and filmmakers from less developed countries with grants, awards, exhibitions, and educational programs. Annual: The goal of our foundation is to support new and established photographers and filmmakers in their quest to document the plight of all people around the world by providing a voice to the voiceless and to those most disadvantaged among

us. Photographers working in traditional, digital, and video photography are encouraged to participate. Entry guidelines can be found online. We encourage entries covering topics ranging from war and famine to disease and the landless—humanitarian projects covering basic human needs in all corners of the world. This foundation was created by documentary photographer Manuel Rivera-Ortiz to provide financial support, especially to photographers and filmmakers whose own lives are traditionally the subject of such documentary work. "For updated deadlines and guidelines, please see our website." Participants will compete for a grant in photography and a grant prize in documentary filmmaking of $5,000 each. The grant is to begin and complete or complete a documentary still photo project. The grant prize is for an already completed "Short-Short" documentary film.

☎ SAN DIEGO COUNTY FAIR ANNUAL EXHIBITION OF PHOTOGRAPHY

2260 Jimmy Durante Blvd., Del Mar CA 92014. (858)792-4207. **E-mail:** entry@sdfair.com; photo@sdfair.com. **Website:** www.sdfair.com. **Contact:** Entry office. Sponsor: San Diego County Fair (22nd District Agricultural Association). Annual event for still photos/prints. This is a juried competition open to individual photographers. Entry information is posted on the website as it becomes available in February and March. Pre-registration deadline: April/May. Access the dates and specifications for entry on website. Entry form can be submitted online.International contest, must be 18 or older to enter April 15. Over 35,000 in prizes. Judged by a team of professional Photographers and college level Photography instructors.

THE SHOW OF HEADS

SlowArt Productions, 123 Warren St., Hudson NY 12534. (518)828-2343. **E-mail:** slowart@aol.com. **Website:** www.slowart.com. **Contact:** Tim Slowinski, director. Cost: $35. Annual contest. "This contest is to select artists for exhibition in 'The Show of Heads' at Limner Gallery. The show features work based on the portrayal and interpretation of the human head." Open to all skill levels. Awards: exhibition at Limner Gallery; 3 artists receive publication in *Direct Art Magazine*: 1 artist receives 2 full pages; 2 artists receive 1 page. Value of awards: $2,200. Deadline: August 31, annually. E-mail or see website for more information.

○ SPRING PHOTOGRAPHY CONTEST

Serbin Communications, 813 Reddick St., Santa Barbara CA 93103. (805)963-0439 or (800)876-6425. **Fax:** (805)965-0496. **E-mail:** julie@serbin.com; admin@ serbin.com. **Website:** www.pfmagazine.com. Annual amateur contest, runs January thru mid-May. Sponsored by *Photographer's Forum Magazine*. Winners and finalists have their photos published in the hardcover book, *Best of Photography*. Entry fee: $4.95-5.95 per photo. See website for entry form.

○ TALLAHASSEE INTERNATIONAL JURIED COMPETITION

530 W. Call St., Rm. 250FAB, Tallahassee FL 32306-1140. (850)644-3906. **Fax:** (850)644-7229. **E-mail:** tallahasseeinternational@fsu.edu. **Website:** www. mofa.cfa.fsu.edu/participate/tallahassee-internat ional. **Contact:** Jean D. Young, coordinator. Cost: $20/2 images. Annual art contest. Artists worldwide, 18+ are eligible. All media and subject matter eligible for consideration. Juried by panel of FSU College of Fine Arts faculty. One entry/person. Awards: 1st-$1,000; 2nd- $500. Color catalog is produced. Open to all skill levels. Photographers should e-mail or visit website for more information.

○ TAYLOR COUNTY PHOTOGRAPHY CLUB MEMORIAL DAY CONTEST

P.O. Box 613, Grafton WV 26354-0613. (304)265-5405. **E-mail:** bowtie1008@comcast.net. **Website:** tc photoclub.webplus.net. **Contact:** Don Sapp, club secretary. Cost: $4/print (maximum of 10). Annual juried contest (nationally judged) held in observance of Memorial Day in Grafton WV. Color and b&w, all subject matter except nudes. All prints must be mounted or matted, with a minimum overall size of 8×10" and maximum overall size of 16×20". No framed prints or slides. No signed prints or mats. All prints must be identified on the back as follows: name, address, phone number, title, and entry number of print (e.g., 1 of 6). Entries need to have hangers on the back for display purposes. All entries must be delivered in a reusable container. Entrant's name, address, and number of prints must appear on the outside of the container. Open to amateur photographers only. Six award categories. E-mail hsw123@comcast.net to receive an entry form.

○○ UNLIMITED EDITIONS INTERNATIONAL JURIED PHOTOGRAPHY COMPETITIONS

198 Brittany Place Dr., Suite V, Hendersonville NC 28792. (828)489-9609. **E-mail:** gregoryleng@aol.com; ultdeditionsIntl@aol.com. **Contact:** Gregory Hugh Leng, president/owner. Sponsors juried photography competitions several times yearly offering cash, award certificates, and prizes. Photography accepted from amateurs and professionals. Open to all skill levels and ages. Prizes awarded in different categories or divisions such as commercial, portraiture, journalism, landscape, digital imaging, and retouching. "We accept formats in print film, transparencies, and digital images. Black and white, color, and digital imaging CDs or DVDs may be submitted for consideration. Prints and large transparencies may be in mats, no frames. All entries must be delivered in a reusable container with prepaid postage to insure photography is returned. Unlimited Editions International also offers the unique opportunity to purchase photography from those photographers who wish to sell their work. All images submitted in competition remain the property of the photographer/entrants unless an offer to purchase their work is accepted by the photographer. All photographers must send SASE (with $1.44 postage) for entry forms, contest dates, and detailed information on how to participate in our International Juried Photography Competitions."

YOUR BEST SHOT

Website: www.popphoto.com. Monthly contest. "Every month, we choose 3 images submitted by our readers to feature in the pages of *Popular Photography*. There are no category restrictions, we just want to see your most creative and well-done work. A gallery of the judges' picks will appear online and the overall winner will be revealed in an upcoming issue of the magazine." Awards/prizes: 1st place $300; 2nd place $200; 3rd place $100. See website for complete details and submission deadlines.

PHOTO REPRESENTATIVES

//

Many photographers are good at promoting themselves and seeking out new clients, and they actually enjoy that part of the business. Other photographers are not comfortable promoting themselves and would rather dedicate their time and energy solely to producing their photographs. Regardless of which camp you're in, you may need a photo rep.

Finding the rep who is right for you is vitally important. Think of your relationship with a rep as a partnership. Your goals should mesh. Treat your search for a rep much as you would your search for a client. Try to understand the rep's business, who they already represent, etc., before you approach them. Show you've done your homework.

When you sign with a photo rep, you basically hire someone to get your portfolio in front of art directors, make cold calls in search of new clients, and develop promotional ideas to market your talents. The main goal is to find assignment work for you with corporations, advertising firms, or design studios. And, unlike stock agencies or galleries, a photo rep is interested in marketing your talents rather than your images.

Most reps charge a 20- to 30-percent commission. They handle more than one photographer at a time, usually making certain that each shooter specializes in a different area. For example, a rep may have contracts to promote three different photographers—one who handles product shots, another who shoots interiors, and a third who photographs food.

DO YOU NEED A REP?

Before you decide to seek out a photo representative, consider these questions:

- Do you already have enough work, but want to expand your client base?
- Are you motivated to maximize your profits? Remember that a rep is interested

in working with photographers who can do what is necessary to expand their businesses.

- Do you have a tightly edited portfolio with pieces showing the kind of work you want to do?
- Are you willing to do what it takes to help the rep promote you, including having a budget to help pay for self-promotional materials?
- Do you have a clear idea of where you want your career to go, but need assistance in getting there?
- Do you have a specialty or a unique style that makes you stand out?

If you answered yes to most of these questions, perhaps you would profit from the expertise of a rep. If you feel you are not ready for a rep or that you don't need one, but you still want some help, you might consider a consultation with an expert in marketing and/or self-promotion.

As you search for a rep, there are numerous points to consider. First, how established is the rep you plan to approach? Established reps have an edge over newcomers in that they know the territory. They've built up contacts in ad agencies, magazines, and elsewhere. This is essential since most art directors and picture editors do not stay in their positions for long periods of time. Therefore, established reps will have an easier time helping you penetrate new markets.

If you decide to go with a new rep, consider paying an advance against commission in order to help the rep financially during an equitable trial period. Usually it takes a year to see returns on portfolio reviews and other marketing efforts, and a rep who is relying on income from sales might go hungry if he doesn't have a base income from which to live.

Whatever you agree upon, always have a written contract. Handshake deals won't cut it. You must know the tasks that each of you is required to complete, and having your roles discussed in a contract will guarantee there are no misunderstandings. For example, spell out in your contract what happens with clients that you had before hiring the rep. Most photographers refuse to pay commissions for these "house" accounts, unless the rep handles them completely and continues to bring in new clients.

Also, it's likely that some costs, such as promotional fees, will be shared. For example, photographers often pay 75 percent of any advertising fees (such as sourcebook ads and direct mail pieces).

MARIANNE CAMPBELL ASSOCIATES

136 Bella Vista Ave., Belvedere CA 94920. (415)433-0353. **E-mail:** marianne@mariannecampbell.com; quinci@mariannecampbell.com. **Website:** www.mariannecampbell.com. **Contact:** Marianne Campbell or Quinci Kelly (149 Madison Ave.,#1102, New York NY 10016). Estab. 1989. Commercial photography representative. Member of APA, SPAR, Western Art Directors Club. Represents 7 photographers. Markets include advertising agencies, corporations/clients direct, design firms, editorial/magazines.

HANDLES Photography.

TERMS Negotiated individually with each photographer.

CASEY

20 W. 22nd St., #1605, New York NY 10010. (212)858-3757; (212)929-3757. **E-mail:** info@wearecasey.com. **Website:** www.wearecasey.com. Represents photographers. Agency specializes in representing commercial photographers. Markets include advertising agencies, corporate/client direct, design firms, editorial/magazines, direct mail firms.

HANDLES Photography.

HOW TO CONTACT Send brochure, promo cards. Responds only if interested. Portfolios may be dropped off Monday through Friday. To show portfolio, photographer should follow up with call. Rep will contact photographer for portfolio review if interested.

TIPS Finds new talent through submission, recommendations from other artists.

RANDY COLE REPRESENTS LLC

153 W. 27th St., Suite 200, New York NY 10001. (212)760-1212. **E-mail:** randy@randycole.com. **Website:** www.randycole.com. Estab. 1989. Commercial photography, video, and CGI representative. Member of SPAR. Represents 11 photographers and CGI artists. Staff includes an assistant. Markets include advertising agencies, corporate clients, design firms, magazine, newspaper, and book publishers as well as entertainment and music companies.

HANDLES Photography.

TERMS Agent receives commission on the creative fees, dependent upon specific negotiation. Advertises in *At Edge, Archive,* and *Le Book* as well as online creative directories. Social media includes Facebook, LinkedIn, and Twitter. Randy Cole Represents is certified by Women's Business Enterprise National Council as a woman-owned, -operated, and -controlled business meeting the criteria of diversity supplies status.

HOW TO CONTACT To contact the agency about representation, please send an e-mail or promo piece and follow up with a call.

TIPS Finds new talent through submissions and referrals.

MICHAEL GINSBURG & ASSOCIATES INC.

520 White Plains Rd., Suite 500, Tarrytown NY 10591. (212)369-3594. **E-mail:** mg@michaelginsburg.com. **Website:** www.michaelginsburg.com. **Contact:** Michael Ginsburg. Estab. 1978. Commercial photography representative. Represents 9 photographers. Agency specializes in advertising and editorial photographers. Markets include advertising agencies, corporations/clients direct, design firms, editorial/magazines, sales/promotion firms.

HANDLES Photography.

TERMS Rep receives 30% commission. Charges for messenger costs, FedEx expenses. Exclusive area representation required. Advertising costs are paid 100% by talent. For promotional purposes, talent must provide a minimum of 5 portfolios—direct mail pieces 2 times per year—and at least 1 sourcebook per year. Advertises in *Workbook*, sourcebooks, and online sourcebooks.

HOW TO CONTACT Send query letter, direct mail flier/brochure, or e-mail. Responds only if interested within 2 weeks. After initial contact, call for appointment to show portfolio of tearsheets, slides, photographs.

TIPS Obtains new talent through personal referrals and solicitation.

CAROL GUENZI AGENTS, INC. DBA ARTAGENT.COM

865 Delaware St., Denver CO 80204. (303)820-2599 or (800)417-5120. **Fax:** (303)820-2598. **E-mail:** carol@artagent.com; art@artagent.com. **Website:** www.artagent.com. **Contact:** Carol Guenzi, president. Estab. 1984. Commercial and advertising photography, illustration, new media, video film/animation representative. Member of Art Directors Club of Denver, AIGA, and ASMP. Represents 15 illustrators, 8 photographers, 6 digital designers, 12 film/video production companies. Agency specializes

in a "worldwide selection of talent in all areas of visual communications." Markets include advertising agencies, corporations/clients direct, design firms, editorial/magazine, paper products/greeting cards, sales/promotions firms.

HANDLES Illustration, photography, digital media, film, and animation. Looking for unique styles and applications and digital imaging.

TERMS Rep receives 25-30% commission. Exclusive area representation required. Advertising costs are split: 70-75% paid by talent; 25-30% paid by representative. For promotional purposes, talent must provide "promotional material after 6 months, some restrictions on portfolios." Advertises in *Directory of Illustration* and *Workbook*.

HOW TO CONTACT E-mail JPEGs or send direct mail piece, tearsheets. Responds in 2-3 weeks, only if interested. After initial contact, call or e-mail for appointment or to drop off or ship materials for review. Portfolio should include tearsheets, prints, samples, and a list of current clients.

TIPS Obtains new talent through solicitation, art directors' referrals, and active pursuit by individual. "Show your strongest style and have at least 12 samples of that style before introducing all your capabilities. Be prepared to add additional work to your portfolio to help round out your style. We do a large percentage of computer manipulation and accessing on network. All our portfolios are both electronic and prints."

CRISTOPHER LAPP PHOTOGRAPHY

1211 Sunset Plaza Dr., Suite 413, Los Angeles CA 90069. (310)612-0040. **E-mail:** cristopherlapp.photo@gmail.com. **Website:** www.cristopherlapp.com. **Contact:** Cristopher Lapp. Estab. 1994. Specializes in fine art prints, hand-pulled originals, limited edition, monoprints, monotypes, offset reproduction, unlimited edition, posters.

HANDLES Decorative art, fashionable art, commercial and designer marketing. Clients include: Posner Fine Art, Gilanyi Inc., Jordan Designs.

TERMS Keeps samples on file.

HOW TO CONTACT Send an e-mail inquiry.

LEE + LOU PRODUCTIONS INC.

12 Juniper Creek Blvd., Pinehurst NC 28374. (310)480-5475. **E-mail:** leelou@earthlink.net. **Website:** www.leelou.com. **Contact:** Lee Pisarski. Estab. 1981. Commercial illustration and photography representative, digital and traditional photo retouching. Represents 2 retouchers, 5 photographers, 5 film directors, 2 visual effects companies, 1 CGI company. Specializes in automotive. Markets include advertising agencies.

HANDLES Photography, commercial film, CGI, visual effects.

TERMS Rep receives 25% commission. Charges for shipping, entertainment. Exclusive area representation required. Advertising costs are paid by talent. For promotional purposes, talent must provide direct mail advertising material. Advertises in *Creative Black Book, Workbook,* and *Single Image, Shoot, Boards.*

HOW TO CONTACT Send direct mail flyer/brochure, tearsheets. Responds in 1 week. After initial contact, call for appointment to show portfolio of photographs.

TIPS Obtains new talent through recommendations from others, some solicitation.

NORMAN MASLOV AGENT INTERNATIONALE

3200 Genesee St., Seattle WA 98118. (415)641-4376. **E-mail:** maslov@maslov.com. **Website:** maslov.com. Estab. 1986. Member of APA. Represents 8 photographers. Markets include advertising agencies, corporations/clients direct, design firms, editorial/magazines, paper products/greeting cards, publishing/books, private collections.

HANDLES Photography. Looking for "original work not derivative of other artists. Artist must have developed style."

TERMS Rep receives 30% commission. Exclusive US national representation required. Advertising costs split varies. For promotional purposes, talent must provide 3-4 direct mail pieces/year. Advertises in *Archive, Workbook,* and *At Edge.*

HOW TO CONTACT Send query letter, direct mail flier/brochure, tearsheets. Do not send original work. Responds in 2-3 weeks, only if interested. After initial contact, call to schedule an appointment, or drop off or mail materials for review. Individual and group consulting available in person or via phone or website.

TIPS Obtains new talent through suggestions from art buyers and recommendations from designers, art directors, other agents, sourcebooks, and industry magazines and social networks. "We prefer to follow our own leads rather than receive unsolicited promotions and inquiries. It's best to have represented your-

self for several years to know your strengths and be realistic about your marketplace. The same is true of having experience with direct mail pieces, developing client lists, and having a system of follow up. We want our talent to have experience with all this so they can properly value our contribution to their growth and success—otherwise that 30% becomes a burden and point of resentment. Enter your best work into competitions such as *Communication Arts* and *Graphis* photo annuals. Create a distinctive promotion mailer if your concepts and executions are strong."

JUDITH MCGRATH

P.O. Box 133, 32W040 Army Trail Rd., Wayne IL 60184. (312)945-8450. **E-mail:** judy@judymcgrath. net. **Website:** www.judymcgrath.net. Estab. 1980. Commercial photography/videography representative. Represents photographers and videographers. Markets include advertising agencies, corporate/client direct, design firms, editorial/magazines, paper products/greeting cards, publishing/books, direct mail firms.

HANDLES Photography, videography.

TERMS Rep receives 28% commission. Exclusive area representation required. Advertising costs paid by talent. Advertises in *Workbook*.

HOW TO CONTACT Send query letter, bio, tearsheets, photocopies. Rep will contact artist for portfolio review if interested.

MUNRO CAMPAGNA ARTISTS REPRESENTATIVES

630 N. State St., #2109, Chicago IL 60654. (312)335-8925. **E-mail:** steve@munrocampagna.com. **Website:** www.munrocampagna.com. **Contact:** Steve Munro, president. Estab. 1987. Commercial photography and illustration representative. Member of SPAR, CAR (Chicago Artist Representatives). Represents 1 photographer, 30 illustrators. Markets include advertising agencies, corporations/clients direct, design firms, publishing/books.

HANDLES Illustration, photography.

TERMS Rep receives 30% commission. Exclusive national representation required. Advertising costs are paid by talent. For promotional purposes, talent must provide 2 portfolios, leave-behinds, several promos. Advertises in *Workbook*, other sourcebooks.

HOW TO CONTACT Send query letter, bio, tearsheets, SASE. Responds within 2 weeks, only if

interested. After initial contact, write to schedule an appointment.

JACKIE PAGE

219 E. 69th St., New York NY 10021. (212)772-0346. **E-mail:** jackiepage@pobox.com. Estab. 1985. Commercial photography representative. Represents 6 photographers. Markets include advertising agencies.

HANDLES Photography. "I have represented many photographers for 20+ years in the New York City advertising industry. I now prefer to do consulting for photographers wanting to obtain major campaign work in the national market."

TERMS "Details given at a personal interview." Advertises in *Workbook*.

HOW TO CONTACT Send direct mail, promo pieces or e-mail with 2-3 sample pictures in JPEG format (under 200kb total). After initial contact, call for appointment to show portfolio of tearsheets, prints, chromes.

TIPS Obtains new talent through recommendations from others and mailings.

PHOTOTHERAPY CONSULTANTS

11977 Kiowa Ave., Los Angeles CA 90049-6119. **E-mail:** rhoni@phototherapists.com. **Website:** www. phototherapists.com. **Contact:** Rhoni Epstein, acquisitions. Estab. 1983. Commercial and fine art photography consultant. "Consulting with a knowledgeable and well-respected industry insider is a valuable way to get focused and advance your career in a creative and cost-efficient manner. You will see how to differentiate yourself from other photographers. Inexpensive ways to customize your portfolio, marketing program, branding materials, and websites will show the market who you are and why they need you. You will be guided to embrace your point of view and learn how to focus your images on making money!" Rhoni Epstein is an Adjunct Assistant Professor at Art Center College of Design, a panel moderator, portfolio reviewer, lecturer, and contest judge. As a coach, Rhoni inspires her clients to step through their fears into their thriving businesses.

HOW TO CONTACT Via e-mail.

TIPS "Work smart, remain persistent and enthusiastic; there is always a market for creative and talented people."

PICTURE MATTERS

(323)464-2492. **Fax:** (323)465-7013. **E-mail:** info@ picturematters.com. **Website:** www.picturematters. com. Estab. 1985. Commercial photography

representative. Member of APA. Represents 12 photographers. Staff: Sherwin Taghdiri, sales rep. Agency specializes in photography. Markets include advertising agencies, design firms.

HANDLES Photography.

TERMS Rep receives 25% commission. Charges shipping expenses. Exclusive representation required. No geographic restrictions. Advertising costs are paid by talent. For promotional purposes, talent must provide promos, advertising, and a quality portfolio. Advertises in various sourcebooks.

HOW TO CONTACT Send direct mail flier/brochure.

MARIA PISCOPO

1684 Decoto Rd., #271, Union City CA 94587. **E-mail:** maria@mpiscopo.com. **Website:** www.mpiscopo.com. **Contact:** Maria Piscopo. Estab. 1978. Commercial photography representative. Member of SPAR, Women in Photography, Society of Illustrative Photographers. Markets include advertising agencies, design firms, corporations.

HANDLES Photography. Looking for "unique, unusual styles; established photographers only."

TERMS Rep receives 25% commission. Exclusive area representation required. No geographic restrictions. Advertising costs are split: 50% paid by talent; 50% paid by representative. For promotional purposes, talent must have a website and provide 3 traveling portfolios, leave-behinds, and at least 6 new promo pieces per year. Plans web, advertising, and direct mail campaigns.

HOW TO CONTACT Send query letter and samples via PDF to maria@mpiscopo.com. Do not call. Responds within 2 weeks, only if interested.

TIPS Obtains new talent through personal referral and photo magazine articles. "Do lots of research. Be very businesslike, organized, professional, and follow the above instructions!"

ALYSSA PIZER

13121 Garden Land Rd., Los Angeles CA 90049. (310)440-3930. **Fax:** (310)440-3830. **E-mail:** alyssa@alyssapizer.com. **Website:** www.alyssapizer.com. Estab. 1990. Represents 11 photographers. Agency specializes in fashion, beauty, and lifestyle (catalog, image campaign, department store, beauty, and lifestyle awards). Markets include advertising agencies,

corporations/clients direct, design firms, editorial/magazines.

HANDLES Established photographers only.

HOW TO CONTACT Send query letter or direct mail flier/brochure, or e-mail website address. Responds in a couple of days. After initial contact, call to schedule an appointment or drop off or mail materials for review.

VICKI SANDER (REPRESENTS)

New York NY 10010. 917-549-4277. **E-mail:** vicki@vickisander.com. **Website:** www.vickisander.com. **Contact:** Vicki Sander. Estab. 1985. Commercial photography representative. Member of The One Club for Art and Copy, The New York Art Directors Club. Represents photographers. Markets include advertising agencies, corporate/client direct, design firms. "A company that promotes photographers by presenting portfolios at agency conference rooms in catered breakfast reviews. Accepting submissions for consideration on a monthly basis."

HANDLES Photography, fine art. Looking for lifestyle, fashion, food.

TERMS Rep receives 30% commission. Consulting available.

HOW TO CONTACT Responds in 1 month. To show portfolio, photographer should follow up with a call and/or e-mail after initial query.

TIPS Finds new talent through recommendation from other artists, referrals. Have a portfolio put together and have promo cards to leave behind, as well as mailing out to rep prior to appointment.

WALTER SCHUPFER MANAGEMENT CORPORATION

401 Broadway, Suite 14, New York NY 10013. (212)366-4675. **Fax:** (212)255-9726. **E-mail:** mail@wschupfer.com. **Website:** www.wschupfer.com. **Contact:** Walter Schupfer, president. Estab. 1996. Commercial photography representative. Represents photographers, stylists, designers. Staff includes producers, art department, syndication. Agency specializes in photography. Markets include advertising agencies, corporate/client direct, design firms, editorial/magazines, record labels, galleries.

HANDLES Photography, design, stylists, make-up artists, specializing in complete creative management.

TERMS Charges for messenger service. Exclusive area representation required. For promotional pur-

poses, talent must provide several commercial and editorial portfolios. Advertises in *Le Book*.

HOW TO CONTACT Send promo cards, "then give us a call." To show portfolio, photographer should follow up with call.

TIPS Finds new talent through submissions, recommendations from other artists. "Do research to see if your work fits our agency."

FREDA SCOTT, INC.

302 Costa Rica Ave., San Mateo CA 94402. (650)548-2446. **E-mail:** freda@fredascott.com. **Website:** www.fredascottcreative.com. **Contact:** Freda Scott, rep/president. Estab. 1980. Commercial photography, illustration, or photography, commercial illustration representative and licensing agent. Represents 12 photographers, 8 illustrators. Licenses photographers and illustrators. Markets include advertising agencies, architects, corporate/client direct, designer firms, developers, direct mail firms, paper products/greeting cards.

HANDLES Illustration, photography.

TERMS Rep receives 25% as standard commission. Advertising costs paid entirely by talent. For promotional purposes, talent must provide mailers/postcards. Advertises in *The Workbook* and *American Showcase/Illustrators*.

HOW TO CONTACT Send link to website. Responds, only if interested, within 2 weeks. Rep will contact the talent for portfolio review, if interested.

TIPS Obtains new talent through submissions and recommendations from other artists, art directors, and designers.

◎ TAENDEM AGENCY

P.O. Box 47054, 15-555 W. 12th Ave., Vancouver British Columbia V5Z 4L6 Canada. (604)569-6544. **E-mail:** talent@taendem.com. **Website:** www.taendem.com. **Contact:** Corwin Hiebert, principal. Estab. 2006. International management agency. Represents a handful of photographers and videographers. Specializes in consulting with freelancers and assisting them with building and growing a successful small creative business. Also full-service business administration and marketing management for creative entrepreneurs. Offerings include: business planning, branding, marketing strategy, portfolio development, website development, social media planning, contract management, client management, project management, proposal writing, estimates and invoicing, itinerate speaking engagements, travel logistics, and production.

HANDLES Illustration, photography, fine art, design and videography.

TERMS Upon acceptance, we charge a minimum monthly retainer of $200 for access and management rights; for specific tasks we use project costing—quoted and applied upon talent's approval. Additional work is quoted and billed upon talent request/approval. Itinerate speaking commission rate is negotiated on a case-by-case basis. Management representation is nonexclusive. Business development consultation available to qualified talent only; full-service management representation is selectively offered at the discretion of the agency. 100% of advertising costs paid by talent. Standard offering includes no paid advertising. Talent must provide full contact information, current headshot, website link, and a sample of their work. For photographers, we require 10 select portfolio images.

HOW TO CONTACT Send link to website and full contact information and a brief business description. Portfolio should include large thumbnails, videographers should provide demo reel (Vimeo or YouTube). A business manager will be in contact within 1 week.

TIPS Obtains new talent through submissions and recommendations from other artists. Keep e-mails short and friendly. No phone calls. "Creatives are more likely to generate demand when their business is well-organized and their marketing efforts elicit curiosity instead of trying to stand out in a crowd of talented peers. Growing your business network and developing your portfolio through personal and collaborative projects makes you more attractive to both reps and buyers. If you need help growing your creative small business, just remember: You are Batman. We are Robin."

◐ TM ENTERPRISES

P.O. Box 3364, Beverly Hills CA 90210. **E-mail:** tmarques1usa@gmail.com. **Contact:** Tony Marques. Estab. 1985. Commercial photography representative and photography broker. Member of Beverly Hills Chamber of Commerce. Represents 50 photographers. Agency specializes in photography of women only: high fashion, swimsuit, lingerie, glamour and fine (good taste) *Playboy*-style pictures, erotic. Markets include advertising agencies, corporations/clients direct, editorial/magazines, paper products/greeting

cards, publishing/books, sales/promotion firms, medical magazines.

HANDLES Photography.

TERMS Rep receives 50% commission. Advertising costs are paid by representative. "We promote the standard material the photographer has available, unless our clients request something else." Advertises in Europe, South and Central America, and magazines not known in the US.

HOW TO CONTACT Send everything available. Responds in 2 days. After initial contact, drop off or mail appropriate materials for review. Portfolio should include slides, photographs, transparencies, printed work.

TIPS Obtains new talent through worldwide famous fashion shows in Paris, Rome, London, and Tokyo; by participating in well-known international beauty contests; recommendations from others. "Send your material clean and organized. Do not borrow other photographers' work in order to get representation. Always protect yourself by copyrighting your material. Get releases from everybody who is in the picture (or who owns something in the picture)."

DOUG TRUPPE

121 E. 31st St., Suite 10A, New York NY 10016. (212)685-1223. **E-mail:** doug@dougtruppe.com. **Website:** www.dougtruppe.com. **Contact:** Doug Truppe, artist representative. Estab. 1998. Commercial photography representative. Represents 10 photographers. Agency specializes in lifestyle, food, sports, still life, portrait, and children's photography. Markets include advertising agencies, corporate, design firms, editorial/magazines, publishing/books, direct mail firms.

HANDLES Photography. "Always looking for great commercial work." Established, working photographers only.

TERMS Rep receives 25% commission. Exclusive area representation required. Advertising costs are paid by talent. For promotional purposes, talent must provide directory ad (at least 1 directory per year), direct mail promo cards every 3 months, e-mail promos every month, website. Advertises in *Workbook*.

HOW TO CONTACT Send e-mail with website address. Responds within 1 month, only if interested. To show portfolio, photographer should follow up with call.

TIPS Finds artists through recommendations from other artists, sourcebooks, art buyers. "Please be willing to show some new work every 6 months. Have 2-3 portfolios available for representative. Have website and be willing to do direct mail every 3 months. Be professional and organized."

V PRODUCTIONS

81 N. Roosevelt Ave., Apt. 11, Pasadena CA 91107. **E-mail:** workshopsonlocation@gmail.com. **Website:** www.workshopsonlocation.com. **Contact:** Gina Vriens, principal producer. Estab. 2014. Workshop & event organizer. Represents photographers, illustrators, designers, fine artists. "V Productions allows creative individuals to focus on their craft, while leaving the rest to us. We not only produce workshops, but also provide on-site workshop support and marketing consulting." Markets include corporate/client direct, festival/conference.

HOW TO CONTACT E-mail link to website and bio. Responds in 1 week.

WORKSHOPS & PHOTO TOURS

///

Taking a photography workshop or photo tour is one of the best ways to improve your photographic skills. There is no substitute for the hands-on experience and one-on-one instruction you can receive at a workshop. Besides, where else can you go and spend several days with people who share your passion for photography?

Photography is headed in a new direction. Digital imaging is here to stay and is becoming part of every photographer's life. Even if you haven't invested a lot of money into digital cameras, computers, or software, you should understand what you're up against if you plan to succeed as a professional photographer. Taking a digital imaging workshop can help you on your way.

Outdoor and nature photography are perennial workshop favorites. Creativity is another popular workshop topic. You'll also find highly specialized workshops, such as underwater photography. Many photo tours specialize in a specific location and the great photo opportunities that location affords.

As you peruse these pages, take a good look at the quality of workshops and the skill level of photographers the sponsors want to attract. It is important to know if a workshop is for beginners, advanced amateurs, or professionals. Information from a workshop organizer can help you make that determination.

These workshop listings contain only the basic information needed to make contact with sponsors, and a brief description of the styles or media covered in the programs. We also include information on costs when possible. Write, call, or e-mail the workshop/pho-

to tour sponsors for complete information. Most have websites with extensive information about their programs, when they're offered, and how much they cost.

A workshop or photo tour can be whatever the photographer wishes—a holiday from the normal working routine or an exciting introduction to new skills and perspectives on the craft. Whatever you desire, you're sure to find in these pages a workshop or tour that fulfills your expectations.

⦾⦿ EDDIE ADAMS WORKSHOP

(646)263-8596. **E-mail:** producer@eddieadamswork shop.com; info@eddieadamsworkshop.com; eawstaff@gmail.com. **Website:** www.eddieadams workshop.com. **Contact:** Miriam Evers, workshop producer. Annual, tuition-free photojournalism workshop. The Eddie Adams Workshop brings together 100 promising young photographers with over 150 of the most influential picture journalists, picture editors, managing editors, and writers from prestigious organizations such as the Associated Press, CNN, the White House, *Life*, *National Geographic*, *Newsweek*, *Time*, *Parade*, *Entertainment Weekly*, *Sports Illustrated*, the *New York Times*, the *Los Angeles Times* and the *Washington Post*. Pulitzer-prize winning photographer Eddie Adams created this program to allow young photographers to learn from experienced professionals about the story-telling power and social importance of photography. Participants are divided into 10 teams, each headed by a photographer, editor, producer, or multimedia person. Daily editing and critiquing help each student to hone skills and learn about the visual, technical, and emotional components of creating strong journalistic images. Open to photography students and professional photographers with 3 years or less of experience. Photographers should e-mail for more information. The Eddie Adams Workshop is an intense four-day gathering of the top photography professionals, along with 100 carefully selected students. The photography workshop is tuition-free, and the students are chosen based on the merit of their portfolios.

⦾◑⦿ ADVENTURE SAFARI NETWORK

201 E. Randolph St., Chicago IL, 60602. (312)470-6704. **E-mail:** info@AdventureSafariNetwork.com. **Website:** www.AdventureSafariNetwork.com. **Contact:** Gary Gullett, president. Estab. 1999. Held daily. "Local travel photography workshops are held frequently in iconic venues in Chicago. These are 'hands-on' workshops with participants learning the camera controls and concepts of photography in easy-to-understand language. There are also regional, national, and worldwide safaris for the more adventurous. Popular adventure opportunities include Africa, India, Alaska, and Cuba with many trips per year. Check the website or call the office for details." Open to photographers and non-photographers of all skill levels and types of cameras (film or digital). The Adventure Safari Network provides large format images used in office settings, as well as images for calendars, cards, and other uses. Also provides qualified photo instructors to several colleges in northern Illinois, and manages the Digital Photography Certificate program at these individual colleges. Tour operator specializing in trips to Africa, India, Alaska, and Cuba. In conjunction with the Adventure Safari Network Foundation, also operates trips for high school and college safaris within the United States and internationally to the destinations listed above.

⦾◑⦿ ANCHELL PHOTOGRAPHY WORKSHOPS

216 Whitman St. S, Monmouth OR, 97361. (503)884-3882. **Fax:** (503)588-4003. **E-mail:** info@anchell workshops.com. **Website:** www.anchellworkshops. com. **Contact:** Steve Anchell. Film or digital, group or private workshops held throughout the year, including large-format, 35mm, studio lighting, figure, darkroom, both color and b&w. Open to all skill levels. Since 2001, Steve has been leading successful humanitarian missions for photographers to Cuba. On each visit, the photographers deliver medicine to a community clinic in Havana and then have time to explore Havana and the Vinales tobacco region. This is a legal visit with each member possessing a U.S. Treasury license allowing them to travel for humanitarian reasons. Though we will be in Cuba for humanitarian reasons, there will be discussion and informal instruction on street photography. See website for more information.

⦾⦿ ANDERSON RANCH ARTS CENTER

P.O. Box 5598, Snowmass Village CO, 81615. (970)923-3181. **Fax:** (970)923-3871. **E-mail:** info@anderson ranch.org. **Website:** www.andersonranch.org. Photography and new media workshops featuring distinguished artists and educators from around the world. Classes range from traditional silver and alternative photographic processes to digital formats and use of the computer as a tool for time-based and interactive works of art. Program includes video, animation, sound, and installations.

⦾◑⦿ ANIMALS OF MONTANA, INC.

170 Nixon Peak Rd., Bozeman MT, 59715. (406)686-4224. **Fax:** (406)686-4224. **E-mail:** animals@animals ofmontana.com. **Website:** www.animalsofmontana. com. See website for pricing information. Workshops held year round. "Whether you're a professional/ama-

teur photographer or artist, or just looking for a Montana Wildlife experience, grab your camera and leave the rest to us! Visit our tour page for a complete listing of tours." Open to all skill levels. Photographers should call, e-mail, or see website for more information.

APOGEE PHOTO WORKSHOP

(904)619-2010. **Website:** www.apogeephoto.com. **Contact:** Marla Meier, editor/manager. To take our online photography class, visit our website for details.

○◑● SEAN ARBABI

508 Old Farm Rd., Danville CA, 94526-4134. (925)855-8060. **Fax:** (925)855-8060. **E-mail:** work shops@seanarbabi.com. **Website:** www.seanarbabi. com/workshops. **Contact:** Sean Arbabi, commercial photographer/instructor. Online and seasonal workshops held in spring, summer, fall, winter. Taught around the world—online with PPSOP.com, and on location with Calumet, Camera West, Tamron, Workshops on the Farm, as well as places and companies around the world. Sean Arbabi teaches through live presentations, software demonstrations, field shoots, and hands-on instruction. All levels of workshops are offered from beginner to advanced. Subjects include digital photography, nature, composition, exposure, personal vision, high-dynamic range imagery, how to run a photo business, lighting, panoramas, utilizing equipment, and a philosophical approach to the art.

○◑● ARIZONA HIGHWAYS PHOTO WORKSHOPS

2039 W. Lewis Ave., Phoenix AZ, 85009. (888)790-7042. **Fax:** (602)256-2873. **E-mail:** info@ahpw.org. **Website:** www.ahpw.org. **Contact:** Roberta Lites, executive director. Estab. 1985. AHPW is a nonprofit, full-service provider of photographic education from capture to print, taught by premier instructors at inspirational locations throughout the Southwest and beyond. "Arizona Highways Photo Workshops is a nonprofit organization dedicated to educating, motivating, and inspiring photographers at all levels. Whether you are a beginning photography enthusiast or at an advanced level, our workshops offer something for everyone. Our workshop environment fosters learning, creativity, and camaraderie and our workshops are taught by some of the most well-respected industry professionals. For more than thirty years we have offered quality education in some of the most beautiful landscapes in Arizona and North America."

○◑● ART IMMERSION TRIP WITH WORKSHOP IN NEW MEXICO

P.O. Box 1473, Cullowhee NC, 28723. (828)342-6913. **E-mail:** contact@cullowheemountainarts.org. **Website:** www.cullowheemountainarts.org. **Contact:** Norma Hendrix, director. Cost: $1,379-$1,579 (includes lodging, 2-4 day workshop, breakfasts, 1 dinner, some transportation, and museums). "Cullowhee Mountain Arts offers exceptional summer artist workshops in painting, drawing, printmaking, book arts, ceramics, photography and mixed media. Our distinguished faculty with national and international reputations will provide a week-long immersion in their topic supplemented with lectures, demonstrations, or portfolio talks. Cullowhee Mountain Arts is committed to supporting the personal and professional development of every artist, whatever their level, by providing the setting and facilities for intense learning and art making, shared in community. We believe that are enlivens community life and that in a supportive community, art thrives best. Our studios are located on Western Carolina University's campus, surrounded by the natural beauty of the Blue Ridge Mountains in North Carolina." Upcoming workshops in New Mexico include: Debra Fitts (Ceramic Sculpture: Intermediate to Advanced), "The Spirit & The Figure"; Ron Pokrasso (Printmaking: All Levels), "Monotype and More: Mixed Media Printmaking"; Nancy Reyner (Acrylic: Intermediate, Advanced, Masters), "Acrylic Innovation: Inventing New Painting Techniques & Styles"; and Sandra Wilson (Painting: All Levels), "Acrylic Textures, Transfers, and Layers." Call, e-mail, or see website for more detailed information including exact dates and locations.

○◑● ART OF NATURE PHOTOGRAPHY WORKSHOPS

211 Kirkland Ave., Suite 503, Kirkland WA, 98033-6408. (425)968-2884. **E-mail:** charles@charles needlephoto.com. **Website:** www.charlesneedle photo.com. **Contact:** Charles Needle, founder/instructor. US and international locations such as Monet's Garden (France); Keukenhof Gardens (Holland), and Butchart Gardens (Canada); includes private access with personalized one-on-one field and classroom instruction and supportive image evaluations. Emphasis on creative camera techniques in

the field and digital darkroom, allowing students to express "the art of nature" with unique personal vision. Topics include: creative macro, flower/garden photography, multiple-exposure impressionism, intimate landscapes and scenics, dynamic composition and lighting, etc. Open to all skill levels. Upcoming workshops include: Monet's Garden with private access in summertime, Great Gardens of Southern England, Atlanta Botanical Garden, Georgia Aquarium with private access, The Palouse, and Seattle Japanese Garden in Autumn. See website for more information and all upcoming workshops. Cost: $125-4,000 depending on workshop.

ART WORKSHOPS IN GUATEMALA

4758 Lyndale Ave. S., Minneapolis MN, 55419. (612)825-0747. **E-mail:** info@artguat.org. **Website:** www.artguat.org. **Contact:** Liza Fourre, director. Estab. 1995. Art and cultural workshops held in Antigua, Guatemala. See website for a list of upcoming workshops. Art and cultural workshops held year-round. Maximum class size: 10 students.

◯◗● BACHMANN TOUR OVERDRIVE

P.O. Box 950833, Lake Mary FL, 32795. (407)333-9988 after 10 am EST. **E-mail:** bill@billbachmann.com. **Website:** www.billbachmann.com. **Contact:** Bill Bachmann, owner. "Bill Bachmann shares his knowledge and adventures with small groups several times a year. Past trips have been to China, Tibet, South Africa, India, Nepal, Australia, New Zealand, New Guinea, Greece, Vietnam, Laos, Cambodia, Malaysia, Singapore, Guatemala, Honduras, Kenya, Tanzania, Greece, Iceland, Morocco, and Cuba. Future trips will be back to Cuba, Antarctica, Eastern Canada, Italy, Eastern Europe, Peru, Argentina, Brazil, and many other destinations. Programs are designed for adventure travelers who love travel, adventure, and want to learn photography from a top travel photographer." Open to all skill levels.

◗● FRANK BALTHIS PHOTOGRAPHY WORKSHOPS

P.O. Box 255, Davenport CA, 95017. (831)426-8205. **E-mail:** frankbalthis@yahoo.com. **Website:** pa.photoshelter.com/c/frankbalthis. **Contact:** Frank S. Balthis, photographer/owner. "Workshops emphasize natural history, wildlife, and travel photography, often providing opportunities to photograph marine mammals." Worldwide locations range from Baja California to Alaska. Frank Balthis runs a stock photo business and is the publisher of the Nature's Design line of cards and other publications.

BEGINNING DIGITAL PHOTOGRAPHY WORKSHOP

P.O. Box 5219, St. Marys GA, 31558. (912)580-5308. **E-mail:** jackie@debuskphoto.com. **Website:** www.debuskphoto.com. **Contact:** Jackie DeBusk, photographer. $59 for 4-hour individual workshop at mutually-agreed location within 50 miles of St. Marys GA; 51-100 miles, $79; 101-150 miles, $99. Public workshops have varying fees and are announced on website. Instructor and participants are each responsible for any meals, parking, or entrance fees (parks, zoos, etc.). Private workshops by request and public workshops announced throughout the year on website. Please see website for dates of upcoming workshops. Participants will learn how to take their SLR and bridge or prosumer cameras off of auto and begin to creatively apply exposure, metering, and white balance settings, as well as learn about focus area, histograms, and principles of sound composition. Workshop emphasis is on outdoor photography. Private workshops are conducted at mutually-agreed locations; public workshops are typically held at state parks or other public venues that offer excellent photography opportunities. Open to beginners. Interested parties should call, e-mail, or see website for more information.

◯◗● BETTERPHOTO.COM ONLINE PHOTOGRAPHY COURSES

23515 NE Novelty Hill Rd., Suite B221, #183, Redmond WA, 98052. **E-mail:** course.sales@betterphoto.com; kerry@betterphoto.com. **Website:** www.betterphoto.com. **Contact:** Kerry Drager, course advisor. BetterPhoto is the worldwide leader in online photography education, offering an approachable resource for photographers who want to improve their skills, share their photos, and learn more about the art and technique of photography. BetterPhoto offers over 100 photography courses that are taught by top professional photographers. Courses begin the 1st Wednesday of every month. Courses range in skill level from beginner to advanced and consist of inspiring weekly lessons and personal feedback on students' photos from the instructors. "We provide websites for photographers, photo sharing solutions, free online newsletters, lively Q&A and photo discussions, a monthly contest, helpful articles, and online photography courses." Open to all skill levels.

❶ BIRDS AS ART/INSTRUCTIONAL PHOTO-TOURS

P.O. Box 7245, 4041 Granada Dr., Indian Lake Estates FL, 33855. (863)692-0906. **E-mail:** birdsasart@verizon.net; samandmayasgrandpa@att.net. **Website:** www.birdsasart-blog.com. **Contact:** Arthur Morris, instructor. The tours, which visit the top bird photography hot spots in North America and the world, feature in-classroom lectures, lunch, in-the-field instruction, 6 or more hours of photography, and most importantly, easily approachable yet free and wild subjects. See the complete IPT schedule here: www.birdsasart.com/include-pages/ipt-updates.

❶❶● BLUE PLANET PHOTOGRAPHY WORKSHOPS AND TOURS

1526 W. Charlotte Ct., Nampa ID, 83687. (208)466-9340. **Website:** www.blueplanetphoto.com. Professional photographer and former wildlife biologist Mike Shipman conducts small group workshops/tours emphasizing individual expression and exloration using all your senses & perception. Workshops and tours are held away from crowds in beautiful and inspiring locations in the US and worldwide, such as Maine, Yosemite, Vancouver Island, Iceland, and Scotland. Group feedback sessions and digital presentations are available whenever possible. On-site transportation and lodging during workshop usually included; meals included on some trips. Specific fees, optional activities, and gear list outlined in tour materials. Workshops and tours range from 2 to 12 days, sometimes longer; average is 9 days. Custom tours and workshops available upon request. Open to all skill levels. Photographers should see website and online contact form for more information.

BLUE RIDGE WORKSHOPS

4831 Keswick Court, Montclair VA, 22025. (571)294-1383. **E-mail:** elliot@blueridgeworkshops.com; brian@blueridgeworkshops.com. **Website:** www.blueridgeworkshops.com. **Contact:** Elliot Stern, owner/photographer. These workshops sell out, so book early. See website for more information and a list of all upcoming workshops.

❶❶● NANCY BROWN HANDS-ON WORKSHOPS

3100 NW Boca Raton Blvd., Suite 403, Boca Raton FL, 33431. (561)866-1224. **E-mail:** nbrown50@bellsouth.net. **Website:** www.nancybrown.com. **Contact:** Nancy Brown. Offers one-on-one intensive workshops all year long in studio and on location in Florida. "You work with Nancy, the models, and the crew to create your images." Photographers should call, fax, e-mail, or see website for more information.

❾❶❶● BURREN COLLEGE OF ART WORKSHOPS

Burren College of Art, Newtown Castle, Ballyvaughan, County Clare , Ireland. (353)(65)7077200. **E-mail:** julia@burrencollege.ie. **Website:** www.burrencollege.ie/workshops. **Contact:** Julia Long, photography. Estab. 1994. "The aim of this beginner-level workshop is to improve all aspects of your digital photography image making. It is ideal for anyone who has a digital SLR but feel that they are not getting the most out of it. The 5-day workshop will guide photographers towards making beautiful photographic prints. Over the course of the 5 days, participants will learn about optimising their camera for producing the best quality image and get a chance to make new work on field trips around the Burren. Participants will then get the opportunity to enhance their image with post-production using Adobe Bridge, Lightroom, and Photoshop, and finally you will get to produce beautiful photographic prints. Use of the college's large-format Epson 7900 printing technology will be available to participants for printing their images with a wide range of photographic paper choices to work with, from glossy photo paper to enhanced matte or premium lustre paper. However, this workshop will have less of an emphasis on printing, but more on the basic skills required to start working in Photoshop.
This course is followed by another 5-day workshop dedicated to a more advanced audience. Both courses are designed to run in conjunction with each other, so participants are welcome to do both or alternatively select one they would feel more comfortable in. Places on both courses are limited. See website for the full range on offer."

❾ CAMARGO FOUNDATION VISUAL ARTS FELLOWSHIP

1 Avenue Jermini, Cassis 13260 France. **E-mail:** apply@camargofoundation.org. **Website:** www.camargofoundation.org. Cross-disciplinary residencies awarded to writers, playwrights, visual artists, photographers, video artists, filmmakers, media artists, choreographers, composers, and academics. Artists may work on a specific project, develop a body of work, etc. Fellows must live on-site at foundation headquar-

ters for the duration of the fellowship. Apartments with kitchens provided. Open to photographers of any nationality. Stipend of US $1,500 available. See website for deadline. Photographers should visit website to apply. If you are interested in applying for future fellowships, please check the website for announcements.

◐◑ THE CENTER FOR PHOTOGRAPHY AT WOODSTOCK

59 Tinker St., Woodstock NY, 12498. (845)679-9957. **E-mail:** info@cpw.org. **Website:** www.cpw.org. **Contact:** Lindsay Stern, education coordinator. Woodstock Photography Workshops & Lecture Series. "Held at CPW in Woodstock NY, our hands-on workshops allow you to expand your craft, skills, and vision under the mentorship of a leading image-maker. Workshops are kept intimate by limited enrollment and taught by highly qualified support staff. Photographers should call, e-mail, or see website for more information and a list of upcoming workshops."

CHEAP JOE'S ARTIST WORKSHOPS

374 Industrial Park Dr., Boone NC, 28607. (800)227-2788. **Fax:** (800)257-0874. **E-mail:** edwina@cheapjoes@com. **Website:** cheapjoes.com. **Contact:** Edwina May, workshop coordinator. Cost: Varies per instructor, discount given for registrations at least 6 months prior to workshop. Workshops held annually: weekly/mid-April through October. Taking a workshop at Cheap Joe's is more than a painting class—it's an experience! Learn from the best instructors in the business. You'll have an individual workstation, discounts on supplies, hotel discounts, delicious lunches provided, awesome customer service, and much more! Classes vary weekly from mid-April through October. Early registration discount available. Open to all skill levels. Interested parties should e-mail or see website for more information.

◕ CATHY CHURCH PERSONAL UNDERWATER PHOTOGRAPHY COURSES

Cathy Church's Photo Centre, P.O. Box 479, GT, Grand Cayman KY1 1106 Cayman Islands. (345)949-7415 or (607)330-3504 (US callers). **Fax:** (345)949-9770. **E-mail:** cathy@cathychurch.com. **Website:** www.cathychurch.com. **Contact:** Cathy Church, Jennifer Mark. Estab. 1972. Hotel/dive package available at Sunset House Hotel. Private and group lessons available for all levels throughout the year; classroom and shore diving is available right on the property.

Lessons available for professional photographers expanding to underwater work. Full camera systems are available for rent or purchase. Photographers should e-mail for more information. Cathy Church has been teaching underwater photography since 1972. She has been inducted into 5 halls of fame related to outstanding accomplishments in an underwater field, and has twice been the president of the prestigious Academy of Underwater Arts and Sciences. She has written 5 books, hundreds of articles and taught thousands of divers in her workshops throughout the US and through her active teaching at her photo centre in Grand Cayman. Cathy currently uses a housed Nikon D810, and is familiar with most smaller systems.

◐◑● CLICKERS & FLICKERS PHOTOGRAPHY NETWORK—LECTURES & WORKSHOPS

P.O. Box 60508, Pasadena CA, 91116-6508. (310)457-6130. **E-mail:** dawnhope@clickersandflickers.com; dawn5palms@yahoo.com. **Website:** www.clickersandflickers.com. **Contact:** Dawn Hope Stevens, organizer. Estab. 1985. Monthly networking dinners with outstanding guest speakers (many award winners, including the Pulitzer Prize), events, and free activities for members. "Clickers & Flickers Photography Network, Inc., was created to provide people with an interest and passion for photography (cinematography, filmmaking, image making) the opportunity to meet others with similar interests for networking and camaraderie. It creates an environment in which photography issues, styles, techniques, enjoyment, and appreciation can be discussed and viewed as well as experienced with people from many fields and levels of expertise (beginners, students, amateur, hobbyist, or professionals, gallery owners, and museum curators). We publish a bimonthly color magazine listing thousands of activities for photographers and lovers of images. Most of its content is not on our website for a reason." Membership and magazine subscriptions help support this organization. Clickers & Flickers Photography Network, Inc. is a 21-year-old professional photography network association that promotes information and offers promotional marketing opportunities for photographers, cinematographers, individuals, organizations, businesses, and events. "C&F also provides referrals for photographers. Our membership includes photographers, videographers, and cinematographers who are skilled in the following types of photography: outdoor and nature, wed-

ding, headshots, fine art, sports, events, products, news, glamour, fashion, macro, commercial, landscape, advertising, architectural, wildlife, candid, photojournalism, marquis gothic—fetish, aerial, and underwater; using the following types of equipment: motion picture cameras (Imax, 70mm, 65mm, 35mm, 16mm, 8mm), steadicam systems, video, high-definition, digital, still photography—large format, medium format and 35mm." Open to all skill levels. Photographers should call or e-mail for more information.

○○● COLORADO PHOTOGRAPHIC ARTS CENTER

(303)837-1341. **E-mail:** info@cpacphoto.org. **Website:** www.cpacphoto.org. Offers monthly workshops on film & darkroom, digital, alternative process, portraiture, landscape, creativity, studio lighting, portfolio development, and more. Open to all skill levels. Also have a gallery with changing juried photo exhibits. Photographers should call, e-mail, see website for more information and a list of upcoming workshops.

○● COMMUNITY DARKROOM

Genesse Center for the Arts, 713 Monroe Ave., Rochester NY, 14607. (585)271-5920. **E-mail:** darkroom@geneseearts.org. **Website:** www.geneseearts.org. "The Genesee Center for the Arts & Education offers programs in all of our visual arts areas: Community Darkroom, Genesee Pottery, and the Printing and Book Arts Center. We offer youth programs, classes and workshops, rent studio space to individuals, and exhibit work in our galleries. Anyone may take classes, though you must be a member to use some of the facilities." See website for more information and upcoming workshops.

○○● CONE EDITIONS WORKSHOPS

P.O. Box 51, East Topsham VT, 05076. (802)439-5751, ext. 101. **E-mail:** cathy@cone-editions.com. **Website:** www.cone-editions.com. **Contact:** Cathy Cone. See website for details on workshop dates and prices. Cone Editions digital printmaking workshops are hands-on and cover a wide range of techniques, equipment and materials. The workshops take place in the studios of Cone Editions Press and offer attendees the unique opportunity to learn workflow and procedures from the masters. These workshops are an excellent opportunity to learn proven workflow in a fully equipped digital printmaking studio immersed in the latest technologies. Open to all skill levels. See website for more information and upcoming workshops.

◑ ◐ THE CORTONA CENTER OF PHOTOGRAPHY, ITALY

(404)876-6341. **E-mail:** workshop.inquiry@cortonacenter.com. **Website:** www.cortonacenter.com. Estab. 1998. Robin Davis leads personal, small-group photography workshops in the ancient city of Cortona, Italy, centrally located in Tuscany, once the heart of the Renaissance. Dramatic landscapes; Etruscan relics; Roman, Medieval, and Renaissance architecture; and the wonderful and photogenic people of Tuscany await. "Photographers should e-mail or see our website for more information."

○● CREALDÉ SCHOOL OF ART

600 St. Andrews Blvd., Winter Park FL, 32792. (407)671-1886. **E-mail:** pschreyer@crealde.org; rberrie@crealde.org. **Website:** www.crealde.org. **Contact:** Peter Schreyer, executive director; Robin Berrie, marketing manager. Crealdé School of Art is a community-based nonprofit arts organization established in 1975. It features a year-round curriculum of over 100 visual arts classes for students of all ages, taught by a faculty of over 40 working artists; a renowned summer art camp for children and teens; a visiting artist workshop series, 3 galleries, the contemporary sculpture garden, and award-winning outreach programs. Offers classes covering traditional and digital photography; b&w darkroom techniques; landscape, portrait, documentary, travel, wildlife, and abstract photography; and educational tours. See website for more information and upcoming workshops.

○●● CREATIVE ARTS WORKSHOP

80 Audubon St., New Haven CT, 06511. (203)562-4927. **E-mail:** haroldshapirophoto@gmail.com. **Website:** www.creativeartsworkshop.org. **Contact:** Harold Shapiro, photography department head. A nonprofit regional center for education in the visual arts that has served the Greater New Haven area since 1961. Located in the heart of the award-winning Audubon Arts District, CAW offers a wide-range of classes in the visual arts in its own 3-story building with fully equipped studios and an active exhibition schedule in its well-known Hilles Gallery. Offers exciting classes and advanced workshops. Digital and traditional

b&w darkroom. See website for more information and upcoming workshops.

○ CULTURAL PHOTO TOURS WITH PHOTOENRICHMENT PROGRAMS, INC.

Ralph Velasco, 7431 E. State St., Unit 120, Rockford IL, 61108. **Fax:** (888)974-6869. **E-mail:** ralph@photo enrichment.com; admin@photoenrichment.com. **Website:** photoenrichment.com. **Contact:** Ralph Velasco, president, CEO (chief experience officer). Estab. 2004. Trips are custom designed to provide a unique opportunity for hands-on experience with a professional travel photography instructor. Learn to see like a photographer, develop skills that will allow you to readily notice and take advantage of more and better photo opportunities and begin to "think outside the camera!" Includes international tours that are fully scouted in advance and led by an award-winning travel photography instructor, author, and international guide Ralph Velasco and/or other highly qualified guest photographers and travel experts. Tours concentrate on international destinations including Morocco, Mexico's Copper Canyon, Cambodia, Central Europe, Romania, Turkey, Vietnam, Iceland, Spain, Egypt, and the Adriatic, as well as fully licensed People-to-People Exchange programs to Cuba (other destinations are added frequently). Costs: varies depending on location and length of trip. Payments accepted: personal check, bank transfer, online invoice, or credit card. Open to all levels of photographers and non-photographers alike, with any equipment. Interested participants should e-mail or visit the website for more information and to register. PhotoEnrichment Programs, Inc. organizes and leads small group cultural tours, with a focus on photography. Destinations include Cambodia, Vietnam, Spain, Tuscany, the Baltics (Estonia, Lithuania & Latvia), Morocco, Central Europe, the Adriatic (Slovenia, Croatia, and Montenegro), Romania, Turkey, Mexico, Cuba, and others.

✪✪◐◑● DAWSON COLLEGE CENTRE FOR TRAINING AND DEVELOPMENT

4001 de Maisonneuve Blvd. W., Suite 2G.1, Montreal Quebec, H3Z 3G4, Canada. (514)933-0047. **Fax:** (514)937-3832. **E-mail:** ctd@dawsoncollege.qc.ca. **Website:** www.dawsoncollege.qc.ca/ciait. Workshop subjects include imaging arts and technologies, computer animation, photography, digital imaging, desktop publishing, multimedia, and web publish-

ing and design. See website for course and workshop information.

◐● CYNTHIA DELANEY PHOTO WORKSHOPS

168 Maple St., Elko NV, 89801. (775)750-4501. **Fax:** (775)753-5833. **E-mail:** cynthia@cynthiadelaney.com; cynthiadelaney@frontiernet.net. **Website:** www.cynthiadelaney.com. **Contact:** Cynthia Delaney. "In addition to her photography classes, Cynthia offers outdoor photography workshops held in many outstanding locations. It is our hope to bring photographers to new and unusual places where inspiration comes naturally." See website for more information and upcoming workshops.

JOE ENGLANDER PHOTOGRAPHY WORKSHOPS & TOURS

P.O. Box 1261, Manchaca TX, 78652. (512)922-8686. **E-mail:** jenglander@joeenglander.com. **Website:** www.joeenglander.com. **Contact:** Joe Englander. Instruction in beautiful locations throughout the world, all formats and media, color/b&w/digital, Photoshop instruction. Locations include Europe, Asia with special emphasis on Bhutan and the Himalayas and the US. See website for more information.

○◐● EUROPA PHOTOGENICA PHOTO TOURS TO EUROPE

(310)621-0914. **Fax:** (310)378-2821. **E-mail:** fra photo@aol.com. **Website:** www.europaphotogenica.com. **Contact:** Barbara Van Zanten-Stolarski, owner. Estab. 1990. (Formerly France Photogenique/Europa Photogenica Photo Tours to Europe). Tuition provided for beginners/intermediate and advanced level. Workshops held in spring (1-2) and fall (1-2). 5- to 11-day photo tours of the most beautiful regions of Europe. Shoot landscapes, villages, churches, cathedrals, vineyards, outdoor markets, cafes, and people in France, Paris, Provence, England. Tours change every year. Open to all skill levels. Photographers should call or e-mail for more information.

○◐● EXPOSURE36 PHOTOGRAPHY

P.O. Box 964, Caldwell ID, 83605. (503)707-5293. **E-mail:** workshop@exposure36.com. **Website:** www.exposure36.com. **Contact:** Jim Altengarten. Open to all skill levels. Workshops offered at prime locations in the U.S. and Canada, including Nova Scotia, Smoky Mountains, Acadia, and the bears in Alaska. International workshops include Russia, Southeast Asia,

Guatemala, and the Northern Lights in Finland. Also offers classes on the basics of photography in Seattle, Washington (through the Experimental College of the University of Washington). Photographers should write, call, e-mail, see website for more information and upcoming workshops.

FINDING & KEEPING CLIENTS

1684 Decoto Rd. #271, Union City CA, 94587. **E-mail:** maria@mpiscopo.com. **Website:** www.mpiscopo.com. **Contact:** Maria Piscopo, instructor. Estab. 30. "How to find new photo assignment clients and get paid what you're worth!" Maria Piscopo is the author of *The Photographer's Guide to Marketing & Self-Promotion*, 5th edition (Allworth Press). See website for more information and upcoming workshops.

FINE ARTS WORK CENTER

24 Pearl St., Provincetown MA, 02657. (508)487-9960, ext. 103. **Fax:** (508)487-8873. **E-mail:** workshops@ fawc.org. **Website:** www.fawc.org. Estab. 1968. Faculty includes Connie Imboden, David Hilliard, Pam Houston, Nick Flynn, Shellburne Thurber, Salvatore Scibona, John Murillo, Joanne Dugan, Rob Swainston and many more.

PETER FINGER PHOTOGRAPHER

1120 Oak Overhang St., Daniel Island SC, 29492. (843)801-2552. **E-mail:** images@peterfinger.com. **Website:** www.peterfingerartist.com. **Contact:** Peter Finger, president. Offers over 20 weekend and week-long photo workshops, held in various locations. Workshops planned include Charleston, Savannah, Carolina Coast, Outer Banks, and the Islands of Georgia. "Group instruction from dawn till dusk." Write or visit website for more information.

○○● FIRST LIGHT PHOTOGRAPHY

10 Roslyn, Islip Terrace NY, 11752. (516)769-2549 (516)965-3097. **E-mail:** info@firstlightphotography. com. **Website:** www.firstlightphotography.com. **Contact:** Gen Benjamin. Estab. 1982. Photo workshops for all skill levels, specializing in landscape and wildlife photography. "We will personally teach you through our workshops and safaris, the techniques necessary to go from taking pictures to creating those unique, magical images while experiencing some of life's greatest adventures through the eye of your camera."

See website for more information, pricing, and registration.

○○● FOCUS ADVENTURES

P.O. Box 771640, Steamboat Springs CO, 80477. (970)879-2244. **E-mail:** karen@focusadventures.com. **Website:** www.focusadventures.com. **Contact:** Karen Gordon Schulman, owner. Estab. 1985. "Photo workshops and tours emphasize photography and the creative spirit and self-discovery through photography. Summer photo workshops in Steamboat Springs, Colorado and at Focus Ranch, a private guest and cattle ranch in NW Colorado. Customized individual and small-group photo instruction available year-round. Karen is an experienced photographic artist and educator based out of Steamboat Springs, CO. Her current passion is the new and exciting world of iPhoneography. Workshops in Creative iPhoneography throughout the year. Karen leads international photo tours in conjunction with Strabo Photo Tour Collection to various destinations including Ecuador, Bali, Morocco, Bhutan, and Western Ireland." Accommmodations, most meals, photo instruction included in all of the above programs. See website for more details and registration information.

○○● FOTOFUSION

Palm Beach Photographic Centre, 415 Clematis St., West Palm Beach FL, 33401. (561)253-2600. **E-mail:** info8@workshop.org. **Website:** www.fotofusion.org. America's foremost festival of photography and digital imaging is held each January. Learn from more than 90 master photographers, picture editors, picture agencies, gallery directors, and technical experts, over 5 days of field trips, seminars, lectures, and Photoshop workshops. Open to all skill levels interested in nature, landscape, documentary, portraiture, photojournalism, digital, fine art, commercial, etc. Details available online.

●● GALÁPAGOS TRAVEL

783 Rio Del Mar Blvd., Suite 49, Aptos CA, 95003. (831)689-9192 or (800)969-9014. **E-mail:** info@gala pagostravel.com. **Website:** www.galapagostravel.com. **Contact:** Mark Grantham. Landscape and wildlife photography tours of the islands with an emphasis on natural history. Spend either 11 or 15 days aboard the

yacht in Galápagos, plus three nights in a first-class hotel in Quito, Ecuador. 25+ departures annually. See website for additional information and registration.

○◑● GERLACH NATURE PHOTOGRAPHY WORKSHOPS & TOURS

P.O. Box 258, Macks Inn ID, 83433. (208)244-1887. **E-mail:** michele@gerlachnaturephoto.com. **Website:** www.gerlachnaturephoto.com; www.facebook.com/gerlachnaturephotographyworkshops. **Contact:** Barbara Gerlach, office manager. Professional nature photographers John and Barbara Gerlach conduct intensive field workshops in the beautiful Upper Peninsula of Michigan in August and during October's fall color period. They lead a photo safari to the best game parks in Kenya each year. They also lead winter photo tours of Yellowstone National Park and conduct high-speed flash hummingbird photo workshops in British Columbia in late May and early June. They conduct inspirational one-day seminars on how to shoot beautiful nature images in major cities each year. Their 4 best-selling books, *Digital Nature Photography: The Art and the Science*, *Digital Wildlife Photography*, *Digital Landscape Photography*, and *Close Up Photography in Nature*, have helped thousands master the art of nature photography. Visit www.gerlachnaturephoto.com for more information.

○◑● GLOBAL PRESERVATION PROJECTS

2783 Ben Lomond Dr., Santa Barbara CA, 93105. (805)682-3398; (805)455-2790. **E-mail:** timorse@aol.com. **Website:** www.globalpreservationprojects.com. **Contact:** Thomas I. Morse, executive director. Offers photographic workshops and expeditions promoting the preservation of environmental and historic treasures. Produces international photographic exhibitions and publications. Workshops and expeditions in order normally done: Arches & Canyonlands, Winter Train Durango, Big Sur, Slot Canyons, Monument Valley, Eastern Sierra, Northern California & Oregon coasts, Colorado Fall Color, Death Valley, and Alabama Hills. See website for details.

●◯ GOLDEN GATE SCHOOL OF PROFESSIONAL PHOTOGRAPHY

P.O. Box 5583, San Mateo CA, 94402. **E-mail:** julie@ppgba.org. **Website:** www.goldengateschool.org. **Contact:** Julie Olson, director. Estab. 1971. Offers 1-2 day photography workshops and evening meetings for established and aspiring professional photographers in the San Francisco Bay Area. Local affiliate of Professional Photographers of America.

○◑● ROB GOLDMAN CREATIVE PHOTOGRAPHY WORKSHOPS

R. Goldman, Inc., 755 Park Ave., Suite 190, Huntington NY, 11743. (631)424-1650. **E-mail:** rob@rgoldman.com. **Website:** www.rgoldman.com. **Contact:** Rob Goldman, photographer. 1-on-1 private instruction for photographers of all levels, customized to each student's needs. "For over 15 years, beginner photographers through seasoned pros have received priceless instruction and support from Rob Goldman's private sessions. He possesses an uncanny ability to inspire and draw out a photographer's absolute best! Whether you're brand new to photography or looking to refine your vision or your craft, Rob's private lessons are the way to go!"

○◑ GREAT SMOKY MOUNTAINS INSTITUTE AT TREMONT

9275 Tremont Rd., Townsend TN, 37882. (865)448-6709. **Fax:** (865)448-9250. **E-mail:** mail@gsmit.org; heather@gsmit.org. **Website:** www.gsmit.org. **Contact:** Registrar. Workshop instructors: Bill Lea, Will Clay and others. Emphasizes the use of natural light in creating quality scenic, wildflower, and wildlife images.

◑● HALLMARK INSTITUTE OF PHOTOGRAPHY

Premiere Education Group, 241 Millers Falls Rd., Turners Falls MA, 01376. (413)863-2478. **E-mail:** info@hallmark.edu. **Website:** hallmark.edu. **Contact:** Ed Martin, school president. Estab. 1974. Offers an intensive 10-month resident program teaching the technical, artistic, and business aspects of professional photography for the career-minded individual. Hallmark Institute of Photography was established 40 years ago to provide an accelerated academic path to a career in professional photography. Our unique 10-month in-residence program is designed to equip the motivated student with all of the tools that he or she will need to successfully launch a career in the very competitive imaging marketplace.

JOHN HART PORTRAIT SEMINARS

John Hart Studio / NYC, 344 W. 72nd St., New York NY, 10023. (212) 877-0516. **E-mail:** johnhartstudio1@mac.com. **Website:** www.headshotsbyjohnhart.com. Estab. 1980. John Hart is a professor of photography

at New York University. His photography sessions concentrate on 1-on-1 instruction that emphasizes advanced portrait techniques—concentrating mainly on lighting the subject in a truly professional manner, whether inside the studio or outside in natural lighting. He is the author of *50 Portrait Lighting Techniques* (Amazon.com; Barnes and Noble), *Professional Headshots*, *Lighting for Action*, and *The Art of the Storyboard* (Nook; eBook). His portrait seminars place a new emphasis on digital portrait photography, the subject of a new book he is working on.

○◐● HEART OF NATURE PHOTOGRAPHY WORKSHOPS & PHOTO TOURS

P.O. Box 1033, Volcano HI, 96785. (808)345-7179. **E-mail:** rfphoto@jps.net. **Website:** www.hawaiiphoto tours.org. **Contact:** Robert Frutos. "Be inspired, be amazed, be creative. Capture the beauty and spirit of the Big Island. Adventure, excitement, and the experience of a lifetime await you on the breathtaking big island of Hawaii! Explore the majestic beauty. Discover the unique splendor. Experience exotic photo ops as well as little-known awe-inspiring locations. Photograph and capture that potential once-in-a-lifetime image." Photographers can e-mail or see website for more information.

○◐● HORIZONS: ARTISTIC TRAVEL

P.O. Box 634, Leverett MA, 01054. (413)367-9200. **Fax:** (413)367-9522. **E-mail:** horizons@horizons -art.com. **Website:** www.horizons-art.com. **Contact:** Jane Sinauer, director. "Horizons offers one-of-a-kind small-group travel adventures in Southern Africa: Sea to Safari; Peru: the Inca Heartland; Ecuador: Andes to the Amazon; Southeast Asia: Burma, and Laos (2014); and, A Foodie's Italy: Parma and Bologna. As of 2013, our catalog will solely be online to ensure that you always have the most up-to-date information. If you would like a detailed itinerary for any trip or have specific questions, please let us know."

○◐● HUI HO'OLANA

P.O. Box 280, Kualapùu, Molokài HI, 96757. (808)567-6430. **E-mail:** hui@huiho.org; huihoolana@gmail. com. **Website:** www.huiho.org. **Contact:** Rik Cooke. "Hui Ho'olana is a nonprofit organization on the island of Molokai HI. We are dedicated to the fine art of teaching. Through workshops and volunteer residencies, our mission is to create a self-sustaining facility that supports educational programs and native Hawaiian reforestation projects. Our goal is to provide an environment for inspiration, a safe haven for the growth and nurturing of the creative spirit." Photographers should e-mail, call, or visit website for more information, including the current workshop schedule.

○◐● INTERNATIONAL EXPEDITIONS

One Environs Park, Helena AL, 35080. (855)232-1998; (205)428-1700. **Fax:** (205)428-1714. **E-mail:** nature@ ietravel.com. **Website:** www.ietravel.com. **Contact:** Charlie Weaver, photo tour coordinator. Includes scheduled ground transportation; extensive pre-travel information; services of experienced English-speaking local guides; daily educational briefings; all excursions, entrance fees, and permits; all accommodations; meals as specified in the respective itineraries; transfer and luggage handling when taking group flights. Guided nature expeditions all over the world: Amazon, Costa Rica, Machu Picchu, Galapagos, Laos & Vietnam, Borneo, Kenya, Patagonia and many more. Open to all skill levels. Photographers should write, call, e-mail, see website for more information.

◕ ISRAEL PHOTOGRAPHY WORKSHOPS – PHOTOGRAPHY BY YEHOSHUA HALEVI

25 Leeb Yaffe St., Jerusalem 93390-56, Israel. (972) (54)637-2170. **E-mail:** yh@yehoshuahalevi.com. **Website:** www.yehoshuahalevi.com. **Contact:** Yehoshua Halevi, owner. Estab. 2003. Weekly and seasonal photography workshops and tours throughout Israel. All workshops are led by Yehoshua Halevi, a National Geographic credentialed photographer, and are held in select, picturesque locations year-round in Jerusalem and seasonally around Israel. Workshops are appropriate for all skill levels and cover a variety of genre and techniques that teach students how to see, compose, and technically master their cameras. Workshops take place weekly throughout the year. Please check www.yehoshuahalevi.com for the current schedule. Interested artists should write, e-mail, or see website for more information. Full-service photography company offering commercial, event, and public relations photography and stock images as well as courses and workshops throughout Israel.

○◐● JIVIDEN'S NATURALLY WILD PHOTO ADVENTURES

P.O. Box 333, Chillicothe OH, 45601. (800)866-8655 or (740)774-6243. **Fax:** (740)774-6243 (call first). **E-mail:** mail@naturallywild.net. **Website:** www.natu-

rallywild.net. **Contact:** Jerry or Barbara Jividen. "Experienced instructors with international photography publication credits. Photography workshops ranging from one-day digital bootcamps for $129 to week-long excursions in a variety of diverse North American locations (prices vary). Open to all skill levels. All workshops feature comprehensive instruction, guide service, pro tips to advanced photographers, editing tips, and portfolio reviews upon request. Workshops longer than two days normally include lodging, meals, ground transportation, entry permits if required, and special group rates, as well as non-photographer guest rates for travel companions. Subject emphasis is on photographing nature, wildlife, and natural history. Instruction focused on equipment use and techniques, proper exposure and equivalent options, composition and artistic merit, flash and lighting, and post-processing support. Free information available upon request, by phone or e-mail."

◑◑ JORDAHL PHOTO WORKSHOPS

P.O. Box 3998, Hayward CA, 94540, USA. (510)909-4026. **E-mail:** kate@jordahlphoto.com. **Website:** www.jordahlphoto.com. **Contact:** Kate or Geir Jordahl, directors. Intensive 1- to 5-day workshops dedicated to inspiring creativity and community among artists through critique, field sessions, and exhibitions.

❀◑◑● THE LIGHT FACTORY

1817 Central Ave., Suite C200, Charlotte NC, 28205. (704)333-9755. **E-mail:** info@lightfactory.org. **Website:** www.lightfactory.org. **Contact:** Dennis Kiel, chief curator. Estab. 1972. The Light Factory is a nonprofit arts center dedicated to exhibition and education programs promoting the power of photography and film. From classes in basic point-and-shoot to portraiture, Photoshop, and more, TLF offers 3 to 8 week-long courses that meet once a week in our uptown Charlotte location. Classes are taught by professional instructors and cater to different expertise levels: introductory, intermediate, and advanced in both photography and filmmaking. See website for a listing of classes and registration.

LIGHT PHOTOGRAPHIC WORKSHOPS

1060 Los Osos Valley Rd., Los Osos CA, 93402. (805)528-7385. **Fax:** (888)254-6211. **E-mail:** info@lightworkshops.com. **Website:** www.lightworkshops.com. "LIGHT Photographic Workshops is located on the beautiful coast of California in the small town of Los Osos. We are halfway between Los Angeles and San Francisco near the Paso Robles wine area. It's a fantastic location for all sorts of photography! Offers small group workshops, private tutoring, Alaska and worldwide photography instruction cruises and tours, printing and canvas gallery wrap services, Canon gear rental, studio and classroom rental. New focus on digital tools to optimize photography, make the most of your images, and improve your photography skills at the premier digital imaging school on the West Coast."

◐◑◑ PETER LLEWELLYN PHOTOGRAPHY WORKSHOPS & PHOTO TOURS

645 Rollo Rd., Gabriola British Columbia, V0R 1X3 Canada. (250)247-9109. **E-mail:** peter@peterllewellyn.com. **Website:** www.peterllewellyn.com. **Contact:** Peter Llewellyn. "Sports and wildlife photography workshops and photo tours at locations worldwide. Sports photography workshops feature instruction by some of the best sports photographers in the world. Workshops include photography, Photoshop skills, and digital workflow. Photo Tours are designed to provide maximum photographic opportunities to participants with the assistance of a professional photographer. Trips include Brazil, Africa, Canada, and US. New destinations coming soon." Open to all skill levels. For further information, e-mail or see website. Costs vary.

◑◑● C.C. LOCKWOOD WILDLIFE PHOTOGRAPHY WORKSHOP

P.O. Box 14876, Baton Rouge LA, 70898. (225)769-4766. **E-mail:** cactusclyd@aol.com. **Website:** www.cclockwood.com. **Contact:** C.C. Lockwood, photographer. Lockwood periodically teaches hands-on photography workshops in the Grand Canyon, Texas ranches, Colorado, Alaska, Louisiana marshes and rookeries, and the Atchafalaya Basin Swamp. Informative slide show lectures precede field trips into these great photo habitats. Call, write, e-mail, or see website for a list of upcoming workshops.

◑◑● LOS ANGELES CENTER OF PHOTOGRAPHY

755 Seward St., Los Angeles CA, 90038. (323)464-0909. **Fax:** (323)464-0906. **E-mail:** info@lacphoto.org. **Website:** www.juliadean.com. **Contact:** Brandon Gannon, director. The Julia Dean Photo Workshops (JDPW) is a practical education school of photography devoted to advancing the skills and increas-

ing the personal enrichment of photographers of all experience levels and ages. Photography workshops of all kinds held throughout the year, including alternative and fine art, photography & digital camera fundamentals, lighting & portraiture, specialized photography, Photoshop and printing, photo safaris, and travel workshops. Open to all skill levels. Photographers should call, e-mail, or see website for more information.

◑ THE MACDOWELL COLONY

100 High St., Peterborough NH, 03458. (603)924-3886. **Fax:** (603)924-9142. **E-mail:** admissions@macdowell colony.org. **Website:** www.macdowellcolony.org. Estab. 1907. Provides creative artists with uninterrupted time and seclusion to work and enjoy the experience of living in a community of gifted artists. Residencies of up to 8 weeks for writers, playwrights, composers, film/video makers, visual artists, architects, and interdisciplinary artists. Artists in residence receive room, board, and exclusive use of a studio. Average length of residency is 1 month. Ability to pay for residency is not a factor; there are no residency fees. Limited funds available for travel reimbursement and artist grants based on need. Application deadlines: January 15: summer (June-September); April 15: fall/winter (October-January); September 15: winter/spring (February-May). Visit website for online application and guidelines. Questions should be directed to the admissions director. Open to writers, playwrights, composers, visual artists, film/video artists, interdisciplinary artists, and architects. Applicants submit information and work samples for review by a panel of experts in each discipline. Application form may be submitted online.

MADELINE ISLAND SCHOOL OF THE ARTS

978 Middle Rd., P.O. Box 536, LaPointe WI, 54850. (715)747-2054. **E-mail:** misa@cheqnet.net. **Website:** www.madelineschool.com. **Contact:** Jenna J. Erickson, director of programs. Workshop tuition $425-760 for 5-day workshops. Lodging and meals are separate, both are provided on-site. Workshops held annually between May-October. Workshops offered in writing, painting, quilting, photography, and yoga. Open to all skill levels. Interested parties should call, e-mail, or see website for more information.

○◑● MAINE MEDIA WORKSHOPS

70 Camden St., P.O. Box 200, Rockport ME, 04856. (207)236-8581 or (877)577-7700. **Fax:** (207)236-2558.

E-mail: info@mainemedia.edu. **Website:** www.mainemedia.edu. "Maine Media Workshops is a nonprofit educational organization offering year-round workshops for photographers, filmmakers, and media artists. Students from across the country and around the world attend courses at all levels, from absolute beginner and serious amateur to working professional; also high school and college students. Professional certificate and low-residency MFA degree programs are available through Maine Media College." See website for the fall calendar.

○◑● WILLIAM MANNING PHOTOGRAPHY

6396 Birchdale Court, Cincinnati OH, 45236. (513)624-8148. **E-mail:** william@williammanning.com. **Website:** www.williammanning.com. Digital photography workshops worldwide with emphasis on travel, nature, and architecture. Offers small group tours. Participants will learn how to photograph with an open mind and shoot with post-production in mind and all of its possibilities. Participants should have a basic knowledge of Adobe Photoshop and own 1 or more plug-ins such as Topaz Adjust, Nik software and/or Auto FX (Mystical Lighting and Ambiance) software. See website for more information and registration.

○◑● JOE & MARY ANN MCDONALD WILDLIFE PHOTOGRAPHY WORKSHOPS AND TOURS

73 Loht Rd., McClure PA, 17841-9340. (717)543-6423. **Fax:** (717)543-5342. **E-mail:** info@hoothollow.com. **Website:** www.hoothollow.com. **Contact:** Joe McDonald, owner. "We are wildlife photographers who not only maintain a huge inventory of stock images for editorial and advertising use, but who have dedicated ourselves to the sharing of photographic and natural history information through our various courses, tours, workshops, and safaris." Offers small group, quality instruction with emphasis on nature and wildlife photography. See website for more information and a list of upcoming workshops.

○◑● MENTOR SERIES ULTIMATE PHOTO ADVENTURE

Bonnier Technology Group, 2 Park Ave., 9th Floor, New York NY, 10016. (888)676-6468; (212)779-5473. **Fax:** (212)779-5508. **E-mail:** michelle.cast@bonnier corp.com. **Website:** www.mentorseries.com. **Contact:** Michelle Cast, brand integration director, Van-

essa Vazquez, 212-779-5475. "For the past 17 years the Mentor Series program has taken photo enthusiasts to destinations across the country and around the world. With top Nikon professional photographers accompanying participants every day and giving advice on how and what to shoot, there is nothing like a Mentor Series trek. You and your photography will never be the same!" Designed to cater to all skill levels. Upcoming locations include: Croatia, Venice, Tampa Sports Video, Nevada Lighting, Costa Rica, Long Island NY, California, Ohio, Grand Tetons, Iceland, Olympic National Park, Quebec, and Vermont. Photographers should call, e-mail, or see website for more information.

○○● MEXICO PHOTOGRAPHY WORKSHOPS

(304)478-3586. **E-mail:** ottercreekphotography@yahoo.com. **Contact:** John Warner. Intensive weeklong, hands-on workshops held throughout the year in the most visually rich, and safest, regions of Mexico. Photograph snow-capped volcanoes, thundering waterfalls, pre-Columbian ruins, botanical gardens, vibrant street life, fascinating people, markets, and colonial churches in jungle, mountain, desert, and alpine environments. Photographers should call or e-mail for more information.

○○● MIDWEST PHOTOGRAPHIC WORKSHOPS

28830 W. Eight Mile Rd., Farmington Hills MI, 48336. (248)471-7299. **E-mail:** officemanager@mpw.com; bryce@mpw.com. **Website:** www.mpw.com. **Contact:** Bryce Denison, owner. Estab. 1970. "One-day weekend and week-long photo workshops, small group sizes and hands-on shooting seminars by professional photographers/instructors on topics such as portraiture, landscapes, nudes, digital, nature, weddings, product advertising, and photojournalism." Workshops held regularly. See website for more information and registration.

MISSOURI PHOTOJOURNALISM WORKSHOP

109 Lee Hills Hall, Columbia MO, 65211. (573)882-4882. **Fax:** (573)884-4999. **E-mail:** reesd@missouri.edu. **Website:** www.mophotoworkshop.org. **Contact:** photojournalism department. Workshop for photojournalists. Participants learn the fundamentals of documentary photo research, shooting, and editing. Held in a different Missouri town each year.

MIXED MEDIA PHOTOGRAPHY

498 Ripka St., Philadelphia PA, 19128. (610)247-9964. **E-mail:** leahwax@aol.com; info@blissbooks.net. **Website:** www.blissbooks.net; www.leahmacdonald.net. **Contact:** Leah Macdonald. Quarterly 2-day workshop; also conducts 1-on-1 workshops with students via personal appointment. "The purpose of the workshop is to alter the surface of the photograph, using organic beeswax and oil paints in multiple forms and techniques to create surface textures and color enhancements that personalize and intensify the photographic image. My mixed-media techniques are used with both traditional darkroom papers and inkjet papers. I encourage creativity and self-expression through image surface enhancement and mixed media techniques to create original one-of-a-kind artwork." Cost: $600; lunch is included, lodging is not. Instructor is available hourly, as well as part-time, for private instruction. Open to all skill levels. Photographers should call, e-mail, or see website for more information.

⊘ MOUNTAIN WORKSHOPS

Western Kentucky University, 1906 College Heights, MMTH 131, Bowling Green KY, 42101-1070. (270)745-8927. **E-mail:** mountainworkshops@wku.edu. **Website:** www.mountainworkshops.org. **Contact:** Jim Bye, workshop coordinator. Annual documentary photojournalism workshop held in October. Open to intermediate and advanced shooters. See website for upcoming dates.

○ TOM MURPHY PHOTOGRAPHY

402 S. Fifth St., Livingston MT, 59047. (406)222-2302; (406)222-2986. **E-mail:** tom@tmurphywild.com. **Website:** tmurphywild.com. **Contact:** Tom Murphy, president. Offers programs in wildlife and landscape photography in Yellowstone National Park and special destinations.

❶ NATURAL HABITAT ADVENTURES

P.O. Box 3065, Boulder CO, 80307. (303)449-3711 or (800)543-8917. **Fax:** (303)449-3712. **E-mail:** info@nathab.com. **Website:** www.nathab.com. Guided photo tours for wildlife photographers. Tours last 7-14 days. Destinations include North America, Latin America, Canada, Galápagos Islands, Africa, and Asia. See website for more information.

◐◑● NEVERSINK PHOTO WORKSHOP

Loujawitz.com, P.O. Box 641, Woodbourne NY, 12788. (212)929-0009. **E-mail:** lhj3@mac.com. **Website:** www.neversinkphotoworkshop.com. **Contact:** Louis Jawitz, owner. Estab. 1986. "Neversink photo workshops concentrate on scenic and nature photography with supervised field trip shooting, as well as portfolio review and critique, discussions related to composition and perspective, technical skills, visual design, using color for impact, exposure control, basic digital workflow, and developing a personal style. Individual or group workshops will be held any day during the summer months, with a possibility of an additional 'Fall Foliage' weekend in October (dates to be determined). See Application page to schedule dates. There will be no private/individual workshops scheduled any day that group workshops are in session." Call, e-mail, or see website for more detailed pricing information and specifics on what all is included in the registration fees.

◑● NEW ENGLAND SCHOOL OF PHOTOGRAPHY

537 Commonwealth Ave., Boston MA, 02215. (617)437-1868 or (800)676-3767. **E-mail:** info@nesop.edu. **Website:** www.nesop.edu. Instruction in professional and creative photography in the form of workshops or a professional photography program. See website for details on individual workshops.

◐◑● NIKON SCHOOL | EDUCATE + INSPIRE

1300 Walt Whitman Rd., Melville NY, 11747. (631)547-8666. **Fax:** (631)547-0309. **E-mail:** nikonschool@nikon.net. **Website:** www.nikonschool.com. Photo education classes located in 25 major US cities with a variety of half-day ($99) and full-day ($159) classes including: Action & People Photography, Elements of Photography, to Landscape and Travel Photography, Creative Lighting, and SSLR Video-Gaming Control. For more information and to register, visit www.nikonschool.com, call (800)645-6687, or e-mail nikonschool@nikon.net.

◑● NORTHERN EXPOSURES

305 SE Chkalov Drive, Suite 111, #244, Vancouver WA, 98683. **E-mail:** abenteuerbc@yahoo.com. **Contact:** Linda Moore, director. Offers 3- to 8-day intermediate to advanced nature photography workshops in several locations in Pacific Northwest and western Canada; spectacular settings including coast, alpine, badlands, desert, and rain forest. Also, 1- to 2-week Canadian Wildlife and Wildlands Photo Adventures and nature photo tours to extraordinary remote wildlands of British Columbia, Alberta, Saskatchewan, and Yukon.

◐◑● NYU TISCH SCHOOL OF THE ARTS

Department of Photography & Imaging, 721 Broadway, 8th Floor, New York NY, 10003. (212)998-1930. **E-mail:** photo.tsoa@nyu.edu. **Website:** www.photo.tisch.nyu.edu. **Contact:** Department of Photography and Imaging. Summer classes offered for credit and noncredit covering digital imaging, career development, basic to advanced photography, darkroom techniques, photojournalism, and human rights & photography. Open to all skill levels.

◐◑● OREGON COLLEGE OF ART AND CRAFT

8245 SW Barnes Rd., Portland OR, 97225. (503)297-5544 or (800)390-0632. **Fax:** (503)297-9651. **E-mail:** admissions@ocac.edu; lradford@ocac.edu. **Website:** www.ocac.edu. Offering MFA, BFA and Post Baccalaureate in Craft, MFA in Applied Craft + Design (a joint program of OCAC and PNCA), continuing education for adults and children. For schedule information, call or visit website.

◐◑● PACIFIC NORTHWEST ART SCHOOL/PHOTOGRAPHY

15 NW Birch St., Coupeville WA, 98239. (360)678-3396. **E-mail:** info@pacificnorthwestartschool.org. **Website:** www.pacificnorthwestartschool.org. **Contact:** Registrar. "Join us on beautiful Whidbey Island and enjoy high-quality photography instruction from our renowned visiting faculty including Sam Abell, Sean Kernan, Arthur Meyerson, and many more." Workshops held April-October, 2-6 days in duration.

◐◑● PALM BEACH PHOTOGRAPHIC CENTRE

415 Clematis St., West Palm Beach FL, 33401. (561)253-2600. **Fax:** (561)253-2604. **E-mail:** info@workshop.org. **Website:** www.workshop.org. The Centre is an innovative learning facility offering photography classes, workshops, and seminars, and digital imaging year round. Also offered are travel

workshops to cultural destinations such as South Africa, Bhutan, Myanmar, Peru, and India. Emphasis is on photographing the indigenous cultures of each country. Also hosts the annual Fotofusion event (see separate listing in this section). Photographers should call for details.

○○● RALPH PAONESSA PHOTOGRAPHY WORKSHOPS

509 W. Ward Ave., Suite B108, Ridgecrest CA, 93555-2542. (760)384-8666. **E-mail:** ralph@rpphoto.com. **Website:** www.rpphoto.com. **Contact:** Ralph Paonessa, director. Estab. 1997. Various workshops repeated annually. Nature, bird, and landscape trips to the Eastern Sierra, Death Valley, Falkland Islands, Alaska, Costa Rica, Ecuador, and many other locations. Open to all skill levels. Upcoming workshop: "Ecuador Hummingbirds," September 21-October 1 in Quito. See website for more information.

❂○○● FREEMAN PATTERSON PHOTO WORKSHOPS

Shamper's Cove Limited, 3487 Rt. 845, Long Reach New Brunswick, E5S 1X4, Canada. (506)763-2189. **Fax:** (506)763-2035. **E-mail:** freepatt@nbnet.nb.ca. **Website:** www.freemanpatterson.com. Freeman made several visits to Africa between 1967 and 1983, three of them at the request of the Photographic Society of Southern Africa. As a result of these contacts and others, he co-founded (with Colla Swart) the Namaqualand Photographic Workshops in 1984, and travels to the desert village of Kamieskroon once or twice a year to teach 3 or 4 week-long workshops. This project has expanded so rapidly that Freeman now works with several other instructors and no longer participates in every program. Freeman has also given numerous week-long workshops in the US, New Zealand, and Israel, and has completed lecture tours in the United Kingdom, South Africa, and Australia. See website for more information and a list of upcoming workshops.

○○● PHOTO EXPLORER TOURS

2506 Country Village, Ann Arbor MI, 48103-6500. (734)996-1440. **E-mail:** decoxphoto@gmail.com. **Website:** www.photoexplorertours.com. **Contact:** Dennis Cox, director. Scheduled group photographic explorations of Turkey and other select destinations to be announced.

○● PHOTOGRAPHIC ARTS WORKSHOPS

P.O. Box 1791, Granite Falls WA, 98252. (360)691-4105. **Fax:** (360)691-4105. **E-mail:** photoartswrkshps@aol.com. **Website:** www.barnbaum.com. **Contact:** Bruce Barnbaum, Sonia Thompson. Estab. 1975. To get details on the workshops, please check the website at www.barnbaum.com, and click on Workshops. If you have any questions on these or other workshops on the program, e-mail barnbaum@aol.com or phone 360-691-4105.

PHOTOGRAPHIC CENTER NORTHWEST

900 12th Ave., Seattle WA, 98122. (206)720-7222. **E-mail:** pcnw@pcnw.org; jbrendicke@pcnw.org. **Website:** www.pcnw.org. **Contact:** Susan Hood, marketing manager. Frequent day and evening classes and workshops in fine art photography (b&w, color, digital) for photographers of all skill levels; accredited certificate program. See website for more information and a listing of upcoming lectures and public programming. We also have a renowned photography gallery, photographic rental facilities for the public and professionals, and artist support programs.

○● PHOTOGRAPHY AT THE SUMMIT: JACKSON HOLE

Clarkson Creative, 1553 Platte St., Suite 300, Denver CO, 80302. (303)295-7770 or (800)745-3211. **Fax:** (303)295-7771. **E-mail:** info@richclarkson.com; chris@clarkson-creative.com; workshops@clarkson-creative.com. **Website:** www.photographyatthesummit.com. **Contact:** Chris Steppig, workshop director. Estab. 30 years. Photography at the Summit: Annual workshop held in the fall. Weeklong workshop with top journalistic, nature, and illustrative photographers and editors. See website for more information.

Adventure Photography Workshop: Annual workshop held in the fall. Weeklong workshop focused on photographing adventure sports, portraits, and lifestyle. Taught by adventure photographers and editors. See website for more information.

◐○○● PHOTOGRAPHY IN PROVENCE

La Maison Claire, Rue du Buis, Ansouis 84240, France. **E-mail:** andrew@photography-provence.com. **Website:** www.photography-provence.com. **Contact:** Andrew Squires, M.A. Workshops May to October.

Theme: What to Photograph and Why? Designed for people who are looking for a subject and an approach they can call their own. Explore photography of the real world, the universe of human imagination, or simply let yourself discover what touches you. Explore Provence and photograph on location. Possibility to extend your stay and explore Provence if arranged in advance. Open to all skill levels. E-mail for workshop dates and more information.

◑◑ PHOTOZONETOURS

E-mail: lk@laynekennedy.com. **Website:** www.photo zonetours.com. Mark Alberhasky. **Contact:** Layne Kennedy. Estab. 2003. Workshops & Photo Tours Worldwide. Schedule includes Iceland, Italy, Costa Rica, Cuba Belize, Ireland, Dogsledding, North Shore Lake Superior, and Minneapolis. For all levels, experienced to beginner. Visit website for prices and description of specific workshops. Creating photo tours worldwide for editorial-minded photographers and writers.

◑◐ PRAGUE SUMMER SEMINARS

Division of International Education, 2000 Lakeshore Dr., International Center 124, University of New Orleans, New Orleans LA, 70148. (504)280-6388. **E-mail:** prague@uno.edu. **Website:** inst.uno. edu/Prague. **Contact:** Mary I. Hicks, program director. Estab. 1994. Challenging courses which involve studio visits, culture series, excursions within Prague and field trips to Vienna, Austria, and Cesky Krumlov, Bohemia. Open to beginners and intermediate photographers. Photographers should call, e-mail, or see website for more information.

⊘ PROFESSIONAL PHOTOGRAPHERS' SOCIETY OF NEW YORK STATE PHOTO WORKSHOPS

2175 Stuyvesant St., Niskayuna NY, 12309. (518)377-5935. **E-mail:** tmmack7@gmail.com; linda@ppsnysworkshop.com. **Website:** www.ppsnysworkshop.com. **Contact:** Tom Mack, director. Weeklong, specialized, hands-on workshops for professional photographers in mid-July. See website for more information.

◐◐● ROCKY MOUNTAIN CONSERVANCY-FIELD INSTITUTE

1895 Fall River Rd., Estes Park CO, 80517. (970)586-3262. **E-mail:** fieldinstitute@rmconservancy.org; rachel.balduzzi@rmconservancy.org. **Website:** www.

rmconservancy.org. Rachel Balduzzi, education director and NGF manager. **Contact:** Rachel Balduzzi. Day and weekend classes covering photographic techniques for wildlife and scenics in Rocky Mountain National Park. Professional instructors include W. Perry Conway, Don Mammoser, Eli Vega, John Fielder, and Lee Kline. Call or e-mail for a free class catalog listing over 200 classes.

○◐● ROCKY MOUNTAIN SCHOOL OF PHOTOGRAPHY

216 N. Higgins, Missoula MT, 59802. (406)543-0171 or (800)394-7677. **Fax:** (406)721-9133. **E-mail:** rmsp@rmsp.com. **Website:** www.rmsp.com. "RMSP offers three types of photography programs: Career Training, Workshops, and Photo Weekend events. There are varied learning opportunities for students according to their individual goals and educational needs. In a noncompetitive learning environment, we strive to instill confidence, foster creativity, and build technical skills."

○◐● SANTA FE PHOTOGRAPHIC WORKSHOPS

Santa Fe Photographic Workshops, 50 Mt. Carmel Rd., Fatima Hall, Santa Fe NM, 87505. (505)983-1400. **Fax:** (505)989-8604. **E-mail:** info@santafeworkshops.com; carrie@santafeworkshops.com. **Website:** www.santafeworkshops.com. Over 120 week-long workshops encompassing all levels of photography and more than 35 digital lab workshops and 12 week-long workshops in Mexico—all led by top professional photographers. The workshops campus is located near the historic center of Santa Fe. Call or e-mail to request a free catalog.

◓ SANTORINI BOUDOIR AND FASHION PHOTOGRAPHY WORKSHOPS

Fyra Santorini Island, 84700, Greece. (0030) 6944-257-125. **E-mail:** giannisangelou@gmail.com. **Website:** www.santoriniboudoir.com; www.santorini workshops.com. **Contact:** John G. Angelou. Estab. 2007. See website for details on workshop dates and prices. Workshops held year-round. Offers boudoir photography workshops, from small groups (mainly 3-5 participants). Fashion and portrait, family, couples photography workshops also available. Custom photography workshops available upon request. See website for more information.

○○● SELLING YOUR PHOTOGRAPHY

1684 Decoto Rd., #271, Union City CA, 94587. **E-mail:** maria@mpiscopo.com. **Website:** www.mpiscopo.com. **Contact:** Maria Piscopo. 1-day workshops cover techniques for pricing, marketing, and selling art and photography services. Open to photographers and creative professionals of all skill levels. See website for dates and locations. Maria Piscopo is the author of *Photographer's Guide to Marketing & Self-Promotion*, 4th edition (Allworth Press).

○○ JOHN SEXTON PHOTOGRAPHY WORKSHOPS

P.O. Box 30, Carmel Valley CA, 93924. (831)659-3130. **Fax:** (831)659-5509. **E-mail:** info@johnsexton.com. **Website:** www.johnsexton.com. **Contact:** John Sexton, director; Anne Larsen, associate director. Offers a selection of intensive workshops with master photographers in scenic locations throughout the US. All workshops offer a combination of instruction in the aesthetic and technical considerations involved in making expressive b&w prints. Instructors include John Sexton, Charles Cramer, Ray McSavaney, Anne Larsen, and others.

○○ THE SHOWCASE SCHOOL OF PHOTOGRAPHY

1135 Sheridan Rd. NE, Atlanta GA, 30324. (404)965-2205. **E-mail:** staff@theshowcaseschool.com; jan@theshowcaseschool.com. **Website:** www.theshowcaseschool.com. Estab. 1996. This community education program provides an easy, affordable, and non-pressure way to explore the art and craft of photography and video through hands-on classes and workshops. See website for upcoming dates.

● SKELLIG PHOTO TOURS

00353 66 9479022. **E-mail:** michaelherrmann@email.de. **Website:** www.skelligphototours.com. **Contact:** Michael Herrmann. Several photography workshops held throughout the year and on demand. Learn new, or improve, your photography skills through landscape photography in the magic scenery of Kerry. Exposure, composition, low-light photography, and a variety of technical and artistic aspects of photography will be covered according to your needs; Also, photo editing in Photoshop and Lightroom. Open to all skill levels. If you are in the mood for the Irish experience, e-mail or see website for more information.

SOHN FINE ART—MASTER ARTIST WORKSHOPS

6 Elm St., 1B-C, Stockbridge MA, 01230. (413)298-1025. **E-mail:** info@sohnfineart.com. **Website:** www.sohnfineart.com. **Contact:** Cassandra Sohn, owner. Workshops held every 1-3 months, taught by our represented master artists. Cost: $100-500, depending on the workshop (meals and lodging not included). Frequent areas of concentration are unique workshops within the photographic field. This includes all levels of students: beginner, intermediate, and advanced, as well as Photoshop and Lightroom courses, alternative process courses and many varieties of traditional and digital photography courses. Interested parties should call, e-mail, or see the website for more information.

○○● SOUTH SHORE ART CENTER

119 Ripley Rd., Cohasset MA, 02025. (781)383-2787. **Fax:** (781)383-2964. **E-mail:** info@ssac.org. **Website:** www.ssac.org. South Shore Art Center is a non-profit organization based in the coastal area south of Boston. The facility features appealing galleries and teaching studios. Offers exhibitions and gallery programs, sales of fine art and studio crafts, courses and workshops, school outreach, and special events. See website for more information and a list of upcoming workshops and events.

○○ SPORTS PHOTOGRAPHY WORKSHOP: COLORADO SPRINGS, COLORADO

Clarkson Creative, 1553 Platte St., Suite 300, Denver CO, 80302. (303)295-7770 or (800)745-3211. **Fax:** (303)295-7771. **E-mail:** chris@clarkson-creative.com. **Website:** www.sportsphotographyworkshop.com. **Contact:** Chris Steppig, administrator. Annual workshop held in midsummer. Weeklong workshop in sports photography at the US Olympic Training Center with *Sports Illustrated* and Associated Press photographers and editors. See website for more information.

○○● SYNERGISTIC VISIONS WORKSHOPS

Colorado Canyons Gallery, 623 Main St., Grand Junction CO, 81501. (970)314-2054. **E-mail:** steve@synvis.com. **Website:** www.ccgal.com. **Contact:** Steve Traudt. Estab. 1980. Through Colorado Canyons Gallery, offers a variety of digital photography, Lightroom, and

Photoshop classes at various venues in Grand Junction, Moab, Ouray, and others. "Steve is also available to present day-long photo seminars to your group." See website for more information and upcoming workshops.

◐◑● TEXAS SCHOOL OF PROFESSIONAL PHOTOGRAPHY

(806)296-2276. **Fax:** (979)272-5201. **E-mail:** Don@texasschool.org. **Website:** texasschool.org. **Contact:** Don Dickson, director. 25 different classes offered, including portrait, wedding, marketing, background painting and video. See website for more information and a list of upcoming workshops.

◐◑● THE THIRD EYE PHOTOGRAPHIC ADVENTURES AND WORKSHOPS

(404)876-6341. **E-mail:** workshop.inquiry@thethirdeyephoto.com. **Website:** www.thethirdeyephoto.com. **Contact:** Robin Davis, instructor; Kathryn Kolb, instructor. Estab. 2012. "Workshops held year-round; check our online schedule. Concentrates on inspirational places, memorable experiences, personal instruction. Our purpose is to empower the connection between in-camera decisions and the personal creative goals of our students, while having a great time in amazing and often mysterious locations. Costs vary depending on the locations and number of days, and cover unique personalized instruction, and typically do not include meals or lodging. Open to all skill levels. Interested parties should call, e-mail, or see our website for more information."

TRIPLE D GAME FARM

P.O. Box 5072, Kalispell MT, 59903. (406)755-9653. **Fax:** (406)755-9021. **E-mail:** info@tripledgamefarm.com. **Website:** www.tripledgamefarm.com. **Contact:** Triple D office and staff. "We raise wildlife and train our species for photographers, artists, and cinema. Wolves, bears, mountain lions, bobcats, lynx, tigers, snow leopards, coyotes, fox, fisher, otter, porcupine, and more are available." Open to all skill levels. Interested parties should write, call, e-mail, or see website for more information.

◐◑● JOSEPH VAN OS PHOTO SAFARIS, INC.

P.O. Box 655, Vashon Island WA, 98070. (206)463-5383. **Fax:** (206)463-5484. **E-mail:** info@photosafaris.com. **Website:** www.photosafaris.com. **Contact:** Joseph Van Os, director. Offers over 50 different photo tours and workshops worldwide. At least 1 tour offered each month; several tours already planned. See website for more details and a list of all upcoming tours.

◐◑● VIRGINIA CENTER FOR THE CREATIVE ARTS (VCCA)

154 San Angelo Dr., Amherst VA, 24521. (434)946-7236. **Fax:** (434)946-7239. **E-mail:** vcca@vcca.com. **Website:** www.vcca.com. VCCA is an international working retreat for writers, visual artists, and composers. Situated on 450 acres in the foothills of the Blue Ridge Mountains of central Virginia, VCCA offers residential fellowships ranging from 2 weeks to 2 months. VCCA can accommodate 25 fellows at a time and provides private working and living quarters and all meals. There is one fully equipped b&w darkroom at VCCA. Artists provide their own materials. VCCA application and work samples required. Call or see website for more information. Application deadlines: January 15, May 15, and September 15 each year.

◐◑● VISION QUEST PHOTO WORKSHOPS

Douglas Beasley Photography, 2370 Hendon Ave., St. Paul MN, 55108-1453, USA. (651)644-1400. **E-mail:** info@douglasbeasley.com. **Website:** www.vqphoto.com. Sarah Rust Sampedro. **Contact:** Douglas Beasley, director. Estab. 1991. Annual workshops held January through November. Hands-on photo workshops that emphasize content, vision, and creativity over technique or gimmicks. Workshops held in a variety of national and international locations. Open to all skill levels. Upcoming workshops: Zen and the Art of Photography in Rockport ME; Breitenbush Hot Springs OR; Woodstock NY; Renewing Your Creative Spirit, Trade River Retreat Center WI. Photographers should e-mail or visit website for more information.

◐● VISUAL ARTISTRY WORKSHOP SERIES

P.O. Box 963, Eldersburg MD, 21784. (410)552-4664. **Fax:** (410)552-3332. **E-mail:** tony@tonysweet.com; susan@tonysweet.com. **Website:** tonysweet.com. **Contact:** Tony Sweet; Susan Milestone. 5-day workshops, limit 6-10 participants. Extensive personal attention and instructional slide shows. Post-workshop support and image critiques for 6 months after the workshop (for an additional fee). Frequent attendees discounts and inclement weather discounts on subsequent workshops. Dealer discounts available from

major vendors. "The emphasis is to create in the participant a greater awareness of composition, subject selection, and artistic rendering of the natural world using the raw materials of nature: color, form, and line." Open to intermediate and advanced photographers. See website for more information.

◐◑● WILDLIFE PHOTOGRAPHY WORKSHOPS AND LECTURES

Len Rue Enterprises, LLC, 138 Millbrook Rd., Blairs town NJ, 07825. (908)362-6616. **E-mail:** rue@rue.com. **Website:** www.rue.com; www.rueimages.com. **Contact:** Len Rue, Jr.. Taught by Len Rue, Jr., who has over 35 years experience in outdoor photography by shooting photographic stock for the publishing industry. Also leads tours and teaches photography.

●◐◑◐○◐● WILD MADAGASCAR, SEPT 15-30, 2017

2701 Del Paso Rd. Suite 130-113, Sacramento CA, 95835. (916)690-6251. **E-mail:** workshops@jenniferwu.com. **Website:** www.jenniferwu.com. **Contact:** Jennifer Wu, owner/tour leader/photographer. "Madagascar is one of the wonders of the world and home to an amazing variety of strange and beautiful endemic animals in surroundings that are close to being other worldly. Join top photographers Jim Martin and Jennifer Wu on this exceptionally special trip as they lead you through the country capturing an amazing variety of strange and beautiful endemic animals. Your tour leaders know where to get the best shots, and they will also give you in the field demos and compositional guidance to enhance the way you see and shoot. This workshop will focus on landscapes and animals in both the wild and contained environments. These animals are not your typical zoo collection. In the land of the indri we will have the opportunities to photograph animals such as the lemur, which resembles a panda that sounds like a humpback whale. We will also photograph thumbnail-sized ground-dwelling Brookesia, to meter-long species that pluck birds out of the air with their tongues, to a collection of thousands of chameleons, and even leaf-tailed geckos and white sifaka lemurs. The photographic opportunities are endless on this exceptional workshop. This tour is intended for intermediate and advanced photographers; however, any skill level is welcome and will enjoy Madagascar's photographic opportunities. Participants should have a working knowledge of

their equipment. Jennifer Wu and James Martin have led dozens of photo tours and workshops domestically and around the world. Jennifer is a Canon Explorer of Light and James has produced more than 20 books. Together they collaborated on *Photography Night Sky* (Mountaineer Books), one of Amazon's most popular books on landscape photography. " E-mail or see website for more information.

◐◑● WILD PHOTO ADVENTURES TV SHOW

2035 Buchanan Rd., Manning SC, 29102. (803)460-7705. **E-mail:** doug@totallyoutdoorsimaging.com. **Website:** www.wildphotoadventures.com. **Contact:** Doug Gardner, host/photographer/cinematographer. "*Wild Photo Adventures* is the only wildlife and nature photography television show of its kind to ever be aired. Join us each week as we travel around the globe to great locations to photograph wildlife, its behavior and its environment. Each week, we will show you where to go, how to find wild subjects, and how to photograph them in new and creative ways. *Wild Photo Adventures* delivers exciting and educational entertainment for anyone who has a love for the great outdoors or photography. Tag along with host Doug Gardner through adverse conditions and terrain in search of that one great photograph. Take a look behind the scenes at what it takes to be a professional nature photographer. Learn new tips and techniques that will bring life back into your photographs. Contact your local PBS station for air dates/times, or watch all the episodes online at www.wildphoto adventures.com/watchshow.html."

THE HELENE WURLITZER FOUNDATION

P.O. Box 1891, Taos NM, 87571. (575)758-2413. **Fax:** (575)758-2559. **E-mail:** hwf@taosnet.com. **Website:** www.wurlitzerfoundation.org. **Contact:** Michael A. Knight, executive director. Estab. 1954. The foundation offers residencies to artists in the following creative fields: visual and literary arts and music composition. There are 2 12-week sessions from mid-January through mid-April, early September-early December, and 1-10 week session from early June to mid-August. Application deadline: January 18 for following year. For application, request by e-mail or visit website to download. Foundation offers 10- and 12-week residencies. Request application by e-mail or visit website to download.

◑● YADDO

The Corporation of Yaddo Residencies, P.O. Box 395, 312 Union Ave., Saratoga Springs NY, 12866. (518)584-0746. **Fax:** (518)584-1312. **E-mail:** chwait@yaddo.org. **Website:** www.yaddo.org. **Contact:** Candace Wait, program director. Estab. 1900. Offers residencies in 2 seasons: large season is May-August; small season is October-May (stays from 2 weeks to 2 months; average stay is 5 weeks). Accepts 230 artists/year. Accommodates approximately 35 artists in large season. "Those qualified for invitations to Yaddo are highly qualified writers, visual artists (including photographers), composers, choreographers, performance artists, and film and video artists who are working at the professional level in their fields. Artists who wish to work collaboratively are encouraged to apply. An abiding principle at Yaddo is that applications for residencies are judged on the quality of the artists' work and professional promise." Site includes four small lakes, a rose garden, woodland, swimming pool, tennis courts. Yaddo's nonrefundable application fee is $30, to which is added a fee for media uploads ranging from $5-10 depending on the discipline. Application fees must be paid by credit card. 2 letters of recommendation are requested. All application materials, including contact information, résumé, work sample, and reference letter, must be submitted online. Applications are considered by the Admissions Committee and invitations are issued by March 15 (deadline: January 1) and October 1 (deadline: August 1). Information available on website.

◐◑● YELLOWSTONE ASSOCIATION INSTITUTE

P.O. Box 117, Yellowstone National Park WY, 82190. (406)848-2400. **Fax:** (406)848-2847. **E-mail:** registrar@yellowstoneassociation.org. **Website:** www.yellowstoneassociation.org. Offers workshops in nature and wildlife photography during the summer, fall, and winter. Custom courses can be arranged. Photographers should see website for more information.

◐◑● YOSEMITE CONSERVANCY OUTDOOR ADVENTURES

P.O. Box 230, El Portal CA, 95318. (209)379-2646. **Fax:** (209)379-2486. **E-mail:** info@yosemiteconservancy.org; kchappell@yosemiteconservancy.org. **Website:** www.yosemiteconservancy.org. Offers workshops year round in Yosemite National Park with programs ranging from birding, snowshoeing, family programs, natural history, backpack treks, photography workshops, and cultural programs. Please see our website for our full schedule along with information on our custom trips.

STOCK PHOTOGRAPHY PORTALS

//

These sites market and distribute images from multiple agencies and photographers.

AGPix www.agpix.com
Alamy www.alamy.com
Find a Photographer www.asmp.org/find-a-photographer
Getty Images www.gettyimages.com
iStock www.istockphoto.com
PhotoSource International www.photosource.com
Shutter Stock www.shutterstock.com
Workbook Stock www.workbook.com

PORTFOLIO REVIEW EVENTS

Portfolio review events provide photographers the opportunity to show their work to a variety of photo buyers, including photo editors, publishers, art directors, gallery representatives, curators, and collectors.

Art Directors Club, International Annual Awards Exhibition, New York City, www.adc global.org

Atlanta Celebrates Photography, held annually in October, Atlanta, GA, www.acpinfo.org

The Center for Photography at Woodstock, New York City, www.cpw.org

Festival of Light, an international collaboration of twenty photography festivals, www.festivaloflight.net

Fotofest, March, biennial—held in even-numbered years, Houston, TX, www.fotofest.org

FOTOfusion, January, West Palm Beach, FL, www.fotofusion.org

The North American Nature Photography Association, annual summit held in January. Location varies. www.nanpa.org

Photo LA, January, Los Angeles, CA, www.photola.com

Photolucida, March, biennial—held in odd-numbered years, Portland, OR, www.photolucida. org

The Print Center, events held throughout the year, Philadelphia, PA, www.printcenter.org

Review Santa Fe, Summer, the only juried portfolio review event, Santa Fe, NM, visitcenter.org

Society for Photographic Education National Conference, March, different location each year, www.spenational.org

GRANTS

State, Provincial, & Regional

///

Arts councils in the United States and Canada provide assistance to artists (including photographers) in the form of fellowships or grants. These grants can be substantial and confer prestige upon recipients; however, only state or province residents are eligible. Because deadlines and available support vary annually, query first (with a SASE) or check websites for guidelines.

UNITED STATES ARTS AGENCIES

Alabama State Council on the Arts, 201 Monroe St., Montgomery AL 36130-1800. (334)242-4076. E-mail: staff@arts.alabama.gov. Website: alabamaarts.egrant.net.

Alaska State Council on the Arts, 161 S. Klevin St., Suite 102, Anchorage AK 99508-1506. (907)269-6610 or (888)278-7424. E-mail: aksca.info@alaska.gov. Website: http://education/aslaska.gov/aksca.

Arizona Commission on the Arts, 417 W. Roosevelt St., Phoenix AZ 85003-1326. (602)771-6501. E-mail: info@azarts.gov. Website: www.azarts.gov.

Arkansas Arts Council, 1100 North St., Little Rock AR 72201. (501)324-9766. E-mail: online form. Website: www.arkansasarts.org.

California Arts Council, 1300 I St., Suite 930, Sacramento CA 95814. (916)322-6555 or (800)201-6201. E-mail: info@arts.ca.gov. Website: www.cac.ca.gov.

Colorado Creative Industries, 1625 Broadway, Suite 2700, Denver CO 80202. (303)892-3840. E-mail: online form. Website: www.coloradocreativeindustries.org.

Connecticut Office of Culture & Tourism, One Constitution Plaza, 2nd Floor, Hartford CT 06103. (860)256-2800. Website: www.cultureandtourism.org.

Delaware Division of the Arts, Carvel State Office Bldg., 4th Floor, 820 N. French St., Wilmington DE 19801-3509. (302)577-8278. E-mail: delarts@state.de.us. Website: www.artsdel.org.

District of Columbia Commission on the Arts and Humanities, 200 I St. SE, Washington DC 20003. (202)724-5613. E-mail: cah@dc.gov. Website: www.dcarts.dc.gov.

Florida Division of Cultural Affairs, R.A. Gray Building, 500 S. Bronough St., Tallahassee FL 32399-0250. (850)245-6470. E-mail: info@florida-arts.org. Website: www.florida-arts.org.

Georgia Council for the Arts, 75 Fifth St. NW, Suite 1200, Atlanta GA 30308. (404)685-2787. E-mail: gaarts@gaarts.org. Website: www.gaarts.org.

Guam Council on the Arts & Humanities Agency, P.O. Box 2950, Hagatna, Guam 96932. (671)300-1204/1205/1206/1207/1208. E-mail: info@caha.guam.gov. Website: www.guamcaha.org.

Hawai'i State Foundation on Culture and the Arts, 250 S. Hotel St., 2nd Floor, Honolulu HI 96813. (808)586-0300. Website: http://sfca.hawaii.gov

Idaho Commission on the Arts, 2410 Old Penitentiary Rd., Boise ID 83712. (208)334-2119 or (800)278-3863. E-mail: info@arts.idaho.gov. Website: www.arts.idaho.gov.

Illinois Arts Council Agency, James R. Thompson Center, 100 W. Randolph St., Suite 10-500, Chicago IL 60601-3230. (312)814-6750 or (800)237-6994. E-mail: iac.info@illinois.gov. Website: www.arts.illinois.gov.

Indiana Arts Commission, 100 N. Senate Ave., Room N505, Indianapolis IN 46204. (317)232-1268. E-mail: IndianaArtsCommission@iac.in.gov. Website: www.in.gov/arts.

Iowa Arts Council, 600 E. Locust St., Des Moines IA 50319-0290. (515)242-6194. Website: www.iowaartscouncil.org.

Kansas Creative Arts Industries Commission, 1000 Jackson St., Suite 100, Topeda KS 66612. (785)296-2178. E-mail: pjasso@kansascommerce.com. Website: www.kansascommerce.com/caic.

Kentucky Arts Council, 1025 Capital Center Dr., 3rd Floor, Frankfort KY 40601. (502)564-3757 or (888)833-2787. E-mail: kyarts@ky.gov. Website: www.artscouncil.ky.gov.

Louisiana Division of the Arts, P.O. Box 44247, Baton Rouge LA 70804-4247. (225)342-8180. Website: www.crt.state.la.us/cultural-development/arts.

Maine Arts Commission, 193 State St., 25 State House Station, Augusta ME 04333-0025. (207)287-2724. E-mail: MaineArts.info@maine.gov. Website: http://mainearts.maine.gov.

Maryland State Arts Council, 175 W. Ostend St., Suite E, Baltimore MD 21230. (410)767-6555. E-mail: msac@msac.org. Website: www.msac.org.

Massachusetts Cultural Council, 10 St. James Ave., 3rd Floor, Boston MA 02116-3803. (617)727-3668. E-mail: mcc@art.state.ma.us. Website: www.massculturalcouncil. org.

Missouri Arts Council, 815 Olive St., Suite 16, St. Louis MO 63101-1503. (314)340-6845 or (866)407-4752. E-mail: moarts@ded.mo.gov. Website: www.missouriartscouncil. org.

Montana Arts Council, P.O. Box 202201, Helena MT 59620-2201. (406)444-6430. E-mail: mac@mt.gov. Website: www.art.mt.gov.

National Assembly of State Arts Agencies, 1200 18th St. NW, Suite 1100, Washington DC 20036. (202)347-6352. E-mail: nasaa@nasaa-arts.org. Website: www.nasaa-arts.org.

Nebraska Arts Council, 1004 Farnam St., Burlington Bldg., Plaza Level, Omaha NE 68102. (402)595-2122 or (800)341-4067. E-mail: nac.info@nebraska.gov. Website: www. artscouncil.nebraska.gov.

Nevada Arts Council, 716 N. Carson St., Suite A, Carson City NV 89701. (775)687-6680. E-mail: infonvartscouncil@nevadaculture.org. Website: nac.nevadaculture.org.

New Hampshire State Council on the Arts, 19 Pillsbury St., 1st Floor, Concord NH 03301. (603)271-3584. Website: www.nh.gov/nharts.

New Jersey State Council on the Arts, P.O. Box 306, Trenton NJ 08608. (609)292-6130. Website: www.artscouncil.nj.gov.

New Mexico Arts, Bataan Memorial Building, 407 Galisteo St., Suite 270, Santa Fe NM 87501. (505)827-6490 or (800)879-4278. Website: www.nmarts.org.

New York State Council on the Arts, 300 Park Ave. S., 10th Floor, New York NY 10010. (212)459-8800. Website: www.nysca.org.

North Carolina Arts Council, 109 E. Jones St., Cultural Resources Building, Raleigh NC 27601. (919)807-6500. E-mail: ncarts@ncdcr.gov. Website: www.ncarts.org.

North Dakota Council on the Arts, 1600 E. Century Ave., Suite 6, Bismarck ND 58503-0649. (701)328-7590. Website: www.nd.gov/arts.

Ohio Arts Council, 30 E. Broad St., 33rd Floor, Columbus OH 43215-3414. (614)466-2613. Website: www.oac.state.oh.us.

Oklahoma Arts Council, Jim Thorpe Building, 2101 N. Lincoln Blvd., Suite 640, Oklahoma City OK 73152-2001. (405)521-2931. E-mail: okarts@arts.ok.gov. Website: www.arts.ok.gov.

Pennsylvania Council on the Arts, 216 Finance Bldg., Commonwealth and North Streets, Harrisburg PA 17120. (717)787-6883. Website: www.arts.pa.gov.

Institute of Puerto Rican Culture, P.O. Box 9024184, San Juan, Puerto Rico 00902-4184. (787)724-0700. E-mail: mgarcia@icp.gobierno.pr. Website: www.icp.gobierno.pr.

South Carolina Arts Commission, 1026 Sumter St., Suite 200, Columbia SC 29201. (803)734-8696. Website: www.southcarolinaarts.com.

South Dakota Arts Council, 711 E. Wells Ave., Pierre SD 57501-3369. (605)773-3301. E-mail: sdac@state.sd.us. Website: www.artscouncil.sd.gov.

Tennessee Arts Commission, 401 Charlotte Ave., Nashville TN 37243-0780. (615)741-1701. Website: http://tnartscommission.org.

Utah Division of Arts & Museums, 617 E. South Temple, Salt Lake City UT 84102-1177. (801)236-7555. Website: www.heritage.utah.gov/arts-and-museums/ops-grants.

Vermont Arts Council, 136 State St., Montpelier VT 05633-6001. (802)828-3291. E-mail: online form. Website: www.vermontartscouncil.org.

Virgin Islands Council on the Arts, 5070 Norre Gade, Suite 1, St. Thomas, Virgin Islands 00802-6876. (340)774-5984. Website: www.vicouncilonarts.org.

Virginia Commission for the Arts, 600 East Main St., Suite 330, Richmond VA 23219. (804)225-3132. E-mail: arts@vca.virginia.gov. Website: www.arts.virginia.gov.

Washington State Arts Commission, 711 Capitol Way S., Suite 600, P.O. Box 42675, Olympia WA 98504-2675. (360)753-3860. E-mail: online form. Website: www.arts.wa.gov.

West Virginia Commission on the Arts, The Cultural Center, Capitol Complex, 1900 Kanawha Blvd. E., Charleston WV 25305-0300. (304)558-0240. Website: www.wvculture.org/arts.

Wisconsin Arts Board, Tommy G. Thompson Commerce Bldg., 201 W. Washington Ave., Madison WI 53703. (608)266-0190. E-mail: artsboard@wisconsin.gov. Website: http://artsboard.wisconsin.gov.

Wyoming Arts Council, 2301 Central Ave., Barrett Bldg., 2nd Floor, Cheyenne WY 82002. (307)777-7742. E-mail: online form. Website: http://wyoarts.state.wy.us.

CANADIAN PROVINCES ARTS AGENCIES

Alberta Foundation for the Arts, 10708 - 105 Ave., Edmonton, Alberta T5H 0A1. (780)427-9968. E-mail: online form. Website: www.affta.ab.ca.

British Columbia Arts Council, P.O. Box 9819, Stn. Prov. Govt., Victoria, British Columbia V8W 9W3. (250)356-1718. E-mail: BCArtsCouncil@gov.bc.ca. Website: www.bcartscouncil.ca.

Canada Council for the Arts, 150 Elgin St., P.O. Box 1047, Ottawa, Ontario K1P 5V8. (613)566-4414 or (800)263-5588 (within Canada). E-mail: info@canadacouncil.ca. Website: www.canadacouncil.ca.

Manitoba Arts Council, 525-93 Lombard Ave., Winnipeg, Manitoba R3B 3B1. (204)945-2237 or (866)994-2787 (within Manitoba). E-mail: info@artscouncil.mb.ca. Website: www.artscouncil.mb.ca.

New Brunswick Arts Board, 225 King St., Suite 201, Fredericton, New Brunswick E3B 1C3. (506)444-4444 or (866)460-2787. E-mail: online form. Website: www.artsnb.ca.

Newfoundland and Labrador Arts Council, P.O. Box 98, St. John's, Newfoundland A1C
5H5. (709)726-2212 or (866)726-2212 (within Newfoundland). E-mail: nlacmail@
nlac.ca. Website: www.nlac.ca.

Nova Scotia Department of Communities, Culture, and Heritage, 1741 Brunswick St.,
3rd Floor, P.O. Box 456, Stn. Central, Halifax, Nova Scotia B3J 2R5. (902)424-4510.
E-mail: cch@gov.ns.ca. Website: http://cch.novascotia.ca.

Ontario Arts Council, 151 Bloor St. W., 5th Floor, Toronto, Ontario M5S 1T6. (416)961-
1660 or (800)387-0058 (within Ontario). E-mail: info@arts.on.ca. Website: www.
arts.on.ca.

The Prince Edward Island Council of the Arts, 115 Richmond St., Charlottetown, Prince
Edward Island C1A 1H7. (902)368-4410 or (888)734-2784. E-mail: info@peica.ca.
Website: www.facebook.com/peiartscouncil.

Québec Council for Arts & Literature, 79 boul. René-Lévesque Est, 3e étage, Québec G1R
5N5. (418)643-1707 or (800)897-1707. E-mail: info@calq.gouv.qc.ca. Website: www.
calq.gouv.qc.ca.

Saskatchewan Arts Board, 1355 Broad St., Regina, Saskatchewan S4P 7V1. (306)787-4056
or (800)667-7526 (within Saskatchewan). E-mail: info@artsboard.sk.ca. Website:
www.saskartsboard.ca.

Yukon Arts Section, Cultural Services Branch, Dept. of Tourism & Culture, Government
of Yukon, Box 2703, Whitehorse, Yukon Y1A 2C6. (867)667-8589 or (800)661-0408
(within Yukon). E-mail: arts@gov.yk.ca. Website: www.tc.gov.yk.ca/arts.html.

REGIONAL GRANTS & AWARDS

The following opportunities are arranged by state since most of them grant money to art-
ists in a particular geographic region. Because deadlines vary annually, check websites or
call for the most up-to-date information.

California

Flintridge Foundation Awards for Visual Artists, 236 W. Mountain St., Suite 106, Pasa-
dena CA 91103. (626)449-0839 or (800)303-2139. Website: www.flintridge.org. For
artists in California, Oregon, and Washington only.

James D. Phelan Art Awards, Kala Art Institute, Don Porcella, 1060 Heinz Ave., Berkeley
CA 94710. (510)549-2977. E-mail: kala@kala.org. Website: www.kala.org. For art-
ists born in California only.

Connecticut

Martha Boschen Porter Fund, Inc., 145 White Hallow Rd., Sharon CT 06064. E-mail:
grants@berkshiretaconic.org. Website: www.berkshiretaconic.org/bReceivebNon

profitsIndividuals/SearchApplyforGrants/MarthaBoschenPorterFund.aspx. For artists in northwestern Connecticut, western Massachusetts, and adjacent areas of New York (except New York City).

Idaho

Betty Bowen Memorial Award, c/o Seattle Art Museum 1300 First Ave., Seattle, WA 98101. (206)654-3131. E-mail: bettybowen@seattleartmuseum.org. Website: www.seattle artmuseum.org/about-sam/art-submissions#bet. For artists in Washington, Oregon and Idaho only.

Illinois

Illinois Arts Council, Individual Artists Support Initiative, James R. Thompson Center, 100 W. Randolph, Suite 10-500, Chicago IL 60601. (312)814-6750. E-mail: iac.info@ illinois.gov. Website: www.arts.illinois.gov/grants-programs/funding-programs/ individual-artist-support. For Illinois artists only.

Kentucky

Kentucky Foundation for Women Grants Program, 1215 Heyburn Bldg., 332 W. Broadway, Louisville KY 40202. (502)562-0045 or (866)654-7564. E-mail: team@kfw.org. Website: www.kfw.org/grants. For female artists living in Kentucky only.

Massachusetts

See **Martha Boschen Porter Fund, Inc.,** under Connecticut.

New York

A.I.R. Gallery Fellowship Program, 155 Plymouth St., Brooklyn NY 11201. (212)255-6651. E-mail: info@airgallery.org. Website: www.airgallery.org. For female artists from New York City metro area only.

Arts & Cultural Council for Greater Rochester, 31 Prince St., Rochester NY 14615. (585)473-4000. E-mail: artsandculturalcouncil@artsrochester.org. Website: www. artsrochester.org.

Constance Saltonstall Foundation for the Arts Grants and Fellowships, 435 Ellis Hollow Creek Rd., Ithaca NY 14850. (607)539-3146. E-mail: artscolony@saltonstall.org. Website: www.saltonstall.org. For artists in the central and western counties of New York.

See **Martha Boschen Porter Fund, Inc.,** under Connecticut.

New York Foundation for the Arts: Artists' Fellowships, 20 Jay St., 7th Floor, Brooklyn NY 11201. (212)366-6900. E-mail: fellowships@nyfa.org. Website: www.nyfa.org. For New York artists only.

Oregon
See **Betty Bowen Memorial Award,** under Idaho.
See **Flintridge Foundation Awards for Visual Artists,** under California.

Pennsylvania
Leeway Foundation—Philadelphia, Pennsylvania Region, The Philadelphia Building, 1315 Walnut St., Suite 832, Philadelphia PA 19107. (215)545-4078. E-mail: info@leeway. org. Website: www.leeway.org. For female artists in Philadelphia only.

Texas
Individual Artist Grant Program—Houston, Texas, Houston Arts Alliance, 3201 Allen Pkwy., Suite 250, Houston TX 77019-1800. (713)527-9330. E-mail: online form. Website: www.houstonartsalliance.com. For Houston artists only.

Washington
See **Betty Bowen Memorial Award,** under Idaho.
See **Flintridge Foundation Awards for Visual Artists,** under California.

PROFESSIONAL ORGANIZATIONS

American Photographic Artists, National, 369 Montezuma Ave., #567, Santa Fe NM 87501. Membership office: 2055 Bryant St., San Francisco, CA 94110. E-mail: membershiprep@apanational.com. Website: www.apanational.org

American Photographic Artists, Atlanta, 2221-D Peachtree Rd. NE, Suite #553, Atlanta GA 30309. (888)889-7190, ext. 50. E-mail: info@apaatlanta.com. Website: www.apaatlanta.com

American Photographic Artists, Chicago, 1901 Grove Ave., Berwyn IL 60402. (312)834-4563. E-mail: apamidwest@gmail.com. Website: www.chicago.apanational.org

American Photographic Artists, New York, 419 Lafayette, 2nd Floor, New York NY 10011. (212)807-0399. E-mail: jocelyn@apany.com. Website: www.ny.apanational.org

American Photographic Artists, San Diego, E-mail: membershiprep@apanational.com. Website: www.apasd.org

American Photographic Artists, San Francisco, 2055 Bryant St., San Francisco CA 94110. (415)882-9780. E-mail: info@apasf.com. Website: www.sf.apanational.org

American Society of Media Photographers (ASMP), 150 N. Second St., Philadelphia, PA 19106. (215)451-2767. Website: www.asmp.org

American Society of Picture Professionals (ASPP), 201 E. 25th St., #11c, New York NY 10010. (516)500-3686. Website: www.aspp.com

The Association of Photographers, 49/50 Eagle Wharf Rd., London N1 7ED United Kingdom. (44) (020) 7739-6669. E-mail: info@aophoto.co.uk. Website: www.the-aop.org

British Institute of Professional Photography (BIPP), The Coach House, The Firs, High St., Whitchurch, Aylesbury, Buckinghamshire HP22 4SJ United Kingdom.

(44) (012) 9671-8530. Fax: (44) (012) 9633-6367. E-mail: membership@bipp.com. Website: www.bipp.com

Canadian Association for Photographic Art, Box 357, Logan Lake British Columbia V0K 1W0, Canada. E-mail: capa@capacanada.ca. Website: www.capacanada.ca

Canadian Association of Journalists, Box 745, Cornwall Ontario K6H 5T5 Canada. E-mail: online form. Website: www.caj.ca

The Canadian Association of Professional Image Creators, 720 Spadina Ave., Suite 202, Toronto Ontario M5S 2T9, Canada. (416)462-3677 or (888)252-2742. Fax: (416)929-5256. E-mail: info@capic.org. Website: www.capic.org

The Center for Photography at Woodstock (CPW), 59 Tinker St., Woodstock NY 12498. (845)679-9957. Fax: (845)679-6337. E-mail: info@cpw.org. Website: www.cpw.org

Digital Media Licensing Association (DMLA), 3165 S. Alma School Rd., #29-261, Chandler AZ 85248-3760. (714)815-8427. Fax: (949)679-8224. E-mail: execdirector@pacaoffice.org. Website: www.pacaoffice.org

Evidence Photographers International Council, Inc. (EPIC), 229 Peachtree St. NE, Suite 2200, Atlanta GA 30303. (866)868-3742. Fax: (404)614-6406. E-mail: csc@evidence photographers.com. Website: www.evidencephotographers.com

The Imaging Alliance, 7918 Jonas Brand Dr., Suite 300, McLean VA 22102. (703)665-4416 Fax: (703)506-3266. Website: www.theimagingalliance.com

International Association of Panoramic Photographers, E-mail: online form. Website: www.panoramicassociation.org

International Center of Photography (ICP), 1114 Avenue of the Americas, New York NY 10036. (212)857-0003. E-mail: membership@icp.org. Website: www.icp.org

The Light Factory (TLF), 1817 Central Ave., Charlotte NC 28205. (704)333-9755. E-mail: info@lightfactory.org. Website: www.lightfactory.org

National Press Photographers Association (NPPA), 3200 Croasdaile Dr., Suite 306, Durham NC 27705. (919)383-7246. Fax: (919)383-7261. E-mail: info@nppa.org. Website: www.nppa.org

The North American Nature Photography Association (NANPA), 6382 Charleston Rd., Alma IL 62807. (618)547-7616. Fax: (618)547-7438. E-mail: info@nanpa.org. Website: www.nanpa.org

Photographic Society of America (PSA), 8241 S. Walker Ave., Suite 104, Oklahoma City OK 73139. (405)843-1437. E-mail: online form. Website: www.psa-photo.org

Professional Photographers of America (PPA), 229 Peachtree St. NE, Suite 2200, Atlanta GA 30303. (404)522-8600 or (800)786-6277. Fax: (404)614-6400. E-mail: online form. Website: www.ppa.com

Professional Photographers of Canada (PPOC), 209 Light St., Woodstock, Ontario N45 6H6 Canada. (519)537-2555 or (888)643-7762. Fax: (888)831-4036. Website: www.ppoc.ca

The Royal Photographic Society, Fenton House, 122 Wells Rd., Bath BA2 3AH United Kingdom. (44) (012) 2532-5733. E-mail: reception@rps.org. Website: www.rps.org

Society for Photographic Education, 2530 Superior Ave., #403, Cleveland OH 44114. (216)622-2733. Fax: (216)622-2712. E-mail: online form. Website: www.spenational .org

Volunteer Lawyers for the Arts, 1 E. 53rd St., 6th Floor, New York NY 10022. (212)319-2787, ext. 1. Fax: (212)752-6575. E-mail: vlany@vlany.org. Website: www.vlany.org

Wedding & Portrait Photographers International (WPPI), 85 Broad St., 11th Floor, New York NY 10004. Website: www.wppionline.com

The White House News Photographers Association (WHNPA), 7119 Ben Franklin Station, Washington DC 20044-7119. Website: www.whnpa.org

PUBLICATIONS

PERIODICALS

Advertising Age: www.adage.com

Weekly magazine covering marketing, media and advertising.

Adweek: www.adweek.com

Weekly magazine covering advertising agencies.

American Photo: www.americanphotomag.com

Monthly magazine emphasizing the craft and philosophy of photography.

ASMP Bulletin: www.asmp.org

Newsletter of the American Society of Media Photographers published five times/ year. Subscription with membership.

Communication Arts: www.commarts.com

Trade journal for visual communications.

Editor & Publisher: www.editorandpublisher.com

Monthly magazine covering latest developments in journalism and newspaper production. Publishes an annual directory issue listing syndicates and another directory listing newspapers.

Folio: www.foliomag.com

Monthly magazine featuring trends in magazine circulation, production, and editorial.

Graphis: www.graphis.com

Magazine for the visual arts.

HOW: www.howdesign.com

 Bimonthly magazine for the design industry.

News Photographer: www.nppa.org

 Monthly news tabloid published by the National Press Photographers Association. Subscription with membership.

Outdoor Photographer: www.outdoorphotographer.com

 Monthly magazine emphasizing equipment and techniques for shooting in outdoor conditions.

Photo District News: www.pdnonlinc.com

 Monthly magazine for the professional photographer.

PhotoSource International: www.photosource.com

 This company publishes several helpful newsletters, including PhotoLetter, Photo-Daily, and PhotoStockNotes.

Popular Photography: www.popphoto.com

 Monthly magazine specializing in technical information for photography.

Print: www.printmag.com

 Bimonthly magazine focusing on creative trends and technological advances in illustration, design, photography, and printing.

Professional Artist: www.professionalartistmag.com

 Monthly magazine listing galleries reviewing portfolios, juried shows, percent-for-art programs, scholarships, and art colonies.

Professional Photographer: www.ppmag.com

 Professional Photographers of America's monthly magazine emphasizing technique and equipment for working photographers.

Publishers Weekly: www.publishersweekly.com

 Weekly magazine covering industry trends and news in book publishing; includes book reviews and interviews.

Rangefinder: www.rangefinderonline.com

 Monthly magazine covering photography technique, products, and business practices.

Selling Stock: www.selling-stock.com

 Newsletter for stock photographers; includes coverage of trends in business practices such as pricing and contract terms.

Shutterbug: www.shutterbug.com

 Monthly magazine of photography news and equipment reviews.

BOOKS & DIRECTORIES

ASMP Professional Business Practices in Photography, 7th edition, American Society of Media Photographers. Handbook covering all aspects of running a photography business.

Bacon's Media Directory, Cision. Contains information on all daily and community newspapers in the U.S. and Canada, and 24,000 trade and consumer magazines, newsletters, and journals.

The Big Picture: The Professional Photographer's Guide to Rights, Rates & Negotiation by Lou Jacobs Jr., Writer's Digest Books, F+W, a Content + eCommerce Company. Essential information on understanding contracts, copyrights, pricing, licensing and negotiation.

Blogging for Creatives: How Designers, Artists, Crafters and Writers Can Blog to Make Contacts, Win Business, and Build Success by Robin Houghton, HOW Books, F+W, a Content + eCommerce Company. Approachable guide to the blogosphere, complete with hundreds of tips, tricks and motivational stories from artistic bloggers.

Business and Legal Forms for Photographers, 4th edition by Tad Crawford, Allworth Press. Negotiation book with thirty-four forms for photographers.

The Business of Photography: Principles and Practices by Mary Virginia Swanson, available through her website (www.mvswanson.com) or by e-mailing Lisa@mvswanson.com.

The Business of Studio Photography: How to Start and Run a Successful Photography Studio, 3rd edition by Edward R. Lilley, Allworth Press. A complete guide to starting and running a successful photography studio.

Children's Writer's & Illustrator's Market, Writer's Digest Books, F+W, a Content + eCommerce Company. Annual directory including photo needs of book publishers, magazines, and multimedia producers in the children's publishing industry.

Color Confidence: The Digital Photographer's Guide to Color Management, 2nd Edition. by Tim Grey, Wiley.

Color Management for Photographers: Hands-On Techniques for Photoshop Users by Andrew Rodney, Focal Press.

Creative Careers in Photography: Making a Living With or Without a Camera by Michal Heron, Allworth Press.

Digital Stock Photography: How to Shoot and Sell by Michal Heron, Allworth Press.

How to Grow as a Photographer: Reinventing Your Career by Tony Luna, Allworth Press.

How to Succeed in Commercial Photography: Insights From a Leading Consultant by Selina Maitreya, Allworth Press.

L.A. 411, 411 Publishing. Music industry guide, including record labels.

Legal Guide for the Visual Artist, 5th edition by Tad Crawford, Allworth Press. The author, an attorney, offers legal advice for artists and includes forms dealing with copyright, sales, taxes, etc.

Licensing Photography by Richard Weisgrau and Victor S. Perlman, Allworth Press.

Literary Market Place, Information Today, Inc. Directory that lists book publishers and other book publishing industry contacts. Available online at literarymarketplace. com/lmp/us/index_us.asp.

O'Dwyer's Directory of Public Relations Firms, J.R. O'Dwyer Company, available through website (www.odwyerpr.com). Annual directory listing public relations firms, indexed by specialties.

The Photographer's Guide to Copyright, American Society of Media Photographers.

The Photographer's Guide to Marketing and Self-Promotion, 4th edition by Maria Piscopo, Allworth Press. Marketing guide for photographers.

The Photographer's Market Guide to Building Your Photography Business, 2nd edition by Vik Orenstein, Writer's Digest Books, F+W, a Content + eCommerce Company. Practical advice for running a profitable photography business.

Photo Portfolio Success: A Guide to Submitting and Selling Your Photographs by John Kaplan, Writer's Digest Books, F+W, a Content + eCommerce Company.

Pricing Photography: The Complete Guide to Assignment & Stock Prices, 3rd Edition by Michal Heron and David MacTavish, Allworth Press.

The Professional Photographer's Legal Handbook by Nancy E. Wolff, Allworth Press.

Profitable Photography in the Digital Age: Strategies for Success by Dan Heller, Allworth Press. By explaining how business is done now, this book helps photographers understand what it takes to sell, deliver, and compete in today's market.

Real World Color Management: Industrial-Strength Production Techniques, 2nd edition by Bruce Fraser, Chris Murphy, and Fred Bunting, Peachpit Press.

Sell & Re-sell Your Photos, 6th edition by Rohn Engh and Mikael Karlsson, North Light Books, F+W, a Content + eCommerce Company. Revised edition of the classic volume on marketing your own stock.

Selling Your Photography: How to Make Money in New and Traditional Markets by Richard Weisgrau, Allworth Press.

Shooting & Selling Your Photos by Jim Zuckerman, Writer's Digest Books, F+W, a Content + eCommerce Company.

Songwriter's Market, Writer's Digest Books, F+W, a Content + eCommerce Company. Annual directory listing record labels.

Standard Rate and Data Service (SRDS), Kantar Media. Directory listing magazines and their advertising rates. Available online at kantarmedia.com/us/our-solutions /mediaplanning-tools/srds-media-planning-platform/srds-online-databases.

Starting Your Career as a Freelance Photographer by Tad Crawford, Allworth Press.

Starting Your Career as a Photo Stylist by Susan Linnet Cox, Allworth Press. This invaluable career manual explores the numerous directions a career in photo styling can take.

Workbook, Scott & Daughters Publishing. Numerous resources for the graphic arts industry. Also available online at workbook.com.

Writer's Market, Writer's Digest Books, F+W, a Content + eCommerce Company. Annual directory listing markets for freelance writers. Many listings include photo needs and payment rates.

WEBSITES

PHOTOGRAPHY BUSINESS

The Alternative Pick www.altpick.com
Copyright Website www.copyrightwebsite.com
APA/EP: Editorial Photographers www.editorialphoto.com
Learnhybrid.pro www.learnhybrid.pro
Photographers Black Book www.photographersblackbook.com
Small Business Administration www.sba.gov

MAGAZINE AND BOOK PUBLISHING

American Journalism Review's News Links www.ajr.org
Bookwire www.bookwire.com

STOCK PHOTOGRAPHY

PhotoSource International www.photosource.com
Selling Stock www.selling-stock.com
The Stockphoto Network www.stockphoto.net

ADVERTISING PHOTOGRAPHY

Advertising Age www.adage.com
Adweek, Mediaweek and Brandweek www.adweek.com
Communication Arts Magazine www.commarts.com

FINE ART PHOTOGRAPHY

Art Deadlines List www.artdeadlineslist.com
TheArtList.com www.theartlist.com
Art-Support www.art-support.com
Mary Virginia Swanson www.mvswanson.com

PHOTOJOURNALISM

The Digital Journalist www.digitaljournalist.org
Foto8 www.foto8.com
National Press Photographers Association www.nppa.org

MAGAZINES

Aperture www.aperture.org
Black & White www.bandwmag.com
Blind Spot www.blindspot.com
British Journal of Photography www.bjp-online.com
LensWork www.lenswork.com
Photo District News www.pdnonline.com
Photograph Magazine photographmag.com
The Photo Review www.photoreview.org
Popular Photography www.popphoto.com
Professional Artist www.professionalartistmag.com
Shots Magazine www.shotsmag.com
View Camera www.viewcamera.com
Visual Studies Workshop www.vsw.org

E-ZINES

The following publications exist online only. Some offer opportunities for photographers to post their personal work.
The American Museum of Photography www.photographymuseum.com
Apogee Photo www.apogeephoto.com
Art Business News www.artbusinessnews.com
Art in Context www.artincontext.org
Art-Support www.art-support.com
The Digital Journalist www.digitaljournalist.org
En Foco www.enfoco.org
Fabfotos www.fabfotos.com

Foto8 www.foto8.com

Fotophile www.fotophile.com

Musarium www.musarium.com

One World Journeys www.oneworldjourneys.com

PhotoArts www.photoarts.com

PhotoLinks www.photolinks.com

Photoworkshop.com www.photoworkshop.com

Picture Projects www.picture-projects.com

PixelPress www.pixelpress.org

TakeGreatPictures.com www.takegreatpictures.com

Zone Zero www.zonezero.com

TECHNICAL

BetterPhoto.com® www.betterphoto.com

Learnhybrid.pro www.learnhybrid.pro

Photo.net www.photo.net

PhotoflexLightingSchool® www.photoflex.com/lessons

The Spruce www.thespruce.com/photography-4127416

Wilhelm Imaging Research www.wilhelm-research.com

HOW-TO

Adobe Tutorials helpx.adobe.com/learning.html

Digital Photography Review www.dpreview.com

Fred Miranda www.fredmiranda.com/forum/index.php

Imaging Resource www.imaging-resource.com

Lone Star Digital www.lonestardigital.com

Photography Review www.photographyreview.com

Steve's Digicams www.steves-digicams.com

GLOSSARY

///

Absolute-released images. Any images for which signed model or property releases are on file and immediately available. For working with stock photo agencies that deal with advertising agencies, corporations, and other commercial clients, such images are absolutely necessary to sell usage of images. Also see *Model release*, *Property release*.

Acceptance (payment on). The buyer pays for certain rights to publish a picture at the time it is accepted, prior to its publication.

Agency promotion rights. Stock agencies request these rights in order to reproduce a photographer's images in promotional materials such as catalogs, brochures, and advertising.

Agent. A person who calls on potential buyers to present and sell existing work or obtain assignments for a client. A commission is usually charged. Such a person may also be called a photographer's rep.

All rights. A form of rights often confused with work for hire. Identical to a buyout, this typically applies when the client buys all rights or claim to ownership of copyright, usually for a lump sum payment. This entitles the client to unlimited, exclusive usage and usually with no further compensation to the creator. Unlike work for hire, the transfer of copyright is not permanent. A time limit can be negotiated, or the copyright ownership can run to the maximum of 35 years.

Alternative processes. Printing processes that do not depend on the sensitivity of silver to form an image. These processes include cyanotype and platinum printing.

Archival. The storage and display of photographic negatives and prints in materials that are harmless to them and prevent fading and deterioration.

Artist's statement. A short essay, no more than a paragraph or two, describing a photographer's mission and creative process. Most galleries require photographers to provide an artist's statement.

Assign (designated recipient). A third-party person or business to which a client assigns or designates ownership of copyrights that the client purchased originally from a creator such as a photographer. This term commonly appears on model and property releases.

Assignment. A definite OK to take photos for a specific client with mutual understanding as to the provisions and terms involved.

Assignment of copyright, rights. The photographer transfers claim to ownership of copyright over to another party in a written contract signed by both parties.

Audiovisual (AV). Materials such as filmstrips, motion pictures, and overhead transparencies which use audio backup for visual material.

Automatic renewal clause. In contracts with stock photo agencies, this clause works on the concept that every time the photographer delivers an image, the contract is automatically renewed for a specified number of years. The drawback is that a photographer can be bound by the contract terms beyond the contract's termination and be blocked from marketing the same images to other clients for an extended period of time.

Avant garde. Photography that is innovative in form, style, or subject matter.

Biannual. Occurring twice a year. Also see *Semiannual*.

Biennial. Occurring once every two years.

Bimonthly. Occurring once every two months.

Bio. A sentence or brief paragraph about a photographer's life and work, sometimes published along with photos.

Biweekly. Occurring once every two weeks.

Blurb. Written material appearing on a magazine's cover describing its contents.

Buyout. A form of work for hire where the client buys all rights or claim to ownership of copyright, usually for a lump sum payment. Also see *All rights, Work for hire*.

Caption. The words printed with a photo (usually directly beneath it), describing the scene or action.

CCD. Charged coupled device. A type of light detection device, made up of pixels, that generates an electrical signal in direct relation to how much light strikes the sensor.

CD-ROM. Compact disc read-only memory. Non-erasable electronic medium used for digitized image and document storage and retrieval on computers.

Chrome. A color transparency, usually called a slide.

Cibachrome. A photo printing process that produces fade-resistant color prints directly from color slides.

Clips. See *Tearsheet.*

CMYK. Cyan, magenta, yellow, and black. Refers to four-color process printing.

Color correction. Adjusting an image to compensate for digital input and output characteristics.

Commission. The fee (usually a percentage of the total price received for a picture) charged by a photo agency, agent or gallery for finding a buyer and attending to the details of billing, collecting, etc.

Composition. The visual arrangement of all elements in a photograph.

Compression. The process of reducing the size of a digital file, usually through software. This speeds processing, transmission times, and reduces storage requirements.

Consumer publications. Magazines sold on newsstands and by subscription that cover information of general interest to the public, as opposed to trade magazines, which cover information specific to a particular trade or profession. See *Trade magazine.*

Contact sheet. A sheet of negative-size images made by placing negatives in direct contact with the printing paper during exposure. They are used to view an entire roll of film on one piece of paper.

Contributor's copies. Copies of the issue of a magazine sent to photographers in which their work appears.

Copyright. The exclusive legal right to reproduce, publish, and sell the matter and form of an artistic work.

Cover letter. A brief business letter introducing a photographer to a potential buyer. A cover letter may be used to sell stock images or solicit a portfolio review. Do not confuse cover letter with query letter.

C-print. Any enlargement printed from a negative.

Credit line. The byline of a photographer or organization that appears below or beside a published photo.

Cutline. See *Caption.*

Day rate. A minimum fee that many photographers charge for a day's work, whether a full day is spent on a shoot or not. Some photographers offer a half-day rate for projects involving up to a half-day of work.

Demo. A sample reel of film or sample videocassette that includes excerpts of a filmmaker's or videographer's production work for clients.

Density. The blackness of an image area on a negative or print. On a negative, the denser the black, the less light that can pass through.

Digital camera. A filmless camera system that converts an image into a digital signal or file.

DPI. Dots per inch. The unit of measure used to describe the resolution of image files, scanners, and output devices. How many pixels a device can produce in one inch.

DSLR. Digital single-lens reflex camera. Combines the parts of a single-lens reflex camera (SLR) and a digital camera back, replacing the photographic film. The reflex design scheme differentiates a DSLR from other digital cameras.

Electronic submission. A submission made by modem or on computer disk, CD-ROM, or other removable media.

Emulsion. The light-sensitive layer of film or photographic paper.

Enlargement. An image that is larger than its negative, made by projecting the image of the negative onto sensitized paper.

Exclusive property rights. A type of exclusive rights in which the client owns the physical image, such as a print, slide, film reel, or videotape. A good example is when a portrait is shot for a person to keep, while the photographer retains the copyright.

Exclusive rights. A type of rights in which the client purchases exclusive usage of the image for a negotiated time period, such as one, three, or five years. May also be permanent. Also see *All rights*, *Work for hire*.

Fee-plus basis. An arrangement whereby a photographer is given a certain fee for an assignment—plus reimbursement for travel costs, model fees, props, and other related expenses incurred in completing the assignment.

File format. The particular way digital information is recorded. Common formats are TIFF and JPEG.

First rights. The photographer gives the purchaser the right to reproduce the work for the first time. The photographer agrees not to permit any publication of the work for a specified amount of time.

Format. The size or shape of a negative or print.

Four-color printing, four-color process. A printing process in which four primary printing inks are run in four separate passes on the press to create the visual effect of a full-color photo, as in magazines, posters, and various other print media. Four separate negatives of the color photo—shot through filters—are placed identically (stripped) and exposed onto printing plates, and the images are printed from the plates in four ink colors.

GIF. Graphics interchange format. A graphics file format common to the Internet.

Glossy. Printing paper with a great deal of surface sheen. The opposite of matte.

Hard copy. Any kind of printed output, as opposed to display on a monitor.

Honorarium. Token payment—small amount of money and/or a credit line and copies of the publication.

Image resolution. An indication of the amount of detail an image holds. Usually expressed as the dimension of the image in pixels and the color depth each pixel has. Example: a 640×480, 24-bit image has higher resolution than a 640×480, 16-bit image.

IRC. International reply coupon. IRCs are used with self-addressed envelopes instead of stamps when submitting material to buyers located outside a photographer's home country.

JPEG. Joint photographic experts group. One of the more common digital compression methods that reduces file size without a great loss of detail.

Licensing/leasing. A term used in reference to the repeated selling of one-time rights to a photo.

Manuscript. A typewritten document to be published in a magazine or book.

Matte. Printing paper with a dull, nonreflective surface. The opposite of glossy.

Metadata. Information written into a digital photo file to identify who owns it, copyright and contact information, what camera created the file, exposure information, and descriptive keywords, making the file searchable on the Internet.

Model release. Written permission to use a person's photo in publications or for commercial use.

Multi-image. A type of slide show that uses more than one projector to create greater visual impact with the subject. In more sophisticated multi-image shows, the projectors can be programmed to run by computer for split-second timing and animated effects.

Multimedia. A generic term used by advertising, public relations, and audiovisual firms to describe productions using more than one medium together—such as slides and full-motion, color video—to create a variety of visual effects.

News release. See *Press release.*

No right of reversion. A term in business contracts that specifies once a photographer sells the copyright to an image, a claim of ownership is surrendered. This may be unenforceable, though, in light of the 1989 Supreme Court decision on copyright law. Also see *All rights, Work for hire.*

On spec. Abbreviation for "on speculation." Also see *Speculation.*

One-time rights. The photographer sells the right to use a photo one time only in any medium. The rights transfer back to the photographer on request after the photo's use.

Page rate. An arrangement in which a photographer is paid at a standard rate per page in a publication.

Photo CD. A trademarked, Eastman Kodak-designed digital storage system for photographic images on a CD.

PICT. The saving format for bit-mapped and object-oriented images.

Picture Library. See *Stock photo agency.*

Pixels. The individual light-sensitive elements that make up a CCD array. Pixels respond in a linear fashion. Doubling the light intensity doubles the electrical output of the pixel.

Point-of-purchase (P-O-P), point-of-sale (P-O-S). A term used in the advertising industry to describe in-store marketing displays that promote a product. Typically, these highly-illustrated displays are placed near checkout lanes or counters, and offer tear-off discount coupons or trial samples of the product.

Portfolio. A group of photographs assembled to demonstrate a photographer's talent and abilities, often presented to buyers.

PPI. Pixels per inch. Often used interchangeably with DPI, PPI refers to the number of pixels per inch in an image. See *DPI*.

Press release. A form of publicity announcement that public relations agencies and corporate communications staff people send out to newspapers and TV stations to generate news coverage. Usually this is sent with accompanying photos or videotape materials.

Property release. Written permission to use a photo of private property or public or government facilities in publications or for commercial use.

Public domain. A photograph whose copyright term has expired is considered to be "in the public domain" and can be used for any purpose without payment.

Publication (payment on). The buyer does not pay for rights to publish a photo until it is actually published, as opposed to payment on acceptance.

Query. A letter of inquiry to a potential buyer soliciting interest in a possible photo assignment.

Raw image file. A file format that contains minimally processed data from the digital camera image sensor. Also called digital negatives, raw files save, with minimum loss of information, data obtained from the sensor and the metadata.

Rep. Trade jargon for sales representative. Also see *Agent*.

Resolution. The particular pixel density of an image, or the number of dots per inch a device is capable of recognizing or reproducing.

Résumé. A short written account of one's career, qualifications, and accomplishments.

RGB. An additive color model in which red, green, and blue light are combined to create a variety of colors. Used for the sensing, representation, and display of images on televisions, computers, and other electronic systems.

Royalty. A percentage payment made to a photographer/filmmaker for each copy of work sold.

R-print. Any enlargement made from a transparency.

SAE. Self-addressed envelope.

SASE. Self-addressed, stamped envelope. (Most buyers require a SASE if a photographer wishes unused photos returned to him, especially unsolicited materials.)

Self-assignment. Any project photographers shoot to show their abilities to prospective clients. This can be used by beginning photographers who want to build a portfolio or by photographers wanting to make a transition into a new market.

Self-promotion piece. A printed piece photographers use for advertising and promoting their businesses. These pieces generally use one or more examples of the photographer's best work and are professionally designed and printed to make the best impression.

Semiannual. Occurring twice a year. Also see *Biannual*.

Semigloss. A paper surface with a texture between glossy and matte, but closer to glossy.

Semimonthly. Occurring twice a month.

Serial rights. The photographer sells the right to use a photo in a periodical. Rights usually transfer back to the photographer on request after the photo's use.

Simultaneous submissions. Submission of the same photo or group of photos to more than one potential buyer at the same time.

Speculation. The photographer takes photos with no assurance that the buyer will either purchase them or reimburse expenses in any way, as opposed to taking photos on assignment.

Stock photo agency. A business that maintains a large collection of photos it makes available to a variety of clients such as advertising agencies, calendar firms, and periodicals. Agencies usually retain 40–60 percent of the sales price they collect, and remit the balance to the photographers whose photo rights they've sold.

Stock photography. Primarily the selling of reprint rights to existing photographs rather than shooting on assignment for a client. Some stock photos are sold outright, but most are rented for a limited time period. Individuals can market and sell stock images to individual clients from their personal inventory, or stock photo agencies can market photographers' work for them. Many stock agencies hire photographers to shoot new work on assignment, which then becomes the inventory of the stock agency.

Subsidiary agent. In stock photography, this is a stock photo agency that handles marketing of stock images for a primary stock agency in certain U.S. or foreign markets. These are usually affiliated with the primary agency by a contractual agreement rather than by direct ownership, as in the case of an agency that has its own branch offices.

SVHS. Super VHS. Videotape that is a step above regular VHS tape. The number of lines of resolution in a SVHS picture is greater, thereby producing a sharper picture.

Tabloid. A newspaper about half the page size of an ordinary newspaper that contains many photos and news in condensed form.

Tearsheet. An actual sample of a published work from a publication.

TIFF. Tagged image file format. A common bitmap image format developed by Aldus.

Trade magazine. A publication devoted strictly to the interests of readers involved in a specific trade or profession, such as beekeepers, pilots, or manicurists, and generally available only by subscription.

Transparency. Color film with a positive image, also referred to as a slide.

Unlimited use. A type of rights in which the client has total control over both how and how many times an image will be used. Also see *All rights, Exclusive rights, Work for hire.*

Unsolicited submission. A photograph or photographs sent through the mail that a buyer did not specifically ask to see.

Work for hire. Any work that is assigned by an employer who becomes the owner of the copyright. Stock images cannot be purchased under work-for-hire terms.

World rights. A type of rights in which the client buys usage of an image in the international marketplace. Also see *All rights.*

Worldwide exclusive rights. A form of world rights in which the client buys exclusive usage of an image in the international marketplace. Also see *All rights.*

GEOGRAPHIC INDEX

ILLINOIS

MINNESOTA

MISSISSIPPI

MISSOURI

NORTH CAROLINA

INTERNATIONAL INDEX

WALES

SUBJECT INDEX

AGRICULTURE

ALTERNATIVE PROCESS

ARCHITECTURE

ARTS AND CRAFTS FAIRS

AUTOMOBILES

AVANT GARDE

BABIES/CHILDREN/TEEN

BUSINESS CONCEPTS

CELEBRITIES

CITIES/URBAN

COUPLES

DISASTER

DOCUMENTARY

EDUCATION

ENTERTAINMENT

ENVIRONMENTAL

EROTIC

EVENTS

FAMILIES

FASHION/GLAMOUR

FINE ART

HEALTH/FITNESS/BEAUTY

HISTORICAL/VINTAGE

HOBBIES

HUMOR

LANDSCAPES/SCENES

SUBJECT INDEX

LIFESTYLE

MEDICINE

MILITARY

NUDES/FIGURES

PARENTS

PERFORMING ARTS

PETS

POLITICAL

PORTRAITS

RURAL

SCIENCE

SEASONAL

SENIOR CITIZENS

SPORTS

WILDLIFE

GENERAL INDEX

Ideas. Instruction. Inspiration.

Find the latest issues of *The Artist's Magazine* on newsstands, or visit artistsnetwork.com.

Receive **FREE** downloadable materials when you sign up for our free newsletter at artistsnetwork.com/Newsletter_Thanks.